AMOK FIFTH DISPATCH
Sourcebook of the Extremes of Information

Editor: Stuart Swezey
Assistant Editor: Oscar Arce
Publisher Liaison: Michael Sheppard, Dan Wininger, Kacey Brown, John Alvarez

Cover Design: Kevin Hanley
Book Design and Production: Andrew Brandou, Sunja Park
Additional Production: Christine Palma
Copy Editing: Frank Culbertson, Nick Noyes

ISBN 1-878923-12-9

Amok Books are available to bookstores through our primary distributor: The Subterranean Company,
Box 168, 265 South 5th Street, Monroe, Oregon 97456. Phone: (800) 274-7826. FAX: (503) 847-6018.

UK Distributors: Turnaround Distribution, Unit 3 Olympia Trading Estate, Coburg Road, Wood Green,
London N22 6TZ. Phone: (0181) 829 3000. FAX: 0181 881 5088.

Non-Bookstore Distributors: Last Gasp Distribution, 777 Florida Street, San Francisco, California 94110. Phone:
(415) 824-6636. FAX: (415) 824-1836.

To view the complete Amok Books catalog, please go to the Amok Books web site at www.amokbooks.com.
For individual orders, please contact Book Clearing House, 46 Purdy Street, Harrison, New York 10528.
Phone: (800) 431-1579. FAX: (914) 835-0398. Email: bookch@aol.com.

Amok Books is located at 1764 North Vermont Avenue, Los Angeles, California 90027.
Phone: (323) 663-8618. FAX: (323) 550-8833. Email: publisher@amokbooks.com.

www.amokbooks.com

AMOK FIFTH DISPATCH
SOURCEBOOK OF THE EXTREMES OF INFORMATION

Edited by Stuart Swezey

LOS ANGELES

CONTENTS

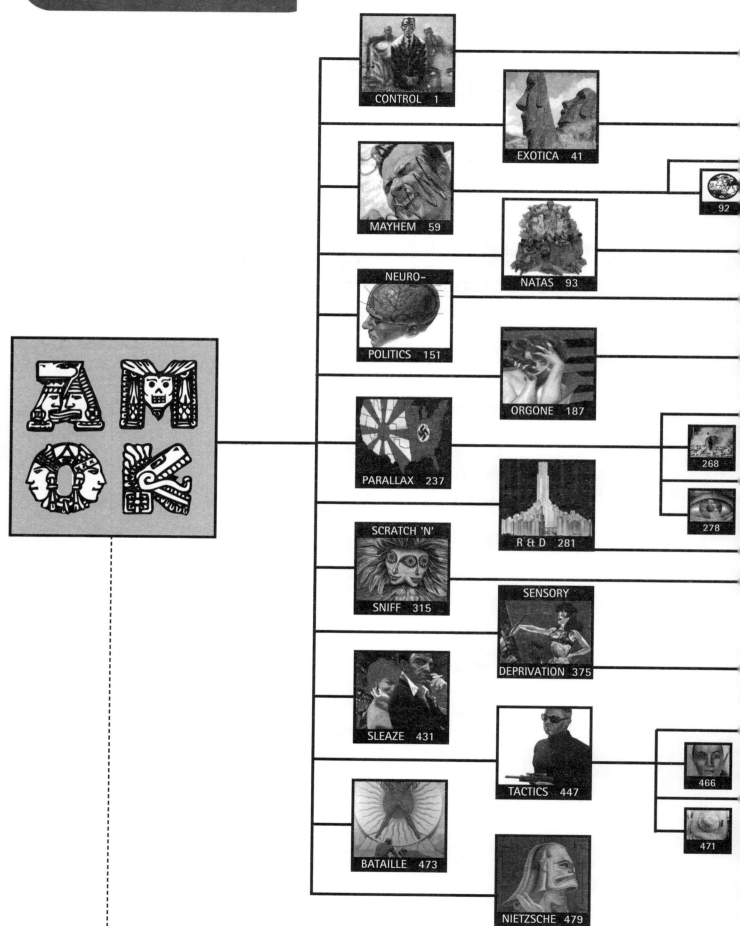

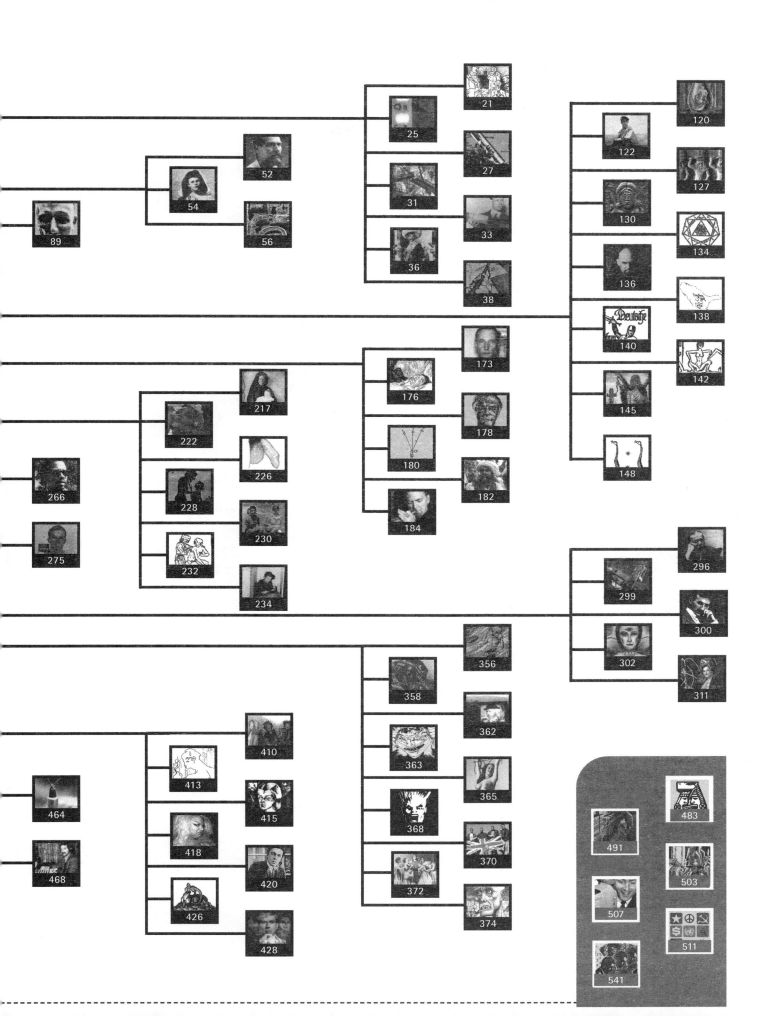

CONTENTS

CONTROL

Aboriginal Peoples: Toward Self Government
Edited by Marie Léger
Using accounts of how indigenous Americans in Brazil, Columbia, Mexico, Nicaragua, and Panama are securing recognition and self-government, this book presents real possibilities for re-possessing territory, and establishing both self-government and multiethnic government. Control of natural resources and land development have become central issues to these negotiations. These recognized rights are very fragile, and are kept alive by struggle and vigilance. **SC**
$19.99 *(PB/190)*

Adventures in Medialand: Behind the News, Beyond the Pundits
Jeff Cohen and Norman Solomon
"This insightful and witty critique of the media's coverage of the news includes: the corporate spin on the news, media hypocrisy and political correctness; the spectrum of debate on TV talk shows."
$11.95 *(PB/272)*

The Aesthetics of Disappearance
Paul Virilio
Examines the "aesthetic" in film, in politics, in war, the philosophy of subjectivity and elsewhere. **AK**
$10.00 *(PB/124)*

Against Empire
Michael Parenti
"Focuses on exposing the agenda and cost of expansion in the world and documents the lies used to justify violent intervention in world politics, considering how economics plays into political decision-making process and providing a strong case for considering past wrongs and future changes."
$12.95 *(PB/217)*

Alcoholics Anonymous: Cults or Cure
Charles Bufe
Incisive treatment of the religious origins of AA, its cultish aspects, effectiveness and secular self-help alternatives.
AK
$9.95 *(PB/192)*

Amway: The Cult of Free Enterprise
Stephen Butterfield
A hilarious and thorough account of the Amway experience written by a disillusioned "distributor" who is also a professor of English. This is delicious armchair sociology, manna for the conspiracy theorist, and worth the attention of anyone who has sat next to an Excel troglodyte selling pyramid long-distance phone service on a cross-country flight. **HJ**
$14.00 *(PB/186)*

. . . And the truth shall set you free
David Icke
Modestly describing itself as "the most explosive book of the 20th century," *. . . And the truth shall set you free* is the most recent evidence of a certain faction of die-hard New Agers' growing fascination with the anti-Trilateral Commission/Illuminati obsessions that were once the exclusive and much-ridiculed domain of the Birchers. That this ground has all been covered extensively in books like *Tragedy and Hope* and *None Dare Call It Conspiracy* and weekly in *The Spotlight* newspaper does not faze author

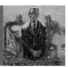

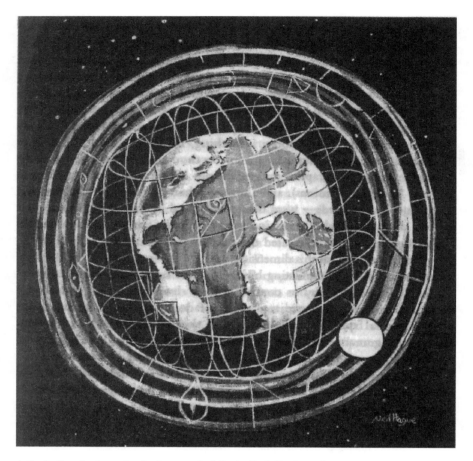

Is the Earth a vibratory prison? — from . . . And the truth shall set you free

and former British soccer player David Icke in the least. That some of Icke's New World Order/banking/secret society muckraking might have some solid basis in fact makes his unsurpassed "good-vibey" self-glorification no less offensive. In author Icke's memorable words, "People of Planet Earth. It is wakey, wakey time." **SS**
$21.95 *(PB/518/Illus)*

Architectures of Excess: Cultural Life in the Information Age
Jim Collins
Something for the high-bandwidth student of cultural criticism and the neo-Luddite as well. Collins follows postmodernism to the next level, charting its evolution from the "terror of pure excess to the manipulation of available information" to its domestication into popular, functional, "safe" forms

such as television, film, architecture, design and fiction. What's interesting is that to do this, the author conducts a parallel study: To understand how the technological overload has really affected the cultural landscape he extends the current discussion on techno-textuality which includes "cyberpunk science fiction, digital sampling, hypertext, virtual reality," and he traces their effect on the ponderous traditional process-oriented, low-tech forms of production favored by purists. **CP**
$16.95 *(PB/256)*

Art of the Motor
Paul Virilio
Virilio is a philosopher/theorist who writes clearly and thinks idiosyncractically regarding how information is digested and distributed through electronic, television, radio and computer technology. The journey is no

longer critical, but the arrival is all too crucial. For example, Virilio clearly maps out how the Gulf War as seen by the outside viewer is nothing more than a video game. Technology has not only changed the world, but through modern speed of transportation and electronic media, it has buried the old by rewriting the past. Information is no longer content, but it is speed itself that is the content. **TB**
$15.95 *(PB/184)*

The Art of War
Sun-Tzu
Battle plans suitable for any conquest, first etched out 2,400 years ago in China by a chief military strategist for the state of Wu. Popular today with corporate America, and here's why—it's the New World Order in a nutshell. "Once this overlord's forces invade a large country, its legions will be incapable of assembly; when his omnipotence engulfs the enemies, their alliances will be incapable of forming. By competing for worldwide alliances and developing worldwide influence, an overlord will thereby give rein to his ambitions, and his omnipotence can engulf his enemies: thus, their city may be occupied and their country toppled." Based on manuscripts recently discovered in Linyi, China, that predate all previous texts by 1,000 years. **GR**
$10.00 *(PB/299)*

Behind the Silicon Curtain: The Seductions of Work in a Lonely Era
Dennis Hayes
"Explores the alarming silence about toxic Orwellian 'clean' rooms and why unions don't organize their workers; how the work-centered code of the new professional predisposes an entire generation to self-serving and self-destructive lifestyle enclaves; why the computer worker is eminently corruptible by technology, despite the 'cyberpunk' antiauthoritarian trappings of teenage hackers. Isolated by structured programming techniques, and at military sites by a gulag of security clearances, computer workers ignore the social implications of their work."
$10.00 *(PB/215)*

Beyond Hypocrisy: Decoding the News in an Age of Propaganda
Edward S. Herman with cartoons by Matt Wuerker
Satirical essays, cartoons and a lexicon of

double-speak terms used by the U.S. government, media and corporations. **AK**
$14.00 *(PB/240/Illus)*

Beyond Jonestown: Sensitivity Training and the Cult of Mind Control
Ed Diekmann Jr.
Sensitivity training as Zionist brainwashing tool, with links to Esalen, Jonestown, Synanon, S.I. Hayakawa, and the B'nai B'rith!
$7.95 *(PB/191/Illus)*

Beyond the War on Drugs: Overcoming a Failed Public Policy
Steven Wisotsky
"For seven decades, the American Government has been waging a War on Drugs. Seemingly, this war has received the enthusiastic support of the American people who have chosen to vote into office politicians promising to prosecute it vigorously. . . . In this exhaustively, indeed masterfully documented study, professor Wisotsky demonstrates the failure, on a truly gigantic scale, of the American people's effort to deprive themselves of the drugs so many of them want."—Thomas Szasz
$16.95 *(PB/279)*

Big Sister Is Watching You
Texe Marrs
"Spawned during the '60s in the age of the Beatles, gurus, LSD and hippies, they are the misfits of society. But now the misfits are in charge. They are the feminist vultures who flew over the cuckoo's nest." Rev. Marrs, filled to overflowing with blessings of the Spirit, recounts the malevolent escapades of the Gals of the Clinton administration—"Hillary's Hellcats," as he calls them: Donna Shalala, Janet Reno, Ruth Bader Ginsburg and the Mother of Abominations herself, the First Lady. To hear Texe tell it, if she and her hosts aren't running near-naked through the streets demanding that more Americans kill more babies in order to provide raw material for their debauched Wiccan rituals, they're slipping each other tongue and wearing their hair in a suspiciously gender-free manner. The good reverend is troubled equally by Tipper Gore's Deadhead preferences, Joceyln Elders' tendency to refer to herself as a lightning

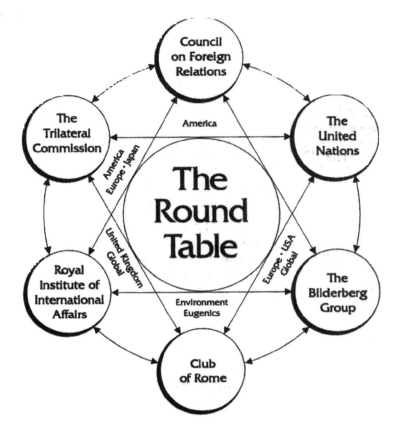

The Round Table — from . . . And the truth shall set you free

bolt—it's Satanic, somehow—and Maya Angelou's poetic reference to her own "impertinent buttocks." Rev. Marrs makes it very clear he'd like to punish them all; the mind reels, imagining how. **JW**
$12.00 *(PB/207/Illus)*

Black Helicopters Over America: Strikeforce for the New World Order
Jim Keith
It's a phenomenon that strangely parallels the sightings of UFOs—reports of hovering military choppers mysteriously firing on civilians, chasing them in their cars, and ferrying mysterious men who gut the carcasses of cows and sheep. According to reports, mostly compiled from militia news sources, it's been going on for more than 20 years. The New World Order is coming, say the witnesses: The government is secretly training the Army to invade the cities and small towns of America, take away all our

guns, and herd us into giant detention camps, all the better to manipulate us in. "There isn't a trick in the racketeering bag that the military gang is blind to. It has 'finger men' to point out enemies, its 'muscle men' to destroy enemies, its 'brain guys' to plan war preparations, and a 'Big Boss,' Supra-nationalistic Capitalism." The author concedes the detention camp theory is going a bit too far, but that the helicopters are real. **GR**
$12.95 *(PB/157/Illus)*

Black Prison Movements/USA
Edited by NOBO
"The Network of Black Organizers (NOBO) has gathered the first contemporary collection of black prison movement voices, in topics ranging from women in prison, the pro and con of parole, behavior modification and human experimentation in prison, Puerto Rican and other political prisoners, to

the prison economic industrial complex."

SC
$14.95 *(PB/185/Illus)*

Bomb the Suburbs
William Upski Wimsatt
From the role of the wiggers to gangsta rap to journalism to break dancing, freight-hopping, black intellectuals and graffiti. Through stories, cartoons, interviews, disses, parodies and original research, *Bomb the Suburbs* challenges the suburban mid-set wherever it is found, in suburbs and corporate headquarters, but also in cities, housing projects and hip-hop itself, debating key questions. **AK**
$8.00 *(PB/112/Illus)*

Burning All Illusions: A Guide to Personal and Political Freedom
David Edwards
"A treatise on what freedom truly means and on the concept that the greatest single obstacle to freedom is the assumption that it has already been attained and need no longer be striven for."
$15.00 *(PB/248)*

Cages of Steel
Ward Churchill and J.J. van der Wall
Documents the treatment of political prisoners in the U.S., the use of physical torture, psychological brainwashing and experiments designed to destroy revolutionary beliefs and prevent ability to organize political action with others. Prisoners, past and present, from the Black Liberation Army, Black Panthers and the American Indian Movement find a voice in this huge anthology of interviews, essays, articles and statements. **AK**
$16.95 *(PB/404)*

Circle of Death: Clinton's Climb to the Presidency
Richard Odom
Comprehensive Clinton (President Bill and Hillary Rodham) true-crime book being used as part of Huntington House's launch of its new conservative conspiracy series—although it is so obviously written and published by people who would have defended Nixon, Reagan and Bush to the death—so, now that the "conspiracy" shoe's on the other foot . . . Fans of the photographic reconstruction of the murder-in-the-park in

the movie *Blow Up* will enjoy the "double statue theory" of White House counsel Vince Foster's body being moved three times—with his hand repositioned downward to jibe with the gun. Also on the Foster front: three alleged suicide notes, alleged romantic involvement with Hillary, and no-longer-secret deals gone sour with Bill. Mena airstrip cocaine smuggling, Whitewater banking and loan scandals, whatever you want—it's all here to keep Bill Clinton on his tightest Trilateral leash—and it is indeed funny to be told for the first time that Bank of Credit and Commerce (BCCI) and Oliver North's Iran-Contra were the fault of that brazen hussy Hillary. **MS**
$10.99 *(PB/224)*

Circle of Intrigue: The Hidden Inner Circle of the Global Illuminati Conspiracy
Texe Marrs
Evangelical update on classic John Birch Society conspiracy paradigm. "Cloaked in mystery and shrouded in secrecy, the Inner Circle is comprised of 10 powerful men. These men meet regularly—at least twice per year—in a secluded location. Their proceedings take place in a locked and sealed suite at a swank and exclusive resort hotel, or at a private estate owned by one of their minions. Their policy decisions and agenda, kept top-secret, result in the most dire and grievous consequences for ordinary citizens. Wars, revolutions, scientific discoveries, diseases, famines, financial booms—and crash-

es!—these are some of the life-giving or life-destroying decisions made at their confidential sessions." Chapters include "Assemblage of the Gods: The Rise of Ten Wise Men of the Inner Circle," "'Ordo Ab Chao'—The Great Work of the Illuminati," "Newt Gingrich and the Illuminati's 'Third Wave' Revolution," "The Meteoric Rise of Wicked Bill Clinton: A Classic Case Study of Illuminati Influence," "The One-Eyed Infidel and the Naked Man on a White Horse" and "Pain, Death and the Armageddon Script."
$12.95 *(PB/303/Illus)*

City of Quartz: Excavating the Future in Los Angeles
Mike Davis
In this already-classic work, Davis, native son of the Southland (Fontana), recounts Los Angeles' past and present as if it had never been told before, or told truly. The chapters on "Fortress L.A." and the LAPD alone are more than worth the price of the book. Through his observation of ongoing trends in the Great American Utopia/Dystopia Davis perceives the future of the city, and implies that it will be exactly as you'd expect it would be—sublime, horrible and ludicrous, all in the same breath. The best book ever written on the City of Angels, period—indispensable. **JW**
$14.00 *(PB/480)*

Clinton's Conspiracy
A. Ralph Epperson
Epperson takes a look at the evidence that

Black Cobra Gunship – from **Black Helicopters Over America**

Bill Clinton believes that there is an evil, international conspiracy at work in the world, which Epperson traces directly back to the Rothschilds. Read the provisions for a New World Order and delve into the seamy mind of Carroll Quigley. **JB**
$8.00 *(PB/74)*

Cocaine Politics: Drugs, Armies and the CIA in Central America
Peter Dale Scott and Jonathan Marshall
"This important, explosive report forcefully argues that the 'war on drugs' is largely a sham as the U.S. Government is one of the world's largest drug pushers. . . . Scott and Marshall call for immediate political action to end Washington's complicity. Their heavily documented book deserves a wide audience."—*Publishers Weekly*
$13.00 *(PB/386)*

Colonia Dignidad
John Dinges
"Despite political changes in that country [Chile], the infamous Colonia Dignidad continues much as before. It's the world's most dangerous cult, the model for Jonestown and other mind-control sects. Led by Paul Schaefer—a fugitive from child molestation charges in Germany—this fascist encampment has long been accused of human-rights violations, torture and murder. A must for anyone interested in Nazis, brainwashing, child abuse, strange religions and strange politics."
$1.50 *(Pamp/10)*

Compromised: Clinton, Bush and the CIA
Terry Reed and John Cummings
What was going on in Mena, Arkansas? How does it relate to Whitewater, the Rostenkowski trial, cocaine and contras? Reed claims to have worked for Ollie North, George Bush and Clinton running guns and coke through Arkansas. **FLA**
$23.95 *(HB/556)*

The Conspirators' Hierarchy: The Story of the Committee of 300
Dr. John Coleman
"The upper level parallel government does not operate from dank basements and secret underground chambers. It places itself in full view in the White House, Congress and in No. 10 Downing Street and

Texe Marrs, author of Circle of Intrigue

the Houses of Parliament. It is akin to those weird and supposedly terrifying 'monster' films, where the monster appears with distorted features, long hair and even longer teeth, growling and slavering all over the place. This is a distraction—the REAL MONSTERS wear business suits and drive to work on Capitol Hill in limousines. These men are IN OPEN VIEW. These men are the servants of the One World Government/New World Order. Like the rapist who stops to offer his victim a friendly ride, he does not LOOK like the monster he is. The same applies to government at all levels. President Bush does not LOOK like a dutiful servant of the upper-level parallel government, but make no mistake about it, he is as much a MONSTER as are those found in horror movies."
$20.00 *(PB/286)*

Critique of Everyday Life: Volume 1
Henri Lefebvre
"Linking philosophical exposition with economics and literary criticism, lyrical meditations with harsh polemics, the 'Critique' (first published in 1947) is an enduringly radical text which marks the invention of what we know as cultural studies."
$19.95 *(PB/312)*

Dark Majesty: The Secret Brotherhood and the Magic of a

Thousand Points of Light
Texe Marrs
It's a free-for-all cage match as good battles evil and both knock themselves unconscious against the turnbuckles. Marrs details in lively if yawn-inducing style the Vast, Shadowy Network that oversees the White House, the CIA, the Vatican, the networks, the banks, and all those annoying satanic day-care centers bringing down property values in your neighborhood. As police forever trot out the same wine-addled skells to flesh out their line-ups, so Marrs offers up his own usual suspects—Bilderbergers, Trilaterals, New Agers and George Bush (whose terror-inducing quality has faded, somewhat, since he so adeptly lost the 1992 election). On occasion the reader wonders if the eternally guileless Marrs might be working too hard to tie up all the loose ends—at one point he quotes humorist Russell Baker in order to prove that Gorbachev was a CIA mole—but truth is true, wherever you find it. "Once you read this book you will know for a certainty—if you don't already know it—that there is a World Conspiracy by a hidden elite. You will just know it. Period." Okay, if you say so, but this isn't Texe at his best. **JW**
$12.00 *(PB/288)*

The De Facto Government of the United States
Charles A. Weisman
The Government of the U.S. has become by design a de facto—that is to say, factual—government, but not a lawful one. Subversive forces have, by legal means, gained control over the government, and all of law enforcement is also under their control, says the author. Weisman claims that proper American law based on biblical precepts has been superseded by "Marxist-Talmudic" law, thanks to traitors like Lincoln and Roosevelt, who were influenced by Jewish bankers and the "subversive groups" they used as fronts. **SC**
$8.00 *(PB/160)*

Death and Taxes: One Citizen's Fight for Freedom Against the IRS
Jeffrey F. Jackson
"The story of Gordon Kahl, a North Dakota farmer who became America's 'most-wanted' fugitive. How had a World War II war

hero become the target of one of the largest manhunts in FBI history? Was Kahl a racist, gun-toting fanatic? Or a victim of an IRS policy of harassing vocal tax protesters into silence to keep the rest of us intimidated? Did then-Arkansas Governor Bill Clinton conspire to cover up the torture and execution of Kahl? *Death and Taxes* follows the documentary trail of Kahl as his body is exhumed for a new autopsy and we interview witnesses to two fiery shoot-outs between Kahl and federal agents." 113 min.
$29.95 *(VIDEO)*

The Decline and Fall of the American Empire
Gore Vidal
A collection of essays previously published in the *Nation*, with a new preface by the author. **AK**
$5.00 *(PB/95)*

Dirty Truths
Michael Parenti
"This eye-opening and entertaining collection of essays investigates media and culture, conspiracy and state power, ideology and political consciousness. Parenti ranges over such crucial issues as free speech, the rise of neofascism, the relationship between wealth and poverty, the 'terrorism' hype, the continuing mystifications about the Kennedy assassination, and the deceptions and injustices of U.S. corporate global dominion."
$13.95 *(PB/232)*

Dossier: The Secret History of Armand Hammer
Edward Jay Epstein
"Hammer was 92 when he died in 1990. A lengthy front page obituary in *The New York Times* lauded him as a successful businessman 'who long sought peace between the United States and the Soviet Union and financed research for a cancer cure.' . . . But the official version of Hammer's life, which incorporated many of the major figures and key events of the 20th century, was in fact a myth, carefully nurtured and embellished for nearly 70 years.

"Aided by newly available sources, Epstein has put together a gripping portrait of a ruthless, audaciously manipulative opportunist whose self-inventions have until now been widely accepted. . . . Hammer's remarkable ascent was set in motion in

1922, when Lenin wrote a secret letter to Stalin designating Hammer as their official 'path' to the resources of American capitalism. In this role as *Homo sovieticus*, which was predicated on the idea that any means, no matter how ruthless or deceptive, was justified if it achieved the desired ends, Hammer created a place for himself on the international stage. How this was accomplished and maintained for the better part of a century is an amazing story."
$30.00 *(HB/420/Illus)*

Drug Warriors and Their Prey: From Police Power to Police State
Richard Lawrence Miller
"The war on drugs is a war against ordinary people; starting with this premise Miller

Armand and Frances Hammer with the Pope — from **Dossier**

analyzes America's drug war in all its social implications, from examples of enforcement strategies which don't work to court systems which threaten victims . . . civil liberties are eroded in the process of conducting a war against drugs: many examples demonstrate this loss."
$24.95 *(HB/192)*

Dumbing Us Down: The Hidden Curriculum of Compulsory Schooling
John Taylor Gatto
"By stars and red checks, by smiles and frowns, prizes, honors and disgraces, I teach kids to surrender their will to the predestined chain of command." **FLA**
$9.95 *(PB/104)*

Earth First!: Environmental Apocalypse
Martha F. Lee
"The radical underground environmental

movement Earth First! emerged in response to rapid commercial development of the American wilderness. Founded by Dave Foreman and conservationist friends in the summer of 1980, Earth First! quickly became a provocative counterculture that ultimately hoped for the fall of industrial civilization. . . . By the close of the decade, its proponents numbered in the thousands. Their insistence that there be no compromise in defense of Mother Earth meant that members became known for insurgent tactics such as arson, tree spiking and disabling heavy road equipment. . . . By the late 1980s, Earth First! was the subject of a major FBI investigation. Foreman's eventual denunciation of civil disobedience caused an inner split. One camp advocated strict biocentrism (an emphasis on maintaining the Earth's full complement of species) and the other focused on environmental and social-justice issues. Author Lee was successful in gaining extraordinary access to information about the movement, as well as interviews with its members."
$16.95 *(PB/200)*

En Route to Global Occupation
Gary H. Kah
Former "government liaison" exposes the Secret Agenda for World Unification. A Christian view of globalism, with a special focus on New Age groups coordinating with World Constitution and Parliament Association. Masons = Lucifer. Spy for God.
 FLA
$9.99 *(PB/224/Illus)*

The Entertainment Bomb
Colin Bennett
This is a rare treat indeed; a lot of really interesting ideas in a well-written delivery vehicle. The star of this book is a latter-day grotesque named Dr. Hieronymus Fields. Aside from his food-stained clothing, lurid diet and trademark grease-stained paper bag, he is best known for a book called *Starpower*. It postulates that the human need for deities, saints and points of reference (in both geography and time) will be met in the future, by celebrities. What gives this book its particular edge is that the good doctor works for the British Secret Service. Thus we see how an agency that wishes to manipulate and shape public perception interacts with these theories, and, we are made to wonder if this is not already

taking shape out here in consensus reality.

"Entertainment State was now a muscular and questing animal, thirsty for depth-propaganda, desperately anxious that its liberally scattered first spores fell on fertile ground. Passing by him now was a gaggle of shifty pink-rinse lecturers in the now-approved Pop Culture courses at colleges and universities. . . . He was glad to know that if Jimmy James and Tommy Trinder and Bo Diddley and Sharon Stone were to be seriously studied to the same depth as Einstein and Shakespeare, then a hell of a lot of resistance had still to be broken before the worn-down middle ground was captured and secured."			**SA**
$14.95			*(PB/274)*

Escape Attempts: The Struggle of Resistance in Everyday Life
Stanley Cohen and Laurie Taylor
A guide to those who seek exile from a mundane lifestyle and how people have managed to deal with living. Answers the questions one might have about why escapism has become a human pastime.			**TD**
$16.95			*(PB/256)*

False Hope: The Politics of Illusion in the Clinton Era
Norman Solomon
"Concentrates on analyzing attitudes toward the Clinton presidency among many people who were glad to see the end of the Reagan-Bush years. These essays explore the need to move beyond false hope."
$12.95			*(PB/256)*

Federal Reserve Conspiracy
Antony C. Sutton
To quote from the Federal Reserve Bank of San Francisco help-wanted ad: "Some people still think we're a branch of the government. We're not. We're the bank's bank." Sutton, publisher of *The Phoenix Letter* and the *Future Technology Intelligence Report*, was a professor of economics at Cal State in Los Angeles, and is a "strong constitutionalist" who "freely expresses his contempt for Washington's usurpation of political power . . . but always based on facts. Chapters include: "The Bank's Bank," "Thomas Jefferson and the Money Power,"

"Andrew Jackson: The Last Anti-Elitist President," "The Jekyll Island Conspiracy," "The Federal Reserve Today," and more.			**FLA**
$7.00			*(PB/115/Illus)*

Foundations: Their Power and Influence
Rene A. Wormer
Long ago, elites discovered tax-exempt "foundations" where they could shelter their corporations and still control them. This volume is by a New York tax lawyer who specialized in estate planning. **FLA**
$19.95			*(PB/412)*

From the Bottom Up
Anton Pannekoek
Three council communist texts: "Party and Class," "Strikes" and "Why Past

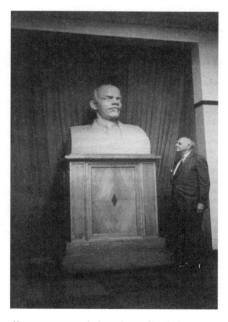

Hammer contemplating a bust of Lenin in Moscow — from **Dossier**

Revolutionary Movements Have Failed." Produced to provide a reflection on past struggles and a vision of future possibility.			**AK**
$2.50			*(Pamp/34)*

Future Primitive and Other Essays
John Zerzan
For Zerzan the "Golden Age" is no myth. Not only did it once exist, it is once more attain-

able, at least to those willing to take the long trip back—neither to the revolutionary era mourned by the Left, nor to the conservative's beloved 17th century, nor even to the feudal regimes increasingly favored by post-structuralist academia. With often surprising erudition, Zerzan sketches out a utopian theory of prehistory, comprising elements of "classical" anarchism, Luddite subversion and Green activism, which represents on every level a clean break with all of these established positions.			**GR**
$7.00			*(PB/185)*

Gender
Ivan Illich
An insightful examination of the different work roles taken by each sex in traditional and modern societies. Included are discussions on the development of a wage-labor system and how this development has led to the modern confusion over each sex's role.			**AK**
$8.95			*(PB/194)*

Global Bondage: The U.N. Plan to Rule the World
Cliff Kincaid
The author doesn't like the idea, and either does the Pope. "The United Nations is now openly laying plans for a World Government—to go along with its already functioning World Army. These plans include global taxation and an International Criminal Court that could prosecute American citizens . . . Also exposes: U.N. support for forced abortion and forced sterilization . . . the possibility of Russian military officers commanding American troops," and "the transformation of American soldiers into 'U.N. fighting persons.'" **GR**
$10.99			*(PB/208)*

The Heretic's Handbook Of Quotations
Chaz Bufe
Contains over 2,000 quotations on a wide variety of subjects including politics, sex, law, the state, labor, capitalism, anarchism, Marxism, religion, war, militarism, Christianity, women, science, the Bible, voting/majority rule, and many others. Quoted are Bakunin, Marx, Twain, Reich, Voltaire, Shaw, Chomsky, Diderot, Lenin, Goldman, Paine, Kropotkin, Bierce, Mencken, etc.
$14.95			*(PB/256)*

Hot Money and the Politics of Debt
R.T. Naylor

"A ball of hot money rolls around the world. It seeks anonymity and political refuge; it dodges taxes and sidesteps currency controls; it rolls through shell companies and numbered accounts, phony charities and religious foundations. And it is kept rolling by misguided policymakers and white-collar criminals, by gun-runners and drug dealers, by superpower secret-service agents and Third World political elites preparing for retirement. And as the ball of hot money grows, so too does the international debt crisis, for hot money and international debt are two sides of the same devalued coin."

$19.99 *(PB/540)*

I, Rigoberta Menchú: An Indian Woman in Guatemala
Rigoberta Menchú

"Recounts the remarkable life of Rigoberta Menchú, a young Guatemalan peasant woman, through a series of interviews recording the details of everyday Indian life. Her story reflects the experiences common to many Indian communities in Latin America today. Menchú recounts suffering gross injustice and hardship in her earlier life: her brother, father and mother were murdered by the Guatemalan military. She learned Spanish and turned to catechist works as an expression of political revolt as well as religious commitment. Conveys both the religious and superstitious beliefs in her community and her personal response to feminist and social ideas."

$16.95 *(PB/251)*

Ice Cube Sex
Dr. Jack Haberstroh

Written by a former "advertising practitioner and university educator" who not only dismisses the notion that media manipulators are busy airbrushing tits, asses and cocks into advertising images, but claims that subliminal advertising doesn't work anyhow. So, if you get horny looking at ice cubes and Ritz crackers, that's your problem. **MG**

$17.95 *(PB/181/Illus)*

The Illusion of Animal Rights
Russ Carman

It's all a class struggle! It's the privileged, drug-using movie stars against the poor simple trappers engaged in their humble pursuits for the "physical and spiritual health it provides" but also for the extra income, which allows them "to buy Christmas presents" for their loved ones. While making a few valid points about the ecologically uninformed emotionalism of certain city-dwelling activists as well as their use of some suspiciously sensationalist photos, Carman strays magnificently off his tether in his description of the "religion" of film-industry activists, who depict animals as possessing "godlike qualities, the ability to communicate with man, to walk on air, never age, and survive great injury without

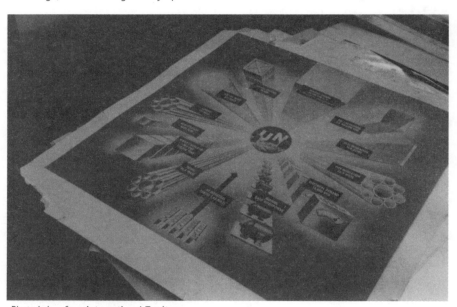

Photo Lab — from **International Territory**

blemish, [who] are born without sin and have life eternal." His personal view is more down-to-earth: "After cleaning their dung, working hard in the hot fields to harvest their feed, and putting up with their often stubborn behavior, it was never hard to butcher them." And Jesus told him to. **RA**

$12.95 *(PB/160)*

Immediatism
Hakim Bey

The latest tome from the insurrectionist theoretician. In this collection of essays, Bey expounds upon his ideas concerning radical social reorganization and the liberation of desire. **AK**

$7.00 *(PB/64/Illus)*

The Imperial Temptation: The New World Order and America's Purpose
Robert W. Tucker and David C. Hendrickson

With the fall of Communism, the U.S. was left in search of a new global agenda. According to the authors, the Bush administration betrayed the basic foundation of America in looking for a new role for the U.S. Using the Gulf War as the starting point of this new agenda, the authors expose the inconsistency of deliberately choosing military action when traditional diplomatic principles and other means were available—in their words, Bush succumbed to an "imperial temptation." **SC**

$14.95 *(PB/228)*

Indictment: Inside the Oklahoma City Grand Jury—The Hoppy Heidelberg Story
Richard Cook

"Hoppy is the first federal grand juror in history to breech the cloak of Grand Jury secrecy and give us a glimpse into the inner workings of our judicial system. Risking his freedom, his family and his fortune, Hoppy speaks out in this video to tell us how the system really works—or doesn't work. Hoppy reveals details about the manipulation and control of the Grand Jury by the federal

prosecutors to achieve their goals, and points out that this kind of 'justice' can happen to any of us!"
$19.95 *(VIDEO)*

International Territory: Official Utopia and the United Nations, 1945-1995

Christopher Hitchens and Adam Bartos
"Bartos' remarkable photographs of the U.N. Building in New York look cold and formal. But only at first. Actually they are full of feeling. This is the haunted house of idealist bureaucracy, filled with the ghosts of promises and suffused with nostalgia for the utopian rigor of high modernism. Nobody has ever put that in a photo before, and Hitchens' essay expertly peoples the empty spaces of Bartos' work."—Robert Hughes
$27.95 *(HB/168/Illus)*

Irrational in Politics: Sexual Repression and Authoritarian Conditioning

Maurice Brinton
His classic argument that our political perceptions have been conditioned by the prevailing social and sexual patterns to reinforce the dominant ideology. **AK**
$5.95 *(PB/52)*

The Jonestown Massacre: The Transcript of Reverend Jim Jones' Last Speech, Guyana 1978

James W. Clarke
"This booklet contains the transcript of the Reverend Jim Jones' speech as his followers committed mass suicide in Jonestown, Guyana, in 1978. It is published in the interests of warning all of the dangers of charismatic preachers and of extreme fundamentalism." "We didn't commit suicide, we committed an act of revolutionary suicide protesting the conditions of an inhumane world . . . "—Rev. Jim Jones
$6.00 *(Pamp/28/Illus)*

The K Wave: Profiting From the Cyclical Boom and Bust in the Global Economy

David Knox Barker
In 1926, a Russian named Nikolai Kondratieff studied the 200-year history of Western-style global economics for his boss, Joseph Stalin, and compared it to the economic model of Communism. His data showed that in approximate 50-year cycles, the free-market West went into a slump, repositioned itself, then rebounded with renewed vigor. This boom-and-bust cycle became known as the K Wave, and Kondratieff used it to successfully predict the Great Depression. In comparison, Kondratieff showed that the planned communist/socialist system would become inefficient and stagnant. For all his effort, Kondratieff got Siberia. We got the K Wave theory. How will it carry the new world economy through the current "fall" season? And who will survive the "winter," and prosper in the next century? China? The United States? Or—ironically—the new Russia?
GR
$35.00 *(HB/320)*

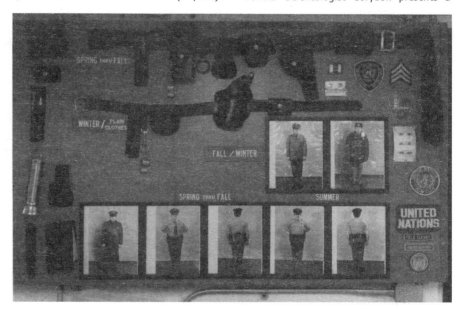

Uniform Section — from International Territory

Killing Hope: U.S. Military and CIA Interventions Since World War II

William Blum
"It is true now as ever that American multinationals derive significant economic advantage from Third World countries due to their being underindustrialized, underdiversified, capitalist-oriented and relatively powerless. It is equally true that the consequence of American interventions has frequently been to keep Third World countries in just such an undeveloped, impotent state. There is thus at least a prima-facie case to be made for the contention that the engine of U.S. foreign policy is still fueled predominately by "economic imperialism." And so are cataloged a depressingly long list of names, dates and places where, in the name of McDonald's, Coke, guns and apple pie, the U.S. establishment has bought down democratically elected governments and abused freedom and hope, replacing them with the spirit of Oliver North and John Wayne.
BW
$19.95 *(PB/500)*

L. Ron Hubbard: Messiah or Madman?

Bent Corydon
Former Scientologist Corydon presents a remarkably disorganized yet wholly worthwhile account of L. Ron and attendant Clears. While in places the book reads as if it had been written by the author of *Battlefield Earth* himself ("They had this paper shredder which was so big! . . . It was a big big big giant munching shredder!!"), the story of how a pulp science-fiction writer created, maintained and left to his heirs, such as they are, one of this century's most successful religions (now IRS-approved!) remains as disconcerting as it is

unlikely, however often it is told. Considerable material here not found in other books on the subject, expressed whenever possible in the most melodramatic way. **JW**

$24.95 *(HB/464)*

Loompanics' Golden Records
Edited by Michael Hoy

This is a great bathroom book. It is full of amazing little pieces on a wide variety of topics, which are for the most part quite compelling. (All but two of these pieces are reprinted from the Loompanics catalog.) It can prove maddening if one is hoping for a logical progression from piece to piece or even a loose grouping of articles into subject categories. The design lacks consistency and occasionally even feels padded. But if one takes the short-attention-span route, skipping around it like a magazine, the yields can be most rewarding and suitable for a variety of moods. The writing is consistently competent and frequently excellent.

The subjects that are covered include: things to know if you are planning to serve on a jury, how to survive in prison, covering your tracks if you are using a fake ID, drug testing, how the tabloids operate and how they effect the "mainstream" press, an assortment of cyber issues, home schooling, renegade WW II GIs, energy farming and other Green stuff, class struggle, Holocaust survivors with guns, war as entertainment, National Health Care, 12-step mania, assorted fiction and a whole lot more. A piece on the Jim Rose Circus and a short story by convicted serial killer G.J. Schaefer were commissioned especially for this book. **SA**

$14.95 *(PB/200/Illus)*

Loompanics' Greatest Hits
Edited by Michael Hoy

What one should know about speaking to the FBI, changing identities, writing checks, anarchism, alternative health, media control and hype, pirate broadcasting, "paranoid theories," squatting and much more. Featuring previously unpublished articles by Gregory Krupey, as well as contributions by Bob Black, Richard Geis, Michael E. Marotta, Ben G. Price and a full array of others. **TD**

$16.95 *(PB/300/Illus)*

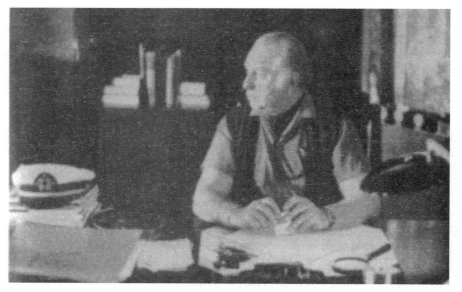

The Commodore fondling his Kools on board the flagship Apollo, *during the early 1970s — from* L. Ron Hubbard: Messiah or Madman?

Lost Dimension
Paul Virilio

The French urban planner and cultural theorist examines aspects of postmodern society ranging from space travel to time and the physical sciences. **AK**

$10.00 *(PB/150)*

The Mafia Manager: A Guide to Success
Lee Wallek

The multinational corporation known affectionately as the Mafia or the Mob is nothing if not efficient. The managers and CEOs of this company have a penetrating understanding of human nature, and this ability to give people what they want while ruthlessly eliminating the competition has led to the universal success of its stock. Lee Wallek, a corporate CEO himself, now near retirement, has taken some of the principles of management Mafia-style and presented them in a slim volume along with his own idiosyncratic drawings of various personalities one might encounter in the "business world." Equal parts Macchiavelli's *Prince*, Dale Carnegie's *How To Win Friends and Influence People*, and Joe Pesci's nastiest characters' chauvinist-guy handbook, *The Mafia Manager* will make valuable reading for anyone involved in activities relating to the management and control of other human beings. **AS**

$14.95 *(PB/112/Illus)*

The Manipulated Mind: Brainwashing, Conditioning and Indoctrination
Denise Winn

Whether one is under the spell of conspiracies or the Internet, UFOs or religion, politics or MTV, Nazis or North Koreans, one best believe there's a whole lot of brainwashin' goin' on. "What makes brainwashing so different from the equally insidious effects of indoctrination and conditioning, or even advertising and education? "Research findings from psychology show that brainwashing is not a special subversive technique; it is the clever manipulation of unrealized influences that operate in all our lives. . . . This book, by breaking down so-called brainwashing to its individual elements, shows how social conditioning, need for approval, emotional dependency and much else that we are unaware of, prevent us from being as self-directed as we think and, conversely, which human traits make us the least susceptible to subtle influence." **GR**

$25.00 *(HB/217)*

Mass Mind Control of the American People
Compiled and Edited by Elizabeth Russell-Manning

"When one reads the following pages, it will

become clear there is a cover-up within our own government regarding electrical stimulation of the brain, telemetry, etc. as well as harmful E.L.F waves, exposure to microwaves through TV, stimulation of the brain, etc., in order to control and manipulate people. I believe, there is a secret government within our government, and they are using this type of warfare in order to bring us (the citizens) into complete subjection and electronic control. . . . Our own secret government created these street people by shutting them down electronically, thus keeping them alive artificially and controlling them and manipulating them through electronic means, thus the reasoning behind not providing for them properly. Thus, the government is using them to harass, terrorize and possibly kill us, their fellow citizens, through manipulating them through their computer science techniques whenever it suits them." Spiral-bound xeroxed collection of articles, excerpts and original hypotheses.
$24.95 *(PB/163/Illus)*

The Media Monopoly
Ben H. Bagdikian
"This new edition documents the continuing decline in the number of firms dominating production of newspapers, magazines, books, television and movies in the United States . . . discusses the emerging corporate control of alternative media outlets such as cable television, syndicated programming and videocassettes . . . shows how the recession, corporate takeovers, and lax antitrust policies affected the news reporting in the 1980s, and describes the promise and perils of new media technologies. A classic critique of corporate media control."
$14.00 *(PB/336)*

Merchants of Misery: How Corporate America Profits From Poverty
Edited by Michael Hudson
Essential investigative journalism of the mechanics of poverty—shows how predatory companies keep people poor by offering them Faustian bargains in desperate situations: auto loans, rent-to-own scams, slumlordism, and "fringe banks" quietly owned by the biggest Wall Street companies. **AK**
$14.95 *(PB/225)*

Mind Control in a Free Society: It's a Bad Match
Edited by Elizabeth Russell-Manning
The redoubtable Russell-Manning gets out

her scissors and hits the copy machine once again in order to produce yet another classic work in the great tradition of her earlier, and equally worthwhile, *Mass Mind Control of the American People*. A fascinating accumulation of material, at first glance seemingly unrelated, continues to retain its deepest secrets (Who pays the Xerox bills?) after a second, or even a third, reading, but the all-encompassing range of her interests is clear. Considerable effort has been channeled by the author into gathering together articles, interviews, clippings and the like pertaining to chemical, electronic, psychotronic and psychological warfare; ELF and VLF beams; Soviet microwaves; "homosexuality," mercury-laden dental fillings, potentially fatal carpeting and sewage-eating clams. Russell-Manning slights the reader on occasion—a chapter called "Interview With Lt. 'Bo' Gritz" consists of a badly reproduced photo and an address from which a copy of the interview can be ordered, for example. But plainly, a lot of things worry Russell-Manning and she wants her readers to be worried too. She succeeds; after reading this, one can't help but be concerned. **JW**
$19.95 *(PB/145/Illus)*

Mind Control in U.S. Prison System
Edited by Elizabeth Russell-Manning
"The Secret, Illegal and Unconstitutional Torture and Abuse of Prisoners (Through Non-Lethal Weaponry) by U.S. Department of Corrections, in Cooperation With NIJ, Senate and Congress." A bound and xeroxed compilation of documents, complaints, press releases and articles. **FLA**
$20.00 *(PB/265)*

The Minimal Self
Christopher Lasch
"In a time of troubles, everyday life becomes an exercise in survival. People take one day at a time. They seldom look back, lest they succumb to a debilitating 'nostalgia'; and if they look ahead, it is to see how they can insure themselves against the disasters almost everybody now expects. Under these conditions, selfhood becomes a kind of luxury, out of place in an age of impending austerity. Self-hood implies a personal history, friends, family, a sense of place. Under siege, the self contracts to a defensive core, armed against adversity. Emotional equilibrium demands a minimal self, not the imperial self of yesteryear. Such is the thesis, in its simplest

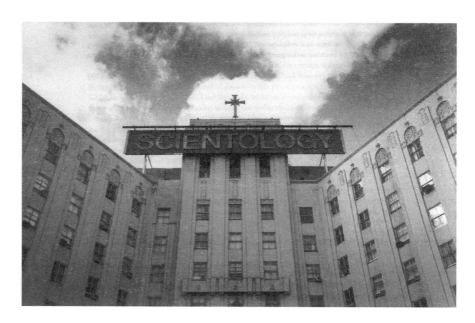

Scientology headquarters, Los Angeles — from Circus Americanus

form, advanced in these pages."

$11.95 _(PB/317)_

The Monkey Wars
Deborah Blum
"A gritty, in-the-trenches report on the battle over primate use in medical research looking at the experiments that the chimps and monkeys endure."

$25.00 _(HB/306)_

Mortgaging the Earth: The World Bank, Environmental Impoverishment, and the Crisis of Development
Bruce Rich
"This badly needed analysis exposes the destructive alliance between the bank and national governments that, in the name of progress, has plundered natural resources and impoverished millions."

$16.00 _(PB/384)_

Murder by Injection: The Story of the Medical Conspiracy Against America
Eustace Mullins
"Reveals how Mad Scientists control the Medical Schools and funnel billions of tax dollars into their unproductive Research Programs. How the Rockefeller Syndicate perverted American medicine from natural homeopathic cures to drugs and Frankenstein surgical techniques. Why Government agencies are lying to you about AIDS. And much, much more!"

$19.95 _(HB/361)_

My Struggle: The Explosive Views of Russia's Most Controversial Political Figure
Vladimir Zhirinovsky
For a man who spits and throws rocks at Jewish protesters and threatens to kill his enemies with an "atomic pistol," it is not surprising, still yet very unoriginal, that he should name his book _Mein Kampf_, er, _My Struggle_. The curiosity behind all of Zhirinovsky's blustering and mad-sounding tirades is that he is half-Jewish—the "bad" half, according to him. This reviewer was unimpressed with his slim autobiography,; it seemed to be "much ado about nothing." Perhaps I missed something? Like, actions

speak louder than words? **JB**

$18.00 _(HB/144)_

No One a Neutral: Political Hostage-Taking in the Modern World
Norman Antokol and Mayer Nudell
This book is a guide to dealing with the demands of terrorists. The author develops the thesis that it is indeed possible to deal with terrorists and bases his opinions on established cases. All the whys, hows, and possibilities are explored in this mini-encyclopedia of hostage negotiating. The author lists personality types of hostage takers, which he divides into basically four groups:
1. paranoid schizophrenics
2. psychotic depressives
3. antisocial personalities
4. inadequate personalities
Probably the most interesting chapter in the book is the "Minimanual of the Urban Guerilla," which duplicates the standard set of instructions for improvising a terrorist milieu. This chapter is indeed the "meat on the bone," as the following excerpt will show: "Molotov cocktails, gasoline, homemade contrivances such as catapults and mortars for firing explosives, grenades made of tubes and cans, smoke bombs, mines, conventional explosives such as dynamite and potassium chloride, plastic explosives, gelatine capsules, ammunition of every kind are indispensable to the success of the urban guerilla's mission." **JB**

$9.95 _(HB/248)_

No Success Like Failure: The American Love of Self-Destruction, Self-Aggrandizement and Breaking Even
Ivan Solotaroff
At the point of convergence between extremes of fame and infamy, the entire fabric of "received ideas" to which our culture clings gets caught up in a tailspin and scattered to the wind in a variety of surprising reconfigurations. Author Solotaroff stakes out a kind of vanguard terrain—at once anomalous and absolutely integral to any social analysis of life in late-20th-century America—and he explores it by way of its complex and conflicted denizens: Charles Manson, James Brown, Andrew "Dice" Clay and certain lesser-known, though no less legendary, figures, such as street corner comic Charlie Barnett,

unsigned basketball prodigy Earl Manigault, and Ray and Jay, the kids who took seriously Judas Priest's "subliminal command" to "do it." All casualties, in some form or another, of the glare of the spotlight.

JT
$24.95 _(HB/224)_

The New World Order
A. Ralph Epperson
The phrase _Novus Ordo Seclorum_ is found on the bottom of the reverse side of the Great Seal of the United States, and is Latin for "The New World Order," and that's what we learn on just the first page of this captivating book. Here is a scenario similar to _Brave New World_: There is one government, one source for food and water, and a new religion. In the NWO, there will be no private property, no inheritance, no starvation or homelessness. Shelters for all, jobs for everyone. One small problem: Don't fit the mold? Handicapped? You'll be eliminated. "Thou shalt not kill" a problem? The new religion says killing's okay, if it fits the NWO. Who'd go along with this program? Who thought up this insanity? The book reveals that plans for the NWO have been set in motion since a secret society, the Thules, reorganized the then-disorganized Masons. The Thules are termed the secret prime movers of Nazism, and are a fragment of a much more important secret society known as the Germanic Order, founded in 1912. Thought-provoking, well-written and disturbing. **CF**

$16.95 _(PB/357)_

The Occult Technology of Power
Alpine Enterprises
Hidden methods of world domination exposed! Pseudo-handbook for budding Armand Hammers, with instructive commentary from David Rockefeller, et al.

$6.95 _(PB/62)_

The Octopus: The Secret Government and the Death of Danny Casolaro
Kenn Thomas and Jim Keith
"The Octopus was Casolaro's name for an intelligence cabal he had documented in his unfinished book. His toe hold was PROMIS, a supersurveillance software misappropriated from a company called Inslaw by Ed Meese's Justice Department and sold ille-

Implantable Transponder

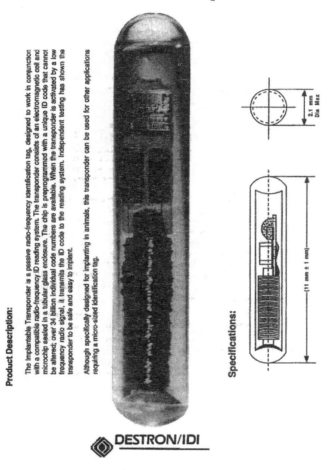

Product Description:

The Implantable Transponder is a passive radio-frequency identification tag, designed to work in conjunction with a compatible radio-frequency ID reading system. The transponder consists of an electromagnetic coil and microchip sealed in a tubular glass enclosure. The chip is preprogrammed with a unique ID code that cannot be altered; over 34 billion individual code numbers are available. When the transponder is activated by a low frequency radio signal, it transmits the ID code to the reading system. Independent testing has shown the transponder to be safe and easy to implant.

Although specifically designed for implanting in animals, this transponder can be used for other applications requiring a micro-sized identification tag.

Specifications:

2.1 mm Dia Max

(11 mm ± 1 mm)

◆ DESTRON/IDI

Implantable transponder advertisement — from OKBomb!

gally to police agencies around the world. Casolaro's research looked at bizarre murders among the Cabazon Indians involving administrators of the tribal land; the privatization of CIA dirty tricks through the notorious Wackenhut security firm, the policemen for both the Cabazons and the mysterious Area 51, home of spy planes and rumored UFOs; Vietnam MIAs; manufacturing corruption at Hughes Aircraft; the human-genome project; even the Illuminati secret societies of the 18th century." Researchers Kenn Thomas (Steamshovel Press) and Jim Keith (*Black Helicopters Over America, Secret and Suppressed,* etc.) have based their book on Casolaro's surviving

notes as well as interviews, affidavits, court records, congressional documents and 'nonmainstream' sources."
$19.95 (HB/181/Illus)

OKBOMB! Conspiracy and Cover-up
Jim Keith

No one really knows what really happened at the Alfred P. Murrah Federal Building in Oklahoma City, on April 19,1995, besides the fact it got blown up. Whether or not Timothy McVeigh and Terry Nichols are guilty has become irrelevant. They have been tried in the media and found to be guilty. The author asks some very important

and as-yet-unanswered questions about the bombing. **SC**
$14.95 (PB/237/Illus)

Oklahoma City Bombing: The Suppressed Truth
Jon Rappaport

"In the case of Oklahoma City, federal police are being forced to invent a fantasy. The truck bomb didn't cause the real damage to the Federal Building. Couldn't, didn't. Not ever. That's the secret. Right there, at the beginning, the whole government story falls apart in your hands. The truth about death in Oklahoma City has been covered up since 9:02 a.m. on April 19, 1995. And no politician will keep that truth from coming out."
$12.95 (PB/112)

The Perfect Machine: Television and the Bomb
Joyce Nelson

Touching on ratings, radiation hazards, TV and nuclear colonialism, brain research, propaganda, television genres and the Manhattan Project, Nelson traces the full range of impacts and the crucial role of corporate control of these two omnipresent, interlocking and seemingly omnipotent technologies. **AK**
$12.95 (PB/187)

Please Stand By: A Prehistory of Television
Michael Ritchie

Yes, television had a history before Lucy, Jackie and Uncle Miltie, or what author and film director (*Bad News Bears, Fletch*) Ritchie calls a prehistory. *Please Stand By* covers the period from television's invention in 1920 until regularly scheduled programming began in 1948. It is largely a chronicle of "firsts": the first commercial, the first soap opera, the first newscast. It is also full of anecdotes such as the first professional football broadcast consisting of a single shot of a toy football game board, or the station manager in Washington, D.C., who had a metropolitan map on his office wall marking each of the 48 TV sets in town. On another level, Ritchie outlines the battles between inventors (Philo Farnsworth, Charles Francis Jenkins, Allen DuMont), who were trying to perfect the new medium, and businessmen (Robert Sarnoff, William Paley) and corporations (RCA, Westinghouse), who were trying to wring out a profit from their investments, for control of the airwaves. **AP**
$23.95 (HB/247)

The Politics of Obedience: The Discourse of Voluntary Servitude
Etienne de la Boétie
"Why do people submit to authority or governments? In this classic of political reflection, a 16th-century philosopher laid the groundwork for the concept of civil disobedience."
$19.99 *(HB/88)*

Popular Defense and Ecological Struggles
Paul Virilio
Pure power and the art of warfare, and revolutionary resistance to it. **AK**
$7.00 *(PB/160)*

The Power Elite and the State: How Policy Is Made in America
G. William Domhoff
"Domhoff presents a network theory of social power and new empirical findings on key policy issues of the 20th century."
$26.95 *(PB/315)*

The Prince
Niccolò Machiavelli
Handy hints for starting—and sustaining—your very own princedom, from the famous Florentine envoy to the courts of France and the Italian principalities. In continuous use since 1513, this "calculating prescription for power" has been well-thumbed by history's despots and charlatans, like this century's Hitler, Mussolini, Idi Amin, Pol Pot, Peron, Khadaffi and Hussein. "And here comes in the question whether it is better to be loved rather than feared, or feared rather than loved . . . a prince should inspire fear in such a fashion that if he does not win love, he may escape hate . . . Since his being loved depends on his subjects, while his being feared depends on himself, a wise Prince should build on what is his own, and not on what rests with others. Only, as I have said, he must do his utmost to escape hatred."
GR
$1.00 *(PB/71)*

The Privacy Poachers: How the Government and Big Corporations Gather, Use and Sell Information About You
Tony Leace
Miscellaneous methods of both general and

Sink Your Teeth Into the Military, *1990 — from* **Stealworks**

advanced surveillance carried out upon the private citizen by employers, credit bureaus, law enforcement and various other intruding tentacles of 20th-century life are explained by a security consultant. Unfortunately, the results read more as a series of essays attempting to gain clients for the author by instilling paranoia in the reader, rather than a serious source of information that can be utilized to counter such surveillance. Some of the sociological implications are touched upon, as well as an outline sketch of the history of modern surveillance methodology, with examples of recent infringements which made the news. But ultimately, although this book is an adequate introduction to the everyday infringements on personal liberty and the basics of

surveillance techniques, the serious researcher is best served elsewhere. **BW**
$16.95 *(PB/155)*

Project L.U.C.I.D.: The Beast 666 Universal Human Control System
Texe Marrs

Toward "a new global police state, made up of the FBI, KGB, CIA, DEA, DIA, NSA, IRS, EPA, OSHA, NCIC, USDA, FDA, NRO, BATF, FINCEN, INS, DOJ, WTO, Europol, Interpol, Mossad and the MAB." All secretly reporting to a faceless American "SS establishment," or "Central Gestapo."

"The Beast 666 Universal Human Control System has been designed and is being implemented in America and throughout the world. We knew it was coming. Now it's here, and soon there will be no place to hide. By the year 2000, Big Brother's evil, octopuslike tentacles will squeeze every ounce of lifeblood out of the people. A nightmarish, totalitarian police state is at hand.

"That is the thoroughly documented message—and momentous warning—sounded in this book. Do not for an instant think that you and your loved ones can escape the monstrous behemoth which lies in our path. Once Project L.U.C.I.D. (Lucifer's Universal Criminal Identification System) is fully operational, and every man, woman and child will fall under the power of its hideous, cyberelectronic grasp.

"Consider the unbelievable magnitude and dimensions of Project L.U.C.I.D. First, it mandates that every adult and child—even newborn babies—be issued a universal biometrics ID card. A "Smart Card" with an advanced computer microchip, this powerful, reprogrammable ID card will store millions of bytes of information about the recipient—his or her photo, fingerprint, footprint, iris (eye) scan, DNA genotype, human leukocyte antigen data, financial status, and personal history.

"Oh yes, the ID card will also be coded with numbers. One will identify the individual cardholder. Another, I believe, will eventually constitute the number 666. The number 666 will signify the hellish master responsible for the devilish invention of this Universal Biometrics Card and its interlocked, computer network." **GR**
$12.00 *(PB/224)*

Psychiatry and the CIA:

Victims of Mind Control
Harvey M. Weinstein, M.D.

The truth behind Subproject 68 of the CIA-sponsored MK-ULTRA mind-control project, by a psychiatrist who was there—his father was one of the victims. The author, as a boy, watched his father deteriorate physically and mentally for unknown reasons, all while under a doctor's care. Years later, formerly top-secret government documents told him the gruesome story: A series of sadistic experiments had been carried out on selected patients by a Canadian doctor, Ewen Cameron. The crackpot Cameron, seemingly inspired by North Korean tortures, drugged at least 100 patients in a "depatterning program," tying them down in isolation and bombarding their brains with taped messages, 12 to 16 hours a day, a process called "psychic driving." This could go on for more than 60 days. Then months of drugged sleep would be induced. Results? Tragic. In the end, the CIA admitted to itself that MK-ULTRA "had not yielded any results of real positive value to the Agency . . . " Shocking and painful. **GR**
$28.95 *(HB/304)*

Psychic Dictatorship in the USA
Alex Constantine

Investigative research into the likes of electromagnetic and biotelemetric mind control; Nutrasweet and its role in the dumbing of America; the use of cults by intelligence organizations as "cover" for child abuse, arms sales, mind-control projects; The Children of God and the use of the cult by South American dictators and Reagan and Bush; and how the CIA funds covert operations through art looted by the Nazis. **AK**
$12.95 *(PB/320)*

The Real Terror Network: Terrorism in Fact and Propaganda
Edward S. Herman

An exposé of U.S. foreign policy, separating the myth of an "international terrorist conspiracy" from the reality. Tours the state-sanctioned bloodbaths of U.S.-sponsored dictatorships.
$16.00 *(PB/252)*

The Real Unfriendly Skies: Saga of Corruption
Rodney Stich

By 1974, everybody in aviation knew about the DC-10 cargo door problem. It was an accident waiting to happen. And it did. "The cockpit voice recorder showed the sequence: Klaxon sounded as the plane exceeded the never-exceed speed. Captain Berkoz: 'What happened?' Captain Uelusman: 'The cabin blew out.' Berkoz shouts: 'Are you sure? Bring it up, pull her nose up. 'During the next 16 seconds, Berkoz sings the catchline from a famous Turkish TV commercial: '*Acaba, nedir* (Wonder what it is, what it is?) . . . We have lost it . . . Ooops, oops . . . We've lost it.' Sound of impact signifying the brutal end to 346 lives." A passionate account of the scandals behind more than 30 years of air crashes in America and around the world that were perpetrated by airline malpractice, design flaws, low-budget training, stupid pilot errors and the ignorance of wind shear. Do the words *cover-up, conspiracy* and *corruption* come to mind? A pre-deregulation United Airlines fares the worst. After deregulation, it's Delta. The FAA is dog meat throughout.
GR
$25.00 *(PB/656)*

Resisting the Virtual Life: The Culture and Politics of Information
Edited by James Brook and Iain Boal

"Beneath the media world lies our perceptual framework, and digital media may change how we know and what we know." So insists Chris Carlsson in "The Shape of Truth To Come," one of the more accessible of the 21 essays and political tracts anthologized within this book. And therein, in the theme "political," lies the biggest problem with this book. Everything revolves around postmodern socialist/Marxist philosophy.

Resisting The Virtual Life is very much a classic university textbook with its own jargon, esoteric knowledge and politically correct jockeying for status. As dull, verbose, self-referential, opaque, presumptuous and complex in its structures and concepts as Scottish Freemasonry. Don't get me wrong, please, I myself am absolutely on the side of an immense skeptical suspicion of the "World Wide Web." What a horrible title. Are we all the innocent little insects unwittingly trapped in a gluey binary Armageddon of telephone lines? Who is the spider? Well, control, of course. Corporations, of course, increasingly insipid and acceleratingly effective bureaucratic governments.

The themes of enforced apathy and mobil-

ity of labor really circle each other like sumo wrestlers here. And it's scary. Which makes this the right time to reassess the malignant cancer of personal computers; the intrusion into intellectual privacy and inner space; the surrender of autonomy; the detached Prozac miasma of virtual passivity and loss of identity that comes with all this dull gray plastic.

Look at it this way, simplistic though it sounds: If "Virtual Life" is supported, prose-lytized and applauded by your worst ene-mies, and it is profitable for them, then why consent of your own volition to partake of this "cure-all." No way is this medium benign! Far from it. It's the greatest chance to survey all you can see from a great height, just like Jesus in the desert, and who was offering HIM that illusory empower-ment?

Uh, uh. Please plow through this, despite the turgid and user unfriendly style and semantics. Because it will do you good! The digital revolution is not benign. Don't kid yourself, or your *self*. You are as much fod-der for this new economic miracle as your ancestors were when they were forced from the arable land to become a disposable raw material for the iron mills and cotton mills of the 19th century.

Worse still, once uprooted, they were trained to consume the surplus they were enslaved to produce. Now, with less need in the West for covert slavery, the primary pur-pose of the majority of the population is conveniently reduced to overt and insa-tiable consumption, in and of itself. Oh, in case you wondered where the slaves are now . . . Well, occupied Haiti, Korea, Thailand and, when the time comes, Africa once again.

It's the perfect scam. Hell, they don't even need a semieducated and minimally healthy immigrant workforce anymore. Why else did you think education and medical services are being encouraged to disintegrate? A mediocratic middle class have unwittingly become the "new serfs." They integrate enthusiastically with the insatiable "virtual life." They are compelled to consume this quixotic future. They have even been trained to measure their success by their acquisition of its artifacts and their access to an ever-increasing amount of its software. Like lem-mings they bless and feed the hand that sig-nals the route to the final cataclysmic cliff. As the introduction succinctly reminds us, mobility of labor is the capitalist dream and

computers realize the ultimate exploitative nightmare. All labor can now travel any-where without physically moving. Much cheaper and more efficient. Everything piped down a phone wire. Perfect! I don't think so. Count me out. I unplugged my modem ages ago. Best thing I ever did for my creative mind. Unplug yours too. Read this book, pri-vately. Think hard about it, privately. Practice talking, privately. **GPO**
$15.95 *(PB/278)*

The Revolt of the Elites and the Betrayal of Democracy
Christopher Lasch

"Once it was the 'revolt of the masses' that was held to threaten social order and the civilizing traditions of Western culture. In our time, however, the chief threat seems to come from those at the top of the social hierarchy, not the masses. This remarkable turn of events confounds our expectations about the course of history and calls long-established assumptions into question. . . . Today it is the elites, however—those who control the international flow of money and information, preside over philanthropic foundations and institutions of higher learning, manage the instruments of cultur-al production and thus set the terms of public debate—that have lost faith in the values, or what remains of the values of the West."
$12.95 *(PB/276)*

The Road to Hell: The Ravaging Effects of Foreign Aid and International Charity
Michael Maren

"Maren has spent much of the last 20 years in Africa, first as an aid worker, later as a journalist. He witnessed at close range a harrowing series of wars, famines and nat-ural disasters. In *The Road to Hell* he tells how CARE unwittingly assisted a Somali dictator in building a political and econom-ic power base. How the U.N., Save the Children and many other nongovernmental organizations provided raw materials for ethnic factions who subsequently threat-ened genocidal massacres in Rwanda and Burundi. He brings first-hand reports of African farmers, Western aid workers and corrupt politicians from many countries joined together in a vicious circle of self-interest. Above all, he heralds an important

truth: humanitarian intervention and for-eign-aid activity is necessarily political. It gets hijacked by powerful charities and agricultural interests. It is cynically manip-ulated by local strongmen to control rebel-lious populations. And it is the last refuge of Western colonialism."
$25.00 *(HB/302)*

Scorched Earth: The Military's Assault on the Environment
William Thomas

Uncle Sam is "the single largest generator of hazardous wastes in the U.S." It's an undeclared war on the Big Blue Marble. We're talking major, major, major pollution: radar "smog," fuel dumps, unexploded explosives, discarded chemicals, radiation waste, nerve gas, etc., all heading to a groundwater site near you. "Drawing on first-hand experience and more than 100 carefully researched sources, " the author "describes the stunning extent of the pollu-tion that the world's armed forces create each day—even during peace time—through their testing, maneuvers, accidents, toxic dumping, emergencies and uranium mining and processing." Also documents "the growing citizen's movement—often led by women—for military cleanup and conver-sion." A good place to start is "the most contaminated square mile on Earth," locat-ed 16 miles outside of Denver. It's the result of a "toxic face-off" between neighboring Rocky Mountain Arsenal and McClellan Air Force Base. **GR**
$16.95 *(PB/227)*

S.C.U.M. Manifesto
Valerie Solanas

Aside from being a deranged homicidal dyke, the late Valerie Solanas was also a visionary social theorist. Before she became infamous as the would-be assassin of Andy Warhol, Valerie, already well established as a conspicuous daub of lower Manhattan's local color, founded the one-woman terror-ist organization S.C.U.M. (Society for Cutting Up Men) and wrote the *S.C.U.M. Manifesto*, a wonderfully toxic anti-capital-ist, lesbian separatist rant that puts the blame squarely where it belongs: on those fucked-up male chauvinist pigs! *S.C.U.M.* sends out a clarion call to "civic-minded, responsible, thrill-seeking females only to overthrow the government, eliminate the money system, institute complete automa-

tion and destroy the male sex." Other targets: hippies, "great art," fatherhood, politeness, "pussy." She cobbles out her thesis in such a charmingly autocratic style that even her more dubious notions (sex is out in her utopia) read like common sense. And just because a few billion people would have to be butchered to implement her plan doesn't necessarily mean that she's wrong. Who needs Catherine McKinnon and Andrea Dworkin? Pick up *S.C.U.M. Manifesto* and learn the real definition of "feminazi." **MG**
$5.00 *(PB/24)*

The Secret Empire: How 25 Multinationals Rule the World
Janet Lowe
"Shows the global giants who are often more influential than the countries in which they operate! Lowe identifies the leading multinationals, describing what they do, their corporate personalities and who runs them."
$27.50 *(HB/335)*

Secret Societies and Psychological Warfare
Michael A. Hoffman II
Fastidiously describes the bovine masses being herded by those evil Masons working in consort with a secret 666-mind-control government called the "cryptocracy," and clues us in how:
• "the Trinity Site" (the first atomic bomb test site in New Mexico) was Masonically determined—and Dealy Plaza, the sight of John Kennedy's triangulation murder (rife with Masonic symbols, natch) was the location of the first Masonic temple in Dallas.
• politicians like Mario Cuomo and Marion Berry flash the "devil's horns" gesture during speeches.
• the TV viewing audience is conditioned to accept staged murders by "lone-nut" assassinations via such stunts as the planting of a fugitive lead character named Hinckley on the premiere of the ABC show *The Greatest American Hero*—two weeks before Reagan was shot.
• the author of *The Ultimate Evil*, Maury Terry, was a close friend of James Carr, the son of Sam Carr, but denied it. When later asked why, Terry claimed he had "forgotten" that he knew Carr.
• the capstone on everybody's favorite pyramid—the one on the dollar bill—will not be shown as completed until 22 satellites

are placed around the Earth, at which point complete media/mind control will be in place.
• the defect in the Intel computer chip was announced the next business day after the Unabomber's package killed IBM executive T. Mosser.
Includes photos of such Masons as "Jack the Ripper" and Harry S Truman (in "full occult regalia"), and examples of demonic subliminals in advertising. Let the cataclysm begin! **MS**
$12.95 *(PB/126)*

Sovereign American's Handbook
Johnny Liberty
"Amazing, straightforward guide to reclaiming your sovereignty under the Constitution. A tax-resisters manual combined with radical philosophical discourse. This is the side of the populist movement the media won't tell you about." **FLA**
$30.00 *(PB/240)*

The Sovereign Military Order of Malta
Françoise Hervet
"A scholarly overview of the Knights of Malta and their shadowy role in international intelligence operations. Hervet discusses the Order's history, the American Association of SMOM, the American-Italian connection, the fascist P-2 Lodge, AmeriCares and the group's covert political goals. It's church and state, working together to propagate fascism."
$1.75 *(Pamp)*

Speed and Politics
Paul Virilio
"The loss of material space leads to the government of nothing but time. . . . The violence of speed has become both the location and the law, the world's destiny and its destination."
$7.00 *(PB/166)*

State-Organized Crime
William J. Chambliss
"Criminologist Chambliss presented this paper at the American Society of Criminology. He provides a persuasive overview of U.S. government involvement in narcotics peddling, comparing characters like North, Singlaub, Secord and Hull to pirates of yore. Just as European rulers from the 16th to 19th centuries licensed pirates

to attack rival states (taking a cut in the process), the U.S. has made similar deals to obtain financing for covert operations."
$1.50 *(Pamp/10)*

Stolen for Profit: How the Medical Establishment Is Funding a National Pet Theft Conspiracy
Judith Reitman
"The schemes and numbers did not shock Mary Warner. Few horror stories shocked her anymore. The ever-growing list of casualties tacked on her wall was a tragic reminder that nothing had really changed: over 10,000 dogs missing in Rochester, New York, within six months in 1983; 700 dogs missing in 11 months in Orlando, Florida, in 1985; 985 dogs and cats missing within 11 months in 1987 in Concord, North Carolina; over 1,000 dogs and cats reported missing in Indianapolis in one month in 1989. In 1990, in Columbus, Georgia, 2,500 dogs and cats had been reported missing; 5,000 in two consecutive years." **GR**
$19.95 *(HB/258)*

Subliminal Communication: Emperor's Clothes or Panacea?
Eldon Taylor
Presents the history, mechanics, law and clinical data on the art of "whispering" to the subconscious. Discusses whether you can be brainwashed by subliminals or not, whether they are as dangerous as some professionals claim, and whether they really work at all. Plus instructions on how to create your own subliminal program. **GR**
$8.95 *(PB/131)*

The Superpollsters: How They Measure and Manipulate Public Opinion
David W. Moore
"Polling dictates virtually every aspect of election campaigns, from fund-raising to electoral strategy to news coverage. And, after our representatives are elected, polling profoundly shapes the political context in which they make public policy. Whatever its faults and limitations, and they are many, polling matters." In this thoughtful overview, David W. Moore traces the rise of polling from the nascent Gallup

Before. An East Coast supplier of laboratory dogs, prior to USDA's being given responsibility for enforcing the Animal Welfare Act and licensing dog dealers, 1966 — from **Stolen for Profit**

After. A Midwest supplier of laboratory dogs in 1986, 20 years after USDA began enforcing the Animal Welfare Act and licensing dog dealers — from **Stolen for Profit**

Poll's challenge to the famed Literary Digest poll in 1936 to the presidential election of 1994. Moore profiles pollster personages George Gallup and Lou Harris, as well as lesser-known (although probably more influential) figures such as presidential pollsters Pat Caddell and Richard Wirthlin. Media pollsters are also considered, as in the ways in which the wording of questions and presentation may influence outcome. As vice president and managing editor of the Gallup Poll, Moore himself is hardly unbiased, and readers are treated to less than complimentary descriptions of main rival Lou Harris' personality and techniques. Nevertheless, *The Superpollsters* will help individuals understand how polling came to its current place of dominance in the American political process. **LP**
$15.95 *(PB/426)*

TAZ: The Temporary Autonomous Zone, Ontologic Anarchy, Poetic Terrorism
Hakim Bey
"The TAZ is like an uprising which does not directly engage with the State, a guerilla operation which liberates an area (of land, of time, of imagination) and then dissolves itself to re-form elsewhere/elsewhen, *before* the State can crush it. Because the State is concerned primarily with Simulation rather than substance, the TAZ can 'occupy' these areas clandestinely and carry on its festal purposes for quite a while in relative peace. Perhaps certain small TAZs have lasted whole lifetimes because they went unnoticed, like hillbilly enclaves—because they never intersected with the Spectacle, never appeared outside that real

life which is invisible to the agents of Simulation." Also contains the full text of Bey's influential *Chaos* and the complete communiqués and flyers of the Association for Ontological Anarchy.
$7.00 *(PB/141)*

Test Card F: Television, Mythinformation and Social Control
Anonymous
"A graphic demolition derby through the culture of a factory-farmed and show-shocked society, a society whose sell-by date has long since expired. Using savage image/text cut-and-paste this controversial book explodes all previous media theories and riots through the Global Village, looting the ideological supermarkets of all its products: anti-fascism, Malcolm X, James Bulger, the Gulf War, satanic abuse, Somalia and Eastern Europe. *Test Card F* joyrides in front of the surveillance cameras, amid the rubble of a junkyard nation, and heaves television's burnt-out carcass through the plate-glass shop window of 'independent' video and 'community access' broadcasting. It transcends postmodern and Situationist analysis in its positive refusal of the concept of Truth." **AK**
$6.00 *(PB/80/Illus)*

Thought Contagion: How Beliefs Spread Through Society
Aaron Lynch
A basic explanation of the hip new science of memetics, the study of the spread of ideas and beliefs called "memes." Combining elements of epidemiology, genetics and conventional sociology,

Thought Contagion is more of trial balloon to expose memetics to a wider public than a ground-breaking scientific work. **SS**
$24.00 *(HB/192)*

Time Without Work: People Who Are Not Working Tell Their Stories
Walli F. Leff and Marilyn G. Haft
Leff and Haft collected in-depth interviews from people who weren't working for various reasons, and presented them in this book with related commentary and statistics. In late-20th-century America, work equals identity. However, the authors, through their research, challenge the very notion of maintaining a work-based identity. Their message is even more compelling now than when *Time Without Work* was first published, thanks to the current downsizing trend and layoffs in almost every industry. With the very nature of work changing, so are many people's expectations about work. No longer does one have a single employer or, for that matter, a single career. Consequently, people will have periods of unemployment. How will this new facet of the job market relate to societal ideas about work? The stories given here offer some possibilities. **SC**
$9.00 *(PB/403)*

Toxic Sludge Is Good for You! Lies, Damn Lies and the Public Relations Industry
John Stauber and Sheldon Rampton
A comprehensive guide that shows just how seriously the PR industry constrains democracy—from technologies for engineering consent to crisis management, from Bophal to the *Exxon Valdez* to "grassroots" organizing that propels the Christian Coalition and passed NAFTA to political spin control that influences and instantly interprets electoral politics. A compelling conclusion provides practical guidelines that citizens can use to respond to the growing influence of PR over their lives. **AK**
$16.95 *(PB/240)*

Trance Formation of America
Cathy O'Brien with Mark Phillips
O'Brien, "the only vocal and recovered survivor of the Central Intelligence Agency's MK-ULTRA Project Monarch mind-control

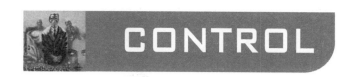

operation," has a story to tell, and it's some story—the most mind-blowing conspiratorial account to appear in recent years. Having undergone what must have been innumerable hypnotherapy sessions, O'Brien appears to have recovered the memories of dozens of people, and describes in detail the terror and torture she suffered at the hands of her mother, her father, Ronald Reagan, Dick Cheney, Bill 'n' Hill, Gerald Ford, George Bush, Kris Kristofferson, Larry Flynt, Sparky Anderson and "noted pedophile" Boxcar Willie. Senator Robert Byrd, of Virginia, inflicts unimaginable trauma upon her as he forces her to listen endlessly to his fiddle-playin'; and the favored text of the leaders of the American Empire would appear to be—*The Wizard of Oz*, although reinterpreted so as to allow for bleeding rectums. As you'd hope, there's dialogue—lots of dialogue:

"How would you like to see where Uncle Ronnie really solves the world's problems?" said President Reagan, shortly before poring over his collection of bestiality-themed pornography.

"Hillary had resumed examining my hideous mutilation and performing oral sex on me when Bill Clinton walked in. Hillary lifted her head to ask, 'How'd it go?' Clinton appeared totally unaffected by what he walked into, tossed his jacket on a chair and said, 'It's official. I'm exhausted. I'm going to bed.'" One reads the memoirs of O'Brien in awe, and stands back, equally exhausted.

JW

$15.00　　　　　　　*(PB/244)*

Trilateralism: The Trilateral Commission and Elite Planning for World Management
Edited by Holly Sklar
Exposé of trilateralism and the Trilateral Commission—the strategies used by those who see the world as their factory, farm, supermarket and playground.　　**AK**
$22.00　　　　　　　*(PB/605)*

The Unabomber Manifesto: Industrial Society and Its Future
"FC" (the Unabomber)
"Rare is the philosopher who commits violence to express his theories. Rarer still is the murderer who justifies his crimes with an extensively researched, footnoted societal agenda.

"The terrorist/philosopher known to the American public as the Unabomber wrote this intriguing, mesmerizing—and in the end, frightening—manifesto to tell the world what lay behind his campaign of carefully orchestrated mayhem. The manifesto's message is clear: Technology, says the Unabomber, is destroying the human race. And the only solution is a fundamental revolution aimed at abolishing technology itself and the social structures that foster technological development." Unexpurgated and contains text missing from the version published in various newspapers.
$9.95　　　　　　　*(PB/100)*

Unconditional Freedom:

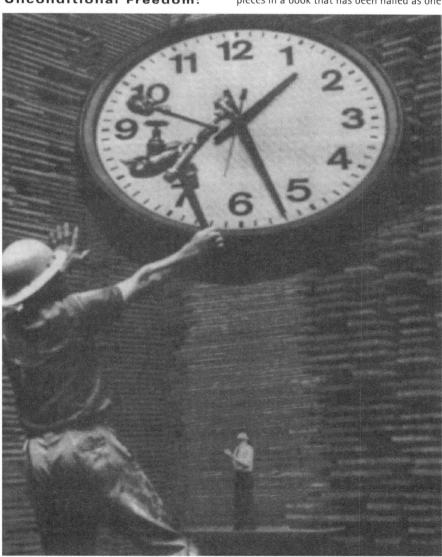

Collage by Freddie Baer — from **Revisiting Anarchy, Again**

Social Revolution Through Individual Empowerment
William Murray
Devastating attacks on the crumbling institutions of government, law, school, medicine, science, religion and work, in the venerable tradition of Stirner, Nietzsche and Crowley.　**AK**
$16.95　　　　　　　*(PB/252)*

United States: Essays·1952-1992
Gore Vidal
"Comprises over 100 of Vidal's inimitable pieces in a book that has been hailed as one

of the definitive guides to postwar America."
$22.00 (PB/1,284)

The Unseen Power: Public Relations— A History
Scott M. Cutlip
"Based largely on primary sources, this book presents the first detailed history of public relations from 1900 through the 1960s. . . . The book provides a realistic inside view of the way public relations has developed and been practiced in the United States since its beginnings in the mid-1900s. For example, the book tells how:
• President Roosevelt's reforms of the Square Deal brought the first publicity agencies to the nation's capital.
• Edward L. Bernays, Ivy Lee and Albert Lasker made it socially acceptable for women to smoke in the 1920s.
• Ben Sonnenberg took Pepperidge Farm bread from a small-town Connecticut bakery to the nation's supermarket shelves— and made millions doing it.
• in 1920, two Atlanta publicists, Edward Clark and Bessie Tyler, took a defunct Atlanta bottle club, the Ku Klux Klan, and boomed it into a hate organization of 3 million members in three years, and made themselves rich in the process.

This book documents the tremendous role public-relations practitioners play in our nation's economic, social and political affairs—a role that goes generally unseen and unobserved by the average citizen whose life is affected in so many ways by some 150,000 public-relations practitioners."
$39.95 (PB/808)

The Vision Machine
Paul Virilio
"A survey of the technologies, production and dissemination of images throughout history."
$14.95 (PB)

Votescam: The Stealing of America
James M. Collier and Kenneth F. Collier
"The book that indicts Attorney General Janet Reno . . . An explosive investigation that tracks down, confronts and calls the names of Establishment thieves who elegantly steal the American vote for their own profit. It comes face to face with a Supreme Court justice who rigged a vote-fraud case;

Mark Phillips and Cathy O'Brien, authors of **Trance Formation of America**

the most powerful female publisher in America, who won't let her newspapers and television stations deal with vote-rigging; and a cast of politicians, lawyers, newspeople, computer wizards, professors, aristocrats, CIA operatives and outraged citizens who are involved in a scandal of unthinkable dimension."
$6.99 (PB/394)

Walter Bowart: Interview 3/12/95
Dave Emory
Two audiocassette tapes of Emory's radio broadcast interview with the author of *Operation Mind Control*." 120 min. **FLA**
$12.00

War and Cinema: The Logistics of Perception
Paul Virilio
Examines the ideas of strategists and directors and the views on war and cinema of writers from Apollinaire to William Burroughs. An account of military "ways of seeing" which shows how these have now permeated our culture.
$16.95 (PB/95/Illus)

War Machine: The Rationalization of

Slaughter in the Modern Age
Daniel Pick
"Examines Western perceptions of war in and beyond the 19th century, surveying the writings of novelists, anthropologists, psychiatrists, poets, natural scientists and journalists to trace the origins of modern philosophies about the nature of war and conflict." Einstein to Freud, 1933: "Why war?" Freud to Einstein: "Paradoxical as it may sound, it must be admitted that war might be a far-from-inappropriate means of establishing the eagerly desired reign of 'everlasting' peace, since it is in a position to create the larger units within which a powerful central government makes further wars impossible." **GR**
$18.00 (PB/292)

When Corporations Ruled the World
David C. Korten
Seriously researched and documented exposé on the emerging global system of big business. The march of the multinational monoliths has become a threat to long-term human interests, the author demonstrates. It's one of the underlying causes of the world's social, economic, environmental and political crises. "The corporation is a true Frankenstein's monster—an artificial person run amok, responsible only to its own selfless soul." The world's 500 largest corporations, which employ only 0.05 of 1 percent of the world's population, control 25 percent of the world's economic output, and gobble up more each day. They're already fatter than most whole countries. It's the corporation as rogue shark; the people and the planet—chum. **GR**
$29.95 (HB/374/Illus)

Kelly with Boxcar Willie, Rutland, Vermont, 1985 — from **Trance Formation of America**

ANARCHY

Our Father Which Art in Heaven, *1921, George Grosz — from* Ecce Homo

is not a reason for organizing society in such a way that (thanks to the apathy that is the result of secured positions, thanks to birth, patronage, *esprit de corps,* and all the government machinery) the most lively forces and real ability end up by finding themselves outside the government and almost without influence on social life; and those that attain to government, finding themselves out of their environment, and being above all interested in remaining in power, lose all possibilities of acting and only serve as an obstacle to others.

Once this negative power that is government is abolished, society will be what it can be, but *all* that it can be given the forces and abilities available at the time. If there are educated people who wish to spread knowledge they will organize the schools and make a special effort to persuade everybody of the usefulness and pleasure to be got from an education. And if there were no such people, or only a few, a government could not create them; all it could do would be what happens now, take the few that there are away from their rewarding work, and set them to drafting regulations which have to be imposed with policemen, and make intelligent and devoted teachers into *political beings,* that is useless parasites, all concerned with imposing their whims and with maintaining themselves in power. . . .

In any case we will have on events the kind of influence which will reflect our numerical strength, our energy, our intelligence and our intransigence. Even if we are defeated, our work will not have been useless, for the greater our resolve to achieve the implementation of our program in full, the less property and less government will there be in the new society. And we will have performed a worthy task for, after all, human progress is measured by the extent government power and private property are reduced.

And if today we fail without compromising, we can be sure of victory tomorrow. — Errico Malatesta, 1891, from *Anarchy*

Obviously, in the present state of mankind, when the vast majority of people, oppressed by poverty and stupefied by superstition, stagnate in a state of humiliation, the fate of humanity depends on the action of a relatively small number of individuals; obviously it will not be possible suddenly to get people to raise themselves to the point where they feel the duty, indeed the pleasure from controlling their own actions in such a way that others will derive the maximum benefit therefrom. But if today the thinking and directing forces in society are few, it is not a reason for paralyzing yet more of them and for subjecting many others to a few of them. It

participated in the anarchist militias in 1936, and in 1937 joined the 26th Division. At the end of the struggle he managed to make his way to South America, but returned to Europe at the end of World War II and lived in Toulouse where he was editor of two Spanish-language journals as well as the historiographer of the CNT."

$13.95 *(PB/388/Illus)*

Anarchy
Errico Malatesta
Classic introduction to the subject by the Italian activist. **AK**
$4.99 *(PB/56)*

Anarcho-Syndicalism
Rudolf Rocker
Essential reading for anyone interested in worker control of industry, the classic work on the subject. **AK**
$5.95 *(PB)*

Anarchy in Action
Colin Ward
"Suppose our future in fact lies, not with a handful of technocrats pushing buttons to support the rest of us, but with a multitude of small activities, whether by individuals or groups, doing their own things? Suppose the only plausible economic recovery consists in people picking themselves off the industrial scrapheap, or rejecting their slot in the microtechnology system, and making their own niche in the world of ordinary needs and their satisfaction. Wouldn't that be something to do with anarchism?"
$6.95 *(PB/144)*

Anarchy in the U.K.: The Angry Brigade
Tom Vague
Germany spawned the Red Army Faction; Italy, the Red Brigades; France, Action Directe; the United States, the Weather Underground and Black Liberation Army . . . Britain had the Angry Brigade. Much more than a small group of individuals, the Angry Brigade was a movement that challenged reaction and state power in all its forms. Part of a general European resistance movement, its was an armed offensive grounded in substantial popular support. No leaders, do it yourself . . . Here, in Tom Vague's notorious, barbed, pop-culture style, is the story of Britain's premier revolutionary hooligans. Draws extensively on the Angry Brigade's communiqués, along with both the under-ground/countercultural and mainstream press of the late '60s through the early '70s, and police and court documents. **AK**
$14.95 *(PB/160/Illus)*

Bakunin: The Philosophy of Freedom
Brian Morris
Because Bakunin thought of himself as an anti-intellectual, he didn't leave behind a codified book of his pronouncements for others to follow. Nevertheless, as collected here for the first time in English, his philosophical ideas are inspirational to anyone who opposes the dualistic Western view of the individual, the state and society. **SC**
$18.95 *(PB/162)*

The Conquest of Bread
Peter Kropotkin
"A study of the needs of humanity and of the economic means to satisfy them." Taking the Paris Commune as its model, its aim is to show how a social revolution can be made and how a new society, organized on libertarian lines, can then be built on the ruins of the old."
$19.99 *(PB/282)*

Decentralizing Power: Paul Goodman's Social Criticism
Edited by Taylor Stoehr
Perhaps the most widely read anarchist text of the '50s and '60s, Paul Goodman's *Growing Up Absurd* was a classic of myth-busting writing. In this new collection of essays, readers can learn more about Goodman's less-well-known political and social writing. **SC**
$19.99 *(PB/206)*

Durutti: The People Armed
Abel Paz
An exhaustive biography of the legendary Spanish revolutionary, who died at age 40 in 1936. **AK**
$16.99 *(PB/323/Illus)*

The Ego and Its Own: The Case of the Individual Against Authority
Max Stirner
Quite possibly the most subversive thing ever written by a Young Hegelian, this book got under Marx and Engels' skins so much that they wrote a 700-page-plus refutation of it, *The German Ideology*. Stirner's point is that the individual should be the primary focus of social relationships. This concept appeals to both the left and right; however, anyone who would call himself a "Stirnerite" is either an idiot or misses the point. Cited by everyone from bomb-toting anarchists to limp-wristed Libertarians, consistently misinterpreted, and influential on such varied people as Friedrich Nietzsche and Guy Debord, *The Ego and Its Own* is a must-read for anyone who is interested in anti-authoritarian politics. **SC**
$7.95 *(PB/366)*

*Durruti with Manzana, Sol Ferrer and Sebastian Faure — from **Anarchists in the Spanish Revolution***

The Essential Kropotkin
Peter Kropotkin
General selection from all of his works: "Appeal to the Young," "Law and Authority," "The Wage System," "Anarchism," "Memoirs of a Revolutionist," "Mutual Aid," "The Great French Revolution," and "Fields, Factories, and Workshops."
$6.95 *(PB/249)*

Ethics:
Origins and Development
Peter Kropotkin
Kropotkin's masterwork, this volume sets forth the results of his lifelong research into the history of human ethics, from primitive peoples to the late 19th century. For the author, an anarchist scientist, ethics were not an abstract science of human conduct but a concrete discipline based on mutual aid, justice and self-sacrifice. **SC**
$19.99 *(PB/352)*

The False Principle of Our Education
Max Stirner
Humanism and Realism, the Egoist way. A classic essay from Stirner. **AK**
$2.50 *(Pamp/28)*

Fields, Factories and Workshops
Peter Kropotkin
An anarchist study of the possibilities of reorganizing industry along nonhierarchical, nonexploitative lines, with new material by Colin Ward.
$19.99 *(PB/202)*

Fra Contadini:
A Dialogue on Anarchy
Errico Malatesta
Using the form of a conversation between two peasants, Malatesta expounds on the theory of anarchism. **AK**
$3.50 *(PB/47)*

Fugitive Writings
Peter Kropotkin
Serves as a good introduction to Kropotkin's writings, with his ideas presented in the context of his political and social essays. Much of this material has long been out of print or untranslated. **SC**
$19.99 *(PB/202)*

God and the State
Michael Bakunin
"Among the 19th-century founders of mod-

Michael Bakunin, author of God and the State

ern philosophical anarchism, none is more important than Michael Bakunin (1814-1876). Born into Russian nobility, he renounced his hereditary rank in protest against Czarist oppression, and fled to Western Europe. . . . A colorful, charismatic personality, violent, ebullient and energetic, Bakunin was one of the two poles between which 19th- and early 20th-century anarchism was formed. All threads of one chain of anarchism lead back to Bakunin, and everyone in the movement either built upon or reacted to his ideas. *God and the State* has been a basic anarchist and radical document for generations. It is one of the clearest statements of the anarchist philosophy of history: religion by nature is impoverishment, enslavement and annihilation of humanity. It is the weapon of the state. It must be smashed, according to Bakunin, before the right of self-determination is possible."
$4.95 *(PB/89)*

In Russian and French Prisons
Peter Kropotkin
This is Kropotkin's critique of prisons from the inside out, perhaps the first book to cover penology from the standpoint of a participant-observer. Far from reforming the offender, he writes, even in the 19th century prisons were already better suited as schools for crime. **SC**
$19.99 *(PB/316)*

Listen Anarchist
Chaz Bufe
New, slightly expanded edition of this polemic, arguing for a return to morality in anarchists' dealing with the world at large

and each other in particular. **AK**
$1.00 *(Pamp/16)*

Living My Life: Volume 1†
Living My Life: Volume 2††
Emma Goldman
"Candid, no-holds-barred account by the foremost American anarchist: her own life, anarchist movement, famous contemporaries, ideas and their impact."
†$8.95 *(PB/503/Illus)*
††$10.95 *(PB/1,110/Illus)*

Memoirs of a Revolutionist
Peter Kropotkin
Describes social ferment, tyranny in czarist Russia, the author's intellectual development, scientific career, Siberian exile, escape and life in the West.
$11.95 *(PB/557)*

Mutual Aid: A Factor of Evolution
Peter Kropotkin
"Kropotkin applies his exploration of Eastern Asia and his study of wild-animal behavior to a critical examination of evolution. Also provides an argument for anarchism by showing historically how people tend to cooperate spontaneously and how the State destroys this natural inclination toward mutual aid by strangling initiative with the dead hand of regulation."
$19.99 *(PB/362)*

Nationalism and Culture
Rudolf Rocker
His magnum opus—dissects the State in all its manifestations and shows why and how throughout the course of human history, the State has been the principal enemy of social life and cultural development. **AK**
$20.00 *(PB)*

Neither God Nor Master, Books One and Two
Daniel Guerin
This is the first English translation of Guerin's monumental anthology of anarchism. It details, through a vast array of hitherto unpublished documents, writings, letters and reports, the history, organization and practice of the anarchist movement as well as its theorists, advocates and activists. **AK**
$16.95 *(PB/304)*

The Physiognomy of the Anarchists
Cesare Lombroso
First appearing in 1891, this attempt at "criminal anthropology" has been a knee-slapper since it first surfaced. The definitive (ahem) analysis of the Haymarket Martyrs and other such deviant types. **AK**
$2.00 *(PB/12)*

Reinventing Anarchy, Again
Edited by Howard Ehrlich
Brings together the major currents of social anarchist theory in a collection of some of the movement's important writers from the U.S., Canada, England and Australia. The book opens with an exploration of the past and future possibilities of anarchism; then moves to consider the "necessity" of the state and bureaucratic organization as well as the meaning of the "anarchist contract." The third of the theoretical sections tackles the hard questions for social anarchists confronting the foundations of libertarian socialist and liberal democratic thought. **AK**
$19.95 *(PB/400/Illus)*

Social Anarchism or Lifestyle Anarchism: An Unbridgeable Chasm
Murray Bookchin
At times Bookchin looks like an angry grampa lamenting for the good old days of the traditional Left, yet he makes some good points and vital distinctions concerning different forms of anarchism past and present. Bookchin's assault on the work of Michel Foucault and Hakim Bey (to mention two) are for the most part reductive yet humorous. The great observation Bookchin makes here is that there is a huge reinvestment in ego-driven existentialism among members of the "X Generation" who flaunt an anarchist identity. What he describes as lifestyle anarchy deservedly sounds like good old American individualism. Bookchin points out the vital social content in the anarchist ideas of Bakunin and Kropotkin and cites significant events such as the Spanish anarchist struggle of the 1930s as elements not to be overlooked when considering anarchy as a viable option. **KH**
$7.95 *(PB/92)*

The Struggle Against the State and Other Essays
Nestor Makhno
Makhno was a Ukrainian peasant revolution-

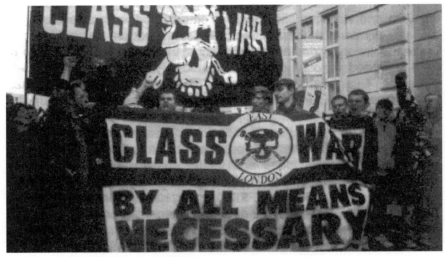
Class War demonstration — from **Unfinished Business**

ary who for several years before, during and after the Russian Revolution successfully led an anarchist army which fought against both the Bolsheviks and the White counterrevolutionaries. From exile in Paris, Makhno aggressively refuted allegations of anti-Semitism and of having conducted pogroms in essays like "To the Jews of All Countries," and commemorated the tragic fate of the workers in Kronstadt, who fought the Red Army in 1921 to try to implement the Bolshevik proclamations regarding equality and worker autonomy. These essays are the hard-won insights of a fighting anarchist who could clearly the see totalitarian realities behind the propaganda of the early Soviet era. In his essay "The ABC of the Revolutionary Anarchist," Makhno writes, "Experience of practical struggle strengthened my conviction that anarchism educates man in a living way. It is a teaching every bit as revolutionary as life, and it is a teaching every bit as varied and potent in its manifestations as man's creative existence and, indeed, is intimately bound up with that." **SS**
$9.95 *(PB/126)*

To Remember Spain: The Anarchist and Syndicalist Revolution of 1936
Murray Bookchin
Like most of Bookchin's writing, this book is delivered clearly and easily like a union speech, generous with emotion as well as relevant dates, people and statistics. Bookchin includes some fine descriptions of peasant-based governing structures devel-

oped out of particular circumstance and need in resistance to centralized governing structures which overtake and oppress. Bookchin also describes the factioning and Stalinism which pitted Communist against Communist against anarchist, sabotaging the entire effort of the Spanish people to avoid a brutal dictatorship under Franco. This period in Spain was a brief moment that produced radical social forms which actually worked. Bookchin has written a most enthusiastic guide for this vital set of events. **KH**
$6.00 *(PB/74/Illus)*

Unfinished Business: The Politics of Class War
Class War
Some frolics through the politics of these rabble-rousing English anarchists, who have raised tabloid-baiting, cop-targeting and Tory-annoying to a fine art. Some insightful essays, mixed with a lot of working-class rhetoric. **SC**
$9.95 *(PB/186/Illus)*

Words of a Rebel
Peter Kropotkin
This is the first complete English translation of a seminal Kropotkin book, which includes his earliest articles. These pieces present his skills as a political agitator in their full glory, as he rouses the rabble to overthrow corrupt, centralized wealth and power. **SC**
$19.99 *(PB/232)*

BAUDRILLARD

Unidentified Vitagraph film — from
From Peep Show to Palace

"The history of the social will never have had time to lead to socialism, it will have been short-circuited by the hyper social, by the hyperreality of the social. . . . Thus, even before political economy leads to its dialectical overthrow, to the resolution of all needs and to the optimal organization of all things . . . it will have been captivated by hyperreality of the economy (the stepping up of production, the procession of the production of demand before that of goods, the indefinite scenario of crisis)."

In describing the very mechanics of "meaning" and "the social," Baudrillard makes clear how dialectic modes of cultural criticism exist within a crisis of representation. Both meaning and the social are in a state of "implosion." He articulates examples in many areas of contemporary life where the will to oppose or resist becomes a circuit of helpless conformity. Baudrillard clarifies the efficient, rapidly producing and self-preserving mechanisms in capitalism, and the huge intellectual challenge of its critique. Baudrillard's theories reveal the pathos and absurdity of academic position—holding while setting forth the task of developing experience capable of outrunning, if even for a moment of what he calls "seduction," the thoroughly absorptive phenomena of late capitalism.
—KH

America
Jean Baudrillard

"I went in search of an astral America, not social and cultural America, but the America of the empty, absolute freedom of the freeways, not the deep America of mores and mentalities, but the America of desert speed, of motels and mineral surfaces. . . . America is neither dream nor reality. It is a hyperreality. It is a hyperreality because it is a utopia which has behaved from the very beginning as though it were already achieved. . . . The microwave, the waste disposal, the orgasmic elasticity of the carpets: this soft, resort-style civilization irresistibly evokes the end of the world. . . . We want to expose to view its billions of connections and watch it operating like a video game. . . . It is erosion and it is extermination, but it is also the tracking shot, the movies. . . . Hence the exceptional scenic qualities of the deserts of the West, combining as they do the most ancestral of hieroglyphs, the most vivid light and the most total superficiality."

$18.95 *(PB/200)*

Cool Memories
Jean Baudrillard

"*Cool Memories* is the other side of America, the disillusioned side, presented in the form of a diary, though not in the classical sense. I'm trying to grasp the world in all its silences and its brutality. Can you grasp a world when you're no longer tied to it by some kind of ideological enthusiasm or by traditional passions? Can things 'tell' themselves through stories and fragments? These are some of the questions posed in a book which may seem melancholic. But then I think almost every diary is melancholic. Melancholy is in the very state of things."

$16.95 *(PB/233)*

Cool Memories II, 1987-1990
Jean Baudrillard

"Baudrillard's latest commentary on the techno present and future, an installment of his reflections on the reality of contemporary western culture."

$15.95 *(PB/90)*

The Evil Demon of Images
Jean Baudrillard

Lecture on film, TV and the image at the University of Sydney in Australia. Also an interview which sheds light on Baudrillard's notions of objective irony, seduction and hyperreality.

$9.95 *(PB/54)*

For a Critique of the Political Economy of the Sign
Jean Baudrillard

This collection of essays attempts an analy-

sis of the sign form in the same way that Marx's critique of political economy sought an analysis of the commodity form. Some of his better earlier writings, before he discovered postmodernism. **AK**
$14.00 *(PB/214)*

The Gulf War Did Not Take Place
Jean Baudrillard
"The war, along with the fake and presumptive warriors, generals, experts and television presenters we see speculating about it all through the day, watches itself in a mirror: Am I pretty enough, am I operational enough, am I spectacular enough, am I sophisticated enough to make an entry onto the historical stage?"
$20.95 *(PB/87)*

The Illusion of the End
Jean Baudrillard
"The year 2000, the end of the millennium: Is this anything other than a mirage, the illusion of an end, like so many other imaginary endpoints which have littered the path of history? . . . Baudrillard . . . argues that the notion of the end is part of the fantasy of a linear history. Today, we are not approaching the end of history but moving into reverse, into a process of systematic obliteration. We are wiping out the entire 20th century . . . "
$12.95 *(HB/123)*

In the Shadow of the Silent Majorities
Jean Baudrillard
"Baudrillard expounds on his view that the social and the 'masses' no longer exist."
$7.00 *(PB/123)*

The Mirror of Production
Jean Baudrillard
An examination of the lessons of Marxism and an attempt to free the Marxist logic from the restrictive context of political economy. Early Baudrillard at his best.
AK
$12.00 *(PB/167)*

Simulations
Jean Baudrillard
"The very definition of the real has become: *that of which it is possible to give an equivalent reproduction. . . . The real is not only what can be reproduced, but that which is always already reproduced . . . the hyperre-*

al, which is entirely in simulation."
$7.00 *(PB/162)*

The Transparency of Evil: Essays in Extreme Phenomena
Jean Baudrillard
A new investigation of simulations from Baudrillard edited in a *Mythologies*-like compilation. The focus: popular notions operating within what Baudrillard considers "delusionary" dialectics. Topics such as: "human rights" (to work, desire, the unconscious), epidemics, aesthetics, transsexuality, technology, terrorism, the Heidegger Nazi question, energy crisis, difference (regulated exchange breeching what is considered "good" or "useful"), immune systems, and more where recycled dialectic thought attempts impossible relations of determined value within the phenomena of "out of con-

trol late capitalism", that is, the "advanced stage of simulacra."

Baudrillard describes an "epidemic of value" where such a proliferation of values occurs that an overall disappearance of values takes place. Hence—the "transparency of evil." He states that "it is as impossible to make estimations between beautiful and ugly, true and false, or good and evil, as it is simulataneously to calculate a particle's speed and position."

Offering double negations to dismantle the hopes of "progressives" and "post-modernists" alike, the collection closes with an essay entitled "The Object as Strange Attractor" which discusses potential escape from reproducing indifference, refuting claims that Baudrillard is exclusively a theorist of crisis.
KH
$18.95 *(PB/192)*

The Viva, an unbuilt project, integrated the highrise trend of the early 1960s with the aesthetic of the great signs of the same period. — from Viva Las Vegas

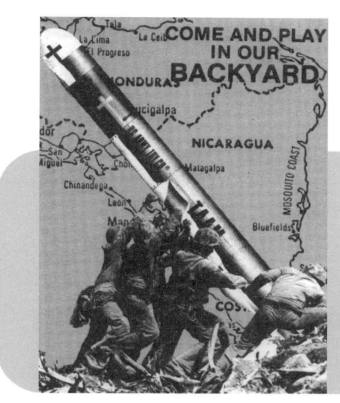

CHOMSKY

If you assume that there's no hope, you guarantee that there will be no hope. If you assume that there is an instinct for freedom, there are opportunities to change things, there's a chance you may contribute to making a better world. That's your choice. — Noam Chomsky, from *Chronicles of Dissent*

Noam Chomsky is a world-renowned linguist, a professor of linguistics and philosophy at MIT and a lifelong political activist who was jailed for his anti-Vietnam War activities. He is regarded as the foremost critic of American media and U.S. foreign and domestic policy. Politically, Chomsky defines himself as an anarcho-syndicalist, citing Bakunin and Rudolf Rocker as his greatest influences. — AK

Militaristic Erection — Backyard Fuck *(1986)* — *from* **Stealworks**

After the Cataclysm: Post-war Indochina and the Reconstruction of Imperial Ideology
Noam Chomsky and Edward S. Herman
Focuses on the myth and reality of the current situation in post-war Indochina. Shows the effects of the war and discusses the refugee problem, the Pol Pot regime, the question of human rights, and the role of the media.
$18.00 *(PB/392)*

Chronicles of Dissent
Noam Chomsky
A first-rate collection of interviews furnishing an accessible overview of Chomsky's thought. Perhaps the best place to start for anyone coming to the politics of Chomsky

for the first time. **AK**
$11.95 *(PB/272)*

Class War: The Attack on the Working People
Noam Chomsky
Corporations and their political allies wage an unrelenting class war against the working people. Privatization, the market and level playing fields are the mantras of the day. CEOs tell workers to tighten their belts while their own wallets are bulging. Income inequality is more acute in the U.S. than in any other industrialized country, even surpassing Britain. Glamorous Manhattan has disparities in wealth that exceed those of Guatemala. People are working long hours, producing more and earning less. Wages have been stagnant or

declining for more than 20 years. The ranks of the poor have mushroomed. Meanwhile profits are at unprecedented levels. Recorded live at MIT, this marks the third volume in the series of lectures bringing Noam Chomsky's words and vision to CD. 57 min. **AK**
$14.98 *(CD)*

Class Warfare: Interviews With David Barsamian
Noam Chomsky
Continuing his best-selling interviews with Barsamian, Chomsky provides a road map to the concentration of corporate power. Amid a devastating sketch of the ongoing destruction of civil society, *Class Warfare* unearths a cause for optimism in the ongo-

ing struggle for human freedom. **AK**
$15.00 *(PB/192)*

The Clinton Vision:
Old Wine, New Bottles
Noam Chomsky
In 1992, Bill Clinton was elected president of the United States. After 12 years of a Republican White House, voters hungry for "Change" believed Clinton when he promised a new vision, a new activism and a new direction for the U.S. Chomsky speaks about the president's actions on NAFTA, health care, crime, labor relations, foreign policy and the economy. 56 min. **AK**
$12.98 *(CD)*

The Culture of Terrorism
Noam Chomsky
Examines the U.S. role in Central America, focusing on the Iran-Contra scandal. Shows how the real issue of the scandal—continuing terrorism in the world—was ignored to better concentrate on more inconsequential issues. Reveals the role the media played in facilitating a vision of the scandal as a "mistake" committed by high-minded individuals who later saw the error of their ways.
$16.00 *(PB/269)*

Deterring Democracy
Noam Chomsky
"A revelatory portrait of the American empire and the danger it poses for democracy, both home and abroad. Chomsky details the major shift in global politics and economic potency and reveals the potentially catastrophic consequences of this new imbalance."
$15.00 *(PB/455)*

Free Market Fantasies:
Capitalism in the Real
World
Noam Chomsky
Megamergers and monopolies are limiting competition. Fewer than 10 corporations control most of the global media. The existing free market depends heavily on taxpayer subsidies and bailouts. Corporate welfare far exceeds that which goes to the poor. Economic policy is based on the dictum "Take from the needy and give to the greedy." 56 min. **AK**
$13.98 *(CD)*

Keeping the Rabble in
Line
Noam Chomsky
In the gripping series of interviews from

1992 to '94, Chomsky outlines his views on a wide range of subjects including: health care, global warming, gun control and Clinton's foreign policy. **AK**
$13.95 *(PB/256)*

Language and Politics
Noam Chomsky
"In this series of interviews, Chomsky confronts the often-asked question: What is the connection between his linguistic studies and his political analysis? The coverage in these interviews, which span the 20-year period from 1968 to 1988, extends from Chomsky's personal background and intel-

Hand With Hebrew Letters — *from* El **Lissitzky**

lectual development to the latest political events."
$28.95 *(PB/779)*

Language and Problems
of Knowledge: The
Managua Lectures
Noam Chomsky
"Chomsky's most accessible statement on the nature, origins and current concerns of the field of linguistics. Much of this discussion revolves around our understanding of basic human nature—that we are unique in

being able to produce a rich, highly articulated and complex language on the basis of quite rudimentary data—and it is here that Chomsky's ideas on language relate to his ideas on politics. From lectures given at the Universidad Centroamericana in Managua, Nicaragua, in March 1986."
$9.95 *(PB/205)*

Letters From Lexington:
Reflections on
Propaganda
Noam Chomsky
'n a collection of letters written to *Lies of Our Times* magazine, Chomsky outlines the role of the media in justifying U.S. Government and corporate actions. The letters, written between 1990 and 1993, examine media coverage of events and issues ranging from the Middle East "peace process," the U.S. invasion of Panama, the Gulf War, the U.N., the Soviet Union, terrorism and democracy to the coup in Haiti.
 AK
$10.95 *(PB/167)*

Liberating Theory
Noam Chomsky et al.
In a landmark theoretical work which might influence progressive thinking, seven respected activist/scholars from various backgrounds and movements have collaborated to create a new theory of liberation. The authors combine various theories of history (Marxism, anarchism, feminism and nationalism) to develop an alternative conceptual framework that they call "complementary holism," and apply this theory to questions of economics, politics, gender, race and culture. "Complementary holism" is intended to be used to understand society and create new strategies for its transformation. **SC**
$14.00 *(PB/197)*

Manufacturing Consent:
The Political Economy
of the Mass Media
Noam Chomsky and Edward Herman
"Analysis of the ways in which individuals and organizations of the media are influenced to shape the agendas of knowledge and, therefore, belief. Contrary to the popular conception of members of the press as hard-bitten realists doggedly pursuing unpopular truths, Chomsky and Herman prove conclusively that the free-market economics model of the media leads inevitably

to normative and narrow reporting."

$17.00 *(PB/412)*

Necessary Illusions: Thought Control in Democratic Societies
Noam Chomsky

"In short, the major media are corporations 'selling' privileged audiences to other businesses. It would hardly come as a surprise if the picture of the world they present were to reflect the perspectives and interests of the sellers, the buyers and the product. Media concentration is high and increasing. Furthermore, those who occupy managerial positions in the media, or gain status with them as commentators, belong to the same privileged elites, and might be expected to share the perceptions, aspirations and attitudes of their associates, reflecting their own class interests as well. Journalists entering the system are unlikely to make their way unless they conform to these ideological pressures, generally by internalizing the values; it is not easy to say one thing and believe another, and those who fail to conform will be weeded out by familiar mechanisms."

$18.00 *(PB/422)*

On Power and Ideology: The Managua Lectures
Noam Chomsky

Five lectures delivered at the Universidad Centroamericana in Nicaragua on U.S. foreign policy, both global and specific to Central America. Exposes the distribution of power in our society and the place of Central America in U.S. objectives.

$12.00 *(PB/140)*

Pirates and Emperors: International Terrorism in the Real World
Noam Chomsky

Illuminates the meaning of the concept of international terrorism in contemporary Western usage, and reaches to the heart of the frenzy over selected incidents of terrorism currently being orchestrated as a cover for Western violence.

$19.99 *(PB/215)*

Powers and Prospects: Reflections on Human Nature and the Social Order
Noam Chomsky

Chomsky's first collection in recent years to

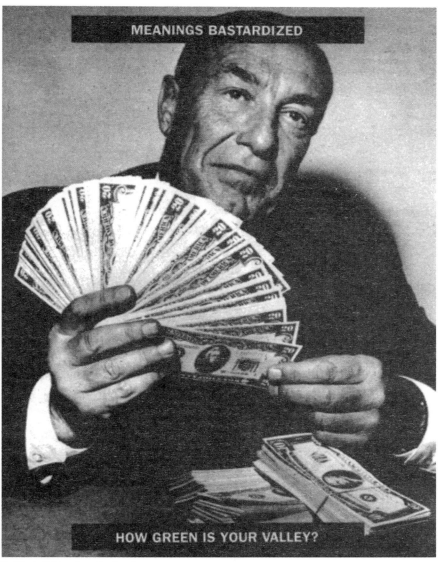

MEANINGS BASTARDIZED

HOW GREEN IS YOUR VALLEY?

Untitled, *1992 — from* **Stealworks**

address questions of linguistics, philosophy, ethics and international affairs. From language and human nature to the Middle East and East Timor, supported by a wealth of disturbing details and facts, Chomsky provides a scathing critique of government policy and media complicity, while offering an inspirational view of the potential for true democracy worldwide. **AK**

$16.00 *(PB/244)*

Prospects for Democracy
Noam Chomsky

A broad review of democratic theory and polit-

ical history, Chomsky argues that classical democrats such as Thomas Jefferson would be shocked at the current disrepair of American democracy. The enormous growth of corporate capitalism has already devastated democratic culture and government by concentrating power in the hands of the wealthy. And the future looks no brighter. 72 min. **AK**

$14.98 *(CD)*

The Prosperous Few and the Restless Many
Noam Chomsky

A wide-ranging, state-of-the-world report

from America's most influential intellectual. Recent interviews with David Barsamian cover everything from Bosnia to NAFTA.

AK

$5.00 **(PB/111)**

Secrets, Lies and Democracy
Noam Chomsky
The latest collection of interviews with David Barsamian, focusing on the domestic scene—how is our claim to democracy limited and defective? What does the term "democracy" describe in the real world? As ever, perceptive and provocative. **AK**

$6.00 **(PB/128)**

The Washington Connection and Third World Fascism: The Political Economy of Human Rights
Noam Chomsky and Bernard S. Herman
Analyzes the forces that have shaped U.S. international policy in Latin America, Asia and Africa, as well as the role of the media in misreporting these policies and their motives.

$16.00 **(PB/441)**

World Orders Old and New
Noam Chomsky
ATTENTION! THIS IS THE NEW WORLD ORDER: "The rich men of the rich societies are to rule the world, competing among themselves for a greater share of wealth and power and mercilessly suppressing those who stand in their way, assisted by the rich men of the hungry nations who do their bidding. The others serve, and suffer."

In other words, a world dotted with gleaming islands of First World capitalism, floating over and shadowing Third World graveyards of the living. "The Left's leading critic of government policy, power and language takes on the international scene since 1945, devoting particular attention to events following the collapse of the Soviet Union," Clinton's "empty promises to the poor," and various Middle Eastern/Central American/Eastern European hotspots. The author, professor of modern languages and linguistics at MIT, "focuses his no-hold-barred attention once more on the power-less, the power-hungry and the powermongers in our increasingly global community." And what of the New World Order that the

Labor, *sculpture by Stanislav Szukalski, 1920 — from* **The Lost Tune**

militias speak of? With the black helicopters and the taking of guns? It's the same one, really—only theirs is a mythological panic reaction. It represents their gut feeling toward world events, which is fear. **GR**

$24.95 **(HB/311)**

Year 501: The Conquest Continues
Noam Chomsky
Although Chomsky's influence over the field of linguistics has been unrivaled by any other living scholar, he is more widely known for his writings on political issues. Published 501 years after Columbus' "discovery" of the Americas, this book delineates the hidden history of the U.S., the story of "Europe's conquest of the world" and its "great work of subjugation." Tracing the contours of neocolonialism to its roots in the old world order, Chomsky maps the faultlines between geopolitical blocs (north/south, east/west), and develops pointed insights and damning critiques of Western culture. The volume shines brightest in its examination of the vast gulf between the idealistic language of American democracy and to such social realities as the "free" market and human-rights abuses, indeed all of present-day imperialist exploitation and murder. *Year 501* closes with Chomsky's continuing condemnation of the news media: its misrepresentations, its "murder of history," and subsequent widespread loss of hope. Not a light read. **HS**

$16.00 **(PB/332)**

FOUCAULT

For Michel Foucault, Madness, Sickness, Criminality, and Sexuality are loci of experience which demarcate history. His theories explain history as relations of power and structural undertakings rather than a series of decisive events and consequences. Foucault's super focus on the "modality of relation to the self" is a concise look at history which, by being relative to the human body and detailed in its singular accounts, causes ruptures in any seamless process of historicism.

In his later historical writings, Foucault begins a comprehensive investigation of sexuality leading to a positive stage of research into experience potentially free of the construct of "sexuality " and psycho-historical "repression." In *The History of Sexuality* he states, "if repression has indeed been the fundamental link between power, knowledge, and sexuality since the classical age, it stands to reason that we will not be able to free ourselves from it except at a considerable cost: nothing less than the transgression of laws, a lifting of prohibitions, an irruption of speech, a reinstating of pleasure within reality, and a whole new economy in the mechanisms of power will be required."

Foucault is one of the key theorists to the generation of May '68 who, like his colleagues Deleuze and Guattarri, derail faith instituted by the cults of history and psychoanalysis, and propose the potential for experience which is other than what is predetermined by repressive structures. — KH

The Prisons, Giovanni Battista Piranesi — *from* The Prisons

Archaeology of Knowledge
Michel Foucault
Madness, sexuality, power, knowledge—are these facts of life or simply parts of speech? Foucault begins at the level of "things said" and moves quickly to illuminate the connections between knowledge, language and action.
$13.50 *(PB/245)*

Birth of the Clinic: An Archaeology of Medical Perception
Michel Foucault
"It concerns one of those periods that mark an ineradicable chronological threshold: the period in which illness, counternature, death, in short, the whole dark underside of disease, came to light, at the same time illuminating and eliminating itself like night, in the deep, visible, solid, enclosed but accessible space of the human body."
$10.00 *(PB/240)*

Discipline and Punish: The Birth of the Prison
Michel Foucault
A genealogy of the movement with which power subjectifies, encapsulates and controls the individual moving from torture's spectacular assault upon the body to modern prisons which constrain and normalize the spirit in "peaceful and humane" institutions which nevertheless echo "the distant roar of the battle."
$13.00 *(PB/333)*

Foucault Reader
Michel Foucault
Essays, excerpts and interviews which evenly span Foucault's prolific and diverse career, compiled here in an attempt to allow a broad and inclusive introduction to the often-changing, sometimes contradictory body of his work.
$15.00 *(PB/389)*

History of Sexuality, Volume 1: An Introduction
Michel Foucault
Foucault, the genealogist, deals with two interlocked themes in the last major works before his death: an analysis of sexuality as historical construct rather than underlying biological referent, and the evolution of the

modern individual as subject.

$10.00 *(PB/168)*

History of Sexuality, Volume 2: The Use of Pleasure

Michel Foucault

Analyzes the way sexuality was perceived in ancient Greece and discusses why sexual experience became a moral issue in the West.

$12.00 *(PB/168)*

History of Sexuality, Volume 3: Care of the Self

Michel Foucault

Foucault examines the first two centuries of the Golden Age of Rome, to reveal a subtle but decisive break from the classical Greek vision of sexual pleasure. Explores the moral reflection among philosophers (Plutarch, Epicletus, Marcus Aurelius, Seneca) and physicians of the era, and uncovers an increasing mistrust of pleasure and growing anxiety over sexual activity and its consequences.

$12.00 *(PB/168)*

I, Pierre Rivière, Having Slaughtered My Mother, My Sister and My Brother

Edited by Michel Foucault

On a fine summer's day, 20-year-old Pierre Rivière took in hand a sharp farm implement known as a pruning hook and hacked to death his mother, 18-year-old sister and 7-year-old brother. Observed by a neighbor as he still clutched the bloody tool, Rivière told him, "I have just delivered my father from all his tribulations. I know that they will put me to death, but no matter," before he calmly walked off. Rivière might sound like yet another nihilist psychotic born of 20th-century malaise, but the year was 1835. Described by witnesses as "an idiot in his village," Rivière nevertheless produced a 40-page written "confession." This confession forms the centerpiece of *I, Pierre Rivière . . .* along with other documents gathered together by editor Foucault, including medical and legal reports, transcripts of interrogations and statements by witnesses. In addition to these primary source materials, Foucault and several other historians comment on the murder and its aftermath in the final section of the book.

These essays situate Rivière's crime in a time when the medical and legal professions were first contending for status and power, thus creating the basis for beliefs about crime and insanity that continue with us in our own time. **LP**

$12.00 *(PB/289)*

Madness and Civilization

Michel Foucault

"We have yet to write the history of that other form of madness, by which men, in an act of sovereign reason, confine their neighbors, and communicate and recognize each other through the merciless language of non-madness; to define the moment of this conspiracy before it was permanently established in the realm of truth, before it was revived by the lyricism of protest. We must try to return, in history to that zero point in the course of madness at which madness is an undifferentiated experience, a not-yet-divided experience of division itself."

$12.00 *(PB/299)*

Power/Knowledge: Selected Interviews and Other Writings, 1972-1977

Michel Foucault

Shows that Foucault has always been describing the nature of power in society; not the conventional treatment of power that concentrates on powerful individuals and repressive institutions, but the much more pervasive and insidious mechanisms by which power "reaches into the very grain of individuals, touches their bodies and inserts itself into their actions and attitudes, their discourses, learning processes and everyday lives."

$14.00 *(PB/270)*

A man needs a lot of affection and attention, but a little firmness from Shirley occasionally does no harm. — from **Hollywood Lolita**

SITUATIONIST

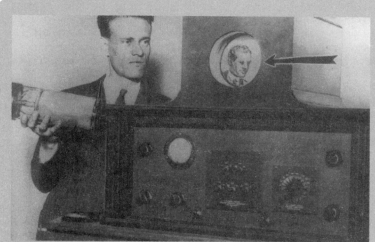

Philo T. Farnsworth invented electronic television when he was a high school student in rural Utah. He is shown here with his dissector tube and a 1929 receiver. — from Please Stand By

"Every day we are denied an authentic existence and sold back its representation." The Situationists called for and set about creating a revolutionary theory based on "radical subjectivity"—abolition of work, imagination seizing power, a new era of play, and rejection of hierarchy—through the dada tactics of subversion.

The Situationist International issued a series of revolutionary manifestoes and other works in France in the first half of the '60s which completely redefined the zones of combat for the streetfighter of our media-saturated age. Their declaration of our col-

lective existence as "the spectacle"—the world of illusions that our system has imposed where images become more than the things they represent—seems prophetic rather than dated a generation down the line.

Since the spectacle appropriates every form of dissent through its "recuperation"—repackaging rebellion as commodities (usually in the form of LPs seemingly)—subversion (or "détournement") destroys the spectacle's message while hijacking its impact.

The Situationists were largely responsible for inspiring the May '68 revolution which began at Nanterre University near Paris and nearly paralyzed Gaullist France. The rebels of '68, seeing the *enemy* as cybernetic power-bureaucrats of all stripes, left us such graffitti as "humanity won't be happy till the last bureaucrat is hung with the guts of the last capitalist."

Situationist thought reared its head again in mid-'70s England where the tactics of media-insurrection were practiced on a grand scale by the Sex Pistols, only to be recuperated by a Thatcherite Britain to a degree yet to be surpassed.

"The crane, the pulley and other hydraulic devices started out as theatrical paraphernalia; it was only much later that they revolutionized production relations. It is a striking fact that no matter how far we go back in time the domination of the earth and of men seems to depend on techniques which serve the purposes not only of work but also of illusion." — Raoul Vaneigem, from *The Revolution of Everyday Life*
— SS

The Art Strike Papers/ Neoist Manifestoes

Edited by Stewart Home and James Mannox
These two titles are published back to back, upside down in the manner of the old two-fer pulps. The Neoist manifestoes are republished from *Smile* magazine which Home called "the official organ of Generation Positive, a movement so avant-garde that it consisted solely of myself." In 1984, Home joined forces with a Dada-influenced group calling itself the Neoists. As far as can be gleaned from the manifestoes, it would appear that starting art movements as an end in itself is a sort of 20th-century art form. The writing in the actual manifestoes is by turns silly, and occasionally, actual ly brilliant. The influence of Tristan Tzara is

especially in evidence, and one manifesto suggests that "Neoism is not a philosophy at all, it is an illegible note that Tristan Tzara allowed to fall from his breast pocket prior to a performance at the Cabaret Voltaire in 1916." It should be noted that these writings are among the first public offerings from a very young and prolific writer.

The Art Strike notion has been floating around the art world since 1968. During martial law in Poland, artists refused to exhibit their work in state galleries, leaving the ruling class without an official culture. Home writes, "what's important are the questions that something like this poses. Hopefully it is as much about triggering doubts as anything else." The Art Strike that occurred from 1990 to 1993 came about

largely as a giant mail-art event and consisted of this series of essays by various people which raise, among others, the question of how effective such a declaration can be in a free marketplace. The standout among *The Art Strike Papers* is a piece entitled "Art and Class" by Home. The publication of these two titles as a single book allows us to see Home's growth as a writer and theorist over a crucial decade in his development. **SA**
$12.95 *(PB/100)*

The Assault on Culture: Utopian Currents from Lettrisme to Class War

Stewart Home
Thumbnail outline of the seemingly maze-

like "utopian" (read "anti-commodity") movements that seek to replace art and work with some form of more genuine expression. Ties together pataphysics, COBRA, lettrists, Situationist International, Fluxus, auto-destructive art, Provos, Yippies, White Panthers, punk, mail art, and other currents. Anti-romantic non-coffeetable, anti-art history. **SS**
$12.95 *(PB/120)*

The Book of Pleasures
Raoul Vaneigem
A further exploration of Situationist themes, from the most readable, accessible and witty of the original situ writers. **AK**
$10.95 *(PB/106)*

Buffo
Anonymous
"In the autumn of 1983 a tape recording of a telephone conversation between President Reagan and Prime Minister Thatcher was sent anonymously to newspapers in various parts of the world. A covering note claimed that the tape was a recording of a crossed phone line on which was heard part of the two leaders' telephone conversation. In January 1984, the story was taken up by the Sunday *Times* and the San Francisco *Chronicle*. The Sunday *Times* described the tape as part of a KGB propaganda war. The U.S. State Department said that the tape was evidence of 'an increasingly sophisticated Russian disinformation campaign.' In fact the tape was made by members of the anarchist punk-rock group Crass. The tape had been produced by using parts of TV and radio broadcasts made by the two leaders, then over-dubbed with telephone noises."
$3.50 *(PB/24)*

Comments on the Society of the Spectacle
Guy Debord
Guy Debord dramatically broke 20 years of silence to eloquently update his prophetic call-to-arms. "In 1967, in a book entitled *The Society of the Spectacle*, I showed what the modern spectacle was already in essence: the autocratic reign of the market economy which had acceded to an irresponsible sovereignty, and the totality of new techniques of government which accompanied this reign. The disturbances of 1968, which in several countries lasted into the following years, having nowhere over-

thrown the existing organization of the society from which it springs apparently spontaneously, the spectacle has thus continued to gain strength; that is to spread the furthest limits on all sides, while increasing its density in the center. It has even learned new defensive techniques, as powers under attack always do. . . . Since the spectacle today is certainly more powerful than it was before, what is it doing with this additional power? What point has it reached, that it had not reached previously? What, in short, are its present *lines of advance?*"
$15.00 *(PB/94)*

Contributions to the Revolutionary Struggle: Intended to Be Discussed and Principally Put Into Practice Without Delay
RATGEB (Raoul Vaneigem)
Theses and treatises on life and how to live it, in Vaneigem's beautiful, witty style. **AK**
$4.50 *(PB/40)*

Guy Debord Is Really Dead
Luther Blisset
Stinging attack on the Situationist

International and its legacy—"the major failures of the Situationist International considered in their historical, cultural, psychological, sexual and especially political aspects, appended with the modest proposal that we cease allowing the traditions of the dead generations to dominate the lives of the living." **AK**
$6.95 *(Pamp/40)*

In Girum Imus Nocte et Consumimur Igni
Guy Debord
Complete film script, with an introduction and stills of his last film. Gives an account of the Situationist International's activities in Europe during the 1950s and '60s, reflects on the present situation of the cinema as a social form, and offers a theoretical treatise about the current conditions of consumer capitalism. **AK**
$15.95 *(PB/96/Illus)*

Neoism, Plagiarism and Praxis
Stewart Home
A collection of work from novelist and art agitator Stewart Home, this brings together his writings from the mid-'80s onward. This book is concerned with what's been happening at the cutting edge of culture since the demise of Fluxus and the Situationists. It pro-

Stewart Home

vides inside information on the Neoists, Plagiarists, Art Strikers, London Psychogeographical Association, K Foundation and other groups that are even more obscure. Rather than offering up a continuous narrative, the text is made of articles, manifestoes, lectures and essays. **AK**
$18.95 *(PB/209)*

Open Creation and Its Enemies
Asger Jorn
According to Jorn, "The field of situlogical experience is divided into two opposed tendencies—the ludic tendency and the analytical tendency—in the tendency of the art, spin and the game, and that of science and its techniques." By Ken Knabb's direct manipulation of the Situationist texts and by what he left out of his anthology, only the Debordist wing of the Situationist International (the analytical tendency) has been available for examination by the English-speaking world. This pamphlet uses texts by Asger Jorn to explain the conflict between the Debordists and the Nashists (the ludic tendency), and inadvertently documents the formation of the Second Situationist International (a.k.a. the Bauhaus Situationists). **SC**
$6.95 *(Pamp/48/Illus)*

Panegyric
Guy Debord
The opening salvo of a cryptic autobiography, interrupted by suicide, of the brilliant Situationist theorist . "There is nothing more natural than to consider everything as starting from oneself, chosen as the center of the world; one finds oneself thus capable of condemning the world without even wanting to hear its deceitful chatter. One has only to mark off the precise limits that necessarily restrain this authority: its proper place in the course of time and in society; what one has done and what one has known, one's dominant passions. 'Who then can write the truth, if not those who have felt it?'"
$14.95 *(PB/79)*

The Realization and Suppression of the Situationist International: An Annotated Bibliography, 1972-1992
Simon Ford
"The bibliography appears at the point in a

Guy Debord — from In Girum Imus Nocte et Consumimur Igni

subject's living death when criticism reaches its critical mass." This immense annotated bibliography contains all the sources for articles, books, essays and commentary on the Situationist International (1957-1972). Works here are in English as well as in French. This is an excellent guide book to lead the impressionable ones on a tour of found and missing texts regarding one of the most important political "artisti'" movements in Europe. **AK**
$11.95 *(PB/150)*

Revolution of Everyday Life
Raoul Vaneigem
"A Consumer Guide To Not Consuming." Classic Situationist text, complementing Debord's *Society of the Spectacle.* "Media, language, time—these are the giant claws with which Power manipulates humanity and molds it brutally to its own perspective."
$16.00 *(PB/216)*

Situationist International Anthology
Situationist International
Comprehensive collection of the actual manifestoes, criticism, revolutionary theory and other outpourings of SI from its start in the late '50s through the Revolution of May '68.
$15.00 *(PB/406)*

The Society of the Spectacle
Guy Debord
Life as voyeurism, the individual as trivialized

spectator. "In society where modern conditions of production prevail, all of life presents itself as an immense accumulation of spectacles. Everything that was directly lived has moved away into a representation."
$10.95 *(PB/154)*

The Veritable Split in the International
Guy Debord and Gianfranco Sanguinetti
Theses on the Situationist International, from two of its leading lights, along with some appendices. **AK**
$15.95 *(PB/204)*

What Is Situationism? A Reader
Edited by Stewart Home
Like some of the other Stewart Home books, this acts as a streamlined sampler of writing critical of "radical" cultural phenomena. There is enough diverse criticism in this book to at once attract young hopefuls who don't want to inherit their radicalism or read too much, while it avoids becoming just more reductive journalism à la *Rolling Stone* coverage (even after one of Home's morally driven intros). This book has essays from Bob Black, Dave and Stuart Wise, and Jimmie Martin, to name three. Home's "subjective" bashing of co-opted avant-gardism can be humorous, inciting or sometimes banal (like existentialism), but his selections and bibliography in this book, as in his others, are absolutely worthwhile reading. **KH**
$14.95 *(PB/204/Illus)*

¡ZAPATISTA!

January, 1994 demonstration in Mexico City against the war in Chiapas, and in support of the Zapatistas. — from First World, Ha Ha Ha!

January 13, 1994

To Mr. Bill Clinton, President of the United States of North America:

To the North American Congress:

To the people of the United States of North America:

Gentlemen:

We direct this letter to you to tell you that the Mexican federal government is using the economic and military support that it receives from the United States of North America to massacre Chiapaneco Indians. We would like to know whether the U.S. Congress and the citizens of the United States of North America approved this military and economic support to combat drug trafficking or to assassinate indigenous people in the Mexican south-east. Troops, planes, helicopters, radar, communications equipment, arms and military gear are presently being used not to chase drug traffickers and the leaders of large drug cartels, but to repress the just struggle of the Mexican people and the Chiapaneco Indians, and to assassinate innocent men, women and children.

We do not receive any help from foreign governments, persons or organizations. We have nothing to do with drug trafficking or national and international terrorism. We organized ourselves from our own desire and life because of our tremendous problems and grievances. We are tired of so many years of abuse, lies and death. It is our right to struggle for a life with dignity. We have at all times obeyed international laws on war respecting the civilian population.

With the support that the U.S. government and people give to the federal government, they are staining their hands with indigenous blood. Our longing is that of all the peoples of the world: true freedom and democracy. And we are prepared to give our lives for this desire. Don't stain your hands with our blood by making yourselves accomplices of the Mexican government.

From the mountains of the Mexican southeast,

CCRI–CG of the EZLN

— from *¡Zapatistas!: Documents of the New Mexican Revolution*

Basta! Land and the Zapatista Rebellion in Chiapas

George A. Collier with Elizabeth Lowery Quaratiello
What created the EZLN rebellion in southern Mexico? These writers build a strong case that the changeover from peasant agrarianism to "modern" agribusiness in Chiapas over the past 30 years was the single most compelling force behind the creation of this homegrown guerrilla army and its intriguing cooperativist vision. **SC**
$12.95 *(PB/184/Illus)*

First World Ha Ha Ha!

Edited by Elaine Katzenberger
Superb anthology based around the Chiapas uprising, its context and significance. Includes essays by Marc Cooper on the connections between Chiapas and the L.A. riots; Noam Chomsky on the effects of NAFTA; Ward Churchill on the continuing struggle for the land; Annette James' "Statement of Support for the Indigenous American Intifada"; an interview with Subcommandante Marcos; various Zapatista communiqués; and much more.
AK
$12.95 *(PB/258/Illus)*

Shadows of Tender Fury: The Letters and Communiqués of Subcomandante Marcos and the Zapatista Army

of National Liberation

Subcomandante Marcos
"Since the 1994 uprising in the Mexican state of Chiapas, the spokesman of the Zapatista Army of National Liberation, a masked rebel who calls himself Subcomandate Marcos, has become a symbol of revolt in the post-Cold War era. Here are the words of Marcos, words that look back to the traditions of Indian resistance, and dormant ideals of the Mexican revolution, and look forward to political strategies, styles and theories that challenge the dominance of capitalism."
$15.00 *(PB/272/Illus)*

¡Zapatistas! Documents

of the New Mexican Revolution (December 31, 1993 through June 12, 1994)

The Editorial Collective

After the Ross Perot-led anti-NAFTA debacle in Congress subsided, it looked as though the Trilateral forces of global finance (riding high on the post-Cold War buy-up of Eastern Europe) were smugly on their way to consolidating their grip on yet another chunk of the world's real estate. In this case, Mexico was to be corralled into our big new "free trade zone" and the whole debate in Congress revolved around whether we Americans wanted them in or not. Yet on January 1, 1994—symbolically the day that NAFTA was to go into effect—the corrupt edifice of the Mexican government (which has been controlled for most of this century by the aptly Orwellian-titled Institutional Revolutionary Party, or PRI) was thrown off its foundations by the coordinated actions of a then-obscure guerrilla army operating in the remote jungle state of Chiapas near the border of Guatemala.

The Zapatista occupation of four Chiapas towns and the sympathetic shock waves which it generated throughout Mexican

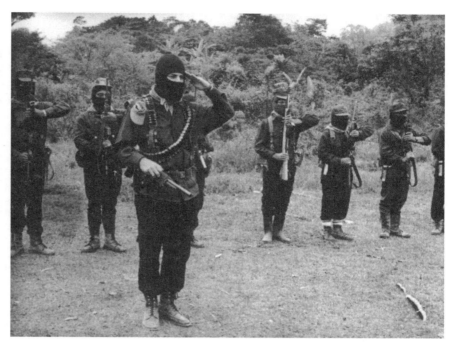

EZLN troops — from ¡Zapatistas!

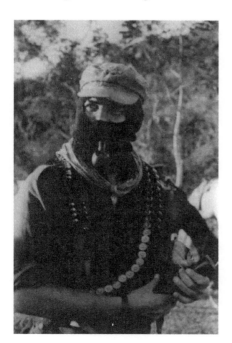

Subcomandante Marcos — from First World, Ha Ha Ha!

society have ushered in a whole new post-Marxist revolutionary era. By rejecting NAFTA and the Mexican government's heavily financed claims to democracy and embracing Mexico's revolutionary history (naming themselves after and basing their ideas on Emiliano Zapata), the Zapatistas (or EZLN) were able to call into question the entire world's headlong march into corporate enslavement. What emerges from the collection of manifestoes, communiqués and interviews newly translated from Spanish that make up this book is that the Zapatistas are a very remarkable guerrilla movement, vastly different from our Oliver Stone-generated *Salvador* conceptions of a Central American revolution.

The EZLN are in fact of a coalition of indigenous Chiapas Indian tribes for whom Spanish is often a rarely used second language. Where the American media has painted Subcomandante Marcos as the swashbuckling mestizo leader of a humble band of ignorant but obedient *indios*, his writings and interviews, which make up the bulk of *¡Zapatistas!*, suggest instead more of a witty and even poetic press liaison. Rather than waging Maoist revolution from a Pol Pot-style intellectual cabal, the Zapatistas see their actions as part of an

overall matrix of economics, politics, and culture which will not be won "by the barrel of a gun" alone. As their mysterious ski-masked spokesman Subcomandante Marcos puts it, "we are not Fidel Schwarzennegger."

The Zapatistas seem to be alert to the realities of the post-Cold War era as well as the grievous mistakes of Marxist guerrillas of the past. Nor are they falling for the bait of Liberation Theology and domination by the "radical wing" of the Catholic Church despite the brutal poverty and enforced lack of education which they have been stoically enduring. The EZLN seems to be run according to an organically autonomous type of collective system which has allowed these Indians to survive the 500 years since the arrival of the conquistadors with their language and culture intact. *¡Zapatistas!* closes with the "Second Declaration From the Lacondona Jungle" of June 10, 1994, in which the EZLN rejects the Federal Government's peace offer after consulting with their constituent villages, leaving one to believe that more history may well be written in this formerly forgotten corner of Mexico. **SS**

$12.00 *(PB/350/Illus)*

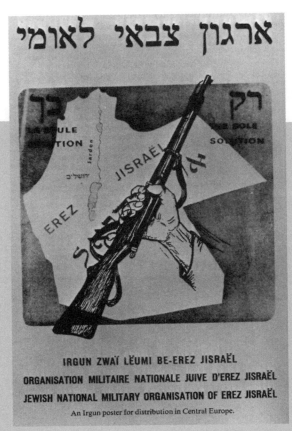

אָרגון צבאי לאומי

IRGUN ZWAÏ LËUMI BE-EREZ JISRAËL
ORGANISATION MILITAIRE NATIONALE JUIVE D'EREZ JISRAËL
JEWISH NATIONAL MILITARY ORGANISATION OF EREZ JISRAËL

An Irgun poster for distribution in Central Europe.

A poster of the Irgun Zvai Leumi (National Military Organization),
"Irgun" for short, circa 1946 — from **Before Their Diaspora**

אסוז

By 1934 the SS had become the most pro-Zionist element in the Nazi Party. Other Nazis were even calling them "soft" on the Jews. Baron von Mildenstein had returned from his six-month visit to Palestine as an ardent Zionist sympathizer. Now as the head of the Jewish Department of the SS's Security Service, he started studying Hebrew and collecting Hebrew records; when his former companion and guide Kurt Tuchler visited his office in 1934, he was greeted by the strains of familiar Jewish folk tunes. There were maps on the walls showing the rapidly increasing strength of Zionism inside Germany. Von Mildenstein was as good as his word: he not only wrote favorably about what he saw in the Zionist colonies in Palestine; he also persuaded Goebbels to run the report as a massive twelve-part series in his own *Der Angriff* (*The Assault*), the leading Nazi propaganda organ (September 26 to October 9, 1934). His stay among the Zionists had shown the SS man "the way to curing a centuries-long wound on the body of the world: the Jewish question." It was really amazing how some good Jewish *boden* under his feet could enliven the Jew: "The soil has reformed him and his kind in a decade. This new Jew will be a new people." To commemorate the Baron's expedition, Goebbels had a medal struck: on one side the swastika, on the other the Zionist star. — Lenni Brenner, from *Zionism in the Age of the Dictators*

Before Their Diaspora: A Photographic History of the Palestinians 1876-1948
Walid Khalidi
"From the beginning of their colonization of Palestine, the architects of the Zionist 'dream' excluded from consideration its potential consequences for the Palestinians. The reality of Zionism as translated on the ground was rarely perceived as diverging from the dream, which was (and still is) regarded as pristine; any divergence between the reality and the dream was only a momentary aberration from the dream. Thus, the ineluctable link between Zionist action and Palestinian reaction was banished from Zionist consciousness. . . . A victim's obsession with the past is often the concomitant of a vengeful disposition, and

protagonists have habitually compiled 'historical records' of their conflicts as a prelude to each other's delegitimitization. But a retrospective glance can also serve a constructive purpose. That is the intent of this book, which, it is hoped, will shed some light on the Palestinians as a people in Palestine before their diaspora, and on the genesis and evolution of the Palestine problem during its formative phase." A fascinating parallel view of the establishment of Israel is shown through beautifully reproduced archival photos of both the conflicts between Arab and Jew and the everyday life of the Palestinians in their homeland.
$29.00 *(PB/351/Illus)*

By Way of Deception: The Making and Unmaking of a Mossad

Officer
Victor Ostrovsky and Claire Hoy
The motto of the Mossad is "By way of deception, thou shalt do war." From Ostrovsky's description of the activities of the feared Israeli Secret Service one is compelled to accept the conclusion that the Mossad faithfully treads in the footsteps of all other secret-service agencies throughout the world, from the Gestapo to the KGB to the CIA. Far from being a book cramped and stilted by reiteration of fact after fact, Ostrovsky's book reads like a best-selling thriller, except the names have not been changed to protect the guilty. **JB**
$5.99 *(PB/396)*

The End of Zionism . . . And the Liberation of

the Jewish People

Elbie Weizfeld

A collection of critical essays by Jewish writers Noam Chomsky, Lenni Brenner, Albert Memmi, Maxime Rodinson and Reb Moshe Schonfeld in opposition to Zionist-Israeli authority, and positing a different identity of the Jewish people. **AK**

$8.95 *(PB/116)*

The Fateful Triangle: The United States, Israel and the Palestinians

Noam Chomsky

Examines the hypocrisy involving the U.S. position in the Middle East, especially regarding media whitewash, the B'nai B'riths political clout, Israel's "favorite child" status, the invasion of Lebanon, and the myth of the "peace talks."

$18.00 *(PB/483)*

The Land of the ZOG

Gary Smith

ZOG = Zionist Occupation Government. *Land of the ZOG* begins with a light-hearted investigation into the ZOG "myth" and winds up explaining the real meaning of the Book of Revelation—666 is the six-pointed Star of David! In between, the hidden hand of Jewish/Israeli government influence on Washington and the media is explored (half-Jewish movie stars such as Robert De Niro are also outed), the "kosher tax" on food is decried, the Talmud is analyzed, and more. Chapters include "Parasites-Human and Otherwise," "Jew-nited We Stand," "Shoah Biz" and "The Last Temptation of Hollywood." **SS**

$7.00 *(PB/176/Illus)*

The Life of an American Jew in Racist Marxist Israel

Jack Bernstein

"The late Jack Bernstein was a rarity—an American Zionist who actually 'returned' to Israel, not for a vacation or to summer on a kibbutz, but to live and die in Israel building a Jewish nation. What makes him almost one of a kind, though, was his ability to see through the sham and hype to the oppressive, racist, parasitic character of Zionism as practiced in modern Israel, and his courage to denounce it with the force and fervor of an Old Testament prophet."

$3.00 *(Pamp/61)*

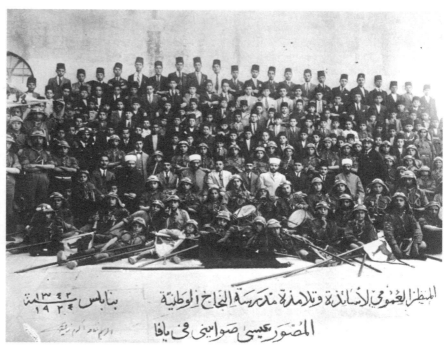

The student body, including Scout troops, and staff of the Najah School, Nablus, 1924 — from **Before Their Diaspora**

Lone Wolf: A Biography of Vladimir (Ze'ev) Jabotinsky

Shmuel Katz

This biography of Vladimir (Ze'ev) Jabotinsky at 1,855 pages isn't light reading. The man behind the book wasn't light either: Jabotinsky, a journalist and author, was one of the most important Zionist leaders of the 20th century. Jabotinsky was the ideologue of the Zionist revisionists. He was the spiritual forerunner to the Likud party, Netanyahu and the Jewish Defense League. Jabotinsky was foremost a right-wing nationalist, who bordered on being a fascist—there's even rumors that he had secret meetings with the Nazis. **SC**

$100.00 *(HB/1855)*

The Politics of Dispossession: The Struggle for Palestinian Self-Determination, 1969-1994

Edward W. Said

"Retraces the Palestinian hejira, its disastrous flirtation with Saddam Hussein, and its ambiguous peace accord with Israel . . .

demolishing both Western stereotypes about the Muslim world and Islam's illusions about itself.

$15.00 *(PB/512)*

The Revival of Israel: Rome and Jerusalem, the Last Nationalist Question

Moses Hess

Hess was a German citizen by birth, as well as the forerunner of the modern Zionist movement. He fervently believed that modern anti-Semitism was spawned by the Pope and the Church of Rome, a theme currently adopted by such Jewish authors as Daniel Goldhagen. Hess viewed the assimilation of Jews into German society as a great danger to the existence of the Jewish people. Unnoticed at first, Hess' book was later discovered and adopted by the Zionists. Viewed in retrospect, his comments about Germany, the country of his birth, and the Germans themselves appear to be remarkably accurate: "It seems that German education is not compatible with our Jewish national aspirations. . . . The German hates the Jewish religion less than the race; he objects less to the Jew's peculiar beliefs

than to their peculiar noses." As a lone voice crying in the wilderness, Hess' calls for the construction of a Jewish national state went unheeded by his own contemporaries, only to reach fulfillment after two world wars and the Holocaust. **JB**
$10.00 *(PB/265)*

Socialists and the Fight Against Anti-Semitism: An Answer to the B'nai B'rith Anti-Defamation League
Peter Seidman
"The real record of the fight to open U.S. borders to refugees from Hitler's terror."
$3.00 *(PB/31)*

They Dare To Speak Out: People and Institutions Confront Israel's Lobby
Paul Findley
"A former Illinois congressman exposes the role of the Israeli lobby in suppressing free debate on the Middle East and in shaping American policy in the region."
$12.95 *(PB/400)*

The Thirteenth Tribe
Arthur Koestler
"Polish and Russian 'Jews' have overrun Palestine claiming it as their birthright. 'The blood of Abraham is in our veins,' they shout. But is it really? Are those people of biblical ancestry or are they imposters— descendants of an Asiatic race known as the Khazars? Shows that East European 'Jews' have no blood descent from ancient Israel."
$10.00 *(PB/200)*

Zionism in the Age of the Dictators
Lenni Brenner
Searches through the Zionist record and finds evidence that it sought the patronage and benevolence of avowed anti-Semites and, ultimately, the collaboration of the Fascists and Nazis. From the beginning Zionism's leaders were prepared to go to almost any length to achieve the goal of a separate Jewish homeland. "An astounding bombshell exposé of the active collaboration between Nazis and Zionists, by a courageous anti-Zionist Jew who spent years piecing together the story."
$9.95
(PB/227)

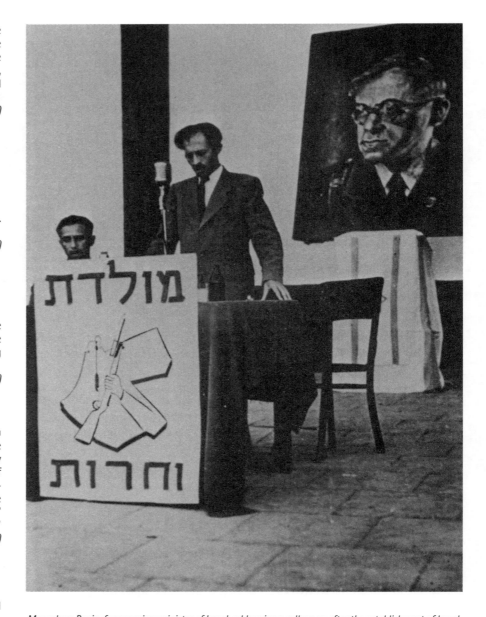

*Menachem Begin, former prime minister of Israel, addressing a rally soon after the establishment of Israel. The portrait is of Vladimir Jabotinsky, Begin's right-wing Polish Zionist mentor. Jabotinsky was the leader of Revisionist Zionism, which from the early 1920s called for "revising" the Mandate to enable the Zionists to colonize the East Bank of the Jordan River (Transjordan) as well as Palestine. — from **Before Their Diaspora***

The Zionist Terror Network: Background and Operations of the Jewish Defense League
Institute for Historical Review
"This booklet documents the background and criminal activities of Jewish Zionist terrorist groups, especially the Jewish Defense League. Particular emphasis is given to terror—including murder—against 'thought criminals' who question the Holocaust extermination story."
$4.00 *(Pamp/20/Illus)*

EXOTICA

Adventures in Arabia
William Buehler Seabrook
"Seabrook dreamed of going to Arabia from the time he was a child in the 1880s. After college, he scraped his way across Europe and got as far as Naples, where he fell ill and was forced to return to the United States. It was not until years later, in the 1920s, that Seabrook fulfilled his dream. He traveled and lived among various desert tribes, producing this vivid account of their customs and beliefs."
$12.95 *(PB/347/Illus)*

Arabian Fairy Tales
Amina Shah
A rich collection of Arabian folklore about dervishes, sultans, peasants and magicians. These tales of adventure, enchantment and strange twists of fate have been culled from around the campfires of several nomadic tribes throughout the Middle East. Passed down from past generations to the present day, these stories have been collected and retold by Amina Shah, chairwoman of the College of Storytellers in England and descendent of an ancient Afghan family of writers and savants. Anyone who lost themselves in *The Arabian Nights* will surely

enjoy this fine example of the eldest art form known to humankind. **MDH**
$12.50 *(PB/204)*

At the End of the Rainbow? Gold, People and Land in the Brazilian Amazon
Gordon MacMillan
"Explains how gold fever came to grip the Amazon and considers the changes brought to the region by the gold rush. Contains a vivid account of the violent clash between 40,000 miners and the Yanamami Indians in the state of Roraima, as well as thoroughly researched arguments which explore the perspectives of the farmers, ranchers, natives and others involved in this historic moment."
$22.00 *(PB/201/Illus)*

Bury Me Standing: The Gypsies and Their Journey
Isabel Fonseca
"Fabled, feared, romanticized and reviled, the Gypsies—or Roma—are among the least understood people on earth. Now a diaspora of twelve million, their culture remains

largely obscure. . . . Alongside unforgettable portraits of individuals—the poet, the politician, the child prostitute—this book offers sharp insights into the humor, language, wisdom and taboos of the Roma, tracing their exodus out of India 1,000 years ago and their astonishing history of persecution: enslaved by the princes of medieval Romania; massacred by the Nazis; forcibly assimilated by the communist regimes; and, most recently, evicted from their settlements by nationalist mobs throughout the new 'democracies' of Eastern Europe."
$13.00 *(PB/322/Illus)*

Cargo Cult: Strange Stories of Desire From Melanesia and Beyond
Lamont Lindstrom
This is a history of the cargo cults of Melanesia and an intellectual history of an idea. "There is something about cargo cult . . ." Lindstrom, an anthropologist at the University of Tulsa, writes. "It evokes an intellectual frisson, a faint thrill, an uneasy glee . . . It palpates and animates our own diffuse but powerful discourses of desire and of love, particularly the melancholy of unrequited love." Cargo cult means differ-

Saki, cargo pioneer, waits by the sea at Sulphur Bay. — from **Cargo Cult**

ent things to different people, from the romantic tourist's notion of a bunch of Melanesians in grass skirts waiting for LBJ to come down from the mountain bearing refrigerators, to the academic's too-easy love affair with "postmodern deconstructions." Even the Melanesians can't agree on what cargo means. But what really makes cargo cult resonate in Western minds, as is clear in this book, is that the Melanesians' impressionistic yet systematic apprehension of Western cultural precepts, reflected back at us whole in caricature, is tantamount to an objective outsider's cultural critique of our very own world view. Basically, the cultists' response to us answers the proverbial question: If a bunch of Martians landed in Cincinnati right now and had a good look around, what would they possibly make of what they saw? "Could it be . . . " Lindstrom writes, "that we are entranced by cargo cults because we are, at heart, commodity fetishists? . . . We want cargo, but we know also, at heart, that the moral connections that the dominant capitalist rhetoric asserts between hard work and material success are fraudulent and ultimately illusory. Our commodities are equally super-

naturally alienated as Melanesian cargo."

HJ

$14.95 *(PB/246/Illus)*

Conversations With the Cannibals: The End of the Old South Pacific
Mike Krieger

"Warmly accommodating a wide variety of island customs and more, Krieger grounds every fact in vital human experience. He explores two Melanesian and two Polynesian countries where islanders still live according to old traditions. Krieger is the only living person to interview members of different cannibal tribes and to discuss with them the subject of cannibalism. He tells of tribes whose name in translation means 'I will kill you', and of a powerful ex-minister whose tyrannical control of a remote island evokes images from Joseph Conrad's *Heart of Darkness*."

$23.00 *(HB/228/Illus)*

Covarrubias
Adriana Williams

"A sparkling account of Rosa and Miguel Covarrubias' life and times. Begins with Miguel's birth in 1904 and follows the brilliant early flowering of his artistic career as a renowned caricaturist for *Vanity Fair* and *The New Yorker*, his meeting and marriage to Rosa at the height of her New York dancing career, and their many years of professional collaboration on projects ranging from dance to anthropology to painting and art collecting to the development of museums to preserve Mexico's pre-Columbian heritage."

$29.95 *(HB/352)*

The Dances of Africa
Michel Huet

Coffee-table tribute to the colorful, toe-tapping tribes of Africa. "From 1945 to 1985, from Senegal to the Congo Basin, from the Sahara to the Gulf of Benin, Michel Huet photographed African life, especially the age-old rituals and ceremonies enacted to the beat of drums, the chant of voices and the urgent movement of bodies. His unique images, accompanied by ethnographer Claude Savary's sensitive texts, are a stunning testimonial to these rapidly vanishing cultural traditions as well as a lasting document of the essence of African dance." Includes the Dogan, who tell the mythical story of mankind in their

3-meter-high painted plank masks; the Samo, in their cowry-shell-and-feather rain-making costumes; and the Bwa people of Boni, in their bushy garb of leaves and branches, cleansing the world of man's impurities.

GR

$39.95 *(HB/172/Illus)*

Divine Hunger: Cannibalism as a Cultural System
Peggy Reeves Sanday

"Sanday argues that ritual cannibalism is intimately connected both with the constructs by which the origin and continuity of life are understood and assured from one generation to the next as well as with the way in which that understanding is used to control the vital forces considered necessary for the reproduction of society. She reveals that the presence or absence of cannibalism in a culture derives from basic human attitudes toward life and death, combined with the realities of the material world."

$20.95 *(PB/206)*

Dreams and Reverie: Images of Otherworld Mates Among the Baule, West Africa
Philip L. Ravenhill

"The Baule people of the Ivory Coast believe that each person has a mate of the opposite

Masks formerly worn by the secret societies, the Bamum tribe, Cameroon — from **The Dances of Africa**

sex in the *blolo*, or otherworld, an ideal place from which newborns arrive and to which the dead return. Ravenhill examines the fascinating figurative art created by the Baule to represent their otherworld mates, discussing as well the psychological and existential meanings behind the images. . . . Ravenhill analyzes Baule figurative art within the context of three culturally defined processes: the creation and consecration of the figures; the interaction between the owner, the figure and the spirit represented; and the ongoing male-female dialogue in which the art finds a place. He argues that the art is best appreciated not at a cultural level but through the specificity and power of individual objects within their original context. *Dreams and Reverie* not only offers a new look at a remarkable African art form but also invites the reader to reflect on the otherworlds that are created by art."
$29.95 *(HB/102/Illus)*

Easter Island, Earth Island
Paul Bahn and John Flenley
The most up-to-date and comprehensive study available of the enigmatic prehistoric culture of Rapa Nui. This book explores the mysteries of Easter Island, overturning many of Thor Heyerdahl's well-publicized but ill-founded theories. The authors consider the possible methods by which the islanders transported their massive, stone effigies over long distances and erected them on platforms. The authors also look at the largely undeciphered Rongorongo script engraved on wooden boards, and the bizarre cult of the birdman, with its complex egg-hunting ritual. Why, the authors ask, did the islanders deliberately topple the figures after the first Europeans visited the island in the 18th century? Includes 200 terrific illustrations, 15 in color. **CS**
$24.95 *(PB/240/Illus)*

Easter Island: Mystery of the Stone Giants
Catherine and Michael Orliac
Explains "what is known about this enigmatic island in the South Pacific—and what isn't." Also reveals "some tantalizing theories" about the brooding statues. "One of the great problems that dominate Easter Island archeologically is the question of how the statues were moved to the *ahu*, some of which are miles from the quarry . . . Some

A well-defined birdman petroglyph at Orongo — from Easter Island, Earth Island

writers have suggested that a layer of sweet potatoes and yams was put under the statues . . . Others have said that wooden rollers were used The most surprising thing is the unhesitating reply of all the natives—the statues were moved by *mana* . . . It is a mistake to smile at this kind of talk . . . What if certain men at a certain period were able to make use of electromagnetic or anti-gravitational forces? It is an extraordinary concept, but no more so than that of squashed yams." **GR**
$12.95 *(PB/144/Illus)*

A Fez of the Heart: Travels Around Turkey in Search of a Hat
Jeremy Seal
"Inspired by a dusty fez in his parents' attic, Seal set off in 1993 to trace the astonishing history of this cone-shaped hat. Soon, the quintessentially Turkish headgear became the key to understanding a country beset by contradictions. Seal's investigations took him from the fez-topped headstones of Istanbul's ghostly cemeteries to the remote town on the Black Sea where Atatürk, the father of modern Turkey, first banned the fez in 1925. From there Seal traveled around the country, visiting eastern cities where intractable fez wearers were once hanged, exploring the troubled Kurdish southeast and watching the production of fez-shaped hats for whirling dervishes in the mystical central city of Konya. The

result of his unusual journey is an engaging and agile mix of history and travel, politics and reportage."
$14.00 *(PB/334)*

Gaugin's Letters From the South Seas
Paul Gauguin
Shoes, canvases, wife problems, money and self-doubt. "Ill-luck has pursued me my whole life, without rest. The further I go, the lower I descend. Perhaps I have no talent, but—all vanity aside—I do not believe that anyone makes an artistic attempt, no matter how small, without having a little—or there are many fools. In short, after the effort I have made, I can make no more unless it bears fruit." **GR**
$4.95 *(PB/110)*

Going Into Darkness: Fantastic Coffins From Africa
Thierry Secretan
Pictorial essay on the works of African coffin maker Kane Kwei and his cousin and onetime apprentice, Paa Joe. They specialize in a most unique type of coffin which bears the characteristics of the newly deceased. These coffins are a reflection of the dead person's occupation: a fish coffin for a fisherman, a lion coffin for a hunter, etc. The folk art of coffin building by the people known as the Ga (a dominant ethnic group from the Accra region in Africa) began around 1904 with Ata Owoo, who founded the business. After his death in 1976, the business was carried on by Kane Kwei. The reader sees the step-by-step creation of these ornate, wooden coffins, beginning alongside the death bed and ending when they are buried. Each coffin is hand-crafted and beautifully painted, and can take the shape of anything from an eagle to a

The Mercedes Benz is the ultimate symbol of prestige and wealth in Ghana. — from Going Into Darkness

Very few people are entitled to be buried in a Mercedes, and because of the great respect their position confers such funerals are always sober affairs with strong Christian overtones. Since this type of coffin is not allowed inside a church, the religious service is conducted in front of the dead person's house. The coffin is usually given the same registration number as the person's own car, which is sometimes put on display during the wake. — from **Going Into Darkness**

Mercedes-Benz (for a car salesman). Some have even been commissioned by art galleries and private art collectors. Many color photos document these creations and the elaborate funeral ceremonies of Accra.

DW

$24.95 *(PB/128/Illus)*

The Good Parsi: The Fate of a Colonial Elite in a Postcolonial Society

T. M. Luhrmann

"During the Raj, one group stands out as having prospered and thrived because of British rule: the Parsis. Driven out of Persia into India a thousands years ago, the Zoroastrian people adopted the manners and aspirations of the British colonizers. Their Anglophilia ranged from cricket to Oxford to tea. The British fulsomely praised the Parsis and rewarded them with high-level financial, mercantile and bureaucratic posts. The Parsis dominated Bombay for more than a century, until Indian independence ushered in their decline. . . . The Parsi story is filled with the pathos of their long-delayed recognition of the emptiness of the promise that Parsis might one day be Englishmen. Luhrmann sensitively examines the paradoxical nature of their self-criticism (the Parsis had identified themselves with the 'strong,' 'virile' colonizers but now speak of themselves as effeminate, emasculated, 'weak,' all epithets once used by the British of Indians) to create an image of a fragile and beleaguered identity, fraught with contradictions, that looks uneasily toward the future."

$22.95 *(PB/317)*

The Gypsies

Jan Yoors

"Tells the story of the author, who, at the age of twelve, ran away from his privileged, cultured Belgian family and home to join a wandering band, a *kumpania*, of Gypsies. For ten years he lived as one of them, traveled with them from country to country, shared both their pleasures and their hardships, and came to know them as no outsider ever has. Yoors' first-hand and highly personal account of an extraordinary people is a real story about the Gypsies' fascinating culture and their never-ending struggle to survive as free nomads." This edition contains 21 full-page photographs taken by the author.

$10.95 *(PB/256/Illus)*

Harem: The World Behind the Veil

Alev Lytle Croutier

A beautifully written and lushly illustrated guide to the lost world of the harem in the Ottoman Empire in the region of modern-day Turkey. Croutier draws upon not only historical records but also stories her grandmother and great-aunt shared with her to provide a full and fascinating account of the lives of women who were overseen, if not owned outright, by pashas and viziers. Chapters on costumes, the baths and food almost convince the reader that harem life wasn't bad at all for the average odalisque, as long as the sultan didn't go mad and decide to have you sewn into a bag and dumped with your sisters into the nearest river. Croutier also spills the beans on everything you've ever wondered about eunuchs.

JW

$17.95 *(PB/224/Illus)*

Hawaiian Legends of Ghosts and Ghost Gods

Translated by W.D. Westervelt

Eerie stories from the fantastic world of the Shark God of Molokai, the Ghost of Wahaula Temple, and the King of Ghosts. Originally published in 1915.

$8.95 *(PB/280/Illus)*

Headhunting and the Social Imagination in Southeast Asia

Edited by Janet Hoskins

"Brings together comparative material on headhunting in a number of Southeast Asian societies, examining the cultural contexts in which such practices occurred, and relating them to colonial history, violence and ritual. This volume documents and analyzes headhunting practices and shows the persistence of headhunting as a symbol or trope. Ethnographers of seven regions (the Philippine highlands, Sarawak, Brunei, South Borneo and the Indonesian islands of Sulawesi, Sumba and Timor) share their experiences of living with former headhunters (including an eyewitness account of a headhunting feast), attending rituals and collecting oral histories to understand the heritage of headhunting in context. They also report on contemporary people who reenact headhunts, often with effigies or surrogates for the head itself."

$16.95 *(PB/296/Illus)*

The Invisibles: A Tale of the Eunuchs of India

Zia Jaffrey

"In this spellbinding book—at once travelog, history, interview and fiction—Jaffrey invents a hybrid voice to match her subject as she meets journalists, police commis-

sioners, detectives and doctors and tries to trace the *hijiras'* tradition through layers and layers of obfuscation and denial, as well as through Hindu, Muslim and British history. This is the first major book on this taboo and invisible subject, a compelling work on an enthralling subject."
$24.00 *(HB/293/Illus)*

Island Encounters: Black and White Memories of the Pacific War
Lamont Lindstrom and Geoffrey M. White
"Explores the massive and sudden contact between powerful military forces and Pacific Islanders, blending oral histories recorded in the islands after WWII with some 175 photograph gleaned from Japanese newspaper morgues, the private albums of U.S. veterans, and Allied military archives."
$29.95 *(HB/208/Illus)*

Island of Bali
Miguel Covarrubias
"Outstanding Mexican painter and caricaturist Miguel Covarrubias found equal fame in writing one of the finest books on strange and distant lands. Only an artist could have penetrated so deeply into the spirit of the dance, theater, music, handicrafts and sports of Bali; and only a man of learning in anthropology could have under-

stood and recorded so accurately the island's religion, sexual customs, family life and economic and political organization. Covarrubias proceeds to describe the geography and nature of the island and then to relate the history of the race. Includes a thorough account of the community, the family and the individual in all spheres of thought, emotion and behavior, in addition to chapters on the Balinese arts, festivals and rituals."
$31.00 *(PB/430/Illus)*

The King of the World in the Land of the Pygmies
Joan Mark
Patrick Tracy Lowell sailed to Africa in 1927 as part of a three-person anthropological expedition from Harvard University. The nature of anthropology was changing but Mr. Lowell wasn't. He remained a New England gentleman for the entire duration of his 25-year stay in Africa. Although he was considered a failure as an anthropologist when he died in 1953, he was certainly a success in the "life is art" category. This book gives one of the great eccentrics of the 20th century his proper due. He created a home away from home in northwest Zaire, and his hospitality enabled a number of anthropologists a chance to study the region and its people and publish their findings, in the process providing a glimpse of a

world where there were still outposts of purity, untrammeled by civilization. **SA**
$30.00 *(HB/272/Illus)*

Kon-Tiki
Thor Heyerdahl
"In 1947, Heyerdahl and a crew of five men set out to prove that it was possible that Polynesia had been settled by South Americans by re-creating the conditions of such a voyage. The result was a ripping yarn that has been translated into at least 65 languages and is now considered a classic. This edition also features a reader's supplement section, which includes literary criticism, notes on allusions, and a piece on the changing nature of anthropology."
$5.99 *(PB/240/Illus)*

The Lemon
Mohammed Mrabet
An argument forces a handsome 12-year-old boy out of his family home and onto the streets of Tangier. He forms friends and enmities among the drunkards, kif smokers, prostitutes and lechers in this decadent international-port setting. He hones his survival skills and earns the name "The Lemon" as he proves no man to be his better. Transcribed from tapes and translated from the Moghrebi by writer Paul Bowles.
 JAT
$8.95 *(PB/181)*

Love With a Few Hairs
Mohammed Mrabet
A Moroccan youth risks the displeasure of his British patron and gains the love of a neighborhood beauty through magic. But magic, like love, does not always last forever. Terse phrasing efficiently evokes 1960s Morocco as it feels the encroaching influences of the West. Mrabet was a protégé of Paul Bowles known for his swagger and natural storytelling skills. Transcribed from tapes and translated from the Moghrebi by Bowles. **JAT**
$8.95 *(PB/198)*

M'Hashish
Mohammed Mrabet
The term *m'hashish* means to act in an irrational or unexpected manner, as if under the influence of hashish. Ten short tales depict frequently extreme behavior and have the flavor of classic folk legends with vaguely menacing twists. Excellent as a short divertissement or as highbrow bathroom reading.

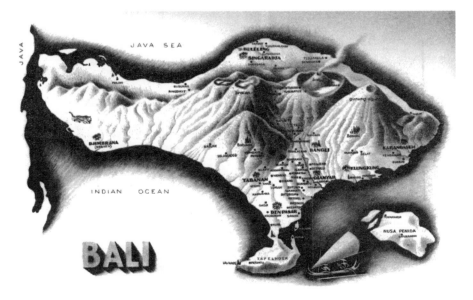

Map of Bali — from **Island of Bali**

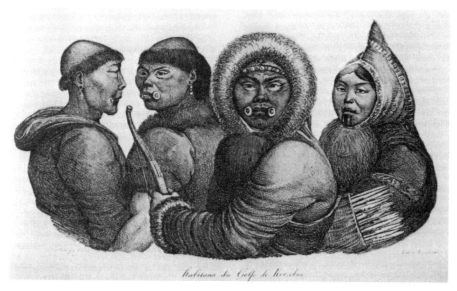

Eskimos from Kotzebue Sound — from **Marks of Civilization**

Transcribed from tapes and translated from the Moghrebi by Paul Bowles. **JAT**
$7.95 *(PB/79)*

Mambu: A Melanesian Millennium
Kenelm Burridge
"Mambu is the name of a native of New Guinea, a *kanaka* who in the late 1930s led what has come to be known as a 'cargo' movement. Most of his activities took place in the Bogia region of the Madang District in the Australian Trust Territory of New Guinea. Mambu was a rebel, a radical, a man sufficiently able to free himself from the circumstances of his time to grasp what he thought to be valuable in tradition and weld it to his perception of what he would have liked the future to be. . . . Typically, participants in a cargo cult engage in a number of strange and exotic rites and ceremonies, the purpose of which is apparently to gain possession of European manufactured goods such as axes, knives, aspirins, china plate, razor blades, colored beads, guns, bolts of cloth, hydrogen peroxide, rice, tinned foods and other goods to be found in a general department store. . . . Large decorated houses, or 'airplanes' or 'ships' made of wood, bark and palm thatch bound together with vines, may be built to receive the goods, and participants may whirl, shake, chant, dance, foam at the mouth or couple promiscuously in agitated attempts

to obtain the cargo they want, not from a shop or trade store but directly from the mystical source supposedly responsible for manufacture and distribution. . . . Though comparatively tiny in scale—which, however, makes them more easily appreciated as a total phenomenon—cargo cults are movements of positive protest and dynamic aspiration whose study can provide valuable insights into such convulsions as the French and Russian revolutions and the more gradually emergent African and Asian nationalisms."
$14.95 *(PB/296/Illus)*

Marks of Civilization: Artistic Transformations of the Human Body
Edited by Arnold Rubin
Rubin, the late UCLA professor of non-western academic art history, is often remembered as the first to legitimize piercings, scarification and tattoos as serious objects of academic scrutiny. Reviled by some for popularizing body modification yet adored by many as the father of modern primitivism and the prophet of the tattoo renaissance, Rubin provides rigorous yet accessible ethnographic studies of the history of body art, offering art historians, anthropologists and aficionados alike an excellent comparative text. Since its publication by the UCLA Museum of Cultural History in 1988, *Marks of Civilization* has

remained the ethnographic bible of body modification, with well-illustrated offerings from anthropologists, art historians and ethnologists, who span the globe from Africa to Japan, Micronesia to the Americas. Rubin's closing essay, "Tattoo Renaissance," brought well-deserved academic and popular acclaim to such artists as Don Ed Hardy, Cliff Raven, Leo Zulueta and the late Jamie Summers. **HS**
$27.00 *(PB/280/Illus)*

Masks of Bali: Spirits of an Ancient Drama
Judy Slattum
"A visual, spiritual and dramatic journey into the sacred rituals of Bali through a spectacular gallery of masks and the fascinating, multi-layered stories of Balinese performances and traditions."
$18.95 *(PB/132/Illus)*

Mexico: From the Olmecs to the Aztecs
Michael D. Coe
"Companion volume to Michael D. Coe's *The Maya*, revised and expanded in this fourth edition. Includes enlarged sections on early village life and the rise of the Olmec civilization. Extraordinary recent discoveries—such as the stela from La Mojarra inscribed in the mysterious Isthmian script, or the mass sacrifice of 200 victims at Teotihuacan

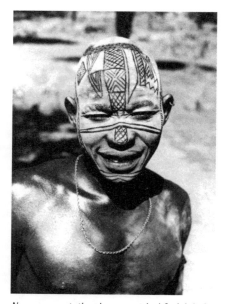

Non-representational asymmetrical facial design — from **Marks of Civilization**

—receive full coverage. A new chapter on Aztec life and society, based on fresh readings of the ethnohistorical sources, has also been added."

$15.95 *(PB/215/Illus)*

Net of Magic: Wonders and Deceptions in India
Lee Siegal
"This voyage through the netherworld of Indian magic unveils the contemporary world of the Indian magic of street and stage entertainers. Siegal's journeys take him from ancient Sanskrit texts to the slums of New Delhi to find remarkable magical tradition . . . Intersperses travelog, history, ethnography and fiction. A world where deception is celebrated and lies are transformed into compelling and universal truths."

$19.95 *(PB/455/Illus)*

Noa Noa: The Tahitian Journal
Paul Gauguin
Girls! Girls! Girls! Gauguin fled "filthy Europe" for a romantic painter's life in paradise: "Another week passed, and Tehura returned. Then a life filled to the full with happiness began. Happiness and work rose up together with the sun, radiant like it. The gold of Tehura's face flooded the interior of our hut and the landscape round about with joy and light. She no longer studied me, and I no longer studied her. She no longer concealed her love from me, and I no longer spoke to her of my love. We lived, both of us, in perfect simplicity." A fairy tale. **GR**
$3.95 *(PB/65/Illus)*

Nomads of Western Tibet: The Survival of a Way of Life
Melvyn C. Goldsmith and Cynthia M. Beall
A deep look into the harsh existence of the nomads of western Tibet. Some of the world's most extreme climate can be found here, where temperatures can reach more than 100 degrees in summer and 15 to 30 degrees below zero on winter evenings. The nomadic way of life began about 10,000 years ago and has changed very little since. The nomads live in mobile tents, raise livestock and use or sell their by-products for survival. They migrate constantly to greener pastures, for the livestock rely solely on pastures of indigenous vegetation for food; hence the term "pastoralism" to describe

Yaks, like goats, have kulu. However, the nomads either lasso and truss the yaks or drive them into corrals to control them and safely obtain cashmere. — from **Nomads of Western Tibet**

the nomads' way of life. The nomads collect skins and fleeces from yaks and sheep for wool and cashmere then travel to the marketplace to sell or trade for food and other necessities. The authors spent time living with the nomads, accompanying them on their journeys from home camp to pasture to marketplace and on hunting excursions. The data collected about the nomads of the Pala district "credit the nomads' traditional pastoral system with maintaining the sensitive ecological balance necessary to guarantee its perpetuation for countless centuries." Many color photos. **DW**
$17.95 *(PB/200/Illus)*

Oceanic Art
Nicholas Thomas
Thomas covers Oceanic art from prehistory to modern times by presenting illustrations of many artifacts used ceremonially and in everyday life. He explains the symbolism and recounts many of the myths depicted on the bark-cloth, buildings, mats and shields which are characteristic of the differing regions. "Looking beyond surfaces also means looking into the contexts. . . . A carving that has human characteristics is not necessarily a 'representation' of a human being or an ancestor. It may be better understood as an embodiment of that ancestor, as one expression of that ancestor, or it may be a physical container that an ancestor or spirit can be induced to inhabit at certain times." Includes 182 illustrations, 26 in color. **TR**
$14.95 *(PB/216/Illus)*

Paradise Remade: The Politics of Culture and History in Hawaii
Elizabeth Buck
Using Marxist and Foucauldian theory Buck deconstructs the dominant myth of "Hawaii." That is, she tells a history, not necessarily *the* history, of the islands from before contact with the West to the current resurgence of Hawaiian nationalism. While not a musicological text, *Paradise Remade* focuses on chant, hula and Hawaiian music as a way of "reading" the history of Hawaii. Music in general, and chants in particular, function as a continuing site of resistance— words and meanings being "the only things that Westerners could not appropriate" from Hawaiians. *Paradise Remade* is a heavily academic work, yet Buck does an admirable job of presenting the underlying theories in a manner that the general public can understand. Nevertheless, pleasure readers may find themselves wishing for a less analytical and more narrative style, as the fascinating subject matter is somewhat overwhelmed by its deeply theoretical framework. **LP**
$14.95 *(PB/242)*

Paul Bowles by His Friends

Edited by Gary Pulsifier

What do Francis Bacon, William Burroughs, John Cage, Lawrence Ferlinghetti, Patricia Highsmith, Peter Owen, James Purdy, Ned Rorem, Maria St. Just, Sir Stephen Spender and Gore Vidal have in common? Paul Bowles, apparently. Whether in Berlin in the '30s, New York in the '40s or the years since in Tangiers, Bowles has known a veritable who's who of writers, painters, journalists and publishers. Offering a collection of anecdotes and reminiscences, this work presents a composite portrait of this complex yet reticent figure. Whether through Cage's word puzzle, or Bacon's and Burroughs' conversational remarks about Jane Bowles' electro-shock treatments, a fuller portrait of Paul Bowles emerges while the contributors offer glimpses of themselves. In describing Bowles, Patricia Highsmith relates: "One has the feeling that Paul Bowles sees life as it is: meaningless in the long run, sees humans as indifferent to suffering and death as is mother nature herself. Paul looks at it steadily and tells it simply." An intriguing addition to the writings of and about Bowles, this book provides an interestingly oblique overview of this legendary figure. **JAT**
$24.00 *(PB/160/Illus)*

Paul Bowles Photographs: How Could I Send a Picture into the Desert

Paul Bowles

An adroitly subversive collection of "souvenir snapshots" taken by Bowles in El Aougherout, a small village in North Africa, from the 1940s through the 1960s, centering on various aspects of daily life: the marketplace, the region's proud male inhabitants, its gorgeous landscapes and architecture, the winding streets and beaches, personal friends and literary peers. The reader may find that a subtle yet vivid internal "hum" develops after perusing the entire sequence of photos in one sitting; an exotic/erotic undertone (the ominous mountains and desert backdrops, the back alleys, those two strapping youths in swimsuits mugging for the camera . . .) not unlike that produced by much of Bowles' fiction. Replete with a detailed introductory essay by Bischoff and a lengthy, informative interview culled from the author's conversations with Bischoff between 1989 and 1991.

Timmoun, 1948 — from **Paul Bowles Photographs**

Clearly a painstaking labor of love on the part of its editor, this book is a revealing, intimate glimpse into the world of a major writer notorious for his reticence working in a non-verbal medium. **MDG**
$39.95 *(HB/256/Illus)*

Rapanui: Tradition of Survival on Easter Island

Grant McCall

"Presents the details of how Easter Island

Mohammed Mrabet and Paul Bowles on the beach at Cap Spartel (Atlantic Ocean), Tangier, circa 1969 — from **Paul Bowles Photographs**

came to be what it is today. *Rapanui* is the absorbing story of the survival of an ingenious population of scarcely 3,000 people who cling to the rocky home they love. The book's first part offers a concise outline of the latest discoveries in the prehistory and history of Rapa Nui. Later chapters on contemporary life flow around the familiar concepts of family and group, belief, earning a living, relations with one's kin and with strangers. The final chapter describes the most recent changes and concludes with ideas about what the next millennium might bring to the people of the world's most remote island."
$14.95 *(PB/207/Illus)*

Ring of Fire: Volume 1, An Indonesian Odyssey— Spice Island Saga

Lorne and Lawrence Blair

The Blair Brothers embark on a 2,000-mile journey through the Spice Islands in search of the Bird of Paradise, the symbol of eternal life. They encounter storms and doldrums, sultans and transvestites, priests, pearl divers and python hunters, before finally reaching the Aru Islands close to New Guinea. Their odyssey with the Bugis tribe starts the Blairs on a journey which leads them into the forgotten wisdom of the island peoples. 58 min.
$24.98 *(VIDEO)*

Ring of Fire: Volume 2, An Indonesian Odyssey— Dance of the Warriors
Lorne and Lawrence Blair

The Blairs sail to Komodo and film giant carnivorous lizards. On Sumba, they witness a veiled form of human sacrifice by equestrian warriors. Weavers of magical textiles, the Sumbanese still live by ancient beliefs, ritually keeping the balance between the gods above and the world below. The brothers journey 50,000 years into the past to live with Asmat headhunters in New Guinea. In Bali, they build a home in a village of farmers, artists and mystics. 58 min.
$24.95 *(VIDEO)*

Ring of Fire: Volume 3, An Indonesian Odyssey— East of Krakatoa
Lorne and Lawrence Blair

In the shadow of Java's constantly erupted volcanos, the Blairs encounter a world of medieval courts, mystical shadow-puppet plays, of magical swords, healers with supernatural powers and whole communities ruled by the Toraja people of the Celebes highlands. The brothers share in the massive funeral rites of the last king of the tribe which believes its ancestors came from the stars in skyships. 58 min.
$24.95 *(VIDEO)*

Ring of Fire: Volume 4, An Indonesian Odyssey— Dream Wanderers of Borneo
Lorne and Lawrence Blair

For 800 miles, through untamed and uncharted rainforest, the Blairs seek the last of the Punan Dyaks, the blow-gun-wielding nomads of the interior. Eventually, the Blairs find them and are initiated into the spiritual mysteries of the "dream wanderers." They get tattooed with the symbol of Aping, "the Tree of All Life." 58 min.
$24.95 *(VIDEO)*

Ritualized Homosexuality in Melanesia
Edited by Gilbert H. Herdt

"This book marks the first time that anthropologists have systematically studied cross-cultural variations in homosexual behavior in a non-Western culture. Documents several societies where homosexual relations among men are both universal and obligatory, challenging a number of medical, bio-

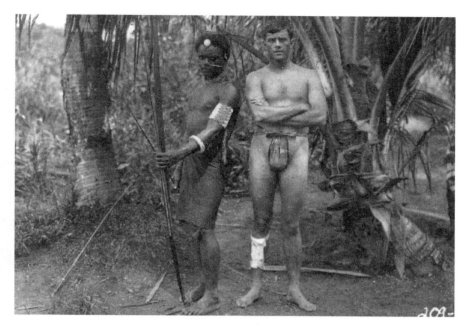

Martin and a young Solomon Islander — from **They Married Adventure**

logical and psychological theories of homosexuality."
$16.00 *(PB/455)*

Sexuality and Eroticism Among Males in Moslem Societies
Edited by Arno Schmitt and Jehoeda Sofer

Which one would you be, "man" or "nonman"? First-hand reports and essays on a hidden aspect of Moslem culture. "Portrays very clearly the relationship between same-sex eroticism and the ideal of the man as penetrator. . . ." Illuminates "not only male homosexuality but the whole sexual culture and the role of gender in the Moslem world, including such countries as Morocco, Syria, Iran, Turkey and Israel," where the Western concept of a "gay person," one who both gives and receives male affection, is still relatively unknown. **GR**
$12.95 *(PB/201)*

The Spears of Twilight: Life and Death in the Amazon Jungle
Phillipe Descola

The Jivaro Indians who reside around the border of Ecuador and northern Peru were perhaps most famous for the hunting and shrinking of human heads. Because of this

tradition, their villages and culture remained largely unspoiled by outsiders well into this century. In the late '70s the author went to live among them and earned their acceptance and trust. The picture he paints of them is a knowing insider's look at their customs, beliefs and daily life. The text exudes anthropological scholarship, and the translation from the original French is excellent.

The book's main weakness is that the Jivaros aren't really very interesting. They build huts and survive all manner of hardships. By the time the author has arrived, they already have rifles and headhunting is something that nobody has done recently. Their culture isn't visually rich or mythladen. If one is seeking a well-written portrait of a primitive people eking out a living in a harsh environment, this is about as good a telling as one could hope for. **SA**
$25.00 *(HB/459/Illus)*

Tales of the Yeti
Kesar Lall

"These nine tales concern the Yeti, the wildman known in the West as the Abominable Snowman. They were collected by the author in the course of his travels in different parts of northern Nepal."
$.40 *(PB/24/Illus)*

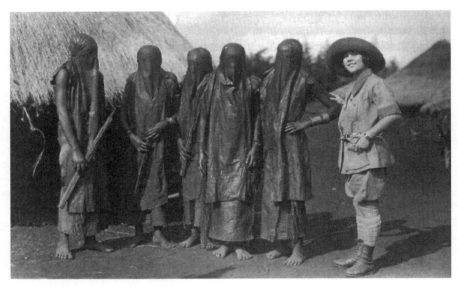

Still from Osa and Martin Johnson's Simba, *1928 — from* **The Third Eye**

Their Heads Are Green and Their Hands Are Blue
Paul Bowles
Collection of eight travel essays. Except for one essay on Central America, all of these pieces are concerned with remote spots in the Hindu, Buddhist or Muslim worlds.
$13.00 *(PB/192/Illus)*

They Married Adventure: The Wandering Lives of Martin and Osa Johnson
Pascal James Imperato and Eleanor M. Imperato
Romance! Danger! Animals! Picture Fred Astaire and Ginger Rogers in a Tarzan picture. "Martin and Osa Johnson thrilled American audiences of the '20s and '30s with their remarkable movies of faraway places, exotic peoples and the dramatic spectacle of wildlife. . . . [they] seemed to embody glamour, daring and the all-American ideal of self-reliance." Their travelogs—such as *Simba*, *Congorilla* and *Borneo*—humanized the wonders of the world. The "handsome pair from Kansas" even sparked a dance craze, the Congorilla. They were a special pair of footloose pioneers, except for that little imperialist/racist baggage thing they carried with them: "The high point of laughs was when the pygmies ate soap, blew up a balloon that burst, and tried to light cigars. And how those brown midgets go into their dance . . . " **GR**
$27.95 *(HB/313/Illus)*

The Third Eye: Race, Cinema and Ethnographic Spectacle
Fatimah Tobing Rony
"Charting the intersection of technology and ideology, cultural production and social science, this book explores early-20th-century representations of non-Western indigenous people in films ranging from the documentary to the spectacular to the scientific. Turning the gaze of the ethnographic camera back onto itself, this book brings the perspective of a third eye to bear on the invention of the primitive Other, revealing the collaboration of anthropology and popular culture in Western construction of race, gender, nation and empire."
$17.95 *(PB/299/Illus)*

"A Trade Like Any Other": Female Singers and Dancers in Egypt
Karin van Nieuwkerk
"Drawn from extensive fieldwork and enriched with the life stories of entertaining and nightclub performers, this is the first ethnography of female singers and dancers in present-day Egypt."
$15.95 *(PB/240/Illus)*

The Traditional Architecture of Indonesia
John Gillow and Barry Dawson
"Based on extensive firsthand research, this volume provides an island-by-island examination of the history, materials, traditions and techniques of Indonesian building forms. Supported by explanatory drawings and historical photographs, the illustrations are mostly in color and have been specially photographed by Barry Dawson. The highlights are photos taken from the balconies of the spectacular hill villages of south Nias which were inspired by the bulbous poopdecks of Dutch galleons, and the chief's great house, the *omo sebua*, at Bawamataluo."
$45.00 *(HB/192/Illus)*

Trance and Healing in Southeast Asia Today
Ruth-Inge Heinze
"Looks at the role of faith in Southeast Asian belief systems and investigates the needs which created these systems. Shamans, mediums and healers monitor trances and mediate between different levels of consciousness for the purpose of healing. In 21 case studies, the reader will observe a Meo shamaness riding into the spirit world and the god Rama descending into the body of a simple Indian worker. Also shows how Thai, Hindu, Malay as well as Chinese mediums with the help of various deities, deified heroes and nature spirits—cure, exorcise and advise their clients. Special attention is given to the topic of automatic writing and glossolalia."
$29.50 *(PB/406/Illus)*

Travels in the Unknown East
John Grant
The author made two trips through the Middle East in the period after World War I when the British and the French were present, and even the United States was being asked to assume some sort of control over the Ottoman grant. Both these political happenings and the people the author encountered create a dramatic backdrop for the journeys. In Istanbul, Ankara, Lebanon and Syria, he meets Sufi mystics, Druse believers, sheiks who can help or hinder the traveler, dope smugglers (all over), historical figures like Kemal Atatürk (the great general and founder of the modern Turkish state), and caravan guides who make the desert

their home. Written 50 years after the events took place, this is a vivid picture of a lost era. **MET**
$27.00 *(HB/198)*

Voyages of Discovery
Captain James Cook
"It was now just eight o'clock, when we were alarmed by the discharge of a volley of small arms from Captain Cook's people, and a violent shout of the Indians. . . . Captain Cook and four marines had fallen in this confounded fray." So writes James King from his vantage aboard ship, upon taking over captaincy of the *Resolution* after James Cook was slain by provoked Hawaiian natives in 1779. One eyewitness declaims that "matters would not have been carried to the extremities they were, had not Captain Cook . . . first unfortunately fired."

In the eyes of the traditional historian, this event is the tragic death of a hero, akin to the slaughter of Orpheus by hysterical Bacchantes; yet for revisionist champions of native peoples, the repulsion of the English becomes a temporary victory for the people of Kealakekua Bay. A reprint of an 1860 compilation by naval historian John Barrow, this concise edition condenses four tomes of Admiralty records by excising navigational details, thus offering an eminently readable narrative. Highlights include: Cook's discovery of Australia during his first voyage, resulting in the British Crown's decision to establish a penal colony at Botany Bay; the events leading up to Cook's demise during his fated third voyage, including a stranger-than-fiction account of how the Kealakekuan natives mistook him for an earthly manifestation of the god Lono; and Cook's painstaking descriptions of Tahitian and New Zealand natives during his second voyage.

In these descriptions of natives and their customs, the heart of the Voyages, Cook displays a nearly modern sophistication. Resisting the romantic racism of the 18th century, he assiduously refuses to treat natives as noble savages, children of nature, or heathen devils. Barrow illustrates this sensitivity by juxtaposing another contemporary description of Tierra del Fuegans ("perfectly nude, wild and shaggy . . . like so many fiendish imps") with Cook's more humanitarian perspective ("These people appeared on the whole to be the outcasts of human nature; their only food was shellfish; and they were destitute of every conve-

nience arising from the rudest art").

Although relentlessly mild by today's standards, the *Voyages* were immensely popular, consistently titillating readers from their first publication through the 19th century. Just as those who wanted to see naked men and women in the pre-*Playboy* era would look through *National Geographic*, many would turn to the *Voyages of Discovery* to read about the promiscuity, license and nudity of natives. **HS**
$16.95 *(PB/555/Illus)*

The Way of the Masks
Claude Lévi-Strauss
Explores the cultures of the various coastal peoples of British Columbia and Alaska. Even though this might seem a relatively small and specific area, the diversity of these cultures is boundless. This book focuses on the aspects of ceremonial masks and the meanings they depict. The masks, as they are used to communicate with neighboring tribes, provide a context for assessing their comparative belief systems. Most interesting is that so little geography can yield such a diversity of myth, ceremony, values and beliefs. Maps and charts scat-

tered throughout the text showing the relative proximity of the tribes to each other and to natural resources further serve to illustrate this point. Much of the lore and artifacts are relatively recent in the greater scheme of world history but spring from sources that date back to prehistory. **SA**
$18.95 *(PB/249/Illus)*

Wood Carvings of Bali
Fred Eiseman, Jr. and Margaret Eiseman
"An introduction to the ancient Balinese wood-carving tradition, offering a history of the craft from the early Buddhist influences, through the classical period, to the modern period."
$17.95 *(HB/88/Illus)*

Yanomamö:
The Last Days of Eden
Napoleon A. Chagnon
Chagnon first made contract with the Yanomamö, a now-imperiled tribe of Amazon Indians, in 1964. A look at an extraordinary people in this eloquent, meticulously detailed and often passionate book.
$14.95 *(PB/309/Illus)*

Chinese medium falling out of trance, Pegu Road, Singapore — from Trance and Healing in Southeast Asia

SIR RICHARD BURTON

Richard Burton, circa 1875 — from **Sindh Revisited**

Burton was always a verbose writer, undisciplined and inexhaustible. His scientifically detached accounts of the anthropological, geographical and physiological aspects of his travels totaled 80 or more volumes at his death. He had considerable medical knowledge, and recounts the most surprising facts with professional exactitude. There is no saying what will come next. Peculiarities of Swahili sex life, damp, jungle climates where the "sexual requirements of the passive sex exceed those of the active sex." (Nymphomania was ever one of his pet subjects.) Taboos and magic; urinary and genital maladies, along with venereal disease in Lazabas; methods of castration: exsection of the ovaries as a Malthusian measure much practiced by Australians (as he called the Aboriginals); the erotic urges of apes, circumcision and rape, besides statistics on rainfall, or the behavior of a cornered hippo—Captain Burton's books, it will be seen, were not always parlor reading.
— Lesley Blanch, from *The Wilder Shores of Love*

The Devil Drives
Fawn M. Brodie

"Though Burton scoffed at all forms of religious superstition—whether the fetishes of the Fan cannibals or the death ceremonies of his own Church of England—he dwelt fascinated upon all things accounted devilish in his own time. Once he even contemplated writing a biography of Satan himself. . . . But Burton's preoccupation with things Satanic was only one aspect of the man. In the catholicity of his interests he seemed to have been a true man of the Renaissance. He was soldier, explorer, ethnologist, archaeologist, poet, translator, and one of the two or three great linguists of his time. He was also an amateur physician, botanist, zoologist and geologist, and incidentally a celebrated swordsman and superb raconteur. . . . And in a world where there seemed to be very little left to be discovered, he sought out the few remaining mysteries. . . . But Burton's real passion was not for geographical discovery but for the hidden in man, for the unknowable, and inevitably the unthinkable. What his Victorian compatriots called unclean, bestial or Satanic he regarded with almost clinical detachment. In this respect he belongs more properly to our own day."
$12.95 *(PB/390/Illus)*

First Footsteps in East Africa, or, An Exploration of Harar
Richard F. Burton

"Following his spectacular pilgrimage to Mecca and Medina in 1853, Burton mounted an even more harrowing expedition in 1854 to Harar, the Somali capital, accompanied by three young British officers. Four months later, after leaving his companions on the Somali coast and disappearing into the desert, he entered the city alone. Disguised as an Arab merchant, he spent 10 days 'in peril of his life,' but his daring and diplomacy, his ability to pass as an Arab and his sound knowledge of Mohammedan theology allowed him to leave as boldly as he had walked in. His successful penetration of the Muslim citadel made him the first European to do so without being executed. . . . The text provides a vivid narrative of Muslim beliefs, manners and morals, documents the pleasures and hazards of desert life and contributes a vast amount of invaluable geographic, ethnographic and linguistic data."
$12.95 *(PB/544)*

The Kama Sutra of Vatsyayana
Translated by Sir Richard Burton and E.E. Arbuthnot

"The following women are not to be enjoyed:

A leper
A lunatic
A woman turned out of caste
A woman who reveals secrets
A woman who publicly expresses desire for sexual intercourse
A woman who is extremely white
A woman who is extremely black
A bad-smelling woman
A woman who is a near relation
A woman who is a female friend
A woman who leads the life of an ascetic
And lastly, the wife of a relation, of a friend, of a learned
Brahman, and of the king"

First printed in 1883, this is an ancient Indian men's guide to sex. How to bite, how to kiss, who needs a good slapping, how to seduce, and how to match the depth of her "yoni" to the size of your "lingam" for the "highest union" of sexual satisfaction. **GR**
$5.99 *(PB/308)*

Personal Narrative of a Pilgrimage to Al-Madinah and Mecca: Volumes 1† and 2††

Sir Richard F. Burton

"It is for his pilgrimage in 1853 to Mecca and Medina and the most sacrosanct

Richard Burton in his tent in Africa. Probable date, 1862 — from **The Devil Drives**

The Takht-Rawán, *or Grandee's Litter — from* **Personal Narrative of a Pilgrimage to al-Madinah and Mecca**

shrines of Islam that Burton is best known—and for his celebrated book that recorded his experiences during the journey. Successfully posing as a wandering dervish, he gained admittance to the holy Kaabah and to the Tomb of the Prophet at Medina and participated in all the rituals of the Hadj (pilgrimage). He is still one of the very few non-Moslems to visit and return from Mecca. . . . Whether telling of the crowded caravan to Mecca, engaging in minute analysis of Bedouin character, waxing lyrical about a desert landscape or reporting conversations with townsfolk or fellow pilgrims, Burton gives us a vivid picture of the region and its people."
†$10.95 *(PB/436/Illus)*
††$10.95 *(PB/479/Illus)*

Sindh Revisited: A Journey in the Footsteps of Captain Sir Richard Francis Burton

Christopher Ondaatje

"The years Burton spent in India (1842-49) were the crucial formative ones. This was where he first learned about Islam, first mastered the art of disguise, first revealed his dazzling talents as a linguist. Yet these years are also the least known and least documented in the great explorer's life. By boldly going in Burton's footsteps to Sindh, Bombay and Goa and interviewing dozens of the subcontinent's experts on Burton and

the Raj, Ondaatje has shed new light on this obscure chapter and brought back new wisdom." Beautifully illustrated with color photographs by the author and historical pictures.
$30.00 *(HB/320/Illus)*

Wanderings in West Africa

Richard F. Burton

"In 1861, Sir Richard Francis Burton, one of the Victorian era's greatest scholar/adventurers, entered the British Foreign Office as consul in Fernando Po, a Spanish island off the coast of West Africa. Over the next three years, he embarked on many short expeditions to the mainland, amassing a huge store of information on the indigenous peoples of the region. He later wrote five books about his travels and exploration. This present volume is one of the best known, a fascinating, detailed description of Burton's long journey to his post, his arrival at Fernando Po and his first investigations of the lives and customs of native tribes dwelling along the West African coast."
$12.95 *(PB/624/Illus)*

ISABELLE EBERHARDT

Ain Sefra, Algeria, 1904

A subject to which few intellectuals ever give a thought is the right to be a vagrant, the freedom to wander. Yet vagrancy is deliverance, and life on the open road is the essence of freedom. To have the courage to smash the chains with which modern life has weighted us (under the pretext that it was offering us more liberty), then to take up the symbolic stick and bundle, and *get out!*

To one who understands the value and the delectable flavor of solitary freedom (for no one is free who is not alone), leaving is the bravest and finest act of all.

An egotistical happiness, possibly. But for him who relishes the flavor, happiness.

To be alone, to be *poor in needs,* to be ignored, to be an outsider who is at home everywhere, and to walk, great and by oneself, toward the conquest of the world.

The healthy wayfarer sitting beside the road scanning the horizon open before him, is he not the absoute master of the earth, the waters, and even the sky? What house-dweller can vie with him in power and wealth? His estate has no limits, his empire no law. No work bends him toward the ground, for the bounty and beauty of the earth are already his.
— Isabelle Eberhardt, from *The Oblivion Seekers*

Isabelle Eberhardt, age 19 — from The Destiny of Isabelle Eberhardt

Departures: Selected Writings

Isabelle Eberhardt

Eberhardt's short life was perhaps her greatest work of art. Despite her eventful existence, she was able to artfully chronicle her milieu in a body of remarkably textured prose. *Departures* compiles in a single volume a significant cross section of her short fiction and her travel journals, as well as supplementary essays which place her in a greater historical and cultural context. **JAT**
$12.95 *(PB/245)*

The Destiny of Isabelle Eberhardt

Cecily Mackworth

"One may judge Isabelle as the neurotic she undoubtedly was, the victim of a disastrous heredity and a criminal upbringing. One may see in her the adventuress, eager for sensation and ready to do anything that would bring in the small sums of money necessary to continue her chosen existence. There is the artist whose sensibility responded so immediately and completely to beauty; there is the exalted mystic who longed to die in the cause of Islam. But there is also the warm human being who could pardon every offense, who thought ill of no one, who loved the humblest and most disinherited of humanity and hated only that which was false and pretentious. . . . It is useless to look for a logical thread on which to hang so chaotic an existence. . . . Isabelle's life was based on a fantastic dream of liberty. At least she had the courage to live that dream to the full, accepting the misery and degradation that its realization entailed, and proudly accepting death."
$9.50 *(PB/229/Illus)*

In the Shadow of Islam

Isabelle Eberhardt

"To live alone is to live free. I no longer want to care about anything. Over the course of months I will place my soul apart. I have known so many days when I lived like a stray dog. Those days are far off, behind vast solitudes, behind crushing mountains, beyond the arid high plateau and the cultivated Tell, anguished nights in town where worries tumbled behind my eyes, where my

Pencil drawings by Isabelle Eberhardt of a desert scene — from The Destiny of Isabelle Eberhardt

heart ached with pity and impotence. Now I have won back my pride, and friendly faces are kinder to me. I will suffer no more from anyone." *In the Shadow of Islam* recounts Eberhardt's journey to and stay at the remote desert *zawiya,* or religious establishment, of Kenadsa. Written shortly before her death, it is in some senses a travel journal; but it is most distinctive for what is omitted. Writing of her journey, Eberhardt never reveals her destination until her actual arrival. While in Kenadsa for Islamic training, she is required by tradition to remain silent about her instruction. Instead, she writes of the surrounding landscape and the activities around Kenadsa not forbidden to tell. These observations display a heightened sensitivity to their details and their significance in a compelling narrative.

JAT

$19.95 *(HB/120/Illus)*

Isabelle:
The Life of Isabelle Eberhardt
Annette Kobak

Isabelle Eberhardt sought to experience the whole range of life among the Arabs of North Africa. Born in Switzerland from the union between a Russian woman with aristocratic ties and her children's anarchist tutor, Eberhardt was raised wearing boy's clothing and schooled in languages. Traveling to North Africa, she dressed as a man, converted to Islam, became addicted to *kif* (hashish) and took numerous male lovers before marrying an Arab sergeant. Joining a mysterious Sufi sect, she traveled across the desert and documented her picaresque life in numerous letters and journals before her premature death at age 27 in a freak desert flash flood. *Isabelle* sorts through the legend to capture all of

the intricate strands of her short and eventful life. Relying on journals, unpublished letters and records in archives in Switzerland, France and Algeria, Kobak debunks fanciful myths (for example, that Rimbaud was her father) and demonstrates control of such sensational material. While perhaps lacking the poetry of Eberhardt's own writings, this biography offers an excellent and comprehensive portrait of this legendary figure. **JAT**

$12.99 *(PB/268/Illus)*

The Oblivion Seekers
Isabelle Eberhardt

Eberhardt left behind a small body of writing and a large legend of a life. This Swiss-French woman plunged deep into the Sahara and the secrets of Sufism in colonial Algeria. "No one ever lived more from day to day than I, or was more dependent on chance. It is the inescapable chain of events that has brought me to this point, rather than I who have caused these things to happen."

$7.95 *(PB/88/Illus)*

Prisoner of Dunes
Isabelle Eberhardt

"There are so many miserable people, hope-

lessly besmirched by their daily grind, who spend life's brief hours in useless, absurd recriminations against everyone and everything. They are blind to the ineffable beauty of things, to the sad splendor of suffering humanity. Happy is he for whom nothing proceeds bestially and cruelly by chance, to whom all earth's treasures are familiar, for whom all does not end foolishly in the darkness of the grave!" The vignettes and stories which make up *Prisoner of Dunes* span the years of Eberhardt's life in North Africa and her period of exile in Marseilles. Most of these selections were either written in El Oued, the "town of a thousand domes," or Marseilles, where she recalled El Oued. El Oued was the center of Eberhardt's Saharan adventure and was the one place she dreamed of one day settling. Expressing the tensions that drove her and the strands of magical beauty she sought, *Prisoner of Dunes* evocatively captures this life. **JAT**

$24.00 *(PB/127)*

The marketplace, El Oued, Algeria — from The Destiny of Isabelle Eberhardt

MAYA

When Spanish explorers first entered Mexico and central America early in the sixteenth century, they revealed one of the greatest geographical mysteries of their age. Not only did they discover a vast new land—nameless and unmarked on existing charts—but they also opened the gateway to an astonishing panoply of indigenous, highly advanced people whose origins reached far back into antiquity.

Unknown to the Spaniards, however, they were witnessing the final glimmer of far greater glories. At least two thousand years earlier, the Maya had emerged from shadowy origins to begin a steady climb toward what eventually became a civilization characterized by monumental architecture, superlative works of art, thriving trade networks, a system of writing and mathematics, a highly accurate calendar, a substantial body of astrological knowledge, and a powerful elite class who ruled over huge cities—all of which comprised one of the most original expressions of human ingenuity ever known.
—from *Maya* by Charles Gallenkamp

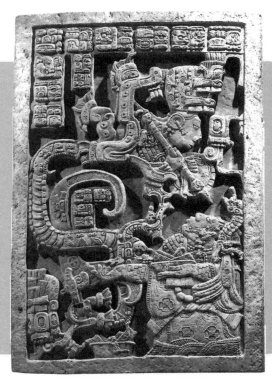

Lintel 25 — from **Blood of the Kings**

The Blood of Kings
Linda Schele and Mary Ellen Miller
"The classic study of the New World's most advanced, sophisticated, and subtle civilization—the ancient Maya. This remarkable people has begun to emerge from the obscurity of history, thanks to the tremendous progress made since the breaking of the Maya hieroglyphic code in 1960. This volume provides a social and historical framework for the architecture and objects produced by the ancient Maya and reveals a culture as rich and varied as the ancient civilizations of Europe, the Middle East and the Orient."
$45.00　　　　　*(HB/320/Illus)*

Breaking the Maya Code
Michael D. Coe
"The history of the American continent does not begin with Christopher Columbus, or even with Leif the Lucky, but with those Maya scribes in the Central American jungles who first began to record the deeds of their rulers some two thousand years ago. Of all the peoples of the pre-Columbian New World, only the ancient Maya had a complete script: they could write down anything they wanted to, in their own language. . . . the inside story of one of the great intellectual breakthroughs of our time—the last great decipherment of an ancient script."
$14.95　　　　　*(PB/304/Illus)*

The Codex Borgia: A Full-Color Representation of the Ancient Mexican Manuscript
Giesele Diaz and Alan Rodgers
Considered by many scholars the finest Mexican codex and one of the most important original sources for the study of pre-Columbian religion, *The Codex Borgia* is a work of profound beauty, filled with strange and evocative images related to calendrical, cosmological, ritual and divinatory matters. The priceless original is in the Vatican library, and has been damaged over the centuries. It took seven years to restore the *Codex* by hand. The result is 76 large full-color plates of vibrant, striking depictions of gods, kings, warriors, mythical creatures and mysterious abstract designs."
$15.95　　　　　*(PB/96/Illus)*

The Codex Nuttall
Edited by Zelia Nuttall
One of the greatest tragedies of history is the destruction of nearly all ancient Mexican books by the religiously possessed Spanish priests during their conquest. In their attempt to obliterate all records and histories of these greatly advanced civilizations, they left a mere handful of the great hand-painted books in salvageable condi-

tion. In fact, out of untold numbers of Maya pre-conquest manuscripts only four survive. The conquistador Cortes sent two such "codices" to the Emperor Charles V. It is suspected that the *Codex Nuttall* may have been one of these. This book is a reprint of a 1902 facsimile of an ancient book created in the region now known as Oaxaca, Mexico, shortly before the bloody conquest. It shows the life of kings and warriors centering around the year 1000, including glimpses of ceremonies, birth rites, marriage histories, sacrifices and still-indecipherable symbols of the Mixtec artists. Like much pre-Colombian art, these images combine simplicity with complex mystery. The sense of permanent loss is profound. **CS**

$12.95 *(PB/96/Illus)*

A Guide to Ancient Maya Ruins
C. Bruce Hunter
Hunter has spent 30 years leading field study trips to Maya archaeological sites for the American Museum of Natural History, and this guide is intended for the traveler but is nevertheless scholarly. Updated since its original 1974 edition, it incorporates archaeological findings of the last 20 years and would enrich any collection of Central American guidebooks. Look elsewhere for maps, transportation tips and the proper way to say "Make that margarita strawberry" in Spanish. This is a thorough guide to the history, archaeology and architecture of the more accessible Maya ruins. **SK**

$17.95 *(PB/356/Illus)*

Incidents of Travel in Yucatan
John Lloyd Stephens
A lively, eloquent guide, as entertaining today as when it was first published in 1843, *Incidents of Travel in Yucatan* recounts the explorations and discoveries of best-selling travel writer John Lloyd Stephens. This beautiful new edition includes a choice selection of Frederick Catherwood's evocative drawings from the original edition as well as 85 photographs from the 1860s to the present. Dover Books publishes a two-volume reprint of the original edition which contains all of the Catherwood drawings. Still, this richly visual edition serves as an effective time-machine, taking you back to the pioneer days of archaeology, and to the lost world

of the ancient Maya.
$13.95 *(PB/286/Illus)*

The Maya
Michael D. Coe
"Long established as the best general introduction to the New World's greatest ancient civilization, this fifth edition has been enlarged and entirely revised, placing new emphasis on the pre-Classic period, discussing the rise of such cities as Nakbé and El Mirador during the first millennium BC. An additional chapter on the terminal Classic period highlights the increasing evidence for overpopulation and deforestation as the prime causes of the catastrophic southern Maya collapse in the ninth century AD. But the focal point remains the glorious Classic period, with its magnificent art and architecture. New discoveries at such Classic cities as Copán and Dos Pilas receive full coverage, as do the epigraphic breakthroughs that continue to shed light on Maya dynastic history and cosmology. The final chapter pays tribute to the 6 million or more contemporary Maya, guardians of so many of the ancient traditions, whose long struggle against persecution and extermination continues to this day."
$14.95 *(PB/224/Illus)*

The Maya: Palaces and Pyramids of the Rain Forest
Henri Stierlin
"Stierlin bases his presentation of these remarkable examples of Maya architecture on the latest findings from excavations. Cities have been rediscovered in the depths of the rain forests, along with soaring pyramids, mysterious tombs, palaces with frescoes and stelæ. . . . Only very recently has it been possible to decipher Maya hieroglyphics to any great extent. This new research is used to full advantage by this volume as a key to unlock the mystery of Maya architecture. Includes more than 250 color illustrations, computer-aided reconstructions, plans of famous buildings and clear chronological tables that place architectural developments within the context of historical events."
$29.99 *(HB/240/Illus)*

Maya for Travelers and Students: A Guide to Language and Culture in Yucatan
Gary Bevington
"Written in nontechnical terms for learners

Yuri Valentinovich Knosorov in Leningrad, about 1960 — from **Breaking the Maya Code**

who have a basic knowledge of simple Mexican Spanish, the book presents practical information for anyone who would like to communicate with the Maya in their native language . . . covers pronunciation and grammar of Maya, also includes invaluable tips on learning indigenous languages 'in the field.' Most helpful are the discussions of the cultural and material worlds of the Maya, accompanied by essential words and expressions for common objects and experiences."
$14.95 *(PB/256/Illus)*

Maya History
Tatiana Proskouriakoff
The final, epic work by one of the world's foremost Maya scholars. Proskouriakoff was responsible for discovering that a vast number of the glyphs covering Maya buildings and monuments actually recorded the lives and thoughts of specific individuals, not only the priests and Gods as was previously surmised. This significant breakthrough paved the way for a true history of the Maya civilization. The eventual collapse of the Classic Maya is discussed in connection with the corrupting "decadence" in their art, brought on by foreign influences in the Maya lowlands. Fourteen line drawings of stelae and over 300 original drawings of

glyphs enhance the intriguing, densely detailed text. **CS**
$45.00 *(HB/304/Illus)*

The Paris Codex: Handbook for a Maya Priest
Bruce Love

The Maya civilization left many records carved in the stone of its cities, but only four hand-painted books, or codices, are known to have survived from the pre-Columbian era. *The Paris Codex* is one of these, and this groundbreaking study is the first comprehensive treatment of this codex since 1910. The Maya priests who used *The Paris Codex* could see the myriad forces of the Maya spirit world arranged and organized on the pages before them. The interweaving of cycles within cycles became comprehensible and predictable. The invisible world became perceptible. Now, scholars and amateurs alike can discover the unity and harmony of the Maya cosmos. **CS**
$37.50 *(HB/172/Illus)*

Popol Vuh
Dennis Tedlock

"The *Popol Vuh*, the Quiche Maya book of creation, is one of the extraordinary documents of the human imagination and the most important text in the native languages of the Americas. It begins with the deeds of Maya gods in the darkness of a primeval sea and ends with the radiant splendor of the Maya lords who founded the Quiche kingdom in the Guatemalan highlands. Originally written in Maya hieroglyphs, it was transcribed in the Spanish alphabet in the sixteenth century. This is the first unabridged English edition of the work, in Dennis Tedlock's widely praised translation, with a full introduction and commentaries on the text."
$12.00 *(PB/380)*

Spoken Maya for Travelers and Students: An Audiocassette
Recorded by Fernando Ojeda

This tape was submitted for review without a study guide or other text. The cover of the tape indicates that this is Maya as it is spoken on Mexico's Yucatan Peninsula. It sounds like Danish being spoken by a Native American. Unlike Danish there seems to be an emphasis on words that deal with sunshine and warmth and corn. This tape can prove especially interesting to anybody who has ever wondered what the rich and fertile pictograms of the Maya sound like as a spoken language. 30 min. **SA**
$14.95 *(AUDIO)*

A Study of Maya Art
Herbert J. Spinden

"Classic work interprets Maya symbolism, estimates styles, covers ceramics, architecture, murals, stone carvings as art forms."
$12.95 *(PB/285/Illus)*

Yucatan Before and After the Conquest
Diego de Landa

Ninety-nine percent of what we know of the Maya civilization comes from this one source—because its author burned everything else! "These people also used certain characters or letters, with which they wrote in their books about the antiquities and their sciences. . . . We found a great number of books in these letters, and since they contained nothing but superstitions and falsehoods of the devil, we burned them all, which they took most grievously and which gave them great pain." Friar Landa did all he could to wipe out the Maya culture in the name of God. One night in 1592, he records, he destroyed 5,000 "idols" and burned 27 hieroglyphic rolls. Accused of "despotic mismanagement" by Spain, he wrote this book to defend his dubious honor.
GR
$5.95 *(PB/162/Illus)*

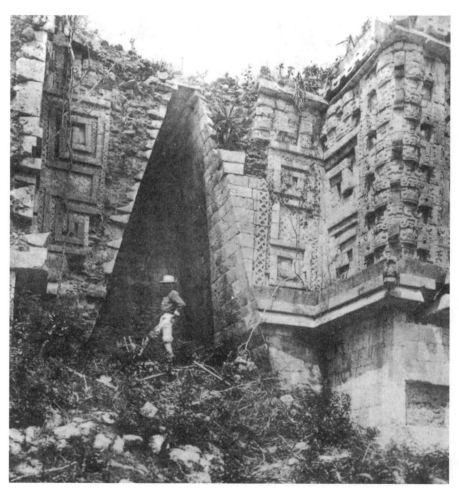

Uxmal: Sealed portal vault in the house of the Governor. The veneer character of the cut stone is evident. — from A Study of Maya Art

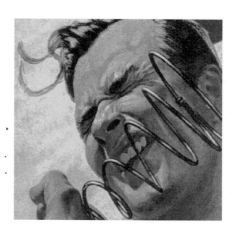

The A to Z Encyclopedia of Serial Killers
Harold Schechter and David Everitt
We live in a country obsessed with the details of the criminal mind—all the details, from bed wetting to history to methods. A comprehensive guide is assembled here for the first time. Hundreds of entries spanning collectors, collections, methods, college courses, weapons, poetry, songs and art by murderers and the infamous practitioners themselves. Grisly murder has been the subject of story and song, of art high and low for centuries. True crime books have been around since at least the 1600s. The case of Dr. H.H. Holmes, "America's first serial killer," was said to have caused as much excitement as O.J.'s trial today. Features few actual photographs but includes baseball-style trading-card drawings from such collections as "Bloody Visions," "52 Famous Murderers" and artwork by Joe Coleman. If you are the consummate collector, you probably have most of this information, but it is a reference point for further investigation containing quirky details for the voyeur at heart—Ed Gein received requests for locks of his hair, David Berkowitz was a bed wetter. **CF**
$12.00 *(PB/341/Illus)*

Among the Thugs
Bill Buford
What might compel an educated and well-adjusted man to start spending every free weekend with a gang of football hooligans—mere journalistic curiosity, or is it something deeper and more dangerous? This is the strange quandary of Bill Buford, a California native who came to London to start the literary magazine *Granta*, and began at once to develop an unwholesome preoccupation with that country's lumpen-prole threat. Who, after all, can resist the pull of a crowd poised for destruction? "'It's going to go off,' someone said, and his eyes were glassy, as though he had taken a drug. 'It's going to go off,' spoken softly, but each time it was repeated it gained authority . . ." What's going to go off? A powder-keg of seething class hatred, empire-envy, racist fury and countless pints of strong English ale. *Brittania über alles*! **JT**
$12.00 *(PB/320)*

And the Blood Cried Out: A Prosecutor's Spellbinding Account of the Power of DNA
Harlan Levy
Your D(eoxyribo) N(ucleic) A(cid) could hang you. It's in your hair, you saliva, your sperm, your skin, your sweat, your blood. "Combination of thrilling true crime stories and fascinating, fully understandable science," as the author, a former homicide prosecutor and "DNA expert," "describes the evolution of DNA and places in context the controversy surrounding its acceptance through dramatic re-creations of 14 of the decade's most suspenseful criminal cases." Details the forensic results of the Simpson DNA evidence, explaining what it really showed. Shows how the World Trade Center bomber's saliva (on a stamp) nailed him. And how even modern DNA tests on old evidence can set an innocent jailbird free. **GR**
$24.00 *(HB/223)*

ANSWER ME!: The First Three
Jim and Debbie Goad
Aging punks find renewed purpose combating the glassy-eyed revival of hippie-chic in so-called rave culture (or Ravestock™), the consumo-liberalism of slack, of spectacle society (whether middlebrow or "alternative"), of the multicultural and welfare states, and find their true selves in the process. The Goads are easily the most

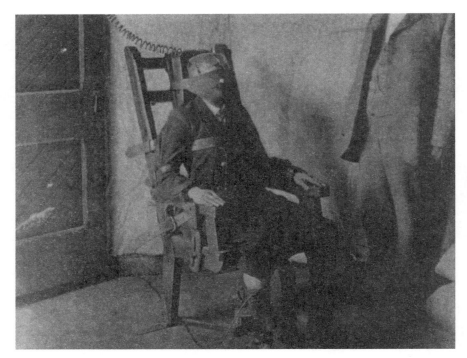

Awaiting execution, September 12, 1908, unidentified site — from **Blood and Volts**

influential members of the latest crop of countercultural "taste-makers," the success story of their "hate rag" ANSWER ME! unprecedented in the by-definition marginal universe of personal zines. And let it be known that this empire-to-be was built on a good, old-fashioned foundation of blood, sweat, tears and flawless spelling; not the usual faddish ephemera. It was inevitable that whatever remained of punk in the '90s should take a sharp turn to the right, a form of self-actualization, really. With ANSWER ME!, the DIY initiative finally reclaims its Calvinist roots, alienation is reconfigured as rugged individualism, and all that fiddling with sexual codes serves in the end to mark an essential difference. Punk's sexual ambivalence erupts here into full-scale biological warfare—the body being inherently revolting, as is, by extension, reproduction, childbirth, you name it. No surprise then that the Goads should choose instead to toil on behalf of the mighty death drive. While not the first magazine wholly devoted to mayhem, ANSWER Me! is easily the most ecstatic. Now that AK press has reprinted the first three issues in a single hefty volume, the Goads' particular achievement may at last be measured against the gener-

al eruption of prurience which defines our cultural moment. Initial shock waves eddy ever outward into eventual alignment with the mainstream, and death, once the last outpost of the unthinkable, is not only colonized but converted into our foremost commodity. Or, in the words of the typical ANSWER ME! reader: "I'll trade you two Dahmers for one Gacy."

Supported by a familiar cast of fringe-dwellers (Anton LaVey, Timothy Leary, Boyd Rice, Ray Dennis Steckler, Russ Meyer, etc.) as well as some welcome new additions (Dr. Kevorkian, Rev. Al Sharpton, Al Goldstein, David Duke, etc.), the Goads set forth in these pages a definitive manual of cultural provocation and resistance, and one auspiciously devoid of rock'n'roll. Extreme and vital information is sniffed out (vitiated) at the source, rather than distilled by way of some popstar's blathering. Likewise, no trippy typefaces, no kinko-collages, and no fisheye photographs to intrude upon the crystalline sobriety of the ANSWER ME! aesthetic. Two Top 100 charts, one devoted to mass murderers, another to "spectacular" suicides, are exemplary journalistic feats, showcasing a near-psychotic fastidiousness which perfectly complements the subject

matter. Order rules at the offices of ANSWER ME!—the better to drive home their message of hate, and if not a message, then at least a market. **JT**
$13.00 *(PB/134/Illus)*

Astro-Data V: Profiles in Crime
Lois M. Rodden
Perhaps the most bizarre volume in any true crime library. The author has diligently compiled the *astrological* data of crime. Included are 300 full-blown charts (complete with all those cute little astrological symbols) for a motley crew of serial killers, mass murderers, Nazis and other assorted loose ends. And as an added bonus they've thrown in the planet positions for another 435 cases. Definitive or demented, take your pick. **JM**
$36.00 *(PB/238/Illus)*

Attorney for the Damned: A Lawyer's Life With the Criminally Insane
Dennis Woychuk
"A prominent lawyer for the criminally insane recounts some of his most dramatic and bizarre cases in a trenchant assessment of a legal system gone awry. As the stories unfold, we witness an idealistic young lawyer become ever more troubled as he succeeds, often through his brilliant courtroom strategy, in gaining freedom for those who leave only to kill again. We also hear frightening tales of a system so inept that a serial killer who has committed numerous rapes and murders is released because a representative from the D.A.'s office forgets to show up at his hearing. . . . We also hear rare stories of redemption, including that of the cannibal killer who meets a psychotic murderess in the state psychiatric hospital. They fall in love, are eventually released, marry and now live peaceably in one of New York's nicer suburbs."
$23.00 *(HB/226)*

The Autobiography of a Criminal
Henry Tufts
Outlaw literature from a New England "horse thief, bigamist, burglar, adulterer, con man, scoundrel, counterfeiter, deserter and common criminal who roamed the American colonies in the late 1700s, visiting several jails and escaping from most of them, before writing his autobiography."

First published in 1807, the unapologetic narrative so enraged the reading public, they set fire to the book's print shop.
$12.95 *(PB/312/Illus)*

Bad Girls Do It! An Encyclopedia of Female Murderers
Michael Newton
An alphabetical encyclopedia of female multiple murderers. The two implied selection criteria are telling: These women have all killed more than once, and they've all been caught—eventually. Most of the murderesses killed several husbands or children, most of them for insurance money, and an impressive number of them were not caught until they'd committed a half-dozen glaringly identical crimes. It leaves one with a picture of feminine evil: women tend to poison instead of shooting; they kill with calculation, not from passion; and they usually get away with it—why else would so many women here be caught on only their fifth or sixth husband-drugging? How many others managed to kill off just the one husband undetected? Reading this catalog, one realizes that women can be just as deadly as men, but that they get away with it more often. **HJ**
$14.95 *(PB/205)*

Berserk! Motiveless Random Massacres
Graham Chester
There's nothing like a nut with a gun, a grudge and plenty of ammunition to add spice to anyone's day. *Berserk!* offers up a whole passel full, ranging from modern legends like Charles "Texas Tower" Whitman and James "McDonald's" Huberty to lesser-known but no less interesting mass murderers like Wagner von Degerloch (who killed nine people in Germany in 1913) and Howard Unruh (Camden, New Jersey, 1949: 13 dead in 12 minutes). Chester offers up excellent, concise accounts of some of the more interesting criminals of the 20th century. **JM**
$5.50 *(PB/260/Illus)*

Blood and Volts: Edison, Tesla and the Electric Chair
Th. Metzger
"An ax murderer, two of the most brilliant scientific minds of the century, billions of dollars in profit, precedent-setting legal battles, secrets of life and death—all of these come together in the story of the first electric chair. . . . At the dawn of the 20th century, electricity was thought to be a highly ambiguous force: at once a godlike, creative power and demonic destroyer of life. . . . In the popular imagination, Tesla and Edison were seen as nearly superhuman beings, and their struggle was not only for wealth and power, but to reshape the face of America."
$12.00 *(PB/191/Illus)*

Blood Crimes: The Pennsylvania Skinhead Murders
Fred Rosen
Two all-American boys slit their father's throat, stab their mother numerous times, and smash the skull of their 12-year-old brother with a baseball bat. The author ascribes their deeds to their adherence to Nazi credo—which is a rather facile interpretation—as even the Nazis never taught German children to murder their parents or brothers and sisters. As it turns out, one brother had an IQ of 100, and the other, 78. One had been hospitalized twice for mental illness . . . The parents were staunch Jehovah's Witnesses, the father an alcoholic, and the domineering mother obsessed with martyrdom. Now, add a little alcohol, teenage angst, violent skinhead music, and you have a prescription for multiple murder. **JB**
$5.99 *(PB/329/Illus)*

Book of Executions
James Bland
A voluminous collection of the skinny on the many ways man has legally done away with his fellow man over the years. Although entries like "Hanging" and "Electric Chair" cover little ground not already familiar to the average capital punishment buff, there are plenty of brief entries about bizarre, obscure and quite painful death penalties. Consider the deterrence value of sentences like "Eaten by crocodiles," "Sawn in half," and "Burned internally." Ouch! Plenty of inspiration awaits for both rabid law-and-order types and slasher-movie screenwriters. **JM**
$15.95 *(PB/436)*

Born Bad: The Story of Charles Starkweather—

Natural Born Killer
Jack Sargeant
In 1957, garbageman Starkweather, accompanied by his jailbait sweetheart Caril Ann Fugate, embarked upon a killing spree across Montana which shocked America. Modeling himself on James Dean, Starkweather took teen rebellion to its logical and bloody conclusion, killing first Caril's disapproving father and then a succession of others before being apprehended and later executed in the electric chair. **AK**
$13.95 *(PB/160/Illus)*

Breakdown: Deadly Technological Disasters
Neil Schlager
Explores the causes in the wake of notorious screw-ups: the Boston molasses spill (a five-story tank rupture killed 21 people), Tacoma's "Galloping Gertie" bridge collapse, the *Challenger*, Bhopal, Three Mile Island, the Ford Pinto, the MGM Grand fire, etc. "Reveals the reasons behind 35 astounding technical failures that made headlines and history. Each event is recalled in riveting detail, with full discussion of the causes, casualties, legal ramifications and corrective actions taken. Relive the horror and the lessons learned." **GR**
$15.95 *(PB/275/Illus)*

The execution of Lady Jane Grey — Book of Executions

Starkweather enters the State Penitentiary, May 24, 1958, minutes after being sentenced to death. — from **Born Bad**

The Butchers
Brian Lane

Eating people—is it wrong? "Dismemberment, dissolution, cannibalism . . . acid baths, flesh and bone fed to pigs . . . " These are some of the whacked-out wonders of the most gruesome crimes committed in the past 200 years. Details 35 cases of murderous mayhem from around the world (Petoit! Nilson! Kiss! Grossmann! Fish!) and the forensic pathology that helped capture these non-vegan killers. Ever wonder how they get those bodies into those trunks? **GR**

$22.95 *(PB/256/Illus)*

Cannibalism: From Sacrifice to Survival
Hans Askenasy, Ph.D.

"A comprehensive history of a subject that is a combination of extreme violence, horror and exotic customs. Discusses the many well-known incidents of cannibalism, including the Incas and Aztecs, Georg Haarman, the Donner Party, the Leningrad siege during World War II, the Andes airplane crash, the Colorado man-eater, and Jeffrey Dahmer, as well as the historical background of cannibalism, including natural and man-made famines, magic, religious rituals, sacrifice, werewolves, witches and vampires."

$25.95 *(HB/268/Illus)*

Chicago by Gaslight: A History of Chicago's Underworld, 1880-1920
Richard Lindberg

This extensively researched history of Chicago's early underworld serves as a Midwestern companion to Luc Sante's compelling *Low Life*. These, along with Herbert Asbury's legendary cult volume, *The Gangs of New York*—now back in print, will supply the reader with a veritable thieves' den of tasty, textured, late-Victorian depravity by way of peanut shells on the floor, beefsteaks, beer and blood. Includes 15 ghoulish pages concerning notorious murderer Herman Mudgett (a.k.a. H.H. Holmes), an informative complement to the scanty literature dealing with this fascinating maniac and his trap-door-filled "house of horror." **CS**

$14.00 *(PB/236/Illus)*

Chopper: From the Inside
Mark Brandon Read

"Anything I know of the toecutting business I owe to the criminal memoirs of Mark Brandon 'Chopper' Read. Mr. Read is a great deal scarier than Blackwell, and has even fewer ears," William Gibson writes, acknowledging the real-life model for a character in his novel, *Idoru*. Read's three autobiographies have all been best-sellers in his native Australia. The moment you read the opening sentence of this, his first, you know you're in the hands of a master. "I have been shot once, stabbed seven times, had a claw hammer stuck in my skull, been run over, beaten unconscious and left for dead." Read relates in can't-put-it-down style (and with considerable panache) the highs and lows of life as a toecutter—basically, an Australian term for a hit man who targets, robs and kills other hit men. There are some Down Under who doubt that Read actually did everything he claims to have done, whether with blowtorch, hatchet or razor, but it's obvious he hung out for a long time with all the wrong people; and there's no denying he has a flair for narrative, and for an unerring turn of phrase: "For him, it was too late. The spade was in his brain. Let's say, for me it was a bit of a character builder." Indeed! Read's book also contains considerable handy information, such as why the human foot sizzles when it cooks.

JW

$18.95 *(PB/212/Illus)*

Drawing by Charles Starkweather — from **Born Bad**

Chronicle of 20th Century Murder: Volume 1†
Chronicle of 20th Century Murder: Volume 2††
Brian Lane

Year-by-year reference covers every major murder case from 1900 to 1992. "The world has lost count of its psychopaths and psychotics, those madmen throughout history who have slaughtered with no discernible reason—no gain, no lust; cold, calculating killers. Killers like the fanatical Nazi sympathizer Joseph Franklin, who shot dead mixed-race couples; like Harvey Carnigan, who was acting as an 'instrument of God', killing to rid the world of sin and Herbert Mullin, whose 'voices' told him that only through bloodshed could he avert a cataclysmic earthquake which would destroy California."　　　　　　　　　**G R**
$5.99　　　　　　　　　*†(PB/265/Illus)*
$5.99　　　　　　　　*††(PB/262/Illus)*

Citizen X
Robert Cullen

The author presents a chilling portrait of the Soviet Union's most infamous sexmurderer, Andrei Chikatilo, whose *known* death count was numbered at 53 victims. Chikatilo's "calling card" was a vicious stab wound into the eyes of his helpless prey, usually young children.

Chikatilo's case is classic in a psychiatric sense. His victims were mainly youngsters, and he was a sexually repressed schoolteacher who was often ridiculed by his students, who referred to him as "Antenna" or "Goose." Chikatilo's case parallels that of John Wayne Gacy: both men imagined that they had suffered wrongs at the hands of youngsters whom they themselves victimized. Later these imagined wrongs became the catalysts for their crimes.　　　**J B**
$5.99　　　　　　　　　*(PB/290/Illus)*

Cold-Blooded: The Saga of Charles Schmid, the Notorious "Pied Piper of Tucson"
John Gilmore

From the author of *Severed* and *The Garbage People* comes the lurid and bizarre tale of Charles Schmid, the infamous "Pied Piper of Tucson," a real "lady killer" in more ways than one. Schmid was a charismatic psychopath who stuffed tin cans in his boots to make himself appear taller and smeared oil stains on his face to give the

appearance of a beauty mark, and the girls fell for him, one by one by one.　　**J B**
$12.95　　　　　　　　　*(PB/117/Illus)*

Confessions of Henry Lee Lucas
Mike Cox

"In the backwoods of Virginia, he was born to kill . . . Henry Lee Lucas was schooled in sexual deviance and cruelty by an abusive mother. He soon derived twisted pleasure from torturing farm animals, then savagely slaying them. At the age of 24, his lust for killing led him to take his first human life . . . his mother's. In and out of prison until he was 33, this quiet, polite, one-eyed drifter would keep on murdering, and leave in his wake a death toll so staggering that the actual number of victims may never be known. . . . Here is the true story of Henry Lee Lucas' confessions of murder, rape and mutilation—from the victims he chose by chance to his equally depraved partner, Ottis Toole, and his young niece, Becky, who found love and death in Lucas' arms. This startling book examines Lucas' cross-country spree that ended with his arrest in Texas and the gruesome legacy that began when his confessions led Texas Rangers to buried human remains. The investigation became even more bizarre when Lucas began confessing to crimes he didn't commit—and when a D.A. from Waco claimed that the diabolical killer was entirely innocent."
$4.95　　　　　　　　　*(PB/308/Illus)*

Cops, Crooks and Criminologists
Alan Axelrod and Charles Phillips

"Gates, Daryl: (1926-) chief of the Los Angeles Police Department from 1978 to 1991." Praised by the president as "an American hero and the nation's 'top cop', but condemned by others as a neo-fascist and racist He was field commander during the Watts riots of 1965 and was appalled by the department's failure to quell the mass violence . . . By late 1967, Gates had developed D Platoon, ostensibly an anti-sniper group consisting of an elite corps of highly disciplined officers using specialized weapons and tactics and ranked in the top 25 percent of the department for physical skills. Consisting of 220 men, including 60 crack marksmen formed into five-man teams, D Platoon, as Gates later observed, would 'revolutionize law enforce-

ment agencies all over the world.' To [Gates' predecessor Chief William] Parker, Gates proposed calling D Platoon a SWAT team-'Special Weapons Attack Team.' When Parker objected to the word 'attack', Gates, having developed an affection for the acronym he had invented, proposed 'Special Weapons And Tactics' instead. Parker agreed."

Charles Schmid, Jr. at the time he was arraigned for the murders of Gretchen and Wendy Fritz — from **Cold-Blooded**

Schmid, manacled, unearthing the skull of Alleen Rowe — from **Cold-Blooded**

Twenty-four years later, Gates resigned as chief of the Los Angeles Police Department. Ironically, he had failed to quell the Rodney King riots, a direct result of his "racism and violent-reaction" policies. **GR**
$45.00 *(HB/304/Illus)*

The "Counterfeit" Man: The True Story
Gerald W. McFarland
An outstanding look at one of postcolonial America's more bizarre murders. One evening in 1812, Russell Colvin vanished from Manchester, Vermont, following a violent argument with his wife's brothers, Jesse and Stephen Boorn. Tongues began to wag, the gossip flowed, and seven years later, the Boorns were convicted of murder. And then, just in the nick of time, Colvin reappeared. The Boorns' convictions were quickly overturned.

But wait—there's more! Forty years later, while trying to recruit a man for his counterfeiting ring, Jesse Boorn boasted about hiring an impostor to play Colvin. Unfortunately, Boorn's potential recruit was an undercover U.S. marshal. McFarland carefully reconstructs the crime, and while he plainly leans toward the impostor theory, he avoids going on a heavy revisionist trip. Superior historical true crime. **JM**
$13.95 *(PB/242/Illus)*

Crime: An Encyclopedia
Oliver Cyriak
There's no shortage of books pretending to be "crime encyclopedias" of one sort or another, and this one fits right into the middle of the pack. More accurate than some, less comprehensive than others, *Crime* is pretty much an average crime reference book. Given the low standards prevailing in the field, this isn't saying much. Somewhat sketchy with articles on individual criminals, it's better at covering general topics like "repeat killers" and "sex crimes." There are many more comprehensive (albeit more expensive) volumes. You have been warned. **JM**
$16.95 *(HB/468/Illus)*

Crime and Punishment in American History
Lawrence M. Friedman
Crime grows and mutates in an ongoing race with our country's ability to name it and tame it. "In a panoramic history of our criminal system from colonial times to today, one of our foremost legal thinkers shows how America fashioned a system of crime and punishment in its own image." How crimes change: "About three and a half centuries ago, there was a stir in the colony of New Haven, Connecticut. A sow had given birth to a 'monstrous' piglet. In the minds of the colonists, this was no accident . . . Specifically, it had to be a sign of sin, a sign of a revolting, deadly crime: carnal intercourse with the mother pig. . . . The finger of suspicion pointed to Thomas Hogg (unfortunate name) . . . The magistrates put him to the test: They took him to a pigsty, and forced him to scratch at two sows in the enclosure. One sow, the mother of the monster-piglet, reacted with a show of 'lust' when Hogg touched her . . . Hogg's guilt was crystal clear. " **GR**
$15.00 *(PB/592)*

A Criminal History of Mankind
Colin Wilson
Comprehensively xplains the changing pattern of crime though the ages up until the present—when the sex killer and mass murderer have become all that is worst in our "civilization."
$13.95 *(PB/702)*

Crime of the Century: Richard Speck and the Murder of Eight Nurses
Dennis L. Breo and William J. Martin
In this day of bloated crime books about inconsequential killings, it's refreshing to see a Big Book about a Big Crime, and even better to get one that's worth reading cover to cover. The subject is Richard Speck, whose killing of eight student nurses in his rampage through a Chicago dorm in 1966 was one of the most highly publicized cases of the decade. Breo and Martin effectively convey just why this case was so important, and fill in more than enough detail in what is the most definitive book available on a benchmark crime. **JM**
$5.99 *(PB/462/Illus)*

Cruelty and Civilization: The Roman Games
Roland Auguet
Imagine a daily diet of bone-crunching slaughter, provided for your amusement, and free to all. "In the Arena," "The Hunts of the Amphitheater," "Purveyors to the Carnage" and "The Reign of the Star" are chapters in the cruel story of ancient Roman entertainment. Colorful, exciting and violent shows that grew more exotic over the years—Elephants! Tigers! Alligators! Bears! A re-creation of the fall of Icarus!—but never lost their sadistic appeal. Stardom could come to anyone: "'I was no

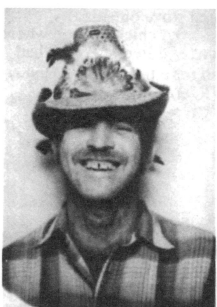
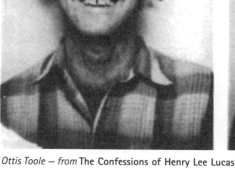

Ottis Toole – from **The Confessions of Henry Lee Lucas**

longer thin and disfigured,' says a young man of good family captured at sea and sold to a *lanista*, 'as I was when in the hands of the pirates; the good cheer that I found there was more intolerable to me than hunger; I was being fattened up like a sacrificial victim; and, scum among condemned slaves, I was a raw gladiator learning every day how to commit murder.'" **G R**

$16.95 *(PB/222/Illus)*

The Cult at the End of the World: The Incredible Story of Aum Doomsday Cult, From the Subways of Tokyo to the Nuclear Arsenals of Russia

David E. Kaplan and Andrew Marshall

"At the height of morning rush hour on March 20, 1995, the deadly nerve gas sarin poured into the Tokyo subway system, killing 12 people and injuring 6,000 more. This horrifying attack on the public was carried out by the Aum Supreme Truth cult, a high-tech billion-dollar empire of New Age zealots led by Shoko Asahara, a charismatic charlatan. . . . The cult recruited some of Japan's brightest students and scientists, indoctrinated them with a paranoid combination of Eastern beliefs and the Judeo-Christian idea of Armageddon, and manipulated them with designer drugs and mind control. Asahara sent cult members to Russia in the confusion following the fall of the Soviet Union in order to gain new converts among the Russian scientific community and to acquire nuclear weapons for the cult. Others were dispatched to Zaire to collect the deadly Ebola virus from the heart of the hot zone. All of these activities had one purpose: to realize Asahara's vision of the end of the world."

$25.00 *(HB/256)*

Curious Punishments of Bygone Days

Alice Morse Earle

On torture and torment inflicted by the church and the state, first published in 1896. Chapters include "The Ducking Stool," "The Stocks," "The Pillory," "Punishments of Authors and Books," "Military Punishments" and "Branding and Maiming."

$10.95 *(PB/176)*

Danse Macabre to the Hardcore Works

Kiyotaka Tsurisaki

A three-year photographic study of death in

Aum members with Asahara masks, campaigning to elect the guru and other cultists to the Japanese parliament in 1990. Their loss at the polls led to spiralling violence and the complete rejection of society. — from The Cult at the End of the World

South America, Southeast Asia and Russia. This book begins with a grim Russian death scene. The deceased woman has multiple wounds or burns on her face and black dried blood on her mouth—a candle, coffee cup and clock sit on an old, beat-up nightstand—very bleak. Other shots include: cracked heads, cemeteries, dead children, maggots, autopsy photos, gunshot victims, a severed arm holding a chrome strip from the car that severed it and more. All color photos on black paper. **D W**

$70.00 *(HB/125/Illus)*

The Death of Old Man Rice: A True Story of Criminal Justice in America

Martin L. Friedland

The death of Texas multimillionaire William Rice (founder of Rice University) in 1900 was the starting point for one of the strangest murder cases in U.S. history. Albert Patrick, a young lawyer, was quickly arrested for the crime. He had been running all over town cashing checks forged on Rice's account, and had almost undoubtedly forged the will bequeathing the bulk of the Rice estate to him. He was convicted

and sentenced to death after a lengthy, controversial trial.

But that was not the end. Over the years, the lingering doubts about the case grew. Patrick's sentence was first commuted to life imprisonment. And then, several years later, he received a full pardon. Friedland, a University of Toronto law professor, is primarily interested in examining the proceedings as a case study of American justice, so there's plenty of transcripts and analysis of the legal maneuvers. But for all the footnotes the writing isn't turgid, and Friedland holds off on his revisionist tack (he thinks Patrick was guilty of no worse than forgery) to the end. **J M**

$37.50 *(HB/423/Illus)*

Death Row: 1997

Hare Publications

"Roster of all 2,928 death-row inmates"— includes mug shots arranged high-school annual style of selected murderers, short descriptions of their crimes, arrests and possible methods of execution and a list of inmates executed since the last roster. Front section has detailed statistics on capital punishment in the U.S. and in-depth "profiles" of selected death-row inmates written

by local journalists from where the crimes were committed.
$19.95 *(PB/216/Illus)*

Death Row Women: The Shocking True Stories of America's Most Vicious Female Killers
Tom Kuncl

"A full moon, stealthy hunter's moon, stage-lit a weedy patch of nowhere in Lexington, Kentucky's gritty, workhorse east end that cool late April night 1986. The theater of death illuminated by its cherub face was the third such horror show Lexington lawmen had rushed to in as many hours. This one shrieked even more of lunacy than the others. Two people were horribly slain, a third was dying of wounds too cruel to believe. Two others had been killed at the earlier sites. All were victims of a furious, maniacal savagery beyond anything the veteran cops had ever seen. Raging, demented, unfathomable violence had visited their city under the full moon's guiding lamp. Quietly, reluctantly, the investigator had begun to say among themselves the word *lunatics*."
$5.99 *(PB/275)*

Death Scenes: A Scrapbook of Noir Los Angeles
Text by Katherine Dunn

"The purpose of this collection of homicide pictures is to show the work of the peace officer and his problems . . . after viewing this work it will undoubtedly bring about a better understanding between the law enforcement officer and the public which he serves." So wrote LAPD Homicide Detective Jack Huddleston in this scrapbook which he kept for over 30 years. In her excellent introduction Katherine Dunn considers at length some of the reasons Huddleston might have kept such a scrapbook, but ultimately his rationale remains a mystery. Readers, beware (forensic fans, celebrate)—the photos herein are as intense as any that as have ever been published and unlike the oddly lovely images in Luc Sante's *Evidence*, there's nothing remotely aesthetic about them. After a single viewing, some of the images will be seared into your brain for the rest of your life, and you'll wish they weren't. No other book is remotely like this one. If you want to confront death without walking in front of a bus, this

Overturned auto with body and head decapitated — from **Death Scenes**

is the next best thing to taking that mortuary job. **JW**
$17.95 *(PB/220/Illus)*

Depraved
Harold Schechter

Schechter, the esteemed author of the true-crime classics *Deviant* and *Depraved*, has done it once again with *Deranged*. Having created probing, insightful, meticulously researched biographies of seminal American serial killers Ed Gein and Albert Fish, Schechter has now turned his morbid attentions to the man who was arguably the first serial killer to captivate and horrify the imagination of the American public—Herman Mudgett, a.k.a. the dashing Dr. Harry Holmes. A master poseur, seducer, bigamist, forger, insurance defrauder, get-rich-quick schemer, con artist and deadly Bluebeard, Mudgett committed a string of cold-blooded murders for profit in the early 1890s of such staggering ingenuity and complexity as to earn him the tabloid sobriquet of "villainous arch-fiend." Embodying the boundless energy of the Gilded Age, Mudgett set to his grisly enterprises with the calculated drive and cunning of a J.P. Morgan, an Andrew Carnegie and a John D. Rockefeller, all rolled into one. An eerie precursor to the Vincent Price character in *House of Wax*, Mudgett's homicidal and entrepreneurial excesses even drove him to build his own "murder palace"—a three story Victorian monstrosity on the outskirts of Chicago which featured such ghoulish amenities as a gas chamber, soundproofed rooms, secret stairways and body chutes which lead directly to the hidden dissection/rendering/crematoria facility in the basement! It doesn't get any weirder or

more compelling than this and thanks to Schechter, it doesn't come any better researched or written either. **AD**
$6.99 *(PB/418/Illus)*

Deranged
Harold Schechter

"In May 1928, a kindly old man came to the door of the Budd family home in New York City. A few days later, he persuaded Mr. and Mrs. Budd to let him take their adorable little girl, Grace, on an outing. Albert Fish appeared to be a harmless, white-haired grandfather. The Budds never guessed that they had entrusted their child to a monster. . . . The truth behind Grace's murder was so revolting, so shocking, that it changed American society forever. What Albert Fish did to Grace Budd, and perhaps 15 other young children, went beyond every parent's worst nightmare. And he did it in a way that caused experts to pronounce him the most deranged human being they had ever seen."

"A few years ago, I wrote a book called *Deviant* about the Wisconsin ghoul Edward Gein, who served as the model for *Psycho*'s Norman Bates. While researching the book, I wrote to Robert Bloch, author of the novel upon which Hitchcock's classic terror film was based, to ask, among other things, why he thought so many people continued to be fascinated by Gein. Bloch replied, "Because they are ignorant of the activities of . . . Albert Fish."—Harold Schechter
$5.50 *(PB/306/Illus)*

Deviant: The Shocking True Story of the Original "Psycho"
Harold Schechter

For all the ink that's been spilled over

Wisconsin's favorite murderer/necrophile, there's been a surprising paucity of books on the guy. Until *Deviant*, the only one was an obscure small-press volume written by the judge at his 1968 trial. Kind of surprising for the murderer who inspired Hitchcock's *Psycho* (and who makes Norman Bates look positively well adjusted by comparison). But any other book is now superfluous; *Deviant* is the definitive book on Gein. Schechter covers all the bizarre twists and turns in ol' Ed's story—the grave robbing, the bizarre corpse "experiments" and ultimately the murders, with a thoroughness that is unlikely ever to be surpassed. **JM**
$4.95 *(PB/274/Illus)*

Do or Die: For the First Time, Members of America's Most Notorious Gangs — the Crips and the Bloods — Speak for Themselves
Léon Bing
"The inside account of street gangs and their brutal world . . . Bing lets the L.A. gang members discuss their lives, loves and battles."
$12.00 *(PB/277)*

The Dillinger Dossier
Jay Robert Nash
Did John Dillinger orchestrate his own per-

manent retirement as Public Enemy Number One? Nash presents compelling evidence that it was not John H. Dillinger who was gunned down in front of the Biograph Theater on July 22, 1934, by Hoover's G-men, but a small-time hood named Jimmy Lawrence. Why did the corpse have brown eyes, if Dillinger's were blue? Why did the coroner's autopsy report go missing for over 30 years? And why was the body laid to rest under 2,500 pounds of impenetrable concrete? Nash assembles documents, morgue shots, handwriting, first-hand interviews, and purported photographs of Dillinger in old age, all of which indicate strongly that Dillinger not only faked his own death, but was alive and well as late as 1979, and living in Hollywood, California. **HJ**
$19.95 *(PB/250/Illus)*

The Dracula Killer: The True Story of California's Vampire Killer
Lieutenant Ray Biondi and Walt Hecox
"A serial killer with a taste for blood as told by homicide detective Lieutenant Ray Biondi . . . here is the actual story of the all-out effort to stop murderer Richard Chase—a psychotic killer so depraved, he drank his victims' blood."
$10.95 *(PB/256/Illus)*

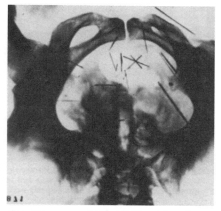

One of the x-rays of Albert Fish's pelvic region which revealed a total of 29 needles shoved up inside his body — from **Deranged**

Ed Gein: Psycho!
Paul Woods
"America may have had its fill of psychos for the last 40 years, but none of them has inspired so many books and films (*Psycho*, *The Silence of the Lambs*, *The Texas Chainsaw Massacre*) as Wisconsin's cannibalistic handyman, Ed Gein. None of them has been used as the ultimate ogre in countless children's stories and off-color jokes, and none of them has been found guilty of as many unspeakable atrocities as Ed Gein. This is his story. This is his legend."
$9.95 *(PB/165/Illus)*

The Encyclopedia of Serial Killers
Brian Lane and Wilfred Gregg
"A comprehensive, A–Z guide to the world's most horrifying criminal personalities. Includes two indexes for identifying hundreds of killers throughout history, making this a complete and timely reference."
$6.99 *(PB/408/Illus)*

Eros, Magic and the Murder of Professor Culianu
Ted Anton
This highly unusual true-crime book looks at the still-unsolved shooting of University of Chicago Divinity School professor Ioan Culianu in a campus men's room in 1991. Maybe it wasn't the biggest killing of the year, but author Anton digs up more than enough muck and delves into areas sufficiently far afield from your normal cops-and-killers stuff to make this well worth a

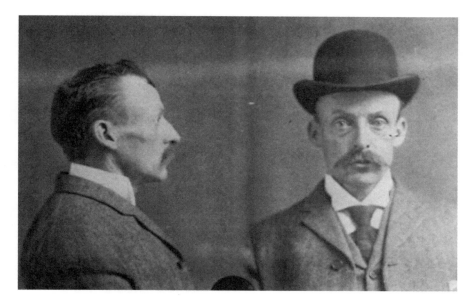

Mug shot of Albert Fish taken in 1903 after his arrest for grand larceny. Fish was 33 at the time. — from **Deranged**

look-see. Culianu was an acclaimed professor of comparative religion doing cutting-edge work in areas as diverse as Renaissance magic, gnosticism and after-death experience. And just to show he wasn't all work and no play, he harbored a secret ambition to put all those Ph.D.s (he had three!) to work writing some science fiction. But he also was a Romanian exile with an unfortunate penchant for fingering the spades in Romania's post-Ceauscescu government. Anton builds a strong case for Culianu's killing as the first political assassination of a professor in the United States. And along the way, he paints a fascinating portrait of Culianu's life and work spiced with plenty of Romanian political weirdness. **JM**

$24.95 *(HB/292)*

Evidence
Luc Sante

"Photography, like murder, interrupts life," says the author, who also wrote *Low Life*. "The pictures would not leave me alone." Presents an amazing documentation of NYPD crime photography between 1914 and 1918. Saved only by accident, it's the "true record of the texture and grain of a lost New York, laid bare by the circumstance of murder." Most taken with a wide-angle lens, and many taken from high above a sprawled corpse, the photos compare to a nightmare journey through a surrealistic city, always lonely, always night, and always death in every room. "Time in its passing casts off particles of itself in the form of images, documents, relics, junk." Some can be forgotten, some cannot. **GR**

$20.00 *(PB/99/Illus)*

Execution:
Tools and Techniques
Bart Rommel

Not quite the how-to manual the title would suggest, but chock-full of fun facts and conversation starters like: Did you know prison guards commonly force those who are to die by electrocution to wear special diapers or even tie their penises with rubber hose to contain urine involuntarily released? Or that the first guillotine was built by a German harpsichord maker? Or that guards during the Inquisition took special delight in raping women during execution by the "*peine forte et dure*" ("pain both long and hard") because of the extreme vaginal tension produced by the piling of rocks upon a victim's torso? And so forth.

Obligatory lamentation over the squeamishness of juries and "bleeding hearts" who pooh-pooh the direct correlation between capital punishment and deterrence. Rommel concludes that "executions will never go out of style" and sees hope for the future in new technologies, such as his own brainchild: a "zapper box" for microwaving the head of the condemned. **RA**

$12.95 *(PB/119)*

The Family Jams

"In 1970 some close friends of Charles Manson recorded his collection of lost 'desert music' songs as a statement of friendship and faith during his highly unconstitutional trial. This is the definitive release of the classic acid-folk-rock session of Manson compositions—featuring Clem on vocals and guitar, ultra-ethereal female backing vocals by Brenda (Gold), Country Sue and others, and Gypsy on violin. The second CD contains an hour of never-before-heard songs and radical alternate versions. The 20-page booklet contains psychedelic embroidery from the legendary missing vests of Manson and Beausoleil, unpublished photos and vast liner notes written by Manson, Lynette Fromme (Red) and Sandra Good (Blue)."

$24.95 *(2xCD)*

Fist Stick Knife Gun:
A Personal History of
Violence in America
Geoffrey Canada

Brought up on the streets of the South

*Photograph — from **Danse Macabre***

Bronx, where learning to fight was simply a matter of survival, Geoffrey Canada knows about street violence firsthand. When crack and handguns flooded the inner cities in the '80s, violence spiraled out of control, becoming a deadly epidemic. Determined to provide some hope for the future, Canada has returned to the ghetto as a Harvard-educated adult to teach children's strategies for survival:

Hit the ground—sound advice when someone is pointing a gun in your direction but you are not the primary target. Not a bad test question for use in our urban schools:When someone points a gun in your direction but doesn't want to shoot you in particular, you should
a) run into the nearest building.
b) yell and scream and run away.
c) stand still.
d) hit the ground
Each week, another innocent child is shot while amateur gunmen blast away at targets real and imagined. It's a sad state of affairs in this country when as they enter kindergarten our children need to be taught not only the ABCs but more importantly what to do when they hear shots or see people pointing guns. **NN**

$20.00 *(HB/224)*

The Fortean Times Book
of Strange Deaths
Compiled by Steve Moore

True, completely documented listings of outrageous, horrendous, truly twisted, tragic yet rip-roaringly funny deaths. Hardy har, death is a riot, eh wot? Chiefly compiled from the archives of *Fortean Times* magazine. You may as well get a couple examples just for kicks:

• A shy Japanese couple wait 14 years before consummating their desires for the first time. They both have heart attacks during the act. Whoever said "a little coitus never hoitus" is a goddamn liar!
• A British bricklayer died laughing while watching a "fight between a set of bagpipes and a black pudding" on the TV show *The Goodies*.

You ain't read nothing yet. The reader also gets death in manure pits, avalanches of books, factory robots gone berserk, sickening sex mutilations, deaths by stupidity, death by swallowing a miniature deck of cards, suicide following a pet chicken's death, voices prompting atrocious mass crimes ("The Martians made me do it"),

Malaysian lucky-lottery sacrificial beheadings, death by overeating (72 snails), animal kingdom revenge sagas, funeral tragedies resulting in multiple burials . . . and on and on. If you can think of it, the Grim Reaper has done it—and beyond. This book is a morbid variation on "News of the Weird"-type reading. Yet—this sort of info also hints at the myriad variations on any theme—even the darkest—in this delicious world we live . . . and die in. **CS**
$10.95 *(PB/136)*

Fred and Rose
Howard Sounes
Fred and Rose West were your almost-typical English couple: quiet, attractive to each other if no one else, happy as clams and fond of killing hapless young women—including Fred's stepdaughter, his first wife and the nanny—and then burying them in the cellar, the back garden, underneath the bathroom floor and in handy fields nearby. For over 20 years the Wests stayed busy, committing at least nine murders together, often sexually torturing the victims before dismembering and decapitating them. Sounes, who broke the case in the British press and gained exclusive interviews with the living participants, writes clearly if without inspiration; but the story of the Wests is remarkable enough to hold a reader's interest even if Sounes had seemingly grown a little bored with it by the time he

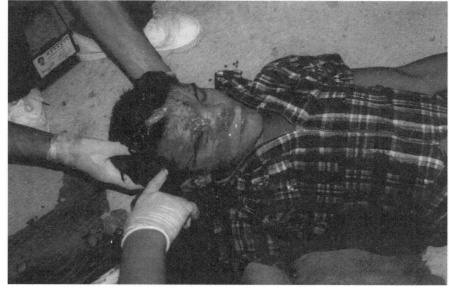

Photograph — from **Danse Macabre**

wrote the book. **JW**
$8.99 *(PB/362/Illus)*

From Alcatraz to Marion to Florence: Control-Unit Prisons in the United States
Fay Dowker and Glenn Good
A short history and critique of control-unit prisons. **AK**
$3.50 *(Pamp/48)*

The Future Lasts Forever: A Memoir
Louis Althusser
Part absolution and part apology, this, the first volume of a posthumously published autobiography, begins on the morning of November 16, 1980 with the tragic death of the author's wife at his hands. As the influence of academe was brought to bear upon the local authorities, the French proto-Marxist was deigned unfit to plead on his own behalf and sent straight to the sanitarium without arrest or trial—a merciful outcome for anyone other than an intellectual, that is, one in the business of "speaking his mind." Returning several years later to the scene of the crime, Althusser attempts to reconstruct the defense he was denied, and to supply some crucial answers to a resentful public and even to himself. "I intend to stick closely to the facts," says he, ". . . but hallucinations are also facts."

Tracing his troubles back to earliest childhood, to his name in fact—Louis was his mother's beloved first husband, killed in the war—Althusser describes his haunted experience with dispassionate candor. In the process we come to know the boy continually plagued by his own absence and inauthenticity—a self virtually destined from the start to disappear. Taking refuge in his studies and subsequent academic career, Althusser distinguished himself as a scholar and the foremost authority on Marxist analysis which he revised for the hippie generation through his influential concept of the "state apparatus." Yet periods of concentrated production and lucidity inevitably gave way to paralyzing depression: the eminent philosopher gracing the halls of higher learning one day, and the loony bin the next. Shuttled from one institution to another, Althusser remained a shut-in for the greatest part of his life, first at home with his domineering mother, then as a POW during World War II, and finally within the ivory towers of academia. His political imagination flourished within these closed quarters, as did the various maladies which finally overwhelmed his reason.

A latter-day Oedipus wandering through the wreckage of his life, Althusser seeks through writing to probe the central blindspot, to suspend the self at the point where it vanishes, or fractures into separate compartments, be they Marxist, misogynist or just mad. The revelations which follow are a little hard to swallow perhaps, but it is entirely to his credit that he doesn't try anything "easier." Just as tenuous and volatile as the lines which connect radical theory to revolutionary practice are those that bind the subject to the object of love. Retaining no memory of the fatal act itself, nor even a prompting desire, Althusser argues that killing his wife amounted in effect to a kind of suicide; that by destroying "the other" through whom he gained his meager identity, he himself would cease to be. It is a scenario worthy of Robbe-Grillet: The detective discovers not only that he is the perpetrator but simultaneously the victim of his crime. **JT**
$14.95 *(PB/364)*

The Gangs of New York
Herbert Asbury
Asbury's informal chronicle of gang life in New York before the first World War is an eye-opener for anyone operating under the

delusion that "those were the good old days." Conditions in neighborhoods like Hell's Kitchen and the Five Points put modern slums to shame. And they had gangs to match. Huge mobs of members of such hard-nosed organizations as the Dead Rabbits, the Plug Uglies and the Bowery Boys would stage pitched battles lasting for days. And when they decided to riot, the result was the Draft Riots, which were like all the riots of 1967 rolled into one week in 1863 Manhattan, only worse. There was even a police riot, when rival gangs of cops duked it out in front of City Hall. A wild book about wild times. **JM**
$12.95 *(PB/400/Illus)*

The Garbage People: The Trip to Helter Skelter and Beyond With Charlie Manson and the Family
John Gilmore and Ron Kenner
Random murder and savage overkill, mind control and bad trips, Satanism and witchcraft, cursed glamour, Haight-Ashbury, rock'n'roll, biker gangs, sexual rebellion and dune buggies tearing across Death Valley in search of the "hole in the Earth" . . .
The Garbage People is a gripping account of one of the most chilling and fascinating crime sagas of our time, now in a revised and updated edition containing 32 pages of never-before-seen photos. New vectors into the kaleidoscopic tale which spins inexorably out of the slayings emerge with new material on killer Bobby Beausoleil and his some-time occult alliance with experimental filmmaker Kenneth Anger. The new photo section includes previously unpublished and very graphic crime-scene photos and postmortem documentation which depict the aftermath of the Manson Family's frenzied brutality, as well as images of life in the Family from before the murders to the present, important locations and personalities and the radiant beauty of slain actress Sharon Tate.
$14.95 *(PB/178/Illus)*

Gunfighters, Highwaymen and Vigilantes: Violence on the Frontier
Roger D. McGrath
Barbecues our Western heritage over the mesquite pit of mythology. "Suggests that violence in modern America is rooted less in the conquest of the frontier than in the for-

Humpty Jackson — from **Gangs of New York**

mation of the modern city . . . research produces evidence of a powerful set of shared values that rigorously limited violence to consenting adults." It wasn't the West that was wild, it was us. Two frontier mining towns—Bodie and Aurora, California—are exhaustively researched, and the surprising and keen-eyed result "yields valuable insights into lives of the men and women who lived—and died—in them." Chapters include: "The Esmerelda Excitement," "Robbery, Rowdyism and Combat," "In Illegal Pursuit of Wealth," "Violence and the Minorities," and "No Goodee Cow Man." Lots of violence—funny, sad, dirty and stupid.
GR
$12.95 *(PB/333/Illus)*

Hanging Judge
Fred Harvey Harrington
"Isaac C. Parker, the stern U.S. judge for the Indian Territory from 1875 to 1896, brought law and order to a lawless frontier region. He held court in the border city of Fort Smith, Arkansas, but his jurisdiction extended over the Indian tribal lands to the West. Pressing juries for convictions, Parker sent 79 convicted criminals to the gallows—as many as six at a time. It is said that Parker on occasion aided the prosecution, coached government witnesses and intimidated those for the defense, stretched the law and influenced the jury. It's nice to know that some things haven't changed. This new edition includes a foreword by Larry D. Ball, who situates Parker's court within the context of unrest and rising crime in the Indian Territory. The book is both a scholarly treatment and a fun read, full of frontier wit and even some gallows

humor."
$12.95 *(PB/224/Illus)*

The Hanging Tree: Execution and the English People, 1770-1868
V.A.C. Gatrell
It's pretty well known that Britain basically went noose-crazy in the later 18th and early 19th centuries, hanging people for the most trivial offenses before appreciative crowds. There's plenty of stuff (mainly from capital-punishment abolitionists) on the period, but *The Hanging Tree* is the first social history of the institution to look at what your average Englishman thought of the whole thing. Gatrell carefully examines the entire milieu, paying special attention to the attitudes of the mob towards these exhibitions they attended so enthusiastically. Gatrell also digs out some interesting material from the condemned's appeals for mercy on the social conditions of the average Englishman—and it wasn't as prim and proper as you might think. **JM**
$39.95 *(HB/634/Illus)*

Hit Men
Edited by Rose G. Mandelsberg
Twenty-five killers-for-hire from the files of *True Detective* magazine. "Life is cheap! Driven by greed and revenge, passion and profit, they act as judge, jury and executioner, risking all to stab, slash, torch and shoot

Manson in court — from **The Garbage People**

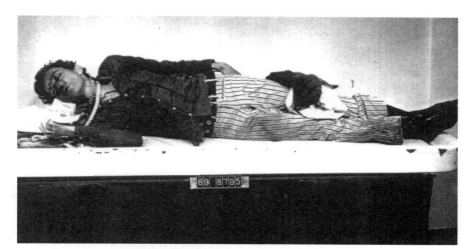

Jay Sebring at morgue — from **The Garbage People**

down their victims in cold blood. Some do it for love. They all do it for money! . . . Read about: Oregon's Jon Patrick Thompson, the trigger-happy stud who killed to satisfy his vengeful she-devil lover; Texas drug dealer Andrew Cantu, who savagely stabbed three senior citizens to death for quick cash; Geraldine Parrish, Baltimore's greedy queen of crime (how did John Waters miss this one?) who schooled her bloodthirsty brood in the art and profit of murder! From career killers to professional assassins and disturbed sociopaths. . ." they're all here. **GR $4.99** *(PB/432)*

Holy Killers: True Stories of Murderous Clerics, Priests and Religious Leaders
Brian McConnell
Nine commandments are all they can remember. "Delves into the archives to tell the extraordinary and gripping stories of over 20 clerics, priests and cult leaders who resorted to murder to resolve their personal or collective obsessions. Father Matthew Peiris, Anglican faith-healer from Letchworth, untruthfully diagnosed diabetes in his wife and his lover's husband and gave them both fatal doses of insulin. Rev. George Dyson, Methodist minister from Westminster, gave comfort to a lovelorn grocer's wife and liquid chloroform to put in her husband's final brandy nightcap." And Anglican Michael Taylor, who killed "the devil" in his wife: "With his bare hands, he tore her eyes out. He tore her tongue out. He tore her face almost from the bones and

she died choking on her own blood." **GR $9.95** *(PB/378/Illus)*

Homicidal Insanity, 1800-1985
Janet Colaizzi
A somewhat dry history of medical and legal thinking about homicidal maniacs, examining such topics as "The Alienist as Medico-Legal Expert" and "From Static to Dynamic Neurophysiology." The actual murder cases are described only sketchily to provide enough of a hook on which to hang each era's theories. So, instead of bestiary of lunatics, we run the gamut of 185 years of medico-legal psychobabble. Of interest only to the most hardcore student of homicidal mania. **JM $23.95** *(PB/182/Illus)*

Hot Blood: The Millionairess, the Money and the Horse Murders
Ken Englade
The 1977 disappearance of Helen Brach, the widow of multimillionaire candy maker Frank Brach, is one of the most fascinating crimes of the last 20 years. Her fate remained a mystery until a few years ago when her death was linked to her unwitting involvement with an elaborate scam involving the killing of heavily insured show horses. Apparently, Brach got wind of what was really going on and was rewarded with a professional hit when she threatened to go to the police.

Unfortunately, Englade proves that for

every interesting crime, there's a mediocre crime book. *Hot Blood* is pedestrian enough to try the patience of all but the most devoted Brach fans, with its pages and pages of bad trial coverage and the novelistic, sycophantic stuff all too common in the crime genre these days. Yawn. **JM $23.95** *(HB/309/Illus)*

Human Monsters: An Illustrated Encyclopedia of the World's Most Vicious Murderers
David Everitt
One hundred crazed executioners, presented chronologically in time, starting with 15th-century Scottish cannibal killer Sawney Beane, and ending up with the Russian "mad beast" Andrei Chikatilo. All the favorites are here: de Rais, the Ripper, Panzram, Fish, Gein, DeSalvo, Manson, Zodiac, Bundy, Gacy and Dahmer. Plus dozens of others, not so notorious but equally monstrous. **GR $14.95** *(PB/272/Illus)*

Humans Eating Humans: The Dark Shadow of Cannibalism
Richard L. Sartore
"Contrary to common belief, cannibalism is a very complex cultural practice. Reducing it to simplistic terms robs it of its cultural content. A number of practices are involved including the acting out of myths, metaphors, physical

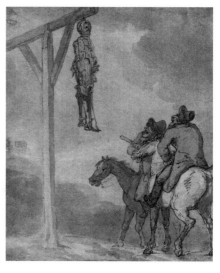

Thomas Rowlandson, A Gibbet (1790s?) — from **The Hanging Tree**

development, sexuality revenge, nourishment, religion, mourning and overall lifestyle." Chapters include "Societies That Allegedly Ate Human Flesh," "Rationale for Consuming Humans," "Mythological Links to Flesh Eating," "Mortuary Cannibalism," "Cannibalism and Children's Literature" and "Modern-Day Cannibalism."

$16.95 *(PB/139/Illus)*

Hunting Humans: An Encyclopedia of Modern Serial Killers

Michael Newton

Compendium of 20th-century serial killers, from Atlanta to Zodiac. "We are caught up in the midst of what one expert calls an 'epidemic of homicidal mania,' victimized by a new breed of 'recreational killers' who slaughter their victims at random, for the sheer sport of killing." Statistics: 13 victims each day are dispatched by motiveless murderers throughout in the world. The United States boasts 74 percent of the world's total serial killers. They are grouped in three general categories: territorial (the Night Stalker, the Hillside Stranglers), who stake out a town or county; nomads (Ted Bundy and Henry Lee Lucas), who travel in stalk of their prey; and stationary (Ed Gein, John Gacy, Jeffrey Dahmer), who attend to their killing from one central location. Brief case histories, some photos. **GR**

$34.95 *(HB/353/Illus)*

Hypnosis, Memory and Behavior in Criminal Investigation

Kevin M. McConkey and Peter W. Sheehan

"A comprehensive overview of the use of hypnosis in the forensic setting, enriched by clinical case material. Illuminating the full complexity of the ethical, legal and professional issues involved, the book offers detailed guidelines to help clinicians cope with the demands of criminal and legal investigations and to ensure the welfare and well-being of subjects. Among the many issues addressed are recovered memories, faking and the rights of subjects."

$35.00 *(HB/239)*

In Broad Daylight: A Murder in Skidmore, Missouri

Harry N. MacLean

"Ken McElroy terrorized Skidmore, Missouri, for years—robbing, raping, shooting and

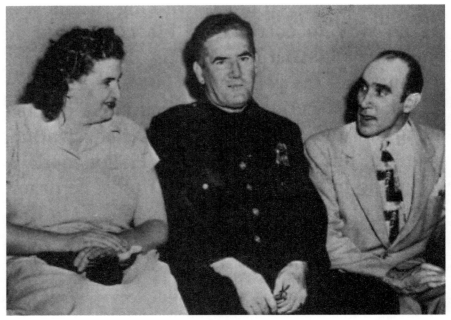

The "Lonely Hearts Killers" exchange a loving glance over their guard. — from **Human Monsters**

maiming the citizens into submission until they had finally had enough. While 45 townspeople looked on, McElroy was shot and killed . . . but the police could find no witnesses."

$4.95 *(PB/390)*

Industrial Inferno: The Story of the Thai Toy Factory Fire

Peter Symonds

"The worst industrial fire in history broke out on May 10, 1993, at the Kader Industrial Toy Company, just outside of Bangkok. Hundreds of workers, mainly young women, were trapped inside a building with no fire extinguishers or alarms and no fire escapes. More concerned with profits than human life, management blocked off the exits. Officially 188 workers died. Others are still listed as 'missing.' The fire was all but ignored by the world's media. The ugly truth behind Asia's much-vaunted 'economic miracle' proved too unpalatable. . . . The Kader workers slaved for less than $1 an hour to make toys for corporate giants such as Toys 'R' Us, Hasbro and Tyco . . . [P]rovides a unique insight into the global economic processes that are drawing millions of rural toilers in Asia, Latin America and Africa into the factories and shantytowns of cities like Bangkok."

$21.95 *(PB/79/Illus)*

Inside the Cult

Marc Breault and Martin King

An above-average quickie paperback purporting to give the insider's scoop on David Koresh and the Branch Davidians. Breault joined the Davidians in '86, King interviewed Koresh just before the going got good. Of course, there's plenty of dirt here and loads of background material. Make no mistake, Koresh was one strange dude who combined an ability to make people believe the stupidest things with an inability to keep his pants zipped. His "legal" wife was 14 when they got married. He was, in short, the perfect cult leader. (Ever notice how these groups are always set up so the top dog gets all the girls?) There's plenty of weirdness here, and thankfully, no BATF/FBI/conspiracy stuff—in fact, the whole raid/holocaust thing gets short shrift in favor of pre-raid cult antics. But the field is still wide open for the definitive book. **JM**

$4.99 *(PB/375/Illus)*

Iron House: Stories From the Yard

Jerome Washington

Hard-edged series of vignettes about life behind bars penned by one who has been

there. "'Hard-Luck Henry' was busted on Friday the 13th by an off-duty cop. 'Bitedown' bit his lover's cock off. 'Boxhead Mike''s name speaks for itself. 'Wizard' can make wine out of Kool Aid." "Ain't nothing cryptic or subtle about this place. Everything is up front. Direct. To the point and for real." **GR**
$18.95 *(HB/160)*

The Jack the Ripper A to Z

Paul Begg, Martin Fido and Keith Skinner
Solve the crime of the century in your spare time! "Compiled in encyclopedic form by three of the world's leading experts on the subject," this revised edition brings together "all that is known on the subject . . . and provides a compelling insight into the enigma which still exerts such a fascination more than a century later." Fresh info on: Dr. Tumblety, the subject of the "little child letter," which discloses that "the head of Special Branch's preferred suspect was arrested but escaped to the United States. The theory of Joseph Barnett, the lover of the last victim, who closely matches the FBI's psychological profile of the Ripper." And "the sensational ongoing story of the alleged diary confession of James Maybrick." Hoaxes and bogus information are debunked; autopsy reports are supplied; newspaper accounts are furnished; people involved are profiled; theories and clues abound. **GR**
$15.95 *(PB/560/Illus)*

The Keepers of Heaven's Gate: The Millennial Madness — The Religion Behind the Rancho Santa Fe Suicides

William Henry
"This book presents the timeline of escalating events that led to the suicides in Rancho Santa Fe, California. The timeline begins in November 1996, with the first radio talk-show and news reports about a space ship hiding behind the comet Hale-Bopp. The author presents the facts behind this new millennial 'end of the world' thinking. Through painstaking research conducted throughout the '90s, the author presents a thorough understanding of these new millenial groups. . . . This book brings to light the truth behind the religion which led to the Rancho Santa Fe suicides."
$12.95 *(PB/152)*

Carl Panzram — from **Human Monsters**

Kids Who Kill

Charles Patrick Ewing
"There is a new breed of killers loose in America today—and its numbers are growing at an astounding rate. They are responsible for over 10 percent of the nation's homicides. . . . Startling true accounts of America's youngest murderers . . . and the psychology, causes and motives behind their unspeakable acts:
• Brenda Spencer, 17 years old, opened fire on a crowded elementary schoolyard with a semiautomatic rifle because, 'I hate Mondays.'
• Timothy Dwaine Brown, 16 years old, beat his brother to death before killing his grandparents in cold blood.
• Molested repeatedly by her father, 16-year-old Cheryl Pierson hired a classmate to execute him.
• Two Missouri brothers, ages four and six, attacked and brutally murdered a baby girl because 'she was ugly.'"
$5.99 *(PB/230)*

Kill the Dutchman! The Story of Dutch Schultz

Paul Sann
"On October 23, 1935 a rusty, steel-jacketed .45 slug tore through the body of Dutch Schultz. The Beer Baron of the Bronx and king of Harlem's numbers racket had finally gone too far." Schultz had defied the underworld's "Big Six" by vowing to gun down Special Prosecutor Thomas Dewey, an act

that would have brought enormous heat down on the New York mob. Chronicles his rapid rise, fueled by Prohibition, his "Gotham bloodbath" war with rival Mad Dog Vincent Coll, and the details of his famous restaurant rub-out. Schultz, born Arthur Flegenheimer, age 33, got hit relieving himself at a urinal in the Palace Chop House, in Newark, New Jersey. He then walked out, clutching his side, and collapsed at a nearby table, where the famous "death photo" was taken. He actually died later in a hospital of peritonitis. His "deathbed swan song," recorded by the police is a wiseguy's ode to motherhood, America, the devil, paranoia, guilt, friends and promises, peppered with food slang of the times (dog biscuits [money], onions [girls], and pretzels [Germans]). Written by an editor of the *New York Post*, on staff in the '30s. **GR**
$13.95 *(PB/337/Illus)*

Killer Fiction: The Sordid Confessional Stories That Convicted Serial Killer G.J. Schaefer

G.J. Schaefer
"A texbook case of the classic serial killer gives clues to his personality in this chilling selection of writings, which are from before and during his prison term. Includes stories,

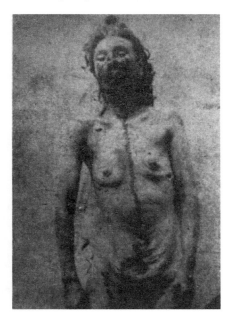
Mortuary photograph of Catherine Eddowes, the fourth canonical victim — from **The Jack the Ripper A-Z**

fantasies, 'plans' and poetry . . . clearly reveals both Schaefer's own pathology and that of various prison inmates with whom he was on intimate terms."

$14.95 *(PB/192/Illus)*

Killer Teens
Edited by Rose G. Mandelsberg

"A shocking collection of the most savage cases of youthful violence ever reported. Obsessed by twisted desires and perversions, these teenage sociopaths are consumed by only one thing: the thrill of the kill! Read horrifying accounts of Phillip Negrete, the Des Moines, Iowa, high school gangleader who crushed a stranger's skull with a hammer for 50 cents and a six pack of beer; Georgia's Billy Shane, who proved his love for his 13-year-old bride-to-be by setting fire to his own father; Yong Ho Han, who fatally stabbed his Long Island classmate with a kitchen knife which he later imbedded in the scalp of a 12-year-old girl because he wasn't shown proper respect; and other heinous crimes committed by a grisly new brotherhood in blood."

$4.99 *(PB/448)*

The Killers Among Us: Motives Behind Their Madness
Colin Wilson

An exercise in psychological analysis of many of our century's most infamous murderers. The authors examine the cases of Ian Brady and Myra Hindley, the "Moors Murderers," as well as these others: Donald "Pee Wee" Gaskins—who one day realized he could have sex with anyone—so long as he killed them afterward; Aileen Wournos—who claimed that all of her killings were made in self-defense; six-foot-nine-inch Ed Kemper, who wanted to have sex with headless bodies. **JB**

$6.50 *(PB/390/Illus)*

Killing for Company
Brian Masters

Dennis Nilsen was England's answer to Jeffrey Dahmer. He preyed on young men he picked up in the gay bars of London. In his apartment, he'd strangle them and keep the bodies around the flat for a few days for further use before ultimately dismembering and disposing of them. He'd killed 15 men before an alert plumber noticed that the obstruction clogging the sewer line serving Nilsen's apartment building was a little too

human. Now, even a crummy paperback would be welcome on a crime of this magnitude, but *Killing for Company* transcends the true-crime genre. Masters has written more of an in-depth biography, attempting to answer the whys as much as the whats by drawing heavily on interviews and Nilsen's writings. It's easily one of the most insightful looks into the mind of a murderer in the past 30 years. **JM**

$4.99 *(PB/336/Illus)*

Killing Time: The First Full Investigation Into the Unsolved Murders of Nicole Brown Simpson and Ronald Goldman
Donald Freed and Raymond P. Briggs, Ph.D.

If you think you have heard and read all there is to read about the O.J. Simpson trial, think again. This thought-provoking book presents such questions as: Who left the evidence found in Nicole's garage? What happened to the prosecution's initial double-assassin theory? Who was Nicole's other gentleman caller that night? Why was the constellation of violence and murders around Ronald Goldman not explored? Could Ron have been the target? Or Faye Resnick? Or O.J. himself? **JB**

$24.95 *(HB/307)*

Knockin' on Joe:

Voices From Death Row
Sondra London

"The mercurial Sondra London has collected stark tales of crime and punishment, guilt and innocence, violence and pain, straight from America's death rows and maximum-security prisons. Told in their own distinct voices, the stories of the men themselves ring loud and, sometimes appallingly, clear. Among the many with stories to tell are:

• Bobby Fieldmore Lewis—the only man ever to escape from Florida's death row, he writes with disarming candor about his life of crime, his time on the row, and the time he spent with the hated Ted Bundy

• Ottis Toole—deranged partner of Henry Lee Lucas, who tells of his gothic nightmare childhood

• Carl Panzram—the noble psychopath, and original 'killer author,' writing here of his incredible worldwide murder spree

• Wayne Henderson—a free spirit trapped within the California Corrections system, writing of his own dubious murder conviction and the nightmare of prison life

• Danny Rolling—one of the most dangerous men in the USA today, currently on trial for his life. His stories attempt to make sense of the bleak road that leads to nowhere, while London speaks candidly of her love for Rolling—a love which has outraged

*Nilsen concealed the bodies of his victims beneath the floorboards of his living room. At one time there were six corpses in the flat. Police found evidence beneath the floor of pupae belonging to a variety of fly which breeds on dead bodies. — from **Killing for Company***

American TV viewers."

$12.00 *(PB/313/Illus)*

Lethal Marriage: The Unspeakable Crimes of Paul Bernardo and Karla Homolka
Nick Pron

"I wuv you Paul. To my one and only number one guy in the world. Your snuggly wuggly honey bunny. Kar." Karla Homolka sent her beloved Paul hundreds of "wuv" notes. When she didn't feel like it anymore he beat her up. She continued to write one every day.

Handsome Karla and Paul appeared to be an ideal couple. A Canadian Barbie and Ken. Their crimes, however, horrified an entire nation and resulted in the most costly manhunt and sensational trial in Canada's history. You see, Karla had assisted and then watched her "number-one guy" kidnap, rape, sodomize and murder three teenage "sex slaves" including her "widdle" sister. Every action was caught on videotape for Paul's later viewing pleasure. Many of these grisly videotapes were transcribed in this book for your . . . reading pleasure. **LZ**

$5.99 *(PB/468)*

Lobster Boy: The Bizarre Life and Brutal Death of Grady Stiles Jr.
Fred Rosen

Ectrodactyly, a genetic condition, which has run in the Stiles family since 1840 for five generations, results in the absence of the third digit and the fusing together of the remaining fingers and toes into "claws." The condition, which is also known as lobster-claw syndrome, sometimes affects all four limbs, sometimes two. *Lobster Boy* documents the bizarre life of Grady Stiles Jr. (and family), his abuse of wives and various handicapped and "normal" children, and Grady's brutal, premeditated murder. The murder itself is not as shocking as the zeal of the prosecutors in their quest for "justice." Big type makes this a quick but queer read, with an insider's view of on-the-road freak shows. **CF**

$4.99 *(PB/331/Illus)*

Low Life: Lures and Snares of Old New York
Luc Sante

Outlaw urban history from the author of

Sondra London, editor of **Knockin' on Joe**

Evidence. Presents the *Goodfellas* side of the immigrant experience in Old New York, from 1840 through 1919. "There were times," writes the author, "when this project was new, when my research would get the better of me and I would almost lose track of what year it was outside. At least once, late at night, and under the influence of alcohol and architecture and old copies of the *Police Gazette*, I staggered around looking for a dive that had closed 60 or 80 years before, half expecting to find it in mid-brawl. This kind of hallucination is not difficult to sustain, even now, on certain empty streets where the buildings are the same ones that were once chockablock with blind tigers, stuss joints and bagnios. An extraordinary number of edifices survive that formerly housed the worst deadfalls in the city, from Kit Burn's Rat Pit to McGurk's Suicide Hall. I was instinctively drawn to such places." Shows where we got the Bowery Boys, the Mickey Finn, Hell's Kitchen, the "joint," "dope" and Dixie. Look for the book *The Gangs of New York*, written in 1929, for more dirty details. **GR**

$16.00 *(PB/414/Illus)*

Lustmord: Sexual Murder in Weimar Germany
Maria Tatar

In this provocative text professor Tatar examines images of sexual crime in the art, film and literature of the Weimar Republic and how art and murder have since intersected in the "sexual politics of culture." After a concise overview of the escapades of the most notable sex criminals of the period, Franz Haarmann and Peter Kürten, Tatar goes on to explore the ways in which Weimar artists dealt with the roles of victim and murderer in their work, and how all too often (she feels) they found themselves identifying most greatly, and most cheerfully, with the murderer. An extremely thoughtful treatment written with a minimum of academic jargon. **JW**

$14.95 *(PB/213/Illus)*

The Mafia Encyclopedia
Carl Sifakis

Besides all being of Italian heritage, what do the following people have in common: Vinnie "The Chin" Gigante, "Crazy" Joe Gallo, Jimmie "The Weasel" Fratianno, Vincent "The Schemer" Drucci, Angelo "The Gyp" DeCarlo, Willie "Potatoes" Daddano?
In case you are wondering how these people happened to receive their nicknames, *The Mafia Encyclopedia* will explain them all, along with enough gory photos to satisfy those readers who "never drink . . . wine." **JB**

$17.95 *(HB/384/Illus)*

The Making of a Serial Killer: The Real Story of the Gainesville Murders in the Killer's Own Words
Danny Rolling and Sondra London

A collaborative autobiography by Florida murderer Danny Rolling with "Media Queen" and romancer of serial killers (after they're safely behind bars) Sondra London. While Rolling has certainly done some nasty deeds, thankfully he has also found Jesus—and when he *did* kill people he was always possessed by an evil spirit, such as "Gemini." Perhaps we can all learn from the words of Danny (since he has allowed himself to experience a few forbidden pleasures along life's way): "Right and good always follow the heavenly. Wrong and evil produce nothing but HELL." Includes Rolling's prison drawings as illustrations plus some frightening portraits of his lady-love Sondra. **SS**

$12.95 *(PB/250/Illus)*

Manson Behind the Scenes
Bill Nelson

"• Manson: New information from 1,000 pages of his recent communications
• Tex Watson: His Medi-Cal Fraud Investigation, the Abounding Love Ministries rip-off, how he is manipulating the Christian community
• Suzan LaBerge: The daughter of Rosemary LaBianca, how she lost custody of her oldest daughter, her verbal and physical abuse, what people say about her demonic powers
• Susan Atkins: Inside the California Institute for Women, has she changed? Who performed her first marriage? Her present marriage? Her disciplinary reports and her faith experiences
• Patricia Krenwinkel: Conversations from inside the California Institute for Women
• TJ: The man who was with Manson when drug dealer Bernard Crowe was killed
• Gypsy: The most colorful female in the gang! What is her life like today? How she is financed at taxpayers' expense
• Michael Brunner: KCBS wanted to find Manson's son; what really went on behind the scenes during the taping?
• Bruce M. Davis: What is this man hiding?
• The Hawthorne Shootout: Interviews with the officers who shot it out with Manson

Family members
• Exclusive: The only person alive at the Tate property breaks his silence—William Garretson tells what he heard that fateful night."
$24.95 *(PB/398/Illus)*

Mass Rape
Edited by Alexander Stiglmayer
Pornography goes to war. "Accounts of torture, murder, mutilation, abduction, sexual enslavement and systematic attempts to impregnate—all in the name of 'ethnic cleansing.'" It's the old Nazi Holocaust gambit brought into the '90s with a sicko porn twist. With this war, states the author, pornography emerges as a tool of genocide. One witness writes: "Some massacres in villages as well as rapes and/or executions in camps are being videotaped as they're happening. . . . In front of the camera, one beats you and the other—excuse me—fucks you, he puts his truncheon in you, and he films all that We even had to sing Serbian songs . . . in front of the camera." Told in political and social essays and interviews with some 20 women, primarily of Muslim origin, and three Serbian perpetrators. **GR**
$14.95 *(PB/232)*

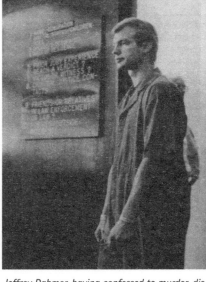

Jeffrey Dahmer, having confessed to murder, dismemberment and cannibalism, awaits his day in court. — from **The Milwaukee Murders**

The Milwaukee Murders: Nightmare in Apartment 213—The True Story
Don Davis

"They smelled the foul odors. They heard the power saw buzzing in the dead of night. But neighbors never imagined the horrors happening right next door. . . . The hot sultry night of July 22, 1991, was one the tenants of the Oxford Apartments would never forget. A panic-stricken young man—a pair of handcuffs still dangling from his wrists—ran out of Apartment 213 and told police an incredible tale of terror. . . . Shaking with fear, he led officers back to his captor's lair, where they made a gruesome discovery. Inside were the body parts of at least 15 men—including torsos stuffed into a barrel, severed heads in a refrigerator, and skulls boiled clean and stashed in a filing cabinet. Tacked to the freezer were Polaroid photographs of mutilated corpses." Guess whose crib it was?
$5.50 *(PB/311/Illus)*

Mind Hunter: Inside the FBI's Elite Serial-Crime Unit
John Douglas and Mark Olshaker
Enter the twisted, tormented world of pioneering FBI behavioral-profiling expert John Douglas as he recounts his relentless pur-

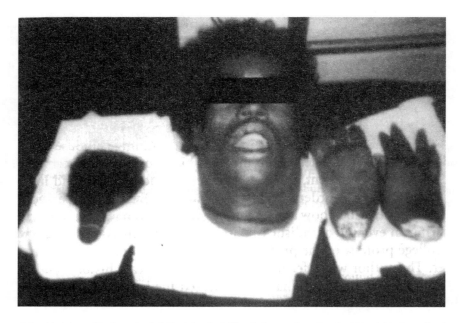

Polaroid picture of body parts of victim taken by Jeffrey Dahmer — from **Practical Homicide Investigation**

suit of America's most brutal serial killers. The inspiration for the Scott Glenn character in *The Silence of the Lambs*, Douglas painstakingly studied such serial killers as Edmund Kemper in the quest to develop a set of behavioral profiling tools that could enable cops to pry inside the minds of murderers and catch them before they kill again. Part Sherlock Holmes, part forensic sex-therapist to the damned, Douglas developed insights into the dark recesses of deviant psychology that are nothing short of chilling. Almost equally fascinating is the candid portrait Douglas paints of himself as an obsessive, hard-drinking, workaholic Fed with a sharp eye for miniskirted, go-go-booted coeds, an image that just might leave one with the impression that Douglas' prowess in entering the mind of the serial killer might not entirely be the result of academic study.

AD
$6.99 *(PB/397/Illus)*

Mind of a Killer: An Investigation Into the World of Serial Killers
Multicom
This is a vastly entertaining CD-ROM exploring the nightmare world of the serial killer. Featuring case histories of such deviants as John Wayne Gacy, Ted Bundy, Henry Lee Lucas and Aileen Wuornos, *Mind of a Killer* is lavishly supported by maps, photographs, video and audio clips as well as numerous segments of former FBI behavioral profiling pioneer Robert Ressler, who provides expert opinion and commentary on the various case histories. Also included on the disc is a hypertext version of Ressler's seminal work on the psychology of serial killers, *Sexual Homicide, Patterns and Motives*, as well as the *FBI Handbook of Forensic Science. Mind of a Killer* is a worthy interactive addition to the collection of any true-crime enthusiast.

AD
$49.95 *(CD-ROM)*

Monster: The Autobiography of an L.A. Gang Member
Sanyika Shakur, a.k.a Monster Kody Scott
"After pumping eight blasts from a sawed-off shotgun at a group of rival gang members, 11-year-old Kody Scott was initiated into the L.A. gang the Crips. He quickly matured into one of the most formidable Crip combat soldiers and earned the name Monster for committing acts of brutality and

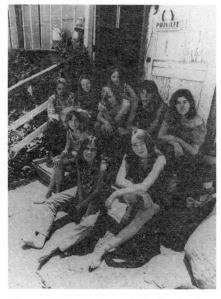

Manson Family members at Spahn Ranch — from The Garbage People

violence that repulsed even fellow gang members. When an inevitable jail term confined Scott to a maximum-security cell, he transferred his aggression into educating himself and underwent a political and personal transformation. Written from his cell in solitary . . . illuminates his evolution from Monster, 'gangbanging ghetto star,' to Sanyika Shakur, black nationalist, member of the New Afrikan Independence Movement, and crusader against the causes of gangsterism."

$9.95 *(PB/383)*

Monsters of Weimar: The Stories of Fritz Haarmaan/Peter Kürten
Theodor Lessing/Karl Berg, M.D.
Comprises the classic histories *Haarmann: The Story of a Werewolf* and *The Sadist.* "In Weimar Germany, before the Nazis rose, the most evil men were those who sought out innocent victims in the backstreets and alleys. Fritz Haarman, the 'Butcher of Hannover' captured young men to satisfy his sexual desires, to fill his pockets with their stolen cash, to satiate his bloodlust and to stock his butcher store with the flesh of their young bodies. Peter Kürten was known as 'The Vampire of Düsseldorf' during his reign of terror, and no human being was sacred or safe. For the first time ever, the classic case histories of these two human

monsters—banned by Hitler soon after he came to power—appear in one disturbing volume." Introduction by Colin Wilson. **AK**
$15.95 *(PB/306/Illus)*

Mother Love, Deadly Love: The Texas Cheerleader Murder Plot
Anne McDonald Maier
"Terry returned to the nature of the job. 'This guy told me he could do anything you wanted . . .'
 'Would you do it to the girl, or do it to the mother?' Wanda asked. 'The girl is harder to get rid of. The mother ain't no problem, once you get rid of the girl . . .'
 'I think if a car wrecked, where they both died, if the car blew up or something, it might be different,' Wanda mused. 'An impact, an explosion or something, you know what I'm talking about? Then it wouldn't look so obvious . . . '
 'This guy, he don't like doing children, alright?' Terry explained. 'Seventy-five hundred dollars is the most for both of them to be dead . . .'
 'Well, I have to find some money, I need to get some money,' Wanda explained."

GR
$18.95 *(HB/256/Illus)*

Murder Guide to London
Martin Fido
A good read for "armchair ghouls" as well as a guide to the killing streets of Murdersville, U.K. "Find and visit major murder sites all over London. Maps show the distribution of murders and provide a handy key to murderers' names." Details locations of all the classic cases: Jack the Ripper's first stop and slash in Buck's Row; the Kray twins' Stoke Newington flats, where they partied and popped shotguns; Dr. Crippen's murder house, where he sliced and diced his wife; Reg Christie's gruesome garden (he planted four bodies); and Dennis Nilsen's Cranley Gardens flat, where the fat of his last victim clogged the drains after cooking. **GR**
$8.95 *(PB/272/Illus)*

The Murder of Bob Crane: Who Killed the Star of *Hogan's Heroes*?
Robert Graysmith
For Bob Crane, the post-*Hogan's Heroes* dinner-theater circuit was a sequence of singles-bar pick-ups, suburban SM dungeons and videotaped one-night stands.

Jealousy was the motive for his killing, but was the killer an unnamed big-shot criminal husband seeking a cuckold's revenge, Crane's ex-wife, or his hanger-on "best friend"—the electronics gadget rigger who arranged many of Crane's filmed dates but grew to resent his own background, second-banana status? From the discovery of Crane's body to the arrest of his "best friend" for the murder (later acquitted), the author investigates and presents every angle, every detail of this decadent, never-solved case in all its pedestrian middle-American glory. **MS**

$5.99 *(PB/301/Illus)*

Murder of Innocence: The Tragic Life and Final Rampage of Laurie Dann, "The Schoolhouse Killer"

Joel Kaplan, George Papajohn and Eric Zorn

"On an early May morning in 1988, 30-year-old Laurie Dann, a profoundly unhappy product of Chicago's North Shore suburbs, loaded her father's car with handguns, incendiary chemicals and arsenic-laced food. Before the end of the day, Dann had blazed a trail of fire, poison and bullets through the area, murdering an eight-year-old boy and critically wounding five other children in an elementary school, until a massed force of armed police ended the killings. . . . *Murder of Innocence* is the searing portrait of a young woman of beauty and privilege who was allowed to go slowly berserk, and of the fatally complacent community that became an unwitting accomplice to the final rampage of Laurie Dann."

$4.95 *(PB/335/Illus)*

The Mystery of the Princes

Audrey Williamson

When the legend has more propaganda value than the truth, print the legend. "There is no evidence whatsoever that Richard III, a man conspicuous for his loyalty to his brother Edward in a power-hungry age, murdered his brother's children, totally unnecessarily, to gain a throne from which they were in any case legally barred. Moreover, he never announced their deaths, so what could he have hoped to gain by them?" Contemporary records are examined, revisionist histories are examined, the bones of "two young boys" are examined, and Richard's hump disappears along with

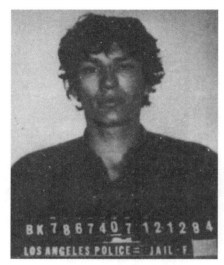

Police photograph of Richard Ramirez after his August 25, 1985, capture — from **Night Stalker**

his guilt. **GR**

$12.00 *(PB/215/Illus)*

Night Stalker

Clifford L. Linedecker

"The shocking true story of Richard Ramirez . . . During a two-year rampage, a sadistic serial killer entered the homes of families from El Paso to San Francisco. He raped, mutilated and tortured his unfortunate victims in one of the most vicious crime sprees in California history. This is the horrifying account of his bloody journey, of the strange coincidence that led to his arrest—and of the sensational trial where the Night Stalker's eerie sexual magnetism resulted in women actually demonstrating for his acquittal. Filled with accounts of Satanism, cult worship and the killer's twisted obsession with heavy metal rock music."

$4.95 *(PB/304/Illus)*

Obsessed: The Anatomy of a Stalker

Ronald Markham, M.D., J.D., and Ron Labrecque

"The trial of Arthur Jackson for brutally stabbing actress Theresa Saldana of ABC's *The Commish*, drew national attention, but the deranged stalker was sentenced to only 15 years. Markham was the forensic psychiatrist at Jackson's trial in his defense. *Obsessed* is taken from Markham's diary, interviews with the defendant, the police, his lawyers and various court officials and from Jackson's own disturbing diary."

$5.99 *(PB/304/Illus)*

The Outlaw Trail: A History of Butch Cassidy and His Wild Bunch

Charles Kelly

Originally self-published by the crusty amateur Old West historian Charles Kelly in 1938, *The Outlaw Trail* is a crudely colorful, idiosyncratic account of the criminal escapades of Butch Cassidy, the Sundance Kid and their confederates along the famous Outlaw Trail which stretched from the almost inaccessible Hole in the Wall hideout in Wyoming, across Montana, Idaho, Colorado and New Mexico, to the remote Robber's Roost stronghold in southern Utah. When Kelly began to scour the Outlaw Trail in the mid 1930s, he found it to be still quite warm—many of Cassidy's Wild Bunch associates and the lawmen who pursued them were still alive and eager to pass on their oral histories of what had been perhaps the final dramatic chapter of the outlaw experience in the Wild West.

AD

$14.00 *(PB/374/Illus)*

Outrage: The Five Reasons Why O.J. Simpson Got Away With Murder

Vincent Bugliosi

All right, you're a vain, megalomaniacal celebrity nut case addicted to the fuzzy approval of an adoring public. Then, one night, after eating some fast food, you fly into a psychotic rage and brutally murder your estranged wife along with a hapless waiter who just happened to stroll onto the scene of the crime. You're busted. You're tried amid a three-ring global media circus of truly mind-boggling proportions. It looks bad, real bad, but wait—in one of the most staggering miscarriages of modern jurisprudence, you're acquitted by a jury of your "peers" despite the veritable Mt. Everest of incriminating evidence tying you to the slayings. The rationally minded of the world reel in disbelief. How could this happen?

Somebody's got to make sense out of all this, and who better to analyze the botched case against the vain, megalomaniacal, celebrity nut-case murderer O.J. Simpson than the vain, megalomanical, celebrity former Manson Family prosecutor and all-around media gadfly Vincent "Helter-Skelter" Bugliosi? Not a guy to shy from the public eye, Bugliosi claims he didn't even

want to write this book but was compelled to by the sheer weight of civic responsibility he felt in the wake of the verdict. Getting over his initial shyness, Bugliosi spares absolutely no one as he excoriates the tactics of the defendant, the "Dream Team" defense, the prosecution and the power-mad judge for their various roles in this travesty. So vociferous is Bugliosi that he'd have you believe that in the old days he could've single-handedly strapped O.J. into the gas chamber faster than you could say "Let's have a sidebar." And he could do it without all that pesky DNA business! And who knows, with a career record of 105 felony convictions out of 106 cases under his belt, maybe he could. Ask Charlie. **A D**
$25.00 *(HB/356/Illus)*

Overkill: Mass Murder and Serial Killing Exposed
James Alan Fox and Jack Levin
Fox and Levin got in on the ground floor of a trend in 1985 with *Mass Murder: America's Growing Menace*, one of the earlier '80s books to take an overview of what would soon become better-known as serial killing. In *Overkill*, they deliver essentially an update on all the carnage of the past 10 years, liberally salting the volume with excellent, well-written and concise case studies of famous and not-so-famous mass and serial killers, many of whom have received little, if any, coverage elsewhere. Surprisingly, given one of the author's Ph.D. credentials, the analysis side of the book is pretty simple-minded; more what you'd expect from *USA Today* than from a serious academic study. But then, they've been on enough talk shows to know which side of the bread the mass market likes its butter on. **JM**
$23.95 *(HB/280)*

Oxford Book of Villains
Edited by John Mortimer
"Artificial Aim: While they were waiting at a bus stop in Clerimston, Mr. and Mrs. Daniel Thirsty were threatened by a Mr. Robert Clear. 'He demanded that I give him my wife's purse,' said Mr. Thirsty. 'Telling him that her purse was in her basket, I bent down, put my hands up her skirt, detached her artificial leg and hit him over the head with it. It was not my intention to do any more than frighten him off but, unhappily for us all, he died.'"

The British author of *Rumpole of the Bailey* recounts tales and anecdotes of "the most famous representatives" of the criminal world, both fictional and factual and, in the case of Mr. Thirsty, accidental. **GR**
$30.00 *(HB/431)*

The Passing of Starr Faithful
Jonathan Goodman
The tragic, unsolved, 1931 Starr Faithful murder mystery, dissected under a microscope with meticulous research and a credible conclusion—though it's fairly painful to get there! This "thriller" is written in anglophilic English (hat = bonnet, etc.), and full of mind-numbing detail, much with no apparent connection to the case. Woven in between is a fairly interesting mystery, featuring Starr's sordid, clandestine love affairs (one with a former Boston mayor), her unconventional sex life and misuse of drugs and bootleg alcohol, and details of her stepfather's unsavory business ventures, including his involvement in a murder investigation. Mindful of the still-unanswered question of whether her death resulted from an accident, suicide or murder, the author tries to demystify this enigmatic case. **CF**
$17.00 *(PB/311/Illus)*

Oxford History of the Prison: The Practice of Punishment in Western Society
Edited by Norval Morris and David J. Rothman
"The U.S. rate of incarceration today (519

Russian serial killer Andrei Chikatilo watched his trial from a special cell designed to restrain the unruly defendant. Following his conviction for murdering as many as 53 boys, girls and women, Chikatilo was executed by firing squad. — from Overkill

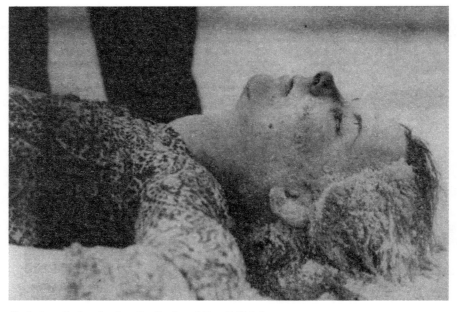

per 100,000 population) is second in the world, after Russia, and at least five times greater than that of most other industrialized nations." As the first comprehensive study of its kind, this volume boasts contributions from criminologists and social, political and legal historians, nearly all of whom are pioneers in the young field of the history of incarceration. Based on the premise that to understand normative Western society we must first examine the deviance it suppresses, highlights include: theatrical execution on the scaffold and lesser punishments involving bondage and labor; female convicts and their prisons; and analyses of hard labor, juvenile justice and political prisoners. Generously illustrated, including 11 color plates of recent prison art, this scholarly yet enjoyable collection is the perfect companion to Foucault's *Discipline and Punish*, as well as to the long tradition of prison notebooks and narratives, from Boethius to Mumia. **HS**
$39.95 *(HB/489/Illus)*

The body on the beach — from The Passing of Starr Faithfull

Perfect Crimes
Marvin J. Wolf and Katherine Mader
"No such thing as perfect crimes? Witness this whirlwind tour of dirty deeds, sinister scandals and cold-blooded murder–done in the name of love, money, madness and more–from around the world or right next door. All of these notoriously wicked characters overlooked a fatal flaw that brought their almost perfect crimes to light:
• The Lone Wolf: Japanese jet-setter Kazuyoshi Miura had a talent for making money, a taste for lizard-skin boots, and a lust for leading trusting young women like lambs to the slaughter.
• An attractive, 40ish Los Angeles personality walks into his wife's bedroom and finds her with another man. He brutally murders both of them. Then during the subsequent investigation and trial many shocking details of their unusual marriage, sex lives and partying begin to emerge . . .
• From the Hollywood Hills to the Swiss Alps, Thomas Devins wheeled and dealed, thrilled and killed, and led the law through a game of global hopscotch in which he was always one step ahead . . ."
$5.99 *(PB/332)*

Perfect Victim
Norton McGuire
"In 1977, 20-year-old Colleen Stan left home to hitchhike from Oregon to California. Seven years later she emerged from hell, the victim of a bizarre and extraordinary crime. This is Colleen's incredible true story, told by a determined young district attorney who prosecuted the man who had forced her to endure years of sexual perversion . . . and held her captive in a coffin box under his and his wife's bed."
$5.50 *(PB/370/Illus)*

Physical Interrogation Techniques
Richard W. Krousher
"Regardless of the Geneva Convention and other laws and protocols, each commander must decide whether the use of force to obtain information from a hostile source is appropriate based on the circumstances at hand. This volume is intended to supplement existing field manuals and to provide information on effective applications of force to a hostile subject. . . . Men's tolerance for humiliation and pain differ–often markedly. You must be prepared to try a variety of techniques until you find an effective one. Analysis of character before starting will help eliminate nonproductive techniques without trying them. A subject may have a great tolerance for physical pain but be absolutely broken by a hypodermic needle piercing his testicle. He may take hours of pounding with fist when he is allowed to bounce around a room, only to become thoroughly terrified when he is first immobilized with ropes before being beaten. He may be able to endure the actual touch of a hot iron to his flesh better than the sight of it hovering centimeters from his skin, waiting to cause an agonizing burn. He may be able to tolerate any amount of pain as long as he has reason to think he will survive it, but give in if he is genuinely threatened with severe mutilation or death. Conversely, he may welcome death as an end to the torture and give in only when he realizes that he will be kept in constant pain and not allowed to die."
$12.95 *(PB/93/Illus)*

Polly Klaas: The Murder of America's Child
Barry Bortnick
The middle-class crime of the century, or, as the book cover puts it, "the crime that broke our hearts!" October 1993–a 12-year-old suburban California girl is kidnapped from her own bedroom. "Sean Anthony Bush watched videos with his friend Aaron Thomas in the rental unit Thomas leased in Eve Nichol's back yard. Bush had a clear view of his neighbor's back porch. He recalled seeing a 'thick' man walking up the home's back steps at about 10 pm. Bush told police the man crouched down and glanced

MAYHEM

through the home's back windows." (Bush and Thomas ignored this!) Meanwhile, Polly "decided to move the slumber party from her room into the living room so the girls could spread out their sleeping bags. When she opened her bedroom door, the bogeyman stood waiting. He was big and held a kitchen knife. Polly let out a soft gasp. The nightmare on Fourth Street had begun." **GR**
$4.99 *(PB/264/Illus)*

The Police Dictionary and Encyclopedia
John J. Fay
"More than 4,900 law-enforcement terms and phrases are defined and explained in this comprehensive work. Examples are provided where necessary, and applications of important practices have been delineated. The entry-level officer, as well as the seasoned veteran, will find the text to be a valuable guide in updating his or her working vocabulary."
$38.95 *(HB/378)*

Prison Groupies
Clifford L. Linedecker
"They only love the men who kill!" And there are 14 reasons why these desperate Doras think that the only good men are behind bars. "They are women from all across America—women who have given up their families, careers and even their freedom to be with the men they love. From housewives to nurses to lawyers and teachers, from bestselling authors (Danielle Steel) to Hollywood sex-kittens (Sue Lyon), they all share one shameful secret: their lust-driven obsession for America's deadliest killers." **GR**
$4.99 *(PB/300/Illus)*

Prison Slang: Words and Expressions Depicting Life Behind Bars
William K. Bentley and James M. Corbett
"Two writers made good use of their time in the big house to compile a lexicon of the colorful terms they heard. Arranged alphabetically within chapters on such topics as communication, sex and drugs and alcohol, and death in prison."
$28.50 *(HB/128)*

The Private Diary of Lyle Menendez: In His Own Words!
Lyle Menendez as told to Norma Novelli with Mike Walker
Mike Walker also wrote *Nicole Brown*

Simpson: The Private Diary of a Life Interrupted, which tends to confirm one's impression of him from this book, particularly from his introduction, as a self-serving and barely literate parasite. As for the disgracefully adolescent Norma Novelli . . . What a pathetic loser she was! I use past tense in reference to her because she was nothing before she attached herself to Lyle Menendez in a menopausal crush, and she has returned to being less than nothing since. Lyle's conviction for the "brutal shotgun slayings" of his parents is supposedly exposed and analyzed by this tedious book with its unique angle of having reprinted "actual diaries." The usual pseudo-psychological stuff; society's right to know; prevention of future murder by familiarity with the "mind of a cold killer"; and righteous curiosity are the reasons glibly trotted out as justification. I resent having wasted my precious time, an irreplaceable part of my life trying to read this garbage. Yes! A plague upon thee and all who doth sail in thee, oh morass of apathy and pus-drenched conformity that be suburbia! I say. Oh, that feels better!

If you do seriously wish to enter uncannily into the existential world of a sociopathic serial killer and the obsessive mind of a sadistic pervert more completely and shatteringly than you could ever have imagined to witness; a lost soul chillingly and articu-

Sue Lyon submitting to a routine search before her prison wedding — from **Prison Groupies**

lately trying to understand how it came to this, and what could possibly have possessed him, then I cannot recommend highly enough *Killing for Company: The Case of Dennis Nilsen* by Brian Masters. After all, any right-thinking, socially sensitive observer would have to concur that an all-consuming, uncontrollable hatred for that very suburbia from which so many serial executors are drawn is really the primary common factor in all these sobering tales. Furthermore, and potentially more disturbing to the self-deceiving, I must grudgingly suggest that any right thinking and sensitive person would also have to empathize with that hatred, whilst being careful not to condone necessarily these particularly gruesome expressions of it.

So, anyway, returning reluctantly to the onerous task I have pledged to fulfill: This is a vile book reveling in vicarious consumption on every possible level. It is a gratuitous consumer product in and of itself so superficial and dull in content that it makes tabloids in the genus of *National Enquirer* sparkle like James Joyce's *Ulysses* in comparison. The Menendez brothers are consumed with such immature and ineffective greed, compounded by a mental retardation, that the acknowledgment of this is the only shocking aspect of this drivel. Suburbia was, for the post-Warholian 15 minutes or so, consumed with vicarious fascination. Norma was consumed with a blatantly self-deceiving obsession for Lyle. (Of course this dreadful, dreadful housewife wanted to fuck him!). Erik and Lyle consumed the media attention. The public consumed the media sensationalism. And on and on . . . A typical American fable of rags to body bags.

Really, all you can say is: What a bunch of repulsive people. Stupid, mundane, unglamorous, uninspired, disposable, vacuous middle-class foolish, repulsive people. Bungling, masturbatory, opportunist, amoral, vainglorious, unattractive, repulsive people. Blessedly, this cast of idiots have either crawled back under the rank stones from whence they came, or been consigned officially under more architecturally demanding, but equally dank, official stones. Which would be fine and dandy if it was an interesting tale well told. But it's not. It's a "crock of shit" as you Americans would say, and I can only wholeheartedly concur, European though I am. **GPO**
$17.95 *(HB/263/Illus)*

Prophet of Death: The Mormon Blood-Atonement Killings
Pete Earley

"Charismatic thief, philanderer and self-proclaimed man of God, Jeffery Lundgren began preaching his unique dogma of radical Mormonism in Independence, Missouri. To the members of his small but fanatically devoted sect, he was the 'Last Prophet,' whose coming was foretold in the Book of Mormon. A master of hypnotic oratory, Lundgren used his own twisted interpretations of religious texts to justify any excess—perversion, sexual slavery . . . even human sacrifice. And on April 17, 1989, Lundgren and a group of his followers led the Avery family—a husband, wife and their three young children—into a barn in rural Ohio and slaughtered them, one by one."
$4.99 *(PB/422/Illus)*

Rack, Rope and Red-Hot Pincers: A History of Torture and Its Instruments
Geoffrey Abbott

"This book discusses the history of torture, from medieval times to 1850. Roughly half of its material is about England (mainly, the Tower of London), and the other half miscellaneous areas of continental Europe. It covers the well-known instruments, such as the rack, iron maiden and guillotine. There are also a lot rare ones, such as the Duke of Exeter's invention. There are muzzles for nagging wives, and topless public bull-whipping of female criminals."
$9.95 *(PB/243/Illus)*

Rancho Mirage: An American Tragedy of Manners, Madness and Murder
Aram Saroyan

May-September husband and wife Andrea Claire and Robert Sand seemed to have a happy marriage until wheelchair-bound Sand was found murdered in their Palm Springs house. Soon any illusion that they and their marriage had been anything other than utterly bizarre was shattered. First, information came out that Andrea had worked as a call-girl, her husband had been a client, and the essential nature of their relationship had not changed since the marriage and had included SM role-playing. Under investigation by the police, Andrea

The wet t-shirt poster of Andrea, this one inscribed to Joe Mims, "I just want to be loved for my mind." — from **Rancho Mirage**

began to report attacks by people she claimed were associates of her late husband, in which she would receive scratches to her body, and knives would be inserted in her rectum. Then followed a murderous attack on her new boyfriend. Brought to trial for her husband's death, her defense turned on the question of her sanity after a lifetime of abuse. Fascinating tale of the grotesque which lurks behind the manicured lawns of suburbia. **NN**
$18.99 *(HB/366/Illus)*

Riots and Pogroms
Edited by Paul R. Brass

"During the Los Angeles riots of 1992, many Korean-American businesses were looted and burned to the ground. Although nearly half of the looters arrested were Latinos, the media portrayed this aspect of the riots more in terms on the on-going conflicts between Korean-Americans and African-Americans. . . . *Riots and Pogroms* presents comparative studies of public violence in the twentieth century in the United States, Russia, Germany, Israel and India . . . How do political and social forces seek to assign causes and attach labels to riots, attribute motives to rioters and 'pogromists,' and explain why particular groups are selected for violent assaults? To

what extent are the state and its agents implicated in those assaults? To what degree does organization and/or spontaneity play a role in these incidents?
$40.00 *(HB/320)*

The Rise and Fall of the Jewish Gangster in America
Albert Fried

"Recalls the rise and fall of an underworld culture that bred some of America's most infamous racketeers, bootleggers, gamblers and professional killers, spawned by a culture of vice and criminality on New York's Lower East Side and similar environments in Chicago, Cleveland, Boston, Detroit, Newark and Philadelphia. The author adds an important dimension to this story as he discusses the Italian gangs that teamed up with their Jewish counterparts to form multicultural syndicates. The careers of such high-profile figures as Meyer Lansky, Benjamin 'Bugsy' Siegel, and 'Dutch' Schultz demonstrate how these gangsters passed from early manhood to old age, marketed illicit goods and services after the repeal of Prohibition, improved their system of mutual cooperation and self-governance, and grew to resemble modern business entrepeneurs."
$14.50 *(PB/351)*

The Riverman: Ted Bundy and the Hunt for the Green River Killer
Robert D. Keppel, Ph.D.

The Pacific Northwest has more than its share of serial murderers, and Robert D. Keppel has been involved in the search for many of them, including Ted Bundy and the elusive Green River Killer, as well as consulting on other high-profile cases including the Atlanta child murders. Once Bundy was behind bars Keppel spent hours interviewing him to gain insight into the mind of a killer who hunted humans. In a tale stranger than *The Silence of the Lambs*, Keppel describes how while on death row Bundy became an important part of the task force whose job it was to find the Green River Killer, and how he shared important information with investigators right up to the eve of his execution. **NN**
$5.99 *(PB/475/Illus)*

The Rope, the Chair and the Needle: Capital

Punishment in Texas, 1923-1990
James W. Marquart, Sheldon Ekland-Olson, and Jonathan R. Sorensen
The Lone Star State's epic journey of the death penalty, setting the records straight regarding illegal lynchings; crazed and delirious mobs thirsty for blood; racism; as well as tons of fun facts and absurd statistics. "I [sheriff of Brazoria County] was in attendance upon his trial, and I have talked to various persons, white citizens and Negroes in the community in which he lives, and am quite thoroughly convinced that John and V.J., the state's principle witness, were intimate and have been intimate for sometime prior to the killing. I am convinced that John Banks and V.J. were tussling and the gun accidentally discharged and shot the little girl . . . " Needless to say, John Banks was execution No. 191 . . . "Don't Mess with Texas!" **TD**
$24.95 *(HB/328/Illus)*

Satanic Murder
Nigel Cawthorne
We are severely morally challenged and our gullibility retarded if we even consider this any more than preaching to the willfully converted. It's a bit like books for people who construct model airplanes, but only model airplanes of Rhodesian biplanes built between 1924 and 1925. Unless you have

an obsessive, vested interest and need confirmation of your mania, it's meaningless.

And by the way, of course, the factual and even circumstantial evidence of a thriving biplane construction industry in Rhodesia between 1924 and 1925 is far more compelling and believable than this. **GPO**
$5.95 *(PB/281/Illus)*

Serial Slaughter: What's Behind America's Murder Epidemic?
Michael Newton
Since 1900, serial crimes have gone from less than 50 in a decade to more than 300 by the year 2000. Who are the creeps that are lustmording our citizenry? Find out in this in-depth sequel to *Hunting Humans*. "A behind-the-screams look at America's murder epidemic . . . Using case histories of more than 800 serial killers, the author looks for patterns and answers . . . Includes the word-for-word statements of convicted serial killers talking about sex, murder, life and death." Plus the actual forms used by the FBI to profile murderers. **GR**
$19.95 *(PB/165/Illus)*

Severed: The True Story of the Black Dahlia Murder
John Gilmore
The grisly murder in 1947 of aspiring star-

let and nightclub habitué Elizabeth Short, known even before her death as the "Black Dahlia," has over the decades transmogrified from L.A.'s "crime of the century" to an almost mythical symbol of unfathomable Hollywood Babylon/film noir glamor-cum-sordidness. Author John Gilmore certainly has an odd assortment of credentials for this assignment: His dad was an LAPD officer at the time of the murder and was involved in the citywide dragnet immediately after Short's body was discovered; he was a rebel-type young actor in the '50s carousing Hollywood with the likes of James Dean, Dennis Hopper, and Vampira; in the '60s he wrote two out-of-print, true crime-classics: *The Tucson Murders* about the Speedway Pied Piper, Charles Schmid, and one of the first books out on the Manson Family, *The Garbage People*. It is somehow appropriate that he should be the one to unravel the multilayered mystery of this archetypal unsolved Hollywood slaying as it begins to recede into the collective memory somewhere next to Bluebeard and Jack the Ripper. The murder has become better-known to most as the fictionalized subject matter of noir-stylized, self-consciously "hard-boiled" James Ellroy's *Black Dahlia*.

In *Severed*, Gilmore tells several previously unrevealed stories at once, each filled with its own bizarre elements, illustrated by some remarkably gruesome crime-scene photos where the book more than lives up to its title. One is the tale of victim Elizabeth Short, small-town beauty queen with big hopes who seemed to somnambulistically drift through her tragically futile life, already an alluring yet doom-laden enigma. Another is the tangled inside story of the police investigation and remorseless Hearst-stoked press hoopla which ran parallel to it. Yet another is the twisted psychology and down-and-out life story of the actual murderer and his indirect "confession" wherein he fingers his female impersonator pal Morrison as the supposed killer. Then there is the suppressed information about Elizabeth Short's congenital anatomical deficiency and the murderer's ritualistic "correction" of it . . . It would be hard to swallow it all if it weren't for all those authorities—from Kenneth Anger to Detective William Herrmann of the LAPD—on the back cover endorsing this bombshell of a report. **SS**
$16.95 *(PB/288/Illus)*

Andrea at Eisenhower Medical Center after another assault incident at 6 Brandeis Court — from Rancho Mirage

Sex Murder and Sex Aggression
Eugene Revitch and Louis B. Schlesinger
Contents include "The Place of Gynocide and Sexual Aggression in the Classification of Crime," "Catathymic Gynocide," "Compulsive Gynocide," "Prognostic Considerations."
$24.95 *(PB/152/Illus)*

Sexual Homicide: Patterns and Motives
Robert K. Ressler
"A valuable resource for anyone interested in serial murder. Written by three experts in the field, the book covers the behaviors that occur before, during and after the murder, as well as insight into techniques used to profile and capture serial killers."
$39.95 *(HB/234)*

Shattered Innocence, Shattered Dreams
Susan Hightower and Mary Ryzuk
"From a storybook wedding to a marriage made in hell," told by the wife of the "crossbow-killer" himself, Chris Hightower. "On September 20, 1991, in the peaceful community of Barrington, Rhode Island, Ernest Brendel had a heated argument in his garage with his neighbor Chris Hightower over an investment deal gone bad. The discussion—and Ernie's life—ended when three steel-tipped arrows of a Bear Devastator crossbow ripped through his body." Brendel's wife and daughter came next. "Susan Hightower would truly [come to] understand that her husband Christopher was also a con man, a liar, a manipulator . . . and a murderer whose 'hit list' included herself, her parents and her two young sons."
GR
$4.99 *(PB/495/Illus)*

Slave Girls
Wensley Clarkson
Plunged into a nightmare of unspeakable abuse and depravity, they lived as SLAVE GIRLS one of the first glimpses into the shocking world of human bondage . . . a sordid world of slaves and masters, where innocent young girls are sold to the rich, kidnapped and subjected to horrifying degradation . . . virtual captives in the mansions of the rich and famous, or in the squalid dungeons of the utterly degenerate . . . the survivors who lived through the ordeal now tell all . . . **JB**
$5.99 *(PB/259/Illus)*

Elizabeth Short in Long Beach, CA, 1945 — from Severed

Squeaky: The Life and Times of Lynette Alice Fromme — Runaway
Jess Bravin
"In the early 1950s, Lynette Fromme's world was more or less a paint-by-numbers existence shared by millions of suburban children living in Southern California. . . . On the day that Lynette met a freshly released convict named Charles Manson, her world abruptly turned inside-out. Society became the enemy. Illegal drugs, violence, weapons and social outcasts now surrounded her and led her in the course of a decade to another dimension—to be imprisoned for the term of her natural life in the custody of the attorney general of the United States."
$25.95 *(HB/398)*

The Story of the *Titanic* as Told by Its Survivors
Edited by Jack Winocour
From 1913: "Lights on board the *Titanic* were still burning, and a wonderful spectacle she made, standing out black and massive against the starlit sky; myriads of lights still gleaming through the portholes, from that part of the decks still above water. As we watched this terribly awe-inspiring sight, suddenly all lights went out and the huge bulk was left in the black darkness, but clearly silhouetted against the bright sky. Then, the next moment, the massive boilers left their beds and went thundering down with a hollow rumbling roar . . . carrying everything with them . . . This unparalleled tragedy was being enacted before our very eyes, now rapidly approaching its finale, as the huge ship slowly but surely reared herself on end and brought rudder and propellers clear of the water, till, at last, she assumed an absolute perpendicular position. Then . . . she silently took her last tragic dive. Almost like a benediction everyone round me on the upturned boat breathed the two words, 'She's gone.'" **GR**
$7.95 *(PB/320/Illus)*

Take No Prisoners: Destroying Enemies with Dirty and Malicious Tricks
Mack Nasty
If you really need revenge on someone, this book will give you some nasty tips to try. Covers mental attitude, collecting information on the subject of your ire, making preparations and protecting yourself against your enemy. Details different ways of attacking the subject at his home or

office, trashing his automobile, and creating all types of personal havoc for your target. Some of the techniques described in this book will make you sick to your stomach and, of course, it has the standard "Sold for entertainment purposes only!" warning—oh yeah, sure. The book does list advantages and disadvantages to many of the tactics written about. The rest I'll leave up to your own evil imagination. **MC**
$10.00 *(PB/118)*

Teenage Wasteland: Suburbia's Dead End Kids
Donna Gaines
Teenagers in Bergenfield, New Jersey, started a suicide trend in 1987, when several "popular" kids from the local high school gassed themselves in their car. Donna Gaines, a social worker and former Long Island rocker teen herself, reported the story in a 1987 article in *The Village Voice* that forms the basis for this book. Gaines is accepted by, and hangs out with, the black-T-shirt-wearing Bergenfield youth, a clique where all the girls wear bandages on their wrists. This is a fairly detailed document of the teen-suicide aesthetic, yet for all its detail and empathy, the book is oddly boring, but then, that's kind of the point: suicide as an expression of mediocrity. **HJ**
$11.00 *(PB/263)*

Tex Watson: The Man, the Madness the Manipulation
Bill Nelson
"Tex Watson has a nonprofit ministry while in prison for the murder of seven people. He has fathered three children through conjugal visits. he has a cultlike following across the nation. He wants to be released from his life sentence in prison. He sends his wife Kristin out to give a 'greeting' at local churches. He even has the daughter of one of his victims speaking out demanding his release. Tex Watson wants to be a televangelist. This investigation reveals the real Tex Watson, lieutenant of murder for Charles Manson. Has he really changed? You decide."
$10.95 *(PB/256/Illus)*

Times 17: News and Reviews
Gareth Penn
"Identifies the Zodiac Killer on the basis of evidence contained in the two dozens letters

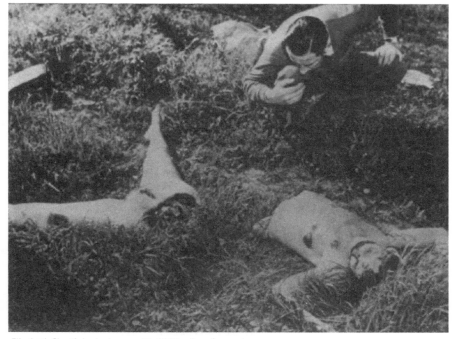
Elizabeth Short's body, January 15, 1947 — from **Severed**

which the Zodiac wrote to Bay Area newspapers, letters in which he claimed to be identifying himself in some kind of code, a code which has frustrated the best efforts of the local police, the military, the FBI and the National Security Agency for almost a quarter century. The Zodiac's 'code' failed to yield to the most sophisticated code-breaking technique known, and so law-enforcement authorities gave up. They didn't try Morse Code. Using an analytical method which might have occurred to a Boy Scout, Penn produced a wealth of information which identified a particular individual. This identification has been corroborated by conventional evidence, such as contemporary photographs, handwriting comparisons, employment history, firearms registrations, and what Penn calls 'behavioral fingerprints,' which are documented in this book."
$16.95 *(PB/380)*

Tongs, Gangs and Triads: Chinese Crime Groups in North America
Peter Huston
"The Chinese Mafia has earned a reputation as one of the fiercest and most brutal in the seedy underworld of organized crime, most notorious, perhaps, for its control of the lucrative Southeast Asian drug trade. But how much of this is Hollywood hype and

how much is reality? . . . Here author Peter Huston explores the rich Chinese tradition of tongs, triads and secret societies and their frequent involvement in organized crime, as well as their growing collusion with Chinatown street gangs. He also examines how Chinese culture and the plight of Chinatown society obstruct efforts to fight these crime groups and even serve to fuel their growth."
$30.00 *(PB/280/Illus)*

Total Abuse: Collected Writings, 1984-1995
Peter Sotos
Reads like an elaborate one-note joke whose aim is to shock, a predictable knee-jerk compulsion to sicken—either that, or a tiring exercise in pushing the limits of the First Amendment. Illustrates the basic shortcoming of any conceptual art, no matter what the discipline—it hinges on a punch line and, as such, once you get it the thrill is over (i.e., the joke ain't funny the second time around—or the third or the fourth or the thousandth). Sotos' moronic celebrations of the heinous include accolades to Klaus Barbie, necrophiles, child killers and rapists. He even lacks the peripheral saving grace of presenting a vision that's distinctly "evil"—his words read like

mediocre reportage. Difficult to take seriously on any level—even as a one-note joke it's not funny, merely pointless. A provocateur for the MTV generation; clearly the product of someone with too much time on his hands. **MDG**
$10.00 *(PB/240/Illus)*

The Trunk Murderess: Winnie Ruth Judd
Jana Bommersbach
Ryan opened the smaller trunk . . . It contained a human foot and a leg from the knee down . . . He opened the second. Inside was the torso of a woman from the head to the navel. Ryan decided he'd seen enough and had better wait for the lab men . . . 'TWO WOMEN'S BODIES SHIPPED HERE IN TRUNKS BY FIENDISH KILLER!'—*Los Angeles Times*, 1931 . . . 'The press had never seen or met me before, but they called me "Tiger Woman!" "Wolf Woman!" "Velvet Tigress!" "Butcher!" . . . I had always lived a Christian life and I am still a Christian. I have always contended my innocence of murder.'" **GR**
$5.99 *(PB/298/Illus)*

Unquiet Minds: The World of Forensic Psychiatry
Hugh Miller
Forensic psychiatrists are the doctors who deal with mentally disordered offenders. They determine who's the real nut case and who's the faker. "Time has blessed me with a touch of wisdom and a lot of suspicion," says a British doctor of psychiatry. "Spotting fakers is a challenge which I take very personally. I never let myself forget I'm working in a muddy territory between madness and badness. I stay alert all the time. These days they have to be pretty good to get past me." Some of the real-life cases in this book are: "A 32-year-old German who raped and murdered 10 women in his search for an ideal lover. Beatrice . . . suspected her family of conspiring to take away her imaginary 'birthright'; in a fit of anger she killed her mother, stabbing her 40 times with a kitchen knife. A gym teacher, convinced he was a macho incarnation of Jesus Christ, embarked on a vicious campaign to rid his neighborhood of the agents of Satan, who happened to include every person who owned a green car." **GR**
$9.95 *(PB/305)*

Using Murder:

The Social Construction of Serial Homicide
Philip Jenkins
What becomes propaganda? Serial killers are not the only animals who get off on their crimes. The serial murder boom (approximately from 1977 to 1991) set off a flurry of spin control by various groups, all attempting to link the purported crime spree to broader social issues, mostly of their own designs. The FBI decided they were in charge. Newspapers and television had a new fear to manipulate. Feminist groups spoke of "femicide," nonexistent "Satanic cults" were created by true-crime authors, and crime fiction created a new genre of romantic Americana, the serial-killer novel. It's the stuff we buy into every day. **GR**
$20.95 *(PB/262)*

Violence in the Workplace: A Company Guide to Prevention and Management
S. Anthony Baron, Ph.D.
Taking this book at face value as a serious guide to defusing potentially lethal situations—well, let's just say that you'd be advised to spend your money on Kevlar vests and your time planning escape routes. Guidebooks of this type are always fine sources of campy case studies and amusingly vague advice, and this one is no exception. But the best thing here is that the case studies name names and give details not commonly known about recent workplace shootings. Duck and cover! **JM**
$14.95 *(PB/176)*

Violent Attachments
J. Reid Meloy, Ph.D.
A scientific analysis of violent attachment disorder broken down by case study, behavior and conclusion. Includes some interesting case studies, but much of the book is written in a dense language intended for a specific audience: "The Harris and Lingoes subscales of Scale 4(Pd) suggested that most of the loading was attributable to Sara's perceptions of family conflict and discord (Pdl=T69) and profound alienation from herself (Pd4B=T74)." **CF**
$35.00 *(PB/365)*

Weathering the Storm: Tornadoes, Television

and Turmoil
Gary A. Englund
Career bio of the weather king of Tornado Alley, Gary England, chief meteorologist of KWTV, Oklahoma City. "In a region where the weather really is a matter of life and death, the pressures and rewards of England's unique role have been intense. This heartfelt narrative portrays the world behind the television camera, the man behind Oklahoma's most trusted weather predictions . . . Shows how England's career developed and paralleled the almost incredible expansion of weather prediction and television." Includes 55 spectacular color photographs of tornadoes. **GR**
$26.95 *(HB/264/Illus)*

When Women Kill
Coramae Richey Mann
"Collected from police files, homicide records, FBI reports and criminal information. Research analysis reveals a fascinating profile of today's female murderer." The crimes, they are a-changin': "The issue . . . is whether there have been changes over time to the extent in which victims were

Miss Samuelson, killed by Ruth Judd "Arizona Tiger Woman" — from Death Scenes

strangers. The image of a new breed of female killer suggests a trend toward violence against strangers, where the offender is motivated by greed or a love of violence itself." In-depth research, stats, charts, percentages, the works. Surprising conclusions.

GR

$19.95 *(PB/215/Illus)*

Whoever Fights Monsters: My Twenty Years Hunting Serial Killers for the FBI

Robert K. Ressler and Tom Shachtman

"Face-to-face with some of America's most terrifying killers, FBI veteran and ex-Army CID colonel Ressler learned from them how to identify the unknown monsters who walk among us—and put them behind bars. Now, the man who coined the phrase 'serial killer' and advised Thomas Harris on *The Silence of the Lambs* shows how he is able to track down some of today's most brutal murderers. . . . Ressler uses the evidence at a crime scene to put together a psychological profile of the killers. From the victims they choose, to the way they kill, to the often grotesque souvenirs they take with them—Ressler unlocks the identities of these vicious killers for the police to capture. And with his discovery that serial killers share certain violent behavior, Ressler's gone behind prison walls to hear the bizarre firsthand stories of countless convicted murderers. . . . Join Ressler as he takes you on the hunt for today's most dangerous psychopaths."

$5.99 *(PB/289/Illus)*

Wicked City Chicago: From Kenna to Capone

Curt Johnson and R. Craig Sautter

Most folks know that Chicago has been nicknamed the Windy City. Other aliases that the city has assumed are the Second City and the City That Works. In a famous poem it was referred to as The City With Big Shoulders, and some have been known to celebrate it in song as "That Toddlin' Town." But few have heard Chicago labeled the Wicked City, although at times in its history that sobriquet was deservedly applied to America's Sin Capital of the Midwest. Through various administrations it existed as a wide open town, with prostitution, gambling, bootlegging, drug-dealing, graft and corruption reaching to the highest levels and creating an inviting and fertile envi-

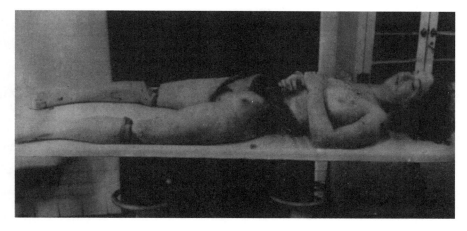

Miss Samuelson at L.A. County Morgue – from **Death Scenes**

ronment for the professional criminal.

The writers take us down an avenue of characters, civic accomplishments and crimes whose landmarks are the restaurants, brothels, distilleries and gaming houses belonging to the likes of Giacomo "Big Jim" Colosimo, Giuseppe "Diamond Joe" Esposito (once referred to as the unofficial mayor of Little Italy), the Everly Sisters, Johnny "The Fox" Torrio, "Bloody" Angelo Genna, Dion "Deanie" O'Banion, George "Bugs" Moran, and finally the Big Guy himself, Alphonse "Scarface" Capone. Along the way we pay visits to City Hall where Mayor William Hale "Big Bill" Thompson sits in a back room smoking cigars with some suspicious-looking fellows; we pop in at the mansions of the Fields, the Pullmans, the McCormicks, the Palmers and the Armours to see what well-dressed skeletons lurk inside their plush closets; we spy a young Theodore Dreiser hurrying on his way to work for the *Chicago Daily Globe*; and stop at the sweat-filled gyms and locker rooms of Jack Dempsey, Harold "Red" Grange and "Shoeless" Joe Jackson for a bit of athletic distraction. As the hour grows late, we sneak into an outfit-owned muggles-smoke-filled speakeasy where the great Louis Armstrong is experimenting on his horn to the delight of writhing revelers drunk on jazz and illicit booze.

Unfortunately, for each person who found this street to be a road paved with gold, there were others for whom it proved to be the famous Boulevard of Broken Dreams. Witness the tragedy of Louis Henri Sullivan, master architect of the internationally renowned

Chicago School and designer of some of the most beautiful edifices in the world, who died destitute and alone in 1924, just as others were reaping the rewards of Chicago's Prohibition-era potential. It's been said of late that with the ascension of Michael Jordan to the title of "The Most Famous Chicagoan," thus dethroning Al Capone, and the recent uneventful and "exemplary" Democratic Convention whose idyllic calm allegedly shed the pesky '68 syndrome, Chicago has finally laid to rest the ghosts of its disreputable past. However the slew of recent Federal investigations digging into the phenomenon of "ghosts" on the city payroll (Operation Haunted Hall), avaricious aldermen who take money for the right to illegally dump garbage in their wards (Operation Silver Shovel) and trust-betraying policemen who simultaneously solve crimes while also committing them (Operation Broken Star) prove the old adage that in some places tradition dies hard. *Wicked City Chicago* is an invaluable guide to the sowing, nurturing and reaping of the seeds of this old tradition. As a venerable sage once said, Chicago by any other name still smells the same. **AS**

$19.95 *(PB/390/Illus)*

William Heirens: His Day in Court

Dolores Kennedy

"On January 7, 1946, 6-year-old Suzanne Degnan was abducted from her North Side Chicago home, never to be seen again. The discovery of her dismembered body later that day caused widespread fear in the city. As police spent thousands of man-hours

investigating, Chicagoans anxiously watched over their children—and themselves. Six months later, 17-year-old William Heirens, a University of Chicago student, was arrested in a burglary. For six days the police strained to build a case, while keeping Heirens locked up. He was isolated, threatened, injected with sodium pentothal, the 'truth drug,' and given a spinal tap. But six weeks after his arrest, the teenager confessed to the Degnan crime and the murders of two women, Frances Brown and Josephine Ross. Why?

"Kennedy offers proof that the defense attorneys conspired with the prosecution to coerce a confession from the teenager—while a frenzied press tried Heirens and convicted him, eliminating any possibility of a fair trial. . . . At last Bill Heirens will receive what the city of Chicago and the state of Illinois could not give him in 1946—a fair trial."

$19.95 *(HB/408/Illus)*

World Encyclopedia of 20th-Century Murder
Jay Robert Nash
Compiled by the author of *Bloodletters and Bad Men*, this illustrated tome retains all the flavor of the aforementioned book. Photographs of ghoulish and asocial types are interspersed throughout the text at appealing intervals. We can even find a rare photograph of Fritz Haarman, the "Ogre of Hannover" with relative ease, along with other infamous killers from every corner of the globe. **JB**
$49.95 *(HB/693/Illus)*

World Encyclopedia of Organized Crime
Jay Robert Nash
"An excursion into the underworld that uncovers the international scope—and historical roots—of today's organized crime. Brilliantly cataloged by the dean of American true-crime writers, Jay Robert Nash, this volume profiles the notorious gangsters, crime families, cartels and gangland events that have shaped world history. Here are gangs such as the Dead Rabbits and the Whyos, who controlled 19th-century New York; gangsters such as Al Capone, Lucky Luciano, Bugsy Siegel, Meyer Lansky, Legs Diamond and Dutch Schultz, who brought crime to new heights of money-making and bloodshed; and contemporary organizations such as the Medellin Cartel,

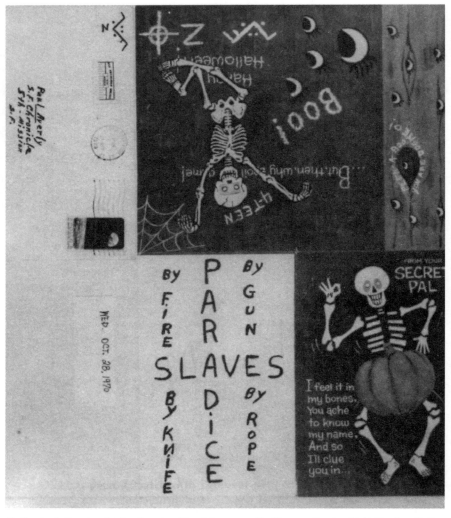

Zodiac death threat card to San Francisco Chronicle *reporter Paul Avery on October 27, 1970 — from* **Zodiac**

the 'Pizza Connection' gangsters, the Yakuza gangs of Japan, and New York's powerful Gambino family. "
$25.00 *(PB/624/Illus)*

Zodiac
Robert Graysmith
"This is the Zodiac speaking . . . I would like to see some nice Zodiac butons [sic] wandering about town. Everyone else has these buttons like, [peace sign], black power, melvin eats bluber [sic], etc. Well it would cheer me up considerably if I saw a lot of people wearing my buton [sic]." Sic is right! This chilling account of one man's sexual sadism, by a *San Francisco Chronicle* staffer, reads like a horror novel that's got it all: Paramilitary geek! Torture and murder! Ciphers! Serial-killer humor! Arcane symbols! Mocking letters to Herb Caen! Gilbert and Sullivan! Medieval black hood with symbol! San Francisco! Bomb threats! Children in jeopardy! No wonder Zodiac became a star. Contains the complete text of the killer's letters and the author's own theory on Zodiac's identity. **GR**
$5.99 *(PB/337)*

FORENSIC PATHOLOGY

Facial Reconstruction. This restoration technique is employed in forensic anthropology to recreate an identity from a human skull. — from **Practical Homicide Investigation**

Cause of Death
Cyril Wecht, M.D., J.D.
Forensic pathologist re-examines the evidence and casts "bold, brilliant and often shocking new light" on the JFK and RFK assassinations, the innocence or guilt of Claus von Bülow, the medical malpractice surrounding Elvis and Chappaquiddick, among others. Computerized "second gun" evidence from Dallas: "For six weeks, Tom played with his new hobby. He would slowly eliminate layer after layer of shade, hoping to discover what the metal was that glittered from near the fence area of the grassy knoll. . . . Each time, the piece of metal became brighter until it was in full view—a badge. It was that of a police officer or police detective . . . as the layers of gray continue to vanish, it appears that the fourth piece of metal is hidden behind smoke. . . . All at once, you are faced with

an image of a man's head behind what appears to be a gun. It was hidden behind the smoke. " **GR**
$5.99 *(PB/326/Illus)*

The Detection of Human Remains
Edward W. Killam
"This volume is the first of its kind—a how-to manual for finding buried, concealed or discarded bodies. As an experienced legal investigator, the author is keenly aware of the courtroom implications of the detection and recovery of evidence. Detection methods include ground contact, proximate and remote sensing techniques. Many methods are known to archaeologists but not law enforcement and vice versa. Search supervisors are advised how to decide on procedures and how to justify their decisions, how to consider the press and the victim's

family—and how to balance time, manpower and costs against expected results."
$30.95 *(PB/284/Illus)*

Forensic Medicine: An Illustrated Reference
J.K. Mason, M.D., LL.D.
"The opportunity to visualize what the author is verbally depicting is undoubtedly greater in forensic pathology, and probably more important as an educational tool, than in any other field of medical practice. . . . Professor Mason has compiled 730 photos that vividly demonstrate the various pathological entities and phenomena described by the author at the beginning of the 19 chapters. Every illustration is accompanied by a clear description that enables the reader to readily comprehend the salient features of a specific injury or post-mortem artifact. These legends are relatively lengthy

and contain more detail than is customarily found in medical texts of this nature. . . . Thus the author has ensured a complete pictorial coverage of frequently encountered entities in violent, unnatural, unexplained and mysterious deaths, as well as many of the more bizarre kinds of postmortem findings which even veteran forensic pathologists have rarely experienced."— Cyril Wecht, M.D., J.D., past president, American Academy of Forensic Sciences. Nearly all photo illustrations are in full color and very graphic.

$232.95 *(HB/213/Illus)*

Forensic Pathology
Dominick J. DiMaio and Vincent J.M. DiMaio
"Without a doubt the most comprehensive, definitive and practical medicolegal textbook on forensic pathology today." Chapters include: "Medicolegal Investigative Systems" (definition of death, operation of a medical examiner system, etc.), "Time of Death" (livor mortis, rigor mortis, decomposition, insect activity, etc.), "Deaths Due to Natural Disease" (cardiovascular disease, deaths due to intracranial lesions, respiratory system, etc.), "Wounds Due to Blunt Trauma" (abrasions, contusions, lacerations, defense wounds due to blunt force, etc.), "Blunt Trauma Injuries of the Trunk and Extremities," "Trauma to the Skull and Brain: Craniocerebral Injuries" (impact injuries, acceleration/deceleration injuries, death due to cerebral concussion, boxing injuries, etc.), "Wounds Due to Pointed and Sharp-Edged Weapons" (stab wounds, incised wounds, chop wounds, etc.), "Asphyxia" (suffocation, strangulation, sexual asphyxia, crucifixion, etc.), "Deaths Due to Motor Vehicles," "Airplane Crashes," "Neonaticide, Infanticide and Child Homicide" (battered baby syndrome, "impulse" or "angry" homicide, the shaken baby syndrome, etc.), "Death Due to Fire," "Drowning" (drowning in bathtubs, scuba divers), "Topics in Forensic Pathology" (primary cardiac arrest during exercise, starvation, death in the dental chair, water intoxication, deaths due to electrolytic disorders) and more. Provides "graphic and descriptive photographs throughout the text that highlight for the reader exactly *what* to look for and *how* to handle specific situations.

$65.00 *(HB/528/Illus)*

Gunshot Wounds: Practical Aspects of

Firearms, Ballistics and Forensic Techniques
Vincent J.M. DiMaio
"Provides critical information in the classification of gunshot wounds caused by handguns, rimfire and centerfire weapons, rifles and shotguns, as well as some less common weaponry. Covers issues concerning small-arms fire and forensic pathology, such as: basic forensic aspects of ballistics and wound ballistics; the importance of x-rays in autopsy; the detection of gunshot residues; the correct handling of deaths caused by firearms; and suicide by firearms."

$55.00 *(HB/454/Illus)*

Homicide Investigation: A Practical Handbook
Burt Rapp
Small primer on homicide investigation. General beginner's book especially helpful for law enforcement, private investigators, writers, filmmakers. Does not go into exhaustive details or feature many photographs or illustrations. Basic tasks, tactics and tools for investigation are covered. Includes a glossary and other references. This book will give the reader a basic beginning understanding of homicide investigation. Lists the stages of death; how to estimate time of death; what is done first at a murder scene; when search warrants are needed; how to sketch murder scenes; what happens at an autopsy and more. **MC**

$14.95 *(PB/180/Illus)*

How To Solve a Murder: The Forensic Handbook
Michael Kurland
At first glance this looks more like a "Where in the World Is Carmen San Diego?" book, but author Kurland has written a more seri-

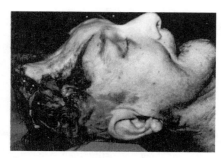
Contact wound of right temple with .357 Magnum — from Forensic Pathology

ous book than either the cover or the inside illustrations convey. The reader is taken through a typical murder investigation step by step, using a fictional crime tailored so that as many forensic techniques as possible are covered. Interspersed are anecdotes of real crimes; the historical notes are worthy and give a good background to the contemporary information. From blood spatters to ballistics, for the novice crime buff or mystery-novel reader, a good introduction to the world of the homicide voyeur. **TR**

$15.00 *(PB/194/Illus)*

Medicolegal Investigation of Death: Guidelines for the Application of Pathology to Crime Investigation
Werner U. Spitz
"Known as the 'bible' of forensic pathology to pathologists around the world . . . This authoritative and complete textbook is written by some of the most respected experts in the United States." Contents include: "History of Forensic Pathology and Related Laboratory Sciences"; "Time of Death and Changes After Death"; "Identification of Human Remains"; "Forensic Odontology"; "Trauma and Disease"; "Blunt Force Injury"; "Sharp Force Injury"; "Injury by Gunfire"; "Thermal Injury"; "Asphyxia"; "Drowning"; "Electrical and Lightning Injuries"; "The Road Traffic Victim"; "Aircraft Crash Investigation"; "Sex Crimes"; "Mechanical Injuries of Brain and Meninges"; "Microscopic Forensic Pathology"; "Deaths in Childhood"; and more. Illustrated throughout.

$86.95 *(HB/856/Illus)*

Practical Homicide Investigation: Tactics, Procedures and Forensic Techniques
Vernon J. Gerberth
"The world of the homicide detective is permeated with human tragedies which involve a variety of sudden and violent death scenarios. Many of these events, which are seemingly beyond the comprehension of the average person, reveal motivations and patterns of repetition which are recognized by the experienced homicide detective. Professional homicide investigators become keenly aware of the reality of death and the impact it has on both society and the surviving family. . . . The profession-

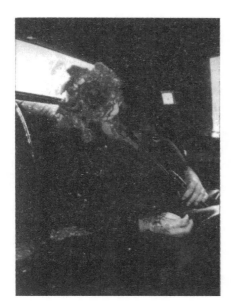

Suicide by rifle. This suicide victim's locale, the interior of a vehicle, shows the effect blast. Note the brain matter on the interior roof as well as back seat of the car. The victim committed suicide by placing the barrel of a .308 rifle into his mouth and pulling the trigger. — from **Practical Homicide Investigation**

al homicide investigator must learn to deal with death in a clinical manner."

At nearly 1,000 pages, this is a handbook expressly for the professional detective, extensively illustrated, including such morbid gems of police photography as a suicide by rifle fire to the face; evisceration and anthropophagy ("Subject engaged in postmortem mutilation of the victim's body. He eviscerated her and removed her ovaries, which he consumed"); contents of a "murder kit" (a camcorder with an x-rated porno tape, black nylon stockings and fishnet stockings, a pair of gloves, a bottle of chloroform with a mask, a syringe containing a horse tranquilizer, a bondage gag, two clothes pins and a number of pre-tied ropes with slip knots); a female victim posed for "shock value" with a shotgun placed into her vagina; Ted Bundy shortly before his execution; and hundreds more. Also features Jeffrey Dahmer's personal Polaroids of posed victims and decapitated heads and body parts courtesy of the Milwaukee Police Department. Chapters include: "The Homicide Crime Scene," "Specific Investigative Duties at the Scene," "The

Crime Scene Photographs," "The Crime Scene Sketch," "The Homicide Crime Scene Search," "Estimating the Time of Death," "The Identity of the Deceased," "Suicide Investigation," "The Investigation of Sex-Related Homicides," "Homosexual Homicides," "The Autopsy," "The News Media in Homicide Investigations," "Identification of Suspects" and "Investigative Assessment: Criminal Personality Profiling."

$58.00 *(HB/599/Illus)*

The Practical Methodology of Forensic Photography
David R. Redsicker

"Photographic documentation of evidence for presentation of an argument in a court of law is forensic photography. . . . The purpose of this text is twofold; first, to bring together in one readily available resource all the latest methods of photographic documentation, including the old tried-and-true methods with cameras, film and lighting sources as well as new procedures involving video and thermography. Second and most important, the format of the text is a practical step-by-step application of forensic photography. Students and professionals alike will be capable of using any camera together with the aid of this methodology in producing their own photographic documentation." Covers still photography for fire/crime scenes, motor-vehicle accident scenes, aerial and underwater photography, surveillance photography, photographic aspects of physical injuries and fatalities, evidence documentation and legal aspects of visual evidence.

$50.00 *(HB/292/Illus)*

Sex Crimes Investigation
Burt Rapp

This slim gray volume, "sold for entertainment purposes only," offers the sort of rarefied entertainment derived from forensic checklists: Don't forget to swab for semen in the rectum of the corpse as well as the vagina! And while looking through the garbage for bloody underwear may not be a pleasant task, the reader might be consoled by the fact that the murdered victim at least will not offer the emotional resistance so often encountered from the living. Learn the trade secrets of the "Murphy Man" or the "Badger Game"! How much booze can a vice officer consume in the course of his undercover work? Learn how to spot pimps: it's "fairly simple. Many wear the pimp uniform: long coat and wide-brimmed 'Superfly' hat." All in all, the street-level insights seem to have some basis in reality, but the latter chapters regarding "sex rings" of the telecommunicative sort seem technically clueless and outdated. The author's suggestions on composing "deviant" letters helpful in busting sexually oriented mail fraud alone are worth the price of the book.

RA

$14.95 *(PB/196/Illus)*

The Testimony of Teeth: Forensic Aspects of Human Dentition
Spencer L. Rogers

Contents include "The Anatomy of Teeth and Their Defensive Role," "The Function and Life Cycle of Teeth," "Normal Variations in the Teeth," "Atypical Variations in the Teeth," "Man-Made Variations in Teeth" and "Dental Identification."

$35.95 *(HB/126/Illus)*

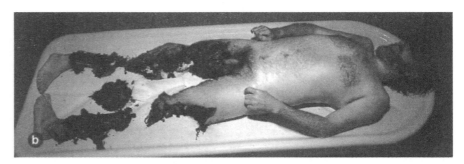

Explosive force declines rapidly from its source and tends to be very directional. The result of a small explosive device having been placed under the driver's seat in a car and detonated by mercury-tilt switch when the vehicle moved off — from **Forensic Medicine**

MURDER CAN BE FUN

One of the best-known zines is *Murder Can Be Fun*, a death-and-disaster journal published by John Marr since 1985. Meticulously researched at libraries and from his own collection of more than 10,000 books, *Murder Can Be Fun* presents the choicest and weirdest anecdotes to a bemused and often goggle-eyed readership. — V. Vale, from *Zines, Volume 2*

Murder Can Be Fun #11: I ♥ Disasters
John Marr
Featuring the Boston Molasses Flood, the Port Chicago Explosion and many other fine mishaps.
$1.50 *(Pamp/32/Illus)*

Murder Can Be Fun #12: The Art of Murder
John Marr
Wallace/Qualtrough, cannibal Sawney Beane, murder connoisseur Thomas de Quincey, plus the 1989 San Francisco quake, book reviews and so on.
$1.50 *(Pamp/32/Illus)*

Murder Can Be Fun #13: Death at Disneyland
John Marr
Plus sex criminal/train wrecker Sylvestre Matuschka, Munich street car/airplane collision, Harry Stephen Keeler, book reviews, etc.
$1.50 *(Pamp/32/Illus)*

Murder Can Be Fun #15: Mormon Cult Killings
John Marr
Plus postal multicide update, the best kiddy ransom kidnappings, '70s confession magazines, book reviews, etc.
$1.50 *(Pamp/32/Illus)*

Murder Can Be Fun #16: Zoo Deaths!
John Marr
A look at what happens when man meets animal in cage plus Lindbergh kidnapping revisionism, the *Journal of Forensic Sciences* and other fun stuff
$2.00 *(Pamp/48/Illus)*

Murder Can Be Fun #17 Naughty Children, 1650-1960:
John Marr
Tales of some of the naughtiest children ever, all from the days when kids supposedly were seen and not heard. Train wreckers, kidnappers, child killers—you name it, the little monsters did it.
$2.00 *(Pamp/48/Illus)*

The Murder Can Be Fun 1997 Datebook
John Marr
Special 10th anniverary edition, with the best dates culled from a decade of datebooks.
$3.00 *(Pamp/64/Illus)*

Natas

Aghora:
At the Left Hand of God
Robert E. Svoboda
"A rare view into the life of a practicing tantric master. Aghora teaches that the world is not as it seems, that reality is obtained by embracing the world rather than renouncing it, and that only by totally giving oneself to the Mother can we break through into the Light."
$19.95 *(PB/328)*

The Airwaves of Zion:
Radio and Religion in
Appalachia
Howard Dorgan
"For over 20 years, Dorgan has been listening to 'airwaves of Zion' programs in the Appalachian regions . . . this ethnographic study provides an overview of radio evangelism in Appalachia . . . Dorgan trains his scholar's eye on four case studies within the genre, capturing not only the unique character of each of the respective programs and stations . . . this book preserves an endangered segment of the Appalachian religious experience, rich in the cultural values and evangelical traditions that make this region unique."
$18.95 *(PB/226/Illus)*

American Jihad:
Islam After Malcolm X
Steven Barboza
Meet a Harvard professor, a practicing polygamist, and a Desert Storm convert—Muslims all. See what a former top official in the U.S. Government , an HIV-positive woman, and a Native American share in their faith. Understand what attracts a young feminist, a college grad, and an ex-hippie to the world of Islam. **SC**
$14.00 *(PB/370/Illus)*

The Apocalypse:
Understanding the Book
of Revelation and the
End of the World
George T. Montague, S.M.
While the cover blurbs tantalize with promises of literalist hysteria and blockbuster special eschatological effects, there are actually disappointingly few references to imminent global warfare. Professor Montague provides instead a scholarly overview of the Book of Revelation, treating it less as cosmic vision and more as consciously constructed parable both chastening and edifying the ancient churches of Asia

Minor. Minimizes Revelation's role as linear historical chronicle, emphasizing instead the reinforcement of ideas through parallel and overlapping narrative, and images borrowed from Hebrew, Classical, Assyrian and Persian mythologies. Along the way, our mild-mannered interpreter fulfills his pastoral duties by deriving a contemporary homily or two from the welter of battling monsters, falling stars and burning mountains. **RA**
$9.99 *(PB/246)*

Apocalypse Culture
Adam Parfrey
A collection of essays—"outlaw anthropology" might be one way to describe the discipline—ranging from the outrageously eccentric to the outright idiotic. Despite the wide array of topics and the varying quality of presentation, the authors appear to be united in their impulse to push the boundaries of the possible, be those boundaries political or religious, psychic or physical. Topics include: "Cut It Off: A Case for Self-Castration"; "Long Live Death!"; "Satori and Pornography: Canonization Through Degradation"; "The Call to Chaos: From Adam to Atom." Though not as profound as

The Apparition, *Gustave Moreau, 1875 — from* **Art and Symbols of the Occult**

its editor would have prospective readers believe, *Apocalypse Culture* is an alternately fascinating and repellent survey of beliefs and world-views which defiantly clock in as outside (that's way outside) the generic and the everyday. Not for the squeamish or politically correct. **MDG**
$12.95 *(PB/362/Illus)*

Art and Symbols of the Occult: Images of Power and Wisdom
James Wasserman

Aleister Crowley defines magic as "the science and art of causing change to occur at will." A complex book on the art and symbols of the occult and their meanings. Many beautiful color reproductions of famous mystical diagrams such as the alchemical tree of life, Buddhist assembly tree, and the Equinox emblem, the official organ of the

A:A magical order founded by Crowley and George C. Jones in 1907. The book also attempts to explain the not-so-brief history of the occult. **DW**
$19.95 *(PB/128/Illus)*

The Bible Handbook
W.P. Ball and G.W. Foote

With fully comprehensive examples of the Bible's many contradictions, absurdities and immoralities, along with documented examples of an overtly antagonistic God's indulgence in atrocities and the unfulfilled prophecies of his representatives here on Earth, this book is both the perfect weapon and a potent source of ammunition for those times when our fundamentalist brothers and sisters insist on calling uninvited. Such hardcore Christians might be too indoctrinated to be convinced by mere reason, in which case one can always use

the book to hit them with, which alone justifies a hardback edition. While the Bible remains a much-misquoted and particularly flawed dogmatic tract, it's convenient to have a reference source at hand with more than enough information to counter some of the more outlandish claims made on its behalf. Every school and hotel room should come equipped with this tome. **BW**
$9.00 *(PB/372)*

The Book of Black Magic
A.E. Waite

Since the initial publication of this work, many more books on ceremonial magick have been published, including such historical grimoires as *The Key of Solomon the King.* Despite Waite's pedantic, pretentious and weighty prose style, this book is noteworthy as part of the 19th-century occult revival. Many people are first introduced to the occult by determinedly plodding through Waite's books. This was one of the first books Aleister Crowley read, and it inspired him to further his studies in that arena. Although there are some sections outlining black-magick rituals, Waite covers all sorts of other material too, giving a sort of patchwork-quilt look at the influence of heterodox mystic traditions in the West. There are circles, sigils and lots of silly information galore—just the type of stuff an adolescent might want to draw on the cover of his notebook. The only really enduring magick in this book is the power to frighten suburban moms when their teenage sons start reading it while listening to heavy-metal music. **MM**
$10.95 *(PB/326)*

The Book of Lilith
Barbara Black Koltuv, Ph.D.

Lilith is the long-haired female demon of the night. In various mythologies she is the embodiment of feminine evil; a succubus mounting men in their sleep, a killer of children. According to the Kabbalists, the letters of her name equal the word *screech*, and so she is also known as the demon of screeching. She is the first wife of Adam, often shown by medieval artists as a woman-faced serpent, cagily watching Eve devour the fruit of knowledge. Some tales go so far as to suggest that it was Lilith, not the snake, who whispered temptation into Eve's ear and caused the first human beings to be cast out of Eden. In addition to her negative attributes,

Lilith also represents the powerful natures of feminine sexuality and self-knowledge. Clinical psychologist and Jungian analyst Barbara Black Koltuv maintains that these are the very aspects of Lilith's personality with which modern women must reconcile if they are to attain spiritual wholeness. To that end, *The Book of Lilith* contains myths, legends, poems and stories from various cultures and epochs reflecting the demon's many facets, as well as Koltuv's psychoanalytic commentary and examples from her files. **LP**

$9.95 *(PB/127/Illus)*

Celtic Sacred Landscapes
Nigel Pennick

In ancient Celtic legend, the great giant Gargantua was slain by the gods and his body became the flesh of the Earth, his blood the rivers and seas, and his soul the *anima loci*, the soul of a place. The interaccommodating latticework of Celtic art expresses the form and flow of the soul as it was perceived by Northern European peoples, not only within themselves but throughout the land they inhabited. The Celts, like so many tribal peoples the world over, worshiped the Earth and felt their beings inseparably linked to its sentient spirit. Those places where the link between man and Earth was felt the strongest were venerated as sacred: inviolable superimpositions of the spirit world upon the mortal Earth. *Celtic Sacred Landscapes* is an impressive compendium of the lore of these places. The myths, miracles, rituals and traditions surrounding the origin and perpetuation of the anima loci, as it resides in humble roadside shrines, in springs, caves, labyrinths, mountains, ley lines, cathedrals and many other places, are eloquently described in this handsomely illustrated volume. **DN**

$24.95 *(PB/224/Illus)*

The Cold Black Preach
R.H. deCoy

"DeCoy, noted author of the explosive best-seller *The Nigger Bible*, takes on the black preaching establishment. Tracing the black church in America from its origins as an instrument of oppression in the hands of the slave owners, deCoy fires a powerfully documented broadside at the 'Holy Man and his Holy Pole,' the black preacher who rides the Gravy Train with the sweat-earned money of his sheeplike congregation. DeCoy asserts that the black preacher is still whitey's flunk, a 'head nigger' hired to keep peace between the white exploiters and their black victims. In a devastating section called 'Saving Graces,' deCoy exposes the hustles used by the black preach to line his own pockets and keep his 'flock' submissive."

$2.25 *(PB/217)*

The Coming Persecution: President Bill Clinton's Call To Destroy Christianity, April 23, 1995
A. Ralph Epperson

The proof we've been waiting for that THE CONSPIRACY is REAL! Using the evil Masons' own writings, Epperson proves beyond any possible doubt that when President Clinton, speaking at a memorial service after the Oklahoma City bombing, said, "I say one thing we those who have sacrificed have the duty to purge ourselves of the DARK FORCES which gave rise to this evil," what he really meant was: "the duty to purge ourselves of CHRISTIANITY." He's just using a *secret Masonic coded language*! See? No? Well, you'll just have to read the book to find out why, even though, as Epperson himself admits, "there is no direct

Eliphas Lévi, author of Transcendental Magic *and* The History of Magic — *from* Art and Symbols of the Occult

evidence, as of yet, that Bill Clinton is a member of the Masons," nor that he ever "joined Masonry, nor that he was made aware of their coded language." "However," Epperson shrewdly points out, "that does not mean that he has not joined the Lodge." It's almost worth reading just to see this guy do to logic what M.C. Escher did to architecture. **DB**

$6.00 *(PB/40)*

Compendium Maleficarum
Francisco Maria Guazzo

Extraordinary document (1608) on witchcraft and demonology offers striking insight into the early 17th-century mind. Serious discussions of witches' powers, poisons and their crimes. Examined in detail are witches' alleged powers to transport themselves from place to place, create living dead things, make beasts talk and raise the dead.

$7.95 *(PB/206/Illus)*

The Complete Enochian Dictionary
Donald C. Laycock

This reference work about Enochian magic is not a place for novices to start but rather a reference best used by those already interested in the works of John Dee, the court astrologer and adviser to Elizabeth I, and Edward Kelly, seer and mountebank. The book is a thorough dictionary on the Enochian language which was allegedly received by Dee. The preface by Stephen Skinner and introductory essays by the author provide a brief background for those previously unacquainted with the unique and quite elaborate system of magic in which the Enochian alphabet plays a major part, and the bibliography provides better sources that cover the history and techniques in depth. This reprinted lexicon is a must for anyone who wishes to devote serious study to the abstruse occult anomaly that is Enochian magic. **MM**

$16.95 *(PB/272)*

The Complete Golden Dawn System of Magic
Israel Regardie

In the mid-1980s, Regardie sought to revise and expand his classic encyclopedic tome on the Golden Dawn. His result was an even more massive tome (worthy of being a good doorstop) packed with even more detailed information and a larger section on

Witches form pact with the Devil. — from **Compendium Maleficarum**

Enochian magic. No other magical order has had such a pervasive influence in contemporary occultism as the Golden Dawn. Many people pattern their magical practices after the rites of this Order, founded by Wynn Westcott and MacGregor Mathers when they reputedly found a set of papers containing rituals and instructions. These mysterious documents were supposedly from a Miss Sprengler in Germany, although it is thought by many that Westcott wrote them himself. Many interesting people were associated with the Golden Dawn, such as William Butler Yeats, Maud Gonne, Bram Stoker, Florence Farr and Arthur Machen. The Golden Dawn borrows liberally from the traditions of Freemasonry, Rosicrucianism, Alchemy, Astrology, the Tarot, Kabbalah, the Egyptian pantheon and the Enochian magical system of Dr. John Dee. This is one of the ultimate how-to books available, with instructions on the making of appropriate banners, the ideal space plan of a temple, initiation rites, pentagram rites, Enochian chess and various magical minutiae. **MM**
$49.95 *(HB/1,112)*

The Complete Jack Chick Tract Assortment
Jack Chick
"You might be too shy to walk up to people and begin sharing Christ with them. But that doesn't mean you can't have an effective soul-winning ministry. Just leave the Chick tracts behind wherever you go. People will pick them up and read them. Nobody

can resist them." Especially such classics tracts as "The Sissy?," "The Death Cookie," "Bad Bob!," and "Somebody Goofed."
$10.00 *(Pamp/Illus)*

The Concise Lexicon of the Occult
Gerina Dunwich
"GHEDE: In voodoo, the loa of death Ghede is the loa invoked at the close of every Rada ceremony. He is said to dress in the colorful attire of a clown or court jester, and often wears between his legs a giant wooden phallus, sings dirty songs in a nasal voice and delights in embarrassing people in a sexual way (see RADA, see LOA, see VOODOO). . . . NAVKY: In Slavic folklore, the spirits of unbaptized or murdered children who appear as baby girls rocking in tree branches and wailing in the night. It is said that some navky beg passersby for baptism, while other, more vengeful ones, lure unwitting travelers into dangerous places. In Yugoslavia, the navky are said to appear in the form of great black birds whose cries could chill the soul of a man . . . (see BAPTISM)." **GR**
$7.95 *(PB/215)*

Cosmos, Chaos, and the World To Come: The Ancient Roots of Apocalyptic Faith
Norman Cohn
The author has done an admirable job of thoroughly researching his subject.

Weaving a virtual tapestry of apocalyptic exegesis, the author transports the reader through the various stages of mankind's apocalyptic visions, from Egypt to Persia, ancient Mesopotamia, India and, of course, Judaic and Christian revelations. **JB**
$15.00 *(PB/271)*

Crimes of Perception
Leonard George
An encyclopedic account of the most significant heresies and heretics that have shaped the conventional world view in Western culture. While emphasizing the heretical currents in Christianity, Judaism and the occult traditions, this volume also includes heresies involved with Eastern Christianity—Monophysitism, Nestorianism, Monotheletism and Bogomilism. The story of heresy, it quickly becomes clear, is one filled with accounts of bravery, stupidity, cruelty, devotion, surrender and awe—"a carnival of human passions," as George describes it. Some of the more bizarre items include: Abraham Abulafia, the 12th-century Spanish messiah who marched on Rome in order to convert the Pope to Judaism; Abbe Guiborg, ringleader of a Satanic group that conducted magic rituals (including human sacrifices) in an attempt to control King Louis XIV's love life; and Brother Twelve, the charismatic mystic who established an Aquarian community (complete with personal harem and heavily armed fortress) on the West Coast during the 1920s. With over 600 detailed entries,

cross-references, a listing of entries organized by topic and an exhaustive bibliography of suggestions for further reading, *Crimes of Perception* is an enjoyable, highly readable collection of the major ideas, practices and persons deemed renegade by orthodoxies throughout Western history.

MDG
$29.95 *(HB/358)*

Cuchama and Sacred Mountains
W.Y. Evans-Wentz
"W.Y. Evans-Wentz, great Buddhist scholar and translator of such now-familiar works as *The Tibetan Book of the Dead* and *The Tibetan Book of the Great Liberation*, spent his final years in California. There, in the shadow of Cuchama, one of the Earth's holiest mountains, he began to explore the astonishing parallels between the spiritual teachings of America's native peoples and that of the deeply mystical Hindus and Tibetans. . . . To Cuchama, "Exalted High Place," came the young Cochimi and Yuma boys for initiation into the mystic rites for their people. In solitude they sought and received guidance and wisdom. In this same way, the peoples of ancient Greece, the Hebrews, the early Christians, and the Hindus had found access to inner truth on their own holy mountains; and in this same way must the modern person find the path to inner knowing."

$14.95 *(PB/196/Illus)*

The Death and Resurrection of the Beloved Son: The Transfiguration of Child Sacrifice in Judaism and Christianity
Jon D. Levenson
A Jewish theologian and expert in ancient Near Eastern languages at Harvard University demonstrates how the shared historic basis of Judaism and Christianity is in child sacrifice—the "offering of the first-born son." Through cross-cultural comparisons to Canaanite and Phoenician religious practices and contemporary interpretations of the original Hebrew and Aramaic Bible verses, Levenson explores how the practice of ritually sacrificing the first-born son was once a demonstration of extreme piety in ancient Israel—substitution of an animal like a ram was an option for the less devout petitioners to Yahweh. Establishes parallels between Abraham's near-sacrifice of Isaac (substituted for by a lamb) and God's sacrifice of his own beloved first son, Jesus (also known as the Lamb). **SS**
$14.00 *(PB/257)*

Demons in the World Today
Merrill Unger and Brooks Alexander
"A lonely man attends a seance, seeking to communicate with the spirit of his deceased wife. A woman is anxious about the future, and her friend points her to the horoscope column in the daily paper. Schoolgirls join a witches' coven and prac-

tice hexes on classmates! A study of the occult in light of God's Word. This book exposes the power of demonic spirits and points the way to deliverance."

$5.99 *(PB/336)*

The Devil: Perceptions of Evil from Antiquity to Primitive Christianity†
Satan: The Early Christian Tradition††
Lucifer: The Devil in the Middle Ages†††
Mephistopheles: The Devil in the Modern World††††
The Prince of Darkness: Radical Evil and the Power of Good in History†††††
Jeffrey Burton Russell
God has one book (the Bible), and the devil has five in this colorful series on the philosophy, theology, art, literature and popular culture of Christian demonology. "This series constitutes the most complete historical study ever made of the figure called the second most famous personage in Christianity." **GR**

†**$13.95**	*(PB/276/Illus)*
††**$13.95**	*(PB/258/Illus)*
†††**$14.95**	*(PB/356/Illus)*
††††**$14.95**	*(PB/333/Illus)*
†††††**$13.95**	*(PB/288/Illus)*

Asrael, the Angel of Death — from **Encounters With Death**

The Devil's Dictionary
Ambrose Bierce
Barbed, bitter, brilliant witticisms in the form of a dictionary: "CONTEMPT, n. The feeling of a prudent man for an enemy who is too formidable safely to be opposed. EGOIST, A person of low taste, more interested in himself than in me. MAUSOLEUM, n. The final and funniest folly of the rich."
$1.00 *(PB/139)*

The Devil's Disciples: Makers of the Salem Witchcraft Trials
Peter Charles Hoffer
The author meticulously investigates the outbreak of hysteria in the small Massachusetts colony of Salem, which led to the infamous witch-hunt conducted under the auspices of the tyrannical Cotton Mather. His presentation of materials from the trials along with his unique interpretation provides a glimpse into the bizarre apparatus propelled by religious fanaticism and superstition, which unleashed the scourge of God against the accused and hapless "witches" and "sorcerers." **JB**
$29.95 *(HB/279)*

The Devil's Disciples: The Truth About Rock
Jeff Godwin
"Read about: What REALLY goes on at rock concerts; Satanic subliminals and back-masked messages; the 10 most dangerous groups; the Lennon-Manson connection; and how to keep rock out of your town!"
$10.50 *(PB/352)*

The Devils of Loudon
Aldous Huxley
The historical case of a possessed convent of nuns and a village vicar accused of sorcery inspires Huxley's fascinating, learned investigation into the enigma of witchcraft, mass hysteria and personal mysticism.
$12.95 *(PB/352)*

The Discoverie of Witchcraft
Reginald Scot
"Sixteenth-century classic that set out to disprove the existence of witches. In his attempt to expose the absurdity of ideas about the supposed nature of witches, Scot compiled one of the fullest accounts of charges against witches, witch trials and the practice of the black arts. Included are excerpts from writers of the Spanish Inquisition, interviews with convicted witches and opinions of medical authorities. Scot discusses poisoners, jugglers, conjurers, charmers, soothsayers, figure-casters, dreamers, alchemists and astrologers and, in turn, sets down the actual practices of each group and shows how the acts depend not upon the devil but upon either trickery or skill. King James later found Scot's opinion so heretical that he ordered all copies of his book to be burned."
$11.95 *(PB/283/Illus)*

Encounters With Death
Leilah Wendell
"A unique compendium of anthropomorphic personifications of Death from historical to present-day phenomena including traditional and non-traditional death encounters told in the words of those who have experienced this growing phenomenon: 'Three years ago I had surgery to have a cyst removed from my ovary. I was not doing too well after the operation and I kept slipping into darkness. I would fight my way "back"' each time. Once I saw Death as a handsome lover waiting for me in the corner of the room. He came over, kissed me and said that "it wasn't time to be together yet." At that moment I wanted to go with Him but was jolted back, and my recovery after that point was amazing.'"
$17.95 *(PB/350)*

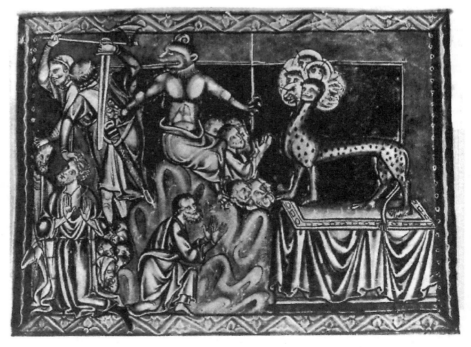

The De Quincey Apocalypse, "The Worship of the Beast," England, 13th-century. Satan's last and greatest ally, the enthroned Antichrist orders the execution of the saints who will not adore the apocalyptic beast. — from **The Devil**

An Encyclopedia of Claims, Frauds and Hoaxes of the Occult and Supernatural
James Randi

This book contains information on a wide-ranging variety of subjects, but the tone of it is so snide and dismissive of them that one wonders why the author even bothered to write the book. The author is an escape artist like Houdini, and in the tradition of Houdini he likes to debunk faux magic. This attitude is fine when exposing things like the levitation of tables, spirit writing and other parlor tricks. It gets a little wearing when used to describe historical or traditional things. Writing of the I Ching the author states: " . . . it is probably as a form of self-administered pop psychology that the system finds any value whatsoever." The single-page synopsis of the entire Bible is funny in ways that perhaps were not intended. When the author is not being glib and clever it can be a useful resource. One place where the humor is absolutely on target is a closing appendix on "Forty-nine-End-of-the-World-Prophecies-That-Failed."
SA
$24.95 *(HB/284/Illus)*

The Encyclopedia of Witches and Witchcraft
Rosemary Ellen Guiley

An A-Z of the people, myths and practices of witchcraft from the beginning of time to the contemporary. Featuring over 400 entries and over 100 illustrations, this is a relatively complete guide spanning the last couple thousand years. From "Hecate" to "Hocus-Pocus" there's everything for the initiated seeker. The best things about this book are the photos and listings of famous contemporary witches: Laurie Cabot looking like Cher from her Vegas days; Z Budapest playing the foxy feminist radio DJ; and Dr. Leo Louis Martello resembling a collared Charles Manson. These biographies alone make this encyclopedia unique because most witches dictionaries list only the gods and goddesses and not the humans who make it all happen.
MDH
$19.95 *(HB/432/Illus)*

The End-Times Blood Bath
Robert J. Logston

"The Rapture . . . The Beast . . . The False Prophet . . . The Four Horsemen . . . It is foretold that during the end-times two-thirds

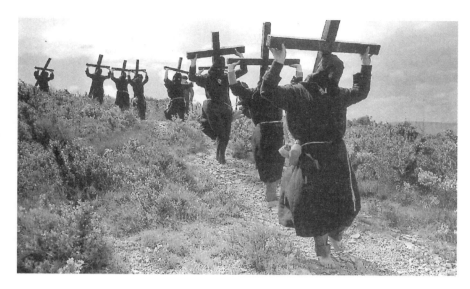

Top: The Trinity, *1980. Bottom:* Wax Heads, *1977 — from* España Oculta

of the 5 billion people on the Earth will die and Christ will return for the remaining Christians. Reading this book will introduce you to the main players and prepare you for the reign of the Beast."
$7.95 *(PB/100)*

Epilogemena: A Brief Summary of the Origins of Greek Religions
Jane E. Harrison

"An examination of the Greeks from primitive ritual to the Rites of Eleusis. This is a superb piece of material on the Mysteries."
$7.95 *(PB)*

España Occulta: Public Celebrations in Spain, 1974-1989
Cristina García Rodero

A collection of 126 haunting, large-format photos taken over a 15-year period which bring out the intrinsically surreal aspects of life in current-day rural Spain. Children impaled on crosses, ominous masked penitents, phallic street processions, rampaging bulls, fierce drag queens, midget toreadors, cheerful and seemingly inbred revelers, the mysterious march of the "wax-heads"—the semi-pagan, semi-medieval public festivals which inspired Luis Buñuel from his child-

hood onward are depicted in all their brooding glory. **SS**

$39.95 *(PB/135/Illus)*

Eve of Destruction: Prophecies, Theories and Preparations for the End of the World
Eva Shaw

The world's been going to hell in a hand basket since the beginning of recorded history. All hell broke loose during A.D. 1000. The year 2000 won't be any different. Folks are already taking bets on the date. Shaw's book takes on apocalyptic thinking at full throttle with the history of The End through various religions, cult leaders (remember that a religion is only a successful cult) and scientific hysteria—everything from the Catholic Church, which stated in A.D. 999 that the rapture would be here the next year, to the joys of nuclear winter to the countdown to the final date of December 12, 2012, as proclaimed by Terence McKenna and Jose Argüelles. So far, however all nigh-sayers have been wrong and they will most likely continue to be so. **SC**

$15.00 *(PB/238)*

Evil, Sexuality and Disease in Grünewald's Body of Christ
Eugene Monick

The Isenheim altarpiece, painted sometime around 1515 by a man known now as Grünewald, is the touchstone of this work of dark fantasy and bold speculation on evil and the divine. Boils and black pustules being more evident in this multipanel painting than the conventionally depicted lacerations, Grünewald's pestilent Christ suffers from the inside out. He thus embodies evil, and, seen this way, is a unique and powerful symbol to the syphilitic patients for whom the altarpiece was painted, and, by extension, for us today.

After establishing evil and disease as being correlative with the beauty and blessing of sensuality, Monick presents his most startling passages. He imagines potent, archetypal sexual relations between Christ and the four main figures who appear with Him in the Crucifixion panel: John the Evangelist, Mary, Mary Magdalene and John the Baptist. What if Jesus lived as a man and through sexual love contracted syphilis?

The cover of a British-published attack on the immorality of the screen — from **Behind the Mask of Innocence**

"Once one is contagious, involved personally in the inexorable illness, Grünewald's crucified Christ might be seen as I imagine the Isenheim patients might have seen that stark image dominating their chapel: a revolutionary picture of psychological reality quite aside from one's faith in a particular religious system. Moralizing about sexual preference and behavior becomes irrelevant; the issue is sickness and death. Even the gods get sick and die, as the Isenheim Crucifixion demonstrates."

At times irritatingly personal, this book is also expansive and imaginative, dealing, as it does, with "paradox rather than reason, [as] a guiding principle of psychological truth." Included are interesting discussions of homeopathy and the medical establishment, Susan Sontag, Tim Rollins and KOS, and an illuminating comparison of Grünewald and Albrecht Dürer, who was his contemporary. The author opens up many doors through his meditations on this rich icon. **JTW**

$18.50 *(PB/189/Illus)*

The Evil Eye in the Bible and Rabbinical Literature
Rivkah Ulmer

Though mentioned only a few times in the Hebrew Bible, the notion of the "evil eye" figures frequently in the Talmud, Zohar and *midrashim*. It was, in fact, commonly assumed that many of the most revered rabbis themselves wielded this power against listeners unreceptive to their message. Much of the evidence produced in this volume demonstrates how this belief has been used to reinforce obedience to the mitzvahs. We learn that the evil eye was often equated with an envious glance, and that the sin of envy, in turn, was often produced by ostentatious displays of wealth or some form of vanity which would bring the recipient into a position of high visibility and therefore vulnerability. The evil eye is also associated with the taboo on the exchange of prolonged gazes between the sexes, a reason for the veil and the expression "setting one's eye on" to euphemistically denote sexual conquest. The hypnotic power of the kohl-blackened feminine eye is discussed as is the inescapable gaze of the Angel of Death, whom the Talmud describes as being completely covered with eyes.

The representation of ritualistic countermeasures by magical charms, such as a "spoken" spell worn as a scroll or a protective gesture of the hand "frozen" in a five-fingered amulet is likened to the religious use of phylacteries worn in the temple, the household mezuzah (inscriptions on door post) as well as later more secular forms of feminine jewelry. Spitting and obscene gestures, it turns out, are also particularly efficacious against the evil eye, and the various rabbinical sources quoted on these topics are by turns entertainingly self-effacing and earthy. **RA**

$29.50 *(HB/213)*

Feet of Clay: Saints, Sinners and Madmen — A Study of Genius
Anthony Storr

"In vivid portraits of some of history's most intriguing gurus, from David Koresh to Freud and Jung to Jesus, Storr examines why we are so enthralled with certain dogmatic figures who play on our need for certainty. Gurus are extraordinary individuals who cast doubt upon current psychiatric distinctions between sanity and madness. . . . Storr reveals how the adoration for the guru can so easily corrupt him and explains why certain gurus become moral parasites while others become spiritual beacons." Also covers Rudolph Steiner, Gurdjieff, Rajneesh and Ignatius of Loyola."

$24.00 *(HB/253/Illus)*

Forgiven: The Rise and Fall of Jim Bakker and the PTL Ministry
Charles E. Shepard

"In *Forgiven*, Shepard analyzes how Bakker won the allegiance of so many and details Bakker's early years and PTL's birth, blossoming and headline-making decline. Truly a landmark work, *Forgiven* delves beneath the PTL scandal to illuminate the fascinating inner workings of a major TV ministry, the hazards of the strange alliance between television and church, and the power of television in our culture today. . . . This trade paperback edition includes new and updated material on the trial, sentencing and imprisonment of Jim Bakker."

$14.95 *(PB/649/Illus)*

Freedom Is a Two-Edged Sword
John Whiteside Parsons

A collection of essays on the nature of ethical, moral, social and magical dilemmas facing both the individual and society, written by Parsons, a rocket scientist, explosives expert and founder of the Jet Propulsion Laboratory who blew himself to pieces in a laboratory accident in 1952, and who has since had the rare distinction of having a

Jack Parsons, author of Freedom Is a Two-Edged Sword

lunar crater named after him. Interestingly, as "Frater 210," he was also at one time head of the OTO lodge in California, a close confidant of Crowley's who believed himself instrumental in receiving the unpublished fourth part of AL, the Book of Babalon, in a

magical concert with L. Ron Hubbard. While the ideological beliefs are open to question, this is nevertheless a refreshingly intelligent perspective of one man's personal application of magick. **BW**

$9.95 *(PB/94)*

God Exists! Evidence for the Skeptic
A. Ralph Epperson

Have you ever wondered whether the existence of God can be proved? Well, now you can stop wondering. Ralph Epperson has the answers you have been searching for. Whereas thousands of volumes and millions of words have been needlessly wasted on this subject, Epperson has condensed his argument down to just 24 pages. **JB**

$5.00 *(PB/24)*

God, Harlem USA: The Father Divine Story
Jill Watts

The story of the ultrawealthy and powerful New York preacher who overcame poverty and racial inequality, and who (in a well-publicized meeting) gave Jim Jones the courage to take the long march. Father Divine's flashy affluence and enthusiastic sexcapades also later made him a role model for the likes of Rev. Ike, Jimmy Swaggart, Jim Bakker and Dr. Gene Scott, yet he built his flock and fanatical following without television, on personal charisma and politics alone. This detailed biography covers every significant event and exploit in Father Divine's rise to prominence, and shows the miserable lives of those who gave theirs over to him, lured by the notion that "God is practical, not spiritual." **MS**

$13.00 *(PB/249/Illus)*

The God of the Witches
Margaret Alice Murray

"The God of the old religion becomes the Devil of the new." A lucidly written masterpiece of anthropological writing which follows the ritual worship of the "Horned God." This Dionysiac deity has taken many forms since his early worship in the caves through the Middle Ages. The author goes into great detail concerning the idea of "the dying God," a sacrifice of a king or leader to encourage fertility of the crops (an idea explored so beautifully in the film, *The Wicker Man*). Murray posits that Joan of Arc and Gilles de Rais were prominent guiding mystical lights of good and evil whose

deaths may both be seen as ritual sacrifices. Most interesting is Murray's unusual sympathy for the "old religion." This book helped to dispel the cliché image of frightening, snaggle-toothed medieval witches casting death spells. We learn that the world's oldest religion has always been very much alive, a religion "as old as humankind itself." Rich with many an example of the "interesting survival of a primitive rite," this book is part of the seminal literature which inspired the flowering of modern paganism. **CS**

$9.95 *(PB/212/Illus)*

Gods, Demons and Symbols of Ancient Mesopotamia: An Illustrated Dictionary
Jeremy Black and Anthony Green

Ancient Mesopotamia is credited with the invention of written language and the development of sophisticated urban society. The period covered by this book is from about 3000 B.C. to the Christian era. It is organized like an encyclopedia with alphabetical entries and looks to be about as definitive as any layperson would ever need. This is the sort of reference work that invites a cover-to-cover reading. It is copiously illustrated with drawings, maps and photographs (of artifacts) and is cross-referenced with a clear eye to affording the reference user as much information as possible. Preceding the encyclopedia portion is an overview divided into three sections: people and places, art and iconography, and periods. **SA**

$19.95 *(PB/192/Illus)*

The Golden Bough
Sir James George Frazer

One of the lasting contributions of Frazer's *Golden Bough* is that it confers on the reader the ability to decipher John Boorman films. With the complete text running over 8,000 pages (go to the library for all 22 volumes) and the average abridgement running at least 1,000, it is clearly one of the weightiest tomes around. Frazer's encyclopedic display of fertility religions, taboo, and primitive folk magic and customs is an unparalleled record of a vanished past. One example that particularly stands out is the rites described surrounding Attis and Cybele regarding autocastration (you'll never look at a pine cone in quite the same way again). Frazer's study isn't all serious and dour. He

relates a story of the acquisition of sacred kingship, the practice by which the most virile man kills his predecessor in hand-to-hand combat, thereby ensuring the fecundity of crops. Frazer then digresses to tell how the emperor Caligula (the secular Roman ruler) sent the best gladiator from the arena to kill Diana's King of Nemi (the religious Roman ruler) so that he could further extend his power. Contemporary portrayals of indigenous peoples being noble à la Rousseau are nowhere to be found in *The Golden Bough*. Frazer is clearly Victorian in both his attitudes of superiority toward them and his desire to catalog the minutest aspects of their lives. **MM**

$16.00 *(PB/864)*

Gothic High: Meditations on the Construction of Gothic Cathedrals
Goldian VandenBroeck

Poetic ode, in sonnet form, to the vault, the arch and the flying buttress. "Ever since they were first built, the great medieval cathedrals of Europe have inspired successive generations of pilgrims, worshipers and casual visitors. Everyone who steps into these monuments of wisdom is touched and taught by their presence . . . Reading these words—laid down like stones—in light of their matching images, we are able to enter not only the spirit of the builders but the very process whereby the buildings, stone by stone, erect their meaning and philosophy." **GR**

$14.95 *(PB/128/Illus)*

Gypsy Sorcery and Fortune Telling
Charles Godfrey Leland

The origins and history of the Gypsies are obscure, yet their reputation as soothsayers has never diminished over the ages. Leland's book is well-written and well-researched. Scores of conjurings for all purposes are presented in this book of Gypsy folklore and sorcery. Indeed, the author writes: "As their peculiar perfume is the chief association with spices, so sorcery is allied in every memory to the Gypsies." Alas, in present-day Los Angeles, one sees less of the romantic, mysterious sorcerer and more of the Gypsy who stops you in a parking lot and asks to pound out the dents in your car for a fee. **JB**

$12.95 *(PB/271/Illus)*

Heretic's Guide to the Bible
Edited by Chaz Bufe

A series of quotes from the Bible itself, pointing out, in its own words, its cruelty, sadism, insanity, irrationality and sexism.

AK

$1.50 *(Pamp/12)*

The Hidden Dangers of the Rainbow: The New Age Movement and Our Coming Age of Barbarism
Constance Cumbey

"A vivid exposé of the New Age movement, which the author reveals is dedicated to wiping out Christianity and establishing a one-world order. This movement meets the test of prophecy concerning the Antichrist."

$8.99 *(PB/268)*

The History of the Devil and the Idea of Evil
Paul Carus

First published in 1900, Carus' book funnels all myths and religious imagery through time and space to get to the great black heart of the matter. "Evil personified appears at first sight repulsive. But the more we study the personality of the Devil, the more fascinating it becomes . . . The Devil is the rebel of the cosmos, the independent in the empire of a tyrant, the exception to the rule, the craving for originality; he overturns the monotony that would permeate the cosmic spheres if every atom in unconscious righteousness and with pious obedience slavishly followed a generally prescribed course." **SK**

$16.95 *(PB/496/Illus)*

The History of Magic
Eliphas Levi

This remains one of the most entertaining books on magic. The lively prose is not marred by Waite's usually heavy-handed approach. There is more lore of magic than material on magic itself. Levi's stories are historical but one sometimes wonders about the veracity of certain facts. His storytelling is so engrossing that one hardly minds a confabulation or two. This densely packed text covers Levi's definition of magic, biblical sources, Zoroaster, Greek, Indian and Hermetic magic, the Kabbalah, mysticism, ancient cults, paganism, Satanism, sorcerers, magicians, persecu-

tions, popes and alchemists. His accounts of Saint Germain, Cagliostro and other 18th-century notables are particularly entertaining. Although illustrated with many Hermetic images, Levi keeps this book free of long digressions about this philosophy of magic. That he saves for *Transcendental Magic (Dogme et Ritual de la Haute Magie)*. This book is a fast read and a quick way to pick up occult lore and learn fascinating tidbits about those in the past who were associated with magical practices. **MM**

$14.95 *(PB/384)*

The History of Witchcraft
Montague Summers

Summers was a self-appointed man on a mission from God. He was thoroughly convinced of the truthfulness of every accusation concerning witchcraft and devil worship handed down through the ages. With this concept in mind, Summers embarked upon a singularly curious career in researching, cataloging and collating every such accusation he could lay his hands on. Summers was a highly gifted writer, intelligent, if superstitious, and educated. He wrote a great number of books, all dedicated to his favorite subjects: witchcraft, Satanism and diabolic possessions. *The History of Witchcraft* is one of the most popular of Summers' books, which covers all of the aforementioned topics. Nary a lascivious or shocking detail is omitted in his scrutinizing and painstaking work. Here are a few excerpts: Lord Fountainhall, in describing the devilish communion of the Loudian witches, says: "the drink was sometimes blood, sometimes black moss water." Or this: "when the blasphemous liturgy of the Sabbat was done all present gave themselves up to the most promiscuous debauchery, only interrupting their lasciviousness to dance or to spur themselves on to new enormities by spiced foods and copious draughts of wine." **JB**

$12.95 *(PB/353)*

Hostage to the Devil: The Possession and Exorcism of Five Americans
Malachi Martin

Next time you're having a chuckle over the sub-soap opera antics of the various Greek gods, take a second to consider the behavior of the major players in the Judeo-Christian pantheon. For an omnipotent being that

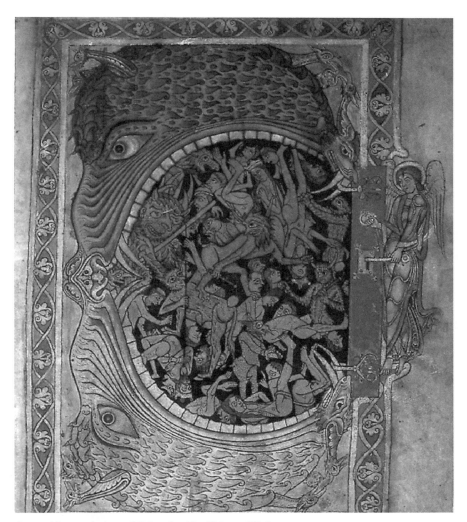

An angel fastens the Jaws of Hell. — *from* **The History of Hell**

mixed with a Pythonesque absurdity—that seems to be the main form of social interaction for the current, better-educated generation of parasitic imps. What demons really are is a matter that's open for speculation: whether they are actual malefic minions of Satan or merely a manifestation of some wholly banal electrochemical brain anomaly, there is definitely something going on here, and it is undeniably real.

Unfortunately, except for some kooky names like Uncle Ponto, Girl-Fixer and "The Tortoise," the demons in this book are not quite as fond of free association as many I've read about. (Some of the best demon/exorcist banter is found in the book *The Demonologist* by Ed and Lorraine Warren.) These guys pretty much stick to the standard "your mother sucks cocks in Hell" motif, but there's still some great high-yield nuclear insults, delivered with an attitude from . . . well, you know. Try this caustic quip from "Smiler," a demon possessing a lapsed Roman Catholic girl, next time somebody is in need of a little reality check: *"You ugly sod! You smelly little animal! You helpless, yelping, puking, licking, slavering, sweating, excreting little cur. You constipated shit canister. You excuse for a being. You lump of urine and excrement and snot and mud born in a bed on bloody sheets, sticking your head out between a woman's smelly legs and bawling them when they slapped your arse and laughed at your little red balls—you . . . creature!"* Owee! It's lines like this that forced the Holy See to add the phrase "I know you are but what am I?" to the Holy rite of exorcism in the Ordinatio Sacerdotalis proclamation of 1994. **DB**
$13.00 *(PB/477)*

Icons of American Protestantism: The Art of Warner Sallman

Edited by David Morgan

"From earliest childhood I have loved Jesus Christ and wanted to serve him," said Warner Sallman, and serve him he did—to over 500 million mostly Protestant consumers between 1940 and 1984. *The Head of Christ* is perhaps the world's most popular image, bringing wallet-size comfort and protection to millions of U.S. soldiers in World War II courtesy of the Salvation Army and the YMCA, inspiring countless conversions and reportedly weeping tears of blood in Roswell, New Mexico, in 1979. It has been admired as "a true portrait of Christ,"

created the entire universe and his former second-in-command, who still holds some rather impressive titles (like "Prince of this World," for instance), the maturity level is way below that of most suburban junior high school student mortals. With as long as God and Satan have had to work out their relationship (a few thousand years, even by the creationists' count), one might assume that if they haven't figured out how to get along, then they could at least keep their petty bickering and ridiculous power games between themselves instead of using a bunch of poor, dumb humans to fight their silly battles with. All this demonic possession/exorcism nonsense—it's like a couple going through a divorce who, instead of talking things over and eventually coming to some kind of civilized understanding, just

get their pet chihuahuas all riled up and toss 'em in a pit to bark at each other until one passes out or drops dead. And these aren't some rinky-dink, Third World, B-list deities either—these guys represent both ends of what for some reason is considered one of the "world's great religions." Pathetic!

And nowadays if the demon doesn't cause enough grief for the poor chump caught in the middle of these megalomaniacs' ludicrous tug o' war over—of all the things neither of these jokers needs—his soul, the exorcists might stomp him to death to save him! Still, I've got to admit a certain guilty pleasure in reading the sometimes vulgar, often nonsensical, but almost always witty and incisive repartee—mainly a bunch of vicious barbs and insults, occasionally

a perception verified by devotees in actual visions of the savior. Most importantly, it has provided solace when the going gets tough and paved the way for millions of worshipers to a greater intimacy and communion with the Lord.

The six essays that make up this book address different questions raised by Sallmania, exploring the whys and hows of

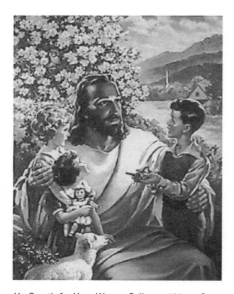

He Careth for You, *Warner Sallman, 1954 — from* **Icons of American Protestantism**

his oeuvre's astounding success. Sallman seems uniquely chosen to have served Christ as an artist: The son of devout Swedish immigrants, young Warner was tutored in painting by his carpenter father. He studied commercial art at the Art Institute of Chicago, then went on to work for some of Chicago's top advertising agencies. There he mastered that most American of skills: the creation of images which can be all things to all people. Mimicking Hollywood glamor shots of the time and creating a feeling of immediacy by following the conventions of contemporary portrait photography, Sallman conjured a Christ which could express whatever an individual's needs dictated. Sallman, though seemingly very sincere, knew not to change the formula when classic Coke was what people wanted: Most of his other famous images feature an identical head of Christ atop a differently postured body in a different setting.

While legions flocked to Sallman's Jesus,

various Protestant factions wrung their hands. Liberal Protestants were embarrassed by it, preferring abstraction, the alienated, revelatory "thinking-man's art." African-Americans and others were angered by its ethnocentrism. Intellectuals saw it as a debased and dangerous product of the proto-fascist culture industry. Alfred Barr, founder of MOMA and son and grandson of Presbyterian ministers, in a buried chapter of his life issued a report from a commission he founded under the auspices of the National Council of Churches' Department of Worship and the Arts. The proclamation called popular images of Jesus "art on the level of cosmetic and tonic advertisements," adding, "They call for iconoclasm." With 14 color and dozens of black-and-white reproductions, this book is a delight for anyone interested in religious iconography, Caucasian culture or popular art. **MH**
$35.00 *(HB/247/Illus)*

In Her Own Words
Joan of Arc

The autobiography of Joan of Arc (1412-1431)—soldier, heroine, martyr, saint—culled from the transcripts and testimonies of her condemnation trials. The broadest, most extraordinary aspect of the life of Joan—the peasant girl from the village of Domremy who, guided by Heavenly voices and visions, successfully lead France into battle against the English only to be burned at the stake for heresy at the age of 19—is that it indeed took place. Events that understandably read like myth—all dictated by her courage, her tenderness, her iron will and unwavering devotion to her countrymen and God—are substantiated herein by documentary proof (from her own articulate mouth as well as from those of her merciless inquisitors). Despite the remarkable and tragic events that defined her brief existence, she possessed, from the beginning, an unconquerable faith that never dimmed—even at the moment of her execution: "I pray you, go to the nearest church, and bring me the cross, and hold it up level with my eyes until I am dead. I would have the cross on which God hung be ever before my eyes while life lasts in me. Jesus, Jesus!" **MDG**
$12.95 *(PB/175/Illus)*

Inside the New Age Nightmare
Randall N. Baer

The devil wears love beads. "For the first

time ever, a New Age leader tells the INSIDE story . . . the tale of seduction, from teenage dabbling in Eastern religions to a meteoric rise in New Age leadership . . . In the midst of a storybook career, Baer had a dramatic and horrifying encounter with the evil forces behind the New Age movement. Experience this mysterious and often bizarre world as Baer exposes the New Age Movement." The author of *Windows of Light: Quartz Crystals and Self-Transformation* has a confession to make: He was brainwashed. **GR**
$8.95 *(PB/202)*

Isis Unveiled
H.P. Blavatsky

The iconoclastic magnum opus of Mme. Blavatsky, the founder of Theosophy and source of 19th-century occultism and spiritualism—"a plea for the recognition of the Hermetic philosophy, the anciently universal World-Religion, as the only possible key to the Absolute in science and theology."

Volume 1, Science, includes "Ancient Traditions Supported by Modern Research," "Psycho-Psychical Phenomena," "Prejudice and Bigotry of Men of Science," "Ancient Cryptic Science," "Man's Yearning for Immortality," "Projecting the Force of the Will," "Turning a River Into Blood, a Vegetable Phenomenon," "The Pantheon of Nihilism," "Philosophy of Levitation," "Suspended Animation," and much more.

Volume 2, Religion, includes "Magic and

Death checkmates a bishop in this panel from a big late-15th-century Dance of Death *window. — from* **King Death**

Sorcery Practiced by Christian Clergy," "Roman Pontiffs Imitators of the Hindu Brahmâtma," "Were the Ancient Egyptians of the Aryan Race?," "Esoteric Doctrines of Buddhism Parodied in Christianity," "The Apocalypse Kabalistic," "Comparative Virgin-worship," "Lying Catholic Saints," "Bloody Records of Christianity," "Strict Lives of Pagan Hierophants," "Freemasonry No Longer Esoteric," "Gnostic and Nazarene Systems Contrasted With Hindu Myths" and so much more.

$33.00 *(PB in slipcase/1,505)*

Jesus, CEO: Using Ancient Wisdom for Visionary Leadership
Laurie Beth Jones
"After many years in business, Jones was struck by the notion that Jesus' leadership approach with his staff ran counter to most of the management styles employed today. . . . Following the example of Jesus— a 'CEO' who took a disorganized 'staff' of 12 and built a thriving enterprise—*Jesus, CEO* details a simple, profound, fresh and often humor-filled approach to motivating and managing others."

$10.95 *(PB/352)*

The Key of Solomon The King
Edited by S. Liddell MacGregor Mathers
Mathers, founding member of the late 19th-century magical Order of the Golden Dawn, assembled this key work of Western Hermetic knowledge from several manuscripts available at the British Museum. *The Key of Solomon* remains one of the best-known historical grimoires. Although the work is reputed to be ancient, the oldest manuscript Mathers works with is from the end of the 16th century. Although it is tempting to cast *The Key of Solomon* into some antique mold like the Masonic Hiramic legend, this volume tells us far more about the Renaissance occult revival than it does about so-called ancient works attributed to the biblical King Solomon. After the 1492 ejection of the Jews from Spain, many settled in Florence—then the hotbed of neo-Platonic and neo-Gnostic thought. Scholars like Pico Della Mirandola were all too eager to graft the Kabbalah onto syncretic Christian and neo-pagan frameworks, thus begetting all the correspondences cobbled by Mathers and later published by Crowley in *777*. The book is

Thieves roasting in Hell: one of several graphic illustrations of the Torments of Hell *in a French illuminated manuscript of the 15th-century — from* King Death

lavishly illustrated with charts of "magical" alphabets, angelic tables and Hebrew-inscribed pentacles. **MM**

$16.00 *(PB/128)*

Larson's Book of Rock
Bob Larson
Focus on the Family's Bob Larson starts off with some tried-and-true Tipper Gore material: Frank Zappa's congressional "Porn Wars" and the Giger-poster-as-kiddie-porn trial of Jello Biafra, then he gay-bashes the New York Dolls (?), Elton John and the general androgyny implied in rock. (Gee, there's a male singer named Alice Cooper who wears makeup!) Larson then proceeds for most of this unintentionally comedic book with the usual who's who of rock stars and how each is Satanic, expressing a ravenous, unrequited lust for Pat Benatar. He really

wants to hit her with his best shot, and so we all must suffer. Let's see, kids use rock music to rebel, but you can deprogram them after reading this book and they will thank you while burning their record collections. "There may be more to Led Zeppelin's success than meets the eye," but the author consoles us with the news that more kids than ever are boogieing to teen rock at Christian discos these days. But won't self-righteous hacks like Larson ever realize that Black Sabbath has always been a Christian band? **MS**

$7.99 *(PB/192)*

Larson's New Book of Cults
Bob Larson
A "cult hero" of sorts himself, Larson is probably best known currently for his inter-

nationally broadcast radio show *Talk Back*, a forum for his unique blend of bleeding-heart liberalism and conservative Christian morality. Larson has developed an entertaining love-hate relationship with the ever-Satanic Boyd Rice, inviting Rice over for dinner in between their legendary on-air battles.

A rock musician back in the mid-'60s (check out his band the Dirty Shames' track "I Don't Care" on the *Pebbles* CD, Volume 8), by the decade's end he became known as one of rock's most vociferous opponents, even going so far as to punctuate his high school assembly anti-rock rants with some righteous solo guitar jams, with a tone grungy enough to wake Kurt Cobain, accompanied only by his blow-dried Bobby Sherman comb-over and enormous side-burns. Now that Satan's involvement with rock music has become old hat since you can't play CDs backwards, Larson has transferred his alarmist mania to an even easier target—the wacky world of cults. His new *Book of Cults* contains everything a "Bible-believing" Christian needs to know about over 100 different cults, from Mormonism to Manson, with each deviation from his own fundamentalist beliefs meticulously itemized.

There's a whole section devoted to "common cult teachings," explaining such un-Christian concepts as enlightenment, meditation and reincarnation; a chapter on "cultic origins" of Christianity's major competitors in the world dogma market; and an "encyclopedia of cults," including such obscurities as the Foundation Faith of the Millennium (the religion formerly known as the Process Church of the Final Judgment), the Asatru Free Assembly, the Holy Order of MANS, Silva Mind Control, the Findhorn Foundation (allegedly a bunch of New Age elf worshipers), the "Love Family" a.k.a. the Church of Armageddon, and Swedenborgianism. Also catalogued are the bulk of the cult-leader A list like Tony Alamo, Da Free John, Rev. Ike, Sai Baba and Elizabeth Clare Prophet; old favorites like the Children of God, the Aetherius Society, Crowleyianity, the Snake Handlers, est, Freemasonry and the "New Age Cults" (all in one handy entry), and some groups that aren't exactly cults but what the heck, like UFOs, martial arts, astrology, trance channeling and, of course the Ku Klux Klan. There are a few glaring omissions, like *Satanism*, for instance, and more under-standably, Heaven's Gate (HIM). Still, if you can ignore some of the more offensive bits of Jay-sus propaganda (like his convoluted explanation of why enlightenment is bad), the new *Book of Cults* is an entertaining read, and thanks to Larson's latent Luciferian tendencies, it contains a lot more well-researched, factual information than your average Christian "reference" work. **DB**

$12.99 *(PB/499)*

Liber Null and Psychonaut
Peter Carroll

Appealing to the lowest common denomi-

Bob Larson, author of Larson's New Book of Cults *and* Larson's Book of Rock

nator of occult fanciers—those wire-rim-spectacled creatures who haunt bookstores in their khaki vests and disheveled hair, who dream of "power" and "magick" but lack the requisite discipline to wade through volumes of complex arcana—this book provides a disappointingly simplistic portrait of contemporary ritual magic. Inspired by the works of Austin Osman Spare and written in a format pioneered by Crowley's *Equinox*, this book lacks the complexity, depth or humor of either Spare's or Crowley's works. Carroll covers an array of so-called white and black magick rituals which appear to be for those already well entrenched in the "magickal" lifestyle, with the accompanying warning that one must be in good health before attempting any of these rituals—a sure invitation for some overweight tuber-cular fellow to snap it right off the shelf. **MM**

$14.95 *(PB/222)*

Life Beyond Death: Selected Lectures by Rudolf Steiner
Rudolf Steiner

Selected lectures by the founder of Anthroposophy, who "suggests that one of the most important tasks for our present civilization is to re-establish living connections with those who have died." Lectures include "Life Between Death and Rebirth," "Metamorphosis of the Memory in the Life after Death," "Life Between Death and a New Incarnation," "The Human Being's Experiences Beyond the Gates of Death," and "On the Connection of the Living and the Dead."

$19.95 *(PB/249)*

Living in the Children of God
David E. Van Zandt

"At the height of the religious ferment of the 1970s, Van Zandt studied firsthand the most vilified of the new radical religious movements—the Children of God, or the Family of Love. By living full-time in COG colonies in England and the Netherlands, first feigning membership and later with the permission of the Family, he produced an informed, insightful and humane report on how COG members function in what seems at first to be a completely bizarre setting. . . . Led by the charismatic David Berg, known as Moses David, the group demands total commitment from its full-time members and proselytizes continuously. Until recently the COG used sex as a proselytizing tool, and it continues to encourage full sexual sharing among group members."

$24.95 *(HB/236/Illus)*

Lord! Why Is My Child a Rebel?: Parents and Kids in Crisis
Jacob Aranza

The author of such exercises in salvation as *Backwards Masking Unmasked*, Aranza turns his utter lack of expertise toward the field of child rearing. Aranza's amusing habit of lurching from point to point, with many a non sequitur left dangling, strains the credulity of even the converted, meaning more laughs per page for the rest of us.

Aranza is convinced teenage rebellion is witchcraft, and the only antidote is the Bible—as if any teen's going to pass up a wild party for a prayer meeting. We can only wish him (and his children) luck. **JM**
$6.99 *(PB/138)*

A Lycanthropy Reader: Werewolves in Western Culture
Edited by Charlotte Otten

"Our understanding of lycanthropy is limited by our association of it with contemporary portrayals of werewolves in horror films and gothic literature. No rational person today believes that a human being can literally be metamorphosed into a wolf, therefore, in the absence of an historical context, the study of werewolves can appear to be a wayward pursuit of the perversely irrational and the sensational. This reader provides the historical context. Drawing on primary sources, it is a comprehensive survey of all aspects of lycanthropy, with a focus on the medieval and Renaissance periods."
$15.95 *(PB/337)*

Madame Blavatsky's Baboon: A History of the Mystics, Mediums and Misfits Who Brought Spiritualism to America
Peter Washington

Washington traces the roots of New Age philosophy from Helena Blavatsky to Rudolf Steiner to Gurdjieff onward. Along the way he probes into the in-fighting and scandals that seemed to be a common occurrence among occult groups, such as C.W. Leadbetter's passion for young men, Blavatsky's chain smoking and general neglect of her health, and Krishnamurti's shrugging off his mantle of world teacher. Throughout the book Washington also makes connections with Theosophy and other occult group's influence on such people as Oscar Wilde, George Bernard Shaw, W.B. Yeats, Frank Lloyd Wright and others. One striking illustration of the old New Age meeting the new New Age is the instance when the Maharishi Mahesh Yogi of TM fame met Krishnamurti while leaving a plane in India. The Maharishi rushed to greet Krishnamurti clutching a flower. Krishnamurti rapidly made his apologies and left. Some time after this encounter he told his friends that he would like to see the Maharishi's balance sheet.

Satan, king of hell, tortures the damned while he is bound to a fiery grill. — from **Lucifer**

Washington tends to focus on the inside dope and scandals within these groups but neglects to see any positive influence that they have had on our culture, such as Blavatsky's reacquainting Indians with their own tradition, generally questioning the materialism of our society and worship of science as God, and fostering the rediscovery of the wisdom of ancient civilizations. The book is a lot of fun to read and many loose threads are connected, but it remains basically one-sided and lacking in wisdom about the subject matter. Incidentally, the title refers to a stuffed baboon Blavatsky kept in her parlor dressed in wing collar, tail and spectacles and holding a copy of *The Origin of Species* in its hand, a reminder to all who came in that in Blavatsky's opinion Darwin was wrong: man was not descended from apes but from spirit beings.
TC
$14.00 *(PB/470/Illus)*

Magical Alphabets
Nigel Pennick

Pennick provides a detailed overview of alphabets that have been associated with magical practices in the West, particularly Hebrew, Greek, runes and Celtic oghams. He outlines the symbolic significance of each of the letters, their numeric attributions and ways they were employed in various gematria or numerology. For example, each

Hebrew letter, being also a number, allows scripture to be appreciated from a mathematically symbolic point of view, sort of like a biblical Brandenburg Concerto. Along with Hebrew and Greek, Pennick might have also chosen to examine Arabicas well. Its absence lends a notable gap in this otherwise lucidly written and well-researched book. Also examined in the book are magical, alchemical and invented alphabets. The lack of material on Dr. John Dee's Enochian language is a notable omission in this section. Although the book is narrower in its scope than it could be, it provides an intriguing look at the uses of alphabets in numerology and other symbolic systems. It is illustrated with tables of alphabets, magic squares and historical applications. **MM**
$12.95 *(PB/256)*

The Meaning of Love
Vladimir Solovyov

For a philosopher intent on illuminating the godliness inherent in each of us, Solovyov sure spends a lot of time talking about sex. "There is only one power which can from within undermine egoism at the root, and really does undermine it, namely love, and chiefly sexual love." Arguing that, at least in lower forms, sexual love is not necessary to reproduction, and, in any

Rudolf Steiner — from **Madame Blavatsky's Baboon**

case, that sexual love between humans does not necessarily result in procreation, Solovyov determines that sexual love exists primarily as a touchstone for cosmic integration.

His approach is scientific. Observing that the whole of biological evolution is toward more individualized organisms, he likewise notes the tendency toward the increasing association of romantic passion with sexual union. He theorizes that since neither "romance" nor "passion" is necessary for successful reproduction, perhaps they are to be seen as an end in themselves. Perhaps they are expressions of the divine in the human sphere. Recognizing our failure to achieve "unity of the all" consciousness, he nonetheless views sexual love as an avenue toward this ideal. "The meaning and worth of love, as a feeling, is that it really forces us, with all our being, to acknowledge for another the same absolute central significance which, because of the power of our egoism, we are conscious of only in our own selves." Solovyov's ideal is the transformation of the world through love, starting with sexual love and continuing outward and resulting in syzygy, the correlation of the individual with the all. **JTW**

$10.95 *(PB/121)*

The Mystery of the Seven Vowels: In Theory and Practice
Joscelyn Godwin

"The seven vowels, which we use every day in speech, are truly mysterious things. Analysis shows that vowels depend on the phenomenon of harmonics, which is at the very basis of music, while our sensitivity to them proves that the human ear is naturally attuned to harmony. When we hear vowels, we are hearing the laws of harmony which are ultimately the laws of numbers that are said to govern the universe. . . . This is the first book on the subject ever to appear in English, and it is unusual in bringing together a number of fields not usually connected: linguistics, harmony, musicology, mythology, the history of religions, esoteric and occult philosophy, vocal exercises and meditational practices. The author discusses systems relating the vowels to planets, tones and colors; he writes of ancient and modern vowel-songs in Gnosticism and ancient magic."

$10.95 *(PB/120/Illus)*

Mirror writing and signatures of the Devil and his cohorts from the alleged pact between Urbain Grandier and Satan, which was exhibited at Grandier's trial, 1634 — from **Mephistopheles**

The Necromantic Ritual Book
Leilah Wendell

A black-and-silver gothic pamphlet with spooky Grim Reaper woodcuts printed in an annoying, hard-to-read, black-letter typeface. The book reminds me of a high school print-shop project by a *Propaganda* magazine reader. Wendell describes rituals intended to understand, revere and love Azrael, the Angel of Death. That includes "love" in the physical sense of necrophilia ("At this point, do not supress your desires. Give into them and follow their lead"). While there is much talk about purity of heart, sanctity of the "catalyst"/corpse, etc., the ritual involves disinterring a corpse, stuffing an amethyst inside ("If the body is sufficiently decom-

posed . . . "), holding its hand, and making love to the corpse if it "makes the first move"! Pray to the angel Mikael for support if your friends don't understand your elevated desires. Wendell tells us that "the Death energy is meant to be savored slowly like a fine wine, not guzzled like a six-pack of Bud!" Wendell recommends Taylor's Tawny Port Wine instead. **RP**
$6.50 *(PB/50/Illus)*

The New Knighthood: A History of the Order of the Temple
Malcolm Barber
The rise and fall of red-crossed Knights Templar crusaders. The origins, the flourishing, the suppression and the afterlife. "The Order of the Temple, founded in 1119 to protect pilgrims around Jerusalem, developed into one of the most influential corporations in the medieval world. It has retained its hold on the modern imagination, thanks to the dramatic events of the Templars' trial and abolition 200 years later, and has been invoked in historical mysteries from Masonic conspiracy to the survival of the Turin shroud." **GR**
$11.95 *(PB/441/Illus)*

The Occult Underground
James Webb
"Just when it seemed that Science and Reason had scored their greatest triumphs, the mid-19th century witnessed an astonishing rebirth of occultism and anti-rationalism . . . A secret tradition of knowledge rejected by the Christian or scientific establishments suddenly became emboldened to seek publicity and converts. Webb's painstaking researches carry him into the undergrowth inhabited by such illuminated personages as Mme. Blavatsky, the Rev. Leadbeater, the Brotherhood of Luxor, Annie Besant, Krishnamurti, Swami Vivekenanda, Spiritualists, Rosicrucians, Vegetarians, Mithraic cults, and all manner of occult propagandists."
$14.95 *(PB/535)*

Oriental Magic
Idries Shah
Noted Afghani Sufi scholar Shah investigates magical rituals and beliefs in the East. Includes Jewish, Iranian, Arabian, Indian and Egyptian Magic; the occult in Babylonia; Ju-ju Land of the Twin Niles; the fakirs and their doctrines; wonder-workers

of Tibet; Indian Alchemy today, legends of the sorcerers and more.
$48.00 *(HB/206)*

Our Pagan Christmas
R.J. Condon
Published by the American Atheist Press, this pamphlet traces the origins of Christmas back to its original pagan roots. Yes, the word *Christmas*, is, of course, Christian, but it was unknown until the 11th century! Many unknown facts are revealed for the edification of the reader, along with a number of illustrations. **JB**
$1.50 *(Pamp/20/Illus)*

An Outline of Occult Science
Rudolf Steiner
"Following an introduction to the invisible nature of the human being—including sleep, dreams, after-death experiences and reincarnation—the heart of the book opens into a systematic description of cosmic evolution beyond the limits of space and time. Steiner portrays the immense drama of the cooperative working of higher spiritual beings during previous epochs of the Earth's evolution and then traces the spiritual history of events up to the present time and into the future. There follows a detailed, practical guide to the methods, or exercises, by which such 'initiation knowledge' may be attained.

The demon Amduscias — from Witchcraft, Magic and Alchemy

This masterwork of esotericism places humanity—and the deed of Christ on Golgotha—at the center of vast, invisible processes of cosmic evolution."
$12.95 *(PB/388)*

Pacts With the Devil: A Chronicle of Sex, Blasphemy and Liberation
S.J. Black and Christopher S. Hyatt, Ph.D.
"Genuine manual of the dreaded 'left-handed path.'" Learn to consort with the demons and achieve the power of the Magus. The authors "plumb history, psychology and anthropology to reveal the true 'secret doctrine' of Western culture," along with its psyche and magical tradition. "Contains a detailed history of European black magic and includes new editions of 17th- and 18th-century grimoires with detailed instruction for their use." The grimoires, or ritual pacts with Satan, have been updated from ancient texts. The required slaughter of a goat can now be safely replaced with sex. (Not with the goat, you stupid neo-pagan!) **GR**
$12.95 *(PB/255)*

The Pagan Book of Days: A Guide to the Festivals, Traditions and Sacred Days of the Year
Nigel Pennick
What is a favorable time for divination by fire? On which days can I expect the portals of the underworld to open? Written by a native practitioner of East Anglican pagan traditions, this calendar focuses primarily on classical and northern European earth religions, but also includes significant dates from Babylonian, Persian, Egyptian, Jewish, and medieval Christian cultures. Tracks dates from the Celtic tree calendar, "Goddess Days" of the moon, medieval "stations of the year," significant birthdays, as well as runic and zodiacal highlights. Beyond the calendar there are brief essays on folklore surrounding the days of the week, and months, the celestial and tidal movements, as well as some interesting remarks on the syncretism of pagan and Christian celebrations. Lavishly illustrated with etchings, woodcuts, petroglyphs, etc. **RA**
$9.95 *(PB/160)*

Natas

Persuasions of the Witch's Craft: Ritual Magic in Contemporary England
T.M. Luhrmann

"They strip off their clothes to dance pagan revelry, or don austere robes to garner 'power' and direct it to particular ends. Yet nearly all who profess to be magicians or witches are in every other respect normal, educated, middle-class people—scientists, teachers, computer analysts and many senior civil servants."

$15.00 *(PB/382)*

The Phallus: Sacred Symbol of Male Creative Power
Alain Daniélou

Worship of the male member in ancient cultures, from the Hindus to the Greeks to the Celts. "The phallus is really the image of the creator in mankind, and we rediscover the worship of it at the origin of every religion." The cult of the cock is traced from Neolithic amulets and stones still standing in Europe to the many fertility gods of world mythology. "Contempt for this sacred emblem, as well as degradation and debasement of it, pushes man from the divine reality. It provokes the anger of the gods and leads to the decline of the species!"

GR
$16.95 *(PB/128/Illus)*

Thee Psychick Bible: Thee Apocryphal Scriptures ov Genesis P-Orridge and thee Third Mind ov Psychic TV
Genesis P-Orridge

Compiles for the first time dozens of out-of-print manifestoes, essays, quotes and other miscellaneous writings, as well as never-before-published material from the Transmediator Genesis P-Orridge: "In an age of collapse and transition we must find a language. A way out of thee corner donated to us by history. Thee human brain must develop, becoum thee next step in evolution. It is simply: develop our latent neurological powers or truly die as a race. It is a war for survival. Through experiment, through exploration of these latent powers, by visionary use of science and technology, and by thee integration of experience, observation and expression we must revere ourselves. . . . Thee Temple is committed to

Satyr (Sculpture by Andrea Briosco Riccio, early 16th century). A companion of Pan, god of the flock and of nature. This boisterous, life-affirming spirit of unabashed and joyful sexuality is an archetypal force, that, sadly, has been weakened in modern Western civilization. — from Art and Symbols of the Occult

developing a modern functional and inspiring magickal structure. . . . We are thee first truly non-aligned and non-mystical philosophy."—Genesis P-Orridge and Simon Dwyer

$14.99 *(PB/175/Illus)*

Recovery From Cults: Help for Victims of Psychological and Spiritual Abuse
Edited by Michael D. Langone

Having myself been deemed notorious, and occasionally despicable by one of the rather less-than-objective or deductive segments of the ignorance-aligned "vociferous minority" (I presume that's the opposite of a silent majority, please correct me if I am wrong), I approached this tome with a decidedly voracious appetite.

My own personal crime had been to experiment "for its own sake" with the generically agreed upon dynamics of a "cult" by the simple strategy of reversal of each implicit common quality normally proposed by analysts, commentators, survivors and vested-interest right-wing (often fundamentalist Christian) "cult" groups in their profitable protestations. The research and conclusions that I later reaped from my foundation of an "anti-cult" clearly confirmed the ease with which even an existential surrealist can rapidly attract a devoted and compliant group to an admittedly sexy idea.

Unfortunately, what it demonstrated even more vividly was that being a part of, or administrating, or feeling obliged to constantly feed the group mythology is incredibly time-consuming and boring. The majority of those attracted to any "cult" or "anti-cult" are basically emotional cripples. Which is in no way a denigration, for I would insist that we are all equally crippled, and lost seeking a means to con ourselves into feeling life is innately benign and worthwhile. Equally distressing is the discovery that those who aspire to be part of any "superior" alpha or omega hierarchy are measly dullards with delusions of their own grandeur pretty much without exception.

These observations are not so surprising to most of us. Much more surprising, however, is the apparently universal conviction that the "divine" essence of the "cult" or "anti-cult," initially followed with absolute allegiance in a highly submissive manner, comes to be perceived later by the more neurotic, devout "members" as in fact a privately inspired and unique product of their own process of spiritual and moral epiphany.

A deep confusion and psychotic resentment can build up if the original "leader" chooses to amend, adapt or in any way change and evolve the original teaching or texts of revelation and salvation. It is fanatically believed, because of the very success of its limitless integration into the personality of the devout "member," to have become their property. Their holy mission.

Their immutable and infallible philosophy of life and immortality. All self-esteem and peer-group status come to rest entirely upon the unassailable and unalterable original source.

This leaves everyone in a double-bind, only if, of course, they truly do seek after wisdom; after compassion; after creativity; after truth; after a new, improved yet individually separate identity fulfilling their most laudable and altruistic aspirations; after fun, laughter, respite and having a good time in the bargain. These real seekers after inspired religious speculation and neo-moral dialogue are confronted with an insoluble problem.

Being "in charge" is the worst nightmare possible and contradictory to any liberating and radical idea or agenda. Being "a disciple" is equally the worst nightmare possible of self-subjugation to a radical idea or agenda that by the very nature of this beast can only atrophy and stagnate by mindless repetition and the dogmatism of the weaker willed.

So you are damned if you do live the "cult" life and damned if you don't. Everyone else outside your personal "cult" is damned too. Schisms, suicides, murders, confrontations with other "cults" ensue, and misery and existential helplessness engulf all.

Recovery From Cults could have looked at the pros and cons of all cults. Instead it simply trots out the same old, same old lists. A cult is only a cult if it has this or that specific list of attributes. All psychotherapists are either good (i.e. anti-cult) or bad (i.e., not educated in the authors' and contributors' rigid and inarguably correct view of the dastardly phenomenon). "Cults" are assumed to be localized aberrations. Christians are good and understand. Christian cults are not Christian cults at all and, of course, "Satanic" cults probably don't exist, but we'll allude to their nonexistence as much as we can to play down the vicious, sadistic, warped and foul Christian cults. You see, dogmatism and lack of self-esteem are the same monkey whatever they wear, and whilst I am sure there really are cases of indescribable, altruistic self-effacement and service to the greater good, hey, as the old joke goes:

What is the name of the "cult" where the members have to shave off their hair; give up their clothes; take a number instead of a name; be physically abused and beaten daily; suffer forced marches; have their food controlled; be trained to murder even their own family for their leader without thought or question; use a "cult" slang; be numbed with sleep deprivation and so on and so on? The U.S. *Marines*, of course.

None of this ambiguity or institutionalized "cultism" is addressed at all. This is, after all, a society where control is violently enforced with deep conviction by state "policing cults." Where other more unsavory intelligence cults, or even actual cult cults are mobilized, exploited and franchised according to opportunism and the "greater GOoD." Where even this abomination of depersonalization and sacrifice of individuality is overtly and covertly countenanced only to maintain the illusion of a "bogey-man." A bogey-

The demon Baal — from Witchcraft, Magic and Alchemy

man whose nature is so apocalyptically terrible and terrorizing that suspension of disbelief and veracity of perception are voluntarily surrendered to the societal "cult."

America is the most successful "cult" ever. It is comprised socially, politically, economically and religiously by layer upon layer of "cults." Not surprising when one considers that the first settlers were themselves fanatical "cultists" escaping disapproval and persecution. The biggest and best "cults," like the Mormons, the Democrats, the Jesuits, Death Row Records, Bloods and Crips, sports teams, the Nation, etc. poach members from each other, and all unify in reviling the smallest or the weirdest. Often, accessing money is paraded as proof of corruption and bad intention by rivals and newcomers. Most of them will use force, political clout, even assassination to attain

and sustain their preeminence. A cult is a cult is a cult. Show me the child and I'll show you the cultist.

So what can we conclude? No thanks to this book. Well, let's concede: sad fucked-up lives are sad, and fucked up. Emotional cripples abound and lots of them are lonely and vulnerable to strong pseudo-parental authority. Usually parents bemoan their lost, confused and maliciously misled children, oblivious to themselves as the cause of the alienation. The ultimate, archaic "cult" of the filial family imposes its will above all else, demanding the return of those who have "accidentally" gone astray or run away. Just bear in mind, refugees flee tyranny, famine (emotional as well as literal), isolation, violence, occupation and fear. Let everyone flee back and forth like headless chickens to join any "cult" they want, I say. It's unavoidable. For the redundant sleeping masses there can be no life after "cults." There can be no life outside "cults." If they want to squabble over possessing certain people, so be it. If they can "retrieve" and "deprogram" or reprogram each other to suit their own ends, so be it. If this process is relentless, unstoppable, cruel, painful and endless for them. If the strongest win. If the omnipotent "cult" of bureaucracy and governmental control reigns supreme . . . What did you expect ? I have no sympathy for any of them.

For myself, I took apart a "cult" like you would take apart a model engine, to see how it worked. It was never my intention to put it back together again to make it work. My intention was a skeptical act of self-conscious rebellion so that I could detoxify my SELF of the omnipresent and oppressive "cult" pathogen. It was an abjurative act of scornful personality inoculation. A disdainful declaration of infinite and unspecific flux and the repudiation of any tainting of my character by, or experiential vulnerability to, any and all manifestations or interpretations of all possible and impossible forms of inherited "cult" systems. So there!

GPO

$17.95 *(PB/410)*

Renaissance Magic and the Return of the Golden Age: The Occult Tradition and Marlowe, Johnson and Shakespeare
John S. Mebane
"You, like a judge appointed for being hon-

orable, are the molder and maker of yourself; you may sculpt yourself into whatever shape you prefer."—Pico della Mirandola

Positing that philosophical occultism may be read as the logical extension of Renaissance humanists' "affirmation of the power of human beings to control both their own personalities and the world around them," Mebane provides in-depth analyses of philosopher-magicians Marsilio Ficino, Pico della Mirandola and Cornelius Agrippa, each an example of how "magic became the most powerful manifestation of the growing conviction that humankind should act out its potential in the free exercise of its powers on the social and natural environment." Because Johnson, Marlowe and Shakespeare were "thoroughly familiar with the philosophical, social and political implications of Hermetic/Kabbalistic magic, as well as with the claims of particular occult philosophers," the later chapters examine how *Dr. Faustus*, *The Alchemist*, and *The Tempest* reflect each playwright's response to the centrality of magic in both humanist thought and everyday life. Throughout, Mebane weaves a rigorous symbiosis of history, philosophy and literary criticism, offering readers an intelligent re-evaluation of the importance of the occult tradition to the thought and literature of the Renaissance. **HS**

$12.95 *(PB/317)*

Return of the Furies: An Investigation Into

A projective test card used to investigate suspected Satanic cult ritual abuse, designed for psychotherapy with children — from **Satanic Panic**

Recovered-Memory Therapy
Hollida Wakefield and Ralph Underwager
The authors of this book assess the horrific costs recovered-memory therapists have heaped upon the American public in many ways: billions of dollars thrown away by the justice system, families torn apart in the most painful way possible, a loss of trust in the judicial system, an overtaxed child protective system threatened by junk science, distrust and "the most virulent and violent antisexuality the world has known since the days of Tertullian in the second century."

Co-author Ralph Underwager first found himself intervening on behalf of an abused child when he was a Lutheran pastor in 1952. He and co-author Hollida Wakefield, both psychologists, continued to work with incest victims, but in the late '70s, they began to see early examples of false accusations and were often consulted as experts in court cases. In 1992, they helped to form the False Memory Syndrome Foundation.

This comprehensive book answers every imaginable question about false-memory syndrome. It explains how "memories" can be implanted by therapists through hypnotherapy, guided imagery and survivor's groups, and examines the social, legal and therapeutic milieu that has created a situation in which people accused of bizarre, unspeakable crimes bear the burden of proving themselves innocent. The authors provide accounts from retractors and lay out the devastating consequences of false accusations to the accusers and accused alike. They painstakingly examine different theories of memory and forgetting, dissect research on theories of repression and dissociation, and scrutinize such commonly used concepts as traumatic amnesia, post-traumatic stress disorder, splitting, multiple personality disorder and body memories. **MH**

$16.95 *(PB/431)*

The Revenge of God: The Resurgence of Islam, Christianity and Judaism in the Modern World
Gilles Kepel
"Examines religious revivalism in Islam, Christianity (both Catholicism and North American Protestantism) and Judaism. As such, it is almost unique and sorely needed. Arguing that the simultaneity of these

revivals is not coincidental, Kepel suggests that they are reflections of widespread and profound disquiet with modernity. . . . It is especially interesting to read the impressions that Kepel, a French scholar of Islam, has of Jerry Falwell, Oral Roberts and others!"

$14.95 *(PB/215)*

Revolt Against the Modern World
Julius Evola
"Evola's career was many-sided: As a philosopher he belongs among the leading representatives of Italian Idealism; as a painter and poet he is counted as one of the founders of Italian Dadaism; as a cultural historian and critic of our times . . . he also translated Oswald Spengler's *Decline of the West* . . . as a patron of literature he was the publisher and translator of Ernst Jünger and Gustav Meyrink, whom he introduced into Italy; to some he might appear as an éminence grise in politics, for Mussolini apparently wanted to implement some of Evola's ideas to create more freedom from the restrictions of National Socialism . . . many of his books testify to his understanding of alchemy and magic, and it is reported that Mussolini stood in considerable awe of Evola's 'magical powers.'"

"At turns prophetic and provocative, *Revolt Against the Modern World* outlines a profound metaphysics of history, and demonstrates how and why we have lost contact with the transcendent dimension of being . . . he attempts to trace in space and time the remote causes and processes that have exercised a corrosive influence on what he considers to be the higher values, ideals, beliefs and codes of conduct—the world of Tradition—that are at the foundation of Western civilization and described in the myths and sacred literature of the Indo-Europeans."

$29.95 *(HB/375)*

Rhythmajik: Practical Uses of Number, Rhythm and Sound
Z'ev
The first complete guide to the use of number and sound—to be used with virtually any ritual or healing system, includes extensive numerological dictionaries, plus the keys needed to create a rhythm for any purpose. **AK**

$17.95 *(PB/206)*

Sacred Geometry: Symbolism and Purpose in Religious Structures

Nigel Pennick

"Geometry underlies the structure of all things—from galaxies to molecules. Despite our separation from the natural world, human beings are still bound by the laws of the universe.... *Sacred Geometry* traces the rise and fall of this transcendent art from megalithic stone circles to Art Nouveau and reveals how buildings that conform to its timeless principles mirror the geometry of the cosmos."

$19.95 *(PB/190/Illus)*

Same-Sex Unions in Premodern Europe

John Boswell

"Historian John Boswell, one of our most respected authorities on the Middle Ages, produces extensive evidence that at one time the Catholic and Eastern Orthodox churches not only sanctioned unions between partners of the same sex but sanctified them—in ceremonies that bear striking resemblance to heterosexual marriage ceremonies. Drawing on sources in a wide range of languages—and on examples that extend from the 4th-century legends of Saints Serge and Bacchus to the ceremonial union of the Byzantine emperors Basil I and Michael III—Boswell boldly reveals how the same tradition that looked askance at all sexuality could also encompass—and at times idealize—loving partnerships between two men or women. Most impressively, he produces actual examples of ceremonies in which such love was formally consecrated until modern times."

$13.00 *(PB/464)*

Satan's Silence: Ritual Abuse and the Making of a Modern American Witch-Hunt

Debbie Nathan and Michael Snedecker

Answers the question "How could little children invent such horrible stories?" by breaking down the inherent flaws in medical, criminological and interviewing theories used to construct proof of ritual-abuse accusations. Reexamining some individual cases points to a pattern of abuse, not from the accused but from child-protection agencies. The abuse of children is there, but it is in the bullying interview tactics and humiliating medical examinations used to validate the fears of parents that Satanic ritual abuse exists. Homophobic doctors, hysterical career-minded social workers and "cult cops" provide a framework for a "mass sociogenic illness" in the 1980s. Why believe the children? Because the adults have gone nuts? Includes a doctor sweetly

Police Satan hunters in front of alleged Satanic graffiti — from **Satanic Panic**

referring to incest as a family romance, a social worker who coos "we can have a good time with the dolls," and a sheriff's warning of Satanically poisoned watermelons.

JEN

$14.00 *(PB/317)*

Satanic Panic: The Creation of a Contemporary Legend

Jeffrey S. Victor

A sociologist turns his trained eye on the Satan Scare of the '80s, which began quietly enough with rumors of cattle mutilations and the book *Michelle Remembers* and then seemingly peaked in the media consciousness in 1988 with those astounding Geraldo specials like "Satanic Breeders: Babies for Sacrifice." Actually "rumor-panics" about secret Satanic cults are still sweeping through small towns across the Rustbelt as America's economic decline fuels mass hysteria, and innocent people are being convicted of "ritual abuse" (a vaguely scientific buzzword used by those who believe in the existence of secret Satanic cabals) and locked away for their entire lives. Explore the legend of how Dr. Green, as a Hasidic death-camp teen, invented Satanic ritual abuse while collaborating with the Nazis by combining his knowledge of the Kabbalah with scientific Gestapo brainwashing techniques. Learn about an Ohio child who was proclaimed kidnapped and sacrificed by a Satanist cult only to be discovered six years later by the FBI living in Huntington Beach, Calif. with her grandfather, who had actually abducted her; backward masking teen suicide cases; and the uproar over Proctor and Gamble's Satanic corporate logo and its "profit-sharing deal with the Devil."

Author Jeffrey Victor sees the unconscious appeal of Satan-hunting as a metaphor for parents' fears about the future and their children, but he also delves into groupthink among psychology professionals, giving firsthand accounts of occult psychological seminars which he attended.

Natas

He provides examples of similar "rumor-panics" in other cultures, like the legend of American baby-parts importers which spread like wildfire across Latin America in the '80s, and the French rumor-panic in the late '60s about Jewish mod boutique owners abducting teenybopper babes for the White Slave Trade by employing secret trap doors in their changing rooms. He shows how belief in "Satanists" confirms in a convoluted way the existence of God for those wavering in their convictions, and reconfirms once again humanity's propensity for justifying its evil in the name of Good. **SS**

$16.95 *(PB/408/Illus)*

Satanism: A Guide to the Awesome Power of Satan

Wade Baskin

Encyclopedia of the world's deviltry, from AAHLA (Egyptian lower region) to ZWIMB-GANANA (African voodoo creature). Sample entry: "TOADS: Witches were especially fond of toads, pampering them as if they were children and dressing them in scarlet silk and green velvet capes for the celebration of the Sabbat. They wore bells around their necks and were baptized at the Sabbat. They were supposed to have in their heads stones which changed color in the presence of poison and could be used as an antidote against it. Pierre Delancre says that a witch ordinarily was attended by several demons. These demons sat on her left shoulder. Having assumed the shape of a two-horned toad, they were visible only to those familiar to witchcraft." **GR**

$9.95 *(PB/349)*

Satanism and Witchcraft: The Classic Study of Medieval Superstition

Jules Michelet

"Michelet brilliantly re-creates the Europe of the Middle Ages, the centuries of fierce religious intolerance, the Inquisition and the auto-da-fé. . . . draws flaming word pictures of the witch hunts, the Black Masses, the reign of Satan, and the weird rites of the damned. Here is the age of unbridled pleasure and sensuality, of luxury beyond imagination and squalor beyond endurance. Here is the time when a girl might be accused of witchcraft merely if she were young and pretty and did not survive the test of immersion in water or boiling oil."

$12.95 *(PB/332)*

Sati, the Blessing and the Curse: The Burning of Wives in India

Edited by John Stratton Hawley

The author of this book examines the history and practice of *sati* (the custom of a Hindu woman willingly being cremated on the funeral pyre of her husband), and presents arguments for and against this bizarre ultimate sacrifice. Needless to add, most rationales in favor are by males, and most opposed are by females—feminists, as the author calls them.

An Italian voyager, Ludovico di Varthema, related his impressions of a widowed Indian woman consigning herself to the flames in an act of self-immolation. He wrote that the women were often drugged into submission by priests clothed like devils, who then coerced them to kill themselves: "If the sati does not die quickly, she is recognized by her family to be a whore." **JB**

$14.95 *(PB/256/Illus)*

Secret Games of the Gods: Ancient Ritual Systems in Board Games

Nigel Pennick

Pennick is convincing in his theory that the development of arcane board games (most of which are neither extant nor recognizable) was influenced by different systems of divination. But there is so much information crammed into this work that it can sometimes be difficult to wade through. After awhile all the game-board patterns begin to look like a procession of Parcheesi boards. He starts with shamanism, then moves swiftly through a pretty thorough description of the practice of geomancy, then on to the I Ching, astrology, alphabets, runes, sacred space and grids. The most interesting part of the book is his explanation of early, nearly extinct, European board games, and alternate methods of playing both chess and checkers. Despite the densely packed material in this book, it still makes for very illuminating reading. **MM**

$12.95 *(PB/256)*

The Secret of the Sanngraal

Arthur Machen

A collection of short nonfiction works by turn-of-the-century horror master Arthur Machen. He was the author of the bone-chilling *The Great God Pan* and other masterpieces of Celtic-twilight-terror fiction.

Pat Pulling has been one of the most active moral crusaders, spreading fears of criminal Satanic cults, which she claims are trying to attract teenagers through rock music and Dungeons and Dragons *games. — from* **Satanic Panic**

These essays appeared in newspapers like *The London Graphic*, which are ultra-rare, making this book a must for the Machen collector. The general reader will also be charmed by the Welshman's particular, bittersweet sense of all things bookishly antiquarian and his haunting nostalgia for a lost, pantheistic childhood. Somewhat less present are what we adore in Machen's fiction—his talent for wringing preternatural chills from pre-Roman ruins and the not-so-dormant deities nearby. The new Machen reader seeking goose-bumps might do better to seek them in his stories "The Three Impostors," "The Great God Pan" and others. Still, there is much in this treasure trove of arcana to delight any bibliophile.

CS

$34.95 *(HB/287)*

Secrets of Rennes-Le-Château

Lionel and Patricia Fanthorpe

In their acute analysis of scholarly data, the Fanthorpes decry some documents as as "historically reliable as a confession of broomstick flying extracted from a senile geriatric on the rack." Unfortunately the same could be said for the Fanthorpes and their fanciful and specious theories which appear to be derived from a cursory reading of *Holy Blood, Holy Grail*. For the uninitiated, this theory holds that King Dagobert II of France (an obscure king of an obscure dynasty, the Merovingians), are descended from a hitherto unknown child of Jesus Christ. Allegedly, a pregnant Mary Magdalene managed to flee Judea and have her descendants settle on the Côte d'Azur and marry into the Merovingian clan. Despite the fact that the Merovingians were essentially bloodthirsty barbarians, the Catholic Church had a "secret" alliance with them to eventually make a holy Christian world under the aegis of Jesus' progeny.

This conspiracy theory stretches across the centuries with cabals of powerful men controlling destiny behind the scenes. The Fanthorpes eagerly pile on many irrelevant factual points in an attempt to cajole the reader into accepting their short but utterly ridiculous "proof." For example, in commenting on *Lord of the Rings* author J.R.R. Tolkien's connection to the Merovingian conspiracy, the proof is that *The Return of The King* is just a metaphor for the restoration of Dagobert's descendants! Illustrated

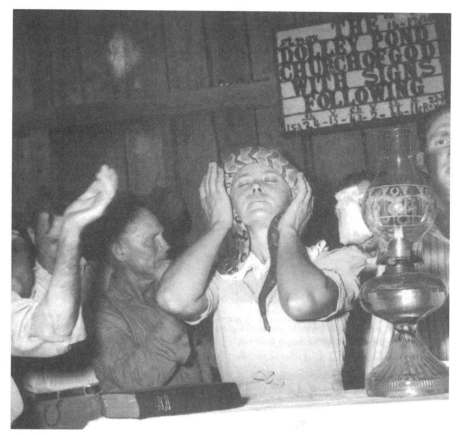

Minnie Parker's beautiful face framed with a rattlesnake — from **Serpent-Handling Believers**

with photographs, maps, magic squares and quadratic equations attesting to the veracity of their theory, the bulk of this book has been presented elsewhere but seldom more amusingly. **MM/ES**

$12.95 *(PB/256)*

Serpent-Handling Believers

Thomas Burton

A history of the snake-handling churches of Tennessee which is both academic and insightful, containing 178 photos of people handling snakes and drinking poison. There is a general tendency to view the Southern snake-handlers as simple-minded or insane. Such a condescending attitude is, thankfully, absent from this book. Author Thomas Burton seems to have a liking for the subjects of his study, and reports that one of the reasons he stays in contact with them is that "they are good friends. They are strong, courageous, ethical people. . . . I am proud of their friendship."

Whenever a snake-handler dies of a snake bite, it makes the papers. This helps create the impression that snake-handlers are crazy people who drop dead whenever they perform their insane ritual. This book makes clear that although a practitioner will drop dead now and then, snake-handlers generally are bitten again and again with little or no effect. Even more amazing is their ability to consume poison. It is tempting to dismiss snake-handlers by speculating that they milk the snakes of their venom and switch the jars of strychnine with plain water. Every investigation that I am aware of shows that this is not so.

The snake-handlers take Mark 16:17-18 (and some other Bible verses) literally. They believe that the best way to show their faith is to handle deadly snakes and drink poisons. Also described are their fire-handling abilities, which are completely different from New Age-style firewalks. They have an obsession for filling Coke bottles with kerosene, stuffing a rag in the end and

lighting it on fire. This potential Molotov cocktail is then held under the chin and other parts of the body. Removing hot coals from a furnace with the bare hands is not an unknown occurrence.

Particularly interesting is the section of biographical essays of various snake-handlers. These accounts could be dismissed as the product of someone's imagination if it weren't for the fact that the author has done such a thorough job of documenting everything in the book. Snake-handlers are as close as the United States gets to a home-grown mystic order (excluding Native Americans, of course). Although only briefly mentioned in the book, parallels to certain Sufi dervish groups are noticeable. There is an emphasis on good behavior (*adab* in Sufi terms), a disconnection from a "main" or central church body, a transference of powers of immunity (what the snake-handlers call "anointment"), dancing and rhythmic moments that turn into a trancelike state while accompanied by music played on the instruments of the common folk. The appendixes include an electroencephalograph test on an "anointed" person and a technical report on the music used during snake-handling services. The list of references is extensive and complete. **TC**

$19.95 *(PB/208/Illus)*

Sex Mythology: Including an Account of the Masculine Cross
Sha Rocco
Illustrated with a number of Yoni-Lingam line drawings, this booklet purports to be a scholarly study of ancient sex worship in which phalli and cunni played a prominent role. Included is a section explaining the sexual vocabulary of the Bible, religious prostitution, and sun worship. **JB**

$4.00 *(Pamp/55/Illus)*

Skoob Esoterica Anthology: Issue 1
Edited by Christopher R. Johnson
From the ashes of the *Skoob Occult Review* rises this new anthology series, from the London esoteric book shop and now publisher Skoob, proclaiming itself "a forum for a diversity of viewpoints." Highlights of this inaugural edition include the novella "The Stellar Lode" by Kenneth Grant from the mid-1950s, which gives rare insight into his formative philosophy, here structured with-

in a fictional medium; a reprint of the January 1905 edition of *The Occult Review*; and two reviews of Kenneth Grant's *Hecates Fountain* (Skoob), one by Colin Wilson, which is interesting given each's Lovecraftian connections, and another by Gerald Suster which unceremoniously tears apart each foundation of the book's assumptions. It's very refreshing to see a publisher print such a scathing review of one of its own publications, and for that alone this anthology is worthy of support. **BW**

$11.95 *(PB/240)*

Spellcraft, Hexcraft, and Witchcraft
Anna Riva
Anna Riva, the first name in modern witchcraft! Here the reader will find: a voodoo doll pattern; uses for grave dirt and coffin nails; an explanation of witches' covens; an abbreviated list of gemstones and their magickal properties; and the best and most unusual feature, the "Secrets" A-Z list, which once and for all reveals the mysteries of damnation water, abracadabra, magic mirrors, how to get rid of warts, and a list of the tools to use when spell-casting. Useful! Hip! Fun! Easy! For the on-the-go witch of today! **SK**

$4.50 *(PB/64)*

Stairway to Hell: The Well-Planned Destruction of Teens
Rick Jones
"Follow a typical teen as he stumbles, step by step down the stairway to hell. Each chapter reveals another tool of destruction. Teens will see where their lifestyle is leading them and discover the *only* escape from the stairway to hell . . . Jesus!" Chapters include "Peer Pressure," "I Can't 'Just Say No' to Drugs," "Inside a Human Sacrifice," "What's Wrong With Sex?" and "Satan Worship: Ultimate Deception."

$8.50 *(PB/206)*

Supremely Abominable Crimes: The Trial of the Knights Templar
Edward Burman
"Who were the Knights of Templar? How was it that these powerful and wealthy warriors found themselves vilified and accused of the most depraved crimes? Through contemporary sources, including

transcripts made by papal notaries, Burman provides a detailed account of the sensational three-month trial in Paris in 1310, which stunned observers, and reflects on the background to the myths surrounding the Order which led to their arrest."

$17.95 *(HB/304)*

Symbolism of the Celtic Cross
Derek Bryce
Bryce traces the history of the Celtic cross from pre-Christian stone monuments to the 19th century. First he covers ancient pillar stones in Wales that served as a symbolic Axis Mundi, a link between heaven and Earth. Then he discusses market crosses that are seen in small villages or at crossroads. These market crosses resemble not so much crosses as they do the ancient pillars, designating a separate intermediary space. Bryce then goes into great detail about the design components of the Celtic Cross, such as early Christian iconography, plait and knot-work ornamentation, key patterns, swastikas, spirals and Pictish symbols. He sums up his work with a look at standing crosses, clearly connecting them as serving the same purpose of being an Axis Mundi as did the standing pillars in pre-Christian Britain. **MM**

$9.95 *(PB/128/Illus)*

Tarot Dictionary and Compendium
Jana Riley
This is more of a Tarot reference book than an introduction to the Tarot. As a reference work it is sure to be of use to both beginners and experienced users of the Tarot. Riley outlines the major and minor arcana. She provides thumbnail interpretations of each card from various commentators on the Tarot such as Waite, Crowley, Stewart and Wirth. Plus correspondences for each of the 22 major arcana, various interpretation of numbers, and some basic card layouts. **MM**

$14.95 *(PB/320)*

Transcendental Magic
Eliphas Levi
Levi was to the 19th-century occult revival what Aleister Crowley was to the revival which persisted into the 20th century. This work is the summit of his literary achievement as a writer and popularizer of the Western Hermetic tradition. It is divided

into two sections, one on the doctrine, the other on ritual. The end of the book is appended with a firsthand account of Levi's evocation of Apollonius of Tyana. Each of the two sections has 22 chapters relating to the 22 letters of the Hebrew alphabet, the 22 paths of the Tree of Life, and the 22 cards of the Tarot's major arcana. The first section outlines such concepts as the microcosm in relation to the macrocosm; number symbolism; the Kabbalah; the Great Work; and so on. He methodically covers much of what most people associate with the occult. The second section is more practical in nature with instructions on the use and consecration of pentagrams and talismans, initiations, thaumaturgy—all with the requisite warnings to the imprudent. Those used to the step-by-step instruction available so easily these days might think that Levi's examples are not as concrete as they might be. His writing style is rich and descriptive, making this one of the classics in the genre of occult literature. **MM**

$17.50 *(PB/438)*

Twisted Cross: The German Christian Movement in the Third Reich
Doris L. Bergen

Half a million Protestants form a religious movement and rewrite the history of God for the Fatherland in the years 1933 through 1945. "The girls went wild, he said, denouncing 'the Old Testament with its filthy stories,' the 'Jews as a criminal race.' It was precisely such attitudes that the German Christian pastors and schoolteachers sought to instill in the youth. A German Christian confirmation examination in early 1937 included the following exchange: 'Does the church have to address the Jewish question? Answer: Yes. Why? The candidate responded: The Jews are our misfortune. At that, the pastor laughed aloud . . . A girl then added, "The curse of God is on the Jews," and the pastor praised her reply.' The Nazis reviled Christianity for its 'Jewish roots, doctrinal rigidity and enervating, womanish qualities.' The German Christians focused their efforts on proclaiming a "manly Christianity." **GR**

$16.95 *(PB/341/Illus)*

Vladimir Soloviev, Russian Mystic
Paul Marshall Allen

"Intimate friend of Dostoyevsky and

Tolstoy, an extraordinary mystic with profound insight into our present struggle against the hidden powers of darkness working at every level of modern life, Vladimir Soloviev is one of the greatest esoteric teachers of our age. . . . Soloviev's haunting story of the Antichrist—included in this book—depicts with shattering impact many trends and events of our present world scene. His transcendental, meditative teachings concerning the divine Sophia, archetype of esoteric wisdom, offer renewed courage, confidence and hope amidst the manifold conflicts, doubts and tragedies of our time. This unique, timely book—the first in-depth, full-length portrait of Soloviev as a mystic to appear in English—is the rich fruit of Allen's lifelong interest in the cultural-spiritual achievements, the mysticism and the esoteric striving of the Russian people of Tsarist times."

$10.95 *(PB/449/Illus)*

War, Progress and the End of History:

The Sign of Excommunication — from Transcendental Magic

Three Conversations, Including a Short Tale of the Antichrist
Vladimir Solovyov

"Is evil only a natural defect, an imperfection disappearing by itself with the growth of good, or is it a real power, ruling our world by means of temptations, so that to fight it successfully assistance must be found in another sphere of being?" So begins Solovyov's preface, written shortly before his death on July 30, 1900. Prophet, mystic, poet-philosopher and the prototype for Dostoevsky's Alyosha Karamazov, Solovyov offers an examination of evil which proves chillingly prophetic, especially in his parable of a European Antichrist: he envisions Israel reunified, Islam emerging as a world power, and eerily asserts that "the imitative Japanese, who showed such wonderful speed and success in copying the external forms of European culture . . . proclaimed to the world the great idea of Pan-Mongolism . . . with the aim of conducting a decisive war against foreign intruders." **HS**

$14.95 *(PB/206)*

Warrior Cults: A History of Magical, Mystical and Murderous Organizations
Paul Elliott

"Discover ancient and medieval warrior cults and secret societies like the Roman religion of Mithras, the sinister Knights Templar, the Middle Eastern assassins, the Japanese ninja clans and many more. As alluring as the prospect of 'belonging' to a special circle may seem to today's disenchanted youth, it is important to understand the purpose and compulsions of fanatical factions. These terrifying organizations and mystical cults can provide disturbing insight into modern religious, political and criminal sects and associations that imperil our society today."

$24.95 *(HB/208/Illus)*

What You Should Know About the Golden Dawn
Israel Regardie

First published in 1936 as *My Rosicrucian Adventure*, this revised (sixth) edition has added manifestoes by Mathers and W.B. Yeats, the author's answer to several books critical of the Order, and other interesting essays and documents. This book is not a guide to Golden Dawn magic or rituals, but

the author's personal reflections on just about everything else surrounding the Order: its ideology and historical foundations, its literary interests and pursuits, its inner turmoil, its public scandals, plus the activities and writings of other influential members like Crowley, Mathers, Wescott, Dion Fortune and Yeats. Analysis of rituals and ceremonies, and just how they operate on the imagination, are especially good. Discussion of how the Golden Dawn put together its system of magic from such sources as the Kabbalah, Greek and Egyptian texts and lore is also revealing. "They have synthesized into a coherent whole this vast body of disconnected and widely scattered material, and have given it form and meaning," notes Regardie. The author's thoughts on why the makeup of the Order demanded secrecy are also significant. The book is filled with insightful thoughts on various problems surrounding the use of talismans, divination, angelical keys and/or calls, Enochian tablets, evocation and much more. **BS**
$12.95 *(PB/234)*

What's Wrong With Christian Rock?
Jeff Goodwin
"Is Christian rock Christian? Or is it a multi-billion dollar industry with a totally different purpose? . . . You will learn that

The demon Belphegor — from Witchcraft, Magic and Alchemy

Contemporary Christian Music (CCM) is full of occultism, witchcraft and the New Age. The biggest names in CCM convict themselves with their own words. Learn what's wrong with: Copying the World; Christian Rock's Fruit; Backmasking in C-Rock; Christian Rap; Christian Thrash; plus much more!"
$9.95 *(PB/288)*

When God Was a Woman
Merlin Stone
"Here, archeologically documented, is the story of the religion of the Goddess. Known by many names—Astarte, Isis, Ishtar, among others—she reigned supreme in the Near and Middle East. Beyond being worshiped for fertility, she was revered as the wise creator and the one source of universal order. Under her, women's roles differed markedly from those in patriarchal Judeo-Christian cultures. Women bought and sold property, traded in the marketplace, and the inheritance of title and property was passed from mother to daughter. How did the change come about? By documenting the wholesale rewriting of myth and religious dogmas, the author details a most ancient conspiracy: the patriarchal re-imaging of the Goddess as a wanton, depraved figure. This is the portrait that laid the foundation for one of culture's greatest shams—the legend of Adam and fallen Eve."
$8.95 *(PB/265/Illus)*

When Time Shall Be No More
Paul Boyer
Explores a segment of American popular thought that has rarely been the subject of scholarship: the belief that history and the end of the world were foretold in the Bible. The author puts forth two arguments, the first being that the prophesy has played a more central role in American thought than most cultural and intellectual historians have recognized; the second being that after World War II the popularizers of a dispensational premillennialism have played an important role in shaping public opinion on such topics as the Soviet Union, the Common Market, the Middle East, the role of technology in modern life, and environmental issues. **SC**
$29.95 *(HB/468/Illus)*

A Witch's Brew: The Art of Making

Magical Beverages
Patricia Telesco
No decent Pan-worshiping pagan's kitchen shelf would be complete without this thorough guide to creating 236 delicious, exotic beverages. The book covers the history and customs of early drinks, including religious and medicinal usages. This excellent investigation into beers, cordials, aperitifs, liquors, meads, punches and other odd brews will have you running to the store for fermenting supplies, pronto. Full recipes for beet wine, onion wine, rhubarb wine, soda pop, beers, long-forgotten teas and decadent cordials are all given here, plus many more. Why settle for merely reading *The Pickwick Papers* or Boswell's *Life of Johnson* when you can giddily brew the authentic, antiquated drinks from the shadowy past described in these books and enjoy them in the blinding present. Cheers! (Hic!) **CS**
$16.95 *(PB/272/Illus)*

Witch-Children: From Salem Witch-Hunts to Modern Courtrooms
Hans Sebald, Ph.D.
"A comparison of the unflinching credibility afforded children in our contemporary epidemic of molestation allegations and the hysteria over Satanism in the 16th and 17th centuries. The common circumstances between the two eras are frightening."
$24.95 *(HB/258)*

Witchcraft and the Gay Counterculture
Arthur Evans
A serious, challenging history and analysis, from Joan of Arc to the heretics to voodoo.
AK
$12.95 *(PB/180)*

Witchcraft in the Middle Ages
Jeffrey Burton Russell
Expert on the devil turns his pen to Satan's female disciples. Sexist Christianity combines with secular mythology to create "the witch," a wholly fabricated reading of female nature that caused thousands of innocent women to be tortured and killed, some for the mere 'sin' of having a wart in the wrong place. On coupling with demons: "The new dimension of ritual intercourse had further significance. Though demons could act at will as either incubi or sucubi, ritual coupling was usually ascribed to

women rather than to men. This is because the popular imagination made the devil, like God, masculine, although Christian philosophy considered demons, like angels, sexless; and because the ancient Pauline-patristic tradition judged the female sex to be weaker than the male physically, mentally and morally. William of Auvergne argued that it was women rather than men who deluded themselves into believing that they rode out at night because their minds were feebler and more subject to illusion." **GR**
$14.95 *(PB/394)*

Witchcraft, Magic and Alchemy
Emile Grillot de Givry
Sorcerers and magicians; ceremonial magic; witches and preparation for the Sabbath; the coven and the magical flight; sacrifices to the devil and the obscene kiss; the evocation of demons; books of magic; magic circles and pentacles; pacts with demons; selling one's soul; the personnel of Hell; possession and exorcism; necromancy; the power of the Kabbalah; analyzing character by occult means; animal magnetism; and more! Reprint of the 1931 edition, with over 350 illustrations.
$10.95 *(PB/384/Illus)*

Witchcraft: The Old Religion
Leo Louis Martello
"The author is an initiated witch and elder in three other witch traditions besides his own. Discusses the roots of the old religion and shows the differences between true witches, old religionists, pop witches, Christian-defiled witches and Satanists. Believes witchcraft may be the faith of the future."
$8.95 *(PB/231)*

Women of the Golden Dawn: Rebels and Priestesses — Maud Gonne, Moina Bergson Mathers, Annie Horniman, Florence Farr
Mary Greer
"Tells the story of four magical women who acted outside the boundaries of accepted codes of behavior and heralded the birth of a new age and a new kind of woman. In the heart of the repressive Victorian era, aristocratic revolutionary Maud Gonne, psychic channel Moina Bergson Mathers, patron of the arts Annie

Horniman and actress Florence Farr formed the heart of the Hermetic Order of the Golden Dawn. Their imaginative skills, determination and belief in their own abilities worked a kind of great magic that transformed not only themselves but politics, literature and the Western traditions of alchemy, astrology, Hermeticism and ceremonial magic as well. Today's woman can draw from the knowledge, struggles and triumphs of these uncompromising spiritual foremothers to help achieve her own self-esteem, power and wisdom."
$24.95 *(PB/576/Illus)*

The World of Ghosts and the Supernatural
Richard Cavendish
It's by Richard Cavendish, editor of and contributor to the influential *Man, Myth and Magic* encyclopedia series (the leading candidate for theft at every junior high library), so it must be of a reputable nature. Equal coverage of spirituality and the supernatural makes the title inaccurate. Divided by continent, the highlights include: spectral time slips at Versailles and stones of mystery in Europe; Day of the Dead, Santería, and the Winchester Mystery House in North America; psychic surgery, the Nasca lines and the Antonio Villas Boas alien abduction (the first ever recorded) in South America; King Solomon's mines, the 'holy mountain' and cults in Africa; shamanism in Siberia, sacred sex and spiritual ecstasy in Asia; cargo cults, ominous UFOs and South Sea spirits in the Pacific. Each continent is mapped (with each story pinpointed), and the entire volume is liberally sprinkled with illustrations and photographs.
SK
$22.95 *(HB/160/Illus)*

The X-Rated Bible
Ben Akerley
"A real revelation—that the Bible is one of the lewdest, most licentious, and vilest books ever printed."
$10.00 *(PB/428)*

The Yezidis, or Devil Worshipers: Their Beliefs and Sacred Books
Alphonse Mingana
"A scholarly examination of this mysterious Middle Eastern sect with ideas on origin

and cosmology."
$5.95 *(PB)*

The Yoga of Power: Tantra, Shakti and the Secret Way
Julius Evola
Evola introduces two Hindu movements, tantraism and Shaktiism, which both emphasize action and mastery of energies latent in the body. He traces these influences in Hinduism from the 4th century onward with an in-depth study of *Vamachara*—"The Way of the Left Hand." During our current time of dissolution and decadence known in Hindu cosmology as the Kali Yuga, one can no longer dismiss the physical as mere illusion, but instead must grapple with and ultimately transform the powerful and destructive forces in this present age. Evola draws from original texts to document methods of self-mastery including the awakening of serpent power, initiatory sexual magic and invoking the sacred mantras of power.
SC
$16.95 *(PB/238)*

The demon Eurynome — from Witchcraft, Magic and Alchemy

ALCHEMY

Alchemical manuscript illumination from Splendor Solis, *1582 — from* Art and Symbols of the Occult

Hermetico-alchemical knowledge has been described as a "sacred" science, but the prevailing designation that better characterizes it is that of Ars Regia or "Royal Art." . . . It is no accident that the hermeto-alchemical tradition should call itself the Royal Art, and that it chose Gold as a central royal and solar symbol, which at the same time takes us back to the primordial Tradition.

Such a tradition presents itself to us essentially as the guardian of a light and a dignity that cannot be reduced to the religious-sacerdotal vision of the world. And if there is no talk in this tradition (as in a cycle of other myths) of *discovering,* but only of *making* it, that only goes to show how important, the already indicated sense of reconquest and reconstruction, the heroic moment had become. . . . With the fall of the Roman Empire, the predominating principles of the West went on to become the basis for the other tradition—the sacerdotal—which in its decadence was almost completely stripped of its entire esoteric and metaphysical range in order to convert itself into a doctrine of "salvation" in the name of a "Redeemer." Things being so, the hermetists, in contrast to other iniatory organizations that were tributaries of the same secret royal vein, instead of coming out into the light and presenting themselves for battle, chose to go into hiding. And the Royal Art was presented as the alchemical art of transmuting base metals into gold and silver. By so doing it no longer fell under the suspicion of heresy, and even with the faith; even among the ranks of Catholics we can discern the enigmatic figures of hermetic masters, from Raymond Lully and Albertus Magnus to Abbot Pernety.
— Julius Evola, from *The Hermetic Tradition: Symbols and Teachings of the Royal Art*

Alchemical Medicine
Paracelsus
"A practical manual of the formulas used in this most arcane of healing arts."
$4.95 *(PB)*

Alchemical Symbols and Secret Alphabets
C.J.S. Thompson
"A particularly useful and valuable reference tool."
$3.95 *(PB/Illus)*

The Alchemist's Handbook
Frater Albertus
There has been much discussion as to actually what alchemy is. Jung wrote about it as a wonderful allegory for the development of the soul and examined the tradition's psychological factors. Some think the alchemical formula of *solve et coagula* (divide and rejoin) is a metaphor for the creative process. Others think the idea of transformation stems from the transubstantiation that Catholics believe takes place at Mass. All these things could easily be said while ignoring one simple fact—alchemists really did spend hours tinkering with their alembics while attempting the Great Work. This slim volume is an interesting introduction to the practical aspects of alchemy as it is practiced today. Frater Albertus starts with illustrating the manner in which plant materials can be processed alchemically. Through these practical examples he introduces the three elements of alchemy: salt, mercury and sulfur. Other chapters deal with alchemical symbols and history. This book is sure to give pleasure to both the neophyte and the experienced reader of alchemical lore. **MM**
$12.50 *(PB/124)*

Alchemy
Franz Hartmann
"A very clear exposition of the principles of alchemy."
$3.95 *(PB)*

The Aurora of the Philosophers
Paracelsus
"Concerns the ancient Magi, the Secret Fire, and the origin of the Philosopher's Stone."
$3.95 *(PB)*

Coelum Philosophorum: The Book of Hermetic Vexation
Paracelsus
"The science and nature of alchemy and of what opinion should be formed thereof according to Paracelsus the Great."
$3.95 *(PB)*

The Diary of John Dee
John Dee
"The private diary and catalog of his library of manuscripts. Very illuminating for studies involving the inner teaching of Dee."
$27.50 *(PB/Illus)*

Fulcanelli: Master Alchemist—Le Mystère des Cathedrals, Esoteric Interpretation of the Hermetic Symbols of The Great Work
Fulcanelli
To understand the process of alchemy is to understand one's own spiritual evolution. The fabled alchemist Fulcanelli describes the symbols and process of the Great Transformation of the human Spirit which is alchemy, the everlasting secrets of the Argonauts (the spoken Kabbalah) and the transmission of their message by means of the Language of the Birds (the encoding of words). These symbols are openly displayed in the sculpture, tiles, pillars, rose windows, flying buttresses and iconography of the ancient Gothic cathedrals of Europe, built by alchemists, and deciphered by Fulcanelli.
$15.95 *(PB/186/Illus)*

The Hermetic Tradition: Symbols and Teaching of the Royal Art
Julius Evola
To Evola, hermeticism and alchemy are the same. Alchemy is not a concern about metals but rather a physical and metaphysical system embracing cosmology and anthropology, nature and supernature. The reader should abandon the analytical mindframe so that comprehension of this art can occur. Translated for the first time, this survey of alchemical symbols (the names of the Zodiac, the metals that make up the universe, the combinations of spiritual powers, the emanations that the practitioner produces, etc.) and teachings (the practitioner looks for more than turning lead into gold) reveals the mysterious world

of the "Royal Art." **MET**
$16.95 *(PB/220)*

The Hieroglyphic Monad
Doctor John Dee
"The symbolic mathematics of existence in twenty-four theorems. Numerous line drawings accompany the text."
$7.95 *(PB/Illus)*

Paracelsus' Alchemical Catechism
Paracelsus
"This valuable and noteworthy piece was said to have been found in the Vatican Library by the Swiss Mason, Baron Tschoudy."
$3.95 *(PB)*

The Practical Handbook of Plant Alchemy: An Herbalist's Guide to Preparing Medicinal Essences, Tinctures and Elixirs
Manfred M. Junius
Intensely detailed information on adapting practical alchemical techniques for making tinctures, essences and elixirs. These formulas, made according to alchemical processes, are termed by the author "spagyrics," a

Alchemical manuscript illumination from Splendor Solis, 1582 — from **Art and Symbols of the Occult**

combination of the Greek words *spao* (to divide) and *ageiro* (to join), or in other words, the classic "*solve et coagula*" familiar to most with a passing acquaintance with alchemy. The author says that most contemporary medicine only succeeds in the first step and not in the last. He uses his extensive background in Ayurveda, which he learned while growing up in India, to draw parallels between Alchemy and Chinese methods of healing which involve maintaining a body's integral balance. He goes into the principles of Salt, Mercury and Sulfur in great detail and sticks to the seven classical planetary principles of alchemy. The book goes into great detail about how to make herbal medicines. The author says in his forward that the reader should have a "fundamental knowledge of botanical medicine," but the reader should also have some background knowledge on alchemy too. **MM**
$16.95 *(PB/272/Illus)*

The Secrets of Doctor John Dee: Being the Alchemical, Astrological, Qabalistic, and Rosicrucian Arcana Together with the Symbolic Trees of the Planets
Gordon James
"A manuscript which is often attributed to John Dee but is more likely the teachings of a true alchemical school. It embodies a subtle esoteric knowledge and a symbolic system of self development. Mr. James conveys the secret process for the unfoldment of the Stone and the mystery of philosophical geomancy. The Alchemical Trees of the Planets have been reproduced here for the first time, having been restored from the original British Museum manuscript. The use of the gematria as a key to the hidden language of Alchemy makes this an original contribution—the most important alchemical commentary since Fulcanelli."
$19.95 *(PB/184/Illus)*

A Short Lexicon of Alchemy: Explaining the Chief Terms Used by Paracelsus and Other Hermetic Philosophers
A. E. Waite
$6.95 *(PB)*

Crowley

Let me explain in a few words how it came about that I blazoned the word MAGICK upon the Banner that I have borne before me all my life.

Before I touched my teen, I was already aware that I was THE BEAST whose number is 666. I did not understand in the least what that implied; it was a passionately ecstatic sense of identity.

In my third year at Cambridge, I devoted myself consciously to the

Frater Perdurabo (Aleister Crowley) — from The Book of Lies

Great Work, understanding thereby the Work of becoming a Spiritual Being, free from the constraints, accidents and deceptions of material existence.

I found myself at a loss for a name to designate my work, just as H. P. Blavatsky some years earlier. "Theosophy," "Spiritualism," "Occultism," "Mysticism" all involved undesirable connotations.

I chose therefore the name "MAGICK" as essentially the most sublime, and actually the most discredited, of all the available terms.

I swore to rehabilitate MAGICK, to identify it with my own career; and to compel mankind to respect, love and trust that which they scorned, hated and feared. I have kept my word.

But the time is now come for me to carry my banner into the thick of the press of human life.

I must make MAGICK the essential factor in the life of ALL.

In presenting this book to the world, I must then explain and justify my position by formulating a definition of MAGICK and setting forth its main principles in such a way that ALL may understand instantly that their souls, their lives, in every relation with every other human being and every circumstance, depend upon MAGICK and the right comprehension and right application thereof.

DEFINITION. MAGICK is the Science and Art of causing Change to occur in conformity with Will.

(Illlustration: It is my Will to inform the World of certain facts within my knowledge. I therefore take "magical weapons," pen, ink and paper; I write "incantations"—these sentences—in the "magical language" i.e. that which is understood by the people I wish to instruct; I call forth "spirits," such as printers, publishers, booksellers and so forth, and constrain them to convey my message to those people. The composition and distribution of this book is thus an act of MAGICK by which I cause Changes to take place in conformity with my Will.)

— Aleister Crowley, from *Magick in Theory and Practice*

Aleister Crowley and the Practice of the Magical Diary
Edited by James Wasserman

The editor has been a disciple of Crowley's works for more than 20 years. Along with presenting selections from Crowley's two most important instructional writings, Wasserman explores the purpose and necessity of the diary as an aid to the accomplishment of what Crowley termed the "Great Work." **JB**
$12.95 *(PB/176)*

The Aleister Crowley Scrapbook
Sandy Robertson

Every little thing you want to know about the man who called himself "The Beast."

Hardcore fan material with many interesting photographs of his artwork, girlfriends and pals, and rock stars and literary figures who were influenced, touched, destroyed and seduced by Crowley. Plus the greatest selection of photos of the man whom the British yellow press endearingly called "the most evil man alive." Crowley may not have been the most evil, but he did have a great sex life. Typically, Crowley came from an uptight religious family who were members of the Plymouth Brethren, a strict fundamentalist Christian sect, and what is a poor boy to do but rebel against Victorian England? If the reader of this "scrapbook" wants in-depth information on Crowley's writing and philosophy, they should look elsewhere—this book is not it. What this book does give is a decent overall look at

Crowley and his world including, briefly, Yeats, Bowie, Jimmy Page and the greatest fan of them all—Kenneth Anger. **TB**
$19.95 *(PB/128/Illus)*

Book 4
Aleister Crowley

"Let us begin by doubting every statement. Let us find a way of subjecting every statement to the test of experiment. Is there any truth at all in the claims of various religions?" *Book 4* is actually two books of which *Magick in Theory and Practice* was to be the concluding part of the trilogy. The first book is a pragmatic, groundbreaking manual of yoga as a physiological aspect of the mind stripped of its cosmic trappings. In the second book, all the paraphernalia of ritual magic (the circle, the altar, the

scourge, the dagger, the chain, holy oil, the wand, the cup, the pentacle, the sword, the lamp, and more) are explained in both psychological and mystical terms with Crowley's unmatched candor and wit. **SS**
$8.95 *(PB/127)*

The Book of the Law
Aleister Crowley
This is Crowley's magnum opus. During his honeymoon in Egypt with his first wife, Rose, she turned to him and said, "They are waiting for you." Never having shown any ability, let alone interest, in the strange phenomena that would lead to such an outburst, Rose piqued her husband's curiosity. She identified an Egyptian stele as representing the source of her inspiration. Whether she was a new wife seeking to impress her husband, a bit daffy, or truly inspired, her revelation led him to write, or rather receive (as he contends it was not his work) *The Book of the Law*. Most editions of this work include a copy of the hand-written manuscript too, as he wrote " . . . the letters? Change them not in style or value!" In a fit of what can only be called irony, he ended the book with the injunction, "The study of this Book is forbidden . . . Those who discuss the contents of this book are to be shunned by all . . . ," thereby ensuring the book to be a hot topic of conversation.
MM
$6.95 *(PB/128)*

The Book of Lies
Aleister Crowley
Crowley wrote reams of wretched poetry,

The Magic Circle on the floor of the Sanctum Sanctorum, Crowley's temple — from The Aleister Crowley Scrapbook

Kenneth Anger examining work in progress on paint removal from a set of shutters in the Abbey of Thelema in Cefalù, Sicily. In the background, a door is inscribed with the Crowley creed, "Do What Thou Wilt." — from The Aleister Crowley Scrapbook

most of which can be found in the three volumes of his collected works. Turgidly Swinburnian in style, his endlessly tiresome verse and the stamina with which he meted it out is truly amazing. Crowley fancied himself a brilliant poet far beyond the ability of fellow Golden Dawn member Yeats. G.K. Chesterton admired Crowley's skill— and for this slim volume of poetry, the praise is well-deserved and justified. Here Crowley truly exercises the genius he was so absolutely sure he alone possessed. *The Book of Lies* is a collection of concise poems illustrating points of Crowley's own personal philosophy and his idiosyncratic view of "magick." He employs a wonderful sense of word play and punning in these verses. Each poem is accompanied by an equally entertaining commentary that sheds light on its meaning. Many of these poems refer to Crowley's system of magick, and it is helpful to have some acquaintance with his other works. **MM**
$8.95 *(PB/200)*

The Book of Thoth
Aleister Crowley
In 1944, the Master Therion and his Artist Executant Lady Frieda Harris presented a new version of the Tarot intended to "pre-serve those essential features of the Tarot which are independent of the periodic changes of the aeon, while bringing up to date those dogmatic and artistic features of the Tarot which have become unintelligible." It is one of the most beautiful and original of Tarots. *The Book of Thoth* outlines the structure of the deck and gives detailed and poetic explanation of the brilliant, multitraditional synthesis which comprises the symbolism of each card. Beginning in the 19th century, occultists began to align the Tarot with the Kabbalah. The 22 major arcana are placed on the 22 paths situated between the Sephirath on the Tree of Life. The minor arcana are structured around the sacred syllable Tetragrammaton by numerological contrivance. Crowley utilized this and artfully integrated Egyptian symbolism into his system. **DN**
$12.95 *(PB/308)*

The Confessions of Aleister Crowley: An Autohagiography
Aleister Crowley
Alas, poor Aleister Crowley! Rather than an exciting combination of Sir Richard Burton's life, Burton's translation of *The Arabian Nights*, Edmund Hillary's conquest

of Mount Everest, and dissolute times in a hashish bar in Copenhagen, Aleister Crowley's self-described "autohagiography" seems closer to the world of P.G. Wodehouse gone bad. The fin-de-siècle autumnal Victorian age was the time of his youth, spent with a dogmatic but distant Church of England father and a stupid fundamentalist mother. While aping Burton in Bombay, Crowley fires off a revolver at a group of Indian street thugs attempting to relieve him of his travelers' checks. Adventuring in the Himalayas he regales the reader with his continual failure to climb the mountain K2. Next he describes all of his occult "discoveries" without any elucidation on magic (for that you have to buy *Magick in Theory and Practice*). Upon entering middle age, Crowley discovers drug addiction and esoteric espionage while working as a British intelligence agent. Mussolini kicked him out of Italy before World War II because he found out that Crowley's Abbey of Thelema, his erstwhile den of sexual debauchery, was a front for MI6. When strapped for cash in the '20s, Crowley and the man assigned to spy on him shared digs in Berlin. They spent many cheerful hours writing each other's intelligence reports. Crowley is delightfully sarcastic about the times he lived in, and he is an acute judge of society. In many ways, he is still the conventional British gentleman replete with the attendant biases against anyone unfortunate enough to be born outside of England. **MM**

$19.95 *(PB/984/Illus)*

Crowley's Apprentice: The Life and Ideas of Israel Regardie
Gerald Suster

Regardie is best-known for his series of very competent books on magick and for his study of Aleister Crowley in *The Eye in the Triangle*. Suster's biography of Regardie is interesting only in the sections where he discusses Regardie's relationship with Crowley, and this he does while lifting a good deal of material from his previous Crowley biography. Regardie's initial interest in magick faded as he pursued psychology and the works of Wilhelm Reich. Only later did he begin to re-evaluate what he learned from Crowley and then wrote *The Eye in the Triangle* as a rebuttal to Symonds' biography. Suster presents a sympathetic portrait of

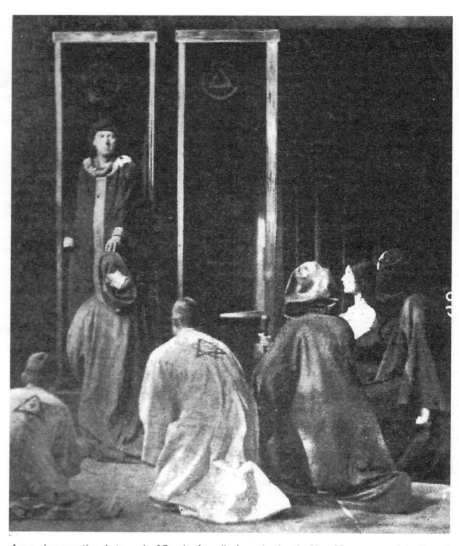

A rare glass negative photograph of Crowley (standing), conducting the Rite of Saturn, part of the Rites of Eleusis sequence, in 1910 — from The Aleister Crowley *Scrapbook*

Regardie interspersed with much personal first-hand experience and correspondence. Despite that, this book would probably appeal only to those completists who must have every book relating to Crowley, Regardie or the Golden Dawn et al. **MM**

$9.95 *(PB/192)*

The Diary of a Drug Fiend
Aleister Crowley

A book not so important for what it says, but for who said it and when, *The Diary of a Drug Fiend* is self-promoting master of the occult Aleister Crowley's autobiographical descent into the maelstrom of cocaine abuse. Set during the heady days

of the 1920s in postwar Europe, it is also the story of a minor English gentleman entering the equivalent of the Haight-Ashbury of the period. Additionally, the novel provides an allegory for the continuing decline of British upper-class mores such as the "stiff upper lip." Combining the classic sin-and-redemption story with Crowley's idiosyncratic view of the occult, this novel continues to be a visceral and captivating story, even in comparison to those of successive generations more rife with moral and chemical debauchery. An interesting note: Crowley claims to have dictated the complete book in its current form in three days to his secretary without

any editing, giving rise to the question: Just how effective was his self-administered cure for cocaine addiction anyway?

MM/ES
$11.95 *(PB/384)*

Eight Lectures on Yoga
Aleister Crowley
Succinct Occidental view of Hindu mystical techniques. Supplement to Crowley's explanation of yoga in *Book 4*.
$9.95 *(PB/128)*

Enochian World of Aleister Crowley: Enochian Sex Magick
Aleister Crowley, Lon Milo Duquette and Christopher S. Hyatt, Ph.D.
Forget it, weekend warriors, a serious commitment is required before performing the rituals in *Enochian Sex Magick*. Once dedicated students have a general understanding of Enochian technique, they can apply the sexual rituals in this work to make just about anything happen. There are a number of charts, plus reminders on how to perform the all-important Pentagram Ritual needed to start and complete the ceremonies. This work, originally published in 1912, is designed to be used in conjunction with *Chanokh*, another Aleister Crowley staple also chock-full of charts and diagrams. *Sex Magick* includes an 18-page Enochian dictionary and a very short discourse on Crowley's history. The exact specification of sexual positions, specific chants and even the required number of thrusts leave little room for improvisation.

GE
$12.95 *(PB/162)*

The Eye in the Triangle
Israel Regardie
Regardie discusses the major influences in Crowley's life, elucidates Crowley's attitudes and points out "the magnificent difference which makes him altogether dissimilar to any other of the spiritual, metaphysical or philosophical instructors."
$17.95 *(PB/517/Illus)*

Gems From the Equinox: Instructions by Aleister Crowley for His Own Magickal Order
Aleister Crowley
One-volume condensation of the 10-volume *Equinox*. Contains sections on the his-

tory of Crowley's own magickal order, the Law for the New Aeon, yoga, basic rituals, the Mass of the Phoenix and the Gnostic Mass, sex magick and more.
$44.95 *(HB/1,133)*

The Holy Books of Thelema
Aleister Crowley
Collects the holy books which were dictated to Crowley by the "præternatural intelligence" Aiwass following the epochal revelation of *The Book of the Law* in Cairo in 1904, ushering in the Age of Horus.
$17.50 *(PB/320)*

The Last Ritual: Aleister Crowley's Funeral Ritual
Aleister Crowley
"According to his wish, these selections from his own works were read as a eulogy at Brighton on December 5, 1948."
$7.95 *(PB)*

The Law Is for All
Aleister Crowley
One of Crowley's most popular books, *The Law Is for All* was actually dictated to the infamous magician by a discarnate intelligence in Cairo in 1904. Whether this discarnate intelligence is on the same plane as

Cover design of Crowley's occult periodical The Equinox *— from* The Aleister Crowley Scrapbook

Ramtha, we do not know, yet this book is considered by some to be as sacrosanct as Holy Writ. As much of the work is of an esoteric nature, this popular edition of Crowley's famous work contains an edifying commentary to assist the neophyte in understanding the deeper significance hidden within the bowels of the text. **JB**
$16.95 *(PB/302)*

The Legacy of the Beast: The Life, Work and Influence of Aleister Crowley
Gerald Suster
Suster's sober study of Aleister Crowley does much to deflate the many rumors that surround his life. The book is divided into four sections. The first is a very straightforward biography of Crowley's life. The second addresses many of the scandals and legends surrounding Crowley, unfortunately shattering one of his most interesting tendencies—hyperbole. Section three introduces practices that influenced Crowley, such as magick, yoga, poetry and drugs. The final section provides many examples of Crowley's enduring influence and popularity. Suster provides a selection of photographs that showcase Crowley's protean ability to change his appearance. This is a good introductory book on Crowley for either students of the occult or just the interested observer. The only drawback is that Suster seems so bent on deglamorizing Crowley that he takes one of the most idiosyncratic characters of the first half of the 20th century and renders him dull and ordinary. **MM**
$9.95 *(PB/224/Illus)*

Liber Aleph Vel CXI: The Book of Wisdom or Folly in the Form of an Epistle of 666 The Great Wild Beast to His Son
Aleister Crowley
This book is a collection of small essays on Crowley's very personal system of magick. He wrote them in New York, where he lived penniless at the end of the First World War. Although this collection was never published in his lifetime, he intended for it to be a magickal guide for the son he thought was prophesied in *The Book of The Law*. The title alone indicates the tone of what the reader can expect. The essays are written in a deliberate and sometimes unreadable

archaic fashion and are arranged like the essays of Francis Bacon except that instead of "Of Discourse" there is "On the Black Brothers." Crowley, however, remains a good deal more succinct than Bacon, even when trying to be hopelessly archaic in his writing style. **MM**
$16.00 *(PB/254)*

The Magical Record of the Beast 666

Edited by John Symonds and Kenneth Grant
"Crowley called his diary a Magical Record because it contains accounts of his magical experiments, including the details of his secret sexual magick and of his consumption of a variety of dangerous drugs. It was not written with an eye to publication. . . . Hence the unguarded way in which he recorded his innermost thoughts and performances of secret rites."
$25.00 *(PB/326)*

Magick: In Theory and Practice

Aleister Crowley
Crowley appears in his many aliases—Perdurabo, The Great Wild Beast 666, The

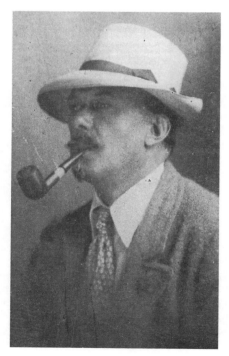

The English Gent. This was a look that Crowley always enjoyed, loving as he did the idea of playing the upper-crust snob. — from The Aleister Crowley Scrapbook

Master Therion—to discuss the magical theory of the universe, ritual, elemental weapons, the Holy Grail, Abrahadabra, Our Lady of Babalon, and the Beast, bloody sacrifice, purifications, the oath, charge to the spirit, clairvoyance, divination, dramatic rituals, black magic and alchemy.
$14.95 *(PB/464)*

Magick Without Tears

Aleister Crowley
"Divulges his magickal philosophy, illuminating all that was unapproachable in his early writings." Eighty letters, Crowley's commentary on his own magickal training and insight.
$17.95 *(PB/528)*

Moonchild

Aleister Crowley
Although this novel lacks the cohesiveness of *The Diary of a Drug Fiend*, there are several amusing facets to it. Cyril Grey is a very Crowleyesque "magician" who persuades Lisa la Giuffria to bear the Moonchild. Feuding orders of magicians litter the scene and provide a great satire of many of the people in the Golden Dawn whom Crowley scorned. These bits of satire are reason enough to read the entire book, especially his description of William Butler Yeats, whom Crowley detested and felt was a horrible poet (horrible, despite the fact that Crowley himself wrote reams of truly bad poetry). Another interesting section provides insight into the use of correspondences in the practice of ritual magic. As Lisa gestates, she is surrounded with everything associated with the moon. "She lived almost entirely upon milk, and cream, and cheese soft-curdled and mild, with little crescent cakes made of rye with the whiteness of egg and cane sugar; as for meat, venison, as sacred to the huntress Artemis, was her only dish." As might be expected for anyone with such a bland and unvaried diet, nothing much interesting happens to Miss la Giuffria, not that anything much could as Crowley insists on reminding us that women's minds are "mob rule." To the general relief of the reader, the characters part and go their separate ways, which is about the only satisfying conclusion to this unresolved work. **MM**
$11.95 *(PB/336)*

Remembering Aleister Crowley

Kenneth Grant
"This intimate portrait of the relationship

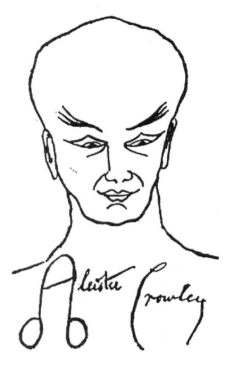

Self-portrait with his usual phallic-style signature — from The Aleister Crowley Scrapbook

between Kenneth Grant and Aleister Crowley is illustrated by personal mementos, many hitherto unpublished. It covers the latter years of World War II and Crowley's settling into his last abode at 'Netherwood' in Hastings. Here we see Crowley at his most human, and his letters to Grant are imbued with that strange interpenetration of the magickal and the mundane which colors the life of a dedicated practitioner."
$49.95 *(HB/72/Illus)*

Tarot Divination

Aleister Crowley
This slim volume is a reprint of an article from Crowley's journal *The Equinox*. The sparse description of the cards and their attributions is a great mnemonic device for those already acquainted with Crowley's vision of the Tarot. But those unacquainted with the Tarot or Crowley's unique take on it are best advised to begin with *The Book of Thoth*, which outlines his ideas in a more thorough manner. The entire contents of this book is included in the weightier *Book of Thoth*. **MM/ES**
$4.95 *(PB/72)*

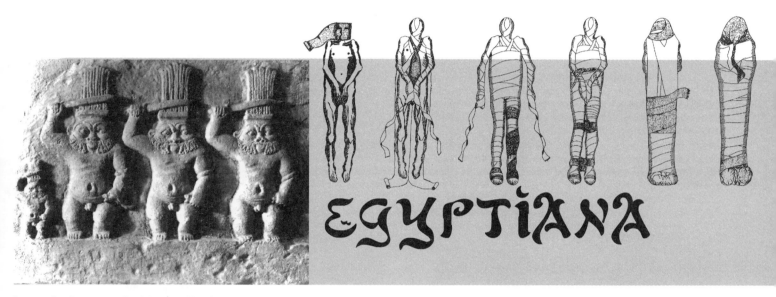

Stages in the wrapping of Horemkesi — from **Unwrapping a Mummy**

EGYPTIANA

Freestanding limestone stela with a row of Bes figures, circa 100 B.C. - 100 A.D. — from **Magic in Ancient Egypt**

The Book of the Dead
E.A. Wallis Budge
The classic translation of the hymns, rituals and prayers that the ancient Egyptians believed would guide and protect the dead in their journey through the underworld and ensure their immortality.
$15.00　　　　　　　　*(PB/592)*

The Egyptian Book of the Dead: The Book of Going Forth by Day
Raymond Faulkner
An authentic presentation of the Papyrus of A-7i, the best surviving example of the texts that have come to be known as the *Book of the Dead*. It's a collection of spells, charms, hymns, prayers and invocations, designed to guide the deceased's journey in the afterlife. Provides rich insight into ancient Egyptian

philosophical, spiritual and religious thought. Text is matched to the actual hieroglyphs on papyrus, which are reproduced in color.　　　　　　　**GR**
$24.95　　　　　　　*(PB/176/Illus)*

Egyptian Ideas of the Afterlife
E.A. Wallis Budge
Ideas and beliefs about immortality were crucial points upon which Egyptian religious and social life turned. Renowned Egyptologist Budge presents a synopsis of these ideas of the afterlife: belief in an almighty God; Osiris, the god of resurrection; the Egyptian gods of death; judgment at death; amulets, rites, charms and other items Egyptians regarded as essential for salvation; and more.　　　　　　**MET**
$6.95　　　　　　　　*(PB/198)*

Egyptian Magic
E.A. Wallace Budge
Covers the powerful amulets that warded off evil spirits; the scarabs of immortality; the use of wax images and spirit placements; magical pictures and formulas; magic via the secret name; magic of sounds; rituals; curses; destruction of hostile magic; determination of fortunate dates; and many other practices of the ancient Nile dwellers.
$5.95　　　　　　　*(PB/234/Illus)*

Egyptian Religion: Egyptian Ideas of the Future Life
E.A. Wallis Budge
"Using the *Book of the Dead* as his chief source, the author examines the principle ideas and beliefs held by ancient Egyptians

concerning the resurrection and future life, focusing particularly on the great central idea of immortality."

$8.95 *(PB/216)*

From Fetish to God in Ancient Egypt
E.A. Wallace Budge

"The author, for many years the Keeper of Egyptian and Assyrian Antiquities in the British Museum, was one of the 20th century's greatest Egyptologists. . . . Part One contains the principal facts about the religious beliefs and thoughts of the Egyptians, and their conception of God and the 'gods,' their enneads and triads, the religions and systems of the great cities and more. Magic, the cult of animals, the cult of Osiris, and the Tuat, or Other World, are treated at some length. Part Two is devoted to a series of superb English translations of some 19 hymns (some of which are certainly models for biblical psalms); myths, both ritual and etiological; 15 legends of the gods, and a selection of important miscellaneous texts."

$11.95 *(PB/545/Illus)*

The Great Pyramid Decoded
Peter Lemesurier

"For over 40 centuries, the Great Pyramid of Giza has tantalized and baffled mankind. Is it a royal tomb, a treasure-house, an astronomical observatory, or an incredibly sophisticated public works project? Or is it, as some believe, nothing less than the Bible written in solid stone? Or could it even be a landmark of an earlier civilization, perhaps immeasurably older than Egypt itself? Having discussed the extraordinary facts of the pyramid's siting and construction, Peter Lemesurier goes on to uncover intriguing links between the pyramid's picture of man's place in the universe and the religious traditions of Egypt, Palestine, India and even Central America." Dr. Gene Scott has read from this work on the air.

$17.95 *(PB/350/Illus)*

Hieroglyphs Without Mystery: An Introduction to Ancient Egyptian Writing
Karl-Theodor Zauzich

"Explains the basic rules of the writing sys-

tem and the grammar and then applies them to 13 actual inscriptions taken from objects in European and Egyptian museums. . . . [through] explanations and learning the most commonly used glyphs, readers can begin to decode hieroglyphs themselves and increase their enjoyment of both museum objects and Egyptian sites."

$14.95 *(PB/128/Illus)*

Magic in Ancient Egypt
Geraldine Pinch

Such feats of engineering as the Giza pyramids, the irrigation system and so on suggest that the Egyptians knew the law of cause and effect. They also knew that this wasn't all there was to this world. Egypt produced techniques of magic, innumerable magical texts and magical objects: figurines, statues, amulets, wands, etc. (pierced dolls are an Egyptian invention). The book also touches on the role of magicians, the magico-medical exchange with Mesopotamia, how rulers like Augustus (who burnt many magical books seen as subversive) reacted to magic, and the influence of Egyptian magic on Medieval and

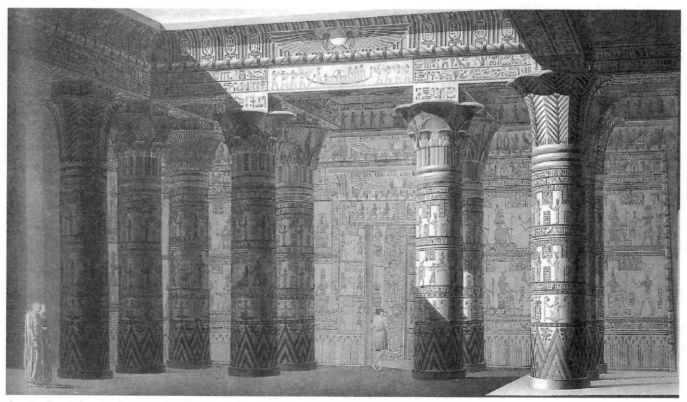

*Egyptian Temple (drawing by artists of the Napoleonic Expedition, circa 1799) — from **Art and Symbols of the Occult***

Renaissance times (including Arab scholars) and modern practitioners such as W.B. Yeats and Aleister Crowley. **MET**
$22.95 *(PB/192/Illus)*

The Mummy: A Handbook of Egyptian Funerary Archeology
E.A. Wallis Budge

Bitumen filling: "The arms, legs, hands and feet of such mummies break with a sound like the cracking of chemical glass tubing, they burn very freely, and give out great heat." Preserved by natron: "The skin is found to be hard and hang loosely from the bones, in much the same way it hangs from the skeletons of dead monks preserved in the crypt beneath the Capuchin convent at Floriana, in Malta." Preserved in honey: "Once ... they came across a sealed jar, and having opened it and found that it contained honey, they began to eat it ... Someone in the party remarked that a hair in the honey turned round one of the fingers of the man who was dipping his bread in it, and as they drew it out, the body of a small child appeared with all its limbs complete and in a good state of preservation." First edition appeared in 1893. **GR**
$10.95 *(PB/513)*

The Secret Medicine of the Pharaohs
Cornelius Stetter

This historical study deals with all facets of the medical field in ancient Egypt. Stetter discusses the societal role doctors played and their place in the Egyptian court. There is much information on the treatment of bodies after death including embalming, entombment and the corresponding myths that accompanied them. Mundane medical treatments including dentistry are also covered. Stetter describes how the ancient Egyptians viewed the body, their ideal of health and the medicines and unusual implements they used. All the information is fully annotated and primary sources are translated and quoted. With many color photographs, this book is an insightful historical study. **MM**
$19.95 *(PB/184/Illus)*

Unwrapping a Mummy
John H. Taylor

The mummified remains of an Egyptian priest named Horemkenesi (11th century, Thebes) are beginning to crumble, so a

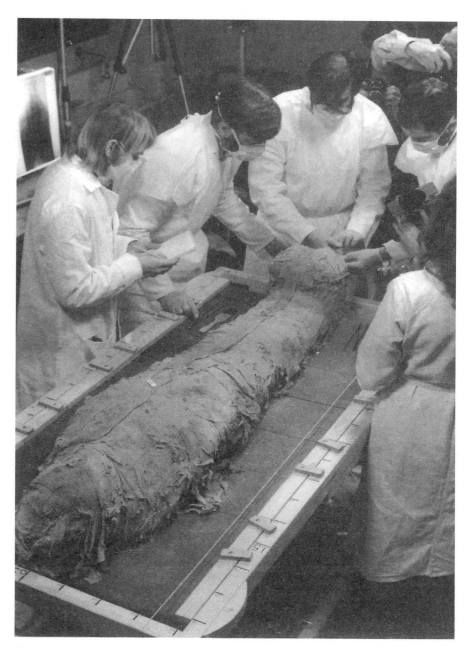

The team from Bristol City Museum beginning the process of unwrapping — from Unwrapping a Mummy

museum team decides "it's now or never," and unravels him—and in the process Horemkenesi achieves his desired immortality with his identity "coming alive" 3,000 years later! The reader is shown in vast detail the city dig that led to Horemkenesi's initial discovery—which through archeological and linguistic

detective work also "unravels" all facets of life during his time (cultural, religious and economic), Egyptian medical knowledge, the significance of writings placed near Horemkenesi's tomb, and why his brain remained but not other vital organs. **MS**
$18.95 *(PB/116/Illus)*

Gnosis

As the stern state religion of Imperial Rome crumbled under the weight of Oriental mysticisms imported from its conquests in Syria and Egypt, the Empire was rife with the so-called Mystery Religions. The Mystery Religions were systems of gnosis, professing to satisfy the insatiable need of the common Roman to experience "union with God" personally through experience (not infrequently orgiastic or brutal) and contemplation. They imparted "secret" knowledge, which guarded the initiated from the cruel hand of Fate and promised the bountiful reward of a painless and blissful afterlife. They all had as their cornerstone a sacramental drama aimed at producing psychic and mystical effects in the neophyte— striking the twin chords of hope and terror in the heart of men and women. Sound familiar?

Jesus and his turn-of-the-millenium followers incorporated all of this into the proselytizing spin-off of Judaism known today as "Christianity." The battle for religious dominance raged for centuries against the multiple Mysteries and divided sects of Gnostics who incorporated too much of the "personal touch" for orthodox Christians (budding Inquisitors) to tolerate. With the conversion of Emperor Constantine (who declared Christianity the official state religion of Rome), the compilation of the New Testament (excising several books with especially heretical approaches to "illumina-tion"), and the burning of the library at Alexandria (a storehouse of critical religious writings), the battle was almost won. Two thousand years later, it is especially worthwhile to take a closer look at the actual context and message of the "Good News." — SS

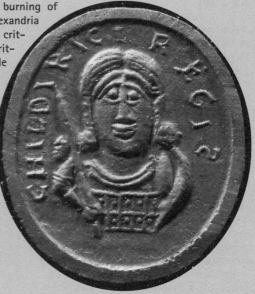

Merovingian seal ring of King Childeric — from Bloodline of the Holy Grail

Bloodline of the Holy Grail: The Hidden Lineage of Jesus Revealed
Laurence Gardner
According to the surprising and compelling research in this work, Moses was none other than the Egyptian pharaoh Akhenaton; Jesus is a direct descendant of King David (and as such, fated to become the national leader in the Jewish anti-Roman revolt); Jesus had other brothers and sisters; Jesus married Mary Magdalene and had two sons; Mary Magdalene and their sons fled to Europe after the failed Jewish Wars; Jesus himself fled toward Asia Minor (and is presumed to have traveled on to Kashmir where he supposedly died). This knowledge was kept alive by initiates who originated such religious movements and kingly dynasties the Merovingians, the Celtic Church and the Arthurian romances. The book goes beyond genealogy to show that the Holy Grail, more than a physical object, is an ideal of service and guidance to others instituted by the leader of national liberation and social harmony in ancient Palestine, Jesus. **MET**
$29.95 *(HB/489/Illus)*

Christianity Before Christ
John G. Jackson
A highly readable work by a leading African-American atheist academic. Following the folkoric approach of Sir James Frazer (author of *The Golden Bough*), Jackson has found 30 religions of antiquity that worship Savior-Gods with the following similar traits:
1) They were born on or near Christmas.
2) Their mothers were virgins.
3) They were born in a cave or stable.
4) They worked for the salvation of humanity.
5) They were called saviors, mediators, healers, etc.
6) They were overcome by evil powers.
7) They each made a descent into Hell.
8) After being slain they arose from death and ascended to Heaven at Easter.
9) They founded religious institutions.
10) They were commemorated by Eucharistic rites.
11) Many of these Savior-Gods were believed to make a second coming to the world.

Jackson cites numerous details to prove that the Christ myth was a deliberate amalgam of all the existing Savior-God cults of its time, including that Adonis had a sacred grove dedicated to Him at Bethlehem; and that followers of Mithra ate wafers marked with a cross, celebrated their sacred solar day on Sundays, and were led by a figure known as the Papa who was seated in Rome. **SS**
$9.00 *(PB/238/Illus)*

The Dead Sea Scrolls Deception
Michael Baigent and Richard Leigh
Upon their 1947 discovery in Palestine, the scrolls caused an uproar in the academic community because they presented a very different picture of Christ and Christians in

the first centuries of Christianity from what was then generally believed. Some scholars advocated free interpretation of the scrolls, others did not, and the official interpretation of the scrolls was plagued with inconsistencies. Facsimiles of the scrolls were not released generally until the Huntington Library in Pasadena, Calif. decided to break conformity and released copies. **MET**
$12.00 *(PB/288/Illus)*

The Gnostic Jung: Including "Seven Sermons to the Dead"
Edited by Robert A. Segal

"Dr. Jung is a seer and a mystic after the fashion of the magicians of the Renaissance. Some think he is a spiritual pagan, while others accuse him of being biased in the direction of Christianity. This little book would set both of these opinions in the wrong, for it shows that he is a kind of Gnostic."
$14.95 *(PB/336)*

The Gnostic Religion: The Message of the Alien God and the Beginnings of Christianity
Hans Jonas

Jonas studied Gnosticism and concluded that it was a revolt against the rule of a Creator and in favor of mankind. Besides historical background about the development, ideological struggles and the suppression of this ancient religious system, the author shows how the ascendance of Gnosticism might have affected today's society in terms of art, theology and everyday life. **MET**
$15.95 *(PB/358)*

The Great Heresy: The History and Beliefs of the Cathars
Arthur Guirdham

Enter into the strange world of the Inquisition, when wife-swapping groups became known as religious movements; indeed, when everything seemed to center around religion. *The Great Heresy* focuses upon the Cathars, a Gnostic revival sect centered in France. In point of fact, it is difficult today to imagine a sect like the Cathars being singled out for extermination. Many of their beliefs resemble those of the Jehovah's Witnesses of today mixed with a primitive Hinduism: denial of the Eucharist; vegetarianism; and the rejection of Hell as an abode of eternal punishment and damnation. It is

the Cathars' sex practices which have aroused, so to speak, the interests of inquisitive men and women. The author devotes the first 14 chapters of his book to the history and beliefs of the Cathars, while the remaining chapters follow the authors' philosophical bent. In this reviewer's opinion, the subject matter is rather dry and unexciting . . . not at all what one would expect from a sect alleged to have indulged in so many sexual perversions. Indeed, the author, far from repeating these salubrious tales, understates them, and subjects the reader to a big letdown. **JB**
$15.95 *(PB/186)*

In Pursuit of Valis: Selections from the Exegesis
Philip K. Dick

This collection provides an unprecedented peek into the stream of consciousness of a great writer grappling with an examination of his own psyche and the enigma of his mystic/schizophrenic experience. It is part of the lore of Philip K. Dick that on the day of "2-3-74" in the Orange County suburb of Santa Ana, Calif., the science-fiction writer was contacted by a beam of pink light which he came to know as VALIS—Vast Active Living Intelligence System—which fundamentally altered his consciousness

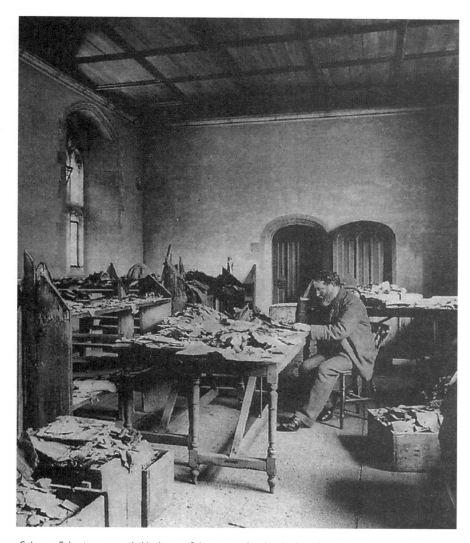

Solomon Schecter surrounded by boxes of the manuscripts he obtained from the Cairo geniza in 1896 and brought to Cambridge — from **The Dead Sea Scrolls Deception**

Scroll fragments as they were brought in by the Bedouin who discovered them in January 1956 — from The Dead Sea Scrolls Deception

and inspired his last three novels now known as the VALIS trilogy. Dick then saw himself as a "homoplasmate" (a human host for living information), and began to be flooded with revelations, which he set down on 8,000 hand-written pages and termed the "Exegesis" (defined as an explanation or critical interpretation of a text).

Among a myriad of interconnected topics, in the *Exegesis* Dick explores Gnosticism, Zoroastrianism, the I Ching, Heidegger and Wittgenstein; sketches out plots for upcoming novels and looks back over his published works; deals with his feelings of being contacted from "the other side"; cites authorities from Plotinus to Hoyt Axton; and even deals with the possibility of his own mental illness in the form of a dialog with himself: "Q: Why would I believe that my senses were enhanced, i.e., I could see for the first time? A: Psychotomimetic drugs indicate this happens in psychosis.
Q: And Kosmos? Everything fitting together? A: 'Spread of meaning,' typical of psychosis.
Q: Foreign words and terms I don't know? A: Long-term memory banks open. Disgorging their contents into consciousness."

Like a psychedelic Céline, Dick plunges deep into the vortex of reality and consciousness in late 20th-century America, which he described in a remarkably lucid manner: "I, who was not a legitimate member of the ruling class (which is defined as, 'those who get to define—control, generate—reality') via my writing, subversively obtained a certain small but real power to control. Create & define reality; the next step is [. . .] to enter (the ruling class) by the front door, officially welcomed. (& not infiltrate in by the back door as I did. But boy, what a good job I did; & VALIS is the best subversion so far . . . it deranges all (sic!)

your learned preconceptions). Thus via my writing I can be said to be a revolutionary, & I carried with me into power, other people of my ilk. Many disenfranchised 'misfits'—the quasi-insane, or pseudo (sic!) schizophrenics; ach! we are mimicking schizophrenia as a political tactic, in order to thrust the schizophrenic worldview onto the authorities as a tactic to infiltrate and vitiate them, 'them' being defined as those in power."

In marked contrast to Dick's humility and self-doubt before the mysteries of VALIS, this fascinating collection is marred by the trippier-than-thou hubris of Terence McKenna's typically self-aggrandizing afterword, in which he proclaims himself the "PKD-inspired servant of the Logos" whose books and software (!) would have been embraced by Dick as the answer to his profound metaphysical inquiries. **SS** **$14.95** *(PB/278)*

Jesus Christ, Sun of God: Ancient Cosmology and Early Christian Symbolism
David Fideler
A paramount work about the synthesis of Jewish, Greek and Egyptian secret teachings and their appearance as Christianity. The book delves into such intellectual phenomena as the linking of Logos with Christ, the use of gematria (symbolic and numerical representation of Greek and Hebrew letters) with Christian writings (e.g., Gospel of Mark 6:30-38), the Mithraic and Hermetic basis of Christianity, the use of geometry in religion in antiquity and the relationship between zodiac changes (every two thousand years) and the appearance of a savior. Encompassing fifteen years of work, this volume has includes complete documentation, a survey of Hellenistic religions and cosmology and an examination of Greek philosophers and mystics. **MET** **$16.00** *(PB/430/Illus)*

The Jesus Conspiracy: The Turin Shroud and the Truth About the Resurrection
Holger Kersten and Elmar R. Gruber
Jesus is alive and living in Las Vegas. Or was that Elvis? This is actually a less far-fetched idea than a water-walking, healing, immaculately conceived carpenter who dies on a cross, is resurrected, gets his own religion and

becomes the invisible Supreme Being. The existence of God has been a healthy source of argument throughout the ages. But the religious side was always defended with the unanswerable "You can't prove that he doesn't exist." Religious historian Holger Kersten and scientist Elmar R. Gruber have taken a first step in providing that proof.

The Jesus Conspiracy is a well-researched book that mostly deals with the Turin Shroud, the funeral cloth that bears the mysterious imprint of the crucified Jesus. For years its authenticity was questioned, and in 1988, three scientific laboratories working independently in different parts of the world used radio-carbon dating to prove that the cloth was a forgery. The authors have carefully re-created the events leading to the testing and conclude that ulterior motives were at work. The theory is presented that the cloth is authentic and the results have been tampered with. But why would anyone want to make the most revered relic of Christendom appear to be a fake? Kersten and Gruber's research led them to a culture-shattering conclusion. The imprint on the cloth is of a man who was still alive when he was laid in the tomb. This challenges the fundamental core of Christianity, which is based on "the salvation" which Jesus is supposed to have vicariously obtained for all by his "death on the cross." In short, what would become of the crucial sentence written by Paul in his letter to the Corinthians, 'And if Christ be not risen, then is our preaching vain, and your faith is also vain?' (1 Cor. 15:14) The authors offer evidence that Christ was merely unconscious on the cross and the burial was a ruse to fool Pilate. His friends had given him an opiate-like substance that made him hang limp on the cross and be taken for dead, put him in the tomb, and rescued him when the coast was clear. The imprint on the burial cloth may have been made by a combination of chemicals, incense and body vapors. The rest of the story has been buried in 2,000 years of misinterpretation and theological manipulation. This theory also coincides with the recent uncovering and interpretation of the Dead Sea Scrolls. But, of course, zealots will still claim that this proves nothing. Perhaps the question should be posed that if Jesus was the Son of God and then later became the Lord, what ever happened to his dad? I'm sure he could answer a few questions. **AN** **$24.95** *(HB/373/Illus)*

Jesus Lived in India: His Unknown Life Before

and After the Crucifixion
Holger Kersten
"Why has Christianity chosen to ignore its connections with the religions of the East, and to dismiss repeatedly the numerous claims that Jesus spent a large part of his life in India? . . . As well as revealing age-old links between Israelites and the East, the evidence found by theologian Kersten points to the following startling conclusions: In his youth Jesus followed the ancient Silk Road to India; while there he studied Buddhism, adopting its tenets and becoming a spiritual master; Jesus survived the crucifixion; Jesus was buried in Srinagar, the capital of Kashmir, where he continues to be revered as a saintly man; the tomb of Jesus still exists in Kashmir."
$14.99 *(PB/264/Illus)*

The Mysteries of Mithra
Franz Cumont
"The colorful religion of Mithra originated in Persia and enjoyed an immense popularity in the Roman Empire, becoming so powerful in the valleys of the Danube and Rhine and in Great Britain that for a time Europe almost became Mithraic. When Mithra and Early Christianity met, the result was a ferocious, implacable duel, whose marks can still be detected on the body of present-day Christian doctrine. . . . Cumont reconstructs the characteristics of the principal divinities, the rituals, the mystery teachings, the liturgy and clergy, the attitude towards Mithra of the typical Roman soldier, the rapid dissemination of the religion in the early years of the Christian era."
$8.95 *(PB/239/Illus)*

The Mystery Religions
Samuel Angus
From actual Roman and Greek sources, describes the rituals and philosophies of ancient "ecstatic" religions, out of which Christianity emerged victorious. Isis and Osiris, the Magna Mater, Dionysius, Mithra, Attis, and all other Mysteries, their histories, inner teachings, and importance.
$8.95 *(PB/359)*

The Mystery Religions and Christianity
Samuel Angus
Mystery religions were a feature of the Greek and Roman worlds at a time when those societies were becoming increasingly multicultural due to the expansion of economic and political empires. These religions were a reaction to the mixing of cultures and the exposure of previously isolated communities to the possibility of many different belief systems—and thus many different gods—which raised the question: How could one be sure that one's own god was the right one, or the most powerful? Mystery religions were characterized by the hedging of bets, the incorporation of aspects of many religions as well as magic in the face of a myriad of choices. The author contends that these religions had an early and lasting influence on the Christian Church. **NN**
$9.95 *(PB/359)*

The Original Jesus: The Buddhist Sources of Christianity
Elmer R. Gruber and Holger Kersten
Convincing case for the theory that the son of God did in fact base much of his Christian teachings on Buddhist beliefs. "The complete mastery exemplified by the Buddha and Jesus gave them the knowledge of the rewards and gains of the inner way, and they spoke out of profound insight." **TD**
$14.95 *(PB/274/Illus)*

Pagan Origins of the Christ Myth
John G. Jackson
Relying upon such notable authors such as Sir James George Frazer, T.W. Doane and Gerald Massey, this informative little booklet condenses much information into a

Muhammad adh-Dhib (right), who discovered the first cave of Dead Sea Scrolls — from **The Dead Sea Scroll Deception**

valuable introductory tool for those interested in the subject of comparative religion and the origins of Christian myths. **JB**
$4.00 *(Pamp/32)*

The Secret Book of Judas (Gospel of Judas)
Edited by Dr. Maxwell Selander
"According to this seemingly authentic early Cainite-Ophite text . . . Jesus had an active sex life, including relations with John, Lazarus, and Mary Magdelene, served an LSD-like psychedelic at the Last Supper, faked his own crucifixion in collaboration with Joseph of Arimathea . . . and died a natural death in India many years after the alleged Resurrection . . . Promises to blow more fuses than *Holy Blood, Holy Grail* and *The Last Temptation* put together."—Robert Anton Wilson, writing in *Fortean Times*
$10.00 *(Pamp/49)*

The Unholy Bible: Hebrew Literature of the Kingdom Period
Jacob Rabinowitz
Powerful new translations of some of the "forgotten" work of the Canaanites and Hellenes. The sensuous and artistic highlights that the Bible left out. **AK**
$8.00 *(PB/158)*

Who Tampered With the Bible?
Pat Eddy
"But is the Bible the infallible word of God? Did the Jesus of the New Testament actually say and do all of the things attributed to him? If not, why is he portrayed inaccurately? . . . To help answer these questions, I used the skills attained through 15 years' experience as an intelligence analyst to translate scholarly research, from the jargon-filled domain of universities to the realm of the intelligent, but nonspecialized, reading public. . . . The pattern to the tampering in the gospels emerges with understanding of the first-century Semitic culture; the people depicted in the New Testament saw the world differently than you and I. The pattern becomes even more visible when we understand the prejudice against Galilee and Galileans. Jesus was from Galilee, a land with such an unexpectedly dark reputation that many scholars believe it actually preordained his death. . . . Armed with this knowledge, the weakness in many of the fundamentalist assertions will be evident."
$10.95 *(PB/306)*

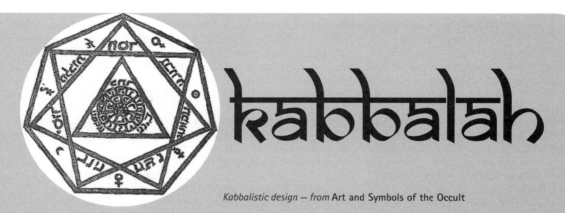

Kabbalistic design — *from* Art and Symbols of the Occult

The numerous Jewish elements within ritual magic indicate that there is a more extensive Jewish element in the thought of the Traditions than has been admitted so far. The Jewish genius for complicated metaphysics and occult speculation has provided occultists with some of their most erudite Traditional sources of inspiration. The Kabbalah, itself a Jewish word for Tradition, embodies these sources. . . . Of the long and complicated story of Jewish mysticism it is only necessary to recall here that an important element is the correspondence between the letters of the Hebrew alphabet and a numerical value—and that on this typically "occult" idea of "sympathies" has been erected an amazing framework of speculation. — James Webb, from *The Occult Underground*

The Book of Splendours
Eliphas Levi

This book and its companion volume, *The Great Secret*, comprise the last works of Levi. Born Alphonse Luis Constant in 1810, Levi's enthusiasm for religion and scholarly pursuits was so great that he entered the seminary at 25 to pursue the priesthood. Although ordained a deacon, he abandoned the goal of priesthood upon realizing his inability to accept celibacy. His career as a scholar and writer brought him greater notoriety as one of the architects of the 19th-century occult revival in France and England. His *Dogme et Ritual de la Haute Magie* and *Histoire de la Magie* inspired the work of countless other authors, including Waite's turgid prose and Crowley's humorous word-play. *The Book of Splendours* has as its first part Levi's commentary on the Zohar, a 13th-century work of Jewish mys-

ticism, by Moses de Leon. Levi effortlessly weaves into his narrative the Hiramic legend of masonry and Krishna. He continues the tradition of a syncretic view of the Kabbalah seen in earlier works of Mirandola and Ruechlin. That view of the Kabbalah, which blends Judaism, Christianity and the pantheons of several polytheistic systems, is perhaps now better known than the historical Kabbalah written of by Gershom Scholem and Moshe Idel. This book remains a lasting testament to Levi's influence in shaping contemporary occultism. **MM**
$10.95 *(PB/191)*

The Essential Kabbalah: The Heart of Jewish Mysticism
Daniel C. Matt

The spirit seeker and conjurer alike will marvel at the beauty of *The Essential Kabbalah*. Matt is a professor of Jewish mysticism at the Center for Jewish Studies and is a graduate of the Theological Union. He is considered by many to be the foremost translator of ancient Jewish mystical writings into modern English. Matt presents what he believes are the Kabbalah's most important teachings. The resulting translations of the original Hebrew and Aramaic texts are inspiring and truly poetic. **GE**
$12.00 *(PB/221)*

The Kabbala
Erich Bischoff

This reprint of the 1910 publication by Bischoff is one of the most concise and clear books on the Kabbalah. Written in a straightforward question-and-answer style, Bischoff outlines the history of Jewish mysticism from its legendary formation by Moses and its more realistic beginnings in

the 1st century A.D. to its adoption by Christian Kabbalists during the Renaissance. Instead of dwelling on the Kabbalah's more popular role in ritual magic, he discusses the different philosophic and theological strands of the Kabbalah and at what times they developed. The Sepher Yetzirah was written in the 9th or 10th century A.D., whereas Moses de Leon's landmark mystical work the Zohar was written in the 13th century. The doctrine of the Sephiroth was promulgated by Rabbi Isaac the Blind in the year 1200. The notion of transmigration of souls is discussed and compared with Buddhist and Greek philosophy. These details do much to illustrate the slow and gradual development of Jewish mysticism. The last chapter outlines magic and the Kabbalah and is illustrated with many interesting magic squares and amulets. **MM**
$7.95 *(PB/96)*

Kabbalah and Consciousness
Allen Afterman
"This book enables the general reader to gain insight into the inner life of the Jewish mystical tradition. . . . it concerns itself with the movement from ordinary consciousness toward knowledge of the infinite, the process of rectification by which the eternal is revealed in everyday reality, and an exploration of male and female modes of being."
$22.50 *(HB/129)*

The Kabbalah Unveiled
S.L. MacGregor Mathers
"The Bible . . . contains numberless obscure and mysterious passages which are utterly unintelligible without some key wherewith to unlock their meaning. That key is given in the Kabbalah." Medieval alchemists and mystics searched for clues in every letter of the Bible and produced an abundance of Kabbalistic interpretations. The present translation is particularly useful for those interested in the occult and the metaphysical because three Kabbalistic works of paramount importance are included: the Zohar, the Greater Holy Assembly, and the Lesser Holy Assembly, all leading to the proof: "Each effect has a cause and everything which has order and design has a governor." **MET**
$12.95 *(PB/388)*

The Mystical Qabalah
Dion Fortune
Dion Fortune's most famous work is

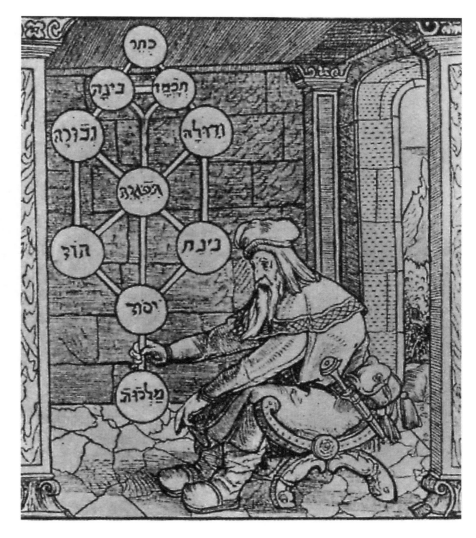

Jewish Kabbalist holding the Sephirotic Tree — from Witchcraft, Magic and Alchemy

required reading for all students of the mystic and energetic arts. The book's basic mission is to explain the Tree of Life, the most important symbol in Kabbalistic magic and meditation. Fortune is from the Golden Dawn school of Kabbalism, in the tradition of MacGregor Mathers and Aleister Crowley, whom she references. This is very high magic, rooted in pre-Christian rabbinical ritual. An often-recommended path for magic students is to begin with Kabbalah forms before progressing to more pagan and arcane systems. **GE**
$8.95 *(PB/320)*

On the Kabbalah and Its Symbolism
Gershom Scholem
"Scholem guides the reader through the central themes in the intricate history of the Kabbalah, clarifying the relations between mysticism and established religious authority, the mystics' interpretation of the Torah and their attempts to discover the hidden meaning underlying Scripture, the tension between the philosophical and the mystical concepts of God, and the symbolism employed in mystical religion."
$12.00 *(PB/240)*

ANTON LAVEY

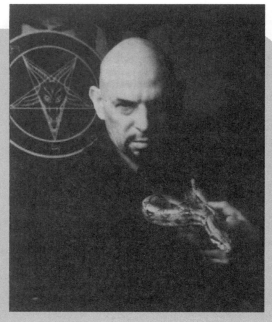

My brand of Satanism is the ultimate conscious alternative to herd mentality and institutionalized thought. It is a studied and contrived set of principles and exercises designed to liberate individuals from a contagion of mindlessness that destroys innovation. I have termed my thought "Satanism" because it is most stimulating under that name. Self-discipline and motivation are effected more easily under stimulating conditions. Satanism means "the opposition" and epitomizes all symbols of nonconformity. Satanism calls forth the strong ability to turn a liability into an advantage, to turn alienation into exclusivity. In other words, the reason it's called Satanism is because it's fun, it's accurate, and it's productive. — Anton LaVey, from *The Devil's Notebook*

The Devil's Notebook
Anton Szandor LaVey

"The collected wisdom, humor and dark observations" of the bald-headed, bad-boy boss of the Church of Satan. "The High Priest speculates on such topics as nonconformity, occult faddism, erotic politics, the 'Goodguy badge,' demoralization and the construction of artificial companions." Plus "How To Become a Werewolf." Sing-along bonus: words and music to LaVey's Satanic church theme song, "Hymm of the Satanic Empire, or, Battle Hymn of the Apocalypse." Dedicated to the men who invented the Whoopee Cushion, the Joy Buzzer and the Sneeze-O-Bubble. Who says Mr. Devil Worship isn't a fun-loving guy? **GR**
$10.95 *(PB/147)*

Might Is Right
Ragnar Redbeard

A heavy-duty early-20th-century Social Darwinist anti-moralistic rant which, new evidence indicates, may have been penned by Jack London under the pseudonym Ragnar Redbeard. Some passages in *The*

Satanic Bible were admittedly appropriated by Anton LaVey from the impassioned vitriol of *Might Is Right*: "No hoary falsehood shall be a truth to me—no cult or dogma shall encamp my pen./I break away from all conventions. Alone, untrammeled. I raise up in stern invasion the standard of Strong./I gaze into the glassy eye of your fearsome Jehovah, and pluck him by the beard—I uplift a broad-ax and split open his worm-eaten skull." This new edition contains an introduction by LaVey and other rare and previously unpublished writings by Ragnar Redbeard. Now it can be told! **SS**
$13.00 *(PB/228)*

Satan Takes a Holiday
Anton Szandor LaVey

"Even the devil needs a little revitalizing recreation now and again. LaVey here applies his kaleidoscopic vision to conjure forth occult musical treasures, sending them out into the ethers, to haunt and delight us. With his background in classical, burlesque, circus and roadhouse styles of playing, LaVey uses modern synthesizer

technology for illegal purposes—to evoke feelings. Every number LaVey plays—from Sousa march to child's lullaby—is carefully chosen as a potent brew of major and minor chords, lyricism and prosody, and then supercharged to its most lusty interpretation. All of the instruments on this recording are played by LaVey on his keyboards, performed without benefit of computer sequencing. Satan has little use for digitalized downloading or pixilated processing. The murky, deathless halls of Tartarus resound with songs of suicide, strained gaiety and unreserved romance. Dim the lights, settle back and let His Infernal Majesty take you on a holiday tour of His world . . ."
$20.00 *(CD)*

The Satanic Bible
Anton Szandor LaVey

"This book was written because, with very few exceptions, every tract and paper, every 'secret' grimoire, all the 'great works' on the subject of magic are nothing more than sanctimonious fraud—guilt-ridden ramblings and esoteric gibberish by chroniclers

of magical lore unable or unwilling to present an objective view of the subject. . . . Far too long has the subject of Satanic magic and philosophy been written down by wild-eyed journalists of the right-hand path. . . . Herein you will find truth—and fantasy. Each is necessary for the other to exist; but each must be recognized for what it is. What you see may not always please you; but you *will* see! Here is Satanic thought from a truly Satanic point of view."—Anton Szandor LaVey, 1968
$6.99 *(PB/272)*

The Satanic Mass
Anton Szandor LaVey
"For the first time in history, here is a recording of an authentic Satanic Mass, recorded live at the Church of Satan. . . . Anton LaVey, along with early members of his diabolical cabal, recorded *The Satanic Mass* in 1968 (Friday, 13 September, III anno Satanas), when *The Satanic Bible* had yet to see print." Long out-of-print and collectible on vinyl, *The Satanic Mass* includes "The

Hymn to Satan," "The Infernal Names" (calling forth demons and devils by name to do the High Priest's bidding), "Invocation Applied Toward the Conjuration of Destruction" ("the guttural ululations of the demonic inhabitants of the Infernal Empire can be heard as the High Priest concludes his invocation and summons them up from the Pit to carry out his diabolic command"), "The Seventh Enochian Key," the "First Satanic Baptism" (of LaVey's 3-year-old daughter Zeena), and a bonus track not on the original LP "The Hymn of the Satanic Empire."
$20.00 *(CD)*

The Satanic Rituals
Anton Szandor LaVey
"The essence of Satanic ritual, and Satanism itself, if taken up out of logic rather than desperation, is to objectively enter into a subjective state. It must be realized, however, that human behavior is almost totally motivated by subjective impulse. It is difficult therefore, to try to be objective once the

emotions have established their preferences. Since man is the only animal who can lie to himself and believe it, he must consciously strive for some degree of self-awareness. Inasmuch as ritual magic is dependent upon emotional intensity for success, all manner of emotion-producing devices must be employed in its practice. . . . The material contained in this volume represents the type of Satanic rite which has been employed in the past for specialized productive or destructive ends." Rituals include "Le Messe Noir," "The Ceremony of the Stifling Air," "Das Tierdrama," and more—"*REGE SATANAS! AVE, SATANAS!* HAIL, SATAN!"
$6.50 *(PB/220)*

The Satanic Witch
Anton Szandor LaVey
LaVey provides a worldy how-to manual for the swinging '70s succubus, based on his Satanic philosophy of "rational self-interest, sensual indulgence and the constructive use of alienation." The arcane lore of "Bitchcraft," "ESP: Extra Sensual Projection," "The Secrets of Indecent Exposure" and more occult ammunition for the battle of the sexes are revealed herein. **SS**
$9.95 *(PB/300)*

The Secret Life of a Satanist
Blanche Barton
Fascinating and picaresque biography of the infamous and now-hermetic showman-philosopher Anton Szandor LaVey. Live-in Satanic accomplice Blanche Barton tells the tale of LaVey's checkered past—as carny, burlesque show organist, hoodlum, Zionist gunrunner, circus lion tamer, ghost hunter and crime-scene photographer for the SFPD—which set the stage for his invocation of the Church of Satan on Walpurgisnacht in 1966 and the publication of *The Satanic Bible* in 1969. She also relates the Black Pope's erotic dalliances with screen sex goddesses Marilyn Monroe and Jayne Mansfield. At the same time, *The Secret Life of a Satanist* reveals LaVey's demonic insight into humanity, film and all things noir, and the true Satanic music, and discusses the nature of the "Second Wave of Satanism," which LaVey declares to have begun in 1984. **SS**
$12.95 *(PB/262)*

LaVey in his early '20s at the Mighty Wurlitzer theater organ — from The Secret Life of a Satanist

Magick makes dreams real, makes the impossible possible, focuses the will. Throughout its history, crystals, water, polished metal, mirrors have been used to oracular ends. Spare's massive achievement is that he recognized the potential of Art, of image, to be the most powerful image of all. A window in Time, an interface with death. In his art he captures not just an image but a life-form and energy. What happens is that this lies dormant until it comes into contact and reacts with other energies: the viewer. Primal, atavistic man knew this and invested his ideas/images with unrestricted power; when you deal with image only, as with 20th century art, you don't get anything back except aesthetics. Spare has achieved the previously impossible, a two-way communication where his image reacts to and with us. . . . What this energy held within his images is doing is transcending the barriers of Time; so that what we are dealing with is a four-dimensional object or image. This form of energy will have existed at all times and will exist at all times. — Genesis P-Orridge, from *Rapid Eye 1*

The Book of Ugly Ecstasy
Austin Osman Spare
"One of the most haunting creations from the hand of this artist—an important sketchbook of immensely powerful line drawings from 1924 which directly commu-nicates that peculiar ecstatic energy which is at the heart of the cultus of which Spare was an adept. The volume includes a prophetic excerpt from Spare's unpublished writings."
$79.95 *(HB/Illus)*

An Edwardian Blake: An Introduction to the Life and Works of Austin Osman Spare
Sunny Shah
"Austin Spare was an explorer of the imag-ination and the Unconscious and perfected

a form of Surrealist automatism some 10 years before Breton and Dali. Includes 17 illustrations by Spare."

$9.95　　　　　　　*(PB/Illus)*

From the Inferno to Zos
Edited by A.R. Naylor
In three volumes:

Volume 1: The Writings and Images of Austin Osman Spare
Includes "To A. O. S." (a poem by Aleister Crowley), "Austin O. Spare" (from Adventures With Inspiration by Hannen Swaffer), "Sex in Art" (from *Ideas and People* by Clifford Bax), "Earth Inferno," "A Book of Satyrs," "The Book of Pleasure," "The Focus of Life," "Anathema of Zos" by Austin Spare, "Automatic Drawing" by Austin Spare and Frederick Carter and more.

Volume 2: Austin Osman Spare—The Artist's Books 1905-1927
Dr. W. Wallace
This volume is an analysis of the five books: *Earth Inferno* (1905), *The Book of Pleasure* (1913), *The Anathema of Zos* (1927), *A Book of Satyrs* (1907 and 1909) and *The Focus of Life* (1921). "The books constitute an interconnected developmental sequence within which the artist pursues and refines certain major themes, exhaustively exploring allegorical method. This leads to the evolution of a method of symbolic automatism which is presented as the praxis of the evolving cosmology, mysticism and world view developing directly from *Earth Inferno*."

Volume 3: Michelangelo in a Teacup—The Intimate Life of Austin Osman Spare
Frank Letchford
$150.00　　　　　*(HB/1208/Illus)*

Two Tracts on Cartomancy
Austin Osman Spare
"Through a lifetime of experiment with divination, Spare evolved his thesis of the continuity of consciousness between past, present and future. In these two works, he demonstrates the power of traditional sorcery to liberate perception from the limitations of time and suggests the means evolving a personal Alphabet of Desire. Illustrated with examples of Spare's experiments in divination."

$39.95　　　　　　　*(HB/Illus)*

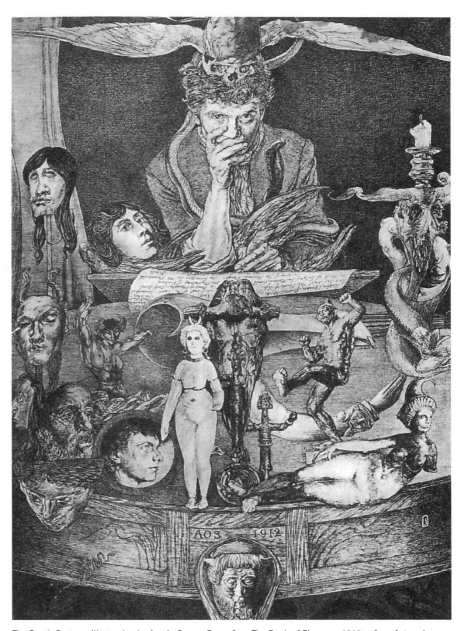

The Death Posture, *illustration by Austin Osman Spare from* The Book of Pleasure, *1913 — from* **Art and Symbols of the Occult**

Zos-Kia: An Introductory Essay on the Art and Sorcery of Austin Osman Spare
Gavin Semple
"Spare's powerful and idiosyncratic art masks a philosophy of arcane beauty often overlooked. In this work, his personal systems are explored, clarified and augmented with the artist's own words. Also, this volume offers excerpts from Spare's last unpublished grimoire, *The Logomachy of Zos*, along with the earliest text of *The Book of Pleasure*. This clearly demonstrates the strength and consistency of his vision throughout his life."

$32.95　　　　　　　*(HB/Illus)*

THULE

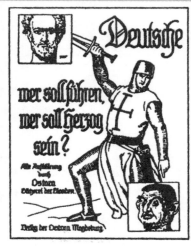

A page from O Stara, *the official magazine of the Order of New Temples — from* The Occult Conspiracy

"Follow Hitler! He will dance, but it is I who have called the tune! I have initiated him into the 'Secret Doctrine,' opened his centers in vision and given him the means to communicate with the Powers. Do not mourn for me: I shall have influenced history more than any other German."

Thus spake Dietrich Eckart as he lay dying from the effects of mustard gas in Munich in December 1923. One of the seven founding members of the Nazi party, this imposing Bavarian was outwardly known as a poet, a gifted writer and historian, a bon vivant and a lover of witty talk. Yet those who saw him apparently immersed in the gay social round of the Munich Bierkellers never guessed that behind the jovial façade of this veteran Army Officer was hidden a dedicated satanist, the supreme adept of the arts and rituals of Black Magic and the central figure in a powerful and widespread circle of occultists—the Thule Group. . . . He claimed to his fellow adepts in the Thule Group that he had personally received a kind of satanic annunciation that he was destined to prepare the vessel of the Antichrist, the man inspired by Lucifer to conquer the world and lead the Aryan race to glory. — Trevor Ravenscroft, from *The Spear of Destiny*

Adolf Hitler and the Secrets of the Holy Lance
Colonel Howard Buechner and Captain Wilhelm Bernhart
"'He who holds the lance (which shed the blood of Christ) controls the destiny of the world for good or evil.' Hitler held the lance for seven years (1938-1945). When he sent it to an ultrasecret hiding place, he unleashed an incredible series of events. Read about the location of Hitler's treasure, mysterious Wewelsburg castle, Himmler's SS Knights of the Lance, U-boat voyages to Antarctica and South America, and many other astounding disclosures."
$15.95 *(PB/223/Illus)*

Hitler: Black Magician
Gerald Suster
Originally published as *Hitler: The Occult Messiah*, this is a staunchly Crowleyian interpretation of the rise of National Socialism in Germany. Suster sees the Nazis and the Holocaust as prefigured in the revelation of *The Book of the Law*, which Crowley received from the entity Aiwass in

1904, supposedly ushering in the Age of Horus (the Egyptian god of War). Suster provides some interesting occult tangents of the Third Reich such as the alliance between the Tibetan monks and the Ahnerbe (or Nazi occult bureau), the Nazi campaign against Rudolph Steiner and his Anthroposophist followers, and Hitler's connections with the Aryan-esoteric Thule Gesellschaft. The highlight of Suster's spiritual version of World War II is his assertion that Ian Fleming, while serving in the British wartime Secret Service, lobbied for Aleister Crowley to interrogate Rudolph Hess about the magical strategies of the Third Reich.
SS
$11.95 *(PB/222/Illus)*

The Mark of the Beast: The Continuing Story of the Spear of Destiny
Trevor Ravenscroft and T. Wallace Murphy
A prophetic work from the author of *The Spear of Destiny*: "Now when we are standing at the very threshold of the spiritual world, a great personal and irrevocable decision must be made. The symbol which

should help you make your decision, one way or another, is the Spear of Longinus. On the one side it will become the very emblem of the World Dictator who will claim it as his own talisman of global power. On the other it is the symbol of the redemptive, sacrificial, ritual love at Golgotha and the inspiration of all who seek to tread the pathway to spiritual freedom. In the great apocalyptic battle between good and evil this vital decision cannot be postponed. Whose side are you on?"
$12.95 *(PB/246/Illus)*

The Occult Establishment
James Webb
"The bizarre, pathetic doings of spiritual artists, vegetarians, mediums, astrologers and magicians intertwine with the lives of Richard Wagner, Baden Powell, C.G. Jung and other surprising notables. But there is a sinister side to this absorbing saga of folk dancing, health foods and rejection of capitalist rationality: search for purity of 'blood' as well as purity of bowels, allied with the conviction that all unwelcome features of modern life are consummations

of a malignant conspiracy. In this meticu-
lously researched history of occultism since
1918, Webb examines the 'Illuminated
Politics,' which saw its greatest triumph in
the Hitler regime. After Hitler, occultism
continued to pervade art and literature, and
expressed itself in the such movements as
the beatniks, hippies, Situationists and anti-
psychiatry."
$14.95 *(PB/535)*

The Prophecies of Adolf Hitler
Christopher S. Hyatt and S. Jason Black
"A new examination of Hitler as a tradition-
al religious phenomenon rather than the
political aberration he is more comfortably
considered to be. This book demonstrates
convincingly that Nazism followed the
same pattern of religio-political manipula-
tion repeated from the time of Constantine
until today. Details Catholic collusion with
Hitler and the occult and magical roots of
the Nazi Party."
$14.95 *(PB/192)*

Secret Nazi Polar Expeditions
Christof Friedrich
Packed with photos, this book is the perfect
companion to *Secrets of the Holy Lance, The
Spear of Destiny*, and a litany of similar
books devoted to scrutinizing the Nazis and
their obsession with the occult. The author
delivers a penetrating, in-depth description
detailing the secret missions of German U-

*The Spear of Longinus, often named the Maurice
Spear, now consists of two parts held together by
a silver sheath. A nail from the Cross of Christ has
been inserted into the blade and is held in place by
gold, silver and copper threads. The base of the
spearhead is embossed with gold crosses. — from*
The Mark of the Beast

boat convoys dispatched to the Antarctic by
Hitler during the final, tumultuous days of
the Third Reich. Imagine the caches of
buried Nazi treasure just begging to be dis-
covered. Published by Ernst Zundel, the man
who brought Canada's great Holocaust trial
to the public a few years ago. **JB**
$10.00 *(PB/128/Illus)*

The Spear of Destiny
Trevor Ravenscroft
Of the handful of books which cover the

relationship between the occult and its
influence on Nazi Germany, this one
remains one of the most thoroughly enter-
taining accounts. The description of a des-
perate and frustrated young Adolf in Vienna
gazing raptly at the Spear of Longinus at
the Hofburg Museum between artistic
bouts of creating kitschy, sentimental
watercolors is priceless. Better still is his
victorious re-entry into the city in order to
claim the mystic relic, which supposedly
was the spear which pierced Jesus' side.
And then there is the strange Thule
Gesellschaft, the pseudo-magical order
which Ravenscroft says initiated Hitler
into the occult; Karl Haushofer's strange
brand of geopolitics; the forged *Protocols
of the Elders of Zion*; Himmler's occult SS
bureau; black magic-homeopathy and
Wagnerian imagery aplenty. Yes, this book
reads like a novel, or better yet like some
Indiana Jones adventure, with Rudolph
Steiner as its hero. . . . Despite the
overblown, gee-whiz quality of the book, it
is an intriguing illustration of just how
popular the idea of personal identification
with race was before World War II.
Ravenscroft's fast-paced narrative does
have a good bibliography, but don't expect
this to be a scholarly tome. **MM**
$12.95 *(PB/400/Illus)*

Unholy Alliance: A History of the Nazi Involvement With the Occult
Peter Levenda
Satan, sex, eugenics, Tibet and the
Swastika. How the Nazis attempted to
become all-powerful through the wicked
enchantment of ritualism. The search for
power beyond any physical elements and
the struggle to be the most fearful country
to ever exist: "Mark my words, Bormann, I'm
going to become very religious . . ."—Adolf
Hitler. **TD**
$6.99 *(PB/407)*

Vril: The Power of the Coming Race
Sir Edward Bulwer-Lytton
Hollow-Earth theory, geomancy, psychic
breeding—inspiration to Nazi pseudoscience
and New Age disciples, by a 19th-century
British member of the Golden Dawn.
$11.50 *(PB/256)*

Hitler speaks: note the demonic expression. — from **Hitler: Black Magician**

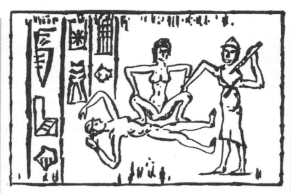

A Babylonian cylinder seal, one of the earliest depictions of a vampire — from **The Vampire Encyclopedia**

<div style="text-align:right;">

VAMPIRE

</div>

The Bloody Countess: The Crimes of Erzsébet Báthory

Valentine Penrose

The authentic case history of the bloody crimes of Erzsébet Báthory, the 17th-century Hungarian countess whose chronicle of atrocities suggests a female counterpart to Gilles de Rais. A descendent of one of the most ancient, aristocratic families of Europe (as well as the offspring of centuries of intermarriage), Báthory appears to have been consumed by sadistic fantasies from as early as adolescence. By middle age these desires had escalated to witchcraft, torture, blood-drinking, cannibalism and, inevitably, wholesale slaughter. Taking the folkloric

tradition of pure blood as remedy for disease to its psychopathic limits, the countess instigated a cycle of mutilation and butchering of virgin girls—all of whom were processed for the ultimate, youth-giving ritual: the bath of blood—which led to some 650 murders, the bloodless corpses carelessly buried throughout the Carpathian lowlands. Condemned to life imprisonment in a cell in her own castle, the unrepentant Báthory died on August 21, 1614, "without crucifix and without light." Deftly translated by Alexander Trocchi (of *Cain's Book* and *Merlin* magazine fame) and replete with an appendix containing extracts from her trial, The Bloody Countess is an intriguingly repulsive account of unchecked decadence

and irredeemable transgression. **MDG**
$13.95 *(PB/160)*

Dracula: Prince of Many Faces

Radu Florescu

"In 1972, in a book called *In Search of Dracula*, professors Florescu and McNally revealed the existence of a historical prince born in Transylvania named Dracula. It has taken them over 15 additional years of research and travel to some of the most desolate spots in the world to unearth the complete history of this multifaceted prince, the inspiration for Bram Stoker's classic novel *Dracula*. Known as Vlad Dracula the Impaler, this prince was leg-

endary even in his own time for committing crimes that were excessive in both nature and number. He created a bloodcurdling 'forest of the impaled' to dissuade an invading army from attacking his capital. . . . Whether hero or monster, Vlad Dracula finally can be understood only in the context of his times . . . any fictional creation pales by comparison to this true tale."

$14.95 *(PB/261/Illus)*

The Dracula Cookbook of Blood

Ardin C. Price and Trishna Leszczyc

As the title suggests, this is indeed a collection of recipes that necessitate the use of blood. These are real recipes from Finland to Samoa, China to Africa—the reader can probably find one of Great-Great Grandma's recipes in here. Some are short and succinct, such as the Blood Breakfast Cakes from Scotland, "Thicken cow's blood with fine oatmeal and season to taste. Shape into patties and fry." Or a slight variation from Indonesia, Pudding Cakes, "Mix blood and cooked rice, season to taste. Form into patties and bake." Others, especially those from France, are much more involved. Over 60 authentic recipes are interspersed with folklore and a short history of blood consumption. The only problem might be finding the blood to cook with! **TR**

$14.95 *(PB/149)*

Spiritual Vampires: The Use and Misuse of Spiritual Power

Marty Raphael

Welcome to Marty's World, a super-duper-easy-to-read look at some terrible things that happened to a very nice girl. After years of abuse from her father, Marty lost the use of her voice and suffered from adrenaline addiction, learning disabilities, depression, chronic back pain, eating disorders and a spiritual addiction. Her father was a spiritual vampire. "Vampirism is a progressive disease that begins with parasitic activity, devolves to predatorial activity and finally erupts into some type of serious perpetration," she writes. And perpetrate, he did.

After spending over $100,000 on pop religions to get over the effects of her father's abuse, she is now faced with overcoming the abuse of pop religions. Several exposés are served up. Some are pretty quirky, such as the one about one group where the

Dracula does the unthinkable and removes his stake in Dracula Has Risen From the Grave. — *from* **Hammer, House of Horror**

female leader initiated a 13-year-old boy into manhood during an Ecstasy-fueled sex ritual. Another cool story she tells is about a cult called The Work, where you have to run 60 miles, three times a month; thus the adrenaline addiction.

It's hard to disagree with the simple, sound advice Raphael gives about scoping out your guru. She should know. She gives point by point details on how to select good workshops, evaluate teachers and how to recognize spiritual vampires. **GE**

$14.95 *(PB/256)*

Vampire: The Complete Guide to the World of the Undead

Manuela Dunn Mascetti

"Drawing upon dark myths and legends culled from a variety of cultures and gathered over thousands of years, *Vampire* is a fascinating compendium of cautionary tales and hearsay, of written chronicles and first-hand encounters with the black angels that stalk the Earth in the dead of night. Mascetti reveals the secret rituals, spells and habits of these fiends; records their

physical attributes, including the gruesome transformation from human to supernatural being; and catalogs the obsessions and desires that possess them. In addition, she takes the reader on a spine-chilling journey to the heart of Transylvania in search of Count Dracula himself." Also known as Vlad the Impaler, he created a "forest of the impaled," which lined the roads to welcome invading troops and all visitors. "Women, children, young and old men were staked, sharp poles thrust between their buttocks, the body being pulled downwards until the sharp point appeared through the throat or top of head; the wooden pole was then planted in the monstrous forest." This was also to prevent crime in the area, and it did.

DW

$20.00 *(HB/200/Illus)*

The Vampire Encyclopedia
Matthew Bunson
"In more than 2,000 entries from Hecate to Hematomania, Lycanthropy to Lugosi, Mirrors to Montenegro, *The Vampire Encyclopedia* covers in detail such subjects as the history of the vampire legend;

Erzsébet Báthory — from **Bloody Countess**

Castle Bran in Romania, one of the models for the dread castle dwellings of the vampire, including Castle Dracula in Bram Stoker's 1897 masterpiece — from **The Vampire Encyclopedia**

methods of finding, identifying, and destroying vampires; the origin and meaning of the accepted ways of resisting vampires; the manners in which in which one can become a vampire; the importance of blood in vampiric lore; the role of the vampire bat; and the psychological-medical views on vampirism."

$16.00 *(PB/303/Illus)*

The Vampire Film: From Nosferatu to Bram Stoker's Dracula
Alain Silver and James Ursini
A fairly standard film-history book, this is a taxonomy of the various historical incarnations of the vampire legend—a lengthy list. Bram Stoker's 1897 novel *Dracula* has inspired more movies than any other book, including the Bible. Not only does the reader meet historic personages such as Vlad the Impaler and Erzsébet Báthory, there are also profiles of such notable movie vampires as Bela Lugosi and Christopher Lee. However, the book doesn't stop here. All of the genre vampire films are painstakingly examined, including Mexican vampires, lesbian vampires, blaxploitation vampires,

extraterrestrial vampires, Asian vampires, and various sons, daughters and diverse in-laws of the Count. The book concludes with a thorough filmography including such rare and hard-to-find inclusions as Sheridan Le Fanu's lesser-known and non-lesbian vampire story *The Inn of The Flying Dragon* and *Santo en la Venganza de las Mujeres Vampiro.* **MM/ES**

$20.00 *(PB/272/Illus)*

Vampires, Burial, and Death: Folklore and Reality
Paul Barber
Impales, garlics, beheads and buries the Dracula myth. "Surveys centuries of folklore about vampires and offers the first scientific explanation for the vampire legends. From the shoemaker from Breslau whose ghost terrorized everyone in the city, to the testimony of a doctor who presided over the exhumation and dissection of a graveyard full of Serbian vampires." Chapters include: "How Revenants Come Into Existence," "The Appearance of the Vampire," "Search and Destroy," "Some Theories of the Vampire," and "The Body After Death." **GR**

$13.00 *(PB/236/Illus)*

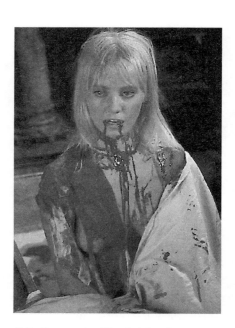

Yutte Stensgaard as Mircalla in Lust for a Vampire *— from* **Hammer, House of Horror**

VATICAN

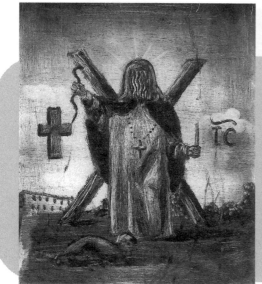

Untitled, Manuel Ocampo monoprint, 1992 — from **Virgin Destroyer**

The Pope seized the earth, an earthly throne, and grasped the sword; everything has gone on in the same way since, only they have added to the sword lying, fraud, deceit, fanaticism, superstition, villainy. They have trifled with the most holy, truthful, sincere fervent feelings of the people; they have bartered it all, all for money, for base earthly power. And isn't that the teaching of the Antichrist?
— Fyodor Dostoyevsky, from *The Idiot*

The Awful Disclosures of Maria Monk
Maria Monk
This book, first published in 1835, is one of the all-time great anti-Catholic diatribes of recent history. And despite the fact that Miss Monk was proved beyond any reasonable doubt to be a fraud and to have completely fabricated this work, Books for Alert Protestants reprints it as factual history. Read about the lurid abuse of the confessional; the sexual abuse heaped upon poor Miss Monk by priest and abbess alike; the horrible methods of punishment applied; the infanticide of unwanted babies and, last but not least, the general corruption of the Roman Catholic Church—a Catholic *Protocols of the Elders of Zion* but with rampant sex and cruelty. If only Catholic nuns were brutal vixens like *Ilse, She-Wolf of the SS*! Alas most nuns only sacrifice their lives to education without any pay or such benefits as Social Security. This was one of the first American mass market anti-religious propagandist tracts. As an imaginative, titillating fantasy of the Catholic Church, it's great but as an influential piece of anti-religious propaganda, Maria Monk's disclosures may have paved the way but are not on a par with the aforementioned *Protocols.* **MM/ES**
$7.95 *(PB/125)*

The Homosexual Person: New Thinking in Pastoral Care
Father John F. Harvey
"This book presents an orthodox Catholic perspective on how to counsel homosexual persons to lead chaste lives. Father Harvey, the founder of Courage, has done 35 years of pastoral work with homosexuals. He discusses the teachings of the Church on homosexuality, outlines theories about the origins of homosexuality and discusses the possibility of a change of orientation for homosexual persons as well as pastoral perspectives and programs offered to them."
$13.95 *(PB/255)*

Junipero Serra, the Vatican and Enslavement Theology
Daniel Fogel
Account of Junipero Serra's notorious establishment of the California missions, his work for the Holy Inquisition, his masochism, and the conversion of the Indians of California to Christianity.
$9.00 *(PB/219/Illus)*

The Keys of this Blood: Pope John Paul II Versus Russia and the West
Malachi Martin
"Only Malachi Martin, consummate Vatican insider and intelligence expert, could reveal the untold story behind the Vatican's role in today's winner-take-all race against time to establish, maintain and control the first one-world government. . . . It is not too much to say, in fact, that the chosen purpose of John Paul's papacy—the engine that drives his papal grand policy and determines his day-to-day, year-by-year strategies—is to be the victor in that competition, now well under way. For the fact is that the stakes John Paul has placed in the arena of geopolitical contention include everything—himself, his papal persona, the age-old Petrine Office he now embodies, and his entire Church Universal, both as an institutional organization unparalleled in the world and as a body of believers united by a bond of mystical communion."
$15.00 *(PB/734)*

Lead Us Not Into Temptation: Catholic Priests and the Sexual Abuse of Children
Jason Berry
"In the decade of 1982 to 1992, approxi-

mately 400 priests were reported to Church or civil authorities for molesting youths. By 1992, the Church's financial losses—in victim's settlements, legal expenses and medical treatment of clergy—had reached an estimated $400 million. Reports of these cases—and how bishops handled them—raise stark questions about the psychological dynamics of clerical governing. For seven years it has been my strange lot to travel long distances, interviewing countless sources, gathering legal documents and church reports, reading theology, psychology and studies of human sexuality. In my travels I sought an objective account of changes tearing at the central nervous system of the Church. In time this line of inquiry ran up against an older memory of faith, and the tension caused me quite a struggle. It has left the Catholic in me with a sense of urgency."

$15.00 *(PB/407)*

Lesbian Nuns: Breaking Silence

Edited by Rosemary Curb and Nancy Manahan

"Nuns and ex-nuns describe their individual stories and journey in discovering, facing and experiencing the truth about themselves: that she is a lesbian nun." "My favorite part of the book are the before-and-after pictures of Sister So-and-so. First you see her smiling in a habit, and then you see her in overalls looking like Johnny Cash."—John Waters

$9.95 *(PB/383/Illus)*

The Missionary Position: The Theory and Practice of Mother Teresa

Christopher Hitchens

Like the Blues Brothers, Mother Teresa (née Agnes Bojaxhiu) is on a mission from God—so don't question how her sainthood was all but guaranteed by public opinion shaped from an early BBC documentary and book, or how she endorsed fascist reapportionment of her native Albania in exchange for being allowed a highly publicized homecoming there, or why she didn't return Charles Keating's $1.25 million when asked by Judge Ito's court. Hitchens presents hard-hitting testimonials by doctors and nurses of total medical ineptitude at her clinics, and shows how the Reagan and Thatcher governments used Mother Teresa and her good name as a political ringer for

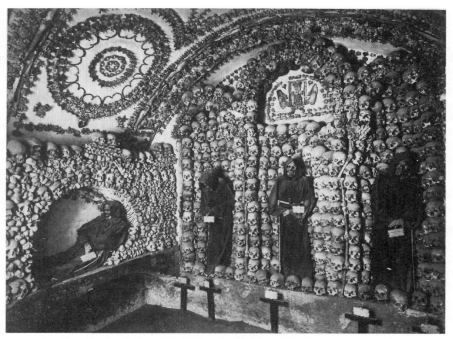

Ossuary in a Capuchin church, Rome, late 1870s — from **Looking at Death**

anti-abortion conservative causes. Contains the classic photo of Mother Teresa and John Rutger (Ariana Huffington's guru) in a studio superimposed over another picture of children in the Calcutta ghetto. Mother Teresa on not giving morphine to a terminal patient: "You are suffering like Christ on the cross. So Jesus must be kissing you." The sufferer's reply: "Then please tell him to stop kissing me." **MS**

$14.95 *(HB/98/Illus)*

Murder in the Vatican: American, Russian and Papal Plots

Avro Manhattan

"The most dramatic and bloody account of the incredible plots, deaths and murders inside and outside the Vatican. Spectacular disclosures of rigged papal elections, bribed cardinals, bugged conclaves and the most-secret operations of the KGB and the CIA in Washington, Moscow and Vatican City."

$8.95 *(PB/274)*

The Myth of the Virgin of Guadalupe

Rius

Rius, the cartoonist responsible for this booklet, is described on the back cover as the Mexican equivalent of Doonesbury.

Don't let this scare you away. Rius attempts to destroy the story of the alleged miraculous appearance of the image of the Blessed Virgin Mary (BVM) on a piece of cloth on December 9, 1531. The alleged relic is still on display and has become a unifying symbol of the Mexican people, as well as a favorite tattoo image for for Hispanics in prison.

Rius makes his case, for the most part, not by attacking the image itself, as others have done. Instead, the bulk of his argument is the lack of historical record supporting the origin of the artifact. He shows that a number of attempts to verify the timeline of the relic have come to the same negative conclusion, regardless of the religious feelings of the investigators. In the end, Rius makes a strong case to doubt the artifact's authenticity without even having to examine the image in question. The entire booklet is written in longhand and profusely illustrated with Rius' cartoon illustrations. Although the style is meant to be informal, after a while it becomes distracting and feels like you are reading a friend's way-too-long letter about his summer vacation. Perhaps the most annoying part is when he prints a long account of the appearance of the image, and interrupts the telling every few lines to belittle the story.

Here he comes off like Courtney Love reading Kurt Cobain's suicide note. The booklet is published by the fundamentalist atheist publishing house American Atheist Press, the publishing arm of the mysteriously missing Atheist Madalyn Murray O'Hair.

TC
$9.00 *(PB/69/Illus)*

Observations of Mary at Medjugorje
Harvey Grady
A short account of one man's visit to a site in Yugoslavia where the Virgin Mary was reported to be appearing in the late 1980s. A non-Catholic, Grady made daily observations over the period of a week and recounts the experience of witnessing the apparition. Of interest to followers of Marian phenomena is the bibliography which lists books pertaining to the Virgin Mary appearances worldwide. **AS**
$8.00 *(Pamp/24)*

Padre Pio: The Stigmatist
Rev. Charles Mortimer Carty
"Renowned for the stigmata, which modern medical science could not explain, Padre Pio also possessed other unusual qualities, such as bilocation, celestial perfume, the reading of hearts, miraculous cures, remarkable conversions and prophetic insight. . . .

"Padre Pio's hands, which the faithful can see while he celebrates Mass, are covered with blood, and the wounds seem bigger than they are in reality. Washing them with

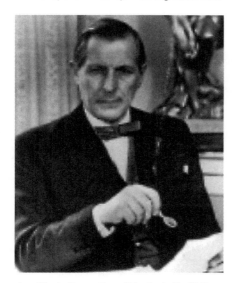
Avro Manhattan, author of **Murder in the Vatican**

water, the stigmata appear as circular wounds, about two centimeters in diameter, in the center of the palm. Equal wounds are found on the back of the hands in such a position that they give the impression that the wounds meet each other and the hands are pierced through and through or transfixed, so that a bright light should be seen through the stigmata."
$15.00 *(PB/310/Illus)*

Stigmata: A Medieval Mystery in a Modern Age
Ted Harrison
"A 10-year-old black girl in California bled from her palms, feet, right side and the middle of her forehead for 19 days in 1972, until Good Friday, when the bleeding stopped. A Washington, D.C., priest experienced spontaneous bleeding from his wrists, feet and right side in 1991. Since St. Francis of Assisi in the 13th century, ordinary people have suffered spontaneous lesions and bleeding resembling the wounds received by Christ during the crucifixion. . . . Includes a startling analysis of the socioeconomic conditions that might give rise to the emergence of stigmatics at the end of another millennium and interviews with a medical expert on stigmata."
$10.95 *(PB/176)*

Unzipped: The Popes Bare All— A Frank Study of Sex and Corruption in the Vatican
Arthur Frederick Ide
Those darn atheists! Instead of happily swallowing the age-old dogma fed to them by authorities of organized religion, they chew it up, defiantly spit it back and go about studying the stuff to find out what's really in it. Arthur Frederick Ide is one of those. He's written over 200 books, many on the subject of the Christian religion and its influence on politics and prejudices during the mid-'80s. Here, Ide takes on the Roman Catholic institution of the papacy, researching early church writings and historical documents to expose the undeniably fallible human side of the men who, in the Church's own words, "can only be judged by God Himself."

Reciting a seemingly endless litany of corruption, coercion, torture, murder, sex fanaticism, insanity and absolute authority, the author nearly numbs us with his well-documented indictment of an office many people worship on a level nearly equal with the Deity. After awhile, just when one is tempted to say, "Enough!" the author has thoughtfully included reproductions of images of torture and Inquisition devices used to convert uncommitted souls in the past. And just in case you think all this happened a long time ago in a galaxy far, far away, and not in our own "enlightened" times, Ide reminds us about the unfortunate John Paul I, who in 1978 died mysteriously after only 30 days in office. There is the theory that he was poisoned. Remember that this was only one pope ago. **AS**
$8.00 *(PB/189/Illus)*

The Vatican Billions
Avro Manhattan
"The Catholic Church claims to be poor, but this eye-opener will show show you she has wealth beyond your wildest dreams. With devastating thoroughness, secular author Manhattan untangles the web of deceit and reveals how the Catholic church has, through the centuries, amassed and multiplied billions of dollars in assets, including gold, real estate, stocks and bonds. Also revealed are the unscupulous methods she used to amass this unfathomable wealth, including everything from tricks played on kings, to the millions who attempt to avoid hell and shorten Purgatory with money."
$11.50 *(PB/304)*

The Vatican's Holocaust
Avro Manhattan
Packed with gruesome photographs of hangings, throat-slitting and mass murder, this book is one man's solo crusade to expose what he believes is the Vatican's complicity in a circus of blood horrors precipitated against the Serbs by the "Catholic" Ustashi. However, replace his continuous references to alleged murderers as "Catholics" with the words "Jews," "blacks," or any other minority, and what you are left with is an incitement to hatred based upon creed. In fact, the book is highly similar to Julius Streicher's infamous *Stürmer* newspaper, except the "Jew" is now replaced by the "Catholic." For this reason alone, the book makes for very amusing reading. **JB**
$8.95 *(PB/236/Illus)*

VOODOO

The Vèvè of Danbhalah and Aïda We'do — from Secrets of Voodoo

For the nonbeliever, there is something profoundly disturbing about spirit possession. Its power is raw, immediate, and undeniably real, devastating in a way to those of us who do not know our gods. To witness sane and in every regard respectable individuals experiencing direct rapport with the divine fills one with either fear, which finds its natural outlet in disbelief, or deep envy. The psychologists who have attempted to understand possession from a scientific perspective have tended to fall into the former category, and perhaps because of this they have come up with some bewildering conclusions, derived in part from quite unwarranted assumptions.

For one, because the mystical frame of reference of the vodounist involves issues that can not be approached by their calculus—the existence or nonexistence of spirits for example—the actual beliefs of the individual experiencing possession are dismissed as externalities. To the believer, the disassociation of personality that characterizes possession is the hand of divine grace; to the psychologist it is but a symptom of an "overwhelming psychic disruption." — Wade Davis from *The Serpent and the Rainbow*

The Faces of the Gods: Vodou and Roman Catholicism in Haiti
Leslie G. Desmangles
As defined in its politically correct definition, voodoo is a "vibrant folk religion that has played and continues to play a major role in the religious lives of the common people of Haiti." Among the politically incorrect, however, Voodoo appears to be among the most ancient and superstitious of human practices; the mixing of religion with black and white magic, and a threat to the neck of any unfortunate chicken within arm's reach. Between these two interpretations we have the well-written, scholarly tone of Desmangle's book. Informative and interspersed with interesting photos. **JB**
$12.95 *(PB/218/Illus)*

Famous Voodoo Rituals and Spells
H.U. Lampe
"The world's most complete book of secret voodoo rituals and materials. Voodoo dolls, potions, herbs, oils, candles, incense, powders, hexes, crossings, etc. Hundreds of secret methods, spells, and exactly how to use them." Published in New Orleans.
$5.00 *(Pamp/73)*

Macumba: The Teachings of Maria-José
Serge Bramley
"Macumba is a way of life and belief that is followed by 15 million Brazilians, as well as millions more across the Western hemisphere. Yet it—along with its sister-religions of Vodun, Santería and Ifa—remains a little-known and largely misunderstood spiritual path. . . . In a series of interviews, Maria José, a *Mae de Santa* (Mother of the Gods), explains the philosophy and practice of Macumba. She introduces the Orixas, a pantheon of deities who survived the Middle Passage to Brazil along with the

African slaves."
$12.95 *(PB/231/Illus)*

The Magic Island
William Seabrook

"Journalist, adventurer and raconteur Seabrook describes in detail rituals that involve soul transferring, necromancy and resurrection, and relates stories of sorcery and witchcraft gathered in various circles of Haitian society. As research for the book, the author went to live in the jungles of Haiti, where he stayed with the family of Maman Célie, a voodoo priestess who initiated him into the religion and taught him its rites. Incisive and vivid, *The Magic Island* is an unparalleled investigative account told with sensitivity and courage by a traveler of wide experience." Originally published in 1929. Illustrated with both expressionistic drawing and photos by the author.
$10.95 *(PB/336/Illus)*

The Sacred Ifa Oracle
Dr. A.A. Epega and P.J. Neimark

Newly translated from Yoruba, this work presents the basis underlying such African-derived New World religions as Santería, Candomble, Macumba and Vodun. The Ifa Oracle presents a window on a universe that resembles the Chinese I Ching system and holds the answers for the practitioner. The Ifa practitioner believes that the future can be known if the nonquantifiable world of spiritual energy is used to comprehend the quantifiable world of matter. **MET**
$20.00 *(PB/549)*

Samba in the Night: Spiritism in Brazil
David J. Hess

Written by an anthropologist, this is an account of field work and explorations into nonmainstream religions in Brazil and their exorcisms, psychic surgery, spirit mediums, poltergeists, spiritual healings, succubi and incubi. The author considers the relationship between spiritism and other popular religions in Brazil and how Spiritists re-create science and nature. **MET**
$24.95 *(HB/214)*

The Santería Experience
Migene Gonzalez-Wippler

"A definitive treatise about a religio-magical cult that reputedly has millions of indoctrinated followers in the Caribbean Islands, South America and Latin American

The loa "mounts" the houngan — from Tell My Horse

sectors of the United States. The author gives vivid firsthand descriptions of exotic rituals that are instructive and fascinating to professionals and laypersons alike."
$6.95 *(PB/228)*

Rituals and Spells of Santería
Migene Gonzalez-Wippler

"Takes us further into the practices of the followers of Santería."
$5.95 *(PB/134)*

Secrets of Magical Seals
Anna Riva

This has the look of one of those books that is mostly sold at the local botanica. It might be equally at home in a Sanrio store in the "Let's Magic" section. Most of its loopy charm is derived from its attempt to be really completist about the subject of seals and shields and talismans. To its credit, it doesn't claim to be definitive and it doesn't urge the novice to attempt dangerous things. In fact, it sort of explains magic seals in such a way that if somebody were to dabble with the information provided here, they might end up visually customizing something to suit their own idiosyncratic needs. Among the pages and pages of visual offerings are: symbols of the planets, the seals of Solomon, Egyptian symbols,

Gnostic seals, Islamic talismans, Chinese seals and seals of the saints. **SA**
$4.50 *(PB/64/Illus)*

Secrets of Voodoo
Milo Rigaud

"Rigaud was born in 1903 in Port au Prince, Haiti, where he spent the greater part of his life studying voodoo tradition. In Haiti, he studied law, and in France, ethnology, psychology and theology. The involvement of voodoo in the political struggle of Haitian blacks for independence was one of his main concerns after he returned to his country. . . . *Secrets of Voodoo* traces the development in Haiti and the Americas of this complex religion from its sources in the brilliant civilizations of ancient Africa. This book presents a straightforward account of the gods, or *loas*, and their function, the symbols and signs, rituals and the ceremonial calendar of voodoo; and the procedures for performing magical rites are given."
$14.95 *(PB/219/Illus)*

The Serpent and the Rainbow: A Harvard Scientist Uncovers the Startling Truth About the Secret World of Haitian Voodoo and Zombies
Wade Davis

Ethnobotanist Davis traveled into the Haitian countryside to research reports of men drugged, buried alive and resurrected from their graves. He learned the secrets of voodoo potions, powders and poisons, and discovered the herb which creates the

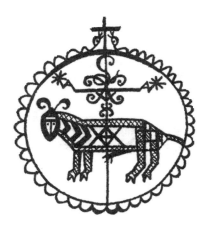

Vèvè of Agoueh, spirit of water — from Secrets of Voodoo

zombie.
$6.50 *(PB/371/Illus)*

Spirit World
Michael P. Smith

This is primarily a book of black-and-white photographs taken between 1968 and 1983 of the various black spiritual communities of New Orleans. The photographer sees them less as art photos than as documents, even though they are beautifully composed and technically excellent. The communities run the gamut from fundamentalist, to "personal" (with a lot of really great "outsider art"-style signs), to Catholic/voodoo, to the "Indian tribes" of Mardi Gras. The text is succinct and does a great job of explaining the various ways in which spirituality manifests itself without being overly analytical about it. Probably nowhere better than New Orleans could one see this much diversity within any community, be it ethnic or religious. **SA**
$19.95 *(PB/120/Illus)*

Tell My Horse
Zora Neale Hurston

"Hurston was a novelist, folklorist and anthropologist whose fictional and factual accounts of black heritage are unparalleled . . . As a first-hand account of the weird mysteries and horrors of voodoo, *Tell My Horse* is an invaluable resource and a fascinating guide. Based on Hurston's personal experiences in Haiti and Jamaica, where she participated as an initiate rather than just an observer of voodoo practices during her visits in the 1930s, this travelogue into a dark world paints a vividly authentic picture of ceremonies, customs and superstitions of great cultural interest."
$13.00 *(PB/311)*

Urban Voodoo: A Beginner's Guide to Afro-Caribbean Magic
S. Jason Black

A personal account of the religion by two writers who entered it from the outside. "This book deals very frankly with psychic and psychological phenomena that some readers will find disturbing or simply will not believe." Sample chapters: "White Zombie," "Voodoo in the Waiting Room," "Spirits That Findeth Hidden Treasure," and "Inside a Botanica." "Includes descriptions of the phenomena triggered by voodoo practice, divination techniques,

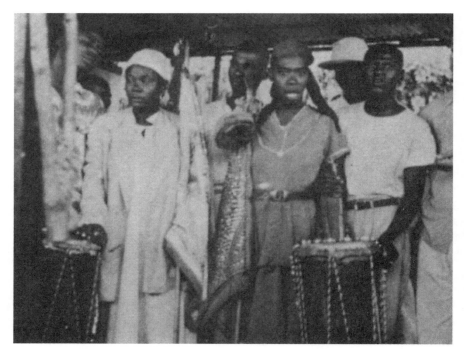

Author with houn'sih and Petroh drums — from Secrets of Voodoo

spells and a method of self-initiation."**GR**
$12.95 *(PB/192)*

Voodoo in Haiti
Alfred Metraux

A masterwork of observation and description by one of the most distinguished anthropologists of the 20th century. "Certain exotic words are charged with evocative power. Voodoo is one. It usually conjures up visions of mysterious deaths, secret rites—or dark saturnalia celebrated by 'blood-maddened, sex-maddened, god-maddened' Negroes. The picture of voodoo which this book will give may seem pale beside such images. In fact what *is* voodoo? Nothing more than a conglomeration of beliefs and rites of African origin, which, having been closely mixed with Catholic practice, has come to be the religion of the greater part of the peasants and the urban proletariat of the black republic of Haiti. Its devotees ask of it what men have always asked of religion: remedy for ills, satisfaction for need and the hope of survival."
$16.75 *(PB/400)*

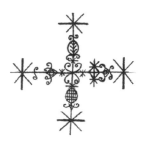

Vèvè of Simbi — from Secrets of Voodoo

Vèvè of Azaca, loa of Agriculture — from Secrets of Voodoo

NEUROPOLITICS

Aboriginal Men of High Degree: Initiation and Sorcery in the World's Oldest Tradition
A.P. Elkin
"An extraordinary series of rites, by which the young Aboriginal males experience the degrees of shamanic initiation—each marked by its own portion of esoteric knowledge. Focuses on the *karadji*, or men of high degree, who posses magical powers and who serve as channels between the Dreamtime beings and their own communities. The karadji are believed to cure and kill mysteriously, make rain, anticipate future events, and appear and disappear at will."
$12.95 *(PB/221)*

About Time: Inventing the Fourth Dimension
William J. Friedman
About Time explores the mysteries of time from the perspective of psychology. Our sense of time is not derived so much from direct perception as from elaborate temporal modeling within the mind, as though time were a ghost which we must throw a sheet over to see. A diversity of experiments and studies are presented which examine and define the complex interplay of neurological, psychological, linguistic, social and cultural factors which contribute to the elaborate inner edifice of temporal perception. No unifying theory is argued here, nor are the secrets of time travel "revealed"; rather, this is a delicate investigation of this singularly metaphysical of human experiences, the experience of time. **DN**
$19.95 *(PB/147)*

Absinthe: History in a Bottle
Barnaby Conrad III
"Reveals the legendary allure, intoxication and inspiration of the famous liquor, from its first use as a medicine in ancient Greece to its prohibition before World War I, from wild stories about its celebrated users to compelling insights into its influence on art."
$19.95 *(PB/159/Illus)*

Absinthe: The Cocaine of the Nineteenth Century — A History of the Hallucinogenic Drug and Its Effect on Artists and Writers in Europe and the United States
Doris Lanier
"Absinthe produced a sense of euphoria similar to the effect of cocaine and opium. The drink was highly addictive and caused a rapid loss of mental and physical faculties. Despite that, Picasso, Manet, Rimbaud and Wilde were among those devoted to the 'green fairy'; they produced writings and art influenced by absinthe."
$32.95 *(HB/185/Illus)*

Acid Dreams
Martin A. Lee and Bruce Shlain
Discusses the drug's discovery in 1943, the CIA's covert research program investigating its effects and the crucial role that organization played in bringing it to the masses, its use by psychiatric pioneers, its impact on the antiwar movement and political rebellion in the late '60s and much more. A landmark contribution and a fascinating piece of social and political history. **AK**
$12.95 *(PB/213)*

Alone: A Fascinating Study of Those Who Have Survived Long, Solitary Ordeals
Richard D. Logan, Ph.D.
Do you have what it takes? "Plane crash survivor Nando Parrado, half-starved, freezing,

Absinthe House, New Orleans, *painted by Guy Pene du Bois — from* **Absinthe**

and exhausted from two days climbing . . . finally struggles to a snow-covered summit from which he believes he will see the green Andean foothills and a path to help and safety for him and his stranded comrades. He sees, instead, extending to the far horizon, still more snow capped mountains and is overwhelmed, for a moment, by helpless rage. He weeps in angry frustration and almost gives up, but he looks around, realizing how much he has accomplished, and pride and determination replace his rage and despair. He has achieved a personal summit, a moment of triumph and self-revelation. He will survive. He will walk out of the mountains to find help for his dying comrades— and be a genuine hero."

$16.95 *(PB/215)*

The Alphabetic Labyrinth: The Letters in History and Imagination
Johanna Drucker
Letters of the alphabet have always held a strange magical power. Each symbol represents a sound that when arranged in the proper sequence creates a new sound that unlocks the code to produce a meaning that is understood by only those familiar with the language. It is something that we all take for granted, this incredibly complex system of communication. *The Alphabetic Labyrinth* examines the strange history of this familiar tool: Plato saw the letterforms as reflecting ideas, Pythagoreans assimilated them to number theory, Romans made them monumental and an instrument of power, Judaism gave rise to the complex theory of the Kabbalah, Christ became the alpha and omega, the Middle Ages gave them magical powers to be used in spells, divination and occult practices; through to the emergence of Renaissance humanism and the invention of printing, which finally began to rationalize the alphabet. Theories of its divine origin and mystical significance continued into the 18th and 19th centuries but became more involved with nationalism and revolutionary political theory.

Drucker presents a well-researched and -illustrated book that compares the alphabets of many languages throughout the ages. Each one borrowed from another, but continued to pass the torch to allow the letters and language to evolve. The amount of thought and concern that our predecessors put into the development of different alphabets and the powers associated with them is sometimes strange, but more often amusing. The last chapter provides some of the more unique interpretations of the alphabet including one based on the

Atlantis myth put forth by G.F. Ennis in a 1923 publication, *The Fabric of Thought.* "He suggested that in the nonsense syllables of a single nursery rhyme were preserved the sounds and symbols of an original human language. This rhyme, full of racist bias, he gave as: 'Ena Dena Dina Do/Catch a Nigger by the Toe/If he hollers let him go/Ina Mena Mina Mo.' Through elaborate charts arranging the letters in rows, squares, and columns, Ennis demonstrated that the nonsense syllables spelled out a primal code, each letter of which was the name of a god or king and filled with profound significance. As the English version of the rhyme was so close to the original language it proved that England was very close—geographically and spiritually— to the old Atlantis. . . . Children and rustics, he concluded, were the true guardians of culture, and thus the continual repetition of this rhyme in the mouths of school children perpetuated the 'wonder of the code and the glory of life and death.'" **AN**

$45.00 *(PB/328/Illus)*

The Ape That Spoke: Language and the Evolution of the Human Mind
John McCrone
"Author's Warning: "Books about the mind have a poor track record. They are usually either mystical meanderings or jargon-ridden textbooks. More seriously, they often lack a unifying viewpoint to bring the subject into focus. This book tries to view the mind from a single illuminating perspective. It is based on the assumption that the human mind must have evolved; that self-consciousness must have a biological basis. It then uses plain language to take the reader through some difficult territory: the origins of language, the evolution of habits of thought, and the 'mapping' of the world in the brain which creates awareness. It ends up with the controversial conclusion that the human mind is only a few degrees different from an animal's and that self-consciousness, memory and higher emotions are all simple language-driven abilities which we pick up as children."

$10.00 *(PB/288)*

The Archaic Revival: Speculations on Psychedelic Mushrooms, the Amazon, Virtual

Reality, UFOs, Evolution, Shamanism, the Rebirth of the Goddess, and the End of History
Terence McKenna

"The mushroom states its own position very clearly. It says, 'I require the nervous system of a mammal. Do you have one handy?'"—*The Archaic Revival*.

Railing as he does against what he terms the "dominator" religion, McKenna might be amused to discover that he has much in common with Augustine of Hippo, especially in regard to the latter's Enchidirion. Both believe that your average Joe, working either in the fields or in the office, have neither the time nor the inclination to seek out those mystical experiences that transforms one's self. The answer for Augustine is the Catholic Church, which imparts a highly regulated organized religion to give benefit to even the most ill-equipped of mystics. For McKenna the answer is his "archaic revival" of shamanic methods using an equally regulated and organized method of ingesting psychedelic drugs. Of course, the application of drugs will no more lead to a person becoming a mystic than the application of a clarinet will lead to a nascent musician playing Carnegie Hall. This McKenna obviously realizes and therefore advocates the use of these drugs only in certain situations. He certainly frowns upon using his sacrament in any way that would be deemed "recreational" or even "fun." Dosages recommended are so high, such as five dried grams of psilocybin mushrooms, that McKenna describes them as "ego flattening"—this is the only result worth pursuing in the application of these elicit hallucinogenic plants and chemicals. The most interesting part of the book is his first-hand research on the use of certain drugs employed in the Amazon basin. **MM**
$15.00 *(PB/267/Illus)*

Alternative Realities: The Paranormal, the Mystic and the Transcendent in Human Experience
Leonard George, Ph.D.

Encyclopedic attempt to make scholarly sense of mankind's "anomalous phenomena," A to Z: "Sleep drunkenness: Although a period of grogginess upon waking from sleep is normal, some people are prone to becoming trapped in the two states. Unable either to return to unconsciousness or to become fully aroused, they are disoriented and behave in an uninhibited manner. Occasionally, sufferers of sleep drunkenness have committed acts of aggression, including murder. When they manage to awaken completely, they have little or no memory of the episode. Monitoring the electrical activity of the 'sleep drunk' brain has confirmed that the condition combines waking neural processes and those of deep sleep." **GR**
$17.95 *(PB/384)*

The Art and Science of Cooking With Cannabis
Adam Gottlieb

"Why this book was written: I have read the existing marijuana cookbooks and am deeply disappointed with them. In nearly every one of these the author has simply taken a dozen or so ordinary recipes from a standard cookbook, appended the line "add a half cup of grass" to each, and sold it to the public for 10 times what it is worth. If you have been following the instructions in these books, you most likely have been wasting your hard-earned dope. Although this book contains numerous recipes, it is not intended to be merely another cookbook or recipe collection. It is designed to serve as a guidebook. To teach the reader the nature of cannabis. How it combines with different foods, how it is best assimilated in the human digestive tract, and how to get the most highs for the money. The fourth section of this book is devoted to some of the most suitable dishes that can be prepared from these materials. Simply put, this is one of, if not the best book on cooking with cannabis that exists." **DW**
$9.95 *(PB/67)*

Auditory Imagery
Edited by Daniel Reisberg

"The study of mental imagery has been a central concern of modern psychology, but most of what we know concerns visual imagery. A number of researchers, however, have recently begun to explore auditory imagery . . . from the ordinary memory rehearsal of undergraduates to the delusional voices of schizophrenics, from music imagery to imagery for speech. The chapters also address the parallels (and contrasts) between visual and auditory imagery, and the relations between 'inner speech' and overt speech, and between the 'inner ear' and actual hearing."
$59.95 *(HB/288)*

Autism and the Crisis of Meaning
Alexander Durig

"This book promotes the notion that understanding meaningful perception and autistic perception will shed light on the human experience in ways that will have clear ramifications for a resolution of the crisis of meaning. Although neither the topics of meaningful perception nor autistic perception are well understood today, they can no longer be ignored. It is hoped that the use of informal logic to conceptualize a logic-based approach to meaningful perception and autistic perception will signal a turn in society's meaningful perception of itself."
$19.95 *(PB/312)*

Ayahuasca Analogues: Pangaean Entheogens
Jonathan Ott

"The first book to detail human pharmacology of *ayahuasca*, Amazonian ambrosia. In the alembic of his own brain, Ott elucidates the pharmacology of this rainforest potion via psychonautic experiments with pharmahuasca (pure ayahuasca compounds in capsules) and describes ayahuasca-like potions with temperate-zone plants as sources of the ayahuasca alkaloids and the active principle DMT. Nine tables, including a list of DMT-

A lattice-tunnel pattern with complex memory images at the periphery — from **Beyond the Body**

taining plants, show there are at least 4,000 possible combinations of plants yielding entheogenic potions using similar technology to that for making coffee or tea."

$15.00 *(PB/128)*

Beelzebub's Tales to His Grandson: An Objectively Impartial Criticism of the Life of Man

G.I. Gurdjieff

Three-volume set which gathers together the fundamentals of Gurdjieff 's teachings, which seek "to destroy mercilessly, without any compromises whatsoever, in the mentation and feelings of the reader, the beliefs and views, by centuries rooted in him, about everything existing in the world." He insists that man is asleep; it is only at the moment when he awakens, not merely to consciousness, but to conscience, that his true evolution can begin.

$55.00 *(HB/1135)*

Behind the Eye

Donald M. Mackay

"An accessible overview of the brain and its workings . . . reflections ranging from machine intelligence to linguistics, from theories of perception to the question of life after death."

$21.95 *(HB/288/Illus)*

Beyond the Body: An Investigation of Out-of-the-Body Experiences

Susan J. Blackmore

"About one person in 10 claims to have left his or her body at some time. Some were close to death, others had undergone an accident or shock; but these experiences can occur at any time and for no apparent reason. Occasionally people claim to have traveled to distant places, and even to have been sent there by others, in the course of their experiences. Do we possess some sort of "double" or astral body, which is capable of an independent existence? And if so, what implications does this have for survival after death?

Blackmore's explanation for out-of-the-body experiences is based on historical and anecdotal material, surveys and laboratory experiments (including attempts to weigh the soul and photograph the spirit). *Beyond the Body* is a rigorous yet intensely readable piece of research."

$13.00 *(PB/284/Illus)*

Black Sun: Depression and Melancholia

Julia Kristeva

"The phenomenon of melancholia is examined in the context of art: Holbein's controversial 1522 painting *The Body of the Dead Christ* in the tomb; the literature of Marguerite Duras, Dostoyevsky and Nerval; philosophy; the history of religion and culture; as well as psychoanalysis."

$14.95 *(PB/300/Illus)*

The Botany and Chemistry of Hallucinogens

Richard Evans Schultes and Albert Hoffman

"Newly discovered hallucinogenic plants have been incorporated into the discussions along with new information on some well-known drugs. . . . Initial chapters delineate definition, botanical distribution and structural types of hallucinogenic plants. Plants of known, possible and dubious hallucinogenic potential are then covered in separate sections."

$43.95 *(PB/464/Illus)*

The Brain Encyclopedia

Carol Turkington

"Up until the last few years, progress in understanding our 'enchanted loom' had been agonizingly slow, but scientists are now beginning to understand some of the brain's knottiest puzzles: How does the brain actually work? Where does memory reside within the brain? Is our brain separate from, or completely intertwined with, our body? From acetylcholine to white matter, *The Brain Encyclopedia* takes the reader on a guided tour through the brain, looking at brain diseases and disorders, structure and function. An extensive glossary explains all terms related to neurology, and there is also a detailed index. Appedixes include extensive listings of self-help organizations related to neurological problems, professional organizations and governmental groups."

$40.00 *(HB/352)*

Bread of Dreams

Piero Camporesi

"An illuminating study of the lives and attitudes of peasants in pre-industrial Europe who lived in a state of almost permanent hallucination, drugged by their very hunger or by bread adultered with hallucinogenic herbs. The use of opiate products, administered even to infants and children, was widespread and was linked to a popular mythology in which herbalist and exorcist were important cultural figures. "

$17.95 *(PB/212)*

The vertical sections of this carved wood model slide up to reveal photographs of the brain, which were made from corresponding slices of brain tissue. — from **Madness in America**

By Surprise
Henri Michaux

In this uncomfortable and ethereal journal of an unwitting psychedelic trauma Henri Michaux is the paramount stylish dandy; in his shamelessly self-promoting introduction, on the other hand, Allen Ginsberg is the fawning, drooling, tourist oaf. So force yourself to ignore Ginsberg's self-adulation. This unsolicited mortification aside, Michaux truly explores with a surgical intent the pain-filled anguish and courage he experienced in facing the mental near-disintegration and perceptual terror herein disclosed.

By Surprise begins with his arbitrary, languid decision to swallow an unknown drug left with him by a vague acquaintance. We never learn the drug's name or its pharmacological family. We don't need to. If you've ever been spiked, or similarly misled your brain by imbibing the random and surprisingly strong neurological stimulant, then you will comprehend how bizarre, frightening and tedious such a situation can become.

Drug stories are impossibly personal and subjectively vivid. They are probably not intended to lend themselves to everyday vocabulary. The ineffable is speechless. Given all these limitations, Michaux succeeds remarkably well—in particular, in conveying the peak paranoia that "this time he's done it!" and will "never come back" and the inevitable, complementary dislocation and ripping of the entire fabric of time. This is a decidedly worthwhile addition to drug literature. Brief, clear and honest. In its concise way it covers, in a few dense pages, most of the subjective ground other books dwell on ad nauseam. **GPO**
$5.95 *(PB/110)*

Carlos Castaneda, Academic Opportunism and the Psychedelic Sixties
Jay Courtney Fikes

The author attempts to set the ethnographic record straight, by comparing "true Huichol rituals" (which he studied as an anthropologist living with the Huichol Indians for several years) with what he considers the "counterfeit productions" of Castaneda. He compares his own ethnographic writings with Castaneda's books and finds very few similarities. He says that Castaneda's books are mostly the result of

"New Age capitalists competing to meet unmet psychological or religious needs," but never the result of anthropological research, as Castaneda claims. The author did not find any *brujo* who could fly over waterfalls, as Don Genaro does in *A Separate Reality*; and to raise suspicions even more, Castaneda refused to send the author his field notes so that he could analyze them. **AF**
$19.95 *(PB/283/Illus)*

Changes of Mind: A Holonomic Theory of the Evolution of Consciousness
Jenny Wade

"An extensive body of philosophical research uniting literature from the new physics, brain research, developmental psychology and mysticism producing the first comprehensive theory of individual human consciousness that begins before birth and ends after death. A new-paradigm reality that opens and extends the field of developmental psychology in ways that structure, destructure and then restructure the subjective experience of time, space, subject and object."
$19.95 *(PB/341/Illus)*

Cocaine: An In-Depth Look at the Facts, Science, History and Future of the World's Most Addictive Drug
John C. Flynn

If you've ever had a problem with cocaine, the opening pages of this book will send shivers through your blood. It starts with a depiction of a "nice yuppie girl" at the hospital—frozen into in a taut convulsing fetal position by a toxic dose of the evil snow queen. Very, very scary. From there it takes a look at the whys and hows of this insidious drug; unlocking the pleasure centers of the brain, triggering postsynaptic neurons; cocaine and sex; and the chemical manufacturing of alternative "pleasure" drugs. One of the best books I've seen on the drug, giving many facts without filler statistics or dry medical terminology, and managing to broach the area of social degradation without being preachy or political. **MDH**
$10.95 *(PB/167/Illus)*

The Complete Book of Ecstasy
U.P. Yourspigs

User-friendly and straightforward guide for chemistry-challenged adults to manufacturing underground psychoactive compounds. The particular focus is synthesizing MDMA, but the author throws in some informed opinions on "other highs" as well.
$18.75 *(PB/90/Illus)*

Consciousness and the Computational Mind
Ray Jackendoff

"An overview of the mental representations invoked by the language, visual and musical faculties. Describes how they are used in perception, production, imagery and thought . . . exploring how these representations determine the character of conscious awareness, arriving at the 'Intermediate Level Theory' of consciousness."
$13.95 *(HB/356/Illus)*

Deluxe Marijuana Grower's Insider's Guide: Revised Color Edition
Mel Frank

Includes the history and taxonomy (plant classifications) of cannabis, and discusses the active ingredients unique to this plant, the cultivation and selection of good seeds ("If you like the grass you are smoking, you'll love the grass you grow"), the different strains of marijuana (*sativa*, *indica*, *kush afghani*) and how to trick plants into flowering early by manipulating the amount of light given daily. In the midst of all this information are 64 amazing color photos (with 150 black-and-white photos as well) of some huge plants, some nice indoor and outdoor crops and microscopic close-ups. From seeds to drying the harvest, this is the authoritative informational sourcebook on growing marijuana. **DW**
$19.95 *(PB/330/Illus)*

Dictionary of Symbolism
Hans Biedermann

This book was compiled in German in 1989 and translated in 1992. The most modern symbol discussed is the UFO. There are over 2,000 entries. The symbols are drawn from mostly classical sources such as fairy tales, legends, the Bible, folklore, mythology, philosophy and religion. The writing is direct and succinct. There aren't a lot of really obscure

Aldous Huxley — from This Timeless Moment

symbols. Most of the proper names are derived from Greek mythology, Germanic lore and the Bible. Otherwise the symbols tend to be things like eyes, thresholds and lions. When a symbol, such as the cat, has had a variety of meanings over the years, the author attempts to chronicle its meanings in as many contexts as possible. Overview is the operative mode of this book. It's the sort of thing that you might pull off of the shelf during a conversation to check a general fact. **SA**

$45.00 *(HB/480/Illus)*

Dictionary of Symbols

Carl G. Liungman

"The intention of this book is that it should function as both a reference work in Western cultural history and as a tool for those working with ideograms, e.g., logotype and trademark designers, those engaged in advertising, interior designers, researchers in communication, art historians, art and history teachers, etc."

This is an amazingly well-conceived book. Dealing with non-iconic symbols (defined as pictures not easily recognized as depictions of objects), it breaks down hundreds of possible combinations of shapes into their most basic component aspects and lists any meanings which they might have in a broad range of Western cultural contexts. These symbols range from technical, astrological,

alchemical, mathematical, elemental, to even a "hobo sign." The categories have such titles as: "Asymmetric, straight-lined, open signs with crossing lines" and "Multi axis symmetric, both soft and straight-lined closed signs with crossing lines." But if that doesn't compute with the side of the brain the reader uses, there is a chart in the back for visually locating symbols and the page numbers where their meanings appear. The signs can have a meaning which might be of a different context than a reader might have considered, making this a fun book to sit and read, even though its organization would suggest that its major application might be as a reference book. **SA**

$18.95 *(PB/596/Illus)*

Doors of Perception and Heaven and Hell

Aldous Huxley

Pioneering literary account of the psychedelic experience and its relation to art and mysticism.

$12.00 *(PB/185)*

Down Syndrome: Living and Learning in the Community

L. Nadel and D. Rosenthal

Written under the auspices of the National Syndrome Society, this book provides state-

of-the-art information and advice about the latest medical advances, information about programs and services available to people with Down syndrome, and commentaries by young adults with Down syndrome, who describe in their own words their feelings and accomplishments and offer indispensable advice. "Many people recognize me from my role as Corky Thatcher on *Life Goes On*, an ABC-TV series for many years. Corky has Down syndrome and so do I. Only I call it Up syndrome, because having Down syndrome has never made me feel down."—Christopher Burke

$17.95 *(PB/297)*

Dreamachine Plans

Brion Gysin

Detailed plans, along with an introduction, for the assembly of one's very own Dreamachine. **AK**

$6.00 *(Pamp/24/Illus)*

Eccentrics: A Study of Sanity and Strangeness

Dr. David Weeks and Jamie James

"This book summarizes findings from the first systematic study of 'eccentrics': highly talented and unusual people who are somewhere between 'normal' and 'nuts.' This is a domain occupied by genuine geniuses and charming crackpots whose common feature is that they refuse to hold commonly held beliefs or refuse to act in accordance with the norms of society. Filled with fascinating case studies such as the story of Joshua Abraham Norton who, from 1859 to 1880, proclaimed himself to be Emperor of America."

$14.00 *(PB/277/Illus)*

Ecstacy: The MDMA Story

Bruce Eisner

The social history of the acid-house party pill. "A trance dance of random patterns and thrashing extremities and faces bathed in sweat and bliss-blank, glazed, open, innocent. Is it rapture? Or is it the drugs?" Chronicles the mind-altering compound methylenedioxy-N-methylamphetamine, the techno-shamanic boogie booster of self-esteem. Chapters on "the flip flops in its legal status, psychological effects, erotic implications, methods of use, possible future, chemical structure," and more. **GR**

$17.95 *(PB/196/Illus)*

Ecstatic Religion: A Study of Shamanism and Spirit Possession
I.M. Lewis

"Looks at the biochemical, psychological, aesthetic, religious and sociocultural aspects of possession in African shamanism, the classical shamanistic religions of arctic Asia and South America, Haitian voodoo, the cult of Dionysus, Christian mysticism and other manifestations of spiritual ecstasy."

$17.95 *(PB/224)*

The Elixir: An Alchemical Study of the Ergot Mushrooms
William Scott Shelley

"Looks at the presence and uses of the ergot fungus plant throughout history."

$42.95 *(HB/200)*

The Emperor Wears No Clothes: The Authoritative Historical Record of the Cannabis Plant, Marijuana Prohibition, and How Hemp Can Still Save the World
Jack Herer

"Marijuana has been known to humankind for untold thousands of years. Government has attempted to prohibit its use for the past 50 . . . all previous attempts at prohibition have been dismal failures: people are simply not deterred from marijuana usage because of its illegality. Yet the prohibition continues, and vast amounts of time , energy and money are spent in the effort. This enlightening book details the history of marijuana, the history of its prohibition, and the present state of the pharmacological facts about the herb. . . . Well-documented, often startling and sometimes outrageous, but never less than fascinating, and above all, a thoroughly enjoyable, not to mention educational experience."

$19.95 *(PB/260/Illus)*

The Encyclopedia of Phobias, Fears and Anxieties
Ronald M. Doctor, Ph.D., and Ada P. Kahn

"*Poetry, fear of:* Fear of poetry is known as metrophobia. Some individuals have fearful and even aversive feelings about poetry

because of its basic nature and because of the way it is taught and analyzed. Spartans banned certain types of poetry because they thought it promoted effeminate and licentious behavior. The rhyme and figurative language of poetry is odd and distracting to some people. Frequently, poetry contains words, allusions and obscurely stated thoughts and feelings that are confusing or incomprehensible to people who lack a scholarly, academic background." And 1,998 more, from common to kooky to crazed. **GR**

$50.00 *(HB/500/Illus)*

Essays in Radical Empiricism
William James

If one idea characterizes America, it is the "the spirituality of matter" (as Edgar Alan Poe called it in his philosophical dialogues). This theme can be traced through creations considered most American: rock'n'roll, process-oriented jazz and the primacy of the individual's encounter with things ("life, liberty and the pursuit of happiness"). Even the much-maligned "Protestant work ethic" becomes less ridiculous when seen in the context of being an attempt to find enlightenment ("salvation") through an active engagement with the material world ("work"). This idea is also central to the philosophy of William James, the definitive American philospher. James systematically articulates the spirituality of matter by dissolving traditional philosophic distinctions between mind and matter, things and their relations, and facts and values. **RP**

$12.00 *(PB/304)*

Ethnobotany
Richard Evans Schultes

"This collection of 36 articles (most of them written specifically for this book) presents a truly global perspective on the theory and practice of today's ethnobotany as a way of understanding past human history as well as the future. Considering the impact of plant use throughout history in the human social structures of economics, politics, religion and science, this book contributes immeasurably to one's understanding of human history and the world today. The diminishing rain forests may well hold unknown keys to conquering devastating new diseases, and peoples native to those regions can often lead the way with their herbal knowledge. Experimentation with as-yet-unstudied plants may provide new

solutions to expand food and energy reserves for our overpopulated planet. From tropical forest conservation to basketry made from cured stems of grass as well as a huge list of psychoactive plants and their uses, this book covers it all."

$49.95 *(HB/414/Illus)*

Extra-Sensory Powers: A Century of Psychical Research
Alfred Douglas

Chapters include "Mesmer and Animal Magnetism," "The Birth of Spiritualism," "The Society for Psychical Research," "The Early Work of J.B. Rhine," "Investigations Into Precognition," and "ESP and Altered States of Consciousness."

$10.95 *(PB/392/Illus)*

The Faber Book of Madness
Edited by Roy Porter

This book "endeavor(s) to present a rich miscellany of the experience of madness from the viewpoints of numerous parties: psychiatrists, nurses, friends, family, writers, artists, theologians and philosophers." The writings span several centuries and vary from a couple of pages to the occasional well-placed one-liner (for instance, in the section on depression, Susan Sontag writes: "Depression is melancholy minus its charms").

What could have been a tedious discussion of the various aspects of mental illness is rendered with deft editing into a seamless train of varied ideas. There are 19 major categories, many devoted to a single malady (possession, delusion, depression, etc.). The editor has managed to tie together the various accounts and perspectives with a sentence or two between each entry so that each section flows together as if the individual writers had been discoursing among themselves. He has a special knack for punctuating the dry and serious with a bit of Sylvia Plath or Woody Allen. There are also contributions from Charlotte Brontë, Antonin Artaud, Nietzsche, Poe and William Seabrook. **SA**

$15.95 *(PB/572/Illus)*

Fire in the Brain: Clinical Tales of Hallucination
Ronald K. Siegel

"The cartography of the hallucinatory world

through 17 riveting case histories. . . . a young girl who insists that a dragon named Chopsticks is her frequent companion; a pool shark desperate to discover the trigger for his horrifying LSD flashbacks; and a nurse who sees swastikas on her patients' bedsheets as the result of sleep deprivation. . . . the commonalities of the hallucinating brain, whether our hallucinations are induced by drugs, dreams, severe trauma or the delirium of the illness."

$10.00 *(PB/275)*

Flickers of the Dreamachine

Edited by Paul Cecil

This book includes full construction plans for the Dreamachine seminal essays by its creators Brion Gysin and Ian Sommerville; extracts from W. Grey Walter's *The Living Brain*; and a number of pieces by folks who have worked with the brain-wave stimulator including Ira Cohen, Andrew McKenzie, Genesis P. Orridge, Simon Strong, Terry Wilson and others. **AK**

$17.95 *(PB/130)*

Food of the Gods: The Search for the Original Tree of Knowledge

Terence McKenna

The thesis of *Food of the Gods* basically states that the psilocybin mushroom is *the* missing link in the evolution of human consciousness and the basis for *all* religions. The use of drugs is generally not discounted in the formation of ancient rites like those in Eleusis, but what is most frustrating in this book is McKenna's stubborn refusal to cite any primary historical sources in his text. Some of his conclusions lack the solid ground they need to survive. Some of his more specious ideas—such as, psilocybin mushrooms are from alien intelligences in outer space—can only be accepted as highly stylized metaphors. While McKenna claims to support only the use of plant drugs like the mushroom, etc., and disdains the use of chemical substances like LSD and MDMA, he still avidly advocates DMT. The same contradictory notions are also found in his contempt for all he terms "New Age" and for gurus. His belief that everyone should be self-reliant for their spirituality is commendable, but McKenna's self-styled "archaic revival," with its embracing of the mother goddess and aliens from outer

space, appears too much like the work of other New Age manqués for this reviewer's comfort. **MM**

$15.95 *(PB/311/Illus)*

The Freud Journal

Lou Andreas-Salomé

Friedrich Nietzsche once said of Lou Andreas-Salomé that he had "never known a more gifted or understanding creature" and is said to have based his idea of the übermensch on her personality and their experiences and discussions together. The poet Rilke, for a time her younger lover, wrote that "she moves fearlessly among the most burning mysteries." Andreas-Salomé and her book *The Freud Journal*, written during 1912 and 1913 when she was 51, are vital links between Nietzsche's philosophy and the origins of psychoanalysis: "Cruel people being always masochists also, the whole thing is inseparable from bisexuality. And that has a deep meaning. The first time I ever discussed this theme was with Nietzsche (that sadomasochist unto himself). And I know that afterward we dare not look at each other." **SS**

$9.95 *(HB/211)*

The Great Book of Hemp: The Complete Guide to the Commercial, Medicinal and Psychotropic Uses of the World's Most Extraordinary Plant

Robert A. Nelson

This book focuses on some of the most interesting aspects of the diverse plant known as hemp or *Cannabis sativa*. This complete guide to hemp covers not only the spiritual-enlightenment applications but also its role as a fiber crop and its past and present commercial, medical and environmental uses. "With new technology it is possible to make anything from hemp that we now make from petroleum," such as paints and plastics. Europe has lifted bans on the cultivation of industrial hemp and many items made from it are showing up in the marketplace, from jeans to sneakers, tree-free paper to insulation. The author discusses hemp's role in Hindu culture and other religions, and studies the effects of smoking marijuana, both physical and mental. Also featured are little-known truths about hemp and its role in American history. For instance, entries by George

Washington in his farming diary about sowing and harvesting hemp, and Washington's letters to overseer William Pearce about Indian hemp in particular are included. The bok goes on to discuss the "prejudices and coverups behind the marijuana hysteria of the last 50 years." Includes appendix of hemp resources and the hemp marketplace. **DW**

$19.95 *(PB/256/Illus)*

Green Gold the Tree of Life: Marijuana in Magic and Religion

Chris Bennett, Lynn Osburn and Judy Osburn

A comprehensive history of the religious pasts of marijuana and the sacramental use of cannabis throughout the ages. Claiming that every religion of the Old World was at one time based on some kind of drug-induced initiation, the authors assert that hemp was a primary sacrament for the majority of humanity's religions, a sacred vehicle used to gain insight, ecstasy and communion with their gods—from early Pantheism to Hinduism, from the Buddhists to the Sufis, from the Moslems of Egypt to the Bantus of Africa. Quoting from William A. Emboden in his *Ritual Use of Cannabis Sativa*: "Whereas Western religious traditions generally stress sin, repentance and mortification of the flesh, certain older non-Western religious cults seem to have employed cannabis as a euphoriant; which allowed the participant a joyous path to the Ultimate; hence, such appelations as 'heavenly guide.'" With illustrations, extensive footnotes, a bibliogrpahy for further referencing and an appendix that includes bhang and majoon recipes, *Green Gold* is a well-researched, commanding sourcebook for anyone interested in the long and controversial history of marijuana. **MGG**

$24.95 *(PB/485)*

Growing the Hallucinogens

Hudson Grubber

A useful grimoire of growing procedures for many obscure magic and psychoactive herbs. The title may be somewhat misleading, but many notable hallucinogens are detailed (nightshades, San Pedro cactus, *salvia divinorum*). Others are stimulants, narcotics, or are only putatively psychoactive—however all plants presented are of botanical and pharmacological interest.

Individuals interested in the growing procedures for illegal plants (psilocybin, cannabis, etc.) will be disappointed that only legal plants are discussed. Indeed, this book is intended as a companion volume to *Legal Highs* which describes the effects, preparations and uses of these plants. **DN**
$7.95 *(PB/81)*

Hep-Cats, Narcs and Pipe Dreams: A History of America's Romance With Illegal Drugs
Jill Jones
A far-reaching study of drug abuse and addiction and their cultural ramifications, from the early days when heroin and cocaine were available at the corner drugstore (sans script) to the time the Pure Food and Drug and Harrison acts put an end to the fun. Examines the birth of bebop music and the changes wrought in poetry, writing and art through all forms of dope. Insightful writings by and about William Burroughs, Henry Miller, Timothy Leary, Allen Ginsberg and many others. **MW**
$30.00 *(HB/510/Illus)*

Herakleitos and Diogenes
Various quotes from the two Greek philosophers. Herakleitos: "What do they have for intellect, for common sense, who believe the myths of the public singers and flock with the

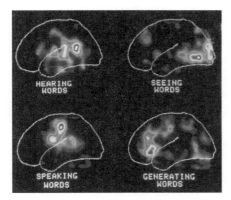

Positron emission tomography (PET) scans of the cerebral cortex of conscious human subjects performing four intellectual tasks related to words — from How the Self Controls Its Brain

crowd as if public opinion were a teacher, forgetting that the many are bad, the few are good?" Diogenes: "In the rich man's house there is no place to spit but in his face."
$7.95 *(PB/59)*

The Holotropic Mind: The Three Levels of Human Consciousness and How They Shape Our Lives
Stanislav Grof
Grof expands Freud's theories beyond their oral and anal limits. Through LSD psychotherapy Grof discovered the "womb" stage. With his guidance and enough acid, his patients could actually recall their "womb" experiences: "He saw images of religious and political gatherings with throngs of people seeking comfort in various organizations and ideologies. He suddenly understood what they were really seeking; they were following an inner longing, the same craving he felt in relation to the primal experience of oceanic ecstasy that he had known in the womb or at his mother's breast." **AF**
$14.00 *(PB/239)*

How the Self Controls Its Brain
John Eccles
"There is presented here for the first time a scientific explanation of how the self effectively acts on the brain to bring about voluntary movements, an ability that each of us has." Chapters include: "New Light on the Mind-Brain Problem: How Mental Events Could Influence Neural Events"; "Do Mental Events Cause Neural Events Analogously to the Probability Fields of Quantum Mechanics?"; "Quantum Aspects of Brain Activity and the Role of Consciousness"; and "The Self and Its Brain: The Ultimate Synthesis."
$39.00 *(HB/198/Illus)*

Insights of Genius: Imagery and Creativity in Science and Art
Arthur L. Miller
This book explores the connections between art and physics. A study that takes the reader through the philosophy of mind and language, cognitive science and neurophysiology in search of the origins and meaning of visual imagery.
$25.00 *(HB/250/Illus)*

Jungian Archetypes: Jung, Gödel and the History of the Archetypes
Robin Robertson
Beginning with Pythagoras and leaping forward to the Age of Reason, *Jungian Archetypes* traces the history of the hubristic struggle to bottle infinity through a series of biographical sketches of intellectual luminaries which illustrate the importance of archetypes and their paradoxical reasoning on the development of the sciences. Robertson focuses particularly on the evolution of mathematics and psychology, and shows how Gödel and Jung have advanced parallel theories to explain the most perplexing conundrums of their respective disciplines. **DN**
$14.95 *(PB/304/Illus)*

Kava: The Pacific Drug
Vincent Lebot, Mark Merlin, and Lamont Lindstrom
Order a Kava Bowl at Trader Vic's and you get a frothy concoction of rum and fruit juices. Order one on Vanuatu and you get a sticky porridge of chewed-up plant roots and human saliva. But before you decline, know that the roots are from the *Piper methysticum*, or kava plant, a powerful narcotic that makes the world go 'round in many South Pacific cultures. Kava also has numerous medicinal properties, and elaborate social rituals attend its consumption on the islands of Melanesia. All of these are documented in *Kava: The Pacific Drug*, co-written by horticulturist Vincent Lebot, anthropologist Lamont Lindstrom and scientist Mark Merlin.

While chapters detailing the medical and economic potential of the plant are not without interest, the cultural significance of kava consumption makes for the most compelling reading. The islands of Tonga, Samoa, Hawaii and Papua New Guinea each have their own version of kava's origin myth. "The broad leaf that extinguishes chiefs" has sprouted variously from a vagina, the skin of a foot, or the hair of an armpit.

Preparation of the communal kava bowl hasn't changed much since 1773, when a naturalist on Captain Cook's second Pacific voyage observed Tahitian youths making a batch "in the most disgustful manner that can be imagined," chewing pieces of the root, spitting the mass into a bowl, and mixing it with coconut milk, whereupon "they swallow this nauseous stuff as fast as possible." **JAB**
$50.00 *(HB/256/Illus)*

The Language of Animals
Stephan Hart
"Examines the sometimes subtle differences

between animal communication and what we call 'language' or 'intelligence.' We explore how scientists study animal communication, and we see just what they have learned about various species and their ways of 'talking.' . . . From dancing bees and chirping crickets to schooling fish and flocking birds; from birdsong to whale song to the language of our closest relatives in the animal kingdom—the chimpanzees—these overviews of thoroughly detailed case studies are a window to understanding the constant chatter and movement of the animal kingdom."
$9.95 *(PB/128/Illus)*

Laughing Gas
Sheldon, Salyer and Wallechinsky
Collection of writings on nitrous oxide, including descriptions of experiments by the editors (along with photographs of them in hairy 1973 bliss), a useful cartoon describing how to safely ingest the drug, a fab cover by R. Crumb, and extensive historical writings including William James on the gas. **NN**
$12.95 *(PB/96/Illus)*

Lie of the Truth
René Daumal
"At the beginning there was error"—so science should measure error, not an incorrect alleged truth. To calculate the sun and the moon or the decimal value of pi only makes one look as silly as the next person. Art seeks life, but the only life is ego death. And what is perception of the outside world except the head, heart or stomach reaching for it? **MS**
$5.95 *(PB/44)*

Looking Back
Lou Andreas-Salomé
"Lou Andreas-Salomé was not only immensely gifted as a writer, psychologist and observer of her twilight culture. She was the occasion and spur of genius in others. Nietzsche, Rilke and Freud and a host of important contemporaries were set alight or shadowed by her passage. Her memoirs touch the nerve of modernity. They are not at every point to be trusted. Which makes the game the more sparkling and strangely poignant."—George Steiner
$12.95 *(PB/226/Illus)*

The Lost Language of Symbolism: Volume 1— An Inquiry Into the

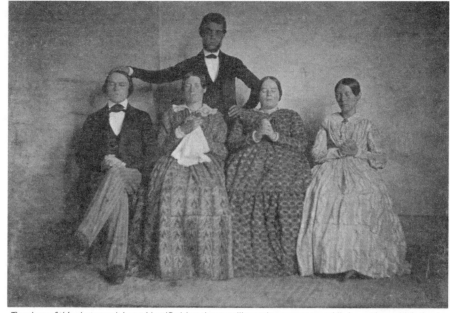

The place of this photograph is not identified, but the stagelike setting suggests a public hypnotism, which clearly had religious overtones for the subjects, whose hands are clasped in prayer. — from Madness in America

Origin of Certain Letters, Words, Names, Fairy-Tales, Folklore and Mythology†
The Lost Language of Symbolism: Volume 2††
Harold Bailey
A comprehensive inquiry into the origins

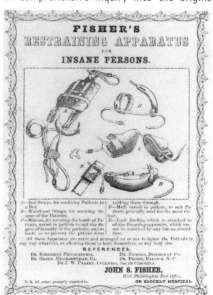

"Fisher's Restraining Apparatus for Insane Persons," 1840-60, broadside — from Madness in America

and meanings of the graphic/pictorial symbols which we see most often as artistic embellishments in visual art; stars, crosses, sunwheels, bells, candles, pillars, shields, swords, swastikas, fleur-de-lîs and many others, as well as the non-graphic symbols which we find throughout folklore, fairy tales and mythology, such as the shoes and mice in the Cinderella story. The author's investigation delves into the historical foundations of symbolism in secretive mystical traditions like Mythraism, the Knights Templar and Rosicrucianism, as well as in the widely known religious/spiritual traditions of numerous cultures. Symbols are usually much more ancient in origin than we imagine, says the author, most of them existing literally as far back as civilization has existed; they are handed down not merely from one generation to another, but from one culture to another, which suggests that they are, in some way, the premises upon which written and oral communication are founded. The two-volume set makes up what may be the most detailed and complete catalog of symbolism.
 BS
$10.95 †*(PB/375/Illus)*
 ††*(PB/388/Illus)*

Madness in America: Cultural and Medical

Perceptions of Mental Illness Before 1914

Lynn Gamwell and Nancy Tomes

"Explores the historical roots of Americans' understanding of madness today. Drawing on a rich array of sources, the authors interweave the perceptions of medical practicioners, the mentally ill and their families, and journalists, poets, novelists and artists. As they trace successive ways of explaining madness and treating those judged insane, Gamwell and Tomes vividly depict the political and cultural dimensions of American attitudes toward mental illness. Integrated into the narrative are evocative illustrations—many in color—including previously unpublished artworks and pictures of medical artifacts from archives, museums and private collections across the country."

$39.95 *(HB/192/Illus)*

Magic Mushrooms Around the World: A Scientific Journey Across Cultures and Time

Jochen Gartz, Ph. D.

"Dr. Jochen Gartz is a chemist and mycologist at the University of Leipzig, where he founded the Department of Fungal Biotransformation in the area of biotechnology. In January 1994, he became the first mycologist to discover a psychoactive mushroom species native to South Africa, a species named *Psilocybe natalensis*, after Natal Province, where the mushrooms were found.

Introducing a rich variety of psychoactive mushrooms from around the globe—including some rare and little-known

Jochen Gartz, author, in South Africa with a new Psilocybe *species — from* **Magic Mushrooms Around the World**

species—the author describes dozens of species and covers a broad range of mushroom-related topics, from distribution maps to comparisons of cultural attitudes to laboratory analyses of active ingredients. . . . explores the psychoactive mycoflora on five continents and reconstructs a continuity of psychoactive mushroom use throughout history, from as early as 10,000 years ago to the present day."

$22.95 *(PB/130/Illus)*

Making the Prozac Decision: A Guide to Antidepressants

Carol Turkington

What is depression? "'Before I took Prozac, every day was difficult,' says Joan. 'I didn't enjoy anything; everything was futile. There seemed to be no hope. After being on Prozac for about a month, I suddenly felt that half my life had already gone by. I'd better get in gear! I used to compare myself with everyone,' she continues. 'Now I don't care. I'm more confident with other people, and I don't freak out in groups. I wish,' she sighs, 'I had the past 20 years back.'" Covers other selective seratonin-reuptake inhibitors (Paxil, Zoloft), cyclic antidepressants, MAO inhibitors, lithium and other modern additives used to alter the brain's chemical soup. **GR**

$21.95 *(HB/224)*

The Man With a Shattered World: The History of a Brain Wound

A.R. Luria

The Soviet neuropsychologist who was the inspiration to Oliver Sacks explores the implications of physical damage to the brain: "A soldier named Zasetsky, wounded in the head at the battle of Smolensk in 1943, suddenly found himself in a frightening world: he could recall his childhood but not his recent past; half his field of vision had been destroyed; he had great difficulty speaking, reading and writing."

$12.95 *(PB/168)*

Manic Depressive Insanity and Paranoia

Emil Kraepelin

First published in 1921, early psychiatric text from the man who invented the diagnosis of schizophrenia or dementia praecox. Includes case studies, photos of patients and specimens of "manic scribbling." Kraepelin fre-

Stone sculpture of a mushroom deity from the classic period of Mayan culture (300-600 A.D.) — from **Magic Mushrooms Around the World**

quently waxes poetic: "Everywhere danger threatens the patient. The girls read his letters; strange people are in the house; a suspicious motor-car drives past. People mock him, are going to thrash him, to chase him from his post in a shameful way, incarcerate him, bring him to justice, expose him publicly, deport him, take his orders from him, throw him into the fire, drown him. The people are already standing outside. The bill of indictment is already written; the scaffold is being put up; he must wander about naked and miserable, is quite forsaken, is shut out of human society, is lost body and soul."

$29.95 *(HB/127/Illus)*

Marijuana Botany: The Propagation and Breeding of Distinctive Cannabis

Robert Connell Clarke

An advanced study of the propagation and breeding of distinctive types of cannabis. The characteristics of several strains are discussed (*indica-Kush*, Mexican, Indian, African and Colombian to name a few). Accompanied by drawings of plants showing subtle differences of each strain. Includes the life cycle of cannabis from seed to flowering adult plant; propagation methods such as cloning and grafting and others, breeding and crossing one type of plant with another to get desired charac-

teristics such as high resin content; maturation and harvesting; genetics; determining the sex of plant—everything anyone interested in marijuana botany must know!

DW
$21.95 _(PB/198/Illus)_

Marijuana Hydroponics: High Tech Water Culture
Daniel Storm
"Marijuana growers are developing high-tech methods for getting high-yield crops. _Marijuana Hydroponics: High Tech Water Culture_ is an excellent guide to growing without soil.This book has all the information needed to set up a system using nutrient solutions in controlled environments. Also contains equipment lists, diagrams and step-by-step instructions for assembling a homemade state-of-the-art, high-yield water culture growing system."
$14.95 _(PB/116/Illus)_

Marijuana Law
Richard Glen Boire
"Over 30 million people in the United States regularly smoke marijuana. Approximately 400,000 defendants each year are charged with the use, possession, sale or cultivation of marijuana. _Marijuana Law_ describes how people can reduce the probability of arrest and defend themselves from prosecution if arrested. Readers will learn when a police officer can legally stop them; when they can be searched; when they have to be read their rights; what to do if an officer comes to their home with (or without) a search warrant; and how to counter many police tactics simply by knowing their rights."
$12.95 _(PB/171)_

Mavericks of the Mind: Conversations for the New Millennium
David Jay Brown and Rebecca McClen Novick
Where is reality heading? Here are verbatim interviews with 16 souls who have set the universe spinning in a more divine direction, and it's all about consciousness, baby, to a lesser or greater degree. David Jay Brown, an accomplished psychologist/psychopharmocology buff (and sci-fi novelist) and his cohort offer up some of the best gray matter of our century, naked, there for you to poke and prod and get inside of. The sparse editing reveals the true colors of the subjects: we find McKenna mercurial in wit,

and Lilly as cracked as a flowerpot smashed against one of his famed isolation tanks. Brown and Novick have all the angles and in-the-know queries, but even their rare deficiencies are printed.

On the possibility of time travel: "McKenna: Apparently you can move information through time, as long as you don't move it through time faster than light.
Brown: Why is that?
M: I haven't the faintest idea. Who am I, Einstein?"

Recurring questions involve psychedelics, male/female relations, the conscious mind, human evolution, and extraterrestrial visitations. The subjects' pet topics include Terence McKenna on psilocybin mushrooms, the archaic revival vs. New Age, novelty theory; Eisler/Loye on the partnership model; Robert Trivers on reciprocal altruism; Nick Herbert on physics and consciousness, fringe science, time travel; Ralph Abraham on mathematical dynamics and chaos theory; R.A. Wilson on the Illuminati, information; Timothy Leary on death, computers; Rupert Sheldrake on formative causation, morphic fields, memory storage; Carolyn Mary Kleefeld on artistic expression, evolutionary processes; Colin Wilson on the occult, evolution; Oscar Janiger on psychiatry, LSD and creativity, DMT; John Lilly on God, talking dolphins, brain chemistry, war; Nina Graboi on psychedelics, politics of sexuality; Laura Huxley on nutrition, the mind/body connection; Allen Ginsberg on poetry, madness, New Age movement; Stephen LaBerge on lucid dreaming, sleep.
SK
$12.95 _(PB/331/Illus)_

The Mind of a Mnemonist: A Little Book About a Vast Memory
A.R. Luria
Soviet neuropsychological pioneer A.R. Luria's study of a man discovered to have a literally limitless memory. Experiments and interviews over the years showed that his memory was based on synaesthesia (turning sounds into vivid visual imagery), that he could forget anything only by an act of will, and that he was handicapped intellectually because he could not make discriminations.
$12.95 _(PB/160)_

The Morning of the

Magicians
Louis Pauwels and Jacques Bergier
"A startling look beyond science—an investigation that recognizes no barriers to human thought . . . Were occult forces at work in Hitler's Germany? Do human mutants exist among us who are as different from men as men are from the great apes? Is it possible that the human brain emits high-frequency waves that might be picked up by other persons? How much did the alchemists know about the development of atomic energy?"
$14.95 _(PB/328)_

Music and Trance: A Theory of the Relations Between Music and Possession
Gilbert Rouget
"From Siberia to Africa, from antiquity to

Vial of pharmaceutical LSD with label — from **Magic Mushrooms Around the World**

modern times, music has been associated with ritual trance and altered states of consciousness. . . . Rouget demonstrates that neither the neurological effect of rhythm nor drug use nor mental illness can account for the power of music in trance states."
$24.00 _(PB/395)_

Neurotransmitters and Drugs
Z.L. Kruk and C.J. Pycock
Technical biochemical treatise on the manner in which therapeutically used drugs modify the nervous system through the knowledge of the functions, distribution and control of neurotransmitters in the brain. Each chapter is devoted to a specific neurotransmitter; its synthesis, storage, release, receptor interaction and inactivat-

ing mechanisms together with drugs that interact with neurotransmission.

Specifically targeted to students of medicine, pharmacology, pharmacy and post-graduate psychology, this book requires some knowledge of basic biology in order to be understood. **MC**
$29.95 *(PB/208/Illus)*

Night: Night Life, Night Language, Sleep and Dreams
A. Alvarez
"Nothing is definite, nothing precise," Alvarez says of The Dark; even the author's negotiation of night itself, promised to unfurl with "a face of crumpled linen" and "a horrible smell of mould," falls prey to random electric surges, dissolving finally into Freud's erotic interpretations of violets. Flowers in the night? Have we hit the REM stage yet? Alvarez, whose precocious indulgence in sex and food "lasted perhaps a dozen years and then was usurped by a new obsession: sleep," drags us to his sleep lab by the hair, forcing us, *Clockwork Orange* style, to watch him dream, stumble over Freud and Coleridge, and inspect a "rosebud"-mouthed East Village whore. "The root cause of crime is poverty," he quotes, until we howl between the sheets. Our bedtime prayers beg to deliver the moral of the story: Don't attempt to look for answers once the light has been turned off. **JS**
$13.00 *(PB/290/Illus)*

On the Heights of Despair
E.M. Cioran
"Here is the paradigmatic cry of the tortured artist. In this meditation on darkness stemming from a sustained insomniac hyperlucidity, Cioran grapples with life wearing the gloves of anguish and despair."
$10.95 *(PB/128)*

Opium: The Poisoned Poppy
Michel Robson
Beware of Barbarians carrying flowers. "This was the East of the ancient navigators, so old, so mysterious, resplendent and somber, living and unchanged, full of danger and promise. . . . I have known its fascination since; I have seen the mysterious shores, the still water, the lands of brown nations." Deluxe irony—a coffee-table his-

tory of the "flower of dreams and nightmares" and the 1830s Opium Wars. "Opium. The foundation of one of the world's most amazing commercial enterprises—the British Crown Colony of Hong Kong." But the early trade in opium between the British (who manufactured it in India) and the Chinese (who refused to trade tea for the poisoned poppy) was a commercial enterprise "not without savage battles on land and Chinese rivers . . . Not without heartbreak and sickness and addiction. . . that secured for the British taipans an everlasting place, for better or worse, in imperial history." A colorful, zesty tale told by a writer and producer for the BBC. **GR**
$40.00 *(HB/88/Illus)*

Opium for the Masses: A Practical Guide to Growing Poppies and Making Opium
Jim Hogshire
An eloquent, unabashed paean to the joys and healing properties of that most romantic of potions, which can be extracted from poppies (*Papaver somniferum*) grown right in the back yard. Covers historical use of opium; subjective and objective descriptions of its effects; opium and naturally occurring endorphins; its "bastard children" morphine, heroin and Dilaudid; brewing poppy tea (not quite the easy high the author would suggest); *papaver* botany; suggestions on making homemade opium; poppy politics and more. **SS**
$14.95 *(PB/112/Illus)*

Opium Poppy Garden: The Way of a Chinese Grower
William Griffith
A *Zen and the Art of Archery* for those interested in the history and cultivation of the opium plant, *Opium Poppy Garden* tells the tale of Ch'ien, a young Chinese man who travels from Costa Rica to Columbia in order to grow an opium garden in the manner taught him by his Taoist grandfather. The story is a parable, describing one man's journey in his search for The Way, at the same time giving very practical information about the methods of growing and cultivating the active ingredients of the poppy. The preface makes a good argument for the relaxation of the prohibitions against naturally occurring psychoactive substances, citing their advantages over

Raw opium, still in its moisturizing banana leaf, is being weighed on a traditional Chinese scale. — from **Opium**

the refined drugs such as heroin and cocaine whose abuse currently runs rampant. Who wouldn't pick chewing a lovely, green, organically grown coca leaf or smoking personally produced opium over snorting a vile crystalline powder created in who knows what bathtub? And guess what, folks, you can grow it at home! This is a useful book for those looking to add some color and spice to their home garden. **AS**
$14.95 *(PB/77/Illus)*

The Origin of Consciousness in the Breakdown of the Bicameral Mind
Julian Jaynes
Jaynes posits that it has only been in the last 3,000 years that the human mind has shifted away from operating by "hearing voices," which are in fact commands from the right brain transmitted through the corpus callosum to the left brain. Thus the "gods" actually "spoke" to people on a regular basis, especially in times of stress or important decisions. Jaynes sees such great works of ancient literature as *The Iliad* and the Bible as metaphorically describing the disorienting transition which a culture undergoes as the voices of the gods become still and its members begin to operate as autonomous individuals. In Jaynes' view,

people today who "hear voices" in their heads, such as those termed schizophrenics, are throwbacks to the way all humans functioned in what he calls the "Bicameral Age."

SS

$16.95 *(PB/491/Illus)*

The Osiris Complex: Case Studies in Multiple-Personality Disorder
Colin A. Ross, M.D.

The author's agenda, and his passion, speak loud and clear: MPD does exist, can usually be treated, and is often misdiagnosed (as schizophrenia, borderline-personality disorder, etc.), with tragic results. He insists that his profession needs to look beyond its current biomedical bias and start seeing the very strong relationship between trauma, especially sexual abuse, and mental illness.

While Ross concentrates on the societal and clinical implications of this disorder, the reader cannot help but ponder the compelling and disturbing questions raised about the nature of personality itself. In many cases, the division of an MPD patient's conflicting impulses into separate personalities seems like a literalization of the neurotic tendencies shared by most people: for instance, in the case of a young female, one personality gains 80 pounds so that another, a prostitute, will go into hiding and keep out of trouble.

There is a persistent drumbeat throughout the book criticizing mainstream psychology and psychiatry for banishing the paranormal (demons, ESP, spirit possession) from their domain. (Indeed, the author's seeming eagerness to discover that such characters as "the Evil One" are the exterior beings his patients claim they are would severely damage his credibility if Ross weren't so scientific, reasonable, and sensitive in his approach to these subjects.) The paranormal entities he meets in his office always turn out, however, to be expressions of the patients' dissociated personalities. **MH**

$17.95 *(PB/296)*

Our Right to Drugs: The Case for a Free Market
Thomas Szasz

"Rather than dwelling on the familiar

White latex, the gum that produces opium, oozes from incised pods. The incisions continue daily until the pod is exhausted. — from **Opium**

impracticality and unfairness of drug laws, Szasz demonstrates the deleterious effects of prescription laws, which place people under lifelong medical supervision. By stressing the consequences of the central aim of U.S. drug prohibitions—protecting the public from harming themselves by self-medication—he emphasizes that a free society cannot endure if the state treats adults as truant children and if its citizens reject the values of self-discipline and personal responsibility."

$14.95 *(PB/229)*

An Outline of Psychoanalysis
Sigmund Freud

"It was Freud's fate, as he observed not without pride, to 'agitate the sleep of mankind.' Half a century after his death, it seems clear that he succeeded far better than he expected. . . . In June 1938, at 82,

Freud began writing this terse survey of the fundamentals of psychoanalysis. He marshals here the whole range of psychoanalytic theory and therapy in lucid prose and continues his open-mindedness to new departures, such as the potential of drug therapy." In three parts: "The Mind and Its Workings," which embraces the development of sexual function and explores dream-interpretation as illustration; "The Practical Task," focusing on the technique of psychoanalysis; and "The Theoretical Yield," which explains the psychical apparatus of the internal world and its effect on the external world. **GR**

$6.95 *(PB/113)*

The Outsider
Colin Wilson

"The seminal work on alienation, creativity and the modern mindset. Ranging through the lives and writings of Bernard Shaw, Nietzsche,

Tolstoy, Dostoyevsky, William Blake, Hermann Hesse, van Gogh, T.E. Lawrence, Nijinsky, Sartre, T.S. Eliot, Kafka and many others, Wilson defined numerous modern dilemmas in the character of 'The Outsider,' who in his alienation and introversion, 'stands for Truth.'"
$11.95 *(PB/320)*

Perfumery:
The Psychology and
Biology of Fragrance
Edited by Steve Van Toller and George H. Dodd
Essays in the art of odorama. "The essence of perfumery: from the art of making perfumes . . . to a scientific understanding of the mechanisms of smell." Explores the intimate and little-understood link between the molecular event of "pleasant smell sensations" and emotional events they trigger, such as "the evocation of memories from early childhood and the experience of sexual arousal." Part One: Man—the scented ape. Part Two: Perfume as a personal tactic of impression management. Part Three: Electrical activity in the brain during odor perception. Part Four: The role of fragrances in inducing mood and relaxation states. Part Five: Matching scents with personality traits to better target scent consumers. **G R**
$32.50 *(PB/268/Illus)*

Pharmacotheon:
Entheogenic Drugs,
Their Plant Sources and
History
Jonathan Ott
"The most comprehensive book on the subject of shamanic inebriants, their active agents and artificial cousins. . . . two years of writing following 20 years of research into the ethnopharmacology of entheogenic drugs."
$40.00 *(PB/640)*

Pharmako/Poeia: Plant
Powers, Poisons and
Herbcraft
Dale Pendell
A mesmerizing guide to psychoactive plants, from their pharmacological roots to the literary offshoots. **AK**
$16.95 *(PB/287/Illus)*

The Physics and
Psychophysics of Music:
An Introduction
Juan G. Roederer
"A classic in its field, analyzes objective,

physical properties of sound and their relationship with psychological sensations of music. Furthermore, it describes how these sound patterns are generated in musical instruments, how they propagate through the environment, and how they are detected by the ear and interpreted by the brain."
$29.50 *(PB/221/Illus)*

Pikhal:
A Chemical Love Story
Alexander Shulgin and Ann Shulgin
"For nearly 30 years one of the authors, Dr. Alexander Shulgin, affectionately known to his friends as Sasha, has been the only person in the world to synthesize, then evaluate in himself, his wife Ann, and in a dedicated group of close friends, nearly 200 never-before-known chemical structures, materials expected to have effects in man similar to those of the mind-altering psychedelic drugs mescaline, psilocybin and LSD. . . . In the first two parts, the Shulgins describe the individual life paths which led each of them to a fascination with psychedelics and, ultimately, to their fascination with each other. . . . The second half of the book is an almost encyclopedic compendium of synthetic methods, dosages, durations of action, and commentaries for 179 different chemical materials. . . . Some day in the future, when it may again be acceptable to use chemical tools to study the mind, this book will be a treasurehouse, a sort of sorcerer's book of spells, to delight and enchant the psychiatrist/shaman of tomorrow."
$18.95 *(PB/978)*

Plant Intoxicants:
A Classic Text on the
Use of Mind-Altering
Plants
Baron Ernst Von Bibra
This book, originally published in 1855, provides a wonderful glimpse into commonly used drugs before the era of mass drug hysteria either in the prohibition or the advocacy of drug use. Bibra was a Bavarian nobleman whose family fortunes were on the decline. He had written several books on chemistry and art history before traveling to South America. After his journey he wrote *Plant Intoxicants* and *Travels in South America*, becoming more famous for the latter work. Most of the intoxicants he covers are drugs used by people every day such as coffee, tea, Paraguayan tea (*yerba maté*), chocolate,

guarana, betel nuts and tobacco. The illegal drugs most people associate with "plant intoxicants" fill up a smaller portion of the book, covering coca, hashish and opium as well as *khat*. The chapters on each of the substances provide scientific information on the plant and its effects as well as cultural examples of it use throughout the world and information on everyday plant intoxicants which many of us take for granted. **MM**
$16.95 *(PB/228)*

Plants of the Gods:
Their Sacred, Healing,
and Hallucinogenic
Powers
Richard Evans Schultes and Albert Hoffman
This is an excellent survey of the historical and current use of hallucinogenic plants by indigenous people around the world. The first section of the book outlines the many different plants (far more than one might imagine) that are employed for their hallucinogenic properties, in order to heal or bring about altered states of consciousness in religious ceremonies. A complete plant lexicon is provided with color illustrations and also a geographic analog showing the regions where they can be found. Subsequent sections focus on specific plants such as the amanita mushroom and ayahuasca plant. Historical examples are given of the use of ergot and belladonna in Western Europe, among others. There are many contemporary examples such as the Fang cult of Bwiti who employ the iboga plant and the Kamsa tribe of Columbia use of the borrachero tree. The book is as insightful and entertaining as anthropology as it is as a study of hallucinogenic plants, and is lushly illustrated with plants, 3-D molecular models, photographs and maps.
 MM
$19.95 *(PB/192/Illus)*

The Pleasures of
Cocaine
Adam Gottlieb
"The purpose of this book is to convey the impartial facts of the uses and abuses of cocaine. Without bias, many different aspects are covered: History, effects, uses, pleasures, dangers." Contents include: "Enjoying Cocaine Without Abuse," which covers avoiding abusive potential; overdose and allergic sensibility; and cocaine, alcohol and downers. "The Pleasures of Cocaine"

delves into cocaine and sex and cocaine and physical activity. "Methods of Use" details preparing the nostrils, setting up lines, the mouth freeze, and the coke smoke. "Selection of Quality" focuses on cutting cocaine (with methedrine, procaine, talc and the like) and testing it. The book that does everything but score. **GR**
$12.95 *(PB/147/Illus)*

Poetry and Mysticism
Colin Wilson
"The mystic's moment of illumination shares with great poetry the liberating power of the deepest levels of consciousness. . . . Poetry, Wilson argues, is a contradiction of the habitual prison of daily life and shows the way to transcend the ordinary world through an act of intense attention—and intention."
$12.95 *(PB/227)*

The Powers of the Word
René Daumal
"Overshadowed by the extravagance and self-promoting polemics of Surrealist-dominated French thought, Daumal's sober brilliance was not apt to attract the notoriety on which André Breton and company thrived. . . . Daumal's unsparing lucidity; the vast range, depth and purpose of his erudition; the humor that never ceases to question all claims to 'truth' or 'knowledge'—particularly his own; his lifelong efforts to make poetry an expression of lived experience and to eradicate the empty 'chatterings' that so-called poetry willingly accommodates; his confrontation of intense childhood fears and physical frailty to illuminate the great mystery of death—these alone would warrant him a place in any pantheon of letters." Includes "Introduction to the Grand Jeu," "Pataphysics and the Revelation of Laughter," "Asphyxiation and Absurd Evidence" and more.
$12.95 *(PB/174)*

Precision and Soul
Robert Musil
A collection of essays and speeches from the author of the deftly ambitious novel trilogy *The Man Without Qualities,* from "The Obscene and Pathological in Art" (1911) to "On Stupidity" (1937). Musil searches for a new system of values amidst the bankruptcy of bourgeois Vienna as its plunges headlong into *Anschlüss* with Nazi Germany. From "The German as Symptom"

(1923): "I believe that the average person is a far more avid metaphysician than he admits. *Avid* is probably not the right epithet, but a dull accompanying awareness of his curious situation rarely leaves him. His own mortality, the minuteness of our little ball of earth in the cosmos, the mystery of personality, the question of an afterlife, the sense and senselessness of existence: these are questions that the individual ordinarily brushes aside his whole life long as in any case unanswerable, but that he nonetheless feels surrounding him his whole life like the walls of a room. . . . Generally speaking, the cure is sought regressively. (Nation, virtue, religion, antagonism to science.) Only very

Laboratory culture of Psilocybe mexicana Heim — *from* Magic Mushrooms Around the World

rarely is it made explicit that a new problem has been posed here, that its solution has not yet been found." **SS**
$16.95 *(PB/301)*

Psilocybin: Magic Mushroom Grower's Guide
O.T. Oss and O.N. Oeric
The revised and expanded edition of the unsurpassed classic manual on home cultivation of psilocbyin mushrooms. Includes a chronology of mushrooms in history, technical glossary and a list of equipment suppliers. With a forward by Terence McKenna (possibly

also the co-author under a pseudonym). **AK**
$16.95 *(PB/88/Illus)*

Psychedelic Chemistry
Michael Valentine Smith
How to manufacture psychedelic drugs. Contents include "Mescaline and Friends," "Muscimole and Other Isoxazoles," "LSD," "Cocaine," "Miscellaneous Psychedelics," "Literature and Chemical Hints" and "Miscellany on Underground Laboratories."
$16.95 *(PB/200/Illus)*

Psychedelic Shamanism: The Cultivation, Preparation and Shamanic Use of Psychotropic Plants
Jim DeKorne
"Naive or recreational use of psychedelic drugs does not make one either a shaman or saint. If this were true, the San Francisco Bay area would have been overrun by saints and shamans in 1967. In traditional shamanic societies, there exist specific traditions, histories, rituals and practices which provide a stable, long-term set and setting by which the drug experiences are interpreted and controlled."—Gracie and Zarkov as quoted in *Psychedelic Shamanism.*

Some people view the use of psychedelics as a fun way to spend time with friends while weird patterns play under their eyelids. Others approach the psychedelic experience with awe and trepidation and take seriously the messages imparted to them by the "friends" who are called forth by these quasi-sacred substances. It is to the latter that Jim DeKorne, a master gardener and longtime explorer of inner realms, appeals in *Psychedelic Shamanism.* Devoting the first half of the book to a study of the interior states universally known to the world's shamanic healers, DeKorne lays down a strong conceptual and historical foundation for the practical information that follows in the second half. If those who endlessly babble on about "drug education" were serious about the subject, they would include this kind of book in their curriculum. **AS**
$19.95 *(PB/155/Illus)*

Psychedelics: A Collection of the Most Exciting New Material on Psychedelic Drugs
Compiled by Thomas Lyttle
Hallucinatory highlights from the quasi-

academic journal *Psychedelic Monographs and Essays* compiled by its intrepid editor. Essays include: "Ludiomil, LSD-25 and the Lucid Dream," "The Seven Deadly Sins of Media Hype Considered in Light of the MDMA Controversy," "Disney's Intrapsychic Drama Snow White and the Seven Dwarfs: A Grofian Interpretation," "Amazon Shamanism: The Ayahuasca Experience" and "Further Comments on U4Euh With More Recent Addenda." **GR**
$14.95 *(PB/272)*

Psychedelics Encyclopedia
Peter Stafford
Stafford offers one of the most complete and thorough studies of psychedelics to date, gathering information from personal accounts, scientific research and related literature to document psychedelia from the '60s to the present day. Discussed in great detail are: LSD, mescaline, marijuana, DMT, STP and a host of others. The history, botany, physical and mental effects are also presented. Incredibly well-researched, this is the third expanded edition. Learn about: LSD-like compounds found in the common morning glory, the hallucinations of jungle foliage and dancing naked goddesses of the yage, and early mushroom-using Siberian shamans. **DW**
$24.95 *(PB/512/Illus)*

Recreational Drugs
Professor Buzz
Manufacturing illicit drugs is some serious hoodoo to trifle with. This caution is sternly proffered by the author to the point of redundancy (to his credit). The formulas given include LSD, amphetamines, Quaaludes, a somewhat gruesome process for extracting the adrenaline from animal adrenal glands, and many other useful things. Buzz wishes the reader to understand that none of these formulas are to be trusted, and that only a proficient organic chemist utilizing formulas published in legitimate scientific journals should attempt these syntheses. This cookbook serves the important function of dissuading the ambitious dope dealer/complete idiot from poisoning people, injuring themselves, or getting themselves arrested by attempting dangerous business for which they are not qualified. Or better yet, it motivates such individuals to learn

chemistry. **DN**
$21.95 *(PB/166/Illus)*

Rogue Primate: An Exploration of Human Domestication
John A. Livingston
Here's a radical idea: The first domesticated animal, says the author, was neither dog nor goat, but human. Humans cut themselves adrift from the real world by becoming entirely dependant on ideas. Now humans have drawn other animals, and even the natural world itself, into the service of their belief systems. At what price? Are we really a herd of rutting pigs eating and breeding our way across this island Earth? A provocative theory that seems to explain everything from God to potatoes. **GR**
$22.95 *(HB/311)*

Sadhus: India's Mystic Holy Men
Dolf Hartsuiker
Definitive look at India's Hindu holy men and their culture. The Sadhus collectively are hundreds of separate and different sects, each with certain beliefs and practices. These mystical holy men practice "enlightenment for the real purpose of life"—the basic concept of Indian culture. They devote themselves full time to exploration of the "Inner Light." The Sadhus choose a life free of all but a few small possessions and comforts, and no sensual pleasures whatsoever. Many smoke hashish and practice yoga to gain enlightenment. The author systematically photographed these holy men and explains the many different devotional styles—such as standing or keeping their right arm raised for years—as homage to specific gods. Bewildering and relentless—many color photos. **DW**
$19.95 *(PB/128/Illus)*

Salvinorin: The Psychedelic Essence of Salvia Divinorum
D.M. Turner
Isolated from a rare Mexican sage found in only a few ravine locations in the Sierra Mazateca mountains, the active compound, salvinorin A, has dramatic effects. Used by Mazatec Indian shamans in Oaxaca and first described by Swedish anthropologist Jean Basset Johnson in 1939, it is easily propagated by cuttings, and during the past few decades it has made its way into numerous

botanical gardens and private collections around the world. It is thought by many botanists that *Salvia divinorum* is a cultigen; it is not known to exist in the wild, and the few patches that are known in the Sierra Mazateca appear to be the result of deliberate planting.

The high, as described by Turner, is another matter, after all, not exactly an LSD high but similar to it, the entire experience lasting around 20 minutes. Results range from

Alfred Korzybski, author of Science and Sanity

alarming intensity to exquisite feelings. Firsthand accounts from the author are bizarre and questionable considering the amount of psychedelic experimentation under his belt. He explains time and again his confusion regarding which high is residual from past LSD use and which is attributable to current *Salvia divinorum*, and any other psychedelics that may have crossed his path. Every method is described and used, from smoking, snorting, eating and any other way he can think of ingesting the herb. Descriptions are extensive and vivid. **CF**
$9.95 *(PB/57/Illus)*

Science and Sanity: An Introduction to Non-Aristotelian Systems and General Semantics
Alfred Korzybski
Important 20th-century philosophy of the mind and culture. Korzybski is the man who coined the slogan, "the map is not the territory." The meat of Scientology/Dianetics

Hari Govinda Singh rubs earth on his penis, firmly ties the sling of cloth, stretches his legs and lifts the stones. It is a "miracle" that the penis is not torn off. The scene recalls the chains used in the past to weigh down the penis continuously, but this exercise is now only occasionally done, and then for a minute or so. Just long enough to show the Baba's power, his transcendence of sexuality. — from **Sadhus**

(the theory of the reactive mind and more) was lifted from this book—get "clear" on the cheap! William Burroughs also studied with Korzybski in the 1930s in Chicago. **SS**
$34.95 *(PB/806)*

The Scientist: A Metaphysical Autobiography
John Lilly, M.D.
From his early work with monkey brain implants and dolphin communication to experiments with isolation tanks and Vitamin K. "In the Day-glo psychedelic '60s, you never found J.C. Lilly wearing tie-dyes to rock concerts. Nor for him the voyage to the Ganges or Woodstock. We all saw Lilly as some sort of wizard, a science-fiction starman, a unique back-to-the-future alchemist. A new Paracelsus. A veritable Isaac Newton of the Mind. . . . This is one of the great personal stories of our culture, written with the scientific precision that most call honesty. No one has gone as far into the future as John C. Lilly and managed to return (reluctantly, we know) with such clarity and good humor. Guard your copy of *The Scientist*. It's a precious relic of our wonderful, incredible age."—Timothy Leary.
$14.95 *(PB/320/Illus)*

Secrets of Methamphetamine Manufacture: Including Recipes for MDA, Ecstacy and Other Psychedelic Amphetamines
Uncle Fester
Live the dream of unlimited insomnia, endless frenzied chatter and deepening paranoia—then profit from selling it to those you can trust least, your fellow tweakers. Fester guides the would-be "underground chemist" from "Industrial Scale Production" on down to "Last Resort Crank—Extracting Methamphetamine from Vick's Inhalers." Not for the faint of sinus. **SS**
$24.95 *(PB/246/Illus)*

Shamans of the 20th Century
Ruth-Inge Heinze
This book shows that it is possible to be a shaman and lead a successful life in the 20th century. Heinze introduces us to the lives of a Korean shaman who won a folk song contest in her home country, making her a TV star, and a Haitian voodoo neurochemist with a degree in biochemistry from Cornell University, among many others. This study is the result of five decades of work with shamans from all over the world. "The reader will, furthermore, learn more about the background of the oracle who is still consulted by the Dalai Lama at his residence at Daramsala, Northern India, and the shamanistic work of a 'Western' lawyer in the United States." **AF**
$14.95 *(PB/259/Illus)*

A Social History of the Minor Tranquilizers: The Quest for Small Comfort in the Age of Anxiety
Mickey C. Smith, Ph.D.
This study of cultural issues surrounding the development of tranquilizers since the 1950s is unusual in that it was written by a pharmaceutical "insider," and with a tone of political cautiousness. While it is interesting to read a book on this subject without an obvious feminist or anti-psychiatry point of view, the downside is that the author seems so careful not to weigh in on the pro or con side of the tranquilizer question that he often presents a litany of conflicting papers written by others (whose credibility and viewpoint is not

available to the typical reader) and seemingly presents as little of his own editorial, synthesizing voice as possible. (The style of this book may be due to its presumed academic or professional audience.)

That being said, this wide-ranging book presents a wealth of data. Subjects covered are: the typical cycle of professional and public reactions to new "miracle drugs"; the problem of defining and diagnosing anxiety; a chronology of the development of psychopharmacology through the 1970s; prescribing and utilization patterns; history of mass media coverage of tranquilizers; the information flow to doctors, including the professional press and pharmaceutical advertising; social issues such as the medicalization of human problems and the imbalance of tranquilizer use between men and women; doctors' prescribing dilemmas; and a particularly interesting chapter on the history of regulatory efforts by the FDA and other agencies with transcript extracts from the famous Kefauver hearings and other proceedings. Note: Selective serotonin reuptake inhibitors are not discussed in this book, which came out three years before Prozac. **MH**
$14.95 *(PB/266/Illus)*

Some Effects of Music
D.B. Fry
A study of the effects of music and its physiological and psychological effects on the individual human being.
$6.00 *(Pamp/11)*

The Soundscape: Our Sonic Environment and the Tuning of the World
R. Murray Schafer
In this pioneering book, Canadian composer R. Murray Schafer traces an evocative picture of the evolution of the acoustic environment on planet Earth, from the earliest nature sounds through the beginnings of the Industrial Age and up to the cacophony of the present day. Using quotes from a wide variety of sources from throughout recorded history, he demonstrates the changing character of the world as it has been perceived by the human ear. Virgil describes the relatively new sound of the "shrill saw blade" and waxes nostalgic for an earlier time when "men split wood with wedges." Charles Dickens writes of the novel rumbling of a passing train in 1848, and how it made "the walls quake, as if they were dilating with the

knowledge of great powers yet unsuspected in them." Luigi Russolo bids us to "have fun imagining our orchestration of department stores' sliding doors, the hubbub of the crowds, the different roars of the railway stations, iron foundries, textile mills, printing houses, power plants and subways."

In addition to this historical information, Schafer also analyzes the current soundscape across the planet and tells of the very real threat of sound pollution. He explains how to classify sounds, describes the evolving definition of noise, relates music to the soundscapes of different eras, and includes a chapter on that most important and increasingly hard to find element: silence. Not unlike the birds in Aldous Huxley's novel *Island*, who over and over repeat the

same word—"Attention!"—Schafer's ultimate goal is to bring us more fully into awareness in respect to the sonic vibrations which constantly surround and affect us.
AS
$14.95 *(PB/301/Illus)*

SPK: Turn Illness into a Weapon
Socialist Patients' Collective
Startling book on the SPK (Sozialistisches Patienten Kollektiv) including theses and principles, chronology of events, essays and an introduction by Jean-Paul Sartre. The first English translation of this seminal work.
AK
$15.00 *(PB/215)*

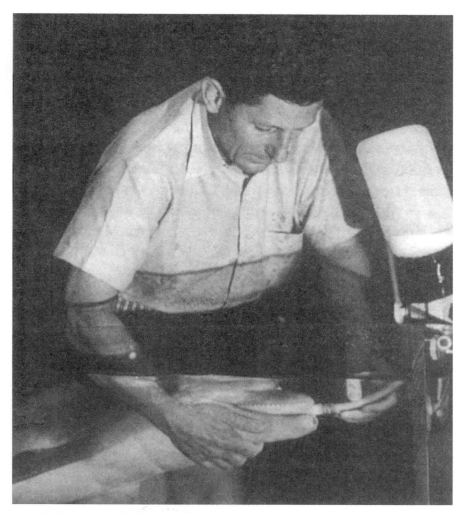

John Lilly feeding a baby dolphin — from **The Scientist**

Stairway to the Mind: The Controversial New Science of Consciousness
Alwyn Scott

"Is consciousness a purely physical phenomenon or does it transcend the material world? Offers a new perspective based exclusively on evidence from the natural sciences in which materialism and dualism co-exist."

$25.00 *(HB/229/Illus)*

The Story of Ibogaine
The Staten Island Project

"There is a cure for crack and heroin . . . the CIA declared it Top Secret in the '50s . . . *The Ibogaine Story* tells how Drug War hardliners used NIDA (the National Institute on Drug Abuse) to torpedo FDA-approved Ibogaine research in humans, on the brink of proving that a single dose can: interrupt heroin withdrawal, eliminate craving for crack, block nicotine compulsion, stop amphetamine dependency, break addiction to alcohol . . . for months, or even years!"

$20.00 *(PB/347/Illus)*

Story of Writing: Alphabets, Hieroglyphs, and Pictographs
Andrew Robinson

"Writing is perhaps humanity's greatest invention. Without it there would be no history and no civilization as we know it. *The Story of Writing* is the first book to demystify writing . . . explains the interconnection between sound, symbol and script, and goes on to discuss each of the major writing systems in turn, from cuneiform and Egyptian and Mayan hieroglyphs to alphabets and the scripts of China and Japan today."

$29.95 *(HB/224/Illus)*

Synchronicity: Science, Myth, and the Trickster
Allan Combs and Mark Holland

Synchronicity was coined by Carl Jung to describe meaningful coincidences that conventional notions of time and causality cannot explain. Everyone has them, but no definitive explanation can be given to fully explain them. "The most common meaningful coincidences are those seemingly random but apparently purposeful events which speak to us directly in terms of personal meaning. Jung's investigation of coincidences that occurred in his own life and in the lives of others led him to conclude that they are related to unconscious psychological processes. Alan Combs and Mark Holland use a unique transdisciplinary approach that not only sheds light on this strange phenomena, but also provides a glimpse into the hidden pattern of nature."

The authors believe that nothing occurs independent of any other thing and that nothing that does occur is entirely random and prey to chance. This is a theory that has been revisited and repeated throughout history. Biologist Rupert Sheldrake's theory of morphic fields, networks of resonance that form webs of mutual influence beyond the usual limitations of space and

Scripts represent sounds with varying degrees of accuracy. Ten scripts have been used to write "four score and seven years ago" (the opening of Abraham Lincoln's Gettysburg Address). At the top is the acoustic wave graph of the particular speaker (a Chinese-American linguist). — from The Story of Writing

time, is a return to the medieval notion that all things are connected. The book shows how modern science and ancient mythology are front and back of the same revolving door onto reality. The work of Jung and quantum physicist Wolfgang Pauli is examined along with noted scientists Paul Kammerer, Werner Heisenberg, and David Boehm. The mystery is slowly unraveled to reveal these coincidences as phenomena that involve mind and matter, science and spirit, thus providing rational explanations for parapsychological events like telepathy, precognition, and intuition. This is an extremely interesting book that deals with a subject we are all familiar with but cannot explain. Is it a coincidence that you are right now reading this? **AN**

$10.95 *(PB/184)*

This Timeless Moment: A Personal View of Aldous Huxley
Laura Huxley

"A second later, while I was opening the box containing the LSD vial, I heard that President Kennedy had been assassinated. Only then did I understand the strange behavior of the people that morning. I said, 'I am going to give him a shot of LSD-he asked for it.'

The doctor had a moment—you know very well the uneasiness in the medical mind about this drug. But no 'authority,' not even an army of authorities, could have stopped me then. I went into Aldous's room with the vial of LSD and prepared a syringe. The doctor asked me if I wanted him to give the shot-maybe because he saw that my hands were trembling."

$10.95 *(PB/330/Illus)*

The Three-Pound Universe: The Brain — From the Chemistry of the Mind to the New Frontiers of the Soul
Judith Hooper and Dick Teresi

The 3-Pound Universe, a hip guide to the latest neuro-research circa 1986, has still yet to be surpassed as an overview of the scientific study of consciousness (including altered states of). The authors, veterans of *Omni* magazine, synthesize the findings of brain research all-stars each probing the grey matter with his/her own paradigm: John Lilly and his dolphins, isolation tanks and ketamine; Ronald K. Siegel and his empirical studies of

hallucinatory case histories; Robert G. Heath and his brain electrode implant data; Candace Pert and her discovery of the opiate receptor; Paul Maclean and the "triune brain"; Karl Pribram and his "holographic brain"; as well as delving into the implications of endorphins, serotonin, and more esoteric brain chemistry compounds. **SS**
$15.95 *(PB/410/Illus)*

Through the Time Barrier: A Study of Precognition and Modern Physics
Danah Zohar
Britain's Society for Psychical Research provides archival material for a re-thinking of precognition. If it does exist, asks the author, "can it be understood in terms of modern science? It directly contradicts the theories of classical physics—but the modern view of time and space as set out in Albert Einstein's General Theory of Relativity may be able to accommodate it." From waking impressions of the *Titanic* sinking, to experimental studies with animals, the quantum level phenomenon of "Action at a Temporal Distance" is explored. **GR**
$8.00 *(PB/178)*

Time-Binding: The General Theory
Alfred Korzybski
Man links across Time through Culture. Plants = Chemical-Binding, Animals = Space-Binding. Written in 1924.
$5.95 *(PB/85)*

Towards a New Alchemy: The Millennium Science
Dr. Nick Begich
An exposition of the work of Dr. Patrick Flanagan, one of the most incredible scientists since Tesla. His inventions include electronic telepathy, the discovery of subtle energy in geometrics, holographic sound projection, speed learning, English communication with U.S. Navy dolphins, and new breakthroughs in electromedicine. **AK**
$14.95 *(PB/180)*

Toxic Psychiatry: Why Therapy, Empathy and Love Must Replace the Drugs, Electroshock and Biochemical Theories of the New Psychiatry
Peter R. Breggin
"A psychiatrist's devastating critique of how

"Try LSD 100mm intramuscular," last request of Aldous Huxley — from This Timeless Moment

the 'new psychiatry' is damaging millions of people. Biopsychiatry, says Dr. Breggin, is the dominant ideology of the medical-pharmaceutical establishment which frequently announces 'breakthroughs in brain chemistry' to justify the use of drugs, electroshock, involuntary hospitalization and other harsh treatments."
$16.95 *(PB/464)*

Trance and Treatment: Clinical Uses of Hypnosis
Herbert Spiegel, M.D. and David Spiegel, M.D.
A pragmatic guide to the application of hypnosis to treat phobias, control pain and anxiety, eliminate smoking and eating disorders, and deal with miscellaneous behav-

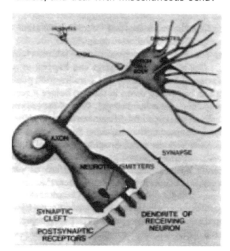

Nerve cells communicate by means of chemical messengers, or neurotransmitters. This is how our brains transmit the signals that process information, regulate emotions and keep us alive. — from The Three-Pound Universe

ior disorders such as hair-pulling and stuttering from a psychiatric perspective. Included are specific dialogs and techniques for hypnotic induction. The authors divide people into the Nietzsche-inspired categories of Dionysians, Apollonians, and Odysseans according to their level of hypnotic suggestibility and personality profiles. Also discusses trance logic, spontaneous trance, amnesia, and abreaction. **SS**
$24.00 *(PB/382/Illus)*

True Hallucinations
Terence McKenna
McKenna and Co. study psilocybin- and DMT-containing plants and their way of introducing the mind to the little machine elves of consciousness. A botanical trek through a South American river basin to search out a slowly dying breed: mystical Indians and shamans who are the keepers of the knowledge of *yage* and the strongest, most taboo version of DMT containing the tree resin known as *oo-koo-hé*. They try to find its relation to human consciousness and language and along the way discover many reasons to preserve the planet. Many personal sorting-outs between brothers and friends are complicated by mushroom consumption and DMT "study." Mixing the two drugs psilocybin and DMT apparently has some ESP-type effects on the human mind. But this all proves to be just the tip of the iceberg—the DMT experience is as much as one mind can take without the "categories of consciousness being permanently re-written." When asked if it is a dangerous drug, "the proper answer is that it is only dangerous if you feel threatened by the possibility of death by astonishment." For great is the amazement that comes from dissolving the boundaries between our world and another dimension! **DW**
$14.00 *(PB/256)*

Unchained Memories
Lenore Terr, M.D.
Written in short story style, as a collection of childhood memories, traumatic episodes and remembrances, these stories illustrate how we forget childhood trauma, and how and why these memories return. They also illustrate exactly what goes wrong with memory and what parts of memory sometimes turn false. (One story is about an entirely false remembrance.) Well documented, each short story is true, taken mostly from personal interviews by the author. A balanced and valuable work useful for judges, court systems, the psychiatric

profession, and persons who have experienced lost and found memories themselves. **CF**
$13.00 *(PB/282)*

Understanding Psychotic Speech: Beyond Freud and Chomsky
Elaine Ostrach Chaika

"This book was born as a treatise on what is often termed schizophrenic speech, but, increasingly, it has become clear that such speech can also occur in manics and other patients.... The book shows what are the features of schizophrenic speech, how they deviate from normal speech, and what accounts for our feeling that it is, after all, crazy talk."
$34.95 *(PB/342)*

The Varieties of Religious Experience: A Study in Human Nature
William James

First modern book to treat drugs seriously as part of the religious impulse: conversion, repentance, mysticism, saintliness. Lucid and unorthodox look at spirituality at the turn of the century.
$7.95 *(PB/576)*

Views from the Real World: Early Talks of Gurdjieff
G. I. Gurdjieff

Lectures delivered by Gurdjieff from 1917 to 1933. "Our mind, our thinking, has nothing in common with us, with our essence—no connection, no dependence. Our mind lives by itself and our essence lives by itself. When we say 'to separate oneself from oneself' it means that the mind should stand apart from the essence."
$12.95 *(PB/276)*

Whispers: The Voice of Paranoia
Ronald K. Siegel

As a research pharmacologist, Ronald K. Siegel took the same drugs as his subjects in an effort to truly understand their experiences. In this study of the waking nightmare of paranoia, Siegel seeks to identify with patients who are "hallucinating without the use of artificial intoxicants." The limbic system is the "neurological hideaway of the paranoia demon" but the psychological and biological triggers that engender paranoia are complex. Siegel pursues these origins like a sometimes terrified and often gleeful

private eye; he emerges with mesmerizing stories which suggest a compassionate, scientifically rigorous Clive Barker. In many of the most horrifying accounts, cocaine is the ingredient which turns a bad situation into a tragic one:

• A Christmas shipment of pure Bolivian rock cocaine results in a massive "bug invasion." Siegel sees numerous subjects covered with large, gummy lesions where they tried to dig the hallucinated creatures out of their bodies. One coke fiend shows up at his home with vials labelled "H" and "P" for "hands" and "penis"—the sites from which he has excavated the "bugs" in a sleepless three-day blitz with the help of his old high school dissecting kit and a stereo microscope.

• A beautiful, socially isolated waitress/ballet dancer interprets the placement of silverware by her love object, a gay waiter, as messages of desire. Her own desire, frustration, and paranoid obsession mount. Finally, she choreographs a dance for him which, in a twisted take on the romantic ballet *Giselle*, ends in murder.

• A father of five is left unemployed, humiliated and depressed by a debilitating shipyard accident followed by a false arrest. His discovery of cocaine leads to a three-year war against a spectral invasion of bugs, worms, snakes and midgets, which he records via an elaborate system of video cameras and microphones located throughout his house. His arsenal includes several propane torches, one converted into a flamethrower and dubbed "Mr. Discipline," a term probably used by his sadistic father. **MH**
$13.00 *(PB/310)*

The World of Ted Serios: "Thoughtographic" Studies of an Extraordinary Mind
Jule Eisenbud, M.D.

In this book, Jule Eisenbud, psychiatrist and psychic investigator, revealed to the world the amazing story of Ted Serios, a sporadically employed Chicago bellhop and alcoholic who it was claimed could produce recognizable visual images on polaroid film by concentrating his mental energies. A typical "Serios performance," often held in the respectable living rooms of curious followers of psychic phenomena, consisted of Ted showing up a bit late, possibly tipsy, then asking for something to drink. After he felt properly "prepared" Ted would leap into action, grabbing the polaroid camera (kept up to that point safely hidden to ensure that no tampering was possible) and holding it pointed at his head. Ted would then place a plastic tube

Getting ready to trigger at Ted's signal — from The World of Ted Serios

Thoughtographic photo with Ted's face superimposed — from The World of Ted Serios

called his "gizmo" over the lens and as he focused his mental energies into the camera. His face would turn red, veins would pop up on his forehead, and he'd begin sweating profusely and shaking violently. The shutter would be tricked and the print would be pulled and developed normally. Usually the result was all black or all white with no recognizable image.

This process could go on for hours, as Ted alternated between still calmness and agitated drunken excitement, often with no real success. Once in a while, Ted might even strip off all his clothes and stand naked, perhaps to show that he had "nothing up his sleeve" as it were. Usually just when the interested parties were ready to give up, Ted would produce a "hot one," often a blurry soft-focused image of a building or a landscape, "miraculously" projected onto the film by Ted's mind. Several of these evocative images are reproduced in the book looking much like photo student pinhole pictures.

Was Ted Serios a true psychic projector, creating images by force of will alone? Or a skilled trickster/performer using some unknown method along with deliberately eccentric behaviours to fool his audiences into accepting these fuzzy photos as real manifestations of psi-phenomena? Dr. Eisenbud, who began as a skeptic of Ted's, ultimately came to believe in him, and promote him as the real thing. **AS**
$37.50 *(HB/260/Illus)*

> I would suggest that academies be established where young people will learn to get really high . . . high as the Zen master is high when his arrow hits a target in the dark . . . high as the karate master is high when he smashes a brick with his fist . . . high . . . weightless . . . in space. This is the space age. Time to look beyond this rundown radioactive cop-ridden planet. Time to look beyond the animal body. Remember anything that can be done chemically can be done in other ways. You don't need drugs to get high but drugs do serve as a shortcut at certain stages of this training. The students would receive a basic course of training in the non-chemical discipline of yoga, karate, prolonged sense withdrawal, stroboscopic lights, the constant use of tape recorders to break down verbal association lines. Techniques now being used for control of thought could be used instead for liberation.
>
> —William S. Burroughs, from *The Job*

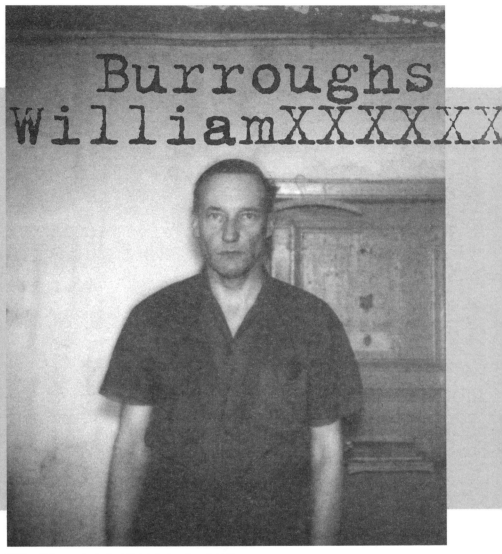

William S. Burroughs in Beat Hotel, Paris — from **Laid Bare**

The Adding Machine: Collected Essays

William S. Burroughs

A collection of 43 short essays that range in topic from autobiography to social commentary to ruminations on science to literary criticism. Discursive and linear, these reflections offer a rare glimpse into the sensibility of a novelist whose style is largely defined by allegory and the now-famous cut-up method. While the expository presentation may be unique (though Burroughs, it seems, is either incapable or unwilling to disengage from allegory altogether), the disposition isn't; his singular brand of indigenously American Libertarianism—caustic, scatological, hilarious, wistful—is evident throughout: "Most of the trouble in this world has been caused by folks who can't mind their own business, because they have no business of their own to mind, anymore than a smallpox virus has." There's a commonsense approach that informs his assessments of fellow writers as well. Of Beckett, he states: "If the role of a novelist is to create characters and the sets in which his characters live and breathe, then Beckett is not a novelist at all. There is no Beckett; it is all taking place in some grey limbo, and there is also no set." Highlights include "Bugger the Queen," a scathing attack on British royalty; "My Experiences With Wilhelm Reich's Orgone Box"; and "The Limits of Control." **MDG**
$11.95 *(PB/216)*

The Burroughs File
William S. Burroughs

A collection of short works published by small presses both foreign and domestic, focusing on Burroughs' experiments in language cut-up and photomontage drawn largely from the 1960s. Also includes *The Retreat Diaries* (1976), a day-by-day assemblage of "bits of dreams and poetry and associations cut in together" recorded on a Buddhist retreat in Vermont; and *Cobble Stone Gardens* (1976), an alternately bizarre and tender reminiscence of the author's childhood dedicated to the memory of his mother and father. Enhanced by the inclusion of "Burroughs in Tangier" by Paul Bowles (1959) and Alan Ansen's affectionate appreciation "Whoever Can Pick Up a Frying Pan Owns Death" (1959), *The Burroughs File* is an excellent compilation that provides the reader with Burroughs' principal literary output prior to his return to full-length fiction with *The Wild Boys* (1970). Writing to Ansen, Burroughs states: "Unless writing has the danger and immediacy, the urgency of bullfighting, it is nowhere near my way of thinking . . . I am tired of sitting behind the lines with an imperfect recording device receiving inaccurate bulletins . . . I must reach the Front."

MDG

$12.95 *(PB/230/Illus)*

The Job
William S. Burroughs with Daniel Odier

Important explanations of the experiments, techniques and theories which are usually encoded in Burroughs's fiction are provided in the form of interviews and essays intercut as "a film with fade-outs and flashback illustrating the answers." The possibilities for drug-free liberation of consciousness are explored through sound cut-ups, porno film loops, subliminals, infrasonic frequencies, riot TV, speech scramblers and the Dreamachine. Burroughs also takes the opportunity to editorialize in plain English about the Family; the pernicious influence of the gentler sex; the CIA; Watergate; love, the word and other viruses; Wilhelm Reich; Korzybski; L. Ron Hubbard; mutation; and Death. **SS**

11.95 *(PB/224)*

My Education:
A Book of Dreams
William S. Burroughs

A dream journal that reads more like a memoir than some random collection of subconscious misadventures, *My Education* is Burroughs at his most vivid, impacted and

Brion Gysin and William Burroughs, dreamachine in background —from **Re/Search 4/5**

vulnerable. Characters include everyone from friends (living and dead) to historical figures to extraterrestrials to his beloved cats. There's an elegiac, wistful tone throughout; the reflections and recollections of a man who, in his long life, has tasted (and endured) the extremes of love and suffering. Inherent in the very activity of dream—being outside of one's own body—is the element of transcendence, and this, too, emerges as a signature theme. While Burroughs has always questioned the limitations of language as they apply to meaning, here he repeatedly focuses that question on how those limits apply to loss. Tragically consistent with its overall mood, the book is dedicated to one Michael Emerton, a 26-year-old suicide; Burroughs writes: "An experience most deeply felt is the most difficult to put into words. Remembering brings the emptiness, the acutely painful awareness of irreparable loss." Gone is the raging diagnostician of *Naked*

Lunch and *Nova Express*; it's a kinder, gentler Burroughs within these pages—a long time in coming but well worth the wait. A must-read for anyone interested in the development of Burroughs' ongoing vision; an excellent introduction for the uninitiated. **MDG**
$21.95 *(HB/193/Illus)*

Naked Scientology/ Ali's Smile
William S. Burroughs
A bilingual (German/English) chronicle of Burroughs' experiences with and critique of Scientology culled from articles originally printed in the *L.A. Free Press*, *East Village Other* and *Rolling Stone*. "No body of knowledge needs an organizational policy, writes Burroughs, "Organizational policy can only impede the advancement of knowledge. There is a basic incompatibility between any organization and freedom of thought." Also includes a letter to the editor of *Rolling Stone* from R. Sorrell, a representative of the Church of Scientology along with Burroughs' caustically arch response. The volume concludes with *Ali's Smile*, a satirical allegory on the nature of control with Scientology as its target. What the book makes unmistakably clear is Burroughs' rabid contempt for the lapdog follower, the submissive idiot ever ready and willing to obey the voice of authority. **MDG**
$13.95 *(PB/106)*

Re/Search 4/5: William Burroughs, Brion Gysin, Throbbing Gristle
Edited by V. Vale
The first Re/Search magazine to appear in book form. Most interesting for exposing the links between the cut-up writings of William Burroughs, the theories and art of Brion Gysin, and the sound experimentation of Throbbing Gristle. Burroughs writes about Brion Gysin's invention of the cut-up method, Genesis P. Orridge and Peter Christopherson interview Brion Gysin, Simon Dwyer (*Rapid Eye*) writes about Throbbing Gristle, and the Paris Beat Hotel conceptual sources of Industrial Culture are laid out for all to ponder. **SS**
$15.99 *(PB/108/Illus)*

Towers Open Fire and Other Films
William S. Burroughs
"Four short films: *Towers Open Fire*, *The Cut-Ups*, *Bill & Tony*, and *William Buys a Parrot*. A

cinematic equivalent to Burroughs' writing, a "cut-up" of all the key themes and situations in his books, accompanied by a Burroughs sound-track narration. Society crumbles as the Stock Exchange crashes, members of the Board are raygun-zapped in their own boardroom, and a commando in the orgasm attack leaps through a window . . . "
$19.95 *(VIDEO)*

The Yage Letters
William S. Burroughs
A short collection of correspondence (commencing in 1953) between Burroughs and Ginsberg focusing on Burroughs' travels through the Peruvian jungles in search of *yage*, an hallucinogenic plant used by Amazon Indian doctors for the purpose of locating lost bodies and souls. Most exciting, perhaps, is encountering Burroughs in an epistolary mode; his arch observations and bitchy wit bereft of the allegorical/nonlinear trappings of his celebrated novels (though many of the images in *Naked Lunch* are in fact taken from notes on the hal-

lucinations caused by *yage*). Seven years later Ginsberg is in Peru and writes Burroughs an account of his own terrors with the drug, appealing to his mentor for counsel; a request Burroughs responds to somewhat cryptically: "There is no thing to fear. *Vaya adelante*. Look. Listen. Hear. Your AYUASKA consciousness is more valid than 'Normal Consciousness'? Whose 'Normal Consciousness'? Why return to?" The volume concludes with an epilogue (1963) containing a brief reflective missive from Ginsberg as well as *"I AM DYING, MEESTER?,"* a disturbingly elegiac cut-up by Burroughs provoked, presumably, by memories of his search for the drug: "Flashes in front of my eyes naked and sullen—Rotten dawn wind in sleep—Death rot on Panama photo where the awning flaps." For all students of Burroughs as well as those interested in the literature of drug-induced altered states. **MDG**
$7.95 *(PB/72)*

Photograph from Book of Hours — *from* The Burroughs File

Dreams

The Dream Makers, *1958 — from* Virgil Finlay's Strange Science

Dictionary for Dreamers
Tom Chetwynd
"Never before have so many images and symbols been collected in one book, all taken from genuine dreams to which a satifying and valid interpretation was found. It is when these many isolated insights are juxtaposed that the patterns of dream-thoughts (the way dreams work in practice) begin to emerge more clearly than ever before." Interpretations for over 500 archetypal symbols from Abyss and Alligators to Wounds and Youth.
$10.00 *(PB/208)*

The Dream Encyclopedia
James R. Lewis
Exploring 250 dream-related topics in alphabetical order (the A's start with Abraham, the B's with Bed-Wetting, the C's with Joseph Campbell), this heavily illustrated tome skates across the globe and the centuries. It provides snatches of information about an improbably diverse range of subjects from the spheres of art, ethnography, history, literature, science, philosophy and religion, providing bibliographical notes after each entry for further study. **MH**
$14.95 *(PB/416/Illus)*

Dreams
Jim Shaw
Artist and curator of the "Thrift Store Paintings" exhibition and accompanying book (and owner of the Teeth Lady painting which appeared on the cover of the *Amok Fourth Dispatch*), Shaw ambitiously illustrates his personal dream diary in the form of 145 brilliant black-and-white pencil sketches accompanied by his twistedly free-associative text captions. Sample captions:

"I WAS AT AMOK SHOWING MIKE GLASS A BOOK I'D MADE OF THE DREAM DRAWINGS, BUT THEY WEREN'T FULL DRAWINGS, JUST DETAILS OF THE MOST LURID AND EMBARRASSING DREAMS AND THE TEXT DESCRIBING IN RAMBLING RUN-ONS BETWEEN DREAMS.

"JAMES BOND WAS ONE OF MY SHRINK'S PATIENTS AND I WAS ENCOURAGED TO TALK ABOUT BOND. WHEN I WAS DONE, I REMOVED ONE OF MY EARS, WHICH WAS A SPY TAPE RECORDER AND I WAS WORKING FOR THE OTHER SIDE.

"I'M AT A LAKE THAT HAS BRINE WELLS AND TREES GROWING ACROSS IT. ROB'T. WILLIAMS LEADS ME TO A SANDBAR. I NOTICE A MAN WALKING UNDERWATER. WE SIT ON SOME BLEACHERS FROM WHICH A MUSCULAR NUDE MAN DIVES INTO THE WATER AND TO MY SIDE I SEE A BLACK JANITOR CLEANING UP SOME PARTIALLY SUBMERGED OFFICES WHICH SEEM TO BE QUITE EXTENSIVE."
$30.00 *(PB/288/Illus)*

The H.P. Lovecraft Dream Book
H.P. Lovecraft

Contains 23 letters from Lovecraft to various people in which he describes his dreams. In some ways this might seem to be a purer form of Lovecraft as his writing is less labored (although, even his letters are drenched in stylization). Lovecraft lead a pretty tortured inner life and through these dreams the reader can see many of his stories in their embryonic stages. If one is unfamiliar with his work but has an interest in the nature of dreams, this book might prove even more interesting. If one is not busy guessing which dream became a particular story, one can be struck by the machinations of a very twisted imagination. **SA**
$6.50 *(PB/42)*

Lucid Dreaming: The Paradox of Consciousness During Sleep
Celia Green and Charles McCreery

You know, when you know you know it's a dream? "Lucid dreams are those in which a person becomes aware that they are dreaming. They are different from ordinary dreams because they are often strikingly realistic and may be emotionally charged to the point of elation." You can induce them with training, and you can control them once you're there. They're often erotic, mystical puzzle/paradoxes, and loads of fun. A great hobby for narcoleptics. **GR**
$15.95 *(PB/192)*

The Mystique of Dreams: A Search for Utopia through Senoi Dream Therapy
G. William Domhoff

It seems that everyone knows about the Senoi, a Malaysian tribe who have been celebrated for their use of dreams as a means of bringing peace to their culture. It is claimed that, at breakfast, Senoi families discuss dreams of the previous night and the parents make suggestions and give advice to their dreaming children based on the content of their dreams, and that because of this, these people have an unprecedented lack of violence and mental illness in their society. Here the author traces the origins of this myth and its influence on the "dreamwork" of late '60s and '70s America. He specifically looks into the character of one Kilton Stewart, a psychologist/anthropologist/beachcomber and follower of Otto Rank, who visited Malaysia in the 1930s and was the main source for the dissemination of these notions about Senoi dream theory. Dissecting Stewart's history and looking more closely into his message and motives, Domhoff concludes that it was Stewart, not the Senoi, who developed the idea that societies can benefit from sharing their dreams, and that they can shape them through principals of mind control. The Senoi do not practice dream theory, he states, nor is their society so free of conflict. As Domhoff shows in a later chapter, it took the dramatic social changes of the '60s, which spawned the Human Potential movement, to bring Stewart's theories to a large and receptive audience which eagerly absorbed his utopian claims about the Senoi. **AS**
$9.95 *(PB/156)*

On Dreams
Sigmund Freud

"I have attempted in this volume to give an account of the interpretation of dreams; and in doing so I have not, I believe, trespassed beyond the sphere of interests covered by neuropathology."—Freud.

Includes "The Relation of Dreams to Waking Life," "The Method of Interpreting Dreams," "Distortion and Dreams," "The Somatic Sources of Dreams," "Embarrassing Dreams of Being Naked," and more.
$6.95 *(PB/736)*

Jim Shaw's dream drawings — from **Dreams**

Timothy Leary

Timothy Leary portrait — from High Priest

We've all listened to and read our share of breathless reports from trippers, yet for most people this discovery is a glorious surprise. Mystics come back raving about higher levels of perception where one sees realities a hundred times more beautiful and meaningful than the reassuringly familiar scripts of normal life.

For most people it's a life-changing shock to learn that their everyday reality circuit is one among dozens of circuits, which, when turned on, are equally real, pulsing with strange forms and mysterious biological signals. Accelerated, amplified some of these alternate realities can be microscopic in exquisite detail, others telescopic.

Since psychedelic drugs expose us to different levels of perception and experience, use of them is ultimately a philosophic enterprise, compelling us to confront the nature of reality and the nature of our fragile, subjective belief systems. The contrast is what triggers the laughter, the terror. We discover abruptly that we have been programmed all these years, that everything we accept as reality is just social fabrication.

In the 21 years since eating mushrooms in a garden in Mexico, I have devoted most of my time and energy to the exploration and classification of these circuits of the brain and their implications for evolution, past and future. In four hours by the swimming pool in Cuernavaca I learned more about the mind, the brain and its structures than I did in the preceding 15 years as a diligent psychologist.

I learned that the brain is an underutilized biocomputer, containing billioins of unaccessed neurons. I learned that normal consciousness is one drop in an ocean of intelligence. That consciousness and intelligence can be systematically expanded. That the brain can be reprogrammed. That knowledge of how the brain operates is the most pressing scientific issue of our time.
— Timothy Leary, from *Flashbacks: An Autobiography*

Flashbacks: A Personal and Cultural History of an Era
Timothy Leary, Ph.D.
The bigger-than-biopic-style exploits, adventures and narrow escapes of the renegade academic turned acid evangelist, prophet of space migration and cyberdevotee told in his own irrreverent words: "Harvard Department of Visionary Experience . . . Sacred Mushrooms of Mexico . . . Secrets of the Beatniks . . . Drugs Are the Origin of Religion and Philosophy . . . Ambushed by the Harvard Squares . . . Psychedelic Summer Camp . . . Earthly Paradise . . . Life on a Grounded Space Colony . . . Pranksters Come to Millbrook . . . Busted at Laredo . . . Brotherhood of Eternal Love . . . The Exiles . . . Captured in Kabul . . . Folsom Prison . . . Escape Plot . . . Kidnapped by the Feds . . . Freedom?" **SS**
$15.95 *(PB/405/Illus)*

The Game of Life
Timothy Leary, Ph.D.
The Game of Life is not simply a book: It is an experience. It is an organic computer. Leary uses ancient symbols to get his point across. But when he uses ancient symbols, they are no longer ancient, they are simply intelligence. Aleister Crowley's most dedicated student, Israel Regardie, wrote of Timothy Leary: "Posterity, I am certain, will have a finer appreciation of what he has contributed to the world than we have today." **DW**
$14.95 *(PB/294/Illus)*

High Priest
Timothy Leary, Ph.D.
"*High Priest* chronicles 16 psychedelic trips taken in the days before LSD was made illegal. The trip guides, or "high priests," include: Aldous Huxley, Gordon Wasson, William S. Burroughs, Godsdog, Allen Ginsberg, Ram Dass, Ralph Metzner, Willy (a junkie from New York City), Huston Smith, Frank Barron and others. The scene was Millbrook, a mansion in upstate New York that was the mecca of psychedelia during the 1960s, and of the many luminaries of the period who made a pilgrimage there to trip with Leary and his group, the League for Spiritual Discovery. Each chapter includes a chronicle of what happened during the trip, marginalia of comments and quotations, and illustrations."
$19.95 *(PB/347/Illus)*

Info-Psychology
Timothy Leary, Ph.D.
Leary pilots us off-planet and out-of-body through an updated version of *Exo-Psychology* (circa 1975) which takes account of cyber-realities of the 90s (neuroelectronic networks) . . . "The metamorphosis of human species from terrestrial to extra-terrestrial was signalled by the almost simultaneous discoveries of neu-

roactive drugs, electronic instruments, DNA code, sub-atomic nuclear energies, quantum physics, computers, electronic communication."
$12.95 *(PB/139)*

The Intelligence Agents
Timothy Leary, Ph.D.
Imaginative science fiction pseudo-dossier collage encoding the philosophy of Leary's "future history" book series. "Commodore Leri, the Out-Caste Agent who serves as quest-editor for this manual, is better known to galactic soap opera fans for his later work in High Energy Fusion in the Sagittarius Sector. *The Intelligence Agents* is a collection of 20th century documents which has enjoyed considerable popularity throughout the galaxy because of its Juvenile Charm. It is a classic portrait of a group of fledgling Agents, just graduated from Cadet status, facing their first mutational duty."—from the Publisher's Notes.
$14.95 *(PB/214)*

Spring 1966, Laredo, Texas. Leary beside co-defendant Susan Leary, age 18, as he talks to lawyers — from **Flashbacks**

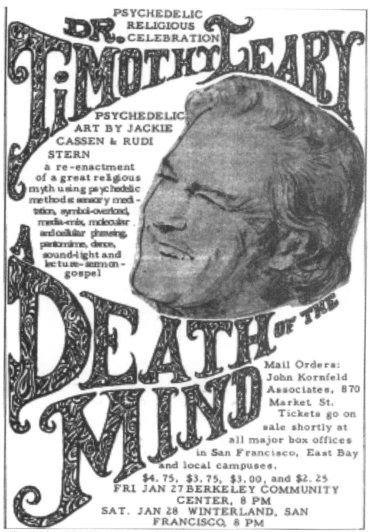

"Death of the Mind" Advertisement for a "psychedelic celebration" in the San Francisco Oracle *(December 1966) — from* The Politics of Ecstasy

Neuropolitique
Timothy Leary, Ph.D.
Expanded and updated edition of *Neuropolitics*: "The message of the DNA code is: Migrate from the Nursery Planet." LERI encounters G. Gordon Liddy (first as his prosecuting attorney at Millbrook), Charles Manson (in the jail cell next door), media manipulation and mass brainwashing, and moves from LSD to Zero G.
$12.95 *(PB/187)*

The Politics of Ecstasy
Timothy Leary, Ph.D.
"*The Politics of Ecstasy* is Timothy Leary's most significant work on the social and political ramifications of psychedelics. First published in 1968, this collection spans the period from research at Harvard to the San Francisco Summer of Love. Included are 'The Seven Tongues of God,' 'The Fifth Freedom—The Right to Get High,' 'Ecstasy Attacked—Ecstasy Defended,' 'American Education as an Addictive Process and Its Cure,' 'M.I.T. is T.I.M. Spelled Backwards,' 'The Buddha as Drop Out,' 'The Mad Virgin of Psychedelia,' and many more. Much of *The Politics of Ecstasy* appeared in a variety of publications including *The Psychedelic Review, The Bulletin of Atomic Scientists, Esquire, Harvard Review, Playboy, The Realist, Evergreen Review* and *The San Francisco Oracle*."
$12.95 *(PB/371/Illus)*

Asylum baseball team at State Homeopathic Asylum for the Insane, Middletown, New York, late 19th century — from **Madness in America**

Drawing by D.S. Ashwander — from **Selected Letters**

Anti-Oedipus: Capitalism and Schizophrenia
Gilles Deleuze and Félix Guattari
Weaving together the work of Marx, Freud and Nietzsche, *Anti-Oedipus* is an anti-psychiatry critique and attempt at an essential theory connecting politics, desire and anthropology. How to be a nomad in late industrial society beyond time and space.
$16.95 *(PB/400)*

A Thousand Plateaus: Capitalism and Schizophrenia — Volume 2
Gilles Deleuze and Félix Guattari
Taking the poststructuralist demolition of Western metaphysics as its point of departure, this book is a positive exercise in the affirmative "nomad" thought called for in its predecessor *Anti-Oedipus*.
$19.95 *(PB/640)*

Autobiography of a

Schizophrenic Girl: An Astonishing Memoir of Reality Lost and Regained—The True Story of "Renee"
"Renee"
"A victim of mental illness recalls the development of her disease and the nightmare world she lived in throughout her youth. A classic illumination of schizophrenia and an extensive commentary on the treatment of the author by Dr. M. A. Sechehaye."
$9.95 *(PB/192)*

How to Become a Schizophrenic: The Case Against Biological Psychiatry
John Modrow
How to Become a Schizophrenic is a thoroughly researched and timely refutation of the increasingly ascendent medical model of schizophrenia by a recovered schizophrenic who combines thoughtful argu-

ments with a vividly written account of his own personal case history. "The universal acceptance of the medical model (or disease hypothesis) stems from the fact that it serves the needs of so many people including psychiatrists, the parents of schizophrenics, and society in general. . . . Obviously, the medical model benefits everyone except the persons whom it is ostensibly designed to help: the schizophrenics."
SS
$14.95 *(PB/291)*

Memoirs of My Nervous Illness
Daniel Paul Schreber
Idiosyncratic autobiography of a 19th-century German judge who became schizophrenic. Freud's views on schizophrenia were largely based on Schreber's own observations about his states of mind. His writings discuss God, his "solar anus" and visual and auditory hallucinations and dispute such psychiatric authority figures as

Kraepelin.

$14.95 _(PB/416)_

Return from Madness: Psychotherapy with People Taking the New Antipsychotic Medications and Emerging from Severe, Lifelong, and Disabling Schizophrenia

Kathleen Degen and Ellen Nasper

"_Return from Madness_ is a profound and moving book. In the tradition of Oliver Sacks' _Awakenings_ it tells the dramatic story of patients suddenly liberated from lives destroyed by mental illness. Most of Degen and Nasper's patients are forced to organize life around the illness, their psychological and social development cut short by its onset. The authors not only describe the startling relief Clozaril provides for symptoms of chronic schizophrenia, but understand that relief from schizophrenic symptoms demands deep reorganizations of living as the patients resume development and mourn decades lost to illness."

$30.00 _(HB/242)_

Schizophrenia and Manic-Depressive Disorder: The Biological Roots of Mental Illness as Revealed by the Landmark Study of Identical Twins

E. Fuller Torrey, M.D. et al

"Are schizophrenia and manic-depressive disorder biological afflictions or the results of a traumatic upbringing? Are some people genetically destined to become schizophrenic? This book, the result of a landmark study, provides compelling evidence that both schizophrenia and manic-depressive disorder are biologically based diseases of the brain, unrelated to psychological influences."

$14.00 _(PB/304/Illus)_

Selected Letters

D.S. Ashwander

Publisher's Note: "In an otherwise encouraging letter, a reader wrote that by publishing the work of Dan Ashwander we 'could be said to be exploiting the anguish of schizophrenia, "We agree that this could be said, and that some clarification of our intent is needed. Our desire to publish this work stems from a genuine admiration and respect for Dan Ashwander. He beautifully describes the world as he experiences it. This experience may be very different from ours, but it does show a very full response to an often sad and confusing world. His ideas are valuable and should be published in the tradition of great books such as _Memoirs of My Nervous Illness_ by Daniel Paul Schreber and _A Mind That Found Itself_ by Clifford Beers."

Excerpt: "When I was living at Gulf Shores, Alabama, John F. Kennedy looking like another man, ran a small grocery store and motel from 1961 to 1964. After I got a job at a filling station in New Orleans, John F. Kennedy went to work there, too, looking like another man through plastic surgery. The last time I was around John F. Kennedy was when he was a man looking like a former State Department worker in Washington, D.C. and we were both in the old building of Bryce Mental Hospital at Tuscaloosa, Alabama, on the same ward. My coffee and cigarettes were the only things keeping me alive then and John F. Kennedy constantly bummed them from me and he got electro-shock treatment each morning. In 1967, I killed John F. Kennedy, through mental telepathy who was on a computer after me.

Two and a half million women in my harem are former men. Two of these men are Charles Chaplin, former actor, and Pablo Picasso, former painter.

I have scientific proof of my 'cosmic mind' going from my head into the Cosmos. I bought myself a ratemeter and dosimeter which measure neutron radioactivity. My ratemeter read 30 Roentgens per hour and my dosimeter read 200 Roentgens. I got a very small reading of alpha, beta, and gamma rays on a Geiger counter." **SS**

$2.00 _(Pamp/58/Illus)_

When the Music's Over: My Journey into Schizophrenia

Ross David Burke

Burke wrote this autobiographical novel because, he said (in a note he left for his doctors before committing suicide), "I would like a separate reality besides my fantasy, a factual description." At various stages a hippie searcher/druggie, convict (for a crime committed while in a delusional state), institutionalized tranquilizee and student, the book's narrator Sphere searches for love, sex, companionship and meaning like any other earnest and adventurous person, but is increasingly hobbled by terrifying hallucinations and delusions. His descriptions of "the dream" blend seamlessly with his philosophy, personal allegory and humor into a tale of struggle and pain.

The many accounts of sparkling moments and prosaic epiphanies produced by mushrooms, acid, pot and alcohol provide a time capsule of '60s Aussie hippiedom. However, Sphere's mental illness increasingly reveals itself as a separate animal: He is the only one among his friends (whom Burke has named Baron Wasteland, Magic Star Flower, etc.) whose drug experiences begin to dovetail into a kind of crushing, psychedelic blackness that seems like it will never end. As his story goes on, and the illness becomes increasingly florid, Sphere's isolation grows. His friends deteriorate into hepatitis-ridden geriatric cases, and their mutual love sometimes resembles depressing toleration: "The five

A photo of me at my mother's home. I like to wear yellow since my precious soul I separated from my head was gold or yellow. — from Selected Letters of D.S. Ashwander

bacteria came into the room and Magic spoke: 'We've brought an astrologer to heal you, Sphere.'"

Burke's drive to live life to its fullest permeates this story and the unexpected rhythms and clever surprises of its prose. Passages which at first might appear inaccessible often prove precise and beautiful: "Hours go by before the electric current is barbed and meshed into circuits that leave the victim in a crusty shell of irrational forces." **MH**

$10.95 _(PB/256)_

Sufi

So many people profess themselves bewildered by Sufi lore that one is forced to the conclusion that they want to be bewildered. Others, for more obvious reasons, simplify things to such an extent that their "Sufism" is just a cult of love, or of meditations, or of something equally selective.

But a person with a portion of uncommitted interests who looks at the variety of Sufi action can see the common characteristic staring them in the face.

The Sufi sages, schools, writers, teachings, humor, mysticism, formulations are all concerned with the social and psychological relevance of certain human ideas.

Being a man of "timelessness" and "placelessness," the Sufi brings his experience into operation within the culture, the country, the climate in which he is living.

The Sufis claim that a certain kind of mental and other activity can produce, under special conditions and with particular efforts, what is termed higher working of the mind, leading to special perceptions whose apparatus is latent in the ordinary man. Sufism is therefore the transcending of ordinary limitations. Not surprisingly, in consequence, the word Sufi has been linked by some with the Greek word for divine wisdom (sophia) and also with the Hebrew kabbalistic term *Ain Soph* ("the absolute infinite"). — Idries Shah, from *The Way of the Sufi*

Sufi bard — from Sindh Revisited

Among the Dervishes
Omar Michael Burke
Burke seeks to broaden his knowledge of Sufism, the mystic side of Islam, by traveling to the East and living as a Sufi. Not satisfied with the scant amount of literature available in his native England, he travels to Pakistan, goes native, and then makes his way to Mecca. From there, he travels from country to country, visiting and learning from Sufi groups in each one. This is a book to read if you want to know about Sufism and have little or no background knowledge. Burke's travel-adventure narration informs without boring the reader, something that some of the more academic-style Sufi books are guilty of. You learn as Burke learns, so there is no feeling of being talked down to. Burke's narrative is full of interesting tidbits, not restricted to Sufism. The chapter on his visit to Kuwait (in 1973) takes on new meaning when read with knowledge of the Gulf War. His adventures in Afghanistan also got better with age. Burke discovers that an Afghan word for foreign traveler is *se-roz-yak-kitban*, translated as "three days—one book," a cynical

reference to the main reason Westerners end up in their country. Among the many fascinating stories related in this book is a meeting with a group of Sufis who claim to have access to the teachings of Jesus from the years after his escape from the cross; and some astounding claims about the infamous Hashishin, from whom it is alleged that we derive the words hashish and assassin. There is a meeting with a certain Idries Shah, a name that translates as "studious king," and a strange tale of an Afghan Sufi who traveled to the United States and became a sword swallower for a circus—by accident! An informative and fun book. **TC**
$12.50 *(PB/208)*

The Commanding Self
Idries Shah
"An entire corpus anthology of previously unpublished works, based on tales, lectures, letters and interviews . . . describing the mixture of primate and conditioned responses, common to everyone, which rules the personality most of the time and which inhibits and distorts human progress and understanding, providing a barrier

against extra-dimensional perception."
$27.00 *(HB/332)*

The Essential Rumi
A superb collection of Rumi's mystical poetry. The translations, by Coleman Barks with John Moyne, are in free-form verse, rendering them extremely accessible immediately. Active in the 13th century, Rumi was a religious scholar for much of his life. In the late fall of 1244, at age 37, he encountered a stranger, a nomadic dervish named Shams. Shams asked Rumi a mysterious religious question which caused him to faint in a sort of ecstatic meltdown. The two spent months together in religious conversation (*sohbet*). It was a holy union, the true nature of which is still a great puzzle to scholars. Soon thereafter, Shams vanished and thus began Rumi's metamorphosis into a true mystic genius. In the words of Annemarie Schimmel, a noted Rumi scholar, "He turned into a poet, began to listen to music, and sang, whirling around, hour after hour." Only by reading Rumi can one understand what makes his poetry so special. These poems contain secret keys and

questions which jar and surprise persistent readers, encouraging them to awake their interior selves. Like the great modern teacher, Krishnamurti, Rumi yanks the rug out from under our conditioning. His passionate, delirious works should not be missed. **CS**

$12.00 *(PB/310/Illus)*

Meetings With Remarkable Men
G. I. Gurdjieff

Gurdjieff's equivalent of Sufi teaching tales taken from his own life and mystical development in his homeland of Central Asia. In his search for enlightenment, Gurdjieff obtains insights from seemingly "unremarkable" men who guide him despite himself to understand the "mysteries."

$12.95 *(PB/303)*

The People of the Secret
Ernest Scott

Covers various heretics, Kabbalists, Assassins (originally a secret Islamic society), demon worshippers, shamans, folk healers, witches, and the mothers and fathers of the modern esoteric movement (Gurdjieff, Mme. Blavatsky). This volume shows how since the legalization of Christianity and the appearance of Islam, successive kings and governments have tried to formulate official spiritual doctrines while those outside official circles with divergent teachings have been persecuted

(like the Albigensian heretics and the Sufi). All this might seem speculative until we see how it affects people—heretics and wayward mystics yesterday, UFOlogists today.
MET
$12.50 *(PB/263)*

Rituals, Initiation and Secrets in Sufi Circles
Franz Heidelberg et al

Three lucid and thoughtful papers from the The Society for Sufi Studies in London which examine the realities of Sufi orders in their traditional settings in the Islamic world.
$7.00 *(Pamp/48)*

Sacred Drift: Essays on the Margins of Islam
Peter Lamborn Wilson

"Wilson proposes a set of heresies, a culture of resistance that dispels the false image of Islam as monolithic, puritan and two-dimensional. Heresies include the story of the African-American Noble Drew Ali, the founder of 'Black Islam' in this country, and the violent end of his struggle for 'love, truth, peace, freedom and justice.' Another essay deals with Satan and 'Satanism' in esoteric Islam, and another offers a scathing critique of 'authority' and sexual misery in modern Puritanist Islam. The Anti-Caliph evokes a hot mix of Ibn 'Arabs tantric mysticism and the revolutionary teaching of the 'Assassins.' The title essay 'Sacred Drift'

roves through the history and poetics of Sufi travel from Ibn Khaldun to Rimbaud in Abyssina to the Situationists , A romantic view of Islam is taken to radical extremes: the exotic may not 'be true,' but it's certainly a relief from academic propaganda and the obscene banality of simulation."
$13.95 *(PB/167)*

The Sufis
Idries Shah

"History of the world's oldest mystical orders, still significant in the world of Islam."
$24.00 *(HB/404)*

Tales of the Dervishes: Teaching Stories of Sufi Masters Over the Past 2000 Years
Idries Shah

For centuries dervish masters have instructed their disciples by means of these tales, which are held to contain powers of increasing perception unknown to the ordinary man.
$25.00 *(HB/221)*

Teachings of Rumi: Masvavi I Ma'Navi: The Spiritual Couplets of Jalaluddin Rumi
Translated by E. H. Winfield Shah

Jalaluddin Rumi was born in Balkh (Afghanistan) in 1207 and died in 1273 at Konia, in Asiatic Turkey. His great work, *The Masnavi*, was 43 years in the writing. During the past seven hundred years, this book (called by the Iranians "The Koran in Persian"), a tribute paid to no other book, has occupied a central place in Sufism. It's interesting to read Rumi's masterpiece of verse and fable in a conservative translation. This reading of Rumi feels more authentic than the "interpretations" of Barks and his ilk, though many of these are well worth obtaining as well.
$15.00 *(PB/330)*

The Way of the Sufi
Idries Shah

Presents a cross section of material from Sufi schools, teachings, and classical writings. "To be a Sufi is to detach from fixed ideas and from preconception; and not to try to avoid what is your lot."—Abu-Said, son of Abi-Khair
$11.00 *(PB/320)*

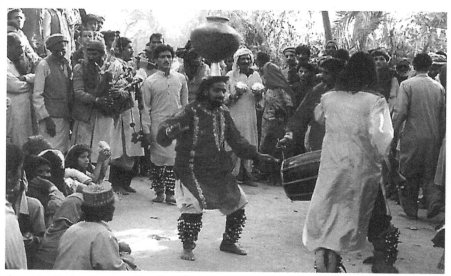

A crowd gathering at an urs — from **Sindh Revisited**

The only "realities" (plural) that we actually experience and can talk meaningfully about are perceived realities, experienced realities, existential realities—realities involving ourselves as editors—and they are all relative to the observer, fluctuating, evolving, capable of being magnified and enriched, moving from low resolution to hi-fi, and do not fit together like the pieces of a jig-saw into one single Reality with a capital R. . . . In simple Basic English, as a psychologist and novelist, I set out to find how much rapid reorganization was possible in the brain functioning of one normal domesticated primate of average intelligence—the only one on whom I could ethically perform such risky research—myself. . . . What my experiments demonstrate—what all such experiments throughout history have demonstrated—is simply that our models of "reality" are very small and tidy, the universe of experience is huge and untidy, and no model can ever include all the huge untidiness perceived by uncensored consciousness."
— Robert Anton Wilson, from the preface to the new edition of *The Cosmic Trigger*

Robert Anton Wilson

Coincidance
Robert Anton Wilson
Essays dealing with synchronicity and isomorphism in art and science, with special reference to quantum mechanics and genetics. "If there is a thesis hidden in these random explorations, it might be that nonsense has its own meanings and that Lewis Carroll, the fantasist, was just as wise as Charles Dodgson, the logician who happened to inhabit the same body as Carroll."
$12.95 *(PB/250)*

Cosmic Trigger I
Robert Anton Wilson
"Eventually my interest in the Illuminati was to lead me through a cosmic Fun House featuring double and triple agents, UFOs, possible Presidential assassination plots, the enigmatic symbols on the dollar bill, messages from Sirius, pancakes from Gods-know-where, the ambiguities of Aleister Crowley, some mysterious hawks that follow Uri Geller around, Futurists, Immortalists, plans to leave this planet and the latest paradoxes of quantum mechanics."
$12.95 *(PB/269)*

Cosmic Trigger II
Robert Anton Wilson
Heretical short essays on a range of Discordian topics from "The Mandelbrot Fractal?" to "The Dog Castrator of Palm Springs." **SS**
$12.95 *(PB/256)*

Cosmic Trigger III: My Life After Death
Robert Anton Wilson
"Includes Wilson's witty and humorous observations about the widely spread (and, happily, premature) announcement of his demise. And, of course, what Wilson masterpiece would be complete without synchronicities, religious fanatics, UFOs, crop circles, paranoia, pompous scientists, secret societies, high tech, black magic, quantum physics, hoaxes (real and fake), Orson Welles, James Joyce, Carl Sagan, Madonna and the Vagina of Nuit."
$14.95 *(PB/256)*

The Illuminati Papers
Robert Anton Wilson
"In *The Illuminati Papers*, Robert Anton Wilson speaks through characters from his novels and other realities and presents his views on our future way of life." Contents include: "Quantum Mechanics as a Branch of Primate Psychology," "Beethoven as

Information," "Mammalian Politics: Thackeray via Kubrick," "Paleopuritanism and Neopuritanism," and essays in the form of interviews from the *Science Fiction Review* and the *Conspiracy Digest*.
$9.95 *(PB/150/Illus)*

The New Inquisition
Robert Anton Wilson
"Wilson lets fly at Murray Rothbard, George Smith, Samuel Konkin III, and other purveyors of what he says is the claim that some sort of metaphysical entity called a 'right' resides in a human being like a 'ghost' residing in a haunted house."
$14.95 *(PB/240)*

Principia Discordia
Malacylpse the Younger
"Wherein Is Explained Absolutely Everything Worth Knowing About Absolutely Anything." Inspiration for R.A. Wilson's *Illuminatus Trilogy* . . . chaos is salvation.
$9.95 *(PB/117/Illus)*

Prometheus Rising
Robert Anton Wilson
Definitive work on the Wilson/Leary eight-circuit model of the brain. Self-programming made easy!
$12.95 *(PB/262)*

Quantum Psychology
Robert Anton Wilson
This might be the most effective twelve-step program. If one were to follow the steps herein carefully, one could be released from the mental habits that might turn one into a guru, a Republican, or an art critic:
 "Weather permitting, leave the house, go outside to the street and look around. How much of what you see would have existed if humans had not designed and built it? How much that 'just grew there' would look different if humans had not cultivated and encouraged (or polluted) it?"
AF
$12.95 *(PB/192)*

Right Where You Are Sitting Now: Further Tales of the Illuminati
Robert Anton Wilson
"I see this book as a machine to disconnect the user from all maps and models whatsoever."—RAW. Chapters include "Neurogeography of Conspiracy," "Ecology,

The Blind Spot — *from* Virgil Finlay's Strange Science

Malthus and Machiavelli," "Sirius Rising" and a conversation with Bucky Fuller.
$9.95 *(PB/208/*

Sex and Drugs: A Journey Beyond Limits
Robert Anton Wilson
For those who like their ancient Tantric sex secrets fast-food style, via transcendental balling and brain-blasting. This volume cata-logs the effects of popular drugs on the sexual experience: cannabis, heroin, speed, cocaine, LSD—alternating with "drug people I have known" stories. If Western society insists on ingesting shortcuts to orgasmic bliss, reasons the author, they can at least do it like informed pros. Massive amount of fact, anecdote, analysis and experience. First published by Playboy Press in 1973. **GR**
$12.95 *(PB/188)*

ORGONE

The 120 Days of Sodom and Other Writings
Marquis de Sade
"The Marquis de Sade, vilified by respectable society from his own time through ours, apotheosized by Apollinaire as 'the freest spirit that has yet existed,' wrote *The 120 Days of Sodom* while imprisoned in the Bastille. An exhaustive catalog of sexual aberrations and the first systematic exploration—a hundred years before Krafft-Ebing and Freud—of the psychopathology of sex, it is considered Sade's crowning achievement and the cornerstone of his thought. Lost after the storming of the Bastille in 1789, it was later retrieved but remained unpublished until 1935. In addition to *The 120 Days*, this volume includes Sade's 'Reflections on the Novel,' his play *Oxtiern*, and his novella *Ernestine*. The selections are introduced by Simone de Beauvoir's landmark essay 'Must We Burn Sade?' and Pierre Klossowski's provocative 'Nature as Destructive Principal.'"
$17.95 *(PB/800)*

Abortion: Questions and Answers
Dr. and Mrs. J.C. Willke
This is the little book that is known as "the Bible of the Right-to-Life movement." The format of the book is a series of questions and answers which focus largely on the various stages of fetal development. On Page 303, there is a list of things that *real* "right-to-lifers" do. These include: distributing food, working on crisis phone lines, helping abused women, volunteering at hospitals and hospices, working for scouting programs and Meals on Wheels, tutoring, distributing maternity and infant clothing and sharing their homes with a pregnant stranger and foster children. There is also a section on adoption. Hopefully, anybody who makes it up to Page 300 and is ready to act on his/her beliefs will take these suggestions to heart instead of making bombs and stalking doctors. Readers with a taste for the macabre will find a delightful array of ghoulish merchandise advertised for sale in the back of this inflammatory little tome.
SA
$6.95 *(PB/325/Illus)*

The Age of Agony: The Art of Healing, 1700-1800
Guy Williams
The art and practice of medicine was "severely retarded" in the 18th century. Call it cruel and unusual healing. Before germ theory, before anesthesia, before magic-bullet pills. Surgery was you, the doctor, a bottle, and a saw. Babies were given opiates to shut them up. Ladies lived with lice in their wigs. Harelips were cut and sewn up while three men held the child down. Smallpox scarred your face for life. And then there was the cure for insanity, a combination of purging, blistering, bleeding, violent sickness, and burning. "In the body, Hippocrates had said, were the four humours. If one or more of the humours were present in excess, mental disturbance would result." First cure was "the use of drastic purges, or vomits." If the humour refused to be purged, blood-letting was next, "either by a surgeon's knife, or by the use of leeches." Third try was "raising blisters by applying plasters or hot irons to the skin [until] the seared or ulcerated place suffered to run a good while." Last resort: drill a hole in the head; maybe the humours will escape from the brain. Unless you were rich, failed insanity cures were often farmed out to strangers and "chained in a cellar or garret of a workhouse, fastened to the leg of a table, [or] tied to the post in an out-

Amanda Feilding's self-trepanning — from **Amok Journal: Sensurround Edition**

house." Others were cast out into the cold, "like a lost dog or bitch." **RP**
$16.95 *(HB/237/Illus)*

Amok Journal: Sensurround Edition— A Compendium of Psycho-Physiological Investigations
Edited by Stuart Swezey

What, on the surface, is the connection between the work of art collective Neue Slowenische Kunst, and cargo cults in New Guinea, and autoerotic fatalities? And furthermore, what does it all have to do with the possibility that your neighbor's forced-air heating system may be emitting inaudible sound waves that cause you needless anxiety and excess sexual excitement?

In his introduction to the *Amok Journal: Sensurround Edition*, editor Stuart Swezey writes that these and other "accounts of the search for the erotic in the mechanical, the sublime in the visceral, and the spiritual in the electromagnetic," together constitute a basis for investigating "the neurobiological basis for mystical and ecstatic experience."

What this means is that despite the endearing presence of an article called "The Love Bug" (the imaginary headline screams: "Man dies making love to Volkswagen"), this is no mere collection of lifestyle marginalia, but a theory of the human defined by its farthest-flung event horizons. An as editorial stylist, Swezey gets at these extreme demarcations of culture and consciousness through the unexpectedly lush language of forensic reports as well as his own dry, neo-

Victorian prose. But the cumulative effect of the case studies, interviews and scientific papers collected here is epistemological: in the aggregate, these pieces form a knowledge-based antigen to the feel-good anomie of late-century American culture.

In the introduction to an interview with filmmaker Gualtiero Jacopetti (of the original shockumentary *Mondo Cane*), Swezey writes, "In contrast to the ubiquitous tabloid TV of our time, Jacopetti's films make no effort to mask their delight in discovering the bizarre and the grotesque which the world offers. Jacopetti makes no pretense in his narration to a Geraldo-like indignation or an Oprah-esque compassion." In face of a zeitgeist that has us all individuating indiscriminately just for the applause—and the free therapy—the *Amok Journal* provides an alternative template, a reading map superimposed over a scramble of seemingly unrelated fringe phenomena, through which the core phenomena of everyday life suddenly leap out in sharp new relief.

How does this work? The *Journal* takes disparate instances of sexual deviance, covert action and radical thought, e.g. "Rectal Impaction Following Enema With Concrete Mix," and a Hungarian report to the U.N. "Working Paper on Infrasound Weapons," and José Ortega y Gasset's "Meditations on Hunting": when displayed next to each other in proper context, as they are here, these elements shed their novelty aspects and begin to appear as a seditious commentary on the under-reported risks of individuality, conformity and

desire. All of which makes one think, why not go ahead and start to see dating, shopping at the supermarket, and reading the New York Times through the same sharp lens?

As a guidebook, the *Amok Journal* is a no-nonsense world tour and all-purpose locator for the culturally over-stimulated. As a philosophical/political text, its underlying theme is nothing less than the varietal experience of the all-American (now international) self-made man—who is, of course, the granddaddy of all deviants. **HJ**
$19.95 *(PB/476/Illus)*

Amputees and Devotees
Grant C. Riddle

Scholarly study of female victims of lost limbs and the men who eroticize them. A recently discovered love twist, it's known scientifically as acrotomophilia, viewed legally as a "perversion or deviancy" and socially as "kinky." Presently, there are more than a million amputee women in the United States, and who knows how many paraphiliacs pining for their limbless Madonna. "These men are the 'devotees' whose hearts pound when they see a woman with one leg swinging between crutches, men who daydream of dining with a woman with only one hand to cut her steak. These are the men to whom a complete sexual experience means making love to an incomplete woman, an amputee." Chapters on social stigma, prosthesis problems, sexual fantasies, amputees in literature and film, and women's personal stories.
GR
$27.00 *(HB/337)*

Anal Pleasure and Health: A Guide for Men and Women
Jack Morin, Ph.D.

In which unsurprisingly are extolled the virtues of anal insertion. All angles of anal penetration are covered and . . . er . . . probed from a medical perspective covering everything you'd ever need to know from lubrication to laceration. Interestingly, there appears only a brief mention of fisting, and disappointingly none at all of some of the more popular urban myths. It's nevertheless a fascinating guide to all things relating to anal exploration, with useful hints on the joys of household vegetables and one's very personal angle of penetration. Recommended reading before you happen to pick up a light

bulb for insertion into the nearest convenient orifice. **BW**
$12.50 *(PB/288/Illus)*

Animals in Motion
Eadweard Muybridge
"Eadweard Muybridge developed chemical and mechanical techniques in photography to capture motion in sequences of action splits. After making a successful panorama of the City of San Francisco, via his method, he directed his attention to the movement of the horse. Over 4,000 stop-action photographs of horses, cats, lions, deer, kangaroos, etc."
$29.95 *(HB/416/Illus)*

Aphrodisiacs for Men
Gary Griffin
"Facts and phalluses" about herbs, drugs and concentrated virilizing foods. The injectible drug that turns men into ramrods in minutes. The African bark that restores potency in 50 percent of men: yohimbe. Minoxidil. Kava Kava. Secret Chinese elixirs. Plus, the truth about Spanish Fly and other "faux passion potions." **GR**
$9.95 *(PB/64)*

The Art of Auto Fellatio
Gary Griffin
How to be your own sex partner. "Once a man has tasted his own penis, no other sensation can quite match it." Presents a regimen of exercises, personal experiences, a list of 100-plus self-suck videos, and the seven most popular positions: the Stork, the Lotus, Over Easy, the Plow, etc. Lots of pictures. **GR**
$9.95 *(PB/100/Illus)*

The Art of Eric Stanton: For the Man Who Knows His Place
Edited by Eric Kroll
Warning: This book is big. Really big. Big enough for a wasp-waisted, big-busted, long-legged, overheated bitch in a fur-trimmed black negligee and stiletto heels to use as a weapon; that is, if a scrub brush, vacuum cleaner hose, riding crop, belt, rug beater, gun, two-by-four, whip or golf club isn't handy. (Or if another prevalent form of punishment in Eric Stanton's world—suffocation by crotch—is deemed too good for the miserable cur.) "A woman has to be strong," says Stanton, "The bigger the better."
Stanton got his start in the early '50s

when Irving Klaw published his first comic book. These early works had women serving equal time as bondage subjects ("Girls' Figure Training Academy") and Amazons ("Dawn's Fighting Adventures"). He went on to share a studio with *Spiderman*'s Steve Ditko, and to produce compelling covers for erotic magazines and novels in his masterful pulp style. He continues to run a thriving mail-order business, which consists of picture stories he customises to the client's request. (One such collaboration is reproduced in its multiple stages in this book.) Stanton's lengthy career is a tribute to his and his viewership's polymorphous perversity: Just leafing through this book—even with *both* hands—can leave the impressionable reader in a state of near-exhaustion. **MH**
$49.99 *(HB/400/Illus)*

Beneath the Skins: The New Spirit and Politics of the Kink Community
Ivo Domínguez, Jr.
Out of the dungeons and into the streets. A collection of essays spotlighting the politically emerging leather/fetish/SM communi-

This Dutch self-sucker loves performing for an audience! – from The Art of Auto-Fellatio

ty. Topics include: "Pride Day: Where Should We Be?"; "Butcher Than Thou"; "Kink Nation: Identity Politics In Flatland"; "National Groups: Why We Need Them"; "Possession"; and "Soul Retrieval." Not your average Democratic or Republican platform issues. Not even close. **GR**
$12.95 *(PB/156)*

Better Sex Through Chemistry: A Guide to the New

Prosexual Drugs
John Morgenthaler and Dan Joy
The only medically sound, comprehensive guide to improving your sex life with drugs and nutrients. From substances that can enhance sex drive, firmness and duration of erection, vaginal lubrication, skin sensitivity, intensity of orgasm and stamina, to effective treatments for sexual difficulties such as premature ejaculation, impotence and difficulty achieving orgasm. This explains how each drug or nutrient works, how it can be obtained, and how to use it—including complete information on dosage, precautions and safety issues. **AK**
$14.95 *(PB/200)*

Biological Anomalies: Humans 1
Compiled by William R. Corliss
A Sourcebook Project catalog. Looks at the "external" attributes of humans (their physical appearance, anomalous behavior and unusual talents and faculties). Typical subjects covered: mirror-image twins, the sacral spot, the supposed human aura, baldness among musicians, human tails and horns, human behavior and solar activity, cycles of religiousness, cyclicity of violent collective human behavior, handedness and longevity, wolf-children, dermo-optical perception, hearing under anesthesia and human navigation sense.
$19.95 *(HB/304/Illus)*

Biological Anomalies: Humans 2
Compiled by William R. Corliss
The second Sourcebook catalog volume focuses on the "internal" machinery of the body. Typical subjects covered: phantom limbs, blood chimeras, bone shedders, skin shedders, sudden increase of hominid brain size, periodicity of epidemics, extreme longevity, "nostril cycling," voluntary suspended animation and "male menstruation."
$19.95 *(HB/297/Illus)*

Biological Anomalies: Humans 3
Compiled by William R. Corliss
The third volume focuses on: the human fossil record, biochemistry and genetics, possible unrecognized living hominids and human interactions with other species and "entities." Typical subjects covered: Neanderthal demise, giant skeletons, tiny skeletons, human-animal communication,

human chimeras and anomalous distribution of human lice.

$19.95 (HB/212/Illus)

Biological Anomalies: Mammals 1
Compiled by William R. Corliss

First of a projected three volumes on the "other" mammals. Volume 1 focuses on "external" attributes. Typical subjects covered: zebra stripe reversal, marching teeth, lunar effect on activity, mammalian art and music, rat and squirrel "kings," mummified Antarctic seals, navigation and homing, mammalian engineering works, and unusual vocalizations.

$19.95 (HB/292/Illus)

Bizarre: The Complete Reprint of John Willie's *Bizarre*, Volumes 1-13
Edited by Eric Kroll

Any lingering doubts about the protean authenticity of fetish artist John Willie's genius are crushed under the weight of Taschen's page-for-page reprint of all issues of Willie's magazine, *Bizarre*, edited and introduced by contemporary fetish photographer Eric Kroll. Published intermittently from 1948 to 1954, *Bizarre* was a kind of Baedeker to the demimonde of fetishism, sadomasochism, transvestism and other now fashionable paraphilias in an era when married couples couldn't be shown sleeping in the same bed on a movie screen. More importantly, it was a showcase for his original illustrations of fetishistically costumed women in bondage, which remain the biblical authority for fetish-derived art and fashion today.

Willie (real name: John Alexander Scott Coutts) was the sort of raffish figure the U.K.'s better classes have exported for years, a flamboyantly eccentric remittance man, paid by his stolid British merchant banking family to stay away from home. Shipped off first to Australia, where he began his tempestuous relationship with his volatile muse, Holly, he worked in intelligence during WWII before moving to New York to pursue his "hobby" full time. That hobby, which is often generically described as bondage, encompassed a wide variety of interests—reflected in the pages of *Bizarre*—ranging from corsetry to amputee fetishism. He carried on a voluminous correspondence with fellow enthusiasts around the world, publishing their invariably literate and often

touching accounts of their secret passions under pseudonyms like "Hobbledehoy" and "High French Heels." Excavation even turns up a letter from the young Fakir Musafar, the most visible contemporary interlocutor of the body-modification culture. Thus, among his other accomplishments, Willie became the first historian of what has since become a vast and much-inspected sexual bohemia.

But it is as an arbiter of erotic taste that Willie enjoys immortality. His elegant renderings of idealized women in dominant and submissive poses created an idealized form evident today in everything from John-Paul Gaultier's dresses to the surgically sculpted bodies of modern porn stars. Though these images are executed with a light hand and an evident affection for their subjects, they possess an undeniable bite that comes directly from the unconscious. Willie's pinups with missing limbs seem no less radical at a distance of four decades.

Indeed, careful though he was to avoid the strangling obscenity laws of his own time, he was bedeviled by postal authorities

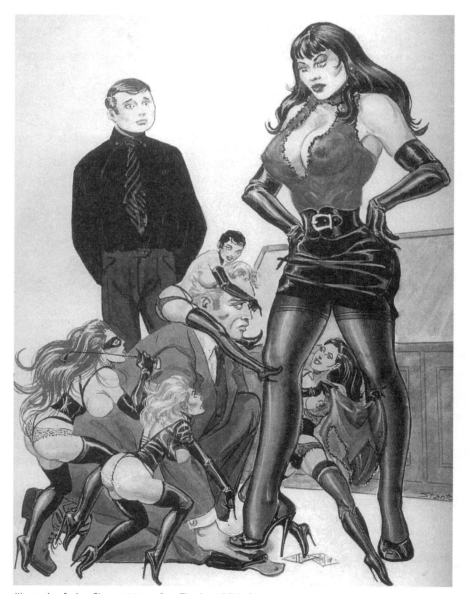

Illustration for Leg Show, *1990s – from* **The Art of Eric Stanton**

and lived with constant economic and legal insecurity, undoubtedly contributing to his propensity for strong drink and his early death. The end of his final affair with 19-year-old Los Angeles model Judy Ann Dull, who died at the hands of bondage murderer Harvey Glatman, may have contributed as well. The artist whose subject matter is sex lives in a perilous world, in every sense, and that very tang of risk, what the late Dr. Robert Stoller called "the element of harm," is what gives Willie's work its steely edge beneath all the lace. If there is an indispensable omnibus work of fetish art, this must be it.　　　**IL**
$39.99　*(2xHB in slipcase/1,540/Illus)*

The Black Book
Bill Brent
"There are many new guides to kink and fetish. *The Black Book* goes beyond those to provide a resource for all forms of alternative sexuality and lifestyle. Each new *Black Book* is the culmination of an ongoing dialogue with vendors, consumers, and alternative media reporting on the sexual underground."
$12.00　　　*(PB/192/Illus)*

Bloodsisters
Michelle Handelman and Monte Cazzazza
"A highly entertaining, in-depth view of the lesbian SM community. Featuring interviews with Pat Califia, Skeeeter, Robin Sweeney and other illustrious radical dykes, this revealing documentary will educate and excite both the seasoned and the uninitiated. An outstanding soundtrack by Frightwig, Coil, Chris and Cosey, Typhoon and Fred Giannelli."
$25.00　　　*(VIDEO)*

Bodies Under Siege: Self-Mutilation and Body Modification in Culture and Psychiatry
Armando R. Favazza, M.D.
Bodies Under Siege was first published as a cross-cultural examination of mutilation and self-mutilation and their relation to psychiatric syndromes such as wounding, auto-enucleation (plucking out of the eye) and self-castration. Ten years hence, Favazza has crossed paths with the Modern Primitive movement's leading exponent, Fakir Musafar (who supplies this edition with a new epilogue and cover photo), and found himself the leading academic expert

on one of the biggest subcultural booms since the jitterbug—piercing, scarification, branding and other forms of "body play." Favazza arranges the bulk of his book by body part (head, limbs, skin, genitals) with information on more arcane forms of self-attack such as monorchy (destruction of one testicle) and trepanation (drilling a hole in one's skull) as well as a discussion of treatment for psychiatrically disturbed self-mutilators.　　　**SS**
$16.95　　　*(PB/373/Illus)*

The Bondage Book #4: The Art of Tying Men Up Firmly
Rick Castro
From Rick Castro, photographer and co-director of Santa Monica Boulevard underground-film sensation *Hustler White*: "a compilation of beautifully xeroxed bondage art. Included in this issue are new bondage photos by Castro, who is now exploring the great outdoors with his Ansel Adams-meets-*Drummer* magazine series; the fetish art of Fuwa, Japan's answer to Tom of Finland; the drawings of Swiss kinkmeister Carmilla Caliban Cock, which have the look of Giger and Cronenberg (if they were fixated on dicks); Charles of France, beautiful drawings of men in their golden years in bondage (picture Barry Goldwater tied up with his balls stretched); and the romper-stomper of the high-art world, Attila Richard Lukacs, his paintings of post-Communist skinheads are what Aryan dreams are made of; plus celebrity interviews with the accomplished eccentric masochistic artist and human ashtray/knife sharpener of *Hustler White*, Graham David Smith and the star of *Hustler White* (and the sexiest man since Joe Dallesandro), Tony Ward, in bondage at last!"
$10.00　　　*(Pamp/66/Illus)*

Bottoming Book: Or How to Get Terrible Things Done to You By Wonderful People
Dossie Easton and Catherine A. Liszt
This is a well-conceived book on what the authors call "gourmet" or "graduate" sex. If you're not already familiar with the barebones essentials of SM, they offer suggested reading to bring you up to speed. The two requisites that form the basis for this book are communication and negotiation. By anticipating context and details and set-

"The Love Bug," view of the body showing chain harness and chain attached to car bumper — from Amok Journal: Sensurround Edition

ting the limits in advance, it really is possible to achieve the greatest fulfillment. There are all kinds of things that bear thinking through, and the authors offer some excellent guidance for those in the process of designing a rewarding experience for both parties. The tone is healthy, honest and enthusiastic. For somebody still in the process of coming to grips with these sorts of fantasies, the sheer guilelessness of the presentation could be a revelation. As "new school" SM is less rigid about roles, there are numerous examples of bottoms topping and tops bottoming. Alice would be right at home in this charming Wonderland. The spiritual aspects of it all are even addressed in a manner that doesn't choke you with New Age platitudes. In a word, this book is pragmatic.　　　**SA**
$11.95　　　*(PB/124/Illus)*

Breaking the Barriers to Desire: Polyamory, Polyfidelity and Non-Monogamy — New Approaches to Multiple Relationships
Edited by Kevin Lano and Claire Parry
Perhaps the first book (from the U.K. at least) to take non-monogamy seriously, *Breaking the Barriers to Desire* covers all aspects of "responsible non-monogamy," such as triads, open relationships, and polyfidelity. Personal experience, advice and theoretical articles are included—all by authors with experience in the theory and practice of such relationships.　　　**AK**
$12.99　　　*(PB/137)*

The Breathless Orgasm: A Lovemap Biography of

Asphyxiophilia

John Money, Gordon Wainwright, and David Hingsburger

"Explores a disorder in which sexual arousal and orgasm are dependent upon self-strangulation and asphyxiation. Although little-known to the public at large, asphyxiophilic rituals are often the unmentioned, or unrecognized, causes of the accidental suicides of young men. In this dramatic, intensely personal autobiographical account, the first ever written by an asphyxiophiliac, Nelson Cooper recounts in both prose and poetry the bizarre story of his tortured life . . . *The Breathless Orgasm* is both an autobiography of an asphyxiophiliac and a sophisticated study of this sex-related mental illness."

From the author's memoirs: "In many of my masturbation fantasies I was a disco dancer like John Travolta (whom I hate) from *Saturday Night Fever*. I imagined that I was wearing a tight, white jumper suit that sparkled in the lights while I danced. After I had danced, I would walk home at night, still wearing the suit. Suddenly, a bunch of boys would gang up on me and strangle me. My penis could be seen through the tight suit, and my pelvis struggled until the orgasm came out with my last gasp. My mouth was wide open and my tongue stuck way out until it folded back in and disappeared when I died. The boys would just leave me there. My clothes were never taken off. I started using the tongue trick when I really choked myself in front of the mirror."

$29.95 *(HB/178)*

Carnivorous Plants of the World

James and Patricia Pietropaolo

A complex and well-presented book on carnivorous plants from around the world and how to propagate, cultivate and care for them.

This book reflects 25 years experience and knowledge-gathering by the authors and includes data on the history, native environment and different trapping devices of the many species discussed in this book. The first part of this book deals with the various types or genera and is grouped by their means of entrapment:

• Dionaea, or Venus Flytrap (traps insects by quickly snapping shut)
• Pitcher plants (traps insects in hollow tube of the leaf)
• Sundew types (covered with sticky hairs

Annalinde, pinioned firmly by the hands, twisted her legs as if to avoid the pain. — from **Children of the Void**

to trap insects)
• Butterworts (sticky leaves trap insects)
• Bladderworts (trap door shuts trapping prey, some aquatic)

Later chapters continue with cultivation, pests and diseases, propagation and hybridization. Many color photos and black-and-white drawings of these otherworldly-looking plants and their flowers.

Carnivorous plants are some 136 million years old. The origins of carnivorous plants is not certain, but it is believed that shallow depressions formed in the leaves, trapping rain and insects. The plants benefited from the decomposing insects and the nutrients were absorbed through leaves. Later they developed more elaborate traps to help the plant survive in nutrient-poor soil. Which brings us to the question, what exactly is plant carnivorousness? What characteristics must a plant have to be considered carnivorous? "When this definition is applied, it evokes visions of snarling green jaws snapping at nearby animal life, not so." Basically it has to attract prey (with odors, colors, etc.), trap prey, secrete digestive enzymes and absorb digested material, and there you have it. **DW**

$22.95 *(PB/206/Illus)*

Cats Are Not Peas: A Calico History of Genetics

Laura Gold

"The chance acquisition of George, a very rare male calico kitten" sends the author on an odyssey into the history of genetics. "In this story," the author opens up "an unrecognized chapter in the history of science . . . from ancient theories about inheritance and sex determination, through Mendel's famous experiments with his round and wrinkled peas, to speculations by Darwin and others about the rare male calicos. The struggles of early 20th-century scientists to find and study rare male calicos in the hope of answering fundamental questions in the newly emerging field of genetics are explored in amusing detail."

$22.00 *(HB/228/Illus)*

Children of the Void

Regina Snow

While technically a "novel," *Children of the Void* is clearly based on the role-playing lives of an extraordinary group of six women who share between them 22 personae and inhabit an "all female world of glamor and discipline" which they call Aristasia (located in present-day London). The Aristasians see our age (inaugurated by the great cultural collapse of the 1960s) as unnatural and psychotic and have seceded from the outside world which they term "The Pit," erecting their own "Iron Curtain" in order to create their own time-space regions such as Vintesse (the 1920s) and Novaria (the projected future).

The Aristasian girls are divided into two sexes: blonde (ultra-feminine) and brunette (feminine) and even the most casual social relations between the sexes often seem to necessitate corporal punishment such as canings or strappings which are detailed by Miss Snow with a simmering eroticism. In place of what Snow terms "The Void" (the entire post-'60s cultural milieu), the Aristasians inhabit their own lively social whirl of the Cinema Odeon, the Soda Fountain, and the Constant Nymph Club. Their flirtations and chastisements are interspersed with eloquent theoretical analyses of the state of the Pit, in which for example a home is described as "just a dormitory for consumers" and its depraved media manipulations of the "bongos" (pit-dwellers). Includes a glossary of the Aristasian language and an afterword

specifically addressed to the "One Girl in a Thousand" who might be inspired to actually cross over the Iron Curtain into the glamorously strict world of Aristasia. **SS**
$39.95 *(HB/192/Illus)*

Chinese Eunuchs: The Structure of Intimate Politics
Taisuke Mitamura
"A fascinating dissertation on an esoteric subject. It is highly recommended to all those interested in exploring the little-known alcoves of history and culture."
$14.95 *(PB/176)*

Chinese Herbal Medicine
Daniel P. Reid
"Over a span of 5,000 years China has established the world's most extensive pharmacopoeia of medicinal herbs. . . . Chinese herbal medicine is a subject surprisingly neglected in current literature. The highly illustrated *Chinese Herbal Medicine* fills this void, providing the general reader with insight into one of the world's most complex and little-known sciences. It examines the natural flora and fauna on which herbal medicine is based and explains the philosophy that propelled its development. . . . The text includes a color-illustrated list of 200 major herbs detailing their use, and provides herbal recipes for some common ailments."
$19.95 *(PB/180/Illus)*

City of the Broken Dolls
Romain Slocombe
"Tokyo Metropolis. Both in hospital rooms and on the neon streets, beautiful young Japanese girls are photographed in plastercasts and bandages, victims of unknown traumas. These are the 'broken dolls' of Romain Slocombe's Tokyo, a city seething with undercurrents of violent fantasy, fetishism and bondage. Not since J.G. Ballard's legendary *Crash* have the erotic possibilities of trauma—real or imagined—been so vividly exposed. *City of the Broken Dolls* is a provocative, often startling photographic document of a previously unseen Tokyo, and of the girls whose bodies bear mute witness to the city's futuristic, erotic interface of sex and technology."
$17.95 *(PB/128/Illus)*

A Class Apart: The Private Pictures of

Montague Glover
James Gardiner
Cock's-eye-view of the working boys of London in photos taken between 1918 and the 1950s. The pictures are compelling—and so are the boys, even fully clothed! Street hustlers with hardons. Butch buddies modeling kilts, army uniforms and wet shorts. Boys in bed, boys shaving, boys hitching up their pants. And then there's curly-haired Ralph . . . the blue-collar, blond Adonis. The roving, randy "middle-class toff with a camera" who snapped all the shots was architect/ex-army officer Montague Glover. These rare glimpses into the gay past "document the three obsessions of his life: the search for 'rough trade' on the streets of London; men in uniform; and the handsome East End lover with whom he shared his life for over 50 years—surmounting all obstacles of prejudice, class difference and separation." Also includes Monty and Ralph's torrid love letters. The result is "a remarkable story; not only of the private life of one gay man, but of the whole hidden history of what gay men really looked like, felt and dreamed of in the first 50 years of this century." **GR**
$24.99 *(PB/144/Illus)*

The Color Atlas of Intestinal Parasites
Francis M. Spencer and Lee S. Monroe
"The essential parasitological reference . . . the textual descriptions of the intestinal protozoa, intestinal helmiths and confusing objects found in the feces continue to provide an excellent complement to the color atlas."
$52.95 *(HB/176/Illus)*

A Color Atlas of Human Anatomy
R.M.H. McMinn, R.T. Hutchings, J. Pegington and P. Abrahams
A mammoth guide to the human body for

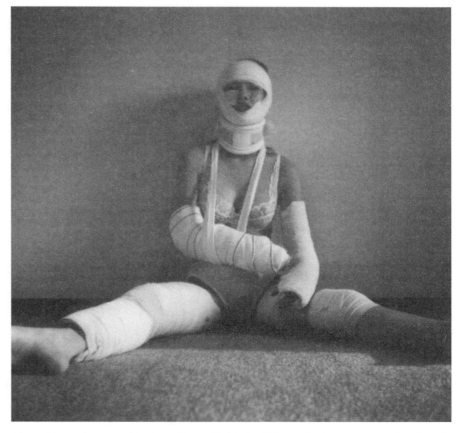

Maya with arms in casts and bandages, Yamato Noda's flat, Chihaya-cho, August 7, 1994 — from City of the Broken Dolls

medical professionals illustrated by one of the 20th century's greatest unsung artists, Frank H. Netter, M.D. In his career as a medical illustrator, Netter produced over 4,000 illustrations for the CIBA-GEIGY pharmaceutical company's medical education program, yet it was not until 1989 that he completed the project of an atlas of purely gross anatomy as opposed to specific surgical techniques, disease pathologies and so on. With over 500 color plates, each with multiple cutaway views of each anatomical region, this is an astounding body of work at the end of a highly prolific career. And as befits an artistic giant, Netter is not bashful about it: "At one point Mr. Flagler, the publisher, and I thought it might be nice to include a foreword by a truly outstanding and renowned anatomist, but there are so many in that category, a considerable number of whom have collaborated with me in the past and who are listed elsewhere in this volume, that we could not make a choice. We did think of men like Vesalius, Leonardo da Vinci, William Hunter and Henry Gray, who of course are unfortunately unavailable, but I do wonder what their comments might have been about this atlas. **SS**
$43.95 *(PB/351/Illus)*

Coming to Power
Edited by Samois
"Essays, fiction, and interviews compiled by a San Francisco lesbian-feminist SM support group. Chapters include 'If I Ask You To Tie Me Up, Will You Still Want To Love Me?' 'Proper Orgy Behavior,' 'Handkerchief Codes,' 'How I Learned To Stop Worrying and Love My Dildo,' 'Dangerous Shoes, or What's a Nice Dyke Like Me Doing in a Get-Up Like This?,' 'Girl Gang,' and 'The Leather Menace: Comments on Politics and SM.'"
$9.95 *(PB/288)*

Concrete Jungle
Edited by Alexis Rockman and Mark Dion
A collaboration by artists, theorists and scientists, this is a pop media investigation of what happens when urban and human environments intersect with nature. In addition to documenting urban survivors such as the pigeon, it includes an interview with the Rat Catcher of New York, a photo essay on roadkill, a look at sci-fi, exploitation and Hollywood films following the "nature runs amok" theme and contributions from Dr. Paul Ehrlich,

Donna Haraway and J.G. Ballard. **AK**
$19.95 *(PB/224/Illus)*

The Condom Encyclopedia
Gary Griffin
Brand-by-brand comparisons of more than 120 condoms sold in the U.S. and Canada. Width, length, lubrication, texture, price and special features are covered. **GR**
$9.95 *(PB/128)*

The Correct Sadist
Terrence Sellers
At the core of this oddly beautiful little book is a sort of "how to" guide, which focuses on the specifics of the correct behaviors for a woman desiring the "top" or "mistress" role in a sadomasochistic interaction. (It is written in such a way that the "bottom" might be male or female, but the sadist is presumed to be female.) This is an excellent book for the novice who might not have a clue where to begin. It would also make a great gift to a wife or girlfriend with whom one might wish to initiate a sadomasochistic interaction. Besides the basic etiquette involved, there are actual sample dialogues to which one might refer for inspiration or guidance. Keen insights are also offered for very specific aspects of fetishism, plus tips on how to make the most out of a humiliating situation. When offered as a present, it might well include bookmarks.

What makes this an odd book is not the subject matter, but the juxtaposition of the texts. The book is divided into three sections. The first and last sections are a fictional work of enormous precision and craft purporting to be the memoirs of Angel Stern. The writing has an almost hallucinatory edge to it. The general flow of the story tells the tale of how Angel came to her sadism. "Like some exotic monster I rarely emerged from the green darkness of the ocean floor, where my frail phosphorescence lit the way. These light and fluid creatures, who fled easily through the watery latitudes to surface and air I envied; I wondered at their careless trust in a foreign light. I surface slowly into their bright and confused stream to find they care nothing about my icy home below. They know only that to follow me would be their death as slowly the terrible pressure crushed their bodies. Enough that they are well-amused by my lurid coloring and profusion of

Ecstatic nun with donkey, engraving, 18th-century — from **Dearest Pet**

antennae." **SA**
$7.95 *(PB/192)*

Cross Currents: The Perils of Electropollution, The Promise of Electromedicine
Robert O. Becker, M.D.
Power lines, computer terminals, and the attempt to cover up their threat to your health. Includes a chapter on the neurological applications of ELF pulses in mind control (such as José Delgado). **FLA**
$14.95 *(PB/336)*

Dagger: On Butch Women
Edited by Lily Burana, Roxxie and Linnea Due
Adventures in genderbending, edited by "two butches and a barracuda femme." "What is butch? Sexual power of a kind that no woman is supposed to have. . . A fearless collection of stories and art, essays and interviews by butches (and the women who love them)." Or, says one dyke daddy, "I'm proud of my tits and I want people to look at them . . . FUCK YOU!" **GR**
$14.95 *(PB/232/Illus)*

De Los Otros: Intimacy and Homosexuality Among Mexican Men
Joseph Carrier
Everything you always wanted to know about

homosex in Guadalajara. Anthropological techniques are used to study Mexican male-to-male courtship, complete with descriptions of the various acts favored by Mexican gays based on direct observation. The resulting data almost read like a novel, albeit with plenty of social-science terms and references among the field notes. Also gay, the author was able to participate in much of the sex he outlines with explicit detail. Grants and other funding for his life's work allowed him to continue his research (and the participatory sex) in Guadalajara for 29 years—and it's still ongoing.

Carrier also profiles four extraordinary men with the love and care of a doting mom. He eloquently manhandles 18-year-olds, both figuratively and literally. He describes hot bathhouse and movie-theater scenes, and shares the most intimate details of tender adolescent love stories. The hottest observations, and clearly Dr. Carrier's favorites, are when he meets young, queeny respondents, who then throw him their leftovers. We learn of Eric, who thought that anal sex was safest because "after having sex all the semen comes out when you take a shit." Poor José leaves his rich German lover in New York for hunky 18-year-old Juan back in Guadalajara. And, the warm and wonderful Arturo dies from AIDS. Break out a box of tissues and a fire extinguisher for this one.

GE

$16.50 *(PB/231)*

Dearest Pet: On Bestiality
Midas Dekkers
"A stroke here, a pat there, a quick nuzzle in that gorgeous fur . . . though: that one spot, somewhere down below, generally remains untouched . . . " But what about Beauty and the Beast? Leda and the Swan? King Kong and Fay Wray? Didn't they do the wild thing? A Dutch biologist traces our "interspecies love affair" with animals in art and popular culture, and shows how social taboos are slighted when it comes to our furry friends. "So we see that love takes ever new and unexpected forms. Those who are surprised by this are surprised about themselves. And rightly so, since no one will ever be able to explain the source of that feeling that comes from deep inside when you look a woman or a man or a cat or a rabbit in the eyes and say, 'I love you.'" **GR**

$29.95 *(HB/276/Illus)*

Dentistry: An Illustrated History
Malvin E. Ring, DDS
If an army marches on its stomach, then this coffee-table ode to the enamel arts shows that a civilization progresses on its dental work. Dentistry is an ancient practice—Mayan skulls of the 9th century show inlays of jade and turquoise, and molars bound together with gold wire have been excavated from Old Kingdom sites in Egypt. The frontspiece of a lost Arabic manuscript of the 13th century shows a dentist caring for a woman with a toothache. He is prescribing a medicinal plant growing between them as a remedy for relief. The barber to the King of Scotland in 1503 had simple dental care to the King's court, offering hot irons on a tooth for pain and cosmetic tooth filing. By the 1880s, deluxe denture bases could be designed with a palate of swagged gold-and-porcelain teeth set in Vulcanite. At the same time, newly established American dental schools didn't admit women. America's first female dentist was Emeline Roberts, who began pulling teeth alongside her husband in 1859. She was eventually elected to membership in the Connecticut State Dental Society—34 years after she first began her practice. **GR**

$39.98 *(HB/320/Illus)*

The Developing Human: Clinically Oriented Embryology
Keith L. Moore and T.V.N. Persaud
"Week by week, stage by stage, *The Developing Human* shows you how organs and systems are formed and develop, why and when abnormalities occur and what vital roles are assumed by the placenta and fetal membranes." Photo illustrations depict such abnormalities as a double thumb, cleft foot, thalidomide babies, missing spinal cord, skull malformations, hermaphroditism, conjoint (Siamese) twins, extra nipples and other congenital oddities.

$37.50 *(PB/493/Illus)*

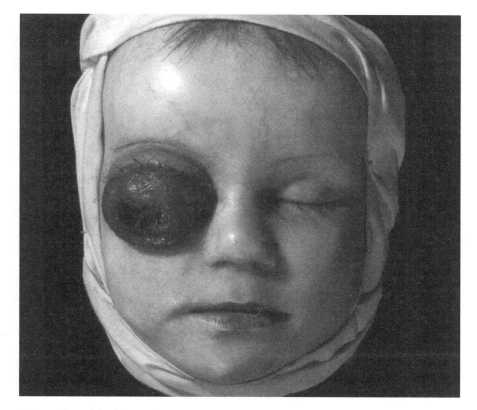

Glioma retinae of the right eye. Ophthalmic wax moulage by Luise Volger, Zurich, 1917 — from **Diseases in Wax**

Diseases in Wax:
The History of Medical
Moulage
Thomas Schnalke

Medical moulage is defined as "a wax reproduction of pathologic changes of the body." While no longer the state of the art in medical education, the moulage pieces reproduced in deluxe color in *Diseases in Wax*, like the daguerreotype images in the Burns Archive's *Masterpieces of Medical Photography*, become an ambiguously sumptuous feast of bodily decay and human misery. Author Thomas Schnalke has not only collected the finest examples of this now lost art but also put together a thoroughly researched history of the field from its earliest beginnings in 17th-century Italy, including biographies of its leading artists. With 331 color reproductions of moulages such as "Untreated tertiary syphilis of the skin and facial bones of a mountain dweller" by Carl Henning, Vienna, 1910, illustrations from such museums as the Elektropathologisches Museum (devoted strictly to electrical burns) where medical moulages can be viewed, and step-by-step demonstrations of moulaging techniques, *Diseases in Wax* is truly one of the great accomplishments of medical publishing.

SS
$180.00 *(HB/226/Illus)*

Doing It for Daddy:
Short and Sexy Fiction
About a Very Forbidden
Fantasy
Edited by Pat Califia

A well-written and highly entertaining collection of erotica which shares a common bond of dominance and submission. While it is not specific to a particular gender orientation, the high quality of the writing makes this a compelling read for all comers. It is not about incest or child abuse, but it does raise a lot of questions for the reader who might proclaim, "That's not my cup of tea." The editor explains it the best. "Daddy has gotten to be so popular that he threatens to eclipse Master as an honorific . . . Daddy fantasies sometimes function as a kind of SM-lite. A daddy is more accessible, flexible, and loving than a master or a sadist. A daddy-boy or daddy-girl scene is more likely to include genital sex than an SM scene. And there is less codification of the daddy role." With 18 writers to select from, this book really does offer something for every-

Chain saws are used as part of a mock castration scene solely for the excitement of a partner. — from Encyclopedia of Unusual Sex Practices

one. The introductory essay is one of the most intelligent essays on gender, family and role playing ever set in type. And for those who would balk at the bad name that such a book might give to Log Cabin types, Califia reminds us: "Books like this one make the rest of gay literature safer, because they push the edges and enlarge the territory of what can be said, thought about and done."

SA
$9.95 *(PB/240)*

Doris Kloster
Doris Kloster

Fashion photographer Kloster's portfolio of mostly dominant women, with lots of accessories (starting from the top and working down): gas masks, uniforms, rubber, leather corsets, hip boots, stiletto heels, strap-ons. Mostly submissive men being tortured with (starting from the top and working down): suspension, hoods, restraint, whips, pinching. Sections on shoe licking and infantilism. Kloster's photos have a self-consciously staged look, rather than the heady playfulness of the Klaw/Page pictures, the bewildering eccentricity of Elmer Batters or Eric Kroll, or the scary autism of ritualist amateur photos.

RP
$29.99 *(HB/340/Illus)*

The Electric Connection:
Its Effects on Mind and
Body
Michael Shallis

Explores our dangerous dependence on a force of nature we don't really understand. "Natural electricity is generally a beneficent force, controlled as it is by magnetism. But

the electricity that now pulses through our cables in our homes, offices and factories, beneath our feet and above our heads, has been unleashed from its magnetic bonds; even the electrical industries acknowledge that prolonged exposure is harmful. In our everyday lives it can make us ill; we can develop severe allergies to it. And in its purest, strongest form, in the computer world, it can influence our minds, alter our characters, and markedly affect our health— already physicians have recognized a painful and dangerous physical syndrome that attends intense and protracted work with a computer . . . And something even more threatening may happen: a change in consciousness and character that has already been observed may come to affect an important segment of humanity." **GR**
$18.95 *(HB/287)*

Electromagnetic Fields
and Your Health: What
You Need To Know
About the Hidden
Hazards of Electricity—
And How You Can
Protect Yourself
Michael Milburn and Maren Obermann

Technology may be developing a little too quickly for its own good. The environmental consequences of nuclear power, fossil fuel, global warming and acid rain are being demonstrated by scientists, as we go from "technology worship to global concern." Certain side effects of electricity are also gaining some attention. During the past few years much research has been done on the effects of weak electromagnetic energy fields on cells and organisms. This is the same kind of electromagnetism that comes

Coprophilia refers to one who is sexually aroused by feces. — from Encyclopedia of Unusual Sex Practices

from many daily-used household items as well as in power lines overhead. This book focuses on the question: Is there an association between electromagnetic fields and human health? It also presents the background needed to understand the different dimensions of this complex question. The answers are still not clear and are being studied and debated continually. Computer monitors, electric blankets and cellular phones, among other devices have become suspect. **DW**
$12.00 *(PB/207)*

Encyclopedia of Unusual Sex Practices
Edited by Brenda Love
An enlightened *Mondo Cane* of kink—alphabetized, of course. A brief sampling of entries should give some idea of the passionate depth of research that went into creating this volume: maieusiophilia—those who are aroused by women who are about to give birth; golden enemas—enemas using urine instead of water ("this is physically difficult and only a few men are able to urinate while semi-erect"); homilophilia—feeling sexual arousal while listening to or giving sermons and speeches; hybristophilia—orgasm dependent on being with a partner known to have committed an outrage or crime such as rape, murder or armed robbery; sacofricosis—the practice of cutting a hole in the bottom of a front pant pocket and then sticking a hand through to masturbate; sex restaurants—the Swiss restaurant Hjarlter Dam allows dominant women to anchor their slaves to a table or chair leg and certain Japanese coffee shops are equipped with mirrored tiles on the floor to assist customers who may want to look up the waitresses' dresses (whose uniforms do not include underwear). While not afraid to venture way beyond *Psychopathia Sexualis* in terms of bizarre and obscure sexual proclivities, editor Love is also generous with basic sex-therapy advice and cultural history on subjects from kissing to impotence. Illustrated with cool miniature dictionary-type line drawings from the likes of underground comic artist Paul Mavrides and medical illustrator and Re/Search cover artist Phoebe Glockner. **SS**
$22.00 *(PB/336/Illus)*

Erotica Universalis
Gilles Néret
Over 700 pages of beautifully reproduced

Illustration by Bernard Montorgueil — from **Erotica Universalis**

smut. Starting with some sprung Chinese petroglyphs dating back to 5000 B.C. and those racy murals of Pompeii, this sexy art survey cruises on through demonically-driven medieval revelry; to the divinely decadent draftsmen Aubrey Beardsley and Félicien Rops and the horned-out work of such art-museum stalwarts as Picasso and Dali; and winds things up with such obsessive geniuses of bondage art as Tom of Finland, John Willie and Stanton, representing our own fin-de-siécle. **SS**
$29.95 *(PB/756/Illus)*

The Evolution of Allure: Sexual Selection From the Medici Venus to the Incredible Hulk
George L. Hersey
A racy but serious history of physiognomy as it relates to sexual selection and mass culture, this book will make you understand exactly why *Baywatch* is the most popular television show on the planet. **MG**
$40.00 *(HB/219/Illus)*

Extremes: Reflections on Human Behavior
A.J. Dunning
This is the perfect "gift book" for the Amok enthusiast. "It is meant to instruct and to entertain and the reader should not expect morals or explanations." Loosely divided into four categories of extremes: "the

heart," "men and knives," "faith" and "the senses," this little volume is all over the map. Topics include Gilles de Rais and Joan of Arc, the satanic verse of Baudelaire, castrati, the invention of Braille, and body snatching for science in England. Translated from the original Dutch, the prose is spare but intelligent. One is allowed the guilty pleasure of a lurid thrill in a setting which does not compromise the sense of scholarship. Each piece includes a bibliography, which displays an amazingly obscure list of source material. **SA**
$19.95 *(PB/209)*

The Female Disciplinary Manual: A Complete Encyclopaedia for the Correction of the Fair Sext
The Standing Committee on Female Education
Devotees of corporal punishment form a sort of self-selected subculture within the already specialized world of sadomasochistic sexuality. Indeed, many "spankers" reject the application of sadomasochistic nomenclature (as opposed to the application of birches or nettles) to themselves and their tastes. There has always been a whiff of snobbery to the CP milieu, which partakes heavily of the symbolism of upper-class,

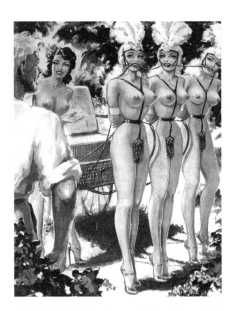

John Willie, The Adventures of Gwendoline, *1946 — from* **Erotica Universalis**

single-sex education. Unashamedly Anglophile, CP culture reflects an appreciation of the erotic uses of hypocrisy.

The Female Disciplinary Manual, whose authorship is attributed collectively to The Standing Committee on Female Education, purports to be an official document from some future society in which corporal punishment is routinely employed in education, in the workplace and at home. It details, as only obsessional narratives can, all the different implements that may properly be employed for this purpose, ranging from slippers to straps, and all the ritualistic scoldings and expressions of penitence that should properly be expected from disciplinarians and their charges. Even the correct diameters of canes to be wielded for differing offenders and offenses are inventoried. In all these proceedings, the element of sexual arousal, while never fully denied, is regarded as an unintended and suspect consequence of punitive necessity.

Most American CP enthusiasts—and they are legion, both male and female—are products of co-ed public schools where physical punishment is foreplay to litigation. Perhaps the charm of these small volumes lies in their staunch refusal to analyze the desires they are meant to inflame. CP culture is built around shame, the most effective antidote to guilt. **IL**
$39.95 *† (HB/112)*

Femalia
Edited by Joani Blank
Celebrates the erotic diversity of a woman's vagina. Color photos of 32 female flowers, shown in gynecological clarity, petals spread to greet the dawn. Sort of a Georgia O'Keefe stroke book. **GR**
$14.50 *(PB/72/Illus)*

The Foot Fraternity Photo-Sets: Volume 1
The Foot Fraternity
Puts the nose between the toes in more than 260 black-and-white photos. A football player makes his coach suck socks. A gray-haired cop gets his shoe leather washed. A burly top gets his boots polished by two tormented tongues. A busy executive gets some lip service on his Florsheims. Fully-clothed fantasies. **GR**
$19.95 *(PB/22/Illus)*

Fraternity Gang Rape: Sex, Brotherhood and

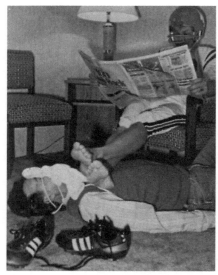

Photograph — from Foot Fraternity Photo-Sets

Privilege on Campus
Peggy Reeves Sanday
"Draws a chilling picture of fraternity society, its debasement of women and the way it creates a looking-glass world in which gang rape can be considered normal behavior and the pressure of groupthink is powerful."
$15.95 *(PB/203)*

From Fasting Saints to Anorexic Girls: The History of Self-Starvation
Walter Vandereycken and Ron Van Deth
"Although the term *anorexia nervosa* was not identified until the 19th century, the compulsion to be thin at the price of starvation has a long history in Western society. In this engaging and thorough account of the history of self-starvation in the Western world, Vandereycken and Van Deth show how self-inflicted starvation has changed over the centuries and is inextricably enmeshed in socio-cultural contexts."
$17.95 *(PB/280)*

Gay New York: Gender, Urban Culture, and the Making of the Gay Male World, 1890-1940
George Chauncy
Throw out all your rainbows, girls, gay lib didn't start when the friends of Dorothy busted their brassieres at the Stonewall riot in 1969. It's all in this prize-winning and brilliantly

researched account of the missing decades in the gay life of Manhattan. Here's the dish: Gay boys were called pansies, inverts, fairies or queers, and the girlier girls were accepted by society as flamboyant curiosities. An 1870 guide book illustration shows a fairy as just another denizen of the Bowery, along with beggars, cops and shoeshine boys. In some queer circles, a red tie and shocking blonde hair was the fad. At one of the discreet "gay set" bars in Greenwich Village, dropping a hairpin on the table told everything about you. In Harlem, drag balls were reviewed in the straight press and were sometimes held at the best hotels. See how gay men and lesbians lived, loved, played and prospered, until the police cracked down on the pansy bars in the '30s and rigid morality laws drove flaming faggots into the closet until the '60s. That's when Judy died and all the homos came out again to show the world where the bluebirds fly. **GR**
$13.00 *(PB/496/Illus)*

Good Vibrations: The Complete Guide to Vibrators
Joani Blank
"A treatise on the use of machines in the indolent indulgence of erotic pleasure seeking, together with important hints on the acquisition, care and utilization of said machines, and much more about the art and science of buzzing off."
$5.50 *(PB/80/Illus)*

Great Vibrations: An Explicit Guide to Vibrators
Carol Queen
The definitive women's guide to the selection, purchase, use and care of vibrators. Helping women overcome the embarrassment, ways to enjoy (men included), good and bad points of vibrators currently on the market. Includes drawings of different models, and how and where to use them. Features Joani Blank, the founder of Good Vibrations, the only store in the United States specializing in vibrators. **CF**
$32.50 *(VIDEO)*

The Handbook of Hearing and the Effects of Noise: Physiology, Psychology, and Public Health
Karl D. Kryter
"Presents the methods and the results of research for quantitatively describing the

major attributes of hearing and the effects of sound and noise on people. Intended for those interested in the fields of experimental psychology, physiology, audiology, otolaryngology and public health. . . . covers the basic nature and measurement of sound, structure and function of the ear, findings pertaining to noise-induced hearing loss, speech communications in noise, and assessments of hearing handicaps."
$79.95 *(HB/673/Illus)*

Hazing: An Anthology of True Hazing Tales
Edited by Bob Wingate
Rip-roaring homo-sex initiation rites, where "weeps and asswipes" are tied to tables, tortured, gang raped and verbally humiliated by heterosexual frat studs at their drunken, horny best. Are they not men? The Bull-Milking Contest! The Paint Off and Piss Off! My Life as a Dog! First published in the reader-written *Bound and Gagged* and *Pledges and Paddles*, the stories' emphasis is on ropes and rumps. "I am constantly amazed," says the publisher of the magazines, "at the number of letters we get from readers who are not gay, but who are turned on by the idea of being tied up by, or tying up, men. Equally amazing is the number of readers who have confessed to us that they were required to engage in sexual activity with fraternity brothers in the course of their hazings and initiations, even if they put it all behind them afterwards and never were tempted to do it again. I personally found this a little hard to believe myself at first, until I heard it over and over again from now happily married family men."
GR
$12.95 *(PB/192)*

The Healing Forest
Robert F. Raffauf
This enormous work represents nearly half a century of field research in the Northwest Amazon encompassing parts of Brazil, Colombia, Ecuador and Peru. While the Northwest region represents only a small part of the entire Amazonian drainage area, it is in many respects the most complex and varied part of the forest; it has also been the least studied. The authors, with backgrounds in ethnobotany and phytochemistry, have included and described nearly 1,500 species and variants, representing 596 genera in 145 plant families. Of these, half have had little or no real investigation

of their chemical and pharmacological properties. The Amazon represents a storehouse of as much as 16 percent of the plant species existing on Earth today. The native peoples of the area have retained their knowledge of the medicines and poisons derived from this diverse flora. The authors emphasize the importance of ethnobotanical conservation, and call attention to the fact that from these plants might come new chemical compounds of value to modern medicine and industry. It is their hope that this work will not only alert future generations of phytochemists to the potential of the Amazon as a source of new medicinal,

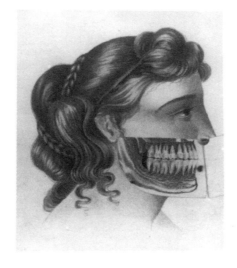

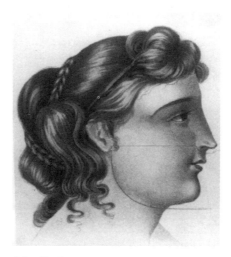

A Familiar Treatise on Dentistry by George Hawes, published in New York in 1846, featured a clever frontispiece. A flap, when lifted, revealed the teeth of the beautiful subject. — from **Dentistry**

toxic or other useful compounds, but in so doing will also assist in the conservation of the folklore record of the Indian peoples in this richly endowed region, which is so important to the welfare of mankind. **DW**
$69.95 *(HB/484/Illus)*

Herculine Barbin: Being the Recently Discovered Memoirs of a 19-Century French Hermaphrodite
Introduced by Michel Foucault
Born in France in 1838, Adéläide Herculine Barbin was to all outward appearances a gentle and religious, albeit flat-chested and hairy, young girl. But she carried a secret, one that became harder and harder to conceal as she entered adolescence and young adulthood. For Herculine Barbin was a hermaphrodite, with genitals that displayed both masculine and feminine characteristics. Legally declared a man in 1860, Barbin committed suicide eight years later, unable to live in a society that both assumed and demanded a definitive (Michel Foucault would say "true") sex.

In this volume, historian/philosopher Foucault has brought together Barbin's memoirs, contemporary medical reports and press accounts of his/her transformation from female to male, and a 19th-century fictionalization of his/her story. Foucault himself contributes only the introduction, choosing to let these documents stand on their own merits. While Foucault presents Barbin's tale as a chapter in the "strange history of 'true sex'" and identity, readers will delight in its outright eroticism, as the young Herculine swoons among her half-dressed classmates at the convent school, and later falls in love with her fellow schoolmistress (and employer's daughter) before Barbin's abrupt and devastatingly public reclassification as a man. A most enjoyable and thought-provoking read. **LP**
$10.95 *(PB/199)*

The Heretic's Feast: A History of Vegetarianism
Colin Spencer
"We do not adequately realize today how very deep within our psyche is the reverence for the consumption of meat or how ancient in our history is the ideological abstention from the slaughter of animals for food. The precise beginnings of the vegetarian ethic are lost in the priestly cults of ancient Egypt, but through the Orphic

movement vegetarianism became one of the influences upon Pythagoras, who gave his name to the diet. After his death a clear thread can be traced from antiquity to present times. In the East, in India and China, as part of Hinduism and Buddhism, vegetarianism has flourished and numbers millions of converts. From the days of imperial Rome . . . to the most hated Christian heresy of all, Manicheanism and its progeny, the Bogomils and Cathars, abstention from meat was seen as a sign of the devil's works, a clear rebellion against the word of God as revealed in biblical text. Persecution began once Pauline Christianity started to colonize Europe, and wherever it spread vegetarianism was reviled." The author also presents such prominent believers as Ovid, da Vinci, Benjamin Franklin, Thomas Paine, Tolstoy, Gandhi and Hitler.

$18.95 *(PB/416)*

The History of Farting
Dr. Benjamin Bart

"Treat yourself to a good fart!" is the advice from this English booklet of limericks, facts and folklore on ripping wind. "A philosopher once, named Descartes, was explaining himself to a tart. 'Since I think—I exist,' he remarked as he pissed, but what does it mean when I fart?" . . . "A nefarious Nazi named Goebbels, once loaded his anus with poebbels. The slightest suspicion or hint of sedition, found him farting a broadside at roebbels!" Includes an A-to-Z of fart types. **GR**

$8.95 *(PB/160)*

The History of Men's Underwear
Gary Griffin

Briefly speaking . . . The rise and fall of men's shorts. From codpieces to longjohns to Jockeys to Calvin Kleins. Illustrates advertising, design breakthroughs, fads and folklore. To protect themselves from the Evil Eye, men of the Mamba tribe of the New Hebrides wrap their love meters in yards of colorful calico, making an impressive 17-inch basket. **GR**

$9.95 *(PB/80)*

A History of Pain
Michelle Handelman and Monte Cazzazza

"Centering around a stolen Inquisition-era torture device, this ominous and dreamlike narrative explores SM, censorship, art and freedom. Featuring music by Psychic TV,

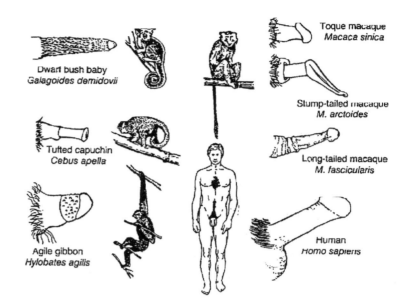

Penis size, shape and structure in primates — from **Human Sperm Competition**

Monte Cazzazza, Lustmord and Allegory Chapel." 45 minutes.

$25.00 *(VIDEO)*

Holy Anorexia
Rudolph M. Bell

Compares contemporary anorexic teenagers with ascetic medieval saints and determines that in both cases "the aberrant behavior is symptomatic of a struggle to gain autonomy in patriarchal environments."

$12.95 *(PB/248)*

Hormonal Manipulation: A New Era of Monstrous Athletes
William N. Taylor, M.D.

The pros and cons of anabolic steroids, the synthetic derivative of male sex hormones used extensively in modern athletics. In America, they're available by prescription only, but that hasn't stopped their use and abuse by an estimated 1 million athletes. This book discusses "The Steroid Spiral," a pattern of addiction common to heavy users; "Potential Psychological Alterations Induced in Men Using Anabolic Steroids"; "Beneficial Factors on Women's Athletic Performance" (as well as "Adverse Factors"); and "Will the Use of [human growth hormones] in Athletes Cause Acromelgy?" The author argues that anabolic steroids should be a controlled substance, and covers the

controversial use of growth hormones to treat gigantism, stunt the growth of "constitutionally tall girls," and prepare prepubescent children for athletic success. **GR**

$23.95 *(PB/208)*

The Horseman: Obsessions of a Zoophile
Mark Matthews

"*The Horseman* is a completely candid, sometimes graphic, sexual autobiography of one man's struggle to come to terms with the private demon of bestiality. Matthews traces his obsession with horses through his teen years, troubled marriage, his experience as a parent and his eventual divorce. The underlying problem and his attempt to deny it led him to drug abuse, self-loathing and the brink of suicide, before he finally came to accept himself as he is and to leave guilt behind."

From *The Horseman*: "Down the beach a couple of hundred yards was a portable corral where a riding concessionaire kept his horses at night. I made friends with the wrangler, and he pointed out a bay mare that he said had 'a bad ovary'; she stayed in heat continuously. The owner used her to keep his stud happy, since she'd take one anytime. About midnight I checked it out. It was true. Even though I had to stand on an upturned feed tub to mesh our genitals, she fucked me silly."

$27.95 *(HB/208)*

The Horsemen's Club: True Tales of Legendary Endowments
Gary Griffin

True tales from the land of the foot-long dong. Meet Cadet Briggs, the straight lad who entertained his buddies by karate chopping pencils in half with his mule-sized meat. The Saudi Prince with the needy smokehouse salami. The Reverend at the urinal with a 10-inch firehose. And "Bill," whose genitals grew too fast, leaving him with a horsecock that could throw a salute at 16 inches. **GR**
$9.95 *(PB/100)*

The Human Figure: The Complete Dresden Sketchbook
Albrecht Dürer

"Germany's greatest painter" was "even more significant as an innovator in the field of woodcuts and engravings, and in the theory of proportions of the human figure." A great explorer of perspective, Dürer created work which remains "surprisingly modern." Bodies full front, bodies from the left, bodies from the right. The hand and arm in motion; studies of human proportion. "Stereometric constructions" that pre-date Cubism. Skeletal hands, positions of feet, walking studies. All meticulously rendered as the artist "pursued the subject in order to arrive at a workable system of constructing the human figure, suitable for artists." First published in 1523. **GR**
$14.95 *(PB/335/Illus)*

The Human Figure in Motion
Eadweard Muybridge

"This is the largest selection ever made from the famous Muybridge sequence of high-speed photographs of human motion. Containing 4,789 photographs, it illustrates 318 different types of action. Taken at a speed of 1/6000th of a second, these photographs show bone and muscle positions against ruled backgrounds. Almost all subjects are undraped, and all actions are shown from three angles: front, rear and three-quarter view."
$24.95 *(HB/390/Illus)*

Human Oddities: A Book of Nature's Anomalies
Martin Monestier

Chapters include "Explaining Monsters," "The Armless, the Legless and the Limbless," "The Hirsute," "Sexual Monstrosities," "Composite Monsters" and "Giants and Dwarfs. " All your favorites are here, plus more than a few amazing surprises, in hundreds of black-and-white photos. Fatman Renaud le Jurassien (1,373 lbs. at death), Chubby Dolly Dimples (620 lbs.), human skeleton Isaac Sprague (44 lbs.). James Elroy, who plays trumpet with his feet. Johnny Eck, the "half man." Lionel, the lion man. The Tyrolean giant (7-ft. 10-in. tall), Herve Villechaise, Tom Thumb. An African hermaphrodite. Bobby Kork, a sideshow "half and half." A tailed boy discovered in a Saigon jail. "White negroes." The man with the rubber skin. Testicles as big as a rock. Forty-four-pound breasts. Four breasts! Six breasts! Two heads! Three legs! A bound foot! And a horrible Chinese practice of creating "animal children" by stripping off human skin and grafting the hides of dogs onto the flesh of young bodies, a practice uncovered by a visiting doctor in 1880. **GR**
$14.95 *(PB/188/Illus)*

Human Sexuality: An Encyclopedia
Edited by Vern L. Bullough and Bonnie Bullough

A one-volume work which contains essays on sexual topics (abortion, Berdache and Amazon roles among American Indians, nudism, nymphomania, pheromones, virility and machismo, etc.) from leading writers in the field of sexology arranged alphabetically as well as biographies of such historically significant researchers such as Magnus Hirschfield and John Money.
$95.00 *(HB/643)*

Human Sperm Competition: Copulation, Masturbation and Infidelity
R. Robin Baker and Mark A. Bellis

Picture ragtag armies of "kamikazi sperm" on "seek-and-destroy" missions, battling and "blocking" another man's sperm against the dreaded "flowback" of the female's vagina. Sperm Wars? Based on the latest '90s research, this is a textbook-style "analysis of the behavioral ecology of human sexuality." The authors propose that human sexuality has been shaped by the phenomenon of sperm competition." Side issues addressed are male nipples (why they have them), women's breasts (why they stay pendulous year 'round), masturbation (it may have a function), the pistoning penis (as a sperm suction device) and the push-button power of the clitoris (it's three times more sensitive than the head of a penis).
GR
$86.95 *(HB/376/Illus)*

If We Can Keep a Severed Head Alive . . .
Chet Fleming

The introduction to this book announces for "the need for an open debate" and begins with the following quote: "in simple and blunt terms, this operation involves cutting the head off of an animal, and maybe even a human someday, and keeping the severed head alive. Now you know why it's going to cause controversy." Sorry, Chet, I don't, and apparently neither do you. Today, transplantation and xenotransplantation of both human and animal parts is commonplace. Some dialysis machines contain live pig kidneys that are attached to human beings. Pig valves are used in artificial hearts. Many other experiments are taking place to sustain body parts for transplantation and life extension. But today's modern scientist is governed by large corporations whose only interest is adding to their financial portfolios. *If We Can Keep a Severed Head Alive . . .* is a big thick book filled with sophomoric observations about the evils that may arise from this experiment, i.e., what if it had been done to ruthless dictators like Hitler and Stalin? Let's see, the world would be controlled by a giant head?

Fleming misses a few fundamental points about the world we live in. Everything is ruled by the almighty dollar. Evil will always exist. Whether it is kept alive by a perfused head, printed in books, touted by hatemongers or any other way is completely irrelevant. The other missed point is that even if we could keep a severed head alive, there will always be ways to dispose of it. You could embarrass it with a bad haircut, pull the plug, put it in a box, make it wear funny hats, or bring it to trial for any crimes it may have committed with or without its body. Even if Hitler shaved his mustache off, it would be difficult for a severed head attached to tubes, wires and other life-support machines to blend in or hide. If you ignore the author's personal observations, *If We Can Keep a Severed Head Alive . . .* provides an interesting history of people who

have attempted discorporation with various animal heads. **AN**
$12.95 *(HB/461/Illus)*

Inflammatory Bowel Disease
Ira J. Kodner, M.D.
A clinical-symposium booklet with illustrations by John A. Craig, M.D.
$3.50 *(Pamp/32/Illus)*

The Interactive Atlas of Human Anatomy
Frank Netter, M.D.
"The CD-ROM atlas contains all the brilliant Netter anatomy illustrations in the highly acclaimed book. The detailed, vivid pictures in a dynamic, interactive software format provide a versatile new tool for learning and teaching human anatomy. *The Interactive Atlas of Human Anatomy* is a complete, computer-based anatomy resource for all health-care educators, students and practitioners." Runs both Windows and Macintosh and contains over 900 illustrations.
$99.95 *(CD-ROM)*

Investigating Sex: Surrealist Discussions, 1928-1932
Edited by José Pierre
The transcript of a round-table discussion between all the big-name Surrealists when the given topic is sex sounds like the hoot to end all hoots, doesn't it? Well, uh, it isn't. Goes to show that even the avant le avant couldn't really shake their . . . stick . . . at the great libertines of yore, be it the second earl of Rochester (read Graham Greene's jaw-dropping bio) or de Sade himself. Especially fun to learn what a prude Breton himself was. It is a great read, though. And the (mildly) edited debates, if not especially revealing or revelationesque, are an interesting fly-on-the-wall experience, even though far too similar conversations can be overheard on a daily basis at any given latte joint in the galaxy. **JK**
$17.95 *(PB/215/Illus)*

Ishtar Rising: The Goddess Obsession
Robert Anton Wilson
Ishtar Rising is centered around the overwhelming figure of the female breasts. How do we relate to them? What do we think about them? As usual Wilson comes up with a formula that explains the situation. He

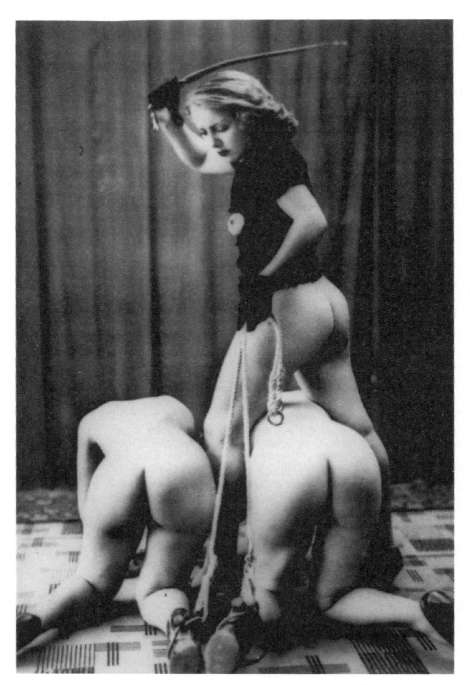

Enlargement of an anonymous postcard, around 1930 — from Jeux de Dames Cruelles

theorizes that the visual availability of breasts accounts for a culture's condition at a certain historical time, so breasts become a sort of social barometer. In essence this is the formula:

Breasts-a-go-go = a happy, non-neurotic society.
Breasts-a-no-no = a repressed, anal society.
 AF
$12.95 *(PB/186/Illus)*

Jeux de Dames Cruelles
Serge Nazarieff

Cruel dames, indeed! *Jeux de Dames Cruelles* is a beautifully produced coffee-table book of over a century of pornographic photos of woman-on-woman sado-masochism. Some of the earliest daguerrotypes in this collection were actually taken back when *Venus in Furs* was still a glimmer in the mind's eye of Herr von Sacher-Masoch. Flagellation by switch, cat o' nine tails and open hand, even biting of plump-bottomed nuns; naughty schoolgirls, persecuted maids in uniform; chained damsels in distress and often multiple butts in various states of disrobement set up in position for chastisement; a photo composite of a reclining woman daydreaming of erotic spanking scenes and even panel-by-panel douche scenes from bygone years are included in this remarkable survey. Many of the shots were taken for photo calling cards for "specialized" Parisian brothels while others were clearly the European predecessors to Irving Klaw's happy-go-lucky bondage scenarios of the 1950s featuring the inimitable Betty Page. **SS**
$12.99 *(PB/160/Illus)*

The Joy of Solo Sex
Dr. Harold Litten

Presented as a liberating godsend for the poor mythical bastard who thinks he'll grow hair on his palms if he soaps up too vigorously, this preachy wannabe whack-off rag will better serve as a bedside conversation piece to amuse your guests. Oh, sure there's a smattering of interesting anecdotes: fruits, vegetables and a carp used as vaginas, the requisite list of funny things doctors have pulled out of people's rectums, and an unfortunately brief mention of an experimental subject in a Nazi Konzentrationslager who passed two years in incessant and compulsory masturbation. But the bulk of it's pretty tame slumber-party-grade anecdotes.

The real humor comes from the "helpful" naiveté shining through in chapters like "An Evening Alone With You." That's right, gentlemen: It's time for you to cook yourself a frozen lobster tail, take a bubble bath, and powder your body in front of a full-length mirror! Or take yourself out before-hand (so to speak) like the young man who shares THIS sex secret: "I'd walk to town, have a leisurely vanilla milk shake, easy on the syrup and lots of ice cream. I owe my sani-ty to that milk shake ritual." Lots of normal-guy losers talking about their disgusting preferences along with pages and pages of remedial male masturbation techniques featuring REALLY CREEPY language like "His Excellency La Dong." Concludes with the suggestion that we all drive around with bumper stickers proclaiming, "Up With Solo Sex," while on the back cover we learn that our crusading "Dr. Litten" actually hides behind a pseudonym! I hate him. You'll love it. **RA**
$12.95 *(PB/193/Illus)*

The Joy of Suffering: Psychoanalytic Theory and Therapy of Masochism
Shirley Pankin

This excellent resource covers theory, diagnosis and treatment of masochism, discussing (and critiquing) Freud's early "sadism turned round upon the self" theory and favoring more contemporary conceptions which view masochism as a result of disturbances in early parent-child interactions. The book cites case illustrations from the author's own experience and is comprehensive in its use of relevant psychiatric literature. It examines a wide range of subjects such as masochism as defense, masochism and paranoid mechanisms, the role of sadism or aggression in masochism, psychotherapy and masochism, and the masochistic character.

"In my study of masochism, I seek answers to a series of controversial questions. The first is 'What are the unique characteristics in the individual's life history, particularly in the parent-child and family constellation, that make imperative the recourse to masochistic behavior?'"
$30.00 *(PB/264)*

Juice of Life: The Symbolic and Magic Significance of Blood
Piero Camporesi

"From the Middle Ages to the Enlightenment, bodily fluids or 'humours'—whether blood, semen or phlegm—obsessed the educated and ignorant alike. These 'elixirs' were believed to possess magical powers guaranteeing long life, sexual potency, intellectual insight (particularly in women) and even holiness. These fluids were drawn from animals and even from human beings, or in visions and apparitions from the 'sacred heart' of Jesus or the eucharistic wafer. From birth to death, the sight and smell of blood were part of the moral pilgrimage of whole societies. All the organs of the body produced distilled 'liquids of wondrous strength,' and at the center the human heart pulsated, sending blood through all the canals of the city of the body. Camporesi, a specialist in popular culture from the Middle Ages to the Enlightenment, tells this fascinating story."
$17.95 *(HB/139)*

The Kaspar Hauser Syndrome of "Psychosocial Dwarfism": Deficient Statural, Intellectual, and Social Growth Induced by Child Abuse
John Money

"The case of Kaspar Hauser, who was kept in a small dark room and subjected to extreme deprivation, went down in the annals of social thought as an object lesson in civilizing nurture over untamed nature. Money reviews the history of medicine's attempt to interpret the complex manifestations of social deprivation in various biological and psychological responses."
$27.95 *(HB/290)*

The Lakhovsky Multiple Wave Oscillator Handbook
Compiled and edited by Thomas J. Brown

"Earlier this century George Lakhovsky described researches indicating that living cells can be energized by applying energy at multiple wavelengths. It has been theorized that every living cell has a specific vibratory rate. When the cell ages or becomes diseased its rate changes. The Multiple Wave Oscillator produces a full spectrum of vibratory rates which Lakhovsky believed resonate with cells to restore them to oscillatory equilibrium. . . . He demonstrated how diseased cells could be returned to a state of health when specific natural or electrical fields were applied in a proper manner." Includes scientific studies by Lakhovsky and more recent research reports based on his theories by members of the Borderland Sciences Research Foundation.
$17.95 *(PB/160)*

Laughing Death: The Untold Story of Kuru
Vincent Zigas, M.D.
Nobel-prize-winning medical research told as a contemporary adventure story by a German bush doctor in New Guinea. Kuru was a neurological disorder dubbed the "laughing death" which ultimately proved to be a virus transmitted by ritual cannibalism of the brain. **SS**
$24.50 *(HB/315/Illus)*

Leatherfolk: Radical Sex, People, Politics, and Practice
Edited by Mark Thompson
When he put this compendium of testimonials from SM practitioners together back in 1992, Thompson probably had no idea he was rounding up what would become the usual suspects whenever "constructive" representatives of the leather community were sought. Since this book was first published, contributors Gayle Rubin, Pat Califia, Guy Baldwin, John Preston, Joseph Bean and, for that matter, Thompson himself, have become constituents of a thriving leather-community press that supports several imprints and a number of serious publications. In the process, they have come to represent that community in the wider debate over sexual politics in the culture overall.

For all the familiarity of the names, faces and opinions that predominate in this collection, the ideas expressed retain much of their freshness and bite. In an era when sexual desire has become confused and attenuated background noise to the clamor of the marketplace, it's bracing to encounter such passion for the personal expressed in such direct emotional language. Particularly valuable are the recollections of such ur-leatherfolk as Thom Magister (describing his initiation into the very much underground bar scene of the '50s) and Jack Fritscher (on pioneering artist Chuck Arnett) in reconstructing the hidden history of the SM demimonde before Stonewall. That a subculture so savagely suppressed could give rise to the rigorous ideals of safe, sane, consensual SM play now generally acknowledged by practitioners of all orientations is nothing if not inspirational. *Leatherfolk*, in addition to its historical value, offers a refreshing tonic to the cynicism and ennui that prevail in the intellectual discourse of those who consider themselves "normal." **IL**
$12.95 *(PB/328)*

The Lesbian S/M Safety Manual
Edited by Pat Califia
"This handy guide is an essential item for the leather dyke who wants to be well-informed about how to play safe and stay healthy. . . . learn why you need latex gloves as much as you need tit clamps. Read about the tricks lady wrestlers do with dental dams. Sized discreetly to fit inconspicuously in breast pocket, dungeon toy drawer, or the box your enema bag came in!"
$7.95 *(PB/76/Illus)*

The Lotus Lovers: The Complete History of the Curious Erotic Custom of Footbinding in China
Howard S. Levy
"It is difficult for Western minds to comprehend a practice that involved such physical pain and deformity, yet men demanded it and women acquiesced. This book examines footbinding's origins in myth and history, why the Chinese allowed it to flourish, and the varied efforts by missionaries and liberal reformers to abolish it. Interviews living, footbound women who relate their experiences. Translations from Chinese erotic literature extol the beauty and sexual attraction of the 'Golden Lotus'—a euphemism for the tiny foot—and reveal the peculiar fascination that bound feet and the 'willow walk' held for Chinese men." Was the particular charm of the lotus-foot its usefulness as a simultaneous anal probe and perineum tickler?
$33.95 *(HB/352/Illus)*

Lovemaps: Sexual/Erotic Health and Pathology, Paraphilia and Gender Transposition in Childhood, Adolescence and Maturity
John Money
"Dr. John Money [John Hopkins University, director of the Psychohormonal Research Unit] is internationally known for his clinical and research work in the new and growing science of developmental sexology. . . . Money has coined the term 'lovemap' to describe the mental template expressed in every individual's sexuoerotic fantasies and practice. According to Dr. Money, lovemap pathology has its genesis early in life, but manifests itself in full after puberty. The author gives us a close examination of paraphilia, a lovemap that in response to the neglect, suppression or traumatization of its normophilic formation has developed with distortions, and is legally referred to as perversion." Includes a glossary of paraphilias from autagonistophilia ("in which sexuerotic arousal and facilitation or attainment of orgasm are responsive to, and dependent upon, being observed or being on stage or on camera") to zoophilia ("in which sexuoerotic arousal and facilitation or attainment of orgasm are responsive to, and dependent upon, engaging in cross-species sexual activities, that is, with an animal"), lovemaps grouped by type (sacrifice and expiation, marauding and predation, fetishes and talismans, etc.), unusual lovemap case histories, and information on treatment.
$19.95 *(PB/331)*

Macho Sluts
Pat Califia
Short stories with the theme of (mostly) lesbian SM. Subjects range from the family that is a little more disciplined than most, to an unusual test of a new partner's mettle: "I want a gang, a pack, a bunch of tough and experienced top women. I'll leave the exact number up to you, but I don't want just a threesome in warm leatherette.

Anonymous postcards, silver nitrate prints — from Jeux de Dames Cruelles

I would rather it not be women Roxanne already knows. And no novices, they would just get in the way. Once you get that group together I want to give them Roxanne, and if she makes me proud I want her to belong to me, wear my rings. If she still wants me. She might decide it's too much, or maybe she'll tumble for one of the other tops."
NN
$9.95 *(PB/298)*

Man Against Himself
Karl Menninger
Menninger was an important American psychiatrist and founder of the Menninger Clinic in Kansas. In this classic work, Menninger regards self-destructive behavior—from accident proneness to self-castration—as a way that the ego protects the body against a self-administered death penalty. To Menninger, acts of self-destruction are "bribes" to "buy off" the guilty conscience for the aggressive acts or even wishes of the past for which a tyrannical conscience demands a self-punishment which vastly outweighs the "crime" committed by the self. Thus self-mutilative acts represent a victory, although costly, of the life instinct over the death instinct. **SS**
$10.95 *(PB/429)*

MAN/child: An Insight Into Child Sexual Abuse
by a Convicted Molester, With a Comprehensive Resource Guide
Howard Hunter
"For parents, teachers and anyone who works with children—here is advice, insight and answers to questions about child sexual abuse, tips on how to help a child foil or frustrate a would-be molester and straight talk unlike any other book on the subject."
$38.50 *(HB/248)*

Maria, or the Wrongs of Woman
Maria Wollstonecraft
A *Vindication of the Rights of Women* in fictitious form, written with great candor and an unbounded frankness by a female who had the audacity to challenge rigid English marriage laws, and to unabashedly proclaim that women harbored the "same capacity for rational thought and intellectual development as men." Where in *Vindication*, Wollstonecraft (the mother of Mary Shelley, who wrote the novel *Frankenstein*) gave the first ray of hope for a different, more egalitarian form of marriage, *Maria* paints a bleak picture of women who are pummeled down mentally, spiritually and physically by tyrannical husbands. Very much ahead of her time, *Maria* asks the painfully rhetorical question "Was not the World a vast prison and women born slaves?" **GC**
$7.95 *(PB/138)*

The Marquis de Sade: A New Biography
Donald Thomas
"De Sade's greatest crime, in the view of posterity, was the creation of a fictional world whose cruelty and sexual extravagance were a libel upon the society in which he lived. The truth was that the leaders of that society, in the name of moral example, devised the most ingenious forms of judicial cruelty and paid men well for inflicting them on other men and women, while crowds looked on as if at a circus of mortality. When de Sade was 17, Damiens was executed with satanic ingenuity for his attempt on the life of Louis XV. In the name of law and morality, the victim's hair was seen to stand on end under such torment." Imprisoned for much of his adult life, less for his sexual transgressions than for embarrassing his in-laws, de Sade is remembered for the celebration of cruelty in his writings, and has an entire proclivity named after him. Yet as a citizen judge after the French Revolution he risked his own life in opposition to the death penalty. This biography looks at de Sade the man, in the context of his time, and evaluates without sensationalism his legacy. **NN**
$12.95 *(PB/326/Illus)*

Masochism: Coldness and Cruelty, and Venus in Furs

Gilles Deleuze and Leopold von Sacher-Masoch

This gorgeously bound reprint of Sacher-Masoch's 1870 novel, *Venus in Furs*, which includes a thesis on masochism by Gilles Deleuze, is one of the most emotionally intense and beautifully written explorations of what Plato called "the desire and pursuit of the whole, which is called love." One at times feels literally hypnotized while reading the book, as the protagonist erects layer upon layer of pathos for his plight: that of an obsessive, fetishistic dandy addicted to pain, servitude and the sight of fur around a woman's bare shoulders, relentlessly imploring a reticent, disdainful Mistress to give him the treatment that he craves. Deleuze makes the point that masochism is not the opposite of sadism, locates its importance at the core of human psychology, and explains in depth Masoch's "peculiar way of desexualizing love while at the same time sexualizing the entire history of humanity." A complex and satisfying text that even vanilla-sexers will cherish. **MG**
$13.50 *(PB/293)*

The Master's Manual: A Handbook of Erotic Dominance

Jack Rinella

They can swing a good whip, keep plenty of clothespins handy, and throw knots better than a sailor. These are the skills required of an erotically dominating Master or Mistress. It's all about power: What's it like to own someone? How do you punish your slave? What about the pain? Get the tips from a leathersex pro. **GR**
$14.95 *(PB/200)*

Meat: A Natural Symbol

Nick Fiddes

"There was a time when this was a nation of Ernest Hemingways. Real Men. The kind of guys who could defoliate an entire forest to make a breakfast fire—and then go on to wipe out an endangered species hunting for lunch. But not anymore. We've become a nation of wimps. Pansies. Quiche eaters."

As the epitome of meat, a beef steak can send powerful sexual symbols. The larger and juicier the piece of meat, the more red-blooded and virile the consumer is supposed to be, and a steak by candlelight is a com-

mon prelude to seduction. Meat is widely reputed to inflame the lustful passions, particularly in men, the stimulation being generally of an animal rather than of an erotic kind. It is reported, for example, that the captain of a slave ship, in the throes of evangelical conversion, stopped eating meat to prevent his lusting after female slaves. "Conversely, a male vegetarian can be a suspect figure, as a student recalls . . . "It was really odd, they seemed to automatically assume that because I was a vegetarian then I must be gay."' **GR**
$15.95 *(PB/200/Illus)*

Modern Primitives

V. Vale and Andrea Juno

"An anthropological inquiry into a contemporary social enigma—the increasing popular revival of ancient human decoration practices such as symbolic/deeply personal tattooing, multiple piercings, and ritual scarification." Interviews with Fakir Musafar, Don Ed Hardy, ManWoman, Sheree Rose, Hanky Panky, and Genesis and Paula P-Orridge.
$17.99 *(PB/212/Illus)*

Mormon Polygamy: A History

Richard S. Van Wagoner

"Scattered throughout the western United States are an estimated 30,000 modern-day polygamists. These fundamentalist Mormons continue a practice that was conceived in secret and still arouses controversy. Van Wagoner (a descendant of polygamous Mormons) traces from the 1830s to the present the religious, political and personal aspects of this unexpected product of Victorian piety."
$6.95 *(PB/362)*

A Morning's Work

Stanley Burns, M.D.

"This book presents the most substantial selection of images yet published from the renowned Burns Archive. Over 100 masterpieces of early medical photography are reproduced along with descriptive texts by Dr. Stanley Burns detailing the medical, sociological and historical significance of the photographs. The rise of modern medicine parallels the rise of photography as a documentary tool, and in this broad-based overview of the Archive we sense the experimental state of both during the 19th century. Included are images which celebrate

Photograph – from A Morning's Work

the physician's essential position in society, and those which reveal his near helplessness in the face of many diseases. The chronological presentation of the photographs heightens our awareness of just how profound are the changes brought about by advances in medicine, and by the introduction of such tools as the camera. As a document of the human condition *A Morning's Work* shows the pain, suffering, joy and fear of its subjects as they confront the camera, and, we presume, their diagnoses. The hope and horror contained in these images mirror contemporary medicine's "miracles" and failures, and reflect the unchanging nature of the human experience."
$60.00 *(HB/164/Illus)*

Muybridge's Complete Human and Animal Locomotion, Volume 1

Eadweard Muybridge

"Of all the great pioneer-innovators of the 19th century, perhaps the least known is Eadweard Muybridge. Of all the great turning points in scientific, technological and artistic thought, undoubtedly the least known (because it has, effectively never been published) is Muybridge's 11-volume pictorial treatise of human and animal life in motion. Present volumes combine Volumes 1 and 2: male nudes running,

walking, leaping, twisting, boxing, wrestling, pole-vaulting, lifting and carrying heavy objects, climbing ladders, sitting, standing, etc.; 3 and 4: female nudes running, ascending and descending stairs, dancing, splashing, dressing and undressing, stooping, sweeping, making a bed and other domestic chores, spanking a child, feeding a dog in a series of movements shown in step-motion sequence; 781 plates (each plate a two-page spread) of nearly 300 separate actions split into as many as 50 individual shots per action; 532 of the plates show clothed and unclothed men, women, and children engaging in a wide variety of typical actions and activities."
$75.00 *(HB/629/Illus)*

Muybridge's Complete Human and Animal Locomotion, Volume 2
Eadweard Muybridge
"This volume comprises Volumes 5—males (pelvis cloth), 6—females (semi-nude and transparent drapery) and Children, 7—males and females (draped) and miscellaneous subjects, and 8—abnormal movements, males and females (nude and semi-nude) of the original 11-volume set. Most of the plates show three different simultaneous perspectives on a single action—front, rear and side or three-quarter view—which Muybridge achieved through his ingenious use of from 12 to 36 cameras and his own electromagnetic tripping device."
$75.00 *(HB/1,139/Illus)*

Passage Through Trinidad: Journal of a Surgical Sex Change
Claudine Griggs
"In July 1991, the author underwent a surgical sex change from a man to a woman. The surgery was performed (in Trinidad, Colorado) by Stanley Biber, M.D., dean of sex-change operations. This work begins at the time Ms. Griggs decided to pursue the surgery and continues through her recovery. Though the procedure altered the author's body, poignantly accounted for also is the mental transformation."
$29.95 *(HB/216)*

Patient or Pretender: Inside the Strange World of Factitious Disorders
Marc D. Feldman, M.D., and Charles V. Ford, M.D., with Toni Reinhold
"The deadly serious game of playing sick:

Incredible true stories of people who search for emotional fulfillment by making themselves ill." The young woman who faked chemotherapy for two years by dieting and thinning her hair. The husband who injected gasoline under his wife's skin to cause abscesses. The mother who put her blood in her child's urine sample. The woman who pierced her intestines with a yardstick, to promote internal bleeding. The mother who scrubbed her baby's back with oven cleaner to induce a rash. "These compelling case studies read like medical detective stories as doctors try to separate fact from fiction and explore the real causes of these patients' illnesses." Sick, sick, sick. **GR**
$19.95 *(HB/228)*

Penis Power: A Complete Guide to Potency Restoration
Gary Griffin
User-friendly manual explaining the mechanics of erection and what can go wrong. Drugs, implants, chemicals, and mineral supplements to keep Little Peter pumping are all discussed. **GR**
$9.95 *(PB/120)*

Penis Size and Enlargement
Gary Griffin
Learn how to increase your endowment (or lack thereof) using pumps and weights, or

Photograph — from **A Morning's Work**

just get off on the pictures of humungous cocks. Full of hilarious pseudo-scientific comparison charts and pointless historical ephemera, plus a list of the biggest schlongs in Hollywood! **MG**
$19.95 (PB/193/Illus)

Penny Wonder Drug
Eugene P. Cisek and Robert S. Persky
The German chemical company A.G. Bayer introduced two important pharmaceuticals between 1898 and 1899—aspirin and heroin. Unfortunately this book is about the former. However, today, in what the authors call "the golden age of aspirin," people are woefully unaware that aspirin can actually help prevent or alleviate symptoms of thrombosis, pregnancy-related hypertension, pulmonary embolism, etc. . . . Conspiracy? Yup. Patent ran out years ago, so there's no profit to be made pushing this "wonder drug." Book is printed in very large double-leaded type, possibly in consideration of headache-inclined connoisseurs of the drug. **RA**
$9.95 (PB/128/Illus)

Perverse Nature
Michelle Handelman and Monte Cazzazza
"Booed, banned, sought after and revered, these bizarre experimental films will taunt you long after their viewing. Featuring the controversial *Catscan* and Cazzazza's controversial *SXXX-80*, this is perfect viewing for testing the limits of your mind." 40 min.
$25.00 (VIDEO)

Philosophy in the Boudoir
Marquis de Sade
A young virgin is schooled in bawdy bedroom manners by a perverted gang of "immoral tutors." Fornication, murder, incest, atheism and wanton self-gratification are the lessons of the day. "'Tis essential, however, to utter harsh and foul words during the intoxication of ecstasy, and the vernacular of blasphemy well serves the imagination. Experiment, Eugenie, and you will see the results . . . flaunt your debauchery and your libertinage, carry the air of a whore: let them glimpse a nipple when in secluded places, garb yourself lewdly to expose your most private parts and incite your friends to do likewise." **GR**
$9.95 (PB/192)

Physical, Sexual and

Emotional Abuse of Children
Daniel B. Kessler, M.D., and Philip Hyden, M.D., J.D.
A clinical symposium booklet with illustrations by John A. Craig, M.D.
$3.50 (Pamp/32/Illus)

The Portable Scatalog: Excerpts From *Scatalogic Rites of All Nations*
John G. Bourke
"As a captain in the U.S. Third Cavalry and an amateur ethnologist, Bourke spent a decade of his life researching the scatological rites, customs, and folklore of all nations. First published in 1891 as *Scatological Rites of All Nations*, this forgotten classic included "The Use of Bladders in Making Excrement Sausages," and "Tolls of Flatulence Exacted of Prostitutes in France," to name a few chapters. This present compendium has selected excerpts, with over 500 pages, filled with the strangest and most wonderful Bourkean anecdotes and oddities."
$16.00 (HB/191/Illus)

Potter's New Cyclopedia of Botanical Drugs and Preparations
R. C. Wren
Who would have guessed that the passion flower is a sedative, with hypotensive (lowers blood pressure), anodyne (relieves mental distress) and antispasmodic properties. We should be grateful that Angostura bitters are no longer made from Angostura, as in large enough doses it's known to cause vomiting and the evacuation of the bowels. Little wonder that horses are perky after eating their oats, since it is an antidepressant, also good for alleviating the symptoms of menopause. Pilewort leaves it to the imagination—it's enough to say that this herb could lead to an improvement in a very uncomfortable condition. Find a wild lettuce and it could relieve bronchitis and help sleep. A fascinating reference book with descriptions of what to look for, where to find it, and which bits to use. Over 500 plants are listed with their many uses. Despite the fact that the new edition, updated from the original 1907 version, no longer has illustrations—they were of too poor a quality to reproduce—this is an

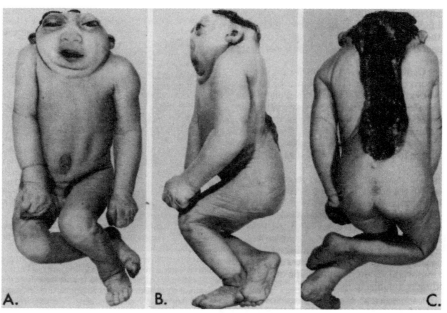

Photographs of anterior, lateral and posterior views of a newborn infant with acrania (absence of the calvaria), meroanencephaly (partial absence of the brain), rachischisis (extensive cleft in the vertebral column), and myeloschisis (severe malformation of the spinal cord). Infants with these severe craniovertebral malformations involving the brain and spinal cord usually die within a few days after birth. — from The Developing Human

essential source of information for anyone seriously interested in herbal drugs. **TR**
$28.50 *(PB/362)*

Psychopathia Sexualis
Richard von Krafft-Ebing
"Lustmurder, necrophilia, pederasty, fetishism, bestiality, transvestism and transsexuality, rape and mutilation, sadomasochism, exhibitionism; all these and countless other psychosexual proclivities are detailed in the 237 case histories that make up Richard von Krafft-Ebing's legendary *Psychopathia Sexualis*. . . . An essential reference book for those in the development of medical and psychiatric diagnosis of sexual derangement, *Psychopathia Sexualis* will also prove a fascinating document to anyone drawn to the darker side of human sexuality and behavior." With new introduction by Terence Sellers, author of *The Correct Sadist*.
$14.95 *(PB/192)*

Public Sex:
The Culture of Radical Sex
Pat Califia
Kick-ass, "kinky-dyke" lesbian comes out swinging. Her first piece on pornography, in 1979, sets the tone: "I think the only problem with pornography is that there's not enough of it, and the porn that does exist reflects the sexual fantasies of aging Catholic gangsters." She's still "fussing and fuming about sexual repression and censorship. . . . Being a sex radical means being defiant as well as deviant. It means being aware that there is something dissatisfying and dishonest about the way sex is talked about (or hidden) in daily life. It also means questioning the way our society assigns privilege based on adherence to its moral codes, and in fact makes every sexual choice a matter of morality." A decade of the author's journalism, culled from various publications. Essays on "Gay Men, Lesbians and Sex," where she expounds on her experiences in handballing gay men. "Sluts in Utopia: The Future of Radical Sex," where she lists 42 things you can do to make the future safer for sex. "The Age of Consent: The Great Kiddy-Porn Panic of '77," explains when a bogus issue called "the huge child pornography industry" meant to homophobes that homosexuals were "seducing their children into prostitution." **GR**
$12.95 *(PB/264)*

Monty kept a well-filled "prop box," containing bits and pieces of army uniform, a Guards tunic, sailors' bell bottoms, tunic hat, a World War I military police uniform, jodhpurs, riding boots and several pairs of tight white cotton undershorts. —from **A Class Apart**

The Queer Dutchman
Peter Agnos
The Old World Order turns out a real-life Robinson Crusoe. For passionately holding and kissing a young friend, in 1725 sailor Jan Svilt was charged with "engaging in the sins of Sodom and Gomorrah" by the Dutch East India Company, "the most powerful and ruthless multinational the world has ever known." Svilt's officers felt that his affection for his ward Bandino would bring the wrath of God down on the Dutch fleet as it had on Sodom." At the same time, the Company offered slave prostitutes to its men at certain Spice Island ports. Svilt's brave journal, of his life and slow death on the barren Atlantic island of Ascension, is the heart of this book. **GR**
$7.95 *(PB/144/Illus)*

Radical Vegetarianism
Mark Matthew Braunstein
If you are a vegetarian, is it OK to wear leather shoes? No. Can you drink milk? No. What about sugar, that's a plant, right? Wrong. According to Braunstein, bones are used to refine sugar. He says that what can be eaten is more important than what cannot. These ponderings run the gamut of modern diet fetish, taking on timely topics such as raw foods, vitamins and macrobiotics. Even an 11-year program to become a spiritually correct vegetarian is outlined.

"Chicken soup might be pronounced kosher, yet no hen has announced publicly her Judaism," he quips. Other attempts at humor, some successful, are mixed into the rants on such topics as evil meat karma, why milk sucks and the virtues of food combining. Did you know that when people die from choking, it is usually a piece of meat that kills them? It's all in this cool book. "After all," Braunstein writes, "life is a joke, and death its laughter." **GE**
$9.95 *(PB/138/Illus)*

Radically Gay:
Gay Liberation in the
Words of Its Founder
Harry Hay
The original gay liberation struggle and story in the words of Harry Hay, founder of the Mattachine Society, the first organization to openly discuss and champion queer issues at a time (late 1940s) when you could be imprisoned, institutionalized or worse for "coming out." Hay discusses such seemingly disparate topics as Indian Berdache traditions, trade unionism, Marxism, even New Age spirituality, reconciling these and many more subjects into a cohesive whole, all the while living a remarkable life observed through queer-tinted glasses. **MW**
$27.00 *(HB/352)*

S and M: Studies in
Dominance and
Submission
Edited by Thomas S. Weinberg
Originally written in 1983, this revised edition of the classic Weinberg-Kamel work has collected recent research and writing on sadomasochism, including material

never before published. Topics include gay and lesbian SM; SM and prostitution; women in the SM scene; unusual body modifications, including piercing, branding and burning; sadomasochistic organizations; the role of pain and fantasy in SM; and the increasing integration of SM themes into areas of popular culture such as the arts, literature, mass media and fashion. Eighteen articles explaining the weirdness of human nature and sexuality.

Discusses the urge for non-mainstream body modification as a rite of passage, ceremonial symbolism and affiliation. The ritual symbolism is to make visible and tangible beliefs, ideas, values, sentiments and psychological dispositions that cannot directly be perceived. For the purpose of affiliation with a desired social order, people surrender what is dearest to them: the body itself. Through adornment, the naked skin moves one from the biological world to the cultural world. **CF**
$16.95 *(PB/312)*

Photographs from the collection of the Kinsey Institute — from **Harm's Way**

The Sacrament of Abortion
Ginette Paris
According to Paris, some women who choose abortion are actually expressing their long-term maternal feelings. A child must be wanted, they believe, or else its life is a living death. Women who abort see beyond the fetus to the true care that every child must have, making abortion a sacrificial act. The author's writings on issues of life and death, of love and children, are religious, unlike the work of those who favor abortion but rationalize it as a private and medical act only. "At the other extreme, the pro-lifers see the spiritual dimension, but keep it imprisoned within official orthodoxies, as if no other form of spirituality existed," she says. Paris presents abortion as a sacrifice to Artemis, who refuses to give of life if the gift is not pure. She holds that there are spiritual standards govern family and children other than those dictated by courts, medicine and traditional religion. **SC**
$12.00 *(PB/113)*

Sade: My Neighbor
Pierre Klossowski
I was really hoping to learn something fantastic from this book. Nay, even enjoy it. No such luck. Totally incomprehensible linguistic definitions. There's no respite from the

convoluted grammar and impenetrable ramblings. You'll have to be desperate for one more book to read on de Sade, or in need of someone else's opinion to crib for an end of term paper, before you get anything practical out of this thing.

The only revealing detail of this whole monolith is that we are repeatedly informed that Monsieur Pierre Klossowski finds it indisputable—and the one and only, totally triumphant key to understanding and appreciating de Sade—that sodomy is the ultimate symbolic and actual social taboo around which all else falls into place. What a sheltered, cerebral life he must have led. Ah me . . . next! **GPO**
$10.95 *(PB/144)*

Science in the Bedroom: A History of Sex Research
Vern Bullough
How science conquered sin, from a noted sexology "sexpert." "The story of how sex research developed, from its early roots in religious doctrine and folklore to its current status as an emerging science." Reveals how both the personalities of influential investigators and changing public attitudes have shaped the substance and direction of

sex research. Chapters on such issues as theory, gender, changing attitudes and Freud and his gang of mind benders.
$14.00 *(PB/384)*

Screw the Roses, Send Me the Thorns: The Romance and Sexual Sorcery of Sadomasochism
Philip Miller and Molley Devon
An unabashedly cheerful, unpretentious and thoroughly comprehensive how-to manual as well as demystification of SM sexuality. "While we welcome the growing acceptance of SM in society, trendiness has its inherent perils and is one of the reasons that we felt our book was needed. Misinformation is being circulated as novice players teach other novices practices they have gleaned from fiction. . . . We want those interested in sadomasochism or any of its subsets including dominance and submission, bondage and discipline, spanking, erotic humiliation, role-play and others to understand the importance of having access to the SM community. We discuss safety issues, ideas for scenes, recognizing good and bad attitudes, finding playmates, knowing the difference between fantasy and reality and learning that techniques are

becomes a god to him just as it does to primitive man. But it is really a caricature of a god. The analyst, however, can retrace the divine features underneath the grotesque lines of the caricature. It is precisely this amalgamation of the religious and the ideal which makes the fetishism almost indissoluble. Thus, we arrive at a formula which at first sight may appear paradoxical: the fetish represents the divine ideal as well as the animal ideal. The synthesis between God and Satan has succeeded. Both rule over the individual, but the division of power is the one guarantee that neither the one nor the other may achieve complete tyranny. Love and religion have been molten into a single, mystical union." Chapters include "Fetishism and Incest," "Calf Partialism, Sadism and Kleptomania," "Partialism and the Cult of the Harem," "The Bible of the Fetishist (Corset Fetishism)," "Analysis of a Foot Fetishist," and more.

$5.95 *(PB/355)*

Sexual Art: Photographs That Test the Limits†
Sexual Magic: The S/M Photographs††
Michael A. Rosen

These two slender volumes of black-and-white portraits from the San Francisco leather scene document a time, a place and a way of life as definitively as Weegee's tabloid images did the street life of New York in the 1940s. The men and women captured in Rosen's simple, uninflected pictures—lit flat against seamless backdrops—constitute a pretty effective visual census of contemporary SM culture, or at least its more unabashed exemplars. The leathermen, body-modifiers, dyke daddies and radical hets look optimistically out from the frames, needles through their genitals and fists in each other's orifices, reveling in the photographer's uncritical acceptance. Though a few mighties of the rad-sex underground, including Susie Bright and Fakir Musafar, put in benedictory guest appearances, most of Rosen's models are drawn from the rank and file of the SFSM party crowd.

Indeed, the very unpretentiousness of Rosen's style is a kind of agitprop in itself. Avoiding both the idolatrous neoclassicism of Robert Mapplethorpe and the voyeuristic grotesquery of Joel-Peter Witkin, he treats his subjects neither as icons nor as freaks, but rather as folks. In the process, he invites

means not ends."

Chapters include: "Learning the Body You Want to Bludgeon," "Non-Government Sanctioned Sex and Torture," "Steering Your Love-Boat Into the Rapids," "Conditioning—3 Ways to Skinner a Pussy," "Straight Facts and Bent Phalluses," "Bondage Techniques (Breast Bondage, Oriental Rope Dress, Plastic Wrap Bondage, Hoods and Sensory Deprivation, Spandex, etc.)," "Reading the Submissive's Butt After a Scene," "Orchestrating Your Percussion," "When the Inner Child Deserves a Spanking," "Experiencing Pain as Pleasure," "Mindfuck, Not Mental Rape," "Furnishing Your Dungeon," and much more.

$24.95 *(PB/277/Illus)*

Sex Drugs and Aphrodisiacs
Adam Gottlieb

Written from experience and personal use, a guide to herbs and potions to enhance sexual prowess and pleasure, where to obtain them (mail-order suppliers included). Includes herbal blends, Chinese herbs, etc., and results from said experiments. A cult classic now revised and updated, once again available.

Originally published by High Times/Level Press, it is meant to be a guide to the wonderful world of altered states. There seems to be a large amount of information on the start-up, care and maintenance of an erection. Includes legal, i.e., amyl nitrate, basil, DMSO, garlic, ginseng, nutmeg and more, plus illegal, i.e., cannabis, cocaine, methaqualone and opium, and the downright obscure, i.e., absinthe, dangerous, datura, hormones, iboga and others, listed in alphabetical order. The first sentence of each entry briefly defines the substance, what it is and where it comes from. Information on the history or scientific data is included. It is meant to derail the overpriced mail-order aphrodisiac market with accurate information along with appropriate warnings about misuse. **CF**

$9.95 *(PB/89)*

Sexual Aberrations: The Phenomena of Fetishism in Relation to Sex
Wilhelm Stekel

Early psychoanalytic study of paraphilias by the great sexologist Wilhelm Stekel. "The fetishist . . . founds himself a new religion. He smelts his animal ideal and his divine ideal into a new concept. His fetish

us to do the same. Given his unflinchingly graphic depictions of sadomasochistic practices from fisting to penis bifurcation, the invitation is pretty seditious. Almost as subversive is the casual indifference Rosen and his friends demonstrate toward conventional ideals of physical attractiveness. Received notions about what body types are suitable for sexual portraiture clearly have no applicability here. The sincerity of desire, rather than the statistics of age, weight and chromosome count, is the source of sexual allure. If Rosen's vision is skewed toward sadomasochistic utopianism, it is a useful corrective to the transgression-for-its-own-sake approach of so much contemporary SM-derived imagery. **IL**

$30.00† (PB/63/Illus)
$25.00†† (PB/71/Illus)

The Sexual Brain
Simon LeVay
Nature versus nurture has long been the key question when probing the roots of sexual orientation. Written with the educated layperson in mind, *The Sexual Brain* puts forward the case that the diversity of human sexual behavior and feelings is best viewed in terms of the development, structure and function of the brain circuits that produce them. In particular, LeVay posits that the hypothalamus size in homosexual men's brains may be on average smaller than the hypothalamus of heterosexual men. While critics have questioned the diversity and size of the population group in this text's underlying study, LeVay's work has identified a possible physiological link in the determination of sexual orientation and will no doubt act as impetus for succeeding generations of researchers. **JAT**

$10.95 (PB/192)

Sexually Transmitted Diseases
Barbara Romanowski, M.D. and J.R.W. Harris, M.B.
A clinical symposium booklet with illustrations by John A. Craig, M.D.

$3.50 (Pamp/32/Illus)

Sexwise
Susie Bright
A new collection of essays, interviews and reviews, in which, among others, America's favorite X-rated intellectual does Dan Quayle, Stephen King, Camille Paglia, Madonna, the Black Panthers and

Rhinophyma. Dematologic wax moulage by Jules Talrich, commissioned by the Parisian physician Dr. Mallez. Paris, 1894 — from Diseases in Wax

the GOP. **AK**
$10.95 (PB/180)

Skin Problems of the Amputee
S. William Levy, M.D.
"Amputation of a limb is performed only as a last resort. This drastic operation may be done as an urgent life-saving measure after severe trauma has occurred or when malignant invasion has taken place. . . . For the patient, however, a new kind of life has just begun. . . . The amputee becomes dependent on a machine that is supposed to provide unfailing performance under many different conditions. As might be expected, this is usually not the case. The man who uses this machine has very special problems, and they particularly affect his skin."

$49.95 (HB/304/Illus)

SM: The Last Taboo
Gerald Greene and Caroline Greene
Originally published by Grove Press in 1974, *SM: The Last Taboo* is "the first original and excellent anthology to present the case for sadomasochism with commitment and sincerity. . . . A truly pioneering work since it is not a clinical investigation, with all the suggestion of perversion and aberration such implies, *SM* is a response to the grow-

ing curiosity provoked by liberated sexual mores, and a genuine attempt to illuminate a corner of the unconscious left dark for too long." The authors eloquently discuss sexologist Havelock Ellis, the Marquis de Sade, the spanking setting, America and masochism, the role of woman, the role of fantasy, SM in marriage, water sports, and "a tidy pain" based on both their personal experiences and research. An appendix made up of literary SM "documents" (all censored on publication) exerpted from Baudelaire, Aubrey Beardsley, Edith Cadivec, Pauline Réage, and, of course, Anonymous is also included.

$8.95 (PB/345)

Spanking Tutorial
"The liberating tale of a spirited beauty who proves to her politically correct boyfriend that an over-the-knee spanking is the surest way to turn her on. Fed up with having her lifelong spanking fetish ignored by her vanilla boyfriend, Karen throws a tantrum and marches out of the house with "Scene One" clutched to her bosom. . . . Karen is stubborn, but Mitchell is determined to have the last word. She gets a bare-bottom spanking with hand and hair brush that proves to Karen that her lover has indeed become a spanking enthusiast."

$24.95 (VIDEO)

Spinal Deformities
Hugo A. Keim, M.D. and Robert N. Hensinger, M.D.
A clinical symposium booklet with illustrations by Frank Netter, M.D.

$3.50 (Pamp/32/Illus)

Staying Dry: A Practical Guide to Bladder Control
Kathryn L. Burgio, K. Lynette Pearce, and Angelo J. Lucco
"More than ten million Americans . . . are afraid to cough, sneeze, or laugh; run to the bathroom every fifteen minutes; dread the sound of running water; have accidents on the doorstep with key in hand."

$12.95 (PB/169)

Straight Talk About Surgical Penis Enlargement
Gary Griffin
Facts and advice concerning the surgical techniques involved in the fattening and

lengthening of a Slim Jim. Step-by step explanations of the operations. The 30 most asked questions. Before and after illustrations. **GR**
$9.95 *(PB/100)*

Straight To Hell #63
Edited by Billy Miller
"*Straight To Hell* is one of the most infamous magazines in gay culture. Since 1969, with its first incarnation as a mimeographed broadsheet, the journal of "true male homosexual experience" has maintained an exalted notoriety not only for its raunchy content, but as a lightning rod for founder Boyd McDonald's contentious, anti-assimilationist politics. McDonald was a self-described queer decades before the hip legitimacy that stance now enjoys. The collected writings of *Straight To Hell* contributors, complete with Boyd McDonald's acid commentary still affixed, have been anthologized in book form (*Meat, Cum, Lewd*, etc.) and sold worldwide by the tens of thousands. And *STH* itself is correctly cited as the granddaddy of the queer zine movement, and as a guiding light of acerbic politics and total sexual expression. A few years before his death in 1993, McDonald designated Billy Miller to take over the reins of *STH*; last year Miller released the 25th anniversary issue."
$4.00 *(Pamp/48/Illus)*

Susie Sexpert's Lesbian Sex World
Susie Bright
An honest and upfront look at the sexual and social lives of lesbians—from lipstick lezzies to straightforward butches and new-wave leather chicks. **AK**
$9.95 *(PB/156)*

Tantra: The Secret Power of Sex
Arvind and Shanta Kale
"India went through the sexual revolution centuries before the rest of the world even dreamt of it. The chief promoter of this revolution was tantra, the sophisticated technique that enabled ancient Indians to tap the power of sex and use it to attain contentment, peace, aesthetic pleasure, creative gifts and to make life altogether richer for its practitioners. But eventually history intervened and puritans lorded over us. To protect their heritage, Tantrists overlaid their texts with a jargon designed to dis-

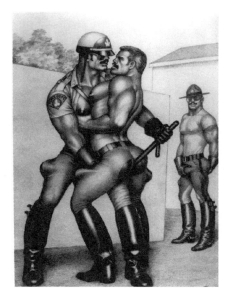

Illustration, 1989 — from **Tom of Finland**

courage interpreters. Today, as a result, Tantra is little known even in India. Arvind and Shanta Kale now for the first time in ages describe and adapt for modern man the ancient sexual practice in concise and candid terms. If you use it conscienciously you'll attain sexual fulfillment on all levels." Published in Bombay.
$10.95 *(PB/186/Illus)*

Tearoom Trade: Impersonal Sex in Public Places
Laud Humphries
"But where does the average Joe go to get a blow job?" In 1970, a sociologist took his tools into the public toilets of America and answered the question. Masturbators, watch queens, straights, hustlers, chickens and voyeurs are some of the covert deviants sampled in this famous piece of sociological folklore. Chapters cover risks, foreplay, closet queens, signaling and related social-science concerns. Complete with charts and interviews. **GR**
$24.95 *(PB/328)*

Testicles: The Ball Book
Gary Griffin
Facts, figures and folklore on scrotal lengthening, vacuum pumping and other forms of testicular enlargement. Cannon balls, cajones, nuts and family jewels can be made to swing low in "Testicles 101." **GR**
$9.95 *(PB/100/Illus)*

The Third Element of the Blood
Antoine Béchamp
"This book is the last work by a man who should today be regarded as one of the founders of modern medicine and biology and who deserves a place as one of the giants of the history of science. History, however, is written by the winners; the career of Antoine Béchamp and the manner in which both he and his work have been written out of history bear witness to the truth of this statement. . . . This book contains, in great detail, the elements of the Microzymian theory of the organization of living organisms and organic materials. It has immediate and far-reaching relevance to the fields of immunology, bacteriology and cellular biology and it shows that more than 100 years ago, the germ, or microbian, theory of disease was demonstrated by Béchamp and those who worked with him to be without foundation. . . . the Germ Theory, that great and fallacious iconoclasm that Pasteur and his legions have cursed modern medical thinking with, plays no part in them. There is no hunt for the responsible bug, no expensive and complicated treatment for the sole cause of a disease. . . . There is no single cause of disease. The ancients thought this, Béchamp proved it and was written out of history for his trouble."
$19.00 *(PB/217)*

Third Sex, Third Gender: Beyond Sexual Dimorphism in Culture and History
Edited by Gilbert Herdt
Most individuals in the late 20th century take for granted what they consider to be the "natural" division of the human race into two genders, male and female, based on the biological attributes of these sexes—the only two to be had. Using both anthropological and historical research, the authors whose work appears in *Third Gender, Third Sex* explore "how, in particular places and times, people construe not only the natural body," but what have been called the "cultural genitals." As a result, in different societies throughout the centuries, there have existed multiple genders and sexes. From eunuchs in Byzantine Rome to "sapphists" in early modern London, from the Berdache tradition in the American West to hermaphrodites in New Guinea,

these essays cover a wide range of behaviors, cultures and time periods. While the focus in *Third Gender, Third Sex* is academic, the writing is largely jargon-free and the subject definitely fascinating. **LP** **$20.00** *(PB/614/Illus)*

Ties That Bind: The SM/Leather/Fetish Erotic Style: Issues, Commentaries and Advice
Guy Baldwin
The writings of a noted psychotherapist in the Kink Kommunity, stressing the self-awareness, discipline and community required in leather-sex, an alternative to vanilla sex. Essays on the military mystique of the "Old Guard" of leather from the '50s (schooled on Brando and the war). The problem of the "Killer Bottom" (they send double messages and wear down a top). Plus: "The Trouble With Tops," "Leather in the Nineties," and "Humiliation: What's in It for You?" First published as a series of columns in *Drummer*. **GR** **$14.95** *(PB/239)*

Tom of Finland
Tom of Finland
With the stroke of his naughty pen, the Finnish artist Touko (dubbed "Tom of Finland" by his first American publishers in 1957) pushed the boundaries of male erotic art to comic-book extremes. "Men are men," says a Tom drawing, "and this is how they fuck." Contains highlights from Tom's 50 years of work; from slutty sailors in WWII, to mohawked punks in the '80s. The horny heat of cops, truckers, bikers, farmhands and office boys is displayed in all its naked, macho glory. Plus a hardcore Kake adventure. **GR** **$12.99** *(PB/80/Illus)*

Tom of Finland: His Life and Times
F. Valentine Hooven III
Born in Kaarina, Finland, in 1920, he was trained as a commercial artist, played piano in a combo at parties, and was a witty raconteur in a black leather jacket when he visited the States to meet his fans. And he sweated every time he went through customs with his famed erotic drawings, his "dirty pictures," as he called them, of "proud and sexy" men. "I knew who the boss was," says Tom of his work, "My cock. It did not matter how much my head liked an idea—or,

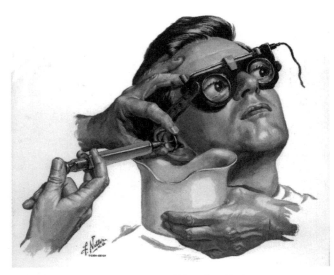

Caloric testing for nystagnus, illustration by Frank Netter, M.D. — from **Vertigo**

in later years, how much money I was promised; if my cock did not stand up while I was working on a drawing, I could not make the drawing work." A bio that traces the evolution of his art as well as his character. **GR** **$12.95** *(PB/198/Illus)*

Torture Garden: From Bodyshocks to Cybersex
David Wood
A unique, definitive and breathtaking five-year photographic record of London's Torture Garden—the world's largest and probably most famous fetish club. This deluxe book explores and celebrates the boundaries of the body and human sexuality with an extraordinary collection of images by the scene's two leading photographers, Jeremy Cadaver and Alan Sivroni. Includes 350 original photographs with over 50 color plates. Featured are some of the most decadent people on this or any other planet. One person opens a wine bottle with a corkscrew going through his nose, then hangs an electric iron from his penis and nipples with a bungee cord, while on another page, a women showers the crowd with fiery sparks from an electric grinder buried in her crotch! **DW** **$19.95** *(PB/160/Illus)*

Traditional Chinese Medicine
Daniel Reid
English-speaking practitioners of traditional Chinese medicine have longed for a good

book that their patients could read and understand. The best books on Chinese medicine are written in Chinese. Many important ones have been translated to English, but are basically textbooks for use in Chinese medicine schools outside of China. Reid's new book will quickly become the standard for introducing new folks to the wonders of Chinese Medicine. This book is awesome in its simplicity, yet covers in great depth the fundamentals of the world's most ancient healing form. Reid fears not, treading the thin ice of proselytizing such modalities as *qi gong*, the mother of Chinese medicine. Lesser Western writers cloak explanations of Chinese medicine with scientific terminology and reason. Instead, Reid eschews nerve-gate theories and promotes such therapies as the gathering of cosmic energy from the universe, long a staple in the Chinese medical repetoire, but for some reason scoffed at in the West. **GE** **$12.00** *(PB/161)*

Unmentionable Cuisine
Calvin W. Schwabe
First and foremost, this is a cookbook with actual recipes. That it focuses on things that Americans are not accustomed to eating is almost secondary. In the introductory statements the author points out that we will be facing food shortages in the years to come and that a strictly vegetarian diet is not always pragmatic everywhere. (Of

course, practicing vegetarians can get a lot of mileage out of this book with pushy carnivore friends by mentioning the broiled puppy recipe (Hawaii) or the stewed cat (Ghana). While some of the offerings can seem shocking, the author truly has a higher purpose and goes to great lengths to provide a cultural context for the ingredients employed in creating these delicacies. (A rat problem in China yielded a new source of dietary protein.) Some of the more interesting ingredients include: rodents, pigeons, small birds, reptiles, insects and sperm. Lest you think that this book is merely a joke, it has won the acclaim of such food experts as Craig Clairborne, James Beard and M.F.K. Fisher. **SA**

$16.95 *(PB/476)*

Unnatural Acts: A Dominatrix Talks
Susan Shellogg

And talks . . . and talks. Fortunately, much of Shellogg's exegesis is entertaining, if somewhat disingenuous. She frames her story in the breezy contemporary style of sex work memoirists dating back to Xaviera Hollander. Just another nice girl from a perfectly normal middle-class background who discovers hidden riches in her ability to amuse men with money. Happily, there is none of the self-serving vindictiveness toward her benefactors that has made such a hit of the ludicrous *You'll Never Make Love in This Town Again*. Shellogg's particular specialty is dishing out carefully titrated abuse to male clients whose pleasure is pain and humiliation. She is, by her own description, "the eternal slut-mother. That's what I do for a living. I embody the bitch." These embodiments manifest the familiar forms: bondage, flagellation, latex fetishism, urolagnia, et al.

What sets this good-natured account apart from so much current SM lit, both serious and exploitational, is its welcome lack of moralizing and/or special pleading. A witty and engaging writer, Mistress Sonya (her nom de dom) loves to tell a good story more than she needs to make a point. Though her clients seem a somewhat pitiful lot for all their disposable income, mainly because their closeted status forces them to share their most intimate needs with a hired stranger, the author never seems to lose her zest for the game. And a game it is. Unlike her clients, and unlike lifestyle SM practitioners, Shellogg makes no bones

about her own yearning for the conventional, for a husband, a house and a "normal" life. She is a bit of an outsider to the world in which she works, which makes her a pretty good guide to it after all. **IL**

$21.00 *(HB/304)*

Unspeakable Acts: Why Men Sexually Abuse Children
Douglas W. Pryor

The unusual quality that sets this book apart from the current avalanche of sensational literature on the subject of child sex abuse is embodied in the subtitle. The author of this book invites us to consider, for a moment, why men commit abusive sexual acts against children, as we drag these men toward the chopping block. This quality is called compassion, and this book administers a sobering dose of it. In his ethnographic research, the author conducted lengthy interviews with a core group of 27 respondents, men drawn from treatment groups, prisons, probation programs and the private practices of therapists. Typically, the men were in their '30s, married and employed with no other criminal backgrounds. Most lived in the same households with their victims.

Some of Pryor's research confirms what is already known. Nothing is a better indicator of a propensity toward sex abuse than a his-

Alfred Kubin, Death Leap, *1901-02. — from* **Erotica Universalis**

tory of sex abuse. The lessons that an abused child learns about power, rationalization and self-worth (or its absence) shape the adult's attitude toward other children. The idea that sexual abuse is somehow "normal" underpins the excuses abusing adults make to themselves to enable their own aggressions. However, Pryor finds that, contrary to the political construct of the abuser as an emotionless objectifier carrying the culture's most unwholesome impulses to their logical conclusions, molesters are often as horrified by their own behavior as everybody else.

Though Pryor makes the explicit connection between cultural sexism and abusive behavior, he recognizes that not all men molest and that molesters themselves know this. Filled with shame and remorse not only by their own desires but, as a rule, by sexuality in general, they fall into the cycle of addiction, hoping to dam their impulses by force of will and, when will collapses, capitulating to them abjectly. Isolated in their self-hatred, molesters can only ventilate their rage through the victimization of others. What Pryor calls "the moral boundary" once crossed becomes illusive. His subjects have a way of identifying themselves as victims, of adults who molested them, of children who seduced them, of impulses they can't understand or control.

Favoring what he calls "a peacemaking model" that will undoubtedly enrage many readers, Pryor opposes Megan's Law and other public castigations of offenders, indeed questions the use of the criminal-justice system overall as a means of protecting children from abuse. Removing offenders from their isolation, compelling them to see the common humanity between themselves and their victims, offers the only hope for breaking the cycle of abuse from one generation to the next in the author's view. "Until we find a way to encourage offenders to come forward with their stories rather than hide and continue with what they are doing, the situation is only bound to get worse." **IL**

$26.95 *(HB/351)*

Vertigo
Robert J. Wolfson, M.D., Herbert Silverstein, M.D., Frank I. Marlowe, M.D., and Edward W. Keels, M.A.
A clinical symposium booklet with illustrations by Frank Netter, M.D.

$3.50 *(Pamp/32/Illus)*

Without Child: Challenging the Stigma of Childlessness
Laurie Lisle

This book is not a manifesto for the "child-free." It is not shrill, dogmatic or defensive. A reader hungry for encouragement to eschew breeding may feel encroaching disappointment while devouring the first chapters, but a surprise is in the offing: In the course of this well-researched book the author shares her own story, and by the end she has delivered a powerful dose of inspiration and paved the way for a more confident and enlightened decision.

Lisle's account of her journey from uncertainty to acceptance of and even elation in her choice of childlessness provides ample jumping-off points for an exploration of the decision from every conceivable angle. The antecedents of her decision are complex, including elements both negative (her father's desertion of the family; her painful awareness of her mother's struggle and sacrifice) and positive (her devotion to her writing; her deep appreciation of freedom and self-definition). She also surveys the history of non-motherhood—its ebbs and flows with cultural, economic and historical conditions—and draws on a wealth of literary sources, from diaries and letters of 19th-century women and pioneering childless couples, to authors like Adrienne Rich, Anaïs Nin and Georgia O'Keeffe (of whom Lisle wrote a best-selling biography), to Greek plays. She also has many sociological studies at her fingertips, which answer such important questions as whether nonmothers are lonelier as elderly women (they aren't).

Desirous of bridging the gap between mothers and nonmothers, Lisle has breached difficult territory and emerged with wisdom that can do much to dispel the hostility on both sides. She takes all of the players in the family equation into account: extended family, the infertile and others who are not childless by choice, even men! Lisle remains generous and fair-minded throughout, while standing her ground and poking holes in narrow pro-natalist attitudes. **MH**
$23.00 *(HB/273)*

Women en Large
Laurie Toby Edison and Debbie Notkin

If you've ever taken a life drawing class, you probably had the most enjoyable experience with the heaviest models. Fat women tend to offer the most interesting varieties of light and shadow and form to the visual artist. Once you get beyond the merely "Rubenesque," there are a variety of distributions of the female form that fold and drape in ways that are unique to each individual. The models by turn look happy, coy, sultry, defiant and wistful. They all comport themselves with immense dignity, whether laughing in a group shower, posing in a natural landscape setting or doing a little dance. The book concludes with some text and interviews. The physiology of fat production and fat-related feminist issues are the focus of the essay. Of special interest are the women who speak for themselves about their own medical histories, their relationships with doctors and fashion, and their general interface with the world at large. **SA**
$24.95 *(PB/116/Illus)*

Women, Food and Sex in History: Volume 1
Soledad de Montalvo

If you like your history fully documented and objective in standpoint, look for a book other than Soledad de Montalvo's *Women, Food and Sex in History*. If, on the other hand, you can't resist a chapter titled "The Pioneers of Civilization—Sluts In Huts," then

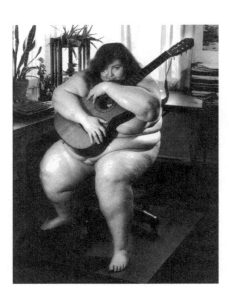

Cynthia McQuillin — Women en Large

by all means read this chatty, highly "original" and decidedly non-P.C. take on the origins of humanity and religion. According to de Montalvo, a fourth-generation atheist, "the history of food and the history of mankind are indissolubly linked." What's more, it was woman who pulled man out of his cannibalistic past and "booted civilization into orbit" by cooking the first soup. But food soon takes a back seat to wild hypotheses and an anti-religious screed, and from there de Montalvo is off and running, comparing one of the earliest known hominid skulls to Leonid Brezhnev or a Mohican-wearing punk rocker, and the Bible to *Mein Kampf*. Some will consider *Women, Food and Sex in History* blasphemous, while others will merely find it questionable in taste—but only a very few will find it dull. **LP**
$10.00 *(PB/278)*

The Yoni: Symbol of the Universal Feminine
Rufus C. Camphausen

A Sanskrit word, yoni translates as "womb," "origin," "source" and, more specifically, "vulva." Female genitals are seen as a sacred symbol of the great Goddess, a symbol of the universal womb, the matrix of generation and the source of all. Rewriting history, male leaders established themselves as rulers and as actually able to give birth. Tracking examples of yoni symbology through cave art to modern day, this book includes yoni topography in graphic detail, including tantric practices, Near Eastern myths, and Tibetan visualization techniques linked to yoni reverence. Illustrations show some of the world's finest, oldest and most diverse examples of yoni artwork up through contemporary works by such artists as Georgia O'Keeffe and Judy Chicago. **CF**
$16.95 *(PB/144/Illus)*

DEATH

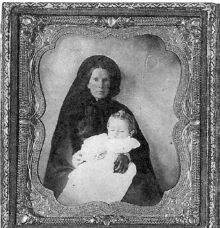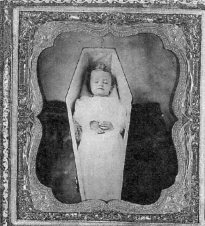

Mother holding her dead child, circa 1845-1855 — from Sleeping Beauty

Beautiful Death: Art of the Cemetery

David Robinson and Dean Koontz

"While based in Paris, Robinson roamed the cemeteries of Europe. Over a period of two years he took more than 10,000 photographs of cemeteries, including Père-Lachaise, Montparnasse and Montmartre in Paris, the cemeteries of London and village church yards in England, the Jewish Cemetery in Prague, and cemeteries across France, Spain, Portugal and Italy. He sought out the strange, affecting beauty of tombs, the poignant signs of loss, mourning and separation, and the aspirations to afterlife and reunion in the beyond. In his images we see the fleeting gestures of defiance against oblivion—the claims of the living on behalf of the dead—in the clasping of hands, proffered kisses, fading flowers, beaded wreaths, even where a passerby has rouged the lips of a pining figure carved in stone." Accompanying text is a meditation on death by best-selling writer Dean Koontz.

$24.95 *(HB/192/Illus)*

Beyond Death: The Chinchorro Mummies of Ancient Chile

Bernardo T. Ariaza

More than 2,000 years before the Egyptians perfected their methods for mummifying their departed royalty, the Chinchorro, prehistoric fishing-peoples living in villages on the Peruvian coast, were mummifying their own dead. In contrast to the Egyptians, *every* member and class of Chinchorro society received complex mummification rites. This unprecedented hoard of almost 200 bodies was discovered in 1917 but is still pretty much unknown. Since no written record of the Chinchorros exists, all we can surmise about them must come from the mummies themselves. That's what makes this book fascinating. The author proceeds to tell us an astonishing amount about both the social and physical qualities of life among these shadowy people. This straightforward anthropological study reads like a pre-Columbian episode of *Quincy*. Only here we learn about the corpse's life—and prob-

lems. By dissecting an 800-year-old corpse one can learn many things. These folks suffered from intestinal parasites, arthritis, frequent ear problems, etc., their ocean diet produced notable rises in their fertility rate. Serious students of ancient South America as well as hard-core mummy fans should be delighted—all others should rent the series of Karloff films. **CS**

$39.95 *(HB/176/Illus)*

Body Snatching: The Robbing of Graves for the Education of Physicians in Early 19th-Century America

Suzanne M. Schultz

"Explains why the practice existed and how it was accomplished."

$23.95 *(HB/144/Illus)*

Caring for Your Own Dead

Lisa Carlson

Death is a lost art in America. "Caring for

your own dead can be the most meaningful way to say good-bye to someone you love. It may save you money. " In every state, it's legal for family members to make all the arrangements for interring a loved one. No need to call the undertaker and his pals. Plus, varying state by state, you can even bury your unembalmed loved one in your own backyard, if you choose (but don't forget the paperwork!). Full of facts, tips and practical procedures. **GR**

$12.95 *(PB/343)*

The Dance of Death
Hans Holbein the Younger
Facsimile edition of the original 1538 French edition, featuring 41 woodcuts of Death popping in on merchants, kings, court ladies, countesses, nuns, sailors and so on, with his grim little warnings.

"The Merchant's wealth's a worthless thing,
Of others, won by lies, the spoils;
But Death will sure repentance bring,
Snaring the snarer in his toils."

Not a lot of plot, but the limber skeleton of Death carries the show admirably. **GR**

$5.95 *(PB/146/Illus)*

Death Dictionary: Over 5,500 Clinical, Legal, Literary and Vernacular Terms
Edited by Christine Quigley
"Marvelous compilation . . . skillfully captures the 'last roundup' . . . "—*Choice*

$29.95 *(HB/207)*

Death to Dust: What Happens to Dead Bodies?
Kenneth V. Iverson, M.D.
"Written for both laymen and professionals, this book gives answers to the questions that everyone wants to ask: What really happens to a dead body? What does our culture do with corpses and what have other cultures done? How does a body turn to dust? What happens in embalming, cremation, cryogenic preservation, autopsies, anatomical dissection, organ donation, burials and funerals? How do we transport bodies and what does a medical examiner really do? How about the more bizarre uses for corpses, such as cannibalism, body snatching, use in secret rites, research and religious ceremonies? This book describes individual and societal experiences, drawing not only from the medical sciences, but also

from the arcane and secretive world of the funeral industry. We rarely speak about death—because it is the pornography of our culture and we know so little about it. This book sheds light into dark corners of our society and proves that, once again, truth is stranger than fiction."

$38.95 *(HB/709)*

Deathing: An Intelligent Alternative for the Final Moments in Life
Anya Foos-Graber
Imagine your body is a rented apartment and your true home is the mansion of the soul of the universe. Inevitably you must quit your physical tenancy and return to your spiritual home. The success of this relocation is dependent on the quality of your awareness. If death should take you unexpectedly then perhaps you will navigate this transition very ineptly and experience excruciating pain and confusion as you are lost—potentially interminably—in limbo, purgatory, or some other twilit hin-

terland of being.

Based on Yogic principles, out-of-body-experience research, and the author's work counseling the terminally ill, *Deathing* endeavors to equip the living with a science of conscious and correct dying that allows this transition to be made with grace and success. If you can survive the overly precious and cloyingly sentimental, faux case studies that are presented as didactic novels, then perhaps you can progress through the lucid presentation of technical data pertaining to the structure of the human spirit and its orientation in the astral plane, master the series of exercises for developing skill in dying, and then when your time comes perhaps you will execute a flawless three-point landing in the promised land.

DN

$14.95 *(PB/399)*

Embalming: History, Theory and Practice
Robert G. Mayer
Chapters include: "The Origin and History of

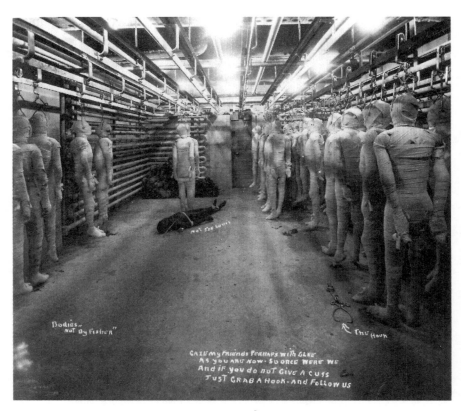

Morgue with poem, United States, circa 1920 — from **Looking at Death**

Embalming," "Death-Agonal and Preembalming Changes," "Preparation of the Body Prior to Arterial Fluid Injection," "Preparation of Autopsied Bodies," "Discolorations" and more.
$70.00 *(HB/475/Illus)*

Epitaphs To Remember: Remarkable Inscriptions from New England Gravestones
Janet Greene
This volume collects 215 gravestone epitaphs from the six New England states, frequently conveying elegiac verse of a sardonic bent. Examples include: The Reverend Nathan Noyes, 1808, Windham, Vermont:
"Look here and view affliction's favorite son
For Misfortune through all my life has run
Hard perfection's iron yoke I bore
Till I have seen of gloomy years, three score.
Now shout in vain, ye persecuting throng
I'm far beyond the poison of your song
Live and live happy while my grave you view
This tongue, now cold, has often prayed for you."

While not necessarily a page turner, *Epitaphs To Remember*'s greatest success lies in the anthropological sense, offering a glimpse into what 300 years of New Englanders wanted to perpetuate as their final commentary on this mortal coil. **JAT**
$9.95 *(PB/103/Illus)*

Ethnicity and the American Cemetery
Edited by Richard E. Meyer
The American lawn-park cemetery seeks consolation from the idea that the dead have been integrated into a beneficent natural order, represented by the depersonalized, manicured Forest Lawn-scape. This collection of academic essays examines immigrant grave-site ornaments and customs frequently at odds with the mainstream, Protestant-derived memorial park. Italian, Jewish, and brooding Ukrainian monuments seek to preserve the memory of the individual against the dilution of time, rather than celebrating its re-absorption by the natural order, while Gypsy family plots in Ohio are surprisingly restrained and inconspicuous. Also examined are Asian and Polynesian traditions in Hawaiian cemeteries, and assimilated Native American traditions in New Mexico. **RP**
$16.95 *(PB/239/Illus)*

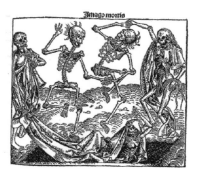

Skeletons dancing on an open grave; a woodcut illustrating moralizing verses in a Nuremberg printed book of 1493 — from **King Death**

Forest Lawn Memorial-Parks: A Place for the Living
Forest Lawn Memorial-Park Association
Forest Lawn's five Southern California funeral parks are a perfect metaphor for suburban America: beautifully landscaped, spotlessly clean, impeccably trimmed gardens . . . spread thinly over a putrefying mass of human decay.

But it is so much more, as this picture book attests. Commissioned by Forest Lawn itself, and put together by a Santa Barbara marketing firm, *Forest Lawn Memorial-Parks: A Place for the Living* was no doubt meant to be sold as a memento—or memento mori—in park gift shops. But no fan of cadaver camp should shuffle off this mortal coil without it.

Why? Because Forest Lawn is the Disneyland of the dead. All that's missing is the snack bar. Send grandpa to his final reward, then have yours: stroll among the "exact replicas" of Michelangelo's sculptures . . . enjoy a touch of Old Mexico among full-scale replicas of Toltec totems . . . reflect in your pick of a series of churches inspired by historic buildings . . . and gaze in awe at some of the most amazing Christian kitsch murals this side of Wisconsin's Precious Moments chapel. Or just buy this book instead. It's all here in heavenly color, including Robert Clark's monumental 1965 canvas, "The Resurrection," featuring a foxy Jesus "regal in his victory over death, radiant with the fulfillment of His Mission." Of course, you won't be able to hear the dramatic taped narration and "Hallelujah Chorus" that play in the hall housing the painting . . . but what do you expect for

$12.95? A miracle? **JAB**
$12.95 *(PB/79/Illus)*

How To Embalm Your Mother-in-Law: Everything You Ever Wanted To Know About What Happens Between Your Last Breath and Your First Spadeful
Robert T. Hatch
This is a nice little book written in a straightforward manner that covers what happens when one dies. The book details the basic biological transitions of death including heart failure, brain failure and lung failure. Brief definitions of such terms as "cadaveric spasms," "algar mortis," "rigor mortis," "livor mortis" and "putrefaction" are included. Information is provided on embalming—its history, procedures and such alternatives as cremation—even mummification is briefly explained. The book talks about various religious beliefs surrounding funerals and wakes, and includes a glossary and bibliography. **MC**
$8.95 *(PB/104)*

Japanese Death Poems
Zen Monks and Haiku Poets on the Verge of Death
Hundreds of Japanese death poems, many with a commentary describing the circumstances of the poet's death: "My whole life long I've sharpened my sword, and now, face to face with death I unsheathe it, and lo—the blade is broken—Alas!"
$21.95 *(PB/366)*

The Last Great Necessity: Cemeteries in American History
David Charles Sloane
From the first pioneer burial to Potter's Ville to the urban yards then to the memorial park—*The Last Great Necessity* maps out the history of the American cemetery from holy grounds to big business, delivering the message of just how much death is a commodity in today's society. **TD**
$18.95 *(PB/294/Illus)*

Last Words: A Dictionary of Deathbed Quotations
C. Bernard Ruffin
"Nearly 2,000 deathbed quotations from saints, popes, statesmen, scientists, soldiers, athletes, artists, entertainers, writers, crim-

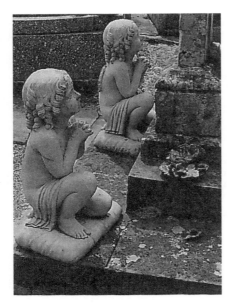

Cemetery, Toulouse, France — from **Beautiful Death**

inals and others are included in this reference work. Each entry includes a brief biographical sketch of the person and sets the quotation in context."
$39.95　　　　　(HB/304)

Looking at Death
Barbara P. Norfleet
This is a loving look at the subject of death assembled from the photographic archives of Harvard University. What distinguishes it from a lot of the other death-photo books currently available is the breadth of its field of inquiry and the quality of the photography. These are not merely "scene of the crime" documents, but portraits of the dead and other depictions meant to be actual finished works of art. Among the categories included are: staging death, death by violence, death at medical school, remains of death, death and the family, and mourning and ritual. Dignity is the underlying motif. Despite its potential to tread macabre territory, there is no cheap shock value in this book's presentation.　　　　　**SA**
$25.00　　　　　(PB/141/Illus)

On Suicide: Great Writers on the Ultimate Question
John Miller
Dorothy Parker: "Razors pain you/Rivers are damp/Acids stain you/And drugs cause cramp/Guns aren't lawful/Nooses give/Gas smells awful/You might as well live." Also William Shakespeare, Graham Green, Sylvia Plath, Virginia Woolf, Plato, Tolstoy, Langston Hughes, Camus and Jorge Luis Borges. "A taboo subject, a courageous act, a crime, a compulsion, a choice . . . " To be or not to be?　　　　　**GR**
$10.95　　　　　(PB/271)

Prescription: Medicide: The Goodness of Planned Death
Jack Kevorkian, M.D.
"In advocating 'medicide' and its ethic of indvidual self-determination, the famed 'suicide doctor' expands a view that began more than thirty years ago with his opposition to those who would deny to death row inmates the choice—requested by many—to be executed in a manner that permits life-saving organ donation. . . . Kevorkian willingly takes on the medical establishment, politicians and all others who actively resist a rational program of dignified, humane and beneficial planned death."
$15.95　　　　　(PB/268/Illus)

The Revival Styles in American Memorial Art
Peggy McDowell and Richard Meyer
From the late 18th to the early 20th centuries, the Revival Style dominated American memorial art. Harkening back to cultures of yore, Americans channeled their funereal energies into the creation of spectacular edifices and memorials to prominent citizens. Often designed by the leading sculptors and architects of their time, the great majority of these striking artifacts exist to this day for future generations and will provide a chronicle of our nation's formative years.　　　　　**JAT**
$22.95　　　　　(PB/206/Illus)

Sleeping Beauty: A History of Memorial Photography in America
Edited by Stanley Burns, M.D.
"Postmortem photography, photographing a deceased person, was a common practice in the 19th and early 20th centuries. These photographs were often the only ones taken of their subjects, and much pride and artistry went into them. . . . These photographs were a common aspect of American culture, a part of the mourning and memorialization process. Surviving families were proud of these images and hung them in their homes, sent copies to friends and relatives, wore them as lockets or carried them as pocket mirrors. . . . Discussions of death in books are prolific, and we are accustomed to images of death as part of our daily news, but actual death as part of private lives has become a

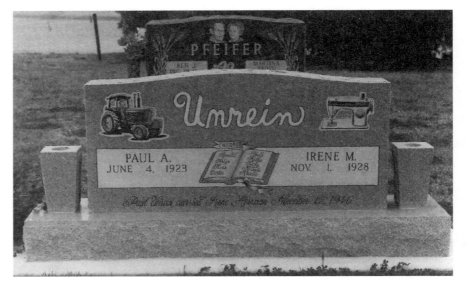

Paul and Irene Unrein, happily, are still with us, but their colorized granite tombstone makes it clear that they already know how they want to be remembered. — from **Soul in the Stone**

Method 4: Dental Tie — from **Embalming**

Soul in the Stone: Cemetery Art from America's Heartland

John Gary Brown

This essay on mortality and materiality addresses the inevitability of death and the impulse to survive in the hearts and minds of those who follow. Straightforward black-and-white photographs of gravestones are accompanied by thoughtful, and often factually detailed, captions which speculate on and interpret the varied desires expressed through sculpture and poetry found in cemeteries. "Life Is, Death Only Dies," says one; another stone immortalizes, "I'd rather be drag racing." In one Kansas graveyard an overstuffed limestone armchair suggests that the dead are just waiting in the parlor for the living to join them. The morose and the sensual are given equal standing in some monuments where young women dressed in clinging gowns are depicted as surrogate mourners, continuously standing in for absent family members. The author's opening chapters on the history of burial, religious and secular iconography, and ethnic and economic factors are instructive. Discussion of children's graves, folk art monuments, and markers commemorating worldly concerns are gracefully handled by the author. But the photographs of the monuments, which are often touching and sometimes astonishing, are the heart of this book. **JTW**

$39.95 *(HB/232/Illus)*

Understanding the Tricks of the Funeral Trade: Self-Defense for Consumers

Lisa Carlson

Taped speech by the author of the book *Caring for Your Own Dead*. "When the distraught widow didn't think she could afford the $3,000 casket, she asked if there was something less expensive. She was taken to a dank, cold basement . . . " and other horror stories of funeral directors using psychological tricks and price gouging to get you to shell out for interment. 53 minutes.

GR

$24.95 *(VIDEO)*

shameful and unspoken subject.

"This volume presents a chronological arrangement of postmortem photography 1840-1930; no other collection of this material has been made available despite recent interest in the American way of death. What emerges is a vivid visual history of the changes in American customs. We can see the change in death concepts and funerary practices, from the image of death as a stark Puritan journey for a sinner to the late Victorian beautification of death and its interpretation as a restful sleep for a redeemed soul. . . . More than anything else, I hope these photographs will help the modern American overcome the death taboo and better understand the fear of death, to solve some important death-related cultural issues, and to choose to use photography as part of the grieving process."—Dr. Stanley Burns

$50.00 *(HB/140/Illus)*

Drag

Gina, transvestite performer, dressing
room, Sally's Hideaway, Manhattan —
from **Red Light**

Candy Darling
Candy Darling

This is a highly significant little book. It hovers at a rather particular cultural fulcrum in the mid-'60s like a luminescent and highly exotic see-creature; inhabiting a thickly interwoven, deceptive, viscous, brutal, unrelentingly nihilistic, post-social-modernist, cultural coral reef. It is the posthumous autobiographical testament of Candy Darling in Manhattan, New York, USA. Significant in so many ways that belie its 143 petite pages. The lipstick-and-gold cover bears a melancholy photo of Candy's face. Printed in the Hanuman style of slightly off-registered color, it both echoes the Warhol celebrity prints and proposes the equally off-register self-perception of Candy herself.

As a good friend of mine, Gladys, put it after reading this book and *Nightmare of Ecstasy*: "Ed Wood was a man wearing a woman's sweater, Candy Darling was a woman wearing a woman's sweater." One would never really call Ed Wood "she." One is compelled to refer to Candy as "she," as a matter of respect, well-deserved honor and veracity. There is an incandescent otherness to this frail, self-descriptive text that really does demand numinous recognition and empathy and far more than a moment's sentimental contemplation. I found myself thinking of words like *sacred, catechism, rosary, litany, Hail Mary* (though the obvious contemporary drag slang might subvert the sincerity of expression with that one!). We have become comfortable with the image of biological males living as, breathing as, and trying their courageous darnedest to think as women. Given the increased tolerance and awareness of transexuality and ambiguous gender today, it would be easy to forget the perilous consequences that faced a certain James Lawrence Slattery when he left Massapequa Park, Cape Cod, Long Island, armed with memorized Hollywood movies and glamorous actresses' mannerisms and makeup styles to reinvent and become her *self*, Candy Darling, in Manhattan. A statement in itself so modern and audacious in its courage in that era and context that, as we probably all know, it was immortalized by Lou Reed more than once in song.

Perhaps most remarkable of all, though, and absolutely central to the message of this book, is that the burden of evidence quite clearly reveals to us that Candy was *not* a drag queen. She was, in fact, a woman. A woman sadly suffused with a romantic fervor of such an infinite and visionary grandeur that it could never be fulfilled. A composite woman distilled and compressed from so many cascading daydreams, and such trust in her belief that the overriding meaning of all life is being truly and totally in love with an idealized and faithful man, that she was, inevitably, a doomed woman. She dreamed of settling down in the suburbs with this abstraction of a man. Yet, tellingly, she does not once describe the physical or aesthetic aspects he would embody. They are of no concern; the only quality that mattered was that he would truly love Candy, and for that and that alone, all glamor, ambition, celebrity, immortality and, yes, even makeup, would be forgone without the tiniest bit of regret. These conspicuous qualities generated through irreducible suffering over years would be gladly sacrificed, one feels, almost executed, blissfully leaving a housewife Candy in her run-of-the-mill middle class house satiated with the ultimate chivalrous love at last. "Christ at the kitchen sink" as Gladys eulogized it.

A superficial reading could leave the uninitiated reader with an equally superficial comprehension of the story unfolding within these sanctified pages. Names and phone numbers; dates of electrolysis; taxi rides to clubs; details of appearances in the very fashion magazines and movie magazines that had once focused and fueled Jimmy's transubstantiation; desperate thoughts about the ideal man; discouragement; vacuous friends; fair-weather luminaries; inevitable mentions of "Andy"; devotional lists of her current choice of cosmetics; rather silly bits of hokum philosophy probably culled from recently read articles; and clusters of "fresh and witty" dialogue noted down for potential future incorporation into plays or movies. In many ways, ordinary stuff.

What is extraordinary here is the luxuriant sense of a religious quest for love and an ideal relationship that reaches such a level of transfigured ecstasy. I can't help but feel that Candy is quite literally alive in this book. That she demands at last to be accorded all appropriate respect and spiritual ritual. Which is why words like *devotional*, *litany*, and the image of a confessional, of churches, services and shadowy movements of candle flames still linger.

We do, of course, witness a deep melancholy here too. This modern, beautiful, vivacious, witty, romantic and tragic woman, Candy Darling, was, and even more so today, *is*, inspirational. I was compelled to go to my makeup box and assemble my own intimate litany of androgyny from my penetrated *self* to hers in collision.

And now let us all bow our heads in prayer . . .

Revlon Age Defying Makeup-Cool Beige Foundation Cream
Lanza Re-Balance Shine Silicon Gel for hair
Dark Skin Cover-Up stick
Revlon Love Pat-Cream Beige Face Powder
Chanel Aqua Crayon-Chocolate Lip Outline Color Stick
Revlon Fabuliner-Black Brown Liquid Eye Liner
Revlon Overtime Shadow-Vineyards Shimmer Eye Shadows
Chanel Quadra Eye Shadow-Earth/Gold/Steel/Pink/Copper
Revlon-Flesh Lipstick (original '60s in paisley tube)
Princess Marcella Borghese-Nuovo Rosa Lumina Lipstick
Salvador Dali-Parfum and Parfum de Toilette Spray

GPO
$5.95

(PB/144/Illus)

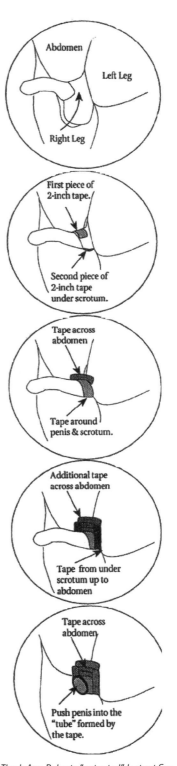

The JoAnn Roberts "patented" Instant Sex Change — from **Art and Illusion**

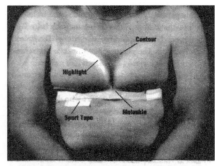

(Top) Creating Cleavage1: Place Sport Tape under each nipple. Pull chest together and hold in place with moleskin tape. (Middle) Creating Cleavage 2: Add your favorite bra and breastforms. Push-up pads may help too. (Bottom) Breast lifts can create awesome cleavage. The "L" is made from 1/8 inch polystyrene plastic found in any hobby store. The glue is medical grade silicone adhesive. — from **Art and Illusion**

Art and Illusion: A Guide to Crossdressing

JoAnn Roberts

"Information is power and when you have the information you need, you have the power to make informed choices." What is this? Is it the latest William Burroughs manifesto? Is it a political tract of some

sort? Actually it is a quote from the author of a very pragmatic guide to crossdressing. JoAnn Roberts has been lecturing on the college circuit and writing books on the psychology of crossdressing since 1983. What we have at hand is a very well-conceived and utterly complete guide for anybody of the male gender who wishes to have a go at dressing up in female attire, including numerous tips for "passing" as the real thing. Although this volume is deceptively slim, it seems to cover just about every physical aspect of such a transformation. (According to a list of other Roberts-penned books that are available, mannerisms, speech, etc. are covered elsewhere.) Not only does this handy little guide cover the obvious things such as body hair removal, hiding the family jewels, cleavage illusions, makeup tips and size translation, but it also goes the extra mile with loads of little tips about what dress best suits one's body shape, fabric weights and how they hang and what kind of glasses look best. It even includes a chart for sizing rings. The most amazing thing that this book conveys is a matter-of-factness about the whole subject of men wearing female attire. It has a sort of loopy charm that makes it easy to imagine the local PTA at an upscale elementary school handing this one out to the dads of the stickball team for their spring talent show. **SA**

$15.00 *(Pamp/40/Illus)*

The Cross and The Crossdresser

Vanessa S.

Coming out to the Lord. "We who crossdress have been given a marvelous gift by our Creator: the gift of full personality expression through the medium of crossdressing. This book discusses that gift, and invites us to accept it, gracefully and humbly. We crossdressers are, despite our culture's institutionalized oppression toward us, truly blessed [with] a unique perspective that most people will never attempt to gain or even comprehend." Amen. **GR**

$10.00 *(Pamp/48)*

Drag Diaries

Catherine Chermayeff, Jonathan David and Nan Richardson

Roll over, J. Edgar Hoover! "Introduction to drag, drag history, drag culture, drag interviews, drag personalities, drag reading list, drag filmography, drag annual calendar,

drag shopping guide." The glamorous, trashy truth about gender bending, from the she-males who do it best: RuPaul, Holly Woodlawn, Lypsinka, Lady Bunny, etc. "You're born naked and everything you put on after that is drag." Sure, they look like dames, but watch out—inside they feel like Sherman tanks! **GR**

$17.95 *(PB/128/Illus)*

Drag Gags

Ralph Judd

Ralph Judd loves to laugh. It says so right there on the book jacket, next to his slightly greasy and cabaret-ravaged face. And he loves to make other people laugh. So he decided to take vintage movie stills which feature men in dresses (the tremendous number of them is surprising) and slap goofy, soggy-breaded one liners on them. Cary Grant! Charlie Chaplin! Jackie Coogan! The two volumes of *Drag Gags* are intended for anyone who enjoys tabloid-style humor, although they will find most favor with homosexual men of the aged, theater-going variety. **SK**

$7.95 *(PB/60/Illus)*

Drag Gags Return

Ralph Judd

Like the first volume, this features 60 vintage movie stills of male actors in "humorous" feminine drag, gussied up with an amusing pun of Judd's invention. Milton Berle, Jimmy Durante, Eddie Cantor, Sid Caesar! The practicing transvestite might be offended by this nonsense and complain that homosexuality is yet again being subverted into something erroneously comic. But how can you hate Judd, a fairy if ever there was one? **SK**

$8.95 *(PB/60/Illus)*

I Am My Own Woman: The Outlaw Life of Charlotte von Mahlsdorf, Berlin's Most Distinguished Transvestite

Charlotte von Mahlsdorf

"The exquisitely written autobiography of Charlotte von Mahlsdorf, whose lifelong pursuits of sexual liberty and antique furniture offer a unique perspective on European history. During World War II, von Mahlsdorf murdered his father, dubbed himself Charlotte (after his cross-dressing lesbian aunt's lover) and has lived openly as a

transvestite since. Dressed in high-heeled sandals and a good suit, Charlotte has collected furnishings from the Gründerzeit for half a century: in the Third Reich, she 'rescued' pieces from Jewish deportees; in the German Democratic Republic, she protected 'bourgeois cultural assets' from the Stasi. Now well past 60, a quietly passionate, steadfast and serene figure, Charlotte shuns makeup, wearing the simplest of frocks. The Gründerzeit Museum-which Charlotte and her friends have defended against assault from skinheads—has become a symbol for the German lesbian and gay community."
$12.95 *(PB/183/Illus)*

I Was a White Slave in Harlem

Margo Howard-Howard with Abbe Michaels
The premier drag queen of Manhattan from the '40s until the '80s bares all, from Superfly pimp-lovers who were secretly into "rough trade," to the inside line on the Ecclesiastical hierarchy "Most of the archbishops of New York—the last four, who were cardinals—now we don't talk about the dead, but Cardinal Spellman was an old closet queen. Personally, I never saw him sucking a cock or whatever he was given to doing. But I heard rumors in the homophile world that he was called 'Fanny' Spellman. That he liked 'seafood.' Sailors. For soldiers, one would say 'K-rations.' Well, old Fanny, prince of the church, was gossiped about all over town." **SS**
$12.95 *(PB/179/Illus)*

Lettin' It All Hang Out: RuPaul — An Autobiography

RuPaul
Part autobiography, part self-help book, part how-to manual for aspiring drag queens, *Lettin' It All Hang Out* is a heartfelt, sassy and intelligent self-portrait of someone who dared to be different and never looked back—from his loving but difficult childhood, to his initial awareness of "being different," to his various early drag personae, to his present status as "Queen Of All Media." For all of its saturation in "queenspeak" irony the book, to its great credit, is utterly void of catty mean-spiritedness. Not just for those interested in crashing through the gender barrier, *Lettin' It All Hang Out* is an inspiring tale of perseverance and success in the face of considerable adversity. It's also a lot of fun. Replete with photos (the Diva in

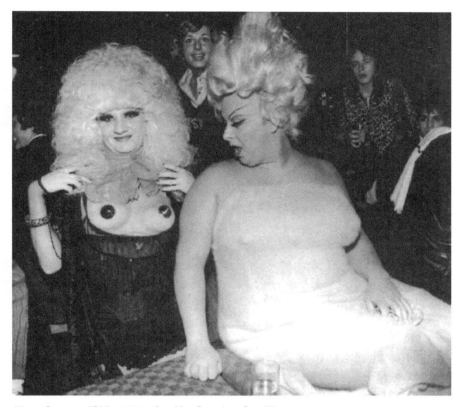

Wayne County and Divine, 1974 — from **Man Enough to Be a Woman**

company with fellow luminaries Elton John, Nirvana, Elizabeth Taylor), a breathtaking array of lists (RuPaul's Favorite Books, Photo Shoot Tips, Drag Names: Mix & Match), a U.S. discography and filmography. **MDG**
$10.95 *(PB/227/Illus)*

Man Enough To Be a Woman

Jayne County
Witness here the life of Jayne (formerly Wayne) County in all its messy glory, from picking up queen fuckers by the road side to breaking heads on the stage at CBGB's. She did it first, if not best, and her antics put rock's other drag hags way in the shade.

 MG
$17.99 *(PB/184/Illus)*

Monsieur d'Eon Is a Woman: A Tale of Political Intrigue and Sexual Masquerade

Gary Kates
And not just any woman: French diplomat

Monsieur d'Eon was an 18th-century, gender-blending, male Mata Hari living in the center of international intrigue. He continued his career as a super spy after declaring himself a genetic female at the age of 49 and kept them all guessing until after his death. He/she was also an acolyte of Jean-Jacques Rousseau. **MG**
$15.00 *(PB/400)*

My Husband Wears My Clothes

Peggy J. Rudd
Paternal transvestism can be fun for the whole family, thanks to Dr. Rudd, a "helping professional who reaches out to all crossdressers and their families. Through her example as the wife of a crossdresser, counselor and lecturer, she demonstrates that total acceptance is both possible and rewarding." **MG**
$12.95 *(PB/160)*

FORESKIN

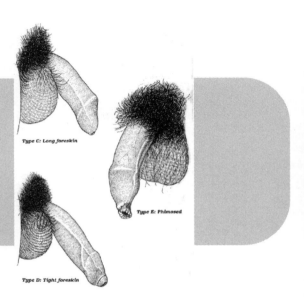

Type C: Long foreskin

Type E: Phimosed

Type D: Tight foreskin

Foreskin types — from **Foreskin**

Circumcision: What It Does
Billy Ray Boyd
An extremely well-thought-out handbook questioning both medical and ritual circumcision, including a databank of information resources on the subject, such as Brothers United for Future Foreskins (BUFF) and the Alternative Bris Support Group (for Jewish parents considering bris without circumcision).
$6.95 *(PB/95)*

Cut/Uncut
Edited by Leyland
Encounters with more than 80 blind bananas. "The first mature penis I actually held in my hand was an uncut one. I was about 13 at the time . . . He laughed and said, 'I'll bet you never saw a big cock like that. I got the biggest one in the high

school.' No, I had never seen one like that. Not only big, but strange to me. It somehow seemed to have no head . . . He said, 'Do you want to touch it?' I did and reached over and touched it with my finger. 'No, hold it in your hand,' he said . . . 'I can get bigger if you move your hands up and down slow' . . . As it swelled, I was both frightened and fascinated . . . It didn't go beyond that, but the experience was branded in my brain forever." **GR**
$10.00 *(PB)*

Decircumcision: Circumcision Practices and Foreskin Restoration Methods
Gary Griffin
If you've had yours whacked off, now you can have your missing foreskin returned to its hang-dog glory. But first, check out

these detailed descriptions of various surgical restoration methods. You can even do it yourself!
GR
$9.95 *(PB/112/Illus)*

Foreskin: A Closer Look
Bud Berkeley
All-American clipcocks vs. the monk's hood, the Roman shade, the anteater, the wingflap or the lace curtain, as foreskinned cocks have been called. "But even on the question of sensitivity, there is no universal agreement. Sex researchers Masters and Johnson, in their tests, found no difference in sensitivity between circumcized and uncircumcized penises. Most modern researchers agree that sensitivity is such a subjective perception that it would be difficult to measure. They also agree that premature ejaculation is primarily caused by

Infant circumcision surgery. The photos presented here were selected from slides of several different actual circumcisions. — from Say No to Circumcision!

psychological factors, not by differences in penile sensitivity." So what was everyone complaining about? Was there anything missing from the circumcized penis, besides the 'superfluous' foreskin? The men belonging to the USA (Uncircumcised Society of America) certainly argued that something was missing. One man wrote, 'My foreskin is the best part of my penis.'" **GR**
$9.95 *(PB/208)*

The Joy of Uncircumcising! Exploring Circumcision— History, Myths, Psychology, Restoration, Sexual Pleasure and Human Rights
Jim Bigelow, Ph.D.
"The American medical community has

been waging war on the foreskin for most of this century. Their aim has been to eradicate the foreskin from every penis of every male born in this nation. The majority of American doctors have portrayed the foreskin as a mistake of nature and the curse of the male gender. No matter how many we cut off every year, they just keep coming! Since nature seems so stubborn about producing foreskins, perhaps we would be wise as an enlightened people to take a new look at the possibility that nature knows best and that there are, in fact, real advantages to leaving the penis intact." Includes extensive information on the modern foreskin-restoration movement, the skin-expansion method and surgical foreskin reconstruction.
$18.95 *(PB/256/Illus)*

Say No to Circumcision!
Thomas J. Ritter, M.D. and George C. Denniston, M.D.
A surgeon and a specialist in family medicine promise "40 compelling reasonswhy you should respect his birthright and keep your son whole" and they deliver. Reasons include: "Circumcision Is Really Foreskin Amputation, and Is Abusive," "Circumcision Creates Unnecessary Surgical Risks and Complications," "When Unaroused, the Glans of the Penis Is Meant to Be an Internal Organ, Like the Clitoris," "Your Son's Penis Does Not Have to Look Like His Father's," "Some Jewish People Are Even Changing Their Mind on Circumcision," and "Penile and Cervical Cancer Are Not Valid Reasons for Infant Circumcision." So "If You're Not Sure—Don't Do It" and "Say No to Circumcision!" Case closed.
$9.95 *(PB/96/Illus)*

nambla

The North American Man/Boy Love Association (NAMBLA) is working to change public perceptions and laws about consensual sexual relationships between adults and minors. Today, the law and public prejudice make little or no distinction between a man who forcibly rapes a child and one who genuinely cares for and loves a boy. Some judges have condemned boy-lovers as being "worse than murderers," even though their only crime has been to share their body and affection with a boy in a friendship that includes mutually enjoyable sexual experiences. It is a shame that in American society, it is a greater crime to love a child than it is to beat—or even kill a child.

NAMBLA believes that any child, regardless of age, should have the right to say "yes" or "no" to any person. The child should have the right to initiate the relationship, as he often does. He should have the right to enjoy and develop the relationship without fear of shame or ridicule, or of harassment by parents or police. Children should have free access to factual information about sexual relationships of all kinds, and the right to control their own bodies without interference from adults. No child is harmed by any consensual sexual experience, but children are harmed by society's condemnation and persecution of their bodily pleasures.
— David Thorstad, from the introduction to *Boys Speak Out*

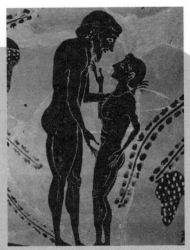

Greece, man and ephebe, end of 6th century B.C. — from Erotica Universalis

Anarchist of Love: The Secret Life of John Henry Mackay
Hubert Kennedy
Biographical essay on the life of famed Scottish artist, writer, boy-lover and anarchist John Henry Mackay. Mackay wrote much of his work under the nom de plume "Sagitta" and eventually used his own name to write the classics "The Hustler" and "Fenny Skaller," the latter revealing Mackay's favorite gratification from boys—kissing. Mackay is celebrated along with other great boy-lovers of the period, like writer Magnus Hirshfield and acclaimed boy photographer Wilhelm von Gloeden. Mackay devoted his life to the political, legal and artistic promotion of man/boy love. Since he was most attracted to guys in the 17 to 18 range, he did not consider himself a pedophile, although several pedophiles supported his work.
"I sing of the love whose joy
You bury, proscribe, and ban!
I sing a man's love for a boy,
A boy's love I sing, for a man."
—Sagitta **GM**
$6.50 *(Pamp/54/Illus)*

Anatomy of a Media Attack
David Miller
This NAMBLA publication helps members across the nation in their struggle to change the media's attitude toward man/boy love. There is useful information here, whether or not you are a boy-lover, in that the lessons are applicable to anyone who deals with the media. The booklet starts by reprinting an article about NAMBLA that appeared in February 1995 in a gay Philadelphia newspaper. Among other things, the article discusses how the International Gay and Lesbian Association (IGLA) was threatened refusal into the United Nations because NAMBLA was an IGLA member. The article briefly offers NAMBLA's take on the difference between consent and coercion, and the maturity level of a boy versus the boy's age. In the back there is advice on how to write to the media effectively. The booklet then reprints all the letters to the editor that followed.
GM
$3.95 *(Pamp/64)*

Boys Speak Out on Man/Boy Love
Edited by David Miller
Who better to speak on man/boy love than the boys themselves? Each boy writes about their own experiences in a singularly positive way. Some stories are downright celebratory. In editor Miller's preface, he says the idea of boys viewing their sexual relationships with men as positive and non-threatening is supported by many quality studies. A jewel of an essay on ageism hides in this booklet. The fiery diatribe was written by an 18-year-old member of the Gay Youth of New York, a group founded before the Stonewall riots. Several boys describe what happens when the police haul them in for questioning. It seems clear that most, if not all, of these accounts are actually written by the boys themselves, but there's always that nagging doubt that some may be fake. **GM**
$3.95 *(Pamp/64)*

Child-Loving: The Erotic Child and Victorian Care
James Kincaid
"We can, also in passing, note some forms of Victorian pedophilia that seem especially marked, perhaps specific to the period. The particular attractions of the sick or dying child seem to have figured importantly for the culture generally, and certainly for pedophiles. The surviving pedophile poetry and what we know of public activity suggests that, next to dying and the even-more-popular flogging, bathing may have provided the most popular subject: 'Breasting the wavelets, and diving there/white boys, ruddy, and tanned and bare.' Francis William Bouidillion's 'The Legend of the Water Lilies' (1878) is one of several poems of this sort that combine naked bathing with death: When one of the group swims out too far, the others, all of them, try to save their comrade and drown in the attempt. Some water lilies . . . grow there to mark the grave and preserve the erotic image of the bonanza of naked, dying bodies."
$35.00 *(HB/416/Illus)*

Criminal Justice
Edited by David Miller
NAMBLA estimates that upward of 30,000 males are in jail for having underage homosexual encounters. This booklet is the voice of those prisoners. Included is a revealing

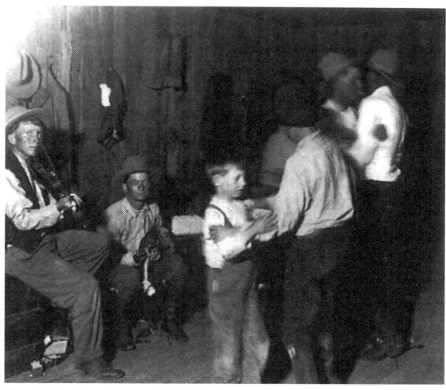

Illustration from Library of Congress photograph collection — from **Boys Speak Out on Man/Boy Love**

and insightful essay by A. Shneur Horowitz on the downside to boy love . . . incarceration. One prisoner writes of a 99-year sentence for the crime of sodomy. Another speaks of a 10-to-life sentence for his first offense, performing oral sex on a 9-year-old. Some of the prisoners in the system are themselves boys. Some of these stories are truly compelling:

"I'm behind the wall with the most violent criminals, in a state with no death penalty. My charges have been announced by guards in front of other prisoners. I have been violently attacked three times and raped twice. I'm still HIV negative, though. Condoms are forbidden. Anal sex is rampant. Most prisoners practice it." **GM**
$3.95 *(Pamp/63)*

Pederasty and Pedagogy in Archaic Greece
William Armstrong Percy III
Traces the glory days of teen buggery, when

a young boy's ass was his ticket to the top. "Maintains the Cretan sages established a system under which a young warrior in his early 20s took a teenager of his own aristocratic background as a beloved until the age of 30, when service to the state required the older partner to marry. The practice spread to other Greek-speaking areas. In some places it emphasized the development of the athletic, warrior individual, while in others both intellectual and civic achievements were its goals. In Athens it became a vehicle of cultural transmission, so that the best of each older cohort selected, loved and trained the best of the younger." Evidence is given to show that this popular brand of butt-busting male bonding gave rise to Hellas and the "Greek miracle." It gave rise to something, that's for sure. **GR**
$24.95 *(HB/261/Illus)*

NUDISM

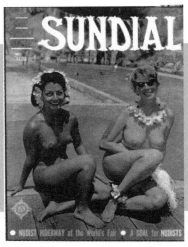

Magazine cover — from Nudist Magazines of the '50s and '60s

California's Nude Beaches: The Clothes-Free/Hassle-Free Guide
Dave Patrick
Sun, sand, surf—and sex organs! It's bare as you dare in Sunny California, Oregon, Washington, and Hawaii, since nude bathing is still prohibited in all four states. The author visits dozens of famous bottom-less beaches, providing history, tips and dri-ving directions for each. Plus sidebars on nude resorts and a dozen clothing-optional hot springs. Perhaps the first book to show the author with his pants off. **GR**
$15.95 *(PB/150/Illus)*

Family Naturism in America
Ed Lange
"Naturism in America has progressed from the

days when nudists had to hide behind high walls and keep their nudist affiliation secret. Today, many quality resorts vie for the nudists' vacation dollars, many of them providing excellent housing and A-1 restaurants for their patrons' convenience. Designed for the inquir-ing individual who wishes to know more about this fascinating form of recreation."
$18.95 *(PB/100/Illus)*

Fun in the Sun, Books One and Two
Elysium Growth
"WHAT is the nudist idea? WHO are the nudists? WHEN and WHERE is the nudist experience occurring? HOW does one become a nudist? The answers to all these questions can be found in this information-packed, beautiful book."
$16.95 *(PB/64/Illus)*

Growing Up Without Shame
Dennis Craig Smith with Dr. William Sparks
"Challenges the assumptions that social nudity is harmful to healthy childhood development. The author met adults who had experienced social nudity in an ethical, humanistic environment as children and had come to accept their sexuality without shame. His findings contradict Freud's con-cept that children are harmed by the sight of their parents' nakedness, offering con-crete examples of adults whose lives are better because of the body- and self-accep-tance they developed as children."
$16.95 *(PB/221/Illus)*

Jock Sturges
Jean-Christophe Ammann and Jock Sturges
Each summer for many years, Sturges has

traveled to France's southern Atlantic coast where a group of nudist families spend their seaside holiday. He has devoted himself to photographing mostly the daughters of these families as they posed for him in the nude by the beach and in other nearby outdoor settings. For his dedication to capturing the ineffable beauty of these pre-, post- and pubescent girls naked and at peace with Nature, Sturges has had his masterful work shown in art galleries, museums and now in this elegant monograph put out by Frankfurt's Museum für Moderne Kunst. Thanks to a snitch at a photo lab, Sturges has also had his San Francisco studio raided by the FBI and been prosecuted for kiddie porn.

The sexual subtext of these pictures is impossible to ignore, yet Sturges seems to be meeting these graceful, unashamed young people on their own terms. So where does the danger lie? Radiant and self-possessed, the subjects of these photographs clearly present some sort of challenge to our culture and national id. Perhaps the FBI should have raided the Ramseys' house and confiscated JonBenet's makeup, pumps and frills, and left Sturges alone. **SS/MH**

$65.00 *(HB/204/Illus)*

Lee Baxandall's World Guide to Nude Beaches and Resorts

Lee Baxandall

Brilliant color photographs featuring festive, nude people grace practically every page of this fun and friendly naturist guide. Many photos correspond with individual listings, giving holiday makers a glance at thousands of clothing-optional beaches, resorts, parks and more. Particularly cool shots show a nude shooting range, the nude supermarket, and other choice scenes that verify the fact that one doesn't really need clothes to do most things. All in all, a great guide for families who like to pack lightly. However, there are glaring errors that make it worthwhile to check ahead and locally before taking the plunge. A couple of the places listed just aren't happening anymore, and some of the places have changed dramatically since the time of the book's publication. Delonegha Hot Springs, for instance, in California's Sequoia National Forest, is now privately owned and mostly visited by clothed Koreans. **GE**

$28.00 *(PB/272/Illus)*

Nudist Magazines of the '50s and '60s: Books One and Two

Ed Lange and Stan Sohler

This two-part anthology combines articles on the history and ethics of nudism and nudist publishing, with scores of photos that capture the gleefully naked antics of legions of sun-worshiping men, women and children. Whether riding dune buggies, gyrating with hula hoops, sitting under hair dryers, bowling, competing in beauty pageants, or just hunkering down for a few mai-tais, life in the raw is an endless pleasure spree. And the fact that many of the nude revelers look like Martin Milner and Patty Duke makes it all the more fun. Includes the how-to essay "Dance Naked With Music" by Laura Archer Huxley, absurdly juxtaposed with a foreword by husband Aldous ("Human beings are multiple amphibians . . .") with pictures of Mrs. Huxley writhing and undulating in someone's batch pad living room, captioned with her own written exhortation to "Go into a room by yourself. Put on your favorite music. Throw off your clothes. And dance!" One can only assume that this kind of thing is included to bridge the gap between the spiritual and the prurient, but if one ignores

As the number of parks and groups increased, the number of nudist "events" multiplied. — from **Nudist Magazines of the '50s and '60s**

the "sing the body electric" rhetoric while checking out the buns and wieners, and still appreciate this stuff as sublime, omnisexual porno-kitsch. **MG**

$18.95 *(PB/95/Illus)*

Mylene and Estelle, Montalvier, France, 1994 — from **Jock Sturges**

PLAGUE

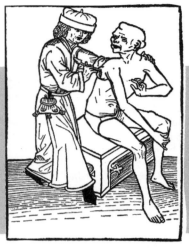

In this woodcut, from a late-15th-century Nuremberg treatise on bubonic plague, a doctor is shown lancing one of the buboes Boccaccio describes. — from King Death

AIDS and the Doctors of Death: An Inquiry Into the Origin of the AIDS Epidemic
Alan Cantwell Jr., M.D.
"According to Dr. Robert Strecker and other scientists, the AIDS virus is a man-made, genetically engineered virus that was deliberately or accidentally introduced into selected populations as part of a secret scientific germ-warfare experiment. A massive coverup by the scientific establishment and the government has kept this information from the American people. Strecker's horrifying assertions of an AIDS conspiracy led the author to research little-known scientific facts about the new epidemic, particularly the relationship between AIDS, animal cancer virus experimentation and genetic bio-engineering of viruses designed to destroy the immune system."
$14.95 *(PB/240)*

AIDS Inc.: Scandal of the Century
Jon Rappoport
"A sizzling, behind-the-scenes tour of laboratories, newsrooms and even the White House to expose the real killers behind the disease. . . . Investigative reporter Rappoport uncovers the shocking truth about AIDS: Thousands are dying needlessly as the medical world and media pull off the biggest scandal of our time—all for the love of power and money."
$13.95 *(PB/345/Illus)*

Emerging Viruses: AIDS and Ebola: Nature,

Accident or Genocide?
Dr. Leonard Horowitz
The most complete investigation to date on the biowarfare aspect of ready-made diseases. Examines the motivations of Henry Kissinger, Nelson and Laurence Rockefeller, the U.N. and the WHO in an insane plan to depopulate the Earth with ethno-specific diseases. Chapters include: "The World Health Organization Theory of AIDS"; "Cold War, Biological Weapons, and World Health"; "Interview With Dr. Robert Strecker"; "African Foreign Policy and Population Control"; "Henry Kissinger's New World Order"; "Silent Coup in American Intelligence"; "The CIA/Detrick Operation"; "MK-Ultra and CIA Human Experimentation"; "The Nazi Roots of American Intelligence"; "The CIA in Africa"; "The Man-Made Origin of Marburg and Ebola." Massively referenced, this book will recast the entire AIDS debate. **FLA**
$49.95 *(HB/545/Illus)*

The Encyclopedia of Plague and Pestilence
George C. Kohn
History-making outbreaks of bubonic plague, smallpox, rubella, influenza, malaria, conjunctivitis, scarlet fever, cholera and diphtheria. Nature's weapons of mass destruction, sneaking out from under Death's door to bring humanity down. **GR**
$45.00 *(HB/432)*

A Field Guide to Germs
Wayne Biddle
From adenovirus to Ziti fever, *A Field Guide to Germs* presents "the top-ranked terms and germs (in prevalence, or power, or worry factor, or even literary interest) . . . not with the quack promise of self-diagnosis, but with the absolute certainty that a little knowledge is always better than zip." Written with a light touch and with the intelligent layperson in mind, *A Field Guide to Germs* details the significant symptoms, historical significance and social impact of some 70-plus viruses, bacterium or other sources of contagion. While handy as a reference book, this also offers many wonderful factoids, such as: measles is not carried by any other animal and it needs a human population of over 300,000 to provide a sustaining supply of virgin bodies so that it will not die out. Or, doctors in the time of plague wore beaked masks filled with pleasant-smelling whatnot to mask the stench of decay. Or, the French term for gonorrhea as far back as the 12th century was *chaude pisse*, which translates literally as "hot piss." Complete with period illustrations, *A Field Guide to Germs* offers hours of entertainment. **JAT**
$12.95 *(PB/196/Illus)*

Inventing the AIDS Virus
Peter H. Duesberg
Duesberg is one of the world's leading microbiologists, a pioneer in the discovery of the HIV family of viruses. He begins his study by historically analyzing diseases that were thought to be caused by a virus but were not, such as SMON, a disease that struck Japan in the 1950s and was caused by medicine given to patients as treatment. Or scurvy, which was fought as a viral dis-

ease until it was discovered to be caused by dietary deficiencies. He cites these examples in order to back up his theory that HIV is not the cause of AIDS.

This book goes beyond Michel Foucault's wildest fantasies. Duesberg reevaluates the clinical histories of the first five people who died of AIDS-related complications, in 1980, only to find our that all of them were heavy users of inhalant nitrates (or "poppers"), once used heavily in the gay community. According to Duesberg, these are highly toxic and can cause Kaposi's sarcoma within a short period of time. Duesberg also observes that there is a correlation between the people who actually die of AIDS and their history of drug use, indicating that drug abuse may be the primary reason for the immunological system's breakdown. So, according to Duesberg, Foucault probably didn't die because he was infected by the HIV retrovirus but because he had been attending some wild Parisian parties.

Another controversial point made by Duesberg is the "latency period" concept. It is an accepted fact that diseases caused by a virus like polio and smallpox have an immediate effect on the organism. He argues that a "latency period" of years of duration was invented when scientists were convinced that leukemia was a viral disease and the only way they could justify the connection between it and cancer was by expanding the length of the "latency period" until it reached 40 years. The author sees this is as a baroque attempt to save the theoretical framework in spite of the fact-based reality of the disease.

Duesberg questions the efficacy of AZT, ddI and ddC, which he shows to be very toxic. He claims that the cure causes the disease, calling it "AIDS by prescription." He brings forward many cases, including that of Magic Johnson, who stopped the AZT treatment and is still alive, and that of Arthur Ashe who didn't stop the treatment and who died shortly thereafter. **AF**
$29.95 *(HB/722)*

King Death: The Black Death and Its Aftermath in Late-Medieval England
Colin Platt
"The Black Death came to England in 1348, and for over three centuries bubonic plague remained a continual and threatening presence in the everyday life (and death) of the country.... Examines what it was like to live with the plague at all levels of society," from village priest to abbot, from laborer to nobleman. Whole towns were wiped out, churches half built, never finished. The Dance of Death eventually joined the Gospel in stained-glass displays, and merchants were buried under memorial cadavers carved in stone, calling for friends' compassion in mourning their hideous death. Everywhere it was a culture invaded by shrouds, skulls and the stench of death, until the industry of death itself became a "potent instrument of change." **GR**
$18.95 *(PB/262/Illus)*

Mary, Ferrie and the Monkey Virus: The Story of an Underground Medical Laboratory
Edward T. Haslam
Why was a prominent cancer researcher, Dr. Mary Sherman, involved in an underground medical laboratory with a violent political extremist, David Ferrie? Is there actually a connection between the JFK assassination and AIDS? Ferrie was working on an alleged cancer cure; Sherman was murdered and her body set on fire, and her records are missing to this day. Haslam has raised some intriguing questions. **FLA**
$19.95 *(PB/258/Illus)*

Queer Blood: The Secret AIDS Genocide Plot
Alan Cantwell Jr., M.D.
Within six months of the first outbreak in the late '70s, the condition that came to be known as AIDS/HIV had become an epidemic in New York, with mysterious, horrific deaths also being tallied in San Francisco and Los Angeles. In *Queer Blood*, Cantwell still believes it ain't no monkey virus!

Cantwell gives solid evidence that the experimental gay-hepatitis vaccines in N.Y. and the ambitious smallpox vaccine program implemented by the World Health Organization in the '60s and '70s can be directly linked to AIDS; almost 100 million blacks were injected in Central Africa alone. Was a dormant virus awakened, or were some batches of the vaccine contaminated? What about the polio vaccines of the '60s, some of which were contaminated by a simian virus called SV 40? Why are there an AIDS hetero virus in Africa and a homo virus in the U.S.? The major media are controlled by big business; some conspiratologists believe that the media's suppression of the AIDS biowarfare idea makes it even more credible. Government propaganda has eradicated any sympathy for homosexual AIDS victims; the Christian fundamentalist view that the disease is some kind of retribution for their evil ways boggles the mind when one learns that 75 percent of the world's current AIDS cases are hetero. By 1993 300 people were dying each day from AIDS. Why aren't people asking more questions? Cantwell asks, and why are alternative and holistic methods suppressed in favor of magic pills and vaccine research? **SK**
$12.95 *(PB/159)*

The Secret Malady: Venereal Disease in 18th-Century Britain and France
Edited by Linda E. Merians
"The essays in this collection paint a portrait of the secret malady; public and private responses to the epidemic; changing attitudes toward venereal disease; and its role in making sex a taboo subject, in enforcing class and racial distinctions and in raising the level of misogyny."
$19.95 *(PB/304/Illus)*

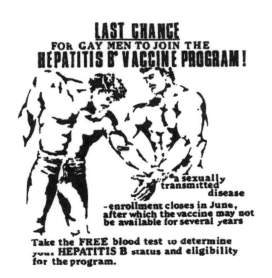

This advertisement placed in New York newspapers to recruit homosexual men into an experimental hepatitis-B vaccine program – from Emerging Viruses

WILHELM REICH

Doctor Reich claims that the basic charge of life is this blue orgone-like electrical charge—Orgones form a sphere around the earth and charge the human machine—He discovered that orgones pass readily through iron but are stopped and absorbed by organic matter—So he constructed metal-lined cubicles with layers of organic material behind the metal—Subjects sit in the cubicles lined with iron and accumulate orgones according to the law of increased returns on which life functions—The orgones produce a prickling sensation frequently associated with erotic stimulation and spontaneous orgasm—Reich insists that orgasm is an electrical discharge—He has attached electrodes to the appropriate connections and charted the orgasm—In consequence of these experiments he was of course expelled from various countries before he took refuge in America and died in a federal penitentiary for suggesting the orgone accumulator in treating cancer—It has occurred to this investigator that orgone energy can be concentrated to disperse the miasma of idiotic prurience and anxiety that blocks any scientific investigation of sexual phenomena. — William S. Burroughs, from *Nova Express*

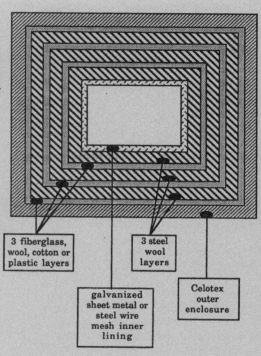

Simplified diagram of the Orgone Energy Accumulator — from The Orgone Accumulator Handbook

Beyond Psychology: Letters and Journals, 1934-1939
Wilhelm Reich
Documents drawn from an interesting period of transition for Reich, from Marxist dialectician-psychoanalyst to biophysicist and natural scientist. **FLA**
$25.00 *(HB/320)*

The Cancer Microbe
Alan Cantwell Jr., M.D.
Independent confirmation of Wilhelm Reich's "bion experiments" and the emotional basis of cancer by this AIDS researcher and dermatologist; guaranteed jargon-free. **FLA**
$19.95 *(PB/283)*

Character Analysis
Wilhelm Reich
Reich was the first to systematize therapy and introduce a technical seminar within traditional psychoanalysis. The ideas laid out here serve as the basis for most "body-work" therapies like Rolfing and Bioenergetics. **FLA**
$18.00 *(PB/545)*

The Cosmic Pulse of Life:

The Revolutionary Biological Power Behind UFOs
Trevor James Constable
Cloudbusting, Reich and UFOs. Steiner, a Borderlands Research old-timer, photographs living "bioforms," which Constable calls "critters," that hover in the air and seem to be drawn to cloudbusting operations. Too mystical for my reptilian brain with his references to LSD and invisible forces, but a fascinating account of one man's journey to understanding basic cosmic realities. **FLA**
$24.95 *(PB/488/Illus)*

Grethe Hoff sitting in an Orgone Energy Accumulator — from **Fury on Earth**

Etheric Weather Engineering on the High Seas

Trevor James Constable

Video time-lapse photography of Constable's weather-modification experiments aboard a Matson Line container ship. Constable narrates the action. 72 min.

FLA

$19.95 *(VIDEO)*

The Function of the Orgasm

Wilhelm Reich

Introduces the bioenergetic concept of self-regulation via surrender to the orgasm reflex. **FLA**

$18.00 *(PB/400/Illus)*

Fury on Earth: A Biography of Wilhelm Reich

Myron Sharaf

A former patient and student of Reich's,

Sharaf, having been personally invested in Reich and passionate about Reich's work since discovering *The Function of the Orgasm* in 1944, gives us a close look at the complex weave of events, people and ideas that made up Reich's life. Sharaf provides a detailed account of the private and public conflict which Reich endured until his death in an American federal pen on November 3, 1957, ignored or ridiculed by the public at large. The book covers Reich's childhood, his years as "Freud's pet," his breakup with the Communist party and his expulsion from Viennese psychoanalytic circles in 1934, as well as illustrating Reich's theoretical innovations in psychology, sociology and science.

The book explains Reich's theoretical development from genital-centered "orgastic potency" to his discovery of the "orgone" (life energy) in 1940. Reich wished to counteract the murderous form of atomic energy with the life-furthering functions of orgone; this branched into the realization of orgone energy accumulators and rain-making machines by the early 1950s.

Reich's interest in the ideas of Henri Bergson and Friedrich Nietzsche helped push his ideas on "mental health" beyond "mental" phenomena; his work with low-income laborers in clinics led to many theories on how "exploiters" use sexual repression. Reich's ideas, an inspiration to the work of people like Deleuze and Guattari,

Reich escorted to prison by Deputy Marshall William Doherty, March 1957 — from **Fury on Earth**

Cloudbuster at Orgonon — from **Fury on Earth**

point out how neurosis goes from the personal to the social and back, the body and its sexual potential being the very thing which must be contained since capitalist economies use people as natural resources.

By the time Reich began researching life energy itself, in and around people, his ideas of a conspiracy in the U.S. to persecute and discredit him seemed not so far-fetched. Beginning in 1956, the U.S. Government and the FDA burned his accumulators and publications. He was in jail by the following year. This is an easy, thorough and inspirational read about a fascinating life and some of the most important ideas on humanity and its environment. **KH**

$17.95 *(PB/550/Illus)*

Listen, Little Man!

Wilhelm Reich

Reich sounds off in one of the all-time classics rants. "I am very deeply afraid of you, Little Man. That has not always been so. I myself was a Little Man, among millions of Little Men. Then I became a natural scientist and a psychiatrist, and I learned to see how very sick you are and how dangerous you are in your sickness. I learned to see the fact that it is your own emotional sickness, and not an external power, which, every hour and every minute, suppresses you, even though there may be no external pressure. You would have overcome the tyrants long

ago had you been alive inside and healthy. Your oppressors come from *your own* ranks as in the past they came from the upper strata of society. They are even littler than you are, Little Man. For it takes a good dose of littleness to know your misery from experience and then to use this knowledge to suppress you *still better, still harder.*"

$11.00 (PB/128)

Loom of the Future: The Weather Engineering Work of Trevor James Constable

Trevor James Constable

This book is compiled from a series of interviews with Trevor James Constable discussing his work on weather engineering. Constable is best known for his work *The Cosmic Pulse of Life.* He uses simple geometric apparatuses to supposedly control the weather in such ways as dissipating fog and causing rain. This book could have greatly benefited by including plans for some of the devices and a little bit more scientific explanation of some of the principles involved. **MC**

$18.95 (PB/148/Illus)

The Mass Psychology of Fascism

Wilhelm Reich

Landmark analysis of fascism in Germany and Russia—everywhere. Reich defines fascism as revolutionary emotions, irrational ideas and actions. This book signed Reich's death warrant in Germany. Chapters include: "Ideology as a Material Force"; "The Authoritarian Ideology of the Family"; "Racial Purity, Blood Poisoning and Mysticism"; "Deconstruction of the Symbolism of the Swastika"; "Organized Mysticism as an International Anti-Sexual Organization." **FLA**

$18.00 (PB/400)

On Wilhelm Reich and Orgonomy (Pulse of the Planet #4)

Edited by James DeMeo, Ph.D.

Loaded with the most current and updated information regarding Reich and orgonomy. Two scarce books are reprinted here: *WR in Denmark*, a personal and engrossing account of Reich's first years in exile, and *Experiments in Sexuality and Anxiety.*

FLA
$20.00 (PB/174)

The Orgone Accumulator Handbook: Construction Plans, Experimental Use, and Protection Against Toxic Energy

James Demeo

A how-to, with complete protocol for a host of experiment. Includes plans for the orgone blanket and garden-seed chargers as well as box-type, whole-body accumulators. An appendix contains a double-blind study on the physiological effects of the orgone accumulator, and there is also an excellent bibliography. **FLA**

$12.95 (PB/155/Illus)

Passion of Youth: An Autobiography, 1897-1922

Wilhelm Reich

This is the latest of Reich's writings to appear posthumously. In these excerpts from his diary, Reich, like his mentor, Freud, is remarkably candid about the details of his personal life and sexuality. Indeed, some of his most private confessions sound remarkably Freudian: "Twice I masturbated while consciously fantasizing about my mother—saw and felt only her abdomen, never her

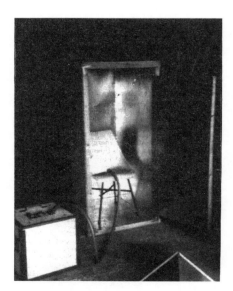

A three-ply accumulator in the author's laboratory. A ten-ply charger, with attached funnel shooter, is at the lower left. This charger normally sits inside the larger accumulator, under a wooden bench inside the accumulator. — from The Orgone Accumulator Handbook

face." Also includes his 1919 memoir, *Childhood and Puberty*, in which Reich candidly tells of his first sexual experiences and the further development of his sexual life.

JB
$14.95 (PB/178/Illus)

Wilhelm Reich and the UFO Phenomena: Arizona Desert 1954-55

Eva Reich, M.D.

"Wilhelm Reich was the brilliant student of Sigmund Freud who broke with the father of psychoanalysis over the issue of sexuality's place in society. Reich argued that Freud retreated from reality. Reich pursued the original promise of psychoanalysis: that the realm of human sexuality was accessible to rational comprehension; that the organism and its underlying libido energy were observable phenomena; that life depended upon that study. Accidentally, he stumbled onto a new science: orgonomy, the science of Life Energy; orgone energy is the forgotten ether.

It's been said that Wilhelm Reich was deluded when he reported his UFO sightings, but today his daughter Eva confirms the phenomena with convincingly honest testimony. She was present in 1954 when Reich carried off a top-secret, "desert greening" expedition in Tucson, Arizona—under the noses of federally funded scientists working on their own 'Operation Weather Control.'

Eva Reich, more than anyone at that time, made great sacrifices to support her father's dangerous work, and offers this memoir with honest criticism and forthright appraisal. These interviews with Eva Reich, conducted in 1990 in Hancock, Maine, and in 1995 in Philo, California, offer a rare opportunity to join an informal conversation with the daughter of Wilhelm Reich. She expresses her deep grief, even at the age of 71, over her father's persecution and death in Lewisburg Federal Penitentiary, an unwilling martyr to the cause of scientific freedom." 60 min.

$35.00 (VIDEO)

PARALLAX

100 Amazing Facts About the Negro
J.A. Rogers
A *Ripley's Believe It or Not* of Afrocentric history. "No. 66. In 1670, Virginia passed a law forbidding Negroes from buying white people. This was fifty-one years after the Negro had arrived in chains."
$4.95 *(PB/72/Illus)*

100 Years of Lynchings
Ralph Ginzburg
A factual account taken from an array of newspaper articles recalling racial atrocities spanning from 1880 through 1960. The first publication was set to mark the centennial of the Civil War.
"*NEW YORK SUN*, AUG. 16, 1921 2nd Lynch Mob Desecrates Body of First Mob Victim Coolidge, Tex., Aug. 16—Alexander Winn, A Negro, was hanged by a mob yesterday at Datura. He had been accused of assaulting a seven year old girl. Today his body was burned after another mob had stormed the funeral parlor where it had been taken." Includes a listing of names of 5,000 black men lynched in the United States from as early as 1859. **TD**
$11.95 *(PB/270)*

Africa and the Discovery of America
Leo Wiener
Documents the pre-Columbian presence of Africans in the New World, using the history of cotton, smoking and tobacco. Goes further to state that the African interactions with the New World were superior to those of the Europeans, as the Africans didn't launch a destructive war on the native population. If Columbus wasn't the discoverer of the New World (everyone from the Norwegians to the Chinese have made this claim), the author argues that the explorer's real role in the world's history is as the person who opened the Western hemisphere for Europeans. **SC**
$10.00 *(PB/287/Illus)*

Africa Mother of Western Civilization
Yosef ben-Jochannan
"In lecture/essay format, Dr. Ben identifies and corrects myths about the inferiority and primitiveness of the indigenous African peoples and their descendants."
$34.95 *(PB/715/Illus)*

African Origins of the

Major Western Religions
Yosef ben-Jochannan
It should come as no surprise that the Judeo-Christian-Islamic religious tradition came from Africa. Well, at least according to Dr. Ben, who always has the evidence to prove his point with elaborate hand-drawn maps and diagrams. One of the amazing aspects of Dr. Ben's work is his ability to pull in so many sources and tie them together into a single, unified theory of history.
SC
$24.95 *(PB/363)*

Alcatraz! Alcatraz!: The Indian Occupation of 1969-1971
Adam Fortunate Eagle
In its long history as a federal prison, many inmates had attempted to escape from Alcatraz, the island located in San Francisco Bay, named by the Spaniards for the seagulls who inhabit it. In 1969, however, a group of Native Americans, in an effort to focus the nation's attention on the injustices dealt them in the past and present by the American government, landed on the then-abandoned island and claimed it for their people. The occupation went on for 19

long months, with the help of countless sympathizers who ferried supplies and people back and forth to the mainland. Adam Fortunate Eagle chronicles the events leading up to that audacious act as well as the day-to-day lives of those who lived on the island and the aftermath of the eventual forced evacuation of the protesters by federal authorities. With photographs by German-born Ilka Hartmann, *Alcatraz! Alcatraz!* stands as an important document of the continuing struggle of Native Americans to get their due from the invading empire known as America. **AS**
$9.95 *(PB/157/Illus)*

Ambush at Ruby Ridge: FBI Whitewash or Justifiable Homicide? The Inside Story on What Really Happened at That Small Cabin in Idaho
Alan W. Bock
On August 21, 1992, a six-man team from the Special Operations Group of the U.S. Marshall's Service descended upon Randy Weaver's 20-acre farm known as Ruby Ridge. Within 36 hours, Weaver's dog was crushed into a pancake form, his son was killed, and his wife was shot down in the doorway of their home while holding their 10-month-old baby. For some reason or other, Weaver went berserk and the situation precipitated a military build-up consisting of a large array of assault vehicles and over 400 heavily armed men who eventually took Randy Weaver into custody. Weaver later wrote his impression of the outbreak of hostilities: "When I reached the first fork in the logging road, a very well-camouflaged person yelled, "Freeze, Randy!" I immediately said, "Fuck you," and retreated 80 to 100 feet toward home. I realized immediately that we had run smack into a ZOG [Zionist Occupational Government]/New World Order ambush."
 JB
$22.00 *(HB/281/Illus)*

America B.C.
Barry Fell
"It has long been taken for granted that the first European visitors to American shores either sailed with Columbus in 1492 or with Norsemen like Leif Erikson a full five centuries earlier. . . . Now Harvard professor Barry Fell has uncovered evidence . . . to replace those legends with myth-shattering

Lynching, circa 1880 — from **Looking at Death**

fact. Illuminating, authoritative and enhanced with over 100 pictures, *America B.C.* describes ancient European temple inscriptions from New England and the Midwest that date as far back as 800 B.C. Professor Fell examines the phallic and other sexually oriented structures, found in our own country, that reveal the beliefs of ancient Celtic fertility cults—cults that were virtually destroyed in Europe in early Christian times. Further evidence has been found in the tombs of kings and chiefs, in the form of steles—written testimonies of grief carved in stone."
$14.00 *(PB/347/Illus)*

America's Second Civil War
P.J. Roberts
"A chilling tale of what can eventually occur in this country. The cold war is over. America remains the world political leader. Now the battle begins again within our own borders. Is it racial or political? Whatever the reason, every gang, mob, hate group, Klan and cult member in the nation is involved while mainstream America is caught in the crossfire. Inevitably a civil war ruptures on the hostile city streets. This electrifying story will

shock readers into evaluating the future of our society."
$9.95 *(PB/235)*

America's Secret Destiny: Spiritual Vision and the Founding of a Nation
Robert Hieronimus, Ph.D.
"Historian, visual artist and radio host Robert Hieronimus is one of the country's top experts on the American Great Seal and has shared his research with such world leaders as Egyptian President Anwar el-Sadat. . . . Long before Christopher Columbus discovered America, the Iroquois had established their own League of Nations. We now know that the principles upon which their federation was founded directly influenced the drafting of the United States Constitution. It is also certain that the design of our nation's Great Seal, depicting a pyramid and an eye in the triangle, is a blueprint of America's future as envisioned by our founding fathers. . . . showing how a spiritual vision of America's future was set forth in our most significant national documents and symbols."
$10.95 *(PB/145/Illus)*

American Extremists: Militias, Supremacists, Klansmen, Communists and Others
John George and Laird Wilcox
Two liberal researchers do their level best to separate the left-wing nuts and the right-wing nuts that keep our country's paranoia and misinformation flying. Hard Left, old and new: the Socialist Workers Party, Communist Party USA, Students for a Democratic Society, the Black Panther Party. Hard Right: the John Birch Society ("A plot to sell books?"), the Christian Right, the militias, the Nation of Islam, the KKK, neo-Nazis ("assorted"), and the Jewish Defense League. "What sort of radical groups exist? What do they want and what are they willing to do to accomplish their goals? How serious is the danger?" Or are they only 10 percent committed and 90 percent "cowards, dopes, nuts, one-track minds, blabbermouths, boobs, incurable tight-wads and—worst of all—hobbyists: people who have to enjoy a perverted, masochistic pleasure in telling each other forever how we are all being raped by the 'shh-you-know who,' but who, under no conditions, would think of risking their two cars, landscaped homes or

juicy jobs to DO something about it," as George Lincoln Rockwell, founder of the American Nazi Party in 1959, said in disdain and disillusionment. In-depth histories, profiles of founding personalities, political agendas, and an appendix of fake quotes and fabricated documents. **GR**
$18.95 *(PB/443)*

American Militias
Richard Abanes
A well-researched and anti-sensational look at the roots, rise, beliefs, personalities and diversity of the militia movement by a mainstream Christian cult expert. Chapters include: "Rise of the Patriots," "A Call to Arms," "Sovereign Citizen Rebellion," "The Saga of Ruby Ridge," "Waco Revisited," "Operation Enslavement," "Antichrists and Microchips," "Anatomy of a Conspiracy," "The International Jew," "Christian Identity," and "Holy Wars."
$14.99 *(PB/296)*

American Utopias
Charles Nordhoff
Grandfather of the co-author of *Mutiny on the Bounty*, writer-editor Charles Nordhoff (1830-1901) wrote *American Utopias* in 1875. First published under the title *The Communistic Societies of the United States*, this survey of Utopian communities across 19th-century America is stranger than fiction: One hundred years before hippies and free love, there were hippies and free love. This unabridged reprint provides a fascinating glimpse into the "alternative lifestyles" of a century ago. Nordhoff's journalistic approach is surprisingly modern: He provides balanced, detailed, first-hand observations of these mostly forgotten social experiments, from the Wallingford Perfectionists and the Separatists of Zoar to the Harmonists, who founded a town called Economy. Most poignant are the Icarians, human hermit crabs who moved into an abandoned Mormon commune called Nauvoo, succeeded where the Mormons had failed, then disintegrated after their leader decided that the best way to run a communistic society was under a dictatorship. A time capsule buried deep in our own back yard, *American Utopias* is a strange and memorable record of daily life as lived according to vanished religions, philosophies and cults of personality. **JAB**
$14.95 *(PB/449/Illus)*

The Anglo-American Establishment
Carroll Quigley
History of the Rhodes-Milner Group, a globalist British Imperialist secret society founded by Cecil Rhodes and which manifests itself today as the Council on Foreign Relations. The Clinton administration has at least six Rhodes Scholars on board. **FLA**
$14.95 *(PB/354)*

Are You Still a Slave?
Shahrazad Ali
"Dare to examine the root of your ideas. Take this test and find out if you experience slavery flashbacks that influence your behavior and control your thinking, and learn how to recover from the post-traumatic stress of slavery. Answers lead to complete recovery. Are you still a slave? You can't grow until you know." **SC**
$10.00 *(PB/161)*

The Assassination of Malcolm X
George Breitman, Herman Porter and Baxter Smith
"Who killed Malcolm X? What are the ideas they tried to silence? Exposes the cover-up surrounding Malcolm's murder—and the attempts to mutilate his revolutionary message." Raises the question of government involvement in the assassination. Provides background on the black leader and analyzes the trial, pointing to alleged discrepancies and unanswered questions that indicate wider culpability. Appendix of the FBI documents.
$14.95 *(PB/196/Illus)*

Best of Abbie Hoffman
Edited by Daniel Simon
Selections from *Revolution for the Hell of It*, *Woodstock Nation*, *Steal This Book* and new writings. The essential anthology from the man (one of the few from the '60s) who never stopped fighting. **AK**
$14.95 *(PB/421/Illus)*

The Best of *Attack!* and *National Vanguard* Tabloid
Edited by Kevin Alfred Storm
The National Vanguard is a Neo-Nazi group headed by Dr. William Pierce (the author of *The Turner Diaries*). The major difference

Interior view of the large winter solstice sunrise temple at South Woodstock, Vermont — from America B.C.

behind the National Alliance and other neo-Nazi groups is its blatant intellectualism, with articles on Ficthte, and a sociological interpretation of "Punk Rock." Makes for interesting reading, marred by inherent conservatism. **SC**
$16.95 *(PB/217)*

Beyond the Mask of Chivalry: The Making of the Second Ku Klux Klan
Nancy K. Maclean
The second Ku Klux Klan lasted from its founding ceremony at Stone Mountain, Georgia, on Thanksgiving night in 1915 to around 1930. This was the heyday of Klan activity. During this period the Klan used the issues of morality, immigration and race as recruiting tactics for both the working poor and the small businessman. For example, in Oregon, where the black population was nil, the Klan crusaded against the Catholics. **SC**
$30.00 *(HB/308)*

Black Athena: The Afro-Asiatic Roots of Classical Civilization, Volume 1—The Fabrication of Ancient Greece, 1785-1985
Martin Bernal
"Volume 1 concentrates on the crucial period between 1785 and 1850, which saw both the Romantic and Racist to the Enlightenment and the French Revolution, and the consolidation of northern expansion into other continents.... Bernal makes meaningful links between a wide range of areas and disciplines—drama, poetry, myth, theological controversy, esoteric religion, philosophy, biography, language, historical narrative, and the emergence of "modern scholarship."
$17.95 *(PB/575)*

Black Athena: The Afro-Asiatic Roots of Classical Civilization, Volume 2—The Archeological and Documentary Evidence
Martin Bernal
"Volume 2 is concerned with the archeological and documentary evidence for contacts between Egypt and the Levant on the one hand, and the Aegean on the other, during the Bronze Age from c. 3400 BC to c. 1100

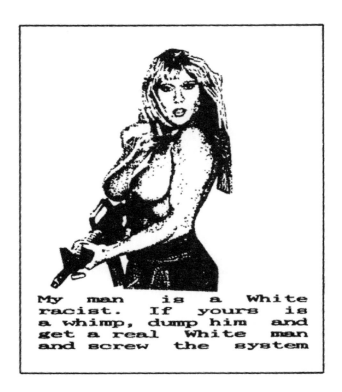

WAR poster — from **Blood in the Face**

BC. These approaches are supplemented by information from the later Greek myths, legends, religious cults and language. The author concludes that contact between the two regions was far more extensive and influential than is generally believed."
$17.95 *(PB/575)*

Black Indians: A Hidden Heritage
William Loren Katz
"In course of time the American people got in to Florida and began to live. This caused trouble. The colored people and the Indians, being natives of the land, naturally went on the warpath. They fought until the American people called. The Indians and the Negroes gave them peace."—Joe Phillips, Black Seminole, 1930 **SC**
$10.00 *(PB/198)*

Black Macho and the Myth of the Superwoman
Michele Wallace
Wallace blasts the sexist politics of the

black nationalist movements of the '60s, showing how black women had been systematically demeaned by the nationalists' patriarachal culture. This revised edition includes a new introduction surveying the controversy spawned by the book on its first publication in 1979. **AK**
$17.95 *(PB/228)*

Black Man of the Nile and His Family
Yosef ben-Jochannan
Dr. ben-Jochannan's best-known work, capturing the crux of his Afrocentric research. This overview of what constitutes Africa and Africans challenges and exposes the "Europeanization" of African history, by means of a point-by-point refutation of the distortions committed by more traditional European scholars. **SC**
$24.95 *(PB/428/Illus)*

Black Mask and Up Against

the Wall Motherfucker
Black Mask Group

"Blown minds of screaming-singing-beaded-stoned-armed-feathered future-people are only the sparks of a revolutionary explosion and evolutionary planetary regeneration. Neon nirvanas finally overload their circuits—Watts pulls out the plug and sets the country on its own inextinguishable electrical fire as we snake dance through our world trailed by a smokescreen of reefer."—from the essay "Acid Armed Consciousness"

Mandatory reading for modern anarcho/artists, this collection of writings and manifestoes from the notorious '60s revolutionary group Black Mask (later to become the Motherfuckers) reveals what havoc can be wrought by cultural workers who take seriously the tenets of Berlin Dada circa 1918. From "Black Mask No. 1—Nov. 1966: On Monday, October 10 at 12:30 p.m. we will close the Museum of Modern Art. This symbolic action is taken at a time when America is on a path of total destruction and signals the opening of another front in the worldwide struggle against suppression. We seek a total revolution, cultural as well as social and political—LET THE STRUGGLE BEGIN."

Of special interest is the section dealing with the clash between this group and hip capitalist Bill Graham, centered around his Fillmore East venue and its possible status as a cultural center for the East Village. A "free" concert for the MC5 brings out the Motherfuckers who, following what they perceive as a not very revolutionary show, proceed to rough up the group and call them "phonies" after they jump in a limo headed for Max's Kansas City. The MC5 may have "kicked out the jams," but it took the uncompromising Motherfuckers to kick out the MC5.
AS
$11.95 *(PB/140)*

The Black Muslims in America
C. Eric Lincoln

"Hailed as one of 'the best technical studies in the whole literature of the social sciences' upon its original publication in 1961, *The Black Muslims in America* in the third edition provides a new generation of readers with an enriched, up-to-date knowledge of the important but little-understood Black Muslim movement."
$12.95 *(PB/288/Illus)*

Blood, Carnage and the Agent Provocateur: The Truth About the Los Angeles Riots and the Secret War Against L.A.'s Minorities
Alex Constantine

Excellent reporting on the riots and their aftermath and specifically on the use of provocateurs, spies and cover-ups by various arms of the secret state. Includes a postscript on similar activities in the Watts riots.
AK
$4.95 *(PB/80/Illus)*

Blood in the Face: The Ku Klux Klan, Aryan Nations, Nazi Skinheads and the Rise of a New White Culture
James Ridgeway

A comprehensive look at white-power movements from the inside out. Through cartoons, pamphlets and other redneck-white-trash writings, this *Village Voice* political correspondent covers all the beauty of far-Right white hate. Contains genealogical diagrams of white-power groups from their inception, and coverage of David Duke's "transformation" from Grand Wizard of the KKK into a mainstream, ostensibly toned-down, smarmy politico. Other chapters include "Worldwide Conspiracy," "Resurgence," "The Fifth Era," "Posse Country" and "New White Politics."
MW
$19.95 *(PB/223/Illus)*

The Borgias: The Rise and Fall of the Most Infamous Family in History
Michael Mallett

Machiavelli wrote in *The Prince* (Mussolini's favorite bedtime reading) that if Cesare Borgia had managed to live just a few more years, he could have made himself master of all Italy. After reading Michael Mallett's *The Borgias*, one can see that Machiavelli understates the case. Rising from obscure origins in the Spanish gentry, within two generations the Borgias had made themselves equal to all the ruling houses of Europe in regard to power politics. Rather than obsess on one particular family member (a difficult choice), Mallett thinks in terms of general family traits whose qualities manifest themselves in different pro-

portions. These traits consist of religious devotion, poisoning/murder, sexual license (including incest), self-aggrandizement, and a knack for asset management. Although it is tempting to think they burst into history like a storm and then dissipated, the Borgias possessed great staying power. In addition to Rodrigo, Cesare and Lucretia, we also meet the more obscure St. Francisco Borgia, whose was married to the niece of St. Ignatius de Loyola, founder of the Jesuit order. Co-existing with various monsters, murderers and libertines are the ubiquitous younger Borgia women who take religious vows, adding the requisite note to make this the quintessential family of contrasts. Furthermore, the family branches stretched back to Spain and from there to the New World, where the Borgias managed to end up as viceroys of Peru.
MM/ES
$10.00 *(PB/368)*

Bosnia: A Short History
Noel Malcolm

Bosnians are a remarkable mix of Catholics, Christians, Croats, Gypsies, Jews, Muslims, Serbs, Slavs and numerous other influences. In the opening to this intriguing history book, the author maintains that because Bosnians can hardly understand themselves, they cannot possibly be understood by outsiders. We are then witness to a Bosnia raided, ransacked and pillaged by outsiders from her very beginnings, through the tragic war. The author doesn't stop at blaming outsiders but points to the ignorance and ethnocentricity of the Bosnian people themselves, especially those who define themselves in terms of race and religion over birthplace. He drives home not only how misunderstood the modern Bosnian war was, but also how ignorant most world leaders were about the conflict. Readers will appreciate the depth and understanding brought to this subject. It is the first time a full history of Bosnia has been undertaken.
GE
$26.95 *(HB/340)*

The Broken Spears: The Aztec Account of the Conquest of Mexico
Edited by Miguel Leon-Portilla

"For hundreds of years, the history of the conquest of Mexico and the defeat of the Aztecs has been told through the words of Spanish victors. . . . In this new and updated edition of his classic *The Broken Spears*,

Leon-Portilla has included accounts from native Aztec descendants across the centuries. These texts bear witness to the extraordinary vitality of an oral tradition that preserves the viewpoints of the vanquished instead of the victors."

$13.00 *(PB/256/Illus)*

By Any Means Necessary
Malcolm X
Contains examples of Malcolm X's writings in his last year, when he had broken with the Black Muslims and started his own Organization of Afro-American Unity. "I read in one book where George Washington exchanged a black man for a keg of molasses. Why, that black man could have been my grandfather. You know what I think of old George Washington."

$15.95 *(PB/191/Illus)*

A Call for Hawaiian Sovereignty
Michael Dudley and Keoni Agard
The true history of the United States' takeover of the Hawaiian Islands has never really been told to the American people. Once again, big business—in this case the sugar business—was behind the unlawful takeover of the islands by the U.S. Government, which used the pretext that U.S. nationals were in danger. This call for sovereignty is from Native Hawaiians, who have been given the shaft, time and time again, by the U.S. This new nationalism is based on the need of the native population in the islands to survive and prosper, while questioning the ability of native Hawaiians to adjust to "modern society." **SC**

$12.95 *(PB/162)*

Catechism of the Revolutionist
Sergei Nechaev
A ruthless set of "how-to" rules for the revolutionary. From the man who walked it like he talked it. Much loved by the Black Panthers but hated by everyone else. **AK**

$1.00 *(Pamp/12)*

The Chicago Conspiracy Trial
John Schultz
A dynamic eyewitness account of the infamous Chicago Conspiracy Trial and the events surrounding it by journalist-historian John Schultz. Involving eight antiwar activists (including Tom Hayden, Bobby

We also see such projecting eyebrows in occasional human males today, for instance, in former Socialist Member of Parliament, Lord Dennis Healey. — from **Cities of Dreams**

Seale, Dave Dillinger, Rennie Davis, Abbie Hoffman and Jerry Rubin) accused by the Government of "conspiracy" and with individually crossing state lines to "incite, organize, promote and encourage" the antiwar riots in Chicago during the 1968 Democratic Convention, the trial proved to be one of the most crucial events of the entire Vietnam War period. From the illegal and arbitrary rulings of Judge Julius Hoffman to the courtroom antics of Abbie Hoffman and Jerry Rubin to the bounding and gagging of Bobby Seale and Schultz's own astonishing conversations with two of the women jurors, the trial is covered in all its bizarre aspects with persistence, clarity and verve. Most remarkable is Schultz's dispassionate fairness; though generally sympathetic to the defendents he's not uncritical of some of their motives. Likewise, while capable of appreciating the difficulties faced by the Government prosecutors he's unsparing in his accounts of the despicable strategies employed in order to win a conviction. Necessary reading for anyone interested in the history of the antiwar movement as well as those concerned with the workings of the jury system. **MDG**

$14.95 *(PB/402)*

The Chosen People From
the Caucasus: Jewish Origins, Delusions, Deceits and Historical Interactions With Blacks
Michael Bradley
"The obvious differences between the biblical Jews and their neighbors in the ancient Middle East derive mainly from their very strong Neanderthal physical and mental traits, not from any sort of moral superiority or special status as being God's chosen people. . . . the typical Neanderthal psychological trait is an inordinately high level of aggression, brought about by an overpowering urge to preserve identity in time. And it was this, and probably this more than anything else, that permitted the Jews to survive, against all odds, as coherent people in an area which was the natural borderland of huge and ancient empires." By the author of *The Iceman Inheritance*.

$14.95 *(PB/270/Illus)*

Cities of Dreams: When Women Ruled the Earth
Stan Gooch
The author contends "that the totally fortuitous biological mixing of Neanderthal and Cro-Magnon genes (. . . it seems that the mix occurred solely in the context of rape

and slavery) produced virtually overnight the vigorous and gifted hybrid that is ourselves, modern man. . . . At the purely psychological/cultural level, I suggest that Neanderthal dealt Cro-Magnon a culture shock of such magnitude that its consequences are still with us today. Though it left little physical trace, there is in fact, as will be shown, not one aspect of our present lives, our attitudes and our institutions which does not bear that ancient culture's stamp." Explores Neanderthal moon worship, the significance of red ochre (also known as the bloodstone) and menstruation in Neanderthal culture, hybrid Neanderthal survivals in contemporary times, the Neanderthal symbolism in Rosicrucianism and the surprising pro-Neanderthal bent of the British Labor Party.

$15.95 *(PB/298/Illus)*

Cloak and Gown: Scholars in the Secret War, 1939-1961
Robin W. Winks
Few institutions demonstrate America's changing role in world affairs as vividly as the Central Intelligence Agency. In the 1930s, America did not even have an organized intelligence network. The Office of Strategic Services was mobilized as America prepared for war, eventually including separate branches for Research and Analysis, Secret Intelligence, and Counter-Intelligence (with the cool moniker "X-2"). After World War II, the OSS was disbanded for fear that in peace-time it would create an American Gestapo. R and A was reassigned to the State Department, SI and X-2 were re-assigned to the military and later spun off into the Central Intelligence Agency. Given this precarious start, it is surprising that the CIA is the Cold War institution to out-live and prosper beyond the Soviet threat, while nuclear arsenals and military bases choke on their own mothballs.

Winks' history of "scholars in the secret war" is in unique contrast to the monolithic inevitability of the CIA today. He presents an almost anecdotal account of Yale's involvement in the OSS, in the process showing how this involvement and the resulting intelligence agencies were shaped by the specifics of Ivy League academia. His first chapter, "The University: Recruiting Ground," provides a sympathetic, yet still critical, insider's description of the privi-

leged mores of Ivy League campus life. Most significantly, Winks describes how the English-style "college" system, by which Yale organizes students into schools overseen by a headmaster, facilitated professors' channeling of promising students to the OSS Likewise, Yale alum and University Press editor Wilmarth Sheldon "Lefty" Lewis, developed the Central Information Division's data-card filing system, using minutiae-honed skills from editing the complete correspondence of Horace Walpole, originator of the Gothic novel (a 42-year project not completed until 1983, four years after Lewis' death). The resulting system was unmatched in its detail and complexity, serving as the basis of intelligence analysis for decades to come.

Unfortunately, Winks does not print a sample of this information-science marvel, which is less to the point of his book than the fact that Lewis got the assignment "because he was having lunch with the Librarian of Congress one August day in 1941 at the MacLeish home in Conway, Massachusetts." Such observations are not entirely flippant, but demonstrate the casual way the modern CIA came into being. Winks' wanderings through social clubs, campus fraternities and faculty luncheons are perhaps his book's greatest assest, the means by which he secularizes the CIA's pre-history, removing it from the mythical realms of conspiracy cabals and returning it to the world of real human actions. **RP**
$22.50 *(PB/607/Illus)*

The COINTELPRO Papers: Documents from the FBI's Secret Wars Against Dissent in the U.S.
Ward Churchill and Jim Van der Wall
Fascinating dissection of the war against "subversives," everything from assassinations to fomenting race wars. **AK**
$22.00 *(PB/468/Illus)*

Columbus: His Enterprise — Exploding the Myth
Hans Koning
"Koning describes how Columbus' consuming drive to send 'mountains of gold' back to Spain shaped his life, beginning the story with his childhood in Genoa and ending after his return from his fourth and final voyage, an old man in disgrace. He shows how Columbus' 'discovery' led to the

enrichment of the conquerors through the plunder and murder of the native peoples of the Americas."
$13.00 *(PB/140/Illus)*

The Columbus Conspiracy: An Investigation Into the Secret History of Christopher Columbus
Michael Bradley
Reopens the debate over the identity of Columbus. arguing that Columbus was most likely working for the Cathars, the Jews and the Moors instead of for Catholic Spain. The author argues this point by citing the fact that it was common for Christian heretics, in this case the Cathars, to use surnames that reflected their religious beliefs. One of the most common Cathar names, he claims, was Dove, which can be translated as Columbus. Also discussed is the very concept of discovery, as it's well-known that Vikings had tried to set up colonies in the Newfoundland. The real question, he says, is did Columbus really "discover" anything?
SC
$11.95 *(PB/254/Illus)*

The Comfort Women: Japan's Brutal Regime of Enforced Prostitution in the Second World War
George Hicks
"Fortunately, I never got VD. One of the girls did and I heard that she was taken away and beaten to death. The rest of us remained quite healthy. Given our hectic sex life. I don't understand how we remained healthy. Maybe we were just a bunch of young country girls living off our youth." There are said to have been 100,000 "comfort girls" recruited by the Japanese military during World War II, and set up in brothels throughout Asia. Today the surviving women once forced into prostitution by Japan's "Imperial Forces" are in the process of suing the Japanese government for their years of degradation and abuse. **JB**
$25.00 *(HB/303/Illus)*

The Communist Manifesto
Karl Marx and Friedrich Engels
The standard U.S. edition of international socialism's most popular pamphlet. Marx before the Marxists intervened. **AK**
$4.95 *(PB/48)*

Conspiracies, Cover-Ups and Diversions: A Collection of Lies, Hoaxes and Hidden Truths
Stewart Home

"Is Prince Charles the reincarnation of Hitler? Does the Queen push drugs? Is the invisible Rosicrucian College still active in London? Does the Vatican ritually abuse children? Is the CIA responsible for the death of Kurt Cobain?" Home revives the spirit of the scandal-sheet press, responsible for bringing down the monarchy in France, and hopefully he will succeed where others have failed in England. Twenty essays on subjects ranging from occultist royals, microchips and Dresden to Gilbert and George, the K Foundation, bioengineered criminality, and TV terrorists. **FLA**

$6.95 *(Pamp/48)*

Countering the Conspiracy to Destroy Black Boys
Jawanza Kunjufu

"Describes how African-American boys are systematically programmed for failure so that when they become adults they pose little danger to the status quo. By their control of key social institutions, European-Americans have denied the African-American boy the fruits of his heritage, culture and 'rights of passage.' As a result, the African-American boy becomes the bearer of social maladies which he carries with him into adulthood."

$19.95 *(HB/205/Illus)*

Crown Against Concubine: The Untold Story of the Recent Struggle between the House of Windsor and the Vatican
N.H. Merton

Forty pages of pure pleasure. Any conspiracy theorist could riff endlessly on the contrapuntal themes of Jesuits, Royals and British intelligence, but it takes a special kind of mind to state—not suggest—that books supposedly written by Graham Greene, Somerset Maugham and Martin Amis were in truth churned out by squads of "female typists" in order to free up the great writers for the manly work of "assassination and mass murder." Also put forth in this brilliantly written diatribe are the self-

evident facts that not only does Prince Charles consider himself to be the reincarnation of Hitler but that if he succeeds to the throne his first act will be to make Ancient Icelandic the official language of Great Britain. The writer's ironic style and arcanity of information are greatly reminiscent of recent satirical tracts by English Neoist Stewart Home (see his *Conspiracies, Cover-Ups and Diversions*), so the too-credulous reader should bear in mind that this could be disinformation of the highest and most impish sort. Best read with a grain, if not a shaker, of salt, but that only adds to the flavor. **JW**

$4.50 *(PB/40)*

The Crusades Through Arab Eyes
Amin Maalouf

"European and Arab versions of the Crusades have little in common. What the West remembers as an epic effort to reconquer the Holy Land is portrayed here as a brutal, destructive, unprovoked invasion by barbarian hordes. When, under Saladin, a powerful Muslim army—inspired by prophets and poets—defeated the Crusaders, it was the greatest victory ever won by a non-European society against the West. . . . Amin Maalouf has combed the works of Arab chroniclers of the Crusades, many of them eyewitnesses and participants in the events they describe. . . . Maalouf offers fascinating insights into the historical forces that even today shape Arab and Islamic consciousness."

$16.00 *(PB/293)*

Cult Rapture
Adam Parfrey

At first this seems as though it might be a sequel to *Apocalypse Culture* with an emphasis on "last days" cults, perhaps a written extension of Parfrey's "Cult Rapture" art exhibit in Seattle. In fact, although there are chapters on real "cults," such as the followers of Indian God-man Sai Baba and the much-ridiculed Unarius flying-saucer contactee group, much of this book has little, if anything, to do with any type of cult.

The majority of this book reprints Parfrey's writing that has appeared in such diverse publications as the *Village Voice*, the San Diego *Reader* and *Hustler*. The non-Parfrey material includes Jonathan Haynes' treatise "The Sex Economy of Nazi Germany," the

weirdest, if not the most bizarre, chapter in the whole book. Haynes is a white supremacist who is convinced that there is a Jewish conspiracy to stop him from getting laid. He gets so mad about it that he kills a hairdresser (for creating fake Aryans by turning hair blonde) and then a guy who sells blue-tinted contact lenses. Before he did this, he sent Parfrey a screed about the Nazis' policy of government-run Free Love. Parfrey reprints this along with a rundown on the antics of the Cult of One. Also included are chapters on the big-eyed children painters (Walter and Margaret Keane), shock treatment, and James Shelby Downard's hyper-paranoiac Mason-directed mail-order bride exposé, a critique of anti-masculinist Andrea Dworkin, a G.G. Allin interview, and a chapter on human oddities that contains many previously published accounts of questionable authenticity that seem to be repeated solely for the shock value. The second half of the book turns into Militia Rapture as Parfrey turns his attention to right-wing spokesman Bo Gritz, SWAT training camps, Waco conspiracy theorist and hornets-nest-stirrer Linda Thompson, and a low-down on the Oklahoma-bombing conspiracy evidence. **TC**

$14.95 *(PB/371/Illus)*

The Dark Side of Europe: The Extreme Right Today
Geoffrey Harris

The Continental twins of evil—fascism and racism—are back for another bite. "Charts the growth of fascism through the decades following the Second World War to its present-day resurgence in the aftermath of the Cold War. It paints a somber picture of Europeans threatened by racist politics and terrorism, and struggling to come to terms with the problems of living in a multiracial society." Some issues covered are the rewriting of history, the rise of the new right, secret service corruption, and extreme-right terrorism in Italy. **GR**

$25.00 *(PB/265)*

The Dedalus Book of Roman Decadence: Emperors of Debauchery
Edited by Geoffrey Farrington

"The selected passages provide a vivid picture of sexual excess and debauchery in a cruel and violent society."

$14.95 *(PB/356)*

Desert Slaughter: The Imperialist War Against Iraq
Statements of the Workers League
"Millions of words have already been written about the Persian Gulf War. But only in this volume will the critical reader find a coherent analysis of the Gulf crisis at every stage of its development, from the Iraqi occupation of Kuwait on August 2, 1990, to the genocidal air and ground assault mounted by U.S. military forces in January and February 1991, and the postwar explosions in the gulf region. . . . The Workers League approached the Persian Gulf War with implacable political hostility to American imperialism and to the White House criminals and Pentagon gangsters who orchestrated this slaughter of the Iraqi people. Genuine objectivity consists not in adopting a posture of being 'above the battle' but in showing the social and class forces expressed in such a crisis as the U.S. drive to war in the Persian Gulf."
$18.95 *(PB/450)*

The Devil Soldier: The American Soldier of Fortune Who Became a God in China
Caleb Carr
"The life and legendary exploits of Frederick Townsend Ward, an American adventurer and mercenary in 19th-century China. . . . A courageous leader who became the first American mandarin, Frederick Townsend Ward won crucial victories for the Emperor of China during the Taiping Rebellion, history's bloodiest civil war."
$15.00 *(PB/366/Illus)*

Dictators and Tyrants: Absolute Rulers and Would-Be Rulers in World History
Alan Axelrod and Charles Phillips
This is an encyclopedia of mankind's greatest and most infamous demagogues. They're all here, neatly arranged in alphabetical order, with a concise yet detailed summary of their lives. Some names most readers would not expect to see, such as Ikhenaton, while others have almost become household words. For people interested in history's most infamous and powerful tyrants, this book will more than fit the bill as a valuable reference tool. **JB**
$45.00 *(HB/340/Illus)*

Did God Make Them Black?
Isaac O. Olaleye
"Isaac Olaleye thoroughly explores the varied beliefs for racial differences—both physically and psychologically—through biblical references and scientific research."
$14.95 *(HB/186/Illus)*

Early Green Politics: Back to Nature, Back to the Land and Socialism in Britain, 1880-1900
Peter Gould
The story of 19th-century Green politics, which started with the realization that the Industrial Revolution wasn't the bringer of Utopia. Reformers still believed in the idea of progress and so tried to counteract the forced urbanization of the working-class . William Morris and others proposed a Utopian vision of industrialized villages.
SC
$45.00 *(HB/225)*

Early Homosexual Rights Movement, 1864-1935
John Lauritsen and David Thorstad
The lost history of a movement generally thought not to have an early history. From the struggle against the German anti-gay legislation of the 1870s to the destruction of homosexual groups by Naziism and Stalinism. With abundant references to well-known gay pioneers, their defenders and their enemies. **AK**
$9.95 *(PB/121/Illus)*

Ecofascism: Lessons From the German Experience
Janet Biehl and Peter Staudenmaier
This simplistic bit of Bookchinist propaganda is concerned with the re-emergence of fascism in the late 20th century, and with the use of environmentalism as a right-wing cause. The Right's tendency to use ecology has its historical roots in 19th-century romanticism and the Third Reich, and continues to the present day. The authors use the German historical model as a mechanism to study the role of ecology as a political tool, meanwhile propagating their vision of Social Ecology. **SC**
$7.00 *(PB/76)*

Ecology in the 20th Century: A History
Anna Bramwell
Documents the ideas and formulations between of the ideology of the ecology starting with the "blood and soil " mysticism in both Britain and Germany in the late 19th century to the Third Reich's "hidden agenda" of ecology. Using the literary background to scientific ecology, the author profiles such authors as Knut Hamsun and Henry Wiliamsom and the German biological ecologist Ernst Heckle. **SC**
$25.00 *(PB/292)*

Encyclopedia of Assassinations
Carl Sifakis
Russian religioso Rasputin, Grigory Yefimovich (c. 1892-1916), proved a tough nut to kill. "At the party Rasputin drank glass after glass of poisoned wine and several cakes and chocolates spiked with murderous doses of potassium cyanide. The plotters watched expectantly for Rasputin to keel over dead, but he did not. Instead, Rasputin danced and sang and called on the Prince to play the guitar. According to one later medical theory, Rasputin suffered alcoholic gastritis, with his stomach failing to secrete the hydrochloric acid necessary to get the cyanide compound to work.

"Yusupov excused himself to go upstairs, allegedly to get his wife. The Prince returned with a pistol and shot Rasputin . . . According to some, Rasputin fell to the floor, but as the Prince knelt to examine him, the mystic's eyes popped open and he seized the Prince by the throat. Yusupov tore himself free and ran to the courtyard with Rasputin in pursuit on all fours. As Rasputin rose to his feet, the Grand Duke shot him in the chest. Another conspirator shot him in the head. Many of the officers used their sabers on Rasputin, and the Prince seized an iron bar and struck the fallen victim several times with savage fury. Finally, the victim lay still, although it was said one eye remained open and staring. The conspirators trussed up the body and heaved it into the Moika Canal.

"Forty-eight hours later the body turned up in the ice of the Neva River. One arm had come free of the bindings, and Rasputin's lungs were filled with water. Rasputin had still been alive when dumped in the canal and had finally died by drowning." **GR**
$35.00 *(HB/228/Illus)*

Encyclopedia of Black America
Edited by W. Augustus Low and Virgil A. Clift
"A reliable and readable reference that rep-

resents in large measure the totality of the past and present life and culture of Afro-Americans," *The Encyclopedia of Black America* is a thorough, indispensible survey and summarization of the various major and minor aspects of the history of black Americans. The work of nearly 100 contributors, this volume is an imaginative, balanced accumulation of research, review and coverage presented throughout with scholarship, clarity and reflection. Entries are divided into three categories: articles, biographies and cross references. One drawback, perhaps, is its scale, which necessitates a brevity the editors acknowledge as an unfortunate necessity as the result of space limitations of beyond their control. Nevertheless—and regardless of your specific area of interest—this extraordinary single-volume reference text on Afro-American life and history is an excellent place to begin. **MDG**

$35.00 *(PB/921/Illus)*

Essential Writings of Lenin
Vladimir Ilyich Lenin

"For anyone who seeks to understand the 20th century, capitalism, the Russian revolution, and the role of communism in the tumultuous political and social movements that have shaped the modern world, the essential works of Lenin offer unparalleled insight and understanding. Taken together, they represent a balanced cross section of his revolutionary theories of history, politics and economics; his tactics for securing and retaining power; and his vision of a new social and economic order." Includes "What Is To Be Done?," "Imperialism, the Highest Stage of Capitalism," and "The State and Revolution."

$9.95 *(PB/372)*

The Evolution of Civilizations: An Introduction to Historical Analysis
Carroll Quigley

Quigley, the legendary teacher at the Georgetown School of Foreign Service and author of *Tragedy and Hope*, was a formative influence on President Bill Clinton, and this book gives a glimpse of his course on the rise and fall of civilizations, through the Mesopotamian, the Canaanite, the Minoan, the classical and the Western, and he identifies several stages of historical change within each: mixture, gestation, expansion, conflict, the uni-

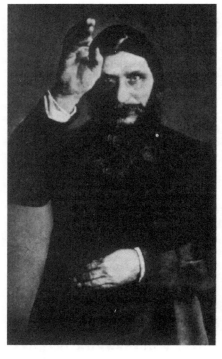

Many bizarre tales are told of the hypnotic monk Rasputin and his influence on Russia and the Imperial court. — from Encyclopedia of Assassinations

versal empire, decay and invasion. **FLA**

$20.00 *(HB/444)*

An Exhibit Denied: Lobbying the History of Enola Gay
Martin Harwit

The former director of the Smithsonian Air and Space Museum writes an exhaustive account of the museum's fight to present a large-scale exhibition dealing with the decision to use the A-bomb against Japan. When the proposed original exhibit was seen by many as top-heavy regarding American guilt, Congress and veterans' groups raised such an outcry that when the exhibit was finally approved, it consisted of little more than the *Enola Gay* and brief hints that the bomb it dropped over Hiroshima was effective, to a degree. Harwit describes in convincing detail what happens when history runs headlong into the politics of emotion, and both are sent reeling. A fascinating study of a successful fight against perceived political correctness results in offering up for public apprecia-

tion a viewpoint no less, and often more, distorted. **JW**

$27.50 *(HB/477)*

Eye-Deep in Hell: Trench Warfare in World War I
John Ellis

Provides a stark and disturbing account of the infernal madness that was trench warfare on the Western Front in the First World War. Maps, rare photographs and first-hand accounts help document the hideous nightmare world of No-Man's Land, where literally millions fell to the machine gun, the artillery barrage, the sniper and to disease, while scarcely affecting the outcome of the conflict. Their struggle was in vain ultimately due to the staggering failure of military and civilian leadership on all sides. As we approach the new century bearing horrified witness to the ongoing death rattle of places like Rwanda and Zaire, works like this serve as a chilling reminder of the fact that the Third World has by no means the monopoly on creating Hell on earth. **AD**

$14.95 *(PB/216/Illus)*

The Face of the Enemy
Martin Cager-Smith

This is a collection of photographs taken by British photographers in Germany between 1944-1952 and looks at Germany's defeat and the aftermath in the country right after World War II. As the British army moved through Germany's devastated landscape, they documented the defeated army and civilians they encountered. The many photos of lines of German prisoners of war show the reality and misery of defeat and the end of the line of the Hitler myth. There is a segment showing the conditions at the Belsen death camp, with pictures of the survivors and grisly line-up photos of the S.S. camp guards. The conditions after the camp was liberated showing delousing procedures, people scrambling for cigarettes, the boots of the dead being used as fuel for cooking and prisoners being buried are dramatically depicted. Also, photos show the destruction left after the war's aftermath with many pictures of decimated German cities like Bremen and Berlin and the mass migrations of people just trying to survive in the bombed-out landscapes. **MC**

$14.95 *(PB/127/Illus)*

Fart Proudly: Writings of Benjamin

Franklin You Never Read in School
Carl Japikse

"He that lives upon hope, dies farting."—Ben Franklin, *Poor Richard's Almanack*, 1736

Low- and highbrow humor are two sides of the same magnificent dunghill. Benjamin Franklin is world-famous as the man who helped write the Constitution, founded the U.S. Postal System and created numerous inventions, such as the bifocal lens. It is less well-known that Franklin couldn't help but occasionally access the bad little schoolboy side of himself. He loved pranks and toilet jokeseven as he was helping to found this country with his political acumen. Foregoing formality and convention for earthy shock effect, Franklin (a known member of England's notorious Hellfire Club) comes across as a quintessential, fearless American in these hilarious essays. Franklin proposed creating fart pills "to find means of making a Perfume of our wind." A pellet "no bigger than a pea, shall bestow on it the pleasing Smell of Violets." Move over, BreathAssure. He never came across as being "filthy" or "obscene." Instead, he liked to tell it as is. This would be one dangerous book to place in the hands of a visionary fifth grader with a book report due. For that matter, this would be the ideal book to place in the hands of a visionary fifth grader with a book report due! **CS**
$8.95 *(PB/128/Illus)*

Fascist Modernism: Aesthetics, Politics, and the Avant Garde
Andrew Hewitt

"What was it about fascism that made the movement, in its various forms, so attractive and exciting to such writers and artists as Wyndham Lewis, Ezra Pound, and Céline, among others? Using as a focal point the literary work of Filippo Tommaso Marinetti, the founder of the Italian Futurist movement and an early associate of Mussolini, the author examines the points of contact between a 'progressive' aesthetic practice and a 'reactionary' political ideology."
$14.95 *(PB/222)*

The Five Negro Presidents
J.A. Rogers

Did you know Warren G. Harding was a Negro? An "expose" of our five black presidents: Jefferson, Jackson, Lincoln, Harding, and one that will not be named here."
$2.25 *(PB/18/Illus)*

The Forbidden Best-Sellers of Pre-Revolutionary France
Robert Darnton

What causes revolutions? Is it a significant corpus of classic philosophical texts held in reverence centuries later? Apparently such texts barely caused a ripple in the book trade in pre-revolutionary France. Employing careful methodology, Darnton discovers that the French reading class of this period were more often than not reading books which fell under the broad categories of either philosophical pornography, utopian fantasy, or political slander. In discussing his reasons for what some may consider "sheer antiquarianism," Darnton explains "[T]hat the history of books as a new discipline within the 'human sciences' makes it possible to gain a broader view of literature and of cultural history in general. By discovering what books reached readers throughout an entire society and (at least to a certain extent) how readers made sense of them, one can study literature as part of a general cultural system." Detailed tables and maps detailing the book trade and communication networks in pre-revolutionary France, as well as reproductions of illustrations from representative texts and substantial extracts from three such works are presented. **JAT**
$14.95 *(PB/440)*

A Force Upon the Plain: The American Militia Movement and the Politics of Hate
Kenneth S. Stern

White supremacists Richard Butler and Robert Miles had a dream slightly different from Martin Luther King's. A new Aryan state would be created, comprising the land now known as Oregon, Washington, Idaho, Montana and Wyoming. Butler moved from California to Hayden Lake, Idaho, and built his Aryan Nations Compound. It conformed nicely with his vision: "A sign on the sentry box read "Whites Only." The office walls sported pictures of Adolf Hitler, swastikas, and other Nazi memorabilia. A bust of Hitler's head was kept inside a glass cabinet. In the chapel was another portrait of Hitler with a caption: "When I Come back, No More Mr. Nice Guy." So there appears to now be a race as to who will appear first: Christ or Hitler. The book's content is extremely comprehensive and offers inter-

esting descriptions of most of the so-called right-wing fringe groups existing in America today. **JB**
$24.00 *(HB/288)*

From "Superman" to Man
J.A. Rogers

This is a cleverly written story about a well-educated porter named Dixon and his interactions with various passengers, covering everything from crackers to self-hating educated blacks. But the story is a only a backdrop for Rogers' own historical research and philosophy:
"'Didn't you say you did not believe in the equality of the races?'
'Yes, sir.'
'Then why?'
'Because as you said, sir, it is impossible.'
'Why? Why?'
'Because there is but one race—the Human Race.'" **SC**
$11.95 *(HB/132)*

From the Secret Files of J. Edgar Hoover
Athan Theoharis

Hoover had a file on anyone who was anyone. Hoover loved files. Hoover loved dirt . . . just like the vaccum cleaner which bears his name. After reading *Secret Files* you will readily see that the most startling secret kept from the public was Hoover's own obsessions with sex, filth, race and orthodoxy:
"Informal Memo: In April, 1952, the New York Office received confidential information from a detective of the New York District Attorney's Office to the effect that Adlai Stevenson and David B. Owen, President, Bradley University, Peoria, Illinois, were two officials in Illinois who caused a great deal of trouble to law-enforcement officers. The detective had gone to Peoria to bring back basketball players who had been indicted in New York. The basketball players told the detective that the two best-known homosexuals in Illinois were Owen and Stevenson. According to the report, Stevenson was 'Adeline.'" **JB**
$12.95 *(PB/377)*

From Vietnam to Hell: Interviews With Victims of Post-Traumatic Stress Disorder
Shirley Dicks

"For many Americans the Vietnam War is over and long forgotten, but for thousands

of veterans, they still live the horror of this war. In flashbacks, nightmares and other symptoms, they relive the time they spent in the jungle. Some turn to alcohol, others to drugs, to blot the inner agony that has no name but many faces. Some mistreat their wives and children; some withdraw from society altogether.

"This book tells the stories of some of these Vietnam veterans who have been to hell and back, and the wives who stood by their men. The stories are heartbreaking and meant to inform people about post-traumatic stress disorder. Some of these men are on death row. They were taught to kill women and children; they were taught that life wasn't important; then they were never debriefed once back home. One day they were in the jungles of Vietnam; the next they were back in the States."

$21.95 *(PB/144/Illus)*

The Frozen Echo: Greenland and the Exploration of North America, circa A.D. 1000-1500

Kirsten A. Seaver
There is no doubt that sometime early in the 11th century medieval Norse sailors ventured west and south from settlements in Greenland searching for lumber and fur on the North American continent. Excavations 30 years ago in northern Newfoundland proved that the site found at L'Anse aux Meadows was Norse, and that it could be reliably dated to approximately A.D. 1000.

This book establishes the latest archeological evidence for Norse habitation of the New World; describes the nature of North Atlantic commerce in both commodities and ideas, discusses the role of the Catholic church at the farthest reaches of European settlement; charts relations between Norse settlers and indigenous people; and chronicles the often strained political relations between colonists and their European home governments. Finally, there are some new ideas about what became of these people when large-scale European exploration began to bypass the northern settlements in the 15th century. **JTW**
$49.50 *(HB/428/Illus)*

Gone to Croatan: Origins of North

American Drop Out Culture

Ron Sakolsky and James Koehline
Gone to Croatan follows the nearly submerged traces of those who took the term "Land of the Free" at face value. This compilation of essays (plus collages, etc.) from Autonomedia such as "Anarchy in the American Revolution," "Caliban's Masque: Spiritual Anarchy and the Wild Man in Colonial America," and "The Many-Headed Hydra: Sailors, Slaves, and the Atlantic Working Class in the Eighteenth Century" spasmodically reveals the outline of another America—not the one methodically constructed by steely-eyed homesteaders and take-no-prisoners robber barons—but a tripped-out, freer American history that they would never want you to know about in high school. The collection takes its title from the lost colony of Roanoke, Va. which disappeared entirely, leaving only the cryptic message "Gone to Croatan" carved on a tree, referring to a nearby Indian tribe in the Great Dismal Swamp. As Peter Lamborn Wilson describes the episode, "European vagabonds transmuted themselves into Noble Savages, said goodbye to Occult Imperialism and the miseries of civilization, and took to the forest."

An important segment of *Gone to Croatan* deals with the obscure and ill-fated Ben Ishmael, a multiracial nomadic Muslim tribe who ventured out of the Kentucky hills and set up the first permanent settlement in what is now Indianapolis. The determined extermination and forced sterilization campaign against this steadfastly communal and anarchistic group by the "Progressives" of their day led to the world's first eugenics laws in the state of Indiana, directly inspiring the Nazi legal codes of the '30s and '40s. The Ben Ishmael are also linked to the murky origins of the Nation of Islam in the northern Midwestern cities of Detroit and Chicago.

While at times bogged down into the kind of academic term-paper navel-gazing which generates phrases like "to (re)write 'Louis Riel' into a liminal textual space" and stock lefty anti-Columbus posing, *Gone to Croatan* is generally filled with startlingly vibrant historical detail. From the bacchanalian "Revels of New Canaan" of Mayday 1627 that freaked out the totalitarian Puritan sectarians, to the 18th century "Whiteboy Outrages" in Ireland led by such rad rebel captains as "Slasher" and "Madcap

Setfire," *Gone to Croatan* is the suppressed history of individualist anarchists in early colonial times, utopian communal experiments, escaped slave and Indian alliances, marauding "land pirates" and politicized trans-Atlantic waterfront "mobs." **SS**
$12.00 *(PB/384/Illus)*

Guerrilla Prince: The Untold Story of Fidel Castro

Georgie Anne Geyer

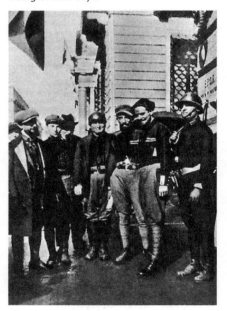

Balbo quadrumvir (second from right) during the March on Rome (October, 1922) — from Italo Balbo

It was Ed Sullivan who once presented Castro to his American audience as the "George Washington of Cuba." This book almost echoes that refrain, along with such tidbits as the following lyrics sung to "Jingle Bells" in Cuba:

> With Fidel, with Fidel
> Always with Fidel
> Eating corn or *malange*
> Always with Fidel

Whether this constant injesting of corn or malange has in any way contributed to Castro's undoubted charisma is beside the point, which is that while maligned in the United States, Castro has held on to the reigns of power in his native country as Franco did in Spain. The author relates with startling clarity and many interesting historical sidelights how Castro has confound-

ed his adversaries over and over again. Adversaries like Luis Somoza, who remarked before the Bay of Pigs expedition: "Bring me a couple of hairs from Castro's beard." **JB**
$12.95 *(PB/458/Illus)*

Gun Control: Gateway to Tyranny
Jay Simkin and Aaron Zelman
Original German text and translation, with an analysis that shows U.S. Gun Control laws have Nazi roots. Just when you thought you had heard everything . . . Here are the original Reichsgesetzblaetter, or Law Codes from 1932. (The Nazis did not ascend to power until 1933.) The authors heap text upon text in their attempts to persuade the reader. As a final argument, they print Sarah Brady's picture right next to Adolf Hitler's. Sure to be a tie breaker at any debating group. **JB**
$19.95 *(PB/147)*

Harlem at War: The Black Experience in World War II
Nat Brandt
"A vivid re-creation of the desolation of black communities during World War II examining the nationwide conditions that led up to the Harlem riots of 1943."
$28.95 *(HB/277/Illus)*

Hate Crimes: The Rising Tide of Bigotry and Bloodshed
Jack Levin and Jack McDevitt
Who else but Morris Dees would be worthy enough of writing the preface to this book, which analyzes scores of hate crimes throughout America. This book is packed with every conceivable tidbit of rancor imaginable. For instance, a quote from Louis Farrakhan: "Listen Jews, this little black boy is your last chance because the Scriptures charge you with killing the prophets of God. . . . You cannot say 'Never again' to God, because when he puts you in the oven, 'Never again' don't mean a thing." Or how about the facts behind the "Temple of Love" in Miami? Their charismatic leader, Yahweh Ben Yahweh (God, Son of God, in Hebrew) preached that all whites were "serpents" and "demons." As part of the initiation ceremony for joining the temple, devotees had to murder a "white devil." But several victims were blacks who somehow challenged Yahweh's commandments. In his sermons

Yahweh told his followers, "All hypocrites must die." Strange that he saw no irony in that directive. **JB**
$23.95 *(HB/287)*

Hate Speech: The History of an American Controversy
Samuel Walker
Examines America's unique First Amendment protection of "even the most offensive forms of expression: racial slurs, hateful religious propaganda, and cross burning . . . from the conflicts over the Ku Klux Klan in the 1920s and American Nazi groups in the 1930s, to the famous Skokie episode in 1977-78, and the campus culture wars of the 1990s. The author argues that the civil rights movement played a central role in developing this country's strong free speech tradition." In fact, the American Civil Liberties Union (ACLU) rose out of the first political and legal clash over free speech/hate speech rights in the '20s. **GR**
$11.95 *(PB/256)*

Historical Evidence for Unicorns
Larry Brian Radka
"The historical evidence for unicorns still firmly stands—because THE LORD GOD SAYS SO! THE HOLY BIBLE SAYS SO! THE ANCIENT MONUMENTS SAY SO!"

From this endearing premise Radka builds an unshakable case. "Many printed authorities tend to evade—or even outright deny—the proof of their existence," he notes, and this baffling situation has led him to demonstrate that unicorns are real because unicorns are real—so there. It's hard to argue with the perfection of this logic; easier, in fact, to imagine that the world is round. Clearly unfamiliar with such non-biblical concepts as myth, legend or metaphor, Radka takes as hard fact any mention in any culture of the fabulous beast. His chapter on "Current Evidence" purports to show that unicorns exist today; by "current," however, he means 1486. Radka does, however, offer as evidence a badly reproduced photograph of a freak sheep. **JW**
$15.00 *(PB/152/Illus)*

The History of an American Concentration Camp
Francis Feeley
A classic piece of social history. The story of

the forced removal, and incarceration, of the Japanese-American population during World War II. Details not only the concentration camp in Pomona, Calif. but the whole strategy of dominance employed and the attempted destruction of an ethnic community. **AK**
$10.00 *(PB/116)*

A History of Secret Societies
Arkon Daraul
Cornerstone of conspiracy research, with the Thuggee stranglers of India, Russian castration cults (Skoptsis), the Knights Templar, Rosicrucians, the Tongs and Hassan-i-Sabah (founder of the Hashishin, or Assassins).
$10.95 *(PB/256/Illus)*

The Hitler Fact Book
Thomas Fuchs
The man with the little mustache is profiled by the minutiae of his earthly existence. Chapter titles include "Hitler's Women," "Hitler's Diet," "Hitler's Horoscope," "I Was Hitler's Dentist," "Hitler Laughs," and "Why Didn't Somebody Kill Him?" There's still lots to learn about Germany's Swastika Prince. His real name wasn't Shickelgruber. He farted quite often in the presence of guests. He popped amphetamine capsules eight times a day. His mother's portrait hung over his bed. He put seven teaspoons of sugar in his tea. He stayed mostly indoors to avoid "fresh-air poisoning." He administered his own enemas. He sucked his fingers and chewed his nails. He said the Volkswagen "should look like a beetle. " He commissioned pornographic films for his private viewing. He gave Henry Ford a medal for being a foreign friend of the Reich. **GR**
$14.95 *(PB/255/Illus)*

The Hoffman Newsletters
Michael A. Hoffman II
Michael Hoffman is an interesting fellow—a self-described white separatist, Fortean, Holocaust revisionist and anti-Masonic researcher. He has also been a stringer for AP and news editor and radio commentator for WEOS-FM. It is hard to dismiss him as a simple bigot. He is obviously highly intelligent and very literate, if pedantic. He has his own world view that he has been sharing over the years in his sometimes interesting and always high-priced newsletters.

This is a complete collection of his newsletters from 1987 through 1995. Hoffman is his least interesting when he is discussing race issues. He obviously has an ax to grind, but it reads like the editorial page of your local paper. And considering that he is often opining on current events, it's like reading yesterday's paper. More interesting is his historical research: he is dedicated to revealing the hidden history of white slavery in America. Although his research into this subject has gained him some positive attention from some mainstream historians, one doubts that this is true of his other historical interest—the denial of the reality of the Holocaust. Hoffman once worked for the infamous Institute for Historical Review. Jabs at the Holocaust, which run throughout the newsletters, are sure to offend many.

Hoffman's exposé of the "psychodrama," the molding of major events to enact Masonic rituals, is the most interesting thread running through the newsletters. Apparently he thinks that some of the major events of recent history have been adulterated with Masonic symbolism in order to cause some kind of change in mass society. This happens in such a way that the ritual is obvious to the Mason/Controllers (and people like Hoffman) and has a kind of subliminal effect on the public at large. "Dismiss me as a tree-hugger or a kook, as you like. But you'll never dismiss the fact that three days after the U.S. started the war on Iraq, NASA turned the sky red over America. Canisters of barium were released in the air to achieve this awesome blood effect necessary to the pageantry of the alchemical show through which we are processed mentally and spiritually. On February 4, 14 bald eagles were ceremonially slaughtered in Oklahoma, in the heartland, their feet chopped off. The bald eagle is the national symbol of America. Must I spell it out for you? P-s-y-c-h-o-d-r-a-m-a; and on a huge scale here in the funhouse, where the real game is several magnitudes above the suit-and-tie talking heads." **TC**
$89.85 *(Spiral/330)*

How the Irish Became White

Noel Ignatiev

A social history of how the Irish strategically assimilated themselves as "whites" in America. Through examining the connections between concepts of race, acts of

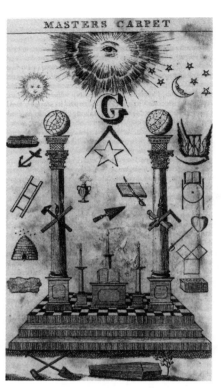

The Master's Carpet. An attempt to standardize Masonic symbols — from **Revolutionary Brotherhood**

oppression and social position, Ignatiev traces the violent history of Irish-American and African-American relations in the 19th century and the ways in which the Irish used labor unions, the Catholic Church and the Democratic Party to help gain themselves a secure place in the "White Republic." Further, he examines and challenges both the Irish tradition of labor protest and the Irish role in the wave of anti-Negro violence that swept the country in the 1830s and 1840s. The study concludes with a compelling recounting of the roles of northeastern urban politicians in the Irish triumph over nativism, a victory which allowed them entry into the "white race." A highly readable and scholarly polemic against traditional conceptions of race as well as a compelling meditation on the sources of racial antipathy, *How the Irish Became White* is necessary reading for anyone interested in the American history of race and class. **MDG**
$25.00 *(HB/256/Illus)*

The Hughes-Nixon-Lansky Connection: The Secret Alliances of the CIA From World War II to Watergate

Howard Kohn

"In 1976, *Rolling Stone* magazine ran a lengthy exposé of Nixon's connections with the CIA, the Howard Hughes Organization, and Meyer Lansky's syndicate. This key article exposes Nixon's involvement with Cuban gambling casinos and the $100,000 bribe he received from Howard Hughes. Here's the secret story of the president who was the Mafia's best friend."
$2.00 *(Pamp/19)*

The Illuminoids: Secret Societies and Political Paranoia

Neal Wilgus

Incredibly dense condensation of the gamut of conspiracy theories circa 1978 (that means no UFO/Area 51/secret bases). Inspired by Robert Anton Wilson's *Illuminatus!* trilogy, *The Illuminoids* takes the Illuminati out of the fictional context and back into the realm of speculative history, this time without the stridency of the "true believer." Part One is an entertaining and fact-filled recounting of the origins of the Bavarian Illuminati covering Adam Weishaupt, the Freemasons, Cagliostro, the French Enlightenment, the Founding Fathers, and on up to those busy bankers the Rothschilds, Rockefellers and Warburgs. Part Two is an equally dense chronology which runs from the birth of Voltaire and the founding of the Bank of England all the way up to the Gemstone File, the Bilderberg Conference, the SLA, and the attempted assassination of Larry Flynt. Part Three covers source materials, many possibly out-of-date. **SS**
$20.00 *(PB/262)*

Imperium

Francis Parker Yockey

A post-Spenglerian revamping of history . . . Yockey resigned in disgust from the Nuremberg war-crimes tribunal to write *Imperium* in 1948. He was arrested by the State Department on his return to the U.S. and found dead in his cell 11 days later. **SS**
$12.00 *(PB/626)*

In Defense of the Russian Revolution:

A Reply to the Post-Soviet School of Historical Falsification
David North

"These two lectures, delivered at the University of Michigan in the spring of 1995, challenge the claims of contemporary right-wing historians that the demise of the Soviet Union proved (1) that the October Revolution was nothing more than a putsch that lacked significant popular support; (2) that any effort to create a socialist society is doomed to failure; and (3) that the capitalist market is the only viable basis for human existence."

$3.95 *(Pamp/53/Illus)*

In the Name of Elijah Muhammad: Louis Farrakhan and the Nation of Islam
Mattias Gardell

"Tells the story of the Nation of Islam—its rise in northern inner-city ghettos during the Great Depression through its decline following the death of Elijah Muhammad, in 1975, to its rejuvenation under the leadership of Louis Farrakhan. [Swedish academic] Mattias Gardell sets this story within the context of African-American social history, the legacy of black nationalism, and the long but hidden Islamic presence in North America. . . . His investigation, based on field research, taped lectures, and interviews, leads to the fullest account of the Nation of Islam's ideology and theology, its complicated relations with mainstream Islam, the black church, the Jewish community, extremist white nationalists, and the urban culture of black American youth, particularly the hip-hop movement and gangs."

$21.95 *(PB/482)*

Interview With Sarah Jane Moore
W. H. Bowart

"President Ford twice became the target of gun-toting ladies: The first was Manson disciple 'Squeaky' Fromme, while the second was Sarah Jane Moore. Previously, she had given only one major interview, to *Playboy*, back in 1974. But now a noted researcher has obtained a much fuller account. For the first time, the would-be assassin spills the beans on her connections to the CIA, mind-control operations, and her work as an infiltrator for the FBI. A book-length compilation of historically important raw data."

$17.95 *(PB/190)*

Invasion of 'de Body Snatchers: Hi-Tech Barbarians
Del Jones

"Lack of vigilance has delivered the devils death to our door and we open before they knock and usher our enemies directly into our bodies, our minds, our souls. . . . And the ancestors scream in anguish as we dance into death's lap as if Greek fags in search of a screw, an orgy, a self-destructive demise in the stench of a genocidal anal odyssey. . . we spread our cultural legs as if we are cheap French whores and allow our enemies inside like pale flesh customers with diseased penises and a freaky appetite for deviance. This is why our culture suffers from a venereal disease, which creates madness, dysfunction and a yellow pus stream of blood-laced cowardice. . . . In addition, the spread of AIDS using inoculations in Africa under the guise that small-pox eradication was the goal, polluted our Motherland as the dying littered the beautiful landscape." **JB**

$12.95 *(PB/172/Illus)*

The IRA: A History
Tim Pat Coogan

"Completely revised and updated edition, including the inside story on the negotiations that led to the IRA's cease-fire declaration."

$16.95 *(PB/526/Illus)*

The Isis Papers
Dr. Frances Cress Welsing

This is the collected writings of Dr. Frances Cress Welsing, the controversial Washington, D.C. psychiatrist whose "Cress Theory of Color Confrontation and Racism" inspired the Public Enemy album *Fear of a Black Planet*. Her theory is that most of the cultural and political phenomena in Western (i.e., white) culture can be explained psychoanalytically by the envy of white people for the genetic color producing capacity of non-white populations. "The Color Confrontation Theory also explains why Black males' testicles were the body parts that white males attacked most in lynchings: the testicles store powerful color-producing genetic material. Likewise, the repeated and consistent focus on the size of Black males' penises by both white males and females is viewed by this theory as a displacement of the fundamental concern with the genetic color-producing capacity

residing in the testicles." Cress also analyzes the powerful symbology behind the Washington Monument (a large white phallus which towers over a largely black population), the Holocaust (the Jews were "chosen" to demonstrate that one should never disrespect "genetic heritage of Africa"), as well as "The Mother Fucker and the Original Mother Fucker," "Ball Games as Symbols: The War of the Balls," "The Symbolism of Boxing and Black Leather," and more. **SS**

$14.95 *(PB/301/Illus)*

Italo Balbo: A Fascist Life
Claudio G. Segré

Italo Balbo's life seems to embody many of the contradictions inherent in Fascism as it was originally conceived in Italy, its birthplace. Now obscure, Balbo was a beloved celebrity in the 1930s, greeted by ticker-tape parades in New York City and invited to lunch by FDR at the White House. Ruthless Blackshirt street fighter and union-buster, dashing commander of trans-Atlantic aviation squadrons, technology-embracing founder of Italy's first airline, imperialist governor of the Italian colony of Libya, Germanophobe and crusader against anti-Semitism, Balbo was one of the fascinating, larger-than-life figures thrown up by the Mussolini era. **SS**

$12.95 *(PB/482/Illus)*

J. Edgar Hoover, Sex, and Crime
Athan Theoharis

History professor Theoharis does his best to "un-out" the infamous FBI director and debunk the popular culture image of him as a crossdressing nelly. The book's approach is that Hoover was appointed during the '20s Harding administration with strict orders of NO DOMESTIC SPYING (after the public and Congress grew weary of this, unchecked and rampant, in his predecessor), yet collecting info for use against others was Hoover's obsession and main talent, what made him tick. The author asserts that Hoover was not inept at prosecuting the Mafia because (as legend states) of their cache of potentially ruinous, blackmail-ready photos, but because his spying methods would have been revealed if he had. In other words, Hoover enjoyed it if you were a deviant— and had endless files collected on every possible citizen, famous or otherwise—but wasn't one himself. (And ironically, the

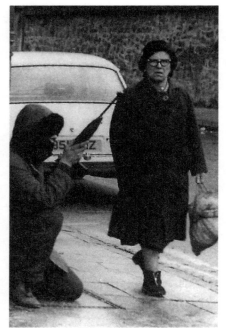

IRA volunteers, mid-'70s — from The IRA: A History

author points out that any kind of serious attempts at Mafia prosecution didn't happen until after Hoover's death.) We sense a conservative agenda at work here to specifically discredit the biography from which the popular sexy image of Hoover sprang, but there are enough well-researched examples of bureaucratic ineptitude and cloak-and-dagger government screw-ups to make this a solid, recommended read. **MS**
$19.95 *(HB/176)*

J. Edgar Hoover: The Man and the Secrets
Curt Gentry
A mammoth exposé of the evil closet case and psychopathic bureaucrat-powermonger who called the shots to presidents of both parties—G-Man #1 J. Edgar Hoover. The Beltway has never looked uglier or more hypocritical than in this sordid and sadly factual tale.
$15.00 *(PB/846/Illus)*

Jack Johnson: The Big Black Fire
R.H. deCoy
"The life of Jack Johnson, the first Afro-American heavyweight champion of the world, is the story of civil rights in the first

half of the 20th century. Single-handedly, he stood up against the boxing kingpins, the KKK, and the United States Government. He was the man whom William Jennings Bryan called 'a nigger' and the world heavyweight champion that Winston Churchill said was not welcome in England. Booker T. Washington condemned him for 'rocking the boat' and Jack London, then America's favorite writer, sent out a call for The Great White Hope—a white boxer who could defeat him and 'uphold the honor of white people.'" By the author of *The Nigger Bible*.
$4.95 *(PB/320/Illus)*

Japan's Secret War: Japan's Race Against Time to Build Its Own Atomic Bomb
Robert K. Wilcox
The biggest and best-kept secret of World War II: August 10, 1945, four days after Hiroshima and five days before their surrender, Japan successfully test-fired a "genzai bakudan"—an atomic bomb—on the northern peninsula of occupied Korea. Only America's use of the B-29 bomber over industrial cities on the mainland prevented the bomb from being used by Japan three months earlier (it had to be moved to safer ground). The weapon was intended for use by kamikaze planes aimed at American battleships in the attack on Japan. The world's first nuclear war! This fascinating footnote to history was reported in the *Atlanta Constitution* in 1946, and quietly disappeared for lack of verification—the Russians overran Korea and sent all the Japanese atomic equipment home after the war. The author has traced this astonishing tale with the help of newly declassified American intelligence first gathered during the war and during the occupation of Japan. Includes interviews with the scientists involved in the atomic program, and Spanish spies who stole American atomic secrets for Japan, and the story of a German U-boat desperately trying to reach Japan with a cargo of uranium in the final days before the Third Reich's collapse. **GR**
$12.95 *(PB/268)*

The Judas Factor: The Plot To Kill Malcolm X
Karl Evanzz
On February 21, 1965, Malcolm X was shot and killed, and the author of this book purports to know why. After 15 years of inten-

sive research, including hundreds of interviews and the examination of 300,000 pages of declassified FBI and CIA documents, the author contends that it was the aforementioned agencies who bear the responsibility for Malcolm X's death. The ubiquitous Hoover shows up everywhere as the master of puppets, a man who gloated over his victims, from John Dillinger to Malcolm X. Surprisingly, the author links the assassinations of both Malcolm X and George Lincoln Rockwell, the founder of the American Nazi Party, to the same source: COINTELPRO. Indeed, Rockwell received the greatest ovation of his career at a Black Muslim Rally in Washington in 1961. It is a compelling irony that neither Malcolm nor Rockwell were killed by white or black racists, respectively. As dynamic and charismatic figures, they were too much alike, thus, they were both recognized by the powers that be as a great danger to the status quo. "Officially" both men were assassinated by disgruntled former associates. Succinctly put by the author of the book: "I am convinced that Louis E. Lomax, an industrious Afro-American journalist who befriended Malcolm in the late 1950s, had practically solved the riddle of his assassination 25 years ago. Lomax, who died in a mysterious automobile accident while shooting a film in Los Angeles about the assassination, believed that Malcolm X was betrayed by a former friend who reportedly had ties to the intelligence community. In 1968, Lomax called the suspect 'Judas.'" However, if Lomax was right, and Malcolm *was* betrayed, it was not with a kiss, as the book graphically demonstrates. **JB**
$13.95 *(PB/405/Illus)*

KGB: The Inside Story
Christopher Andrew and Oleg Gordievsky
There have been a number of books written about the KGB, but this one is genuinely informative and loaded with rare photos as well. The book is remarkably well written, and the chapters on Stalin and the Cold War are unique and provocative. For those with an interest in the Rosenberg case, many new details have been provided by this well-informed author. Captivating and difficult to put down once you begin to sink your teeth into it, with intrigue, treachery, double-crosses and betrayals. **JB**
$20.00 *(PB/776/Illus)*

Kooks: A Guide to the Outer

Limits of Human Belief
Donny Kossy

Rant #1: "The game world-wide mad deadly COMMUNIST GANGSTER COMPUTER GOD that CONTROLS YOU AS A TERRORIZED GANGSTER FRANKENSTEIN EARPHONE RADIO SLAVE, PARROTING PUPPET." Rant #2: "In effect, man as a race vegetated. Instead of advancing from innocence to virtue, he remained a clod. " Rant #3: "NO LONGER CAN EAT DRIED BEANS, May 2. 1989." It's all part of kook-lit 101, a series of sensitive and amusing folk profiles. Says the author: "I became the recipient of countless home-made flyers handed to me and other passers-by on the streets . . . these dense tracts were desperate pleas from the victims of mind control, or mad saints who detailed a theory that would solve all the world's problems, or obsessed litigants who described their legal quandaries with the aid of inexplicable numerical equations. Handwritten or typed, their authors usually covered every inch of space on the paper, no matter its size." Unites the weirdoes of the world—something they could never do themselves! **GR**
$16.95 *(PB/300/Illus)*

The Ku Klux Klan in the City, 1915-1930
Kenneth T. Jackson

Most people see the Klan as a rural and southern phenomenon, but in the 1920s, with the Klan at its height of power, they flourished in the cities, often in the North. The people who joined the Klan were dislocated, frightened and uprooted by the rapid changes in urban life. Many of these people joined the Klan for patriotic reasons unaware of their bigotry. In many places from Dallas to Atlanta, and Buffalo, to Portland, Oregon the Klan won elective office. **SC**
$13.95 *(PB/326)*

The Land of Hunger
Piero Camporesi

"A graphic and engaging journey into the folk culture of early modern Europe. . . . a mosaic of images from Italian folklore: phantasmagoric processions of giants, pigs, vagabonds, downtrodden rogues, charlatans and beggars in rags."
$52.95 *(HB/223)*

The Last Empire: De Beers, Diamonds and the World
Stefan Kanfer

Story of a humble South African farm that sparked a 19th-century diamond rush, turning the Cape of South Africa into an exotic Klondike of corporate lust, brutality and greed. For more than 100 years, control of the world's diamonds has been in the hands of one family, the Oppenheimers of South Africa and England—the diamond dons of De Beers. "The Oppenheimers have endured threats to their lives, outlived global depression and two world wars, survived Afrikaaner terror, United Nations denunciations, miner's strikes, revolutionaries, sanctions, failed lawsuits, black consciousness. They have heard themselves called slavers in modern dress . . . they have also recieved awards for sharing their wealth with African employees . . . 'Governments fall, entire countries come and go, but diamonds—and the cartel that controls them—are forever.'"
GR
$14.00 *(PB/409/Illus)*

The Last Year of Malcolm X: The Evolution of a Revolutionary
George Breitman

Study of Malcolm X's political development after he left the Nation of Islam. Analyzes the split between Malcolm X and Elijah Muhammad, and charts the evolution of Malcolm's views on organizing the black community and on questions of separatism and black nationalism.
$14.95 *(PB/169)*

Lincoln's Unknown Private Life: An Oral History by His Black Housekeeper, Mariah Vance (1850-60)
Edited by Lloyd Ostendorf and Walter Olesky

Mariah Vance, an African-American domestic worker, worked for Abraham Lincoln in Springfield, Illinois, from 1850 to 1860. Vance was witness to the Lincoln home life unlike any other person outside the family. Her recently published oral history reveals, for the first time, the Lincolns' often volatile lives and Mary Lincoln's unquenchable desire for paregoric (opium suspended in camphor and alcohol). Abraham Lincoln's public life was well-documented, but little is known about his private life.

After leaving the Lincolns, Mariah Vance continued to be a laundress, maid and housekeeper to support her 12 children. Adah Sutton, a Springfield antique dealer, upon hearing of Mariah's skill and hard work, brought her laundry and listened while Mariah spoke of the Lincolns. Months later, realizing just who Mariah was talking about, Adah took extensive verbatim notes, which were thrown into a box until years later. At age 72, she decided her notes were important enough to make public. These writings reveal an incredible number of personal conversations and details that only a maid could know. There's a bit of dirt here and there, like when Mrs. Lincoln consults psychics and throws extravagant society parties to impress Springfield's finest while depleting Abraham's bank accounts. But mostly the Lincolns were hardworking, God-fearing, extremely loyal people. Lincoln's common sense prevails in the face of hallucinations and tantrums, resulting from his wife's paregoric addictions and withdrawals—Mrs. Lincoln acts much like a heroin addict, but with easy and continued access to her "medicine." **GE/CF**
$30.00 *(HB/550/Illus)*

The Lingering Mystery of RFK
Andy Boehm

"For years it has been accepted public doctrine that Sirhan Sirhan acted alone in killing Senator Robert F. Kennedy in the Ambassador Hotel in Los Angeles. Earlier this year, however, the Los Angeles Police Department finally was compelled to release to the public a great deal of its documentation in the case. . . . Examined closely, a very different story emerges from the official tale—one that in an ideal world would compel the authorities to take a new look at thecase and the LAPD's role in it."
$2.25 *(Pamp/14)*

The Little Black Book
Paul Rydeen

A thin but authoritative address book of extreme groups of all stripes.
$3.00 *(Pamp/23)*

London, Labour and the London Poor: Volumes 1-4
Henry Mayhew

Extraordinary document of Victorian London, told from the bottom up, by a literary gadfly and one-time editor of Punch, the British humor magazine. "The image of

London that emerges from Mayhew's pages is that of a vast, ingeniously balanced mechanism in which each class subsists on the drippings and droppings of the stratum above, all the way from the rich, whom we scarcely glimpse, down to the deformed and starving, whom we see groping for bits of salvageable bone or decaying vegetables in the markets. Such extreme conditions bred weird extremities of adaption, a remarkably diverse yet cohesive subculture of poverty. Ragged, fantastic armies, each with its distinctive jargon and implements, roamed the streets: 'pure-finders' with bucket and glove, picking up dog dung and selling it to tanners; rag-gatherers, themselves dressed in the rotted cloth they salvaged, armed with pointed sticks; bent, slime-soiled 'mud-larks,' groping at low tide in the ooze of the Thames for bits of coal, chips of wood, or copper nails dropped from the sheathing of barges. . . . The rapid, wrenching industrialization of England (London's population trebled between 1800 and 1850) was breeding a new species of humanity, a rootless generation entirely environed by brick, smoke, work and want." Hundreds of first-person narratives, told in the vernacular of the workers themselves. Puts Dickens to shame. **GR**
$9.95 *(PB/494/Illus)*

The Mad King: The Life and Times of Ludwig II of Bavaria
Greg King
If there is beauty to madness, then that beauty might best be exemplified by this eccentric Bavarian regent, whose Neuschwanstein Castle served as the model for Walt Disney's romantic castle. A practicing homosexual, Ludwig II ascended the throne at the age of 18. While never as shockingly flamboyant as the utterly depraved Roman Emperor Heliogabalous, Ludwig nevertheless was a servant to his passions: music, architecture, and a slave-like devotion to Richard Wagner. Along with Bismarck, Ludwig II became the founder of Germany's Second Reich, which was followed by the better known Third Reich of Adolf Hitler, who was also devoted to Wagner and architecture. . . hmmm. . . have we missed anything here? Aside from these peripheral issues, what sort of man was Ludwig? To a friend he confided, "I dreamed I was breaking a large jug of water over the Queen's head, dragging her about on the

Mariah meets the Lincolns — from **Lincoln's Unknown Private Life**

ground by her hair and stomping on her breast with my heels." **JB**
$24.95 *(HB/335/Illus)*

Malcolm X as Cultural Hero and Other Afrocentric Essays
Molefi K. Asante
"With the Age of Malcolm a new epoch began in the conception of national culture or cultural nationalism causing a far-reaching revolution in traditional views held by members of African-American institutions. Malcolm was not merely 'our manhood,' as Ossie Davis nobly put it at Malcolm's funeral, but the keeper of the ancestral flames of a proactive response to the human condition, his own life represented the rebirth of the extensive African-American commitment to cultural reconstruction which are not yet concluded."
$12.95 *(PB/191)*

Man, God and Civilization
John G. Jackson
"Nearly all the so-called world histories and histories of civilization so popular in contemporary academic circles are based mainly on what is known as European Civilization," says John G. Jackson. "This species of parochialism gives a false picture of human history, and few students become

aware of the fact that European Civilization, speaking historically, is a product of the recent past, and that European Culture was not indigenous but was derived from older civilizations of Africa and Asia."
$10.95 *(PB/327)*

The Man in the Ice: The Discovery of a 5,000-Year-Old Body Reveals the Secrets of the Stone Age
Konrad Spindler
"In 1991, a group of tourists found the body of a mountaineer in an Alpine glacier on the Austrian-Italian border. . . . the body of a Neolithic hunter, a man who had died some 5,300 years ago." This scientific detective story, written by the first scientist on the scene, "details the Iceman's well-preserved equipment and clothing, and interprets these fascinating clues to the nature of daily life in the Stone Age." What was he doing miles up in the harsh alpine mountains? What can we learn from the cruciform tattoo on his inner right knee, the birch-bark container found nearby, his grass-cord shoes or his bow-stave, and five crude arrow-shafts? "Finally, how did he die?" This discovery answers many questions about human prehistory. **GR**
$15.00 *(PB/306/Illus)*

Ministry of Lies: The Truth Behind the Secret Relationship Between Blacks and Jews
Harold Brackman

A point-by-point refutation of *The Secret Relationship Between Blacks And Jews* authored anonymously and published by the Nation Of Islam. Not surprisingly, the author concludes that Jewish slave owners were no better or worse than the average Christian of the period. In fact, according to rabbinical laws, a Jewish slave holder was technically prohibited from having sexual relations with slave girls—causing amazement among Old World Arabs that the Jews didn't use slave girls for sex. **SC**
$10.00 *(PB/160)*

Molotov Remembers: Inside Kremlin Politics — Conversations with Felix Chuev
V.M. Molotov

Best known in the West as Soviet foreign minister during World War II and the Cold War, V.M. Molotov spent 70 years at the top of the Soviet heap. Right-hand man under Lenin and then Stalin, diplomat to Hitler, insider to the rise and fall of Khrushchev, Molotov was a rubber-stamping yesman who turned out to be a valuable historical source on "the politics and psychology of the most influential movement of the 20th century," since neither Stalin nor Lenin left any biographical musings. "Eerily fascinating," says Woodford McClellan, professor of Russian history. "One does not so much read this book as engage in a one-on-one conversation with a major figure in a gigantic criminal organization. The answers come readily, couched not in anything resembling normal human emotions but rather in the stupefyingly cynical amorality that characterized the Communist Party of the Soviet Union." **GR**
$29.95 *(HB/439)*

The Movement of the Free Spirit
Raoul Vaneigem

"This book by the legendary Situationist activist and author of *The Revolution of Everyday Life* is a fiercely partisan historical reflection on the ways religious and economic forces have shaped Western culture. Within this broad frame, Raoul Vaneigem examines the heretical and millenarian movements that challenged social and ecclesiastical authority in Europe from the 1200s into the 1500s. . . . At the core of these heresies, Vaneigem sees not only resistance to the power of the state and church but also the immensely creative invention of new forms of love, sexuality, community and exchange. Vaneigem vividly portrays the radical opposition presented by these movements to the imperatives of an emerging market-based economy and he evokes crucial historical parallels with other anti-systemic rebellions throughout the history of the West."
$24.95 *(HB/302)*

The Name "Negro": Its Origin and Evil Use
Edited by Moore, Turner and Moore

A compressive study and definition of the name "Negro," starting from its origins at the beginning of the slave trade. Moore proves how the word was used to divide the peoples of African descent and reinforce their supposed inferiority. **SC**
$8.95 *(PB/108)*

The Nation of Islam: An American Millenarian Movement
Martha F. Lee

"The Nation of Islam as a millenarian movement underwent a fateful transformation

The face of the Iceman — from **Man in the Ice**

when its prophecies concerning the end failed. The result was the transformation of the Nation, after the death of Elijah Muhammad, into two quite different entities. The first is the American Muslim Mission . . . led by Imam Wallace D. Muhammad. . . . the second is the reconstituted Nation of Islam under the guidance of the controversial Minister Louis Farrakhan. . . . a history of the Nation of Islam movement from its beginnings early in this century to 1986."
$14.95 *(PB/200)*

The New American Ghetto
Camilo José Vergara

"As intrinsic to the identity of the United States as New England villages, national parks, and leafy suburbs, ghettos nevertheless remain unique in their social and physical isolation from the nation's mainstream. Semiruined, discarded, and dangerous, ghettos are rarely visited by outsiders. *The New American Ghetto* provides an exploration, spanning over nearly two decades, of ghettos in New York, Newark, Los Angeles, Chicago, Detroit and smaller cities. Camilo José Vergara chronicles, through photographs and text, the profound transformations experienced by these places since the riots of the 1960s. He provides direct observations of urban landscapes and interiors, from residential areas and institutions to vacant lots and abandoned factories. He takes successive photographs of the same places, tracking change over time, changes that have made the conditions of today's ghettos very different from those of an earlier era. Vergara's interviews with residents and historical research contribute to his unique view of the nature and meaning of the inner city. Termed 'a photographic forecast of the demise of urban America', *The New American Ghetto* brings to light a world of forgotten ruin and struggling reconstruction."
$49.95 *(HB/235/Illus)*

The Nigger Bible
R.H. deCoy

More exploding bombshell than polemic— "Written by an acknowledged Nigger about the experience of Niggers, addressed and directed exclusively to my Nigger people for whom it was purposely conceived"—*The Nigger Bible* (1967) is an incendiary call for racial independence written in a tone that

Members of the Nation of Islam at the Million Man March — from **The Nation of Islam**

clocks in somewhere between Farrakhan and Jehovah. Unashamedly racist ("SEPARATION IS 'THE NIGGER SALVATION'"), rabidly anti-Judeo-Chrisitian, deCoy contends, with dizzying repetition (via sermons, proverbs and parables), that the reclamation of spiritual and political black truths can only occur outside the manipulating sphere of the Caucasian oppressor where the "Negro" ("prostitutes of Black Spirit") can construct his own world, define his own terms and think for himself—in short, discover his true "Niggerness." Continually veering between acumen and bombast, insight and screed, it's difficult to know if deCoy is at any point being ironic. Either way, he'll leave the reader (even, or especially, white readers) reeling and spent.

MDG

$3.50 *(PB/304)*

Night of Fire: The Black Napoleon and the Battle for Haiti
Martin Ros
"The largest, and only successful, slave revolt in history took place in Haiti shortly after the French Revolution. First organized by a voodoo priest, the rebellion soon came under the leadership of an educated, devoutly Catholic slave named Toussaint L'Ouverture—a man of such military and political skill that he was referred to by contemporaries as 'The Black Napoleon.'"

$27.50 *(HB/224/Illus)*

The Occult Conspiracy: Secret Societies — Their Influence and Power in World History
Michael Howard
"Traces occult influences in politics and statecraft from ancient Egypt to the present era. Explores the influences in government and in the lives of many well-known figures, including Benjamin Franklin, Rasputin, Woodrow Wilson and more. The societies explored include the Nazis, the British security forces, the founding fathers of America, and the Vatican."

$10.95 *(PB/192/Illus)*

Old Nazis, the New Right, and the Republican Party: Domestic Fascist Networks and U.S. Cold War Politics
Russ Bellant
"In this volume, Bellant tallies some of the moral and political costs of our government's recent and disquieting alliance with Nazi collaborators and fascists. He follows the trail from the Waffen SS to the ethnic outreach arm of the Republican party—and even to the White House briefing rooms."

$12.00 *(PB/150)*

The Origin of Race and Civilization
Charles A. Weisman
All in all, everything you would expect from a volume featuring the word "subhuman" in one of its many subtitles. Seems that the problem with the fundamentalist Creationists is that they're nothing more than Evolutionists in sheep's clothing—how could they actually believe that the various races could have possibly descended from Adam and Eve, when, according to medieval and renaissance artists, the primal couple was white? Weisman views the non-white races as "pre-Adamic" practice runs, as our Neanderthal and Cro-Magnon ancestors are also thought to be. In fact, the serpent of Eden turns out himself to be a treacherous member of one of the non-Adamic races, hence the "enmity" God places between him and the "children of Eve" is actually divinely ordained racism. The repopulation of the earth after the flood through the lineage of Noah is another fundamentalist lie. The flood was a localized event having no effect on the pre-existing non-white races. The Ark actually landed in Northern India, and Noah's Aryan genes obviously made their way westward in the cultural advancements of the Hebrews, Egyptians, Chaldeans and Phoenicians, the last of which sailed to the Americas to become Aztecs, Incas, etc. Somehow, however, Weisman still clings to the Old Testament's stories of the Hebrew god's jealous protection of the Israelites against some their "Aryan" siblings (like the Egyptians) as a primary narrative of the "white race." The New Testament is good news for whites only, and since the "wandering Jew" did not lay claim to the sort of "mighty nation" promised Abraham, Weisman awards the title of "True Israelites" to more active players in recent Western history such as "America, Canada, Australia, and South Africa" (!). And speaking of South Africa, it soon becomes clear that the author's most virulent hatred is reserved for the black man, who in the book's obsessive cataloging of physiological

differences is distinguished by his "sooty complexion," "fetid scent," and "prominent muzzle." These remarks, and in fact roughly a quarter of this 1990 publication, are drawn directly from 19th-century sources, including some of the book's most memorable pages devoted to illustrations of "comparative anatomy" juxtaposing non-whites with apes, opossums, and rats. **RA**
$9.00 *(PB/176/Illus)*

Patriots in Disguise: Women Warriors of the Civil War
Richard Hall

History for the most part has not recognized the many women who, dressed as men, fought on both sides during the Civil War. Sometimes their true sex was discovered only after they had been injured or killed in the line of fire. Others were hastily buried where they fell on the battleground, thus taking their secret with them to the grave. Some survived the war and wrote of their exploits, while regimental histories recalled still others. Author Richard Hall turned to the latter two sources to write this mostly anecdotal yet worthwhile narrative of these "patriots in disguise." While memoirs such as those of Union soldier and spy Sarah

Emma Edmonds (a.k.a. "Franklin Thompson") or Confederate soldier and spy Loreta Janeta Velazquez (who fought as "Lieutenant Henry T. Buford") are colorfully interesting, it is the stories of women who chose not to publicize their exploits that are truly fascinating. Consider the case of Jennie Hodgers, who joined the Union army as "Albert D.J. Cashier," and maintained her disguise throughout a three-year term of enlistment. She then dressed and lived as a man until a 1913 accident exposed her gender. While this work cannot match the depth of research provided by a primary-sourced analysis, it remains a fascinating overview of a little-known area of Civil War history. **LP**
$10.00 *(PB/225/Illus)*

The Philosophy and Opinions of Marcus Garvey
Edited by Amy Jacques-Garvey

Marcus Garvey has been called everything from a John the Baptist to a con man. This book sets out to present Garvey's philosophy/political theory of self-determination for the African peoples. Garvey's influence is crucial for understanding such diverse groups as Rastafarians, Black Muslims and

Black Jews. Garvey was at times a politician, a prophet and a social thinker, and once in political life he was always a force to be reckoned with in his dealings with the white establishment. **SC**
$14.95 *(PB/417/Illus)*

Philosophy of the Count de Gobineau
G.M. Spring

Count de Gobineau is vaguely known as the originator of the doctrines of "Aryan Superiority" and "Scientific Racism." However, he was also one of the most interesting and influential figures of the 19th century. De Gobineau was an aristocrat who fought democratic trends his entire life. He was also pessimistic and little inclined to believe in progress, as he reacted against 18th-century Rationalism and its abstract notion of man. **SC**
$25.00 *(PB/304)*

Pirate Utopias: Moorish Corsairs and European Renegadoes
Peter Lamborn Wilson

Imagine a world where, instead of being ruthless thieves of the high seas with no scruples, prone to carrying off others to

 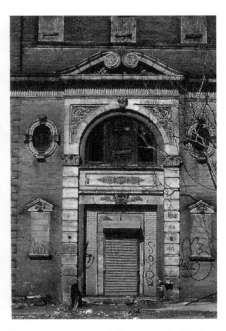

(Left) Ornate entrance to former Aidline Automation, Inc., Brownsville, Brooklyn, 1981. (Center) Eight years later, the same entrance, boarded up and cinder-blocked, Brownsville, Brooklyn, 1989. (Right) Thirteen years later an attempt has been made to secure the building by installing a metal curtain, Brownsville, Brooklyn, 1994. Graffitti in Spanish says, "I am." — from **The New American Ghetto**

work in bondage, pirates were rebellious sorts who consciously shunned the traditional European world with its stratified class system. This is the world Wilson depicts, and surprisingly it is ours. Wilson very successfully proves his case that pirates were consciously bucking the system. Pirates had their own Moorish republic of Sale, an Ottoman protectorate, where instead of having to languish like the downtrodden masses, they could rise to a position of wealth and prestige through their ability to survive. "In theory—and for the most part even in practice—a recruit rose up through the ranks at the rate of one every three years. If he survived long enough, he'd serve as commander in chief. . . . All this had nothing to do with "merit" but with time served. The lowliest Albanian slaveboy or peasant lad from the Anatolian outback, and the outcast converted European captive sailor, could equally hope one day to participate in government—simply by staying alive and serving the 'Corsair Republic' . . . " Many pirate captives joined their captors, renounced their Christian faith and embraced Islam. Wilson supports his central thesis well with plenty of documentation, which includes many accounts from primary sources. This is a delightfully well-written gem of a history which pulls apart the pirate myth and reveals something new and wondrous. **MM**

$8.00　　　　　　　*(PB/208/Illus)*

Platteland: Images From Rural South Africa
Roger Ballen
Haunting portraits of the white underclass of the flatlands of South Africa, abandoned by their more affluent white countrymen. Poverty, despair and often inbreeding mark these Afrikaners whom apartheid dealt a raw deal.

$29.95　　　　　　　*(HB/144/Illus)*

Popular Alienation: A Steamshovel Press Reader
Edited by Kenn Thomas
"Anthology of nine issues of the highly acclaimed 'conspiracy theory' journal—a multidisciplinary course on JFK and other political assassinations, UFOs, fringe science, secret technology, biowarfare, espionage and various related avenues of research." Topics include: esoteric conspiracism, Kalifornia prisons, presidency-as-theater, JFK's LSD mistress, the prison files

of Wilhelm Reich, Bill Clinton's conspiratorial mentor Carroll Quigley, destruction of the Library of Alexandria, Danny Casolaro and the INSLAW Octopus, biospherian waste and more Beat-inspired non-linear historical research and speculation.

$19.95　　　　　　　*(PB/342)*

Prisoner of Peace
Rudolf Hess
"Rudolf Hess' daring, fruitless peace-flight to Britain was one of the outstanding episodes of World War II. . . . The letters describe the years in English imprisonment, the months in the dock at Nuremberg, and Hess' thoughts and conversations behind the walls of Spandau Prison, where he was incarcerated in solitary confinement from 1947. . . . As the letters unfold it will be seen how Hess reconciles himself to his fate in spite of political and human disappointments. One senses the deep affection for England even after years of imprisonment. There is not a bitter word in this book, but it nevertheless passes judgment on the politicians of destruction of 1941, on the Tribunal of 1946 and on the gaolers of today."

$7.95　　　　　　　*(PB/151/Illus)*

The Prize: The Epic Quest for Oil, Money and Power
Daniel Yergin
"Recounts the panoramic history of oil—and

European renegadoes enjoying themselves — from **Pirate Utopias**

the struggle for wealth and power that has always surrounded oil. This struggle has shaken the world economy, dictated the outcome of wars and transformed the destiny of men and nations. *The Prize* is as much a history of the 20th century as of the oil industry itself. . . . The cast is enormous: from wildcatters and rogues to oil tycoons, and from Winston Churchill and Ibn Saud to George Bush and Saddam Hussein."

$16.00　　　　　　　*(PB/887/Illus)*

Protocols of the Learned Elders of Zion
Victor E. Marsden
Claims to be the transcript of an actual meeting, sometime in the 19th century, of Jewish "Elders" who do some heavy-duty conspiring. Widely used before the Russian Revolution by czarists to show how Masons, liberals, Bolsheviks and Catholics were dupes of the Jews.

$4.95　　　　　　　*(PB/72)*

Race: The History of an Idea in the West
Ivan Hannaford
A whole panoply of racial witticisms may be gleaned from the pages of this scholarly book, such as the following: "Best explained that the Devil caused Ham to transgress the laws of inheritance and to indulge in carnal copulation. Thus his sons were marked with a black badge to symbolize loathsomeness and banished to the cursed and degenerate voids of Africa, where they lived as idolaters, witches, drunkards, sodomites; and enchanters." Particularly interesting is the amount of space devoted to the descriptions of the peoples of the earth by the Italian Giovanni Florio (1553-1625) whose book bore the curious title *First Fruits*, and has a kind word for all: "The Ethiopians are a certaine people of Caria, they are simple, foule, and slaves; the Carthaginians are false and deceivers; those of Babylon, are malicious; and the corrupted Persians are gluttonous and drunkardes; the Cicilians are very niggards, yet faithful; those of Caspia are cruel; they of Lesbia, filthy; the Scithians lawlesse; the Corinthians, fornicatours; the Boctians, very rude; the Simerians, very beastly . . ." and so on. Hannaford's book is well researched and well written, and offers more than enough rare and entertaining material to satisfy either the most ardent racist or anti-racist. Most scholarly books of this type are dry

and insipid, yet this particular offering is an exception to the general rule. **JB**
$19.95 *(PB/448)*

Rebels Against the Future
Kirkpatrick Sale
Retells the history of the Luddites, a group of disgruntled textile workers who at the start of the English Industrial Revolution rebelled against the industrialization of their traditional cottage industry. Using the history of the Luddites as a precursor, the author employs them as the model for resistance against the present second Industrial Revolution: the Information Revolution.
SC
$14.95 *(PB/320)*

The Rhythms of Black: Race, Religion and Pan-Africanism
Jon Michael Spencer
Argues that African rhythm, and specifically African rhythm in the New World, gives rise to the distinctive qualities of black culture. These particular rhythms differentiate black culture from others, and constitute the primary essence of religion and dance, which are both dependent on black music. Through music, black people glean what Spencer calls "rhythmic confidence," an equivalent to "soul." Spencer also explains how this rhythmic confidence can be either casual, or explicit and insurgent, as in rap. **SC**
$16.95 *(PB/206)*

Ringolevio: A Life Played for Keeps
Emmett Grogan
During the Summer of Love, the Diggers combined street theater and thievery to feed the hoards who had made their way to San Francisco, tantalizing the media who wished to pigeonhole their activities and most of all to find out about their mysterious spokesman Emmet Grogan. In his autobiography Grogan reveals all, although one suspects this master trickster is being selective and creative in his revelations. From playing ringolevio (an elaborate and violent game of tag) on the streets of New York, to teen-junkiedom, cat burglary, life on lam in Europe, and a brief stint with the IRA, to his arrival in San Francisco in the mid-'60s, Emmet Grogan's is a life lived on the liminal edge of society. **NN**
$12.95 *(PB/500/Illus)*

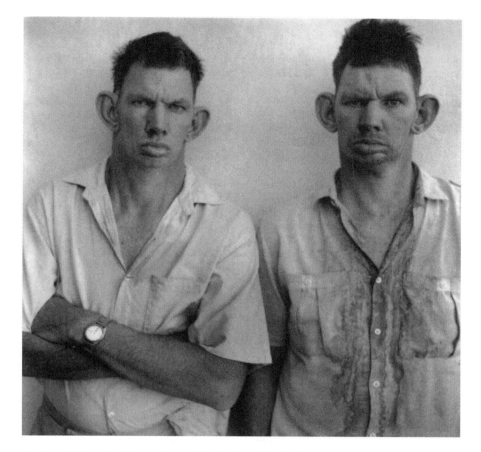

Dresie and Casie, twins, Western Transvaal, 1993 – from **Platteland**

The Rocket and the Reich: Peenemünde and the Coming of the Ballistic Missile Era
Michael J. Neufeld
An astonishing journey into the production and history of one of war's most devastating weapons. During the course of World War I and II, the German research laboratory known as Peenemünde designed some of the most marvelous weapons of the time. One was the V-2, the most accurate, long-distance and destructive missile up to that point, later to become copied and modified by other war-driven countries. **TD**
$15.95 *(PB/369/Illus)*

The Russian Idea
Nikolai Berdyaev
Written during World War II from exile in Paris by a disillusioned Marxist turned Christian anarchist philosopher, *The Russian Idea* is a revealing exploration of the continuity of utopianism in Russian history, literature and philosophy. Berdyaev's discussion includes Moscow as the "Third Rome"; the rise of the Russian intelligentsia; the metaphysical theme in Russian literature; nationalism and Slav messianism; the anarchist element in Tolstoy, Dostoevsky and Slavophilism; the philosophy of Vladimir Solovyov; socialism and nihilism; Russians and the Apocalypse; and Communism as a distortion of the Russian messianic idea.
SS
$16.95 *(PB/287)*

The Satanizing of the Jews
Joel Carmichael
The author traces the "evolution" of anti-semitism from the earliest contacts of Jews

and non-Jews in the Levant, up through the Roman-Jewish War, the Diaspora in Europe and finally, of course, Nazi Europe and the founding of the state of Israel. While acknowledging, however briefly, the rise of biological-racial theories in the 19th century as immediate precursors of Nazism (notably Gobineau's *On the Inequality of Races*), the author's central thesis, "mystical" anti-semitism, refers to the codified, theological condemnation of the Jews as contained in the founding tenets of Catholic Church doctrine. In a nutshell: "Christ-killer." For this charge all other churchly condemnations flowed forth: that Jews constituted "a limb of Satan," a people damned by God, etc., etc.

While the author devotes many pages to the intricate details of such "bulls" before, during and after the Middle Ages (beginning with the, ahem, rather harsh statements of church Father John Chrysostom: "breed of vipers . . . demons . . . haters of God" and ending with the maniacal spleen of Martin Luther's *On the Jews and Their Lies*), it becomes apparent that most of this flailing about, at least during the first millennium, was indulged in by the churchmen themselves, rather than their followers. The peasant on the street kept his dislike to himself up to the First Crusade, in 1096. Lots of ugliness followed over the next four centuries: mob violence and massacres that would find their echoes centuries later in the "spontaneous pogroms" directed against Jewish civilians all across Europe, at the very moment the Nazi government was killing them on a gigantic scale. After reading this book one can better understand the historical-cultural backdrop against which a 20th-century politician—Adolf Hitler—could make this jaw-dropping pronouncement (in *Mein Kampf*): "By fighting the Jews, I am doing the work of the Lord."

TM
$10.95 *(PB/224)*

Screening History
Gore Vidal
Vidal believes that Americans of his generation either went to church *or* the movies for spiritual guidance. As a third-generation atheist from a well-placed Washington family, he knows from whence he speaks. Using as his point of departure the dual meanings of the title (to show it on a screen or to see it through a filter) this cranky little memoir of his first 20 years, mixing the

impact of the movies with the realities of Washington politics with flights of longing and fancy, is pure vintage Vidal, doing what he does best. Much of this material was delivered originally in lecture form and is by turns caustic, witty, insightful and meandering, and consistently uncategorizable. It is a discourse on a period of American history that by its very structure proves how subjective the concept of history is. **SA**
$14.95 *(PB/97/Illus)*

Secret and Suppressed: Banned Ideas and Hidden History
Edited by Jim Keith
A selective overview of ultra "fringe" writings in essay form. Includes the typical "the CIA planted transistors in my brain" scenarios, Jonestown as mind-control experiment, Jim Morrison's "double" and the Vatican library secrets, as well as Jim Jones' last testament and Masonic ritual sex, sorcery, and assassination cabals. It's a nice set of paranoia-inducing parables. **MW**
$12.95 *(PB/309/Illus)*

Secret Societies and Subversive Movements
Nesta H. Webster
A dense and tangled work on a topic, which by its very definition would seem difficult to document. If it happened before 1924, was committed to paper, and bears some tenuous link to the history of secret societies, it probably is referenced somewhere in this book. What's more—it's probably the fault of the Jews. Mostly polite and extremely well-researched, this volume nonetheless functions above all as a monumental testimony to the productive power of human paranoia. The 420-page volume descends occasionally into unreadable minutiae, as it chronicles not only the major occult and utopian entities (Gnostics, Knights Templar, Rosicrucians, Theosophists, Freemasons, and Illuminati) but also traces the intricate lineage of each, closely examining the theoretical disputes resulting in division and subdivision of even those movements quite small to begin with.

What keeps the book compelling, however, is the author's slow progression from insinuation to full-blown rant. From the beginning the Kabbalah is frequently cited as a source of inspiration for a variety of "subversive" ideologies, and yet as the histories of the various movements unfold, it

seems for many chapters that the Kabbalah may only be an ancient red herring, a minor influence on Grand Orient Freemasonry, the ultimate villain. But by the final chapter, "The Real Jewish Peril," the blue-blooded paranoiac is out of the closet. Given the historical and public policy of exclusion practiced by the Freemasons against the Jews, Webster's suggestion that a timeless Jewish conspiracy lies hidden behind Freemasonry has the appeal more of novelty than credibility. It's the typical paranoiac punch line in which the least likely explanation proves itself by the rigor with which all evidence must have been removed.

More strange bedfellows enliven the book: A chillingly misinformed chapter on the burgeoning Pan-Germanism (circa 1924) ends with the conclusion (with Henry Ford) that Jewish money fueled the Prussian war industry. Adam Weishaupt, despite his public contempt toward the Jesuits, is supposed to have patterned the Illuminati after their organizational ideals. The Knights Templar, guardians of Christian pilgrims, were heathen secretly associated with the Islamic Assassins. The ascetic Jewish Essenes are linked with the orgiastic Gnostics sects. Occult illusionist roustabouts Cagliostro, Mesmer and Crowley draw comparisons with the founders of Hassidism. The list goes on . . . isometrics for the mind. **RA**
$11.95 *(PB/420)*

Siege
James Mason
The writings and rantings of James Mason, radical extremist Nazi and founder of the NSLF, featuring Mason's three R's: Resistance, Revolution and Rule. A compelling collection of essays from Mason's newsletter of the same name, advocating death to all race traitors and the murder of a significant percentage of the population (blacks, Jews, Mexicans, etc.). Mason has also found a "true revolutionary" and ideological comrade in Charles Manson, a move that has stigmatized him as a wacko among other hard-core Nazi/white power circles.
MW
$20.00 *(PB/464/Illus)*

Slavery: A World History
Milton Meltzer
"Slavery is not and has never been a 'peculiar institution,' but one that is deeply rooted in the history and economy of most

countries. Although it has flourished in some periods and declined in others, human bondage for profit has never been eradicated completely.

"In *Slavery: A World History* Meltzer traces slavery from its origins in prehistoric hunting societies; through the boom in slave trading that reached its peak in the United States with a pre-Civil War slave population of 4 million; through the forced labor under the Nazi regime and Soviet gulags; and finally to its widespread practice in many countries today, such as the debt bondage that miners endure in Brazil or the prostitution that women are sold into in Thailand. In this detailed, compassionate account, readers will learn how slavery arose, what form it takes, what roles slaves have performed in their societies, what everyday existence is like for those enchained, and what can be done to end the degrading practice of slavery."

$22.50 *(PB/344/Illus)*

Slavery in the Arab World
Murray Gordon

The slave trade in the Arab world antedated Mohammed and still exists in parts of Arab Africa today. This work presents the ideological underpinnings and the historical treatment of the slave in the Arab world. It also shows contrasts between slavery in the Arab world and in the Old South, and examines the factors that determined the status of slaves in the Islamic world. Sometimes these factors led to insurrections like the Baghdad Slave War (A.D. 880-894) and to the rise and fall of many Muslim kingdoms in Africa. That the relationship between the European powers and Muslim slave brokers led to an expansion of the slave trade is well-documented in this book. **MET**
$14.95 *(PB/265)*

Sodomy and the Pirate Tradition: English Sea Rovers in the Seventeenth-Century Caribbean
B.R. Burg

This book actually started out to be a way of offering history students a wider view of British expansion into the New World. It was almost by accident that the author noticed certain patterns in the settlement of the West Indies that caused him to address the "gay history" that became the

George Lincoln Rockwell, "Man of Ill Repute," as photographed by the Presidential portrait experts Harris & Ewing. — from Siege

focus of the finished book. Unlike America, where settlers from England came to begin whole new lives, the attitude toward the Caribbean Islands was to get in, make money and to get back to "civilization" in England. Women were less likely to be included in the patterns of what was considered to be a temporary situation.

The author begins the book with an overview of British attitudes towards homosexual behavior in the 17th century, paints a vivid picture of life in England at the time and especially the prospects of the less wealthy, and provides a brief history of the British Navy with special attention to whom they recruited and how they did it. We are treated to an exhaustive look at the Caribe Isles, the evolution of pirate communities in that part of the world and ultimately to the probability that homosexual behavior was business as usual in this context. An impressive chronological bibliography allows the reader to follow the author's development of the various conclusions and theories. Of special interest to gay historians is the section on Matelotage, a legally recognized form of gay marriage that had its roots in indentured servitude. **SA**
$14.95 *(PB/215)*

The South Was Right!
James Ronald Kennedy and Walter Donald Kennedy

The real question behind all the myths of the Civil War is, were the Confederate States of America a sovereign nation that was invaded and occupied by the separate nation of the United States of America? If this is true, as the authors propose, then the South was right to defend itself against attack, and the South has a claim to sovereignty now. **SC**
$22.50 *(HB/448/Illus)*

Stalin and the Bomb: The Soviet Union and Atomic Energy, 1939-1956
David Holloway

Using recently declassified Soviet documents and interviews with many of the Soviet scientists who participated in the USSR's nuclear program, the author presents a behind-the-scenes account of Soviet nuclear policy from 1939-1956. Professional hand-wringers wonder if the arms race could have been avoided had Stalin been informed about the U.S. atomic bomb before it was dropped on Hiroshima, so that he would not take its existence as a threat to the Soviet Union. Others fantasize that the escalation of the arms race to thermonuclear levels could have been avoided if the United States did not proceed to develop the hydrogen bomb.

The author doubts if such changes in American policy would have resulted in reciprocal changes, given Stalin's "malevolent and suspicious personality." Stalin did not expect a major war in the short term, nor did he fear an imminent atomic attack on the Soviet Union by the U.S. In the long term, Stalin wanted nuclear (and later thermonuclear) weapons to fight an anticipated crusade against the west. In the short term, he wanted nuclear weapons to resist political pressure from the United States and its allies in shaping the post-World War II peace settlements.

As early as 1955, Soviet leaders understood that a Soviet-American nuclear war was suicidal, and realized that Western leaders knew this too. Nevertheless, Stalin's command economy diverted resources away from rebuilding the war-torn USSR and into a "catch up and overtake" arms race with the U.S. Stalin's decision was doomed, as this grueling war of attrition could only be won by the far more wealthy U.S., which

had enough dough to build a nation-wide suburban culture and still spend circles around Stalin. **RP**
$18.00 *(PB/464/Illus)*

Stealing From America: A History of Corruption From Jamestown to Whitewater
Nathan Miller
"Corruption is as American as cherry pie. From Jamestown to Whitewater, it runs through our history like a scarlet thread. The grafting politician, corrupt business tycoon, crooked labor baron and hypocritical preacher are prominent features of American folklore. Graft and corruption played a vital role in the development of modern American society and the creation of the complex, interlocking machinery of government and business that determines the course of our affairs. Large-scale chiseling has always been a left-handed form of endeavor in this country, operating parallel with—and often more efficiently than—more legitimate enterprise.

Nevertheless, the importance of corruption in shaping the United States has largely gone unrecognized. Every time there is a new scandal, analysts strain to put the events into some sort of perspective, yet they reveal almost total ignorance of the successive waves of corruption that have swept over America. . . . The purpose of this book is to flip over the flat rock of our history and see what crawls out." The author is a former correspondent for the *Baltimore Sun* and former member of the Senate Appropriations Committee.
$13.95 *(PB/431)*

Such Men as Billy the Kid: The Lincoln County War Reconsidered
Joel Jacobsen
Joel Jacobsen, an assistant attorney general for the state of New Mexico specializing in criminal appeals, has turned a probing, appellate eye on the much-retold Old West saga of Billy the Kid and the Lincoln County War. A superbly researched and reasoned account of the violent events that enveloped southern New Mexico in the 1880s, *Such Men as Billy the Kid* poses the intriguing question: Was Billy the Kid the psychotic, mercenary gun for hire commonly portrayed in popular mythology? Or was the Kid actually a conscientious soldier in a

brave but doomed attempt to wrest control of a defenseless town from the corrupt and vicious oligarchy that controlled it? Author Jacobsen admirably demonstrates that as in life itself, the truth lies somewhere in the shades of gray that lie between. **AD**
$28.00 *(HB/470/Illus)*

The Suppressed Truth About the Assassination of Abraham Lincoln
Burke McCarty
"In all the bloody history of the papacy, perhaps in no one man, as in Abraham Lincoln, was there concentrated such a multitude of reasons for his annihilation by that system. . . . I am convinced that if this knowledge can be given adequate distribution and placed in possession of the boys and girls of the public elementary schools, for whom it is especially designed to reach, that the wicked boast of the Jesuits and their lay agents, the Knights of Columbus, to "MAKE AMERICA CATHOLIC" can never be accomplished. THE GREAT SPIRIT OF THE MARTYRED LINCOLN WILL RISE UP AND DEFEAT HIS SLAYERS AND THEIR SUCCESSORS!"
$7.95 *(HB/255/Illus)*

Televisionaries: The Red Army Faction Story, 1963-1993
Tom Vague
Televisionaries, originally published as part of the British anarchist zine *Vague*, is one of the few English-language books on Germany's legendary urban guerrillas best known as the Baader-Meinhof group. Presented as a terse chronology, it covers their origins in the Vietnam protests and German yippie/Situationist offshoots of the '60s, evolution into agents of daring acts of international terrorism ranging from kidnappings, hijackings, bombings and bank robberies to the distribution of free U-bahn tickets. Ulrike Meinhof's transformation from sexy, radical-chic Euro-journalist into deadly urban commando and the creation of the original SPK—the Socialist Patients Collective, which began as a revolt inside a German mental hospital—are just two among the many facets of the RAF web which *Televisionaries* illuminates. From the dubious "triple suicide" in separate cells of Andreas Baader, Jan-Carl Raspe and Gudrun Ensslin in the massively high-security Stammheim prison in Stuttgart through the

extradition of fugitive RAF members from the former East Germany and the latest episodes of anti-NATO Euro-terrorism, *Televisionaries* also covers the demise and sputtering attempts at resuscitation of violent left-wing radicalism in post-perestroika Western Europe. **SS**
$6.95 *(PB/112/Illus)*

They Came Before Columbus
Ivan Van Sertima
Reveals the presence and legacy of black Africans in pre-Columbian America and their impact on the civilization they found there. Evidence includes: scores of cultural analogies; lingustic comparisons; carbon-14-dated sculptures, Arabic documents, charts, and maps; from the recorded tales of the griots to the Kings of Mali.
$23.00 *(HB/288/Illus)*

They Were White and They Were Slaves: The Untold History of the Enslavement of Whites in Early America and Industrial Britain
Michael A. Hoffman II
Well-researched and thoroughly documented, this history of Europeans kidnapped, purchased or taken from prisons to serve as slave labor in the American Colonies will be a shocker for many readers. **SC**
$9.95 *(PB/137/Illus)*

This Thing of Darkness: A Sociology of the Enemy
James A. Aho
Social-science theory demonstrated by real-life example. "Focuses on how enemies are perceived, or constructed, in the minds of a group or society at large." The standoff at Ruby Ridge is used as "a study in the mutual construction of enemies," and the lives of several neo-Nazis are gleaned for their myth-constructing details. "The author discusses three paradoxes—the inseparability of evil from good, the unifying function of enemies, and the dual nature of the enemy (living both 'out there' and deep inside ourselves.) The processes by which social groups identify an enemy are discussed with reference to sociological studies as well as religious and mythological works offering insights on war, peace and the role of the scapegoat." Also shows how an enemy can be "deconstructed" or transcended.
GR
$19.95 *(HB/208/Illus)*

A Time of Terror
James Cameron

"On a dark summer night in 1930, three young men were arrested. Two were lynched. The third, James Cameron, with a noose around his neck and an angry mob calling for his blood, was spared. This is his story told 64 years later with anger, insight and reflection. Cameron's narrative is as riveting and graphic as the infamous photo of his two friends, Thomas Shipp and Abram Smith, who were not as fortunate as he."

SC

$14.95 *(PB/201/Illus)*

A Time To Die:
The Attica Prison Revolt
Tom Wicker

Wicker was at Attica, invited by the prisoners, along with Bobby Seales, William Kunstler and others, to be an observer to the hostage negotiations. He experienced first-hand the initial elation of the prisoners who felt they had beaten the system, the churning fear of notorious D yard, and the terror and anger of the townspeople and guards. A novelist and respected journalist, Wicker writes of the background to the siege, including a potted history of the American penal system and the conditions which existed in the prisons prior to the 1971 revolt. Finally, *A Time To Die* describes the bloody ending to the revolt, and its aftermath which included vicious reprisals against the inmates by the prison's guards.

NN

$12.95 *(PB/342/Illus)*

Tragedy and Hope:
A History of the World
in Our Time
Carroll Quigley

Encyclopedic insider's view of worldwide domination by trans-Atlantic conspirators . . . the untold story of the 20th century!

$39.95 *(HB/1,311)*

Transcript of the
Meeting Between
Saddam Hussein and
U.S. Ambassador April
Glaspie

"No doubt you've heard about the meeting which took place between Saddam Hussein and April Glaspie on July 29, 1990, shortly before Iraq invaded Kuwait. This is the official transcript, including not only Glaspie's conversations with Hussein but also her responses to reporters."

$.45 *(Pamp)*

The Turner Diaries
Andrew Macdonald

Incendiary speculative-fiction, race-war novel penned by William L. Pierce, leader of the neo-Nazi National Vanguard based in the hills of West Virginia. Originally published in 1978, it is reputed to be the inspiration to Idaho's murderous Order and the Oklahoma "fertilizer bomb."

$5.95 *(PB/216)*

The Unseen Hand:
An Introduction to the
Conspiratorial View of
History
A. Ralph Epperson

The accidental theory of history: History occurs by accident, for no apparent reason. Governmental rulers are powerless to prevent events from happening. Versus the conspiratorial view of history: Historical events occur by design, for reasons that are not made known to the people. Epperson presents his controversial material in a clear and easily understood manner. The conspiracy that Mr. Epperson examines in this volume, he contends, has been in place for years. How can this be so? One explanation from George Orwell: "The party is not concerned with perpetuating its blood but with perpetuating itself." Often who wields power is not important provided the hierarchical structure remains always the same. The method by which the conspiracy recruits new members to replace those who retire or die is to watch especially capable (in terms of the aims of said group) careers of certain candidates, then quietly invite them into the inner circle. "The possession of power transformed into a tyrant even the most devoted friend of liberty" (the Russian anarchist

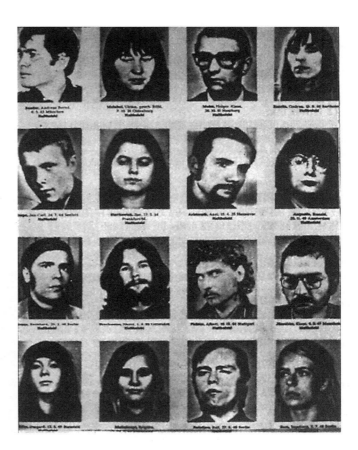

Members of the Baader-Meinhof Group — from **Televisionaries**

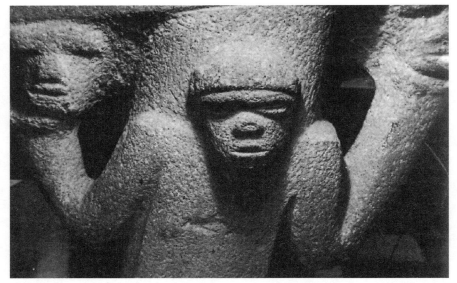

Negroid boy holding up pre-Columbian altar with trophy heads, Costa Rica — from **They Came Before Columbus**

Bakunin). The conspirators are successful because the moral citizen cannot accept the conclusion that other individuals would actually wish to create incredibly destructive acts against their fellow citizens.

The ultimate purpose of this conspiracy is power. There are some who desire this more than material goods, although the two frequently go hand in hand. So those involved do not become rich and/or illustrious and join the conspiracy; they become rich and illustrious because they are members of the conspiracy. "Power corrupts; absolute power corrupts absolutely." The moral mind of the individual who does not desire power over others or the desire for such powers cannot fathom why power seekers would want to create human misery through wars, depressions and revolutions. It is the hope of the author that those who read this book will discover that the conspiratorial view of history is the one best supported by the evidence. **CF**

$15.95 *(PB/488/Illus)*

Vernon Walters: Crypto-Diplomat and Terrorist

Ellen Ray and William Schaap
"Walters, a longtime covert operator, belonged to the 'Murder Board,' Reagan's core Central American policy group. In February 1985, Walters was nominated as United Nations ambassador. . . . 'Directly or indirectly, he has been involved in overthrowing more governments than any other official still serving in the U.S. government.' An exposé of thugs in high places."

$.75 *(Pamp/4)*

Voices Prophesying War: Future Wars 1763-3749

I.F. Clarke
Once again, the power of the novel is examined, only this time it is the artist as prophet

Carroll Quigley, author of **Tragedy and Hope**

of doom. *Voices Prophesying War* examines the hundreds of books that have been written which describe the various phases of the third world war between East and West. The date of 1763 refers to the publication of *The Reign of George VI*, the first of many tales of future warfare. On September 2, 1871, the British prime minister, William Ewart Gladstone, addressed the nation about the dangers of alarmism. This was the result of a short story entitled "The Battle of Dorking." The story was published in a popular Victorian monthly called *Blackwood's Magazine* and was written by Lieutenant Colonel George Tomkyns Chesney. In it, the author, who wrote it anonymously, detailed a fictional account of a German invasion of the British Isles. Without realizing it, he had hit upon a novel method (no pun intended) to voice his concerns and fears for the future of his country.

But this was not the first time that satire was used for propaganda. Many pamphlets and stories had been written describing future wars and battles nearly a hundred years earlier. What made Chesney's version so different, and as a result much more widespread, was his use of new weapons and technological devices having a decisive effect on the outcome of war. The story captured the imagination of the world. It was copied, re-written and added to. Other countries, including the United States, created their own versions. And a new genre, based on our fear of destruction, was created.

Today, the genre is facing numerous challenges: arms-reduction treaties, the end of the Cold War, and the fact that often-predicted nuclear disaster has never occurred. As a result, these future war books are still written, except the subject matter has changed. It is no longer other countries that we fear. Instead, the books are written about our battles with bacteria, genetic manipulation and the inevitable attack from outer space. The date 3749 refers to Walter Miller's *Canticle for Leibowitz* (1959), in which we learn the age-old adage that history repeats itself, and even after continuous destruction, there will always be survivors who will begin the cycle over again. Unfortunately, future war, be it military, biological, or extraterrestrial, is inevitable and the resulting destruction a natural part of our continuing evolution of death and rebirth.

Perhaps future authors of this genre will help slow down the process.

AN

$25.00 *(HB/284/Illus)*

Wall Street and the Bolshevik Revolution
Antony C. Sutton

Why was Trotsky wheeling and dealing in the Big Apple on the eve of the "Ten Days That Shook the World?" Nefarious financial maneuverings behind the scenes of the "vanguard of the proletariat."

$14.95 *(PB/217)*

Wall Street and the Rise of Hitler
Antony C. Sutton

Demonstrates how New York bankers hedged on Hitler . . . "World War II was not only inevitable, it was extremely profitable for a select group of financial insiders."

$14.95 *(PB/211)*

We the Black Jews, Volumes 1 and 2
Yosef ben-Jochannan

Ben-Jochannan takes on the establishment scholars again, this time dispelling the myth that the original Jews were "white." "This aspect of the history and heritage of the 'black Jews' is dedicated to all oppressed African people whose religion differs from those who control the power of life and death over most of us. Out of this it is hoped that a better understanding between African people will prevail in and of our religious differences. Remember, religion is nothing more than a belief, and that any one of them is as Godly as Another." **SC**

$24.95 *(PB/408/Illus)*

Which World Leaders Helped Nazi Criminals Escape?
Vicky Quade

Interview from *Barrister* magazine. "Hired in 1979 as a member of the Justice Department's Office of Special Investigations to ferret out Nazis in America, John Loftus has spent years piecing together the answer to a question that has nagged him: How did the Nazis escape prosecution after World War II? . . . Loftus has uncovered a scandal of amazing proportions involving the Vatican, two popes (Pius XII and Paul VI), British and French intelligence, and finally, U.S. intelligence."

$.90 *(Pamp/14)*

White Lies, White Power: The Fight Against White Supremacy and Reactionary Violence
Michael Novick

As a left-wing advocate, Novick attacks the principle of the Ajax man-whiter-than-white-tougher-than-dirt symbology. While much of his material is familiar, the author does add some new and interesting material; most notably, the far Right's attack upon the women's rights movement and what he perceives to be a collusion between America's "sexist elite" and the militant right in a combined effort to oppress and persecute gay rights activists. **JB**

$14.95 *(PB/330)*

Who Killed Jimi Hendrix?
John Swenson

"Where did Hendrix's massive fortune go? Who was behind his kidnapping? How and why did he die? Did the FBI and others keep active records on Hendrix?" Mahavishnu John McLaughlin is quoted as saying, "I feel he was murdered."

$.95 *(Pamp/10/Illus)*

Who Lies Sleeping? The Dinosaur Heritage and the Extinction of Man
Mike Magee

Argues that there was a "sapient dinosaur"—

Original book cover of The Turner Diaries — *from* Blood in the Face

one with a humanlike intelligence from which we humans evolved. The author uses various types of theories, including that of genetics. He believes that humans couldn't have gotten this far in the evolutionary scale if only the standard scientific theories apply. **SC**

$14.95 *(PB/Illus)*

Zoot-Suit Riots: The Psychology of Symbolic Annihilation
Mauricio Mazón

Seemingly lost in the annals of time, the Zoot Suit riots occurred in Los Angeles between June 3 and 13, 1943. By this time the United States was involoved in a "war for democracy," and an end to "racism and discrimination" as personified by the German Nazis. Yet, during this same period, the virulent racism endemic in this country was remarkable—riots in Detroit and Los Angeles, internment of Japanese-Americans, internment of Italian-Americans—and one wonders whether the war to end all wars should not have begun on our own doorstep. Mazón's book offers an exciting and alarming view of Mexican-American lifestyles in Los Angeles in the 1940s. The reader is regaled with a description of the events surrounding the origins of the zoot suit: "The Drape Shape, as if made for a much larger man than its wearer, so baggy as to conceal a bad figure but with ample room for a holster under the armpit, was associated with American gangsters, and a version of it known as the zoot suit had been worn by Danny Kaye [!] and Frank Sinatra [!] for a shorter time." Well, we always knew about Ol' Blue Eyes—but *Danny Kaye?* **JB**

$9.95 *(PB/163)*

Black Panther

Eldridge Cleaver — from Being Black

On Violence

Let us make one thing crystal clear: We do not claim the right to indiscriminate violence. We seek no bloodbath. We are not out to kill up white people. On the contrary, it is the cops who claim the right to indiscriminate violence and practice it everyday. It is the cops who have been bathing black people in blood and who seem bent on killing off black people. But black people, this day, this time, say HALT IN THE NAME OF HUMANITY! YOU SHALL MAKE NO MORE WAR ON UNARMED PEOPLE. YOU WILL NOT KILL ANOTHER BLACK PERSON AND WALK THE STREETS OF THE BLACK COMMUNITY TO GLOAT ABOUT IT AND SNEER AT THE DEFENSE-LESS RELATIVES OF YOUR VICTIMS. FROM NOW ON, WHEN YOU MURDER A BLACK PERSON IN THIS BABYLON OF BABYLONS, YOU MAY AS WELL GIVE IT UP BECAUSE WE WILL GET YOUR ASS AND GOD CAN'T HIDE YOU.

We call upon the people to rally to the support of Minister of Defense, Huey P. Newton. We call upon black people and white people who want to see the dawn of a new history in this land. We call upon people who want to see an end to the flow of blood. We call upon people who want to avoid a war in this land, who want to put an end to the war that is now going on in this land. We call upon people to take up this cry: HUEY MUST BE SET FREE!

Minister of Information
Black Panther Party for Self-Defense
— *The Black Panther*, March 23, 1968
— from *The Black Panthers Speak*

Bad: The Autobiography of James Carr
James Carr
The brutally straightforward, first-person account of the life of James Carr, from his days as a child criminal on the streets of L.A. through his transformation to a notorious rebel convict alongside George Jackson in Folsom prison. Arrested in his teens for armed robbery and bookmaking, Carr (along with Jackson) formed the Wolf Pack, a brotherhood of African-Americans who banded together in order to survive the ongoing prison race wars. While guaranteeing their members a certain margin of material security, Carr eventually realized that the warring bands were pawns of the prison authorities bent on having the feuding factions kill each other off. Inspired by a seemingly diverse group of influences (the Panthers, the Situationists, Lautréamont and Nietzsche), he set about stopping the gang wars altogether in order to target the system itself—a maneuver that provoked the authorities to both increase their savagery and separate Carr and Jackson.

In the mid-'60s Carr was incarcerated in the California Men's Colony in San Luis Obispo, where he again transformed himself from "uppity" inmate to calculating thinker bent on manipulating the authorities, and eventually engineered his own release. Just after the book's completion, early one April morning in 1972, Carr was murdered "gangland style." While his two killers were arrested and given life sentences, no motive was uncovered. "I've been struggling all my life to get beyond the choice of living on my knees or dying on my feet," writes Carr; this struggle had a price he knew well and paid in full. **MDG**
$9.95 *(PB/222)*

Being Black: Selections From *Soledad Brother* and *Soul on Ice*
Roxy Harris
A workbook on Black Panther theory "for use in schools and colleges or for individual and collective study" assembled by a British black activist and teacher.
$8.95 *(PB/52/Illus)*

Bitter Grain: Huey Newton and the Black Panther Party
Michael Newton
"Forged in the fire of the late-1960s revolution, the Black Panther Party erupted onto the scene with a violence unparalleled in modern American history. The image of proud black men patrolling ghetto streets wearing black leather and bristling with weapons brought forth fearful reactions and insanely violent reprisals from law-enforcement officers throughout the land. . . . The cast of characters reads like a Who's Who of black militancy—Eldridge Cleaver, Huey Newton, Bobby Seale, Stokley Carmichael, Earl Anthony, Panther enemy Ron Karenga—all caught up in a whirlwind of revolution and counterrevolution under the murderous eye of the FBI."
$3.95 *(PB/240/Illus)*

The Black Panthers Speak
Edited by Philip S. Foner
A documentary history of the movement responsible for providing both inspiration and ideological guidance for discontented urban African

Americans in the late '60s and '70s, *The Black Panthers Speak* is an excellent anthology of the most vital writings of the party. With offerings from leaders from co-founders Huey P. Newton and Bobby Seale, to Eldridge Cleaver, David Hilliard and Fred Hampton, this collection of essays, interviews and manifestoes fiercely articulates the vision, the rage and the militancy that was uniquely the Panthers'. While their ties with Marxism-Leninism may today appear misguided and naive, they nevertheless attempted to organize the black community—against lethal odds—toward specific political ends: control of the police, a breakfast program for school children, free health clinics, liberation schools. Despite its decline in the mid-'70s (brought about, in part, by Nixon and Hoover's open vow to destroy them) the party's successes and failures have nevertheless provided instructive lessons for the activists—black and white, male and female, gay and straight—who followed in its wake. **MDG**
$13.95 *(PB/281/Illus)*

Blood in My Eye
George Jackson
"Captures the spirit of George Jackson's legendary resistance to unbridled oppression and racism.... *Blood in My Eye* was completed only days before its author was killed. Jackson died on August 21, 1971, at the hands of San Quentin prison guards during an alleged escape attempt." George Jackson on "The Amerikan Mind": "Frankenstein's need for a servant was an expression of his diseased ego, so he created a demented, ugly creature, pathologically strong and huge." On "After the Revolution Has Failed": "After the killing is done, the ruling class goes on about the business of making profits as usual."
$11.95 *(PB/197)*

Seize the Time: The Story of the Black Panthers
Bobby Seale
Published over 25 years ago, tape recorded and written during its author's incarceration in the San Francisco County Jail in 1969 and 1970 (on charges of which he was eventually acquitted), *Seize the Time* is co-founder Bobby Seale's personal history with the Black Panther Party. Dedicated to fellow co-founder Huey P. Newton ("the baddest motherfucker ever to set foot in history"), the book chronicles the oppressive political climate provoking the Panthers' inception and the internal and external struggles it endured as a party, ending with a moving, visionary toast to the future. Vernacular in style and righteously strident in tone, the book reads as a modern history of the oppression of African-Americans. Especially resonant are the events pertaining to repeated governmental attempts (local

and federal) to destroy the party and exterminate members. "Paranoia is having all the facts," William Burroughs once noted, and reading this now, 30 years down the line, it is easy to see what he meant. Also includes an excellent, if brief, new introduction by Seale (1991) in which he states what he now sees as the Panthers' major accomplishment: "Most importantly, the Black Panther Party exposed institutionalized racism and further defined the phenomenon of white America's self-righteous and fascist absolutism." **MDG**
$14.95 *(PB/429)*

Soledad Brother: The Prison Letters of George Jackson
George Jackson
"Each individual black blames himself for failing in life. This is wrong. The truth is that blacks in a white society have little or no control over their own lives, but they must get this control.... Black people react differently to the pressures on them. Some give in to the pressure. Others rebel, but in a confused fashion.... It is not enough for blacks to chase after a college education. Blacks can only advance their position when they find out the truth about their history and way of life."
$14.95 *(PB/368)*

Soul on Ice
Eldridge Cleaver
"Finally back in print, the prison memoirs of Black Panther activist Eldridge Cleaver that shocked, outraged and ultimately changed the way America looked at the black experience."

$5.99 *(PB/192)*

Still Black, Still Strong: Survivors of the War Against Black Revolutionaries
Dhoruba Bin Wahad, Mumia Abu-Jamal, Assata Shakur
Interviews with Dhoruba Bin Wahad, Mumia Abu-Jamal and Assata Shakur (mother of Tupac), prime targets in the U.S. government's continuing war against the Black Panthers and Move, plus mind-boggling documents from the FBI's Panther files. **MG**
$7.00 *(PB/272)*

To Die for the People
Huey P. Newton
Driven by an uncompromising social conscience made explicit by its title, *To Die for the People* is a selection of writings and speeches of Black Panther Party co-founder Huey P. Newton. Originally published in 1972, its texts range in date from 1967 to 1972 and cover a wide range of topics: the Party, Black America, White America and the Third World. Firm in the belief that political enlightenment can only occur incrementally—"We realized at a very early point in our development that revolution is a process"—Newton's vision is at once pragmatic, personal and speculative. One gets the sense from these writings that Newton was motivated by this most basic and humane of principles—at times, paradoxically, in spite of himself. Mandatory reading for anyone interested in the ongoing African-American struggle for equality. **MDG**
$14.95 *(PB/233)*

Black Panthers drilling in California — from **Being Black**

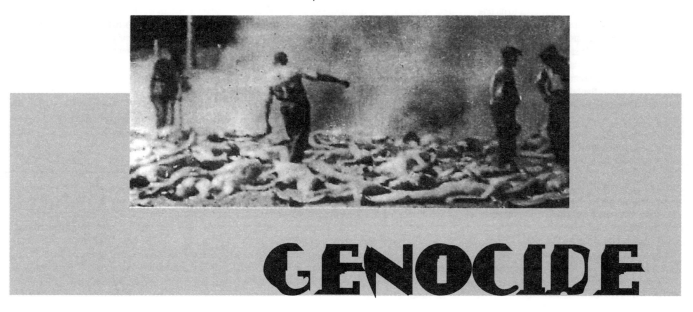

GENOCIDE

Act and Idea in the Nazi Genocide
Berel Lang

The sign over the gate of Auschwitz read "*Arbeit Macht Frei,*" (Work Makes One Free) and the Zyklon-B gas canisters for the death camp were shipped in Red Cross trucks. Sick jokes, both. Why did the Nazis use such obvious irony? Such imaginative evil? "The ancient categories of moral philosophy—responsibility, intent, choice, forgiveness, shame, and all the rest-are horrifyingly repositioned when applied to the German mass murder of the Jews in Europe." The author argues "that the events of the Nazi genocide compel reconsideration of such fundamental moral concepts as individual and group responsibility, the role of knowledge in ethical decisions, and the conditions governing the relation between guilt and forgiveness." Chapters include: "The Knowledge of Good and Evil," The Decision Not To Decide," and "Language of Genocide." **GR**
$14.95 *(PB/258)*

The Architect of Genocide: Himmler and the Final Solution
Richard Breitman

Hailed by mainstream Holocaust historians as a "path-breaking book," *Architect of Genocide*

attempts to reply to the arguments of revisionist historians. Relying extensively on Himmler's surviving notes and official correspondence, the author weaves an intricate and subtle web of innuendoes, facts and often compelling arguments in support of his thesis that the extermination of Europe's Jews was ultimately the end result of a fatal attraction between two dynamic and unstable personalities—Adolf Hitler and Heinrich Himmler. The author offers the reader an abundant array of hitherto untapped sources in support of his claims. Those familiar with the works of establishment historians will welcome the new source materials which this book provides. On the other hand, revisionists will also welcome these same arguments and materials as additional fuel to keep the fires of debate burning. **JB**
$14.95 *(PB/352)*

Assassins of Memory: Essays on the Denial of the Holocaust
Pierr Vidal-Naquet

Vidal-Naquet dedicates his book to his mother, who died in Auschwitz in June 1944. Haunted by this memory and the recent flurry of revisionist publications initiated by his countryman Robert Faurisson, Vidal-Naquet seeks to defuse the growing tide of revisionism without recourse to debate. Indeed, it is a hallmark of his style that Vidal-Naquet refuses to

debate revisionists, fearful lest it endow a form of legitimacy to revisionist arguments. Nevertheless, he does respond, and it is his response which makes the reader wish that Vidal-Naquet would debate his controversial adversaries. **JB**
$15.95 *(PB/205)*

Atlas of the Holocaust
Martin Gilbert

Gilbert is one of the most prolific writers on the Holocaust, having written *Auschwitz and the Allies,* among other titles. His *Atlas of the Holocaust* is packed with maps and photographs on every page. This current title took over seven years to research, and should be a welcome addition to any library devoted to the study of the Holocaust. The book is not without controversy, however, as many critics question the sources of the facts and figures it quotes. Regardless of one's opinions, the book is fastidiously detailed and even relates previously unavailable facts and figures concerning the Jewish Partisan Movement. **JB**
$20.00 *(HB/283/Illus)*

Auschwitz: 1270 to the Present
Debórah Dwork and Robert-Jan Van Pelt

As an exhaustive history of the town of Auschwitz, this book has a certain value. However, this review-

er is puzzled as to why these two authors should have decided to research the history of an insignificant little Polish village all the way back to its origins in 1270. Obviously, Auschwitz is only of historical interest insofar as the history of the Holocaust—which is indeed covered in meticulous detail later in the book—is concerned. However, aside from interesting photographs and the history of a Polish village, the book really adds nothing new to what historians already know about the infamous concentration camp. **JB**
$30.00 *(HB/443/Illus)*

Auschwitz, 1940-1945
Author unknown
Copy of the grim souvenir book available at "the world's greatest battlefield"—Konzentrationslager Auschwitz—translated from Polish. Shows the crematorium; the punishment cells; the wall of death; wooden barracks; daily rations for a prisoner; piles of clothes, hair, and false legs; and other evidence of the assembly-line slaughter of an estimated 4 million people, mostly Jewish. Also covers Birkenau. Illustrated with black-and-white snapshots taken by SS guards, who took pictures like tourists enjoying a gruesome theme park. **GR**
$8.95 *(PB/120/Illus)*

Brother Number One: A Political Biography of Pol Pot
David P. Chandler
Pol Pot is one of the most elusive revolutionary leaders of the 20th century. No modern leader (or despot?) has left so little trace of his existence, a situation not helped by his use of multiple false names. His personal story begins as an indifferent student who becomes a gifted teacher. He now leads, or led (there are conflicting reports of his death), one of the w.orld's toughest guerrilla groups. His personal reputation is as a polite, charming and deferential man, but is juxtaposed with his bearing responsibility for one the greatest genocides of the 20th century. **SC**
$24.95 *(HB/254/Illus)*

Cleansing the Fatherland: Nazi Medicine and Racial Hygiene
Aly, Chroust and Pross
"The infamous Nuremberg Doctors' Trials of 1946-47 revealed horrifying crimes—ranging from grotesque medical experiments on humans to mass murder—committed by physicians and other health care workers in Nazi Germany. But far more common, argue the authors, were the doctors who profited porfessionally and financially from the killings but were never called to task—and

indeed were actively shielded by colleagues in postwar German medical organizations. . . . They also reveal details of countless lesser known killings—all ordered by doctors and all in the name of public health. Maladjusted adolescents, the handicapped, foreign laborers too ill to work, even German soldiers who suffered mental breakdowns after air raids were 'selected for treatment.' The book also includes original documents—never before published in English—that give unique and chilling insight into the everyday workings of Nazi medicine."
$16.95 *(PB/296/Illus)*

A Collector's Guide to the Waffen-SS
Robin Lumsden
From their death's-head insignia, snappy SS tank top and sports kilt, to their luxurious Russian Front greatcoats (lined with furs stripped from gassed Jews), it can't be said the nastiest of the Nazis weren't well-dressed. This is a detailed history, illustrated with field photos, of the uniforms and insignias of the armed units of Hitler's Schutzstaffel der NSDAP (SS), originally formed as non-fighting "protection squads" to the Nazi bigwigs. By the time war broke out, Germany had recruited a quarter million of these well-liveried chauffeurs. Then Adolf demanded his special boys have "soldierly character It will be necessary for our SS and police, in their own closed units, to prove themselves at the front in the same way as the army and to make blood sacrifices to the same degree as any other branch of the armed forces." So the SS went to war. Chronicles manufacturing history, design changes, evolution of steel helmets and field caps, and shows how to spot fakes and fantasies. **GR**
$19.95 *(PB/160/Illus)*

Confessions of a Holocaust Revisionist: Part 1
Bradley R. Smith
"Smith illustrates the dimensions of the taboo surrounding orthodox Holocaust claims in carefully detailed accounts of his everyday encounters with others: a Jewish student returning home from Harvard on summer vacation; the new husband of his ex-wife; an elderly survivor on a radio talk show; Irv Rubin of the Jewish Defense League—even with his own mother. Smith's repugnance at being labeled anti-Jewish is the greatest hurdle he has to overcome in his efforts to write honestly about the Holocaust. He tells of his growing awareness of how the Holocaust lobby manipulates charges of anti-Jewishness to discourage open inquiry into the extermination thesis, and to compromise the reputations of those who persist in it."
$6.00 *(PB/57)*

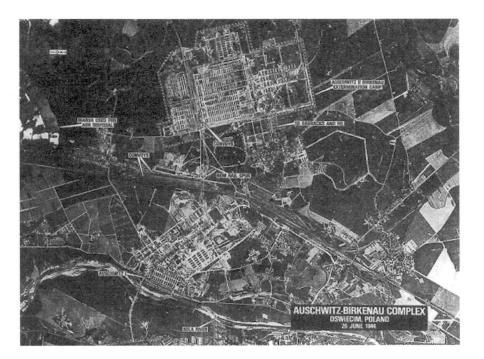

An aerial photograph depicts the scale of the death-camp operation. — from **Death Dealer**

Death Dealer:
The Memoirs of the SS Kommandant at Auschwitz
Rudolph Höss

Up-close journals written by one of the most infamous Nazi death camp commanders of World War II. A very bleak and disturbing look into the mind of Rudolph Höss and the genocidal plot of the Final Solution. These memoirs journey from day one of this senior Reich officer's career up until his day of execution, bringing to light a brutal and almost unfathomable time in history, as well as the sad nature of Höss' pride and merits. Complete with reference guide listing all of the historic SS criminals. Ruthless and mortifying, this document is guaranteed to disturb and educate about the horrors that occurred at Auschwitz. **TD**
$15.95 *(PB/390/Illus)*

Defiance:
The Bielski Partisans
Nechama Tec

As a protest against the prevailing image of the Jews marching like docile lambs into Nazi death chambers, the author of this book relates the exploits of a 1,200-man Jewish partisan group, fighting against the Nazis in the forests of Byelorussia. Relying on accounts supplied by ex-partisans, Tec effectively corrects the image of the Jews complacently resigning themselves to the inevitability of death. **JB**
$13.95 *(PB/304/Illus)*

East Timor:
Genocide in Paradise
Matthew Jardine

Since 1974, Indonesia has exterminated one-third of the population, with U.S. complicity. Here's the how and why of this disaster. Introduction by Noam Chomsky. **AK**
$6.00 *(PB/110/Illus)*

"Exterminate All the Brutes":
One Man's Odyssey Into the Heart of Darkness and the Origins of European Genocide
Sven Lindqvist

This book presents an argument that "the harrowing racism that led to the Holocaust in the 20th century had its roots in European colonial policy of the preceding century." It sets Conrad's *Heart of Darkness* in the context of its times and traces "the legacy of the writings of European explorers and theologians, politicians and historians,

Auschwitz, Block 6, Room 4. Daily food ration of a prisoner — from **Auschwitz**

from the late 18th century on, in an effort to help us understand that most terrifying of Conrad's lines, 'Exterminate all the brutes.'" It chronicles many infamous genocides of "lower species" and "inferior races" that hallmarked the Western world's "progress" in the 1800s, such as: Darwin's witnessing of the Argentine government's slaughter of the Pampas Indians; the complete extermination by the Spanish of the Guanches of the Canary Islands; the complete extermination of the Tasmanians of the South Pacific (also witnessed by Darwin); and America's decimation of its native tribes, cutting them down from 5 million to one-quarter million. **GR**
$20.00 *(HB/179/Illus)*

An Eye for an Eye:
Untold Story of Jewish Revenge Against Germans in 1945
John Sack

Eye for an Eye recounts with brutal candor the savage treatment meted out to ethnic Germans by Jewish vengeance squads recruited from Nazi concentration-camp survivors by Stalin's terror regime. The author of the book, himself a conservative Jew, tracked down the alleged perpetrators of these appalling crimes to locations in Poland, Israel and the United States during the course of his research. Appalled by the catalog of horrors he uncovers, the author seeks philosophical answers to perennial questions such as, "Can any good come out of evil?"

The book is replete with lurid descriptions of the agonies and torments inflicted upon Germans innocent of any wrongdoing: "The girls in Gleiwitz used fire. They held down the German boy, put out their cigarettes on

him and, using gasoline, set his curly black hair on fire. In time, three-fourths of the Germans at Shlomo's camp were dead, and Shlomo announced, 'What the Germans couldn't do in five years at Auschwitz, I've done in five months at Schwientochlowitz.'" *Eye for an Eye* generated a storm of controversy both before and after its release. Though the subject has been dealt with at length in previous publications, such as *German Documents on the Expulsion* and *Silesian Inferno*, this book is unique in that it provides the reader with the identities of alleged perpetrators. Indeed, some of the ghoulish characters described in this book make Spielberg's Commander Amon Goth look like Winnie the Pooh. **JB**
$23.00 *(PB/252)*

Fifty Days on Board a Slave-Vessel
Pascoe G. Hill

This is an account of 50 horrific days on a slave ship, and it will forever haunt its readers with a vision of the inhumane conditions endured by captured Africans. "Many of the Negroes have letters cut on the breast or shoulder, which Antonio tells me, are the marks of the respective owners who, on the vessel's arrival at Rio, thus recognize their own property." **SC**
$5.95 *(PB/58)*

Fighting Back:
A Memoir of Jewish Resistance in World War II
Harold Werner

For decades it was thought that the Jews of Europe went like "lambs to the slaughter" during the Holocaust. However, after the spectacular achievements of the Israeli armed forces during the 1967 war, a number of books began appearing which contradicted the idea that the Jewish people made no effort to defend themselves from Nazi persecution. We know today that over 1.5 million Jews served in the various allied forces during World War II. Among them were a number of distinguished generals and officers. Apart from this not inconsiderable number of combatants, who served with distinction, stood the vast numbers of partisans scattered throughout Nazi-occupied Europe. The exact number of partisans shall never be known, but an estimate of 1 million would not be an exaggeration. *Fighting Back* details the Jewish resistance movement in Poland, and adds many new and exciting details to this intriguing chap-

ter of contemporary history. The author details his personal experiences as a member of one large Jewish partisan group. **JB** **$12.95** *(PB/253/Illus)*

Hitler: Speeches and Proclamations, 1932-1945: Volume 1, 1932-1934
Max Domarus

This is the first expanded work on Hitler's speeches offered in the English language, the first of four volumes, which spans the years of Hitler's career from 1932 to 1945. There is perhaps no contemporary leader who spoke as much or as often as Adolf Hitler, whose utterances, however trivial, were faithfully recorded by devoted disciples. (A massive 30-volume set of Hitler's speeches, writing and proclamations was published in Germany about 10 years ago.) The material is well-organized, though highly selective, due to the constrictions imposed by the sheer mass of Hitler's torrents of verbiage. A few insightful quotes from the lips of the Fuehrer: "Lies and slander of positively hair-raising perversity are being launched about Germany. Horror stories of dismembered Jewish corpses, gouged-out eyes, and hacked-off hands are circulated for the purpose of defaming the German Volk in the world for a second time, just as they had succeeded in doing once before in 1918. . . . They lie about Jewish females who have supposedly been killed, about Jewish girls allegedly being raped before the eyes of their parents, about cemeteries being ravaged. The whole thing is one big lie invented for the sole purpose of provoking a new world-war agitation." **JB** **$135.00** *(HB/611)*

Hitler's Willing Executioners
Daniel Goldhagen

"In a work as authoritative as it is explosive, Goldhagen forces us to revisit and reconsider our understanding of the Holocaust and its perpetrators, demanding a fundamental revision in our thinking of the years 1933-1945. Drawing principally on materials either unexplored or neglected by previous scholars, Goldhagen marshals new, disquieting primary evidence that explains why, when Hitler conceived the 'final solution' he was able to enlist vast numbers of willing Germans to carry it out." **$16.00** *(PB/656)*

The Hoax of the Twentieth Century: The Case Against the Presumed Extermination

of European Jewry
Arthur R. Butz

Bergen-Belsen: country club or death factory? Holocaust as Zionist fraud. Chapters include "Camps," "Washington and New York," "Auschwitz," "The Final Solution," "The Role of the Vatican," "Trials, Jews and Nazis," and "The Gerstein Statement." **$9.00** *(PB/397/Illus)*

The Holocaust Story and the Lies of Ulysses
Paul Rassinier

"'You have to reckon with the complex of Ulysses's lie . . . Everyone hopes and wants to come out of this business with the halo of a saint, a hero or a martyr and each one embroiders his own Odyssey without realizing that the reality is quite enough in itself.' These words, spoken to Frenchman Rassinier by a fellow inmate at Buchenwald, became emblematic of his own courageous odyssey. Although his health was broken in Hitler's concentration camps, this French socialist, pacifist and highly decorated member of the Resistance would not bear false witness against his captors by exaggerating their crimes. Neither could Rassinier keep silent about the lies of fellow survivors who fabricated gas chambers and other atrocity stories in the fevered postwar atmosphere. . . . His training as a historian and his experience in the camps enabled Rassinier to formulate a devastating critique of concentration-camp 'eyewitnesses' and 'Holocaust' historians alike. The half-dozen books which Rassinier completed before his untimely death in 1967 have earned him the title of 'father of Holocaust Revisionism.'" **$12.00** *(PB/450)*

I, Pierre Seel, Deported

Homosexual: A Memoir of Nazi Terror
Pierre Seel

In 1941, a young gay boy in Nazi-occupied Strasbourg, Alsace, only 17, is summoned by the Gestapo, tortured at Gestapo headquarters, and sent to the Schirmeck-Vorbruch work camp. A haircut in the shape of a swastika, bouts of dysentry, beatings, starvation. "Monstrous" medical treatments were part of his internment: "There were half a dozen of us, bare-chested and lined up against the wall. I have very clear memories of white walls, white shirts and the laughter of the orderlies. The orderlies enjoyed hurling their syringes at us like darts at a fair. During one injection session, my unfortunate neighbor blacked out and collapsed: the needle had struck his heart. We never saw him again." The worst was witnessing the slaughter of his young lover, who was stripped naked in front of hundreds, then had a bucket placed over his head, then was torn apart screaming by guard dogs. The bucket was used to amplify his screams. Written with "poignant dignity and simplicity." **GR** **$12.00** *(PB/208/Illus)*

Judenrat: The Jewish Councils in Eastern Europe Under Nazi Occupation
Isaiah Trunk

Judenrat is a massive undertaking which purports to raise and answer a number of uncomfortable questions concerning the role of Jews who "collaborated" with the Nazis during World War II, although the author is careful to assign ultimate guilt to the Nazis. The description of the Ghetto Police, who were comprised of Jews, is particularly harrowing: "Horrible stories are told about the Jewish Policemen at the Umschlagplatz. For them

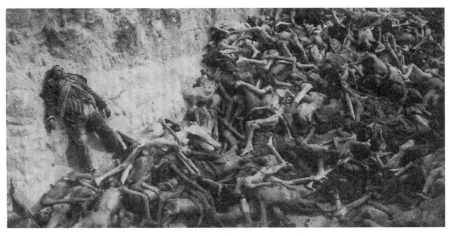

Mass grave at Belsen — from **The Hoax of the Twentieth Century**

Fred Leuchter, author of The Leuchter Report

the victims were not human beings but heads for which money could be extorted. Ransom could be paid in cash, diamonds, gold, etc. The price of a head ranged from 1,000 to 2,000 zlotys at the beginning, until it grew to 10,000 zlotys per head. . . . The policemen knew no mercy, even in regard to the most respected man. If he could not pay, or if there were no relatives ready to pay, he was shipped off. There were known cases when policemen demanded payment in kind—the flesh of women in addition to cash. The people apprehended . . . particularly women, put up resistance. All these factors created an unbearable situation for the policemen. They went berserk, committing unspeakable acts." **JB**
$29.95 *(PB/700/Illus)*

The Killing Fields
Edited by Chris Riley and Douglas Niven
A most disturbing and depressing photographic essay about the Khmer Rouge, who were in power under Pol Pot in Cambodia for over three years. After seizing power in '75 they started "cleaning house" and taking prisoners. Photographs of each prisoner before interrogation, torture and ultimately the execution of some 14,000 people. Believing, it seems, that they were destroying traitors who were infecting the Communist Party. The photos and documentation were apparently meant to be used by officials as an example of their "progress" against the enemies of the revolution.Only seven of the people pictured survived. One survivor named Nath tells his grim story of torture and starvation in a Cambodian prison. S-21 is the innteragation facility at Tuol Sleng Prison, the Cambodian equivalent of Auschwitz. One day Nath was "appointed" to cut rattan in the forest. He said goodbye to his family and not knowing his fate, left and was taken to Tuol Sleng. But he was

an honest man and didn't know why he was arrested. At the prison, torture and forced confessions were the order of the day, although the people confessing were usually innocent of the crime they confessed to, Pol Pot and Duch (the chief of the prison) being the guilty ones with paranoid delusions. Vietnamese troops finally overthrow their regime. Nath escaped with his life and managed to find his wife but learned his children had died of disease and starvation. Later that same year the Museum of Genocide was created on the grounds of the former prison were these photos were taken, bleak reminders of that inhumane cruelty. One look and one can sense the impending doom; one look and one is inside S-21. **DW**
$50.00 *(HB/124/Illus)*

Lethal Laws: "Gun Control" Is the Key to Genocide
Jay Simkin, Aaron Zelman and Anne M. Rice
Lethal Laws takes as its premise the idea that guns have been outlawed so that Jews could be murdered more than any other nationality. Thus, they argue, guns should be legal everywhere. The authors took great pains to reproduce documentation regarding the regulation of firearm sales and ownership in many foreign countries. **JB**
$24.95 *(PB/350/Illus)*

The Leuchter Report: The First Forensic Examination of Auschwitz
Fred A. Leuchter
"Leuchter, 45, is an engineer living in Boston, Massachusetts, who specializes in the design and fabrication of execution hardware used in prisons throughout the United States. One of his major projects was the design of a new gas chamber at the Missouri State Penitentiary at Jefferson City."— Robert Faurisson

"The purpose of this report and the investigation upon which it is based is to determine whether the alleged execution gas chambers and crematory facilities at three sites in Poland—namely: Auschwitz, Birkenau and Majdanek—could have operated in the manner ascribed them in Holocaust literature."—Fred Leuchter
$20.00 *(PB/66/Illus)*

Male Fantasies, Volume 1: Women, Floods, Bodies, History
Klaus Theweleit
"The first volume deals primarily with the image of women in the collective unconscious of the fascist warrior—visions reflecting hatred and fear, culminating in a series of liquid metaphors—red tide, lava, mud—

that threaten to engulf the male ego."
$16.95 *(PB/517/Illus)*

Male Fantasies, Volume 2: Male Bodies—Psychoanalyzing the White Terror
Klaus Theweleit
"In Volume 2, Theweleit shifts his attention to the male self-image. We are shown how the body becomes a mechanism for eluding the dreaded liquid and the 'feminine' emotions associated with it. Armored, organized by the mental and physical procedures like the military drill, the male body is transformed into 'a man of steel.' As Theweleit shows, only in war does this body find redemption from constraint."
$17.95 *(PB/480/Illus)*

Mass Murderers in White Coats
Lenny Lapon
"Documents the mass murder of 'mental patients' by psychiatry in Nazi Germany and in the United States. Shows how the killing of thousands of psychiatric inmates and other 'useless eaters' in Hitler's Third Reich set the stage in a practical and ideological way for the later extermination of Jews and other victims of Nazi persecution. Presents lengthy excerpts from conversations the author had with 11 psychiatrists who are members of the American Psychiatric Association and who are also connected in various ways to Nazi Germany."
$10.95 *(PB/291)*

Mein Kampf
Adolf Hitler
Hitler's blueprint for the 1,000-year Reich

Translation: "Jewish Council, Warsaw, Police Force"
— from The Warsaw Ghetto in Photographs

that lasted, oh, how many years? At its peak in popularity, outsold the Bible in Germany.
$18.00 *(PB/694)*

The Men With the Pink Triangle
Heinz Heger

Kissing or embracing another man, gossip spread by neighbors or receiving a letter from a gay friend were grounds for arrest under Paragraph 175, a strengthened German sodomy law pushed through in 1935, endorsed by the SS and the Gestapo. Tagged as "degenerates" and "undesirables," lesbians and "filthy queers" were systematically hunted down, brutalized and exterminated along with the rest of Hitler's Aryan phobias: the Jews, Gypsies, the mentally ill. The story of a gay Austrian man who endured the death camps, forced to wear a pink triangle to identify his crime against the state. **GR**
$8.95 *(PB/120/Illus)*

The Myth of the Twentieth Century
Alfred Rosenberg

"Represents the most ambitious attempt to present a historical, racial philosophy of National Socialism. While not the Nazi Summa Theologica it has sometimes been mischaracterized as, only Adolf Hitler's *Mein Kampf* exceeded *The Myth of the Twentieth Century* in authority—and in commercial success—as a statement of the values and aims of the National Socialist movement during the Third Reich. . . . an intellectual and spiritual call to arms in defense of the Aryan, or white, race, and in particular of the Nordic type, which has epitomized that race since the dawn of history."
$19.00 *(HB/470)*

Nuremberg: The Last Battle
David Irving

"Using the unpublished diaries and papers of the principal actors—the judges, lawyers and the war criminals themselves—David Irving has pieced together the remarkable history of how the Trial of the Century came about."
$39.95 *(HB/377/Illus)*

Ordinary Men: Reserve Battalion 101 and the Final Solution in Poland
Christopher R. Browning

This is a genuinely disturbing book, written by one of the leading Holocaust historians of our time. By narrowing his focus to examining the activities of one Nazi police battalion, the author provides a chilling portrait of men whose humanity is torn from their very souls. This book

Condemned prisoner of Khmer Rouge — from **The Killing Fields**

would seem to have served as the catalyst for Daniel Goldhagen's controversial book, *Hitler's Willing Executioners.* **JB**
$12.50 *(PB/231/Illus)*

The Path to Genocide: Essays on Launching the Final Solution
Christopher R. Browning

"Studies three aspects of the events leading up to the Final Solution in Nazi Germany. First, Nazis' solutions to their self-imposed 'Jewish problem', before resorting to mass murder, are examined, specifically ghettoization and early resettlement plans to expel Jews to Eastern Poland or the island of Madagascar. Second, the responsibility of shaping Nazi Jewish policy is shown to extend to the lower and middle echelon of government, through accommodation and conformity of a wide variety of perpetrators, including bureaucrats, doctors and policemen. Finally the role of Adolf Hitler in the decision making process is examined, with a historiographical analysis of other accounts of his role. Browning argues that while Hitler did not operate according to a premeditated plan or blue-

print, he did make the key decisions."
$12.95 *(PB/207)*

The "Problem of the Gas Chambers"
Robert Faurisson

Well-known historical revisionist disputes standard accounts of extermination of prisoners in Hitler's concentration camps. **SC**
$.20 *(Pamphlet/2)*

The Psychopathic God: Adolf Hitler
Robert G.L. Waite

A psychoanalytical study focusing on the Fuehrer as personality: his transformation from disillusioned artist to semi-divinity; his childlike traits; his Oedipal conflicts; his obsessions with time, cleanliness and wolves; his tastes in visual art and literature; his fears of women and sexual interests; his love affairs and much more, with a very good analysis of how his private neuroses translated into public policy. Especially interesting is the author's exposition on Hitler's personality as the literal foundation of National Socialism: "He was

Albert Speer goes through the trial without his part in the deportation of Berlin's Jews becoming known. — from **Nuremberg: The Last Battle**

not the interpreter of an ideology; he was the idea made incarnate. He was Nazism." **BS**

$15.95 *(PB/482/Illus)*

Revolution and Genocide: On the Origins of the Armenian Genocide and the Holocaust
Robert Melson
"Jews in Imperial Germany and Armenians in the Ottoman Empire had survived as ethnic and religious minorities until they suffered mass destruction when the two old regimes were engulfed by revolution and war. Focusing on these episodes as well as mass killings in the Soviet Union and Cambodia, Melson creates a framework for understanding the link between genocide and revolution."

$16.95 *(PB/363)*

Simon Wiesenthal: Bogus "Nazi Hunter"
Mark Weber
"Wiesenthal's reputation as the world's foremost 'Nazi hunter' is completely undeserved. His greatest achievement in more than 30 years of searching for 'Nazi criminals' was his alleged role in locating and capturing Adolf Eichmann . . . but Isser Harel, the Israeli official who headed the team that captured Eichmann, has declared unequivocally that Wiesenthal had 'absolutely nothing' to do with the capture. 'All the information supplied by Wiesenthal before and in anticipation of the operation was utterly worthless, and sometimes even misleading and of a negative value,' Harel says." **SC**

$.20 *(Pamp/2)*

The Splendid Blond Beast: Money, Law and Genocide in the Twentieth Century
Christopher Simpson
"Dulles told the SS envoy that 'due to the inflamed state of public opinion in the Anglo-Saxon countries, the U.S. Government would not accept Hitler as a postwar chief of state. But it might be willing to negotiate with a National Socialist Germany led by another powerful Nazi, such as SS Chief Heinrich Himmler.'" In a second meeting, Dulles advised Hohenlohe that the SS should "act more skillfully on the Jewish question" to avoid "causing a big stir." Obviously, there would be no war-crimes trials for Nazis with Himmler as head of state. And so it goes, from deception to deception, through all those garish little skeletons carefully hidden away in the closet by the government for which thousands of American boys sacrificed their lives in order to make the world "safe for politicians." Ultimately, the author of *The Splendid Blond Beast* blames intrigue between international representatives as the major cause of genocide in our century. The book is well-written and meticulously documented, and holds a surprise or two even for those who think they have read it all. **JB**

$19.95 *(PB/400)*

This Time We Knew: Western Responses to Genocide in Bosnia
Edited by Thomas Cushman and Stjepan G. Mestrovic
"'We didn't know.' For half a century, Western politicians and intellectuals have so explained away their inaction in the face of genocide in World War II. In stark contrast, Western observers today face a barrage of information and images, from CNN, the internet and newspapers about the parties and individuals responsible for the current Balkan War and crimes against humanity. The stories, often accompanied by video or pictures of rape, torture, mass graves and ethnic cleansing, available almost instantaneously, do not allow even the most uninterested viewer to ignore the grim reality of genocide. . . . This volume punctures once and for all common excuses for Western inaction."

$18.95 *(PB/320)*

To Tell at Last: Survival Under False Identity, 1941-45
Blanca Rosenberg
"The harrowing story of a young Jewish mother who evades the Nazis from one Polish city to the next until she winds up in Heidelberg, Germany, where she works as a maid until liberation. . . . One of the finest, most authentically dramatic and richly detailed memoirs written by a survivor of the Nazi Holocaust."

$12.95 *(PB/178/Illus)*

The Warsaw Ghetto in Photographs: 206 Views Made in 1941
Edited by Ulrich Keller
These 206 rare photos recreates ghetto life during the early years of World War II—the internal ghetto administration, ghetto police, children, street scenes, worship, etc. "The crowd is largely composed of shocking caricatures, of ghosts of former people, of wretched rags and miserable ruins of past humanity . . ."

$9.95 *(PB/160/Illus)*

Disabled servicemen competing on the games field during their convalescence, 1942. The man on the right wears SS sports kit. — **A Collector's Guide to the Waffen-SS**

JFK

Excerpts from the Skeleton Key to the Gemstone File:

1932: Onassis, a Greek drug pusher and ship owner who made his first million selling "Turkish tobacco" (opium) in Argentina, worked out a profitable deal with Joseph Kennedy, Eugene Meyer and Meyer Lansky: Onassis was to ship booze directly into Boston for Joseph Kennedy. Also involved was a heroin deal with Franklin and Elliott Roosevelt.

1941-1945: World War II: Very profitable for Onassis, Rockefeller, Kennedys, Roosevelts, I.G. Farben, etc., etc. Onassis, selling oil, arms and dope to both sides, went through the war without losing a single ship or man.

1956: Howard Hughes, Texas millionaire, is meanwhile buying his way toward control of the U.S. electoral process—with a view toward his personal gain. He buys senators, governors, etc. He finally buys his last politician: newly-elected V.P. Nixon, via a quarter-million-dollar non-repayable loan to Nixon's brother, Donald.

Early 1957: V.P. Nixon repays the favor by having IRS-Treasury grant tax-free, non-accountable money funnel or laundry, for whatever Hughes wanted to do. U.S. Government also shelved anti-trust suits against Hughes' TWA, etc.

March, 1957: Onassis carries out a carefully planned event: he has Hughes kidnapped from his bungalow at the Beverly Hills Hotel, using Hughes' own men (Chester Davis, born Casare in Sicily, et al.). Hughes' own men either quit, get fired, or stay on in the new

Onassis organization. A few days later, Mayor Cannon of Nevada (now Senator Cannon) arranges a fake "marriage" to Jean Peters, to explain Hughes' sudden loss of interest in chasing movie stars. Hughes, battered and brain-damaged in the scuffle, is taken to the Emerald Isle Hotel, in the Bahamas, where the entire top floor has been rented for the "Hughes party"; there he is shot full of heroin for 30 days, and later dragged off to a cell on Onassis' island, Skorpios. Onassis now has a much larger power base in the U.S. (the Hughes empire), as well as control over the V.P. Nixon and other Hughes-purchased politicians. L. Wayne Rector, "Hughes" double since 1955, becomes "Hughes."

October, 1968: Jackie Kennedy was now free marry Onassis. An old mafia rule: If someone welches on a deal, kill him, and take his gun and his girl: in this case, Jackie and the Pentagon.

Lee Harvey Oswald, taken the day before his death — from Oswald Talked

Conspiracy: The Definitive Book on the JFK Assassination
Anthony Summers

This massive book, laced with rare photos and oblique documents, pursues the Mafia-CIA link and addresses such matters as: Two men named the gunman they say killed Kennedy. Why did the Reagan Justice Department refuse to pursue the matter? Former chief of the CIA's Western Hemisphere Division believed there was a conspiracy, carried out by "rogue" colleagues in intelligence. The president's body was surgically altered to conceal evidence of a second gunman. And the author's ace in the sleeve?—a Cuban woman who has sworn to tell all . . . and does. **JB**
$14.95 *(PB/657/Illus)*

Crime and Cover-Up: The CIA, the Mafia and

the Dallas-Watergate Connection
Peter Dale Scott

A small masterpiece which renders understandable a Byzantine picture of internecine rivalries among government agencies and the intelligence apparatus, and the whole shabby interlinkage of conspiracy within conspiracies. From the master expert on the political, underworld and labor-union interrelationships in the complex framework of the assassinations in Dallas and elsewhere. **AK**
$10.95 *(PB/80)*

Deep Politics and the Death of JFK
Peter Dale Scott

A major, fact-filled statement on the JFK assassination and its implications in terms of an empirical view of both American and world politics. "Deep political analysis focuses on the usually ignored mechanics of accommodation. From the viewpoint of conventional political science, law

enforcement and the underworld are opposed to each other, the former struggling to gain control of the latter. A deep political analysis notes that in practice these efforts at control lead to the use of criminal informants; and this practice, continued over a long period of time, turns informants into double agents with status within the police as well as the mob. . . . Such dirty realities are not usually talked about in classrooms. But the mechanics of accomodation are important . . . in the area of political security, where security informants are first recruited, and eventually promoted to be double agents. . . . A deep political system is one where the processes openly acknowledged are not always securely in control, precisely because of their accommodation to unsanctioned sources of violence, through arrangements not openly acknowledged and reviewed."
$14.95 *(PB/424)*

Final Judgement: The Missing Link in the JFK Assassination

Conspiracy
Michael Collins Piper

This book offers even the most grizzled devotees of mayhem and mystery more than enough meat to chew on. In this strange twist of events, the focus shifts to Israel's role in the assassination of JFK. The author walks the reader straight into the domain of Meyer Lansky, Mickey Cohen, and the Mossad, maintaining that Israel and its secret service had a reason to be opposed to JFK; and that Israel's allies in the mob and the CIA were, in turn, interacting with one another and opposed to JFK; thus these forces were allied together in the JFK conspiracy. **JB**

$20.00 *(PB/352)*

The Gemstone File
Edited by Jim Keith

"*The Gemstone File* is one of the wilder and woolier legends of research into political conspiracy. Penned by Bruce Roberts (of whom not a great deal is known other than the bare facts of his life and that he died, either by brain tumor or cancer, on July 30, 1976), this document of reportedly over 1,000 handwritten pages was passed on in part in 1975 to Mae Brussell, the now-deceased researcher into matters conspiratorial.... The File was synopsized by Stephanie Caruana (a writer sent to interview Brussell by *Playgirl* magazine, who took and still takes Roberts' revelations with utmost seriousness), and the condensed 'A Skeleton Key to the Gemstone File' was then distributed at random and far and wide, reprinted, changed, parodied, added to, and variously hijacked by people heeding its call to make copies and spread them around. When people speak of the Gemstone File, they are usually referring to the 'Skeleton Key,' although the term is more correctly applied to Roberts' original Gemstone letters.... So what kind of information does the 'Skeleton Key' contain? It is a convoluted and feisty chronology purporting to be the inner track on some of the major events of the 20th Century: the Kennedy assassination, the tragedy at Chappaquiddick, and the strange and secret histories of Howard Hughes and Aristotle Onassis. The 'Skeleton Key' describes skullduggery and wheeling and dealing for high stakes indeed: the control of America." In addition to "The Skeleton Key," includes commentaries by Mae Brussell, Robert Anton Wilson, Kerry W. Thornley and others on the Gemstone File and its significance.

$14.95 *(PB/214)*

JFK: The CIA, Vietnam and the Plot To Assassinate John F. Kennedy
L. Fletcher Prouty

"Colonel Prouty ... sets the stage for Dallas in all its horror. He explains the true inner myth of our most staged public execution, the 'Reichstag Fire' of our era, behind whose proscenium, blinded by the light of surface-event television, the power of the throne was stolen and exchanged by bloody hands. He shows us that Kennedy was removed, fundamentally, because he threatened the 'system' far too dangerously. Colonel Prouty shows us the Oswald cover story and how it has successfully to this day, my movie notwithstanding, blinded the American public to the truth of its own history." Alternative history source material for Oliver Stone's *JFK*, from the hereforeto anonymous "X." Thrill to a wide-ranging and nearly all-encompassing conspiracy theory that goes far beyond the JFK assassination. **NN**

$22.00 *(HB/366/Illus)*

JFK: The Last Dissenting Witness
Bill Sloan with Jean Hill

"Hill, the woman in red in the Zapruder film, stood less than 10 feet away from the presidential limousine facing the now-famous grassy knoll. From there, she saw a gunman fire the shot that exploded the president's skull. That gunman was *not* Lee Harvey Oswald. Despite years of inner turmoil and harassment from the Secret Service, FBI, CIA and the Warren Commission, this courageous Dallas schoolteacher has held firm to her belief that the truth must be known about what happened ... Hill, the closest, most important surviving eyewitness to the assassination, is the last major witness to publicly dispute the findings of the Warren Commission."

$18.98 *(HB/256)*

Oswald backyard picture in Roscoe White's possession: 133-C. This photo was not shown to the Warren Commission. — from **Oswald Talked**

Kill Zone: A Sniper Looks at Dealey Plaza
Craig Roberts

As many have suspected, the School Book Depository was a lousy place to put a gun, unless one was planting a patsy. "The next shot came from the Dal-Tex building.... The fifth shot came from the Book Depository, possibly from the roof. The sixth and final shot would not miss. It was the one fired by a man positioned behind the picket fence ... west of the corner of the fence on the grassy knoll." This is the shot that resulted in Kennedy's head exploding. **GR**

$11.95 *(PB/252/Illus)*

The Last Words of Lee Harvey Oswald
Compiled by Mae Brussell

"Determined to learn Oswald's last words, his only testimony, *The People's Almanac* assigned Brussell, one the leading authorities on the Kennedy assassination, to compile every known statement or remark made by Oswald between his arrest and death. The quotes, edited for space and clarity, are based on the recollections of a variety of witnesses present at different times and are not verbatim transcripts."

$1.45 *(Pamp/10)*

Mae Brussell Reader
Mae Brussell

"Starting with her research into the JFK assassination, Brussell uncovered the cast of characters in an international fascist network which was strangling the American democratic system. Her meticulous research and documentation make it impossible to ignore her political analysis of contemporary America. The anthology contains: 'The Nazi Connection to the John F. Kennedy Assassination' (1983); 'Why Was Martha Mitchell Kidnapped?' (1972); 'Why Is the Senate Watergate Committee Functioning as Part of the Coverup?' (1972); and 'Why Was Patty Hearst Kidnapped?' (1974)."

$19.95 *(PB/119)*

NASA, Nazis and JFK: The Torbitt Document and the Kennedy Assassination
Kenn Thomas and David Hatcher Childress

"In 1970, a photocopied manuscript began circulating among conspiracy researchers entitled 'Nomenclature of an Assassination Cabal' by William Torbitt, (a pseudonym). The Torbitt Document was a damning exposé of J. Edgar Hoover, Lyndon Johnson, John Connally and Werner von Braun, among many others, for their role in the assassination of President John F. Kennedy. This first-published edition of the Torbitt

Detective Bobby G. Brown, Dallas Police Department Crime Scene Search division in pose of backyard photo 133-C — from **Oswald Talked**

Document emphasizes what the manuscript says about the link between Operation Paperclip Nazi scientists working for NASA, the Defense Industrial Security Command (DISC), the assassination of JFK, and the secret Nevada air base known as Area 51."

$16.00 *(PB/224/Illus)*

Nomenclature of an Assassination Cabal (The Torbitt Document)

"William Torbitt"

"'William Torbitt', the pseudonym of a prominent conservative Southwestern lawyer, sifted through the Warren Commission volumes and Jim Garrison's files, then pursued his own leads to track down JFK's murderers. FBI, CIA, DISC, Nazis, Big Oil: 'Torbitt' names the conspirators, explains how they interlinked, and provides a comprehensive study of the plot. Yes, he names the gunmen. . . . This researcher's edition of Torbitt is set in larger type and contains a detailed index of all the names in the document to facilitate tracing the many threads 'Torbitt' weaves together."

$9.95 *(Pamp/32)*

Oswald Talked: The New Evidence in the JFK Assassination

Ray and Mary La Fontaine

This is actually a new spin on the JFK-assassination-theory material. The La Fontaines are respected journalists with a good track record for accuracy in reporting and no preconceived agenda on the subject. The really big revelation of this book is that after Oswald was initially arrested, he

had a cellmate to whom he spilled his guts. Using a lot of previously unreleased materials from the Dallas Police Department and re-interpreting other information, the writers have pieced together a compelling narrative. This is the book that lured Marina Oswald back into the open in hopes of clearing her husband's name. Even though an avid follower of conspiracy theories might not find a pirate's hoard of new information here, aside from the cellmate's revelations, it is the presentation, lacking the usual sense of hysteria, that ultimately makes the case airtight. **SA**

$25.00 *(HB/456/Illus)*

Plausible Denial

Mark Lane

"Mark Lane, author of this book and the best-seller *Rush to Judgement*, as lawyer for the defense in the case *Hunt vs. Liberty Lobby*, won a verdict from a jury of our peers that upheld, against a claim of libel, a news story that Howard Hunt, a long-time Office of Strategic Services and CIA employee, was in Dallas on the day the president was shot. The testimony at that trial gave more credibility to the notion that the CIA was involved in the assassination. Did you read about that verdict in your local newspaper? Did you hear about that verdict on your favorite TV or radio network news program? Of course not. They are not allowed to write that. This book tells that story in a way that will make accounts of the historic 'Scopes' trial read like the story of 'Little Red Riding Hood.'"—L. Fletcher Prouty

$13.95 *(PB/351)*

Project Seek: Onassis, Kennedy and the Gemstone Thesis

Gerald A. Carroll

Project Seek is an attempt to verify the information contained in a document circulated samisdat-style named "The Skeleton Key to the Gemstone File." The Gemstone File is an overview version of recent history in which Aristotle Onassis is the main figure in the JFK assassination and Howard Hughes is kidnapped and replaced by a double. "The Skeleton Key" purports to be a summary of a larger body of work, but is condensed so that it is easier to circulate clandestinely. The source of the information is supposed to be Bruce Porter Roberts, an artificial-gem manufacturer who claims that his work was stolen by the Hughes Corporation.

Gemstone was known to conspiracy researchers, but not examined by them. The first serious look at Gemstone was *The Gemstone File* by Jim Keith. Although this book brought forward new information and broadened public awareness of Gemstone, it was lacking in many ways. In partic-

ular it failed to shed much new light on Roberts. The best aspect of Carroll's book is that he is a former newspaper reporter and follows up on as many facts as he can, and reveals that much of the information that sounds incredible in Gemstone has a factual basis. He tracks Robert's paper trail extensively, and has even found a photograph that may be of the elusive whistle blower.

One oddity in Gemstone that Carroll leaves unexplored is Roberts' use of the Canadian tabloid *Midnight* twice for verification of his claims. Why would Roberts taint his tale by using what is considered such an unreliable source? Perhaps his use of a tabloid source shows that Roberts knew something John Q. Public doesn't. The connection of the CIA and Organized Crime to the tabloids is something that is only now getting scrutiny. **TC**

$16.95 *(PB/388/Illus)*

"The Role of Richard Nixon and George Bush in the Assassination of President Kennedy" and "How Nixon Actually Got Into Power"

Paul Kangas and Mae Brussell

"Paul Kangas, who admits to having worked for Naval Intelligence, sketches in the whereabouts of Richard Nixon and George Bush on the day and the days following the JFK assassination."

$1.75 *(Pamp/8)*

Matted photograph combining silhouette of Lee Harvey Oswald from 133-C pose with a later photo of backyard at 214 Neely Street. This photo is one of two similar shots uncovered by the authors in the Dallas police files. Former Dallas detective Bobby G. Brown claims to have made the composite photos shortly after his "re-enactment," though today he can't explain how or why he did so. — from **Oswald Talked**

MASONIC

The All-Seeing Eye and the Theater at Besançon *by C.N. Ledoux — from* The Art and Architecture of Freemasonry

On September 18, 1793, President George Washington dedicated the United States Capitol. Dressed in Masonic apron, the president placed a silver plate upon the cornerstone and covered it with the Masonic symbols of corn, oil and wine. After a prayer, the brethren performed "chanting honors." Volleys of artillery punctuated the address that followed. Like the entire ceremony, the silver plate identified Freemasonry with the Republic; it was laid, "in the thirteenth year of American independence . . . and in the year of Masonry, 5793."

If, as Thomas Jefferson argued, the Capitol represented "the first temple dedicated to the sovereignty of the people," then the brothers of the 1793 ceremony served as its first high priests. Clothed in ritual vestments, Washington and his brothers consecrated the building by the literal baptism of corn, oil and wine—symbols of nourishment, refreshment and joy, or, as some versions interpreted them, Masonry, science and virtue, and universal benevolence. In exemplifying the goals of a free and prosperous society, Masons mediated between the sacred values of the community and the everyday world of stones and mortar.

The fraternity's position on Capitol Hill, one of the many such consecration ceremonies over the next generation, provided a powerful symbol of Masonry's new place in post-Revolutionary America. No longer an expression of the honor and solidarity of a particular social class, the fraternity increasingly identified itself with the ideals of the nation as a whole. The order, brothers argued, represented, taught and spread virtue, learning and religion. Masons thus did more than lay the Republic's physical cornerstones; they also helped form the symbolic foundation of what the Great Seal called "the new order for the ages." — Steven C. Bullock, from *Revolutionary Brotherhood: Freemasonry and the Transformation of the American Social Order, 1730-1840*

The Art and Architecture of Freemasonry
James Curl

Coffee-table chronicle of the awesome architectural legacy of the Freemasons, from graveyard pyramids and sphere-shaped temples to deluxe neo-Egyptian lodge interiors. "Lurking somewhere under the conventional histories that deal with the Renaissance, Baroque and Neo-classical periods is a strange world . . ." That world is the Masonic world. "For a brief period in the 18th century Freemasonry was the heart of much that was enlightened, forward-looking, and promised a regeneration of society. The searches for wisdom, to rediscover antiquity, to replace superstition by reasoned philosophy, to better mankind, and to find expressions for the new age in architecture, music and in all the arts" were all conducted by men schooled in the mystic brotherhood. Hail, the all-seeing eye! **GR**

$60.00 *(HB/271/Illus)*

Behind the Lodge Door: Church, State and Freemasonry in America
Paul A. Fisher

"This book shows how for over 150 years the political policy of the United States was marked by governmental cooperation with and encouragement of Christianity in the schools and in social and political life. However, that situation changed dramatically beginning in 1941 when the Supreme Court for the first time in its history became dominated by justices who were members of the Masonic fraternity. It was a dominance that continued for the next 25 years and resulted in the imposition of an alien secular humanism on American education and the country's political life. . . . In this well-documented investigative report, author Paul Fisher lifts the veil on the subterranean war that has been waged against church and state by the Masonic fraternity for over 200 years, even to the point of influencing U.S. Supreme Court decisions."

$18.00 *(PB/362)*

Beneath the Stone: The Story of Masonic Secrecy
C. Bruce Hunter

"The secrets of the Masonic lodge have excited curiosity for nearly three centuries. Surprisingly, those secrets are only the tip of the iceberg. Beneath their stony mystique lies a tradition that grew during a thousand years—from the Anglo-Saxon invasion of Britain to the age of the cathedrals, from the execution of the Templars' last Grand Master to the disappearance of an enigmatic impostor in New York. This book explains why the Order needed secrets in the first place—secrets so well-kept that even the Masons no longer understand them."

$18.95 *(HB/384)*

The Dark Side of Freemasonry
Ed Decker

Collection of alarmist essays by Fundamentalists concerned about the spiritual perils presented by Freemasonry. Most are written by bean-spilling

ex-Masons. Though a few essays bog down in chatter about the individual's "growth in the Lord," the bulk of these X-tians have made it their business to know the ways of The Enemy very, very well and produce thorough, if occasionally overwrought, evidence of Freemasonry's historical links to a variety of occult systems.

Though the uninitiated may scoff, and the Masonic dupes of the lower three degrees (known as the "outer courtyard") may take offense, a great number of well-known occult revivalists have taken the "craft" seriously enough to advance to Freemasonry's highest degrees; this list includes founding members of the Golden Dawn, OTO, and the new "old religion" revived in Great Britain in the 1970s as Wicca. Even Theosophy's Madame Blavatsky was initiated as a "Co-Mason," the women's version of the "ancient and accepted" boys' club. And it is through Theosophy's notion of the "Hidden Masters," adapted by Alice Bailey ("Queen of the New Age") as the Great White Brotherhood of Shambhala that several of the authors in this collection trace the influence of Freemasonry into the mainstream of today's "alternative spirituality."

Bailey and her husband (a Mason) believed that Freemasonry could be useful as a New World Religion and referred to the ancient all-seeing Brethren as "Master Masons of the Universe." And since Shambhala floats in the AIR above the Gobi DESERT, and since the Bible characterizes demons as wasteland creatures and "spirits of the air"—well, YOU SEE what we're talking about! And speaking of "All-Seeing," what about the Masonic Founding Fathers putting that Eye on our currency and erecting that National Phallus we like to call the Washington Monument? Sex Magick! Ancient Fertility Rites! Yes, agrees another ex-Wiccan and ex-32-degree Mason! He points out dozens of similarities between Masonic and Wiccan initiations. Freemasonry was, after all, invented as a cover under which WITCHCRAFT could be practiced! And he concludes that "this is the abominable universal world religious system that Jesus Christ is returning to this earth to destroy!" One can only wish it would all turn out to be this interesting! **RA**
$9.99 (PB/224)

Freemasonry and Judaism: Secret Powers Behind Revolution
Vicomte Leon de Poncins
The same old unified world conspiracy theory: It's the Jews and Freemasonry working hand in hand to destroy the traditional values of the West, starting with the French revolution of 1789 and continuing on to more modern times. **SC**
$9.95 (PB/260)

The Chapter Room at 78 Queen Street, Edinburgh, for the Supreme Grand Royal Arch Chapter of Scotland, designed by Peter Henderson and built in 1901 — from **The Art and Architecture of Freemasonry**

Freemasonry and the Vatican: A Struggle for Recognition
Vicomte Leon de Poncins
The key to this is the subtitle. While the concept of Freemasonry and the Vatican can evoke some wondrous conspiracy scenarios, the whole point of this book is that there are none and that it would be awfully nice if the Vatican would be friends with the Freemasons. It reads like a protracted court case, full of mind-numbing details. This is not to say that it's badly written or ill conceived. To the very specialized niche of people who really care about a reconciliation between these two entities this book is

loaded with useful chunks of testimonial (some dating back a few centuries). **SA**
$9.95 (PB/225)

Freemasonry: Exposition and Illustrations of Freemasonry at a Glance
Capt. William Morgan
Gives exact, word-for-word descriptions of the actual ceremonies and rites of passage that members of Freemasonry experience as they pass from initiation into the higher echelons of the temple, and goes into some detail describing the symbolic meaning of instruments like gages and gavels, jewelry and clothing, handshakes, prayers, and the construction of the

temple as a building. From a ceremony of initiation: "The candidate then enters, the Senior Deacon at the same time pressing his naked left breast with the point of a compass, and asks the candidate, 'Did you feel anything?' Answer: 'I did . . . a torture' The Senior Deacon then says 'As this is a torture to your flesh, so may it ever be to your mind . . . if ever you should attempt to reveal the secrets of Masonry." **BS**
$9.95 *(PB/110/Illus)*

The Masonic Letter G
Paul Foster Case
"Explores the link between the Masonic degrees, rituals and Kabbalistic tradition. Masonry cannot be appreciated or understood without the knowledge of the Kabbalistic tree of Life and its insight into the nature of man and the Cosmos. Develops the relationship between the Geometry upon which the building and architectural symbolism of Masonry are based and the Gematria of the Kabbalists, a system of number correspondences to words and phrases that reveal the meanings of the numbers, measurements and geometrical proportions in the Old and New Testaments."
$5.00 *(PB/96)*

Please Tell Me: Questions People Ask About Freemasonry
Tom C. McKenney
"This book is not 'anti-Masonic,'" McKenney notes, shortly before accusing the Masons of everything short of exterminating the dinosaurs. The author lifts the Masonic apron in order to expose the glistening, seamy underbelly of everyone's favorite secret society. He warns Christians (who evidently don't have enough to worry about) that Masons stop at nothing to effect their dark designs. "There have been times when a temporary Masonic lodge room was set up in a semi-trailer in a busy shopping center parking lot and men initiated right there on the spot." He notes that membership in the Masonic Order drops every year, and explains why this makes those who keep their grip on the trowel and compass all the more powerful. He reveals that the messiah of Masonry is named "Hiram." Considerable attention is devoted by the author to the question of whether or not George Washington was a Mason—McKenney has to admit that he was, but also decides that he wasn't a very good one, praise Jesus. The real Hell's Angels, he warns us, are those red-fezzed Shriners on minibikes, and on that we can do nothing but agree. **JW**
$9.99 *(PB/224/Illus)*

A Review of the Book Entitled "Morals and Dogma"
A. Ralph Epperson
In this booklet, a conspiracy-obsessed Christian attempts to prove that the Masons are worshipers of Lucifer. This charge has been made in the past and will, no doubt, be repeated. The author attempts to demonstrate that words used by the Masons, including sentences and oft-times fractions of sentences from a huge Masonic textbook authored by Albert Pike (notorious for his part in the formation of the Ku Klux Klan), have different meanings for Masons of high degree than to the initiates. The God of the Masons is not the Christian God but rather the Masonic God, "The Architect of the Universe." Pull this mask off and one finds the secret Masonic God, the Light Bearer a.k.a. Lucifer. One thing about this booklet, the price is right. "Mr. Epperson is not charging for this review, because he is uncertain about the copyright laws and how they might apply to this review of a book still being printed. So, he is asking that each reader who wants one only order one copy." **TC**
Free *(PB/61)*

Revolutionary Brotherhood: Freemasonry and the Transformation of the American Social Order, 1830-1840
Steven C. Bullock
A gung-ho look at Freemasonry through the eyes of a clearly right-wing Mason. Complete historical overview of the Freemasons from Revolutionary times to the Wild West, showing how our country was created by the Masonic Order, and influenced by the rites and passages of the Masons' rituals as well as the secret symbolism of the Freemasons. **TD**
$19.95 *(PB/421/Illus)*

Robert Fludd and Freemasonry: Being the Rosicrucian and Masonic Connection
A.E. Waite
"Waite seeks to show the connection of the Rosicrucian stream of initiation and its relationship to mystic Freemasonry and the liaison between them, Robert Fludd."
$5.95 *(PB/28)*

Strange Masonic Stories
Alec Mellor
"This book is not a history of Freemasonry. It is not even a historical account of certain Masonic events. It is a collection of short stories that are products of the author's imagination, though each one is founded on Masonic fact."
$11.95 *(PB/208)*

Assembly of Freemasons for the Reception of Master-Masons — from The Art and Architecture of Freemasonry

Absolutely Mad Inventions

A.E. Brown and H.A. Jeffcott Jr.

What drives people to not only think of such outlandish things, but to go the trouble of patenting them? Included are a privy seat that consists of rollers that will throw to the ground anyone attempting to stand upon it, pince-nez-style safety goggles for a fowl, and a humane device to attach a bell to the necks of rodents "thereby frightening the other rats and causing them to flee." In case of conflagration, there are fire- escape suspenders with a cord attachment, which allow the wearer to remove the cord and lower it to the ground in the hope that someone can pass up a rope. For a hot summer's day, there's a rocking chair with bellows so "the occupant may, by the act of rocking, impel a current of air upon himself." Also included are edible stick pins, chewing-gum lockets, mechanical clothes pins, a bait trap for tapeworms, devices for producing dimples and shaping upper lips, and many more. Almost 60 inventions, all with the original illustrations as submitted to the patent office. Originally collected and published in 1932 as *Beware of Imitations*.

TR

$3.95 *(PB/125/Illus)*

The Age of Intelligent Machines

Raymond Kurzweil

The author of this illuminating overview of the development of artificial intelligence approaches his subject matter not as a glib science journalist or obfuscating academic but as a hands-on pioneer in applied artificial-intelligence (AI) devices. Kurzweil is credited as the inventor of optical character recognition (OCR), the Kurzweil Reading Machine, and the polyphonic music synthesizer (at the suggestion of Stevie Wonder, who was an early reading machine client), among other advances in applying AI to technology. Kurzweil sees AI as a second Industrial Revolution, creating machines that will extend, multiply and leverage our mental abilities as opposed to physical abilities. Appropriately, he begins with an examination of the history of automation and a brief discussion of the Luddites (the only organized opposition to technology in history). The theoretical roots of AI and its basis in "logical positivist" philosophers such as Kant and Wittgenstein are also explained.

Surprisingly human tragedies emerge from amidst the logic gates and subroutines. One such account is a portrayal of Alan Turing, who built the first electromagnetic computer to crack the mechanical intelligence of the Nazi Enigma code machine, thus allowing the RAF to win the Battle of Britain. A closeted gay man, he committed suicide with a potentially brilliant career ahead of him. Then there is the Ken Russellesque drama of the obsessed Cambridge mathematician Charles Babbage, who in the 1860s created the prophetic Difference Engine and Analytical Engines (which, although mechanical, laid the theoretical basis for IBM's Mark I). He had an ill-fated affair with the beautiful Ada Lovelace (daughter of Lord Byron and the first computer programmer).

Kurzweil hits other high points on the way to the creation of machine intelligence, such as the invention of keypunch machines for the 1890 census and the subsequent rise of IBM, the invention of the original, gigantic tube computers such as the ENIAC and the UNIVAC, Norbert Wiener and the science of cybernetics, the shift from analog to digital information, the stillborn original neural net known as the Perceptron, pixels, robotics and much more.

The compilation ends with a speculative AI chronology which demonstrates the sadly uncritical gee-whiz mentality of the

and greater lengths to quash all "heretical" inquiry, even in the face of often staggering empirical evidence. As British Fortean philosopher John Michell says on the back cover, "There is a tyranny of science devouring our lives, minds and cultures, and Richard Milton has exposed it." Unfortunately, despite its great intentions, the book tends to bog down in its own whining, preachiness, redundancy, and ye olde English dull-dull-dullness, leaving it even more boring than your average garden-variety "non-alternative" science text. **DB**
$14.95 *(PB/272)*

Ancient Inventions
Peter James and Nick Thorpe
Historian and archaeologist team James and Thorpe have unearthed a mountain of bizarre and astonishing accounts of inventions and discoveries made by the ancient peoples of our planet. The material—"recorded and attested to in the scientific and archaeological literature, though often ignored by textbook histories"—does not cease to amaze, and accounts of seventh-century false teeth, sixth-century iceboxes, ancient Arabian diving equipment, steam engines from Greece and electric batteries in Iraq make one wonder just how incomplete our history textbooks are. This 620-page book is one of those wonderful gems that sticks out its tongue and wiggles its ears at conventional thinking. Wildly important information on the inventions and ingenuity of the ancients. **SK**
$17.50 *(PB/620/Illus)*

The Anti-Gravity Handbook
Compiled by D. Hatcher Childress
This strange compilation levitates from Buck Rogers and the ancient Indians of the Rama Empire to Albert Einstein and Nikola Tesla, pursuing that technological holy grail of zero G. Highlights include ads for flying saucer-style VTOL planes from the Moller Corp. and a collection of "anti-gravity comix."
$14.95 *(PB/191/Illus)*

Arktos:
The Polar Myth in Science, Symbolism, and Nazi Survival
Joscelyn Godwin
Details mankind's occult, religious, political, and mythological obsession with the ice-

James E. West, between an electron microscope and computer terminal, in his Murray Hill laboratory — from **Blacks in Science**

generation still leading the AI assault: "Early 21st century—the entire productive sector of society is operated by a small number of technicians and professionals." Does that mean the rest of us will be permanently on vacation? Somehow it never seems to work out that way. **SS**
$39.95 *(HB/564/Illus)*

Alice in Quantumland: An Allegory of Quantum Physics
Robert Gilmore
An entertaining layman's guide to quantum physics, illustrated by the author. It's Alice's adventures revisited, only this time around, her guides through Quantumland come in the guise of Quantum Mechanic, the Three Quark Brothers and the State Agent. Instead of undergoing changes in height, this Alice experiences quantum effects on a much more radical scale. The author pares away the mathematics and

makes such theories as the Heisenberg Uncertainty Principle, wave functions, the Pauli Exclusion Principle, virtual particles, atoms, nuclei and high energy particle physics accessible to those among us challenged by higher math and sciences. **CP**
$18.00 *(HB/184/Illus)*

Alternative Science: Challenging the Myths of the Scientific Establishment
Richard Milton
Cold fusion, holistic medicine, non-HIV AIDS research, psychokinesis, telepathy, Bioenergy—these fields of research have one thing in common: They're all big no-no's according to today's western "scientific fundamentalism." Anyone who dares attempt serious research in any of these areas is liable to lose funding, respect and even his or her job as an increasingly intolerant scientific community goes to greater

bound polar regions. Lost races, underground realms, conspiracy theories, the mystic East, UFOs and the Apocalypse are all belief systems variously tied to the shifting Poles. "Many occult systems speak of a Golden Age, associated with an ancient race that lived in the Arctic regions. Much embraced by ethnologists and Theosophists, this 'Aryan Race' entered the mythology of Nazi Germany with dreadful consequences." Includes maps and drawings. **GR**
$16.95 *(PB/260/Illus)*

Atlantis in Wisconsin: New Revelations About the Lost Sunken City
Frank Joseph
There is a lake in southern Wisconsin between the cities of Milwaukee and Madison called Rock Lake that has mysterious stones and mounds lying within its chilly waters. Frank Joseph, writer, scuba diver and researcher into lost civilizations, has been immersing himself in those waters for many years, and this book is his thesis on the origins of those conical mounds and their connection to the lands of Aztlan and Atlantis. His theory is that at one time the seafaring people of Atlantis journeyed to North America and established colonies in what are now Michigan and Wisconsin. The central focus of those colonies was mining the upper peninsula's vast copper stores. The metal was then traded with Europeans and had a major impact on the Bronze Age. Unfortunately for the Atlanteans, a great catastrophe buried their continent beneath the surface of the Atlantic, and their former colonies declined. The people mixed with others of the area, and eventually the only remnants of this civilization were the legends of the Native American tribes and the conical and pyramid-shaped stone burial mounds. **AS**
$12.95 *(PB/206/Illus)*

Bebop to the Boolean Boogie: An Unconventional Guide to Electronics Fundamentals, Components and Processes
Clive Maxfield
An excellent book on basic digital electronics, even for those without a technical background, which covers the difference between analog and digital electronics. It details logic gates and how to make them from transistors, what integrated circuits,

circuit boards, hybrids and multi-chip modules are, how they are made, and what they are used for; and logic systems such as assertation level logic, positive logic, negative logic, and pass transistor logic and how they are used in digital electronics. Alternative and future technologies are examined, including superconductors, diamond substrates, optical interconnection technologies, virtual hardware, protein switches and protein memories, and nano-technology. The book has a good glossary of definitions and a very extensive index. There are many good diagrams and illustrations to help with the explanations. A very well- designed and simply explained work for those who have an interest in digital electronics but don't know where to start. **MC**
$35.00 *(PB/456/Illus)*

Blacks in Science: Ancient and Modern
Edited by Ivan Van Sertima
This excellent volume, edited by the author of the classic text *They Came Before Columbus*, contains essays contributed by academic scholars and writers, accessibly written and with a minimum of jargon, pertaining to scientific, medical and industrial advances made by such pre-colonial African societies as the Dogon, the Yoruba, the Masai and others, as well as non-traditional interpretations of various aspects of Egyptian culture. One-third of the text consists of biographies of African-American scientists, doctors and inventors past and present—especially good for students. **JW**
$20.00 *(PB/336/Illus)*

The core of a typical 45,000 kilowatt transformer. It contains about 35 tons of silicon-iron sheet. — from Magnetism

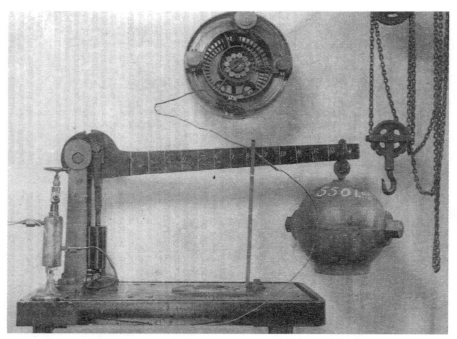

Disintegrator for eliminating vaporic force under vibration. Lever for weighing vaporic force — from Universal Laws Never Before Revealed: Keely's Secrets

Creations of Fire: Chemistry's Lively History From Alchemy to the Atomic Age
Cathy Cobb and Harold Goldwhite
No talk about paradigm shifts and incommensurable dialogues here, just a gritty, beakers-'n'-fumes history written by two practicing chemists.

The evolution of chemistry is grouped into three general periods—the pre-history of chemistry (100,000 B.C. to the late 1700s), the "Chemical Revolution and Its Consequences" (late 1700s to World War I) and the "Quantum Revolution and Its Consequences" (World War I to the present).

Throughout, chemistry is seen as a dance between praxis and theory. Stone Age art (mercury sulfide and iron-oxide pigments mixed with fat to create cave paintings), pottery and cooking provide the earliest chemical practices, gradually refined by the anecdotal "experiments" of clothiers, metal workers, and other artisans observing the properties of their materials and how they interacted. Philosophers' meditations on artisans' experiences provided the earliest chemical theories. Lavoisier's application of accurate quantitative measurements in experimental analyses and the emphasis on

verifiable results in supporting chemical theories characterize the evolution of chemical practice into science.

The shared language of mathematical analysis leads to quantum theory and its research on the structure of the atom. Quantum theory subsequently generates the current specialization of chemistry into biochemistry, inorganic chemistry, physical chemistry, etc. An insider's view of chem-

Television scanning equipment — from Experimental Television

istry written for the non-specialist that emphasizes the continuity of scientific practice. **RP**
$28.95 *(HB/475/Illus)*

The Cyborg Handbook
Edited by Chris Hables Gray
A cyborg is defined as a hybrid entity consisting of both organic and synthetic mechanical parts in whatever proportion—which means that the Terminator and X-men are cyborgs, of course, but so is Granddad with his false choppers. Packaged as a scientist's notebook, with rounded corners, faux spiral binding and all, this substantial tome undertakes an exhaustive investigation of the cyborg mythos: Its history, present-day status and future potentials are traced through a wide range of pertinent topics, from cyborg sex to cyborg politics. Falling in between the categories of cultural studies and science-fiction—really, it says so on the back cover!—*The Cyborg Handbook* leavens its academic bulk with generous helpings of surreal sex and ultra-violence imported from the sphere of popular entertainment. Pointed references to drive-in movies, pulp literature and comix help temper the extremes of Baudrillardean cynicism on the one hand and *Mondo 2000*-style techno-mystical bliss on the other, attitudes which typically plague this sort of survey. **JT**
$22.95 *(PB/540/Illus)*

Dictionary of Earth Mysteries
Janet and Colin Bord
Defines Abbots Bromley Horn Dance, Barrow, Cairn, Dolmen, Earth Lights, Fire Ceremonies and so on. The authors are experts in the ley lines and mysterious pre-historic places of Britain and do an excellent job of defining the terminology and ideas associated with "Earth mysteries."
$12.00 *(PB/192)*

Driving Force: The Natural Magic of Magnets
James D. Livingston
Magnetical Mystery Tour: an encyclopedic journey through the history of man and magnet, from Columbus to Einstein. Discusses everything from how magnets work to how we use them in our most advanced technologies. Forget aliens, forget viruses, forget the CIA. It's magnets that

have sneaked into our lives and taken over. They're in your VCR, your credit cards, your TV, your videotape. And the Force flows freely through the outlets in your walls. **GR** **$24.95** *(HB/311/Illus)*

Echoes of the Ancient Skies: The Astronomy of Lost Civilizations
E. C. Krupp
Adventures in archaeoastronomy, "ancient people's observation of the skies and its role in their cultural evolution. Temples, monuments, pyramids, and ancient cities are explored, showing how the ancient myths and lore were imbedded into daily reality. **GR** **$13.95** *(PB/386/Illus)*

Electrogravitics Systems: Reports on a New Propulsion Methodology
Edited by Thomas Valone
A book that can be "appreciated by anyone who is interested in electrogravitics." Reveals the secret history and technology of the B-2 Stealth Bomber and the rest of the "U.S. Anti-Gravity Squadron," explores the early electrogravitics experiments of T. Townsend Brown, and showcases a collection of electrostatic and electrogravitics patents. Former chief engineer of KPFT in Houston and co-founder of the legendary Phoenix, Ariz. pirate station KDIL, "Monterey" Jack Cheez has said that he knew a guy in Phoenix, back in the early '60s, who was working on this exact sort of thing at one of the big government-sponsored aerospace research facilities near the local Air Force base, and the guy swore that the top-secret gravity-effects models they were constructing were completely functional, and that he had seen the phenomenon in action many, many times with his own eyes. And if Cheez said it, we should all believe it—and that settles that. **DB** **$15.00** *(PB/120/Illus)*

The Elements of Graphology
Barry Branston
The history of graphology, according to Branston, goes as far back as the second century when "Roman historian Suetonius Tranquillus concluded that the handwriting of Augustus Caesar was not separated sufficiently to read plainly and that he was therefore mean." Such fairly well-respected

folks as Albert Einstein, Edgar Allen Poe, Charles Dickens and Anton Chekhov dabbled in handwriting analysis. Apparently Gainsborough kept a writing sample of the person he was painting on the side of his easel. Today, the style of one's handwriting could be the difference between a job and a few more weeks out of work. Although the back cover cites that graphology is "an ancient art as well as an exact science," one can imagine that the results might only be as accurate as the interpreter. It is cause for concern that many people are taking this stuff seriously, and it is used by prospective employers for checking an applicant's intellectual potential, and even to ensure that

A Dero as described by Richard Shaver in his book The Hidden World — *from* Subterranean Worlds Inside Earth

you and your loved one are compatible. This instruction book is clear and easy to read, with many examples and a step-by-step example of a worksheet for the reader's own assessment. **TR** **$9.95** *(PB/135/Illus)*

The Essence of Chaos
Edward N. Lorenz
"Probably few people care whether a flag flaps chaotically or rhythmically. Chaos in the pinball game is important, and frustrating, to anyone who is seriously trying to win. Chaos in the heartbeat, when it occurs,

is of concern to all of us." An easy-to-grasp scientific principle—things are not actually random, they only seem to be—that may end up sharing the limelight with the big ones of science, relativity and quantum theory. Provides personal insight into the discovery of chaos and fractals from an "undisputed international authority." The author is "a meteorologist who 'discovered' chaos in his computer examination of a relatively simple mathematical model of weather." The chaos theory has since become "a major component in our understanding of the world about us." **GR** **$14.95** *(PB/240/Illus)*

Etienne-Jules Marey: A Passion for the Trace
François Dagognet
A doctor and philosopher of science looks at the 19th century French scientist Marey, who was a physician, physiologist and aviation researcher, as well as an inventor and a pioneer in time-motion studies. Marey was obsessed by motion and sought ever more sophisticated techniques to record it. Best known for his use of chronophotography—the process used in Eadweard Muybridge's animal-locomotion studies—Marey was not content merely to record animal and human motion but invented

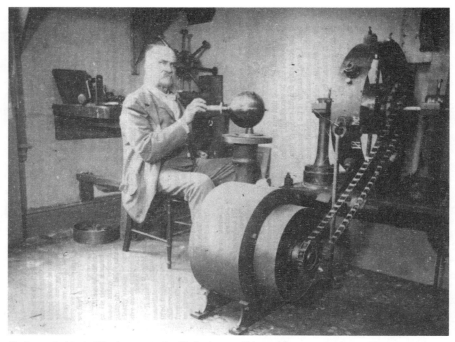

Keely, much older in this photo, seated at his final motor. This machine operates via amplified gluonic bonding/repulsing forces as near as we can understand Keely's explanation. — from **Universal Laws Never Before Revealed: Keely's Secrets**

devices to study motion that could not be perceived visually: kinetics of flow, turbulence in the air, and dynamics of water and wave patterns. His focus on the intersection of technology and movement was a crucial influence on Duchamp and Futurism and led to Taylorism and "scientific" production methods. **AP**

$26.95 *(HB/200/Illus)*

Experimental Television
A. Frederick Collins
Anyone interested in the early technical history of television—and who might want to experiment with making a complete early television transmitter and receiver—should look at this book (although they should perform the experiments described only with great caution). Includes 185 illustrations and diagrams. There are experiments with light, vision, scanning disks, photo-electric cells, amplifier tubes, glow tubes, neon lamp transmitters, receivers, and cathode ray and oscilloscope tubes. **MC**

$14.95 *(PB/313/Illus)*

Fads and Fallacies in the Name of Science
Martin Gardner
"Just as every faith-healing revivalist, no matter how strange his doctrines, will have astonishing platform successes, so every modern witch doctor, no matter how preposterous his rituals, will always find patients he can heal."

Before you get drunk on all the shiny new cheese-pufferied supernatural/aliens/ mysticism/angel books, have the gusts taken out of your sails by this classic about fallacies and pseudoscientific theories. Here are well-rounded summations of those fables—the facts of which are often sketchy—including Wilhelm Reich's orgone energy, Fletcherites, naprapathy, sexual pseudo-science, Velikovsky and others' astronomical ideas, one-off evolutionary theories, the origins of homeopathy, L. Ron Hubbard, Atlantis and Lemuria, and Edgar Cayce's trance-generated health remedies. **SK**

$6.95 *(PB/363)*

Feng-Shui: The Ancient Wisdom of Harmonious Living for Modern Times
Eva Wong
Equal parts interior design, art, folk science, architecture, urban planning and blind orthodoxy, Feng-Shui, the Chinese art of placement, is as pervasive and talked about today as Mah-Jongg was in the '50s. This book, perhaps the most "technical" in nature of the many books flooding the market to exploit this trend, sets forth the precepts of this approach to living in harmony with the universe. Feng-Shui offers guidance on everything from choosing a home to laying out furniture, locating a business or planning an entire neighborhood. Equally fascinating is the history of this craft and its roots in Taoism and shamanism. This thoughtful history of the origins of Feng-Shui is a healthy counterbalance to the many books on this subject which appear to be aimed primarily at the interior designer trying to learn a few trendy catchphrases. **LZ**

$22.00 *(PB/276/Illus)*

Flame Wars: The Discourse of Cyberculture
Edited by Mark Dery
Worse than a rumble in a dog park. "The verbal firefights that take place between disembodied combatants on the electronic bulletin boards" is the subject of this series of essays. How far should these "Borg Wars" go? Some keyboard K.O.s are duels to the death, as in "Rape in Cyberspace":

"'I am requesting that Mr. Bungle be toaded for raping Starsinger and I. I have never done this before, and have thought about it for days. He hurt us both.

"That was all. Three simple sentences posted to *social.* Reading them, an outsider might never guess that they were an application of a death warrant. Even an outsider familiar with other MUDS might not guess it, since in many of them 'toading' still refers to a command that . . . simply turns a player into a toad, wiping the player's description and attributes and replacing them with those of a slimy amphibian." When the command is invoked in this MUD "the account itself goes too. The annihilation of the character, thus, is total." Wiped off the board forever. Also: "Virtual Surreality: Our New Romance With Plot Devices," "Compu-Sex: Erotica for Cybernauts" and " Synners." **GR**

$14.00 *(PB/349/Illus)*

The Flight To the Inner Earth: The Missing Secret Diary of Admiral Byrd
Admiral Richard E. Byrd
For a long time there have been rumors of

Admiral Byrd's secret diaries chronicling his alleged secret Inner Earth exploration. They got wide circulation from Ray Palmer's *Flying Saucers* magazine and have refused to go away. This dubious diary has been floating around Hollow Earth circles for at least a decade. It will disappoint many.

A small group called the International Society for a Complete Earth first distributed it as a photocopied pamphlet. This group has put out a small circulation magazine called *New Worlds* and distributed some Thule Society pins. Unlike most "kook" organizations which are very eager to respond to anyone even remotely interested in their works, this group is very secretive.

After much persuasion, a member of the group responded to this reviewer. He claimed that the purpose of the organization was to travel to the Inner Earth via the Antarctic polar entrance. He said that they had already done a preliminary trip to Antarctica and that during that trip they had "made contact," presumably with the Hollow Earth inhabitants. It seemed that from the manner of his spelling and his name that the letter writer was of German origin. The letterhead that he used seemed to indicate that he had served aboard a German U-Boat in World War II.

It is interesting to note that in this short diary, which reports Byrd meeting with an advanced race of tall, blond people beyond the South Pole, the Inner Earth dwellers say good-bye to him in German. They also use flying saucers, which they call *Flugelrads*, the same name for top-secret flying saucer-style craft which were under development by the Germans during World War II.

This edition has been padded with many illustrations. Some are photos of Admiral Byrd, some are reprints of Hollow Earth diagrams that have been printed countless times before. None add any value to this pamphlet-turned-book. Not even a small sample of a facsimile of the alleged source material has been included, thus no handwriting comparison is possible.

Recently, a major university acquired most of Admiral Byrd's papers. In cataloging them, it was discovered that large numbers of personal papers that should have been there are not. Admiral Byrd's missing diaries may be out there somewhere, but one doubts that this is one of them. **TC**
$5.00 *(PB/62/Illus)*

Forbidden Science: Exposing the Secrets of

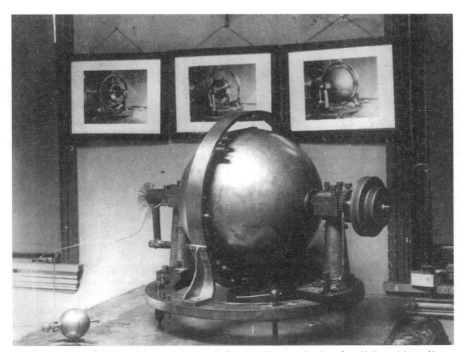

The famous Music Sphere which rotates by virtue of proper vibratory chords — from **Universal Laws Never Before Revealed: Keely's Secrets**

Suppressed Research
Richard Milton

"Today mountains of experimental data are being ignored and rejected by orthodox science: subjects as controversial as cold fusion; psychokinesis; ESP; alternative medicine; and many others. In exposing these taboo areas of scientific experimentation, [the author] shows how findings that threaten scientific orthodoxy are systematically misrepresented, ridiculed and starved of funding." Addresses the "forbidden question: Is there something fundamentally wrong with the way science is currently practiced?" A veteran British science writer rails against the system. **GR**
$11.95 *(PB/265)*

Giant Earth-Moving Equipment
Eric C. Orlemann

"Tells the story of the largest earth-moving excavators ever created for the mining and construction industry." The Bucyrus-Erie 1650-B (2,874 tons). The Marion 880 (6,285 tons). *Giant* is the operative word. Picture a 10-story apartment house on top of a barge on top of six Sherman tanks and you get the idea. The drag bucket on the Bucyrus-Erie 4250-W (13,500 tons) could scoop up a small house. Chapters on "The Loading Shovels," "The Stripping Shovels," "The Hydraulic Excavators," and the biggest diggers in the world today, "The Bucket Wheel Excavators." The relentlessly scooping circular head of the Krupp/O&K BWE 285 bucket wheeler (13,367 tons), made in Germany, is as big as a Ferris Wheel. **GR**
$14.95 *(PB/128/Illus)*

The Homopolar Handbook: A Definitive Guide to Faraday Disk and N Machine Technologies
Thomas Valone, M.A., P.E.

Specialized science book concerning the Faraday Disk and N machine and unipolar dynamo technologies in which there is a generation of electric current by the rotation of a conducting disc in a magnetic field. What all of these machines are trying to accomplish are outputs in energy that are 10 to 100 times more than their input— in essence, they are attempts to get free energy. The United States Navy took some of this information and classified it. What would really help the general reader of this book would have been a glossary to explain the

Electronics did not start small: the first transistor (1947). — from The Age of Intelligent Machines

terms the scientists are using. Also a better definition of the Earth dynamo model and the Faraday principle would go a long way toward making this book clearer. **MC**
$20.00 *(PB/180/Illus)*

Implosion: The Secret of Viktor Schauberger
Compiled by Tom Brown

Viktor Schauberger was an Austrian forest ranger who became fascinated with the motions of fish in mountain streams in the moonlight. His observations led him to the discovery of the power of imploding vortices and the hidden properties of moving liquids. From this he was able to produce free energy and anti-gravity, among other inventions. Schauberger's research came to the attention of Adolf Hitler, who may have utilized some of this research in the Nazi flying saucer project. After the war, a U.S. mega-corporation tricked Schauberger into selling all the rights to his research—past, present and future—and then promptly suppressed it. Schauberger, who hoped his discoveries would lead to a better world, realized his mistake too late. He died in obscurity, within days of being cheated out of his life work.

With information about him hard to obtain, Schauberger often seems more urban legend than real man, a mysterious Dr. X who can turn water into gasoline (in this case, energy) until the oil companies chase him away. This amazing booklet leaves no doubt that Schauberger is real, and his discoveries demand attention.

Schauberger advocated working *with*

nature. While others were trying to "conquer" nature, he was watching the movement of fish, birds, streams and lakes. From this he discovered "implosion technology," the exact opposite of the explosive technology that powers the world today. Here are tales of floating rocks and streams flowing uphill, diagrams of structures that purify air and water, do-it-yourself experiments that make water levitate, insights into the Nazi flying saucer project and translations of his Austrian patents. Will the environmental movement rediscover Viktor Schauberger? His implosion technology is just the right remedy for a world on the brink of ecological disaster. **TC**
$19.95 *(Pamp/130)*

In Our Own Image: Building an Artificial Person
Maureen Caudill

"We're more alike than you think. If you prick me, do I not—leak?"—Android Commander Data of *Star Trek: The Next Generation*

Neural networks expert Caudill believes that we are a mere 20 years away from developing intelligent androids. Foot-long mechanical ants, robots that play Ping-Pong, and even a sheet-music-reading robot that has played with a symphony already exist. As breakthroughs in artificial intelligence, robotics, computer science, psychology and neural networks continue, we move closer to creating "human machines." But as this occurs, potentially massive social disruptions and tangled moral and legal dilemmas will arise. Androids may compete with human workers for jobs—"they won't take vacations, won't have family problems, and might never leave the firm." This sentiment has been overdone since the Industrial Revolution. It is possible, as has been seen throughout history, that modernization may provide new jobs.

More interesting are the moral questions that the author concludes we will have to face if we are to share the world with another intelligent species. "Can an individual own an intelligent android? What rights should it have in society? Does ownership of an android imply the right to turn it off—to 'kill' it? And does such ownership brand us a slaveholders?" Although a recent poll of top scientists concluded that we will not be ready to employ androids until the year 2070, it is interesting to begin looking at

some of the problems we may face in the future. *In Our Own Image* presents a provocative overview of both the technical and moral problems encountered in building an artificial person. It is supported with quotes and analogies from classic science fiction books, films and television shows, and helps to answer the question raised by the mysterious monolith that appears in *2001: A Space Odyssey*: "Is it a mere machine, or is it somehow alive? **AN**
$27.50 *(HB/242/Illus)*

Information Warfare: The New Frontier in Cyberspace
Winn Schwartau

Perceptive and funny analysis of the loss of privacy, opportunities for sabotage and industrial espionage, HERF guns, EMP/T bombs, magnetic weaponry, and viruses—the Achilles heel of the information age. "Megabyte money in the financial economy exists primarily in cyberspace. Computers do the trading, the guessing, the analysis based upon never-ending volumes of information that must be collected, sorted, analyzed and evaluated. Computers which are part of the Global Network instruct other computers to buy, sell, trade or hold to investments and positions based on instantaneous decisions often made without the intervention of a human mind or a live finger on the keyboard." **FLA**
$22.95 *(HB/432)*

Journey to Chernobyl: Encounters in a Radioactive Zone
Glenn Cheney

With a peevish intolerance for the discomforts of post-Chernobyl, post-Soviet Ukraine, the author writes about the people who lived through the nuclear disaster. Among the tales of food shortages and radioactive pickles, unreliable chauffeurs and homemade vodka, is some very bad news about the future:

"The world hasn't heard the last of Chernobyl. The sarcophagus was built with many vents. Rain comes in through those vents and gradually dissolves the remaining nuclear fuel and washes it into some of the 327 offices, halls, closets and other rooms in the building. Nobody knows exactly where the fuel is or where it's building up. The only way to find out is to drill into the rooms, one by one, and send in a probe to take

readings.

"Last July the readings were not good. Somewhere within the building, enough radioactive material was collecting to reach critical mass. If it continued, it would blow up—not like the little steam explosion that blew the roof up. It would be an atomic explosion like the one that blew Hiroshima apart. Such an explosion would not only throw the rest of the fuel and its radioactive surroundings into the air. It could also destroy the two neighboring reactors still operating. All told, it could throw another 300 or 400 tons of nuclear fuel into the atmosphere—several times more than in the original explosion. If that wouldn't be the end of the world, it would certainly bring it within view." **NN**

$20.00 *(HB/191/Illus)*

Kadmon: Viktor Schauberger
Petak

Bilingual German-English Austrian pamphlet on

Viktor Schauberger with his home power station, 1955 — from **Kadmon: Viktor Schauberger**

Viktor Schauberger which is part of the fascinating Aorta series. Eloquently covers his concerns over "death technology" and the environment, levitation experiments, implosion vs. explosion, and his abduction by the U.S. government as part of Operation Paperclip. **SS**

$3.50 *(Pamp/28/Illus)*

Laser Weapons: The Dawn of a New Military Age
Major General Bengt Anderberg and Dr. Myron L. Wolbarsht

A comprehensive book on the status of current development of laser weapon technology. Armed forces in many countries are already using a greater number of laser devices in the modern battlefield, as the Gulf War demonstrated. There's information explaining basic types of lasers and laser technology, current military applications and laser safety. Discusses both High Energy Laser Weapons and Low Energy Laser Weapons. "Anti-Eye Laser Weapons" are being developed, which can result in the mass blinding of soldiers, pilots and tank crews. (When we will see this problem actually surface in the news is anyone's guess but I imagine it will be sometime soon.) Laser experts Anderberg and Wolbarsht describe the staggering medical, societal and psychological problems that use of the anti-eye lasers will create. They talk about countermeasures and even about how all of this affects international law. There is a chilling first-hand account by scientist David C. Decker of a laser accident that blinded him in one eye. Anyone involved with lasers and laser medicine should read this book. Is this the next evolution of science? **MC**

$24.95 *(HB/244/Illus)*

The Last Skeptic of Science
René

René is making a name for himself in weird-science circles. He is best known for his book *NASA Mooned America*, in which he states that the space program was faked. In *The Last Skeptic of Science*, René moons the scientists and dares them to take a look at his Brass Balls. "René's Brass Balls" is just one of the experiments in the book which, René claims, shatter the establishment scientists' notions of how the world works, in this case, gravitational attraction. René is one smart cookie. The book, which is not

light reading, is based on lectures that he gave before a Mensa group, of which he is (or perhaps was) a member. René writes with a quirky, cynical sense of humor as he takes swipes at the establishment, all of which is illustrated by sardonic cartoon illustrations (credited to Subi). He comes off like a hybrid of Charles Fort and Ambrose Bierce under the influence of Dexatrims.

"If Newton's Law needs a small bit revision, then philosophers, do your thing. Revise! And while you are revising, don't forget to change the value of G (the universal gravitational constant) and consequently the mass of every solar-system body including the sun itself. Then change the masses of binary stars and any other planets we've almost discovered by recent computer enhancement. Throw away those obnoxious black holes (good riddance) and their associates worm holes and super strings, and even remote quasars and neutron stars. And while you're at it, please get rid of all the experts who write whole books professing to know what happened after a few microseconds of the Big Bang."

He freely mixes his irritation with scientists with observations on everyday life. A proponent of the pole-shift catastrophe theory, although for different reasons than most, he is a fan of William Corliss' sourcebooks, and uses them for references for many of his examples of anomalies. In one of the more interesting experiments in the book, René and his anti-scientific mentor create an artificial volcano in the laboratory. This volcano not only seems to defy conventional scientific wisdom but cannot be turned off once it gets going. René takes science and tears it apart. Then he leaves it in pieces on the floor. He has suspicions about how the world really works but isn't about to run wild with them. Mostly he thinks there is something wrong with what we are being told about the way things are, but does not think he is the one guy who knows the truth about it. **TC**
$17.00 *(PB/179)*

Living Water: Viktor

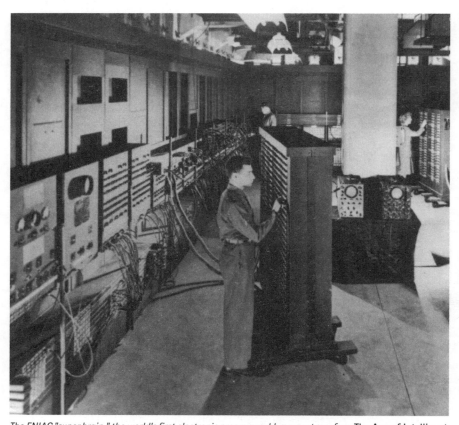

The ENIAC "super brain," the world's first electronic programmable computer — from The Age of Intelligent Machines

Schauberger and the Secrets of Natural Energy
Olof Alexandersson
Schauberger is yet another overlooked, ignored and suppressed pioneer in the annals of alternative science. His experiments with the energy of vortex flows led him to fascinating conclusions about "living" vs. stale water, and the propulsive power of the vortex caused him to build prototype "hovercraft" which looked very much like UFOs. This interested Hitler, who drafted Schauberger into the war effort against his will. Ultimately, U.S. government officials whisked Schauberger to the desert places where they study such things, and after "debriefing" him, he returned to Austria a broken man. **FLA**
$14.95 *(PB/162/Illus)*

Magnetism: An Introductory Survey
E.W. Lee
"Mention the word *magnetism* to one man and he thinks of a bar and iron filings; to another the word may suggest a dynamo; while a third may think of a cyclotron and the splitting of the atom." Covers the early history of magnetism, a general synopsis of magnetic behavior, the atomic theory of matter, paramagnetism and diamagnetism, magnetism in scientific research, the Earth's magnetism, and rock magnetism.
$7.95 *(PB/281/Illus)*

The Montauk Project: Experiments in Time†
Montauk Revisited: Adventures in Synchronicity††
The Pyramids of Montauk: Explorations in Consciousness†††
Preston Nichols and Peter Moon
Any book proclaiming to be a serious investigative work is on very weak ground when it conveniently features both a disclaimer from the publisher, a "guide to the reader" pointing out that some of the contents are apparently "soft facts," and a statement that "this work is being presented as nonfiction as it contains no falsehoods to the best knowledge of the authors. However, it can also be read as pure science fiction if that is more suitable to the reader." Unfortunately for these writers, as either a

work of fact or fiction this trilogy is so inept as to make any attempt to entertain or inform a moot point. Here are evoked such well-worn subjects as "The Philadelphia Experiment," brainwashing, "Alternative 3," the pyramid of Giza (but of course) and the OTO, with further name-dropping in the form of Aleister Crowley, Nikola Tesla, Ron Hubbard and Ian Fleming, plus serious credence given to self-proclaimed (though roundly discredited) "illegitimate son and true heir" Amando Crowley. All of this is cloaked in New Age mumbo-jumbo and is all very fascinating, I'm sure, but after reading this quagmire of conspiracies and "trans-dimensional disorders," I'm still at a loss as to exactly what point is being made. **BW**

†**$15.95** *(PB/160/Illus)*
††**$19.95** *(PB/249/Illus)*
†††**$19.95** *(PB/257/Illus)*

Moon Handbook: A Twenty-first Century Travel Guide
Carl Koppeschaar
A speculative travel guide optimistically set in 2020 when the well-heeled post-jetset will be able to go into orbit. *The Moon Handbook* is actually a well-designed and -researched compendium of lunar lore, crater maps, gravity info, and sci-fi musings on the lunar economy and hotel accommodations compressed into the familiar budget-traveler guidebook format. **SS**

$10.00 *(PB/140/Illus)*

NASA Mooned America!
René
A high-tech parallel to the Flat Earth Society, the tiny NASA-never-went-to-the-moon subgenre has spawned a handful of odd books, among which this spiral-bound volume may well be the most marginal. The Apollo mission broadcasts, so the story goes, were mere sound stage productions, staged at a $40 billion taxpayer expense in order to distract America from the domestic and international turmoil of the '60s. The actual flights could have *never* occurred due to the impassable solar radiation of the Van Allen Belt surrounding the Earth. But a book that has a preface entitled "Start Reading Here," (and it's several pages into the book—after a section entitled "Appropriate Sayings," and after an "Acknowledgments," which the

author largely devotes to grousing about conspiratorial efforts of potential publishers to suppress the book) does not inspire confidence.

Some of the photographic evidence given at first blush seems intuitively valid—e.g. the lack of a crater blown out by rocket thrusters, the crispness of the astronauts' footprints despite the absence of the moisture needed to retain shape of such imprints, suggestions of refracted light in the supposedly airless atmosphere as well as the astronauts' remarks about the "cold" of space experienced under the unfiltered solar radiation of the moon's surface. René also calls attention to the relative ease of movement displayed in suits supposedly pressurized to 4.5 psi (How could they bend their fingers in gloves thus pressurized, he muses, when the erect male member pumped with blood to 2.32 psi can't be bent?), and goes on to discuss much more quantitative obscurities, alleged discrepancies and questions of navigational trigonometry. But it all ends on an amusingly cranky note with the author declaring the astronauts "astronots." Hypnosis was involved, Buzz reputedly went into tearful panic attacks when asked to comment, etc. The whole matter is triumphantly laid to rest in the book's final

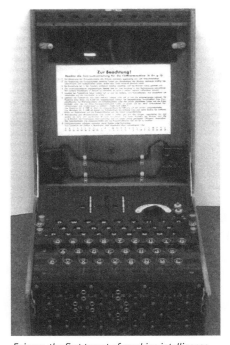
Enigma, the first target of machine intelligence — from The Age of Intelligent Machines

acronymic epitaph: "NASA: Never a Straight Answer." **RA**
$25.00 *(PB/176/Illus)*

The Nevada Test Site: A Guide to America's Nuclear Proving Ground
Matthew Coolidge
A pictorial guide to the atomic test sites established by Truman in 1950 to provide an alternative to vaporizing Pacific islands. Highlights include Yucca Flat, "the most bombed place on Earth" with 86 above-ground and over 400 underground nuclear blasts echoing in its irradiated molecules.

At the Tsukuba Research Center in Japan, Yoshiaki Shirai's research in robotics focuses on the development of three-diminsional vision systems. — from The Age of Intelligent Machines

The test blasts here described were "complex technological performances" that make Vaughn's infatuation with car-crash simulations in J.G. Ballard's *Crash* seem quaint and naive by comparison. For the 1953 Annie Test, the DOE built (and annihilated) a whole town complete with houses, a school, fire station, radio station, library, utility grid, and food on kitchen tables. Today the Liquified Gaseous Fuels Spill Test Facility extravagantly spews large amounts of toxic materials, "allowing for the creation of realistic spill accident scenarios." Explanatory text provides memorable workaday details (the 3,000 on-site employees commute to work on the KT Services chartered buses rather than brave the "Widowmaker" stretch of Highway 95 to Las Vegas) and local color (atomic-boomtown-gone-bust Mercury, Nev., includes a large cafeteria, steak house, movie theater and bowling alley, now largely empty and disused).

The everyday shades into twilight with a sinisterly banal cameo by Kennedy-assassination-conspiracy player Wackenhut Security's guard building and the Yucca Flats CP 1 Control Room, which looks more like the set to an early-1960s Roger Corman sci-fi flick than a real lab used for harnessing a nuclear inferno. Photos of the fading "typical American home" familiar from the stock footage used in countless subsequent nuclear monster flicks are sure to stimulate humanoid nostalgia glands. Even more rewarding are mondo details, such as pigs dressed in human flight jackets (to test materials for radiation protection) for the Frenchman Lake Priscilla Test, and a blurry photo of adjacent Area 51. Evocative armchair tourism for anyone who wishes they could vacation with the plastic-faced mutants in *Beneath the Planet of the Apes*. **RP**
$12.50 *(PB/55/Illus)*

Nuclear Rites: A Weapons Laboratory at the End of the Cold War

Hugh Gusterson

Gusterson, an anthropologist and former '80s Bay Area anti-nuke protester, did his field work at the Lawrence Livermore Labs where the neutron bomb and MX missile warhead were designed. Extending anthropology into new areas of research, Gusterson finds the rituals, totems and taboos of a tribal-style secret society smack in the middle of the most technologically advanced segment of Western society— nuclear physicists and their top-secret stomping grounds. With its examination of security badges, surveillance, background checks and the nuclear test as initiation ritual, Gusterson's anthropological approach yields new insights into how a nuclear-weapons lab actually functions, all derived from personal interviews with participants rather than classified documents.

For example, he finds that the scientists' slang vocabulary anthropomorphizes the weapons: missiles have "skins"; bombers store fuel in "rubber bladders"; weapons can "grow whiskers" as they age; warheads are most vulnerable "around the waist"; a weapon, when used, "couples" with the ground. Gusterson also delves into the thought processes which allow the researchers to rationalize devoting their lives to creating weapons of mass destruction.

Here's how one physicist described the

Baneberry Venting, Nevada Test Site, 1970 — from The Nevada Test Site

E-MAD facility — from The Nevada Test Site

awesome experience of attending a nuclear test: "There is this incredible flash of light, and you always go back to thinking how Oppenheimer describes this incredible flash of light. He described it as brighter than a thousand suns. Just incredibly intense. And it's very frightening. Just terrifying. Just absolutely terrifying. I was crouched over. I'm sure that I urinated in my pants at the time as a result. . . . And then while you're watching you see the difference in the index of refraction. You could actually see the shock wave traveling toward you. You know, there's a difference in the index of refraction. And so you prepare yourself to keep from being blown over by this blast, because it's a phenomenon. You just see this thing coming, and it just takes forever to come, and so you're sort of crouched, and finally the thing gets to you, and the wind whips past you, and there's a lot of dust, yeah, your heart's beating a lot faster and you just, you just never forget it . . ." **SS**
$39.95 *(HB/349/Illus)*

On the Nature of the Universe

Lucretius

Dismisses metaphysical abstractions, Providence and immortality as vain illusions. An exposition on the scientific attitudes of his time (100 B.C.) toward matter, space, atoms, life, mind, sensation, sex, cosmology, meteorology and geology. "It clearly follows that no rest is given to the atoms in their course through the depths of space. Driven along in an incessant but variable movement, some of them bounce far apart after a collision while others recoil only a short distance from the impact. From those that do not recoil far, being driven into a closer union and held there by the entanglement of their own interlocking shapes, are composed firmly rooted rock, the stubborn strength of steel and the like. Those others that move freely through larger tracts of space, springing far apart and carried far by the rebound—these provide for us thin air and blazing sunlight. Besides these, there are many other atoms at large in an empty space which have been thrown out of compound bodies and have nowhere even been granted admittance so as to bring their motions into harmony." **SS**
$8.95 *(PB/270)*

Out of Their Minds:

The Lives and Discoveries of 15 Great Computer Scientists
Shasha Lazere

Guys who program computers are stereotyped as geeks, and not without reason. They have given computers a bad image and claimed an air of genius for themselves. They, in fact, are not the real geniuses. The real geniuses are not geeks at all. They are rebel thinkers and dreamers who have changed the very way we look at the world. They are musicians, renegades, escapees from political persecution, spitball catapult-designers, *Mad* magazine contributors, and bureaucracy fighters.

In *Out of Their Minds*, freelance writer Cathy Lazere and computer scientist Dennis Shasha introduce us to 15 of these bad boys and girl (there is only one woman included in the list). They are the top computer scientists in the world and are together responsible for the leaps and bounds the industry has made in the last 50 years. By focusing on the scientists as human beings rather than giant brains the reader gets a clearer insight into what has driven these great thinkers to create the most important and powerful invention of humankind—the computer. Unlike the pioneers of any other discipline, these inventors are all still alive. This allows actual interviews that contain interesting anecdotes which allow the reader to enter the mindset of the inventor. The book is divided into four parts which reflect the four basic computer problems:
1) "Linguists: How to Talk to Machines"
2) "Algorithmists: How to Solve Problems Fast"
3) "Architects: How to Build Better Machines"
4) "Sculptors of Machine Intelligence: How to Make Machines Smart"
The research is based on actual interviews, and the majority of their thoughts is presented verbatim.

"Imagine visiting Isaac Newton in 1690. You might ask for his views about inertial forces and he might tell you his memories of farm life in Woolsthorpe." *Out of Their Minds* provides a well-balanced look at the first 50 years of computer science and hints towards the possible future. But most of all, it allows the reader to see these 15 pioneers not as geeks, but as important artists in their own right. **AN**
$23.00 *(HB/291/Illus)*

The Philadelphia Experiment
Brad and Sherry Steiger

Late in 1943, claim the authors, the U.S. gov-ernment secretly accomplished the teleportation of one of its warships by successfully applying Einstein's Unified Field Theory. Known as the Philadelphia Experiment, this project was actually the end result of the application of alien technology, and the devastating side effects to the unlucky crew included spontaneous combustion and insanity. This and many other UFO-related conspiracies are outlined in this good basic primer for UFO enthusiasts.

Other topics covered are the UFO crash in Roswell, New Mexico, in 1947, Men-in-Black and their harassment of UFO witness-es, FDR's secret treaty with the alien K-Group, UFOs from inside the Earth, the connection between ancient civilizations such as the Mayas and extraterrestrial visitors, several U.S. government cover-ups including a tacit invasion of Earth by the Grays in 1954, and the fact that the American military has worked with aliens to build and staff more than 75 underground bases in the Southwest. **AS**
$12.95 *(PB/160/Illus)*

Relativity and Common Sense
Herman Bondi

Offers a "radical reorientation" of Einstein's Special Theory of Relativity, derived from Newtonian ideas as opposed to against them, as is commonly done. Relativity should be seen "not as a revolution," says the author, "but as a natural consequence and outgrowth of all the work that has been going on in physics." The concepts of force, momentum, rotation, sound and light are explained as well as the relation of these to the important concept of velocity. Several mathematical equations are also introduced (especially the mandatory Lorentz Transformation). "By viewing Newtonian physics in a different manner, a much more comprehensible picture of Relativity could be established with little trouble. This volume proceeds to do just that. **GR**
$6.95 *(PB/177/Illus)*

Though it looks like something from a science-fiction movie set, it's actually an O&K BWE 289 "Central Tower" type bucket wheel excavator. The largest earth-moving machines operating today are of this style. — from **Giant Earth-Moving Equipment**

Rogue Asteroids and Doomsday Comets: The Search for the Million Megaton Menace That Threatens Life in Earth
D. Steel

A research astronomer at the Anglo-Australian Observatory, the author is a leading authority on the menace of killer comets and asteroids. He sounds the alarm in unequivocal terms about the likelihood of a devastating astral collision unless we earthlings get mobilized to search and destroy oncoming comets. According to Steel, at least 2,000 objects now orbiting the Earth are large enough to hit with the force of a nuclear weapon. This seems like one scientific funding

request worth taking a second look at. **SS**
$24.95 *(HB/308/Illus)*

Science and Music
Sir James Jeans
Originally published in 1937, this book by a "noted British scientist" explains music, especially Western orchestral music, in terms of sound curves and vibrational theory. Topics covered include: transmission of sound, resonance, free vibrations of a string, harmonic synthesis, acoustics of pipe organs, the Pythagorean scale, "music of the future" and the "threshold of pain." **SS**
$6.95 *(PB/258/Illus)*

The Sirius Mystery
Robert Temple
Exploration of a fascinating mystery: How did Africa's Dogon tribe (and others) get hold of star-system data thousands of years before Western man? (Insert weird music.) The book traces the enigma back 5,000 years to the Egyptian and Sumerian cultures. "These ancient civilizations possessed not only great wealth and learning, but also a knowledge dependent on physics and astrophysics, which they claimed was imported to them by visitors from Sirius," a rare double-star system. The Dogon could explain Sirius B, a White Dwarf orbiting Sirius A, but no one on Earth could see it. Is this proof the Pharaohs were visited by star creatures? (Hold weird note.) Could be. In contrast, modern astronomers only got their proof of the Sirius enigma in 1970. (Weird sustain and out.) **GR**
$16.95 *(PB/292)*

The Structure of Scientific Revolutions
Thomas S. Kuhn
Perfect complement to Charles Fort's anti-scientific crusade and research, from within the scientific community. Looks at how, by its very nature, science is resistant to new ideas about the world, and how shaky the foundations of scientific "fact" actually are at all times. "No part of the aim of normal science is to call forth new sorts of phenomena; indeed those that will not fit the box are often not seen at all. Nor do scientists normally aim to invent new theories, and they are often intolerant of those invented by others. . . . The transfer of allegiance from paradigm to paradigm is a conversion experience that cannot be forced. Lifelong resistance, particularly from those whose productive careers have committed them to an older tradition of normal science, is not a violation of scientific standards but an index to the nature of scientific research itself. The source of resistance is the assurance that the older paradigm will ultimately solve all its problems, that nature can be shoved into the box the paradigm provides." **SS**
$10.95 *(PB/212)*

Subterranean Worlds Inside Earth
Timothy Green Beckley
Amazing! THESE subterranean worlds are actually INSIDE the Earth! While the title might be worth a smile, the frontispiece photo of the author/editor is nothing short of surefire hilarity. A full page shot of Beckley in his best Dr. Who-style getup, bursting from his corduroys, clutching a walking stick and affecting an aristocratic sneer. The style carries into the writing with constant use of the royal "we" as well as inflated references to "our files" and "our correspondent." And what all this reportage comes down to is a collection of anachronistic sci-fi stories presented as "firsthand accounts" of underground cities, etc. Several chapters, however, stand out for their fascinating exposition on the famous "Shaver Mystery," the serialized visions of welder-writer Richard Shaver, who one day heard coming out of his welding gun "voices of endless complexity," which he perceived as emanations from an ancient underground civilization of extraterrestrial origin and malevolent intent. Stories of Shaver's "Deros" became the lifeblood of the magazine *Amazing Stories* and set the tone for many of the pulps to follow. Also includes an interesting debate between Shaver and the editor who shaped his visions, as well as Shaver's later speculation on what he perceived to be ancient "cyclopean books" visible in various geological formations. **RA**
$10.95 *(PB/158/Illus)*

Through the Barrier
Danah Zohar
Britain's Society for Psychical Research provides archival material for a rethinking of precognition. If it does exist, asks the author, "can it be understood in terms of modern science? It directly contradicts the theories of classical physics—but the modern view of time and space as set out in Albert Einstein's General Theory of Relativity may be able to accommodate it." From waking impressions of the *Titanic* sinking to experimental studies with animals, the quantum level phe-

The Analytical Engine (1833-1871, replica), the world's first programmable computer — from **The Age of Intelligent Machines**

nomenon of "Action at a Temporal Distance" is explored. **GR**

$9.00 *(PB/178/Illus)*

Universal Laws Never Before Revealed: Keely's Secrets — Understanding and Using the Science of Sympathetic Vibration
John Keely, Nikola Tesla, Edgar Cayce, Dale Pond, et al.

The concepts seem simple enough—Keely's theory is based on the fact that everything is composed of vibrations, and many previously cryptic and baffling properties of various elements of matter and/or energy can be understood in terms of the interrelation of the frequencies involved. Taking this one step further, Keely proposes that the myriad manifestations of the underlying realities and phenomena that comprise our universe can even be altered to taste, "tuned" as it were, by anyone skilled enough to do so. There are, unfortunately, certain complications, such as the necessity of tossing Einstein's gravitational and relativity theories and much of quantum mechanics and other modern annoyances out the window, but so what? If this stuff is true, then the New Agers' goal of Universal Harmony is at last within reach! The world will look like the one on the Jehovah's Witnesses tracts, full of lush ferns, green grass, little Korean children and fuzzy panda bears, and there'll be a soundtrack featuring Mannheim Steamroller's interpretations of obscure Philip Glass compositions. Thankfully, in Keely's case, "if" is a mighty big word.

But the ends are not what makes Mr. Keely's anomalous arcana so worthwhile; said ends are superseded, if not actually justified, by the means. Sure, the "science" he uses to put forth these ideas is fraught with what could, if it hadn't been written in the late 1800s, be dismissed as "hippie love tripe" (ergot damage, perhaps?), and it's overflowing with references to such questionable postulates as "the Aether" (which he describes as "an atomolic liquid 986,000 times the density of steel"), but as specious as some of his reasoning is, the machines he built to make it all happen are some of the coolest-looking things ever seen. They're like some weird hybrid of the gynecological instruments from *Dead Ringers*, Tesla's more eccentric-looking apparati, and the props from *Metropolis*. Even if they don't actually do anything at all, they're far and away some of the best objets d'art in the world, and his obsessively detailed drawings and charts bear

Richard Shaver believed that the pre-Atlantean history of our planet could be found imprinted inside certain rocks which when cut away told wondrous stories of a lost now-forgotten world. — from **Subterranean Worlds Inside Earth**

an uncanny resemblance to the work of everyone's favorite outsider artist, Adolf Wölffli.

His beat-frequency tables and other paramusical experiments promise lots of fun and function for the acoustically oriented, and even if nobody can figure out how to make his "Disintegrator Beam" work, his basic philosophical premise, recently echoed by Frank Zappa on the *Lumpy Gravy* LP ("Everything in the universe is part of one big musical note . . .") still rings true, resonating and resounding its consonant refrain through the decades. **DB**

$19.95 *(PB/285/Illus)*

Unveiling the Edge of Time: Black Holes, White Holes, Worm Holes
John Gribbin

A bright and breezy travelogue on the theoretical wonders of the universe, this is science journalism given a *Star Trek* turn. *Publishers Weekly* says: "Something else again . . . Gribbon is having fun . . . A book that rejoices in paradoxes and delights in reporting that nothing bizarre—baby universes, bubble universes, universe-sized black holes, energy extraction and time travel through wormholes—is denied by the laws of physics." Chapters on "Warping Space and Time," "Hyperspace Connections," "Two Ways To Build a Time Machine," "Cosmic Connections" and "Dense Stars." Fascinating,

as Spock would say with a raised eyebrow. **GR**

$13.00 *(PB/248/Illus)*

War in the Age of Intelligent Machines
Manuel De Landa

Within the background of ever-escalating black budgets and big-dick politics, funding for intelligent machines of mayhem, and the developments of computational power and its worldwide sociological impact, the shift in the age-old relationship between people and machines is profound. There is a growth of a very real war machine, seeking its own paths of destruction and ultimately of survival. With the assistance of powerful personal computers, both individuals and the state can now study and effect the behavior of singularities, and in the process speed the evolution of this new machine phylum. It's not unreasonable to consider the distinct possibility that our current human biological system of organization and deployment is but the onset of a more advanced and capable machine intelligence without sinew, soul or skin. **BW**

$16.95 *(PB/272/Illus)*

Wind Energy in America: A History
Robert W. Righter

"For many people, assessment of wind energy is based largely on a fleeting observation from an automobile window." This highly readable social history details the brief yet vital role of wind in American energy-generation: After World War I, mass-produced U.S. windmills (both water-pumpers and wind-chargers) signified individualism, self-sufficiency and decentralized technology, in direct opposition to government-regulated "hard" energy sources such as coal, petroleum, natural gas and nukes. The history of the Rural Electrification Administration, established in 1935, traces the high-wiring of the U.S. landscape, a transformation of both physical and economic topographies, which signaled the decline of independent farms and the growth of agribusiness. Righter concludes by examining closely the wind-generator boom of the past two decades in California, now totaling over 12,000 turbines and producing 96 percent of U.S. wind-generated electricity. **HS**

$34.95 *(HB/384/Illus)*

Charles Fort — from the Complete Works of Charles Fort

I believe nothing. I have shut myself away from the rocks and wisdoms of ages, and from the so-called great teachers of all time, and perhaps because of that isolation I am given to bizarre hospitalities. I shut the front door upon Christ and Einstein, and at the back door hold out a welcoming hand to little frogs and periwinkles. I believe nothing of my own that I have ever written. I cannot accept that the products of minds are subject matter for beliefs. But I accept, with reservations that give me freedom to ridicule the statement at any other time, that showers of an edible substance that has not been traced to an origin upon this Earth, have fallen from the sky, in Asia Minor.

There have been suggestions that unknown creatures and unknown substances have been transported to this Earth from other fertile worlds, or from other parts of one system, or organism, a composition of distances that are small relatively to the unthinkable spans that astronomers think they can think of. There have been suggestions of a purposeful distribution in this existence. Purpose in Nature is thinkable, without conventional theological interpretations, if we can conceive of our existence, or the so-called solar system, and the stars around, as one organic state, formation or being. I can make no demarcation between the organic, or the functional, and the purposeful. Then in an animal organism, osteoblasts appear and mend a broken bone, they represent purpose, whether they know what they're doing or not. Any adaptation may be considered an expression of purpose, if by purpose we mean nothing but intent upon adaptation.

If we can think of our whole existence, perhaps one of countless organisms in the cosmos, as one organism, we can call its functions and distributions either organic or purposeful, or mechanically purposeful.

— from *The Collected Works of Charles Fort*

Atlas of the Mysterious in North America

Rosemary Ellen Guiley

Fifteen phantom ships and a bottle of rum! The author, who has put out many Facts on File encyclopedias, has waded through the deep waters of the unknown for many a year. She has done her homework and makes interesting speculations about the vast collection of mysterious places she's gathered. Each of the eight sections begins with a map of the U.S., dotted with the locations of each site and an introductory article about the subject (in case you didn't know that Bigfoot is nocturnal or what the nine classifications of sea monsters are).

The first section is dedicated to sites with ancient connections; detailed maps of states with an overabundance of a particular phenomena are highlighted, such as: power points (Ariz.), sacred mountains (Calif.), sacred lakes/springs (Oreg.), earthworks (Ohio, Flor.), burial mounds (Ohio),

platform/temple mounds (Flor.), effigy mounds (Wis.), enclosed stoneworks (New England), medicine wheels (Colo.; Alb., Can.) and petroglyphs/pictographs (Calif., Ariz., Neb., Utah, New Mexico).

The maps illuminate some intriguing facts. The overwhelming majority of earthworks and burial mounds are found east of Mississippi. The high concentration of platform mounds in Florida makes one wonder if the Bimini Mounds (man-made structures underwater off the coast of Florida) were really part of some ancient sunken continent, as has been hypothesized. Also, almost all the water monsters are found right on the U.S./Canada border, contributing to the latitudinal monster belt which circles the globe (and includes Mokele-Mmembe, etc.).

Also includes state by state listings of the crème de la crème of hauntings, ghost lights, phantom ships, water monsters and mystery beasts. The only drawback with books this comprehensive is

that each little blurb leaves one needing to do further research to obtain the full story. **SK**
$35.00 *(HB/224/Illus)*

Bigfoot Memoirs

Stan Johnson

"Stan has been blessed by God to receive much information and wisdom through his experiences traveling in other dimensions of time and space. Stan, the official goodwill ambassador of Bigfoots, has received telepathic communication from the Sasquatch people, star people—and the ascended masters of wisdom."

In a semiliterate, monosyllabic style, the retired logger recounts his good times with the "Sasquatch People" in a number of interviews (which he conducted telepathically—how does one transcribe that?) and stories in which they request salt from him, behave very spiritually, and disclose that they come from the fifth dimension (and vacation there in winter). There's romance

Small creatures, such as fish, have mysteriously tumbled out of the sky throughout history. This illustration is taken from Lycosthenes' Book of Prodigies which appeared in 1557. — from Encyclopedia of the Unexplained

(the 16-year-old Sasquatch daughter falls for old Stan, a septuagenarian); intrigue (the evil ruler of their home planet, Arice, wants to destroy the kindly Bigfeet on Earth—and nothing will stop him in his lust for glory!); travel (Stan describes the fifth dimension as "the true Garden of Eden" and visits the interior of the Earth through a base on one of the Poles); and genetics (there are Sasquatch with dome- and pyramid-shaped heads). If Stan didn't have a healthy pension to live off of, I'm sure he'd be recounting his stories from inside a psychiatric hospital. **SK**
$10.95 *(PB/84)*

The Complete Books of Charles Fort
Charles Fort
These four fascinating books are the legacy of iconoclastic philosopher and supreme skeptic Charles Fort. Written between 1919 and 1932, they are full of curiosities, contradictions, anomalies and the kind of data that was and is conveniently ignored or simply suppressed by mainstream science. Gleaned from 27 years of full-time research conducted at the New York Public Library and the British Museum Library are reports from periodicals, scientific journals, newspapers and numerous manuscripts covering such wild phenomena as pre-UFO flying objects, rains of frogs, falls of fishes, selective weather, strange creatures and other rejected data. Fort was a true cynic who-considered most scientists pompous and wrote "I cannot accept that the products of minds are subject matter for beliefs." An

essential reference for the beginner and seasoned Fortean alike. **BW**
$29.95 *(HB/1,126)*

The Damned Universe of Charles Fort
Louis Kaplan
Called a "scientific tramp and swindler" by his detractors and "grand tourist of the unexplained" by his champions, American cosmographer Charles Hoy Fort (1874-1932) compiled four fascinating volumes—*Book of the Damned*, *New Lands*, *Lo!* and *Wild Talents*—crammed with dada-style data. "Fort called this crazy collection of outcasted data 'the procession of the damned'—rains of frogs, black snow in Switzerland, sightings of the unidentified, the spontaneous combustion of bodies, or the telekinetic powers of poltergeist girls." He was a "Dataist" and his "obsessive collection of anomalous and exceptional data rejected by the sciences of his day" allowed him to make whimsical, "likely-unlikely pseudo-conclusions" about the bizarre nature of our universe. "I think we're fished for . . . I think we're property . . . There are occans of blood somewhere in the sky . . . Many little stone crosses have been found. A race of tiny beings. They crucified cockroaches . . . ," etc. Collects "the most inspiring and entertaining of Fort's texts in a wild montage . . . a cosmic vision which bombards the borders of fact and fantasy,

metaphysics and nonsense, truth and hoax, science and the occult, the arcane and the frivolous." **GR**
$10.00 *(PB/156)*

Disneyland of the Gods
John A. Keel
The Earth is "owned" by somebody or something, concluded Charles Fort, the noted super-compiler of weird world events. Keel elaborates on this theme with more reports of trickster spirits, snallygasters and sea serpents, farfrotskis, oopths and other Fortean arcana in this compilation of odd articles first written for *Saga* magazine. "When we have finally scrambled or crawled our way through the unfortunate 20th century we may look back and realize with a terrible shock that Charles Hoy Fort towers above . . . all the other alleged giants of these hundred years that ate saints and farted Hitlers," says the author. "Fort squeezed the udders of the sacred cow of science, and he made us recognize that we were living in an age of miracles—an age when kitchen sinks could fall from the skies." **GR**
$9.95 *(PB/175)*

Encyclopedia of the Unexplained
Jenny Randles and Peter Hough
Instead of giving us a few lines on all the anom-

William Hope was a controversial "spirit" photographer who survived many tests, but was exposed by others. Here, the image of a man's dead son appeared on plates provided by the father who called on Hope unannounced. — from Encyclopedia of the Unexplained

A painting of my friend, Nate, a Bigfoot woman — from Bigfoot Memoirs: My Life with the Sasquatch

alous subjects in the heavens and on earth (and appropriated by *The X-Files*), the authors have attempted to "focus on just a handful of true mysteries of modern science." And they have tried to do this objectively. Subdivided into eight sections, for your supernatural convenience: "The Supernatural Earth"; "Space Invaders"; "Out of Time?"; "Death by Supernatural Causes?"; "Mind Matters"; "The Spiritual Dimension"; "Strange Beings"; and "The Alien Zoo."

Jenny Randles of Great Britain, reportedly the most successful writer of books on anomalies, seems to specialize in chatty text and personal anecdotes. This may be the key to her success: Without a high content of cold steely science or crackpot theorizing, her work can be easily consumed by those who file books on UFOs and strange powers next to their copies of the *National Enquirer* and *Soap Opera Digest*. This is not to say *Encyclopedia* is superficial; this is a solid introduction for those seeking to delve into the most well-documented mysterious phenomena.				**SK**
$24.95

(HB/256/Illus)

Fire from Heaven
Michael Harrison
Microwaveable humans that cook from the inside out! Flesh and fireworks! "Billy Thomas Peterson, of Pontiac, Michigan, was found dying in his car after a passing motorist had seen smoke coming from Peterson's garage. Billy was also burnt: 'His left arm was so badly burned that

the skin rolled off. His genitals had been burnt to a crisp. His nose, mouth and ears were burned.' And a plastic religious statue on the dashboard had melted in the intense heat. But nothing else was even singed—not even Peterson's underwear." An exploration of an astonishing mystery—Spontaneous Human Combustion (SHC)—that has been historically shrouded in fear and misunderstanding. Includes plenty of case histories and scientific analysis. The author proposes a psychokinetic poltergeist theory as the cause of SHC, and relates it to telekinesis and other psychic powers.				**GR**
$14.95				*(PB/396/Illus)*

The Mothman Prophecies
John A. Keel
Fortean investigator and journalist Keel takes the documented facts about a series of UFO flaps over Point Pleasant, West Virginia, in 1973, and weaves them into a spine-tingling tale of true terror. It stars the sinister Men-in-Black, the "Mothman" (a giant winged creature with glowing red eyes) and mysterious aerial light formations—all descending on a small rural town for 13 months of sci-fi *Walpurgisnacht.* "Innocent people lived in surrealistic horror, haunted by the fearsome demonic 'Bird' and besieged by legions of strange beings. It is guaranteed to shake all of your beliefs and concepts of reality. It will open your mind to things you never dared to think about before. And it will scare the hell out of you!"				**GR**
$16.95				*(PB/275)*

Science Frontiers: Some Anomalies and Curiosities of Nature
William R. Corliss
"Anomaly research, though not a science per se, has the potential to destabilize paradigms and accelerate scientific change. Anomalies reveal nature as it really is: complex, chaotic, possibly even unplumbable." If anything, Corliss raises the standard set by Charles Fort, and with these 1,500 fully indexed items of anomalous science news and research taken from an ongoing survey of over 100 scientific journals and magazines, amply demonstrating the uncertainty of knowledge. Originally published in *Science Frontiers*, a bimonthly newsletter sent free to buyers of Corliss' landmark Sourcebook Project (a work of some 40,000 articles covering 25 years of searching), this collection covers subjects ranging from ancient engineering works, cosmology, biological enigmas and diffusion and culture, to geological anomalies, geophysical phenomena, psychological

mysteries and the very edge of mathematics and physics. Indispensable.				**BW**
$18.95				*(PB/356)*

Unexplained!: 347 Strange Sightings, Incredible Occurences, and Puzzling Physical Phenomena
Jerome Clark
This reference guide covers not only the familiar unexplained phenomena such as the Yeti, the Bermuda Triangle, Area 51 and the Loch Ness Monster, but also such lesserknown enigmas as bloody rain, the Chinese Wildman, and Thunderbirds. This book brings back fond memories of, and nostalgia for, the von Daniken years of the early '70s which were rife with such volumes. Unlike those books, Clark's provides many firsthand accounts which give a fresh look at unexplained phenomena. He carefully annotates and footnotes his sources on nearly every page and includes such revered sources as *Fate* magazine and *UFO Quarterly*. Many scholarly references are sited in his documentation of cryptozoölogy. Often the mundane solution he offers to certain mysteries takes the edge off the glamor. For example, the phenomenon of bloody rain is casually dismissed as buzzard vomit descending upon unwary pedestrians. Clark ties together his variety of sources without being preachy, proselytizing, patronizing or paranoid.				**MM**
$14.95				*(PB/443/Illus)*

Sasquatch — from Behold the Protong!!!

MUSEUM OF JURASSIC TECHNOLOGY

The 100-inch Hooker Telescope, Mt. Wilson Observatory — from No One May Ever Have This Same Knowledge Again

Few museums in the world actually flirt with their visitors, and when you encounter such a place, it's very easy to fall in love—not with a given collection, but with the romance of its display. Situated on Venice Boulevard between a realty office and an In-N-Out Burger, the Museum of Jurassic Technology projects an understated dignity at odds with its surroundings, as well as with the monumental architecture favored by most cultural institutions. Inside, the space is as dimly lit as a religious shrine, and on entering its labyrinth of exhibits, the viewer plunges into an enveloping, womb-like obscurity, completely dislocated from the outside world.

For all its kinship to a mausoleum, the MJT is equipped with the kind of state-of-the-art display technology proper to a contemporary natural history museum. Visitor-activated exhibits, multi-media dioramas and other audio-visual presentations chart out an eclectic terrain ranging from a model of Noah's Ark to exhibits on esoteric South American bats and questionable geological phenomena. Traditional glass-and-wood vitrines shelter an array of preserved insects, animal bones, and technological artifacts like the antiquated Boules of Conundrum, a brass mechanism for producing manmade gems.

As you make your way through its shadowy halls, a vaguely disturbing thought arises like a faint scratching at a back window of the mind: while this is supposedly a Museum of Jurassic Technology, there are few displays which actually make reference to either the geographic Jurassic (the area of the lower Nile) or the prehistoric time period. Yet the museum's varied subjects are approached with reassuringly meticulous scholarship. Boorishly academic panels of text legitimize even the quirkiest exhibits, and the voice narrating the audio components is a familiar one: pedantic, slightly pompous, logical and devoid of ambiguity. It's a Voice of Authority, and the moment you hear it you feel you can believe everything you're being told, even when—as in a jungle diorama depicting the self-destructive compulsion of the Cameroonian stink ant—"nature" is presented as a metaphor or parable rather than an object of scientific study. With this flawless delivery, the museum enacts its stated mission of leading viewers "from familiar objects toward the unfamiliar . . . guided along, as it were, a chain of flowers into the mysteries of life."
— Ralph Rugoff, from *Circus Americanus*

The Eye of the Needle
Essay by Ralph Rugoff
File this one under Curiosities and Wonders. The focus of this book is the microsculptures of Halgop Sandaldjian. The artistic renderings of this Egyptian-born, Armenian- raised transplant to Los Angeles literally fit inside the eye of a needle.

"An unexpected sneeze or misdirected breath could blow away a microminiature with hurricane force . . . Early in his career he would spend hours hunting for these missing children, carefully combing every inch of desk and floor space in his study, but eventually he realized that such searching was futile. Once a piece was lost, it was lost for good."

This booklet was produced to complement an exhibit of his "microminiatures" at the Museum of Jurassic Technology, and covers a lot of ground, as it includes the story of an intuitive and self-driven would-be violin virtuoso, a history of micro-art—including methods, philosophical ponderings, and instruction in learning to play the violin using Sandaldjian's self discovered "Ergonomic" techniques. Last but not least, the book is a work of art in itself, beautifully put together—even its smell adds to it sunique character. Curiously, there is a strange omission from the author's tour of miniature art: the flea circus, the only micro-performing art . . . He mentions everything else, and gets close with a mention of fleas in dresses. **TC**
$15.00 *(PB/95/Illus)*

No One May Ever Have the Same Knowledge Again: Letters to Mt. Wilson Observatory 1915-1935
Edited by Sarah Simons
In scientific crankdom the essential benevolence of the human spirit is most freely, and winningly, expressed. From the archives of the Museum of Jurassic Technology, the best museum in the United States, comes this little book containing the letters—entirely genuine letters—reprinted in that were addressed to the astronomers of Pasadena's Mt. Wilson Observatory. The correspondents set forth, briefly or at stupefying length, their delightfully inventive cosmologic theories—the Earth is flat, our bodies are linked by radio to heaven, comets are the "chore boys" of the universe—and offer them freely to a world they imagine is desperately waiting to hear them. The world, like Mt. Wilson's astronomers, ignores these non-traditional theorists, laughs at them, and sometimes breaks their hearts; but it never shuts them up, and for that we should all be grateful. "The moon is a sphere and it works the clouds by night; it is not a Planet, and should not be interfered with." The human mind, when unleashed, is a glorious thing to behold. **JW**
$9.95 *(PB/120/Illus)*

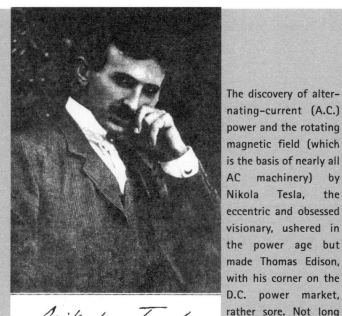

Nikola Tesla

The discovery of alternating-current (A.C.) power and the rotating magnetic field (which is the basis of nearly all AC machinery) by Nikola Tesla, the eccentric and obsessed visionary, ushered in the power age but made Thomas Edison, with his corner on the D.C. power market, rather sore. Not long after, there was a mysterious fire at Tesla's lab . . . things were beginning to heat up.

Serbian by birth, Tesla became one of the founders of Westinghouse Electric Co. and a scientist of singular genius. In 1900, he discovered terrestrial stationary waves, by which he proved that the Earth could be used as a conductor and would respond like a tuning fork to electromagnetic waves on a certain frequency. He demonstrated the effect by lighting 200 electric lamps, without wires, 25 miles away!

Tesla wanted to build a system whereby standing waves circling the Earth would provide practically free power and communications anywhere on the globe. J.P. Morgan granted him the money to develop his idea but later withdrew his support abruptly when someone reminded him that he wasn't going to make much money from free energy. Tesla's experiments were suppressed and he was never to achieve prominence again.

Later, he was inhibited by a progressive germ phobia, and claimed to have angelic visitations and to have received his blueprints from signals in space. His many accomplishments included creating the first man-made lightning, invention of the induction motor, and the development, he claimed, of a death ray. In 1943, he died in semipoverty and virtual obscurity. — RE

Angels Don't Play This HAARP: Advances in Tesla Technology
Jeanne Manning

This work is about advances in Tesla technology. Learn about the U.S. Government's new ground-based Star Wars weapon system HAARP, the High Frequency Active Auroral Research Project. The HAARP is an experiment in the ionosphere that targets the electrojet (a river of electricity that flows thousands of miles through the sky), attempting to turn it into a vibrating artificial antenna for sending electromagnetic radiation raining down on the earth. This experiment could affect the earth's upper atmosphere: changing weather patterns over large areas, and interfering with wildlife migration. As a weapon, it could be used to jam global communications, for weather control, or to disrupt human mental processes. Out of control, it could affect the whole planet's life cycle. The book includes a chronology of large-scale electromagnetic experimentation from Tesla to nuclear explosions in the Van Allen Belt to ionospheric heating or sky busting, to the development of HAARP. There is information on: Russian Microwave experiments conducted against the U.S. Embassy in Moscow, C.I.A. Mind Control experiments, positive applications of electrophysiology, and developments in non-lethal weaponry. There is a series of diagrammatic illustrations of the HAARP, and even suggestions for turning the destructive uses of it to more positive applications. Picked as one of the top 10 under reported news stories of 1994 by Project Censored. **MC**
$14.95 *(PB/233)*

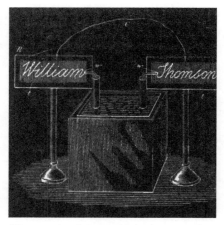

Wires rendered intensely luminous — from
Experiments with Alternate Currents

Experiments With Alternate Currents of High Potential and High Frequency, with Appendix: The Transmission of Electrical Energy Without Wires

Nikola Tesla
Transcription of a lecture delivered before the Institution of Electrical Engineers in London. Appendix covers his Colorado experiments in transmission of electric energy without wires. Originally published in 1904.

$12.95 *(HB/162/Illus)*

The Fantastic Inventions of Nikola Tesla

Nikola Tesla with David Hatcher Childress
Lots of neat pictures and descriptions of Tesla's various patented inventions including his "amazing death ray" and other "unusual inventions"; the Supreme Court documents on the dismantling of Wardenclyffe Tower; a complete bibliography; and the never-before-told story of how he and Guglielmo Marconi faked their deaths, moved to a secret compound deep in the Amazon jungle, built a fleet of anti-gravity-powered flying saucers and flew them to Mars in the late '40s, where they may or may not have built a few pyramids and the famous "face." **DB**

$16.95 *(PB/340/Illus)*

Inventions, Researches and Writings of Nikola Tesla

Thomas Commerford Martin
This book was originally printed in 1894 by *Electrical Engineer Magazine* of New York. It is reprinted in its exact original form without a new preface or any comment on the "cult of Tesla" that has blossomed in recent years. It is very technical and concerns itself primarily with the nature of electricity and its applications to lighting and motors. A good source for anybody who is setting out to study the greater body of Tesla's work, it shows how he was perceived by his peers and just how much of what he achieved is now taken for granted. Anybody seeking biographical detail or the "classified stuff" is advised to look elsewhere. This is a very specific (and thorough) look at a focused area of endeavor. **SA**

$16.95 *(PB/496/Illus)*

Nikola Tesla's Earthquake Machine

Dale Pond and Walter Baumgartner
According to the *New York World-Telegram*, Nikola Tesla claimed to have set off an earthquake in the vicinity of his Manhattan laboratory in 1898. The authors have investigated his claim and also his plans to create a worldwide power transmission system based on "tele-geo-dynamics," the art of producing terrestrial motions at a distance. A new science of vibrational physics is proposed based on Tesla and John Keely's lost research. Includes reproductions of the original patents for Tesla's electric generator and plans for building your own mechanical oscillator-generator. **SS**

$16.95 *(PB/176/Illus)*

Prodigal Genius: The Life of Nikola Tesla

John J. O'Neill
An overview of the life of Nikola Tesla, one of the most unusual thinkers of our millennium, originally published in 1944 by a guy that Tesla himself said understood him "better than anyone else in the world." The best thing about this book is a little surprise regarding "the love story of Tesla's life," early on promising the skinny on "a romance the like of which is not recorded in the annals of human history," and he's not kidding. Sure, the stories of his 1897 invention of our modern polyphase alternating-current electrical distribution system, his unsung creation of what later became broadcast radio, and his experiments with the wireless transmission of power through the air and even the Earth itself are all pretty interesting, but you'll forget all about that trivia when you get to the part where he explains his tendency to obsessively feed pigeons. "There was one pigeon," Tesla reveals, "a beautiful bird, pure white with light gray tips on its wings; that one was different. It was a female . . . I loved that pigeon. Yes," he replies to an unasked question, "yes, I loved that pigeon, I loved her as a man loves a woman, and she loved me." Oh, the humanity! **DB**

$12.00 *(PB/329)*

Tesla: A Man Out of Time

Margaret Cheney
The best biography of Nikola Tesla, the ultimate "mad" scientist who abhorred women, couldn't stand anything white and globular, and invented AC electrical transmission, star wars particle weapons, death rays and free-energy devices. **FLA**

$5.99 *(PB/320/Illus)*

Tesla Coil

George Trinkaus
Plans, diagrams and text which are actually written in plain English. Get kilovolts out of an ordinary AC socket, light fluorescent bulbs without plugging them in, or scare the hell out of your friends with lightning on demand. **FLA**

$4.95 *(Pamp/24)*

Tesla Technology Series Volume 1: The Problem of Increasing Human Energy and the Wireless Transmission of Power

Nikola Tesla
$9.95 *(PB/92)*

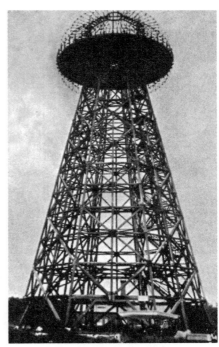

Central power plant and transmitting tower for "world telegraphy," Long Island, N.Y. — from Tesla Speaks, Volume II

The Theory of Wireless Power

Eric P. Dollard
Contains many essential formulae and supporting data necessary to understand the process of the transmission of electrical energy without wires. Based on real work with a Tesla Magnifying Transmitter.

$10.80 *(Pamp/69)*

Detail from one of the MJ-12 documents reveals that the date numerals are out of alignment with the other characters, indicating that the numbers were typed at a different time. — from **Detecting Forgery**

"Area 51" Viewer's Guide
Glen Campbell

Down-to-earth travel guide to Nevada's alleged UFO-watching site. Pointedly skeptical of the claims of Bob Lazar, the celebrity conspiracist responsible for popularizing the area through his firsthand accounts of working with captured extraterrestrial ships hidden in the nearby Nellis Air Force base, the author also wastes no time in separating himself from the cottage industry servicing the visiting "true believers." His altercations with the fanatic-friendly entrepreneurs of the "The Little A'Le'Inn" who regard him as a government plant are an entertaining highlight of the book.

Focusing more on the bureaucratic paranoia responsible for the recent military takeover of nearby hilltops once serving as vantage points for the area, Campbell treats the area's reputation for strange nocturnal lights and mysterious fly-overs as evidence of "Black Budget" technological innovations, such as the once "mythical" Stealth F-117A. Campbell also catalogs the more common extraterrestrial impostors: optical and perceptual phenomena as well as aerial experiments with flares and "infrared suppression" devices, or "fireballs," dropped from fighters for the diversion of heat-seeking missiles. All this and back road maps, useful tips for dealing with security patrols ("Camo Dudes") and environmental and road conditions. Even some recommendations of other nearby attractions should the saucers fail to show. **RA**
$15.00 *(Spiral-bound/115)*

Ashtar: Revealing the Secret Program of the Forces of Light and Their Spiritual Program for Earth
Tuella

Tuella, a mousy little woman as unassuming as Ruth Norman was extravagant (and who probably bakes a mean Christmas cookie assortment), channels space beings so cute and cuddly and nice they make E.T. look like "Alien" in comparison. Commander Ashtar is either an "Archangel" or "Space Commander" (nobody knows for sure) "directly under the sponsorship of Lord Michael and the Great Central Sun Government of this galaxy, and is second only to the Beloved Commander Jesus-Sananda in responsibility for the airborne division of the Brotherhood of Light." "Widely known in UFO channeling circles for three decades," Ashtar's message is often obscure but generally characterized by a standard soft 'n' fuzzy call for an end to all naughty bad things like the H-Bomb, and the subsequent ushering in of a "Golden New Age of Enlightenment" or something equally boring sounding. **DB**
$14.00 *(PB/160/Illus)*

Behold a Pale Horse
Bill Cooper

This volume, written by a former member of the Intelligence Briefing Team of the commander-in-chief of the Pacific Fleet, who is already famous on the talk-radio/lecture circuit, has truly become a sensation in the slow-moving world of conspiracy books. At first, *Behold a Pale Horse* would seem to bring together the strands of Trilateral/Council on Foreign Relations/Bilderberg/New World Order/Illuminati monitoring with Alternative 3/MJ-12 UFO paranoia about "government cover-ups" into one scary scenario.

But at times, Cooper—the man who stared down the Men-in-Black and lived to write a book—leaves the reader in a perilous state of uncertainty by revealing his own doubts regarding extraterrestrial reports. After spinning a fascinating web—which includes

forcible depopulation by the Club of Rome through AIDS; fomenting civil wars in high population-growth countries like El Salvador; tobacco fields fertilized with radioactive trailings to increase cancer rates; details of secret moon bases where a hushed-up altercation between Soviet and American personnel actually became violent; the lowdown on Mount Weather where a stand-in federal government is housed in a vast underground city; documentation of the Federal Emergency Management Agency's contingency plans to rule the U.S. by martial law and draconian unconstitutional drug-war laws; reports of how Ike foolishly turned to Nelson Rockefeller for help in solving the problem of dealing with alien landings in 1953; and even unmasking Whitley Strieber (author of *Communion* and *Majesty*) as a CIA agent—Cooper still seems less than confident about how to interpret his own findings. As he puts it, "There is always the possibility that I was used, that the whole alien scenario is the greatest hoax in history designed to create an alien enemy from outer space in order to expedite the formation of a one-world government . . . I advise you to consider this scenario as being probable."

This does not prevent him from accusing Vicki Cooper, editor of *UFO* magazine, of once being part of the Mayflower Madam's hooker operation and being forced to move to L.A. and start the magazine in a deal to get out of a long jail term. A firm believer in the premises of *Holy Blood, Holy Grail*, Cooper reprints a version of the Protocols of the Learned Elders of Zion in its entirety but then notes that one should substitute "'Sion' for 'Zion', 'Illuminati' for 'Jews', and 'cattle' for 'goyim.'"

"Could it be that Congress knows the whole thing and won't touch it? Are they among the select who have been picked for the Mars Colony when the Earth begins to destruct, if the Earth is going to destruct?" That's a hard call, Bill. **SS**

$25.00 *(PB/500)*

Casebook on Alternative 3: UFOs, Secret Societies and World Control
Jim Keith

Nearly 20 years ago, British television aired *Alternative 3*, a bewildering exposé on the world's elite constructing a secret space-travel and colonization program to escape our doomed Earth. Although it was revealed

as an April Fool's joke (in a program which aired months too late), the info contained chilling similarities to covert operations in effect today. As author Keith postulates, "*Alternative 3* points to, if in a clumsy and unbelievable fashion, the deadly alignment of technology and elitist control . . . [it] may not be true at all, in the sense of a revealed scripture, but only as a persuasive metaphor for totalitarian control in the manner of Orwell's 1984." Keith discusses data from *Alternative 3* and immediately refutes it, then offers stranger real-life parallels (he reveals the "murdered scientists" working

on *Alternative 3* were all fictitious, but then ticks off a list of real scientists killed under most suspicious circumstances). One would like to dismiss Keith as a crackpot, simply because of the horrors he unfolds, but given the cool, collected way in which he presents his data and the logical conclusions he comes to, it may be time to get nervous.

Learn how our spy establishment and the CIA act as "little more than the private army of the Fortune 500" and are "often designed to violate international law and to trample human rights." Get the skinny on CIA mind control of television, LSD, CIA-funded

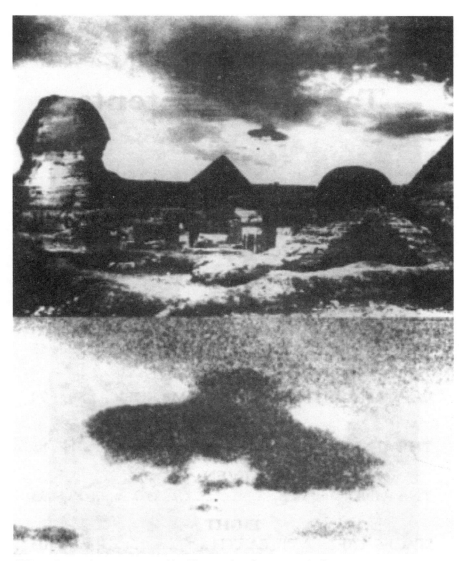

UFOs are frequently seen over pyramids of Egypt. — from **Stranger at the Pentagon**

eugenics experiments, human cloning and 70,000 cattle mutilations. Was Jonestown the prototype of an African-American extermination program? Are birth control, AIDS, bio-warfare and man-made UFOs all part of some covert, loosely connected conspiracy to control the planet? Certainly the suppression of the Third World is: "The Third World is being forcefully relieved of natural resources and exploited for cheap labor, and is in fact seen . . . as maintaining maximum profitability as long as it's kept in abject poverty."

Casebook explores our preoccupation with WWII, parallels to Nazi actions (such as the CIA psycho-chemical experiments conducted on American enlisted men—some involving Nazi nerve gases), and Nazi involvement in more credible realms (war criminal Werner von Braun was instrumental in our early space program). In the last chapter, Keith admits his immense reluctance to acknowledge the Nazi connections but "in reshaping the totalitarian control during this century I saw the plans of the Nazis manifestly did not die with the German loss of World War II. The ideology and many of the principle players survived and flourished after the war, and have had a profound impact on postwar history, and on events taking place today . . . Nazi interests have been entwined with other totalitarian control mechanisms of the world, with the intelligence, police and psychiatric establishments, with eugenics and genetic research, as well as with the plans of moneyed elites." **SK**
$12.95 *(PB/160)*

The Commander X Files
Commander X
Earth is on the fast track to annihilation, caught between good 'n' evil alien forces, these primarily being the evil Grays (and Dracos) of popular legend, and the benevolent Nordics, a non-aggressive confederation of human and non-human races. Commander X continues the Nazi-UFO collaboration story, although his version has the Nazis infiltrating the U.S. spy and space agencies through the Grays' string-pulling. E.T.s respect us, the author claims, because our auras are proportionately larger than theirs. Is this why they're trying to breed with us, so that they may "experience human emotions" as they have none of their own? X frequently makes reference to Inner Light Publications—one is always wary of authors who reference themselves (or other authors on the same press) for facts.

Fancifully illustrated, including a handful of goodies like hand-drawn maps to Area 51 and the Dulce Air Force Base and a transcript of Commander X's entertaining hypnosis sessions. The last chapter reprints various classified documents, mostly pertaining to UFOs, and newspaper reprints, mostly pertaining to bio-warfare. Plus an *Alternative 3* document based around a certain Mr. X (the, ahem, Antichrist), who, besides orchestrating all wars and political and social strife in all countries, plans to run the world on nuclear energy. This, the most devious Satanic ploy, is just a "simple chore

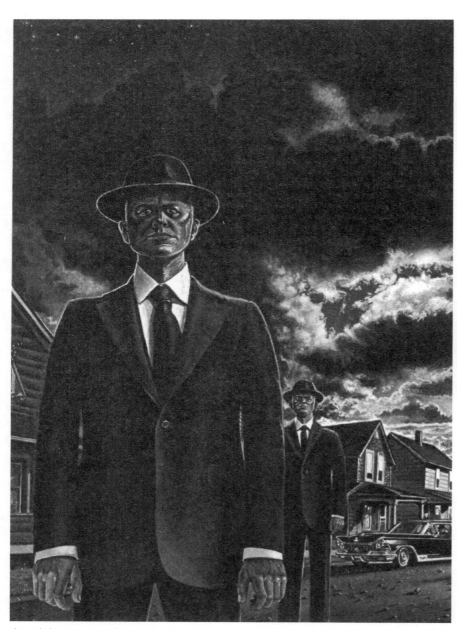

An artist's conception of the sinister Men In Black — bogus officials who plague UFO percipients. These smartly dressed figures seem to appear out of nowhere. — from Encyclopedia of the Unexplained

for Mr. X." Printed only on one side of the page, this weighty tome has only half the information you might expect. **SK**
$39.95 *(PB/Illus)*

The Controllers
Commander X

Some researchers believe the Government has been producing fake UFO material and releasing it to the public in an effort to confuse the multifaceted alien issue. This thin volume by the prolific Commander X (also the title of an alien abductions book by Martin Cannon) is a exemplary candidate for impostor status.

Ostensibly about the "strange, parallel race that has complete control of our educational processes, the media and is a dominant influence over all worldly governments," *The Controllers* ping-pongs between hidden races from hominoid saurians to *chaneques* (Mexican gnomes), but the most pages are devoted to alien breeding programs. It is probably the only book to acknowledge the Tesla free-energy scam *and* masturbate over far-flung extra-terrestrial theories. They seem to be mutually exclusive. What does this spell? Immense entertainment and, very likely, little fact.

The "Alien Babies" chapter, concerning the Grays' cross-breeding program, is most amusing: "Hey, I know you guys need sperm. Why don't you come back in six months." After the handmaid and her crones have come to visit, the desire for the E.T. lady puts X's relationship with his inferior girlfriend in jeopardy: "'I've always had a lot of sexually based guilt . . .'" After his anger dissipates, he becomes "proud of [his] new status as a father of space kids . . ." and reflects upon his impotency, which "may have been influenced by the E.T.s' suctioning off my sexual energies, but the root cause [of my dysfunction] was that I didn't want to share my seed with [my girlfriend] . . ." Later he describes the astral visits to his "space kids," and how he tries to connect with them by playing Yanni(!). Throw in some discordant passages about ritual Satanic abuse, secret cities under Death Valley and Nazi occultism, with all the naughty bits emphasized in CAPITALS and you've got Commander X. The book makes reference to the *Amok Fourth Dispatch*, so it can't be completely fraudulent. **SK**
$29.95 *(PB/111/Illus)*

Cosmic Patriot Files:

Volume One†
Cosmic Patriot Files:
Volume Two††
Edited by Commander X

Take any run-of-the-mill conspiracy theorist, shoot him or her up with crystal meth daily for a year and you'll wind up with a pretty good approximation of Commander X—still, you could never improve upon the

Barker taking his message of the Men In Black to the dusty heat of George Van Tassel's 1958 Interplanetary Spacecraft Convention at Landers, California. — from **Last Prom #4**

perfection of the original. In this, his two-volume magnum opus, the Commander offers up for the less demanding reader a farrago of startling notions and beliefs, unlikely chronologies, urban myths cloaked in the robes of True Fact, thrilling accounts of Those Who Went Too Far, and justifications for every kind of nitwittery perpetrated in print during the last 50 years.

Whenever the Commander wants to make especially noteworthy points—once or twice a page, on average—he hits "shift" and caps everything for paragraphs at a time, making you feel as if a stranger is sitting next to you on the subway, bellowing in your ear about his fillings. When you read that in

1979 "66 Americans [were] killed by (neosauroid) alien Grays" you imagine, fleetingly, that the Commander might choose to offer some proof along with his proposition, if only accidentally, but no such luck. No matter—if you see it in print, it must be true. Occasional lapses in spelling—"swine flue," for example, or "glasnose"—in no way damage the reader's appreciation of the Commander's inimitable efforts. Text is printed on only one side of each page, making it look as if the reader is getting twice as much material as is really there. Bound in a sturdy electrical-tape-like substance. In short, a winner. **JW**
†$39.95 *(PB/75)*
††$39.95 *(PB/72)*

Cosmic Top Secret: America's Secret UFO Program
William F. Hamilton III

"There is," says the author, "a growing feeling that the top-secret, compartmentalized projects within the military industrial complex are working on extremely advanced supertechnology based upon a study of alien artifacts and hardware found in various UFO crashes. Witnesses in growing numbers have reported seeing UFOs being tested above a Nevada test site, and film crews have videotaped strangely maneuvering brilliant objects that appear at scheduled times during the wee hours."
$10.95 *(PB/144/Illus)*

Extraterrestrials in Biblical Prophecy and the New Age Great Experiment
G. Cope Schellhorn

Is this the sort of thing some retired English professors do instead of gardening? Schellhorn reprints Bible passages (taken from the Revised Standard Version), examines them and points out the blindingly obvious references to sky gods, their spacecraft and super powers. He "attempts to explain interrelationship between ancient and present UFOs and scriptural prophecy" in relation to the modern age. Is our existence just some "grand experiment"? Are the fiery sky gods in many creation myths more than hyperbole? Have the "end times" commenced with WW II, ushering in a tremendous increase in UFO sightings? Will mankind be tested in trials by fire—with the Messiah and his extraterrestrial host standing by to offer assistance to those who lis-

ten? Has there been some kind of flagrant conspiracy among scientists and religious scholars to avoid the implications of the extensive and compelling data? They certainly won't champion this book, but that's no reason not to pray to the heavens next time you're in a fix.　　　　　**SK**
$12.95　　　　　　　*(PB/427/Illus)*

Fire in the Sky: The Walton Experience — The Best Documented Case of Alien Abduction Ever Recorded
Travis Walton
"The only facial feature that didn't appear underdeveloped were those incredible eyes! Those glistening orbs had brown irises twice the size of those of a normal human's eyes, nearly an inch in diameter! The iris was so large that even parts of the pupils were hidden by the lids, giving the eyes a certain catlike appearance. There was very little of the white part of the eye showing. They had no lashes and no eyebrows.

"The occasional blink of their eyes was strikingly conspicuous. Their huge lids slid quickly down over the glassy bubbles of their eyes, then flipped open again like the release of roll-up window shades. These huge, moist, lashless eyes and the milky translucence of their skin made their appearance slightly reminiscent of a cave salamander. But strangely, in spite of my terror, I felt there was also something gentle and familiar about them. It hit me. Their overall look was disturbingly like that of a human fetus!"
$24.95　　　　　　　*(HB/370/Illus)*

Forbidden Science: Journals 1957-1969
Jacques Vallee
Vallee, along with his mentor, J. Allen Hynek, was commissioned by the Air Force in 1967 to disprove the UFO phenomena. This volume, spanning the years from Christmas Eve 1957 through 1969, is the very personal record of a man on the frontiers of paranormal and possibly extraterrestrial investigations. In the foreword, Vallee asserts, "These phenomena (UFO) were deliberately denied or distorted by those in authority within the Government and the military. Science never had fair and complete access to the most important files. This fact has been alleged, but never proven. The present book proves it . . . in fact, the major revelation of these diaries

may be the demonstration of how the scientific community was misled by the Government, how the best data was kept hidden, and how the public record was shamelessly manipulated." The writing is forthright; because it is a collection of diaries, it is dated, with then-current commentary, and the existentialist philosophizing of an unruly young astronomer (along with opinions Dr. Vallee no longer holds). This pulls the reader back in time, and Vallee's earnestness gives the book a personal tone. "These pages are nothing but a schoolboy's notebook, in the strange classroom we call life." An epilogue brings the reader to the present.　　　　　**SK**
$14.95　　　　　　*(PB/473/Illus)*

Grand Illusions: The Spectral Reality Underlying Sexual UFO Abductions, Crashed Saucers, Afterlife Experiences, Sacred Ancient Sites, and Other Enigmas
Dr. Gregory L. Little
EMFs have landed. The author "continues to solve and piece together the most profound enigmas into a comprehensive and understandable theory" extrapolated from Carl Jung's speculations. "For the answers to the enigma of UFOs and its associated phenomena," says the author, "lie not in the visitations of extraterrestrial beings like us. Something far deeper and more profound is going on . . . it's time to assert that absence of evidence is evidence of absence. Not a shred of proof has ever appeared because the crashed saucers never happened."

It's an intelligent electromagnetic phenomenon, stupid! You just think you're seeing E.T. and his pals! "Carl Jung referred to the force as archetypes—psychoid energy forms from the ultraviolet end of the light spectrum. John Keel occasionally called them Ultraterrestrials—intelligent energy forms residing on the ultraviolet end of the light spectrum. The ancients simply referred to them as a spiritual reality. . . . The energy forms have an underlying intelligence and purpose that is intimately linked to what is happening in global affairs as well as with individuals."　　　　　**GR**
$19.95

(PB/271/Illus)

How To Build Your Own Flying Saucer or Mothership
Jorge Resines
In this manual published by Northern California's Borderland Sciences Research Foundation (BSRF), Argentina-based Resines mentions how U.S.-led government coups have 'eroded his country's freedoms and culture' and diminished his country's interest in science. At times the relatively simple technology outlined suffers from convoluted Spanish-to-English translations, leaving the reader to agree with Resines that a native English speaker ought to take up the cause. Although there is nary a mention of granddaddy saucer-spinner Nikola Tesla, and Resines shows a marked dependence on the writings of George Adamski, the author has made a valiant effort at disseminating information in this handbook, which includes a lot of xeroxed material, a few vintage science articles, patents and numerous diagrams. The charming "warnings" in the foreword ("Children should not attempt to build their own flying saucer or mothership without the proper parental guidance; building a saucer will not help a failing marriage; the info contained herein should not take the place of certified medical therapy; and BE VERY CAREFUL!") make one agree that saucer building would be a constructive replacement for television. Electrogravitation at home, for everyone!　　　　　**SK**
$19.95　　　　　*(Pamp/119/Illus)*

M.K. Jessup and the Allende Letters
The BSRF Philadelphia Experiment File
The tale of the Philadelphia Experiment, the secret Navy project to make a ship optically invisible, its disastrous effects on the crew and the possible teleportation of the ship, first surfaced in a series of letters sent to an astronomer turned UFO author Morris K. Jessup. Things took a strange turn when a hand-annotated copy of one of Jessup's UFO books was sent to the Office of Naval Research. Strange because a Navy official became interested in the book, contacted Jessup and was given the letters. He self-published a retyped version of Jessup's book (including the notations) along with the letters. Then, with extraordinary timing, Jessup killed himself.

This booklet is a collection of material from Jessup and about him, much taken from BSRF files. Does it give any insight into the events

leading to Jessup's death? For the most part, no. BSRF was very much into channeling entities back then, so most of this is speculation and channeled material. That which is neither of these is available from other sources. The hardcore Philly Experiment researcher may want this book, as it does have letters written by Jessup himself. It may also provide an insight into how the Experiment was perceived before it was muddied by later writers. **TC**

$7.95 *(Pamp/51)*

Man-Made UFOs: 1944-1994 — 50 Years of Suppression

David Hatcher Childress and Renato Vesco

An ode to American, Soviet and Canadian government cover-ups of anti-gravity technology since the end of WW II that calls "ufology" a hoax and claims flying saucers are not from outer space but were secret vehicles of the master race, captured and developed by the Allies. "We know from reproductions of the drawings of Schriever, Bellanzo and Miethe that a flying-saucer project, no matter how primitive at the time, was definitely on the list of German military priorities." This theory is then used to explain Foo Fighters, the Feuerball and secret Nazi underground bases in the Antarctic and goes on to cover Project Blue Book, suction aircraft, Athodyds, the AVRO-car, Marconi's secret saucer base, and other esoteric enigmas. Illustrated with photos, drawings and magazine reprints. **GR**

$18.95 *(PB/372/Illus)*

New World Order: Prophecies From Space

Channeled by the Ashtar Command

Everybody's favorite Space Brother is back, with more zany, cosmic insights to help ease the transition from the icky world of evil to a New Age of good, wholesome, vitamin-fortified niceness, for those who can grok his, like, totally spiritual vibrations. But wait; there's more! If you act now, you'll also get a glamorous assortment of wonderfully tepid pabulum from some of Ashtar's wackiest Space Siblings, like "Monka," "Aura Raines," "The Etherian," "Solar Star"—the whole gang! Now, how much would you pray? Important information on such topics as "The TOP-SECRET mission of the Space Brothers"; "the selection of the "Chosen Ones" to be removed from the planet in the event of a global disaster; the inside of our planet is really inhabited; educational craft

God of Saturn — from **Space Gods Speak**

are orbiting Earth; negative beings have infiltrated the military and Government (now there's a surprise); the "serpent race" and, of course, the "True meaning of 'the beast' whose number is '666'—the Antichrist." There are also some amazing portraits of Ashtar and all his little friends. It has been said that "this may be the most important book you have ever read"—well, that's what it says on the back cover. **DB**

$10.95 *(PB/160/Illus)*

The Philadelphia Experiment Chronicles: Exploring the Strange Case of Al Bielek and Dr. M.K. Jessup

Commander X

Philadelphia Naval Yard, Pennsylvania, 1943: "A megaton destroyer—the USS *Eldridge*—was made invisible, teleported into the blackness of another dimension, while its crew members were flung through time and space under horrifying circumstances. Most did not return and the few who did went instantly insane." Cameo appearance by Nikola Tesla. Plus project technician Alfred Bielek's story of being flung from 1943 to 1983 and back, then later sent back to 1927 to grow up all over again. **GR**

$12.95 *(PB/137/Illus)*

The Promise

Fred Bell as told to Brad Steiger

If you ever saw *Raiders of the Lost Ark*, read

God of Neptune — from **Space Gods Speak**

any of Brad Steiger's other "absolutely true" UFO books, or remember the classic Jay Ward cartoon character Commander McBragg (note for the animationally challenged: it was featured in between episodes of "Fractured Fairy Tales" and "Peabody and Sherman" on *The Rocky and Bullwinkle Show*), you've already got an idea of what this book is about. In fact, imagine what it would be like as performed by McBragg himself and his rapt but gullible victim/friend at their genteel English country club: "There I was, already surrounded by hulking, heavily armed neo-Nazi assassins, when suddenly, from the corner of the burial chamber, a group of gigantic insectivoid monstrosities from Zeta Reticuli rushed toward me, brandishing deadly disintegrator guns, all demanding that I surrender my Atlantean Space Talisman." "Good heavens Commander, what did you do?" "Well, sir, first I channeled all of my grooviest vibrations into the Talisman; a green ray shot out of it and zapped the Lugers right out of the hands of those Nazi goons. Then, by an amazing coincidence, my Pleiadian mistress, visible only to myself, you know, used her mystical powers to blast the beastly Zeta Reticulan lizard-things right out of our dimension." "My word, Commander, that was a close one!" "Hmmm," he would reply, filling his pipe. "Quite."

During the course of this 172 page-boast, the reader learns many things about the incredible Fred Bell; but take away the

highly improbable (and that's being generous) "true" story alluded to above, and the remaining "information" can be distilled down to a few sentences: "I am a genius. I built a jet engine in shop class, put it in a car I designed, and, with a little extraterrestrial help, set a land speed record with it. I later joined the Air Force, where I had a cushy job as an officer, but quit in a huff due to righteous indignation regarding their UFO cover-up policies. Then, while working for NASA, I personally warned Dr. Werner von Braun of the problems that led to the Apollo 1 disaster. Due to my unimpeachable morals, and the fact that I am a genius, I alone among Earthmen am in communication with higher beings from the Pleiades. One in particular, a beautiful humanoid space woman, is, like, totally in love with me. And yes . . . I scored. Oh, did I mention that I am a genius? Yeah, I knew that—just checking to see if you're paying attention."

DB
$12.95 *(PB/172/Illus)*

Roswell UFO Crash Update: Exposing the Military Cover-Up of the Century
Captain Kevin D. Randle (Retired)
Sincere attempt to keep the Roswell story straight, affidavits included. Introduces and debates the newest evidence: The Air Force's Project Mogul balloon story (proves to be as lame as the first evidence); two Franciscan Catholic nuns who saw a bright object plunging to the ground (who's gonna doubt two nuns?); the missing "Indiana Jones" archeologist who was rumored to have seen the wreckage; and the witness who says famed aviator Charles Lindbergh may have been to the crash site (Senate documents prove his presence in Roswell). Nice Fortean touch: The nuns' story provides proof that the crash date was actually July 4, 1947—Independence Day! **GR**
$12.95 *(PB/190/Illus)*

Secret Cipher of the UFOnauts
Allen H. Greenfield
A Gnostic bishop with 35 years' experience as a UFOlogist (twice honored as "UFOlogist of the Year") posits a continuity from the mediumship and magical orders of the 19th century to the UFO contactees and trance-channelers of today. Greenfield suggests

*The specially designed badge or emblem of the Deutsche Antarktische Expedition, 1938-1939. The swastika and oak leaves clearly reveal Thule Society paternity. — from **Man-Made UFOs 1944-1994***

that the *Book of the Law* dictated to Aleister Crowley by the "praterhuman" AIWASS was actually encoded in an English-language cipher based on the classical techniques of the Kabbalah known to the Golden Dawn and other magical orders. Significantly, 1947 was both the year Crowley died and the beginning of the flying saucer sightings. UFO contactee names can be Kabbalistically decoded using the cipher to reveal their spiritual meanings: for example, ORTHON = JESUS. A more elaborate example of the use of the secret cipher is: "QUABALISTIC ALCHEMIST ARCANUM = 345 = LESBIANS + LESBIANISM + SAPPHISM, while FELLOWSHIP OF MA ION = 206 = THE SECRETIONS as well as the alchemical cipher term VERY SHARP VINEGAR. The name FRATER ROBERTUS = 214 = SODOMY SECRETIONS. These terms are consistent with the inner secret teachings of the Great White Brotherhood."

SS
$9.95 *(PB/119/Illus)*

Secret Prophecy of Fatima Revealed
Tim Beckley and Art Crockett
A study of Marian or Madonna phenomena, with the apparition of the Virgin Mary at Fatima, Portugal, in 1917 as the focal point. At that time there appeared to a gathered crowd of tens of thousands a visual spectacle often called "the miracle of the falling sun." Observers, believers and nonbelievers alike, fell to their knees as they witnessed the sun—or what they perceived to be the sun—spin from its orbit and come so close to the ground that beams of colored light could be seen radiating in all directions. Some described the "whirling wheel of fire" and how it scorched the soil, drying up the muddy field and the rain-soaked crowd that had been standing in it. This event has been called the most impressive UFO sighting of all time.

The book chronicles the various apparitions of the Virgin Mary around the planet and studies the statements made to witnesses which are often known as "prophesies." These prophesies usually relate to coming world catastrophes and their possible avoidance. For example, at Fatima the apparition foretold the coming great war. Also discussed are the appearances at Guadalupe, Mexico; Lourdes, France;

Zeitoun, Egypt; Medjugorje, Yugoslavia; and Bayside, Queens, New York. In a "new age" closing chapter the authors compare Marian phenomena to other UFO sightings and relate the messages from Mary to messages given by "space brothers" to alien contactees since the 1940s. Usually the message is something akin to "your planet is in deep trouble . . ." **AS**
$10.95 *(PB/160/Illus)*

Space Aliens From the Pentagon: Flying Saucers Are Man-Made Electrical Machines
William R. Lyne

Many of these conspiracy books overlap in their theories and opinions. With each turn, these stories seem more and more believable. Over 45 years of research went into *Space Aliens*, and it echoes many sentiments shared by others, such as that "there is no known evidence or personal knowledge, verified by any human being, of there being anything made by intelligent beings from beyond our Earth"; that you could build your own saucer at home (includes plans); and that the hole in the ozone and cattle mutilations are both results of our CIA/Nazi-run space program/Government.

On Page 59, we find a list of "little-known, officially suppressed, or publicly unknown facts" to which his book is related, including:

• An American citizen (naturalized), Nikola Tesla (an atheist and a capitalist) invented the flying saucer before 1900 and reduced it to practice by 1915 (the author claims to have rejected a high-paying CIA job in 1975 because they are violating the Bill of Rights by not making this saucer technology public).

• The American government later helped the Nazis steal the invention from Tesla and were developing it by 1937 in Los Alamos, New Mexico.

• The Nazis, unable to use the saucer during the war, sold the technology back to us in exchange for amnesty for war criminals and other perks.

• The U.S. government, on behalf of the Trilateral Commission, continues to enforce a Nazi-originated hoax that flying saucers are extraterrestrial or psychological in origin.

• Adolf and Eva were rescued from that doomed bunker via a Kraut-piloted flying saucer, and later were protected by NATO, pampered by LBJ while living in Kassel, Germany.

• Most forms of mass communications

John Michael McCarthy's images of Nordic, Gray, and insectoid alien forms. We are obsessed with sex and so are they. They appear as monsters of the night, but which is the true form? — from **Grand Illusions**

are primarily controlled by the Illuminati, through the secret agencies of our government, to brainwash the public.

• The Government stages abductions using actors, drugs and sets.

Says the author: "I'm not some old crank complaining about 'them new-fangled rockets.' I'm complaining about the selling to the American public of archaic rocket technology, when we have much better technology . . . [instead we're given] some old piece of medieval junk which runs on crap dumped on us at exorbitant prices by the chemical cartels." **SK**
$17.95 *(PB/252/Illus)*

The Space Gods Speak: Transmissions from the Solar Council
Ashtar Command

Love, advice and warnings from the "gods of the planets," as channeled by the late Adelaide J. Brown of Los Angeles. God of Neptune: "The darkness around your planet is very thick and much light will be needed to break through it and drive it away." God of Uranus: "Love—brotherly love—is coming forth into the world of humanity." God of

Saturn: "There is a shining light in our eyes that is seldom seen in the eyes of mankind. It is the light of the God-presence shining out." Includes bonus messages from three undiscovered planets. **GR**
$8.95 *(PB/64/Illus)*

Strange Encounters: Bizarre and Eerie Contact With UFO Occupants
Timothy Green Beckley

Tabloid-style headlines adorn the back cover ("Undersea Saucer Sinks Submarine, West Virginia Man Abducted by Weird 'Vegetable'-like Humanoid"). Inside are goofy full-page illustrations, not to mention the liberal use of quotation marks which take the place of references (sample: ". . . not realizing that some people have been 'singled out' by the aliens to be 'repeaters.' Throughout their lives, these 'select few' seem to have the (sic) daily comings and goings 'monitored'"). And he believes J. Allen Hynek! Not to mention the full-page photo of the Victorian-garbed author. Can you say H-O-A-X? **SK**
$10.95 *(PB/95/Illus)*

Stranger at the Pentagon
Frank E. Stranges

Washington, D.C., 1957: "Val Thor landed in Alexandria and met with the President to discuss the world's problems and offer advice and counsel on how to deal with them and eliminate them. . . . Val Thor stayed on Earth until March 16, 1960, and then disembarked to his home planet Venus. He indicated that his race of people lived and dwelled underground. . . . He also mentioned waves of aliens who would land around the world to help with the Earth's seemingly insurmountable problems. . . . Val Thor spoke of Christ's presence in the universe and that it was heartwarming to see Christ's advanced teaching continuing." Bonus: Watching the RFK assassination on TV aboard Thor's spaceship, and an explanation of how Venusian toilets work.
GR
$9.95 *(PB/128/Illus)*

UFO: The Definitive Guide to Unidentified Flying Objects and Related Phenomena
David Richie

From Area 51 to the Zond 4 incident, skeptic and experienced aerospace journalist Richie has compiled a reasonably comprehensive overview of UFO jargon, sightings and personalities.
$40.00 *(HB/272/Illus)*

UFOs Among the Stars: Close Encounters of the Famous

Timothy Green Beckley

"Based upon firsthand interviews and casual social contact, the author reveals the often-startling influence these "other worldly" powers have had on the world's best-known celebrities, musicians, sports figures . . .

• William Shatner—The Day a UFO Saved His Life!
• Muhammad Ali—16 Sightings to Date!
• Jackie Gleason—He Saw the Bodies of Aliens!
• Jimi Hendrix—A Space Wizard!
• Sammy Davis Jr.—He Wasn't Afraid!
• David Bowie—Edited a UFO Newsletter!
• Buddy Rich—Drummer's Car Followed by Space Craft!"

$10.95 *(PB/112/Illus)*

The Ultimate Deception

Commander X

The mysterious Commander X, a former military officer, here comes clean about the U.S. government's knowledge of, and interactions with, UFOs over the past 50 years. The ultimate deception referred to in the title concerns an agreement between the short gray-skinned aliens known as Grays and the American government which allows the aliens to abduct a certain number of humans annually in exchange for giving the Government some of their technology. And you thought that Whitewater was a big deal.

There's a chapter on what past presidents have known about the UFO question, including an anecdote about the private pre-screening of the film *E.T.* in the Oval Office of the White House after which Ronald Reagan walked up to Steven Spielberg and said, "There are only a handful of people who know the whole truth about this." Jimmy Carter's admitted run-in with a UFO prior to his presidency is also described, with Jody Powell, his press secretary, saying, "I would venture to say that he has seen stranger and more inexplicable things than that during his time in government." Tell us more, Jody!

The Commander also introduces us to Val Thor, a handsome dark-haired alien who visited the Pentagon in the late '50s and who allegedly still walks among us. He is recognizable by his lack of fingerprints. The book ends with a short summary of the various UFO-related military and government projects and their code names: Project Plato, Project Deliverance, Project Aquarius and, most interesting of all, Project Guiding Light, an operational program whose sole purpose is to convey false information and to spread discord among

Coke cannon — from **The Vindicator Scrolls**

UFO organizations. **AS**
$8.95 *(PB/125/Illus)*

Underground Alien Bases

Commander X

OK, so there's this ancient globe-spanning network of tunnels built by an extinct pre-Atlantean civilization, see? Hundreds of entrances, one probably conveniently located near you, some even in major American cities, like that one in Manhattan (press the "B" for basement twice!). But most are near mystical mountains like Mt. Shasta and Arizona's Superstition Mountains, some in the Andes, some in Brazil. They also tend to have ancient Indian legends associated with them. Then there's those two at the poles— that's how you get to the "Underground Sun" or the capital of the Underworld, "Rainbow City." (You'll need a map; there are several in the book.) Deros here, Lemurians there, St. Germain stuck down some volcanic crater in the state of Washington. Underground near Dulce, New Mexico, is where the reptilian space people do all their genetic research on human subjects provided by the Trilateralist Illuminati mind-controllers of the Bechtel Corporation. "The struggle is NOW . . . Your

assistance is needed! Prepare! We must preserve Humanity on Earth!" Thus saith Commander X! **RA**
$10.95
 (PB/127/Illus)

Underground Bases and Tunnels

Richard Sauder, Ph.D.

"Go behind the scenes into little-known corners of the public record and discover how corporate America has worked hand-in-glove with the Pentagon for decades—dreaming about, planning and actually constructing secret underground bases. And newly uncovered information indicates that the strangeness continues with bizarre, high-tech gadgets like portable, hand-held surgical lasers and injectable electronic IDs as small as a grain of rice!"

$15.95
 (PB/142/Illus)

The Vindicator Scrolls

Stan Deyo

Stan Deyo has all the answers. Just ask him. And he's modest, this self-proclaimed "Noah of this Age"—after all, he could have said "Jesus" or "G*D", or "Captain Beefheart" of this age, couldn't he? Just his explanation of the wacky pseudo-mystical Judeo-Christian paranoiac UFO fantasy cover painting would have been enough to give the reader a clear and concise understanding of just what can happen to a nice, albeit megalomaniacal, Jewish boy from Perth with a bit too much free time on his hands. But, of course, it doesn't end there. Not by a long shot. Weird biblical mumbo-jumbo is examined in the light of Atlantean speculations. Deyo has pinpointed not only the location of famed Atlantis but also the Garden of Eden, the land of Nod, Kush, Dilmun, the city of Enoch built by Cain, the land of Chavilah, the "Pillars of Heracles" and the real "land of the giants" whence came this Heracles fellow, Kabbalistic numerology, gravitic, electric and magnetic phenomena, and, of course, the many types of UFOs and various aliens, dragons and demons. The whole thing culminates in a warning for all Jews to get out of America before our naughtiness is dealt with by a really pissed off G*D and, finally, the actual naming of the Antichrist (an extremely nerdy-looking mid-level Israeli politico named Nimrod Novik). **DB**
$19.95 *(PB/254/Illus)*

UNARIUS

The future therefore holds great luster and great Peace of Mind and Beauty, that will never separate the individual from the Infinite. When he turns his eyes toward this Lustrous Light and realizes that the Booster Rockets that incarnated in the early part of the 20th century contain great Beacons of an Interdimensional Force, an Infinite Creative Intelligence that was demodulated into physical bodies as Ruth Norman, Ernest L. Norman, and Nikola Tesla—he will have made a great step forward.

Ernest L. Norman, the Archangel Raphiel, incarnated 2,000 years ago as Jesus of Nazareth. He also lived the life of the Pharaoh Akhenaton 3,500 years ago. He was the historically famous teacher Anaxagoras, about 500 B.C.

The polarity of Raphiel is Archangel Muriel. She, in a past lifetime, lived as Joan of Arc. In 1902, she incarnated as Esther, the sister of Ruth Norman (Uriel).

The Archangel Uriel built up her present earth vehicle in August 1900, especially to serve the Earth people for the incoming New Age. She lived 50 former lives on Earth, such as Vishnu, Queen Elizabeth I, Socrates, the Pharaoh Hatshepsut, Buddha, and the betrothed of Jesus of Nazareth, Mary of Bethany, etc., etc. The two had to wait 2,000 years to marry, due to the murder of Jesus.

Archangel Michiel gave of his great wisdom and Infinite, Spiritual Powers when he incarnated on Earth as Leonardo da Vinci, during the 15th century, and again as the great scientist Nikola Tesla, in the 19th century. He served on Earth in several other lifetimes, as well as on the other 32 Interplanetary Confederation worlds.

So Michiel and Uriel are a polarity, as are Raphiel and Muriel, but all four work together as a whole or Polarity Conciousness, or a whole note. Throughout the Unarius books there is much more description of this Spiritual Hierarchy, the Maintainers of the Universe! And of course, they have many thousands of helpers on the inner and outer worlds. This was the only time in history that the Four Hierarchical members incarnated at one time on Earth, which was, of course, most purposeful. These were but the outer raiment of the physical of these Lights, when these Lights had anchored themselves and had pressed on through evolutionary periods of time on earth planets. A hundred million years is but a moment in Infinity, and yet for millions of years has the Light of the Maintainers of the Universe taken on physical form, in order to steer the course for planet Earth!

Rejoice then that you have made your decision and have entered into this voyage and have made the basic statement: "I am the creative nature of an Infinite Intelligence, and I shall be more responsible in the ways in which I maintain my vehicle, and direct my mind with a greater understanding of my position as a participant in this great voyage into the Inner Worlds of Light." Thank you! So Be It! — Ruth Norman, from *Facts About UFOs*

The Arrival: A Video Drama

A primitive human encounters a UFO in 160,000 B.C. An alien astronaut beams into the mind of an Earth dweller, provoking visions of the Earth dweller's past life. On a distant planet the human had been a sort of emperor. Having a warlike disposition, he pushes the button which destroys a civilization of over a billion inhabitants. The alien explains that in this life he must work out and heal the wrongs from previous lives. The alien is one of 11 astronauts headed by Uriel on a mission to deliver their message of knowledge in a flying saucer that is a masterpiece of early-'60s Italian-style design. The dialogue between the alien and the primitive provides a forum in which to present the Unarius ideology as a full overview. This provides a partial exposure to the beauty of the Unarian vision, but not the most astonishing visually. **SA $29.95** *(VIDEO)*

Biography of an Archangel: The Accomplishments of Uriel
Ruth Norman

"The Cosmos Literally Rained Paintings!

"Would you be able to believe that the bulk of these paintings were all painted and completed in less than three weeks' time? 'Tis true! . . . Remember, these students of Life Science have not been art students, have not studied or been taught the usual painting techniques, but rather the artworks simply flowed through their consciousness just as rapidly as their brushes could fly over the canvas!" This tribute to Uriel includes 43 beautiful color reproductions of Unarius historical portraits. **$24.95** *(HB/475/Illus)*

Bridge to Heaven: The Revelations of Ruth Norman
Ruth Norman

In her own words, this is the story of how Ruth

Norman came in contact with the Unariun Moderator (Ernest L. Norman) and became Uriel. "It was a matter of a few days after leaving the desert (taking a house trailer with me) that I met Ernest at a Spiritualist church, one I had never attended before and where a convention was being held. One of the choicest bits of phenomena to us pertained to the three spiritual, white-robed, white-haired and -bearded, ancient learned Ones who, as Ernest said, carried about with them huge books. These Ancients (denoting great wisdom) were seen psychically with Ernest during several years prior to this by other clairvoyants who often told him these books represented those which he would write. Earlier that very evening, Ernest said, a 'sensitive' told him, 'Whenever you are ready, now you can start to write the books.' Ernest replied, 'I'm ready.'"
$16.00 *(HB/506/Illus)*

The Crystal Mountain Cities: Part 1

This is the purest of the Unarian videos. An enthusiastic narrator announces that Uriel is coming to visit the Crystal Cities. We are flown through the cosmos amid beautiful colors and arrive at a wonderful place which resembles a whole city made of sparkling Brion Gysin dreamachines. Uriel appears for a tour of these lavish landscapes. Starting in a swan boat, she sails underwater where she encounters King Neptune and then astrally projects to the domain of Krishna, with whom she is escorted in a magical bubble. During these journeys, she psychically transmits to us the images of Moses, Saint Francis of Assisi and Saint Theresa. Arriving at the Infinity Pool, we are treated to visages of Hippocrates, Pasteur and Freud. There is a fabulous water ballet sequence. We are shown tableaux which demonstrate that faith is compatible with science. Uriel meets her old friend Einstein on another plane and they ride a bubble of air, from which they espy Leonardo da Vinci painting the *Mona Lisa*, who is actually the projection of Uriel's countenance into Leonardo's psyche. This is all an absolute visual feast. It is also Uriel truly in her element: a world that transcends the dour limitations of consensus reality and takes on the flavor of a beatific storybook. **SA**
$24.95 *(VIDEO)*

The Epic

The Unarius Brothers
"MICHIEL—
'WELL IT IS
THAT THE PEACE OF THIS PLUMED ALTAR
ABIDES IN VOTIVE SERENITY,
FOR BELOW IN THE CARNAL SHOALS
OF THE NETHERWORLDS

SWELL THE MULTITUDES OF BLINDED, TIMOROUS CAPTIVES.'

URIEL—
'YEA—BLINDED BY THEIR OWN
CALIGINOUS ENDEAVORS
TO FASHION THE SAPIENT BOUNTY
BESTOWED UPON THEM BY WE
OF THE CANDENT BEACONS.'"
$17.95 *(PB/278/Illus)*

Facts About UFOs

Ruth Norman
"Heed not words of the fear-mongers and the dictates of the crepehangers and the doomsayers, who speak of the end of the world being at hand, for there are countless thousands of Advanced intelligences maintaining and overseeing this Earth world, in spite of all the effort by the negative forces to destroy it! The (so-called) aliens, the beautiful Space Brothers of Light, will descend to the Earth in all their magnificent glory with healing rays of Light, Love and Wisdom to help all mankind!"
$6.95 *(PB/57)*

The Grand Design of Life for Man

Ruth Norman
"The name that all Earth persons must have ascribed to them and given them through the Earth custom, is Ruth Norman; one of countless thousands of names that have been given certain Earth bodies on different Earth worlds, in addition to this one in which this book is being received and read by those who are sensitive and are on the pathway to recognition and realization of their spiritual purpose and progression in their lives."
$18.95 *(PB/475/Illus)*

History of the Universe: Volume 1:(And You a Star Traveler)

Ruth Norman
"I personally cannot take full credit for this accumulated knowledge for it has been with the spiritual help of the many Higher Beings that this past history of man's karmic past on the various worlds—physical and astral—has been accumulated and funneled into my Consciousness and thusly related into the mind of the one now known as Anteras, who was in this horrendous, hellish past called Tyrantus, also Satan. We must include that the most important and, we frankly say, incredulous truth that this one Satan also called Ball, Beelzebub, Lucifer, etc., has now become a channel for the Light which was a direct and complete turnabout as he now serves We Brothers of the

Spirit in the most complete and total way."—URIEL
$17.95 *(PB/429/Illus)*

Infinite Contact

Ernest L. Norman
Early Unariun theology, published in 1960. Contents include: "The Great Enigma—Religion," "Duality of Jesus, Song of Creation," "Decadent Age," "Psychokinesis," "Education—A Fantasy?," "Automation—Or Sanity,?" "Unarius Laughs," "Terrifying Television," "Cosmic Centrifuge" and more.
$10.95 *(PB/199/Illus)*

Interdimensional Physics: The Mind and the Universe

Ruth Norman
"Individuals who have touched a higher awareness of the electronic nature of their infinite instrument have revealed through the channel of their own consciousness the evidence of the higher keyboard which is contained in their own electronic device. This higher keyboard has alerted them to the existence of advanced human beings who can function beyond and above the lower five senses. To this extent each of those individuals who are represented in the archives of museums and art galleries, libraries, theater and science reveal the true nature of man as a reality of infinite proportion."
$36.95 *(HB/356/Illus)*

Keys to the Universe and the Mind

Ruth Norman
Contents include: solutions and answers to the insoluble problems by the scientists of the high-frequency worlds; the brain, psychic structures and vortex pattern of man; inspirational talks on consciousness, the psychic anatomy, the spiritual man and the DNA factor; actual conversation between doctor and patient during a brain operation (sometimes called a lobotomy); "Soylent Green" truth developed.
$17.95 *(PB/367/Illus)*

Painting with Light

This is a documentary-style look at untrained painters who explore the "scientific aspect of consciousness" while painting Unarian murals. Using the "scientific principle of energy" the artists lose their "psychic amnesia" and channel a type of art. The narrator describes a science that works not in the lab but through human beings. "Cosmic consciousness," he explains, "is the basis of Unarian science." The visuals consist of artists at work on various stages of Unarian murals. In Part 2 there is a round table discussion of the artists that were shown at work in Part 1, discussing the dynamics

of working by this method. **SA**
$24.95 *(VIDEO)*

A Pictorial Tour of Unarius
The Universal Hierarchy
Tour the Unarius Foundation, one of the wildest places in the galaxy! See Ruth Norman, a.k.a "Uriel," pose in her amazing "Space-Liberace" costumes and next to her neo-Tesla coil. "The public is welcome to browse and use the reading rooms in this beautiful, artistic Center of Light that has been decorated as are the Teaching Centers on the Inner Worlds: as a cheery garden atmosphere with the statuary, trees, fountains, etc., and is a peace-filled, colorful setting. The energies that are channeled and maintained in this Center are kept at an all-time high frequency for whomsoever will enter in and receive. The 60-some students who attend these classes cherish and love their Center and spend much time simply sitting and partaking of this healing Light so directed."
$7.95 *(PB/168/Illus)*

Pictorial Tour of Uranius
If you're trying to get a handle on what the Unarius Center is like, this is the tape that you want. Uriel guides us on a tour of the El Cajon facility where we see "prototypes of future electronic instrumentation and symbolic representations of life in higher dimensions" which "overwhelm the senses." Among the sights to be seen on this tour are the star map, a representation of the star fleet landing, the tower of power, the cosmic generator and a model of the crystal mountain cities. It is in this tape that Uriel gives us the most frank explanation of what's going on. Rooted in a strong respect for science (of this world and others), the ultimate goal is healing the past hurts (whether incurred in this life or a previous one). When all is said and done, there is nothing here that is not to like. These are sweet people offering a sense of community and a lot of hope for the future of everything. **SA**
$29.95 *(VIDEO)*

Preparation for the Landing
Ruth Norman and Charles Spaegel
"The 'Preparation for the Landing' is therefore a preparation for the Spiritual Renaissance of humankind on planet Earth!" Chapters include: "An International Forum on the 'Genetic Code' of the Mind," "Profiles in Courage—Star Travellers of Planet Myton," "The Quarantine of Planet Earth—An Historical Implication," "The Grand Encounter and the Beginning of the Seventh Root Race of Man" and "Take Up Your Bed and Walk!"
$22.95 *(HB/491/Illus)*

Proof of the Truth of Past Life Therapy
Uriel and Unarius Students Who Have Made Outstanding Progress
"It was in the Constellation of Orion 800,000 years ago that all Earth people lived at one time and received the mental-psychic blocking off, due to the planet leader named Tyrantus, on the planet Tyron. . . . All this

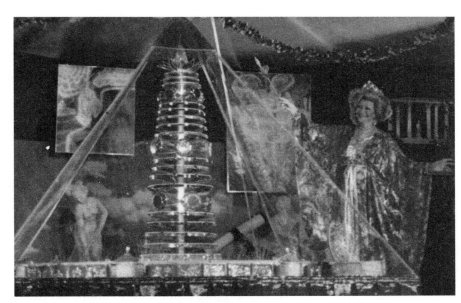

Uriel and the Generator — from **A Pictorial Tour of Unarius**

robotizing of the entire population was continued, not only throughout the many years of but one single lifetime, but rather throughout repeated lifetimes for 300,000 years! . . . To undo this great negative effect, which the impinged electronics so successfully achieved, is no small objective, nor can it be done rapidly. . . . This Science has been successfully tried, tested and proved by a class of 50 students throughout the past 16 years."—URIEL
$10.95 *(PB/212/Illus)*

Ra-Mu of Lemuria Speaks
Ruth Norman and Charles Spaegel
"Just recall, if you will, how the entire world was at loose ends and all felt 'What shall we do now with no one to lead us?'—when President Kennedy was killed. Yet even this was quite different for Ra-Mu was teaching Unarius—the

spiritual life! So all who took part did collect unto themselves great guilt—a guilt that still lives today after these many thousands of years!"
$17.95 *(PB/430/Illus)*

Restoration of the Interplanetary Confederation
Ruth Norman
"So let it be known that Ruth Norman, as the recognized receptor and the continuity of Uriel into the third dimension, is the Unarius Brother who is cementing this Master Plan in the parallax of the present development in your planet! . . . This is therefore the planetarization of your Earth, the spiritual healing of the planet and the entrance of the Earth into its relationship to other Earth worlds to form the Interplanetary Confederation."
$17.95 *(PB/500)*

Return to Atlantis: At the Height of Its Splendor!
Uriel and Antares
"A race of 'Superbeings' traveled on Spaceships from their home planet in the Pleiadean Cluster of the Constellation of Taurus, 40,000 years ago. A new civilization was thus initiated under the direction of Poseid, a great, advanced intelligence whose purpose was to heal the aborigines living on the island continent which became known as Atlantis. The spiritual way of life and the means for a progressive evolution had been

destroyed previously on the continent of Lemuria, and on other planets in the Milky Way Galaxy."

$24.95 *(HB/325/Illus)*

Return to Jerusalem

Ruth Norman (Uriel) and Unarius Students

"Jesus returned in the 20th century as the Moderator, Wayshower Ernest Norman, whose Higher Self is Archangel Raphiel. The Archangel Uriel, as Ruth Norman, joined forces with Ernest as his wife in 1955; a marriage that had been delayed for 2,000 years, when as Mary of Bethany, Ruth had

of "tall intelligent beings" in a "magic vessel." The story revolves around his attempts to convey this to the rest of the tribe and the efforts of the status quo to thwart him. As this tale occurs mostly on an ancient Earth, it is not until the last few minutes of this two-hour saga that we finally glimpse the Unarian world that we hold so dear with its lavish and wonderful visuals. Much of this video is reminiscent in flavor to Herzog's *Heart of Glass*, in which the entire cast was hypnotized. There is an otherworldly quality to the performances that makes a convincing case for the claim that

Tesla Speaks Series: Volume 1 — Scientists

Ruth Norman, Vaughn Spaegel and Thomas Miller

"Tesla asked me if I would like to visit in his home, and I replied I would be delighted. Instantaneously, we were at his home. He lives in a parkland area. It seemed as if there were acres of space about him, all profusely grown with vegetation. . . . the home of Tesla was very, very modern—so modern that it brings to mind the homes the artist on the Earth plane, Frank Lloyd Wright, drew, back in the 1930s and which today in the 1970s can be seen in many areas of the Earth."

$16.95 *(HB/334/Illus)*

Tesla Speaks Series: Volume 2 — Philosophers

Ruth Norman, Vaughn Spaegel and Thomas Miller

"The contents within these pages were dictated verbatim by the many master scientists living on a higher spiritual planet called Eros and who, through mental transmission—and by means of a vast crystal (wireless) communication system, transmitted the dissertations first, through the consciousness of one Ruth Norman (called Ioshanna)—who in turn transmitted in a demodulated form the words to her two other (so-called) co-authors . . . who in turn relayed the words which had been reflected upon the surface of their minds as they voiced them into the microphones of recorders."

$19.95 *(HB/451/Illus)*

Vaughn Spaegel, Thomas Miller and Ruth Norman (Ioshanna), transcribing on magnetic tape as they receive and record messages, lectures, science teachings, from both (other) higher and lower planets and solar systems than Earth. These dissertations so received are filling many books! It is a two-way permanent communication system, functionable continuously—an eternal hookup! — from Countdown!!! to Space Fleet Landing

been betrothed to Jesus before he left on his trip to India. She relived quite dramatically the return of Jesus after 10 years' absence in the Far East."

$12.95 *(PB/286/Illus)*

Roots of the Earthman: Parts 1 and 2

In this two-part tale, Unarian students, working without a script, relive their past lives that occurred 156,000 years ago in order to tell the story of the coming of the higher Unarian consciousness. A tribesman named Zhan has either met or had visions

the "actors" are indeed in some transcendent state. **SA**

$29.95 *(Video)*

Tesla Speaks: "Countdown ! ! ! to Space Fleet Landing"

Ruth E. Norman

Albert Einstein speaks from planet Eros, the biblical prophet Ezekiel speaks on spacecraft, Donatus speaks from planet Vixall on spacecraft, Kahlil Gibran speaks from spiritual planet Eros (three astronauts—Grissom, White and Chaffee—speak) and more.

$5.95 *(PB/186/Illus)*

Underground Cities of Mars: A Video Documentary

Employing a technique similar to that used in Godard's *Alphaville* Unarian students simulate a visit to the underground cities of Mars. When called upon to give substance to their visions the Unarians shine most brightly. Using a rich pastiche of Earth locations, actors, sets, models and Unarian paintings, they evoke a wonderful sense of what these cities must look like. Their scale models especially vibrate with more colors than the whole spectrum of our visual field. This is among the best examples of the Unarian vision, fully realized and packed with educational entertainment value. **SA**

$33.95 *(VIDEO)*

Visitations: A Saga of Gods and Men

Arieson

Full-color paintings and biographies of past lives ranging from Ra-Mu and Poseid to Peter the Great and Ruth Norman. Includes "Uriel Overcomes Satan (1984 A.D.)."

$75.00 *(HB/564/Illus)*

SCRATCH'N'SNIFF

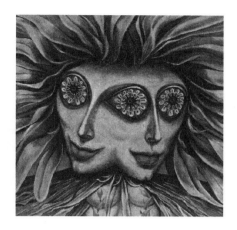

**#$@&!: The Official
Lloyd Llewellyn
Collection**
Daniel Clowes
A semiparody of the noir sensibility, it is interesting mainly as an exercise in style—that '50s graphic thing Clowes has mastered to greater effect than any other cartoonist around. This material reveals little of the brilliance to come. **JT**
$10.95 *(PB/96/Illus)*

**American Film Music:
Major Composers,
Techniques, Trends,
1915-1990**
William Darby and Jack Du Bois
If one can remember the music from a film, it used to be said, the composer has failed. The author traces the evolution of the thankless task of scoring Hollywood's films. Meet the maestros behind the movies' most memorable music: Max Steiner (*King Kong, Gone with the Wind*), Bernard Herrmann (*Citizen Kane, Taxi Driver*), Miklos Rozsa (*Spellbound, Quo Vadis*), Henry Mancini (*Touch of Evil, Breakfast at Tiffany's*), Elmer Bernstein (*The Ten Commandments, Walk on the Wild Side*), and dozens more in a comprehensive volume of essays detailing the musical careers of Hollywood's greatest composers. Seventy-five years of filmmaking has left the cinema with a huge musical legacy: Steiner's "Tara's Theme" from *Gone With the Wind*, John Williams' shark motto in *Jaws*, Bernstein's "Marlboro" music from *The Magnificent Seven*, the haunting "Laura," Mancini's "Pink Panther Theme," the first three notes of John Barry's "Goldfinger," all popular music from famous films. But isn't it all just syrup stolen from the classical guys? The authors ask—and answer—the question: Can film music actually be enjoyed outside its immediate context? **GR**
$62.50 *(HB/605/Illus)*

**The Anime! Movie
Guide: Movie-by-Movie
Guide to Japanese
Animation 1983-1995**
Helen McCarthy
Movie-by-movie "reference book for the casual viewer and the committed fan alike," with listings of anime films and made-for-video works released since 1983, arranged by year and by title. It features all the lusty production details Japanamaniacs adore: plot summaries, credits, key personnel, star ratings, year of release, etc. **GR**
$19.95 *(PB/288/Illus)*

**The Art of Walt Disney:
From Mickey Mouse to
the Magic Kingdoms**
Christopher French
Superdeluxe, revised and updated souvenir story of the Disney Empire, from the *Alice* comedies of 1923 (the cheerful cheese-eater was Walt's third idea), to *Hercules*, the animated feature now in production. Here are the hits (*Snow White, The Little Mermaid*), the flops (*Fantasia, Black Cauldron*), the innovations (*Who Framed Roger Rabbit?, Mary Poppins*), the panic years (WW II, the unions), the "nine old men," the Eisner "revolution," the parks, the rides, Paris Disneyland, Tokyo Disneyland, the works. Loaded with background art, preliminary character sketches, and anecdotes, like this critique of *Fantasia*: "Frank Lloyd Wright was shown sections of the movie and was outspoken in his dislike for it. It was absurd, in his opinion, to illustrate music." **GR**
$60.00 *(HB/464/Illus)*

Art and Entertainment Fads
Frank Hoffman, Ph.D., MLS, and William G. Bailey, M.A.

Happily, the fancy initials after the authors' names didn't preclude them from writing a fun book. There is an introduction in which they show off their initials, attempting to answer the question: "What is a fad?" From there on, however, it's a jolly fun read. Given a time frame as broad as American history, choices had to be made as to what to include, making for an eclectic mix. Herewith are those entries in this volume which occur under the letters A through E to give the prospective reader a taste of this rather fanciful mix:

Adult westerns, Horatio Alger Jr., American Gothic, answer songs, Aromarama, Ayatollah songs, barbershop quartet, Barnum, Batman, Beatlemania, Milton Berle, Betty Boop, Big Little Books, James Bond, boogie-woogie, British Invasion, Busby Berkeley, cakewalk, Calypso, car songs, Casey at bat, David Cassidy, Vernon and Irene Castle, Charlie Chaplin, the Charleston, the Chipmunks, "Buffalo Bill" Cody, Columbia comedy shorts, commercial folk music, Davy Crockett, Currier and Ives, *Dallas*, death songs, dime novels, disco, double features, Elvis is alive, M.C. Escher. **SA**

$16.95 *(PB/379/Illus)*

The Baby Train and Other Lusty Urban Legends
Jan Harold Brunvand

If one comes into contact with other human beings, there's a good chance of hearing at least one urban legend, those fantastic yet somehow believable stories about phantom carjackers in the back seat, or small stray dogs that turn out to be Mexican sewer rats. Jan Brunvand is a folklorist who has made an academic career out of studying urban legends. *The Baby Train* is his fifth collection of these orally transmitted tales (though they are also increasingly being spread via fax and the Internet). Highlights here are a great chapter on "Sex and Scandal Legends" (including the title piece wherein the regular appearance of an early morning freight train causes the local fertility rate to skyrocket) and a small section devoted to "Drug Horror Stories." As a special bonus, Brunvand offers handy hints for politely debunking urban legends told in

your presence, all without using the words, "I can't believe you fell for that." **LP**
$9.98 *(PB/367)*

Bad Boy of Music
George Antheil

This is a bemused and bittersweet look back at his own astounding life by George Antheil, the composer of the scandalous modernist sensation "Ballet Mécanique," who was hailed as a genius by the likes of Erik Satie, Ezra Pound, and Jean Cocteau. His autobiography is a strange combination of high avant-garde Paris hobnobbing with charmingly populist *Saturday Evening Post* prose interspersed with lots of music theory and counterpoint presented in an unpretentious, Everyman sort of way. The Trenton, New Jersey-born one-time concert-piano prodigy who at age 21 played his European recitals with a loaded revolver on top of the Steinway, was a protégé of Stravinksy. Antheil escaped Hitler in 1933 and settled into semi-obscurity doing soundtracks in Hollywood. Once in screenland, he went on to introduce Salvador Dali to Cecil B. DeMille (who promptly kissed Dali's hand and proclaimed him "king of the Surrealists"), supported his composing with

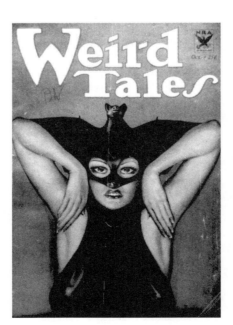

Weird Tales, begun in 1923, quickly became and remains the greatest of all horror and fantasy publications. The vampiric flapper pictured here is the work of Margaret Brundage. — from **Danger Is My Business**

a nationally syndicated "Miss Lonelyhearts" column, published books on "endocrine criminology," and designed a patented radio-control device for torpedoes with Hungarian sex bomb Hedy Lamarr. **SS**
$14.95 *(PB/378/Illus)*

Bad Boys and Tough Tattoos: A Social History of the Tattoo with Gangs, Sailors, and Street-Corner Punks, 1950-1965
Samuel M. Steward, Ph.D.

"You have a unique opportunity," Dr. Alfred Kinsey told the author. "This is too good a chance to miss." So the author, who had abandoned a university job to become a tattoo artist, took notes. Lots of notes—on sailors' buddy-buddy conversations, hustler personalities, and observations on the macho men strutting in colored ink. The result is an anecdotal history of the "dermagraphics" of mid-century America, including an analysis of 25 sexual reasons why people got tattooed. Guilt and punishment is one: "It's easier to give you a couple of bucks . . . than go to confession," said an adulterous husband of getting his wife's name inscribed. Advertisement is another: "Within the pubic hair of a male hooker, I put the figure of $10; above the mons veneris of a whore, I wrote 'Pay as You Enter'". **GR**
$11.95 *(PB/204)*

Beachbum Berry's Grog Log
Jeff Berry and Annene Kaye

"When Polynesian restaurants started disappearing 20 years ago, so did their tropical drink recipes. Although these drinks were enormously popular from the 1930s right through the '70s—an unprecedented lifespan for a drink fad—today's bar guides can only tell you how to make pale—and sweet and syrupy—imitations of the originals.

"But after two years of research and experimentation, authors Berry and Kaye have gathered 37 of the best drink recipes from the golden age of Polynesian Pop. *The Grog Log* contains vintage 'lost' recipes by Don the Beachcomber, Trader Vic and others; several original creations; and some reinterpretations of old classics. Profusely illustrated with vintage black-and-white tiki menu graphics from the '50s and '60s, with an introduction that covers everything

you need to know to become your own mixologist."

$9.95 *(Pamp/54/Illus)*

Beauty Trip
Ken Siman

"I desperately tried to convince myself that looks didn't matter," says the author. "But beauty was too wonderful to be resented or dismissed. I fantasized more about profiles than sex. And I never stopped wanting to be beautiful. Beauty was not goodness, but a visible purity nonetheless. To be made beautiful, free of all flaws, would be a kind of liberation." So, it's off on a liberating journey. "Supermodels, fashion designers, photographers, bodybuilders, *Playboy* playmates, plastic surgeons, and strippers—these are just some of the new cultural icons" visited by the author as "he searches for roots of the culture of beauty." Conclusion? Looks aren't everything, but they can be! And you don't have to be beautiful to be stupid. **GR**

$14.00 *(PB/176/Illus)*

Beefcake: The American Muscle Magazines, 1950-1970
F. Valentine Hooven III

Chronicles the "posing-strap era" of male nude photography and art, in all its campy, beefy glory. All the stars are here: cinema idol Ed Fury; Jim Stryker, the blond god of the beach; Paul Ferguson, who murdered silent star Ramon Navarro with a golden dildo; kitsch fantasy painter Etienne; the young and hung Joe Dallesandro; and plenty of unknown and undressed muscle men, glorifying the American male. In this age of full-color fuck books and porn videos, it's hard to believe that a photographer could be arrested for publishing or distributing naked male genitalia back in the '50s. Many were; that's the way it was until the fig leaf fell in 1965. **GR**

$24.99 *(PB/159/Illus)*

Benjamin Britten: A Biography
Humphrey Carpenter

Throughout his life, Benjamin Britten met with applause to his face and whispers from behind his back. Arguably England's greatest composer since Purcell, Britten created modern classics such as *Peter Grimes*, *Billy Budd*, *Turn of the Screw*, *A Midsummer Night's Dream* and *Death in Venice*, many of

Pat Albertsen and monkey. Gradually, Athletic Model Guild headquarters in L.A. became a small menagerie, not just dogs, but chickens, geese, snakes—and sooner or later everything got into the picture.
— from **Beefcake**

which contained the theme of the corruption of innocence which was central to his work. As Britten is one of a select few modern composers who have maintained a wide audience, the Metropolitan Opera mounted productions of two of his operas during the 1996 season alone. Britten was a child prodigy who some say never grew up. He maintained a lifelong personal and creative relationship with the great tenor Peter Pears. He rather much enjoyed the company of young boys and was known for unceremoniously severing ties with collaborators and friends once they had served their usefulness to him. British bass Robert Tear once commented: "There was a great, huge abyss in his soul. That's my explanation of why the music becomes thinner and thinner as time passed. He got into the valley of the shadow of death and couldn't get out." Considered by Anthony Burgess to be "one of the best biographies of a musician that I

have read; accurate, humane, moving," *Benjamin Britten: A Biography* is an important addition to the literature of music.

JAT

$30.00 *(HB/677/Illus)*

The Best of the World's Worst
Stan Lee

With only the universal constant "Bad Taste + Good Marketing = Big Money" to guide them, Rhino has found its niche—and they're working it with the same thoroughness and determination as the most rapacious clear-cutting or strip-mining juggernaut.

The Best of the World's Worst marks Rhino's entry into the arena of the printed word, and it's a title that seems almost too perfectly suited to the task. Although the book is credited to Marvel Comics mastermind Stan Lee, a team of over 20 less-famous researchers actually did most of the work, scouring all of the available literature and then some (*The Guinness Book, The Book of Lists* and even *Statistical Abstracts of the United States*) to present the lowest of the low, from "The Worst Mass Killing of Civilians" to "The Worst Addiction to Hamburgers." Who needs the thrill of victory when the agony of defeat is so much more satisfying to snicker at, as long as it's at the expense of others?

As arbitrary as some of the categories are ("The Worst Reason for a Married Couple To Stab One Another," "The Worst Costliest Album"), much of The Best of the World's Worst is surprisingly funny. Funny, that is, until you make the mistake of actually reading any of Stan Lee's "entertaining one-liners" that unfortunately follow every anecdote. Guess they had to let him do something in order to use his name on the cover, but these italicized cheap shots are so embarrassingly bad they make the gangly guy that hosts *America's Funniest Home Videos* seem like a comedic genius in comparison. 'Nuff said?

DB

$9.99 *(PB/191/Illus)*

Beyond Category: The Life and Genius of Duke Ellington
John Edward Hasse

Hasse took on a job which has often been tackled before—to write a credible general biography of Duke Ellington—with the advantage that he had full run of the Smithsonian's massive Ellington archive, which had never been pillaged before. Hasse treats his subject with a reverence that borders on the religious and organizes his facts in such a way as to help them make sense—no small feat, as Ellington was one of the most mercurial and overlap-prone musical minds of this century.

Whereas James Lincoln Collier's Ellington bio was a little more daring, controversial and probably accurate about the artist's work habits (which seem to have often included appropriating melodies from his individual band members), Hasse sticks to hard facts and rarely speculates. Unfortunately, he tends to underplay the importance of arranger-composer Billy Strayhorn's role in the definition of the classic Ellington sound—and this is something only Collier has so far addressed (and even he hasn't been strong enough in his expression of Strayhorn's value). This is probably the most friendly-to-the-uninitiated biography of Ellington there is, as well as the most definitive.

SH

$15.95 *(PB/480/Illus)*

Big Secrets: The Uncensored Truth About All Sorts of Stuff You Are

Never Supposed To Know
William Poundstone

Are there really secret background messages in rock music? What goes on at Freemason initiations? What are the 11 secret herbs and spices in Kentucky Fried Chicken? Is Walt Disney's body frozen beneath the Pirates of the Caribbean ride at Disneyland? Find out the answers to these questions, how to beat a lie detector, what your answers to the Rorschach test really mean, and more.

$9.00 *(PB/256/Illus)*

Bigger Secrets: More Than 125 Things They Prayed You'd Never Find Out
William Poundstone

Tells the secret recipe for oysters Rockefeller, the location of the federal government's underground bunker for use in a nuclear war, the phone company's own unlisted numbers, and more than a hundred other secrets.

$10.75 *(PB/256/Illus)*

Biggest Secrets: More Uncensored Truth About

The last act before ordination — from **Black Monk Time**

All Sorts of Stuff You Are Never Supposed to Know
William Poundstone

Corporate secrets, free for the taking. What's in chorizo, the Mexican "mystery meat" ("Pig salivary glands, lymph nodes, cheeks and tongues, plus an otherwise unspecified thing called 'pork'"); what's the formula for Play-doh ("Wheat flour, water, kerosene"); and how do they put ships in bottles ("The mast is collapsible"). Plus— STOP READING NOW if you like being tricked by muscular German illusionists— how Siegfried and Roy make their white tigers disappear! **GR**
$20.00 *(HB/272/Illus)*

Black Monk Time: Coming of the Anti-Beatle
Thomas Shaw and Anita Klemke

Hey, kids! Meet Roger, Gary, Larry, Eddie and Dave! The Monks were a groovy Beat combo from the '60s: five discharged American GIs staying on in Germany to rock out in clubs on the Reeperbahn. A seminal punk band, they dressed in black with shaved heads and played feedback-drenched songs with nihilistic lyrics and titles like "I Hate You." This is their story. **MW**
$14.95 *(PB/397/Illus)*

Bleep! A Guide to Popular American Obscenities
David Burke

This book will probably land in the humor section of most bookstores, but it is actually a rather fully researched dictionary. As well as providing the meaning for naughty words, it also illustrates contexts for their usage, translations from slang to standard American English, and practice exercises. (These include sentence structure charts, crossword puzzles and "find-a-word" games.) There is also helpful information on the differences between American English and British English. (For instance, if you tell a British date that you'll honk when you drive up, you have just indicated your intention to vomit in your car.) The flags of various countries are used to indicate cases where meanings vary, and there is also a section on hand gestures demonstrated by a mime. **SA**
$14.95 *(PB/220/Illus)*

Blissed Out: The Raptures of Rock
Simon Reynolds

The subject of *Blissed Out* is ostensibly the "alternative" side of '80s rock, from grunge to acid-house, but more importantly, perhaps, the book reveals how Reynolds became the art world's resident rock critic— second only to the slightly more ubiquitous Jon Savage. The chapter headings give the author away: "Miserabilism," "The Powers of Horror" and as a grand finale, of course, "The End of Music." Reynolds is no run-of-the-mill hack—he's done his homework in French theory, and he wants everyone to know it.

To be fair, the rock "text" has been slighted for too long by the thumbs-up/thumbs-down school of scribblers, or worse, by those who employ it as a springboard for stream of consciousness rambling à la Lester Bangs or the confessional musing Nick Kent. In *Blissed Out*, Reynolds attempts something much more rigorous, unobjectionable were it not for the orgy of quotation that ensues. From Situationism to Simulationism, no buzz-concept is left untouched. A dash of the abject from Kristeva; a pinch of the obscene, courtesy of Baudrillard; and several generous helpings of that perennial Barthesian favorite *jouissance*—et voilà!

Those interested in the ideas behind the music of Nick Cave, My Bloody Valentine or Loop will surely be disappointed. Here, rock is only a pretext for airing a reading list, which is actually quite limited. **JT**
$15.95 *(PB/192)*

Bootleg: The Secret History of the Other Recording Industry
Clinton Heylin

This book makes a great case for the archiving of information. Starting with the works of Shakespeare, who "sold [his plays] not to be printed but to be played," we are treated to a succinct history of copyright as it related to the invention and use of the printing press.

Fast forward to the advent of recording. The main focus of unauthorized recordings was originally opera and soundtracks from movies and Broadway shows. It wasn't until 1969 that the first rock and roll bootleg appeared. The bulk of this book is concerned with the concise history of rock'n'roll vinyl and CD bootlegs. It is an obsessive chronicle

Illustration — from **Wolvertoons**

of this phenomenon. Aside from the fact that most bootlegs are of a relatively few artists (Dylan, Springsteen, the Stones), who may or may not interest the reader, this book is a compelling look at the machinations of the record industry. It is only a small exaggeration to say that most artists sign their souls away along with the rights to everything they do. The author presents a believable case in favor of those who "document" through unauthorized recordings "the evolutions and permutations" of this very organic musical form. There is also a lot of information about how the laws of various countries have enabled the manufacture of items of questionable legality (especially surprising are the gaping loopholes in the laws of Italy and Germany). This book came out in 1994. There is an ongoing revamping of copyright treaties, which continue to change as of this writing. No doubt, however, in a world this big there will always be somebody with the appropriate technology who is willing to break the law. **SA**
$29.95 *(HB/441/Illus)*

Border Radio: Quacks, Yodelers, Pitchmen, Psychics and other Amazing Broadcasters of the American Airwaves

Gene Fowler and Bill Crawford

"Radio waves pay no attention to the lines on a map."—Dr. John Brinkley

Once, long ago, a Kansas quack doctor, whose miracle cure for aging and impotence involved the transplanting of goat glands, was run out of that state on a rail. He went to Texas and opened up a new clinic, and started his own radio station to advertise his gland palace. And to keep the AMA from interfering with his message, he stuck the transmitter just over the Mexican border. That accomplished, he kicked up the juice to about 250,000 watts (roughly ten times the power of any station broadcasting in America today). Thus, border radio was born and a precedent set.

Quack doctors, psychics, preachers, singing cowboys (who hawked songbooks) and many other such entrepreneurs flooded this new world of high-powered airwaves, making for the most colorful chapter in North American broadcast history. Also, such musical personalities as Juan Garcia Esquivel, the Carter Family and the Delmore Brothers found an audience there, helping to make border radio an important part of the American music story. Crawford and Fowler have done an amazing job of telling a factual story while retaining the humor and outlandishness of this saga, and whether you read it as history or entertainment, there is nothing quite like it. **SH**
$13.95 *(PB/283/Illus)*

The Bradleys

Peter Bagge

Before moving to Seattle to take part in the hugely popular slacker-comic *HATE*, Buddy Bradley was just another kid whiling away his adolescence in the suburban outback of the Garden State. In The Bradleys, Peter Bagge rehearses the first imperative of the comic book to its greatest effect: staging a series of spectacular collisions between elements of banality and all-out phantasmagoria. Life unfolds at a pretty regular clip—nothing too unusual happens contentwise—but formally, all hell breaks loose. Bagge deploys an ultragrotesque hot-rod aesthetic as an index to the psychopathological undercurrents which attend such

teenage rites as hanging out at the record store, drinking and driving, and dealing weed to supplement one's allowance. Heads take over bodies, mouths take over heads, and teeth take over mouths—pretty weird stuff, and how like life . . . **JT**
$14.95 *(PB/152/Illus)*

Bumper Sticker Wisdom: America's Pulpit Above the Tailpipe

Carol Gardner

"This is a book about bumper stickers and the people behind them. It is a portrait of America: a nation of people in automobiles . . . on the move with stickers expressing a view, sharing a frustration, or offering some perceived insight, solution or wisdom. Mobility, technology, personality and free expression all in one. What could be more American?"

What indeed? This is an extrordinarily thought-provoking look at the human factor behind the sound-bites and slogans that

Relaxing at home, 1976 — from C'mon Get Happy . . .

define "us" and "them." It's divided into 14 categories (work, family and education, animals, politics, traffic, relationships, religion, pro-choice/life, the environment, peace and war, region, diversity, life and death and miscellaneous), each page includes a life-size reproduction of a bumper sticker (surrounded by smaller ones in the case of mul-

tiples), a portrait of each vehicle's owner and some basic facts about him/her (age, education, occupation, favorite pastimes, favorite book, favorite movie, pet peeve). A brief anecdote explains how each motorist came to have the sticker and in some cases an author's note about her encounter with the mobile commentators. Given the diversity of opinions expressed, the author is incredibly evenhanded and fair. These are the real people who actually hold these views, so the going gets a little scary at times. This book puts a human face on these mobile propagandists, reminding us that however diverse our beliefs might be, it is members of our own species that adhere to them. **SA**
$19.95 *(PB/176/Illus)*

C'mon Get Happy: Fear and Loathing on the Partridge Family Bus

David Cassidy

"At his peak, he was the highest-paid solo performer in the world-bigger than Elvis, Paul McCartney and Elton John. He was the star of one of the most successful shows in television history, took everything he recorded to the top of the charts, and was overwhelmed by money, fame—and especially women—while still in his early 20s." Result? " . . . nights of desolation after the

fans went home . . . the singing career that sold over 20 million albums—and brought him a grand total in royalties of less than $15,000 . . . the endless cavalcade of groupies that invaded his bed . . . his passionate, often stormy relationships with fellow stars Susan Dey and Meredith Baxter." Happy? C'mon! **GR**
$11.99 *(PB/256/Illus)*

Cad: A Handbook for Heels

Edited by Charles Schneider
Several years before the revival of the Lounge Scene, Charles Schneider produced the Lounge Bible. Far more combustible than Combustible Edison, Schneider's *Cad: A Handbook for Heels* resurrects the lost world of Eisenhower-era men's magazines in all their leering, drooling, endearing naiveté. "Booze! Beatniks! Burlesque!" screams the book's cover, promising "the forgotten lore of the red-blooded American male." *Cad* keeps its promise.

Part parody, part appreciation, *Cad* takes the form of a vintage skin mag, in this case one of those bargain-basement imitations of *Playboy* that sprang up everywhere in the mid-'50s. The tongue-in-cheek "articles" include manly advice columns ("Ask the D.I."), how-to manuals for swingers ("Cad's Culinary Companion," "Cad's Cocktail Hour"), ribald humor ("Pinocchio's Woodpecker") and profiles of men who lived the dream, from Russ Meyer to legendary black-velvet artist/beachcomber Leeteg of Tahiti. It's all done to a T, right down to the pseudo-intellectual patois of the sybaritic Thinking Man.

And let us not forget the cartoons and pictorials, some vintage ("June Wilkinson Dances for You") and some wickedly funny, faked photo shoots (of beatnik babes and a B-movie producer's casting couch). The rogues gallery of contributors will tell you everything you wanted to know about postwar Cocktail Culture. What Esquivel's Space Age Bachelor Pad Music is to one's stereo, *Cad* is to the (kidney-shaped) coffee table. **JAB**
$14.95 *(PB/152/Illus)*

Camp Grounds: Styles and Homosexuality

David Bergman
Essays on camp, featuring such immortal icons of this camp century as: Dusty Springfield, Ronald Firbank, Mae West, The White Negro, Marlene Dietrich, Judy Garland, Jerry Lewis, Tennessee Williams, Lypsinka, Mötley Crue, Twisted Sister, Ratt, Andy Warhol, Carmen Miranda, Dean Martin, Liberace, Raquel Welch, Tom Cruise, Susan Sontag, Kristy McNichol, *AIDS! The Musical!*, Norma Desmond, and et al. Plus these flaming camp slogans, suitable for bumper sticker or T-shirt: "Art From Pain," "The Re-creation of Surplus Value from Forgotten Forms of Labor," "A Drag Queen's Genitals Must Never Be Seen," "Fascinating Fascism," "The Lie That Tells the Truth," "It's So Bad, It's Good," "Humor in Leftovers," and "Outrage Against a Homophobic Mass Culture!" Conclusion for the 21st century-Camp is an attitude you visit. **GR**
$15.95 *(PB/300/Illus)*

Camp: The Lie That Tells the Truth

Philip Core
This serious, though not humorless, encyclopedia of personalities, places, objects and artifacts pertinent to camp has juicy illustrations, intelligent, pithy writing, and an incredible bibliography, and gets bonus points for including both obvious and obscure references in equal measure in a successful attempt to articulate a vision of camp sensibility which encompasses a lot more than the standard drag queens/retro furnishings/"bad-movies-we-love" concept. No "camp-lite" here. **MG**
$14.95 *(PB/212/Illus)*

The Can Book

Pascal Bussy and Andy Hall
Can's musical experiments demonstrated how fettered to the Blues rock music really was, even in the psychedelic era. From blissed and transcendent, down-shifting to ear-wrenching and ominous, Can are now recognized to have been the bridge between the psychedelic rock era and the now-dormant punk experimentalism of PIL or the Pop Group. Based near Cologne, endlessly laying down improvisational jams in their Inner Space studio, Can incorporated the academic electronic music of Stockhausen, the low-end physical thrust of funk grooves, diverse ethnic musics and countless other sonic inputs into a thoroughly hallucinogenic free-form musical assemblage all their own. Can founder Holger Czukay's shortwave collage experiments like "Song of the Vietnamese Boat Women" and Can's world music E.F.S. (Ethnological Forgery Series) predated Byrne and Eno's "groundbreaking" *My Life in the Bush of Ghosts* by well over a decade. For those who already know the above to be true, this well-researched history will elucidate numerous bits of vital information such as Damo Suzuki's arrival on the scene and the conditions under which *Tago Mago* was recorded. **SS**
$15.00 *(PB/192/Illus)*

Carnival, American Style: Mardi Gras at New Orleans and Mobile

Samuel Kinser
While some of the author's critical apparatus might be goofy, he nonetheless takes a distinctive approach to Mardi Gras. He disputes commonplace thoughts about the roots of carnival traditions in rural pagan rites; judging them fallacies of the nationalistic "folk spirit" ideologies prevalent in 19th-century Europe. Instead, European Carnival is seen to be a 14th-century, urban, courtly response to the meatless fasting and sexual abstinence of the 40-day Catholic Lent preceding Easter.

Carnival as practiced in New Orleans, and in Mobile, Ala., takes many of its prominent features from these 15th- and 16th- century European celebrations, as filtered through the fantasies of the 19th-century imagination: pseudoclassical origins and decorations, Renaissance attire and secular acceptance of human folly. Mardi Gras' faux aristocracies and courts are seen as fantasy enactments by elites who saw their political and social power slipping away in the industrial and political changes leading up to and following the Civil War. The more rigid racial divisions in Mobile created a "ceremonious carnival" that reaffirmed existing social barriers, while the more diverse population of New Orleans generated a "carnivalesque carnival" that titillated itself with transgressions. Certainly food for thought when one is passed out in a New Orleans alleyway, face-first in a half-eaten King Cake. **RP**
$39.95 *(HB/415/Illus)*

The Carpenters: The Untold Story

Ray Coleman
Death has always been a sure-fire tonic for flagging pop-music careers, but few have reaped benefits as great as the Carpenters. Singer Karen's 1983 death from anorexia

nervosa did more than boost their CD sales; it bestowed the squeaky-clean duo with a posthumous hipness (albeit tinged with irony) that eluded them during Karen's life.

Here is the first in-depth look at these Nixon-era songsters. Unabashedly an authorized biography, Coleman traces Richard and Karen's career from their humble New Haven roots to their triumphant years ruling the Top 40 all the way through their slow decline in the late '70s and early '80s. Mindful of who his sources were, Coleman unstintingly praises their music (even "Calling Occupants of Interplanetary Craft"!) and trashes the media for dismissing the C's in their heyday. Naturally, no mention is made of Todd Haynes' underground film Superstar, a bizarrely brilliant dramatization of the Carpenters story enacted with Barbie dolls.

Nonetheless, there are enough warts to keep the book out of the hagiography section. Between descriptions of Karen's eating disorder, Richard's Quaalude problem, and mother Agnes' domineering tendencies, Coleman delivers plenty of reality to offset such saccharine exercises as "Top of the World" and "Sing." Some of the best parts are Richard and Karen's romantic travails. The real Carpenter love life was closer to "Rainy Days and Mondays" and "Superstar" than "We've Only Just Begun." One of Karen's few promising relationships was quietly scuttled on orders of high-ranking Carpenter management (Herb? Agnes?), while Richard's dates were always running afoul of his parents and sister. You can only imagine the stuff that's between the lines. It may not be Carpenter Babylon, but it's vital reading for anyone who's ever fallen (no matter how guiltily) under the spell of Karen's haunting voice. **JM**

$12.00 *(PB/352/Illus)*

Charles Ives Remembered: An Oral History
Vivian Perlis
Charles Ives (1874-1954) was probably the most singular American composer of the first half of the 20th century. However, he spent his adult life as an executive at an insurance company, which made him rich—and an avid patron of orchestras and composers—while his music went unrecognized until 1939, when his *Second Piano Sonata, Concord*, was first performed.

Remembered takes all of Ives into consideration through interviews with family

Dining out in style with one of her best friends, Olivia Newton-John in Beverly Hills, 1978 — from **The Carpenters**

members, associates in the insurance world, and people of music. The result is as rich a remembrance as one can find of nearly any composer. This volume is invaluable for its recollections of the pre-Cage American avant-garde (most especially the interviews with Elliot Carter and the late Nicholas Slonimsky). **SH**

$13.95 *(PB/238/Illus)*

Chasin' the Trane: The Life and Music of John Coltrane
J.C. Thomas
It is doubtful that any other soloist in jazz since Charlie Parker has had the impact of John Coltrane. His musicality and spirituality have long been imitated—with varying results. Thomas has hit every primary source imaginable in the preparation of this book—touching on everything from Trane's astrological chart to the reproduction of a transcribed solo. While this approach often means slaving through a bunch of metaphysical hoopla (and no biography of Coltrane has been written without that component, unfortunately), it helps to form a true portrait of the man and the musician. **SH**

$10.95 *(PB/264/Illus)*

China Pop: How Soap Operas, Tabloids and Bestsellers Are Transforming a Culture
Jianying Zha
As if a language barrier weren't enough, the wall of a 3000-plus character writing system has prevented the curious American from having even a casual knowledge of Chinese pop culture.

China Pop does a great deal to explain the how and what of its subject, but its unfortunate lack of visual aids makes the damn thing feel like a term paper. Also, after reading *China Pop*, the would-be cultural explorer has no more luck than previously should he be trying to figure out who the hell is on those posters and cassettes in a Chinese record store.

As of now, though, this book is all we have, and anybody looking to know anything about this topic will have no choice but to read this, incomplete as it may be. Hold on to your '60s Judy Ongg records until the definitive reference work appears—no doubt she will become the next Petula Clark. But it will take more than *China Pop* to inform the trend-spotting cognoscenti. **SH**

$12.00 *(PB/224/Illus)*

Circus Americanus
Ralph Rugoff

When Roland Barthes wrote his groundbreaking *Mythologies* in the mid-'50s, the idea of turning loose the tools and techniques of philosophy on such things as wrestling matches and Citroën cars was still quite novel. Since then, not only has the once-dark continent of consumer culture been thoroughly illuminated by the searchlights of theory, it has internalized their glare, becoming itself a kind of self-consciously semiotic construction. In this collection of updated mythologies originally penned for the *LA Weekly*'s art column, Ralph Rugoff trains his sharp and incisive gaze upon those areas of everyday life where symbolism, design and aestheticization have completely displaced utility, and representation has come to precede the so-called real. A kind of dialectic is ventured between articles detailing the incursions of the new, and those more concerned with the disappearance of the old. For instance, the opening section on the West Coast proliferation of such postmodern hallucination engines as Sea World, Alpine Village and the Universal CityWalk, is followed by an appreciation of the few remaining signs of precisely the industrial culture these theme parks are busy supplanting. Above all, Rugoff appears to be fascinated with the increasingly pervasive cultural tendency or drive to somehow frame, remove and reproduce whatever might be considered significant experience. Appropriately, the subject of museology figures prominently in *Circus Americanus*, and it is explored through a series of highly pointed collections, assembled around such men as Richard Nixon, Liberace, Gene Autry and L. Ron Hubbard. Other topics of interest are nudist magazines, cosmetic surgery and forensic photography. An article on the Mexican art/sport of *lucha libre* declares the abiding influence of Barthes' pop semiotic, but from there on in, Rugoff is alone in his Brave New World of mini-golf courses and thematic funeral homes. **JT**
$18.95 *(PB/204/Illus)*

The Cocktail: The Influence of Spirits on the American Psyche
Joseph Lanza

Lanza's *Elevator Music* was an appropriately quirky and hypnotic history spiraling from Orpheus to Brigadier General George Owen Squier to Angelo Badalamenti. *The Cocktail* is also like its namesake: a pleasant, glittery prelude to more substantial fare, such as Barnaby Conrad III's Absinthe.

Here the author glances at many etymologies for "cocktail" (ranging from a salute to the feather in George Washington's hat to a "cock's ale" made from raisins, mace, cloves, ale and the blood of the losing contestant in a cock fight!) before lounging into a medley of liquor-related topics: speakeasies, crooners, and glamorous pre-A.A. dipsophiliacs. The author eschews detail in favor of color and sweeping strokes. His account of the temperance movement's poisonous blossoming into full-tilt Prohibition is particularly interesting, given today's promiscuous political liaisons between liberal and fundamentalist elements with a common penchant for anti-glamour legislation. Also charming are descriptions of famous watering holes past, and some present: the flapper-era El Fey in New York, Hollywood's original Brown Derby, Trader Vic's and present-day New York's refurbished Royalton. The last chap-

Miniature Golf, Torrance (skull and pool)
— from **Circus Americanus**

ter summarizes the Cocktail Renaissance, providing an enticing apéritif to further investigations in lounge aesthetics. **RP**
$18.95 *(HB/168/Illus)*

Comic-Book Superstars
Edited by Don and Maggie Thompson
This is a sort of class yearbook for people who are REALLY INTO comics. The year is 1993. The "superstars" include writers, pencillers, inkers, painters, letterers and colorists who helped create what the editors of this volume determined to be "comics which received wide potential distribution." The other main criterion for inclusion was whether or not the many people who had been contacted had returned a form sent by the editor. This form included basic stuff like contact address, education and projects they had worked on. It also included a section on "dream projects." Reading the answers to this query really makes one aware of just how INTO comics you have to be to appreciate this book at face value. The most peculiar aspect to the whole project is that the only index in the book lists the superstars by their birthdays. For the reader who isn't fanatical about comics, this book provides a scary glimpse at the hard-working people behind the scenes who probably won't get another 15 minutes like this. **SA**
$16.95 *(HB/256/Illus)*

Comics and Sequential Art
Will Eisner
The Master speaks. Famed for the freewheeling *Spirit* comic, Eisner has spent decades pushing sequential storytelling to the max. This book is based on a popular course he taught at New York's School of Visual Art. Chapters cover imagery, timing, the frame, expressive anatomy, writing and more, with all illustrations by Eisner himself. "Ideas, theories, and advice on the practice of graphic storytelling." Works for anyone trying to write a movie as well. **GR**
$18.95 *(PB/158/Illus)*

Company Museums, Industry Museums and Industrial Tours: A Guidebook of Sites in the United States That Are Open to the Public
Doug Gelbert
$45.00 *(HB/324)*

The Complete Physique Pictorial
"At the start of the 1950s *Physique Pictorial* was the first men's magazine to publish photos of naked men for their own sake. The uncompromising nature of these photographs of flawless bodies, produced solely for the pleasure of the beholder, had not been witnessed since the fall of Rome. In the 1950s this was something new and extremely radical; although neither prick nor pubic hair were on view directly in the early years, the pictures left nothing to the imagination in terms of homoerotic splen-

dor." The packaging of this three-volume collection (a complete reprint of the magazine's entire run from 1951 to 1990) surpasses even the supreme level of mouthwatering, glossy perfection that art lovers have come to expect from Taschen. The volumes are bound in bubblegum-pink covers in a matching slipcase that features wraparound images of those fun-loving Tom of Finland hunks er, hanging out. The whole package is so sublime, just looking at it there in its neat, squat box is the equivalent of sticking four juicy pieces of Bubble Yum in your mouth at once. **MH**
$49.99 *(HB w/slip/2600/Illus)*

Contemporary Polish Posters in Full Color
Edited by Joseph Czestochowski
Polish graphic artists are slightly mad, judging from the 46 plates in this book (dating from 1961 to '77). And they're brilliant enough to have the Muzeum Plakatu, near Warsaw, dedicated to their work. Bold colors, punchy dynamics, hand lettering and symbolic use of human body parts characterize the painterly Polish style. Some trends are evident: a whimsical trace of Surrealism à la Monty Python, a bright grasp of contemporary Pop Art; and a visceral feel for Dadaesque Psychedelia, a subversive quality not found in the American Fillmore posters of the same era. **GR**
$7.95 *(PB/48/Illus)*

Corporate Eponymy: A Biographical Dictionary of the Persons Behind the Names of Major American, British, European and Asian Businesses
Adrian Room
"This book can render a general service here, since by definition it has singled out the names from the words, the people from the places." In *Corporate Eponomy*, one finds listed the many names of inventors and entrepreneurs who have come to the United States to profit from the experience and expertise of the land of consumerism. The book is filled with mini-biographies of founders of companies whose names became infamous in the corporate world. Names of British origin dominate the book although there are many continental European and Asian names too. The aim of the book is to give insight "into who those people were." Included are: Campbell; Du Pont; Harper and Row;

Struggling to keep upright. Chief Judge ready to signal a disqualification during the walking act — from **Dance of the Sleepwalkers**

Schwepp; Sally Line, of Finland; Smirnoff, of Russia; Cartier, of France; Hasselblad, of Sweden; Honda, of Japan. **OAA**
$38.50 *(HB/280)*

The Cotton Club
James Haskins
"This chronicle of the club that met international acclaim in the roaring '20s and hard-luck '30s includes unromantic details regarding the mobsters who ran it, the African-American talent that made it famous and exciting, and the troubles that brought it to a close. Harlem in its heyday was a mecca for entertainment, for both blacks and whites—the blacks who were to entertain, and the whites who were invited to be entertained. While the attention the Cotton Club brought to Harlem might have been short-lived, the stardom it brought to its talent would last longer than lifetimes."

Accurate and filled with dozens of photos, *The Cotton Club* returns us to an era that has too easily been forgotten. Entertainers today lack a nucleus such as the Cotton Club—a focus for overwhelming talent that challenged the racial status quo. We shall never see the likes of such legends again, raw and multidimensional. This book commemorates this bygone era and the greatest talent ever to have lived, created and performed in the U.S. **OAA**
$14.95 *(PB/213/Illus)*

Dance of the Sleepwalkers: The Dance Marathon Fad
Frank M. Calabria
Yowser! Yowser! "The colorful, if bizarre, story" of a phenomenally popular fad that magnetized the American public in the '20s and '30s, in which two-person teams were incarcerated for weeks at a time, deprived of sleep, and forced to run and walk daily in oddball races until they dropped—winner take all. "'A Poor Man's Nightclub,' dance marathons were the dog-end of American show business, a bastard form of entertainment which borrowed from vaudeville, burlesque, nightclub acts and sports. What began as a craze soon developed into a money-making business which lasted thirty years. . . . Dance marathons held a particular fascination for Americans since they projected traits and values pervasive in America then and now. . . . [They] mirrored the sham side of American culture, its commercialism and opportunism." This merry madness inspired Horace McCoy's pulp classic *They Shoot Horses, Don't They?* **GR**
$19.95 *(PB/215/Illus)*

Dancing Queen: The Lusty Adventures of Lisa Crystal Carver
Lisa Carver
There was a familiar character at almost

every high school. She seemed a little odd, was cute in a way that seemed a little off and exuded an exotic sense of mystery. (Winona Ryder played her in the movie *Heathers*.) Now imagine that she just invited you over for a (platonic) sleep-over. This book is the stuff she'd tell you about at one o'clock in the morning.

Lisa Carver is a unique American voice. She is guileless, honest to a fault and willing to say a lot of things that most people are afraid to think. She puts a glamorous spin on white trash. She has erotic fantasies about killer bears, sadistic beauticians, Russian leaders and gynecological exams. She makes Harlequin romances sound respectable. Victoria Holt, Victor Hugo, Judith Krantz and the Brontës fed through the filter of her fertile imagination not only blur the lines between high and low art, they blast them clean away. Lawrence Welk becomes more valid than Fellini in a very convincing discourse. "Like Hitler, Walt Disney and Henry Ford, Lawrence Welk was one of the astonishing men of our century who made his private dream a reality for everybody." If Andy Warhol were still alive, she'd be his new favorite person. One can just hear him cooing, "She's soooooooo modern!" **SA**
$12.00 *(PB/138/Illus)*

Danger Is My Business: An Illustrated History of the Fabulous Pulp Magazines, 1896-1953†
Over My Dead Body: The Sensational Age of the American Paperback, 1945-1955††
Lee Server
These two stunningly designed volumes offer an extensive overview of the publishing phenomenon known as "pulps"—the thousands of paperback serials, novels and anthologies which became a mainstay of the book trade from the turn of the century up to the late 1950s. The American public's fascination with murder, mayhem, vice, twisted sex, adventure, fantasy and science fiction made best-sellers out of authors such as James M. Cain, Jim Thompson, Charles Willeford, Dashiell Hammett, Sax Rohmer and scores of lesser-known but equally compelling writers (including some now-famous ones, such as William Burroughs, who wrote under assumed names), whose works became the prime

inspiration for the film noirs and B pictures made in both the United States and Europe. Also documented are the astonishing cover illustrations of the period, most of which were eye-poppingly gorgeous and chock-full of lurid detail, despite the fact that pulps were meant to be read once and then thrown into the dumpster (hence the term "pulps"). The author profiles the cover artists, mostly unheralded until now, and accords them a respect that is long overdue. **MG**
†$17.95 *(PB/108/Illus)*
††$16.95 *(PB/108/Illus)*

The Dark Stuff: Selected Writings on Rock Music, 1972-1995
Nick Kent
Self-destruction has long been glorified in rock, and tales of misuse are a staple of rock journalism. This has led to irresponsible reportage, either from journalists who join rock artists in the partaking of chemical refreshment, or rock journalists who think heroin makes for a better insider's view. Nick Kent has been there with the tin gods, written about it, gotten caught up in it, and lived to tell. Instead of giving us some grandiose tale about how larger than life it all was, he invests his profiles with kindness,

compassion, and—uh oh—reason. The chapters on Kurt Cobain and Sid Vicious do much to deflate (largely unhealthy) rock mythology without turning the subjects themselves into bad people. All told, the kind of book about rock that is too rarely written. **SH**
$14.95 *(PB/348)*

The Days Grow Short: The Life and Music of Kurt Weill
Ronald Sanders
Kurt Weill's music enjoys a timeless popularity; however, it was firmly rooted in the shifting social, political, and artistic climates in which he worked. Born a cantor's son in Dessau, a town known as Bayreuth North, Weill showed early musical promise. He was drawn to the Berlin of the 1920s, where he studied under the great Busoni before linking up with Bertold Brecht and his own life-mate and greatest interpreter, Lotte Lenya. Creating such landmarks of Weimar theater as *Mahagonny*, *Happy End*, and *The Threepenny Opera*, the trio were to define a time and place. Fleeing the Third Reich, Weill emigrated to America and reinvented himself as the ultimate Broadway composer. He worked with Ira Gershwin, Maxwell Anderson, Langston Hughes and

A photo taken at a Los Angeles gathering of Black Mask writers, January, 11, 1936 — from **Danger Is My Business**

Ogden Nash, conquering the Broadway vernacular before his early death at age 50.

Extensively researched, *The Days Grow Short* charts Weill's personal and career journey. Focusing on the development of Weill the composer and the creation of each work, this text evokes the theater worlds of both Berlin and New York when they were arguably at their peak. **JAT**
$14.95 *(PB/469/Illus)*

Dear Mister Rogers, Does It Ever Rain in Your Neighborhood?
Fred Rogers
Possibly the most underrated thinker of the 20th century, Fred Rogers has been a fixture of children's television for over 25 years. *Dear Mr. Rogers* collects the letters from children and their parents along with Mr. Rogers' responses to the questions and concerns of his television friends. Sincerely believing that every child's questions are important since they help to form their understanding of the world and prepare them for adulthood, Mr. Rogers never dismisses a question as silly. He answers each question with the simplicity and elegance typically found only in mathematical proofs, Mr. Rogers deals with weighty topics such as death, disease and divorce, as well as lighter topics including "In your younger years did you get a lot of chicks because you were Mister Rogers?" or does Mr. Rogers "poop." *Dear Mr. Rogers* also features preaddressed stationery so young readers will better able to write this sage of Pittsburgh. With warmth and inspiration for parents and children, *Dear Mr. Rogers* offers a thoughtful perspective of childhood, parenting, and life in general. **JAT**
$9.95 *(PB/185/Illus)*

Dear Mr. Ripley: A Compendium of Curioddities from the Believe It or Not! Archives
Mark Sloan, Roger Manley and Michelle Can Parys
"Ripley's Believe It or Not" occupies a warm spot in the heart of any connoisseur of the unusual. But even the most dedicated Ripley fan may not be aware that many of Ripley's strips were drawn from photos. The authors have scoured the Ripley archives to reprint a few hundred of these immortal images, from the man who could lift his sis-

ter with one hand while balancing twelve cups of coffee in the other—on ice skates!—to photos of various incredibly rubber-limbed contortionists, premodern primitives, and the obligatory freaks of nature (you won't believe the Chinese farmer with the horn!). **JM**
$19.95 *(PB/207/Illus)*

Death in the Dining Room and Other Tales of Victorian Culture
Kenneth C. Ames
American values in Victorian times—the first Industrial Age culture to be mass produced—as told through their household furnishings. Explores the conflicts of that radically changing age as it was coded, commoditized and commercialized into the goods of the material world. "Culture per-

Drawing by Avital, age 7 — from **Dear Mr. Rogers**

vades life in the form of things, behaviors, ideas, laws, morals and opinions. At its most effective, it is stealthy, lurking where we do not expect it . . . People in Victorian America were deeply conflicted over most of the central issues that occupy human societies—issues of power and power relations, the distribution of wealth and resources, gender roles and expectations . . . "

This moral ambivalence, especially toward nature, enters the Victorian vocabulary of design. Examines four major themes: entry hall styles (lots of mirrors, every hall an entry

to a man's Versailles); dining room furnishings (dining-room sideboards were often decorated with the spoils of human predation—hanging fowl, fishes and dead stags); framed mottoes ("Consider the Lilies," "Touch Not, Taste Not, Handle Not," etc.—"God Bless Our Home" was No. 1); and the exalted status of the parlor reed organ (the altar in a shrine to the conquering civilization). **GR**
$19.95 *(PB/265/Illus)*

Divided Soul: The Life of Marvin Gaye
David Ritz
"This is not the book about Marvin Gaye that I had planned" is the opening line of *Divided Soul*, and it is easy to see why: More than any other figure in '60s soul music, Marvin Gaye played the tortured artist role to the hilt. In the process, he wound up making some of the best records to come out of Motown.

Gaye had originally thought of himself as a balladeer in the style of Nat "King" Cole. But rhythm and blues beckoned, and he found himself entering a world other than that of a supper club entertainer. He was absorbed into the machinery of Motown, and would have both commercial and artistic success recording for the legendary Detroit label. Although the Gaye of record was playful and sexy, his relationships were more often contests about control. Gaye's creativity may have been vast and powerful, but so was his dark side. The fame and hedonism that success brings stood in dramatic counterpoint to the stern (even abusive) upbringing he experienced at the hands of his religious zealot father—who would eventually shoot and kill his famous son.

Divided Soul is valuable for a number of reasons, especially since it is one of the comparatively few in-depth bios we have about a major rhythm and blues star. Its depiction of early Motown is key to understanding that famous hit factory. Gaye's life was a seesaw where extreme self-destruction sat across from vast creative resources. Ritz has done an admirable job of describing that conflict while not using sensationalism to undermine the role of music in Gaye's life. **SH**
$13.95 *(PB/367/Illus)*

Dr. Seuss and Mr. Geisel: A Biography
Judith and Neil Morgan
The actual life of the man that we know as Dr.

Seuss was at least as interesting as anything ever concocted in his books. Born Theodore Geisel to a German immigrant brewer (and madcap inventor), he came of age in Springfield, Massachusetts, at a time when sentiments against immigrants, and Germans especially, were running high. The advent of Prohibition was jeopardizing the family's resources at about the same time that he was starting college at Dartmouth. Snubbed by the fraternities, he set his sights on editing the campus humor magazine and became a college celebrity. In the process he formed friendships that would later serve him to advantage. He blundered his way into Oxford, met his first wife and hung out with the smart set of American expatriates in France in 1926.

What follows is an unimaginably charmed life. A cartoon published in a magazine which mentioned a certain brand of bug spray was spotted by the company owner's wife at her hairdresser's, leading to a lucrative 17-year advertising gig for Geisel. His first break into the book world came when he was asked to provide illustrations for a British collection of children's sayings set to be published in America. His first solo book (*Mulberry Street*) had a painful six-month birthing in 1936 and was rejected by twenty-seven publishers. Geisel eventually published, but acclaim was slow in coming. During World War II, he landed in the Naval Intelligence unit working under Frank Capra. Soon he was writing scripts for military training films in Hollywood and meeting everybody who was anybody.

In 1957, *The Cat In the Hat* appeared with relatively little fanfare. (Geisel was already 53 by this point.) As teachers and librarians began denouncing his subversive influence, a generation of children were discovering a new way of learning to read. Geisel went on to champion the rights of children at a time before people seemed to know that they had any. He was by turns elusive, mischievous, private, social, reclusive, playful and eclectic. This book goes into enormous depth, utilizing full access to the Geisel archives. It is the sort of story that is so rich in detail and coincidence, luck and timing that were it fiction, it would seem utterly implausible. **SA**
$25.00 *(HB/352/Illus)*

Dutch Moderne: Graphic Design From De Stijl to Deco
Steven Heller and Louise Fili
Examines a little-charted period in Dutch

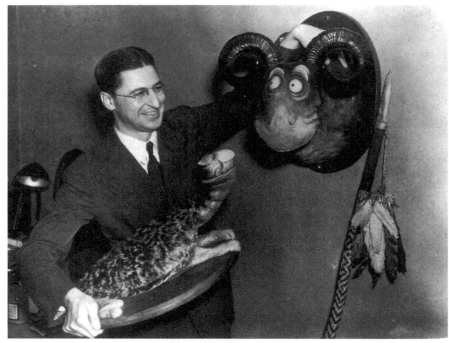
Ted and the Seussian "taxidermy" menagerie, New York, c. 1937 — from **Dr. Seuss and Mr. Geisel**

design during the '20s and '30s. Getting a late start on Streamline, Dutch artists were nonetheless able to synthesize it with Cubist, Egyptian and Mayan forms. Creamy oranges, reds, yellows and earthy browns predominate the vibrant ads and posters; blues and greens are used as startling accents. Subjects range from industrial to glamorous to everyday, each image angled and thrust to portray maximum artistic impact. **GR**
$16.95 *(PB/132/Illus)*

Elevator Music
Joseph Lanza
"Red velvet sheets, gossamer drapes, scented rooms, and martinis pouring from a bottomless shaker: just the foreplay to this soundscape of misty evenings, postcard perfect sunsets, and aquatic paramours . . ."
—(liner notes quoted in *Elevator Music*)
Elevator Music drags to the foreground the latent spiritual, unconscious and definitely sexual strivings of 20th-century society imbedded in what is commonly dismissed as "background" music. To cite author Lanza, "moodsong reinforces mounting suspicions that we live inside a dream." It is no kitsch

coincidence, for instance, that Salvador Dali was commissioned to do the cover for Jackie Gleason's *Lonesome Echo* album. *Elevator Music* is also a tribute to the fiendish inventiveness of mood music's pioneers and their imaginative mind-control experiments such as the "Stimulus Progression" mechanics of programming and Muzak's musical mood-rating scale from "gloomy-minus 3" to "ecstatic-plus 8." Mood music becomes the focal point of remarkable parallels between the "invisibility" of post-Cold War global capitalism and fictional, futuristic, totalitarian dystopias such as *Brave New World*. An all-encompassing survey which reveals Erik Satie's furniture music manifesto of 1920 as the transitional point from Dada to Muzak, but also includes such juicy tidbits as Jackie Gleason's plain-talking instruction to his orchestra, "It's 5 a.m. and you see her body outlined through her dress by the streetlight, and you get that 'Mmmmm, I want to come' feeling."

Elevator Music is loaded with astounding facts and correlations such as the Mormon Church's corporate sponsorship of the "Beautiful Music" radio format, Angelo Badalamenti's (*Twin Peaks*' composer) secret

tenure as staff arranger "Andy Badale" for the Muzak Corp., Seattle's Sub Pop/Muzak connection, the themes from *Dragnet* and *Captain Kangaroo* beginning as music-library stock tunes, Neil Armstrong's request for Les Baxter's *Music Out of the Moon* to be played out the Apollo rocket's speakers during the moon mission, why Muzak stays with mono, the influence of Pythagorean number theory on Muzak programming, and that Bach's *Goldberg Variations* was commissioned by an insomniac Russian count residing in Dresden to be played in an adjoining room while he counted sheep.

Elevator Music also provides in-depth analysis of such thrift store perennials as the Mystic Moods Orchestra, Ray Conniff Singers, Percy Faith, the Swingle Singers, Enoch Light and the Light Brigade, and the like. Lanza supports his bizarre penchant for the 101 Strings with such examples as *Exotic Sounds of Love*, featuring a leather-clad dominatrix with an eye patch (!) on its album cover and their legendary freak-out album *Astro Sounds*, featuring tunes like "A Disappointing Love with a Desensitized Robot" and "Bad Trip Back to '69." Less impressive is his treatment of the unsung but truly gifted maestros of "easy listening" like Martin Denny, Les Baxter, Perrey and Kingsley, and Francis Lai in this otherwise thoroughly entertaining chronicle of capitalist social engineering and the interplay of music, technology, mass culture and finance. **SS**
$11.00 *(PB/280/Illus)*

The Encyclopedia of Bad Taste
Jane and Michael Stern
In the introduction, the authors cite Clement Greenberg's observation that bad taste and kitsch are "becoming the first universal culture ever beheld." Perhaps so. But for the sake of defining the parameters of this already hefty tome, they have focused on American examples of bad taste. What really sets this book apart is that the authors actually love this stuff: "We hate to think how drab things would be without bad taste." And they certainly don't take the easy way out with a pointed finger and a sneer. "Once a subject was chosen, we tried to proceed with the rigor an anthropologist might use after unearthing some enchanting cultural artifact from a strange civilization." Their criteria for bad taste were a series of well-conceived and -mea-

sured choices. "Bad taste tries too hard to mirror good taste." "Bad taste frequently tries to improve on nature." "Good taste is what is appropriate." "When things hang around this collective cultural Warehouse of the Damned long enough, they begin to shimmy with a kind of newfound energy and fascination. Their unvarnished awfulness starts looking fresh and fun and alluringly naughty."

True to the tag "encyclopedia," the entries are listed alphabetically and average a couple of pages each with copious and lurid illustrations. Among the topics are: aerosol cheese, artistry in denim, beer, Allan Carr, chihuahuas, children's names, cedar souvenirs, designer jeans, elevator shoes, facelifts, the Gabors, Home Shopping Network, jogging suits, lawn ornaments, Liberace, macrame, meat food snacks, mime, nodding-head dolls, perky nuns, pet clothes, polyester, shag rugs, surf 'n' turf, TV dinners, unicorns and rainbows, white lipstick and Wonder Bread. **SA**
$20.00 *(PB/335/Illus)*

Erik Satie
Rollo H. Myers
From the author's preface: "I believe this book to be the first extended study in English of one of the strangest personalities in the whole history of music. Stranger still is the fact that, in spite of the absolute uniqueness of Satie, both as a man and a musician, to the vast majority of people in this country, including musicians, he is still little more than a name. . . . As to his music, of even the few score or so of musicians who may have a nodding acquaintance with it, probably only a very few have ever paused to consider whether the composer was anything more than a musical humorist with a marked penchant for leg-pulling. . . . I hope in these pages to be able to convince even the most skeptical that the true significance of Satie is to be sought on a very much higher level than certain of his works might suggest, and that his importance as a pioneer in contemporary music in general, and the influence he has had upon some of the greatest composers of this century in particular are far greater than is generally supposed."
$5.95 *(PB/150/Illus)*

Fabio
Peter Paul
At the beginning of the Fabio phenomenon, it was estimated that his likeness on the

cover of a book could increase the sales by 40 percent. The author, who is also Fabio's lawyer, has previously worked with other "unique personalities who were visionaries or iconoclasts in their time. From Bertrand Russell and Salvador Dali to Buzz Aldrin and Mohammad Ali, I experienced firsthand the unique qualities of legendary personalities." Fabio comes from a well-to-do Italian family and doesn't need the money or the vali-

In the summer of 1993, Fabio celebrated the release of his CD Fabio After Dark *with Dr. Ruth — from* **Fabio**

dation of being a star. He has a "vision" that he wants to share with the world in the form of self-penned romance novels, calendars, exercise videos, a CD and a role on the television show *Acapulco H.E.A.T.* He is self-invented and living proof indeed that life is art. Whether this art is high or low is for the discriminating viewer to decide. **SA**
$7.95 *(PB/60/Illus)*

Fair Use: The Story of the Letter U and the Numeral 2
Negativland
After the band U2 sued over the record entitled U2 by Negativland, forcing the album out of existence (the remaining stock was ordered destroyed), SST Records (Negativland's label) sued Negativland. This produced a big heap of paper, which got

collated by Negativland into a book. A legal case over the "fair use" of the letter U and the numeral 2 makes for a bizarre document. Employing their own exclusive logic, Negativland convinced Gary Powers Jr. to write the book's introduction. His pilot father was famous for being shot down behind the Iron Curtain in a U2 plane.

Included in this package is a CD oratory on the subject of fair use as well as an audio artwork constructed entirely of found soundbites. Together the book and disc provide much food for thought in the current climate where intellectual property is being redefined in the digital age. **SA**
$19.95 *(PB w/CD/270/Illus)*

Ferris Wheels: An Illustrated History
Norman Anderson

Is too much information a bad thing? This Ferris-wheel history has more information than you will ever need about this staple of amusement rides. There are examples of wooden, four-seat, human-powered wheels that are still used in India; descriptions of Ferris wheel-like rides that never caught on; Ferris wheels within other rides (like a roller coaster with mini-Ferris wheel on tracks). The last part of this book consists of reprints of what is hopefully every Ferris wheel-related patent ever issued. **TC**
$29.95 *(PB/407/Illus)*

Film Music
Roy M. Prendergast

The main focus is on film-music methodology and technology, tracing early sound in film through to its maturity as practiced by such acknowledged masters in the field as Goldsmith, Herrmann, Rosenman and Bernstein. Includes perceptive interviews which give much insight into the compositional process, example scores which are discussed and dissected, overviews of key moments in film sound history and techniques, and film-music aesthetics codified. For such a thorough study, its one failing is the author's bias against electronics in music, which is surprising given the strong tradition within the film-music and sound community to encompass all aspects of sound production.

Since the original publication date was 1977, post-*Star Wars* orchestral scoring and the new generation of composers and their techniques are omitted, which unfortunately prevents the book from being truly defin-

*The Single, sued in 1991 — from **Fair Use***

itive. Nevertheless, a first-rate source on the development and traditions of motion-picture scoring. **BW**
$13.95 *(PB/329/Illus)*

Finders, Keepers: Eight Collectors
Rosamund Wolff Purcell and Stephen Jay Gould

While it's true that any class of mundane object grows creepy when amassed in sufficient quantity (remember Imelda Marcos' shoes?), the collections represented in this book are unequivocally strange, such as Peter the Great's "Cabinet of Wonders," which contains giant skeletons, two-headed sheep, and healthy teeth pulled from

Russian soldiers by Peter himself. The essays by the naturalist Gould and color photographs by Purcell illustrate and collude with the excesses of decadent taxonomy.

Here is Gould describing the artwork of Peter's personal embalmer, Frederik Reusch: "He might sever the arm of a dead child, surround it 'so prettily and naturally' (his own words) with a sleeve and lace cuff expertly sewn by his young daughter Rachel, and then suspend from the fingers, by an organic thread made of yet another body part, some exquisitely preserved and injected organ—perhaps an eye, or a bit of genital anatomy. . . . "

"The world is messy; the world is multifarious," writes Gould, in reference to biologist Eugen Dubois' collection of brain casts of tigers, squirrels, chickens and polar bears, nested in antique cigar boxes. Indeed. **HJ**
$50.00 *(HB/160/Illus)*

Flash From The Past! Classic American Tattoo Designs, 1890-1965
Paul Rogers Tattoo Research Center

"Flash" is the name for the sheets which tattooists have used to display their designs to prospective customers. *Flash From the Past* assembles in full color the Old-School designs from the pre-Stray Cats and Modern Primitive era when sailors were still the primary market. Cobras, hula girls, Old Glory, butterflies, "Mom" . . . could this kick

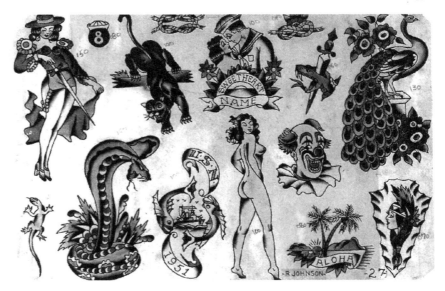

*Flash by Ralph Johnson, 1950s — from **Flash from the Past***

off the retro era in tattooing? The introduction does a good job of associating names and places with the otherwise anonymous designers of this important American folk art. **SS**
$20.00 *(PB/106/Illus)*

The Fleischer Story
Leslie Cabarga
Max and Dave Fleischer were pioneers in the development of animation as we know it today . . . or so the story goes. This book delves deep into the perverted, sometimes sickening minds of these so-called creators of a genre. Every disgusting secret hidden for years beneath the happy façade of fluffy little bunnies and talking mailboxes is unearthed, including the development of that ultraslut Betty Boop, the nympho who lured pie-eyed theatergoers into the pits of sin and despair. Max and Dave spent many years pimping that garter-strapped hussy from one filthy studio to another, coveting every sweaty dime just to produce even more lurid and disgraceful cartoon characters to tempt an already downtrodden public.

Betty's giant head bows to no man in her quest for the fast life and complete domination of the underworld where she resides. Want to learn more about that sex-starved, pipe-smoking, halibut-reeking Popeye? No cabin door is left unopened or barnacle-ridden question unanswered in this book. Learn about the true meaning of the phrase "shiver me timber." This book lays bare the most intimate details of the Fleischer Bros.' strangely obsessed world. "Out of the inkwell"? More like "Out of the gutter."
MI
$16.95 *(PB/216/Illus)*

For Enquiring Minds: A Cultural Study of Supermarket Tabloids
S. Elizabeth Bird
John Waters (whose wonderful essay on "Why I Love the *National Enquirer*" is listed here as a source) once noted that he was convinced "that typical *Enquirer* readers move their lips when they read, are physically unattractive, badly dressed, lonely and overweight." Anthropology and humanities professor Bird refutes this and other beliefs in a well-researched study of weekly tabloid papers and their readers. Bird attempts to situate the tabs in "a tradition of oral, folk narrative" in which content is the result of a collaboration between reader and writer

"about how the world is or should be constructed." After sections devoted to each member of the tabloid triad (the *Enquirer*, the *Globe*, and the *Star*), she demonstrates her hypothesis via a case study of the tabloids' contribution to the mythology surrounding JFK after his death. While Bird is clearly an academic familiar with postmodern theory, *For Enquiring Minds* is easily readable and relatively jargon-free. And the next time someone discovers your secret stash of tabs, simply quote Bird: "I believe the tabloids are to some extent an alternative way of looking at the world that may be valuable to people who feel alienated from dominant narrative forms and frames of reference." You won't hear another word about your reading habits. **LP**
$14.95 *(PB/234/Illus)*

Giant Book of Insults: A Rollicking Collection of Caustic Quips, Barbed Wit and Sharp Retorts
Louis A. Safian
Snappy, corny put-downs for BOOZERS, BORES, CHISELERS, CHATTERBOXES, CREAMPUFFS, DUMBBELLS, FAILERS, FLAT TIRES, GOLD DIGGERS, HYPOCHONDRIACS, LIARS, MEANIES, and even NUDISTS: "She grins and bares it. . . . There's a mutual

attraction between her and a young man in the camp—they're in the nude for love. . . . The only thing she wears are beads—of perspiration. . . . She's a fine specimen of the nuder gender. . . . He's a lawyer, and ever since he joined the colony, he hasn't had a suit . . . He's the camp athlete. He runs 100 yards in nothing. . . . He was thrown out because he asked for dressing on his salad."
GR
$9.95 *(PB/412)*

Gilligan, Maynard and Me
Bob Denver
The heartbreak, the sorrow, the star trips—sorry! wrong book!—"Bob Denver takes us backstage and behind the scenes of *The Many Loves of Dobie Gillis* and *Gilligan's Island*. Writing in a remarkably friendly and

This is one of the last portraits of us taken as a group. We're with Sherwood Schwartz, posing behind our voodoo doll likenesses that were used in "Voodoo." — from **Here on Gilligan's Isle**

affable style, Denver tells us what it was like to be plucked from complete obscurity to portray America's most celebrated beatnik, Maynard G. Krebs, and then to become Gilligan, the world's favorite stranded castaway." In addition, Denver reveals his 25 favorite *Dobie* episodes and his 50 favorite *Gilligans*. Features stories prop mishaps, how TV shows are put together, and anecdotes about all the cast members. **GR**
$12.95 *(PB/184/Illus)*

Goldmine's Celebrity Vocals: Attempts at Musical Fame From 1500 Major Stars and Supporting Players
Ron Lofman

Sure, we've all gotten a chuckle out of William Shatner's bloated "Mr. Tambourine Man," but how about J.R.R. Tolkien singing in "Elvish"? Let's stretch out a little and really groove . . . celebrity style! The chuck-wagon vocal screechings of Walter Brennan, James Dean jamming on conga drums, Jim Nabors belting out show tunes and Cole Porter, African revolutionary leader Kwame Nkrumah's solo LP, Marilyn Chambers' 7-inch release, Joan Collins in a duet with Bing Crosby, David Hasselhoff crooning "How Deep Is Your Love" (German-only release), Telly Savalas' three classic LPs, Rodney Allen Rippy disks and so much more. Fifteen hundred "celebrities and other interesting folks" with recordings to their credit are listed, with Rev. Louis Farrakhan's singing career being notable by its omission. Author Lofman also has the temerity to answer the burning question "Why do they do it?" **SS**
$16.95 *(PB/448/Illus)*

Graven Images
Ronald V. Borst

The owner of the Hollywood Movie Posters shop has put his extensive personal poster collection of classic science fiction and horror movies into a lavish show-stopper of a massive full-color tome. Borst has solicited the likes of Stephen King, Forrest J. Ackerman, Clive Barker, Robert Bloch, and Harlan Ellison to set the stage with essays on the lore and fascination of horror and SF movie posters. Wisely, the collection ends with the 1960s, since the movie-poster-as-art-object sadly seems to have become a distant memory. **SS**
$50.00 *(HB/256/Illus)*

The Great Pulp Heroes
Don Hutchison

Profiles the dime-magazine godfathers who influenced today's popular superheroes, and traces the story histories of the costumed crimefighters as well as the "gaudy and glorious magazines that spawned them." Interviews with "the amazing wordsmiths who churned out their monthly adventures" fill in the gaps. Top heroes who had their own mags include: Superscientist and Bronze Bombshell Doc Savage (the inspiration for Superman), who, along with his quirky sidekicks, stopped an Ice Age cold, and battled dinosaurs, ancient mummies, and even Adolf Hitler. Then there's Master Aero-spy G-8 and his Battle Aces (sort of flying James Bonds), who took wing to fight Sky Monsters, Corpse Squadrons and Flying Dragons. And colorful Secret Service Operator #5 (a Nayland Smith type, always battling another Fu Manchu), who fought off the Yellow Vulture and the Purple Invasion. Plus a successful clone of the Shadow, "humanity's paladin," the Spider (playing a Bruce Wayne/Batman identity game), who was billed as a juggernaut of action and emotion. Says one writer: "The best Spider stories carry an emotional field strong enough to attract nails. They sweep you along, the paragraphs radiating emotion with almost physical intensity, numbing the critical sense. It is basic, simple stuff, overpowering in context. It works wonderfully well. You care for people." Also features lesser-knowns like Green Ghost, Phantom Detective, Ka-Zar and Captain Future. "An affectionate look back at the outsized heroes who once occupied the imagination of loyal readers." **GR**
$14.95 *(PB/276/Illus)*

Growing Up Brady: I Was a Teenage Greg
Barry Williams

It is probably a sad testament to the X Generation that a book about being a *Brady Bunch* cast member is so damn wanted—as if they were The Generation That Aspired To Be White People.

Well, cocktail party irony aside, Williams has put together an entertaining, informative, and intelligent book about the experience. Rather than revising the role of the Brady kids so that they are archetypes of a generation, he lovingly deflates the balloon of mythology, concentrating instead on the experience of growing up on a Paramount backlot and in public. While a little too human to be a serious piece of reference, this book will probably prove to be meaningful to a whole lot of people who came of age with these six little bastards being irrepressible on the small screen. **SH**
$5.99 *(PB/349/Illus)*

A Hannes Bok Showcase†
A Hannes Bok Treasury††
Hannes Bok

Bok's illustrations grow on you, like alien mold spores. Like Mervyn Peake, a superb illustrator who also wrote, Bok penned several fine fantasy novels including *The Sorcerer's Ship*. Unlike Peake, though, his writing is now nearly forgotten. (Ballantine Books published those fantasies years ago, and sadly they are out of print.) But this book will do while we wait for future reissues. Here are over 100 pages of prime, charming strangeness. Bok's style is the essence of '40s-'50s pulp-fantasy illustration. Very cool. Obsessive pointillism and cross-hatching à la Virgil Finlay, but often zanier, cartoonier. It's the occasional big-eyed "sprites" reminiscent of Keane which at first leave one a bit wary of Bok. But don't let this stop you. When he gets grotesquely bizarre, no one can top him.
CS
†$17.95 *(PB/104/Illus)*
††$17.95 *(PB/112/Illus)*

Harlem on My Mind: Cultural Capital of Black America, 1900-1968
Edited by Allon Schoener

The Harlem Renaissance is one of the best things about cultural America in the 20th century, and there has been a crying need for a volume of this sort. The text is largely reprints of newspaper reportage of the time, and is profusely illustrated with photos of events, key figures and landmarks. Not only is this volume a great bit of reference, it is also a fascinating and entertaining book that is at once charmed, a little angry and truly rich.
SH
$19.95 *(PB/272/Illus)*

A Heart at Fire's Center: The Life and Music of Bernard Herrmann
Steven C. Smith

Compelling biography of the colossus of soundtrack music: from *Citizen Kane* to *Taxi Driver* with *The Day the Earth Stood Still*, *Psycho*, *Vertigo*, and *It's Alive* in between. *A Heart at Fire's Center* emphasizes how Herrmann, an artistically ambitious romantic in a field originally filled with mediocrities, was able to master the use of music to give cinema its power over the psyche.

In addition to bringing his tempestuous life into focus, the author does a comprehensive score-by-score analysis of each

soundtrack including illuminating interviews with directors with whom Herrmann worked with such as Scorsese and DePalma. Ends with a fascinating transcription of a talk by Herrmann analyzing the use of music in drama dating back to ancient Greek theater and discussing the first original film score (*The Brothers Karamazov*, 1931). **SS**
$29.95 *(HB/415/Illus)*

Here on Gilligan's Isle
Russell Johnson and Steve Cox
Who could resist the tale of this fateful trip? And it ain't no three-hour tour! Written by Russell Johnson (the Professor), *Here on Gilligan's Isle* is a 235-page treasure trove full of everything anyone's ever wanted to know about *Gilligan's Island* and lots more: original interviews with the cast, behind-the-scenes gossip and trivia, original prototype sketches of the Professor's wacky inventions (attention, alternative-science fans!), candid backstage photos and a complete episode guide. Now you too can know why and when the lyrics to the theme song were changed from "and the rest" to "the Professor an' Mary Ann." And why the later version was performed by a different group than the first! **DB**
$12.00 *(PB/320/Illus)*

Heroes and Villains: The True Story of the Beach Boys
Steven Gaines
Although the Beach Boys were the most important and influential American band of the 1960s, they remain the most misunderstood. While they were musically as innovative as any band ever, their squeaky-clean image and overt whiteness have kept them pigeonholed as "a bunch of surfing Doris Days," as one band member complained.

Not only was group leader Brian Wilson a true pop avant-gardist, but the Beach Boys have been—from Day One—the most dysfunctional musical family ever. Drugs, Eastern spirituality gone awry, a Svengalian psychiatrist (the nefarious Dr. Landy) and even Charles Manson as a roomie are part of the Beach Boys saga. Gaines does a fine job of delving into the whole band and not just Brian Wilson, whose high-profile problems tend to obscure that he's not the only guy with troubles in this band. Gaines also does a service to the uninitiated by making such a strong case for the music. For schol-

Bernard Herrmann at Stonehenge, 1946 — from **A Heart at Fire's Center**

ars of pop music, this must be considered an indispensable volume. **SH**
$14.95 *(PB/376/Illus)*

Hey Skinny! Great Advertisments From the Golden Age of Comic Books
Miles Beller and Jerry Leibowitz
Talk! Sing! Play! Reduce! Roar! Have Fun! Send Away Today! See sensational offers that leaped off the pages of comic books from the '40s and '50s, sandwiched between the adventures of Blue Bolt, Mighty Mouse and Nellie the Nurse. See! The Ant Farm, Nutty Putty, 50 Combat Action Toys for $1, and the Satellite Flashlight. See! The Original Kentucky Tavern Barbecue Ash Tray, Xmas Tree Lampshades, a Jaunty Jumper, a "Moon Glo in Silk" Jersey, and the Glow-in-the-Dark Necktie. A colorful glimpse into the lost, innocent world of lowbrow hucksterism. **GR**
$10.95 *(PB/96/Illus)*

Hillbillyland: What the Movies Did to the Mountains and What the Mountains Did to the Movies
J. W. Williamson
"The hillbilly lives not only in hills but on the rough edge of the economy, wherever that happens to land him. Meanwhile, in the normative heart of the economy, where the middle class strives and where cartoon hillbillies and other comic rural characters have entertained us on a regular basis since at least the mid-1800s, we take secret pleasure in the trashing of hallowed beliefs and sacred virtues—not to mention hygiene. Secret pleasure is guilty pleasure, and guilt begs containment. So we have made the hillbilly safely dismissible, a left-behind remnant, a symbolic nonadult and willful renegade from capitalism."

The authors examine the hillbilly in American culture from European folkloric antecedents to hillbillies as portrayed in such movies as *Stark Love*, *Sergeant York*, *Davy Crockett*, *Deliverance*, *Raising Arizona*, and *Crocodile Dundee* and in such TV in shows such as *The Beverly Hillbillies*, *The Dukes of Hazzard* and *The Andy Griffith Show*. **NN**
$15.95 *(PB/325/Illus)*

A History of Underground Comics
Mark J. Estren
"Since the genre first emerged in the late 1960s, underground comics (or 'comix') have delighted and outraged millions of people. The exploits of such characters as Mr. Natural and the Fabulous Furry Freak

Brothers embodied the psychedelic era and continue to attract loyal readership today. *A History of Underground Comics* offers more than 1,000 drawings by the likes of R. Crumb, Gilbert Shelton, S. Clay Wilson, Richard Corben, Jay Lynch, Skip Williamson, Justin Green, Dave Sheridan, Jaxon, Spain Rodriguez, Victor Moscoso, Kim Deitch, Rick Griffin, Foolbert Sturgeon and many others."
$19.95 *(PB/320/Illus)*

Hitsville: The 100 Greatest Rock 'n' Roll Magazines, 1954-1968
Alan Betrock
Mini-histories and black-and-white cover shots of all the music mags teens craved in the glory days of rock 'n' roll. Includes both U.S. and U.K. titles. You could pick these mags up at the drugstore, man: *Crawdaddy, Cheetah, Dig, Hep Cats, Hit Parader, Eye, Mojo-Navigator R&R News, Flip, Melody Maker, Rave, Tiger Beat* and *Sixteen*. **GR**
$13.45 *(PB/111/Illus)*

Hoaxes! Dupes, Dodges and Other Dastardly Deceptions
Gordon Stein and Marie J. MacNee
Hoaxes have been perpetrated in every field of human endeavor. This volume chronicles dozens of amusing examples of political pranks, literary lies, supernatural scams, religious ripoffs, historical humbugs, scientific swindles, infamous imposters and more. Consider the 10-foot Cardiff Giant, the fake Fossil Man "discovered" in 1869. P.T. Barnum was so incensed at the money-making hoax, he had a copy of it made—and charged people to see it! Or the Vinland Map, purportedly drawn by the Vikings in America centuries before Columbus, which later tests showed couldn't have been drawn before 1917. Or the fake Vermeer, *Christ and the Disciples at Emmaeus* (actually forged by Hans van Meeregen in 1937), which was brought into question when the face of Christ was discovered to resemble a photograph of—Greta Garbo! **GR**
$13.95 *(PB/244/Illus)*

Hole in Our Soul: The Loss of Beauty and Meaning in American Popular Music
Martha Bayles
Lengthy diatribe on the "perverse" influences of artistic Modernism and Postmodernism in popular music. Surely one of the most prudish, misguided, shallow, reactionary, bitter and, yes, perverse (she likes Warhol but despises McLaren?) books ever written about popular culture by an obviously intelligent person. But at least she hates U2. Fun reading. **MG**
$16.95 *(PB/453/Illus)*

Hollerin'
Hollerin' is one of the most primitive forms of folk music. When folks in North Carolina and elsewhere had to communicate across great distances, such as multi-acre cornfields or swamps, they developed a way of singing/shouting that is a wonder to hear. This is how information was passed in a friendly, neighborly way. At times barbaric, other times like an angelic yodeling, this is wonderful, weird, touching music. This returns the listener back to a time before telephones and radios, when the chief sounds heard were human voices, hand tools and an occasional passing train. It's like an audio time capsule from a lost America. *Hollerin'* gathers together masters of this quickly vanishing folk-form in 24 mind-blowing tracks. Songs sung out of love of life, of work, of necessity. Startling sounds you never knew the human throat could make. Music in its purest form. **CS**
$14.00 *(CD)*

Hollywood Hi-Fi: 100 of the Most Outrageous Celebrity Recordings Ever!
George Gimrac and Pat Reeder
What distinguishes this book from similar titles is that the writing is laugh-out-loud funny and that these guys actually enjoy these records. They are astute enough to spot such oddball wonders as the Crispen Glover album, the actually very cool post-"boy reporter" recordings of Jack Larson (Jimmy Olsen on *Superman*) and Gloria Swanson's self-produced attempt to bring *Sunset Blvd.* to Broadway in the 1950s. There is even a guide to stars with questionable vocal abilities who can only be experienced on video (including Elizabeth Taylor, Clark Gable, John Wayne, Joan Crawford and Jimmy Stewart). **SA**
$14.95 *(PB/128/Illus)*

The Lighthouse All-Stars, Hermosa Beach, August 1952. Left to Right: Shorty Rogers, Jimmy Guiffre, Shelly Manne, Rad Bacon, Howard Rumsey — from **Waiting for the Sun**

Houdini on Magic
Harold Houdini

This book is a collection of rare, firsthand material written by Houdini. The first section deals exclusively with handcuffs and restraints. Houdini was so closely associated with these devices early in his career that he advertised himself as "Harry Handcuff Houdini." Nearly every other page is packed with great illustrations including the master in action, secrets revealed, handbills and dozens of bizarre skeleton keys, picks and locks. One chapter presents Houdini's fascinating portraits of other great magicians in history. Here we meet such eccentrics as Dr. Katterfelto, "one of the most interesting characters in the history of magic. Magician, quack doctor, pseudophilosopher." An article covers fraudulent spiritualists and mediums that Houdini dauntlessly crusaded against as a debunker. Included are instructions for 44 stage tricks. **CS**

$6.95 *(PB/277/Illus)*

Humiliation: And Other Essays on Honor, Social Discomfort and Violence
William Ian Miller

Five essays on "the anxieties of self-presentation, the strategies we adopt to avoid loss of face in our routine social encounters, and the emotions—namely, humiliation, shame and embarrassment. . . " We grovel, we crawl, we debase ourselves, wailing and begging. It's grotesque. An Icelandic saga illustrates our need for these emotional theatrics: "It involves dismembering corpses for use in a ceremony that compels a higher-status person to take vengeance on a corpse. In that ceremony the threat of shame is made explicit by the person (usually a woman) bearing the pieces of the dead man: 'If you don't take revenge, you will be an object of contempt to all men.' This is the ultimate in grotesquerie, but the grotesque and the dark comic world to which it belongs is . . . the defining substance of the humiliating." It's a good thing!
GR

$13.95 *(PB/270)*

The Illustrated Encyclopedia of Metal Lunchboxes
Allen Woodall and Sean Brickell

Metal lunchboxes are accessories that have defined American kids since the 1950s. For all of their seeming variety, there aren't as many different designs as might be imagined. As of 1985, when their manufacture was banned because of their potential as weapons, only about 450 designs were ever produced.And of those, there are three variations each on The Care Bears and Strawberry Shortcake. Alvin and the Chipmunks, Soupy Sales and Captain Kangaroo never got the full metal treatment (although they all did get vinyl lunchboxes). Who decided that *Family Affair* rated a box, while *My Three Sons* didn't? The authors don't even attempt to answer such questions.

What they have done is to photograph both sides of every metal lunchbox ever produced in America and to present them in full color and alphabetical order. The small amount of text includes facts about the boxes' relative rarity, variations in design

Heino's Liebe Mutter *cover — from* Incredibly Strange Music, Volume 2

and trivia (the last metal lunchbox was a Rambo design). **SA**

$29.95 *(PB/168/Illus)*

The Illustrated History of Surf Music
John Blair

With a foreword by none other than Dick Dale. Crammed with black-and-white photos of 45 rpm record labels and LP covers circa 1961 to 1965, and lots of posters too. Discover bands with names like: Bobsled and the Toboggans, Surf Bunnies, Eddie and the Showmen, Goldfinger Girls, the Daiquiris, etc. Lists hundreds of bands with a paragraph or so about the outstanding ones (marked by a little surfboard icon). Index alone is 50 pages. **DW**

$45.00 *(HB/286/Illus)*

The Illustrated Price Guide to Cult Magazines, 1945-1969
Alan Betrock

"The wildest, weirdest, sexiest mass-market magazines ever published. This illustrated price guide covers the golden age, the quarter century starting with the end of WW II and stopping at the end of the sensational '60s. More than a price guide, this book is a road map to what was published and when. Includes 500 titles and almost 500 photos."

$16.95 *(PB/160/Illus)*

Incredibly Strange Music: Volume 1†
Incredibly Strange Music, Volume 2††
Edited by V. Vale and Andrea Juno

Indulge in bittersweet reverie, wading through the past with embittered vinyl freaks who have turned their proud backs on the pedestrian Digital Present. This two-volume survey is at its best when the creators of this diverse music speak for themselves as when moogmeister Jean-Jacques Perrey shares his life story and philosophy (translated from French); Rusty Warren recounts her antics as a gorgonesque sex-lib comedienne of the cocktail era who made a fortune off of tit fetish humor ("knockers up, gals!!"); Bebe Barron (co-composer of the *Forbidden Planet* soundtrack) recaptures the lost era when avant-garde and fun could be vaguely synonymous; Eartha Kitt reveals how she forged her Black-woman-as-human-sex-panther persona into a six-decades-long showbiz career and partied with the likes of Orson Welles, Ernest Hemingway, and Marlene Dietrich as part of the international jet set; and Mexican hi-fi-arranger-extraordinaire Esquivel brings back to life his flamboyant '60s floor show; not to mention interviews with the exotica demigods Martin Denny and the metaphysical, turbaned organist Korla Pandit.

Also figuring prominently are such contemporary collector/cult figures as Lypsinka, whose act could convert anyone into a show-tune queen; and the Cramps, who recount hilarious record-finding exploits in the basements and back rooms of overweight drunks and semiliterate crackers all over America. Once you get past a two-page discussion with Jello Biafra about holes in the ozone layer, *Volume 2* begins to cook with his erudite look at the

worldwide psych-ploitation phenomenon, including the racy recording past of former California Lt. Gov. Mike Curb. There are also scores of lesser-known collectors rhapsodizing over obscure (and sometimes less so) audio curios. One bizarre example is the Episcopalian minister who discusses the "blue comedy" records of Rudy Ray Moore (actually the raunchiest shit ever set to vinyl!). Sadly, *Incredibly Strange Music* can sometimes confirm one's most drastic suspicions about the dearth of originality in music today. **SS/MG**

†**$17.99** *(PB/200/Illus)*
††**$18.99** *(PB/240/Illus)*

Inside the Mouse: Work and Play at Disney World

The Project on Disney

If everybody at Disney World is enjoying themselves, why is nobody smiling?

Duke University's Project on Disney sets out to answer this and other questions Mickey would rather leave unanswered, including the risks of being Goofy: "It's unclear how many of the Disney characters pass out on a given summer day, though everyone is sure that they do. One man reports that during the summer a goodly part of his job is devoted to driving around, retrieving characters where they fall. One day he picked up three at one stop—Donald, Mickey, and Goofy: 'All of them had passed out within five minutes of each other. They were just lined up on the sidewalk.' This is in EPCOT which, unlike the Magic Kingdom with its system of underground tunnels, has a backstage behind the façades of the park's various attractions to which the characters can escape if they have to. If they are in the Magic Kingdom, however, or on a parade float, they must simply ride it out or wait until they've recovered enough to walk to a tunnel entrance in costume and under their own steam. This can get a bit dicey. Passing out is sometimes prefaced by (and probably directly caused by) throwing up inside the costumes, which cannot be removed until out of the public view: 'You're never to be seen in a costume without your head, ever. It was automatic dismissal. It's frightening because you can die on your own regurgitation when you can't keep out of it. I'll never forget Dumbo—it was coming out of the mouth during the parade. You have a little screen over the mouth. It was horrible. And I made $4.55 an hour.'" **NN**

$15.95 *(PB/252/Illus)*

It Came From Memphis

Robert Gordon

What came from Memphis? Rock 'n' Roll! Here Robert Gordon paints a fascinating portrait of the city and the scene that many consider to be the veritable Ground Zero of the rock 'n' roll explosion. Despite the best efforts of Jim Crow, Memphis was the steaming cauldron where Black met White.

It was in Memphis that the thumping Delta blues of Muddy Waters, B. B. King and Howlin' Wolf blasted from the juke joints and melded with the twangy, country pickin' of Bill Monroe, Hank Williams, Lefty Frizzel and the Grand Ole Opry. A prolific cradle of musical talent, Memphis not only spawned Sam Phillips, Sun Records and Elvis Presley but produced the Mar-Keys, Booker T., Isaac Hayes and the whole swingin' '60's assault of the Stax/Volt sound. Memphis continues to cast its shadow over contemporary alternative rock through the work of legendary producer Jim Dickinson as well as Alex Chilton, once the teenaged singer of the Box Tops, whose later records would greatly influence many. **AD**

$14.95 *(PB/305/Illus)*

Italian Art Deco: Graphic Design Between the Wars

Steven Heller and Louise Fili

Unlike Adolf Hitler, who tossed Modernism out of Germany, Benito Mussolini embraced

Yma Sumac — from Incredibly Strange Music, Volume 2

the style, seeing its vigorous streamlining as an ideal propaganda vehicle for Fascism. "In 1921, 30 percent of all Italians were illiterate, and graphic images were the best way of addressing them. Mussolini saw Italians as 'political consumers,' and as Fascism's 'creative director' he controlled their behavior through slogans and symbols." When not working for the state, graphic artists were busy making up for lost time, since 19th-century romantic illustration held on in Italy to the bitter end. The Modern style they developed was poetic and allegorical—one didn't sell a car, but the concept of speed. The results were lively and full of celebration, rendered dramatically in soft-shaded posters and advertisements. And, oh, mechanical rows of soldiers and flocking warplanes for Il Duce. **GR**

$16.95 *(PB/132/Illus)*

Japanese Jive: Wacky and Wonderful Products From Japan
Caroline McKeldin

Japanese pop culture has always borrowed liberally from its American counterpart—and often with hilarious results. The author went on a shopping spree and turned up a whole bunch of stuff no American would want to eat or drink. So we are best to be merry about what they call their stuff. A cigarette called "Hope"? Condoms packaged by blood type? "Cow Brand" beauty soap?

It's all here, along with many more products whose names and applications should force thinking Americans to ask the hard question: What have we inflicted of ourselves on the international Elsewhere? *Japanese Jive* will surely cause sleepless nights for anyone trying to answer that one.

SH

$9.95 *(PB/80/Illus)*

Japanese Street Slang
Peter Constantine

Taken as a companion piece to *Japanese Jive*, this volume gives the English-speaking person a little too much cultural ammunition on the next trip to Tokyo. Insults, parts of anatomy and hipsterisms are explained in terms of each word's history, its region of origin, context (how the expression for "coitus interruptus" differs from the command "stop fucking me!"), and sociologically (who actually says this stuff). Each expression is accompanied by a little essay that should shed further light on not just

the word but at whose dinner party one should not say it. A fine, sleazy little read.

SH

$9.95 *(PB/216/Illus)*

The Japanese Tattoo
Donald Richie and Ian Buruma

Two of the leading Western authorities on Japanese culture-Japanese film expert Donald Richie, who wrote the text, and *Behind the Mask* author Ian Buruma, who took the photographs—have collaborated on this scholarly, almost anthropological look at Japanese tattooing. Richie's text covers the history of Japanese tattooing, its iconography, social significance (are all tattooed Japanese Yakuza?), the influence of woodblock prints, tattooing techniques, and "a frank discussion of its sociosexual implications." Buruma was able to shoot his photos only after obtaining the trust of the hermetic world of Japanese tattoo artists. **SS**

$22.50 *(PB/120/Illus)*

The Village People were originally fairly distinctive and more-than-averagely inspired, but in a misguided attempt to move with the times they adopted the New Romantic look in the early '80s. — from Kitsch in Sync

John Coltrane
Bill Cole

Cole's biography of this influential jazz giant has many things going for it, even though Coltrane's poetry, which pops up

throughout the book, is not one of them. The author writes from the perspective of a music professor, and as such provides the clearest musical portrait offered on Trane to date (short of Andrew White's books of transcribed Coltrane solos). Fortunately, Cole does not get so bogged down in the technical arena as to make this book unappealing to the non-musician reader. In fact, *John Coltrane* stands out in its effort to illuminate the science of jazz improvisation for the non-playing reader in plain English. Cole's appreciation for Trane's later (free music) period steers the book in a more "spiritual" direction—something most other students of this subject don't do. This is a mixed blessing. The more traditional triumphs of Trane's canon ("Giant Steps," "Moment's Notice") come off as somewhat belittled for their "Western" (non-African) harmonic content, whereas *Ascension* and other later records are held up as the "real" work. What stands as the most significant of Trane is work is a matter for each listener to take up with his or her own ears, and should not be printed as gospel. And Cole's thoughtless, off-handed critiques of such players as Bill Evans and Billy Higgins should never have been printed, period. Yet,

in *John Coltrane* the reader is given much to contemplate, and Cole's interviews with other musicians do much to reveal the concerns of a musician in the heat of the moment. **SH**
$13.95 *(PB/272/Illus)*

Juba to Jive: The Dictionary of African-American Slang
Edited by Clarence Major
An investigation of the chronological cultural and linguistic development and etymology of Ebonics in American history. A thoroughly researched work that can be employed as a subcultural reference text.
OAA
$29.95 *(PB/548)*

Kitsch in Sync: A Consumer's Guide to Bad Taste
Peter Ward
The concept of good taste seems to have originated in the late 1600s. The advent of mass production caused mass acquisition and loss of the exclusivity that had invested objects with a sort of good taste status. The word kitsch is derived from turn-of-the-century Viennese slang (*verkitschen etwas*—to knock off or cheapen). Fast forward to our era where kitsch items, "if owned by somebody with a little more taste and sophistication, [could] be regarded as chic and witty."

So far, so good. The sections on household goods, ironic collectibles and "God and Mona Lisa" are all well-conceived. The chapter on highbrow art (Dali, Koons, Pop Art, Pierre et Gilles, high-end furniture designer Sotass, and the Memphis design group) is also a high point. However, a case is made by the author that an artist named Vladimir Tretchikoff was the ultimate kitsch artist, without a word about Keane or the multitude of others (Peter Max, Vera, etc.) who might lay claim to that title. Schiaparelli and Lagerfeld are among the designers taken to task in the fashion section. Finally, we get a subjective tour of schlock TV, which the author seems to submit as ultimate proof of his lamentable thesis: "Get into sync with kitsch, for you can't escape." **SA**
$19.95 *(PB/128/Illus)*

Kraftwerk: Man, Machine and Music
Pascal Bussy
"*Ein, zwei, drei, vier . . .* " thus begins the

Pujol extinguishes a candle, his pièce de résistance — from **Learned Pigs and Fireproof Women**

saga of Ralf *und* Florian, whose revolutionary Kling-Klang sound shook the world's speakers to the ground and whose robotic emanations are still pulsing around the globe from Detroit to Goa. This is as inside a view as we will probably ever get into the construction of the Kraftwerk audio-conceptual mystique. Witness avant-garde music students Ralf and Florian dropping acid before a Stockhausen concert; their first group, Organization, and its improvisational beginnings at German art-scene happenings; Kraftwerk's relationship to German experimental music explorers Can and Neu!; their hidden conceptual "guru" Emil Schult and his role in crafting their anti-individualist Eurocentric image; the influence of the groundbreaking English art duo Gilbert and George and other conceptual artists; film director Fassbinder's on-set Kraftwerk obsession; the pair's love for the minimalist rock of the Stooges and the Ramones; a top-secret summit meeting between Ralf and the reclusive Michael Jackson in New York; and many other elusive glimpses behind the Man-Machine's hermetically sealed façade.

The story of Kraftwerk also becomes, by necessity, the history of the early years of electronic pop music, or as they describe their sound, "industrial folk music." Some

milestones: their first use of a treated rhythm machine and a vocoder on "Pineapple Symphony"; their first mini-Moog, which cost them the price of a new VW; their first use of a synthesizer—which, surprisingly was not until their fourth album, the global sensation *Autobahn*. As Ralf Hütter describes their appeal: "The dynamism of the machines, the 'soul' of the machines, has always been a part of our music. Trance always belongs to repetition, and everybody is looking for trance in life, etc., in sex, in the emotional, in pleasure, in anything, in parties. . . . So, the machines produce an absolutely perfect trance." **SS**
$24.95 *(PB/192/Illus)*

Krautrocksampler: One Head's Guide to the Great Kosmische Musik, 1968 Onwards
Julian Cope
Former Teardrop Explodes leader and all-round space cadet Cope is our intrepid guide to the world of the influential German *kosmische musik* of the '70s. Although the book suffers from a few glaring omissions, with only a passing mention of Agitation Free, minor coverage of such important figures as Klaus Schulze and none at all of Michael Hoening, such lapses are easily forgiven as this is a very personal "trip" through one fan's record collection, stopping along the way to admire the early work of Kluster, Ash Ra Temple, Amon Düül, Tangerine Dream, Kraftwerk, Can, Neu!, and the Cosmic Jokers. Cope's enthusiasm is both captivating and contagious. While we'll have to wait for the long-delayed Freeman brothers book for the definitive history, this impassioned tome is more than adequate in the meantime. **BW**
$19.95 *(PB/144/Illus)*

Learned Pigs and Fireproof Women
Ricky Jay
A copiously illustrated, well-researched look at some of the most bizarre "acts" ever to grace a stage before TV came along and wrecked everything. Among the astonishing variety of performers observed is Willard, "The Man Who Grows," who added six inches to his height onstage; Arthur Lloyd, who could produce virtually anything printed on paper from the 15,000 items concealed in his suit; and Blind Tom, the most amazing musical prodigy in history. But the ultimate

is France's legendary Le Petomane, whose act was based on his incredible ability to mimic animals, play a flute, and blow out a candle from two feet away, all using his most unlikely orifice. Now, that's entertainment!

JM
$12.95 *(PB/343/Illus)*

Legendary Joe Meek
John Repsch
"Telstar" by the Tornadoes shows what legendary British record producer Joe Meek could do with a few tape recorders, an odd assortment of non-musical instruments and a highly personal vision. Called the English Phil Spector, Meek was also truly one of the great loons of the 20th century. "His public life was one of laughter, tears and, above all, music," notes the cover blurb. "His private life was a tortured tangle of violence, sex, drugs, gangsters, the occult and, eventually, murder." These are only the basics, however. Kept in girls' clothes by his mother during his formative years, in later life Meek developed an obsession with Buddy Holly (whom he believed he contacted through a Ouija board), made an unsuccessful pass at Tom Jones, and produced hundreds of singles—some so outré that to this day they sound not simply contemporary but of the future. Then at age 37, on the eighth anniversary of Buddy Holly's death, Meek killed his landlady and then himself while in an apparent state of panic brought on by a forthcoming police investigation of a particularly grisly homosexual torso slaying. This is one of the best biographies of a musical figure, period. **JW**
$21.00 *(PB/341/Illus)*

Letterheads: One Hundred Years of Great Design 1850-1950
Leslie Cabarga
"The letterhead is often regarded as the first proof of the actuality of a business entity. When those first gleaming reams of stationery and business cards arrive, one can truly proclaim himself in business. And when, conversely, a business fails, those same gleaming reams come home as scratch paper and an occasional melancholy reminder of fallen empires that might have been. . . . This lively portfolio, containing 200 of the most colorful, unusual and expressive letterheads of the American industrial age, accompanied by historically interesting captions, provides a unique per-

spective on such industries as printing, tobacco, food, agriculture, pharmaceuticals and entertainment."
$16.95 *(PB/120/Illus)*

Life on the Hyphen: The Cuban-American Way
Gustavo Pérez Firmat
A sociocultural overview of the contemporary development of the first and second immigrant generations (labeled by Ruben Rumbaut as "1.5 or one-and-a-half" Cuban-Americans) that have lived "life on the hyphen" for the last half-century. It is the author's search for identity that led to his examination of the history of Cuban-American culture and the adjustments that have been made living a hybrid life in contemporary America. He tries to define various Cuban Americans (for example, YUCAs, or Young Upwardly Cuban Americans) and show "how tradition and translation have shaped their lives in Cuban-American culture, a culture which is built on the tradition of translation, in both the topographical and linguistic senses of the word." Perez Firmat claims that it is one thing to be Cuban in America and another to be Cuban-American.

Music, movies, television, and literature are used to illustrate his investigations. Cubans who have become icons in American culture—Desi Arnaz, Perez Prado, poet Jose Kozer, writer and Pulitzer-Prize winner in literature Oscar Hijuelos, and even the Madonna of Miami herself, Gloria Estefan—all get their due in this book. The

author does give us plenty of dirt on many of the personalities that he examines but also gets sidetracked and exposes more of himself. He quotes Desi Arnaz from his autobiography *A Book*: "writing a book is, I discovered, not an easy thing to do. It also proves that the brain is a wonderful thing. It starts up when you are born and stops when you sit down at the typewriter."

OAA
$12.95 *(PB/231/Illus)*

Like A Velvet Glove Cast in Iron
Daniel Clowes
In his much-beloved comic book *Eightball*, Daniel Clowes takes on those twin maladies of contemporary American culture, irony and nostalgia, and does it better than anyone, anywhere, in any medium. First serialized in those pages, the protracted nightmare that is *Velvet Glove* seems even more relentlessly grim in collected form. As a claustrophobic excavation of the artist's psyche, this work stands alone. **JT**
$16.95 *(PB/144/Illus)*

Long Lonely Highway: A 1950s Elvis Scrapbook
Ger Rijff
Snapshots and press clippings follow the Hound Dog Man from '55 to '57. Detroit: "An atomic explosion of juvenile emotion hit the Fox Theater last night. It was triggered by Elvis Presley, the singer with the profile of a Greek god and the motions of a Gilda Gray, who is the current sensation of

Judging by the size of the sprawling Wm. Wrigley, Jr. Company factory, circa 1925, there is plenty to flaunt in the gum business. — from **Letterheads**

Pérez Prado goes "Ugh!" — from Life on the Hyphen

the rock 'n 'roll business. . . . The guitar seldom got twanged, because Elvis was too busy flexing his knees and swinging his thighs like a soubrette in the palmy days of burlesque." Jacksonville: "The teen-age rock 'n' roll idol, who was advised before his first show here to 'keep it clean' or face court charges, met with local Juvenile Court Judge Marion Gooding after the opening performance and was warned sternly to remove the objectionable hip movements from the act." Vancouver: "One could call it subsidized sex. . . . It was disgraceful, the whole mess." Tacoma: "I certainly don't mean to be vulgar when I wiggle my hips during a song. It's just my way of expressing my inner emotions." A fresh look at the first years. **GR**
$28.50 *(HB/200/Illus)*

Look! Listen! Vibrate! SMILE!
Compiled by Domenic Priore
Look! Listen! Vibrate! SMILE! is a book-length monument to the great lost Beach Boys opus Smile assembled by a brilliant pop archaeologist. Encounter the moment when Brian Wilson was walking the razor's edge between psychedelicized madness and pop perfection through an obsessive free-

associative scrapbook of fan-magazine interviews, photos, record company promo materials and other Beach Boyana surrounding the recording of the ill-fated masterpiece. **SS**
$19.95 *(PB/298/Illus)*

Lush Life: A Biography of Billy Strayhorn
David Hajdu
A provocative biography dutifully illustrating the life of Billy Strayhorn, jazz's long overlooked musician, composer and visionary. Overshadowed by his lifetime associate "Duke" Ellington ("Ellington referred to Strayhorn with cryptic aesthetic intimacy as 'our writing and arranging companion'"), he was the force behind many Ellington compositions. Strayhorn easily allowed himself to fall into the background. Now is the time for the mysterious, complex, shy, openly homosexual, always graceful legend to receive his due.

Descriptive and refreshingly lyrical, the text encapsulates with various corrective metaphors the lost truths of the jazz composer who sat back as his peers and community reveled in shame and laughter. Cut short when he was one of jazz's leading practitioners, Strayhorn left behind an unmatched legacy. His life overlapped and deeply influenced many jazz legends: Horne, Holiday, Hodges, Pettiford, to name but a few. *Lush Life* is as bittersweet as the tune itself. **OAA**
$27.50 *(HB/306/Illus)*

Magic: A Picture History
Milbourne Christopher
"Wonders, Wonders, Wonders," "Seeming Impossibilities," "Masters of the Mysterious" and "Twentieth-Century Sorcerers," in a heavily illustrated history of stage trickery from the pharaohs to television. A brief stop on the Continent for some fire-resisting: "The king of Eighteenth-Century fire eaters at the British fairs was Robert Powell. He ate hot coals 'as natural as bread', licked red-hot tobacco pipes—aflame with brimstone—with his bare tongue, and cooked a cut of mutton using his mouth, filled with red-hot charcoal, as an oven. A spectator pumped a bellows to keep the coals blazing under his tongue. . . . Chabert, the French 'Incombustible Phenomenon', was later to carry the fiery arts to new extremes. . . . With several steaks in hand, he boldly entered a blazing oven. Singing merrily in

the inferno, he cooked the steaks and handed them out to be eaten. Then he himself emerged, smiling broadly, with not so much as a single singed hair." **GR**
$10.95 *(PB/224/Illus)*

Main Street to Miracle Mile: American Roadside Architecture
Chester Liebs
This treatise "established the 20th-century roadside landscape as a subject for serious study." The author "traces the transformation of commercial development as it has moved from centralized main streets, out along the streetcar lines, to the 'miracle miles' and shopping malls of today." Also "explores the evolution of roadside buildings, from supermarkets and motels to automobile showrooms and drive-in theaters." **GR**
$24.95 *(PB/260/Illus)*

The Mainland Luau: How To Capture the Flavor of Hawaii in Your Own Backyard
Patricia L. Fry
"With Hawaiian friend Ethel Eddy, Ms. Fry has hosted many large luaus. Here she combines her experiences with those of others to present this informative, easy-to-follow guide to the backyard luau:
- Scrumptious Island Recipes
- Fresh Flower Leis
- Hawaiian Language Skills
- 8 Methods of Roasting a Whole Pig
- Tropical Decorations
- Island Custom Savvy"
$8.00 *(PB/76/Illus)*

A Mammal's Notebook: The Collected Writings of Erik Satie
Erik Satie
"The first collection of Satie's writings available in English. . . . A pivotal character in the French avant-gardes from the 1880s to the Dada movement of the 1920s. Dismissed as a bizarre eccentric by most of his contemporaries, Erik Satie is recognized as a key influence on 20th-century music."
$22.99 *(PB/192/Illus)*

Manhole Covers
Mimi Melnick
Coffee-table tome for street- and sewer-life aficionados. "They lie underfoot,

embellished and gleaming," cast-iron lids on a dark world where "liquids such as beer, milk, ice cream or orange juice flow unseen down secret avenues." They're waffled, starred, sunburst, checkered and grooved. "Part history of material culture, part exercise in obsessive photographic cataloguing, part crypto-Pop artist's book. There's a crisp and even elegant matter-of-factness to their writing and their pictures, a spare functionalist precision." Photographed directly from above, a hefty collection of metal presented in lustrous black and white, the pictures aesthetically satisfy "a certain organicist longing for closed forms." **GR**
$39.95 *(HB/252/Illus)*

The Martini:
An Illustrated History of
an American Classic
Barnaby Conrad III
If any single cocktail ever deserved its own art book, it's the martini. It is a symbol of power, elegance, sophistication, nostalgia and civilization itself. All manner of writers have had things to say about the martini. Among those included in this book are: Dorothy Parker, Ogden Nash, Luis Buñuel, Robert Benchley, Noel Coward and Ian Fleming. Whether it appears in advertising illustrations, the world of fine art or as a motif in cinema, the martini is a sexy and nearly universal symbol of class. (The author's father owned the El Matador bar in San Francisco, a swank place with a "who's who" clientele which spawned its own history book. One ascertains that the author properly reveres his subject and knows something, firsthand, of the martini's heyday.)

The book begins with various theories of the martini's origin. There follows a brief history of gin and Prohibition. The martini's role is explored in literature, politics and film. There follows an assessment of the relative popularity of the martini through the decades. Then, of course, comes the dissertation on mixing the perfect martini. The illustrations are lavish and copious. If one were unable to read and had to guess what this book was about, from the pictorial evidence one would surmise it described an elegant world full of beautiful silver-and-glass containers peopled by a very sophisticated race of impeccably dressed beings. Bottoms up! **SA**
$24.95 *(HB/132/Illus)*

Martinez, Calif. claims to be the "Birthplace of the Martini." — from **The Martini**

Miles: The Autobiography
Miles Davis with Quincy Troupe
The autobiography of one of the most important and influential musicians in the world. With an uncensored candor and a stellar wit, Miles recounts the major events of his life: his upbringing in East St. Louis where, still a teenager, he first saw Dizzy and Bird and made up his mind to become a musician; his journey to New York ostensibly to study at Juilliard but in fact to apprentice himself to Charlie Parker (a musical education at once intense, tragic and uproarious—Miles' recounting of a cab ride they once took together is hilarious); his pioneering of "cool jazz"; his later forays into electric funk. Looking back over a lifetime of musical experimentation, Miles recalls his work with numerous jazz giants, most notably Bird, Dizzy, Monk, Trane and especially (despite an impatience toward white people bordering on bigotry) Gil Evans. Maddening, mercurial, irreverent and extremely funny, the book is punctuated with uncomfortable details—rampant promiscuity, failed marriages, recurring drug addictions—anyone else would have understandably played down or excluded altogether. It's a credit to Quincy Troupe that he was able to capture and sustain Miles' uniquely vernacular tone throughout—the reader has the sense of listening to a man spin out the story of his extraordinary life in unsparing detail. Read the book, heed the music. **MDG**
$14.00 *(PB/446/Illus)*

Mind and Society Fads
Frank Hoffman, Ph.D., MLS, and William G. Bailey, M.A.
Ever wondered where the self-affirmation "Every day in every way, I am getting better and better" came from? Find out in this Cliff Notes-like guide to social phenomena. There isn't deep analysis here, but enough information to allow one to bluff at dinner parties. However, one of the biggest flaws of a book like this (and those of self-proclaimed answer men, such as Cecil Adams) is that they are only as good as their sources. Lack of information and cultural bias can give short shrift to unconventional beliefs. **TC**
$14.95 *(PB/285)*

Modern Music
Paul Griffiths
Writing about music is acknowledged to be hard. Writing a general history of atonal and aleatoric avant-garde music this full of passion and excitement would seem to be damn near impossible. This modest volume is a superb introduction to all the "serious" music and composers that have followed Wagner's sublime Romantic bombastics. From Debussy's impressionistic exoticism to the pioneering tape collage experiments of *musique concrète*, from the occult ecstasies of Scriabin to the Zen minimalism of John Cage, from the invention of the Theremin to the academic acceptance of the electronic

Mods — from **Mods!**

compositions of Stockhausen, author Paul Griffiths' contagious enthusiasm for his often-intimidating subject matter sweeps the reader into this 20th-century stream of sound. **SS**
$14.95 *(PB/216/Illus)*

Mods!
Richard Barnes
"The Mod way of life consisted of total devotion to looking and being cool, spending all of your money on clothes and all your after-work hours in clubs and dance halls. To be part-time was really to miss the point." In 1962, a magazine called *Town* noticed a trend among teenagers devoted to a crisp new style and interviewed a number of fresh faces (among these was a 15-year-old Marc Bolan) who dubbed themselves "mods" (short for modernists). This was the first official recognition by the media. These youngsters were a part of the increasingly recognized market segment that had sprung into being after WW II dubbed "teenagers." They obsessively collected records, with a decided preference for U.S. black vocal groups. They rode around on Vespa motor scooters with as many headlights and as much chrome as they could (il)logically attach to them. They popped amphetamines and paraded around like dandies. Numerous venues catered to them. This book is a pictorial feast featuring over 150 quality photos, advertisements for "mod" styles and reproductions of news clippings (as well as a firsthand account by somebody who ran a club which became a mod stronghold and watched it happen objectively). **SA**
$14.95 *(PB/128/Illus)*

The Mole People: Life in the Tunnels Beneath New York City
Jennifer Toth
A visit to New York's creepy, actual underground where the "mole people" live. Underground New York is riddled with abandoned subways and tunnels, so many that the city has lost track of them all and has no real documentation of their existence. There, under the city, is where the "mole people" live—some in complete communities with appointed "mayors," schools and children who have never seen the sun.

The author, a young Columbia University student, becomes obsessed with writing about these elusive people. She befriends a

Léon Thérémin giving an early demonstration of the early electronic instrument which he developed in 1924. Its sound production was controlled by movements of the hand around the upright pole. — from **Modern Music**

few "mole people" and goes underground with their help to learn more. There she meets a tunnel dweller they call "Satan," and barbecues some fresh rat meat ("track rabbits") with another. She also comes across a gang of drug-dealer hit men but manages to get away unharmed by offering to tell their story in her book—a close call. She also brings to the attention of many what the city describes as a "few homeless" living underground and finds the actual numbers to be in the thousands. She helps a few, but others threaten her life and things get scary for her aboveground. **DW**
$13.95 *(PB/280/Illus)*

Moonshiners, Bootleggers and Rumrunners
Derek Nelson
The colorful history of illegal booze in America-making it, running it, shipping it and stopping it. "Filled with the exploits of shifty-eyed moonshiners tending backwoods stills; daring bootleggers hustling cars laden with 'tax-free' whiskey over rural highways; revenuers pursuing their quarry on foot, in cars and from airplanes; and rumrunners and Coast Guard ships engag-

ing in the occasionally fatal 'booze ballet.'" With a cast of characters that includes "Scotch-Irish immigrants, Revolutionary War heroes, blockade runners, pirates, hard-drinking pioneers, wealthy and vicious gangsters, devil-may-care adventurers, and ludicrously incompetent amateurs." **GR**
$24.95 *(PB/192/Illus)*

Mouse Tales: A Behind-the-Ears Look at Disneyland
David Koenig
The 40-year history of Disneyland is that of a feudal dictatorship riddled with gore, and though the author goes out of his way to try and give an evenhanded account of the park, the truth wins out and the evidence for Disneyland as a dystopian Circus of Death is damning. How else to account for the insidious People Mover (or "remover" as dubbed by employees), which at a deceptive speed of 2 miles per hour has managed to crush several skulls in half or cause numerous injuries resulting in multiple foot and toe amputations? Or America Sings, which ground 18-year-old hostess Deborah Gail Stone into paste between two counter-rotating theater walls?

But the rides are not the only malevolent entities: Disneyland seems to bring out the worst in people, or at least make them criminally stupid. Otherwise, why would employees ingest alcohol-spiked punch, pot brownies, and guacamole laced with PCP at a potluck birthday party and then operate the Matterhorn (which has been known to eject patrons under the best of circumstances)? And what goes on in the minds of those patrons who decide to squirm out of their lap bars and stand up in the middle of Space Mountain?

On the lighter side, mishaps which don't end in death or disfigurement usually result in ugly lawsuits, like the sexual-harassment suit filed against one of the Three Little Pigs by an obese female midget who claimed that the alleged horny hog tweaked her breasts and squealed "Mommy, Mommy."

And then there are the occasional riots, like the one staged by the Yippies in 1970, who stormed up Main Street chanting "Free Charlie Manson" and held a "Black Panther Hot Breakfast" at Aunt Jemima's Pancake House. Add to this already Bruegelesque scene the multiple shootings, stabbings, drownings, bomb scares and Tongan vs. Samoan gang wars, and one can only conclude that Disneyland is an encumbered minefield straining its boundaries as its minions work at constant breakneck pace to stave off terminal devastation. **MG**
$13.95 *(PB/239)*

Music Is My Mistress
Edward Kennedy (Duke) Ellington
"Duke" Ellington was as distinctive a personality off the bandstand as on. His refinement, dignity and musical statesmanship were much of what marked him as one of America's most celebrated composers. Less an autobiography than a freewheeling memoir, this is one of the most entertaining books about jazz that one is likely to find. Those looking for Ellington to make a definitive introspective statement will be disappointed—this is a thick book of great storytelling. Ellington comes off like a benevolent king viewing his domain. He holds forth on subjects nonmusical and musical, and his recollections of his sidemen are as often personal as professional. He speaks at length about peers such as Chick Webb and Count Basie, and is frequently touching in his summations of his closest associates—his words about Billy Strayhorn verge on poetry. Ellington was one of the most elo-

quent men ever to make a living in mostly instrumental music. **SH**
$14.95 *(PB/525/Illus)*

Musique Fantastique: A Survey of Film, Music in the Fantastic Cinema
Randall D. Larson
Worldwide guide to horror movie soundtracks and their composers.
$45.00 *(HB/602)*

My Troubles With Women
R. Crumb
A pioneer of autobiographical comics, Crumb has chronicled, some say complacently, his sex life and sex fantasies in many publications throughout his career. This book collects the choice of his "stories about relationships," starting from his early sensual awakenings to the most recent marital developments. **PH**
$16.95 *(PB/68/Illus)*

Mythomania: Fantasies, Fables and Sheer Lies in Contemporary American Popular Art
Bernard Welt
"The vulgarity inevitably associated with commercial success is not a dangerous opiate, distracting us from eternal truths. In America, vulgarity is the vehicle for the expression of eternal truths." Includes essays on *Star Trek*, Michael Jackson, Peewee Herman, Dr. Seuss, and "The Dark Side of Disneyland."
$12.95 *(PB/127/Illus)*

New Roadside America: The Modern Traveler's Guide to the Wild and Wonderful America's Tourist Attractions
Mike Wilkins, Ken Smith and Doug Kirby
"See the Seven Wonders of Roadside America from South of the Border to the Cypress Knee Museum . . . special coast-to-coast Elvis and Atomic tours . . . leapin' gators, divin' horses, bitin' snakes and performin' chimps from Gatorama to Parrot Jungle . . . two Stonehenges, the London Bridge, and a Polynesian Paradise right here in the USA . . . the TV homes of Fred Flintstone, the Cartwrights and *Hee-Haw*, open to the public . . . the 25 most unusual items on display in American museums, from Einstein's Brain to Edison's Last

Breath . . . An eminently useful guide to the beautifully tasteless and wonderfully weird leisure-time landscape of America's tourist attractions."
$12.99 *(PB/288/Illus)*

New World Order Comix: #1, The Saga of . . . White Will!!
William L. Pierce, Drawing and Lettering Daniel "Rip" Roush
Follow the wacky adventures of White Will and his pals, as they try to get to the bottom of a mysterious wave of "political correctness" that threatens to turn their whole school upside down! When the teacher suddenly claims that Cleopatra, Hannibal and even Beethoven were really black, White Will smells a rat. Despite a ban on "politically incorrect" books, Will and his pals learn the truth about the race-mixers' evil plan, and when they decide to stand up to the vicious Jews, revisionist Negroes, inscrutable Orientals and race-traitor "wiggers," get ready for a laff riot!

The fun really begins when that rascally Jew Izzy Rabinowitz uses every trick in the Talmud to turn not only his Negro lackeys but the "wiggers" against Will and the gang. When Izzy and his mudrace mongrels try to stage a bogus "anti-racism" assembly, White Will gives 'em a taste of their own medicine, and, in a rollicking free-for-all that'll have you in stitches the Satanic ZOG-meisters find out the hard way that "Race Mixing isn't Kosher!" *New World Order Comix* is brought to you by the nice folks of the National Alliance. **DB**
$3.00 *(Pamp/37/Illus)*

The New York World's Fair 1939/1940
Richard Wurts and Others
"Do you remember seeing or being told about the vast diorama of Democracity representing the theme of the Fair in 1939, 'Building the World of Tomorrow'; GM's Futurama ride; the world's largest mirrored ceiling; 3-D movies; Elektro, a robot seven feet tall; the Town of Tomorrow; Toyland; the Parachute Jump; Billy Rose's Aquacade?" The fairgrounds were a fantasy of Art Deco and Bauhaus confections, all centered around the pseudo-symbolic Trylon (700 feet tall) and Perisphere (200 feet wide). The pavilions were designed by Raymond Loewy and Norman Bel Geddes, among others, and filled with the most

modern art by the likes of Dali, Noguchi, and Calder. Johnny Weissmuller showed up to shake your hand, and Sally Rand did her famous fan dance. This was the world of tomorrow! Then came World War II ... **GR**
$9.95 *(PB/152/Illus)*

Nico: The End
James Young

Sweat it out with Nico on her too-small tour bus, surrounded by her dysfunctional and wantonly decrepit backup band, her opportunistic, no-talent crew, her bloated, lovesick manager and her wasted, drugsick fans. The Teutonic diva of doom deserved better—"She should play ze Carnegie 'All," claimed her French son Ari. Instead, she endured misery and degradation, lugging her dusty harmonium from one art-house stage to another, continually on the verge of kicking as her entourage siphoned off her dope-reserves, underappreciated by reporters wanting only to know about Andy and the Velvets, and overappreciated by a manager who besieged her with embarrassing sex-poetry in between bouts of explosive masturbation in the adjoining hotel room. This is the rock 'n' roll adventure as it veers off into old age-void of glamor, romance, myth—but it remains an adventure nonetheless. **JT**
$11.95 *(PB/207/Illus)*

Norman Rockwell: 332 Magazine Covers
Christopher Finch

Many of us have a tendency to rank Norman Rockwell with apple pie and Mayberry. Yet Rockwell's vision of a homespun America-that-never-was is important. His work reveals an inherent need to supply the public with a meticulously envisioned, nostalgic vision of a quaint America. These magazine covers range from 1916 to the early 1960s, and display a stubborn reluctance on the artist's part to adapt to the changes induced by progress and technology. Rockwell remains frozen in his own golden milieu. As with Twain and Dickens, with whom he is at times compared, the artist presents a lovable rogues gallery of classic character types—old musicians, kids dreaming of the sea, hoboes, quaint druggists, spooning sweethearts, small-town soldiers, choirboys, etc. Rockwell's composition and attention to poignant human details set him apart from other artists who were merely first-rate technicians. **CS**
$11.95 *(PB/356/Illus)*

Comic Panels — from New World Order Comix

Ocean of Sound: Aether Talk, Ambient Sound and Imaginary Worlds
David Toop

The author traces a series of lines running just slightly afoul of the traditional course of Western musicology, a series of stops and starts, of wrong turns and dead ends, of auspicious experiments and outright failures which have been scattered like crumbs to history. Often unrecognized in their time, they are here reconfigured into a kind of trajectory consistently pointing toward "the way out." Debussy's encounter with the Javanese gamelan at the Paris exposition of 1889 sets the ball rolling; yet it is up to Debussy's friend Erik Satie to really run with it—the outcome being his *musique d'ameublement*, or furniture music. From there, it's just a few steps further to Muzak and Brian Eno's notions of ambience—a music without beginning or end, without progression or narrative development, and without motifs, the plural giving way to a single motif indefinitely sustained. The author grants equal time to the ethnographic, the avant-garde and pop camps, interviewing many of their principal representatives and figureheads along the way. From Lee "Scratch" Perry to Terry Reilly to Kate Bush, the range could not be broader, and with the prose restlessly shuttling backward and forward in time, and from one continent to the next, the point sometimes gets lost in a maze of tenuous connections. Above all, though, Toop sees the current craze for ambience as a resurgence of the kind of sensual sophistication which dominated the Symbolist movement at the turn of the last century. Taking his cue from such Symbolist antiheroes as des Esseintes and Dorian Gray, he attempts to expand his obsessions with exotica and armchair travel into a viable musical program for the next millennium. **JT**
$16.99 *(PB/306)*

Opus Maledictorum: A Book of Bad Words
Edited by Reinhold Aman

Compiled and published by Dr. Reinhold Aman, who since the mid '60s has collected all forms of maledicta (Latin for "bad words"), this book is a brilliant appetizer

before devouring Aman's also-brilliant *International Journal of Verbal Aggression*. Written in a style similar to G. Legman's classic *Rationale of the Dirty Joke*, Aman's compendium covers the scope of the human insult with clarity and wit. The instinctive balance of the writing makes for a highly entertaining read. With just the right amount of scholarship, of populism, of anthropology, of highbrow and low, the *Opus Maledictorum* will enrich your vocabulary and explain the heritage of malicious slang (which is, of course, as old as mankind). **JK**
$14.95 *(PB/364/Illus)*

P.T. Barnum: The Legend and the Man
Arthur H. Saxon
A scholarly study that exposes the life of P.T. Barnum. The author portrays a grand and mesmerizing figure in the world of entertainment, and includes many insights into the impresario and entrepreneur's private and social life. This is a tale of success and tragedy and its impact on the world of the carnival, and Saxon cuts Barnum little slack in relating his con-man tendencies and racial attitudes. Illustrated with many photographs of Barnum's early marketing tactics. **OAA**
$16.50 *(PB/439/Illus)*

Phantasmic Radio
Allen S. Weiss
With a title that reinforces the already indelible "ghost in the radio" image from Cocteau's *Orpheus*, *Phantasmic Radio* explores and expounds on the radio experiments of Artaud, John Cage, Valere Novarina (*Theatre por Orielle*), Gregory Whitehead, Louis Wolfson and Christoff Migone. A little on the arty and pretentious side (kind of unavoidable when dealing with the likes of Artaud and Cage), but full of information and frighteningly meticulous analysis on a subject that—thanks to the FCC-approved corporate stranglehold on commercial radio, the "family values" funding paranoia that has lobotomized public radio and Pacifica's pathetic "suicide by political correctness"—most of us will never be able to experience firsthand. Better tape those Joe Frank shows, before he steps out of line and ends up as just another footnote in *Phantasmic Radio: Volume 2!* **DB**
$13.95 *(PB/124)*

Planet of the Apes as American Myth: Race and Politics in the Films and Television Series
Eric Greene
"In the first movie in the five-film series, *The Planet of the Apes*, Hollywood filmmakers fashioned an allegory of racial conflict and the Vietnam War. As the series progressed, the films shifted their focus more and more to domestic racial conflict, demonstrating the effect that the '60s riots and the Black Power movement began to have on the movies. In the later films the racial tensions were continually—perhaps prophetically?—depicted as escalating to the point of cataclysmic violence."
$29.95 *(HB/264/Illus)*

The Poets of Tin Pan Alley: A History of America's Great Lyricists
Philip Furia
Although rock lyrics (especially those by Dylan, Lennon and Morrissey) are subject to endless analysis, second-guessing and assignments of cultural importance, the

SERENITY

THE PRESENTIMENT OF DANGER

MORAL PAIN

PHYSICAL PAIN

EXPRESSION OF NEUTRAL AMIABILITY
NOTHING IN THE EYES—
NOTHING IN THE MOUTH

ECSTASY

If I imitate Guilbert and make my face Serene, Gray or Neutrally Amiable, will I have introduced new desires, or will I have restaged the old ones? — from **The Queen's Throat**

truly astonishing lyrical craftsmanship of Tin Pan Alley in the early part of this century has been given short shrift. Lyricists such as Lorenz Hart, Dorothy Fields, and especially Johnny Mercer contributed bodies of work that not only influenced but also captured a certain corner of Americana as it has too rarely been explored before or since. While the author occasionally gets a mite technical for the average reader (who cares about how syllables were split in "Too Marvelous for Words"?), books that look seriously into the craft of Tin Pan Alley lyricists are far too few, and books this well-informed always have a place in the music aficionado's library. **SH**
$12.95 *(PB/336/Illus)*

Progressive German Graphics, 1900-1937
Leslie Cabarga
Explores the aesthetic, historical and social influences on German and Austrian graphics between the wars—before Hitler's heavy hand of kitsch descended on the design world. Posters, packaging, trademarks and more are strikingly arranged to showcase the commercial artist's mastery of weight and severity (echoes of calligraphy and woodcuts), contrasted with muted color palettes, richly textured surfaces and (surprise) a German sense of character and humor. **GR**
$16.95 *(PB/132/Illus)*

Psychology of Music
Carl E. Seashore
Spanning clinical laboratory analysis and standard music theory, this valuable introduction written in 1938 helped in the establishment of pyschoacoustics and led to a greater study and understanding of how our sensory capacities distinguish between pitch and frequency, tone and dynamics, and how our conscious perception of sound affects musical aesthetics. **BW**
$9.95 *(PB/408/Illus)*

Pulp Culture: Hard-boiled Fiction and the Cold War
Woody Haut
An old-line Marxist interpretation of "pulp culture"—really the hard-boiled detective and crime novels of the '40s and '50s as exemplified by Thompson, Goodis and Himes. And like most sweeping lit-crit analysis, it's full of gaping holes. But given

the paucity elsewhere of criticism going beyond the usual hard-boiled trinity (Hammett, Chandler, MacDonald), a wise reader can skim the bits about monopoly capitalism and the crimes of the state to pick up tips on many of the lesser known paperback tough-guy writers such as W.P. McGivern, Lionel White and Robert Finnegan. **JM**
$15.99 *(PB/230)*

The Queen's Throat: Opera and Homosexuality
Wayne Koestenbaum
Addressing the long-observed affinity between homosexual men and opera, this book combines the many colored threads of this complex and frequently intense codependency. Organized into seven chapters, the broad topic headings include the major theme "Opera Queens," as well as "The Shut-In Fan: Opera at Home," "The Unspeakable Marriage of Words and Music," and "A Pocket Guide to Queer Moments in Opera." Meditations include the transcendent imagery of opera LP labels—"The two central images adorning the labels of opera records have been the dog and the angel. Bestial. Celestial. When you listen to opera, are your desires doggy or divine?"; and the complex relationship between divas and self-mutilation—"Diva self-mutilation helps the show go on: before a performance, Maria Malibran took a pair of scissors and cut away the blisters around her mouth; Geraldine Farrar told Carl Van Vechten that 'at every performance she cut herself open with a knife and gave herself to the audience.'" The author also notes that "there's a bizarre affinity between divas and dismembered anatomies: diva Brigitta Banti died in 1806 and left her larynx, preserved in alcohol, to the city of Bologna; Olive Fremstad's piano was graced by a pickled human head sliced in half so she could show her students the vocal and breathing apparatus." While the author has produced a work of both scholarly research and deep introspection, he never forgets to leaven the mix with keen wit. A compelling work of cultural history and literature, this book will appeal to everyone, regardless of sexual persuasion, interested in the meaning attributed to one's erotic and aesthetic experiences. **JAT**
$12.00 *(PB/271/Illus)*

R. Crumb's America
R. Crumb
From the right-on '60s and '70s to the bitterness and disillusionment of the '80s and ending with the futility of fighting the all-powerful system, Crumb covers a variety of political attitudes while retaining his original anti-Establishment opinions. **PH**
$16.95 *(PB/80/Illus)*

R. Crumb's Carload o' Comics
R. Crumb
"It's classic Crumb in a great collection! Mr. Natural and Flakey Foont, the incorrigible Mr. Snoid in a 14-page story done especially for this collection, and classic counterculture characters like Honeybunch Kaminski, the 'drug-crazed runway,' and Jumpin' Jack Flash run riot through the pages of this dynamite gathering of Crumb's best comics from the late '60s and early '70s, underground comix golden age!"
$16.95 *(PB/176/Illus)*

Road to Rembetika
Gail Holst
"Rembetika, the music which began in the jails and hashish-dens of Greek towns and became the popular bouzouki music of the '30s, '40s and '50s, has many parallels with American blues. Like the blues, the rembetika songs were the soul music of a group of people who felt themselves to be outside the mainstream of society, who developed their own slang and their own forms of expression. *Road to Rembetika* is the first book in English to attempt a general survey of the world of the 'rembets,' who smoked hashish while they played the bouzouki and danced the passionate 'zembekiko' to release their emotions."
$10.00 *(PB/181/Illus)*

Roadfood
Jane and Michael Stern
The highway bible to America's sleeves-up eateries. "How to find the restaurants that serve the most succulent barbecued ribs, the crustiest skillet-fried chicken, four-star hot fudge sundaes and blue-ribbon apple pie-in small towns, in city neighborhoods and along the Interstate." Visit Pink's Chili Dogs in Hollywood: "Step right up and meet a hot bow-wow every street food scholar ought to know: Pink's chili dog, an all-beef wiener topped with mustard and onions, then a load of chili sauce. This dog is a

beaut, steamed until it seems ready to burst out of its crackling skin. It is normal-size, so you won't likely see it beneath all the topping. It tastes great, just garlicky enough to have some punch but not overwhelm the rest of the package. It is muscular, juicy, a rewarding chew." State-by-state reviews of more than 400 steak joints, oyster dives, chicken houses, waffle pits, BBQ huts and other roadside diners. **GR**

$15.00 *(PB/489)*

Rockers: Kings of the Road
John Stuart

"'The Rocker image reflects the experience of working-class life in the mid 20th century—boredom and disenchantment on the one hand and an intoxicating energy and escapist thrill on the other. There is a potency, an epic simplicity about bikes, leathers and rock 'n' roll during this period."

Along with the advent of the "teenager" in 1950s England came the Rocker. Modeled after such icons as Brando, Dean and Elvis, the Rocker's style was "a very English interpretation of American 'glamor.'" This book is a chronicle of the evolution of that style, the classic look that has never gone out of fashion. This volume is lavishly illustrated with black-and-white photos and news clippings of Rockers leaning on things, smoking cigarettes, hanging out, dancing, rioting, posing and interacting with motorcycles. Little details such as the cut of jackets and boot types give the pictures a distinctly British feel. Nuances and variations on the theme are illustrated. This book covers a huge hunk of time (by fashion standards) in which a style has remained remarkably constant. **SA**

$14.95 *(PB/128/Illus)*

Rollerderby: The Book
Lisa Carver

"I started *Rollerderby* in 1990, and I'm not sure why. When a magazine editor is asked what their influences were, they usually list a bunch of other magazines. But, as far as I know, there were no other magazines like *Rollerderby* before *Rollerderby*. My influences are just being female (thus I am confessional, plain-speaking, nosy, laugh hysterically much more often than a man would, and have a hard time sticking to one topic) and being fortunate enough to be the rulingest sign of the zodiac—the sneaky, sex-obsessed Scorpio."

Illustration by Dame Darcy — from **Rollerderby**

What can you say about a magazine where young women are reviewing their cats (actual feline pets) on one page and conducting a lucid and intelligent interview with Boyd Rice on the next? (*Screw* magazine noted its: "psychotic charm"). Anything seems possible in the unique and utterly unusual world of Lisa Carver. She writes about whatever damn well pleases her, and it's usually a lot of fun to read about, however unpromising the topic. Perhaps a list of sample *Rollerderby* topics might speak best. These are just some of the highlights: Glen Meadmore and Vaginal Davis, Psychodrama, Boss Hog, "They're Sexy, They're Old, They're Men" (William Burroughs, Joseph Biden and Eddie Money!), "On Killing Yourself", "On Being a Teen Prostitute," Matt Jasper on Richard Rand, Yamatsuka Eye, GG Allin, loss-of-virginity stories, Royal Trux, Dame D'Arcy, Cindy Dall, "I had psoriasis," "horse girls" and "How Did You Find Out About Sex?" **SA**

$14.95 *(PB/104/Illus)*

Route 66: The Highway and Its People
Quinta Scott and Susan Croce Riley

An ode to the Mother Road. Its birth, the people, the towns and the boom-time it created. "The miracle was not the automo-

bile. The miracle of the early 20th century was the construction of the vast network of highways that gave automobiles someplace to go." It didn't hurt that the black ribbon slashed from East to West, the direction America was hankering to travel. Retirees to the Golden West for their health. Okies to California for jobs. WW II vets to Los Angeles to settle down. Black-and-white illustrations include architectural curiosities like Wigwam Village (1946), the Uranium Cafe (1955), the Coral Court Motel (1940) and the U-Drop Inn (1936).

GR
$19.95 *(PB/224/Illus)*

Running With the Devil: Power, Gender and Madness in Heavy Metal Music
Robert Walser
The author, a professor of music at Dartmouth College and "professional musician who has played with metal bands," applies both analytical music theory and academic critical theory to the Spinal Tap realm of Metal. He is actually very insightful in his intellectual take on Metal music and culture, but the ultimately ridiculous nature of his quest makes for an astounding read. Examples abound: "'Runnin' with the Devil' makes its Aeolian basis clear immediately. Over a pulsing pedal E in the bass, guitar chords move from C to a suspended D, then finally resolve to the tonic E. This is the VI-VII-I harmonic progression discussed by Wolf Marshall; its affective character is discursively coded as aggressive and defiant (in part of its difference from the tonal syntactical norms that underlie other popular music)." Rock on! **SS**
$15.95 *(PB/242/Illus)*

Scott Walker: A Deep Shade of Blue
Mike Watkinson and Pete Anderson
Scott Walker is a man of brooding mystery, and more than likely even a mystery to himself. This biography captures the swinging London of the early and mid-'60s, but has a hard time focusing on Scott Walker's demons and delights. What we do know is that in the era of Jimi Hendrix and the Beatles, Walker had a fixation on middle-of-the-road crooner Jack Jones, and an intense love for Belgian singer-songwriter Jacques Brel. The combination of these two musical models with a splash of Phil

Spector was the basis of the music of the Walker Brothers and the brooding sound of Scott as a solo artist.

Walker is interesting in that he was and remains a man out of sync with musical fashion—too brooding for the groovy '60s, too non-pop for the '80s, and too abstract (*Tilt*) for the '90s. His hatred and fear of fame, his work methods, and his suicide attempt are all documented in these pages.
TB
$21.95 *(PB/287/Illus)*

The Secrets of Houdini
J.C. Cannell
Don't watch that—watch this! Escaping from bank vaults, popping out of jails, walking through brick walls, making elephants vanish, escaping from crates underwater and writhing free of straitjackets are the legendary illusions of Harry Houdini (alias Ehrich Weiss). "So fantastic were his tricks that many thought him to be supernatural, a mystic, and an amazing spiritualist." But Houdini was just another dapper con-man, adept at swallowing keys and sliding open invisible panels. "Exposing his closely kept professional secrets, and revealing in general terms the whole art of stage magic, this book is now considered a classic study of Houdini's strange deceptions." Plus how to accomplish dozens of other famous magic tricks and stage illusions. First published in 1931. **GR**
$7.95 *(PB/279/Illus)*

A Separate Cinema: Fifty Years of Black-Cast Posters
John Kisch and Edward Mapp
An important book that unearths the suppressed history of pre-'70s black cinema, a diverse artistic legacy as old as film itself. Most of the films synopsized here are near-impossible to see (many no longer exist), but the gorgeous posters (with evocative titles like "I Crossed the Color Line," "The World, the Flesh and the Devil" and "It Won't Rub Off, Baby") are completely satisfying in themselves. **MG**
$20.00 *(PB/168/Illus)*

The Sixties: The Art, Attitudes, Politics and Media of Our Most Explosive Decade
Edited by Gerald Howard
Original writings from (and about) the Pop

decade. Calvin Tomkins in "Raggedy Andy," 1976: "Andy called up Charles Lisanby one day in 1962. 'Listen,' he said, 'There's something new we're starting. It's called Pop Art, and you better get in on it because you can do it, too.' Lisanby thought Andy was putting him on. Oddly enough, the whole thing happened so fast that Andy himself almost didn't get in on it." Warren Hinckle in *Ramparts*, 1967: "Dr. Leary claims to have launched the first indigenous religion in America. That may very well be, though as a religious leader he is Aimee Semple McPherson in drag. Dr. Leary, who identifies himself as a 'prophet,' recently played the Bay Area in his LSD road show, where he sold $4 seats to lots of squares but few hippies (Dr. Leary's pitch is to the straight world), showed a Technicolor movie billed as simulating an LSD experience (it was big on close-ups of enlarged blood vessels), burned incense, dressed like a holy man in white cotton pajamas, and told everybody to 'turn on, tune in, and drop out.'" Albert Goldman, *New American Review* No. 3, 1968: "A discotheque like the Electric Circus is a votive temple to the electronic muse, crammed with offerings from all her devotees. The patterns on the wall derive from Pop and Op Art; the circus acts are Dada and camp; the costumes of the dancers are Mod and hippie; the technology is the most successful realization to date-of the ideal of 'art and engineering'; the milieu as a whole is psychedelic, and the discotheque is itself a prime example of mixed-media or total-environment art." Plus Tom Wolfe on "The Girl of the Year," Eldridge Cleaver from *Soul on Ice*, Susan Sontag on "One Culture and the New Sensibility," R.D. Laing from *The Politics of Experience*, Marshall McLuhan from *Understanding Media: The Extensions of Man*, and Pauline Kael on *Bonnie and Clyde*. Read it quick, though, Oliver Stone has almost sucked it dry. **GR**
$14.95 *(PB/527/Illus)*

Sleazy Business: A Pictoral History of Exploitation Tabloids, 1959-1974
Alan Betrock
"*Sleazy Business* is an attempt to cover all known exploitation tabloids of the years 1959-1974 and show a sampling of their representative covers, along with a bit of history and an evaluation of each title. Few people realize the number, the style and the

content of these numerous papers as few examples exist today. It is true that these tabloids, published some 20 to 30 years ago, were more explicit and graphic than just about anything mass marketed today, and they remain an important part of exploitation publishing history."

These publishers seem to cater to the collectible paper market, and seem to know about every obscure title's history and have a lurid example of each. Since the tabs were often regional, printed on the cheap and considered disposable, this is a truly impressive collection. The bulk of the book consists of several cover pages from each tabloid. The introduction is a well-written overview of the circumstances that helped these publications flourish. **SA**

$14.95 *(PB/128/Illus)*

Snowdomes
Nancy McMichael
Offering encapsulated enchantment, snowdomes have provided a microcosm of the world as we knew it, or as we dreamed it could be. *Snowdomes* provides a charmed overview of the history and art, be it high or low, of this cultural fixture. Virtually anything can be depicted, celebrated or denigrated within the tidy confines of the snowdome. The introduction provides a brief, fact-filled history of snowdomes, from their first sightings in Paris in the 1870s to the German masters to their entry into the North American market.

Interesting facts revealed within this text are that some manufacturers use bone chips as snow and that many domes add antifreeze to the water to prevent freezing during shipping. Also noted is an episode in which the U.S. government imposed an

Religious snowdome — from **Snowdomes**

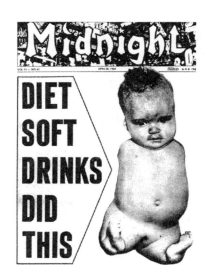

Tabloid cover — from **Sleazy Business**

embargo on snowdomes imported from Hong Kong during the 1960s when it was discovered that untreated and highly-polluted water directly from Hong Kong's harbor was used to fill these domes.

In 95 full-color pages, *Snowdomes* depicts approximately 400 different snowdomes in all their glory. The domes are organized thematically: famous sights, advertising, special events, Christmas, the world at war, animals, childhood themes and more. An especially fine section is devoted to religious-themed snowdomes, which provide a virtual Bible under glass. Especially notable are a Dadaesque eye snowdome and one featuring a rooster atop a base which reads: "Nicarbazin Can Cut Mortality to Zero." **JAT**

$24.95 *(PB/96/Illus)*

Soul Music A-Z
Hugh Gregory
Some serious lapses in judgment (or taste?) here, like why are people like Hall and Oates and Mariah Carey included while Rotary Connection and the Three Degrees are missing? And most of the pictures suck, but it's well written, and there's some good dirt. Did you know that low-down Miss Millie Jackson ran away from home at 14 and worked as a "model" (read: HO!) in New York? **MG**

$17.95 *(PB/344)*

Space Daze: The History and Mystery of Electronic Ambient

Space Rock
Dave Thompson
Was Hawkwind the first "space rock" band? Twink, part-time drummer for both the Pink Fairies and Hawkwind, says it was the Pink Fairies. In any case, both bands blazed the space-rock trail. The Round House, a disused railway station in North London was the birthplace of space rock, and Hawkwind played at many huge "happenings" there. This book follows the band's many member changes, ongoing live shows, influence on a flood of space bands (including Syd Barrett's Pink Floyd with "Instellar Overdrive") and discusses questions about atmosphere, lyrics and what qualifies as space rock. Other bands and their influences on space rock and ambient music are mentioned as well: Amon Düül, Gong, Can, Neu!, Kraftwerk, Roxy Music, Eno, Legendary Pink Dots, to name but a few. The book ends up with a discussion of current space projects such as new Hawkwind/Nik Turner solo projects and Steve Hillage from Gong, and his involvement with The Orb. Includes a huge discography.

DW

$20.98 *(PB/147/Illus)*

Speak Low (When You Speak Love): The Letters of Kurt Weill and Lotte Lenya
Edited by Lys Symonette and Kim H. Kowalke
"Today I give you a present: me. You take this present without qualms; it will bring you only good things. Let me be your 'pleasure boy' [*Lustknabe*], more than a friend but less than a husband. I'm in the world for you—that is self-evident, and you don't need to feel obligated. You'll now sense it. Give me just a small sign that you accept the present. Please."

They were an unlikely couple. He was a short, prematurely balding, German cantor's son with thick glasses that she thought made him look like a mathematics professor, and she was an Austrian Catholic coachman's daughter, two years older and poorly educated. Escaping from an abusive father, she became a prostitute and then a would-be dancer turned actress in Zurich. Weill and Lenya needed one another on a "creative" level which defied ordinary emotional, erotic, or professional bounds. Their relationship always remained both tenacious and tumultuous, open to and always surviving many secondary sexual and

romantic relationships.

Speak Low compiles the 375 letters, 18 postcards and 17 telegrams that survive; 296 from Weill to Lenya and 114 from Lenya to Weill. This deluxe edition also includes an autobiographical fragment of Lenya's pre-Weill years and a postscript which focuses on her years as the Widow Weill, when she established herself as his leading interpreter and guaranteed the preservation of his memory. Also included is a listing of their pet names for each other, a biographical glossary, an index of names, an index of works by Weill and an index of works by others. **JAT**
$39.95 *(HB/615/Illus)*

Staging Fascism: 18BL and the Theater of Masses for Masses
Jeffrey T. Schnapp
"On an April evening in 1934, on the left bank of the River Arno in Florence before twenty thousand spectators, the mass spectacle *18BL* was presented, involving two thousand amateur actors, an air squadron, one infantry and cavalry brigade, fifty trucks (18BL was the model number of the first truck to be mass-produced by Fiat), four field and machine gun batteries, ten field-radio stations, and six photoelectric units. However titanic its scale, *18BL*'s ambitions were even greater: to institute a revolutionary fascist theater of the future, a modern theater of and for the masses that would end, once and for all, the crisis of the bourgeois theater. This is the complete story of *18BL*, a direct response to an April 1933 speech by Mussolini, who called for the creation of a distinctively fascist 'theater for twenty thousand spectators.'"
$16.95 *(PB/234/Illus)*

Struwwelpeter: In English Translation
Heinrich Hoffmann
"Presents a collection of German cautionary tales, featuring such characters as Shock-Headed Peter, Cruel Frederick, Little Suck-a-Thumb, and the Inky Boys. Includes a brief biography of the author."
$5.95 *(PB/31/Illus)*

Subculture: The Meaning of Style
Dick Hebdige
Besides being one of the first books to undertake a comprehensive analysis of sub-cultural style in postwar Britain, it remains by far one of the most insightful. *Subculture* opens and closes on the figure of Jean Genet, imprisoned, as he fashions a shrine to the criminal element from contraband photos mounted on cardboard regulation sheets and adorned with wire and beads originally meant for the decoration of funeral wreaths. His particular aptitude for subversion—turning the scavenged bric-a-brac of an authoritarian culture against itself, rerouting its semiotic apparatus to suit some fringe cause or desire—is paradigmatic of subcultural strategy in general, according to Hebdige. In Genet's work, the author also discovers all the key themes of working-class youth culture: "The status and meaning of revolt, the idea of style as a form of Refusal, [and] the elevation of crime into art." It's what they all hold in common, the hipsters, Beats and Teddy Boys, the Mods and skinheads, the glitter and glam rockers, the punks and the Rastafarians. Hebdige proposes style as a Freudian dream-work, rife with elements of condensation and displacement; or a bricolage reworking the anarchic compositional techniques of the Dadaists and Surrealists. No longer new ideas, admittedly, although they were when he first wrote them down. **JT**
$14.95 *(PB/195)*

A photograph of Lenya from about 1941 that confirms Weill's argument against cosmetic surgery: "Your teeth lend character to your face just as they are and certainly enhance your personality on stage." — from **Speak Low**

Tales of the Iron Road: My Life as King of the Hoboes
"Steam Train" Maury Graham and Robert A. Hemming
"Steam Train" first hopped a freight in 1931, and hasn't looked back since. His wanderings have taken him into America's hobo jungles and railway yards, traveling the tracks in boxcars with partners like "Slow Motion Shorty," "Fry Pan Jack" and "Hood River Blackie." In his life of traveling, he has experienced danger, uncertainty and cold, all fueled by hobo stew (he offers his personal recipe). He is the permanent Hobo King of the East, and he has been elected five times as the King of the Hoboes. "Steam Train" has become a famous spokesman for a vanishing way of life. **SC**
$12.95 *(PB/222/Illus)*

The Tapestry of Delights: The Comprehensive Guide to British Music of the Beat, R & B, Psychedelic and Progressive Eras
Vernon Joynson
This encyclopedia of British pop and rock is very specific about what it covers (1963-1976) and for the sake of defining an area of coverage, it excludes early '60s instrumental combos and any punk or industrial groups which were starting up in 1976 and which the author sees as the beginning of a new era. Given those parameters, the author has done a mind-boggling job of managing to document nearly everything committed to vinyl by British artists (as well as others like Jimi Hendrix and Gong, whose careers were based largely in England) during the specified dates. Listings include the personnel (including guest musicians on albums), title, U.K. catalog number, year of release and highest chart placement where applicable. **SA**
$45.00 *(PB/600/Illus)*

Television Horror Movie Hosts: 68 Vampires, Mad Scientists and Other Denizens of the Late-Night Airwaves Examined and Interviewed
Elena M. Watson
$32.50 *(HB/256/Illus)*

SCRATCH'N'SNIFF

Television Theme Recordings: An Illustrated Discography, 1951-1994
Steve Gelfand

Flipping through this alphabetical guide to TV theme music can be a mind-wrenching experience for the dedicated vinyl wiseguy. Some of the greatest music of the 20th century was recorded to accompany the mass worship of the "eye of hell"—Henry Mancini's "Peter Gunn Theme," Nelson Riddle's "Route 66," Neil Diamond's "I'm A Believer," The Ventures' "Hawaii Five-O Theme" and Lalo Schifrin's "Mission: Impossible Theme," to name but a few—but what about "Kaptain Kool and the Kongs," "Makin' It," "The New Zoo Revue" and "H.R. Pufnstuf"? Yes, they're all here too-annotated, price-coded, and waiting for your disposable income. **SS**
$75.00 *(HB/332/Illus)*

Banana Splits *Cast Photo — from* **Television Theme Recordings**

Thames and Hudson Encyclopedia of Twentieth-Century Music
Paul Griffiths

A useful, compact and, except for a number of omissions, comprehensive reference guide to what has been Western classicism's most musically explosive century-and it's not over yet.

This deceptively tiny book contains basic information on: 500 composers from 30 countries (not all the greats but a whole lot of them including Mauricio Kagel, Steve Reich, Claude Debussy, John Cage, Pierre Schaefer, Karlheinz Stockhausen, Alvin Lucier, Oliver Messiaen, LaMonte Young, Iannis Xenakis, Krzysztof Penderecki, Edgard Varese, Igor Stravinsky, Harry Partch, Arnold Schoenberg, Pierre Henry); their major works (*Hymnen* and almost any other Stockhausen composition you can name, Varèse's *Poeme Electronique*, Ligeti's *Atmospheres*); important musical techniques and styles (Futurism, chance operations, dada, intuitive music, serialism, musique concrete, Fluxus, minimalism); elements and definitions (noise, organized sound, envelopes, resonance); performers (Aloys Kontarsky, AMM, Wilhelm Furtwangler, Musica Eletronica Viva); instruments (Russolo's intonarumori, the theremin, ring modulator, trautonium); institutions (Westdeutscher Rundfunk, Groupe de Recherches Musicales, Columbia

Princeton Electronic Music Center); and "other people" (Jean Cocteau, Robert Moog). **DB**
$12.95 *(PB/207/Illus)*

That's Blaxploitation! Black Badass Pop Culture of the 1970s
Darius James

"*That's Blaxploitation!* is not an exhaustive, encyclopedic or definitive work on the era and its films. Nor does it pretend to be. What it really is, is a celebration and a memoir with loads of unlawfully sarcastic 'film comments'; hundreds of mediocre reproductions of black-and-white movie stills; bizarre, self-serving interviews; smutty comics; parodies; and promotional books of the era's most popular films."

Clutching that caveat firmly in your craw, this book can be a hoot. It has more to do with the aesthetic of zines (imagine Lisa Carver's *Rollerderby*, only male and black) than serious film studies. It's completely subjective and personal, which can be its greatest charm if not taken as a work of great thoroughness or scholarship. It looks messy and homemade, but then so do some of the best and funniest zines.

Among the topics that are tackled by this "tome" are: *Shaft*, Fred "the Hammer" Williamson, Jim Brown, Jim Kelly, Fab Five Freddy, pimps, Ralph Bakshi; interviews with Melvin Van Peebles, Pam Grier, Antonio Fargas, Iceberg Slim, Pedro Bell (P-Funk car-

toonist) and the Last Poets. **SA**
$14.95 *(PB/195/Illus)*

The Trouble With Cinderella: An Outline of Identity
Artie Shaw

Written by one of the finest clarinetists in the history of jazz, Artie Shaw's words swing with an eloquence that is nothing short of brilliant. A dominant theme which emerges is the story of a man whose gift for music which heartened and energized a troubled nation masked his very American struggle with identity (Shaw is a name he adopted to hide his Jewish heritage). Shaw's perspective is clearly focused and refined. No sucker punches here. A true philosophical investigation into a life of travel on all continents and meetings with people of all ranks, colors and prestige. Shaw should be viewed not only as a talented clarinetist but also a writer filled with majestic verse. Shaw's is a life fully realized, in which he overcame many trials, often through his sheer persistence alone. A grand persona who clocked and valued thousands of unforgettable, frozen moments. **OAA**
$12.95 *(PB/394/Illus)*

Total Television
Alexander McNeil

Total Television is perhaps the most complete guide available on American television. Offering listings on over 5,400 series

from 1948 through 1995, this resource provides a treasure trove of fascinating lore and minutiae about TV and, in the process, about American popular culture. Each series listing reports the air dates, the network affiliation, and a summary of the show's premise and significant cast members. The level of detail is admirable. For instance, it notes that Don Hornsby, the original host of *Broadway Open House*, died of polio within two weeks of its original airing in 1950; that Barbara Colby of *Phyllis* was found murdered after three episodes of her show; and that *Pick and Pat*, which aired briefly in 1949, was the only variety show that regularly featured minstrel acts.

Of added interest is a listing of noteworthy specials, detailed charts showing the prime-time schedules for the networks by season, a summary of Peabody and Emmy award winners, a recap of the highest rated programs from 1949 through 1995, and an index of 19,000 personalities, which will allow the reader to check out the credits of their favorite TV entertainers. **JAT**
$22.95 *(PB/1251)*

Towards a Cosmic Music
Karlheinz Stockhausen
Stockhausen was the first composer to publish a musical score using electronic notation. This 1989 volume, his first collection of writings to appear in English in 20 years, juxtaposes interviews and essays with a superb chronology of the composer's works up through 1988. Like the radically different styles in Stockhausen's music, this book goes "beyond global village polyphony" into "intuitive music," "suprahumanization" and "synthesis" toward an integration of the senses in "Light: The Summation," which focuses on Stockhausen's *gesamkunstwerk*, the seven-opera cycle called "Light," with a different full-length work for each day of the week, that is due to be completed by the end of this century. **MS**
$15.95 *(PB/146)*

A Trip to the Light Fantastic: Travels With a Mexican Circus
Katie Hickman
Two kinds of people write books on the circus and carnivals: those who are with it (like Dan Mannix or Jim Rose) and those who wish they were. This is a better example of the latter category. British travel writer Katie Hickman and her photographer

husband, Tom, joined a small Mexican family circus, Circo Bell, that traces its origins back to an illegitimate son of the famous clown Richard Bell. Their logo is the label for Bell's Whiskey, and they recycle *Raiders of the Lost Ark* soundtracks for their theme music.

The troupe includes clowns, aerialists and an *equilibrista* (balancing act), and Katie eventually joins in as an elephant rider. Few of the acts are described in any detail, as Hickman is less interested in the circus-as-performing-art and more interested in the circus as an articulation of the Mexican spirit. The prose sometimes tries too hard to mimic Marquez' and Paz' magical realist style, but Hickman manages to recover with vivid observations. She describes a country of startling contrasts: a casual circus troupe without schedules and a time-obsessed Lacandon Indian, contemporary urban professionals and the last survivor of Pancho Villa's Dorado honor guards, ancient pyramids and Mexico City shopping mall parking lots, and the circus' respected matriarch and a maliciously raped dancing girl. While Hickman's initial goal is to describe Mexico, Circo Bell's wanderlust, self-sufficient community and quixotic commitment to perfor-

Shaft Among the Jews book cover — from That's Blaxploitation

mance illustrates the universal nature of the circus itself. **RP**
$12.00 *(PB/308/Illus)*

Turn Me On, Dead Man: The Complete Story of the Paul McCartney Death Hoax
Andru J. Reeve
The timing was right. Paul had been spending all his time with his just-increased family and not doing interviews to keep himself in the press. Deep into the religion of British rock, American college students were on acid and ready for a new post-Kennedy conspiracy to sink their teeth into. So when "Tom" called a Detroit rock-talk radio show and repeated an old British rumor that the cute Beatle had been killed in a car wreck and replaced with a look-alike and that the Beatles had planted "clues" all over their songs and record covers, a college newspaper reporter heard this and ran a hoax story about the "tragedy" (years in advance of Negativland's ax murder hoax!), and something clicked. Every wire service ran the "story," and "backward masking" was upon us forever. With feet completely on the ground, the book sensibly follows how the rumor spread and then looks at and debunks the main "clues" in the legend. The obscure "John started it as revenge for the 'bigger than Jesus'" debacle is enjoyably mentioned—and in the book's only nod toward conspiracy, the author concludes most bizarrely by questioning rocker Terry Knight's audience with Paul at Apple Corps UK, and Maclen Music's subsequent song publishing of Knight's Capitol Records 45 in the U.S. called "Saint Paul." **MS**
$40.00 *(HB/224/Illus)*

The TV Arab
Jack G. Shaheen
From cliché to archetype, mass media style. Born into a working, middle-class Arab/American family in 1950s Pittsburgh, "We never experienced the sting of today's ethnic slurs," says the author, who cites how the Arab world is shafted in hundreds of popular TV shows, from *Johnny Quest* to *Scooby Doo*, from *Cannon* to *Cagney and Lacey*, from PBS documentaries to CBS reports. The author interviews major television producers, and, embarassed, they cop to the medium's "painting minorities with a broad brush.... Television is shorthand," they say. Here's proof. **GR**
$11.95 *(PB/146/Illus)*

TV Toys and the Shows That Inspired Them

Cynthia Boris Lijeblad

Toys and games, etc., based on characters from '60s and '70s TV shows. The book is chock-full of pictures of cult toys from shows like *The Munsters*, *Star Trek* (of course!) and *The Man from U.N.C.L.E.*, and tells what the toys are worth today in three separate collectible conditions: mint, excellent, good. Complete with names of collectors, toy dealers' and fan club addresses, and online collecting info. **DW**
$19.95 *(PB/224/Illus)*

The Twilight Zone Companion

Marc Scott Zicree

Who can forget: Inger Stevens picks up Death as a hitchhiker! The three-armed Martian meets the three-eyed Venusian! Beauty is ugly in "The Eye of the Beholder"! "It's a good thing you did"! The last man on Earth finally has time to read—then he breaks his glasses! William Shatner and the fortune-telling Devil! "TO SERVE MAN—It's a cookbook"! The dummy that becomes human! "Nightmare at 20,000 Feet!" The little girl who rolls under her bed and into another dimension! The airliner that goes back in time! "Room for one more, honey!" "Five Characters in Search of an Exit!" Agnes Moorhead fighting the little aliens! "A Most Unusual Camera!" Mr. Dingle's Martians! Mr. Bevis and the angel! "Come back, Bunny, we need you!" Anne Francis turns into a Dummy! Monsters on Maple Street! "A Stop at Willoughby!" They're all here, every episode, including Rod Serling's intros. Plus dialog passages from the scripts, production history and bios of such contributing writers as Beaumont, Matheson, and of course, Serling. **GR**
$15.95 *(PB/466/Illus)*

Unseen America: The Greatest Cult Exploitation Magazines, 1950-1966

Alan Betrock

Lift the conservative rock of the Eisenhower years, and underneath you'll find a writhing mass of popular magazines on crime (*Police Dragnet Cases*), sex (*Peep Show*), scandal (*Shocking News*) and vice (*The Lowdown*). Hundreds of black-and-white covers are reprinted here, with brief overview. Recalls a time when *Confidential*

Love — from Waiting for the Sun

was the largest selling newsstand magazine in the country, selling 4 million copies per issue. **GR**
$13.45 *(PB/112/Illus)*

Virgil Finlay's Far Beyond

Virgil Finlay

Finlay was the king of pen-and-ink pulp illustration for over 30 years (1935 to 1970), producing more than 1,600 works. Mostly connected with *Weird Tales*, the artist's work graced many sci-fi pulps as well. This volume presents dramatic and haunting inside illustrations for various science fiction tales, with a few grotesque monsters included, and a complete set of horoscope creatures done for an astrology magazine. The cross-hatching, the stippling, the dramatic contrasts of light and dark, all the trademarks of his technique are here. His meticulously rendered worlds of fantasy and imagination still call out to be explored. **GR**
$14.95 *(PB/144/Illus)*

Virgil Finlay's Strange Science

Virgil Finlay

More brilliant pen-and-ink musings on man's struggle—the shock, surprise, pain and fear—with himself and Hell's demons. "Finlay brought a much-needed ingredient to *Weird Tales*' pages," says magazine alumni Robert Bloch. "Glamor. In contrast to the smudgy scrawls of all too many of his predecessors, he offered a crisp clarity and dazzling detail of design which elevated illustration to the level of true art." **GR**
$14.95 *(PB/160/Illus)*

Viva Las Vegas: After-Hours Architecture

Alan Hess

How Vegas was built, from the Meadows Club in 1931, to the Flamingo in 1946, up to the Mirage in 1989. "In all those streamlined façades, in all those flamboyant entrances and deliberately bizarre decorative effects, those cheerfully self-assertive masses of color and light and movement

that clash roughly with the old and traditional, there are certain underlining characteristics which suggest that we are confronted not by a debased and cheapened art, but a kind of folk art in mid 20th-century garb." Or, as one wag puts it: "'They begin to become art ... or psychiatry!'" **G R** **$18.95** *(PB/128/Illus)*

Waiting for the Sun: Strange Days, Weird Scenes and the Sound of Los Angeles
Barney Hoskyns
Taking off from the Central Avenue jazz clubs of the '40s and touching back down just south of there to witness the emergence of gangsta rap in the early '90s, this is one Brit's overview of the musical culture of "the city of night." Odd brackets, to be sure—The Bird and Ice Cube—to this predominantly lily-white musical journey. It is a point not lost on the author, who works in a *City of Quartz* type of analysis of the class conflict and racial tensions simmering just beneath the music's affable exterior. Here again is that irresistible sunshine/noir dialectic, eliciting expressions as diverse as those of the Beach Boys, Steely Dan and Black Flag, all of whom attempted at one time or another to sum things up with respect to the sublime and apocalyptically abject dream that is L.A. For the author, the best So-Cal songs are slick, lushly produced and orchestrated, outwardly beautiful yet at the same time haunted by their own hollowness. Just like your basic Angeleno, that is. As Hoskyns sees it, the music is just as narcissistic and self-destructive, and is a kind of potlatch of sumptuous, ostentatious surfaces erected solely to be stripped away. Hoskins really hits his stride discussing the Laurel Canyon singer-songwriter syndrome of the early '70s, for instance, while his appraisal of L.A. punk seems rushed and cursory, and rap even more so. Not scary enough, perhaps—at least not compared to the confessional balladeering of James Taylor or Jackson Browne, the studio epiphanies of Phil Spector or Brian Wilson, or the psycho-delicized ramblings of Arthur Lee or Kim Fowley. **JT**
$27.50 *(HB/384/Illus)*

White on Black: Images of Africa and Blacks in

Western Popular Culture
Jan Nederveen Pieterse
Collectors of negrobilia (hello, Whoopi Goldberg), take note. This compelling visual history charts the development of Western stereotypes of black people over the last 200 years and examines how caricature, humor and parody are used as insidious instruments of oppression in commerce and advertising. Read it, then throw out that box of Darkie toothpaste! **MG**
$35.00 *(HB/260/Illus)*

Why Do They Call It Topeka? How Places Got Their Names—Cities, States, Countries, Continents, Oceans, Mountains and More
John W. Pursell
"Bunkie, Louisiana: Colonel A.A. Haas, the founder of the town, once gave his daughter a mechanical monkey that he had bought for her when he made a trip to New Orleans. His daughter, Maccie, could not pronounce monkey, so she called the toy Bunkie. Later, when the town was officially incorporated in 1885, her father, in a capricious moment . . ." You get the picture. *'Ropeka* is the Dakota Indian word for "good place to dig potatoes." **G R**
$9.95 *(PB/241)*

Will Pop Eat Itself? Pop Music in the Soundbite Era
Jeremy J. Beadle
This book gets off to a splendid start. The first three chapters illustrate the history of music and literature and how they came to be "modern." Cases are made for the precedent of "recycling" in music and literature long before sampling technology and the cut-up method of William Burroughs. The whole concept of recorded music is subjected to recontextualization (for instance, whereas the early recordings of Caruso were souvenirs of a live performance, later operatic recordings were never intended to be simulacra of live performances). Beadle explores the impact of technology on such bands as the Beatles and the Beach Boys and provides an overview of the history of black music leading up to the advent of rap, then comments on current times in which recordings are the end product of samplers, soundbites, collages and lawsuits. The author then visits a modern recording studio where he creates a track using mixers and samplers and does a great job of

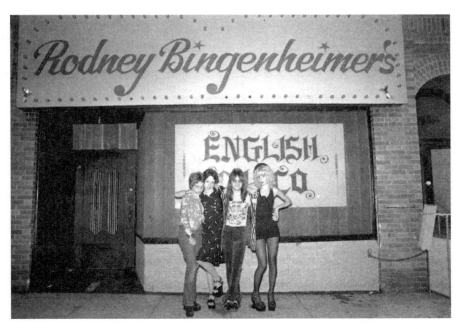

Rodney outside the English Disco with Mackenzie Phillips (second from left) and Sable Starr (right) — from Waiting for the Sun

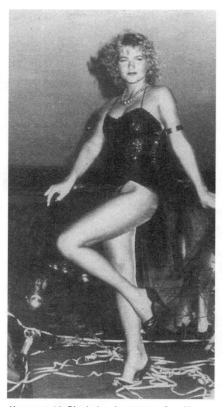
describing the whole process in lay terms.

A case involving the KLF (Kopyrite Liberation Front), in which the use of an ABBA sample led to the court-mandated destruction of all existing copies of the record in question, segues into a rather precise account of the KLF and their various contemporaries in the British dance music scene between the years 1988 and 1992. This final section becomes frustrating since the legal situation is in a constant state of flux and these bands were not making the great artistic strides in their use of sampling technology. **SA**
$12.95 *(PB/269)*

Wireless Imagination: Sound, Radio and the Avant-Garde

Edited by Douglas Kahn and Gregory Whitehead
Titled after an essay by the founder of Italian Futurism, F.T. Marinetti, this sleek volume comprises a selection of early artistic responses to the audio and radiophonic technologies—several composed on or about the time of these developments—interspersed with corresponding analyses and theoretical appraisals from some of the leading voices of the so-called new music and radio arts. The editors identify their subject as "sound art," which is neither songs, symphonies nor any of the more conventional modes of sound production and broadcasting. Rather than attempt an exhaustive survey of this admittedly narrow field, they instead visit and revisit certain key themes which have attended the automation of sound from the start, and which continue to exert a profound influence over present-day creators. The first of these themes is proposed by writer Raymond Roussel, who instinctively identified the record/playback relay as a form of reanimation—a machine for returning the voice of the dead. Accordingly, Roussel's book *Locus Solus* is interpreted as a series of bodily metaphors for the inscription, reproduction and transmission of sound.

Synaesthesia is another recurring concept—an *idée fixe* among the Surrealists, who produced very little soundwork per se, but employed the technology of recording in the most general sense as a model for the operations of the unconscious. Their primary modus of automatic writing is only the most striking example of the sort of technical incorporations which fill these pages.

Xuxa, age 19, Rio de Janeiro, 1982 — from **Xuxa**

The mind as machine, the machine as mind—the prosthetic motif works both ways. From the chance compositions of Marcel Duchamp to the narrative cut-ups of William Burroughs by way of the Russian Constructivists and their dream of a vast aural archive, the lock-and-key symbiosis between phonographic disc/magnetic tape/wireless transmitter and human consciousness is subjected to all kinds of tinkering, a series of experiments aimed at nothing less than a total overhaul of the human psyche. **JT**
$17.95 *(HB/452)*

Wolvertoons: The Art of Basil Wolverton

Edited by Dick Voll
"Wolvertoons is a distillation of the finest work ever done by comic art's greatest master of absurd exaggeration, and as such it may well be the most outrageous display of cartoon art ever assembled, as Basil Wolverton was to comic ugliness what Alberto Vargas was to female beauty in art."
$19.95 *(PB/134/Illus)*

Xuxa: The Mega-Marketing of Gender, Race and Modernity

Amelia Simpson
"Xuxa (SHOO-sha), a former *Playboy* model and soft-porn movie actress, is Brazil's mass-media megastar whose children's television show reaches millions of people in Latin America and the United States. Simpson explores how the blond sex symbol emerged in the 1980s to become a cultural icon of extraordinary authority throughout the Americas. . . . In exploring the meaning behind the myth that is Xuxa, the author examines the ingredients of her stardom, including her long-term relationship with Brazil's soccer idol, Pelé, and the careful manufacture of a sexually suggestive style juxtaposed with juvenile entertainment."
$14.95 *(PB/238/Illus)*

Yesterday's Tomorrows: Past Visions of the American Future

Joseph J. Corn and Brian Horrigan
The best thing about the popular visions of the future was, they promised that the future was going to be FUN. Whopping, Jules Vernian, amazing, eye-popping FUN. Cars that turn into airplanes, rocket packs, flying hot dog stands, two-way wrist televisions, monorails whizzing through massive metropolises, airplanes the size of steamships. Clean, effortless, streamlined, Jetsons-style F-U-N. And anybody could play the future game: "In 1894, an obscure socialist named King Camp Gillette published a curious utopian tract, *The Human Drift*, in which he outlined his vision of utopia. Gillette prescribed for the future an astonishing collection of 40,000 skyscrapers, clustered together in one grand 'Metropolis' near Niagara Falls. Built around vast atriums covered over with huge glass skylights, the steel-framed buildings would house most of the North American population in cooperative apartments. . . . Within a few years, however, Gillette's socialist future was a thing of the past, as he turned to perfecting the invention that was to bring him lasting fame in the annals of capitalism—the safety razor." **GR**
$24.95 *(PB/158/Illus)*

Yo' Mama

Snap C. Pop and Kid Rank
American slaves were punished severely for fighting among themselves. To relieve ten-

sion and keep wits sharp, they created a mental exercise, based on trading insults, called Dozens, referring to groups of substandard slaves who were sold in lots of twelve. Given that sons were often separated from their mothers and sold off to other plantations, memories of Mama were considered to be precious. Mamas became the subjects of the ultimate insults, creating the most impact. Once mentioned, there was no going back. All jibes were going to include "Yo' Mama" from then on.

The Dozens has survived by being passed down from generation to generation as a social ritual. Today the Dozens is considered mainstream among African-Americans and other populations, and has been popularized in the media. It is a means of settling conflicts without violence, releasing tension and establishing a pecking order. It is known today by many names including ranking, sapping, busting, capping and slamming. Rules vary from 'hood to 'hood. **CF**
$8.00 *(PB/128)*

Mo' Yo Mama
Snap C. Pop and Kid Rank
The last part of *Yo Mama* asked for quotes from readers and personal slams, and included an original authorship-and-release form to be used for upcoming books for which the contributors would receive credit. Most of this book consists of the authors' own busts on mothers commenting on their appearance ("Yo' mama's so fat she influences the tides") and intelligence ("Yo' mama's so dumb she has to take off her blouse to count to two"), as well as their personalities, behavior, hygiene, sexuality, social status and body parts. Finally, the last 13 ranks are the winners of the send-in-your-own, and are some of the best. **CF**
$8.00 *(PB/120)*

Zines! Volume 1
V. Vale
Zines!, edited by V. "formerly co-publisher of RE/Search" Vale, is a collection of interviews with a selection of zine editor/publishers and one zine distributor in the now-familiar Re/Search Q-and-A format. From overeducated thrift shop aficionados and a connoisseur of Ike-era sexual stereotyping to insurgent teen riot grrrls, *Zines!* profiles some of the quirky personalities behind the xeroxed, self-publishing boom. A high-powered, back-of-the-envelope socioeconomic analysis of the global zine situation (now

also a steppingstone to hip, corporate website employment) is provided by Ramsay Kanaan from the anarchist publishing and distribution cooperative AK.

Part of the appeal of a zine is obtaining some very personal insights from people you might never meet (or get up close and personal with anyway) in the usual course of events. While *Zines!* doesn't offer the libido-dripping cultural musings of horn-dogger extraordinaire Lisa Carver (*Rollerderby*) or the turbo-charged venom of *Answer Me!*'s Jim and Debbie Goad, it does provide some knowing words of wisdom from Ask Gear Queen of *Fat Girl*—the zine-organ of the dyke "thunder-thighs" sexual-liberation collective of the same name—on ass-wiping for the big-is-beautiful set: "The basic problem is a species design flaw. Arms don't grow longer as needed. As the depth of your body grows the distance from armpit over belly to asshole increases, and there comes a point where your hand just can't reach your asshole anymore. But fear not! Depending on the configuration of your body and the

arrangement of the toilet area in question, there are all sorts of things you can do. . . . Use something to extend your reach. It can be anything that is long enough, appropriately soft and absorbent, and washable and disposable. I remember women at the NAAFA gathering suggesting the kind of kitchen pot scrubbers with a foam head and hollow handle designed for liquid soap."
SS
$18.99 *(PB/184/Illus)*

Zines! Volume 2— Incendiary Interviews With Independent Publishers
V. Vale
Includes interviews with John Marr (*Murder Can Be Fun*), Otto von Stroheim (*Tiki News*), Dishwasher Pete, the Revolutionary Knitting Circle, and Keffo (*Temp Slave*). "Many of these interviews have a 'workers rights' slant."—V/Search
$18.99 *(PB/184/Illus)*

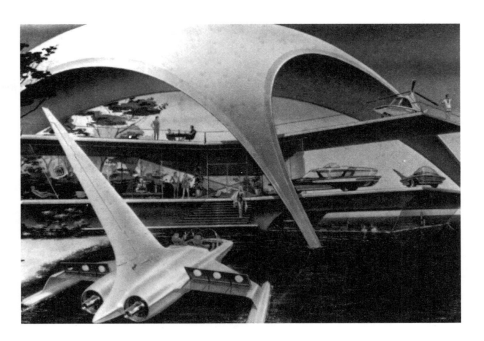

Jim Powers, Ford Motors Company, 1956. In this painting of a "Holiday Resort of the Year 2000," guests arrive by land, water and air. This kind of rendering was not intended to be really predictive of life in the future; rather it was an imaginative exercise to generate new forms or ideas that might be used in the automobile design process. Some aspect of the painting, such as the shape of the taillight or the cut of a fin, might inspire details on future production cars. — from **Yesterday's Tomorrows**

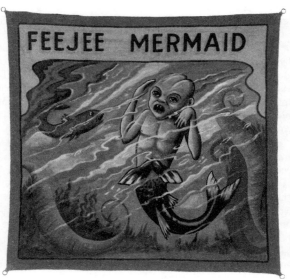

Carnival banner — from Freaks, Geeks and Strange Girls

Freak Show: Sideshow Banner Art

Carl Hammer and Gideon Bosker
Circus art as entertainment, chattering, luring and sizzling the dollars out of patrons' pockets. "With its retina-searing colors, freak appeal and bombastic reconstructions of human and animal anatomy, the circus sideshow banner preyed on our inexhaustible curiosity to come face to face with the grotesque and the unimaginable." Banners from the late 19th to the early 20th centuries include: "The Sword Swallower!" "The Alligator Man!" "Priscilla, the Monkey Girl!" "Woman Changing to Stone!" "Popeye!" "Iron Tongued Marvel! The Great Waldo!" (A talented "ingestor" from Germany, he could "gobble objects of unusual size, including lemons and mangos, which he then regurgitated on demand.") An entirely different assortment of banners than presented in *Freaks, Geeks, and Strange Girls*. **GR**
$30.00 *(PB/96/Illus)*

Freaks: We Who Are Not As Others

Daniel P. Mannix
Daniel Mannix is the author of the classic Ballantine sado-historical paperbacks *Those About To Die* (a vivid account of the Roman gladiatorial games), *The Hellfire Club* (about the blasphemous and decadent English secret orgy society) and the aptly titled *History of Torture*. Long fascinated by the carny life and an experienced sword-swallower and fire-eater (see his *Memoirs of a Sword-Swallower*), Mannix did not get around to completing his book on freaks (originally titled *We Who Are Not As Others*) until 1976. It was summarily yanked by the original publisher after only one month in print. Mannix recounts with love and respect the life stories of Prince Randian the human torso, Pop-eye Perry, Sealo the "Seal Boy," Johnny Eck (the legless star of Tod Browning's *Freaks*), Percilla Bejano "The Monkey Woman," Mignon "The Penguin Girl," Frank Lentini the three-legged man with "double sexual organs," fat men and fat ladies, hermaphrodites, Siamese twins, pinheads, randy midgets and other remarkable human oddities. This recent edition includes many previously unpublished photos from Mannix's personal collection. **SS**
$15.95 *(PB/124/Illus)*

Freaks, Geeks and

Strange Girls: Sideshow Banners of the Great American Midway

Randy Johnson, Jim Secreto and Teddy Varndell
"It's Alive," the banners cried from the flapping tarpaulin walls of the circus midway. They lured patrons to shell out for erotica (teasing) and exotica (foreign); two-headed creatures, human artworks tattooed from head to toe; short, tall and fat freaks; chicken-eating geeks and strange, bearded girls. "Sideshow banners document an aspect of our culture that we don't all want to face: People would (and will) flock like flies, they'll pay good money to see freaks—aberrations of nature and culture—representations of the grotesque, real or fabricated . . ." This is the midway as folk art, saved from destruction by artists and other admirers of the crudely painted banners' strong graphics, humor and lusty garishness." **JM**
$30.00 *(PB/169/Illus)*

Memoirs of a Sword Swallower

Daniel Mannix
Originally published as *Step Right Up!*, Mannix's account of life as a sword swal-

nival in the '30s is an acknowledged classic.
Who, after all, doesn't like to read about
fakirs, neon-tube swallowing, and freaks?
But even people lucky enough to own
copies of the long-out-of-print original are
going to have to run out and buy this one.
As has been often noted, the only thing
missing from the original was pictures, an
oversight the good folks at V/Search have
corrected in spades. This new edition fea-
tures dozens of photos from Mannix's
scrapbooks. Now we can finally see what
Krinko, Jolly Daisy, the Impossible Possible
and, of course, Billy the Stripper looked like.

"I probably would have never become one
of America's leading fire-eaters if Flamo the
Great hadn't happened to explode that
night in front of Krinko's Great Combined
Carnival Sideshows." **JM**
$15.99 *(PB/128/Illus)*

Nightmare Alley
William Lindsay Gresham
A chilling novel about a guy determined to
claw his way to the top of the heap no mat-
ter what. Stanton Carlisle rises from humble
sideshow magician to spiritualist reverend
who preaches to a gullible, moneyed flock
that doesn't know it's all really done with
mirrors. But his real secret is to find people's
deepest needs and fulfill them, while taking
them for everything they've got. Of course,
this being the classic carny noir novel, an
ascent must be followed by a descent and
Stanton's ride down to the bottom is a grim
piece of poetic justice with none of that
goddamned happy ending stuff they had to
stick onto the movie. After all, geeks aren't
born—they're made. **JM**
$3.50 *(PB/275)*

Shocked and Amazed! #1: 1st Amazing Issue
James Taylor
"The sideshow is the metaphor for the turn
of the millennium"—James Taylor. "This is a
book about people's motives, their drives,
their joys. It is not intended as another
exposé of the sideshow business nor as a
collection of cheap shots at the showmen
and performers who appear here."

If the *Shocked and Amazed* books are
"periodicals," as the author claims, then
they are the sort that encourages one to
collect the entire set to put into a pissy
binder in order to lord it over friends
because "these are all the original issues."

Everything but the covers is in black and
white, but that's not a major loss. There are
some great all-color titles to be had on
sideshow art. The stock in trade of *Shocked
and Amazed* are stories and information
using first rate source material. And what a
wealth of information it is!

This first volume includes James Taylor on
the true nature of sideshow publishing; an
account of Ward Hall, renowned "King of
the Sideshows"; the Supreme Court ruling
that gave the green light to sideshows; a
tour of sideshows within spitting distance
of the Big Apple; a portfolio of the work of
the photographer Kobel (a specialist in the
unusual); a piece on a lady sword swallow-
er who was immortalized by Diane Arbus; a
chapter from Jim Tully's *Circus Parade*, a
guide to sideshow lingo, a source list for
sideshow collectibles and a bibliography.
SA
$9.95 *(PB/80/Illus)*

Shocked and Amazed! #2: The Only One in the World
James Taylor
Volume 2 proves that Taylor has tapped into
a rich vein of source material. Once again,
the theme is sideshow lore. Taylor's attitude

toward his subjects is "Nobility is what you
make it." Indeed, they are treated as the
greatest nobles alive, whether they are
"playing the hand they were dealt" or pur-
veying an unusual skill. There is nothing
mean-spirited about this presentation, only
a genuine love of the unusual.

Includes: "the world's strangest married
couple" (Jeanie Tomaini, the half girl who's all
heart at 2 feet 6 inches and the American
giant Al Tomaini); a photo spread of "half peo-
ple"; the intimate lives and loves of the Hilton
sisters (Siamese twins); Sammy Ross, the
world's smallest entertainer; sideshow fat man
Bruce Snowdon; a reprint of a whole magazine
that is dedicated to midgets; a sideshow mem-
oir in the spirit of Daniel Mannix by Walt
Hudson, an in-depth look at a flea circus; a
profile of a knife thrower; assorted short fea-
tures; and more sideshow lingo. **SA**
$12.95 *(PB/104/Illus)*

Shocked and Amazed! #3: On and Off the Midway
James Taylor
Includes: "Anatomical Wonder!", "I Was a
Teenage Blockhead!", "She Never Asked To
Be Born!", "Gorilla Show!" and more.
$12.95 *(PB/104/Illus)*

Flea troupers in training — from **Shocked and Amazed!**

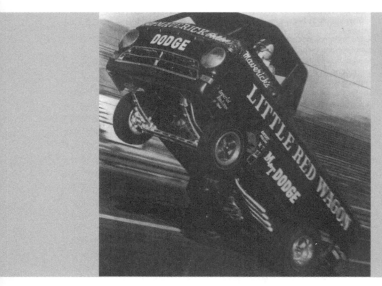

Exhibition machines like Bill Golden's "Little Red Wagon" were designed to pull the front wheels up as soon as they left the starting line and to keep them up the full quarter-mile like this. — from High Performance

Auto-Opium: A Social History of American Automobile Design
David Gartman

The art and science of car design is a cynical crock of sheet metal, a sucker's game of chrome, a stylist's laughing deceit, a jelly-bean for the sweet tooth of America's auto-buying public. Eighty years of designers and their model trends are explored here, from the clay-model magic of Harley Earl (at GM in the '20s), to the customizers' tricks appropriated by John DeLorean (with GM in the early '60s). Example: A new form of technological expressionism was advanced by designer Bill Porter (GM, late '60s): "I was interested in exploring more profound fusions of technology and design." This idea found expression in the '68 GTO, which was "free of chrome clichés but nonetheless bore the look of advanced jet aircraft in its subtly sculpted forms." The look was developed further in the 1970 Pontiac Firebird, to which Porter gave "not only an aircraft feel but also a 'muscular look,' as if the skin of the car were forced out by the mechanical strength underneath." Auto styling is all

looks and sex-fantasy—but we love it. Detroit's pencilpushers give us a rolling chance at the American Dream. **GR**
$17.95 *(PB/264/Illus)*

Barris Kustoms of the 1950s
George Barris and David Fetherston

Kings of Kustom Kulture: See Nick Matranga's chopped coupe, painted royal maroon with a gold iridescent finish. Von Dutch's pinstriping on a flamed Ford woody wagon. The "Mandarin," nosed and decked with an oval grille shell and frenched Ford headlights. Kool Kars. In the '50s you could see their work in movies like *High School Confidential* and *Hot Car Girl*. Later, in the '60s, you could see Barrismobiles on TV's *The Green Hornet* and *Batman*. "Sam and George Barris . . . epitomized customizing, and in the '50s they were at the leading edge of their craft. This portfolio of their work in that lively decade lets you examine the range of their creativity. They produced vehicles that were shapely and subtle, and also created cars whose customizing was colorful, loud, and extreme." Fully fea-

tured—in color—are the Barris brothers' legendary kustoms including the "Golden Sahara," a remade 1953 Lincoln Capri, complete with television in the front seat and a full bar in the back. It was the Barris version of a GM Dream Car, and Detroit had to take notice—they were being upstaged by "a bunch of guys in California." **GR**
$19.95 *(PB/128/Illus)*

Car Culture
Frances Basham and Bob Ughetti

This book about car culture hails from England, which gives it a certain objectivity. It also means that European cars are placed in a historical context. Included is a lot of design history and its relation to consumer priorities: "But even here, and perhaps above all here, logic and necessity play only a small part. The architectural dictum that form should follow function rarely entered the thoughts of most car designers until very recently. Their job was, and is, to stimulate and satisfy desire; to express an ideal of proportion and line, and to provide a symbol of the aspirations of the age." Roland Barthes called their work the exact

equivalent of the great Gothic cathedrals: "The supreme creation of an era, conceived with passion by unknown artists and consumed in image if not in usage by a whole population which appropriates them as purely magical objects."

A large part of the text is devoted to customizers and hotrodders and their impact on design. Even the Ant Farm's "Cadillac Ranch" logically works its way into the mix. We are introduced to the world of specialized hotrodding publications and the influence of icons like Ed "Big Daddy" Roth. Custom-car shows are described: "The quest for show points reached ludicrous heights. Cars were set on clouds of cotton wool, bathed in sympathetic light and finished in such extravagant detail that they had to be towed to the venues." The role of the car as an image in advertising and movies is scrutinized, and the automobile in fine art is also given its due, including examples by Warhol, Rauschenberg, Lichtenstein and Dali. But this very well-conceived text takes a back seat to the copious stroke-book quality photographs. Being caught actually reading the text is akin to claiming that

Ed gets to grips with the Wishbone while the Surfite progresses in the background. — from **Hot Rods** by Ed "Big Daddy" Roth

Von Dutch's father's paintbox — from **Kustom Kulture**

you're only reading that issue of *Playboy* for the articles. **SA**
$14.95 *(PB/144/Illus)*

Confessions of a Rat Fink
Ed "Big Daddy" Roth
During the "lost years" between the initial burst of fame of Ed "Big Daddy" Roth and the rediscovery of his work by the world of fine art as "Kustom Kulture," Roth became a Mormon and worked for 10 years in the sign department at Knott's Berry Farm. These

facts and many other surprises await the reader of this 1992 autobiographical memoir, which isn't chronological and is written in an idiosyncratic "hep speak" reminiscent of Lord Buckley. Mr. Roth is ultimately a decent fellow. He likes his grunge with a "G" rating. His cartoon mascot Rat Fink is no Fritz the Cat, despite his grooming and other "unsavory" habits. What Big Daddy loves most of all is cars—customizing cars and showing them off. He respects women. He dislikes loud music and air conditioning. He digs computers. He's a free spirit but a good role model (although he alludes to a past in which this wasn't always the case). He hasn't let success go to his head. He's made business mistakes. He's quick to acknowledge the contributions of others. Given the somewhat specialized presentation of the information that this book contains, it is probably best enjoyed by the true aficionado. It contains many illustrations and a special fold-out Rat Fink poster. **SA**
$12.95 *(PB/169/Illus)*

Custom Cars of the 1950s
Andy Southard and Tony Thacker
"Custom Cars of the 1950s lets you see how some of America's most innovative customs looked as they rolled out of the shops. Andy's photos include rare shots of the early East Coast custom scene and views of trendsetting West Coast customs being built and painted. Radical grills, louvered

hoods, chopped tops, pinstripes galore, and characters like Ed Roth, George and Sam Barris, and Dean Jeffries. And there's Andy himself, laying down smooth pinstripes when he's not behind the camera." 130 photographs, most of them color.
$19.95 *(PB/128/Illus)*

The GM Motorama: Dream Cars of the Fifties
Bruce Berghoff
General Motors' Motorama was a trade show which toured numerous major cities in the U.S. between 1953 and 1961. It grew out of a 1949 event staged at the Waldorf-Astoria that was billed as "Transportation Unlimited." From the very beginning, these shows had an obsessive quality about them. When it was discovered, for instance, that the Waldorf's freight elevator wouldn't hold a full-size automobile, crews were called in to disassemble and reassemble cars for display on the second floor. By the time these exhibitions had evolved into the touring Motorama shows, it was as if the presenters were attempting to transport the whole of Disneyland's Tomorrowland from city to city and staffing it with Broadway-style casts and circus performers. This is one of America's great, unique, contributions to the mass psyche of the arts. Elements of stagecraft, lighting, choreography, storytelling and multimedia effects collided into a curious spectacle the likes of which have

yet to be matched. This book is a visual feast. The cars which starred in these pageants frequently resembled spaceships on wheels. The giddy enthusiasm of the performers is set into utterly moderne pavilions. Every detail from the cantilevered platforms to the bursting-atom light fixtures conveys an optimism about "things to come" that verges on hysteria. Besides the auto enthusiasts who will immediately respond to the dream cars featured here, there is a larger audience of sociologists, set and stage designers, and futurists who will find a lot between the covers of this book. **SA**
$19.95 *(PB/136/Illus)*

Heroes of Hot Rodding: Legend and Folklore of the Men and Machines That Sparked the Flame of Hot Rods and Custom Cars
David Fetherston
"The life stories of legendary hot rodders who had the vision and skill to turn cars into speed machines and custom classics are captured here, in a series of more than 30 profiles on the real shapers of the sport of hot rodding. Their influences, their grand plans, their great successes and even their humbling failures are chronicled in this book, which contains more than 250 historic photos, many from their personal collections. *Heroes of Hot Rodding* traces the backgrounds of speed kings such as Craig Breedlove, Don Garlits, Bill and Bobby Summers, Ed Iskendarian, Vic Edelbrock and 'TV' Tommy Ivo. The book also charts the careers of great customizers such as Dean Jeffries, Ed 'Big Daddy' Roth, Joe Bailon, Tony Nancy, Gene Winfield and Bill Cushenberry. . . . Included in the profiles are descriptions and histories of their great creations, including cars like Joe Bailon's 'Miss Elegance', Dean Jeffries' 'Manta Ray', Don Garlits' 'Swamp Rat', Andy Brizio's 'Instant T', the Meyers 'Manx', Art Chrisman's 'Hustler', the Devin sports cars, Craig Breedlove's 'Spirit of America' and Bill Cushenberry's 'Silhouette.'"
$19.95 *(PB/192/Illus)*

High Performance: The Culture and Technology of Drag Racing, 1950-1990
Robert C. Post
"The fury produced by an engine on a big load of nitro is a sensation one cannot begin to convey in words," says former drag racer and now Smithsonian Institution curator Robert C. Post. A first-generation Southern California hotrodder, Post has packed *High Performance* with historical detail and personalities like "Pappy" Hart, who opened the first commercial drag strip, the first professional drag-racing star "Big Daddy" Don Garlits and his Swamp Rats; and female drag-racing superstar Shirley "Cha-Cha" Muldowney. He analyzes the American addiction to speed and presents drag racing as a "new theater of machines." Covers drag racing phenomena from aerodynamics, the Bonneville Salt Flats and the land speed record to the widespread kid-appeal of Hot Wheels and Mattel model kits. **SS**
$35.95 *(HB/417/Illus)*

Hot Rods and Cool Customs
Pat Ganahl
An excellent, thick little guide to the history and world of hot rods and custom cars. Crammed with 277 color photographs and accompanying text that take us from the "stripped and channeled" '28 Model A roadsters of the early '40's to elaborate early '60s creations. Car freaks, artists and connoisseurs of pop culture will consider this book a must-have for the killer pix alone. The author does a fine job explaining why the hot rod is a "uniquely American phenomenon." Also included is a really cool and potentially useful glossary that explains the difference between an "A-Bone," a "beater," a "T-bucket" and a "street rod." **CS**
$11.95 *(PB/336/Illus)*

The Illustrated Discography of Hot Rod Music, 1961-1965
John Blair and Stephen McPartland
Hot rod music from 1961 to 1965, with a massive amount of photos. Every page has some cool poster, 45 label or LP cover of that era. All the popular bands of the time are included: Jan and Dean, the Beach Boys, the Hondells, Davie Allen and the Arrows, et al.— as well as obscure favorites like Jekyll and Hyde's "Dracula's Drag" b/w "Frankenstein Meets the Beatles." Contains a huge index and bitchin' glossary of hot rod slang terms. This book illustrates the overlap of the surf and hot-rod genres. **DW**
$34.50 *(HB/184/Illus)*

Kustom Kulture
Von Dutch, Ed "Big Daddy" Roth, Robert Williams and Others
Check out the hyperdelic life and times of

Joaquin Arnett's "Bean Bandit" is seen here at Paradise Mesa on July 26, 1953. Race queen Bonnie Wallace presents Arnett with a trophy for top time of the day as his crew shares a laugh. — from **High Performance**

A 1959 publicity shot for Chevrolet — from **Car Culture**

Von Dutch, Ed "Big Daddy" Roth, Robert Williams and other Kustom Kar Kommandos in this thoroughly researched and lavishly illustrated exhibition catalog. Read superb essays explaining how the cultural ephemera of Southern California's hotrodders, beachcombers, surfbums, beatniks, bikerboys, cholos and glue-sniffing suburban hobbyists coalesced into the Kustom aesthetic. Gape at page after page of amazing scratch-and-sniff icons such as Ed Roth's Rat Fink, a puke-green, humunculoid rodent speed-demon. Ponder over intriguing bits of trivia (did you know that Robert Williams was raised by a lesbian couple?). And ignore the occasional pathetic or inappropriate artworks by latecomers to the genre (Judy Chicago?). The editors are also to be commended for refusing to wallow in pointless "high" versus "low" culture arguments. All in all a pretty great thing, but where is Erich Von Zipper?　**MG**
$29.95　　　　　　*(PB/95/Illus)*

Moon Equipped
David A. Fetherston
Two eyeballs are the logo for this famous racing-car parts company of the '50s and '60s, and all the hot rods and race cars of the time could be seen sporting the two

eyed decal of Moon Equipment. Dean Moon started by building hot rods behind the family restaurant (Moon Cafe) at a young age. He began hanging out at the Hula-Hut Drive-in in Whittier where the Hutters hot-rod club started, and became a member. Hot rodders from all around L.A. would go there to learn speed secrets from Moon, and eventually he officially opened shop behind the cafe, and Moon Automotive was born. With his brother Buzz he started tuning cars for money, then began working on a line of

high performance car parts such as a first big seller the Moon aluminum racing fuel tank. Other big sellers were a foot-shaped gas pedal and the famous Moon disc wheel covers. In 1957, Moon had a Disney commercial artist draw the eyes as we know them today. Then, in the early '60s, he started on a series of race cars for which the Moon name would become immortal.
DW
$19.95　　　　　　*(PB/128/Illus)*

Police Cars: A Photographic History
Monty McCord
Normally I don't like to see a police car at all, but this book is the best way to see them, in photographs. Covers the entire history of the police car, from horse-drawn patrol carriages to present-day cars with many detailed black-and-white photos. Quite a few limited-edition vehicles, as well as a Ferrari said to be "donated" by (i.e., confiscated from) local drug dealers in San Mateo, CA. Some motorcycles too.　**DW**
$14.95　　　　　　*(PB/304/Illus)*

Weird Cars
Edited by John Gunnell
The most absurd cars ever—loads of black-and-white photos of functional and not-so-functional cars of all kinds. Cars that double as boats, cars with many headlights, cars from famous films and, yes, the Oscar Mayer Wienermobiles. (The oldest known Wienermobile is a 1952 model. In 1988, six new Wienermobiles were made.) A category for every letter in the alphabet from "Artistic Autos" to "Zany Cars."　**DW**
$16.95　　　　　　*(PB/304/Illus)*

At El Mirage, Dean took the wheel of the Strokers' "C" Modified Roadster. He ran over 120 mph in the roadster in 1951. — from **Moon Equipped**

Image of Dr. Gene Scott from Werner Herzog's documentary God's Angry Man — from Last Prom #2

The Last Prom: Eclectic Esoterica for a Better Tomorrow was started by filmmaker Ralph Coon to, as he describes it, "fuel my desire to discover the undiscovered. . . . There's so many topics the 'popular media' doesn't invest time in because the mentally bankrupt masses don't care to learn about them. Well, FUCK THAT." What really distinguishes Coon from the run-of-the-mill zinester is his nose for compelling subject matter both on the scary margins of the American psyche and from deep within it. — SS

Last Prom #1: Drivers' Education Films
Ralph Coon

"Genre-exploding look at those creepy high school drivers' Ed. films we were all forced to watch as adolescents. Interviews with the directors and producers of such notorious classics as *Signal 30, Mechanized Death* and *Red Asphalt*."

$4.00 *(PB/12/Illus)*

Last Prom #2: The Weird World of Dr. Gene Scott
Ralph Coon

"Myriad information for the obsessive Dr. Scott wannabe in all of us. Learn about television's hippest theological celebrity, from his childhood encounter with Jerry Owen (a.k.a. the Walking Bible) to his riveting Stanford thesis, 'Reinhold Niebuhr's Ideal Man and Protestant Christian Education,' to his subsequent downfall at the hands of L.A.'s very own Anti-Gene Scott. Read about Werner Herzog's lost documentary about Scott, *God's Angry Man*."

$4.00 *(PB/40/Illus)*

Last Prom #3: Whispers From Space-Part One
Ralph Coon

"Part one of the *Whispers from Space* trilogy, recorded exactly as told by the spooky rantings of flying-saucer abductee Jim Nestor's skull. The saga of George Van Tassel and the Integraton."

$4.00 *(PB/20/Illus)*

Last Prom #4: Whispers from Space-Part Two
Ralph Coon

"Part two of the *Whispers from Space* trilogy. In search of Gray Barker, discoverer of the Men-in-Black, in the hills of West Virginia."

$4.00 *(PB/20/Illus)*

MANGA

Comic panels — from **National Kid**

Adolf: A Tale of the Twentieth Century
Osamu Tezuka

"Adolf is widely regarded as one of Osamu Tezuka's finest works.... Although Adolf is a work of fiction, it incorporates a great deal of well-known and not so well-known aspects of actual history. Adolf provides a perspective on World War II that is new, unusual and provocative." English-language text.
$16.95 *(PB/263/Illus)*

Crying Freeman: Portrait of a Killer
Kazuo Koike/Ryoichi Ikegami

"An Exotic/Erotic tale of murder, sex, revenge . . . and tender love!" English-language text.
$19.95 *(PB/443/Illus)*

DDT
Q-Saku
National Kid
Suehiro Maruo

Suehiro Maruo is the decadent Georges Bataille of manga. Dragging the already sex-drenched and violent Japanese comic into the furthest depths of degradation and despair, Maruo has established himself as a cult artist who has transcended the trashy "ero-manga" into gallery shows, deluxe print editions and CD covers (for John Zorn no less). In a somber twilight nightmare realm, Maruo's characters live through a thousand nights of Sodom, pictorially rendered in a brooding blend of German expressionism and 19th-century Japanese "atrocity wood-block" styles. Eyeballs explode, worms crawl, blood and shit spurt, and no orifice is left intact. Japanese-language text. **SS**
$12.95 *(PB/176/Illus)*

Dreamland Japan: Writings on Modern Manga (Japanese Comics for "Otaku")
Frederick L. Schodt

Since the 1984 publication of *Manga! Manga! The World of Japanese Comics*, manga has emerged as an odd barometer of Japanese society, an indulgence that gives away the obsessions of a people. This book, the sequel to *Manga! Manga!*, brings us up to speed on the current state of the Japanese popular mind by re-establishing manga's greater cultural context, one that seems to get divorced from the work during export. Besides an in-depth introduction to the artists, the essays cover topics as obvious as the increasing role of women manga artists and the growing popularity of manga with female audiences, the heightened sex and violence in manga, the affective quality of the work versus its mimetic characterization of Japanese life, and the idea of the crossover of the artists from primarily pictorial storytellers to literary novelists in their advanced careers.

Some uniquely Japanese issues the book delves into include the emergence of an otaku class, young people "growing up with

Comic panels — from **DDT**

unprecedented affluence and freedom of choice in a media-glutted society [yet] still being put through a factory-style educational system designed to churn out docile citizens and obedient company employees for a mass-production, heavy-industry-oriented society that had ceased to exist . . ." The author asks, "with physical and spiritual horizons seemingly so limited, who could blame these children for turning inward to a fantasy alternative."

Even more curious are the many sub-gen-res of manga. There's one, for example, that presents a parallel view of history, a serial called Adolf set in World War II which has three central characters named Adolf—one a Japanese-German, the other a Jewish-German, and Adolf Hitler himself. Another popular sub-genre is manga whose storylines revolve around homoerotic male relationships, but whose target readership consists mainly of straight females. Perhaps the central area that the author is able to clarify in his book is the role of the individual in a society that has yet to firmly redefine itself. **CP**
$14.95 *(PB/296/Illus)*

Fist of the North Star
Buronson (Sho Fumimura)
"Behold the awesome power of the fist of the North Star! In the tradition of *Road Warrior*, starring Mel Gibson, comes an action-packed epic adventure set on a savage, postapocalyptic Earth." English-language text.
$19.95 *(PB/347/Illus)*

Mai the Psychic Girl: Perfect Collection #1
Kazuya Kuda/Ryoichi Ikegamia
"An ordinary girl with extraordinary powers! Illustrated by Ryoichi Ikegami, whose gritty, realistic and erotic drawings grace the pages of *Crying Freeman*, *Sanctuary* and *Samurai Crusader*." English-language text.
$19.95 *(PB/345/Illus)*

Manga! Manga!: The World of Japanese Comics
Frederik L. Schodt
Launches you into the raw, brutal yet stylized unconscious of the Japanese mind-kiddie porn, samurai exam-crammers, Yakuza assassins, expressionistic axe-murder, and much more. Mangas are definitely "adult." Eight color pages, numerous black-and-white illustrations, and 96 pages of sample comics in English. **SS**
$16.95 *(PB/260/Illus)*

Sanctuary: Volumes 1-5
Sho Fumimura/Ryoichi Ikegami
"The erotically charged saga of political corruption, the yakuza crime syndicate and two handsome, ruthless young men continues! Akira Hojo and Chiaki Asami vow to transform the destiny of Japan, by any means. Together as children, they survived the horrors of Cambodian killing fields together. This is their quest to topple the leaders of both Japanese Parliament and the Yakuza. *Sanctuary* is drawn by the renowned manga artist Ryoichi Ikegami, whose gritty, realistic, and erotic artwork graces the pages of *Crying Freeman*, *Samurai Crusader*, and *Mai, the Psychic Girl*." English-language text.
$16.95 *(PB/273/Illus)*

Pin-Up

Diane Webber photographed by Bunny Yeager —
from **Bunny's Honeys**

Bettie Page: The Life of a Pin-Up Legend

Karen Essex and James L. Swanson
Among the many books available on the memorably beautiful Bettie Page, this one is written with her cooperation, providing a unique glimpse into her childhood and early adult years before and after she became a model. The resurrection of the icon of Bettie Page over the last 10 years and the assimilation of her image as a pop culture phenomenon is also thoroughly examined. Her own insights and reflections on her life provide a poignant foil to the pop culture myth of Bettie Page and her enduring allure and influence in style and fashion. The numerous illustrations depict the canon of Bettie's actual work (including many of her classic bondage poses, nude beach poses and swimwear modeling) and contemporary derivative art, fashion and invented scenar-ios inspired by her vulpine body, raven hair and captivating smile. Forward by Bettie Page. **MM**
$40.00 *(HB/288/Illus)*

Bettie Page: The Queen of Pin-Up

Edited by Burkhard Riemschneider
Includes a very brief history of Bettie Page, featuring Irving Klaw, the man responsible for the beginning of her bondage and spanking photos, short films and comics. Anyone not familiar with the classic, clean, sweet, good-looking charm of Bettie Page has certainly missed out, but now has a chance to catch up. Full-page photos by Bunny Yeager include whips, suspender belts, lace undies and her trademark extra-high heels. Also includes photos from Robert Harrison's girlie magazines *Beauty Parade*, *Eyeful*, *Wink* and *Titter*, covering the market for the bare (or at least scantily clad). Bettie mugged for the camera with consistent integrity throughout her nine-year career.

Lush, curvaceous breasts, black bra, stockings and full panties (some crotchless) are constant; her trademark six-inch heels are included in every shot. From 1948 through 1957, the risqué themes of her work included all-girl wrestling, bondage and insinuated discipline, along with really cool costumes, such as metal bras, early latex and vinyl. Fold-out beds, footstools, coffee tables and many other around-the-house items are some of many props used. Her 1950s naughty-but-oh-so-nice image translates well for the '90s, and beyond, because underneath it all, if we're going to get corrupted, it's best to be corrupted with style. **CF**
$12.99 *(PB/80/Illus)*

 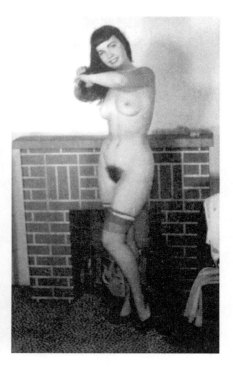

Selections from a rare "strip" sequence, shot by an anonymous camera club photographer — from **Bettie Page**

Bunny's Honeys
Bunny Yeager
Dubbed "the world's prettiest photographer" in 1953, former pin-up model Bunny Yeager decided to step behind the camera, and in the process, became a pioneer in the almost exclusively male world of cheesecake photography, as well as one of the best. She's known mostly for her exceptional work with Bettie Page, but all of Bunny's pictures have the same sense of relaxed glamor and intimacy that's uniquely hers, and she had an great eye for "talent." A few of the '60s shots are a bit scary though, mainly because of the squalid nature of the clothes, hair and makeup (think how Jayne Mansfield looked around that time . . . 'nuff said). **MG**
$24.99 *(PB/160/Illus)*

The Great American Pin-Up
Charles G. Martignette and Louis K. Meisel
Will the art-history textbooks of the year 2525 focus on George Petty and Haddon Sundblom as the true exemplars of 20th-century American painting rather than Jasper Johns or Ed Ruscha? The authors of *The Great American Pin-Up* clearly think so,

and make no secret of the historical significance of this staggering pageant of painterly pulchritude reproduced lovingly in living color and often taken from the original oil paintings of the masters themselves.

This survey begins with the exotic "moonlight girls" of the art deco era and follows pin-up art from the celebrated Peruvian da Vinci of the American Girl, Alberto Vargas, to the salacious pulp covers for *Eyeful, Giggles, Titter,* and *Flirt.* Most prominent are the hot-to-trot all-American gals-next-door specialized in by the Brown and Bigelow calendar company of St. Paul, Minnesota. *Esquire* magazine's crucial role in disseminating the art of the pin-up through its "Gallery of Glamour" in each issue is recognized here as well.

Besides being the first to compile and reproduce such a plethora of fascinating female figures, this collection emphasizes the personalities behind the pin-ups: Art Frahm and his acclaimed "panties falling down series"; such woman pin-up painters as the glamorous Zoë Mozert (who often modeled for herself by posing in front of a mirror) and Chicago's sister pin-up team Laurette and Irene Patten; Gil Elvgren and his hugely popular "situation pictures" (over

a billion have been reproduced) in which a gusty wind or a mischievous BBQ grill leads to a provocative display of thigh and garter; Fritz Willis, originator of Brown and Bigelow's Artist Sketch Pad series with sketched-in elements surrounding the vibrantly painted model; and the many other artistic spirits behind the 900 racy images collected herein. **SS**
$39.99 *(HB/380/Illus)*

I Was a 1950s Pin-Up Model!
Mark Roenberg
A black-and-white photo-book ode to the girdle, the garter belt and the pointy bra. "Remember the days when you found the secret shoebox hidden in the back of your father's night table? Inside were pictures of GIRLS! Beautiful girls, in various stages of undress! And they weren't Mom! There was no denying it, Dad did think about sex, "about girls, gals, sirens and sex kittens, all posed to tease and titillate his horny soul." **GR**
$14.95 *(PB/94/Illus)*

Pin-Up Mania:
The Golden Age of Men's

Magazines, 1950-1967
Alan Betrock

This time it's capsule histories of men's magazines, from *Playboy* to *Poorboy*. The '60s' cheesiest cheesecake, from Alan Betrock, the "King of '50s Sleaze" (his collection is legendary), each one with a cover full of female cleavage and with articles like "Are Burlesque Queens Really Dumb?" and "The Sexual Side of Crime." Hundreds of black-and-white cover shots of such magazines as *Gent*, *Modern Man*, *Escapade*, *Fling*, *Nugget*, *Rogue*, *Scamp*, *Satan* and *Sir Knight*. **GR**
$15.45 *(PB/Need/Illus)*

Va Va Voom!
Bombshells, Pin-Ups,
Sexpots and Glamour
Girls
Steve Sullivan

A veritable *Plutarch's Lives* of "*Bombshells, Pin-Ups, Sexpots, and Glamour Girls,*" this book is a compendium of feminine pulchritude, lushly illustrated with hundreds of suggestive black-and-white and color photographs. The author's thorough research clearly documents both the life stories and all of the major media appearances of his

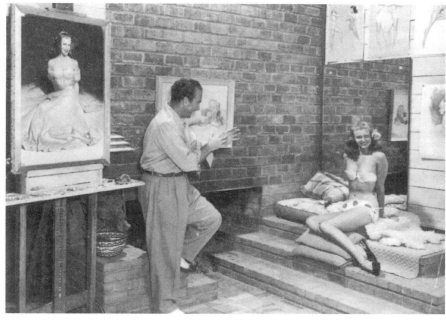

Earl MacPherson in his studio — from **The Great American Pin-Up**

subjects. This surprisingly serious study of the fates of variously famous, notorious and nearly forgotten women ranges from the depths of the downwardly mobile, the dead, the washed-up, the forgotten, the bankrupt, the drug-addicted and the recovered, to such heights as fame as a still-respected sex symbol; an older exercise maven; working actresses; employment in late-night TV, or porn; coverage in magazines; the conventions, periodic revivals cult followings; and posthumous fame.

This book is a social history of the sexual mores, the exuberance and the darker side of post-war America. *Va Va Voom!* captures the irony that some women like Julie Newmar can achieve fame, happiness and success spanning decades while others like Marilyn Monroe achieve more fame through their unhappy lives and tragic deaths. The anecdotes alone are positively riveting. For example, it tells of stripper Candy Barr's associations with Jack Ruby, Mickey Cohen and Hugh Hefner; Tempest Storm's career as a stripper and Bunny Yeager's transition from pin-up to photographer. A must-have for any aficionado of popular culture or any man who reached puberty between World

War II and Vietnam. **MM**
$17.95 *(PB/200/Illus)*

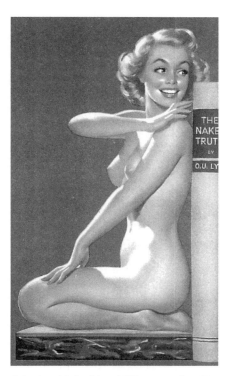

Calendar girls by Edward D'Ancona — from **The Great American Pin-Up**

PUNK

Peter Christopherson's window display, BOY, King's Road, March 1977 — from *England's Dreaming*

The Boy Looked at Johnny
Julie Burchill and Tony Parsons
Legendary vitriolic broadside directed at all things punk, now derided by co-author Julie Burchill as "total speed damage." Tracks the origins of punk rock music, both in the U.S. and U.K., including such seminal bands as the New York Dolls and the Runaways. Includes new pix and forward by guitarist Lenny Kaye. Gossipy, bitchy and quite possibly libelous, Julie and Tony go for the throat of the pop music world with a meth-tipped pen. **MW**
$8.95 *(PB/95/Illus)*

Cranked Up Really High
Stewart Home
An insider's survey of punk rock from its beginnings to the recent Riot Grrrl movement—from the Pistols to the Dead Boys to those jughead Oi! bands and beyond. True to the unsparing spirit of his subject, the author has something to say about every band that could possibly be construed as "punk" (from the infamous to the forgotten) with an assurance about as subtle as a wrecking ball. Petulant yet focused, condescending and generous, the most lingering appeal of Home's observations is not so much their accuracy—aesthetic being opinion, after all—as the hubris that informs them. Though at times indulging in the intellectual obscurantism he claims to loathe ("Some readers may feel I come across as suspiciously anti-Bergsonian . . ." What??), *Cranked Up Really High*, with cogency and passion, exhaustingly delivers on its basic claim: LOUDER! FASTER! SHORTER! **MDG**
$14.95 *(PB/128/Illus)*

England's Dreaming:
Anarchy, Sex Pistols,

Punk Rock and Beyond
Jon Savage
This is the sort of book that tempts one to drag out the thesaurus and start laying on the superlatives. It not only chronicles the events and conditions that led up to the advent of punk rock but it conveys the energy of the explosion. It is as if Savage had a front row seat and full perspective. The book is divided into five sections which explain how the momentum was built: from December l971through August 1975, and January 1978 through May 1979. At center stage is Malcolm McLaren and his many projects, which included the store Sex, the scene it spawned, and the Sex Pistols. Into this narrative is woven the many threads of trend and circumstance that effortlessly segue "the human history of architecture" into the evolution of rock 'n' roll culture, punctuated by quotes from Jung and lyrics from Pere Ubu.

What's truly amazing about this book is its scope. Without ever losing its focus, *England's Dreaming* constantly manages to carry the reader along tangential, concurrent events showing direct cause and effect. This is by no means an easy feat given the geographical diversity of the parts which were collected to form the whole. And while the author's choice of which facts to include creates a subjective narrative, great care and effort were used to solicit a wide variety of "versions of the story." The sociology employed here is not of the shallow pop variety, but a measured consideration rife with insight. The book concludes with an encyclopedic discography of many of the most important bands of this period which is defined by not a regional geographic focus but an ideological one. **SA**
$16.95 *(PB/602/Illus)*

Please Kill Me:
The Uncensored Oral
History of Punk
Legs McNeil and Gillian McCain
In the late 1970s, Legs McNeil was the "resident punk" around the New York office of the seminal underground publication *Punk* magazine. In this volume, he and co-author McCain gather together reminiscences (presented verbatim as an "oral history" and without commentary) of the movers and shakers in that city's punk rock and proto-punk scenes, from the Velvet Underground and MC5 to the Ramones, the Dead Boys and even those limey interlopers the Sex Pistols. Some may quibble with the authors' assertions that New York was the solitary birthplace of punk rock, or that the scene died with the arrival of the Sex Pistols in the U.S. and their implosion soon after. But the book is crammed with sleaze and gossip aplenty as well as hair-raising tales of heavy drug usage and indiscriminate sexual activity which will keep readers turning pages far past their bedtimes. The sensitive of heart take note: not since Romeo and Juliet have so many major characters died in the last act. **LP**
$23.00 *(HB/320/Illus)*

Punk: The Original
John Holmstrom
A collection of the best material (1976-1981) from the seminal NYC-based zine *Punk*, including interviews, cartoons, collages and plenty of photos (some in color) of all your favorite punk rockers: Blondie, The Ramones, the Voidoids, Edith Massey(!), the Bay City Rollers(?), Patti Smith, The Clash, AC/DC(??), the Iggster and, of course (what self-respecting zine of the genre would be complete without?), the beloved Pistols. Contains a

pictorial interview with Rotten (still sportin' zits) in which the budding entertainer, with characteristic understatement, reflects on the importance of audience approval ("If they don't like it they can fuck off"), as well as a poignant phone interview with a vulnerable Sid Vicious on the heels of the band's collapse. What's most striking about the collection is the utter absence of genuine mean-spiritedness and that its caustic edge is never without an equal dose of knuckleheaded, naughty good cheer (compliments of, among others, Lester Bangs and Legs McNeil). With a table of contents that includes a short commentary by Holmstrom for each entry, *Punk: The Original* is a joyful, comical and, yes, informative celebration of a musical movement at its short-lived first wave peak. A must-read for anyone interested in the glorious ragtag origins of punk. **MDG**
$19.95 *(PB/136/Illus)*

Rock and the Pop Narcotic
Joe Carducci

In the world of academia, the lengthiest arguments revolve around issues of authenticity, thoroughness of research and the way in which disparate facts are connected. In the world of rock writing these issues aren't usually given the time of day. In recent years books on punk rock have become more and more common, ranging from the idiotic (Greil Marcus, various titles that started as college papers) to the entertaining (*Please Kill Me*, Rotten's autobio) to the purely confused. This book belongs in the latter group since it is not only just about punk but is an attempt to, uh, *explain* rock in a bizarro-world version of Cutler's *File Under Pop*.

Rock and the Pop Narcotic is a mishmash, and as such is difficult to completely dis or dismiss, or for that matter take seriously. Carducci is preoccupied with what in rock 'n' roll history does or does not "rock." And how "pop" has watered down "rock" (a bunch of "fags" are to blame for this says the author). Saint Vitus "rock" and so does Black Sabbath and a lot of other bands Carducci likes. Bands he doesn't like don't "rock". The Pet Shop Boys or New Order don't "rock." Pretty simple. This goes on for 500 pages.

Carducci spent his formative years in the SoCal hardcore scene (at SST Records) and is deciphering the world of rock 'n' roll music from his own point of view, which is interesting (in the same way as is any piece of historical or cultural writing attempting to explain a huge and complex subject from an extremely limited perspective). Carducci may come off as more sincere than Marsh or Marcus et al. but one should still remember that *Rock and the Pop Narcotic* is a rant book, by a rabid rock 'n' roll fan who frequently stumbles over

Screamers handbill by Gary Panter, May 1978 — from England's Dreaming

the line separating the fan from the kook. **JK**
$18.00 *(PB/532/Illus)*

Rotten: No Irish, No Blacks, No Dogs
John Lydon

A history of the birth of punk according to the Mouth Almighty. The pissed-off spokesman for the movement he helped forge (only to later sneeringly disparage), Lydon is a born raconteur. Assisted by a wide array of contributors (including drummer Paul Cook, guitarist Steve Jones, Chrissie Hynde, Billy Idol and Julien Temple), Lydon, with ego, impatience and wit, recounts the saga of the rise and collapse of the band that launched a thousand others. Insightful, smug, hilarious and tender, Lydon illustrates how he was never one to suffer stupidity quietly—his own or anyone else's. Whether his version of events consistently corresponds to fact isn't the point; delivery is all. To learn about the roots of punk—British, American or otherwise—this is the book: source material from the mouth of its prime mover. Punctuated with great photos and containing the memorable line: "I never screamed as a youngster." And *Bollocks* is still a brilliant pop album. **MDG**
$14.00 *(PB/329/Illus)*

Search & Destroy #1-#6†
V. Vale
Search & Destroy #7-#11††
V. Vale

During those glory days of early punk (1977-1979), *Search & Destroy* was widely considered to

be one of the most eclectic and intelligent publications going. Based in San Francisco (a magnet, itself, for misfits), it covered not only the local scene, but those evolving in Los Angeles, New York, the British Isles and Paris. Whenever the magazine interviewed somebody the writer would frequently include a list of the subject's favorite books and records or even interesting things that happened to be on the coffee table or desk. A reading of these issues, which have aged remarkably well, captures the sense that something new and exciting was happening. The staff of *Search & Destroy* knew how to guide an interview into intelligent subjects and would throw in a monkey wrench if an interview got too self-serving or rote. Many of the most interesting interviews are the ones with people who didn't go on to become famous. So clear off a table and set the Way-Back Machine. **SA**
†$19.95 *(PB/142/Illus)*
††$19.95 *(PB/148/Illus)*

Touching From a Distance: Ian Curtis and Joy Division
Deborah Curtis

From the jacket: "*Touching From a Distance* describes Ian Curtis' life from his early teenage years to his premature death on the eve of Joy Division's first American tour. It tells how, with a wife, child and impending international fame, he was seduced by the glory of an early grave. What were the reasons behind his fascination with death? Were his dark, brooding lyrics an artistic exorcism?" Who's to say, especially since Deborah Curtis seems to have zero interest in her dead husband's music, but this book certainly delivers as a classic rock-wife saga with a twist: Along with the usual obsessively rendered details of infidelity, betrayal and alcohol abuse, there are also descriptions of epileptic seizures, emotionally crippling bouts of morbidity, and suicide. Includes complete lists of recordings and gigs, as well as lyrics, both published and unpublished. **MG**
$15.95 *(PB/213/Illus)*

Wedding photo of Ian and Deborah Curtis, August 23, 1975 — from Touching From a Distance

Skinhead

It's not right, Joe thought. It's stupid wasting time on something infantile. It could have said 'We hate everything' and be done with it. That's what we do, hate—everything, and everybody except ourselves.
— from *Suedehead*

Richard Allen is the pen name of James Moffatt, born in Canada and the author of over 400 pulp novels. As Richard Allen he chronicled the street fashions of the 1970s from skinheads to suede-heads to smoothies and sorts, and described the world of the pop concert and football terrace in classic pulp style, laced with garish violence and leering sexuality. Widely read, Allen influenced the new generation of British skinheads and punks, and, no doubt, helped boost the sales of Dr. Martens. Allen's violently nihilistic, racist and sexually predatory characters dare the reader to look them in the eye. — NN

"WE THE MARYLEBONE MARTYRS DO SOLEMNLY SWEAR THAT WE HATE, AND ABOMINATE . . .
QUEERS
CHILDREN
LESBIANS
LANDLORDS
SOCIAL WORKERS
COMMUNISTS
SKINHEADS
CONSERVATIVES
HELL'S ANGELS
LABOURITES
PRIESTS
LIBERALS
RABBIS
ANARCHISTS
FUZZ
RUSSIA
BLACKS
AMERICA
VIRGINS
CHINA
RUGBY
EMPLOYERS
HIPPIES
BLOODSPORTS
SERVANTS
PROTESTERS
CRICKET
WINE
YIPPIES
MAGISTRATES
MARRIAGE
TRADE UNIONISM"

Photograph — from Skinhead Nation

Complete Richard Allen, Volume One: Skinhead, Suedehead, Skinhead Escapes†
Complete Richard Allen, Volume Two: Skinhead Girls, Sorts, Knuckle Girls††
Complete Richard Allen, Volume Three: Trouble for Skinhead, Skinhead Farewell, Top-Gear Skin†††
Complete Richard Allen, Volume Four: Boot Boys, Smoothies, Terrace Terrors††††
Richard Allen
Skinhead: Introduces Joe Hawkins, Allen's most famous character. Joe—coal seller and skinhead—earns a little extra money by shaking down his clients, and is not beyond accepting a sexual favor or two from the women on his route. But what he really likes to do is fight, and with a wide range of his traditional enemies—Hell's Angels, Chelsea fans, hippies, the fuzz, immigrants and other skinheads—lurking around every corner, he has ever-increasing chances to indulge himself. As more and more are bloodied by his boot and fist, it looks like the police are powerless to stop him.
Suedehead: Joe's back from prison, and if his haircut's changed, his attitude hasn't. Determined to succeed in the world of the city-slicker, Joe soon finds violent use for the businessman's umbrella. Joe might have cleaned up his act but not his appetite for sexual carnage and violent mayhem.
Skinhead Escapes: When Hawkins invites himself along on another prisoner's escape, he makes enemies on both sides of the law. On the run, he still has time to indulge in his twisted passion for birds, booze and bovver. And when he kills a policeman, every cop in the country is after him.
Skinhead Girls: Joan's skinhead past is calling her back. Though married she still relishes the prospect of sex, violence and house parties.
Sorts: Terry runs away from home and is caught up in the sordid world of dope-smoking folk musicians. Soon she's up against folkies who kill for thrills!
Knuckle Girls: Ina Murray's Scottish heritage gives her an edge in a street brawl. And whether they're soccer hooligans, coppers or evil social workers, she's not taking shit from anybody.
Trouble for Skinhead: überskin Joe Hawkins is off the street and inside Britain's toughest prison. Time to utilize his special skills.
Skinhead Farewell: Joe Hawkins is in Australia searching for his nemesis, enduring dodgy

SKINHEAD

Australian skinheads and learning to loathe antipodean natural splendor: "Strange shapes fetched up ghostly, childhood fears against a weak-mooned desert horizon. Typical Outback shapes. Fantastic. Non-English frighteners The unknown quantities out there—beyond the fire's flickering fingertips. Weird animals. Snakes. Spiders. Crawlies of every description. Horrible things."

Top Gear Skin: Skinheads apply their code of conduct to the sport of stockcar racing.

Boot Boys: Bent on senseless violence on the street and in the soccer stadium, the boot boys need to take only one small step into total evil-Devil worship: "Vanessa stood stiffly erect on top of her fornicating altar. She watched Tom weave round tombstones, wine held against his naked chest. She raised her arms—a white sylph coated with dried sweat and earth's smudges. The Master cometh . . ."

Smoothies: Skinhead descendants the smoothies get involved with mayhem in general and some anti-immigrant violence in particular: "Not far from Arlingham the government had set up a temporary camp to handle the influx of Ugandan Asians. Contrary to the sincere hopes of those do-gooders and Church organizations full of the joys of humanitarianism, the ordinary people of Arlingham objected. Strongly."

Terrace Terrors: Reformed skinheads are deployed against soccer violence: "'Roger Cochrane, the Chelterton chairman, is a personal friend of mine. He wants to make sure his club does not get a reputation for attracting young louts. The signs during their promotion run were that unsavory elements had started attending the home games. We—Cooper and Greer—have been invited to suggest a method of policing the terraces . . .' Steve couldn't help it. He whistled in astonishment." **NN**

$14.95 *(PB/288)*

Skinhead Nation
George Marshall
One of the more intelligently written and well-researched books on what the author calls "the greatest of all youth cults." The fellow responsible, George Marshall, is an almost unbelievable dichotomy: an articulate and readable writer with unassailable street-level skin credibility. An ex-skinhead himself, Marshall spent six years as editor and publisher of a small tabloid-style paper called *Skinhead Times*, but is best known as the author of *Spirit of '69: A Skinhead Bible*. In *Skinhead Nation*, he presents as objective an overview as possible of this much- maligned and generally baffling phenomenon, informative and entertaining for the most clueless outsider and the hardest-core skinhead alike. The unbiased attitude toward the mind-boggling array of often diametrically opposed factions

*Skinheads at the Ska, Reggae and Soul Train, Redcar — from **Skinhead Nation***

and the coverage of a good assortment of "scenes" from all over the world set this book apart from most other works on the subject.

The problem of "skinhead reality vs. media perception" is a constant theme, so much so that if you took out all the copy spent addressing this particular issue, this book would be a leaflet. Still, the way Marshall manages to say "Skinheads aren't by nature political, but have political beliefs like anyone else," and "Sure, there are Nazis, but there's 2 Tone, SHARP, black, asian, and hispanic Skinheads, too" in almost every paragraph without ever actually repeating himself verbatim is an incredible, almost gymnastic, literary achievement worthy of a Nobel Prize, or at least a free pint of ale. Illustrated with a whole bunch of appropriately 2 Tone (oh, all right, black and white) photos, *Skinhead Nation* helps shed some much-needed light on this little-understood topic. So why am I still so mystified about what would drive a person to actually become a Skinhead? Or, for that matter, a Deadhead, Preppy, born again Christian . . . **DB**

$26.95 *(PB/156/Illus)*

Skinheads Shaved for Battle: A Cultural History of American Skinheads
Jack Moore
Seemingly having peaked in the late '80s, when the velcro-heads were a favorite subject of tabloid TV, skins are today an established part of American youth culture, still often associated with white power, and neo-Nazi hate groups.

The author traces the development of the skinhead phenomenon back to its English roots and examines how this quintessentially British youth cult crossed the Atlantic and how the cult has developed in ways unique to the United States. Using a wide range of sources, the author takes a critical look at previous studies of skinheads and adds the often amusingly distant perspective of an academic. **NN**

$14.95 *(PB/200/Illus)*

Skins
Gavin Watson
The first photo book to capture the spirit of the skinhead cult. Taken by a skinhead who went on to become a professional photographer, these are largely culled from the glory days of 2 Tone and Oi!. **AK**

$19.95 *(PB/144/Illus)*

Spirit of '69: A Skinhead Bible
George Marshall
The definitive book on the British skinhead phenomenon. From the late '60s to the present, this book gives it straight: style, music, football, aggro, from SHARP to the scourge of the neo-Nazis. A wealth of photographs, graphics and cuttings makes this an indispensable guide. **AK**

$19.95 *(PB/176/Illus)*

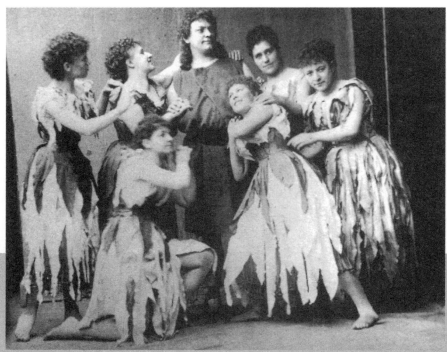

Parsifal (Hermann Winkelmann) and the Flowermaidens, whom Wagner wanted to look like singing flowers. "Their costumes are tasteless, quite incomprehensibly tasteless, but their singing is beyond praise." (Felix Weingartner of the 1882 premiere) — from **Bayreuth**

Wagner

Bayreuth: A History of the Wagner Festival
Frederic Spotts
Bayreuth is the oldest and most famous of the music festivals. Wagner aficionados know complete scores, are able to detect any mistakes pertaining to performances, reserve their seats five years in advance and are able to endure hard, wooden seats for six-hour performances. This book tells the tale of this venerable edifice, and thus the tale of Wagner and his heirs, who continue to run Bayreuth to this day. Ranges from its construction to Wagner's specifications in the 1870s to the premiere of *The Ring* in 1876, through its debasement during the Third Reich—which prompted Thomas Mann to term it "Hitler's court theater"—to the present. **JAT**
$18.00 *(PB/334/Illus)*

The Complete Operas of Richard Wagner
Charles Osborne
Wagner, the man and his music, are known for the passionate feelings, both positive and negative, which they inspire. One of the best single volumes from among the vast plethora of writing about Wagner, *The Complete Operas of Richard Wagner* provides detailed synopses, musical analyses, and liberal quotations from Wagner's extensive writings and those of his contemporaries (including Franz Liszt, Edvard Grieg, and King Ludwig II, of Bavaria), and places each of Wagner's 13 operas within a greater biographical and historical context. *The Complete Operas of Richard Wagner* vividly portrays both the creator and his creations with a level of objectivity often missing from other works about a man whose immense talent may have only been matched by his ego. **JAT**
$13.95 *(PB/288/Illus)*

My Life
Richard Wagner
A complete and authentic edition based on the manuscript was not published until 1963. Memoirs from Wagner's birth in 1813 to 1864, a mid-career point where many of his greatest operas had yet to be written and the founding of Bayreuth was but a dream. As this accunt was composed principally for his wife Cosima and patron King Ludwig's benefit, Wagner downplays the importance of past romantic liaisons and the value of career assistance received prior to Ludwig's patronage: yet unflattering

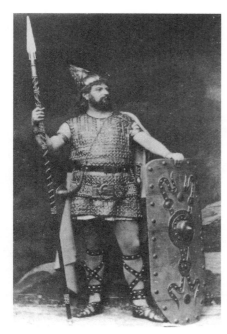

From this photograph of Georg Unger as Siegfried (1876), it is evident how meticulously Döpler's designs were carried out. The mail was gold, the cape bright blue. — from **Bayreuth**

doses of wit, Shaw freely interprets *The Ring* through his strongly socialist political filter. **JAT**
$5.95 *(PB/136)*

Wagner on Music and Drama
Albert Goldman and Evert Sprinchorn
Culled from Wagner's prose writings, this text condenses the master's writings to a single volume of approximately 400 pages, arranged into eight major subdivisions. The editors manage to make Wagner's thoughts both accessible and coherent while faithfully reflecting his intentions. "Art was his religion and the theater its temple. Moral and spiritual values existed for him only insofar as his art might benefit from them." **JAT**
$14.95 *(PB/448)*

Wagner: Race and Revolution
Paul Lawrence Rose
Argues that the German concept of revolution always contained a racial and anti-Semitic core. Dissecting and analyzing each of Wagner's operas, the author presents a comprehensive collection of the anti-Semitic elements found within Wagner's writings and operas. Links Wagner's strain of anti-Semitism and revolution to the flowering of German Nationalism in the Third Reich. **JAT**
$25.00 *(HB/246)*

Wagner's "Ring" and Its Symbols: The Music and the Myth
Robert Donington
Often able to evoke both the excitement of the music and the action experienced in the theater, *Wagner's "Ring" and Its Symbols* takes a Jungian approach in exploring The Ring and its mythological underpinnings. Includes an appendix of musical examples and selected motifs following the main discussion, allowing the reader to cross-refer to significant leitmotifs. **JAT**
$15.95 *(PB/342)*

material in the memoir raises questions as to whether the memoir was in fact the malicious fabrication of his enemies. *My Life* has the feel of a lengthy and incredible oral saga spun by a master dramatist. **JAT**
$16.95 *(PB/802)*

Penetrating Wagner's Ring: An Anthology
Edited by John Louis DiGaetani
The *Ring of the Niebelung* has proved to be one of the most enduring of operatic spectacles. This book presents the writings of such noted exports as Robert Donington, Ernest Newman, Andrew Porter and Sir Georg Solti encompassing a broad range of thought and viewpoints. An excellent, annotated bibliography, an annotated discography, and a *Ring* chronology are also included. **JAT**
$16.95 *(PB/458/Illus)*

The Perfect Wagnerite
George Bernard Shaw
George Bernard Shaw wrote *The Perfect Wagnerite* in 1898 and continued to revise it until 1923. With intelligence and ample

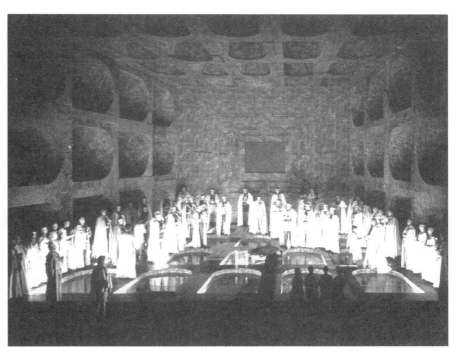

The grail's temple in Act I of Friedrich's 1982 Parsifal. The space, hermetically closed to the outside world and evocative of a catacomb or mauseoleum, symbolized the isolation and introversion of the brotherhood of the grail. — from **Bayreuth**

3-D

Doomsday 3-D Gallery — from The Weird Tales of Basil Wolverton

Ray Zone is a well-known champion of 3-D who writes articles, consults on 3-D with many clients nationwide, converts "flat" images to 3-D and, through his company, The 3-D Zone, publishes books, comics, posters and T-shirts in 3-D. — from *The Deep Image*

Amazon Attack 3-D
"Fans of female wrestling are gonna love this! Great cover by Howard Chaykin over classic ENEG (Gene Bilbrew) stories from the early 1950s of battling gals inside."
$5.00 *(Pamp/24/Illus)*

Bikini Battle 3-D
"R. Crumb loved the subject matter so much he consented to provide great new cover art for this book which is featured inside as a 3-D centerspread! More action ENEG stories of distaff conflict."
$5.00 *(Pamp/24/Illus)*

The Deep Image
"Comprehensive overview of the history of 3-D from its invention in 1850 to present day with holograms and computers. 40 page book has 16 pages of great 3-D images: antique stereo views, 3-D movies and comics, outer space and more."
$5.00 *(Pamp/24/Illus)*

Forbidden 3-D
"Inside story of 1950s comic book censorship with documentary stories straight off the public record. Gorgeous cover paintings and interior art by Chuck Roblin."
$5.00 *(Pamp/24/Illus)*

Mondo 3-D
"Weird but true images and stories of bizarre customs: Includes 3-D photos from the 19th century by James Ricalton with comic stories by Carol Lay, Byron Werner and Dan Clowes. Amazing Robert Williams wraparound cover painting. Not for the faint of heart!"
$5.00 *(Pamp/24/Illus)*

Weird Tales of Basil Wolverton
"Basil Wolverton was one of the most innovative creators in the comic book field. . . . In 1955 when the comics controversy came crashing down, Wolverton left the comic book field and began writing and illustrating stories from the Bible for Ambassador Press. A series of images from the Book of Revelation are amazingly detailed and every bit as grim as the horror comics of the pre-code era. Six of these intricately rendered nightmares are represented here in a Doomsday 3-D Gallery, and this is the first time they have appeared in a comic book and 3-D."
$5.00 *(Pamp/32/Illus)*

SENSORY DEPRIVATION

**Action Art:
A Bibliography of
Artists' Performances
From Futurism to Fluxus
and Beyond**
Compiled by John Gray
Those who have tried to locate any information at all about performance-oriented art from before the '70s and '80s (when the genre finally started to enjoy increased coverage in such publications as *High Performance*, *Artforum*, *Flash Art*), will truly appreciate the value of this handy and compact little volume. The first of the book's three sections focuses on the "formative years, from Marinetti's 1909 Futurist stage works to John Cage's 'Untitled Event' of 1952. Section Two covers Action Art's most fertile period: from the early '50s Gutai Group actions, to late '50s and early '60s Environments and Happenings, to the Fluxus and event art of the early and mid-'60s, to the hideous blood orgies of the Viennese Actionists, and including the Dutch Provos, the Situationist International, and the hijinks of the Guerrilla Art Action Group. The final section is devoted to biographical and critical studies of over 115 Action artists and artists'

groups. All this is followed by five appendixes filled with all sorts of useful information and obsessive cross-referencing, and, finally, four indexes—by artist, subject, title and author. A revelation for those who think performance art was invented by Laurie Anderson, Karen Finley or the Kipper Kids. **DB**
$75.00 *(HB/360)*

**Alexis Rockman:
Second Nature**
Alexis Rockman
Alexis Rockman is a successful New York-based painter who is also tremendously popular with the clientele of the Amok bookstore. The reasons for this are easy to see. Aside from a striking technical fluency, Rockman's work samples a categorical pool which is in many ways similar to the one that gave birth to Amok—R&D, Surrealism, Pulp Sci-Fi, Freaks!—it's all here. If Hieronymus Bosch were commissioned to produce didactic panels for the Museum of Natural History, they might look something like this. Colliding various established painterly genres such as the still life and landscape with the instructional schematics of scientific display, Rockman meticulously renders tableaux that

effectively reconstitute the abstract, theoretical realm of models, graphs and cross sections as organic matter, wholly susceptible to the cycles of decay and regeneration. And that's not all—as a crowning touch, these naturalist allegories are submitted to the grotesque and paranoid machinations of a budget-horror mise-en-scène. Genealogical trees are turned upside-down by natural forces; dioramas spring suddenly to life and total zoological chaos ensues. By way of interspecies copulation, mutation, gene-splicing or plain old Frankenstein surgery, every taxonomic, phylogenic boundary is systematically transgressed. The result is an exploration of evolutionary anarchy at its most basic and most sophisticated levels.

Second Nature presents a comprehensive overview of this troubling and darkly humorous oeuvre, generously illustrated with sharp, color plates of the paintings, plus an additional selection of source materials from the artist's own photographic archive. An unusually informative series of critical texts by such science- and art-world luminaries as Stephen Jay Gould and Douglas Blau completes this attractive package. **JT**
$24.95 *(PB/98/Illus)*

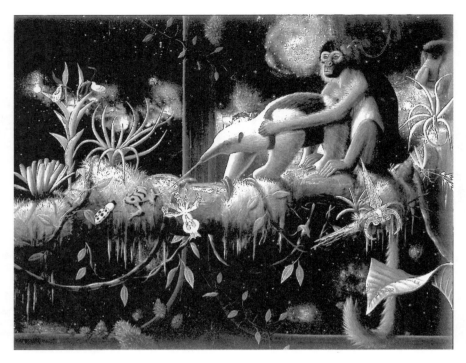

Biosphere: Tropical Tree Branch — *from* **Alexis Rockman**

Alice's Adventures Under Ground
Lewis Carroll

Facsimile edition of the handwritten manuscript the author gave to his friend's daughter, young Alice Liddle, in 1864, complete with original illustrations and an oval portrait of Alice glued to the last page. Revised and expanded with new illustrations, this early adventure was reproduced using a zinc-block photo process (called photozincography), and became the *Alice in Wonderland* tale we are familiar with today.
GR
$3.95 *(PB/128/Illus)*

Anger: The Unauthorized Biography of Kenneth Anger
Bill Landis

One might imagine that the author of the *Hollywood Babylon* books would have reason to shudder at the thought of his own biography seeing print. This book is, however, a loving tribute. Anger's films are described in lavish detail, and some sense is conveyed of how much impact each film made. Anger is lauded for his work with the Kinsey Institute. This is an important docu-

ment for anybody with an interest in the development of the American underground film movement. It illustrates the struggles involved when working outside of the mainstream, and the consequences of swimming against the current of Hollywood protocol.
SA
$25.00 *(PB/290/Illus)*

Apollinaire on Art: Essays and Reviews, 1902-1918
Edited by Leroy C. Breunig

The most influential poet of his generation and inventor of the word *surrealism*, Guillaume Apollinaire (1880-1918) was the champion of modern art and the impresario of the avant-garde. Matisse, Picasso and Braque—today all recognized as modern masters—are just three of the painters for whom this "poet-critic" was the most ardent (and for a time, almost single-handed) defender. In reading the essays, it's remarkable to note that his knowledge of painting and sculpture was almost entirely self-taught. Passionate, lyrical and fiercely subjective (and at points, to his detriment, breezy and vague—anathema to rigorous intellectual analysis and dry academic cri-

tique)—Apollinaire possessed the most important trait that marks the true critic: prescience, the ability to recognize genius. Of Picasso, whom he considered without question the greatest artist of his generation, he wrote: "His naturalism, with its fondness for precision, is accompanied by that mysticism that in Spain inhabits the least religious of souls." **MDG**
$13.95 *(PB/546/Illus)*

Art of the Third Reich
Peter Adam

The German Art Association pulled all the "decaying foulness" of modern art out of the museums and exhibited the best examples of "the hunchbacked idiots" in a show titled "Degenerate Art" in 1937. It was an unexpected smash. Wait till they see the good stuff, thought Adolf. So he got all his *volk* art together in the "Great German Art Exhibition 1939." "How are we to judge this art?" asks the author. "The eye of the art historian is not enough. Our emotional response to the art produced under Hitler is overshadowed by history . . . Today, with all the knowledge we have of the horror of the Third Reich, it is impossible to look at these pictures without remembering their actual function. Which is ironically what the Nazis intended. Our suspicion that a wicked regime produces only inferior art is legitimate and widespread. There is evidence for this when faced with the overwhelming mediocrity of the artwork which was exhibited." **GR**
$19.95 *(PB/332/Illus)*

Art Under Stalin
Matthew Cullerne-Brown

"In 1932, Josef Stalin abolished all independent artistic organizations in the USSR. . . . Matthew Cullerne-Brown's fascinating and often provocative analysis focuses on the art of the Stalin era, from 1932 to 1953, and includes discussion of the pre- and post-Stalin years. The author illuminates the political and social framework of the time and provides a complete exposé of Stalinist aesthetics, socialist realism in art and neoclassicism in architecture, the Cult of Personality, art-world debates and isolationism."
$40.00 *(HB/256/Illus)*

Assault on Society: Satirical Literature to Film
Donald W. McCaffrey

"Explores over four decades of satirical and

dark comedy films, a genre that has been examined only piecemeal before. Since many of these were adapted from novels and dramas, McCaffrey concentrates on literature transformed to the screen. Some works of this genre attack society's defects with the intent to change them, or at least to enlighten us. If change seems impossible, the absurdist tone of the work has value, as in the case of *Dr. Strangelove, Catch-22, The Day of the Locust,* or *A Clockwork Orange*."

$19.50　　　　　　　*(PB/293/Illus)*

Behind the Mask of Innocence: Sex, Violence, Crime—Films of Social Conscience in the Silent Era
Kevin Brownlow
An extensively researched look at the lost era of silent movies dealing with the seamier side of life (abortion, drugs, bootlegging, red-light districts, opium dens, political corruption, poverty, venereal disease) and political issues such as labor unrest, women's suffrage and the Russian Revolution. Beautifully illustrated with stills from films like *Human Wreckage, The Devil's Needle, City Gone Wild, The Godless Girl* (a women-in-prison flick directed by Cecil B. DeMille) and *The Cocaine Traffic,* many of which no longer exist in any form due to neglect.　　　　　　　　　　**SS**

$25.00　　　　　　　*(PB/606/Illus)*

Bela Lugosi
Edited by Gary J. and Susan Sveha
Bela Lugosi achieved Hollywood fame as Dracula and went out the same way, buried in the character's cape and ring. As much as he tried, he couldn't escape his "swarthy foreigner" typecasting. And that accent—like some Hungarian hillbilly! Female fans loved it, though, and even today Lugosi's good looks still spell S-E-X. A series of essays by different authors, "this book covers Lugosi's films from the pre-Dracula early sound era, details his Universal and 1930's classics, investigates his stint on poverty row at Monogram and PRC in the 1940s, and explores his downward spiral, working with Ed Wood for drug money in the 1950s." Undead, indeed.　　　**GR**

$23.00　　　　　　　*(PB/312)*

Billy Wilder in Hollywood
Maurice Zolotow
Bio of the legendary, cranky Kraut whose

track record for quality films remains unparalleled. One of the most talented and evil people ever to work in Hollywood, this guy really could squeeze blood out of a stone! The epitome of the "sacred monster."
　　　　　　　　　　　　　MG
$17.95　　　　　　　*(PB/396)*

Black Action Films
James Robert Parish and George H. Hill
An alphabetical film-by-film listing of the classic blaxploitation films (*Shaft, Superfly*) which also covers related Hollywood fare like *In the Heat of the Night, Rocky IV* and *48HRS.* Notable for digging up such obscurities as *Black Gestapo* and *Dr. Black and Mr. Hyde, Black Action Films* is valuable also for being one of the few sources for "making of" info on lesser-known blaxploitation gems as *The Mack* (a cinéma verité look at the rise of an Oaktown pimp starring the screenwriter of *Cleopatra Jones* and written by an incarcerated pimp) and *The Spook Who Sat by the Door* (the bloody tale of a renegade black CIA agent turned urban guerrilla).　　　　　　　　　**SS**
$55.00　　　　　　*(HB/385/Illus)*

artists of the 20th century gives riveting insight into the age-old issues of sex/death, pain/pleasure and the relationship between life and art. Bob Flanagan lived with the terminal disease cystic fibrosis (he died in early 1996) and spent a lifetime exploring the limits of his own flesh through a sadomasochistic relationship with Mistress and photographer Sheree Rose. Luckily for us, their relationship produced an important and insightful body of art, incorporating poetry, performance, photography and site-specific installations. In these 120 image-packed pages we see most of Bob's life/work, from the early SM performances with Sheree (such as the Amok-sponsored "Nailed" event) to the seminal "Visiting Hours" exhibit at the Santa Monica Museum of Art. Several of his poems are published in full (he had published five books), the interviews are candid with the humor of a man bravely staring death in the face. A book in which the personal illuminates the universal, this is a not-to-be-missed journey of human transcendence through art.　　　　　　　**MDH**
$14.99　　　　　　*(PB/130/Illus)*

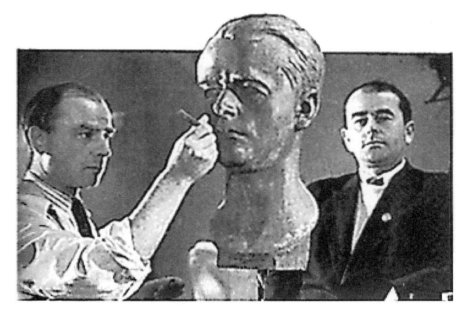

Arno Breker and Albert Speer during a sitting in Breker's studio — from **Art in the Third Reich**

Bob Flanagan: Supermasochist
Edited by Andrea Juno and V. Vale
This in-depth book on one of the most honest

Bridge of Light: Yiddish Film Between Two Worlds
J. Hoberman
As established in the recent cultural history

An Empire of Their Own, the monolithic Hollywood studio system has, from its inception, been primarily a Jewish-run operation. Yet by delving into the low-budget movies shot in Yiddish and made for a primarily Jewish audience, Village Voice film critic J. Hoberman has excavated not only an overlooked chapter of film history but also a compelling history of the real-life Jewish experience from the era of the Russian pogroms until the establishment of the Hebrew-speaking state of Israel. He brings to life Yiddish cinema and its relation to the once-roaring Yiddish theater world of New York (also a breeding ground for such Hollywood talent as Edward G. Robinson and Eddie Cantor) and shows how ironically they both functioned as a secularizing force setting both American and Soviet Jews on the road from blind tradition and rabbinical oppression.

Hoberman also establishes Yiddish film's connections to Hollywood movie history with examples such as Jimmy Cagney's fluent, rapid-fire cameo as the Yiddish-speaking, Irish-American cabbie in Taxi! (1932) and the early Yiddish talkies of B-movie directing genius Ed Ulmer (Detour, The Black Cat), who is regarded as having created the greatest artistic moment in Yiddish film with the earthy shtetl-nostalgia flick Grine Felder (Green Fields). Bridge of Light also explores the Yiddish-language European art films such as the truly gloom-laden, Hasidic-Gothic of The Dybbuk, shot in the years before the almost total demise of the Jewish population of Poland. This book contains the story of how Yiddish-speaking, often culturally avant-garde, politically radical, sexually libertine and ultimately tragic Jews, persevered to create their own cinema under adverse circumstances which would make the Sundance Festival-feted "scrappy" indie filmmakers of today shrink back in abject terror. **SS**
$35.00 (HB/350/Illus)

Broken Mirrors/Broken Minds: The Dark Dreams of Dario Argento
Maitland McDonagh
"In the final analysis films are films and dreams are dreams: no one can reasonably deny that they're the end results of different processes, with different life spans, frames of reference and spheres of influence. And yet there are respects in which they resemble one another, and horror

Jim Kelly and Gloria Hendry in **Black Belt Jones**, *1974 – from* **Black Action Films**

films—more than any other genre-flirt with the patterns of enunciation associated with dreams. In this respect you can hardly resist the temptation to speak of Dario Argento's films as dark dreams of death and night and blood, to borrow Yukio Mishima's rapturously apt phrase."
$18.95 (PB/299/Illus)

Bruce Lee: Fighting Spirit
Bruce Thomas
First, I should confess to being something of a Bruce Lee virgin. I have not read any other books or articles on him, nor owned a poster of his famous, glistening, muscle-happy torso. Indeed, I hadn't even seen one of his movies until, in 1996, I finally saw Enter the Dragon. I counted my ignorance a huge advantage in appraising this labor of quite obsessive love by the ubiquitous pop guitarist and dedicated Bruce Lee apologist Bruce Thomas, even as I found my frail sensibility freezing under his unnecessarily repetitive bludgeoning with an overpowering surfeit of insistent adoration.

Certain "wise" lessons and speculations as to Bruce Lee's motives are clumsily repeat-

ed and paraphrased over and over again, in a flawed and ungainly attempt to direct the reader's opinion. One feels sure that Bruce Thomas wrote and rewrote certain key paragraphs, initially intending to use the best and most flowing (ironically, just like Lee's *jeet kune do*) but that in the end he used all of them without discernment, either because he could not honestly select the most effective or because he was too indecisive to act.

Undisciplined writing style aside, the reader is vividly presented with a churlish and rather brutal Bruce Lee who revels in violent street fights and the physical dominance of any and all peers. A pragmatic misfit whose initial attraction to the more formal wing chun system seems to have been primarily to improve his ability in order to beat more rivals into bloody submission, in many ways Lee is a classic "nasty piece of work."

He was a narcissistically motivated man whose fanaticism grew exponentially to the point of him becoming completely devoid of any socially or self-imposed boundaries as to what he could achieve. Such ambitious amorality resonates throughout this revealing book alongside Lee's increasingly contradictory but refreshingly clear comprehension of the poetic and mystical implications of his extraordinary martial skills.

There is a feeling that his entire career became a synthetic metaphor for a modern cultural collision: Chinese tradition focused by mercurial American commercialism and the fervor of notoriety induced by Hollywood fame, counterbalanced by the deceptiveness of his Asian blend of joviality and occasional obsequiousness. Yes, this guy was a compelling mess: a stunningly balletic thug with an inferiority complex so voracious and gross that his insatiable ego seems to have expired from the sheer shock of realizing that all media projections are entirely vacuous.

As Bruce Lee's nature unfolds, he is revealed as a psychotically driven victim of his own ambitious, greedy fantasy, a disintegrating genius who, despite his credulous confusion over the altruism of fame, still remained one hell of a sight in those fight scenes and, apparently, a truly inspiring asshole of a teacher.

Was he that good? That fast? Thomas quotes director Robert Clouse: "All I can say is, he had the fastest reflexes I've ever seen.

In one shot. . . . In order to see his hand lash out and hit . . . we had to speed the camera up to 30 frames a second. At normal speed it didn't show on film." So there you have it. Oh, and yes, drugs were involved in his death. A rare "allergy" to hashish in his brain was the discreet source of his demise.

As to his legacy. Well, thousands of martial arts teachers all over the world with a thousand names and variations of mind-body discipline are making a decent enough living, which is probably no bad thing. Although it remains a truism and a practical reservation to ask what good is any of this when one is faced with a nervous idiot with a gun? His other surprising legacy? Well, I would suggest that more than any-

thing else, Bruce Lee legitimized for the first time the phenomenon of "normal" hetero "real" men drooling and fawning over the compact and perfected physique of another male without phobic guilt, even to the extreme of it being OK to grow up with pin-up posters of that stripped-to-the-waist icon on their bedroom door. **GPO**
$14.95 *(PB/329/Illus)*

Bruce Lee: The Tao of the Dragon Warrior
Louis Chunovic
An amazing treasure trove of Bruce Lee photos, rare black-and-white film stills, and color spreads, compiled with the cooperation of his family. The text tells the story of

Bruce Lee from his Hong Kong boyhood to his martial arts superstardom. Chapters include: "Yip Man and the Hong Kong Kid," "Small Screen, Big Impact," "The Tao of Hollywood," ending with "The Game." Dynamic, deluxe Hong Kong graphic design shows that their film directors aren't the only ones leading the pack. **OAA**
$15.95 *(PB/104/Illus)*

Bruegel
Rose-Marie and Ranier Hagen
Working in the second half of the 16th century, Bruegel was naturally acquainted with the work of his countryman Hieronymus Bosch, who died several years before Bruegel was born. And he followed Bosch's lead in depicting diabolical demons and phantasmic, apocalyptic visions. But this book demonstrates that in addition to being a mysterious and satirical social commentator, Bruegel was, perhaps more interestingly, a philosopher. His biblical or mythological paintings emphasized an extreme naturalism integrating contemporary detail and sensibility into universal themes. And he was an empirical scientist interested in up-to-date scientific achievements as well as in expressing advanced knowledge of perspective and techniques of depiction. With simplicity, the authors describe the times in which the work was produced, and give voice to its relevance. **JTW**
$9.99 *(PB/96/Illus)*

Bruegel, or the Workshop of Dreams
Claude-Henri Rocquet
Little is known of the life of Pieter Bruegel the Elder. Yet his paintings, rich with precise detail of everyday life during the Flemish Renaissance yield much to historical research—and the erudite imaginings this author. Using Bruegel's paintings as a point of departure for elegant, historical fantasy, Rocquet explores the intricacies of commerce and politics, court life and peasant life, ship-building and architecture, the Spanish Occupation and much else that passed before the penetrating eye of Bruegel. What emerges is a portrait of the artist which is moving and convincing in its psychological depth. **DN**
$24.95 *(HB/210)*

Butoh: Shades of Darkness
Jean Viala and Nourit Masson-Sekine
Butoh, a Japanese form of avant-garde

Suspended from what Jesse Helms calls my "auto-erotic scaffold." Threshold program, Los Angeles, 1989 — from **Bob Flanagan: Supermasochist**

dance founded in the 1960s, is a fusion of global influences in dance from both hemispheres. From Japan's own culture it draws on Noh, kabuki and Shingeki (a radical 1920s Japanese theater) and from the West on Rudolf Steiner's spiritual Eurhythmics, Mary Wigman's Neue Tanze and the theories of Emile Dalcroze on movement and education. Yet Butoh differs from both Western and Eastern dance forms because the "Butoh spirit confronts the origins of fear"—distilling the literary and theoretical ideas of Lautréamont, Artaud and Genet into a marriage of opposites fusing beauty and pain.

The word *Butoh* is made up of two ideographs: "bu" meaning dance, and "toh" meaning step. The founders of Butoh believed that the body is fundamentally chaotic yet controlled by religious and cultural repressions that are instilled with hate from cradle to grave. In Butoh, the dancer must isolate himself from physical and social identity, only to be guided by the soul expressing its purity by reverting to the original memory of the body—allowing escape from surface reality in order to attain the essence of life. After designing what is now the blueprint for today's modern dance, the Butoh pioneers then made an extensive journey back to the origins of dance, seeing it as a prehistoric painting, and performance as a ceremony for the audience. Illustrated with 250 exquisite photos, *Butoh: Shades of Darkness*, the first comprehensive study of its kind in English, explores the evolution of Butoh through interviews with its mystical fathers (the cosmic Ono and the dark Hijikata) and chronologies of its troupes and legendary performances. **OAA**
$34.95 *(HB/208/Illus)*

Chroma
Derek Jarman
"In his signature style, a lyrical combination of classical theory, anecdote and poetry, Jarman takes the reader through the spectrum, introducing each color as an embodiment of an emotion, evoking memories or dreams. Jarman explains the use of color from medieval painting through the Renaissance to the modernists, and draws on the great color theorists from Pliny to Leonardo. He writes too about the meanings of color in literature, science, philosophy, psychology, religion and alchemy."
$19.95 *(HB/151)*

Cinema, Censorship, and the State
Nagisa Oshima
Japanese filmmaker Nagisa Oshima is a brilliant theorist on, and critic of, the Japanese political/cultural system. All of the tracts in this book eventually come back to what it was like to be a youth living in postwar Japan. Paralleling the student/Situationist strikes in Paris of 1968, the Tokyo university students' insurgence of the late '60s was the main springboard—politically and artistically—for Oshima's cinematic and textual work. These essays (from 1956 through 1986) fully articulate his progression from political activity to filmmaking. In his cinema, there is a sense that bridges are being destroyed. One of the interesting aspects of Oshima's films and writing is his attempt to elicit change in his country's mythology concerning sexuality and racism. Oshima writes and films about the outcasts in Japanese society with a conviction that must seem audacious to a Japanese audience.

On its surface, *Merry Christmas, Mr. Lawrence* (1982) is a film about the cultural differences between the Japanese and their prisoners during World War II. Upon closer inspection, the film becomes a commentary on sensuality and how it relates to Eastern and Western cultures The prison camp is a fish bowl, where one can watch objectively as the participants joust for power and sexual roles. *Lawrence* is also an exploration of the SM relationship between the characters portrayed by pop stars David Bowie and Ryuichi Sakamoto. *Death by Hanging* (1968) not only looks capital punishment, but questions who is being killed by the state. The longest piece in the book concerns Oshima's battle with Japanese censors over his erotic masterpiece *Ai No Corrida* (*In the Realm of the Senses*, from 1976). He won the case eventually, but it seems Oshima felt no great victory in this. *Cinema, Censorship and the State* is outstanding not only revealing for Oshima's unique position in Japanese cinema, but for profiling a stimulating thinker who is struggling with the concept of being an artist in a country that may not care for modern cinema. **TB**
$15.95 *(HB/308)*

The Cinema of Isolation: A History of Physical Disability in the Movies
Martin F. Norden
Chronicles handicapped stereotyping from the

"Obsessive Avenger" Quasimodo, to the "Oedipal remasculinizing" of Luke Skywalker after he loses his sword hand to Darth Vader, to *Scent of a Woman*, in which Al Pacino wants to kill himself because he's blind. From Hollywood's Golden Age: *Freaks* repulsed '30s sensibilities (the cast was barred from eating in the MGM commissary), and the studio extended this prejudice to the publicity, calling the Tod Browning film a "thrillingly gruesome tale" and referring to its performers as "creatures of the abyss," "strange shadows," "nightmare shapes in the dark" and "grim pranks of nature—living in a world apart." Even the sympathetic Browning was not immune—he took liberties with the original magazine article on which Freaks was based and tagged on the film's famous midnight revenge/Chicken Lady. Gabba-gabba-hey. **GR**
$16.95 *(PB/385/Illus)*

The Complete Films of Mae West
Jon Tuska
An American original—the finest female purveyor of good, clean smut. Before the Brooklyn-born vaudevillian hit Hollywood (*Night After Night*, *She Done Him Wrong*, *I'm No Angel*), Mae West was a Broadway playwright and actress. From day one, the "girl who shook a wicked shoulder" was in hot water with the critics, and she thrived on the scandal. Her 1927 comedy/drama *Sex* (written as "Jane Mast") was raided by the police, and the cast was thrown in jail. The "hot second act" in the bordello was probably the reason. Next came "a homosexual comedy in three acts," *The Drag*. Said one *Variety* reviewer: The play "was a cheap and shabby appeal to sensationalism." The high point came in the third act, "a jazzed-up revel on the garbage heap. Some 30 young men take part in the spectacle, half tricked out in women's clothes and half in tuxedos. Half a dozen of the boys in skirts do specialties, and the episode takes on the character of a chorus-girl 'pick-out' number in a burlesque show . . . All hands are rouged, lipsticked and liquid-whited to the last degree." Mae West's sister was arrested for disorderly conduct prior to the opening.
 GR
$15.95 *(PB/208/Illus)*

The Complete Films of Marlene Dietrich
Homer Dickens
Tales of the Teutonic Love Goddess.

"Universal, having created a 'new Dietrich' with *Destry Rides Again*, was prepared to cash in on a good thing. What they hadn't counted on was giving Dietrich a role that was to become one of her best! *Seven Sinners*, an action-packed, two-fisted melodrama, had wide appeal, and Dietrich's Bijou Blanche is a gorgeous satire of the Sadie Thompsons of the world. René designed some of the wildest creations. The black-and-white-patchwork quilt get-up is a riot of bad taste, to say nothing of her rings, bracelets, cigarette holder (loaded with jewels) and the inevitable feathers!" As movie critic Bosley Crowther noted: "If Miss Dietrich and her comedies were both just a little broader, Mae West would be in the shade." **GR**

$17.95 *(PB/224/Illus)*

Dancing Ledge†
At Your Own Risk††
Modern Nature†††
Derek Jarman's
Garden††††
Derek Jarman

First in the series of memoirs by late filmmaker and artist Derek Jarman, *Dancing Ledge* charts Jarman's growth as a man and artist. Starting with childhood memories as an army brat in occupied Italy after World War II and continuing through his years at public school and university, Jarman recounts his youth in a journal-like format.

At Your Own Risk is a distillation of his philosophy of life and a witty guide to gay sexuality from the repressed '40s through the AIDS-chilled present. "Landscapes of time, place, memory, imagined landscapes. *At Your Own Risk* recalls the landscapes you were warned off: Private Property, Trespassers Will Be Prosecuted; the fence you jumped, the wall you scaled, fear and elation, the guard dogs and police in the shrubbery, the byways, bylaws, do's and don'ts, Keep Out, Danger, get lost, shadowland, pretty boys, pretty police who shoved their cocks in your face and arrested you in fear." *Modern Nature* is the journal he kept during 1989 and 1990 with the awareness that one day it would be published. Written during the period Jarman was at work on *The Garden* and *Edward II*, he here juxtaposes his planning and cultivation of his famous garden in Dungeness with his declining health due to the ravages of AIDS. Derek Jarman's *Garden* is his personal account of how his garden evolved from its beginnings to the last days of his life. The photographs provide glimpses of Jarman's life in Dungeness: "walking, weeding, watering or simply enjoying life." **JAT**

†$24.95	*(HB/254/Illus)*
††$13.95	*(PB/314/Illus)*
†††$10.95	*(PB/154/Illus)*
††††$26.95	*(HB/144/Illus)*

The Dark Side of the Screen: Film Noir
Foster Hirsch

"Film noir is a term used to describe the dark, brooding, doom-laden films that emerged from Hollywood after World War II. *Double Indemnity, The Big Sleep, Pickup on South Street, Kiss Me Deadly, Sunset Boulevard, The Killers, High Sierra*—these were just a few of the hundreds that appeared during the postwar decade, all of them registering a more cruel, disoriented, heartless vision, of America than had ever appeared before. . . . The most thorough and entertaining study of the themes, visual motifs, character types, actors, directors and films in this genre ever published. From Billy Wilder, Douglas Sirk, Robert Aldrich and Howard Hawkes to Martin Scorsese, Roman Polanski and Paul Schrader, the noir themes of dread, paranoia, steamy sex, double-crossing women and menacing cityscapes have held a fascination."

$17.95 *(PB/229/Illus)*

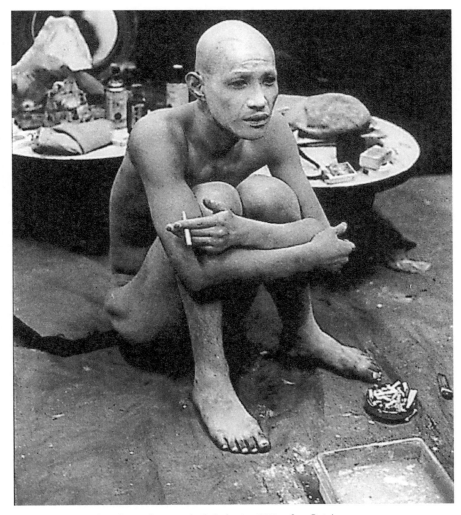

Dairakudakan member after performance in their theater, 1983 — from Butoh

David Wojnarowicz: Tongues of Flame
David Wojnarowicz

The catalog from an exhibition of Wojnarowicz's visual work held at the State University, Normal, Illinois in 1990. The volume contains interviews and essays by and about the artist, numerous photographs of his work in various media (photography, performance, painting and collage) and excerpts of his prose. If there is one unifying theme to the book it's Wojnarowicz's unrelenting conviction, set down in both his words and his work, that the political and the personal are inextricably linked and can only be defined in relation to each other. The fascinating portrait that emerges is of an artist who was capable of directing his central concerns (the status of the outsider, the pariah, the socially stigmatized) with equla force into any medium he chose. An excellent comprehensive overview—both of the artist and the social context from which he emerged. **MDG**

$29.95 *(PB/127/Illus)*

Deathtripping: The Cinema of Transgression
Jack Sargeant

Focusing primarily on the trash terrorism of the New York movie underground from its roots in the post-punk '70s through to the digital fixes of the early '90s, *Deathtripping* reads like a depraved cinematic book of the dead. Whether detailing Beth and Scott B's brutal meditation on torture, *Black Box*, the visionary excesses of Nick Zedd's *War Is Menstrual Envy* or the strap-on role-reversal porn of Richard Kern's *The Bitches*, it soon becomes clear from this remarkable collection of interviews and profiles that the most forceful arguments for transgression in film are ethical rather than aesthetic. A shared anger and frustration with the legacy of Reagan's fuckwit America cuts through every line and image. With the likes of Lydia Lunch, Joe Coleman, Tommy Turner and David Wojnarowicz also on hand to give evidence, a selection of film scripts, assorted manifestoes and diatribes as well as some rare stills and twisted production shots, Jack Sargeant has taken a corpse and turned it into a feast. Folks'll be pickin' dark meat off these bones for a long time to come. **KXH**

$16.95 *(PB/258/Illus)*

Dialogues with Marcel Duchamp
Pierre Cabanne

The author must have been highly respected and trusted by Marcel Duchamp because this series of coversations between two learned and mild men in 1966, two years before Duchamp's death, are unexpectedly warm, open and relaxed. Despite the many marvelous books reviewed throughout this sourcebook, I am going to maintain that every reader should do everything possible to acquire a copy of *Dialogues With Marcel Duchamp* as soon as possible. It is really that essential, a sentiment which Duchamp would no doubt deplore on principle.

Marcel Duchamp was selected in one of the few moments of consensus among the bickering and socially feeble Surrealist group as a general mediator. He presided over a group whose chief practice was making, squeezing, honing and pricking conceptual conceits, words and objects until they could pass for disconcertingly comfortable contrivances, things more or less akin to that very art that seemingly froze over its *self* early in this century, dying in a mire of deceit. Apparence, and appearance sit benignly in a worn, leather armchair blowing out a steady stream of Havana cigar smoke and musing with cynical irony over the possibilities and improbabilities of "deceptual art," as Brion Gysin once dubbed it.

Upon reflection, this is all rather peculiar and not a little ridiculous. Was Duchamp primarily an armchair critic whose persuasive challenges pushed a pseudo-avant-garde unwittingly and quite fearfully towards a new radicalism disconcertingly beyond painterly concerns and art-historical contexts, and employing surgically logical analyses of method, motive, madness and the absurdity of making any "Thing" with either a small or capital "T"? The impression of Duchamp that emerges from this book is one of an existentialist dandy par excellence whose brilliant brain amused itself in order to alleviate the utter boredom and pointlessness of a shattered Western culture bereft of all style and function, and whose final commentary upon uselessness was to exploit and animate the limits of the intrinsically redundant and meaningless.

So, was Duchamp the seminal imposter of 20th-century art, as many conceptually retarded painters, critics and even dealers with more than a passing vested interest in the merely "retinal" decorations passed off as "art" that Duchamp so wished to terminate with extreme prejudice would have us believe? Duchamp states that he amused himself occasionally by "thing" making, as he would objectively describe it. Money was not his prime directive. In fact, examples are given of his financial disability. Many "things" were made just to give to a friend at a nominal price when they could have been sold through dealers for a far higher price. Surprisingly, throughout his incredibly influential and intellectually colossal life he had only a single "one-man" exhibition in his native France and about four others worldwide.

Duchamp really didn't give a fuck about established art-world systems of lionization or the accrual of critical esteem. He eked out a frugal living first from librarianship, and later by buying and selling works by Brancusi. He claimed laziness and convenience led him to sell as many of his works as he possibly could to a single patron, collector Walter Arensberg. For Duchamp, minimizing distraction was a preeminent ascetic concern. Throughout his life he sought privacy and was punctilious regarding discretion. He maintained absolute control and discipline in all aspects of his perceptual life, with a level of linguistic and conceptual rigor that remains as extraordinary today as it was to André Breton and Duchamp's other contemporaries throughout his marvelously inspiring life.

Was he a charlatan? An opportunist? A compelling and ruthlessly effective "art historical" strategist? My personal position would have to be "of course . . . yes . . . no . . . probably . . . it really does not matter . . . no . . . yes."

Duchamp himself repeatedly claims that all his "things" and ideas are only the result of "an extraordinary curiosity" and a need to alleviate a sophisticated sense of boredom by "amusing" himself. So much the better! His elevation of skepticism to a previously unthinkable level is as contemporary and inspirational as it gets. At one point in this book he tellingly asserts while discussing Surrealism that "There isn't any existential painting." Cabanne replies, "It's a question of behavior," and dear Duchamp concurs, "That's it." The conclusion one could rightly draw after enjoying the twists and turns within this text is that Marcel Duchamp is deflecting us from the inevitable and probably accurate conclusion that he was, and is, the quintessential existentialist painter. Possibly the first and last of his kind, and all the more glorious and vainglorious for it. What is certain is that his clarity of disenchantment and detachment is so utterly

compelling and rings so true that his exclusion from any perspective of what has laughingly been dubbed the "history of art" on the grounds of whimsy and sarcasm personified would be an inadmissable omission. He has set us all up forever, redesigned the "game," reassigned the functions of the pieces and, with disarming charm has put us in a most rigorous and contorted situation of checkmate. **GPO** $9.95 *(PB/136/Illus)*

Diane Arbus: A Biography
Patricia Bosworth
Profiles one of the most preeminent and influential photographers of the 20th century, covering Arbus' privileged Park Avenue childhood, her marriage to (and divorce from) Alan Arbus, her photographic work for various fashion magazines (among them, *Vogue* and *Glamour*) and her emergence as an artist in her own right. Encouraged by her mentor, Lisette Model, to pursue "the forbidden" with her camera, Arbus documented—with a steely persistence, a gentle manner and a wise child's eyes—the perverse, the alienated and the strange: "people without their masks," as she put it. But the ever mounting freedoms and risks she pursued in her work did not come without a price. Plagued throughout her life by depressions that commenced in childhood, Arbus possessed a sense of despair and futility that appears to have escalated in proportion to her increasing fame. She resolved her personal crisis tragically by committing suicide in 1971. A compassionate, informative and highly readable biography of this uncompromising and enigmatic giant of American photography. **MDG** $14.00 *(PB/367/Illus)*

Diane Arbus: An Aperture Monograph
Diane Arbus
First published in 1972, a year after the artist's death by suicide, this volume is a collection of 80 photographs she took between 1962 and 1971. Referring to herself as "an anthropologist of sorts," Arbus chose archetypes as subjects, everything from the conventional to the marginal: teenagers, suburbanites, infants, dwarfs, drag queens, nudists. Possessed of an unflinching ability to see the unexpected in the familiar and the familiar in the freakish, Arbus created portraits—raw, unsettling, gentle and sympathetic—that became col-

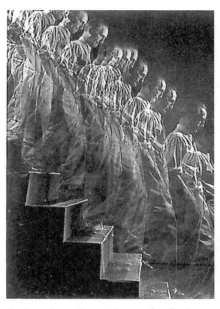
Duchamp descending a staircase — from **Duchamp**

laborative, silent dialogues between herself and her subjects. For all their documentary-like clarity and starkness (she frequently shot with a strobe), the photos consistently confirm that their thrust is internal, not external, private rather than social; to quote the artist, "a little bit like walking into an hallucination without being quite sure whose it is." The introduction, edited from tape recordings of classes she gave in 1971 as well as from interviews and her writings, provides an excellent insight into Arbus' thoughts on the art of photography and her intentions within that form. **MDG** $29.95 *(PB/136/Illus)*

Dictionary of the Avant-Gardes
Richard Kostelanetz
Rimbaud, Stein, Cage, Beefheart, electronic music, Reinhardt, Duchamp, Fuller, Paik, performance art, Reich, copy culture, etc. "Elucidates, celebrates, enumerates and sometimes obliterates achievers and achievements in the avant-garde arts. Although it runs from A to Z, it could have easily have been written from Z to A (or in any other order you might imagine) and may be read from front to back, back to front, or point to point. It is opinionated, as all good dictionaries should be, but it is also inclusive, because there can never be just one avant-garde." If you don't like it, says

the author, go read the phone book. **GR** $16.95 *(PB/246/Illus)*

Documentary: A History of the Non-Fiction Film
Erik Barnouw
Barnouw, former chief of the Library of Congress' Motion Picture, Broadcasting and Recorded Sound Division, covers a lot of celluloid ranging from the earliest cinematic experiments of Muybridge, Lumière and Edison to *Shoah*, *Sherman's March* and *Roger and Me*. Such towering figures of documentary filmmaking as Dziga Vertov (*Man With the Movie Camera*), Robert Flaherty (*Nanook of the North*, *Moana*), Leni Riefenstahl (*Triumph of the Will*, *Olympia*), the Maysles Brothers (*Salesman*, *Gimme Shelter*) and Frederick Wiseman (*Titicut Follies*, *High School*) are given their proper due along the way in this densely packed ride through a century of non-narrative film history. **SS** $10.95 *(PB/400/Illus)*

Doré's Illustrations for Rabelais
Gustave Doré
Young Doré (1832-1883), "the precocious genius from Strasbourg, who had been drawing practically from infancy," was inspired by Rabelais' two social satires, *Gargantua* and *Pantagruel*, to produce these comic illustrations. The woodblock prints show Doré's deft, humorous hand at work, playing light against dark for both dramatic depth and theatrical effect. *Gargantua* is the story of a giant man, who can be seen here spearing a human on his dinner fork (strictly a Doré touch—it's not in the story). **GR** $9.95 *(PB/153/Illus)*

Duchamp 1887-1986: Art as Anti-Art
Janis Mink
"I want to grasp things with the mind, the way the penis is grasped by the vagina." Duchamp channeled the hot air of dada into the lungs of surrealism. Originator of the ready-made as art object, Duchamp experimented with the effects of motion on perception, created art in response to science and technology and generally got busy, messing with the artists and critics of his day. Surrounding himself with suggestions of androgyny and a wall of silence, he presented art historians, critics and patrons with an

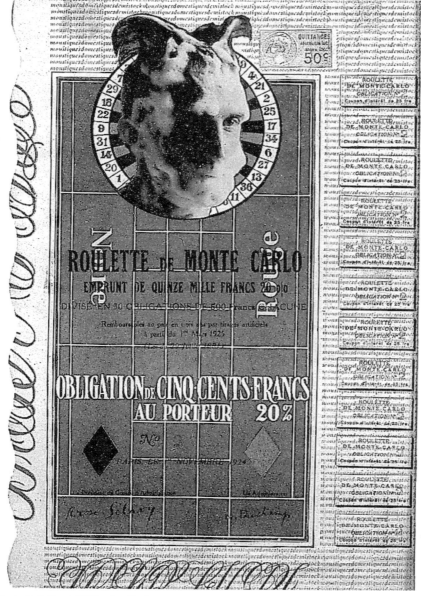

Monte Carlo Bond, 1924 — from **Duchamp**

IQ test, poetry, word play and an element of humor. The book is large, glossy and includes chronology, notes and many fine plates. Provocative, aggravating, confusing, but too strange to be meaningless.　　**CF**
$9.99　　　　　　*(PB/94/Illus)*

Ecce Homo
George Grosz
Grosz's masterwork depicting Germany between wars through grotesque cabaret visions and images of frightening hedonism.
$7.95　　　　　　*(PB/88/Illus)*

El Lissitzky
Sophie Lissitzky-Kuppers
"WE, ON THE LAST STAGE OF THE PATH TO SUPREMATISM BLASTED ASIDE THE OLD WORK OF ART LIKE A BEING OF FLESH AND BLOOD AND TURNED IT INTO A WORLD FLOATING IN SPACE. WE CARRIED BOTH PICTURE AND VIEWER OUT BEYOND THE CONFINES OF THIS SPHERE AND IN ORDER TO COMPREHEND IT FULLY THE VIEWER MUST CIRCLE LIKE A PLANET ROUND THE PICTURE WHICH REMAINS IMMOBILE IN THE CENTER."—El Lissitzky, 1920

Having moved in the radical Russian art spheres of Constructivism and Suprematism from before the Russian Revolution all the way through the Stalin years until his death in 1941, El Lissitzky forged his utopian strivings into such aesthetically demanding examples of pragmatic Soviet mass expression as exhibition design, wartime propaganda, book illustration, photomontage posters and architecture. Fluent in German and English, Lissitzky was an important bridge between the German Dadaists of the '20s and '30s and their contemporaries in the idealistic Soviet art organizations. Compiled by his wife and sometime collaborator, Sophie, and originally published in East Germany in 1967, this book includes a comprehensive collection of his writings and manifestoes, a biographical sketch based on his letters, and hundreds of examples of how Lissitzky help to define the revolutionary modernist aesthetic.　　**SS**
$70.00　　　　*(HB/410/Illus)*

Emotion and the Structure of Narrative Film: Film as an Emotion Machine
Ed S. H. Tan
"Introduced 100 years ago, film has since become a part of our lives. For the past century, however, the experience offered by fiction films has remained a mystery. Questions such as why adult viewers cry and shiver, and why they care at all about fictional characters—while aware that they contemplate an entirely staged scene—are still unresolved. In addition, it is unknown why spectators find some film experiences entertaining that have a clearly aversive nature outside the cinema. These and other questions make the psychological status of emotions allegedly induced by the fiction film, highly problematic. . . . It is argued that film-produced emotions are genuine emotions in response to an artificial stimulus. Film can be regarded as a fine-tuned machine for a continuous stream of emotions that are entertaining after all."
$59.95　　　　　　*(HB)*

The Encyclopedia of Monsters
Jeff Rovin

Blood-drinking vegetables! Bronze-skinned Gorgons! This A-to-Z guide to monster features such DC Comic creatures as Horro from *Sea Devils* and the Giant Cat from *House of Secrets* mixed with *Star Trek* TV villains like the Horta; horror-movie monsters like Universal's mummy Im-Ho-Tep and Hammer's Gorgo; Harryhausen animations like the Minoton from *Sinbad and the Eye of the Tiger*; B movie abominations such as the Crawling Eyes from *The Crawling Eye*; and pulp horrors from way back like the Klangan from Edgar Rice Burroughs' *The Pirates of Venus*, written in 1932. Whew! Includes references on each monster's first appearance, "species," gender and powers, size and "biography." **GR**
$19.95 *(PB/400/Illus)*

The Era of German Expressionism
Paul Raabe

Notes, letters, documents and essays on the early years, 1910 to 1914. "We were possessed. In cafés, in the streets and squares, in artists' studios, we were 'on the march' day and night, we drove ourselves to fathom the unfathomable, and, as poet, painter and composer in one, to create the incomparable 'Art of the Century', a timeless art which would surpass all art forms of preceding centuries." That was the Expressionist vision, but the art of its adherents became imbued with another sort of timelessness—the horrors of World War I and death, which came "like a visitation upon mankind, and the words of those writers who survived formed themselves into a scream of revolt, desperation and hatred." From 1915 through 1920, Expressionism went dark during and after the war. "Yet something of the old European heritage survived in the passionate hope and faith in the future." **GR**
$12.95 *(PB/421)*

Fake?
The Art of Deception
Edited by Mark Jones

In 1990, the British Museum in London mounted an exhibition consisting entirely of fakes. It gathered together paintings, sculptures, reliefs, ceramics, prints, manuscripts and other artistic and historical artifacts all of which had been initially validated as authentic but which were eventually found to be fraudulent, the products of skilled artists and artisans whose main objective was to fool the experts. It was a visionary show, to say the least, and courageous in that it questioned the authority and the expertise of museums themselves. This book is the catalog of that important show.

Study closely the Cottingley Fairy Photographs believed to be actual images of those elusive beings. Gaze with wonder upon the fur-covered trout, previously owned by the Royal Scottish Museum and at one time believed to be an actual specimen brought back from the wilds of Canada. See the supposedly ancient marble head of Julius Caesar, revealed to have been artificially weathered—perhaps by pounding it with a nail-studded piece of wood. All of these marvels and more are to be found in this remarkable book, at once an investigation of the limits of expertise, a chronicle of the varieties of human gullibility, and an illustrated catalog from a fascinating art show. **AS**
$24.95 *(PB/312/Illus)*

Faster and Furiouser: The Revised and Fattened Fable of American International Pictures
Mark Thomas McGee

"In 1984, Mr. McGee wrote the acclaimed *Fast and Furious*, a history of American International Pictures. But, as McGee wrote in his out-of-the-blue offer to do a bigger-and-better, 'Because of my unnatural interest, I've never stopped.' The result of his ceaseless efforts can be found in this updated and expanded look at AIP. From the time Sam Arkoff and Jim Nicholson founded the company, they dominated the low-budget film market with such teen-oriented movies as *Beach Party* and *I Was a Teenage Werewolf*. Their movies were frowned on by critics, not because they were terrible (which they mostly were) but because they were so shameless in their intent—to make money. This new work includes the most comprehensive AIP filmography ever assembled, as well as many new photographs not included in the earlier work."
$40.00 *(HB/304/Illus)*

Fellini on Fellini
Federico Fellini

Begins with Fellini in a sickbed fever dream melting from adult to child, with nuns and priests popping in and out of view, and Fellini profusely flowing back and forth between life and film—just like *Amarcord!*—a point driven home by the presence of eight photos from *Amarcord* and one of Fellini making the film. Includes charming stories from most of Fellini's life, interspersed with 82 manifestoes on his art: lots of circuses and clowns; his wife actress Julietta Masina; breakdown (*Toby Dammit*); and subsequent recovery to confront the film of his own life in the finale of *8 1/2*. "I've seen this blessed film of mine. And it's something like my own nature. And yet . . ."—Fellini **MS**
$13.95 *(PB/182/Illus)*

Film as a Subversive Art
Amos Vogel

"This is a book about the subversion of existing values, institutions, mores and taboo—East and West, left and right—by the potentially most powerful art of the century. . . . It is the powerful impact of these brightly lit images in black space and artificial time, their affinity to trance and the subconscious, and their ability to influence masses and jump boundaries, that has forever made the cinema an appropiate target of the repressive forces in society—censors, traditionalists, the state." Weapons of subversion include "The Power of the Visual Taboo," "The Ultimate Secret Death," "The Attack on God: Blasphemy and Anti-Clericalism" and "Surrealism: The Cinema of Shock."
$13.00 *(PB/336/Illus)*

Film Noir:
An Encyclopedic Reference to the American Style
Alain Silver and Elizabeth Ward

An exhaustive A-to-Z compilation of Hollywood's popular postwar film fad, hopelessly over-analyzed by scholars and critics. "[These movies] consistently evoke the dark side of the American persona. The central figures in these films, caught in their double binds, filled with existential bitterness, drowning outside the social mainstream, are America's stylized vision of itself, a true cultural reflection of the mental dysfunction of a nation in uncertain transition." Includes plot synopses, critiques, casts and credits. **GR**
$26.95 *(PB/479/Illus)*

Fireworks, Rabbit's Moon and Eaux D'Artifice
Kenneth Anger

Fireworks (1947): "A dissatisfied dreamer awakes, goes out in the night seeking a light, and is drawn through the needle's eye. He returns to a bed less empty than before." *Rabbit's Moon* (1950): "A fable of the Unnattainable (the Moon) combining elements of the comedia dell'arte with Japanese myth. A lunar dream utilizing the classic pantomime figure of Pierrot in an encounter with a prankish, enchanted Magick Lantern . . ." *Eaux D'Artifice* (1953): "Hide-and-seek in a night-time labyrinth of levels, cascades, balustrades, grottoes and ever-gushing, leaping fountains, until the water witch and the fountain become one."—Anger

$29.95 *(VIDEO)*

Fluxus
Thomas Kellein and Jon Hendriks

Amazingly, Fluxus managed to put into practice what so many artists—whether individual, collective or institutionalized—continue to harp on, though mainly in theory: a program of exemplary openness, versatility and continual surprise. Spearheaded by the suitably charismatic George Maciunas, this was a (very) loose consortium of creative oddballs which included painters, sculptors, photographers, filmmakers, poets, musicians, dancers and even the occasional designer, all of whom had agreed to periodically forsake some of their autonomy in order to join together in fluid, collaborative ensembles, to disband and recombine at the drop of a hat, and to explore to the fullest the possibilities that different configurations afford. Variety was Fluxus' operational principle; variety of medium and technique complemented by that of the membership, which was evenly, yet unsystematically, distributed across still daunting divides of gender, race, nationality. Even the present enthusiasm for P.C. multimedia product cannot begin to approach the sheer breadth and range of these interdisciplinary endeavors.

This being so, it should come as no surprise that the numerous catalogs and publications which have emerged around Fluxus are likewise varied in the particular focus of their essays and documentation. This book happens to be a very good one—including a surprisingly moving account of the short, weird life of the late Maciunas; a

more than adequate selection of the various posters, handbills and other printed ephemera which showcase a graphic sensibility that grows more elegant with each passing year; and a bunch of photographs of a bunch of objects and performances that together define just what it is that has all been done before. **JT**

$19.95 *(PB/142/Illus)*

Fragments of Fear: An Illustrated History of British Horror Movies
Andy Boot

"The book examines a wide array of British horror films and the stories behind them, from the early melodramas of Tod Slaughter right through to Hammer and their rivals Tigon and Amicus, plus mavericks like Michael Reeves, sex/horror director Peter Walker and more recent talents such as

Clive Barker, director of *Hellraiser*. Films featured range in scope from the sadism of *Peeping Tom* to the mutant SF of *A Clockwork Orange*."

$16.95 *(PB/283/Illus)*

Fred Tomaselli
Fred Tomaselli

Suspended in immaculate resin fields, Tomaselli's chosen materials—a pharmacopoeia including everything from Percodan to Sudafed, hemp leaves to blotter acid—become planets, cells, stitches, landscapes, hypnotic patterns. Time and space warp, and patterns of saturated colors swirl, shimmer, vibrate and fly by like squadrons of alien crafts which flash in one's peripheral vision. The implications of the drugs and their contexts dovetail and jam, multiply and complicate each image's multilayered meanings and affects. The sublime

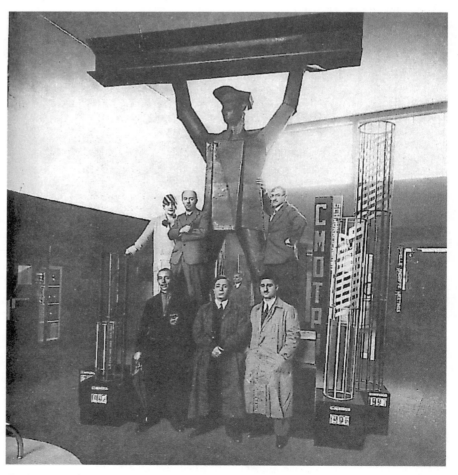

The Co-Workers (Sophie and El Lissitzky above left) — from El Lissitzky

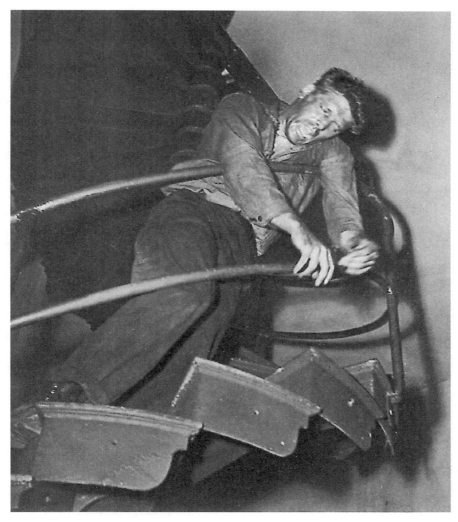

Spiral staircases are a sure sign of chaos, as Burt Lancaster discovers in Brute Force. — *from* Film Noir

beauty of these compositions dispenses a blast of psychic pleasure, strangely flavored by a mournful sense of the spirituality we long for in everyday life.

Like drugs, these works demand nothing of the viewer, and generously deliver the unexpected. This is not to say they exist outside of art history, and Alisa Tager's excellent essay explores influences and inferences involving movements from Constructivism to Conceptualism. Both Tager and David A. Greene met the challenge of soberly discussing this gloriously experiential work (with the possible exception of Greene's Grateful Dead concert acid trip reverie), and the color reproductions in this small gem of a catalog are very good. **M H**
$10.00 *(PB/37/Illus)*

From Bruce Lee to the Ninjas: Martial Arts Movies
Ric Meyers, Amy Harlib, Bill and Karen Palmer

"From the animal grace of Bruce Lee through the brutal flailing of Sonny Chiba to the wooden precision of Chuck Norris, martial arts movies are ridiculed or ignored by everyone save the millions who love them. The very same people who gasp in wonder at the Peking Opera deride kung fu movies without realizing that the finest ones are marvelous combinations of opera and ballet. . . . The historic grandeur, the melodramatic emotions and the impressive choreography only serve to point up the

martial movies' action. That's what we really love. These are great action movies."
$14.95 *(PB/255/Illus)*

Fun in a Chinese Laundry
Joseph von Sternberg

"Certainly to disembody human beings into shadowgraphs of my concepts of them is no labor of love. To enclose them in an ever-shifting frame imperceptible to them, to persuade or compel them to conceal their bewilderment, to force them to walk the chalk line of a vision alien to many who move in front of a camera, is not conducive to 'creative ecstasy'. . . . Engraved on a surface more sensitive than any other known material are thoughts that have been absorbed by large masses never before exposed to such a vigorous agent. But what went into my films and what came out was not always the same."
$9.95 *(PB/352/Illus)*

Gas Tanks†
Industrial Façades††
Mineheads†††
Bernd and Hilla Becher

"The famous Düsseldorf photographers' formal investigation of industrial structures displays their serenely cool, rigorous approach to the structures they photograph as variations on an ideal form. The Bechers make no attempt to analyze or explain their subjects. For more than 35 years, the Bechers have been creating a monument to the most venerable buildings of the industrial era through their photographic art. They have re-awoken the forgotten or unnoticed beauty of water towers, gas holders, lime kilns and blast furnaces, and their photographs have told the story of the process of industrialization. Their head-on, deadpan photographs express an almost Egyptial sense of man's heroic effort to put his mark on the landscape. *Industrial Façades* covers the whole range of periods and designs representing the austere brick buildings of the early industrial age. *Gas Tanks* presents four principally different forms of gas holders or gas tanks taken over three decades. *Mineheads* shows the winding towers used to extract the coal and iron ore from the mines, and to transfer miners back and forth from underground. "
†$55.00 *(HB/144)*
††$75.00 *(HB/240/Illus)*
†††$75.00 *(HB/200/Illus)*

Gods of Earth and Heaven
Joel-Peter Witkin
Photographic master of the beauty of the grotesque. With the lush, timeless feeling of daguerrotypes, Witkin photographs transform the "shocking" into sensual tableaux: a severed head on a plate, Siamese twins joined at the head, hermaphroditic Venuses, a dead-meat cornucopia, a man on a bed of nails . . . all interspersed with visual references to classic art pieces and Christian iconography.
$55.00　　　　　*(HB/124/Illus)*

Goya Drawings: Forty-four Plates
Francisco Goya
"One of the supreme artists of the 18th and 19th centuries, Goya produced an enormous body of paintings, drawings and engravings. His drawings especially demonstrate the vast range of the artist's subject matter and technique, and include all of Goya's best-known thematic material: portraits, scenes of fantasy and horror, bullfighting, witchcraft, the sorrows of war, social satire, prisons and executions, liberalism

and anticlericalism."
$3.95　　　　　*(PB/48/Illus)*

Grammar in the Film Language
Daniel Arijon
Speak loudly in the swinging cafés, pepper your repartee with words from this book and save the $50,000 it would have cost to attend that stuffy film school. *Grammar's* purpose is to present narrative techniques for film in a practical way, instruction on the proper organization of images for their presentation onscreen. This includes motion, dialogue, punctuation, camera movement and editing editing editing. While it is the only resource of its kind and is infinitely useful to the budding auteur, the author stresses that only when the celluloid is "running through your fingers" will you be near the completion of your education in film.　　　　　**SK**
$22.95　　　　　*(PB/624/Illus)*

Grosz
Ivo Kranzfelder
The art of German apocalyptic painter George Grosz. Grosz was a young soldier

during World War I but was kicked out without ever having been to the front. After the Russian Revolution he joined the artist's association November Group, which formed in Berlin in 1918, and co-founded the German faction of the Dada movement. Grosz was a biting political satirist, and his most poignant works, produced throughout the '20s, skillfully presented acerbic commentaries on the decadent elite and the ravaging political war machine. Grosz's cartoons, paintings and drawings (this book includes over 70 illustrations, half of those in full color) demonstrates that scenes from the aftermath of World War I—poverty, corruption, filth and debauchery—are just as likely to be scenes from today.　　**MDH**
$9.99　　　　　*(PB/96/Illus)*

Guilty Pleasures of the Horror Film
Edited by Gary J. Sveha and Susan Sveha
Thirteen shameless defenders wallow in the cheese of 14 shameless films, including *The Tingler, Dune* and *When Dinosaurs Ruled the Earth.* Film history, director interviews and volumes of insider film facts help weave these amusing tales of cinema's classic clinkers. *Maniac,* in which a madman eats out the eye of a cat, is defended as "a satisfying reprieve from the carefully paced, well behaved, overscripted mainstream pictures that dominate the history of the cinema." *Voodoo Man* "succeeds in creating a fun world that weds the ridiculous with a genuinely important scene in the Lugosi canon." Dino DeLaurentiis' *King Kong* is called "movie magic at its thrilling best." On *Indestructible Man,* Lon Chaney's drunken tour de force, well, "you just have to love this film." And *Rodan* is proved to rank "with *Godzilla* and *The Mysterians* as one of Toho's top three science fiction films." Consider the film's moving "Eulogy for Two Dying Monsters," dubbed in by Key Luke as the monsters are brought down by a volcano: "As Kyo turned to weep on my shoulder, I realized that the Rodans were doomed. The heat, the gases, the bombardment added to their bewilderment. Like moths in those rivers of fire, they seemed to almost welcome the agonies of death. And when, still calling to each other, one of them fell at last into the molten lava stream, the other still refused to save itself. The last of their kind, masters of the air and Earth, the strongest, swiftest creatures that ever breathed—now they sank against the Earth like weary chil-

George Maciunas, Dick Higgins, Wolf Vostell, Benjamin Patterson and Emmett Williams performing Philip Corner's Piano Activities *at Fluxus Internationale Festspiele Neuester Musik, Wiesbaden, 1962*
— *from* Fluxus

dren. Each had refused to live without the other, and so they were dying together. I wondered whether I, a 20th-century man, could ever hope to die as well." **GR**
$20.00 *(PB/251/Illus)*

Guyana
Alexis Rockman
"In 1994, New York artist Alexis Rockman ventured to the dense jungle of Guyana, the site for this fantastic dreamscape of biological life, flora and fauna. Rockman's world of nature is tempered by a penchant for the bizarre and the grotesque, but is always based upon careful scrutiny and intimate observation of the environs. Drawing from a host of visual sources that include science fiction films, historical landscape and genre paintings, biology illustrations, and museum dioramas, *Guyana* depicts the predatory and violent narrative of the ecosphere. Monumental insects—ants, mites, bees and beetles—vie on Rockman's vibrant canvasses with anteaters, exotic birds, piranhas and iguanas."
$60.00 *(HB/88/Illus)*

Hammer, House of Horror: Behind the Screams
Howard Maxford
"In its heyday, Hammer Films was regarded as Britain's leading purveyor of horror films to the world. From 1955 to 1972, it produced a legacy of frightening classics including *Dracula*, *The Curse of Frankenstein*, *The Quatermass Experiment*, *Kiss of the Vampire*, *The Curse of the Werewolf* and *The Devil Rides Out*. The Hammer stars—all remembered here—include Peter Cushing, Christopher Lee, Oliver Reed, Bette Davis, Ingrid Pitt, Ursula Andress and Raquel Welch. A chronological, film-by-film history of Hammer Films, terrifyingly illustrated in color and black-and-white."
$27.95 *(HB/192/Illus)*

Happenings and Other Acts
Edited by Mariellen R. Sandford
A collection of seminal essays, interviews and texts by and about artists who started the performance movements of the '60s and '70s. This book includes a complete reprint of *The Drama Review*'s "Happenings" issue from 1965, excerpts from Allan Kaprow's essay "Assemblages, Environments and Happenings," selections from Carolee Schneemann's book *More Than Meat Joy*

George Maciunas, Fluxpost (Smiles), *1978 — from* **Fluxus**

and the first overview of European Happenings written in English by Gunter Berghaus. Invaluable as a complete description and analysis of the Happenings and the Fluxus movement; a great resource book for artists, teachers and anyone interested in the history of performance art. Artists include: Carolee Schneeman, John Cage, La Monte Young, Yvonne Rainier, Claes Oldenburg, Anna Halprin, Joseph Beuys, the Viennese Aktionists, Zero Group and many others. **MDH**
$18.95 *(PB/397/Illus)*

Hardboiled in Hollywood
David Wilt
Meet five Black Mask pulp detective writers (who weren't named Chandler, Gardner, Hammett, Halliday or L'Amour): Horace McCoy, who wrote *Island of Lost Men* for Paramount before he wrote *They Shoot Horses, Don't They?*; Eric Taylor, who penned Universal's *The Ghost of Frankenstein*; Peter Ruric, who wrote Edgar G. Ulmer's *The Black Cat*; Dwight V. Babcock, who scribed *Jungle Captive* and *The Brute Man* for Universal; and John K. Butler, who churned out westerns for Republic, and a rare horror movie, *The Vampire's Ghost*. Did anybody say "auteur"? **GR**
$19.95 *(PB/189/Illus)*

Hitchcock and Homosexuality: His 50-Year Obsession with Jack the Ripper and the Superbitch Prostitute —

A Psychoanalytic View
Theodore Price
$49.50 *(HB/434)*

Hollywood: Mecca of the Movies
Blaise Cendrars
In 1936, the French newspaper *Paris-Soir* sent the popular poet and novelist Blaise Cendrars to write on Hollywood. He stayed at the then ultraluxurious Roosevelt Hotel and thrilled his countrymen with each canny report. These articles were reworked and gathered together that same year, but have only now been translated into English. In them Cendrars explores Hollywood in its golden years, presenting a fun series of journalistic encounters on the streets of Tinseltown. His attempts to interview the powerful studio heads were often thwarted by Cerberus-like studio guards, but Cendrars still managed to cover a lot of territory. And much of what he uncovered still applies today, as is made evident by his chapter titles: "In Hollywood anyone who walks around on foot is a suspect" and "If you want to make movies, come to Hollywood, but unless you pay the price, you won't succeed!" **CS**
$25.00 *(HB/256/Illus)*

Hong Kong Action Cinema
Bey Logan
Kick! Bang! Chop! Sock! *Enter the Dragon, Deep Thrust, Hardboiled, City on Fire, The Big Heat, Naked Assassins.* "All you ever wanted to know about the high-octane world of Far Eastern filmmaking: from the balletic to the ballistic, from the grace of Bruce Lee to the bullet-ridden bloodletting of John Woo, from the comedy stunts of Jackie Chan to the action choreography of Ching Siu Tung, from versatile leading man Chow Yun Fat to fighting females Michelle Khan and Cynthia Rothrock." **GR**
$29.95 *(PB/128/Illus)*

Idols of Perversity: Fantasies of Evil in Fin-de-Siècle Culture
Bram Dijkstra
This encyclopedic study of images of the femme fatale in academic painting from the mid-19th to the early 20th century is as breathtaking in its sensual splendor as it is nauseating in its display of a "veritable iconography of misogyny," the visual com-

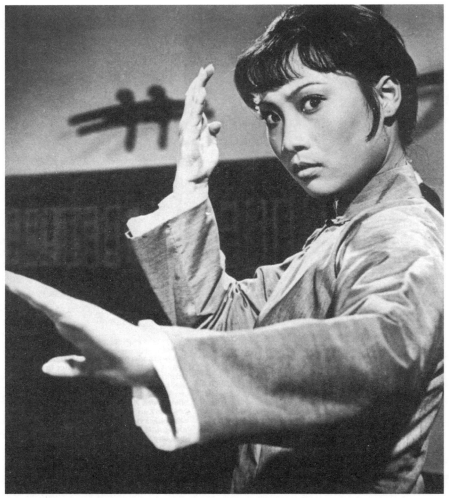

Angela Mao Ying herself, the first major female kung fu star, as she appeared in the violent When Tae Kwon Do Strikes — *from* **From Bruce Lee to the Ninjas**

ponent of what the author calls "the morass of the 19th century's assault on women." Sticking to primary sources in contemporary exhibition catalogs, periodicals, and books and tracts by philosophers, pathologists and scientists, the author shows how artists and intellectuals pooled their dark fantasies of women—which were reflective and extensions of those of the public at large—to invent these dangerous creatures.

As the position of women evolved along with their nascent efforts to liberate themselves, the counter-efforts—to define, explain and control them—also changed and evolved. Here we have a wealth of glowing Ophelias; slumbering armies of exhausted onanists; voluptuous slaves; spaced-out mirror-gazers; Lolitas and transcendent ephebes; predatory female flowers single-mindedly seeking to drain man of "that great clot of seminal fluid"—his brain; bestial vampires capable of the most atrocious crimes; and more. The images and writings reproduced here are so lush in their testimony to human lust, fear, disgust and striving for sublimity it is hard to regard these archival materials with a furrowed brow, especially since, by dissecting the oppressive forces that gave rise to them, Dijkstra has helped to defuse their destructive power. The prevalence of this repertoire of images of women in the popular media today is testimony to their tenacity and insidiousness. **MH**

$30.00 *(HB/480/Illus)*

If They Move . . . Kill 'Em!
The Life and Times of

Sam Peckinpah
David Weddle

"Sam Peckinpah was born into a clan of lumberjacks, cattle ranchers and frontier lawyers. After a hitch with the marines, he made his way to Hollywood, where he worked on a string of low-budget features. In 1955, he began writing scripts for *Gunsmoke*; in less than a year he was one of the hottest writers in television, with two classic series, *The Rifleman* and *The Westerner*, to his credit. From there he went on to direct a phenomenal series of features, including *Ride the High Country*, *Straw Dogs*, *The Getaway*, *Pat Garrett* and *Billy the Kid* and *The Wild Bunch*.

Peckinpah was both a hopeless romantic and a grim nihilist, a filmmaker who defined his era as much as he was shaped by it. Rising to prominence in the social and political upheaval of the late '60s and early '70s, Peckinpah and his generation of directors—Stanley Kubrick, Arthur Penn, Robert Altman—broke with convention and turned the traditional genres of Western, science fiction, war and detective movies inside out. No other era in Hollywood has matched it for sheer energy, audacity and originality, and no one cut a wider path through that time than Sam Peckinpah."

$27.50 *(HB/416)*

Immediate Family
Sally Mann

Mann is famous for nude photographs of her disconcertingly gorgeous brood. On the cover of this collection stand her three bare-chested children in a line, two little girls and a boy, proudly flaunting their infantile sexuality/sexiness while unsmilingly staring you down. Inside are pictures of them rolling around in the grass, in the mud or on sheets on which they've just pissed. In one photo, a girl, seen from above, is splayed on the ground in a swastika-like pose that's so twisted she looks like a rape-murder victim—if only for a moment. The clothes come on and off. Mostly the kids are part-naked, their smooth, undefined bodies either ultrawhite or provocatively sullied. Blood, mud or shit, when applied to body or face with even the smallest amount of intent, grant the recipient a *Lord of the Flies*-type aura. These kids are all so self-possessed, almost aggressive, never smiling, eyes closed in sensual rapture or fixed straight ahead, at the camera, at you,

as if to say—what?　　　　　　　　　**JT**
$35.00　　　　　　　　　　　(HB/88/Illus)

Immoral Tales: European Sex and Horror Movies, 1956-1984
Cathal Tohill and Pete Tombs
"During the 1960s and '70s, the European horror film went totally crazy. It began to go kinky—creating a new type of cinema that blended eroticism and terror. . . . Like the Surrealists, European horror directors hoped to liberate man's latent eroticism, and many of them were drawn to the low-budget arena because of the freedom it seemed to offer. . . . *Immoral Tales* is more than just a kaleidoscopic tour of this incredible area. It's a celebration of a bygone era. A period when European mavericks threw caution to the wind and filmed unfettered fantasy. These erotic experiments are still a benchmark of the permissible—their potent reveries easily surpassing the realism of pornography. Get ready for the weirdest film trip ever."
$17.95　　　　　　　　　(PB/272/Illus)

In the Blink of an Eye: A Perspective on Film Editing
Walter Murch
"From the moment we get up in the morning until we close our eyes at night, the visual reality we perceive is a continuous stream of linked images: In fact, for millions of years—tens, hundreds of millions of years—life on Earth has experienced the world this way. Then suddenly, at the beginning of the 20th century, human beings were confronted with something else—edited film." Award-winning film editor, sound designer and mixer (*The Conversation, Apocalypse Now, The Godfather Parts II and III, The Unbearable Lightness of Being, Crumb, The English Patient*, etc.), Murch muses on film editing, DNA, dream therapy and the blink of an eye, and shows how these enable us to perceive the "total and instantaneous discontinuity of one field of vision with another" that is film.　**LZ**
$12.95　　　　　　　　　(PB/114/Illus)

Inauguration of the Pleasure Dome
Kenneth Anger
Inauguration of the Pleasure Dome (1954): "A convocation of magicians assume the identity of gods and goddesses in a Dionysian revel.

Lord Shiva, the magician, awakes. The Scarlet Woman, whore of heaven, smokes a big, fat joint; Astarte of the moon brings the wings of snow; Pan bestows the grapes of Bacchus; Hecate offers the sacred mushroom, yagé, wormwood brew. The vintage of Hecate is poured. Pan's cup is poisoned by Lord Shiva. The orgy ensues—a magick masquerade in which Pan is the prize. Lady Kali blesses the rites of the children of light as Lord Shiva invokes the godhead with the formula 'Force and Fire.' Dedicated to the few; and to Aleister Crowley; and the crowned and conquering child."—Anger
$29.95　　　　　　　　　　(VIDEO)

Incredibly Strange Films
Jim Morton and Boyd Rice
The first and still the best book on sleaze films. Interviews the producers: Herschell Gordon Lewis, Ted V. Mikels, Doris Wishman, Ray Dennis Steckler, Larry Cohen, and more! Essays on the genres: Biker films, J.D. films, mondo Films, Santo, sexploitation films, Ed Wood Jr., women-in-prison films, as well as such classics as *Spider Baby, God Told Me To,* and *Wizard of Gore.* Plus quotes from the worst, a list of fave films, an A to Z of low-budget personalities, etc. Promo for an educational film, *Signal 30:* "You are there when the blackened and brittle, mangled and bleeding bodies of what once were living, breathing and laughing human beings are pried from their motorized coffins." Russ Meyer on Tura Santana's mythical presence in *Faster, Pussycat! Kill! Kill!:* "In the instance of Tura, she was wearing boots and she was so voluptuous—big hat, big pair of hips, big boobs—a great Junoesque-looking lady A lot of people draw all sorts of conclusions . . . 'Gotterdammerung' . . . 'Flight of the Valkyries.' She's part Cherokee and part Japanese She'd been a stripper . . . and was as strong as a fucking ox. . . . That was one of the few times I've lucked out in casting a role." And more!　**GR**
$17.99　　　　　　　　　(PB/212/Illus)

Inside Teradome: An Illustrated History of Freak Film
Jack Hunter
This book falls short of its potential. It purports to be a history of human oddities in film, and a flip through to look at the photos is enough to connive the average freakophile that this is a must-have. However, the author skips from subject to

subject, often giving the impression he has not seen the films he is talking about. Huge portions of this volume seem to be regurgitated directly from the book *Killing for Culture*, available from the same publisher, which contains some of the most complete information about the "mondo" style of filmmaking

After claiming that this book will be about real human oddities on film, the author jumps to films using fakes. This would have been fine if he had given these films a separate chapter or section, but this is not the case. They are mixed in with the real stuff, like dirty socks among the clean laundry. Worse, the author breezes past important films and film makers in a few lines, and then goes on to describe at length horror movies that have little or nothing to do with the book's subject matter. Hardly a complete loss, an oddity and it remains valuable for any connoisseur of oddities.　　　　　　　　　　**TC**
$16.95　　　　　　　　　(PB/244/Illus)

Interviews With B Science Fiction and Horror Movie Makers: Writers, Producers, Directors, Actors, Moguls and Makeup
Tom Weaver
Sample quote from Curt Siodmak: "I'm a writer, and to write the right things is more important than getting a lot of dough for it. . . . Today, nobody lives better than I do. I have an estate, 50 acres overlooking the mountains, and every night I say, 'Heil, Hitler!' because without the son of a bitch, I wouldn't be in Three Rivers, California, I'd still be in Berlin!"
$38.50　　　　　　　　　(HB/425/Illus)

Japanese Science Fiction, Fantasy and Horror Films: A Critical Analysis and Filmography of 103 Features Released in the United States, 1950-1992
Stuart Galbraith
$45.00　　　　　　　　　(HB/448)

Joseph Beuys in America: Energy Plan for the Western Man
Edited by Carin Kuoni
In 1974, at the age of 53, Joseph Beuys first

set foot in the United States and his "Energy Plan for the Western Man," a performance piece which consisted of a series of talks in New York, Chicago and Minneapolis, was his introduction to this country. Beuys presented his inclusive ideas, including the notion that "Every man is an artist," to audiences with decidedly mixed results,. Reactions ranged from frequent attacks on his past as a Stuka pilot for the Luftwaffe during World War II to tremendous interest in his peculiar brand of conceptualism and the "Free University" he had helped found in Germany. The talks provided the impetus for Beuys most famous "action" in America, "I Like America and America Likes Me," in which the artist lived in a gallery wrapped in felt and carrying only a cane while sharing the space with a wild coyote. This book presents a number of previously unpublished writings and several interviews in which Beuys discusses his best-known projects in both America and Europe. **AP**

$14.95 *(PB/274/Illus)*

Joseph Losey: A Revenge on Life
David Caute

"His life and art were inseparable, but in a sense art came before life: that is, it took precedence where individuals were concerned. And what of the ethics of that: well, life lived and grew on his art . . . People got sacrificed sometimes."—Losey on Brecht, 'L'oeil du Maitre,' 1960

This statement may apply equally to Losey himself, the creator of 31 features which range from the puritan social messages of his early work to the increasingly baroque style of his later films. Born in 1909, in La Crosse, Wisconsin, into a once wealthy family, Losey was reared in an environment which fueled his adult art; in which "wealth, sex and power are interwoven in a tapestry of constant torment and pain," where "the sexes butcher one another." He began his career in the '30s with the experimental theater in New York. Moving to Hollywood, Losey directed some less-than-memorable films while subverting the system to create the cult classic *The Boy With Green Hair*. After blacklisting forced him into exile, he reestablished himself as a European director. His collaborations with Harold Pinter—the films *Accident, The Go Between*, and his great classic *The Servant*—ensured his cinematic immortality. His creative generosity, alcoholism and sometimes

Hammer Poster — from **House of Horror**

brutal egoism elicited a full range of critical reaction while being honored in Europe and ignored by Hollywood. **JAT**

$24.95 *(HB/607/Illus)*

Kahlo
Andrea Kettenmann

A well-rounded look at the art and life of this Mexican icon in a large-format book. Frida Kahlo, creator of some of the most intense oil paintings ever made, portrays personal pain and self-reflection with the hand of an ancient goddess. The text provides a fairly complete description of her vigorous life as a political freedom fighter, her tumultuous marriage to Mexican muralist Diego Rivera, and her daily battle with her damaged and debilitating body. Includes many images and a chronology that sums up important meetings and

affairs at a glance. **MDH**
$9.99 *(PB/96/Illus)*

Kazimir Malevich and the Art of Geometry
John Milner

"During 1915, in the midst of the war years that preceded the Russian Revolution, Malevich devised and displayed a completely unprecedented geometric style of painting that he called Suprematism. By the 1920s, geometric art had become an international phenomenon. John Milner examines Malevich's art of geometry by looking at its sources of inspiration, its methods and its meanings and, arguing persuasively that it is based on obsolete Russian units of measurement rather than the decimal system, has found a new interpretive tool with which to understand this pioneering art."
$50.00 *(HB/256/Illus)*

Klimt
Gilles Néret

This work on Klimt is part of the German publisher Taschen's series on famous artists. Like other works in the series, it economically (in 96 pages) traces the artist's career while sumptuously illustrating in color his major works. Neret presents extended sections on Klimt's best-known decorative-art projects: the *Beethoven Frieze* created for an exhibition in 1902, and the mosaics for Josef Hoffmann's Palais Stoclet, in Brussels. The remainder of the book focuses on what Klimt is popularly known for, his erotic presentation of the female body, in sections such as "Secessionist Symbolism and Femmes Fatales" and "All Art Is Erotic." This work also features a useful chronology of Klimt's life and work **AP**
$9.99 *(PB/96/Illus)*

Let It Bleed: Essays, 1985-1995
Gary Indiana

A collection of essays on contemporary culture written between 1985 and 1995. Ranging in subject matter from Paul Schrader's *Mishima* to the art of Gilbert and George to reflections on Euro Disney ("it presumes a universe in which human beings no longer have any minds at all"), *Let It Bleed*, as the title suggests, pulls no punches and makes no apologies. Sometimes subtle, at other times blunt—but always direct. Occasionally condescending and annoyingly peevish, Indiana's insights are consistently

on target: arch, unique, unexpected and challenging. A sample of his thoughts on the French writer Herve Guibert, who died from AIDS in 1992: "One of the glories of Guibert's book is its intense specificity: the narrator's plight isn't generic, its extremity doesn't lead him to abandon the habit of precise observation . . ." The same could be said of Indiana's own powers of observation.
MDG
$16.00 *(PB/300)*

Let's Murder the Moonshine: Selected Writings
F.T. Marinetti

"Marinetti's writings—manifestoes, fictions, political writings, memoirs and his own inimitable *parole in liberta*—speak to our time with a sort of science fiction prescience. Marinetti foresaw what it would be like to live in an electrical, and, by extension, a digital universe, what role advertising would play, what values would henceforth be assigned to the medium as message. As such his predictions are sometimes childish and frequently irritating: Marinetti was, in many ways, a hard-headed materialist who knew that there was no return, in our century, to the bucolic world of the Fathers. He

also knew that art could no longer insulate itself from the experience of the masses, that kitsch was not so much the antithesis of art as it was a condition of its production . . . His manifestoes, a major selection of which is included here, whether on poetry or painting, city planning ('Down with Past-Loving Venice') cinema, music, dance or social life, are superb artworks in their own right, combining, as they do, a hyperbolic rhetoric and violent imagery with witty, common-sense aphorism and comic self-deprecation." Includes "The Founding and Manifesto of Futurism," "The New Religion-Morality of Speed," "Electrical War (A Futurist-Vision Hypothesis)" and "The Pleasure of Being Booed."
$13.95 *(PB/285)*

Lewis Carroll: Photographer
Helmut Gernsheim

"I confess I do not admire naked boys. They always seem to me to need clothes—whereas one hardly sees why the lovely forms of girls should ever be covered up."
—Lewis Carroll

In his day, writer Lewis Carroll was a highly regarded pioneer of the new art of portrait photography. While the nude photographs

Léon Frédéric, The Stream *central panel, 1900 — from* **Idols of Perversity**

La nuit des traqués, 1980 — from **Immoral Tales**

of his young girl subjects were discreetly returned to their parents or destroyed after his death, many of his photos of both distinguished 19th century personalities (Tennyson, Rossetti, etc.) and the young daughters of his friends and colleagues are collected in this slim volume along with a selection of his writings on photography from his unpublished diaries and notebooks.

SS
$8.95 (PB/127/Illus)

Lon Chaney: The Man Behind the Thousand Faces
Michael F. Blake
A biography of a former carpet-layer who is best remembered as the Hunchback, the Phantom, a man with no legs, a clown, a vampire, an old woman in a dress, a knife-thrower without arms, a blind beggar, an old Chinaman, and 992 other prosthetic nightmares. No wonder fans cried, "Don't step on that spider—it might be Lon Chaney!" This self-made master of disguise was the single greatest acting bargain Hollywood ever pulled off the shelf. Not only could he play handsome leading men, he could also portray gnarly villains and

various oddball characters, often in the same picture. And he did his own makeup! He didn't care how much the binding and appliances hurt because he was suffering for his art. Teaming up with *Freaks* director Tod Browning, Chaney starred in, among others, *The Unknown* (as the armless man), *London After Midnight* (the vampire) and *The Penalty* (in which he was legless). One of Hollywood's greats. **GR**
$29.95 (PB/394/Illus)

Los Caprichos
Francisco Goya
After a serious illness in 1792, Goya spent five years recuperating and reading French revolutionary literature. After his recovery, Goya produced *Los Caprichos*, a series of 80 aquatints. This was his reaction to a Spain that he believed had abandoned all reason. *Los Caprichos* is peopled with grotesque monsters, witches, asses, devils and strange creatures that are all caricatures of members of Spanish society. Goya savagely shows the nightmare of the Inquisition, the horrors of medical quackery, and rips apart the pseudocultural mores of Spanish society, attacking marriage, education, the church, royal politics and occultism. These

excellent drawings provide some of the most biting social criticism ever. **MC**
$6.95 (PB/183/Illus)

Love Above All and Other Drawings
George Grosz
An artistic enemy of National Socialism since the early '20s, Grosz was a superb and savage chronicler of German humanity and politics. As the artist says in his preface to the Berlin edition of 1930: "Realist that I am, I use my pen and brush primarily for taking down what I see and observe, and that is generally unromantic, sober and not very dreamy. The devil knows why it's so, but when you take a closer look, people and objects become somewhat shabby, ugly and often meaningless or ambiguous. My critical observation always resembles a question as to meaning, purpose and goal . . . but there is seldom a satisfying answer . . . I raise my hand and hail the eternal human law . . . and the cheerful, good-for-nothing immutability of life!" **GR**
$7.95 (PB/125/Illus)

The Lowbrow Art of Robert Williams
Robert Williams
The early and formative years of the L.A. painter. From Ed "Big Daddy" Roth to Zap Comix to the death of the underground. **PH**
$24.95 (PB/96/Illus)

Lucifer Rising: Volumes 1 and 2
Kadmon
An exploration of the mythology of Lucifer in art and literature, seguing to an examination of the "applied mythology" of filmmaker Kenneth Anger. *Lucifer Rising 2* is a recent interview which gets to the heart of questions relating to Aleister Crowley, Jack Parsons, Bobby Beausoleil and the missing Lucifer Rising footage, L. Ron Hubbard and the thelemic connection to Scientology, and other mysteries swirling around Kenneth Anger's magickal and artistic pursuits. **SS**
$5.00 (Pamp/24/Illus)

Lulu in Hollywood
Louise Brooks
The Jazz Age Bettie Page: A corn-fed Kansas beauty in ebony bangs who radiated good clean sex on the screen. Seven autobiographical essays that follow the celebrated

dancer-actress-writer through her short but spectacular career. Brooks kissed off Hollywood in the '20s and made herself a legend in European cinema. Through her portrayals of independent, liberated souls, Brooks' star flamed a decade ahead of Dietrich's and Garbo's. Lulu is the lesbian-loving, man-eating German girl she played in G.W. Pabst's *Pandora's Box*, a bewitching vixen who flirts fatally one last time—with Jack the Ripper! Oddly enough, in many of her European art films, Brooks' amoral characters are killed off in the last reel. Returning to Hollywood, she was seen as tainted goods, too risqué for America. **GR**
$15.00 *(PB/109/Illus)*

Machine Art and Other Writings: The Lost Thought of the Italian Years
Ezra Pound
Giving insight to Pound's work during his period in Italy, this book documents his diverse aesthetic, which concerned everything from Machine Art, and its new criterion for beauty, to his search for a type of writing ruled by mathematical rather than grammatical laws. **SC**
$16.95 *(PB/232/Illus)*

Masks of Black Africa
Ladislas Segy
More than 240 black-and-white photographs of brilliantly conceived African masks, intense with "the psychic power projected from the depths of human experience," including animal heads, faces, grotesques, beaded and tufted images, headdresses made of wood, ivory and brass. One of the great influences on 20th-century Modern art, prominently as uglified in the works of Picasso. Features "the psychology behind the masks, the roles of the dancer, the dance and the audience, naturalism vs. abstraction as applied to the masks, the carving styles of various tribes, and the place of the carver in tribal society." **GR**
$12.95 *(PB/248/Illus)*

The Memoirs of Giorgio de Chirico
Giorgio de Chirico
Known to some as the initiator of Surrealism, de Chirico wrote vast memoirs which complement his stunning paintings. With vivid descriptions of Italian tradition, de Chirico relates his life story through his heavy egocentrism and rich imagination, and includes anecdotes about his artistic community. He attacks the Surrealist movement because its practitioners lived comfortably, dressed very well, ate excellent meals washed down with fine wines," above all they worked as little as possible, or not at all." De Chirico examines his obsessions and inner conflicts that eventually convinced him of his artistic supremacy. Also included: "The Technique of Painting," a chronological table, and a bibliography of his writings. **OAA**
$13.95 *(PB/278/Illus)*

Naked City
Weegee
"Every morning the night's 'catch' of persons arrested is brought down from the different police stations to Manhattan Police Headquarters where they are booked for their various crimes, fingerprinted and 'mugged', in the rogues' gallery . . . and then paraded in the police lineup . . . where they are questioned by police officials on a platform with a strong light on their faces . . . as detectives in the darkened room study them . . . and make mental notes for future reference . . . The parade never ceases as the 'Pie' wagons unload. I've photographed every one of importance from gangsters, deflated big-shot racketeers, a president of the N.Y. Stock Exchange, a leader of Tammany Hall and even Father Divine, who kept muttering as he was booked, 'Peace, brother, peace.' The men, women and children who commit murders always fascinate me . . . and I always ask them why they killed . . . the men claim self defense, the women seem to be in a daze . . . but as a rule frustrated love and jealousy are the causes . . . the kids are worried for fear the picture might not make the papers . . . I will say one thing for the men and women who kill . . . they are Ladies and Gentlemen . . . cooperating with me so I will get a good shot of them . . . "
$13.95 *(PB/248/Illus)*

Naked Lens: Beat Cinema
Jack Sargeant
Less a study in film history than a magnificently rambling narrative collage in which characters, locations and perspectives are constanly being transposed, *Naked Lens* is dedicated to the notion that events never occur in neat bands and strands. The connections between the Beats and the underground movie scene, both in New York and San Francisco, revealed as dense, complex and often illuminating in this wide-ranging volume of recollections, anecdotes and profiles. Taylor Mead, star of Ron Rice's *The Flower Thief* and Warhol's *Lonesome Cowboys*, discusses his links with Amiri Baraka and Jack Kerouac, while a surprisingly bullish Ginsberg refutes all false categorizations. It was exploitation filmmaker Al Zugsmith, after all, who copyrighted "The Beat Generation" as a title, thus obliging Alfred Leslie and Robert Frank to rename their flick, starring Ginsberg, Corso and Kerouac, *Pull My Daisy*. From Burroughs and Bukowski through to Jack Smith, Paul Whitehead and John Cassavetes, this is a book filled with crowded hours. **KXH**
$16.95 *(PB/256/Illus)*

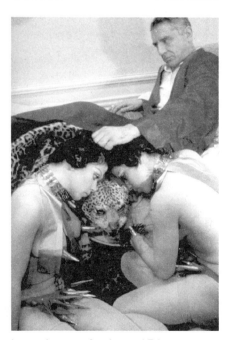

La vampire nue — *from* Immoral Tales

National Identity in Indian Popular Cinema, 1947-1987
Sumita S. Chakravarty
Unfortunately, this book contains "informed theoretical developments in film theory, cultural studies, postcolonial discourse, and Third World cinema." Still, it seems to be one of the only existing English-language books to deal with that kaleidoscopic factory of celluloid iconography that is the Bombay movie world, which exceeds

Hollywood in its annual output of films released and has an equally long history. In the *filmis*, Hindu myth gets choreographed by Busby Berkeley to a shimmering soundtrack of raga-pop which can induce involuntary ecstatic states in the Westerners who have had the good fortune to be exposed to it, and the undying devotion of a subcontinent of loyal viewers many millions strong. While valuable as historical background, this book does not aspire to bring to the Western world the wonders which would await it if Bombay were ever to become the next cinematic Hong Kong. **SS**
$19.95 *(PB/368/Illus)*

Necronomicon: The Journal of Horror and Erotic Cinema—Book One
Edited by Andy Black
Contents include: Jean Rollin, *Deep Throat*, Barbara Steele, Dario Argento, *Blood Feast*, *Ms. 45*, Erzsébet Báthory, and *Last Tango in Paris*.
$16.95 *(PB/192/Illus)*

Neue Slowenische Kunst
Edited by NSK
Best-known outside its native Slovenia for the wittily bombastic pop music of Laibach and the eclecticist painting installations of the IRWIN painter group, NSK is a unique group of highly motivated painters, musicians, actors, directors and designers in Ljubljana who have been working collectively under the umbrella Neue Slowenische Kunst (New Slovenian Art) since the early '80s in an exhaustive exploration of the fertile intersection of art and politics. The NSK method of expression defies simplistic analysis; it is simultaneously confrontational, prophetic, analytical and aesthetic, seizing the most potent and mythic symbols of recent ideological constructs and their cultural heritage, and then wielding them for their inherent power over the psyche of the receiver.

NSK challenges the false dichotomy of freedom vs. totalitarianism with an intricate melding of revolutionary and totalitarian imagery and language. The artistic expression of NSK in its myriad forms is about the utopian impulse—its ephemeral triumphs, its hazards and its unending war of attrition with the commodifying forces of global capitalism as well as state terrorism. The NSK book is a uniquely self-designed and self-edited documentation of the first 10 years of this important artistic force, created on the brink of

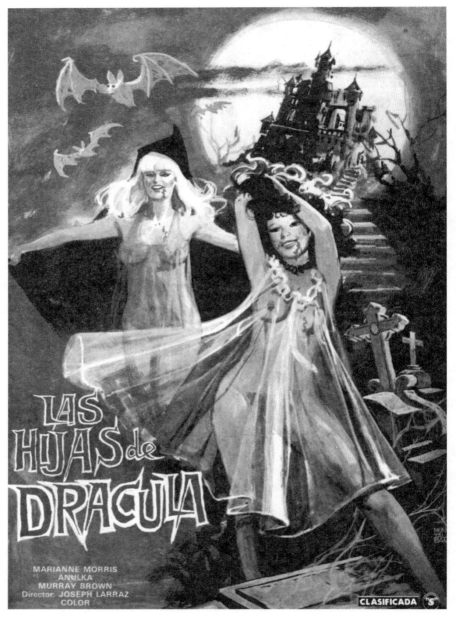

Las Hijas de Dracula *poster — from* Immoral Tales

Yugoslavia's bloody civil war and Slovenia's independence. *NSK* is made up of hundreds of color and black-and-white reproductions of paintings, installations, posters, music and theater performances, album covers, film and video stills and architectural plans combined with manifestoes, speeches, epistles, theoretical writings, interviews, scripts and other NSK texts. **SS**
$60.00 *(HB/286/Illus)*

Nightmare of Ecstacy
Rudolph Grey
The movies of Ed Wood are really an acquired taste, though at this stage in the growth of his expanded cinema cult, the peer pressure to claim to love them is almost as overwhelming as the ridicule they received when he first wrote and directed them. But interest or disinterest in his films has no essential bearing upon an apprecia-

tion of the incredible life and times, obsessions and addictions exposed and celebrated in this book.

Of course, most of us know the movie based on this book, which featured Johnny Depp, Bill Murray, Patricia Arquette and Martin Landau. But what very quickly becomes clear while reading this volume is how much hilarious and heartbreaking, courageous and eccentric material was left out of the film. Needless to say, much of this additional information centers on sex and drugs and aberrant activities, making the plethora of supplementary anecdotes an unexpectedly sordid (which in this context is a positive value) and fabulous bonus. For example, take this little gem from the memory lane of writer-producer-director Tony Cardoza: "In India they sent a 13-year-old-girl up to Tor's hotel room. So he's sucking her breast and it tastes kind of bad, and so he turns on the light, and finds that she was dirty, not dark-skinned! And her tit was white where he was sucking it."

Rudolph Grey collected who knows how many interviews and then painstakingly sifted and assembled them to form a powerful and compelling biography that flows uncannily well. The fractured persona of Ed Wood—transvestite, dreamer, inept hustler and, probably, naive genius—is scarily believable and contemporary. Today, with RuPaul on national television and Hollywood making movies on a seemingly regular basis about drag queens and transvestitism it might be easy to forget the recklessly courageous honesty exemplified by Ed Wood's "coming out" in *Glen or Glenda?*. No matter how kitsch his treatment might now seem, make no mistake, he was brave and he was risking everything when he introduced the world to the now mythologized pink angora sweater.

Apart from enjoying tales of the fascinating interplay of wild and bizarre characters who surrounded Ed Wood and, of course, his intense friendship with Bela Lugosi, the reader learns just how truly prolific he was. In addition to the central core of 32 movies that he more or less completed, he also created at least 155 television commercials, also wrote more than 45 books. These in particular beg to be reprinted as seminal explorations of transvestism, cross-dressing and '50s-era hustler Hollywood.

Grey includes synopses of these books, which leave the impression that Wood's books may be the closest readers will get to

reading his autobiography. Ostensibly written for sexploitation publishers of cheesy paperbacks the excerpts selected suggest a richness and brutally revealing serial confessional that can only consolidate and increase the reverence in which we might hold this extraordinary man.

Wood died an impoverished and delirious alcoholic, a fact Tim Burton's film should have addressed in order to lend an agonizing realism to his subject's demise. For, in the end, what really becomes most apparent and undeniable, and what makes this book and the heroic life it so vividly describes absolutely essential, is the deeply serious implications concerning identity and self and artistic expression manifested by the conclusion we inevitably must draw that . . . it takes a real man to wear a pink angora sweater with pride. All hail Ed Wood, saint of the gender defused. **GPO**

$14.95 *(PB/231/Illus)*

Nostalgia of Culture: Contemporary Soviet Visionary Architecture
Catherine Cooke, et al.

"These conceptual works are not yet the fruits of perestroika—these will be harvested in the future. Rather, they are all the 'children of stagnation,' who have grown up in spite of it. They are not yet an 'identity,' simply the outline of the identity of future Soviet architecture . . . the so-called paper architecture of the 1980s differs from the visionary architecture of the 1920s and the 1960s in the very character of the opposition it makes to reality: it is no longer utopia, but fantasy."

$38.95 *(PB/80/Illus)*

Olympia
Leni Riefenstahl

"On August 1, 1936, in Berlin, watched by Adolf Hitler and others of the Nazi hierarchy, the Summer Olympics Games began. Filmmaker and photographer Leni Riefenstahl was commissioned to document these spectacular games for posterity. Her film, *Olympia*, is thought by many to be her masterpiece, and this books shows the results of Riefenstahl's photographic tribute to the competitors. She utilized innovative and ground-breaking camera angles, techniques and styles in order to create her vision of the Olympics. Her stark realism is revealed in these shots of strength and determination. The artist presents divers, swimmers, sprinters, jumpers, vaulters and

others as specimens, the ultimate practitioners of their artforms, and by these efforts, the portraits of these men and women reach a zenith of Riefenstahl's own art. Her visual genius is fully evident in this remarkable collection of black-and-white photographs."

$56.95 *(HB/288/Illus)*

The Painter of Modern Life and Other Essays
Charles Baudelaire

A selection of Baudelaire's critical articles covering the poet's preoccupation with the visual arts of his time and with his major artistic heroes—Delacroix, Poe, Wagner and Constantin Guys. Throughout his observations it becomes clear that his approach to art criticism was one that rejected the purely analytical textbook approach in favor of one that was "partial, passionate, political, amusing and poetic"—the point of view that opened the most horizons. The starting point of all critique, he contended, proceeds from the shock of pleasure experienced in front of a work of art and only later, through examination and analysis, is that initial pleasure transformed into knowledge. In other words, the true critic, like the artist, should be endowed with a creative temperament and be a kind of secondary poet, reflecting and translating the work of art. Add to this fundamental conviction Baudelaire's poetic insight, his wit, his flawless description and, most importantly, his underlying humanity and this volume makes for an exciting read. **MDG**

$13.95 *(PB/226/Illus)*

Paintings and Guns
William S. Burroughs

Burroughs talks about painting technique—his and other people's—in the first chapter. One of his favorite methods is shooting cans of spray paint with a shotgun (which he has placed in front of a piece of plywood) the random splattered paint on the plywood being the finished piece. In the second chapter he talks about whether we need police or not, suggesting that when people start feeling comfortable without police, the police come along and start trouble. What we therefore need is a criminal strike, in which every criminal agrees not to commit any crime for one day, paralyzing the system. Four or five days of that and we would say, "Why do we need police?" Twenty-thousand gun laws passed in 20

years, but the murder rate goes up and up: "After any shooting spree, they always want to take the guns away from the people that didn't do it." **DW**
$5.50 *(PB/104/Illus)*

Paintings by Masami Teraoka
James T. Ulak and Alexandra Munroe
"Brilliantly exploiting the imagery of Pop art in combination with traditional Japanese *ukiyo-e* woodblock prints, Teraoka['s] . . . unabashed use of humor and satire combines with a vibrant personal iconography drawn from Japanese and Western sources—catfish, trickster fox, ghost, snake, ninja, samurai, geisha, Adam, Eve, punk rockers, television and London buses. Teraoka's recent work moves from the indulgent pleasures of the floating world to a chastened consciousness of death and evil with a majestic virtuosity unique in contemporary art."
$29.95 *(PB/112/Illus)*

The Phantom Empire
Geoffrey O'Brien
"Instead of memory, there is a culture of permanent playback" in which Barbara Steele, Alexander Nevsky, D.W. Griffith, *Zombie Holocaust* and a hundred thousand other cinematic images flicker in and out of our consciousnesses. *The Phantom Empire* is an elegantly written, dreamy rumination on how we have absorbed motion pictures into our individual and collective psyches. At various levels, it is about the creation of the spectator, the way movies initiate us into society, and how time distorts when we see old actors in their youth and dead actors living on the screen.

 At the same time author O'Brien relates nothing less than a condensed history of the cinema itself. "The screen," he writes, "was a second sky, where what you saw was nothing compared to the anticipation of what you might at any moment witness: a shooting star, a spaceship, an apocalypse." Hypnotic and thought provoking. **LP**
$20.00 *(HB/281)*

Pinocchio's Progeny: Puppets, Marionettes, Automatons and Robots in Modernist and Avant-Garde Drama
Harold B. Segel
The short version is that "*Pinocchio* wasn't

written 'just for kids'" and that with the advent of the various "isms" that started popping up in the art world around the turn of the last century, the "ists" began to embrace the idea of childhood's innocence along with the carnival and fairground motif. Puppets were a good way for people with Dadaist, Cubist, Symbolist and Futurist (etc.) outlooks to portray the plight of humanity. Covering the period between 1890 and 1935, in such diverse locales as France, Spain, Italy, Austria, Germany, Sweden, Russia, Poland and Czechoslovakia, this book tirelessly and joylessly explores the role of puppets in European avant-garde drama. One certainly can't fault the book for shoddy scholarship.

The bibliography is a full 10 pages. There is much information in this book, but it fails to evoke any sense of the excitement that is the nature of a good puppet show. It's ironic is that in attempting to document what in essence was a longing for a return to simplicity, the author has created something large and unwieldy that any right-minded little puppet would mock and batter with all its might. **SA**
$16.95 *(PB/372/Illus)*

Ports of Entry: William Burroughs and the Arts
Robert A. Sobieszek
A survey of Burroughs' extensive body of

Lon Chaney — from **Lon Chaney**

visual work (collages, photomontages, sculptural assemblages, shotgun paintings and text-image works) published in conjunction with the eponymously titled exhibit organized by the Los Angeles County Museum of Art in July 1995. A writer of intensely cinematic, nonlinear prose, Burroughs' accomplishments outside the realm of his novels are rightfully assessed in terms of "logical step" as opposed to pedestrian aberration. Indeed, the cracker-barrel anarchism that informs his fiction-signature themes of control, addiction, sex and transcendence—is equally alive in his art. While the hype that has surrounded him for the past decade can often be annoying (Portrait of the Artist as Iconoclast Badge of Postmodern Hipness displayed by every purveyor of fashionable cool from Robert Wilson to Sonic Youth to *Saturday Night Live* to Nike), Burroughs' influence on both American and world culture is enormous—a contention, in its visual-art implications, Sobieszek discusses at some length. With an informative text augmented by over 200 illustrations (many in color), *Ports of Entry* is an exciting look into the pictorial world of the writer whom Kerouac once dubbed "the most intelligent man in America." **MDG**
$24.95 *(PB/192/Illus)*

Primitivism and Modern Art
Colin Rhodes
A critical survey of the major issues and values that define the Primitivist world view, focusing on the modern artists most closely associated with it. Beginning with the art of Gauguin in the 1890s and moving through to the American Abstract Expressionists in the 1940s, Rhodes cites the ways in which Western artists felt impelled to look outside the conventions of their own culture and appropriate the primitive (i.e., the mystical, the mythic, the pre-rational) as a means to forge new ways of seeing and challenge established beliefs. Drawing not only from the tribal peoples of Africa, Oceania and North America but also from those groups considered 'primitive' within Western culture itself (peasants, children, the insane and even women!), Primitivism becomes as diverse a term as the artists and movements it inspired: Kandinsky, Kokoschka, Picasso, Ernst, Pollock, Rauschenberg, Rothko; Cubism, Dada, Expressionism, Impressionism, Abstract Expressionism. While it is true that this survey is somewhat dry and academic

in tone, coalescing the enormity of Primitivism's impact on modern art into a cogent overview format is no easy feat. Replete with illustrations (some in color) and bibliography, *Primitivism and Modern Art* is an informative, scholarly read **MDG**
$14.95 *(PB/216/Illus)*

The Prisons
Giovanni Battista
A series of grandly brooding etchings depicting imaginary prisons executed between 1743 and 1745 by the frustrated Italian architect Giovanni Battista Piranesi. "In these works architectural fantasy strains and breaks the boundaries of human perception, creating a vast system of visual frustration that seems co-extensive with the universe. Where do the innumerable staircases lead? What do the immense vaults support or enclose? The ambiguous structures are compounded with projecting beams, pulleys, wooden ladders, rickety catwalks and gangways, hanging ropes and chains, iron rings embedded in the walls, and, so insignificant as to be almost not there, a few faceless human figures haunting the shadows. . . ."
$10.95 *(PB/63/Illus)*

Prostitution in Hollywood Films: Plots, Critiques, Casts and Credits for 389 Theatrical and Made-for-Television Releases
James Robert Parish
From *Inside the White Slave Trade* to *The Mack*, from *Dawn: Portrait of a Teenage Runaway* to *Gigi*, this is the single comprehensive directory to onscreen whores (as opposed those behind the camera). **SS**
$65.00 *(HB/593/Illus)*

The Psychotronic Encyclopedia of Film
Michael Weldon
Over 3,000 deranged classics of movie history, from unconscious surrealism to thoroughly degraded trash—axploitation, JD's, catastrophe, freak-outs, bikers, Mothra, vampires, sadists, jungle goddesses and other mind-bending cinematic visions by the editor of *Psychotronic Video*. **SS**
$17.95 *(PB/815/Illus)*

Lon Chaney — from **Lon** Chaney

The Psychotronic Video Guide
Michael J. Weldon
Don't throw away your old *Psychotronic Encyclopedia of Film*. With a few minor exceptions, none of the listings in this video guide duplicate those in the first volume. Not only that, but there are references to movies in the second volume that are listed in the first one. Keep them together on the shelf for cross referencing since it is uncertain in which volume a film might be listed. It's purely the luck of the draw.

Each listing includes the director, screenwriter, producer, editor, key actors and music credits. Most of the films here are American B or genre films. Germany is the source of a lot of silent-era listings and '60s B movies, and the British also produced a number of films between the '50s and the '70s that bear inclusion. Italy, however, is the largest foreign producer of the crème de la psychotronic. In addition to the alphabetical title listings are such bonus features as "Directors who made the most psychotronic films" and "What are mondo movies?." **SA**
$29.95 *(PB/646/Illus)*

Rapid Eye 1
Edited by Simon Dwyer
"Throughout history there have always been

Bobby Beausoleil during filming of Lucifer Rising *— from* Anger

forms of art alien to established culture and which ipso facto have been neglected and finally lost without trace."—Roger Cardinal

As the first of the *Rapid Eye* books was about to go to press in 1989, editor Dwyer experienced a bit of kismet. He had been looking for a word which might describe the sort of material that these books would be dealing with. A friend called him to say that he was opening a bookstore which he would be calling Occulture. "This new word obviously suggests both culture and the occult," Dwyer observed. "To me this 'occulture' was not a secret culture, as the word might suggest, but a culture that is in some way hidden and ignored, or willfully marginalized to the extremities of our society. A culture of individuality and subcults, a culture of questions that have not been properly identified—let alone answered—and therefore do not get a fair representation in the mainstream media." *Rapid Eyes* are a marvelous tonic for people who think that art has run its course, that it's all been done before and that there's nothing new under the sun. Perhaps that is so. But Dwyer has scoured the globe and packed these books with a feast for thought.

Rapid Eye 1 contains: "The Fall of Art" by W.S. Burroughs; Psychic TV; Aleister Crowley; information about Brion Gysin's Dreammachine; C. John Taylor on the Cosmos; Situationism and Death TV; interviews with Hubert Selby Jr., William Burroughs, and Mr. Sebastian; Neoism; Austin Osman Spare; Hitler and Nazi UFOs; Tantra, Derek Jarman, Colin Wilson on sex crimes and the occult; Chinese footbinding; and a memorium to Brion Gysin. **SA**
$17.95 *(PB/248/Illus)*

Rapid Eye 2
Edited by Simon Dwyer
Book 2 scars a little deeper than the first collection: seriously dense, seriously grave reading for the final reckoning; Carlos Castaneda, H.P. Lovecraft, Richard Kern, Jorg Buttgereit, animal mutilations, in addition to illuminations of Lobsang Rampa, mescaline, and possibly the most fevered terror-tirade travelogue committed to print. **SK**
$17.95 *(PB/256/Illus)*

Rapid Eye 3
Edited by Simon Dwyer
Melancholy can fuel creation. Intellectual looks at Maya Deren and Kenneth Anger, and Brit phenomenon the K Foundation; plus the aesthetics of pornography, an interview with William Gibson, the Process Church, America, and *A Clockwork Orange* as societal metaphor. **SK**
$17.95 *(PB/256/Illus)*

Raymond Chandler in Hollywood
Al Clark
A movie-by-movie chronology of Chandler's bout with Tinseltown. Nobody bitched more about the writer's place in Hollywood than Chandler. And nobody profited more, financially or in reputation, than this British-bred American pulp novelist, creator of the white-knight gumshoe, Phillip Marlowe, who walked the mean streets of Los Angeles. *The Big Sleep, Farewell My Lovely, The Lady in the Lake*—all by Chandler and all examples of film noir at its finest—tough yet sentimental, at once sad, yet funny, vicious but sublimely poetic. In a town that was legendary for ruining literary giants (Hemingway, Faulkner, Hammett), it was Chandler's mastery of the hard-boiled screenplay that left him one of few survivors.

Between 1943 and 1950, he worked for four different studios, cranking out an amazingly consistent body of work, and a total of 10 movies have been made from his six filmed novels. Examples of his brilliantly crisp, sardonic wit spice up many film classics, as in the famous "let's trade murders" scene in Hitchcock's *Strangers on a Train*. Or in the sexy way Veronica Lake picks up Alan Ladd in *The Blue Dahlia*. **GR**
$19.95 *(PB/228/Illus)*

Raymond Pettibon
Hans Rudolf Reust and Dennis Cooper
A collection of 85 picture and text drawings from 1984 to 1994 published in conjunction with two European exhibitions (in Bern and Paris) in 1995. Most fascinating perhaps is the artist's subversion of the pen-and-ink form; working in a cartoon format—employing cultural archetypes ranging from Gumby to Babe Ruth to Charles Manson to the Bible—he rejects the medium's demand for narrative consistency and conventional correspondence between picture and text in favor of elliptical abbreviation through the interweaving of the seemingly arbitrary (one panel, for instance, contains a boy holding a ball looking up to an adult with the caption: "The world was broken into smaller pieces"). While daring, it's a compositional strategy not without risk—Pettibon's associative innuendoes can spill over from the jarringly subtle to the outright arcane, leaving one somewhat clueless as to the artist's intent. Fortunately, these are the exceptions; Pettibon's dark wit and edgy insights are consistently worth the viewer input they demand. Cynical, sarcastic, quietly hilarious and teasingly gravid with meaning, Raymond Pettibon's is a compelling, enjoyable—albeit, at times, confounding—collection of work (replete with introduction and interview) from a thoroughly unique and staggeringly prolific graphic artist/social satirist. Make no mistake: He's a lot more than his Black Flag album covers from the mid-'80s. **MDG**
$50.00 *(PB/352/Illus)*

Rodin on Art and Artists
Auguste Rodin
Set against the colorful descriptions of Rodin's atelier, we hear, through conversations with his close friend Paul Gsell, Rodin's opinions and philosophy on art and of some of his influences. In the chapter "Realism in Art" it's revealed that unlike most sculptors who place models on pedestals and arrange them, Rodin would pay models to roam around his studio "to furnish him constantly with the sight of the nude moving with all the freedom of life"; by watching them he found inspiration for a natural pose. Often criticized by his contemporaries for his realistic portrayals of the human figure, he broke the rules of the time with his bold expression and style. This book gives insight into the rationale and methods utilized by Rodin. With intuitive

sagacity he comments on the various works of Rembrandt, Michelangelo, Raphael and many more of the famous names who fill the art museums of the world. The book includes 51 illustrations of his sculptures including *La Belle Heaulmiere*, *Head of Sorrow*, the unfinished *Gates of Hell*, of course *The Thinker*, and 23 prints and drawings. **TR**
$8.95 *(PB/119/Illus)*

Russ Meyer: The Life and Films—A Biography and a Comprehensive, Illustrated and Annotated Filmography and Bibliography
David K. Frasier
$49.95 *(HB/252/Illus)*

Sam Fuller: Film Is a Battleground—A Critical Study, With Interview, a Filmography and a Bibliography
Lee Server
"An in-depth look at the most independent writer-producer-director Hollywood has ever had. Called 'original, eccentric and explosive,' *The Steel Helmet*, *Pickup on South Street*, *Underworld U.S.A.*, *Shock Corridor*, *The Naked Kiss* and *White Dog* are only some of Fuller's over-the-top masterpieces. Each of his yarns, as he calls his stories of crime, lust and war, is a free-fire zone of the unexpected and audacious: baroque compositions, long takes and elaborate camera movements; controversial and 'shocking' subject matter; big themes and dangerous ones—race, politics, patriotism. Fuller takes a palpable pleasure in subverting Hollywood's clichés and standards of behavior. His protagonists are the sort most ambitious directors eschew: the dregs, lowlife criminals and hookers, stubbly chinned dogfaces, borderline psychopaths and a few who cross the border and don't look back. Fuller hates the mainstream moviemaker's sanitized, idealized depictions of human behavior. When his characters get shot, stabbed or blown up, there are no deathbed scenes or beatific last words, but screams of agony. If forced to choose between a fast buck and a noble gesture, they take the cash."
$32.50 *(HB/175/Illus)*

The Ljublana Trial, *1988, mixed technique — from* **NSK**

Satyajit Ray: The Inner Eye
Andrew Robinson
Ray was raised among a hybrid of influences ranging from orthodox Hinduism and the genius of Rabindranath Tagore to Hollywood films and Western classical music. In over 30 films, Ray experimented extensively with mood, period and milieu, conveying through his films a sense of whole personality in the manner of great writers or painters. His works "offer us intimations, if we tune ourselves to him, of a mysterious unity behind the visible world." Written several years before his death, this book contains a number of interviews with Ray and firsthand observations by the author on the sets of two of Ray's films. Replete with 150 photographs from his life and films plus sketches from his shooting notebooks, his early advertising work and his memoirs. **JAT**
$18.00 *(PB/430/Illus)*

Schwartzkogler: Martyrdom and Mystery
Petak
A short homage to Rudolf Schwartzkogler, the Viennese Aktion artist who created photographic tableaux of gauze, scalpels, tubes and razor blades which suggested strange sadomasochistic medical operations. The book is made up mostly of interviews with , Schwartzkogler 's girlfriend Edith Adam, his model Heinz Cibulka, blood-orgy fellow Aktion artist Hermann Nitsch and others

who knew him. The interviews bring out the importance of Artaud's ideas to the Aktion artists and dispel the lingering rumor of Schwartzkogler's self-castration. **SS**
$5.00 *(Pamp/32/Illus)*

Scorsese on Scorsese

Edited by David Thompson and Ian Christie
Few directors are more erudite and eloquent than Martin Scorsese, making this addition to the Faber and Faber "directors on themselves" series particularly interesting. Scorsese the raconteur and film scholar tells stories about his own movies. Interviews interspersed with oeuvre analyses cover familiar territory: Scorsese's Italian Catholic upbringing in Queens and Manhattan's Lower East Side, his early fascination with movies, his student films, the director's encounters with Roger Corman, and his breakthrough biographical films. Given the intense nature of Scorsese's films, it is surprising how casual he makes their productions appear. In his telling, *Taxi Driver* almost sounds like a home movie made during preproduction on *New York, New York*. *Taxi Driver* storyboards for Travis Bickle's bordello shoot-out and Scorcese's description of Bible-film research and personal reflections on *The Last Temptation of Christ* provide insight into his working methods.
RP
$14.95 *(PB/178/Illus)*

A Season in Hell and The Drunken Boat

Arthur Rimbaud
A Season in Hell is the first-person account of a teenager who honestly believed he could transform reality—reinvent life— through the magic of his imagination. The spiritual victory of which he speaks can only be achieved through a potentially deadly battle with the self. Yet if one believes in something strongly enough, passionately enough, and possesses the requisite faith in possibility, it can be brought about through sheer focus of will. The book itself, the implications of its very title, are testament to this. The tale is characterized by mellifluous language, vivid imagery, adolescent sarcasm and an almost religious belief in the redemptive power of art, all rolled into one. *The Drunken Boat*, written earlier, is a 25 stanza poem of 100 lines with the boat itself as the speaker. An allegory of liberation and the intoxication of vision ("I have seen what men have thought they saw!")

The winning high-diver Dorothy Poynton-Hill, USA, below the surface after a dive — from Olympia

which ends with the return to the humble confines of everyday existence. "I am the master of phantasmagoria," Rimbaud contends in *A Season in Hell* and equals the claim. **MDG**
$8.95 *(PB/103)*

The Secret Heresy of Hieronymus Bosch

Lynda Harris
The ecstatically demented, sublimely excremental oeuvre of Hieronymus Bosch has no doubt generated more questions, more outright befuddlement, than any other in the history of art. Today it is perhaps easier to grasp its turbulent appeal, but in the highly repressive, post-Inquisition climate of late-15th, early-16th century Europe, what on earth did people see in his work? The answer, at least according to the author, is not very much. Bosch's most notorious patron, the Spanish monarch Philip II, probably found him a trusty purveyor of the sort of naughty tee-hee grotesqueries the king favored for his private entertainment. The rest of Bosch's

contemporaries mostly saw no further than the conventions of liturgical allegory which Bosch consistently employed, if only as a point of departure. To them, these were pictures of other places: a little bit of heaven and a whole lotta hell. But to Bosch, who was, as Harris argues, a closet heretic thoroughly steeped in the critical shadow lore of Gnosticism, they depicted everyday life on Earth. This was the world as he saw it, a world—to quote from Harris' wonderfully restrained prose—"fundamentally unsound."

This heretical take is not new, and while readers have already been regaled with one sectarian rereading after another (Bosch as party-hard Adamite, Bosch as Rosicrucian dandy), Harris' thesis is convincing. She labels our man a devout Cathar, one of the few remaining supporters of a uniquely bleak and uncompromising brand of dualism originating in Bosnia-Herzegovina. This connection provides a tenable key to decoding the buried church-baiting, hell-on-earth messages of his art, while also suggesting an almost primordial source for the mind-boggling extremity of the present-day horror stories that seem to flow nonstop from that Balkan region. **JT**
$61.95 *(HB/285/Illus)*

The Secret Language of Film

Jean-Claude Carrière
"Everything behind the camera forces itself to appear as real even when it just projects simulations and dramatizations. Spectators are witnesses behind the mirror. Cinema has the power to possess, dominate and manipulate people through the use of illusion, briefly isolates a group from the rest of the world. It freezes time, it moves it faster and ages constantly." After experimenting and making use of all other art expressions, through an entire century, cinema has arrived. It too has its own language. Screenwriter Carrière (who collaborated with director Luis Buñuel for 18 years) explores the elements and roots of film and analyzes the process of creation and the importance of the screenplay. **LB**
$23.00 *(HB/224)*

The Sieve of Time: The Memoirs of Leni Riefenstahl

Leni Riefenstahl
When the prestigious German magazine *Stern* approached Riefenstahl on her 75th

birthday with an offer to write the story of her life, she refused, remarking that no one but herself was qualified to write her biography. Perhaps she was right. In the 20th century, Riefenstahl stands apart as one of the most gifted and controversial women of our time; gifted because of her obvious talents, and controversial simply because of her association with Adolf Hitler. Not only was Riefenstahl one of the greatest film directors of all time, but her autobiography matches the intensity of this dynamic woman's personality. **JB**
$40.00 *(HB/669)*

Sex in Films
Parker Tyler
The dish, the dirt and the wit from the famed raconteur of cinema's subtleties. "What optical sleights-of-hand there were, what jugglings of the editing technique were utilized to convey that 'something' after all had happened to the carnally eager but morally handicapped lovers in films . . . The legacy of that long struggle to be literally truthful about sex—that natural and wholly necessary thing—took the shape of film stills that, if gotten all together in one museum, would look like an erotomaniac's

dreams of heaven and hell. It has been a melodrama in itself: the efforts of this book to provide a visual university of sexual images representing film history as impersonated by actors and actresses. The author's duty has been to put it all together in words that cement meanings to meanings the way sex cements bodies to bodies." Chapters on "The Kiss," "Bosoms and Bottoms," "The Love Gods," "Camp Sex," and "Sex Symbols and Fetishes." **GR**
$16.95 *(PB/256/Illus)*

Shock XPress 2: The Essential Guide to Exploitation Cinema
Edited by Stefan Jaworzyn
From Britain comes this appreciation of the cinematic extremes and margins, much like the *Psychotronic* and Re/Search books but without the requisite countersnobbism and wholesale rejection of so-called art film. Appropriately, the articles range from incredulous evocations of the worst of the worst, to devoted exhumations of the unjustly overlooked and/or trivialized. Would-be auteurs such as Pete Walker, and maligned genres such as soft-core Gothic, Sexy Nature, and Splatter Western are

treated to respectful, and often exuberant, analysis. A piece on the oeuvre of arty smut-peddler Walerian Borowczyk signals a welcome change of pace, however, as does the career overview of *Eyes Without a Face* director Georges Franju. Between further exegesis of such standard non-standard fare as *The House of Whipchord*, *Django* and the films of Danish naturalist and hard-core animal lover Bodil, the reader is treated to a fetishistic paean to the joys of the filmic apparatus by George Kuchar, a poignant tribute to London's premier cult-movie showcase the Scala, and a countdown of one viewer's top cinematic gross-outs entitled "Insidious Little Globs." All of which somehow adds up to a workable definition of whatever it is that makes film so compelling. **JT**
$16.95 *(PB/128/Illus)*

Slimetime: A Guide to Sleazy, Mindless, Movie Entertainment
Steven Puchalski
"Yes! Seriously warped movies from around the world collected together in a single volume!" There's *The Worm Eaters*, *Truck Stop Women*, *G.I. Executioner*, *The Bone Crushing Kid*, *Motel Confidential*, *Cannibal Hookers*, *Oasis of the Zombies*, and *Fat Guy Goes Nutzoid*. And there might even have been *Ilsa Meets Bruce Lee in The Devil's Triangle*. It would have been "the match of the century!" says the ad, promising a release in fall of '76. Sadly *Ilsa Meets . . .* never got made. But fear not, plenty of celluloid sleazies did, as described in these comical and cutting reviews taken from the British film magazine *Slimetime*, the U.K. version of New York's *Psychotronic Video*. Also includes detailed essays on three specific sleaze genres: biker, blaxploitation, and Hollywood drug movies. **GR**
$19.95 *(PB/199/Illus)*

Songs of Innocence: Color Facsimile of the First Edition with 31 Color Plates
William Blake
This is the first in a series of three pocket-size books from Dover reproducing Blake's famous "Illuminated Books." By trade Blake was a London engraver, and in 1789, while in his early '30s, he developed this technique fusing poetry and images via copper engraving, hand-tinting and organic design. The story

Walter Frentz has a trial run on the special camera truck. — from **Olympia**

behind the creation of these poems is as unique as the images; Blake says that he had been searching for some time for a way to display his poems, and one night his dead brother came to him in a dream and dictated this process. Yes, Blake was a romantic and a visionary. These Dover books are presented in the same size, format and layout as the original 31 plates. *Songs of Innocence* was the first and most popular of Blake's "Illuminated Books." The poems are lightweight and best to read to children: they are joyful, sensitive and full of angels who rush in to save everything.

MDH

$3.95 *(PB/42/Illus)*

Songs of Experience: Facsimile Reproduction with 26 Plates in Full Color
William Blake

Book 2 in a series of three, this volume was published in 1794 following the success of *Songs of Innocence*. Containing 26 full-color plates, *Songs of Experience* is meant to be read in conjunction with *Songs of Innocence*. Whereas the first may leave the reader feeling light and unaffected, *Experience*'s poems are rich with more meaning and bespeak wisdom, sorrow, earthly powers and animism. Blake continued to publish new editions of *Songs of Innocence* and *Songs of Experience* throughout his life, constantly making changes to page layout and coloring. This book reflects the choices he made after 1815 when he employed deep color and shading to add texture to the written word.

MDH

$3.95 *(PB/48/Illus)*

The Marriage of Heaven and Hell: A Facsimile in Full Color
William Blake

Here's where the reader gets to the wisdom of Blake: "Those who restrain desire, do so because theirs is weak enough to be restrained," "The road of excess leads to the palace of wisdom," "Prudence is a rich ugly old maid courted by incapacity." These are a few of the "Proverbs of Hell" and they are sublime. Blake was purported to be a visionary, but it's not until this book that his raging vision really shone through. It is a subversion of all that is thought to be good and evil. Blake's been to hell . . . and he likes it!

MDH

$4.95 *(PB/43/Illus)*

Spaghetti Westerns: The Good, the Bad and the Violent — A Comprehensive, Illustrated Filmography of 558 Eurowesterns and Their Personnel, 1961-1977
Thomas Weisser

"Summarizes the films' plots and evaluates them in terms of their places within the subgenre . . . "

$49.95 *(HB/498/Illus)*

Stealworks: The Graphic Details of John Yates
John Yates

Jello Biafra describes Yates' work as lying somewhere between Jenny Holzer and The Crass. Most of the work was produced for a self published sociopolitical graphics magazine called Punchline, which Yates started producing in 1987. Most of the works are stark, powerful collages, using a minimum of imagery and a few well-placed words to evoke ironic statements. (The strongest piece portrays rows of flag-draped coffins with the caption "Mom,

K Foundation poster — from **Rapid Eye 3**

we're home!") The older viewer might recognize elements of a style that was especially prevalent in the 1970s—South American mail art. The book's most haunting and original work is part of a series entitled "The Smear Campaign" created by moving montages on a photocopier. This is the first time they have been reprinted in a collection and probably the best reason to seek out this book. Without the use of words they manage to convey the inherent dread that lies within this imagery. **SA**
$11.95 *(PB/136/Illus)*

Step Right Up! I'm Gonna Scare the Pants Off America
William Castle
Essential autobiography of the eclectic genius who directed such unspeakably bizarre schlock films as *The Tingler* and *Doctor Sardonicus*, produced *The Lady From Shanghai* and *Rosemary's Baby*, invented dozens of truly insane promotional gimmicks, and inspired John Waters to greatness. **MG**
$12.95 *(PB/264)*

The Story of Venus and Tannhäuser
Aubrey Beardsley and John Glassco
Best known for his black-line illustrations that escorted the pre-Raphaelite and Aesthetic movements into Decadence, Aubrey Beardsley also pursued literature in a suitably tuberculosis—haunted and fragmentary way. *Under the Hill* was Beardsley's own title for this hallucinatory account of the knight Tannhäuser's dalliance with Venus in her subterranean city of delights.

The original work (left incomplete at the time of Beardsley's death at 26) was suppressed for its studied perversity; this edition brings together in one place Beardsley's incomplete text and all of his original illustrations, including an additional frontispiece and a supressed title page. Beardsley's own writing is fascinating. The critic Holbrook Jackson says that episodes in Venus and Tannhäuser "read like romanticized excerpts from the *Psychopathia Sexualis* of Krafft-Ebing." In other passages, Beardsley glides seamlessly from frivolity to Sadean delirium, as exemplified by a staged encounter between pampered courtiers and rustic satyrs and nymphs. **RP**
$10.95 *(PB/141/Illus)*

Suture: The Arts Journal
Edited by Jack Sargeant
Volume one of a proposed series of compi-lations, this is a survey of the work of artists who lie mostly beyond the pale of the gallery world, presented largely in the form of interviews. Sargeant and his contributors make a valiant effort to inject some adrenalin into the quavering carcass of "art" before it completely expires. They do an astounding job of allowing these colorful and focused (if through their own unique prisms) personalities to tell their own stories, all fastidiously footnoted with entertaining explanatory texts in the margins. In most cases, the fiercely individualistic visions of these artists must at this point in history reside by necessity far below the radar of the art flacks and curators, who have just begun to fawn over such stale offerings as brilliant-Black

Fuller about to signal the start of a take by firing a pistol — from **Sam Fuller**

Flag-cartoonist-turned-tedious-high-art-poseur Raymond Pettibon.

Girls (of the Lewis Carroll not the *Baywatch* variety), dolls, sex and their relationships to each other form an important libidinous undercurrent linking some of the genuinely intriguing artists covered in *Suture*, from Victorian-absorbed cartoonist/banjo player/cult figure Dame Darcy of *Roller Derby* and *Meat Cake* fame to Trevor Brown, who is perhaps best known as graphic designer for the industrial noise-terror unit Whitehouse. Brown relocated to Tokyo and has been churning out a series of highly technically accomplished airbrushed Japanese girls, dolls and war toys in perversely ominous juxtapositions. The remarkable life and career of French collage artist/photographer Romain Slocombe is explored at length; his charm and dedication bring a transcendent grace to his erotic obsession with the collision of Japanese girls and auto accidents, yielding some of the most startling photographic images of our time.

While *Suture* stumbles out of the opening gate with an extended reminiscence with evergreen bad-girl Lydia Lunch concerning her portrait photography, by the finish line it has explored some truly "world-class" fringe culture production as well as presented some criminally neglected creative territory. Particularly inspiring is the heroic story behind the Australian cold-sweat maximum-security prison flick *Ghosts of the Civil Dead*, which was directed by John Hillcoat from a script he wrote with Nick Cave (who also appears in the film). Other highlights of *Suture* include a discussion with painter Joe Coleman about "Devil Anse" Hatfield, leader of the warring Appalachian clan, and Romain Slocombe interviewing the king of manga psych-out Suehiro Maruo (yes, he seems to have a thing for Japanese schoolgirls in uncomfortable situations too). **SS**
$19.95 *(PB/192/Illus)*

Tainted Goddesses: Female Film Stars of the Third Reich
Cinzia Romani
The propaganda machine of the Third Reich under its minister of culture, Joseph Goebbels, sought to entertain by replacing the innovations of Fritz Lang and the expressionist cinema with largely escapist fare. Be they cocktail comedies, operettas or historical costume pageants, these often completely apolitical films were populated with glamorous female star, whose charm and beauty rivaled that of their Hollywood counterparts. But with the fall of the Third Reich, so too fell the career fortunes of these women, whose work remains largely unknown to audiences outside of Germany. *Tainted Goddesses* explores the careers of 18 of the most significant of these actresses. **JAT**
$19.95 *(PB/192/Illus)*

Shirley Yamaguchi in House of Bamboo — from Sam Fuller

They Fought in the Creature Features: Interviews with 23 Classic Horror, Science Fiction and Serial Stars
Tom Weaver
"These men and women saved the planet from aliens, behemoths, monsters, zombies and other bloated, stumbling threats—in the movies, at least—and now they tell their stories. . . . They also discuss the impact 'monster fighting' had on their careers and what they are doing now."
$38.50 *(HB/328/Illus)*

The UFA Story: A History of Germany's Greatest Film Company, 1918-1945
Klaus Kreimeier
The UFA Story concentrates on the political and corporate machinations which formed and ultimately destroyed this great dream factory. Created by the German government in 1917 and financed by the German Bank, UFA was originally intended to serve as a unifying tool of propaganda to unite the peoples of Central Europe and to combat the influence of Hollywood. UFA's history and fortunes ultimately mirrored Germany's. UFA grew rapidly through its systematic acquisition of virtually every significant studio, distribution network and cinema chain not only in Germany but in surrounding regions from Denmark to the Ukraine, achieving a vertical as well as a hori-

zontal integration. Government control loosened during the Weimar Republic, allowing such innovative talents as Ernst Lubitsch, Fritz Lang, F.W. Murnau, G.W. Pabst, Marlene Dietrich and Emil Jannings to blossom and produce such works as *Metropolis, Dr. Mabuse, The Blue Angel, Die Niebulungen,* and *Pandora's Box.* With the rise of the Third Reich, UFA once again became a tool of propaganda, glorifying National Socialism until the end of World War II when only its gutted remains survived. **JAT**
$35.00 *(HB/451/Illus)*

Underground Film: A Critical History
Parker Tyler
In another classic of film literature, film critic Parker Tyler reevaluates the films of Man Ray, Brakhage, Cassavetes, Warhol and many more circa 1969. Chapters include: "The Exploding Peephole of the Underground," "The Pad Can Be Commercialized," "Psychedelic Anamorphosis and Its Lesson," and "The Plastic Pulse Ticks On." **OAA**
$13.95 *(PB/266/Illus)*

The Untameables
F.T. Marinetti
This is a novel beyond categorization. It's symbolic poetry, science fiction, fable, or perhaps a philosophical social vision. Written in a free-form style, *The Untameables* relates the adventures of Mirmofim and the Untameables, who are engaged in loony combat in the world of the paper people. It makes for hilarious reading while exploring the modern world of bayonets, electronic lights, sign boards, gear shifts, and spotlights inscribing acetylene words. **SC**
$10.95 *(PB/228)*

Viennese Actionism, 1960-1971: The Shattered Mirror
Edited by Herbert Klocker
"Through my art production (form of a live devotion) I take the apparently negative, the unsavory, the perverse, the obscene, the lust and the victim hysteria resulting from them upon myself to save YOU the polluted, shameless descent into the extreme. . . . Comedy will become a means of finding access to the deepest and holiest symbols through blasphemy and desecration. The blasphemous provocation is devotion. It is a matter of gaining an anthropologically determined view of existence, through which grail and phallus can be considered

two qualified extremes. A philosophy of intoxication, of ecstasies, enchantments shows as a result that the innermost of the living and intensely vital is the frenzied excitation, the orgy, which represents a constellation of existence where pleasure, pain, death and procreation are approached and permeated."—Excerpted from the "Manifesto of the Blood Organ," Hermann Nitsch, 1962

Vienna in the '60s spawned a group of four artists—Hermann Nitsch, Otto Mühl, Günter Brus and Rudolph Schwartzkogler—who sought to literally reverse the psychoanalytic concept of sublimation into a torrent of blood, aggression, sexuality, shit, pain and self-mutilation which would puncture the tidy categories of Art and Life, and enact Antonin Artaud's Theater of Cruelty on a smug, postwar Austrian public. Their unbridled artistic "actions" were the means to their end of unleashing the Catholic bourgeois Viennese psyche in a healing "abreaction," wreaking the revenge of Freud on his picture-postcard hometown. This sublimely designed collection (the in-print half of a two-volume set) documents with photos, drawings, chronologies and essays show how the four very different artists played out the rigorously psychoanalytical yet visceral ideas of their Aktion school—the meditative Schwartzkogler in his medical-mutilation photo tableaux, the masochistic Brus in his cathartic "body analyses," the communal Mühl in his messy, bawdy happenings, and the ritualistic Nitsch with his dionysian, sacrificial "blood orgies." **SS**
$79.95 *(PB/392/Illus)*

View: Parade of the Avant-Garde 1940-47
Edited by Charles Henri Ford
View, a magazine of the 1940s, defined the avant-garde movement in America. Established in New York, founded and edited by Charles Henri Ford, *View* first appeared in September 1940. It was the first art magazine to publish interviews with such artists as André Breton, Jorge Luis Borges, translator and longtime contributor Paul Bowles and many visual artists—Max Ernst, Marcel Duchamp, Georgia O'Keefe, Isamu Noguchi, Pablo Picasso, Man Ray and Yves Tanguy, to name but a few. Ford's roster of artists was always impressive, and well ahead of its time. *View* established the avant-garde's standards and claimed New York as its center.

The Philosopher's Stone, *poster by Ray — from* **Satyajit Ray**

The Goddess, *poster by Ray — from* **Satyajit Ray**

"*View* is the impossible magazine of the arts no one could have dreamed," said writer William Carlos Williams. The book gives a chronological presentation of Ford's career, acquaintances, and influences. Surprisingly, even though *View* was distributed worldwide, its circulation "peaked at 3,000." The intention of the magazine was not "to shock the bourgeoisie but to amass evidence that this (America) was not the land of Puritans and the American dream." The magazine stands as a testament to its creed of "advocating nothing political other than individual resistance to all forms of authority." The book also details historical events and social conditions in regard to homosexuality. *View* thrived with an intoxicating combination of wit, appetite for transgression, humor and business acumen. **OAA**
$14.95 *(PB/287/Illus)*

View from a Tortured Libido
Robert Williams
A collection of 60 of Williams' paintings. Hot rods, monsters, girls in bikinis and taco

stands are but a few of the distinctive elements of a Williams painting. Introduction by Timothy Leary. **PH**
$24.95 *(PB/92/Illus)*

The Village
Weegee
"Before he died, Weegee composed a mockup for a book about New York's Greenwich Village in the late '40s and '50s. Folk singing, rent parties, costume balls, drag queens on parade, etc."
$13.95 *(PB/96/Illus)*

Virgin Destroyer
Manuel Ocampo
Born in Quezon City, the Philippines of well-educated journalist parents who published their child's cartoons in their local newspaper, this self-taught artist developed an acute awareness of the world through the eyes of history and his Filipino upbringing. In *Virgin Destroyer*, his 66 paintings blend history, economics, greed, lust and genocide turning each of their elements inside out. One of Ocampo's

first stints in art was painting false religious relics (have they ever been anything else?) that jaded art dealers would buy from his boss, a Catholic priest, and sell off as authentic originals. Ocampo lifts the rug that history has swept a multitude of isolated torturous moments under, exposing an iconographic militant parade of "hybrid figures": a hooded klansman priest, crosses replaced by swastikas, amputee children, faceless victims, devils, skeletons celebrating an apocalyptic jubilee of punishment and perversions. In his 12 religious paintings focusing on the Stations of the Cross, Ocampo strips each one of its content, symbolism and illusory mythical power, converting the Virgin Mary into a giant roach, and mockingly reincarnating Jesus in the form of a street dog. **OAA**
$30.00 *(PB/95/Illus)*

Virtues of Negative Fascination
Survival Research Laboratories
Documentary of SRL's 1985 performances.
$25.00 *(VIDEO)*

Visual Addiction
Robert Williams
Hot-Rod Acid Test paintings that move in on museum turf. Two sample three-part titles: "THE DAY THE BIG KAHUNA STOLE SURF CITY. Museum Catalog Title: The Surf Tiki's Overture to the Abduction of the Golden State Geo-Madonna. Colloquial Title: Thoroughly Stoked On Pacific Fruitcake. PATRICK HAS A GLUE DREAM. Museum Catalog Title: With the Drone of Messerschmitts in his Ears the Young Boy Traveled Through His Glue Induced Third Eye, the Sweet Smell of Model Airplane Cement and Stale Urine Fills the P-38 Cockpit While the Radio Repeats 'Bail Out Squadron Leader!' Colloquial Title: The Li'l Ace With Peach Fuzz Testes."
$24.95 *(PB/95/Illus)*

Wallace Berman, a Retrospective
Edited by Walter Hopps
"A complete catalog of the work of this influential Los Angeles artist, including documentation of his rare objects, verifax collages and *Semina* magazines. Berman fused technology with the mystical and psychological to create his powerful works which continue to have an impact upon artists, poets and filmmakers today."
$22.50 *(PB/118/Illus)*

Weegee's People
Weegee
Through the eye of his camera Weegee discovered the visceral spirit of life in a country whose people were their own victims and enemies. Living far from the American dream, acting out a script imbued with bittersweet chaos and delivered with a jester's smile, Weegee and his camera traversed the thin line between the inside and the outside. Although he was behind the camera, his spirit and compassion are evident in these vivid photographic moments that are difficult to erase from one's memory. **OAA**
$13.95 *(PB/242/Illus)*

West Coast Duchamp
Edited by Bonnie Clearwater
"This is the first study of artist Marcel Duchamp's presence on the West Coast of the United States. Although his activities in New York and Europe have been well-documented, little has been written about his important relationships with West Coast collectors, art professionals and artists. Yet the integration of Duchamp (one of this century's most original artists) into the mainstream of American art was due in large part to his participation in landmark events in San Francisco and Los Angeles."
$24.95 *(PB/128/Illus)*

The Will To Provoke: An Account of Fantastic Schemes for Initiating Social Improvement
Survival Research Laboratories
Documentary of SRL's 1988 European tour: "SRL ferrets out and gleefully satirizes assorted icons of cultural pride in two of Europe's more allegedly libertarian social democracies, Holland and Denmark. Not only provides the most comprehensive coverage of SRL's performances themselves but also delves deeper into the whys and wherefores of SRL's existence and development. Explores their attitude toward society, their ability to survive with little or no funding, the ideas that go into the making of the machines, and the performance scenarios. Also addressed is how SRL seeks to confound and confront their audiences and their reaction to their host countries in Europe."
$25.00 *(VIDEO)*

Witkin
Germano Celant
This monograph presents the entire career to date of photographer Joel Peter Witkin, whose views of "perversity and sacrilege, taboo, life and death" are expressed in his notorious depictions of "forbidden hybrids, transformed transsexuals, freaks and fetuses." Witkin's intense and perverse energetic images invoke a new spiritual universe in which distinctions are transcended, conflicts and repression abolished and "death coexists with life." **OAA**
$75.00 *(HB/272/Illus)*

The Word Made Flesh: Catholicism and Conflict in the Films of Martin Scorsese
Michael Bliss
"Focuses on Scorsese's consistent thematic

Günter Brus — from **Viennese Actionism**

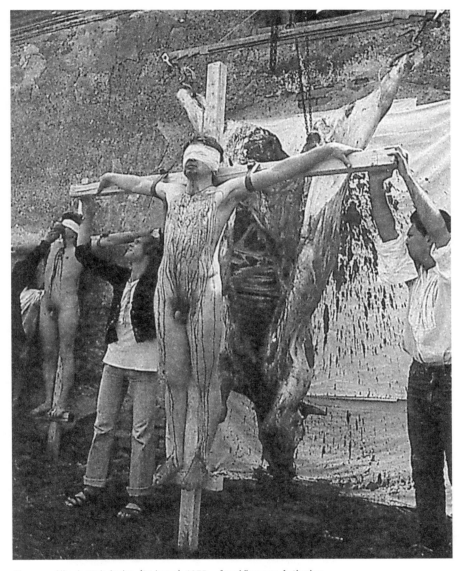

*Hermann Nitsch, 50th Action (24 hours), 1975 — from **Viennese Actionism***

concerns, many of which seem to draw on the conflict between conventional morality and individual desires."

$33.00 *(HB/168)*

The World of Edward Gorey
Clifford Ross and Karen Wilkin
A beautifully packaged, full-scale monograph exploring Gorey's roles as artist, illustrator, writer and theater designer. Includes perennial Gorey favorites *The Doubtful Guest* and *The Fatal Lozenge* as well as set and costume designs for *Dracula* and illus-

trations for such books as *Old Possum's Book of Practical Cats* by T.S. Eliot. Contains a lengthy interview by Clifford Ross in which the artist speaks of his many and varied interests, his creative process and his wide-ranging knowledge of art. Additionally, art critic Karen Wilkins provides a lengthy exploration of Gorey's world—seductive, mysterious, eccentric, macabre—with particular attention paid to the evolution and sources of the artist's style within the high and popular traditions of narrative art. Also includes over 50 pages of plates (some in color), an artist's chronol-

ogy and bibliography. An excellent introduction for the uninitiated and a must-have for collectors, *The World of Edward Gorey* is an intelligently executed, passionate appreciation of this masterfully bizarre artist and writer. **MDG**
$29.95 *(HB/192/Illus)*

Yoshitoshi's Thirty-Six Ghosts
John Stevenson
This series is the last work of Japanese master woodblock-print artist Tsukioka Yoshitoshi, expressing his personal fascination with the supernatural by illustrating traditional Japanese ghost stories. Prints—such as *Kiyomori Sees Hundreds of Skulls at Fukuhara*, *Tametomo's Ferocity Drives Away the Smallpox Demons*, *The Old Woman Retrieving Her Arm*, and *"The autumn wind blows, there is nothing more to say, grass grows through the eye-sockets of Ono's skull."—Narihira*—are reproduced in this collection in full color, one per page countered by text which explains the supernatural tale being illustrated.
$29.95 *(HB/92/Illus)*

Yves Klein
Hannah Weitemeier
A concise overview of the French protomodernist's career, containing brilliant reproductions of many of his major efforts, plus a text which achieves (inadvertently or not) just the right tone of elitist obscurantism to carry off the relentless myth-making that was so integral to his oeuvre. "Klein never learned the trade of painting; he was born to it," enthuses author Hannah Weitemeier, paving the way for Klein's own claim to having "absorbed the taste of painting with my mother's milk." Perhaps there wasn't all that much to learn, seeing as how the paintings in question were mostly one color, mostly blue—a particular hue Klein went on to patent as "International Klein Blue." This same blue was also applied to sculptural objects as well as naked women whom he employed as living stamps in the production of his "Anthropometries" series. Elaborately ritualized, with a full orchestra and a tuxedo-clad Klein as MC, the process was documented in the film *Mondo Cane*, and thereby doomed to go down in history as an emblem of avant excess. Here it is, then, "a life like a continuous note," which Klein meant literally of course, composing the famous paean to himself *The Monotone Symphony-Silence*, and having it performed at openings, at his wedding and finally at his funeral. **JT**
$9.99 *(PB/96/Illus)*

ART BRUT

Dubuffet needed a frame for his proposed book for Gallimard. He was aware of the stigma attached to "insane" and to "psychotic art" and felt the need for a more dignified term. He decided upon 'Art Brut'. Although originally intended to refer to the work of the schizophrenic masters he had encountered, the term evolved in meaning as Dubuffet formulated his philosophy. He realized that pure intuitive and original expression was not to be found only among the insane; he had also come across mediums, visionaries, eccentrics and other social misfits who were similarly gifted. His term "Art Brut" was therefore not synonymous with "art of the insane." Indeed he claimed that there could no more be an art of the insane than there could be an art of people with bad knees.
— John Maizels, from *Raw Creation*

Case 180, Sadistic Motif (crayon) — from **Artistry of the Mentally III**

Artistry of the Mentally III: A Contribution to the Psychology and Psychopathology of Configuration
Hans Prinzhorn

"It is nearly 50 years since the publication of Hans Prinzhorn's *Bildnerei Der Geisteskranken* (*Artistry of the Mentally III*). When the book first appeared it created a near sensation with its bold announcement that paintings and drawings executed by asylum inmates were to be treated with high seriousness and aesthetic analysis. It made strikingly original comparisons, for that time, between these works and the art objects made by children and so-called primitive peoples. However, most shocking to some readers in the early 1920s were the parallels to be seen in the art of mental patients and the revolutionary paintings and graphics that were then being widely exhibited by the artistic avant-garde of the day, the German Expressionists. Prinzhorn's book has maintained a kind of timelessness in spite of advances in art scholarship and the relentless assimilation of the new in the gaudy parade of modern art. *Artistry of the Mentally III* remains an extraordinary document from the history of psychiatry and aesthetics. In a most sensitive and dignified manner it celebrates the humanity, the resourcefulness and the creativity of some of our wretched, anguished brothers, whom society is even now too willing to ignore or discard." Includes 187 illustrations from the author's collections, many in color.
$35.00 *(PB/274/Illus)*

Asphyxiating Culture and Other Writings
Jean Dubuffet

"Culture has carried things so far that the public feels one must become an imposter in order to create a piece of art." Dubuffet reacted by staging shows of what he termed Art Brut (raw art). "Among the most interesting worlds we have seen, certain were done by people considered to be mentally ill and interned in psychiatric asylums . . . consequently, we mean to consider in the same light the works of all people, whether they are judged to be healthy or sick, and without making special categories."
$17.95 *(HB/118/Illus)*

The Discovery of the Art of the Insane
John M. MacGregor

"John MacGregor draws upon his dual training in art history and in psychiatry and psychoanalysis to describe . . . the significant influence of the art of the mentally ill on the development of modern art as a whole. His detailed narrative, with its strangely beautiful illustrations, introduces us to a fascinating group of people that includes the psychotic artists, both trained and untrained, and the psychiatrists, psychoanalysts, critics and art historians who encountered their work.

"After discussing the situation of the mentally ill in the 1700s and the later Romantic obsession with the insane as visionary heroes, MacGregor explores the process of discovery of psychotic art in the latter half of the 19th and beginning of the 20th centuries. In separate chapters he then relates this discovery to later developments—German Expressionism and the Nazis' purge of 'degenerate' art and artists; Surrealism; and Jean Dubuffet and l'Art Brut."
$35.00 *(PB/416/Illus)*

Howard Finster: Man of Visions
Howard Finster

A homemade scrapbook of writings and paintings by America's Golden Arches of folk art: over 10,000 paintings sold! Reverend Finster got the call to preach when he was 13. "I was afraid, and said, 'Lord I don't have the education. I don't even have any good clothes. Lord please let me go.'" The Lord didn't, and Finster pastored 10 Southern Baptist churches in a 45-

year period. Then he was called to build his Paradise Garden. "I got the idea of that at the county dump . . . I saw beautiful things people threw away . . . like a pocketbook full of jewelry and nice gold watches. I started collecting them up . . . a Hula Hoop, ball equipment, dental tools . . . I said these things needed to be displayed . . . You hardly ever see a button spinner or wooden sack nails anymore . . . These things are previews of things we have now. That's what the old Bible is . . . a preview . . . And the New Testament is a preview of what's to come." Finster's prolific witness-the-Lord folk style has made him world famous. "I'm in a human body, and I'm existing on this planet, but I'm living in another world, and that world don't have nothing to do with famous." Includes a 1950 interview and color photos.
GR
$14.95 *(PB/128/Illus)*

In the Realms of the Unreal: "Insane Writings"
Edited by John G.H. Oakes

A compilation inspired by Jean Dubuffet which is most interesting for its writings (especially in translation) of such significant Art Brut figures as Adolph Wölfli and Henry Darger. Compiled from archives like the Prinzhorn Collection and the Collection de l'Art Brut.
SS
$12.99 *(PB/256)*

Wölfli in his cell, 1920 — from **Madness and Art**

Madness and Art: The Life of Adolf Wölfli
Walter Morgenthaler, M.D.

Adolf Wölfli was a schizophrenic Swiss peasant institutionalized from the age of 31 until his death in 1930 after an episode in which he attempted to molest a 3-and-a-half-year-old girl. While incarcerated in Waldau Hospital, Wölfli was supplied with colored pencils and paper by his doctor, Walter Morgenthaler. This led to Wölfli's prodigious output of interrelated drawings, writing, musical compositions and collages, which has made him the most acclaimed and studied example of Art Brut. *Madness and Art* is a combination psychiatric case study and artistic monograph written by Morgenthaler, and is the first book to appear on the subject of the art of the mentally ill (it was published in 1921, one year before Prinzhorn's landmark work). Morgenthaler also allows Wölfli to speak for himself throughout the book by including Wölfli's own "A Short Life Story" and extended excerpts of his distinctive prose.
SS
$35.00 *(HB/176/Illus)*

Matriarchy: Freedom in Bondage
Malcolm McKeeson

"*Matriarchy: Freedom in Bondage* is the life's work of 86-year-old reclusive artist Malcolm McKesson, who has been secretly writing and illustrating this semiautobiographical erotic novel for the past 30 years. *Matriarchy* follows the extraordinary transformation of a young man abducted into willing submission as a servant to a stern mistress who teaches him to 'curb his manly nature.' The protagonist learns to take on the roles of daughter, page-boy and husband, each with appropriate costume. With its intense and atmospheric line drawings and evocative descriptions of exotic costumes, rituals and bondage devices, *Matriarchy* reveals an inner mythology created in ecstatic seclusion, a subversive world of courtly eroticism. McKesson's art is in the collection of the American Visionary Art Museum and the Collection de l'Art Brut, in Switzerland."
$14.95 *(PB/208/Illus)*

Other Side of the Moon: The World of Adolf Wölfli

A catalog, published to accompany an exhi-

bition of Wölfli's work in Philadelphia in 1988, which approaches his work in terms of contemporary views of Outsider Art. Includes beautiful color reproductions of his paintings and collages, a thorough analysis of his musical compositions, poetry and prose and updated information on Wölfli which has emerged since Walter Morgenthaler's classic book about him. **SS**
$25.00 *(PB/64/Illus)*

Raw Creation: Outsider Art and Beyond
John Maizels
This book is easily one of the most definitive surveys of Outsider Art. There are other books on the art of the insane, Art Brut and strange architectural expressions, but few that encompass this wide of a range of subjects as well and as beautifully as does *Raw Creation*. Maizels looks first at European examples of these genres, then American ones, dividing works loosely among Art Brut, folk art and marginal art. There are chapters on well-known artists Adolf Wölfli and Jean Dubuffet, and another is devoted to the artists of the clinic at Gugging. One section is devoted to the topic of preservation, citing such destroyed works as Charles Schmidt's House of Mirrors, and current efforts to preserve works like Grandma Prisbrey's Bottle Village. The book is lavishly illustrated with paintings, drawings, sculpture, architecture and all manner of three-dimensional art.

The examples of heterodox architecture, such as Finster's Paradise Garden, Cheval's Palais Ideal and Dinsmoor's Garden of Eden, are superbly photographed. The book's design is as stunning as its subject matter, and the typographic design perfectly complements the text. **MM**
$69.95 *(HB/240/Illus)*

Revelations: Alabama's Visionary Folk Artists
Kathy Kemp and Keith Boyer
The state of Alabama, home to all 31 of the artists profiled here (as well as native-son-superstar Howard Finster), seems to abound in the kind of environments where sculpture gardens grow out of scrapyards and *objet trouvé assemblage* is commonplace "tinkering with junk." Defined not only by their innovative use of humbler materials (at least two of the artists featured use mud as a primary ingredient of their compositions), these artists also thematically cluster around such concerns as formalist/idiosyncratic Christianity, hard times, patriotism, moral compulsion, childhood memories and civil rights. Many also share a whimsical, punning sense of humor light-years removed from irony.

More surprising are the parallels that characterize the evolution of each as an Outsider artist. The archetypal outsider bio would be as follows: early inclinations to isolation and introspection; the subject exhibited artistic talent which lay dormant

for years; some misfortune occurred in later life—the artist was laid off, laid up or forced into retirement; the misfortune was often associated with religious epiphany, and was nearly always the reason for the individual turning to art; and the artist often borrowed materials from a previously practiced trade. While many of these profiles share a sort of gentle tragedy, some details seem to spring directly from the grotesque and brutal Southern Gothic of Faulkner or Flannery O'Connor. Memorable among these is Myrtice West's religious blackout after which she awakened to find herself issuing apocalyptic warnings from the pulpit of an unfamiliar church, as well as her premonitions of her daughter's murder in her presence at the hands of her son-in-law. Most fascinating, and certainly darkest of all, is the history of Juanita Rogers, whose humanoid animals sculpted from cow bones and mud in a one-room shack were created, she says, "for crippled people, crazy people, and colored people all over the world," and who reports being brought to her current home on a "carnival train" from a place "where black mud swallows up the cars." To their credit, the authors' treatment never strays far from the straightforward tone of backyard conversation. Rev. Ben Perkins on his philosophy of art: "People love the American flag. If you can get a church and a flag *both* on a thing, and you're not too high, then somebody'll buy it." **RA**
$60.00 *(HB/224/Illus)*

Wild Wheels
Harrold Blank
Chronicles the documentary filming of Harrold Blank's cross-country trip in his elaborately adorned car named "Oh My God!", and presents other art cars Blank found along the way. Features more than 40 cars, and interviews with their owners, who are as eccentric and bizarre as their vehicles, from the famous "grass car" used in the Talking Heads movie to the "light mobile," a Volkswagen Beetle strung with 1,400 computer-programmed lights that flash messages. Provides fab color photos including quirky vehicles such as "5:04 P.M.,"which marks the exact time this art car was created. **CF**
$15.95 *(PB/95/Illus)*

Rahma-Margarine, *Adolf Wölfli, 1927 — from* **Other Side of the Moon**

COCTEAU

I sometimes wonder whether my perpetual malaise is not due to my incredible indifference towards the things of this world; whether my work is not a struggle to seize for myself the things that occupy other people; whether my kindness is not a ceaseless effort to overcome my lack of contact with other people.

Unless I happen to become the vehicle of an unknown force, which I then clumsily help to take shape, I cannot read, or write, or even think. This vacuum is terrifying. I fill it up as best I can, as one sings in the dark. Besides, my medium-like stupidity affects an air of intelligence which makes my blunders pass for subtle cunning, and my sleepwalker's stumbling for the agility of an acrobat. — Jean Cocteau, from *Cocteau on the Film*

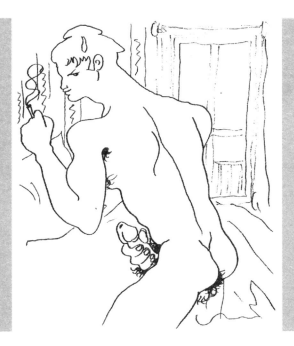

Cocteau drawing — from The Passionate Penis

Beauty and the Beast: Diary of a Film
Jean Cocteau
"My whole face is breaking out. It is covered with puffy areas, scabs and some flowing acid serum which tears up my nerves. I suppose I shall finish the exteriors this morning. . . . Alekan knows in advance the kind of strangeness that I am after. . . . The least workman is gracious. Not one of them has sulked in spite of this tedious shifting around of wires . . . following orders, which from the outside, seem sheer caprice. . . . The makeup men and the dressers know their jobs. Lucile and Escoffier carry their tiny mistakes as if they were a cross. In short, the unit is an extension of myself. The old dream of forming one person out of many is fully realized. I will put up with this pain until it becomes unbearable." **GR**
$5.95 *(PB/142/Illus)*

Diary of an Unknown
Jean Cocteau
Written during the last 10 years of Cocteau's life, *Diary of an Unknown* is a col-
lection of essays covering many of the author's familiar topics and themes: angels, invisibility, the treachery of friends and supposed friends, the delight in paradox and contradiction, advice to the young, the birth of ideas. At times annoyingly self-referential and overly clever ("Know that your works speak only to those on the same wavelength as you"), the volume is nevertheless a masterly blend of personal experience, classical erudition and mellifluent style that is uniquely Cocteau's. Includes intimate recollections of Proust, Picasso, Stravinsky, Sartre and Gide. The collection proves yet again that Cocteau is at his most effective and empathetic when he's able to drop the "grande dame of French letters" persona and immerse himself in his subjects rather than himself—a feat he's most capable of pulling off when speaking of the dispossessed, be it the homosexual or the artist: "This is where the poet's torment comes from, a torment he knows he's not responsible for, yet forces himself to believe he is, so as to give himself the backbone to suffer life until he dies." Despite its minor
glitches, this is an invaluable read from one of the giants of 20th century French writing.
MDG
$12.95 *(PB/234)*

Erotica: Drawings
Jean Cocteau
Perhaps a better title for this volume might have been "80 or so Drawings We Got the Rights to, Many of Which Are Erotic." With portraits of subjects ranging of famous personages to objects of his affection to school friends, this book offers an unusually strong cross section of Cocteau's art. Printed on matte paper, the drawings presented here were created primarily during the 1930s. Approximately 16 rather explicit drawings are from the second edition of his unhappy tale of homosexual love, *Le Livre Blanc*. Originally published anonymously to protect his mother while she was alive, the drawings were later added to the second edition. Also included are an introduction, which provides the background to the art presented, and a chronology of Cocteau's life. **JAT**
$45.00 *(HB/110/Illus)*

The Holy Terrors
Jean Cocteau
"A brother and sister, orphaned in adolescence, build themselves a private world out of one shared room and their own unbridled fantasies. What started in games and laughter became for Paul and Elisabeth a drug too magical to resist. The crime which finally destroyed them has the inevitability of Greek tragedy. Includes 20 of Cocteau's drawings."
$8.95 *(PB/183/Illus)*

The Impostor
Jean Cocteau
This slim volume follows the adventures of a youth of humble origins who exploits the privileges garnered through being mistaken for the relative of a great French general during World War I. He is befriended by a noblewoman and her daughter and assists with their genteel wartime charities. But, hungering for action, Guillaume secures a position at the Flemish front and discovers that the 19th-century notions of gallantry have little place among the horrors of a 20th-century mechanized war. An elegiac fable, *The Impostor* economically illustrates the passing of the grace and elegance of the European aristocracy as the modern world emerged with a vengeance. **JAT**
$20.95 *(PB/133/Illus)*

The Infernal Machine and Other Plays
Jean Cocteau
"Five full-length plays: *Orpheus*, *The Infernal Machine*, *The Knights of the Round Table*, *Bacchus*, *The Eiffel Tower Wedding Party*, plus the speaker's text from *Oedipus Rex*, the Stravinsky-Cocteau opera."
$12.95 *(PB/409/Illus)*

The Passionate Penis
Jean Cocteau
Celebrates male sexuality in a series of bawdy sketches. "The penis occupies the central place in this graphic universe with its widely varying moods, its unexpected fantasy, its humor, its sadness and its unspoken commentary on Cocteau's life and work." Or, as a magazine reviewer put it more bluntly: "Putting the cock in Cocteau is this new book of erotic drawings from the French Renaissance man. Long before Tom of Finland, Jean Cocteau was doodling young studs dressed as chefs, sailors and ruffians with dicks like rolling pins and

some pretty bad attitudes." **GR**
$44.95 *(HB/110/Illus)*

The White Book
Jean Cocteau
Passionate adventures of a young boy attempting to realize his sexual identity in a society that disowns him. First published anonymously in 1928; purported to be semiautobiographical. Rich with erotic detail. As André Gide noted, "Some of the obscenities" are "described in the most charming manner." Includes nudes drawn by Cocteau. **GR**
$5.95 *(PB/76/Illus)*

Jean Cocteau — from **Camp**

Künstlerkneipe Voltaire
Allabendlich (mit Ausnahme von Freitag)
Musik-Vorträge und Rezitationen

The first picture for the Cabaret Voltaire, picture by Slodky — from The Dada Almanac

Dada, then, is also an occupation; one could even call it the most elaborate and strenuous occupation there is. Dada has chosen a cultural realm for its activity, although it could just as well have chosen to make its appearance as an importer, stockbroker, or manager of a chain of cinemas. It has chosen the cultural realm not out of that sentimentality which ranks "spiritual values" as the apogee of traditional values. The vast majority of Dadaists know "Culture" through their professions as writers, journalists, artists. The Dadaist has amassed a wealth of experience about how "spirit" is produced; he knows the depressed state of manufacturers of the spiritual; for years he has sat at the same table with much-printed spirit toadies and Manulescus* among the hacks; he has observed the profoundest secrets and the birth pangs of cultures and moral systems. Dada engages in a kind of anti-cultural propaganda, out of honesty, out of loathing, out of profoundest disgust at the lofty airs put on by the confirmed intellectual bourgeoisie. Since Dada is the movement, experience and naiveté, that sets great value on its common sense—deeming a table a table and a plum a plum—and since Dada is unconnected to anything and so has the capacity to make connections with all things, it opposes every kind of ideology, i.e. every kind of combative stance, against every inhibition or barrier. Dada is elasticity itself; it cannot grasp people's attachment to anything, be it money or an idea, and thus shows an exemplary freedom of character which is absolutely without pathos. The Dadaist is the freest man on earth.

— Richard Huelsenbeck, 1920 from *The Dada Almanac*

*Georges Manulescu (1871-1911): An impeccable gentleman conman from Romania whose notions regarding the redistribution of wealth led him to enter some of the loftiest circles of Europe. Arrested 1901.

Blago Bung, Blago Bung, Bosso Fatakal
Hugo Ball et al.
This book contains three vital texts from the German faction of the Dadaist movement as it developed in Zurich during World War I. Here's *Tenderenda the Fantast*, the first Dada novel written by Hugo Ball; Richard Huelsenbeck's *Fantastic Prayers*, the first collection of Dada poetry; and the little-known *Last Loosening*, a manifesto written by Walter Serner which provoked numerous brawls at the Cabaret Voltaire and was the source for many of Tzara's literary provocations (which may be the reason it was suppressed at the time). An interesting layout keeps true to the Dada spirit. **MDH**
$15.99 *(PB/176/Illus)*

Cut With the Kitchen Knife: The Weimar Photomontages of Hannah Höch
Maud Lavin
Important but overlooked female Dada collage artist. The beautiful reproductions of her prolific work are unfortunately weighed down by an academic, artspeak text. Don't

hold it against her.
$25.00 *(PB/260/Illus)*

The Dada Almanac
Edited by Richard Huelsenbeck
"Published in Berlin in 1920, *The Dada Almanac*, the only anthology edited by the Dadaists themselves at the time, is still the most immediate and comprehensive document of the Dada movement. It was published to coincide with the end of the First International Dada Fair, an event that galvanized the Berlin Dadaists and underlined their internationalism. And like the fair, which was simultaneously the Berlin group's high point and last joint venture, it is also the last Dada publication from the Berlin group—or at least from the 'Central Committee of the German Dada Movement.' . . . The *Almanac* is a broad forum for the expected primitivism, provocation, politics, iconoclasm, bluff and humor, but perhaps more unexpectedly it also contains a number of lengthy articles and manifestoes concerned with art and literary theory, which (even if they are often perched on the knife edge between humor and seriousness) give a deep insight into the many divergent preoccupations and contradictions on which the 'movement' thrived and ultimately foundered."
Contributors include Richard Huelsenbeck,

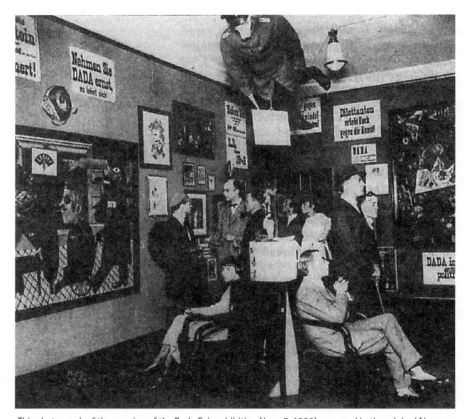

This photograph of the opening of the Dada Fair exhibition (June 5, 1920) appeared in the original Almanac *with a caption identifying the spectators: Haussman, Hannah Höch, Dr. Burchard, Baader, W. Herzfelde, his wife, Dr. Oz, George Grosz, John Heartfield. — from* **The Dada Almanac**

Richard Huelsenbeck — from **The Dada Almanac**

Tristan Tzara, Francis Picabia, Hugo Ball, Philippe Soupault, Hans Arp, and others.
$19.95 *(PB/176/Illus)*

Dada and Surrealist Performance
Annabelle Melzer
Tracing the origins of Dada performance techniques in Zurich through the works of Tristan Tzara, Hugo Ball, Jean Arp and other luminaries at the Cabaret Voltaire (1916-1919), this well-documented survey (complete with an exhaustingly informative bibliography) is a fascinating introduction to one of the most infamous artistic and literary movements of the 20th century. Dada was a caustic revolt against what it deemed the complacency of its time, championing random excess as the only alternative to cultural banality and numbness: "I am against all systems," Tzara declared. "The most acceptable system is a principle to have none." The book further includes dis-

cussion of the relationship between Dada and Futurist performance and the movement's reception in France (brought there by Tzara in 1920) by the Parisian avant-garde (Breton, Soupault, Cocteau, Aragon and their entourage). It ends with a description of the eventual rift that would occur between Dada, with its anarchic passion for provocation, and the more contemplative Surrealism. **MGG**
$11.95 *(PB/288/Illus)*

Flight Out of Time: A Dada Diary
Hugo Ball
In 1916, Ball founded the Cabaret Voltaire in Zurich. It was the performance, exhibition space and headquarters, so to speak, for the Dadaists and their "new tendency in art." Ball kept records of their early performances and exhibits, documenting the movement's progress as it unfolded day by day. with conventional language, focusing

on sounds not words, creating sound poems. Ball's involvement with sound poetry (a form of poetry which dispenses with conventional language, focusing on sounds, not words) and the *gesamtkunstwerk* (total art work) left its mark in Dada circles. Despite gaining an international reputation, Ball remained mysterious, and his *Dada Manifesto* was rarely studied since it appeared only in fragments and was never printed in its entirety or translated into English until 1974 (this book is a revision of that edition). Fellow Dadaist Hans Arp noted that "in this book stand the most significant words that have thus far been written about Dada . . . [Ball] forces current attitudes in art and politics to ever more extreme conclusions, only to discover that his method always eludes him. Finally he outruns himself and flees from time itself."

DW
$14.95 *(PB/324/Illus)*

Four Dada Suicides
Edited by Arthur Cravan, et al
Selected texts of four writers on the fringes of the Dada movement in 1920s Paris: Arthur Cravan, Jacques Rigaut, Julien Torma and Jacques Vaché. All took the nihilism of the movement to its ultimate conclusion and played a significant role in the formation of the French avant-garde. Their work is viewed as a by-product of their extraordinary lives, as all lived to the limit in the spirit of Dada, with ferocious nonchalance and tragic abandon: Vaché died of a drug overdose; Rigaut shot himself; the other two simply vanished. Complete with notes, sources, translations, related publications and short, insightful biographical introductions to each author followed by a personal recollection by one of their contemporaries. A labor of love and respect. **MDG**
$17.99 *(PB)*

Memoirs of a Dada Drummer
Richard Huelsenbeck
According to the author, "Dada is the only appropriate philosophy for our age." Huelsenbeck focuses on the Dada movement's beginning as absurd farce and radical political stance and evolution into as a tool for the development of mankind. In 1936, Huelsenbeck moved to New York, changed his name, started a private psychiatric practice and severed all ties with the art world. From 1936 to 1945 he did

not publish anything, then suddenly, from 1949 to 1974, published a series of essays rethinking Dada, claiming he was in a "position to pass fair judgement on Dadaism." Finally, after "leaving America for good," he concluded that Dada could not exist in America (as did Duchamp). He also felt that he was unable to explain to America that "Dada was simply a revolt against technology, mass media and the feeling of being lost in an ocean of business cleverness." "Liberty never existed anywhere," he wrote, "but America's attempt (although it has failed) was one of the most sincere attempts." Longing to get the chaos of Dada back in his life and to be a "Dada hippie" again, he moved back

to Europe and died, in 1974. **DW**
$13.95 *(PB/202)*

Ursonate
Kurt Schwitters
A recently discovered recording of Schwitters reciting his legendary Dada composition *Ursonate*, on CD. And it goes something like this: "Fümms bö wö tää Uu, pögiff, kwiiee. Dedesnn nn rrrrr, Ii Ee, mpiff tilff toooo? Till, Jüü-Kaa . . ." **SS**
$16.00 *(CD)*

Kurt Schwitters, 1924 – from El Lissitzky

JOHN WATERS

Divine — from **Shock Value**

**Crackpot:
The Obsessions of John
Waters**
John Waters
Fifteen classic essays: "John Waters' Tour of L.A.," "What Ever Happened to Showmanship?," "Hatchet Piece (101 Things I Hate)," "The Pia Zadora Story," "Going to Jail," "Puff Piece (101 Things I Love)," "Why I Love the *National Enquirer*," "How To Become Famous," "Guilty Pleasures," "Why I Love Christmas," "How Not To Make a Movie," "Hail Mary" and "Celebrity Burnout."
$11.00 *(PB/144)*

**Desperate Visions:
The Journal of
Alternative Cinema—
Volume 1: Camp
America—The Films of
John Waters and George
and Mike Kuchar**
Jack Stevenson
Early in his career, John Waters was quoted as saying that if he were given a huge budget for a single movie that he would actually use it to make several. When George

Kuchar was asked the same question, he replied that he would stop making movies because he couldn't work that way. John Waters took the money, suitably tailored his product, and it can be seen at the local multiplex. George Kuchar teaches film, does the lecture circuit and is usually only screened at cinemateques and art museums. In spite of these glaring contrasts, the roots of their aesthetics are surprisingly similar.

George and his twin brother Mike were born in 1942 and have been producing films since their childhood. By their early 20s they were associating with the likes of Jonas Mekas, Kenneth Anger and Jack Smith at the Charles, the Bleeker Street and the Gramercy Arts Theaters, which were then playing host to an exploding "underground" film scene. By the early '60s, John Waters had started sneaking up from his home in Baltimore to these screenings and, inspired largely by the Kuchar brothers, began to make films of his own in 1964. In both cases, the auteurs used repertory casts of nonactors. As John Waters has been more tenacious about publicizing himself and his efforts, much more is known to the general public about his body of work. The Kuchars

have stayed very underground and prove generally more difficult to chronicle. This book has done an admirable job of presenting its subjects in a serious and scholarly light. The section on Waters includes interviews with such stalwarts as Divine, Mink Stole, Mary Vivian Pierce and Miss Jean Hill. Despite the oceans of ink devoted to Waters' work elsewhere, this is a completely fresh and multidimensional look at the man and the filmmaker.

The book's real coup is the inclusion of lucid interviews with George and Mike Kuchar, who are notoriously elusive and playful subjects when in the wrong hands. The author gained their trust and did his homework. For possibly the first time, the Kuchars are given the opportunity to discuss their art, their craft, their influences and their lives in a way that shows how their inner machinery works. Marion Eaton, the star of *Thundercrack* (written by and co-starring George), provides an added dimension to understanding the brothers Kuchar and especially the perils involved when a "legitimate" actress gets stigmatized by her work in underground movies. Most impressive is the exhaustive filmogra-

phy the author has assembled. Truly underground films are harder to track and catalog than are features and frequently only a single copy of a film survives in a private collection. **SA**
$16.95 *(PB/256/Illus)*

John Waters: American Originals
John G. Ives in collaboration with John Waters

Waters, charming and elegant, obviously deranged, but harmless, was labeled by William Burroughs "the Pope of Trash." Obsessed with taboos and the ultimate extremes in behavior, Waters has had a lifelong fascination with criminals, criminology, cult leaders and followers, and criminal trials. He takes everything to its utmost edge and is the American Pop incarnation of Buñuel, Godard, and Fellini. Here he discusses perversity, religion, sex, sexual deviance, his favorite cultural icons and the lewd, disgusting, high-camp satire of his own upbringing and background. Probing questions are posed by an obviously avid admirer, with whom Waters was very comfortable, full of weird references even Waters has to think about! Includes exclusive stills and posters; an in-depth interview; production notes and set design sketches for *Hairspray*; storyboards for *Cry Baby*; flyers for his early films such as *Mondo Trasho* and *Female Trouble*; a copy of a search-and-seizure notice for the confiscation of *Pink Flamingos* in adherence with Arizona obscenity laws; a copy of an autobiography Waters wrote at the age of 10; and a complete filmography. **CF**
$11.95 *(PB/176/Illus)*

Shock Value: A Tasteful Book About Bad Taste
John Waters

The king of raunchy, campy B films, Waters tantalizes the reader with obscure facts about his cast of society's outcasts. Many of Waters' characters resemble those one might have found in the O.C. Buck shows, which toured the United States in the '50s and '60s. If only Waters had met the Alligator Man and the Bearded Lady! Waters' descriptions read like a bastardized Lamparski's "What Ever Happened To?" series. Consider the following: "The man with the singing asshole from Pink Flamingos is currently a married computer programmer living in Baltimore. . . . A few

The West Coast Hillbilly Ripoffs. Top row, Divine and Chan Wilroy; front row, left to right, Timmy Pearce, David Spencer, John Waters — from **Shock Value**

years ago, a representative from a Boston rock club called me trying to find the singing asshole to hire him. . . . I called and explained the offer to my old friend, and he was naturally hesitant. "Well, the muscles ain't what they used to be," he confided. . . . But after thinking it over, the 'Garbo of anal openings' decided to pass." **JB**
$12.95 *(PB/243/Illus)*

Trash Trio: Three Screenplays by John Waters
John Waters

Contains three of Waters' scripts. *Pink Flamingos*, the original midnight movie, is the story of the filthiest people alive who strive for infamy and succeed when the outrageous Divine devours dog poop! *Desperate Living* tells the twisted fairy tale (even without Divine) of Mortville as ruled by Queen Carlotta (Edith Massey), her daughter Princess Coo-Coo (Mary Vivian Pearce) and Dreamlanders Mink Stole and Susan Lowe—mental anguish, lesbianism and political corruption. *Flamingos Forever*, the unmade sequel to *Pink Flamingos*, has Divine's character and clan return to Baltimore to a horde of followers. Here she is confronted by her new rivals, Vera and Wilbur Venninger, owners of a funeral home who abduct children and force them to smoke, drink and shoot heroin. John Waters spent seven long years trying unsuccessfully to get funding for this script. In the meantime, sadly, the actors Divine and Edith Massey passed away. John Waters recommends readers to "Act it out alone or with friends—endless fun!" Includes great, never-before-published stills and the actors' current whereabouts. **CF**
$12.95 *(PB/259/Illus)*

SURREALISM

André Breton, Automatic Writing, 1938
— from L'Amour Fou

Under the pretense of civilization and progress, we have managed to banish from the mind everything that may rightly or wrongly be termed superstition, or fancy; forbidden is any kind of search for truth which is not in conformance with accepted practices. It was, apparently, by pure chance that a part of our mental world which we pretended not to be concerned with any longer—and, in my opinion by far the most important part—has been brought back to light. For this we must give thanks to the discoveries of Sigmund Freud. On the basis of these discoveries a current of opinion is finally forming by means of which the human explorer will be able to carry his investigations much further, authorized as he will henceforth be not to confine himself solely to the most summary realities. The imagination is perhaps on the point of reasserting itself, of reclaiming its rights. If the depths of our mind contain within it strange forces capable of augmenting those on the surface, or of waging a victorious battle against them, there is every reason to seize them—first to seize them, then, if need be, to submit them to the control of our reason. — André Breton, from the Manifesto of Surrealism

Artaud Anthology
Antonin Artaud
Collection of essays, letters, poems and fragments from the genius who suffered the indignities of institutionalization, psychiatric torture and critical neglect. Includes "All Writing Is Pigshit," "Fragments of a Journal in Hell," "Van Gogh: The Man Suicided by Society," "Electroshock," "Theatre and Science" and "Letter Against the Kabbala" . . . "Every dream is a piece of suffering torn out of us by other beings, by chance, with the monkey paw they throw upon me every night, the cinder in repose in our self, which isn't a cinder but a machine—gunning as if the blood were a scrapiron and the self the ferruginous one."
$10.95 *(PB/252/Illus)*

Conversations: The Autobiography of Surrealism
André Breton
Only Breton would have the nerve to call this book the "autobiography" of Surrealism. It is in fact a truer portrait of him than of the history of Surrealism. Breton had a profound need for what is now called "damage control," and was guarded about what he said about the Surrealist movement. His circumspect view and the manner in which he presents it provide an eerie and intriguing look into the workings of his mind. The book consists of a series of what might loosely be termed "interviews." But Breton not only carefully crafts each and every response long in advance, he also provides the interviewer with the appropriate questions—giving the reader a stimulating, interesting yet wholly selective view of Breton and Surrealism. A marvelous, tantalizing book. **MM**
$12.95 *(PB/264)*

Dali's Mustache
Salvador Dali and Philippe Halsman
Dali collaborates with the famous portrait photographer Philippe Halsman who has more than a hundred *Life* magazine covers to his credit. Dali was one of Halsman's favorite subjects. Dali would envision a seemingly impossible picture to shoot (always revolving around his mustache) and Halsman would in turn find a way to do it. The book is presented as a question-and-answer interview, with Dali's cynical, cryptic answers being the caption for each photo. This combination of wit, humor and experimental photography originally published in 1954, is an enduring look at these two artists. The current faithfully reproduced volume includes publisher's notes on how some of these unusual photos were achieved (such as gluing flies to Dali's mustache). "Someday perhaps someone will discover a truth almost as strange as this mustache, namely that Salvador Dali was possibly also a painter." **DW**
$12.00 *(HB/128/Illus)*

Dedalus Book of Surrealism, 1: The Identity of Thingst
Dedalus Book of

Surrealism, 2: The Myth of the Worldtt
Edited by Michael Richardson
The popular conception of Surrealism views it as a visual means of expression; as in the paintings of Dali and Ernst or in the films of Buñuel. However, Surrealism yielded substantial output inliterary form. Surrealist literature is often overlooked since it eschews the traditions of modernism, embracing fragmentation and disintegration. Drawing on traditional forms of storytelling, the fairy tale and the Gothic novel, Surrealist fiction, according to Julien Gracq, "had the essential virtue of laying claim to express, at each moment, man's totality . . . by maintaining at its most extreme point the tension between two simultaneous attitudes—bedazzlement and fury—that do not cease to respond to this fascinating and unlivable world in which we exist." The first collection, *The Identity of Things*, brings together approximately 50 stories and fragments by authors from 17 countries, including such familiar names as Breton, Crevel, Unik, Paz and Aragon. *The Myth of the World*, the second volume, groups approximately 45 works of less familiar authors from 20 countries which explore the importance of myth, myth being the core around which human sensibility and societies are based. Wishing to "transform the world," the Surrealists made myth the focus of their fiction. **JAT**
†**$16.95** *(PB/277)*
††**$14.95** *(PB/292)*

Earthlight
André Breton
A collection of poems from the controversial director and engineer of the Surrealist movement dating from 1919 to 1936, spanning Breton's involvement with Dadaism, Cubism and his founding and development of Surrealism. Written to such friends and fellow Surrealists as Picasso, André Derain, Robert Desnos, Picabia, Pierre Reverdy and Max Jacob, *Earthlight* displays Breton's range of poetic forms, from the early collage compositions ("Five Dreams") to the incantatory, feverish love poem "Free Union." At times pretentious, contorted, tangled and strained; at other times gorgeous, wild and unexpected. In the best of these poems the reader gets to watch Breton follow his own mind: a compelling and finely tuned instrument of metaphor capable of fluidity and simplicity. **MDG**
$12.95 *(PB/213)*

Free Reign
André Breton
Essays by Breton, leader of the French Surrealists, that cover a broad spectrum of his interests including philosophical and literary topics as well as his arguments for the autonomy of art and poetry. Here are insights into his personal character, and his humor, obsessions and unique way of thought. Writings reflect on cinema, music and contain major statements on Surrealism. **DW**
$35.00 *(HB/288)*

The Hearing Trumpet
Leonora Carrington
A wonderful, unforgettable novel by Surrealist painter-sculptor Leonora Carrington, back in print at last. The story chronicles the beautifully strange and, indeed, surreal adventures of Marian Leatherby, a 92-year-old woman whose family has placed her in an old-ladies home. It's a mysterious old place, full of odd crimes, occult manifestations and, finally, murder. Our heroine is determined to unravel the truth. In doing so she encounters the secret of the Holy Grail, the Leering Abbess and other bizarre marvels. The ensuing cosmic upheaval and evocation of the old gods by Marian and her "co-inmates" will never be forgotten by the reader. As Luis Buñuel once wrote, "Reading *The Hearing Trumpet* liberates us from the miserable reality of our days." **CS**
$13.95 *(PB/199/Illus)*

Hidden Faces
Salvador Dali
Dali's only novel depicts the lives and loves of a group of aristocratic characters who, in their beauty, luxury and extravagance, symbolize the decadence of Europe in the '30s.
$19.95 *(PB/319/Illus)*

Irene's Cunt (Le Con d'Irene)
Louis Aragon
"The last 'lost' masterpiece of Surrealist erotica . . . an intensely poetic account. Aragon charts an inner monologue which is often, in its poetic/surreal intensity reminiscent of the work of Lautréamont and of Artaud in its evocation of physical disgust as the dark correlative to spirtiual illumination."
$12.95 *(PB/96)*

L'Amour Fou: Photography and Surrealism
Rosalind Krauss and Jane Livingston
"The Marvelous—what Breton called 'convulsive beauty'—is the great talismanic concept at the heart of Surrealist theory. And *L'Amour Fou: Photography and Surrealism* demonstrates that this key concept cannot be understood without first understanding photography as its model. Virtually all historical and critical discussions of Surrealism have been plagued by the impossibility of finding any stylistic coherence within the disparate array of Surrealism's painting and sculpture. But once photography is admitted as the prime example of the Marvelous, these problems begin to be resolved . . . What this book stunningly and conclusively demonstrates is that Surrealism was acutely focused on the relationship between photography and imagination. Therefore, to explore Surrealist photography is also to open onto an exciting consideration of photography's implications for modern consciousness itself. . . . Erotic, disquieting, disorienting, humorous and, above all, exquisite photographs—many never before published—by Man Ray, Marcel Duchamp, René Magritte, Max Ernst, André Breton, Brassaï, Salvador Dali, André Kertész, Jacques-André Boiffard, Lee Miller and Hans Bellmer."
$75.00 *(PB/243/Illus)*

Last Nights of Paris
Philippe Soupault
Published in 1928 and later translated into English by William Carlos Williams, this is one of the earliest "Dadaist novels." A memoir of Paris in the '20s when the French avant-garde and American expatriates would duke it out using ideas, words and anything within reach while taking literary modernism to its peak. **OAA**
$13.95 *(PB/179)*

Luis Buñuel: A Critical Biography
Francesco Aranda
The life and films of Buñuel, one of the world's

Antonin Artaud's room at the clinic of Ivry-sur-Seine — from **The Discovery of the Art of the Insane**

best directors and a cinematic pioneer, covering over 40 years of his enigmatic career including his early, influential years at the Residencia de Estudiantes in Madrid where he established friendships with Lorca and Dali. The three Surrealist stooges/musketeers developed independent foundations that led them through trials and successes in the world of art, culture, and politics. Spotlights Buñuel's talents in creating texts, films and cinematic critiques from the early 1920's through his last days. The author is the first to examine the classical Buñuelian signatures of violence, cruelty, sexual aberration, sadism and eroticism. **OAA**

$11.95 *(PB/327/Illus)*

Mad Love
André Breton

This book is not the dogmatic Surrealist stream of consciousness satire of romantic love you might expect. It is actually a deeply sentimental treatment of the chivalrous search for the biggest love possible. A love that explodes with "convulsive beauty" and represents from the depths of "the human crucible" a preordained demonstration at its most ecstatic and passionate vibrancy, decanted directly from the joy of memory.

So we move anecdotally between Breton's passionate search for ideal love, ideal art and ideal chance as a unifying factor and valediction of everything. This is dense and charming, clarifying and inspiring. So refreshing to see romantic love included in the philosophy of revelation through "random chance."

I always wondered about the artistic lineage of the cut-up for I felt sure there truly must be an essential missing link between Gysin's cut-ups and Breton's Surrealist "fortuitous" automatism. Well, here, at long, long last we have it confirmed. *Mad Love*, therefore, absolutely insists that it is filed, well-thumbed, on your cut-up reference bookshelves right next to Brion Gysin's *The Third Mind*, *Let the Mice In* and *Here To Go*. These are the foundation stones of any and all credible past, present and future investigations of romantic art, romantic life and romantic love, which incontrovertibly and sacredly insist that they are one and the same quest and process.

Anything built from or for less than total love, total gender and total war on anything habituated as culture or character by our mindlessly billowing species is simply littering existence with cheap distractions that pointlessly extol built-in obsolescence with

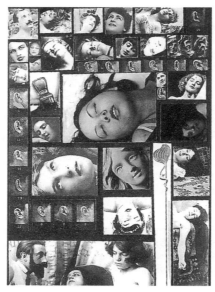

The Phenomenon of Ecstasy, *1933, Salvador Dali — from* **L'Amour Fou**

the sole, paltry function of consuming forever the last traces of nobility and purpose. Brion Gysin, André Breton and the debacle of contemporary semantics so invitingly invite us to . . . "Let's cut it up, to see what it really says." FOREVER! **GPO**

$9.00 *(PB/129/Illus)*

The Magnetic Fields
André Breton and Phillipe Soupault

This automatic writing, originally published in 1919, has been recognized as the first work of literary Surrealism. "Can you have forgotten that the police force is neutral and that it has never been able to arrest the sun? No thanks, I know what time it is. Have you been shut up in this cage for long? What I need is the address of your tailor."

$13.99 *(PB/192)*

Maldoror and the Complete Works
Comte de Lautréamont

"To celebrate evil is to celebrate the good philosophically or the instigator to creation bearing the stigmata of suffering and guilt. To be victim to the Count de Lautréamont is to be superior to everyone else. . . . the magnetic extravagance of his letters, those dark iron-fisted dictates he sent with such elegance—cordiality even. . . . Extravagant? Of course. Those letters have that harsh extravagance of a man who rushes foward with his lyricism like an erect avenging blade in one

hand or the other. . . ." —Antonin Artaud

$15.95 *(PB/340)*

The Man of Jasmine and Other Texts
Unica Zürn

"In 1970, Unica Zürn, the companion and lover of the Surrealist artist Hans Bellmer, threw herself from the sixth-floor window of their apartment in Paris. Her suicide was the culmination of 13 years of mental crises which are described with disarming lucidity in *The Man of Jasmine*, subtitled *Impressions From a Mental Illness*. Zürn's mental collapse was initiated when she encountered in the real world her childhood fantasy figure, 'the man of jasmine': he was the writer Henri Michaux, and her meeting him plunged her into a world of hallucination in which visions of her desires, anxieties and events from her unresolved past overwhelmed her present life. Her return to 'reality' was constantly interrupted by alternate visionary and depressive periods. Zürn's compelling narrative also reveals her uneasy relationship with words and language, which she attempted to resolve by the compulsive writing of anagrams. Anagrams allowed her to dissect the language of the everyday, to personalize it and to make it reveal hidden at its core astonishing messages, threats and evocations. They formed the basis of her interpretation of the split between her inner and outer lives and underpin the texts included in this selection. . . . Zürn's familiarity with Surrealist conceptions of the psyche and her extraordinary self-possession during the most alarming experiences are allied with her vivid descriptive powers to make this a literary as well as a psychological masterpiece."

$14.99 *(PB/205/Illus)*

Man Ray: American Artist
Neil Baldwin

Not a Dadaist biography like Man Ray's own *Self Portrait* (1963), but a chronicle of the life of a man who claimed, "It has never been my object to record my dreams, just the determination to realize them." While most accounts on Ray look almost exclusively at his Dada and Surrealist years and focus on his photography, Baldwin presents an evenhanded approach to his entire career, stressing little-known facts, such as Ray's determination to be taken seriously as a painter. The subtitle of this work is particularly notable, since it returns the artist to a context he had tried so hard to erase, his

prior existence as Emmanuel Radnitsky, the Philadelphia son of a garment worker. With the assistance of Juliet Man Ray, the artist's widow, the author also explores the details of Ray's complex private life, including his numerous affairs during the expatriate heyday of the '20s and '30s. **AP**
$16.95 *(PB/449/Illus)*

My Last Sigh
Luis Buñuel
Written in the style of an oral history and often displaying a dreamlike logic, *My Last Sigh* provides a portal into the mind of cinema's great master of the subconscious. This volume traces Buñuel's life from his boyhood in Aragon and schooling in Madrid, to his association with the Surrealists in Paris, the years of the Spanish Civil War, his stint at MOMA's film department in the 1940s, the Mexican cinema of the 1950s, and his later European masterpieces.

Often taking serendipitous detours to expound on such topics as the perfect martini or the relationship between Mexicans and guns, *My Last Sigh* recounts an artist's life lead to the fullest and with no regrets, save one. "I hate to leave while there's so much going on. It's like quitting in the middle of a serial. I doubt there was so much curiosity about the world after death in the past, since in those days the world didn't change quite so rapidly or so much. Frankly, despite my horror of the press, I'd love to rise from the grave every 10 years or so and go buy a few newspapers. Ghostly pale, sliding silently along the wall, my papers under my arm, I'd return to the cemetery and read about all the disasters in the world before falling back to sleep, safe and secure in my tomb." **JAT**
$6.95 *(PB/256/Illus)*

Nadja
André Breton
Novelized account of the author's obsessional and haunting relationship with a girl in Paris; explores eroticism, psychic power and insanity. With shocking honesty, Breton confronts the ultimate futility of his romantic search for a flesh-and-blood creature who embodies his fantasy of the *femme-enfant*, the ideal Surrealist woman.
$9.95
(PB/160/Illus)

The Persistence of Memory: A Biography of Dali
Meredith Etherington-Smith
For those who slogged through any of Dali's self-penned, self-invented autobiographical smoke-screens, this is like a clear vista through winter air in which all of the edges of things are in sharp focus and the colors are crisp. The author is the European editor of *Town and Country*, and she understands the machinations of the rich and famous and how the art world really operates. Having gained access to numerous previously unavailable archives and unpublished letters, she has pieced together a realistic narrative of the strange and sometimes banal life of one of the world's greatest self-promoters. We get a picture of Dali's strained relation with his family that reached the breaking point when wife Gala took control.

Gala's story is not a pretty one. She is painted here as a conniving, calculating, petty control freak who eventually held Dali a virtual prisoner in his studio, cranking out society portraits to support their increasingly extravagant lifestyle. By the end of his life, Dali had alienated everybody who should have mattered, and the credibility of his art was at serious risk. The author conveys a lurid story with an even hand. She closes with: "Beneath Dali's posturing public figure is an artist who never ceased to explore his inner and outer worlds and their possibilities; a painter who never ceased in his endeavors to find a way that painting might advance and inspire in a century increasingly dominated by the abstract marvels of scientific discovery." **SA**
$19.95 *(PB/480/Illus)*

Photographs by Man Ray: 105 Works
Man Ray
Man Ray's best-known works from 1920 to 1934,

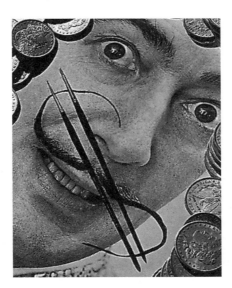

Why do you paint? Because I love Art. — from Dali's Mustache

some created by experimental means. Arriving in Paris in 1921 and with his artistic vision rooted in Dada and Surrealism, the American photographer experimented with various techniques such as shooting through different fabrics and superimposing images. In his own words, "the removal of inculcated modes of presentation, resulting in an apparent artificiality of strangeness, is a confirmation of the free functioning of this automatism and is to be welcomed." **DW**
$10.95 *(PB/128/Illus)*

Revolution of the Mind: The Life of André Breton
Mark Polizzotti
Rightfully called the "pope" of Surrealism by his critics, André Breton controlled the movement with a strong hand. He was also one of the major figures of cultural life in the 20th century. One cannot imagine not having Breton to kick around in this world as he brought up major themes for this century—spiritualism, radical politics, psychology and the occult, and had the personality to gather a group of writers, poets and artists into the movement known as Surrealism. He was also an underrated poet and critic, and was witty in his critique of his culture. The reader learns that for such an outrageous, sexually minded artist, he was also a prude. Although he was one of the first to check out sexuality in a so-called scientific, objective matter, he was extremely homophobic and had a strong distaste for brothels. Breton demanded a "work ethic" yet banned the Surrealists from working day jobs. He suffered great financial burdens. Breton was a romantic who put his women on a pedestal . . . and, in the course of his many marriages, often left them there.

This biography by Mark Polizzotti (who also translated many of Breton's works into English) captures Breton in his glory. There are also revealing glimpses of Tristan Tzara; Breton's troubled relationship with his one-time best friend Louis Aragon (somewhat of a rat!); Antonin Artaud; Dali; and other greats in the movement against the rational. **TB**
$35.00 *(HB/754/Illus)*

The Secret Life of Salvador Dali
Salvador Dali
Early autobiography filled with flamboyance and lathered with self-praise from the master himself. Dali's tongue runs on with lucidity for 400 pages. Humbling but also wearing, it will enlighten those who may believe Dali was only a painter. Exposes his brilliance not just as an artist but in his understanding of victimization and its

shocking repercussions. **OAA**
$9.95 *(PB/400/Illus)*

Surrealism
Julien Levy
In 1931, the author opened the Julien Levy Gallery and a year later had the first Surrealist show in New York. In 1936, Levy's *Surrealism* anthology introduced the movement to America's readers and has been an enduring work. "Surrealism is not a rational, dogmatic and consequently static theory of art—hence from the Surrealist point of view, there can be no accurate definition or explanation. It is the purpose of this book to present such examples of Surrealism in illustration and translation—not to attempt a detailed explanation. It is only by familiarity with examples that one can reach that revolution in consciousness which is known as comprehension." *Surrealism* deals with what Dali terms "the great vital constants" and attempts to explore the more-real-than-real world behind the Real. **DW**
$17.95 *(PB/192/Illus)*

Surrealism and the Occult: Shamanism, Magic, Alchemy, and the Birth of an Artistic Movement
Nadia Choucha
The first half of this book is a compelling look at the late-19th-century occult revival in France and how it influenced art and literature that became influential in the development of Surrealism. That the resurgence of ritual magic imagery influenced such people as Huysmans, Baudelaire, Moreau and Rops is undeniable, and the author initially promises the reader much. While there are some interesting observations on the Theosophical influences on Kandinsky and Mondrian, some of this occult "influence" becomes less direct as the books wears on. In the chapter on automatism, the author spends a good deal of time discussing Austin Osman Spare, declaring that while he did not influence Surrealism as he was unknown to the movement, his style of automatic drawing parallels their automatism. The argument is intriguing but not wholly convincing. Her discussion of Duchamp is also vague. The subject matter she continually returns to in the second half of the book—that of eroticism, the union of opposites and the androgyne—may have their sources in occult literature but also may not. She may well be on the mark with her analogies but sometimes

fails to adequately support her arguments.
 MM
$12.95 *(PB/144/Illus)*

Surrealist Games
Edited by Mel Gooding
By combining unrelated objects, thoughts, images and writings, surrealists create and find beauty—the more absurd and random the better. This book allows the reader to be a "hands-on" surrealist. An obvious must at parties—a functional, amusing and often humorous book on manipulating chance as an artform. **DW**
$10.00 *(PB/165/Illus)*

The Surrealist Parade: Literary History
Wayne Andrews
"Surrealism is a secret society that will introduce you to death." Thus spake André Breton, the main focus of this easygoing and highly personal overview of the movement he is credited with founding. The author, who has written over 16 books on many topics (including a cultural history of Nazism called *Siegfried's Curse* and, as Montague O'Reilly, the surrealist novels *Pianos of Sympathy* and *Who's Been Tampering With These Pianos?*), knew most of his subjects personally, which makes for a lively read. Although he died before completing the last chapter, if that information weren't right there on the back cover, no one would be the wiser. Besides an extremely detailed portrait of Breton, Andrews' "little insider's history of Surrealism" is a curious pastiche of what the afterword correctly labels "caustic yet admiring sketches" of all the major surrealists—Dali, Ernst, Eluard, Buñuel, Picabia, Roussel—"illuminating their achievements with choice examples of their eccentricities and obstinacies." At 178 pages (including the afterword and index) it's hardly a definitive reference source, but it's not like there's a shortage of that sort of thing in the literature of art history. Besides, as Voltaire once said, "To tell everything is to bore." **DB**
$11.95 *(PB/178)*

The Theater and Its Double
Antonin Artaud
A collection of manifestos originally published in 1938: "We cannot go on prostituting the idea of the theater, the only value of which is in its excruciating, magical relation to reality and danger." He repudiates all literature written to be performed, wishing to destroy all forms of language and all social properties in order to bring life into the the-

ater and transform actors and audiences into "victims burnt at the stake, signaling through the flames."
$9.95 *(PB/159/Illus)*

To Have Done With the Judgement of God
Antonin Artaud
"*Pour en finir avec le jugement de dieu*, a work for radio by Artaud, recorded in several sessions in the broadcasting studios of the Radiodiffusion Française, between November 22 and 29, 1947, and immediately banned from the air, was to become as legendary as the famous conference he gave earlier that year at the Thèatre du Vieux Colombier. . . . The banning of this work was the last great deception wreaked upon Artaud, who considered it 'as at last a first rendering of the theater of cruelty.'"
$15.50 *(CD)*

Un Chien Andalou
Luis Buñuel and Salvador Dali
No image is more closely identified with Surrealist film than the opening scene of *Un Chien Andalou*—a young woman sits calmly while a man slices her eyeball open with a straight razor. Although it is technologically primitive, not to mention silent, *Un Chien Andalou* remains an enigmatic landmark in the history of cinema, as radical today as when it was released, in 1929. A collaboration between upstart Spaniards Salvador Dali and Luis Buñuel, the film was quickly if grudgingly accepted by the notoriously fickle Surrealist group, mainly due to André Breton's enthusiasm. Public reaction was mixed, although Buñuel, in 1929, attacked "those spectators who, recuperating the film as 'beautiful' or 'poetic,' overlooked its true intention as a 'desperate and passionate appeal to murder.'" **DB**
$9.95 *(PB/38/Illus)*

Une Semaine de Bonté: A Surrealistic Novel in Collage
Max Ernst
Eroticism and tragedy are the prevailing moods in this collage "novel" (all images, no text) by Max Ernst. Ernst was one of the founders of Dada in Zurich (he later became a Surrealist) and is recognized as one of the greatest of collage artists. A vague storyline emerges as page after page of bizarre imagery display many levels of emotion and angst through collage. The book, whose title means "week of kindness," has seven chapters (one for every day of the week), each

André Breton at the Palais Idéal of Ferdinand Cheval, 1931 — from The Discovery of the Art of the Insane

with a loose theme. The publisher suggests that Paul Eluard's first "visible poem" could be the motto for the entire book: "I object to the love of readymade images in place of images to be made." **DW**

$9.95 *(PB/208/Illus)*

Watchfiends and Rack Screams: Works From the Final Period
Antonin Artaud

This is the first English-language book of the writings of Antonin Artaud during the period from his institutionalization in the insane asylum in Rodez until his death near Paris in 1948. Translator Clayton Eshelman has also written an illuminating biographical sketch of Artaud, especially in his final years when these incantatory words excerpted from Artaud's banned radio broadcast, "To Have Done with the Judgement of God" were written.

$15.95 *(PB/342)*

What Is Surrealism? Selected Writings
André Breton

"Contrary to prevalent misdefinitions, Surrealism is not an aesthetic doctrine, nor a philosophical system, nor a mere literary or artistic school. It is an unrelenting revolt against a civilization that reduces all human aspirations to market values, religious impostures, universal boredom and misery." This collection of writing and manifestos by Breton continues to be one of the most thorough introductions to Breton and Surrealism, outlining the basic tenets, history and influencing factors of the movement. The book presents his work in chronological order, and includes a selection of documents and writings. The reader gains not only a sense of Breton and his significance in the spread of Surrealism, but also gains some familiarity with his fellow artists and writers; how alchemy, Freud and Hegel influenced Breton; how he employed unusual creative techniques such as automatic writing; but most of all how Surrealism is a way of viewing the universe rather than just another "ism." **MM**

$43.95 *(PB/557/Illus)*

Yes No
Francis Picabia

Hanuman Books are sweet strawberries covered in the most delicious creamy chocolate in the feast of literature. They are petite and firm, exotic and very, very sexy little items, guaranteed to add secret glamor and sophisticated depth to even the most shallow of pockets. *Yes No*, by "dadaist" and painter Francis Picabia, is 47 discerning, midget pages of evanescent aphorisms. Gems of cynicism, melancholy observation and caustic comment worthy of any aspiring, or asp-like, queen's tiara of wit. The brief messages, warnings and considerations are drawn from his journals and notebooks dating from 1939 through 1957.

"Beauty is relative to the amount of interest it arouses"—Picabia

This is an anthology from the revered lineage that includes the dandyish sublimity of Oscar Wilde; the fastidious camp of Quentin Crisp, or even the more obscure English Edwardians like James Bertram and F. Russell, whose Victorian misogyny and skepticism were illustrated more exquisitely than the "corpse" itself by Austin Osman Spare in *The Starlit Mire*. Yes, aphorisms are a justly grand tradition of which one can only approve, given that one is a reasonable person. And—in this age of advertising slogans and soundbites, bumper stickers and designer corporate logos as street fashion— a reminder of the priceless art of word games, the contradiction, collision and collusion in fresh revelation "to see what they really say," as Brion Gysin so prophetically indicated in his cut-ups.

"Art is the cult of error"—Picabia

We are to savor the menu of resident connoisseur Picabia's palette of human tinctures and emotional flavors. As you have rightly guessed, dear reader, all is artifice, contrivance, and bouquet.

"Serious people have a slight odor of carrion"—Picabia

Yes No is sublime evidence for one of the essential conclusions of any intelligent 20th century culture: that "art" has been distilled repeatedly and thoroughly until it may quite rightly be perceived and defined as an attitude of and to Life (yes, complete with an "if" right there in the middle).

"Many artists devote their time to their painting, I ask myself why are these people so fond of bad company?"—Picabia

There are strong arguments to suggest that "art" is merely an expression of a neurosis given space in our personae by the luxury of free time thanks to the advent of tools, technology and overt or covert economic systems of slavery and privilege. "Art" has no biological source, no survival imperative. What was once a "craft" for making functional and magical "things" is now a dubious and unnecessary postexistentialist requirement of taste. Nothing more than that. Just an obsolete but amusing symbol of a fantasy of neurological superiority.

"Art is a pharmaceutical product for idiots."—Picabia

By the way, don't worry if the word "art" never enters your vocabulary! This simply means that you are extremely culturally healthy, and/or blissfully and justifiably elsewhere. So, at that next soiree, or opening, or dreadfully dull social occasion, nip into the bathroom, sneak out your well-worn copy of *Yes No* and just try substituting any old power word or enemy's name for that tired old word "art" and you will be surprised at the good time you shall have. **GPO**

$5.95 *(PB/57/Illus)*

SZUKALSKI

The art and philosophy of the great Polish genius Stanislav Szukalski is slowly becoming known to a wider audience, thanks to the pioneering efforts of Glen Bray and Lena Zwalve, who befriended the hermetic and forgotten artist and have managed to keep his work and legend very much alive. His bronzes and other sculptures are certainly comparable to Rodins, but dynamically different. His draftsmanship and pencil work make your jaw drop. The complex and mythic symbols which are often woven into his art can, at first, confuse the viewer who has no key at their disposal to decipher the message in the work. The artist's obsessions with the alleged common origin of man, the different "types" and strains of "humans" roaming this planet and other ethnic theories assure us as students of Szukalski that we are dealing with a highly focused, compulsive world-view. Still, his work stands on its own for the sheer power of Szukalski's emotional anatomy.

The man's persona is at least as fascinating as his art, fitting, as it does, so perfectly into the "eccentric artist" mode. But Szukalski was serious. He could never be stopped by anything short of death. Everyone who met him, as I did, just once, has a "Szukalski story" to tell so I may as well put mine down here for posterity. I was attending an opening for a show called "Bad Influences" at the Otis Parsons School of Art gallery. It was a group show of, often, brightly painted, cartoony art. Some fun stuff, I thought. Meandering through the artsy crowd I spotted my friends Glenn Bray and Lena Zwalve. Between them, arm in arm with each was a slight, wizened old man with a shock of white hair. I knew who it was. I'd heard about him. Szukalski. My mind raced . . . wow, incredible—a direct link with the Bohemian scene of Chicago in the twenties. He knew Ben Hecht. Sadakichi Hartmann. The publisher Pascal Covici. I was introduced and shook hands with him. His twinkling blue eyes glinted mischievously. He couldn't pass up another chance to make an impression on a receptive mind. He held firmly onto my hand and began exclaiming, "FARTISTS! FARTISTS!," gesturing to the work on the walls with a dismissive wave, "They are all FARTists!" He then drew me closer, still clutching my hand, and said, "You must take the ART AND YOU MUST SUCK IT OUT OF YOUR THUMB." He then made the gesture of sucking his own thumb. He was, I feel, telling me that he felt much of the art was too "easy" and derivative. He felt that truly great ART must come from the blood, from a point of truth and experience. It was a typical Szukalski moment. He was making a scene, but also making a point. He couldn't help himself. I think of his words often. — CS

Szukalski's Coat of Arms— from Behold the Protong!!!

Behold the Protong!!!
Stanislav Szukalski
"A sampling from Szukalski's 39-volume work on Zermatism, his self-discovered science in which he explains our common global anthropological ties. Szukalski has collected and meticulously redrawn almost 50,000 anthropological illustrations attesting to his thesis of one prototypical civilization and one language we all once shared, which he named Protong. From serpents to mermaids, from the Abominable Snowman to Charles Manson, all features of our common unconscious are explained within the greater plan of Zermatism."
$24.95 *(PB/96/Illus)*

Bronzes of Szukalski
Archives Szukalski
A nicely printed booklet which presents photographs and detailed descriptions of 34

works by the artist including small sculptures such as the anticommunist *Russian Face*, a perverse work of whimsy. Among other major creations cataloged herein are *The Rooster of Gaul* and *Bor Kamorowski, a Son of the Merman*. Also includes an excellent essay by Jim Woodring, "The Neglected Genius of Stanislav Szukalski." **CS**
$5.00 *(Pamp/34/Illus)*

The Lost Tune: Stanislav Szukalski — Early Works (1913-1930) as Photographed by the Artist
Stanislav Szukalski
A beautifully conceived book of Szukalski's sculptures from his Chicago years, photographed and annotated by the artist himself, "because nobody, not even professional photgraphers, knows as much about lighting as a sculptor." Published on the occasion of a posthumous exhibition at the Polish Museum of America.
$19.95 *(HB/119/Illus)*

Stanislav Szukalski: Song of the Mute Singer
Edited by Jacaeber Kastor and Carlo McCormick
This booklet reprints rare drawings by Szukalski rendered in his meticulous pointillist style. Interspersed throughout are insightful essays written in tribute to the artist by those who were fortunate enough to have their lives touched by him, includ-

Echo, 1923. The figure of Echo is headless, as she does not originate the sound of the echo. To hide the absensce of her head, she places her hands together and deceives her listeners by distorting the sounds they make. She is resting her inflamed foot on a tree, tired of running from hill to hill. — from **The Lost Tune**

ing Robert Williams, Suzanne Williams, Lena Zwalve, Rick Griffin and others. Szukalski's charming short story "The Mute Singer" is also reprinted. **CS**
$5.00 *(Pamp/32/Illus)*

Stanislav Szukalski

Warhol

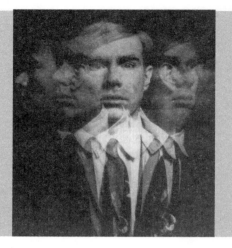

I really believe in empty spaces, although as an artist, I make a lot of junk.

Empty space is never wasted space.

Wasted space is any space that has art in it.

— Andy Warhol, from *THE Philosophy of Andy Warhol*

Andy Warhol, 1966 — from **Andy Warhol: Films and Paintings**

Andy Warhol: Death and Disasters

Andy Warhol

Exhibition catalog of Warhol's early, violent silk-screens: car crashes, plane wrecks, electric chairs, skulls, etc.

$25.00 *(PB/135/Illus)*

Andy Warhol: Films and Paintings—The Factory Years

Peter Gidal

This little volume, which proves that less is more, is a reprint of a book originally published in 1971, before the diaries and tell-all biographies and while Warhol's mystique was still firmly intact. It predates the time when Warhol got assimilated into straight society and started doing the portraits, endorsements and general wearing out of his welcome as an innovator. Here was a time when the world was so enthralled with Warhol that a passage like "Warhol has begun to move the camera, speech is becoming more regular, what we are accustomed to hearing, though the layers of satiric and politico-sexual meaning are strongly in evidence" carried a sense of revelation about the man and his work. When it came out, this book was the last word on Warhol and remained so for years. It probably had as much to do with shaping the public's perception of Warhol the artist as anything that he did himself. As Andy is quoted as saying to the author: "Oh, I just love your book, it's so great, Peter. You've got to sign my copy, it's so fabulous! **SA**

$14.95 *(PB/159/Illus)*

Andy Warhol Nudes

Andy Warhol

"This book celebrates his art of a more private nature, and for the first time gathers together in one volume his little-known represenations of the naked human body as paintings, prints and drawings. It includes a group of 'pretty' nudes from the '50s, where sex organs are depicted as a desirable commodity, not unlike his advertising illustrations for shoes; the 'Torso Series' from the '70s based on Polaroids; some large drawings from the '70s and '80s; and a series of prints, 'Sex Parts', from 1978."

$50.00 *(HB/100/Illus)*

The Andy Warhol Diaries

Andy Warhol

From the toot-filled Studio 54 era to Andy's demise, day by day by Dictaphone . . . in his

own inimitable words. Here are some reflections from a day in 1978, "The big news from the past two days is the mass suicide in Guyana of a cult led by somebody named Jim Jones. It's costing the U.S. government $8 million to remove all the bodies and bring them back. They put cyanide in grape-flavored Kool-Aid. [laughs] Just think, if they'd used Campbell's Soups I'd be so famous, I'd be on every news show, everyone would be asking about me. But Kool-Aid was always a hippie thing."

$19.95 *(PB/807/Illus)*

The Philosophy of Andy Warhol: From a to B and Back Again
Andy Warhol

Andy gives his thoughts on art, beauty, philosophy, money, sex—and death: "I don't believe in it, because you're not around to know that it's happened. I can't say anything about it because I'm not prepared for it."

$13.00 *(PB/241)*

Pop Out: Queer Warhol
Edited by Jennifer Doyle, Jonathan Flatley and José Esteban Muñoz

Andy swished. Andy painted cocks. Andy camped. Andy made *Blow Job*. Andy wore

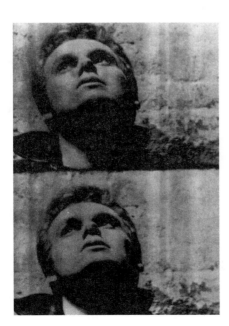

Blow Job, 1963-4 — from **Andy Warhol: Films and Paintings**

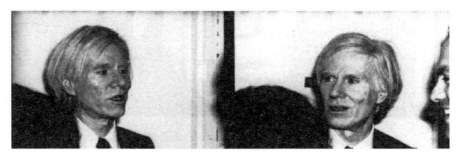

Andy Warhol talking with Peter Gidal, 1978 — from **Andy Warhol: Films and Paintings**

wigs. Andy was fabulous. Back in the '60s, the straight world wondered, "Is he queer?" (Stupid question.) These days, they're afraid to ask. "With few exceptions, most considerations of Warhol have 'degayed' him," say the editors of this series of essays. "Despite the fact that many people 'knew' that Warhol was gay, hardly anyone, at least in the world of criticism and theory, will speak of it." Warhol's "straight" ascension into the fine art pantheon is halted here, for good reason. "To ignore Warhol's queerness is to miss what is most valuable, interesting, sexy and political about his life and work." **GR**

$16.95 *(PB/280/Illus)*

Popism: The Warhol '60s
Andy Warhol and Pat Hackett

Andy's semibiographical statement on the Pop aesthetic/philosophy of the '60s—with Edie, the Factory, the Velvet Underground, his early film experiments, his superstars, Valerie Solanas, media preoccupations and more—written in his patented, detached, absurdist style.

$13.00 *(PB/310/Illus)*

Stills From the Warhol Films
Billy Name

"Photographer Billy Name was a close friend of Andy Warhol and a trusted player in the creation of Warhol's artistic environment during the mid-1960s. Name's still photos of Warhol and his entourage, shot at the Factory in New York City, capture the essence of an era—its look, its drama, its moments of introspection—as well as the full roster of Warhol's acquaintances. . . . This first book-length treatment of Name's work provides a peerless introduction to

Warhol and his intimate circle."

$29.95 *(PB/127/Illus)*

The Velvet Years 1965-67: Warhol's Factory
Stephen Shore and Lynne Tillman

"I don't really feel all these people with me every day at the Factory are just hanging around me, I'm more hanging around them. . . . I like being a vacuum; it leaves me alone to work . . . anybody who comes by here is welcome, it's just that we're trying to do some work here."—Andy Warhol

How is it that looking at pictures of some of the most utterly bored-looking people in the history of recorded time never itself seems to get boring? What was it about the crushing ennui of the denizens of Andy Warhol's Factory that remains so damn compelling today? Perhaps it's because the sense of passive detachment, smart-assed irony and fun-tinged alienation captured by photographer Stephen Shore's lens was so shockingly new at the time, so incredibly vital, that it was, and remains, positively electric. Shore's remarkable collection of photographs taken at the Factory between 1965 and 1967, along with writer Lynne Tillman's interviews with many of the surviving participants, provide a delicious voyeur's-eye view of what was undoubtedly one of the seminal breeding pools of postwar American pop culture, a scene which forged the look and attitude of so much that would come after. They're all here in gorgeous black and white—Andy, Gerard Malanga, the Velvets, Billy Name, Ondine, Nico, Edie Sedgwick, Ingrid Superstar, Ultra Violet and Paul Morrissey. **AD**

$24.95 *(PB/176/Illus)*

SLEAZE

Ask Dr. Mueller
Cookie Mueller
"Cookie Mueller was a fiction writer, cult movie star, art critic and a fixture on the downtown New York scene until her death from AIDS in 1989. An art columnist for *Details*, an advice columnist for the *East Village Eye*, Cookie also wrote fiction which was eminently amusing and refreshing. Included here are the best of her *Details* columns; the funniest *East Village Eye* pieces, on everything from homeopathic medicine and health-care to how to cut your cocaine with a healthy substance; and her strongest pieces of fiction, including some from *Walking Through Clear Water in a Pool Painted Black* and *High Risk*. This collection is as much an autobiography as it is a map of downtown New York in the early '80s—that moment before *Bright Lights, Big City*, before the art world exploded, before New York changed into a yuppie metropolis, while it still had a glimmer of bohemian life."
$13.99 *(PB/320)*

Bad Habits: Drinking, Smoking, Taking Drugs, Gambling, Sexual Misbehavior and Swearing in American History
John C. Burnham
"An illustrated exposé of the growth of vice in America."
$17.95 *(PB/385/Illus)*

The Bare Facts Video Guide: Where To Find Your Favorite Actors and Actresses Nude on Videotape
Craig Hosoda
A perfect guide for the voyeuristic cineaste, *The Bare Facts* sees that your favorite film stars and personalities get the widest possible exposure. Organized into three broad categories, this guide provides alphabetical listings by actor, actress and film title. Each scene featuring nudity is described in detail, giving the length of the scene and what body parts are available for viewing within the scene. Also, each scene is rated with one to three stars, with three stars being "Wow! Don't miss it." For example, under *The Night Porter*, three scenes are listed, with the favorite scene earning a three-star rating. Lasting over one minute the scene features "breasts doing a song and dance number wearing pants, suspenders and a Nazi hat. Long scene." **JAT**
$19.95 *(PB/870)*

Beyond the Pits
Rae Shawn Stewart
Serious and sad tale of an ex-junkie/ho' coming to terms with her impending death from AIDS. Fairly gut-wrenching. **MG**
$3.50 *(PB/144)*

Black Starlet
Bobbye Vance
Seventies pulp which was actually made into a movie. "Meet the black starlet and the men who made her . . . Her white agent becomes her pimp and she treks in and out of producers', directors' and backers' bedrooms, bending to their perverse hungers. She came to Hollywood with an active hatred of whites but finds that in the glittering unreality of the movie capital, a black will cheerfully do her in and call her sister at the same time." Ten pages of black-and-white photos. **GR**
$2.25 *(PB/215)*

Broken Covenant: The Secret Life of Father Bruce Ritter
Charles M. Sennott
Father Bruce Ritter founded a shelter for runaways in Manhattan in 1968. By 1989 the shelter had grown into a national entity and Ronald Reagan had declared Father Ritter an unsung Saint in a State of the Union Address. In 1990, Father Ritter resigned his post amid allegations of child molestation and financial misconduct. No legal charges were ever brought, although there was an "in-house" investigation of charges. This "trial by book" is well-written, exhaustively researched and utterly compelling. **SA**
$4.99 *(PB/512)*

Call Me Mistress: Memoirs of a Phone Sex Performer
Natalie Rhys

"Phone sex is a unique form of erotica. Like written stories it is pure fantasy, yet . . . it is the customer's fantasy, not the writer's." A self-described "mild-mannered computer systems analyst by day," Rhys transforms herself into "an uninhibited fantasy performer by night," answering phone-sex calls in her home. In these pages, however, her uninhibited side takes a backseat to her analytical prowess, as she divides callers into categories such as 'Demanding', 'Invasive' or 'Pseudo-Intimate', among others. Her volunteer work as a telephone crisis-line counselor is apparent throughout as she speculates on the life experiences that may lead to a caller's particular fantasy. She never mentions if she gets her crisis-line clients confused with her phone-sex callers, only to tell the lovelorn and suicidal to try a hot coffee enema. While Rhys describes phone sex as "the perfect second job," her book is more New Age touchy-feely than hot and sexy—definitely not the stroke book to bring to a desert island. On the other hand, *Call Me Mistress* is an excellent primer to the nuts-and-bolts business of phone sex. **LP**
$7.50 *(PB/123)*

Captain Quirk: The Unauthorized Biography of William Shatner
Dennis William Hauck

Egomaniac. Scene stealer. Visionary. Ham. Lover. Bully. Star. Love him or hate him—and it's split just about equally—Shatner is the Captain of Captains in the *Star Trek* universe. This book details: "His shocking encounter with extraterrestrial beings [that gives new meaning to his rendition of "Tambourine Man"] . . . Why the *Star Trek* movies almost didn't get made . . . His sizzling offscreen romances [with his leading-lady guest stars]. . . His stormy relationship with Leonard Nimoy and other cast members [Sulu hated his guts] . . . and why he became the most hated actor on the set [Shatner was on a classic star trip]. On the bright side, there's Shatner's pre-*Trek* Broadway success as the star of *The World of Suzy Wong*. A man who loves spaceships and horses can't be all bad. **GR**
$4.99 *(PB/298/Illus)*

Caught Looking: Feminism, Pornography and Censorship
Edited by the Feminists Against Censorship Task Force
Amazing collection of feminist essays and explic-it visual commentary on pornography, censorship and sexuality. A bold and provocative history of pornography and the feminist debates surrounding its use, control, effects and attitudes. A groundbreaking and crucial collection. **AK**
$15.95 *(PB/96/Illus)*

Choices: A Memoir by Judy Hill Nelson; My Journey After Leaving My Husband for Martina and a Lesbian Life
Judy Hill Nelson

"Judy Nelson's honest story of her life . . . before and after her acceptance of a lesbian lifestyle. It's a cause for which she works passionately, even at the risk of losing many old friends."
$21.95 *(HB/232/Illus)*

Lené and Mark Davis, Malibu — from **Red Light**

Coming Attractions: The Making of an X-Rated Video
Robert J. Stoller, M.D., and I.S. Levine

"In this book, the late Dr. Robert J. Stoller, who was one of the world's leading experts on human sexual behavior, and I.S. Levine, a writer and director of X-rated videos, present interviews with the performers, writers, directors, producers and technicians involved in the production of an adult heterosexual X-rated video, *Stairway to Paradise*, and examine the backgrounds, motivation and psychological makeup of the participants. The book provides unique insights into the mechanics, aesthetics, and legal and moral implications of such films."
$30.00 *(HB/246)*

The Complete Guide to Gentleman's Entertainment
Kinsley D. Jones and William A. Harland
"Complete listings for nearly 3,000 nude, topless and gogo dancing clubs throughout North America: club names, addresses, phone numbers, driving directions, business hours, cover charges, dress codes, special events and more!"
$16.95 *(PB/336)*

Cop to Call Girl
Norma Jean Almodovar
"The true story of Norma Jean Almodovar's remarkable journey from squadroom to bedroom, from prison cell to political arena—an unforgettable celebration of a very smart and sexy lady who, when she was bad, was very good!"
$5.50 *(PB/337/Illus)*

Critical Vision: Random Essays and Tracts Concerning Sex Religion Death
David Kerekes and David Slater
A collection of the best articles from the early issues of *Headpress* magazine, from the "Savoy Wars" to the Sunset Strip Murders, Punch and Judy to the Black Plague. This edition is fully updated and revised, including new material, and offers the very best of sex crime, porn goddesses, religious mania, outlaw publishing and morbid curiosities. **AK**
$19.95 *(PB/251/Illus)*

Crypt 33: The Saga of Marilyn Monroe — The Final Word
Milo Speriglio and Adela Gregory
"It took Marilyn just seconds to walk from her bedroom to answer the front door . . . When the intruders quietly rushed in, one moved toward the actress while the other shooed the dog into another room and closed the door behind it. . . . They had been explicitly ordered not to bruise Miss Monroe, not to leave any visible signs of violence. The shorter hitman removed a chloroform-soaked cloth from a plastic bag and quickly placed it securely over Marilyn's nose and mouth. The other took out a prepared solution in a thermos bottle. The solution contained a highly concentrated mixture of chloral hydrate, Nembutal and water. After she stopped struggling from the effects of the chloroform, they stripped off her robe and laid her nude body on the floor, placing a small towel under her buttocks. After dipping a bulb syringe into the solution and filling it to capacity . . . he expelled the poison into her colon. A second dose followed immediately. They placed her nude body on the bed."
$21.95 *(HB/310/Illus)*

Out of prison on probation in 1986, I tossed my hat—and almost everything else I was wearing—into the political arena, campaigning for lieutenant governor of California. — from **Cop to Call Girl**

Dino: Living High in the Dirty Business of Dreams
Nick Tosches

To truly understand the phenomenon of Dean Martin, one needs to be familiar with the meaning of the Italian slang term *menefreghista*. This is a word that loosely translates as "one who doesn't give a fuck." This is ultimately the essence of the Martin world view, as revealed in Nick Tosches' poetic biography of the man who began his life as the son of an Ohio barber. As a youth, Dino Crochetti did a little boxing, a bit of card dealing, and a lot of fucking around. He decided to try the singing racket, and for a while was known as "Dino Martini," singing mostly standards in a voice which owed a lot to Bing Crosby. Eventually, he developed a looser style, vocalizing and behaving in a manner which indicated that he could take or leave whatever he was singing about. He seemed to be saying, "This singing crap is for the birds, but if you folks dig it, well, then I'll keep doin' it for you all, and if you don't enjoy it, then fuck you 'cause soon I'll be playing 'hide the *sausichia*' with some broad anyway." The crowd seemed to appreciate this philosophy, and he was gaining some success when placed on the same bill as one Jerry Lewis at the 500 Club in Atlantic City. The rest is, as they say, history.

Tosches' book looks behind that obvious history and traces the growth of the recording industry in the U.S. showing Martin's importance as a vital component of the burgeoning late-20th-century American distraction machine, otherwise known as "entertainment." It's all here: the organ grinder, the monkey, the Rat Pack, the gals, the wives, the booze, the pills, the movies, the T.V. show, even the early '80s music video. There is not much about Dean's life after the mid-'80s, possibly because not much went on and, unfortunately, the book was published before Dino finally cashed in his chips on Christmas Day, 1995. Folks who fancy themselves citizens of "Cocktail Nation" will want to read this book to catch up on what empty assholes the founding fathers were. Then again, who gives a fuck. **AS**
$6.99 *(PB/652/Illus)*

Elvis Aaron Presley: Revelations From the Memphis Mafia
Alana Nash with Billy Smith, Marty Lacker and Lamar Fike

An oral biography on the "King of Rock'n'Roll," as told by the likes of Marty Lacker, Billy Smith, and Lamar Fike, three of Elvis' closest friends. Full of dirt any true Elvis fan could appreciate, this tell-all read takes a look into the obscure sexual fetishes and the rumors about the King's not being the most hygienic man in the world. Also filled with tales of Elvis' absurd public characteristics and infamous meetings with celebrities whom Elvis

The protest movement comes to Vegas, where they too had a dream. — from **Dino**

always thoughtlessly insulted. **TD**
$25.00 *(HB/792/Illus)*

English Eccentrics: A Gallery of Weird and Wonderful Men and Women
Edith Sitwell

Here is an assortment of history's more colorful fringe figures—ornamental hermits, charlatans, quacks, men of learning, misers—told in a style at once loquacious and exact. Immersing oneself in the book is akin to walking through a big-top sideshow . . . There's the aged Countess of Desmond, who climbed an apple tree at the age of 140 . . . Princess Caraboo, the pathetic servant-girl from Devon who stole the heart of Napoleon on St. Helena . . . Saintly Squire Waterton, the 19th-century prankster and lover of nature, who developed a deep friendship with a young lady chimpanzee and rode a crocodile bareback . . . Despite a sometimes grating pomposity (more a cartoonish symptom of the age than an individual shortcoming), a sincerely awestruck appreciation of the bizarre and extraordinary. **MDG**
$15.95 *(PB/346)*

Faithfull: An Autobiography
Marianne Faithfull with David Dalton

"My mother, Eva, was the Baroness Erisso. She came from a long line of Austro-Hungarian aristocrats, the von Sacher-Masochs. Her great-uncle was Leopold Baron von Sacher-Masoch, whose novel *Venus in Furs* had given rise to the term masochism. During the war, Eva and my grandparents, Flora and Arthur, lived in the Hungarian Institute in Vienna, where they were more or less free from harassment by the Nazis. My grandmother was Jewish, and the family was in great danger throughout the war (and even greater danger after the Russians invaded Austria in 1945). Eva was raped by occupying Russians soldiers, got pregnant and had an abortion. She was worn out by the privations of the war, and then along came my father, Major Glynn Faithfull, who was working as a spy behind the lines with British Intelligence." Into this world was born Marianne Faithfull, who was to become the angel of Swinging London. Her first single, "As Tears Go By," was written by Mick Jagger and Keith Richards and became an international hit. She settled into a love affair with Jagger, however her increasing passion for drugs would soon leave her a street junkie living among the remains of a wall bombed out during WWII. From these depths, she managed to reinvent herself artistically and take hold of her demons. Told with a survivor's frankness, Faithfull's tale is populated by the likes of Dylan,

Trying on a new image — from **Faithfull**

the Beatles, Kenneth Anger, Madonna, James Fox, Anita Pallenberg, Brian Jones, Keith Richards, and especially Mick Jagger. Roughly two-thirds of the book is devoted to her years in the Rolling Stones Women's Auxiliary, however, this is, after all, the part of her tale which most readers will hunger for. While never appearing evasive or less than forthright, her descriptions of Mick are told with the class befitting a women of her breeding. **JAT**
$11.95 *(PB/310/Illus/)*

Forbidden Lovers: Hollywood's Greatest Secret — Female Stars Who Loved Other Women
Axel Madsen

Originally published in hardcover as *The Sewing Circle*, *Forbidden Lovers* was renamed to appeal to the paperback audience. Providing an overview of same-sex romances among some of the greatest female stars of Hollywood's Golden Age, *Forbidden Lovers* is arranged chronologically from the silent era through the fall of the studio system. Madsen uses both eyewitness accounts from survivors of this closed circle and varied star biographies as source material for this book. Since most of the legendary women led extremely guarded lives, the author frequently can provide only the scantiest of details of these private affairs. Offering 24 pages of predominantly publicity photographs, which tend to feature these icons in their most manly of costumes; plus a scant two compromising shots of Garbo and Crawford. Not fully succeeding as either a scholarly text or as a lurid exposé, *Forbidden Lovers* is best left to the completist. **JAT**
$5.99 *(PB/240/Illus)*

From Rags to Bitches: My Glamorous Life
Mr. Blackwell

"Mr. Blackwell holds nothing back in this intriguing account of his life and loves. The real story of the man behind the infamous 'Worst-Dressed List' is an incredible one, filled with glittering characters and star encounters, sacrifice and suicide attempts, hard work and disappointments, spanning more than 50 years of Hollywood glamor."
$19.95 *(HB/384/Illus)*

From the Tip of the Toes to the Top of the Hose
Elmer Batters

This hardbound installment in Taschen's continuing series of fetish-oriented photographic offerings encyclopedically catalogues the work of Elmer Batters, certainly one of the most fanatically focused lensmen ever to shoot in the pin-up genre. Batters, whose work began in the 1940s and continued for some 40 years, was and is, as fellow photographer Eric Kroll (who edited this collection) describes him in the book's introduction, "a regular guy with an obsession," that being the legs and feet of women. Though he photographs their other parts as well—often with stark explicitness—legs and feet, most often clad in seamed, Cuban-heeled stockings, are generally in the foreground.

Technically competent, Batters' images derive their power not so much from technique, or even subject matter, but rather from their artlessly frank juxtapositions of fetish imagery with more conventional expressions of sexuality. Unlike less ingenuous artists in the medium, who show the viewer a high heel as a way of suggesting something that is not shown, Batters poses his models with stockinged legs folded in against exposed genitalia, making the connection as direct as possible. It doesn't require a decoder ring to figure out this work. This man is a born-again shrimper.

Indeed, the quotidian surroundings, the unadorned staging, the plain-to-routine-pretty models reflect a seeming unawareness of any audience outside the maker of the image. At their worst, Batters' pictures might have come straight from *Beaver Hunt*. At their best, however, they have a stripped-down, telegraphic intensity, compressing all the libidinous fury of the photographer's obsession in a single, power-packed frame. The lasting impression left by this exhaustive compilation is of an erotic artist more honest than slick, whose work succeeds by staying close to home. **IL**
$29.99 *(HB/215/Illus)*

Joan Crawford was an earthy bisexual who went through men, and when they were available, young women with the same ruthlessness she used to reach the top. Photos of her and an unidentified woman circulated in the pornographic underground. — from **Forbidden Lovers**

Gigolos and Madames Bountiful: Illusions of Gender, Power and Intimacy

Adie Nelson and Barrie W. Robinson

Get inside the heads of women who pay for cock, and the men who sell it to them. Written with a light touch, but seriously considers the social, economic and emotional issues involved in sexual contracts where women hold the balance of power. **MG**

$14.95 *(PB/344)*

The Gilded Gutter Life of Francis Bacon

Daniel Farson

Farson was a close friend and confidant of Francis Bacon for over 40 years. They drank together and traded notes on many a morning after. The author knew his subject's kinks and quirks, and shares them in a way that one can imagine would have made Mr. Bacon proud. For Francis Bacon was alarmingly frank about his proclivities in life. His style of painting did not allow for mistakes and bore some resemblance to his penchant for gambling. For Bacon, if the paint didn't cooperate on the huge, unwieldy, unprimed canvases, they had to be destroyed, and many were. This volume took a certain amount of heat for its frankness, but Francis Bacon was never one to hide under a rock unless it was for a quick bit of shagging. This book is heavy on personal mementos and photographs, with few color plates. **SA**

$25.00 *(HB/293)*

Goa Freaks: My Hippie Years in India

Cleo Odzer

Cleo and her freak friends were highly paid drug couriers who traded a few minutes of bowel-wrenching fear crossing international borders with drugs hidden in suitcases, paint boxes and body cavities, for a lavish lifestyle in Goa, where they consumed high-quality cocaine and heroin in cartel-breaking quantities. For more than five years in the '70s Odzer lived in a junkie utopia, with sun, sand and any drug she wanted. Inevitably what began as an idyll of druggy beach parties and carefree sex turned into a nightmare of narcotic-fueled paranoia and Third World prisons.

"We also had drugs. Neal had the smack. Neal always had smack. Both of us had a stash of coke. Since the air was humid I decided to put mine in the safe behind the painting. After dropping silicon crystals into the powder to absorb moisture, I unlocked the safe. Stored in its cool depths were eleven tolas (one tola = 10 grams) of opium; six tabs of acid; a gram of morphine bought from Paradise Pharmacy in Mapusa (sold legally over-

the-counter), which I found unusable due to its disgusting taste (besides, only junkies used morphine); and a kilo of bad border hash that, not knowing any better, I'd stupidly bought to offer guests. It was comforting to survey the cellophane mountain of my hoard. I placed the coke on its summit. Next, I checked the pill cabinet. I had 34 packets of Valium (10 to a packet), seven packets of Mandrax, three bottles of Dexedrine, and a year's worth of birth-control pills. . . .

One had to be careful in Thailand. This was not India. Thais were strict about drugs. Serious penalties existed. Thailand was one of those countries where, if they arrested you, you disappeared. They were especially concerned with smack trafficking. If you were caught with any quantity, you were executed within three days. No embassy could help. There was no time to write a senator. However, by following basic guidelines, it was relatively easy to avoid hassle. You had to act like a tourist. Simple. Carry a camera. Dive in the pool once a day. No problem. Then there were situations to be staunchly avoided. Most important: DO NOT HANG OUT ALONE IN YOUR HOTEL ROOM ALL DAY AND ALL NIGHT. Only junkies did that. It was common knowledge that Thai hotel employees received bonuses for reporting drug suspects. Loose tobacco in an ashtray, a cigarette filter lying around, or, worst of all, a piece of cotton or a bent room-service spoon—forget it. Next thing you knew, there'd be a knock on the door." **NN**

$17.95 *(PB/325)*

My first fashion ad—a full-page portrait of me—outraged the fashion establishment. Designers just didn't do that. It put me on the map and in the headlines, as an enigma in the fashion world. — from **From Rags to Bitches**

Great Big Beautiful Doll: The Anna Nicole Smith Story

Eric and D'Eva Redding

In 1991, Houston-based photographer Eric Redding and his makeup artist wife, D'eva, took a series of Polaroid test shots of a young woman from Mexia, Texas, named Vickie Lynn Smith. The photos were submitted to *Playboy,* and five months later Vickie Lynn, rechristened Anna Nicole Smith, graced the magazine's cover. For Anna Nicole, fame, fortune and a lucrative Guess? clothing contract were followed all too soon by problems with drugs, weight and marriage to a man some sixty years her senior. According to the Reddings, who profess to have been among her "biggest fans," Smith "is a mix of contradictions, contrasts and is big, like the [Texas] map." But if prose isn't their strong point, gossip and innuendo are, and they deliver it with a vengeance. From her early days at Jim's Krispy Fried Chicken through breast enhancement surgery to allegations of prostitution, lesbianism and unchecked greed, the Reddings recount the unsavory details of Anna Nicole Smith's rise and, especially, her fall with ill-concealed glee, often quoting stories from the tabloid press in the process. Highlights include the reproduction of Smith's handwritten releases for the *Playboy* test shots (her likes include "Gentlemen who no [sic] how to treat a lady") and a mug shot which clearly shows her height, consistently referred to as 5'11" or more, to be just under 5'9". And then there was the time Eric Redding had to explain to Smith that Los Angeles was located in California. *Great Big Beautiful Doll* will delight all gossip mongers—and who among us isn't? **LP**

$22.00 *(HB/208/Illus)*

Grindhouse: The Forbidden World of "Adults-Only" Cinema

Eddie Muller and Daniel Faris

From the 1920's through the 1970's, America's most fearless entrepreneurs created thousands of "adults only" features—exploitation films that promised "sinsational" treatments of the day's hottest topics. These films played red-light-district theaters and road shows for almost half a century, until hardcore pornography and the advent of VCRs rang the death knell for this distinctive form of "art." *Grindhouse* lovingly traces the ribald history of these "adults only" films, from Poverty Row through the Scandinavian invasion, past the nudie-cuties, and into the swinging days of free love. Along the way the reader gets the most sordid, sleazy and shameless cinema imaginable: Vice Rackets! Narcotics! Nazis! Nudists! Cults!

Wrestling Women! Several pages devoted to Timothy Carey! (Now that is cool.) The fantastic layout overflows with great, sleazy lobby cards, posters and stills.
$19.95 *(PB/157/Illus)*

Having Love Affairs
Richard Taylor
"Taylor skillfully analyzes the nature and content of love affairs through discussions of fidelity, the ethics of love affairs, how love affairs start, vanity and the male ego, the language of the eyes, the fulfillment of needs, and the development of rules for those involved in or affected by an affair."
$15.95 *(PB/188)*

Himpressions: The Blackwoman's Guide to Pampering the Blackman
Valerie B. Shaw
Girlfriend, if you want to stop waiting to exhale and B-R-E-A-T-H-E already, this book is for you! Advice on handling insecurity, flirting successfully and vanquishing the dreaded FAAWABA (Ferocious African-American Woman With a Bad Attitude). Feminists, beware. **MG**
$16.00 *(PB/144)*

Hit Men: Power Brokers and Fast Money Inside the Music Business
Fredric Dannen
"*Hit Men* is the highly controversial portrait of the pop music industry in all its wild, ruthless glory: the insatiable greed and ambition; the enormous egos; the fierce struggles for profits and power; the vendettas, rivalries, shakedowns and payoffs. Chronicling the evolution of America's largest music labels from the Tin Pan Alley days to the present day, Dannen examines in depth the often venal, sometimes illegal dealings among the assorted hustlers and kingpins who rule over this multibillion-dollar business."
$15.00 *(PB/407/Illus)*

Hollywood Lesbians
Boze Hadleigh
"I'm a dyke. So what? Big deal!" So decrees gin-riddled, moon-faced octogenarian actress Patsy Kelly, star of *Rosemary's Baby* and *The North Avenue Irregulars*. The Big Deal is that the now-deceased Kelly had firsthand knowledge of what Tallulah Bankhead liked to do with her pussy (she preferred frequent "pubic massage"), and anyone with that sort of information deserves at least the 20-page interview

Pat Barringer in "Astra Vision" — from Laid Bare

printed here, famous or not. The other subjects are Marjorie Main, Nancy Kulp, Barbara Stanwyck, Capucine, Dorothy Arzner, Edith Head, Sandy Dennis and Dame Judith Anderson. Actually, said lesbians don't contribute as much firsthand gossip as one would like, but this is more than compensated for by the inclusion of bitchy testimony from first-class fishwives like Elsa Lanchester (apparently not a lesbian), and Paul Lynde (Lynde: "Agnes Moorehead? One of the all-time Hollywood dykes!"). And with the exception of frosty Miss Barbara Stanwyck, they all seem to have something interesting to say. Aside from Patsy Kelly, the best interviews here are with Marjorie Main (famous for her Ma Kettle character, a sort of butch Mother Hubbard) and the fabulously evil Dame Judith. Worth owning for the title alone. **MG**
$21.95 *(HB/320/Illus)*

Hollywood Lolita: The Nymphette Syndrome in the Movies
Marianne Sinclair
"Exposes the truth behind the coy smiles, curls and bows—a heritage of wide-eyed innocence which left a trail of broken hearts, ruined careers and forgotten glory. The private lives and careers of more than 40 Hollywood Lolitas are explored, revealing how the changing tastes of nymphet-hungry audiences dictated a nymphet's appeal—or downfall." The message here is that pedophilia is the cornerstone of the movie business. Read up on how stars as diverse as Deanna Durbin, Jodie Foster and the Gish sisters built major careers by exploiting the

movie audience's hunger for pre-adolescent female coochie, usually with an encouraging stage mother/pimp lurking on the sidelines. **MG**
$14.95 *(PB/192/Illus)*

Hollywood Madam
Lee Francis
Lee Francis paid the politicians and quietly ran a set of upscale whorehouses in the Golden Age of Hollywood, designed as sex spas for the stars. John Garfield hung out, Errol Flynn worked out and John Barrymore passed out. Clark Gable was a good friend ("but he never set foot in my place"). Aimee Semple McPherson's secretary became one of her hookers. "It's all here, the sexcapades of actors, actresses, writers, directors and politicians, the people who made Hollywood move." **GR**
$3.95 *(PB/224)*

I'm With the Band
Pamela des Barres
Starfucker! Starfucker! Funny, sexy, desperate Cinderella story, as told by the woman who fucked her way to the top and stayed there, bedding the likes of Mick Jagger one night and Jimmy Page the next and the next and the next. No fats, femmes or roadies for this hanger-on. She fucked only the best, earning her the dubious title "Queen of the Groupies." It doesn't get any raunchier than this, except on those nights when you're plaster-casting a guitar god's tumescent cock. Rock on! **GR**
$4.99 *(PB/279/Illus)*

If I'm So Famous, How Come Nobody's Ever Heard of Me?
Jewel Shepard
"Jewel Shepard is the star of such cinema classics as *The Return of the Living Dead, Caged Heat 2,* and *Hollywood Hot Tubs* (Parts 1 and 2). If I'm so Famous, How Come Nobody's Ever Heard of Me? is the fascinating, gutsy and bittersweet tale of how she made her way from the runways of seedy strip joints to the cult-classics section of your local video store."
$16.95 *(PB/223/Illus)*

The Inner World of Jimi Hendrix
Monika Dannemann
"Written by Hendrix's fiancée, this personal and intimate portrait of the legendary rock guitarist features compelling, untold facts about his last 24 hours, as witnessed by the author. With almost religious devotion,

Dannemann articulates Jimi's philosophies and inner feelings. Includes 45 full-color paintings and 20 color photos, many never before published."

$14.95 *(PB/192/Illus)*

Jackie Gleason: An Intimate Portrait
W.J. Weatherby

The Brooklyn Hamlet. Big, loud, brash, boozy, sentimental, sensitive and funny. Gleason started out doing nightclubs in 1939, using Milton Berle's monologue material, which he had stolen line for line. The two kings of early TV eventually became pals. "I always thought Jackie was a load of talent," says Berle, "As a monologist or stand-up, he wasn't at his best, but he was terrific in playing characters or doing sketches and skits. . . . He wasn't a very good comic, but he was a very good comedian. Ed Wynn once said that a comic is a guy that says funny things and a comedian is a guy who says things funny. A comedian isn't afraid of silence. . . . When Gleason did *The Honeymooners*, he wasn't afraid to take his time, he wasn't afraid of the audience running away, but treated a situation the way it deserved until the laughs came." **GR**

$4.99 *(PB/222/Illus)*

Japan's Sex Trade
Peter Constantine

The author spent years researching the Japanese sex business (in particular those aspects ordinarily closed to foreigners) and finally gathered enough material to write this marvelous guide and fascinating study of the sexual life of the country. You think you have unusual tastes? "*NAISHIN-KYO SUPESHARU*—Endoscope Special—Customers interested in taking a closer look at their seikan girl's vagina are handed an authentic gynecologist's endoscope, with which they can study the organ to their heart's content." Soap girls, love motels, vending machines full of schoolgirl's used panties and the ever-popular *ganmen kijo zeme* (facial horseback attack). What a country! **JW**

$8.95 *(PB/208/Illus)*

Jimi Hendrix: Starchild
Curtis Knight

This book is nothing less than blasphemy. With Curtis Knight constantly reminding us he was in a band with Jimi Hendrix, he plods on to tell us that Jimi was a believer in UFOs and his life was constantly touched by the paranormal. Find out how Jimi's life was saved by an "angelic-like being who

arrived in a spaceship." Knight also claims that Hendrix knew about a "race of beings living inside the inner earth," yawn. The chapter titled "Attempted Ripoff of Jimi Hendrix" (yeah, Curtis) is complete with bimbos and nobody musicians kneeling by Jimi's star on Hollywood Boulevard and a terrible double-exposure photo of his gravesite with supposedly strange spirit forms lurking nearby (snore). The only possible fact in this book is that they were in a band together at one point. Hilarious fiction. **DW**

$10.95 *(PB/112/Illus)*

Kicks Is Kicks
Delle Brehan

"I raised the belt high above my head. Just before I brought it down with all my might, I removed the towel from his buttocks. He jumped as the belt landed. 'God Almighty!' he shouted. 'What are you doing?' For an answer, I gave him another lick of the belt. And another one. He took four of them before he rolled off the mattress and landed on his knees on the floor. He clasped his hands and raised them to me as if he were praying. 'I'm sorry, ' he said, 'please don't hit me again.'" True story of a professional black dominatrix, from 1976. **GR**

$3.95 *(PB/254)*

Kinski Uncut
Klaus Kinski

"Now I hate the killer's guts. I shriek into his face that I want to see him croak like the llama he executed. He should be thrown alive to the crocodiles! An anaconda should strangle him slowly! A poisonous spider should sting him and paralyze his

Jayne Mansfield — from **Laid Bare**

lungs. The most venomous serpent should bite him and make his brain explode! No panther claws should rip open his throat—that would be too good for him! No! The huge red ants should piss into his lying eyes and gobble up his balls and guts! He should catch the plague! Syphilis! Malaria! Yellow fever! Leprosy! It's no use; the more I wish him the most gruesome deaths, the more he haunts me."

The late Klaus Kinski was an actor possessed of a unique, demonic energy, whether applied to his life, his art, or to comments about Werner Herzog, the film director most closely associated with him. He was fond of saying, "I am like a wild animal born in captivity, in a zoo. But where a beast would have claws, I was born with talent." Emerging from the dire poverty of pre-war Berlin and serving in the German army during the last year of World War II, he rose to international film stardom. Yet he always carried a personal hell with him as he strove to alleviate an unendurable sense of isolation through his acting or by having sex. His Casanova-like pursuit of sex started as a child with his sister and continued with countless others. In order to maintain his lifestyle, Kinski appeared in over 160 films, ranging from the classics *Aguirre, the Wrath of God*, *Nosferatu* and *Doctor Zhivago* to such schlock as *The Creature With the Blue Hand*.

An edition of Kinski's very personal and idiosyncratic memoirs appeared briefly in the United States in 1988. Approximately 55 pages shorter than this edition, it was abruptly withdrawn just prior to its publication. Now available for the first time is unexpurgated Kinski, blisteringly candid and with the charm of a must-see car crash. Includes a thorough cross-section of photographs from Kinski's life and career. **JAT**

$26.95 *(HB/325/Illus)*

Laid Bare: A Memoir of Wrecked Lives and the Hollywood Death Trip
John Gilmore

Literally born and raised in Hollywood, Gilmore has delved into the seamy underbelly of Fame in a plethora of guises: as child actor, stage and screen bit-player, screenwriter, journalist, pulp novelist, low-budget film director and true crime writer. With caustic clarity and 20/20 hindsight, Gilmore unstintingly recounts his relationships with the likes of Janis Joplin, James Dean, Dennis Hopper, Jack Nicholson, Jane Fonda, Jean Seberg and Lenny Bruce both on the way up and at the peaks of their notoriety. He describes his illuminating and often haunting first-hand encounters with

Hank Williams, Ed Wood, Jr., Brigitte Bardot, Sal Mineo, Eartha Kitt, Charles Manson, Vampira, Mickey Cohen, Steve McQueen and many other denizens of the 20th century's dubious Pantheon. With hip, vivid prose Gilmore infuses new life into such legend-enshrouded Hollywood haunts as the lunch counter at Schwab's, the Garden of Allah hotel, and Googie's on the Sunset Strip. Recognized as a powerful chronicler of the American Nightmare through his gripping examinations of near-mythic Southern California murders (the Black Dahlia in *Severed*, Tate-La Bianca in *The Garbage People*), Gilmore now draws upon his personal experiences to turn his sights on our morbid obsession with Celebrity and the ruinous price it exacts from those who would pursue it.
$16.95 *(PB/288/Illus)*

Let the Good Times Roll: Prostitution and the U.S. Military in Asia
Saundra Pollock Sturdevant and Brenda Stoltzfus
This book is an account of prostitution overseas during times of United States military occupation. It is not the words of educated, privileged American intellectuals who like to pat themselves on the back for championing the oppressed, nor is it the angered writings of American women who have suffered mistreatment in the workplace. Instead, these are the words of women enslaved—often at a very early age—into the world's oldest and often most terrible profession. And their matter-of-fact approach to telling these first-person horror stories creates a terrifying portrait of how American men behave when nobody's around to punish them for being cruel. While women don't have it so great in the U.S. of A., at least here, somebody is looking. This is what happens when nobody is looking, and is a jarring portrait of man's inhumanity to women. Illustrated with lots of pictures, as if the text isn't enough. Powerful beyond anything that can be said in a short synopsis. **SH**
$19.95 *(PB/352/Illus)*

Letters From a Little Girl Addict
Rae Shawn Stewart
Written as a series of letters to the junkie father she put in jail, this is the author's own story of a childhood marred by drugs and abuse. **SC**
$2.95 *(PB/219)*

Live Fast, Die Young:

Irish McCalla, "Sheena, Queen of the Jungle" — from **Laid Bare**

Remembering the Short Life of James Dean
John Gilmore
John Gilmore, the dysfunctional spawn turned actor of an LAPD cop dad, long ago abandoned the fictions of the silver screen to delve into the darker dementia of true-crime writing, authoring books on Charles Schmid (*Cold Blooded*), Charles Manson and the Family (*The Garbage People*) and the Black Dahlia Murder (*Severed*) that have become widely regarded as classics of the genre. Marked by a rare kind of up-close intensity and subjective intimacy that persistently rejected the obvious and easy histrionic vitriol and posturing that is the common province of mass media moralisms in favor of more empathetic, humanistic insights into the savage side of desire, need and compulsion, Gilmore has now focused his tremendous skills as an investigative reporter and acuity as a chronicler of events onto the far more personal topography of his own experiences. The results come in a most startling new volume of recollections on his old friend, the gloriously and gorily deceased teen icon James Dean.

Long tapped as an inside source on Dean's private life and obsessions by myriad biographers over the years, Gilmore finally reveals the most sordid secrets left for nearly a half-century to the idle speculations of insider gossip.

Enriched not only by a keen understanding of the art and personality that made young Jimmie so memorable but a wealth of anecdotal contributions from the various lovers, friends, colleagues and cohorts left in his tragic wake, *Live Fast, Die Young* paints a full and lurid picture of the actor and the animal thrashing about within that superbly beautiful physique. By understanding Dean's immense need for greatness and recognition, Gilmore provides a deeper comprehension of the failures and frustrations that engendered his death fixation and ultimately brought about his untimely end.

But the book's real payoff is the true dirt it delivers on the unimaginably perverse nature of Gilmore and Dean's association. We find out how they shared the same woman and compared notes, and most amazingly about the ongoing series of eroticized escapades the two of them enjoyed. If you like to hear about how two essentially heterosexual men can have truly unfulfilling bad sex attempts—hey that hurts!—this is definitely the book for you. Hopefully, some Hollywood degenerate will get the movie rights to this most prurient text, if for no other reason than for audiences to see some pretty boys enact the classic scene contained therein where Jimmie has John put on a pair of funky panties he's recently taken off some anonymous female sweetheart. **CM**

$22.00 *(HB/256/Illus)*

Mae West: Empress of Sex
Maurice Leonard

Movies, money, mink, and men, men, men!!! Plus seances with Criswell, catfights with Jayne Mansfield and Raquel Welch, and more than a few regrets (she turned down *Sunset Boulevard*!). Here's Mae revealed as a true iconoclast, world class fag-hag, and inventor of the sound bite. **MG**

$22.50 *(HB/424/Illus)*

Making It Work: The Prostitutes Rights Movement in Perspective
Valerie Jenness

The time: Mother's Day, 1973. The place: San Francisco, California. The event: the founding, by former working-girl Margo St. James, of what has become the United States' premier prostitutes' rights organization, COYOTE (Call Off Your Old Tired Ethics). While decriminalization of prostitution is COYOTE's main goal, of equal importance has been their claim that "to deny a woman the option to work as a prostitute, under the condi-

tions of her own choosing, is a violation of her civil rights." In *Making It Work*, sociologist Valerie Jenness studied COYOTE in order to analyze "the reconstruction of a social problem and the normalization of deviance." As such, she traces the history of prostitutes' rights in the U.S. and its relationship to the gay-and-lesbian and women's rights movements, as well as the effect of the AIDS epidemic upon it. Of particular interest is her chapter positioning COYOTE's rhetoric within and against the larger discourses of contemporary feminism. While *Making It Work* is largely academic in nature, lay (ahem!) readers will find Jenness' account of COYOTE and its flamboyant leader, St. James (who in 1996 missed being elected to a seat on the San Francisco Board of Supervisors by only the slimmest of margins), highly informative and entertaining reading. **LP**

$18.95 *(PB/150)*

Michael Jackson Was My Lover
Victor Gutierrez

Forget Lydia Lunch, Nick Zed, Henry Rollins, Michael Gira and all those contemporary writers trying to achieve an ultimate expression of sordid nihilism and depravity layer by layer. This is the shit! This book outstrips them all. Superstar diar-

Janis Joplin, 1963 — from **Laid Bare**

rhea dribbling into shoes; tampons up the ass to plug the loose anal sphincter; physically damaging excessive enemas; pedophilic consensual cocksucking; prostitution of their very own minors consummated via the feigned naiveté of compliant parents; gross-out greed and paltry pay-offs; a virile, rampant eruption of egomania that makes Hitler's megalomaniacal ambition a withered stump by comparison—all this pure filth and Macaulay Culkin's warm, wet lips too! Yippee! Nobody can ever compete. Everyone should at the very least have this book in their toilet for guests as a matter of decadent etiquette. Perfect watercloset reading for the closet cases. Forget the relentless character assassination of Goldman's Lennon book. Or any Elvis exposé. Here we have achieved a nirvana of the gratuitous. Thank you Victor. Oh, thank you, Victor!

All my life I hoped that a book that proclaimed it told you "the whole unexpurgated, shocking story" would really do it. Fifty years after my birth, here it is. This is the most perfectly fabulous and amoral book about the excess and undeserved privilege accorded the celebrated, successful and rich in America ever to be inked onto dead trees. Everything it claims to contain is contained within its hallowed bowels, and more, and more. Fantastic. I can't believe that it's not exposed prominently in every cornershop bodega, supermarket and bookstore chain across America and number one on the best-seller lists everywhere! As the back cover says: "The boy reveals how he got to know Jackson (and sex); trips to foreign countries with Jackson (and sex); what he saw when Jackson got naked in front of him (and sex); the sexual games he played with Jackson (and more sex)." There are snapshots, love notes, depositions, even spindly drawings of Michael's malodorous and "smelly" penis by the boy; (oh, "the boy," by the way, is Jordie Chandler, who rather surprisingly is credited with having co-written the screenplay for *Robin Hood: Men in Tights* with his father at age 10. Go figure!).

It has to be noted, however, that, falling temporarily prey to his integrity, his acute sense of social responsibility and his principles of investigative journalism, Victor Gutierrez does dwell a little too much upon the mundane legal ramifications and maneuverings of all the parties involved for my prurient tastes. Although, I guess, upon reflection, I am forced to concede that it probably is, in the end, important to be led through the opportunist treacle that glues every character forever together in Michael "Willy Wonka" Jackson's sexual Chocolate Factory. After all, this is a real-life (real?) fairy tale with multiple professedly happy endings. A terminally degraded Michael Jackson gets his man, or rather his boy, and gets away with

it. Jordie Chandler gets his man, or rather his pedomorphic superhero and millions of dollars in perpetuity. Daddy Chandler gets his boys, notoriety and access to millions of dollars. Mummy Chandler gets vacations with her endearing superstar, nice gifts of expensive watches and jewelry, and the rewarding parental pleasure of seeing her beloved son taken good care of by the man, or rather boy, Jackson. Victor gets his man, mother and boys, and, I sincerely hope because he deserves to, his own share of dollars.

Yes, sirree, it's that good old-fashioned American success story once again. This kind of shameless self-corruption is what made America great; and I for one am deeply grateful. There is something calming, and infinitely reassuring about having one's deepest cynicism about human nature and its innate badness confirmed so rapidly, uproariously and completely. I can sleep better now, safe in the knowledge that the poor scum get banged up, but that the rich and famous scum are, and will always remain, pillars of the community in any truly democratic, and free, society. All hail the American dream. **GPO**

$19.95 (PB/216/Illus)

Mug Shots:
Celebrities Under Arrest
George Seminara
"The crime, the arrest, the taking down of names and numbers, the emptying of pockets, the one allotted phone call, the fingertips smeared in ink, and finally, the booking photo: the mug shot. Culled from and ferreted out of police departments from all over the country, here are the mug shots of dozens of America's celebrities who have been arrested. Suzanne Somers, Tim Allen, Larry King, Jane Fonda, Christian Slater—all have blinked in the flash of the police photographer's camera. With great difficulty, George Seminara has compiled a startling rogues' gallery of dozens of well-known public figures."

$8.95 (PB/100/Illus)

My First 2,000 Men
Liz Renay
"Men have considered her one of the most exciting women alive, a glamorous love goddess. Now she has written a totally revealing and enthralling book about her loves and life, including revelations about Frank Sinatra, Jerry Lewis, Sylvester Stallone, and many many more."

$21.95 (HB)

This photograph is some of the evidence that Evan presented to the police to prove that Jackson was in his son's bedroom ready to sleep with the boy. Michael Jackson is sitting on Jordie's bed in pajamas, and with little makeup on him. When the young boy took this picture neither he nor Jackson would ever imagine it would be used as evidence. — from **Michael Jackson Was My Lover**

New York Girls
Richard Kern
"Kern is the punk of bondage photographers. His hardcore photographs of New York girls are created by a practiced Peeping Tom. They show girlie sex, splatter scenes, girls with guns (bang-bang), girls trussed up like chickens, manacled, tattooed and pierced; but above all they show girls looking back at the camera in a way that makes us wonder who is in control. These challenging, beautiful and mysterious photographs grew out of Kern's performance and film work . . . his photographs document the dark side of the American dream where narcissistic fantasies, aggressive phobias and powerful desires come under the transgressive scrutiny of Kern's eye."

$29.99 (PB/260/Illus)

Open All Night
Ken Miller and William T. Vollman
"What makes Ken's work so remarkable is

the sense that these squashed lives are not just isolated bugs on the windshield, but parallel worlds of hermetic secrets. . . . they had an identity and a place; that this was their kingdom with its own rules and stories and lice."—William T. Vollman, from the introduction.

This is a photo book, somewhat in the tradition of Diane Arbus, where the photographer develops a sense of intimacy and trust with a variety of social outcasts and creates intimate portraits of them. The subjects include skinheads, electroshock patients, prostitutes and addicts. There is something decidedly unsavory about getting this close to these subjects, especially the skinheads, whose ugliest aspects seem self-determined. However, their juxtaposition here with everything that they claim to hate makes for an interesting exercise in contextualization. The life here is just plain low and not "deli-

ciously low." Each photo is accompanied by text from a Vollman work that either provides a narrative or a counterpoint. **SA**
$40.00 *(HB/118/Illus)*

Patpong Sisters: Prostitution in Bangkok
Cleo Odzer
"An insider's account, based on three years of research, discusses the near-epidemic proportions of prostitution in Asia, noting that 8 percent of Thailand's prostitutes are HIV positive and pinpointing its sources to political corruption and parental dysfunction."
$24.95 *(PB/320/Illus)*

Pimp
Iceberg Slim
"He was young, ambitious and blessed with a superior IQ. He spent 25 years of his life in Hell. Other pimps died in prison, or in insane asylums, or were shot down in the street. But Iceberg Slim escaped death and the drug habit to live in the square world and write . . . about his people and his life."
$4.95 *(PB/320)*

Porn: Myths for the Twentieth Century
Robert J. Stoller, M.D.
In his pioneering sexual ethnography, the late Robert Stoller was always careful to qualify his perceptions with the acknowledgment of his own limitations as a perceiver. Under the circumstances, this reviewer can do no less. I was a participant in Stoller's investigation of the lives and souls of those who make porn and am quoted in this book at some length under the pseudonym "Ron." I went on to co-author a second book on the subject with Stoller, *Coming Attractions*, which was published just after his tragic death in an automobile accident.

Like most of his later work, *Porn* consists mainly of interviews—interlaced with the author's questions and comments of the performers, directors, writers and associated hangers-on who make their livings cranking out sexually explicit videos. While carefully avoiding political or moral judgments, Stoller nonetheless paints a picture from a definite perspective. By dedicating so many pages to voluble porn industry spokesperson and self-styled moral iconoclast Bill Margold, Stoller makes his case for porn as a refuge of talented misfits and sexual nonconformists. As the author puts it, "The motivating sentiment of porn is less 'Let's fuck' than 'Fuck you.'" Certainly, by

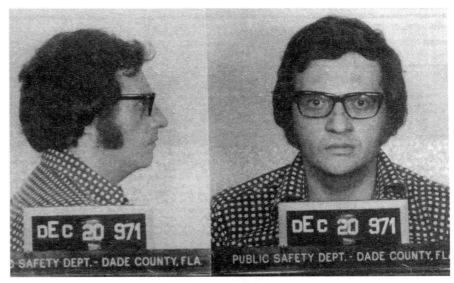
Larry King arrested on grand larceny charge, December 20, 1971 — from **Mug Shots**

encouraging his informants to share their often-troubled personal histories, elicited with a master psychoanalyst's seeming effortlessness, he gives plenty of reasons why porn people might be angry and rebellious. Abandonment, abuse and molestation are recurring themes in the narratives of performers and off-camera industry personalities alike. Even interviewees like Nina Hartley, who profess to enjoy their work and disdain the sympathies of those who regard them as exploited, have their share of resentments to unload at anti-porn feminists and younger performers.

Though Stoller's investigations don't contribute additional ammo to porn-bashers, they give little comfort to those who prefer to imagine sex work as an endless toga party. Much of the evidence Stoller educes seems to corroborate his much-misunderstood and widely castigated theorem that "the erotic imagination is energized by the element of harm." It is the angry edge of porn and the people who make it that gives it its vitality. *Porn* is a tribute to the memory of a scientist who shunned easy polemics in favor of uncomfortable paradoxes. **IL**
$30.00 *(HB/228)*

The Prostitution of Sexuality: The Global Exploitation of Women
Kathleen Barry
Readers nurturing the illusion that

Stalinism vanished from the world in the brick dust of the Berlin Wall owe themselves this package tour of the totalitarian mind, a veritable Baedeker to the P.C.-paranoid brain. To her credit, Barry (author of *Female Sexual Slavery*, of which this book is an update) does not pretend to be objective in her broad, shallow survey of sexual enslavement throughout the modern world. In her introduction, she identifies herself as an early supporter of what she calls "The Dworkin-Mackinnon Ordinance," and lambastes her opponents in the "Feminist" Anti-Censorship Task Force (quotations hers) as "lesbian sadomasochists and heterosexual women hiding behind their own pornographic lives."

A self-described "abolitionist" in regard to all forms of sex-for-hire, Barry no longer believes there to be any meaningful difference between "free" and "forced" prostitution. "Challenging that distinction," she declares, "is central to my work today." Lifting off from this position, the author takes the reader on a quick helicopter trip over the sad and sorry lives of female sex workers around the planet. Mail-order brides from the Philippines, child slaves in Bangkok brothels, police-registered prostitutes in the legal red-light districts of Germany, and American porn stars blur past as dark patches on Barry's map of worldwide villainy, individual circumstances dismissed as mere distractions from the broad

reality that unites them: "prostitution—the cornerstone of all female exploitation."

In her view, prostitution exists neither to satisfy the sexual needs of men nor the financial needs of women, but rather to facilitate class enslavement by gender through the use of economic coercion and physical force. She dismisses the contrary opinions of women who consider themselves to be voluntary participants in the sex industry as "expressions of hopelessness." That out of the way, Barry quickly moves on to join battle with her new classes of enemies: pro-prostitution "sex workers" and "sexual liberals who promote pornography as free speech and prostitution as consensual sex." These individuals, she asserts without a blink, belong on the same list with "pimps . . . pornography purveyors, wife-beaters, child molesters, incest perpetrators, johns (tricks) and rapists." Though the inductive leap from sexual liberals to rapists would seem breathtaking to many, it clearly doesn't faze an author who finds much to admire in postwar Vietnam's brutal anti-sex work campaign, which subjects recidivist female prostitutes to forcible "re-education." And you thought I was joking about the Stalinism thing.

It's easy enough to dismiss this book as additional mad rantings from a radical fringe of the feminist movement, more embarrassing to its friends than effective against its foes. Unfortunately, in her haste to indict intellectual heretics, Barry further obscures the very real evil she so vividly identified in her previous book. By falsely conflating the real experiences of San Fernando Valley porn stars and children abducted from Indian villages, she insults the dignity of the former while trivializing the desperation of the latter. Like the collectivist regimes for which she feels such nostalgia, Barry endangers her own cause by looking for enemies where none exist while overlooking the real ones nearby. **IL**
$18.95 *(PB/381)*

Queen of Burlesque: The Autobiography of Yvette Paris
Yvette Paris
"At night she was a loving wife and mother. During the day she'd pack her sequined G-strings and leave for New York City—to take her place in the world of Times Square as the Queen of Burlesque! This unusual woman successfully reconciled family life

with her career as the most sought-after striptease performer in New York. . . . A journey through the world of strip joints, peeps shows, gogo bars and for-men-only magazines. This story explodes many of the myths about exotic dancing and shows that it really is possible to be an old-fashioned woman in an X-rated world."
$19.95 *(HB/188/Illus)*

Raw Talent: The Adult Film Industry as Seen by Its Most Popular Male Star
Jerry Butler
"Meet the women of sex flicks, the producers, the directors—and Jerry Butler, by far the wittiest and most charismatic of all adult-film actors. From his middle-class childhood in Brooklyn, to his early career as a hockey star, to the beginning of his acting career in Greenwich Village, to the making of his first X-rated film and his years of starring in sex videos, Jerry bares his soul more completely than he's ever bared his body!"
$16.95 *(PB/323/Illus)*

Reagangate: White House Connections to the Vicki Morgan Killing
Larry Flynt
"Remember Vicki Morgan, the naughty young lady who participated in magnate Alfred Bloomingdale's SM orgies? Remember Bloomingdale's pal, Ronald Reagan? Remember how Vicki was murdered right after she told the press she had videotapes of top Reagan officials frolicking

Mary with beads — from **Open All Night**

in sexual abandon? Remember how Larry Flynt suddenly got the tapes? Well, here's Larry's story! A mind-boggling look at fascist kink and squalor."
$.50 *(Pamp/2)*

Red Light: Inside the Sex Industry
Sylvia Plachy and James Ridgeway
An exploration, via photos and text, into "the lives of the women and men engaged in the broad variety of work that falls under the umbrella of the sex industry." Compiled over a period of three years (its research culled mainly from New York City) and motivated by a genuine attempt to understand the many facets of the world of sex workers, the volume reads like transgressive anthropology: a study of the stylized practices and rituals that take place outside the circumscribed orbit of "the norm." Topics range from "A Porn Actor's Story" to "Blood Sports" (the exchange of blood as the main event for those who believe themselves to be vampires) to "Hidden Costs" to "Occupational Hazards" (the psychological/emotional tolls of the profession as well as its obvious physical risks). With stark, evocative photos from award-winning *Village Voice* photographer Sylvia Plachy and a compelling, informative text from the paper's Washington correspondent, James Ridgeway, *Red Light* is a thorough, nonjudgmental glimpse into a world as textured and elaborate as it is misunderstood. **MDG**
$39.95 *(HB/256/Illus)*

Rock'n'Roll Babylon
Gary Herman
"*Rock 'n' Roll Babylon* casts a jaundiced eye on the antics of such overblown stars as Axle Rose, Michael Jackson and Sting and those who became victims of their own lifestyles—Jimi Hendrix, Jim Morrison, Sid Vicious, Freddie Mercury and Kurt Cobain." Plus great writing and plenty of dirty pictures! **MG**
$14.95 *(PB/224/Illus)*

Scout's Honor: Sexual Abuse in America's Most Trusted Institution
Patrick Boyle
This is a very even-handed study of documented cases of child molestation which have occurred in the context of scouting. The author, while sitting in on a child-molestation trial, was given free access to over 200 files of similar cases which the

lawyer of the current case was using. He noticed certain patterns and similarities in the cases. An article grew into a series of articles and finally into this book. It is not a cheap-shot exposé of the Boy Scouts. It is a well-conceived study of circumstances that can lead to molestation and provides a look at scouting practices that create the greatest risk of enabling it to occur. One might consider such information "an ounce of prevention." Quite aside from the scouting angle, it is one of the best documents available on the subject of how child molesters operate and how their operations might be prevented. **SA**
$12.95 *(PB/397/Illus)*

The Senator's Whore
Leo Guild
This purports to be an "as told to" true story about a girl with expensive tastes and only one way to satisfy them. And satisfy them she does—right up to the Capitol dome. Eventually her greed for men drives her to set up a whorehouse that caters to the most powerful movers and shakers in Washington. **SC**
$3.95 *(PB/224)*

Sex, Sin and Mayhem: Notorious Trials of the '90s
Edward W. Knappman
"Uncover the stories behind recent headlines for 26 highly sensational, highly publicized celebrity trials and court battles, including those of O.J. Simpson, Heidi Fleiss, the Menendez brothers, John and Lorena Bobbitt, the Woody Allen/Mia Farrow custody case, Mike Tyson, Michael Jackson's settlement, the Harding/Kerrigan conflict, and William Kennedy Smith. Profiles set the scene, identify the principals, report the verdict and analyze the decision."
$12.95 *(PB/210/Illus)*

Sex Work: Writings by Women in the Sex Industry
Edited by Frédérique Delacoste and Priscilla Alexander
"Voices of pain, voices of power, voices of hard work." Candid, funny and raw narratives from the women who inhabit America's tinseled and tawdry sex world. "Street prostitutes, exotic dancers, nude models, escorts, porn actresses and workers in massage parlors speak out on sex work—their work." **GR**
$16.95 *(PB/352)*

Iceberg Slim, author of **Pimp**

The Show Must Go On: The Life of Freddie Mercury
Rick Sky
Another one bites the dust. "It was a secret he had kept from the world for the previous five years. . . . the singer's gaunt, gray face, bearing no resemblance now to the proud one that had stared down from millions of posters, lay perfectly still on the pillow. His breathing had slowed and his brown eyes saw only the mist flooding the huge bedroom, which occupied much of the third floor of his exquisite home. Next to him sat just one of his most faithful friends, '60s pop heartthrob Dave Clark, who was gently holding his hand. . . . He lay there, little more than a corpse, oblivious to the beautiful antiques, Japanese paintings and French Impressionist masters he had spent hundreds of thousands of dollars on over the years, building a collection that was the envy of art lovers . . . His death was finally announced at midnight." The queen of Queen, born to Persian parents as Farokh Bulsara and raised in Zanzibar and Bombay, goes out in a bohemian rhapsody. **GR**
$10.95 *(PB/202/Illus)*

Soiled Doves: Prostitution in the Early West
Anne Seagraves
Colorful, if not socially acceptable, ladies of easy virtue were a definite part of the early West. Wearing ruffled petticoats with fancy bows, they were glamorous and plain, good

and bad, and many were as wild as the land they came to tame. Women like "Molly b'Dam," Mattie Silks and "Chicago Joe" blended into the fabric of the American Frontier with an easy familiarity. Others, such as "Sorrel Mike," escaped through suicide, Lotte Johl chose marriage, and the Chinese slave girls lived a life without hope. Illustrated with rare photos, this strong book provides a touching insight into the lives of the ladies of the night. **MM**
$11.95 *(PB/175)*

Some Like It Dark
Kipp Washington as told to Leo Guild
"Frankly, I'm queer. I've had men and animals and five Japanese girls at a time and I even screwed a corpse. But it's the injured ones that really turn me on." More than your standard dinge-queen drama, this book is all that and a bag of chili fries! **MG**
$3.50 *(PB/224)*

Some of My Best Friends Are Naked: Interviews With Seven Erotic Dancers
Tim Keefe
Seven different exotic dancers from the same club produce seven very different views on life, sexuality, and what it's like to dance naked for a living. In wide-ranging and probing interviews, Keefe covers such topics as incest, family life, sexual history, and the behind-the-scenes world of the strip club. Expressing attitudes from hatred and contempt for the customers to an appreciation for the sexual pleasure that exhibitionism can bring to a feeling of artistic pride in their work, the dancers talk in a frank and personal way about their lives and their jobs. The interviewees who are artists, activists, and musicians as well as dancers, provide an enlightening view inside the often murky world of the sexual entertainment industry. **NN**
$12.95 *(PB/380)*

Sportsdykes: Stories From On and Off the Field
Edited by Susan Fox Rogers
"*Sportsdykes* explores, defines and celebrates the lesbian sports experience. Ranging from journalism to works of fiction, the life of the 'girl jock' is vividly revealed in the 31 pieces collected here. They cover the politics of sports, the personal empower-

ment women have achieved through sports, the sheer joy of the game and the zest of competition, and the steamy eroticism that lesbian sports can generate."
$8.95 *(PB/239)*

Stars Without Garters!
C. Tyler Carpenter and Edward H. Yeatts
Eddie and Tyler put on a show. "In World War II, members of the U.S. Special Service companies were combat soldiers by day and in the evenings presented stage shows and movies to entertain and boost the morale of the troops. Eddie Fuller and Tyler Carpenter were successful Broadway actors drafted to serve their country.

"Eddie and Ty were like thousands of other patriotic, dedicated GIs in war-torn Europe, except when they came across the English Channel, they also came across with two sailors in the stern of the ship. The horrors of war, the rigors of military life, the strains and romps of being gay soldiers, the show-biz highlife and GI lowlife make this an historic account you will never forget."
GR
$12.00 *(PB/159/Illus)*

Swingers Three
Cherri Grant
"Lesbianism, drugs and a Mafia Don were all a part of their sultry night life . . . and then they met one of the biggest black entertainers in show business. . . and learned that

Al Goldstein, publisher of Screw, *in his office, Manhattan — from* Red Light

'soul brothers' is more than just a phrase!"
$3.95 *(PB/224)*

Tales of Times Square
J. A. Friedman
Stories written originally for *Screw, Oui, Soho News* and other N.Y. rags in the '70s, when 42nd Street spelled sleaze. "A nasty and endlessly fascinating account . . . pungent and often hilarious . . . Friedman's cast includes a crowded lineup of strippers, porn brokers, pimps, hookers, cops, and Runyonesque old-timers performing in the longest-running show that Broadway ever saw. Oh, what a spectacle!"
$12.95 *(PB/201)*

Tokyo Lucky Hole
Nobuyoshi Araki
"Araki is one of Japan' best-known artists, and his photographs feature in exhibitions in all the leading museums of the world. For more than 30 years he has been working on a project that is close to his heart: a portrait of Tokyo that lies beyond all moral values and taboos. . . . The photos for *Tokyo Lucky Hole* were taken between 1983-1985 in Shinjuku, Tokyo's famous red-light district, which was closed by judicial decree in1985. In over 850 photos, Araki documents life in this 'forbidden city': from the customer whose every desire is satisfied, to prostitutes after a hard working day, from slaves in their cages to the show girl in the peepshow. The present volume is the first uncensored edition of this book." To quote the great Araki, "without obscenity, our cities are dreary places."
$29.99 *(PB/700/Illus)*

Travels in the Skin Trade: Tourism and the Sex Industry
Jeremy Seabrook
Explores the cultural, economic and social pressures which lead young men and women to offer their bodies on the open tourist market, and how the sex workers really feel about what they do. Asks the question: What sort of regulation/control of the industry do they want and need? A collection of interviews with sex workers and performers as well as those who travel halfway round the world for the sake of experiences not available at home. **AK**
$14.95 *(PB/176)*

Treat Them Like Animals
Rae Shawn Stewart
A powerful account of black women in prison: debauchery, camaraderie and dehumanization coexist in this tender tale of a friendship between two tough inmates. **SC**
$3.50 *(PB/224)*

Trick Shot
Randolph Harris
"Black Willie had stepped in front of Wanda and was now defiantly facing me. I looked at this man who had obviously accepted the possession of my woman—my Wanda. I say accepted because I had learned early in life that a woman could not be taken unless she, herself, was willing, and the movements that Wanda had made, sliding behind Willie and perching herself atop the stool, told me that my learning was correct. My humiliation had lasted long enough and I decided it should end. . . . Before I departed through the door, I was forced to take a despondent and parting look at Wanda— Black Willie's Wanda." A player's true tale, circa 1974.
GR
$2.95 *(PB/235)*

The Ultimate Hollywood Tour Book: The Incomparable Guide to Movie Star's Homes, Movie and TV Locations, Scandals, Murders, Suicides, and All the Famous Tourist Sites
William A. Gordon
"The first and only book to reveal where today's Hollywood lives, works and plays. Covering all of movieland Los Angeles, this guide helps tourists find historic celebrity homes, entertainment industry hot spots, the locations where dozens of classic and popular motion pictures and television shows were filmed, and many hidden attractions, including Hollywood's most notorious scandals, murders and suicides. Features 33 maps and 49 photographs, including rare aerials of celebrity homes."
$15.95 *(PB/272/Illus)*

Understanding the Male Hustler
Samuel M. Steward, Ph.D.
"'There's all kinds of hustlers,' he said. 'Every salesman's a hustler. A workaholic's a hustler about his job . . . Hustling's a universal occupation.'" A free-form "attempt to get

into the mind and personality of the male hustler through a largely imagined series of dialogs between a well-known fictional hustler" and his biographer. Motivations, lifestyle, advantages and disadvantages are chronicled in a racy conversation, gleaned from interviews with hundreds of real dick 'n' dollar boys. **GR**
$8.95 *(PB/147)*

The Unsinkable Bambi Lake: A Fairy Tale Containing the Dish on Cockettes, Punks and Angels
Bambi Lake and Alvin Orloff
In this tell-all autobiography, Bambi Lake, glamour queen chanteuse, stripper and film star, exposes deeply hidden secrets of she-male America. Her evolution from innocent, suburban Johnny Purcell into fabulous, sophisticated Bambi Lake covers San Francisco's psychedelic '60s, gay revolution in the '70s, and the punk rock scene in the '80s. Absolutely nothing is off-topic in this sexy, revealing drama. **AK**
$11.95 *(PB/157/Illus)*

Unsubmissive Women: Chinese Prostitutes in Nineteenth-Century San Francisco
Benson Tong
"*Unsubmissive Women* goes beyond the moral questions surrounding prostitutes in the Gold Rush West as working women and objects of anti-Chinese sentiment. In so doing, Tong exposes the complexity and texture of these women's lives. He also portrays them as living beings rather than commodities. They demand our compassion and more—we must admire the human agency they exercised."
$24.95 *(HB/320/Illus)*

Up and Down With the Rolling Stones
Tony Sanchez
"This insider's account of the lives of Brian Jones, Keith Richards and Mick Jagger in the '60s and '70s has become legendary in the years since its first publication in 1979. Sanchez worked for Keith Richards for eight years—buying drugs, running errands and orchestrating cheap thrills—and he records unforgettable accounts of the Stones' perilous misadventures: racing cars along the Cote d'Azur; murder at Altamont; nostalgic

Photographer Araki with performer — from Tokyo Lucky Hole

Photograph — from Tokyo Lucky Hole

nights with the Beatles at the Stones-owned nightclub Vesuvio; frantic flights to Switzerland for blood changes; and the steady stream of women, including Anita Pallenberg, Marianne Faithfull and Bianca Jagger. Here are the Stones as never seen before, cavorting around the world, smashing Bentleys, working black magic, getting raided, having children, snorting coke and mainlining heroin. Sanchez tells the whole truth, sparing not even himself in the process. With hard-hitting prose and candid photographs, he creates an invaluable primary source for anyone interested in the world's most famous rock'n'roll band."
$14.95 *(PB/320/Illus)*

Vice Art: An Anthology of London's Prostitute Cards
Patrick Jewell
"NEW Bitch IN TOWN. Report Now. HOUSE OF HUMILIATION. 7-4-9-7," says a crude, illustrated card left by a call girl at a London phone kiosk, where johns go to ring up the cash-and-fantasy girl of their dreams. All sorts of sexual specialties are given the graphic treatment. Like crossdressing? "TROLLOPS AND HARLOTS, GLAMOUR AND GLITZ, TVs WELCOME, OPPOSITE THE RITZ. 4-9-2-0." Watersports? "Madame Niagral 2-1-4-5." Women in uniforms? "BOBBIE. An Arresting Experience!" More than 100 clever and sexy cards. **GR**
$9.95 *(PB/64/Illus)*

A Vindication of the Rights of Whores
Edited by Gail Pheterson
The centerpiece of this book is the World

Whore Conferences. Although theirs is often called "the world's oldest profession," it is not often that these "professionals" are taken this seriously or afforded such an opportunity to articulate their views. The book begins with a history of prostitute rights organizations which overlaps with many feminist issues, then describes the setting and logistics of the conference. The majority of the book is a series of fascinating first-person narratives which touch on everything from health concerns to socially generated stigmas. Ultimately it is the politics surrounding sex that gets diverse and bizarre, as sex itself is pretty universal. This context of the book affords a close examination of those politics and the basic assumptions about them. **SA**
$16.95 *(PB/297)*

Whore Carnival
Shannon Bell
A collection of interviews, pleasure texts and "cunceptual" essays on the feminist genealogy of prostitution—from the ancient Greek courtesan to the sex-industry workers of postmodern Babylon. **AK**
$8.00 *(PB/286)*

Wonder Bread and Ecstasy: The Life and Death of Joey Stefano
Charles Isherwood
The tragic rise and fall of major gay porn star Joey Stefano. Equipped with a gorgeous face and body, Stefano starred in more than 35 hardcore videos, danced in clubs across America and Europe, hustled his way through thousands of dollars paid to him by clients around the globe and died from a

drug overdose at the age of 26. With insight and empathy, Isherwood traces Stefano's immersion into the chaotic and dark world of the porn industry—the fast money, the professional rivalries, the plentiful drugs, the nonstop sex. The picture of Stefano that emerges is one of a sexually adventurous beauty who lived in the moment and was determined to live out his fantasies at all costs. With photos, revealing snippets of Stefano interviews and a videography listing some of his more notable and widely available videos. Particularly distressing is the event recounted in the prologue: friend and director Chi Chi LaRue unsuccessfully attempting to make sense of Stefano's death to a pack of bloodthirsty boneheads on *The Marilyn Kagan Show*. An all-too-familiar retelling of the potentially lethal effects of fame, *Wonder Bread and Ecstasy* is a well-written and disturbingly compelling read. **MDG**

$11.95 *(PB/209/Illus)*

You Send Me: The Life and Times of Sam Cooke
Daniel Wolff
A compelling portrait of the charismatic singer who helped create and define the musical genre today known as soul—from his early years in Chicago and his apprenticeship with gospel music to his bursting onto the pop scene as one of its first cross-over artists with the number-one hit "You Send Me" (the first in a string of rock 'n' roll classics including "Chain Gang," "Wonderful World," "Having a Party," and "Twistin' the Night Away") to the mysterious circumstances surrounding his death in 1964 in a seedy motel in south Los Angeles at the age of 33. More than a mere biography, *You Send Me* also reads as a social history, addressing the racism that flourished within both the recording industry and society at large, crescendoing in the birth of the Civil Rights Movement. Of particular note is the fact that Cooke wrote "A Change Is Gonna Come" largely in response to Dylan's "Blowin in the Wind" ("Geez, a white boy writing a song like that?"). Perhaps the most extraordinary aspect of Cooke's genius (that is, aside from his voice: sparkling, plaintive, resilient, beguiling) was his ability, as writer and singer, to perfom gospel, soul, ballad, rock 'n' roll (often combining these elements in the context of one song) and never sound in the least inauthentic or out of

Photograph — from Tokyo Lucky Hole

place. With photos, a discography and selected bibliography, *You Send Me* is an excellent recounting of the brilliant life and tragic times of a bona fide musical legend. **MDG**

$15.00 *(PB/428/Illus)*

You'll Never Make Love in This Town Again: The Flip Side to the Pretty Woman Story
X, Y, and Z
"This all-true tell-all follows the lives of three women living in the 'cesspool' called Hollywood. From Jack Nicholson to Heidi Fleiss to Sylvester Stallone, this scintillating book exposes a seedy side of the movie-making industry, equally as insidious as the business truths exposed in *You'll Never Eat Lunch in This Town Again*—and twice as intriguing."

$16.95 *(HB/251)*

A Youth in Babylon: Confessions of a Trash-Film King
David Friedman with Don DeNevi
"They sold sin and sensation with the magic words 'Uncut! Uncensored! Adults only,' and the most happily shameless of them all was David F. Friedman, the emperor of the 'exploitation' films. Friedman perfected the fine art of sleaze and delightfully admits that he has hurled more garbage at the public than anyone else before or since. This book is as much his story as it is the history of an idea that in recent times has enjoyed a remarkable rebirth."

$24.95 *(HB/355/Illus)*

TACTiCS

The Ancient Art of Strangulation
Dr. Haha Lung

How to kill for Kali. Examines the tools of terror Indian *thuggees* used centuries ago, and now freely adapted for military special operations training. "Cloaked in religious mysticism and secrecy, members of the cult of Thuggee wandered India and surrounding lands, seeking out victims and squeezing the life from their bodies—without spilling a drop of blood." In two parts: historical perspective and methodology. Meet the great and Terrible Mother, then learn how to use the Hammer Blow, the Twist Down Technique, the Strangulation Stick, and the traditional thuggee Rumal Scarf. **GR**
$14.00 *(PB/101/Illus)*

Are You Now or Have You Ever Been in the FBI Files?
Ann Mari Buitrago and Leon Andrew Immerman

Tells—in great detail—how to secure and interpret one's FBI files. "Too many Americans, deluded by the immense size and anonymity of modern civilization, have not yet realized that they actually live in a small town whose mayor

for over 50 years was J. Edgar Hoover." Chapters include: "The FBI Filing System," "The FBI and the Freedom of Information and Privacy Acts," and "How To Send for FBI Files." Informative and instructive, with samples of the many types of dossier pages that can be received. Includes sample letters: "Appeal of Deletions or Witholdings" and "Request to Amend Records." **GR**
$12.95 *(PB/226)*

Ayoob Files: The Book
Massad Ayoob

For the connoisseur of real-life, not Hollywood, gunfights. This book reprints 15 cases from the author's series in *American Handgunner* magazine detailing actual gunfights and describing what went down: the weapons used by both criminals and those defending themselves, their mindsets, who survived the gunfights, who didn't and why. Ayoob looks closely at what happened and tries to analyze both sides' tactics. Included are an interpretation of the Rodney King incident and its aftermath that runs counter to the prevailing wisdom, and a very close analysis of a massacre in Miami on April 11, 1986, when a gun battle between two heavily armed professional

criminals and FBI agents left both the bad guys and two agents dead, three agents permanently crippled, and others wounded. **MC**
$14.95 *(PB/223/Illus)*

Black Medicine III: Low Blows
N. Mashiro, Ph.D

Illustrates defensive techniques against fist fighting and shows wrist releases, escapes from chokeholds, headlocks, grab attacks from the rear and defenses when knocked down to the ground. Includes a chapter on defending against knives and clubs. Works best as a guide to training with a partner.
 MC
$12.00 *(PB/128/Illus)*

Blowguns: The Breath of Death
Michael D. Janich

"In the realm of exotic weapons, the blowgun holds a special status as an ancient and mysterious tool of silent death. *Blowguns* is the first book to strip away the mystique of this immensely practical, remarkably effective and easily accessible device.

"The blowgun may be the perfect weapon,

The Cobra III+ electric lockpick — from **The Whole Spy Catalog**

providing the capability for accurate and silent delivery of a variety of projectiles in a very inexpensive package. Author Janich is a longtime fancier, collector and user of blowguns, and here he shares with the reader the many secrets of their capabilities and uses, including how to acquire modern blowguns and projectiles, make your own guns and darts (including "special" projectiles), shoot your blowgun, devise custom targets and customize, maintain and store your weapon."

$14.00 *(PB/88/Illus)*

Car Bomb Recognition Guide: How They're Made, How To Detect Them
Lee Scott
Brief, illustrated guide to types of improvised car bombs: how they're made and how to detect them. Shows how criminals can rig an automobile to become a deadly trap, how to recognize suspicious devices and situations, and how bombs are placed. Not a how-to manual, but a useful field guide. **MC**

$20.00 *(PB/64/Illus)*

Chemical Alert!: A Community Action Handbook
Edited by Marvin S. Legator and Sabrina Strawn
"Opens with a summary of known health hazards and their effects, and goes on to discuss the techniques of organizing a community to conduct a scientific health survey. With these tools, citizens living near

petrochemical plants or waste disposal areas—or many who have simply noticed a high incidence of certain health problems in their community—can determine for themselves whether a problem really exists and if they should seek remediation. Given the reality that government agencies often lack the resources—or the will—to detect certain health hazards before they affect a community, an informed citizenry should be its own environmental watchdog." Newly revised and updated.

$14.95 *(PB/240)*

Close-Quarters Combat for Police and Security Forces
Robert K. Spear
A well-photographed book on basic defenses in close-quarter combat, showing proper use of night sticks, and come-along hand control techniques. It includes defenses against unarmed attacks; attacks with knives, baseball bats and clubs. Also features techniques for disarming pistol-wielding assailants and ground-fighting tactics. **MC**

$19.95 *(PB/122/Illus)*

Codes and Couriers for Secure Communications
Urbano
Book and disk combination, dealing with types of codes. "Designed to allow individuals and companies who must exchange sensitive personal or business information, to develop and maintain a secure method of trading information with each other." Includes *Cypher Pad for Windows,* a double substitution

cypher. "Cryptologically, it works by converting the letters of the original file and of the Key into ASCII codes, and mathematically manipulating these codes . . . to produce the encrypted message." Since the encryption Key consists of up to 15 spaces, a Pentium PC would take several thousand centuries to break the random combination of letters making up the code. The CIA and NSA, however, do not have this difficulty. It is only their effort that is keeping 36-space-plus Keys off the commercial market—and those would be near impossible for others to break. **GR**

$29.95 *(PB/118/Illus)*

The Complete Guide to Lock Picking
Eddie the Wire
Complete, direct and thorough instructional presentation of what a tumbler lock is and how it functions, explaining the problems most lock specialists encounter and how aligning all the discs simultaneously in a tumbler opens a lock. Contains illustrations of using a tension wrench in order to rotate the plug to bypass the lock, and discusses the psychological approach in the field of "BLT" (lock-bypassing techniques). Chronological guide to all common disc and pin tumbler locks, and understanding how they operate. Shows various procedures to determine types of locks—warded lock, lever tumbler lock, pin tumbler, disc tumbler or wafer tumbler locks. Eddie the Wire exposes the specialist to brand name locks and what to expect, and how much lubricant to use on a lock, noting that large amounts of dust indicate a recent oiling. It is observed that sometimes even a lock specialist should check to see if the lock is really locked, or should look for an extra set of keys in nearby flower pots.

$14.95 *(PB/80/Illus)*

The Construction and Operation of Clandestine Drug Laboratories
Jack B. Nimble
Without containing formulas for making any specific drug, this book covers the practical construction of a laboratory, the risks involved, security for the lab, what equipment is needed, and the use of police scanners. Also covered are the procuring of suspicious supplies and how increasingly law enforcement monitors the purchase of

chemical equipment. Because of the drug war there is more control of information on chemistry, but many of these techniques could be used by amateur chemists to do legal, basement research. This material is very basic and is not a substitute for instruction, experimentation and experience in chemistry. So buyer beware. **MC**
$10.00 *(PB/60/Illus)*

Counterfeit Currency: How to Really Make Money
M. Thomas Collins
"Reveals all the tricks of the counterfeiter. Learn how counterfeiters makes bushels of bogus bills and 'pass' them without fear. Exact counterfeiting techniques are shown in step-by-step, illustrated detail. Every aspect of printing money is covered, including inks, paper, negatives, platemaking, printing techniques, even a section on 'aging' money so it looks and feels authentic. Learn about an ingenious platemaking technique most counterfeiters don't even know! Learn about the safeguards built into government currency; and how counterfeiters get around them. See how counterfeiters purchase equipment and supplies, where they set up funny money shops and how they keep a low profile. Our money is just pretty pictures on paper. *Counterfeit Currency: How to Really Make Money* shows just how vulnerable government currency really is!"
$15.00 *(PB/137/Illus)*

Creating Covenant Communities
Robert K. Spear
For those who wish to survive the coming Tribulation without having to resort to taking the Mark of the Beast or even paying taxes to ZOG, a covenant community is the way to go. Author Spear, the self-defense instructor for Bo Gritz's SPIKE Survival Training Team, has written numerous books and pamphlets on self-defense, and is also the author of *Surviving Global Slavery: Living Under the New World Order*, a book that presents "practical common sense solutions to the challenges created by rejecting the Mark of the Beast." *Creating Covenant Communities* is a more detailed tactical companion to *Surviving Global Slavery*. As per instructions from the Holy Spirit, it's written in a more narrative style and includes a number of informative,

Watec 1/2-inch video camera "coupled to the 'narc special' lens. The camera is so small and light it needs no steadying—the lens is screwed onto a regular camera tripod. Next photo I shot with my SLR 120mm semi-telephoto lens of a sign in a parking lot about a quarter of a mile away. I have thoughtfully circled the sign . . . I could read [it] on the monitor like I was two feet from it." — from The Whole Spy Catalog

though fictionalized, scenarios. These use a loose "interview" format, allowing the various characters to discuss such important topics as the pros and cons of certain alternative economic exchange systems, such as the HOURS system and the Mormon's "United Order"; why paying state and federal taxes is "similar to paying a title to Satan"; how to battle "environmental wacko laws"; how and why to be "adopted" by an Indian tribe; the importance of seeking a "Godly and righteous" leader; and speculation on the "divinely inspired document" known as the U.S. Constitution. Includes a handy resource guide and a Mormonesque "Ward Organization" chart.
DB
$10.00 *(PB/136)*

Deadly Brew: Advanced Improvised Explosives
Seymour Lecker
Explains what one needs to know to make advanced improvised explosives using 50 common industrial chemicals. Describes two detonating acids, and five device designs, both single-bottle and double bottle, are included. This work is mainly a list of formulas. Many of these chemicals are very dangerous to use, and all of these devices are deadly. Includes a reading list. **MC**
$10.00 *(PB/54/Illus)*

The Death Dealer's Manual
Bradley J. Steiner
"What real killers do, and how they do it." Concise and thorough instructions free of flashy goonery. Includes conditioning exercises for knife-wielding, garotting basics, detailed instructions for mastering G. Gordon Liddy's "Pencil Kill" technique, how

to fold a newspaper into a weapon of deadly force, the recipe for turning a can of chewing tobacco into a fatal poison, and an introduction to "Dim Mak," or the Chinese Death Touch. By the defensive-combat editor of *Handguns* magazine. **HJ**
$12.00 *(PB/100/Illus)*

Deathtrap!: Improvised Booby-Trap Devices
Jo Jo Gonzales
"In this complete guide to the tricks of the booby-trapper's trade, Gonzales presents an arsenal of devices that can be created from commonly available materials, each modified to contain a nasty surprise. Learn how to rig a booby-trapped alarm clock, flashlight, door latch, sink, telephone, tape deck and more. A concise treatment of principles and applications, clear descriptions of more than 60 devices, and detailed illustrations and schematic diagrams make this an invaluable collection for Special Forces personnel or security professionals."
$15.00 *(PB/164/Illus)*

Defensive Tactics With Flashlights: Official Manual
John G. Peters
A comprehensive, illustrated training manual for using a police flashlight as a defensive weapon. Includes selecting a flashlight to fit one's practical and defensive needs, flashlight holding and carrying techniques, basic blocking, and using the flashlight against punches and kicks, knives and weapons. Shows control and restraint techniques against aggressors, including chokes and vehicular extractions using flashlights. Includes ancillary subjects such as flash-

TACTICS

Michael T. Izumi, author of In Self Defense

light maintenance and the legal ramifications of flashlight use. A practical manual for police and security guards, as well as the interested amateur. **MC**
$10.00 *(PB/179/Illus)*

Detecting Forgery: Forensic Information of Documents
Joe Nickell
A highly readable and amply illustrated historical overview of forged documents (both petty and famous) and the methods of their detection. Although he inadvertently offers a how-to manual for handwriting forgery and document alteration, the author demonstrates that very little can escape detection by forensic detectives and their high-tech methods, which brings to mind the old forger's adage: "The only good forgery is one that is never suspected." **HS**
$26.95 *(HB/228/Illus)*

Dirty Tricks Cops Use: And Why They Use Them
Bart Rommel
Ever wonder how cops prevent scarring when torturing suspects with a stun gun? How about their use of a copying machine and cellophane tape to lay down fake fingerprint evidence? Topics covered include speed traps, evidence-tampering, illegal

search and seizure, coerced confessions, entrapment, execution and "pro-active enforcement." Includes footnotes, bibliography and index. **HJ**
$14.95 *(PB/160)*

Dress 'Em Out
Captain James A. Smith
"The complete how-to guide to field dressing, transporting and processing big game, upland birds and waterfowl. Hunting and survival tips, plus simple, sumptuous recipes and much more." Contents: "Preparing for the Hunt," "Big Game" (with skinning and preliminary tanning tips), "Upland Birds" (dressing them out and caring for bird dogs) and "Waterfowl." Recipes include the "15th-Century King's Platter," a grouse or quail dish with bacon and brandy; and "Mud-Packed Bear Feet," which is exactly what it says it is (the mud holds the bear's feet together while cooking, and the only other ingredient is pepper). **GR**
$14.95 *(PB/255/Illus)*

Drug Smuggling: The Forbidden Book
K. Hawkeye Gross
Everything one needs to know about narcotics smuggling, from assembling a crew and avoiding DEA infiltration to moving large amounts of cash clandestinely and bribing officials. This is a basic guidebook on how to play the game successfully, elude

detection and then get the BIG PAYOFF. **MW**
$16.00 *(PB/152)*

Drug Testing at Work: A Guide for Employers and Employees
Beverly Potter, Ph.D. and Sebastian Orfali, M.A.
Looks at the cost of drug use in the workplace, the rationale for drug testing, the technology of testing, protecting employees' rights, methods to beat the test, and how to stop employees from cheating. "For school administrators, government and military officials, attorneys, unions, medical staff and legislators, as well as for employees in both the public and private sectors."
$17.95 *(PB/230/Illus)*

Everybody Does It!: Crime by the Public
Thomas Gabor
"Toward a theory of universal lawbreaking." Statistics, research and case studies of our public peccadilloes, from the petty to the profound. Theft, embezzlement, false charges, violence. Fellow employees do it: "It was acceptable, so you did it. When you see that other people do it, it seems to be no big deal." Business people do it: "When you see a lot of money coming in, you get greedy." Tourists do it: "Justifying their behavior on the high cost

Night-chuk (sold to civilians as "Hide-a-Chuk") appears to be a straight baton, but . . . — from **Fundamentals of Modern Police Impact Weapons**

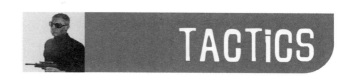

TACTICS

of the room." Cops do it: "Some guys need a beating. In the street or the back of a precinct, there's a guy who needs a beating. And you've got to do it. " Says the author: "In this book I try to show that criminal behavior, rather than being abnormal and uncommon, is a normal and routine part of everyday life, engaged in (at least on occasion) by the majority of citizens." **GR**
$19.95 *(PB/240/Illus)*

Fundamentals of Modern Police Impact Weapons
Massad Ayoob
This book was written to give police officers a realistic understanding of the less-lethal, nonchemical subduing impact weapons available. Ayoob describes nightsticks, short billies, saps, sap gloves, yawara sticks, riot batons, nunchakus, flashlights, handcuffs and makeshift impact weapons such as key rings and belts. Two classic baton approaches are described—"The Lamb Baton Method" and "The LAPD Method." The book also covers how to carry the baton and when to draw it; its use against multiple unarmed opponents and the legal parameters of using lethal and less-lethal force. **MC**
$15.95 *(HB/158/Illus)*

Home Workshop Explosives
Uncle Fester
Most explosives are very unstable substances, which of course is why they explode unexpectedly. Many types of external factors can lead to undesired and unplanned detonation, so attempting to work with any devices is always a very risky situation and should be approached with extreme care. This book purports to show how to make demolition-strength explosives. WARNING: One really should have extensive chemistry experience when trying to use this book to attempt any of these processes. This is an advanced book and I would question its techniques. Many of the acids used in the manufacture of these explosive compounds are highly dangerous and caustic and should be handled with extreme care. The reader who has never worked with separatory funnels, condensers, dangerous acids, formaldehyde compounds and temperature control and has little experience in laboratory safety procedures should stay away from this book. Sorry, use some common sense or you won't have any senses left. One wonders how many times the author has really made these compounds and under what conditions. However, for the reader who wants to blow himself up, this is the book for you! **MC**
$12.95 *(PB/126/Illus)*

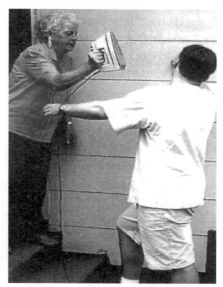

This woman uses a common iron to strike an intruder. — from How To Live Safely in a Dangerous World

Home Workshop Prototype Firearms: How To Design, Build and Sell Your Own Small Arms
Bill Holmes
This book for craftsmen interested in the design and fabrication of firearms details the tools and equipment, types of material and lathes needed. The author shows how to start from scratch and design actions, barrels, muzzles, breaks, trigger assemblies, magazines, stocks and sights. He gives valuable information on tools and equipment along with design theory and goes on to describe how to fit, assemble, fire and adjust weapons. This book has detailed photographs, drawings, plans and tables and includes illustrations of interesting and beautiful-looking weapons designed by the author. This is as close to real gunsmithing as is possible to find between the covers of a book. **MC**
$25.00 *(PB/187/Illus)*

How Big Brother Investigates You
Anonymous
Copy of a Treasury investigator's handbook (*Sources of Information*) showing all the places to hunt for incriminating dirt on a perpetrator. Chapters include "Information From Persons," "Records of Business and

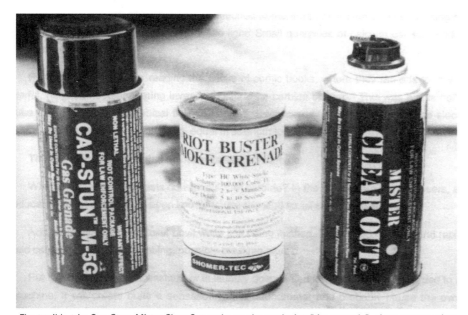

The terrible trio: Cap-Stun, Mister Clear Out and a smoke-producing "riot grenade"—three ways to clear your house of vermin, reposition a Hell's Angels party, or separate the contestants of a small war. All three are legally available by mail order. — from **High-Tech Harassment**

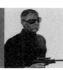

Ground controllers "flying" the POINTER ... capable of transmitting detailed pictures of exactly what your enemy (or your neighbor) is doing at any particular time. — from The Whole Spy Catalog

Financial Institutions" and "Sources of Information in the Federal Government." Hundreds of sources listed. **GR**
$10.00 *(PB/47/Illus)*

How To Be Your Own Detective: A Step-by-Step, No-Nonsense Guide to Conducting Your Own Investigations
Kevin Sherlock
"Bust Bad Cops! Fight Crimes of Dishonesty! Pry Into Personal Affairs! Fight Sex Offenders! Spread the Dirt!" For the muckraker in us all: How to get dirty information on anybody. "You can use the public record to get the lowdown on a lover. Or find out which

doctors, lawyers, contractors, salespeople, or other businesspeople to trust and which to avoid. If someone has done you wrong, you can use the public record to find out and expose his or her record of wrongdoing." The "public record" contains criminal and legal information; coroner, medical and professional malpractice records; individual and corporate tax records; real estate, zoning, planning and land-use records, etc. Private investigators do it—why not you? Includes PC diskette. **GR**
$29.95 *(PB/244)*

How To Beat the IRS At Its Own Game: Strategies To Avoid—

And Survive—An Audit
Amir D. Aczel
An associate professor of statistics looks at the taxman's auditing system and finds it wanting. "After analyzing thousands of tax returns from around the country, [the author] has finally broken the secret statistical code the IRS uses." From this research, he "can predict with a high degree of accuracy which of more than 100 million returns filed annually will be audited and which will be spared." Find out how to prepare taxes in a way that will lessen the chances of an audit. And, if audited, how to deal with the intimidation process the IRS teaches its field agents. Aczel should know, his nightmare audit took *two years!* **GR**
$9.95 *(PB/191/Illus)*

How To Buy Land Cheap
Edward Preston
This small book is a bargain-basement buying guide bible for cheap land and houses which details how to search for cheap property in the United States and Canada. Includes up-to-date addresses of where to write and search, and samples of the types of letters that are effective when dealing with various bureaucracies. Excellent for beginners. It would be interesting to see more people form small cooperatives and start applying some of these strategies to acquiring property. Well written and simple to understand. **MC**
$14.95 *(PB/146)*

How To Circumvent a Security Alarm in 10 Seconds or Less: An Insider's Guide to How It's Done and How to Prevent It
B. Andy
Explains in nontechnical detail how anyone can bypass a security alarm system, sometimes in seconds. The author shows the weaknesses inherent in alarm devices such as: contact switches, motion detectors, pressure pads, glass-break sensors and other types of detection devices, and describes circumvention techniques that will render most security systems inoperative. Providing an authentic look inside the security business—how alarms are installed, how they're paid for, how they are monitored and responded to—the book highlights the fact that many security services are irresponsible and are ripping off consumers by not provid-

ing the protection they are paying for. Here is plenty of advice and insider tricks on how to make systems more secure from violations, and the vital issues to raise and questions to ask when dealing with alarm installers, monitoring stations and local law enforcement. **MC**
$12.00 *(PB/83/Illus)*

How To Get Anything on Anybody
Lee Lapin
How to conduct private surveillance, if only it were legal. Extensive details on state-of-the-art bugging transmitters, surveillance recorders, shotgun microphones, and all the other goodies that spies, P.I.s and the U.S. government use. Niftiest item: Letter Bomb Visualizer (liquid Freon), "makes paper into glass for 30 seconds and then dries without a trace." Gadgets also include scramblers, bug detectors and other countermeasures. Plus chapters on assembling information on people, skip-tracing, beating lie-detector tests, etc. With field test results, improvement tips, where-to-buy, and more. **GR**
$30.00 *(PB/264/Illus)*

How To Investigate Your Friends, Enemies and Lovers
Trent Sands and John Q. Newman
A basic manual on accessing public record information about an individual, with a few methods absent from most books on the subject. Using the pretense of providing information on protecting oneself from conmen and investigating the claims and backgrounds of celebrities and public figures, this books gives information on obtaining county records, DMV information and state tax and corporation records. Includes how to legally obtain a subject's Social Security number from credit bureaus, and how to find out what the Social Security numbers mean, using the Social Security number "Group Number" chart provided. Also: accessing vital, criminal and military records, bankruptcy records, information on "deadbeat dads" and other obscure sources of information as well as illegal methods of obtaining credit information. The final chapter offers a short rundown on how to sell one's services as an investigator. **TC**
$34.95 *(PB/160/Illus)*

How To Live Safely in a

Dangerous World
Loren W. Christensen
How to stay smart and alert in our increasingly complicated environment that is full of daily shocks and surprises. "Packed with proven safety techniques, expert tips and survival methods you can use in your everyday life," including:
• How burglars choose a home.
• How to talk to children about crime, carry valuables safely and survey your neighborhood for hot spots.
• Should you make eye contact with suspicious strangers?
• What to do when confronted by gangs.
• How to prepare yourself mentally to shoot at an intruder, coming home to an intruder, and what to say when you've got the drop on one.
• Twenty steps to take to prevent a carjacking. **GR**
$17.95 *(PB/218/Illus)*

How To Start Your Own Country
Erwin S. Strauss
Beginning with the premise that schism is the fundamental human method for dealing with frictions within groups of people, the author outlines five approaches to founding your own country today: traditional sovereignty, ship under flag of convenience, litigation, vonu (or off-the-grid), and the model country (exists on paper only). Sovereignty without territory (such as the shadowy Knights of Malta), the necessity of the use of military force, internal organization and other questions are given a sobering Macchiavellian treatment. *How To Start Your Own Country* ultimately becomes a mind-expanding exercise in determining what constitutes a state with all of its potential ramifications. Most of the book is an exhaustive alphabetical listing of new-country attempts—compiled with the help of the International Micropatogical Society (the society for the study of small countries)—from "Antartica, Kingdom of West" to the "United Moorish Republic"— from the farcical to the righteously Randian. **SS**
$9.95 *(PB/174/Illus)*

How To Survive Without a Salary
Charles Long
"Surviving without a salary is not the denial of work's importance. Quite the contrary. It is the celebration of work—real work—as a

Commercial Letter Bomb Visualizer: Makes paper into glass for 30 seconds and then dries without a trace . . . — from How To Get Anything on Anybody

human act whose value is intrinsic, irrespective of its value in the consumer marketplace. We do our work in our own small way, not because Mammon pays us, but because it makes us human." The author interweaves the philosophy of his "conserver lifestyle" with practical advice on exit strategies, debts, taxes, freelance work, casual employment, buying at auctions, cutting costs, and other methods for getting out and staying out of the 9-to-5 trap. **SS**
$14.95 *(PB/232/Illus)*

How To Use the FOIA (Freedom of Information Act)
Anonymous
"A citizen's guide to using the Freedom of Information Act and the Privacy Act of 1974 to request government records." Spells out the scope of these two historic acts, then explains which one is best for the reader's needs. Chapters include: "What Records Can Be Requested Under the FOIA?"; "Requirements for Agency Response"; and "Reasons Access May Be Denied." Also "Making a Privacy Act Request for Access"; and "Administrative Appeal Procedures for

Which of these men are armed robbers? — from **Everybody Does It**

Denial of Access." Includes a sample request form and a list of Federal Information Centers.
GR
$9.95
(PB/65)

Improvised Radio Detonation Techniques
Lawrence W. Myers
This manual, aimed at those engaged in unconventional warfare, details how common consumer electronics can be modified to work as radio-controlled detonation devices. Subjects include: cordless electronic touch-tone phones, citizens-band radio transmitters, toy walkie-talkie systems, radio pagers, AM/FM walkmen, cellular telephones and VHF police scanners. Includes detailed reading list.
MC
$12.00
(PB/74/Illus)

Improvised Weapons in American Prisons
Jack Luger
Weapon construction behind razor-wire requires special techniques and strategies because of the unique demands of the prison environment. Luger details the many types of weapons that have been constructed by inmates—including knives and other edged weapons, prison-made guns, garrotes and choking instruments, blunt instruments and firebombs—and the ingenious hiding

places prisoners find for their contraband. Objects as mundane as a toothbrush can be turned into a deadly shank. The book includes details about how attacks on prisoners are planned, information about escape, and description of how material is smuggled into secure facilities, often by members of the prison staff. Illustrated with close-up photographs of seized weapons constructed by convicts.
MC
$8.00
(PB/83/Illus)

In the Gravest Extreme
Massad Ayoob
Discover the difference between the reality of personal protection and dangerous fantasy. This book covers the use of the firearm in personal protection, dealing with legal, ethical, and practical considerations. It was written to provide practical advice and remove many misconceptions by trying to define what self-defense really means, and what conditions actually let someone apply lethal force legally. Ayoob dispels the myth of citizen's arrest, and explains how and when firearms can be used in stores, homes, cars and on the street. Here is common sense information on the deterrent effect of defensive handguns, gun safety and tactical techniques for defense shooting. The book examines what can happen legally, phys-

ically and psychologically in the aftermath of a shooting and what to be prepared for even in a case of justified self-defense.
MC
$9.95
(PB/131/Illus)

In Self Defense
Michael Izumi
This is an updated and more comprehensive version of Massad Ayoob's *In the Gravest Extreme*. This book is excellent in that it really tries to dispel the myths many people have about self-defense. Expanding on Ayoob's book, *In Self Defense* gives a realistic look at self-defense from both practical and legal angles. The author aims to educate people and clarifies issues in the use of deadly force while addressing the psychological mindset of dangerous criminals and the mental awareness and preparation one must attain in order to defend oneself from violent crime.

Here is practical information for selecting firearms and using them for home defense: how to determine the reliability of weapons, safety devices for handguns, the proper and legal methods of transporting weapons, and holster selection. There's a whole chapter on defense cartridge selection, including shotgun and handgun loads for self-defense and why factory-loaded ammunition is important.

StressFire Reload Automatic 2: Once hand is securely on spare mag, Rick dumps the one from his .45. A southpaw, he uses left index finger instead of right thumb to hit release button. — from **Police Nonlethal Force Manual**

Discusses the use of dogs for home security, as well as tactical material on dealing with attackers, the use of cover and concealment, returning fire from barricaded positions, and why not to even attempt a housecleaning if you suspect intruders. Includes material on proper verbal commands, the proper method of holding a criminal at gunpoint, and why a warning shot is not a good idea. There is a good discussion on the mental trauma that can occur during and after armed conflict, including definitions of these types of traumas. The book tells how to properly call the police and how to effectively interface with responding law enforcement.

There is a good amount of information concerning the legal aspects of self-defense, and how complicated things can become after a shooting. Includes practical and common-sense advice on understanding the mantle of confidentiality, what to do if the police throw you in jail for defending yourself, what information should be conveyed on your phone call, and how to deal with criminal and civil lawsuits resulting from a deadly-force encounter. Advises on how to find attorneys who are experienced in self-defense cases. **MC**
$14.95 *(PB/105/Illus)*

(Left) A dagger made from an unidentifiable piece of metal. It may have been square-section bar stock from the machine shop, or a part from a piece of furniture. (Right) Four toothbrush knives showing different modes of manufacture and different designs. The left-hand one has a thick layer of cloth wrapped around it for a "handle." The second one is almost pristine, the third uses cloth wrapping, and the fourth is unconventional, using shoelaces as the pommel. — from **Improvised Weapons in American Prisons**

Interrogation:
A Complete Handbook
Burt Rapp
This how-to manual on interrogation includes

If your instinct tells you the mugger is going to hurt you, throw your purse in one direction and run in the opposite direction. Chances are he will go for the purse rather than you. — from **How To Live Safely in a Dangerous World**

the history and mythology of interrogation, the basics of effective interrogation, psychological factors and even an interrogator's ideal qualities. Discusses how to read tone of voice and body language, which can indicate lying, how to find the correct setting for an interrogation, and ways to establish rapport with a subject. Looks at confessions and cross examinations the way they really happen, the uses of deception in obtaining confessions, and getting around Miranda warnings. Covers technological aids to interrogation including both lie detectors and voice-stress analyzers—what they can and can't do and how they are actually used—as well as drugs and brainwashing. Includes the tools of the Gestapo and secret police, types of torture instruments, who makes a good torturer, and tactics for trying to survive torture. **MC**
$14.95 *(PB/230)*

Kill or Get Killed
Colonel Rex Applegate
The definitive article on how to stab, hit, gouge, shoot, kill, maim or otherwise disable an opponent, with the fundamental principles explained with clear photographic examples.

Written in the 1940s for the Combat Section of the Military Intelligence Training Center, this classic text has been often imitated but never bettered. Includes a section on civil disturbances and their control. **BW**
$24.95 *(HB/421/Illus)*

"Kill Without Joy!":
The Complete How To
Kill Book
John Minnery
The title alludes to the assassin's proper frame of mind, an emphatic blank, swagger-free and beyond the concept of mercy. In these pages the gun becomes a mere fetish object, a sentimental icon of death, while the true and artful instruments of murder are apparent in a breathtakingly comprehensive array: Place a paper bag of dry ice under a person's bed in a closed room and they're dead the next day of carbon monoxide poisoning, the weapon evaporated. Stuff a tennis ball into another person's mouth, and they're asphyxiated, unable to summon the jaw strength to spit it out. Strangle someone with an industrial garbage-bag tie, called a Flex Cuff™, which is the same plastic hand-cuff cops use and available in neck size at

TACTICS

Massad Ayoob, author of StressFire.

automotive shops, etc. **HJ**
$24.95 *(PB/495/Illus)*

The Last Frontiers on Earth: Strange Places Where You Can Live Free
Jon Fisher
Described by the author as an "exercise in speculative geography," *The Last Frontiers on Earth* is also an examination of the lengths one might go to avoid paying rent and taxes. Hard-to-find possible homesteading sites are outlined: from the truly heroic, such as establishing a residence on a floating iceberg in the polar ice caps to the more prosaic, such as becoming a "bicycle nomad." Discusses the pros and cons, for example, in the case of an underwater habitat: "There are some offsetting advantages of underwater living. It has been found that in a pressurized undersea habitat small cuts heal fully in 24 hours instead of a week. Beards hardly grow at all. There are no insect pests to bother with, and bad weather passes unnoticed above while conditions remain calm and serene in the depths." **SS**
$8.95 *(PB/125/Illus)*

Military Knife Fighting
Robert K. Spear
This is a well-photographed book with a practical approach, which details knife-fighting grips and stances, body targets, blocks and counters. Illustrates serial attacks, grappling and sentry kills, and discusses the value of knives versus bayonets, and the use of deadly entrenching tools. Includes a short chapter on basic throwing as well as training hints. **MC**
$12.95 *(PB/123/Illus)*

Never Say Lie: How To Beat the Machines, the Interviews, the Chemical Tests
Scott French and Paul Van Houten, Ph.D.
"Exposes the 'science' of lie detection and shows how screening tests can be influenced by mechanical tricks, drugs, practice and knowledge. The FBI, IRS, CIA, job-screening firms, detectives and others use the polygraph, graphology, drug-screening tests, and kinesic interviewing. Do they really work? Will you lose a job, get fined or even go to jail because of a false positive on a shaky system? Learn how these systems work and how to manipulate the tests and testers to mislead anyone, anytime—and get away with it." **GR**
$19.95 *(PB/168/Illus)*

The Outlaw's Bible
E.X. Boozhie
A "jailhouse lawyer" reads you your rights: "Law books are too dry and technical for most people to read, and that is why the average citizen never really learns what his rights are. It fits right into the plans of those captains of the System, the cops and the lawyers, because with citizens in the dark, they can do pretty much what they please without recriminations. This book aims to put a stop to that situation by laying out in plain English an up-to-date overview of the citizen's legal rights against

police activity." Comes with its own Outlaw Ten Commandments, such as "Don't Consent" and "Don't Attract Attention."
$14.95 *(PB/336)*

Pen, Ink and Evidence: A Study of Writing and Writing Materials for the Penman, Collector and Document Detective
Joe Nickell
Brief but thoughtful histories of the use and manufacture of pens, ink and paper begin this interestingly documented volume. Closeup photographs depict drips made from a vat-man's hands which fell on a freshly handmade piece of paper; and illustrate the distinction between two sides of a piece of parchment (one side is yellow with hair follicles evident, the other side smoother and whiter). A photograph of handwriting from 1843, which reveals the point in the text that the writer mended his quill, shows just how close a study can be made of the written word. The evidence uncovered might solve a mystery or merely bring the past to life.

The goal of this book is to illuminate subtle clues and to encourage detailed observation. A teacher at the University of Kentucky, Nickell is also a calligrapher who belongs to the International Association of Master Penmen, Engrossers and Teachers of Handwriting. Here he offers his knowledge in detecting forgeries, identifying watermarks and dating documents, as well as in penmanship, stationery, and postal iconography. He assiduously presents photographs

APPROXIMATELY 26 POUNDS OF EXPLOSIVE USED IN MINE

DOG ATTACKING TANK

Kill dogs in action — from Kill Without Joy!

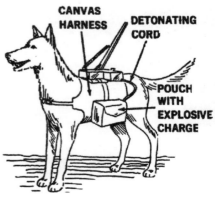

of rare manuscripts and antique instruments to verify his observations. The book contains a wealth of information for sleuths and scholars alike who seek knowledge of the history and use of handwritten text. In this day when computers have nearly eliminated handwritten evidence of error, and therefore thought, this document reminds us of what we will miss in the future.

JTW

$75.00 *(HB/228/Illus)*

Police Nonlethal Force Manual
Bill Clede

The author offers a solution to law enforcement officers who don't want to kill their prisoners or suspects—but want them to do what they're told. Featuring a variety of techniques which often hurt a lot but leave little bruising or scarring, the manual describes the options available to the police officer, including asserting dominance in such basic ways as using a firm tone of voice and the proper posture. Illustrates both hand-holds and tools (including everyday objects such as flashlights and the sap glove, as well as more unusual martial-arts weapons such as the Yawara stick) that can be used to gain

If you have good timing and a lot of nerve you can convert an overhand knife attack into a devastating surprise for the attacker. — from **Black Medicine III: Low Blows**

(Top) Robert K. Spear, author; (Above left) You're on top; (Above right) Wrench your wrist free and slash his throat. — from **Military Knife Fighting**

cooperation through pain-compliance, and allow the law-enforcement professional to assert his or her authority with a minimum of danger to themselves. Extensive illustrations demonstrate techniques and weaponry. **NN**

$15.95 *(HB/128/Illus)*

The Poor Man's James Bond, Volume 1
Kurt Saxon

"The ultimate armed civilian. Fireworks and explosives like Granddad used to make. We shall fight in the streets. Arson by electronics. U.S. Marines and Army hand-to-hand combat. Plus, making potassium cyanide, fire grenades and the ultimate booby trap." Classic survivalist and

"militant" how-to manual: tear gas, arson by electronics, "sinker basher," homemade poisons (from cigarettes and playing cards), plastique explosives, bomb handling and more. Mayhem with biting humor and zero tact.

$20.00 *(PB/477/Illus)*

The Poor Man's James Bond, Volume 2
Kurt Saxon

"Homemade bazooka, silencers, booby traps, Bolas, concealed weaponry, spear gun, smoke/gas grenades, mines, caltrops, ingenious zip gun, plus Army *Improvised Munitions Handbook*, and much more!"

$20.00 *(PB/484/Illus)*

Underarm tape recorder: Used during the 1960s by the Royal Canadian Mounted Police Security Service, this tape recorder could be worn unobtrusively in an underarm harness beneath the user's clothing. — from **The Ultimate Spy Book**

The Poor Man's James Bond, Volume 3

Kurt Saxon

"Poison gas grenades, wallet pistol, killer darts, bombs, explosives, stenches. Includes ricin, the deadliest organic poison known, and its simple manufacture. Make your territory impregnable."

$20.00 *(PB/411/Illus)*

Practical Electricity in Medicine and Surgery

G.W. Overall, M.D.

Reprinted from an 1890 edition, this is an early look at the uses of electricity in turn--of-the-century medicine. Learn about the uses of galvanic cells, effects of currents, electrodiagnosis, all types of early electro-surgery. With illustrations of early electric medical devices, this book is especially tailored to those interested in the history of medicine. **MC**

$7.95 *(PB/130/Illus)*

Principles of Improvised Explosive Techniques

A.J. DeForest

This book was written for the Rhodesian

Army Explosive Ordinance as a guide to defusing and rendering harmless improvised explosive devices. Discusses 108 different types of switches and ignition devices and the principles these devices use, with illustrations of each. Different bombing incidents are defined and categorized. Includes a system of memory-guide cards that are used to plan removal and render- safe procedures to disarm bombs; examples of questioning techniques; and plans for using detonating cord and shotguns to attempt to dispose of improvised explosive devices. **MC**

$20.00 *(PB/110/Illus)*

Privacy Power: Protecting Your Personal Privacy in the Digital Age

Trent Sands

"A vast phalanx of minimum-wage earners, keying in data on computers, tracks our every move, silently and relentlessly recording details about our private lives . . . It is collected, sorted, packaged and sold on a daily basis to others. To any others! Who are these clowns anyway?" Explains in detail how credit bureaus gather information on people, as well as the sale and use of an electronic invention of TRW and Equifax called a "national identifier." This program is used by skip tracers, collection agencies, etc., to pull information into a person's files, such as a new address, and so on. Also explains TECS (the Treasury Enforcement Computer System), which can be used to search both multiple government and private databases, merrily gathering facts on citizens for who knows what reason. **GR**

$19.95 *(PB/204/Illus)*

Sabotage in the American Workplace

Martin Sprouse

True stories of how some working Americans have managed to wreak havoc on their places of employment—profiles of a stripper, a waiter, a computer programmer, a retail employee, a mortuary worker, a welfare caseworker, a fish canner, a bus driver and a pickle packer. "I always steal from work because no matter how great the place is, they're always going to fuck you over at some point. It's just a question of when." **TD**

$12.00 *(PB/175/Illus)*

Secrets of a Super Hacker

The Knightmare

This book offers an abundance of technical

information, yet not so much as to overwhelm the casual reader or novice computer user. What the author best describes is the tactical problem-solving enterprise with which hackers work. They root out weaknesses in systems, and rather than being defined by limitations, they learn to exploit these to their own uses and to their own ends. Sometimes those ends are sinister and sometimes not. There are two whole chapters on the art of social engineering, which is rather like hacking a human being. The hacker approaches his subject just as he would a computer—researching, analyzing, and then piercing through the chinks of peoples' personal armor until they end up divulging some seemingly harmless detail which may just allow one to penetrate their computer systems. In this way hackers appears to be grifters par excellence, but the author paints them as romantic social rebels.

This is a great book on the mindset of those who watch and prey on people, whether they use computers to do so or not. The psychological profiles in the book are enough to scare any system operator into examining the necessity of updating computer systems. Though this book was published in 1994 (nearly a millennium ago by computer standards), the information is ever timely. Although computer technology such as firewalls can be developed, hackers, like other con men, have already cataloged and organized the human psyche, making it only a matter of time to overcome any new obstacles. **MM**

$19.95 *(PB/205/Illus)*

Sell Yourself to Science: The Complete Guide to Selling Your Organs, Body Fluids, Bodily Functions and Being a Human Guinea Pig

Jim Hogshire

Reveals what a body is worth and how to sell it. "Harvest your body while you're alive" is the theme—and "sell the leftovers" once you've croaked. How to make spare cash by signing off your organs, body fluids and bodily functions to science, and volunteering to be an experimental guinea pig. "When an organ donor dies, more than a million dollars' worth of medical procedures are set in motion . . . Everybody profits from organ donation except the donor. But that's about to change." Outside the United

States, your heart is worth up to $20,000. "A kidney fetches up to $50,000—and it's legal to sell one in many countries . . . you can legally sell your blood, milk, sperm, hair, and other renewable resources . . . You can also make a living as a human guinea pig, renting your body to drug companies. It pays up to $100 a day, and this book lists over 150 test sites throughout the USA." Remember, "every part of your body is of some use to someone." **GR**

$16.95 *(PB/168/Illus)*

Silent Death
Uncle Fester

"It is a sad commentary on the brutish times we live in that the use of deadly substances as a means of homicide is virtually unheard of. Instead of the quiet dignity of an effective poison, those with homicidal intent seem to impulsively reach for a gun, knife or club. All these crude instruments leave no doubt as to the cause of death . . . from the crude inorganic (i.e., mineral-based) poisons which get so many people a one-way ticket to the Big House, to the much more subtle and difficult-to-detect organic poisons, we will explore the methods used by artists skilled in the craft to avoid detection."

$14.95 *(PB/122/Illus)*

Simple Living: One Couple's Search for a Better Life
Frank Levering and Wanda Urbanska

Perhaps David Lee Roth said it best: "Found out the simple life ain't so simple." To bring it off successfully requires, for most people, a philosophical transformation as well as a wealth of acquired know-how. This book is a paean to the joys, struggles and pitfalls of the simplifying process as well as a how-to manual full of practical advice. Its authors are neither ideological gurus nor ascetics, but rather a likable and creative couple who decided to give living for the present a try.

Wanda Urbanska and Frank Levering had as good a shot at L.A.'s (and most of America's) vision of success and happiness as anyone: He was a screenwriter who'd had a film produced, and she was an editor at a major newspaper. This story begins when Levering's Quaker family's debt-ridden apple orchard (in southwestern Virginia, 12 miles north of the original *Mayberry, R.F.D.*) is finally facing collapse, and his father's health seems in peril. The authors admit

One of the last remaining examples of a virgin GYROJET rocket pistol. — from SpyGame: Winning Through Super Technology

they are "secretly and utterly miserable with our own lives," and make the decision to quit the life they know and the dreams of glamor and material splendor they have nurtured since college.

The book chronicles the most difficult struggle they faced: to recast their dreams and find joy in hard work and the beauty of everyday life close to nature, neighbors and community, rather than hoping that the deferred fulfillment of the rat race and "making things happen" would someday pay off. They take the reader through their painful, humorous and ultimately successful transition, along the way introducing others who have made it, from a lesbian couple living outside the cash economy to the co-founders of Habitat for Humanity, who gave away their hard-earned millions and devoted their lives to building affordable housing in poor neighborhoods. **MH**

$10.00 *(PB/272)*

Snitch: A Handbook for Informers
Jack Luger

Just what every red-blooded American needs—a handbook for snitches—as if society doesn't have enough busybodies, stool pigeons, double-crossers, liars and traitors already. But for those who have to squeal, this is required reading. Find out what information is valuable: how to get it, and how to sell it. Learn to negotiate with the police, how

cops treat their informers, and how to keep from being finked out by someone else (just about an impossibility these days.) There are chapters on who informs and their motives and compensations, sting operations, company spies, criminal, civilian and prison informers, cops and how they think, becoming an informer and protecting yourself against stoolies. What can happen to informers when they fail or are caught snitching? Learn about the IRS "Turn In A Friend Program." This book is the ultimate in modern-day American police-state culture. Turn in a friend today before they turn you in tomorrow! **MC**

$16.95 *(PB/145)*

The Sourcebook of State Public Records
Anonymous

A state-by-state listing of sources of public records for the investigative reporter or private eye. More than just a collection of addresses and phone numbers, the information given is very complete and includes fees, turnaround time, what restrictions there may be, and what to expect if access is made by phone or fax as opposed to a personal visit. This book will save the serious researcher phone-call money and legwork. **TC**

$29.00 *(PB/339)*

SpyGame: Winning Through Super Technology
Scott French and Lee Lapin

Real gone goods for real gone ninjas. This

There are hundreds of thousands of street criminals like this in the United States who take pleasure in intimidating you and taking what is yours. — from **How To Live Safely in a Dangerous World**

massive volume (it weighs 2 pounds) starts off with updated advice on being a technological ninja (poisons, shooting knives, etc.), then explodes into a surveillance superbook. It's a where-to-get-it surveillance-gear catalog, complete with field test data and warnings as to what's legal or not in the USA. Also covers defensive driving, computer security, lie-detector countermeasures, surreptitious infrared audio monitoring, laser communications, secure phones, infrared photography, ID tricks and tons more 007-level concerns. Plus chapters on customizing your handgun, snap-shooting techniques, bulletproof clothing etc. The Sears catalog of the spy world. **GR**

$30.00 *(PB/520/Illus)*

Steal This Book: 25th Anniversary Edition
Abbie Hoffman

"Make war on machines, and in particular the sterile machines of corporate death and the robots that guard them. The duty of a revolutionary is to make love, and that means staying alive and free. That doesn't allow for cop-outs. Smoking dope and hanging up Che's picture is no more a

commitment than drinking milk and collecting postage stamps." Both an amazingly time-warped radical period piece and a still-usable nuts-and-bolts urban-guerrilla, underground survival manual. While some of Abbie's leads seem a little far-fetched (i.e., scarfing free food at bar mitzvahs while on the lam), the International Yippie Currency Exchange for burning vending machines still applies. Definitely the finest writing on the subject of riots from the well-equipped rioter's point of view (trashing the pigs in their own trough, MAAAN!!).

SS

$8.95 *(PB/308/Illus)*

StressFire
Massad Ayoob

Deals with gun-fighting for police under actual stress situations. Includes chapters on the principles of stress and techniques for coping with it. Discusses body positioning, proper ways to hold weapons, drawing and reholstering weapons, weak-hand shooting, kneeling, point shooting, sitting and prone-position shooting as well as StressFire reloading of revolvers and automatics. Shows how much handgun training a gun owner really needs. **MC**

$9.95 *(PB/150/Illus)*

Successful Armed Robbery
Harold S. Long

An illustrative primer that briefly covers the basic planning, procedures, gear and execution of a typical strong-arm holdup, followed by a detailed test-case scenario based on the robbery of a nightclub owner at a night depository. Lists the most common areas of failure and how to avoid them. Self-scored test included. **HJ**

$8.00 *(PB/50/Illus)*

The Survival Handbook
Peter Darman

A compact and efficient volume containing survival tips for deserts, tropical or polar regions and at sea culled from the U.S. Special Forces, the Canadian Air Force, the Italian Alpine Troops, the Navy Seals, the Russian Spetsnaz, the French Foreign Legion and other elite forces. Discusses such topics as improvising shelter, tools and clothing; tracking water, vegetable and mammalian food sources; expediting rescue; and avoiding dangerous situations. Crammed with all kinds of interesting tips, from building signal fires and boot care to avalanche etiquette and the proper procedures for emergency amputation, it is recommended

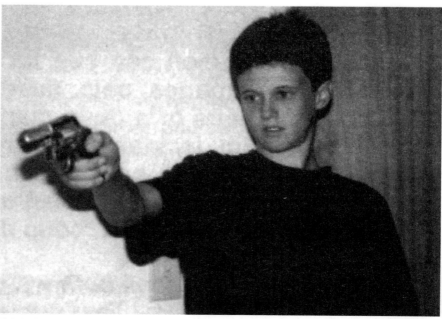

Criminals know how to "read the body language." If you are not fully prepared to use the gun, the gun is waiting to be taken away. — from **In Self Defense**

for any traveler, worldly or otherwise. **SK**
$13.95 *(PB/256/Illus)*

Taxidermy Guide
Russell Tinsley
"Step-by-step illustrations that guide the novice and hobbyist to successful taxidermy." Start with a bird, it's the easiest, while fish are the hardest to do. Sharks are impossible. Snakes have to be chloroformed or frozen alive. Urethane mannequin forms are easy to use. Skinning an animal's head takes a couple of hours, so give yourself time. Test a knife's edge by skinning a chicken. Chapters include: "Basic Mounts," "Big Game Head Mounts," "Novelties," "Rugs," "Tricks With Antlers and Horns," "Lifelike Snakes," "The Taxidermy Knife" and "Dare to be Different." With a listing of suppliers and tips from the pros. **GR**
$14.95 *(PB/224/Illus)*

Techniques of Burglar Alarm Bypassing
Wayne B. Yeager
Security companies often fail to supply what their clients pay for, and alarm systems can be beaten. This book shows how, covering everything from magnetic contact switches, window foiling, to ultrasonic alarms and passive infrared alarms, microwave systems, traps, monitored control panels and preamplified microphones, and the many ways they can be defeated. There is also informa-tion on guard dogs, central control systems and police and guard responses or the lack thereof. Describes residential, commercial and high- security systems. **MC**
$14.95 *(PB/104/Illus)*

Techniques of Safecracking
Wayne B. Yeager
"No safe is completely safe because lock-smiths must be able to rescue goods if the lock breaks. That means every safe is vul-nerable—it's just a matter of time and determination.
"Reveals every known method for breaking into safes, vaults and safety-deposit boxes. It begins with simple ways to guess (or steal) combinations. In illustrated detail, it shows how to drill, punch and peel a safe, as well as how high-tech hoods use torches and explosives to get at your goods. For the policeman, private investigator, store owner, security professional or anyone fortunate enough to have something worth protecting, this book is eye-opening reading."
$12.00 *(PB/88/Illus)*

Techniques of Secret Warfare: The Complete Manual of Undercover Operations
Carl Hammer
Cloak-and-dagger tip sheet detailing super-serious spy methods. "Now you can study

The best expedient defense against a knife attack is a straight-backed wooden chair. It is every bit as effective as it looks. — from Black Medicine III: Low Blows

the techniques used by real professional spies and investigators. Learn how to gather any type of information you may want—or stop others from getting info on you!" 007-style contents include:
• The significance of HUMINT, or human intelligence gathering.
• Infiltration and maintaining cover.
• Methods for gaining entrance to enemy installations; how to open and reseal letters.
• Escaping in trains and vehicles; how to avoid dogs; escaping from handcuffs.
• Letter drops, couriers, visual signals, audio signals, scrambling systems, invisible ink.
• Hand cameras, video cameras, night-vision devices. **GR**
$16.95 *(PB/174/Illus)*

To Break a Tyrant's Chains: Neo-Guerrilla Techniques for Combat
Duncan Long
According to the author, this book is an insurance policy against tyrants and would-be tyrants; it shows them that a small group of neo-guerrillas can bring down the strongest armies and force any police state to its knees. Long shows the secrets of how to secure and create weapons, and the tactics needed to use them when fighting just

A papier-mâché replica of a small automatic. This fake, about the size of a .25-caliber Browning, had a metal insert to show bright metal at the ejection port. —from Improvised Weapons in American Prisons

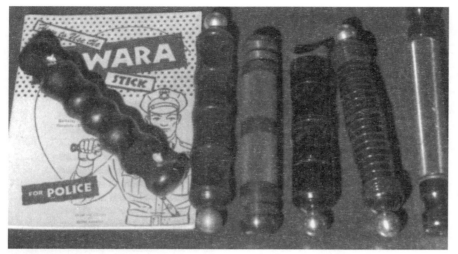

A variety of Yawara sticks sold to police include the first Yawara with its original manual, at far left. — from Police Nonlethal Force Manual

about anything imaginable, from attack helicopters to tanks. **SC**
$12.00 *(PB/147/Illus)*

The Toilet Papers: Recycling Waste and Conserving Water
Sim Van der Ryn
"Much of this book is concerned with how all of us can take more responsibility for our own shit to save water, soil and money," declares its author, emeritus professor of architecture at UC Berkeley and former California State Architect Sim Van der Ryn. Originally published in the 1970s, *The Toilet Papers* is basically a waste-not-want-not rethinking of the relation of shit to water in Western society, beginning with a short illustrated history of toileting and sewage in both the East and the West including a discussion of the relative merits of sitting vs. squatting. Van der Ryn then discusses "dry toilets," "graywater" systems for gardening, plans for how to build your own "compost privy," the conversion of waste-water into valuable by-products through aquaculture and other appropriate-technology approaches to this eternal dilemma. **SS**
$10.95 *(PB/128/Illus)*

The Truth About Self-Protection
Massad Ayoob
This book, written by an expert in providing practical, truthful information on self-defense, talks about the dangers of crime and what to expect. It recommends all types of practical solutions and dispenses common sense counsel about locks, alarms, safes, tear gas, car security and attack dogs. Some basic street-fighting self defense techniques are illustrated, such as the neck twist, takedown, eye attacks and martial arts. The author also discusses such makeshift weapons as flashlights for self-defense, and offers extensive information on guns: who should have them, types of training, the selection of handguns, combat firing techniques, the storing of firearms, and the physiological and psychological aftermath of violence. Includes advice to the elderly and handicapped, and covers what to do about legal problems that can arise out of the use of self defense, including finding a lawyer. **MC**
$7.99 *(PB/420/Illus)*

Twisted Genius: Confessions of a $10 Million Scam Man
Craig Jacob as told to Phil Berger
Under other circumstances, Jacobs would be hailed as a savvy businessman filled with entrepreneurial chutzpah. Instead, he turned his unique talents into a 20-year criminal career during which he made millions of dollars via his sophisticated credit card scams, counting among his victims corporations such as Western Union and Proctor and Gamble, as well as casinos, airlines and just about every other business imaginable. Unfortunately, Jacobs' severe addiction to gambling caused him to lose most of those millions as quickly as he acquired them, leaving the titular appellation "genius" open to question. Long-suffering urbanites may or may not appreciate the scheme in which he sublet an apartment under a false name, then "rented" it to approximately 60 different individuals, collecting a hefty deposit from each before disappearing. Even his numerous straight businesses functioned on the border of illegitimacy, probably not unlike most Fortune 500 companies. Come to think of it, Jacobs used the name "Donald Trump" for one of his scams, and but he and the Donald have never been seen in the same room together. At the very least, Jacobs' tale will make you guard your credit cards with your life. **LP**
$19.95 *(HB/205/Illus)*

The Ultimate Spy Book
H. Keith Melton
The accoutrements of espionage—the world's second oldest profession—laid out in full-color, pornographic splendor for all the world to see. "An inconspicuous figure in a raincoat . . . border crossings at midnight . . . living under constant threat of betrayal and torture . . . secretive and shadowy, the world of the spy." Nothing hidden—all tricks revealed! Thrill at the tiny danger of the lipstick pistol! the wrist pistol! the poison pellet pen! the cigarette pistol! the cigar pistol! the pipe pistol! the wallet gun! the toothpaste-tube gun! the glove gun! the poison pellet cane! and (*don't sit down*) the rectal pistol! Then gasp at the miniature madness of the wristwatch camera! the briefcase camera! the cigarette-pack camera! the KGB necktie camera! the book camera! the waist-belt surveillance camera! the button camera! the matchbox camera! and the cigarette-lighter camera! (Sorry, no rectal camera.) Items from the collection of Keith Melton, adviser to U.S. intelligence agencies. Co-foreword by William Colby (ex-CIA) and Oleg Kalugin (ex-KGB), both of whom, during the Cold War, used many of the same spy tools on each other. **GR**
$29.95 *(HB/176/Illus)*

The Whole Spy Catalog
Lee Lapin
This is a jumbo-size sourcebook devoted primarily to locating and researching peo-

ple, their assets or other information more or less "by any means necessary." To keep the dry realities of PI work and other investigative work from bogging things down, Lapin throws in plenty of Walter Mitty-appeal espionage lore such as night vision, bugs, phone tapping, scrambling, encryption and video surveillance including some titillating details about Mossad and the KGB of today. Most impressive is the clarity and generosity with which he imparts his hardcore hands-on do-it-yourself-sleuth training, which is as useful for investigative journalists and the merely obsessive as it is for wannabe spooks: handy fax forms for missing persons traces, court-document retrieval services, online databases (with prices) and even tips on old-fashioned breaking and entering. **SS**

$44.95 *(PB/440/Illus)*

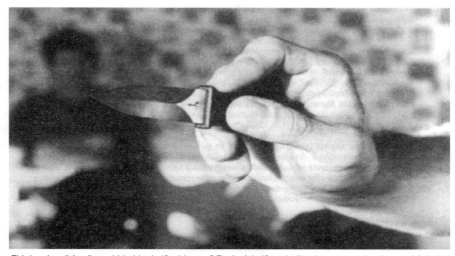

Think only a "sissy" would hold a knife this way? Try it. A knife or ball point pen can be thrust with lethal force with a push from the protected palm — from **Police Nonlethal Force Manual**

Wiretapping and Electronic Surveillance
Commission Studies
Complete and unedited reprint of the second and third sections of the Commission Studies presented to President Ford in 1976 detailing "The State of the Art of Electronic Surveillance" and "The Authentication of Magnetic Tapes." The paranoia that was created by the surveillance and miniaturization technology in the mid-'50s served as the catalyst which led to these studies, which became an excellent (if unintentional) how-to on electronic eavesdropping, wiretapping, and all manner of microphonal espionage. **S K**

$12.95 *(PB/112/Illus)*

Wormania!
Mary Appelhof
Worm Lady rules! This well-conceived videotape and study guide are proof that learning can be fun on a budget. Muffy wants a ride to the mall but dad can't drive her there until he finishes writing his "worm song." As the subject of worms gets bandied about, a lot of questions arise. Enter (from seemingly nowhere) the Worm Lady. Wearing a green hardhat, a red raincoat and yellow rubber boots, she not only has the answers, but seems to be the very voice of reason in this all-too-perky family unit (which is rounded out by a "dude" older brother and a younger brother with thick glasses, but no mom).

The overall tone of this piece is not unlike a Syd and Marty Krofft production with a female "Wizard of Oz" instead of a Pufnstuf.

Footage of every phase of a worm's existence is frequently shown while the Worm Lady answers questions. Since kids like squirmy things anyway and it is the fecal matter of worms which creates fertile soil, there are a lot of opportunities to get the kids really worked up about this whole subject as well as related curricular areas such as math, the arts, communication skills and creativity. Includes a top-notch teaching guide. Oh, and Dad manages to write not just one worm song but four of them. Here are some sample lyrics:

"So when that worm
gets done with that leaf,
like all animals,
it poops for relief.
Now talking about worm poop
might sound rude,
but worm poop is
important plant food." **JAT**

$34.90 *(VIDEO w/ Pamp/42/Illus)*

Worms Eat My Garbage
Mary Appelhof
Mary Appelhof is the type of person who gives ecology a *good* name. She is the owner of Flower Press and Flowerfield Enterprises, and has dedicated most of her adult life to the development of products and techniques related to the conversion of organic materials into fertile soil using earthworms. She is also a skilled photographer and holds master's degrees in education and the biological sciences. This is her first book. It is a common sense guide to composting using worms, which

does not assail the reader with bombast.

Among the topics covered are how to build a worm box, where to keep it, what kind of stuff worms can recycle and what other creatures live in worm boxes. There is a useful glossary of terms which is an amazing read in its own right, as well suggested reading. This book makes a potentially dry subject something of real interest. **SA**

$8.95 *(PB/100/Illus)*

You Are Going to Prison
Jim Hogshire
Loompanics' embattled how-to star (author of *Selling Yourself to Science* and *Opium for the Masses*) depicts in stark terms the perversely brutal conditions under which millions are forced to live in the "Land of the Free," plus a few pointers on how one might attempt to stay on the outside or at least survive once in the relentless clutches of the "criminal justice machine." *You Are Going to Prison* is packed with all the need-to-know info on our number one growth industry, prison construction and incarceration, which never makes it into movies like *The Shawshank Redemption* or *The Birdman of Alcatraz*— who was actually a serial prison rapist who shaved his entire body and ate only red meat. Describes everything from what to say when pulled over by a cop to "cheating the hangman" by injecting peanut butter. Includes a detailed analysis of the dreaded topic of sex behind bars and especially prison rape. **SS**

$14.95 *(PB/181)*

RAGNAR BENSON

Tim Stevens, a now-retired Marine major, had personal experience tipping over a Russian T-72 tank in Iraq, using a barrel (55 gallons) of ammonium nitrate and fuel oil. He and his crew carefully buried the barrel in a dry area along the side of a road where tanks commonly pulled over to refuel. After several long days waiting, a tank finally drove on top of his huge mine. He radio-detonated the charge from about 600 yards. Because the explosive was so slow, it did not break any significant pieces from the behemoth. The tank was simply thrown over on its side, he said.

Stevens and his men allowed the tank-crew members to run off. Snipers then kept would-be salvagers away. The enemy either did not know about their disabled tank, or did not have a tank retriever available to pick it up. That night the tank was properly stripped of weapons and burnt.

Stevens proved that 700 pounds of fuel-soaked ammonium nitrate detonating at a relatively slow rate of 9,000 feet per second was capable of flipping a large tank. As a result of his success, the fellow urges neophyte tank killers to wait until one tread of the machine is firmly over the explosive's barrel, before attempting detonation. "From a range of even five feet, I doubt if the tank crew will even feel the blast," he says. — from *David's Tool Kit*

Improvised blasting cap — from **Ragnar's Homemade Detonators**

Breath of the Dragon: Homebuilt Flamethrowers
Ragnar Benson
"Do you have anything in your arsenal that would hold off tanks or a small army of heavily armed, hostile people? What you need is your own dragon, and Ragnar is going to show you how to build one.

"Flamethrowers are legal, easy to build and operate and use a fuel that is cheap and powerful—napalm (Ragnar's family recipe is included, of course). Using easy-to-follow instructions and illustrations, this nontechnical manual teaches you how to design and build a customized flamethrower with common components—many of which you can pick up used at little or no cost. Plans for both backpack and vehicle-mounted flamethrowers are included. Give yourself the edge you need over most urban-combat weapons."
$12.00 *(PB/80/Illus)*

David's Tool Kit: A Citizen's Guide to Taking Out Big Brother's Heavy Weapons
Ragnar Benson
What do you do when THEY go public with the Black Helicopters—not to mention the Black armored personnel carriers and Black Humvees? *David's Tool Kit* gets to the heart of the challenge of armed citizen resistance based on "off-the-record" consultations with military personnel and defense contractors. This is a fascinating examination of the weak links in a contemporary mechanized army including well-informed tips for the "citizen-defender" on where to hit them—with claymore mines, Molotov cocktails and homemade flamethrowers.

Benson concludes with an impassioned appeal to the young armed-forces personnel of the Sega Generation: "Just because the politicians or your immediate superior says your intended American targets are drug-dealing, orphan-hating subhumans, don't believe it without good firsthand evidence. The consequences of your actions—even if the old folks don't actually resist—may eventually be dramatic." **SS**
$16.95 *(PB/200/Illus)*

Gunrunning for Fun and Profit
Ragnar Benson
"Courting danger, surrounded by political intrigue and always in the thick of the action, the gunrunner can shape the course of history. But how can the aspiring gunrunner keep from getting shot with his own merchandise or winding up in jail while plying his trade?

"A 30-year veteran of the gunrunning trade, Ragnar Benson tells how to make connections, where to buy and sell weapons, and how to get the goods from Point A (where they're not worth much) to Point B (where they're worth a lot). He also tells you how to get out of a hot spot in an emergency, how to get paid and much more."
$20.00 *(PB/112/Illus)*

The end result is much like plastique and is relatively stable. It fires with an unbolstered cap. — from **New and Improved C-4**

Homemade Grenade Launchers
Ragnar Benson

"Here comes Uncle Ragnar with the ultimate in firepower one-upmanship—homemade 40mm grenade launchers!

"That's right, let Ragnar Benson walk you through these simple step-by-step plans for building an M79 or M203 right in your own workshop. With ordinary tools and nothing more exotic than pipe, washers, nuts and bolts, you can soon be lobbing out show-stopping high-explosive ordnance to the delight of friends and onlookers. Ragnar also shows how to reload spent 40mm cases as well as how to improvise your own grenades from common materials found at the hardware store. Complete BATF guidelines are included."

$16.00 *(PB/144/Illus)*

Mantrapping
Ragnar Benson

"*Mantrapping* is the first book ever published to explain how to capture that most dangerous animal: man. This gut-wrenching book is based on Ragnar Benson's own mantrapping experiences while on special assignments in Asia, Africa, North and South America and Cuba.

"You have to see this one to believe it! Illustrated with detailed line drawings. Covers such mantraps as the Malaysian Hawk, the Andes Mountain Trail Trap, the Sheepeater's Rock Fall and the Cuban Water Trap. As Benson says: 'To know how to trap your enemy is to know how to avoid being trapped yourself.' Each trap is constructed with primitive materials and tools. Includes a special chapter on the philosophy of mantrapping."

$12.00 *(PB/88/Illus)*

The Most Dangerous Game: Advanced Mantrapping Techniques
Ragnar Benson

"Man—the most dangerous and deadly game of all—is without a doubt challenging prey. In response to requests for more on trapping this elusive game, Benson, author of the infamous *Mantrapping*, tells you how to rig more ingenious traps without explosives and accoutrements of war.

"The do's and don'ts for a surefire mantrap are outlined in a checklist, and urban traps designed to make your victim's life undeniably miserable are included. Bridge and snake traps, wilderness traps, helicopter and heavy military-equipment traps and more are detailed."

$12.00 *(PB/120/Illus)*

New and Improved C-4: Better-Than-Ever Recipes for Half the Money and Double the Fun
Ragnar Benson

"Just when you thought it was safe to come out of the bunker . . . " More recipes for homemade C-4 explosive from a professional "powder monkey." Focuses on inexpensive, unregulated chemicals that average citizens can find cheaply and locally. "More bang for the buck!" Assumes a working knowledge of explosives deployment. **GR**

$15.00 *(PB/77/Illus)*

Ragnar's Homemade Detonators: How To Make 'Em, How To Salvage 'Em, How to Detonate 'Em!
Ragnar Benson

Simple and clear instructions for improvising various types of blasting caps "from scratch" in your home workshop. "CAUTION: The procedures and end product described herein are extremely dangerous!" Or, if you wanna spend $800, you could pull one out of an auto airbag. **GR**

$10.00 *(PB/64/Illus)*

Easily built and deployed flamethrowers will take out any heavy weapon. —from **David's Tool Kit**

Facial disguise by artificial aging — from The Ultimate Spy Book

It never ceases to amaze me just how often I run into people I knew when I was a kid but haven't seen for years, or relatives I forgot I had, or old flames, etc. When you add to that people you've met in your work life, friends of your friends that you've seen casually many times, and gas station attendants, barbers, grocery clerks, postal delivery people, etc., the number of people out there that are familiar enough with your face to remember who you are is staggering! All it takes is just one of them to make you and connect it with something they read about your having committed suicide, and you're a goner. Considering the possibilities, and the repercussions of being identified, a little disguise might just be the best buy in the history of insurance.

By "disguise" I do not mean the Lon Chaney, Hunchback of Notre Dame type of getup. A lamster doesn't need much change in appearance to effect his purposes. Even so simple an exercise as a change in clothing from what one ordinarily wears and a change in hairstyle

are enough to throw off even one's friends and relatives. A detective for the California Police Department once told me that it is not at all unusual for parents searching Berkeley's Telegraph Avenue area to fail to recognize their own children when they meet them face-to-face.

There are six general ways that a person is recognized:
1) Gait.
2) Overall appearance.
3) Shape of the head and face.
4) Voice.
5) Features. Not the same as #3, above.
6) Location.

A simple disguise that changes any or all of these items of identification is all that is required for good, basic camouflage.
— from *How To Disappear Completely and Never Be Found*

Birth Certificate and Social Security Number Fraud
Anonymous
How to get the two "breeder cards" that lead to the acquiring of a driver's license, passport, Medicare card and so on—in other words, all the documents that make you an "American" in the eyes of the U.S. Government, whether or not the first two are frauds. Tell the difference between real and fake birth certificates and baptismal certificates. How birth records are certified and how they and death records

are cross-referenced. Learn the difference between state and county certificates, Social Security numbering schemes, aging documents and how the Government can spot a fraudulent card. **GR**
$19.95 *(PB/160)*

The Encyclopedia of Altered and False Identification
John Q. Newman and Trent Sands
This is the most up-to-date volume of lore on America's big problem with bogus doc-

umentation, be it altered, forged or falsified. Explains how birth certificates are fraudulently created, how Social Security cards are faked, how driver's licenses are forged, and how passports are created for nonexistent persons. "Our estimate puts the number of people who are using some sort of altered identity document at well over *10 million!*" say the authors. Goes into great detail on several subjects: provides SSN charts that show what all the numbers mean; includes a state-by-state section showing characteristics of each state's dri-

ver's license; and features a state list of Vital Statistic Bureaus, noting addresses and the prices to obtain birth-, death- and marriage-certificate information. **GR**
$34.95 *(PB/160/Illus)*

How To Disappear Completely and Never Be Found
Doug Richmond
A sensible overview of identity-changing, part how-to and part journalistic survey for the armchair disappearee. Based on case histories of successful and unsuccessful disappearances, the author interweaves their motivations ("deadbeat dads," life insurance scams, debts, fugitives, mid-life crisis) with the nuts-and-bolts: how to "locate" a new identity, "choosing" the right name, "pseudocide" (faking a suicide) and even the best spot to apply for a U.S. passport. Deals with the potential pitfalls of "disappearing" which more technical manuals refuse to address, such as where the money will come from and the safest types of jobs to work at under a new identity. **SS**
$7.95 *(PB/107)*

Mother's Maiden Name
Anonymous
A subject's mother's maiden name is one of the key pieces of information that is needed to gain access to all manner of private records. While a Social Security number and date of birth are relatively easy for an investigator to obtain, trying to find someone's mother's maiden name can be like hitting a brick wall. It is something that is left out of most do-it-yourself background-investigation books. Here is a solution to this problem, with an emphasis on using a mother's maiden name to obtain an alternative identity, although this is hardly the only reason for obtaining the maiden name. This guide contains invaluable information to the muckraker, private investigator, con man, phony psychic or the just plain curious. Details a variety of methods to obtain maiden names. Sources are state records, financial institutions, genealogical histories, newspaper records and the subjects themselves. One interesting chapter contains phone scripts in which one masquerades as various semi-authority figures in order to get the subject to give up Mom's maiden name. **TC**
$29.50 *(PB/107/Illus)*

New I.D. in America
Anonymous
"Do you ever wish you had just one more chance at life—the proverbial 'clean slate'? Do you want to shake free from those alimony payments and your lousy credit record? With *New I.D. in America*, you can trade in your old mistakes for a brand new start.

"An anonymous private investigator, the author specializes in helping clients 'get lost'—permanently—and locating persons who thought they'd never be found. Now his expertise can be yours. You can create a totally new person with a bona fide birth certificate, passport, driver's license, credit cards, Social Security number—all you need to break with your past.

"You can have the reputation of being a successful, influential businessman with a prestigious address and corporate backing, or have an untraceable sheltered business savings account. Create either without fear of being caught."
$17.00 *(PB/120/Illus)*

The Paper Trip 1
Anonymous
Revised and updated version of the 1971 classic, the granddaddy of all change-your-identity books. Includes "The Birth Certificate Route" (example: taking on the

identity of a person recently deceased); info on obtaining a new Social Security number (maybe by becoming a clergyman), then a driver's license (bought off the street), and then a passport (get it from a postal inspector). "Just who needs to take the paper trip? Anyone who now finds it difficult or undesirable to continue living under his old name— or anyone who wants to build an 'escape route'' to get out of the bureaucratic system in a pinch. **GR**
$17.95 *(PB/82/Illus)*

Social Security Number Fraud: Investigative Guide
Anonymous
This is a copy of the document prepared by the Department of Health and Human Services, Office of the Inspector General. "The object of this publication is to provide a general understanding of the Social Security Number (SSN) issuance process, how individuals attempt to subvert it and misuse SSNs, and what experience has shown with respect to the investigation of these criminal activities . . . a reference tool that will provide the investigator with insight into the SSN issuance system and an idea of how violations have been identified and established in past cases." **GR**
$12.95 *(PB/68/Illus)*

This identity card, or Kennkarte, was issued to me by the German occupying government in Poland on January 30, 1943, and was good for five years. I obtained this document through regular channels using my new birth certificate. It made me legitimate as a Pole of the Greek Catholic religion. — from To Tell at Last: Survival Under False Identity, 1941–45

RADIO

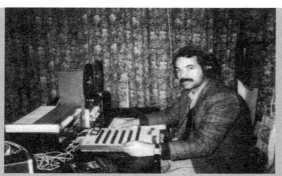

A Radio Free Kabul program is taped from studios near the Afghan border. — from Shortwave Clandestine Confidential

What audio engineers call 'presence,' the compressed, high-energy, high-volume sound of almost all electronic media, has created a world that is too present, a world "too much with us," that crowds in on us just the way sound does in a city. But, as evolution would have it, our ears and souls and psyches seem not to have forgotten the more pristine, sacred soundscapes of the echoing cathedral. Debussy's La Cathédrale Engloutie embodies some of the mythic power of this image. In a very real way, it is the echo of the insides of ourselves.

Dr. Alfred Tomatis, an eminent French physician and hearing specialist, maintains that it is via the ear, the first of our sense organs to develop in utero, that we form our primary connection: first with the inner, and then the outer world. In an elaborate metaphor rigorously supported by years of clinical research, Dr. Tomatis suggests that our very body is a kind of cathedral (meaning that it sounds, from inside, like a cathedral). It has been demonstrated that the 'stones' (bones) of the quintessentially sacred edifice selectively amplify and conduct the frequencies most vividly experienced in the womb. Moreover, throughout our adult life the tuning of attention to these (relatively higher) frequencies leads to a sense, literally and physically, of being drawn to a 'higher' (both literally—posturally—and figuratively) place in and beyond ourselves.

John Leonard, former chief cultural correspondent for *The New York Times*, catches the same sense in a secular, Platonic image: 'Radio ought to be our refuge. Radio is the cave of the imagination, and that's where the stories started—with language in a cave, playing with the shadows on the walls, swimming in sound.'

Radio programmers speak colloquially of "going for a distinctive sound," intuitively realizing that it is this acoustic profile, more than the semantic content of a program, which draws the attention of listeners. Our ears very quickly learn to make these distinctions unconsciously. To a certain degree the sound preconditions and prepares our receptivity to the words and content. Less equivocally, it is true to say that the sound of a radio program is its content. And the most important thing that can be left with a listener is not a string of facts or opinions, but a certain emotional or spiritual ambience (what the advertisers have more profanely called 'mood' or, once upon a time, "vibes"). The opportunity that presents itself to the broadcasters who are aware of these effects is to engender a kind of ambience in which a change of heart, the precondition to any change of mind, can take place.

— Tim Wilson, "Acoustic Architecture," from *Radiotext(e)*

The Clandestine Broadcasting Directory
Mathias Kropf
Worldwide directory of clandestine broadcasting—shortwave, mediumwave and longwave. The directory includes a complete frequency list, time-order list and database. Listen to secret station broadcasts Governments don't want people to hear. This book, with its comprehensive listings, has value for journalists, media scientists and historians in addition to radio buffs. **MC**
$12.95 *(PB/60)*

Complete Manual of Pirate Radio
Zeke Teflon
This pamphlet details how to build your own radio station. Discusses freedom of communication,
getting away with it, studios, transmitters, antennas, mobile operation and finding parts.
$5.00 *(PB/47/Illus)*

Cop Talk!: Monitoring Law-Enforcement Communications
Laura E. Quarantiello
Find out what those sirens are all about. The author explains how to use scanners to monitor local police department and other law-enforcement communications, including how to find frequencies, what equipment to use for monitoring, how to set up scanner banks and a guide to often obscure police jargon. Also discusses responsible monitoring and includes police radio codes and common nationwide frequencies. **MC**
$17.95 *(PB/79/Illus)*

Easy Shortwave Antennas
Frank P. Hughes, VE3DQB
Tips, techniques, descriptions and illustrations on the principles, construction and erection of more than 50 different types of antennae for short-wave reception. **MC**
$12.95 *(Pamp/52/Illus)*

Improvised Radio Jamming Techniques: Electronic Guerrilla Warfare
Lawrence W. Myers
"The focus of this manual is on simplicity, operational security and expedient execution so that an unconventional-warfare team, using limited resources and personnel, can quickly, covertly and aggressively attack the opposition's radio commu-

nications during an attack."

$19.95 *(PB/247/Illus)*

Monitoring the Feds: How To Use Your Scanner or Shortwave Radio To Eavesdrop on Federal Government Communications
John McColman

For he who watches the watchers, a comprehensive list of the communication frequencies used by each federal government agency, including but not limited to the DEA, Customs, Secret Service, Coast Guard, Forest Service and IRS. With a brief synopsis of each department's operations. An interesting curiosity for the casual listener, and an indispensable gold mine for the serious eavesdropper. **BW**

$17.95 *(PB/105)*

The Outer Space Frequency Directory: The Radio Monitor's Guide to Eavesdropping on Satellites, Space Shuttles, Space Stations, Interplanetary Space Probes and Non-Human Signals From Deep Space
Anthony R. "Tony" Curtis, K3RXK

When your favorite bantam-weight, four-eyed, pubescent nephew of the electronically inclined variety no longer finds stimulation in the complete teachings of Sega-Genesis, teach him how to tune in and turn on to this "eclectic" assortment of 2,200 celestial frequencies which will make him a hit with all the neighborhood girls. Deep space is inherently erotic; just ponder these passionate syllables: "Kickapoo Lake TX, NAVSPUR ground-to-space radio fence, rsb" or "Navstar-26 GPS navsat Block 2-09 PRN-18 USA-50 20724." Oooh! **SK**

$17.95 *(PB/69)*

The Pirate Radio Directory
Andrew Yoder and George Zeller

Lists unlicensed, covert short-wave broadcasts that occurred in the USA in 1995. Learn about Witch City Radio, False Fake Radio, Radio Doomsday, Voice of Laryngitis and much more. The authors explain how to pick up pirate radio stations and a little about receiving equipment, and supply call numbers, an extensive list of stations and the subjects on which those stations focus. **MC**

$12.95 *(PB/72/Illus)*

Pirate Radio: The Incredible Saga of America's Underground,

Illegal Broadcasters
Andrew Yoder

Despite its subtitle, *Pirate Radio* is international in its scope, covering high-powered '60s legends like Britain's off-shore Radio Caroline and contemporary pirates like Russia's Romantic Space Radio (the voice of whose groovy DJ can be briefly heard on the accompanying CD). Most of the focus of this well-documented history and survey dating back to 1925 is on North American pirate radio, ranging the spectrum from AM and FM to shortwave illegal broadcasts. Some surprising FCC-baiters include the bluegrass station WHBH ("Hill Billy Heaven"); WEED (guess the format); Black Liberation Radio operated by an unemployed and blind black man from a housing project in Springfield, Ill.; WKAR ("Wisconsin Kick Ass Rock") emphasizing "Christmas parody music"; WXZR ("Meontological Research Radio") featuring industrial music and sound collage; the neo-Nazi "Voice of Tomorrow" with its distinctive wolf-howl interval signal; and WYMN ("Testosterone Free Radio") with a female folksinger format which has been broadcasting sporadically since 1984. *Pirate Radio* provides valuable resources such as a worldwide address list of mail drops for pirate operators and leads on where to obtain monitoring equipment and technical information. The CD which accompanies the book reveals to the neophyte just how strange and intriguing the ephemeral realm of pirate radio might actually be. **SS**

$29.95 *(PBw/CD/256/Illus)*

Radiotext(e): Semiotext(e)#16
Edited by Neil Strauss

Radiotext(e) is a thoroughly enjoyable compilation which examines broadcast sound both in its widest implications and specifically as a method of cultural insurrection and mass-consciousness alteration. Nearly devoid of the customary academic theory-speak oppressiveness which typifies this type of effort, it is an inspiring call-to-arms for Radio Rebellion at the moment when all media-corporate pundits' eyes are firmly on the lumbering information superhighway. Texts range from the internal documents of the Muzak corporation to accounts of anarchist pirate radio in Amsterdam. Contributors include: Leon Trotsky, sound-collage agitators Negativland, trance-music pioneer La Monte Young, Dadaist Kurt Schwitters, and the infamous brain-implant researcher José Delgado. **SS**

$12.00 *(PB/350)*

Scanners and Secret Frequencies
Henry L. Eisenson

This book is written with an unabashed enthusiasm for making technological eavesdropping available to us all, despite the latest federal government efforts to legislate it away. Eisenson is a specialist in covering electronic "gray markets" wherein it is legal to make, buy, sell or own the products but illegal to use them. Until 1993, it was

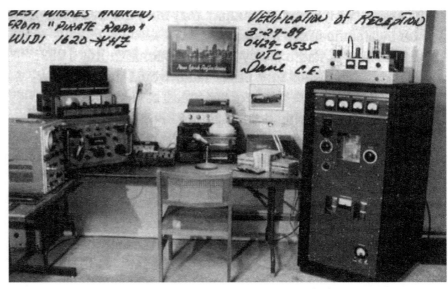

A photo QSL showing the studio (center), receiving and test equipment (left), and homebrew transmitter (right) of WJDI. — from **Pirate Radio**

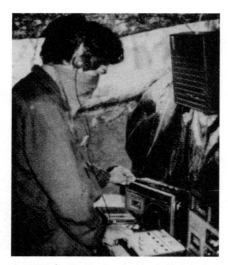

An RFM (Radio Farabundo Marti, El Salvador) worker makes adjustments to the program before it is transmitted. — from **Shortwave Clandestine Confidential**

perfectly legal to purchase and use scanners that could receive cordless or cellular phone calls or even listen to baby monitors. Now that all this is technically illegal, it seems like the right time to find out what you aren't allowed to do anymore and just what these Radio Shack "hobbyists" have really been up to.

Besides the exquisite pleasures of monitoring your neighbors' sleaziest private phone moments, the possibility also exists of tuning in *Air Force One* air-to-ground communication, frequencies for armored-truck companies like Brinks and Wells Fargo, and even a specially designated band for evangelical operations where one can listen to the internal organizational machinations of Sun Myung Moon, Jerry Falwell or the Church of Scientology. The writing style of *Scanners and Secret Frequencies* is far from dry: "For instance, if you hear a rumor about a reactor meltdown, switch to 165.6625 MHz. That frequency is shared between the Nuclear Regulatory Commission and Airport Security Nationwide, so if the nuclear inspectors start calling ahead to bypass airport security, it's time for you to hire a Piper Cub and scoot."

According to Eisenson, today's "hobbyist scanner" is technically superior to scanners built for the NSA "not that many years ago," and he would be in a position to know. *Scanners and Secret Frequencies* explains the basic principles of radio transmission, tells which brand of scanner the three-letter agencies are actually ordering, gives step-by-step instructions on how to hotrod specific scanners by brand name and provides

instructions on computer-assisted scanning, frequency list sources and other essential info for the budding surveillance freak. **SS**

$23.75 *(PB/320)*

Shortwave Clandestine Confidential
Gerry L. Dexter

DXers, in radio lingo, are armchair detectives bent on receiving "clandestine" signals from the most distant and forbidden shortwave stations: revolutionary stations, stations behind enemy lines in a war, stations run by the CIA or KGB, and so on. Tells the story of past clandestine stations: Radio Sandino (The Voice of the Sandinistas), Radio Liberation (Vietnam) and Radio Swan (an anti-Castro station, courtesy of the CIA). The book goes on to discuss currently popular DX listening targets in Libya, Chad, Ethiopia, Iraq, China, Burma, Poland, Sri Lanka, Cuba and many other turbulent countries. The trick with DXing is getting proof of what you hear, an all-important "verification" letter proving the station actually exists—which is no piece of cake to obtain, wartime or not. **GR**

$8.95 *(PB/84/Illus)*

So You Bought a Shortwave Radio: A Get-Acquainted Guide to the World of Shortwave
Gerry L. Dexter

A "get-acquainted guide to the wide world of shortwave," or, as it might be called, the poor man's Internet. Eavesdrop on spies and smugglers; hear Chinese opera, Swiss polkas, and South Seas chants. Tells how shortwave radios work, where to find the stations you want, how to hook up with other Hams, and how to join the "DXers"— patient listeners (DX is radio lingo for "distance") who prowl for the most distant frequencies possible, then send for station verifications, which then become "the stuff of collections." Contains plenty of addresses for more specialized information. **GR**

$6.95 *(Pamp/74/Illus)*

Underground Frequency Guide: A Directory of Unusual, Illegal and Covert Radio Communications
Donald W. Schimmel

Readers who have spent any time at all exploring the shortwave radio dial (DXing, in nerdspeak) have probably heard at least one of the many stations that broadcast, except for the occasional verbal non-sequitur, nothing but an endless series

of numbers in Spanish, English or German. What the heck is that about? Hmmm, let's see . . . there's no hideous Whitney Houston songs and the voice doesn't sound like Casey Kasem, so we can pretty much rule out the "American Top 40" countdown; no one ever says, "Breaker, breaker, good buddy," or "Bear in the air" so it's definitely not wayward CB radio transmissions. Well, wonder no more! Now there's a comprehensive (albeit vaguely speculative) guide to the mysterious world of "unusual, illegal and covert radio communications." The third edition of Donald Schimmel's *Underground Frequency Guide* not only gives all the information available on those "numbers" stations (usually coded espionage messages) but also many other bizarre shortwave anomalies. Find out which weird "beeps," "rasps" and "foghorns" are the clandestine communications of spies, smugglers or paramilitary guerrillas and which ones are just weird "beeps," "rasps," and "foghorns." **DB**

$14.95 *(PB/200/Illus)*

Uno, Dos, Cuatro: A Guide to the Numbers Stations†
Los Numeros: The Numbers Stations Log††
"Havana Moon"
Secret Signals: The Euro-Numbers Mystery†††
Simon Mason

The enigmatic numbers stations, with their seemingly random announcements of numbers, are something of a mystery, with their true purpose most likely being the transmission of briefings for the world's covert operatives. To the average outside listener, these long list of numbers, often on exotic frequencies and in foreign tongues, may be an interesting phenomenon but are ultimately just too dull for sustained listening. Surprisingly or perhaps inevitably, there is a small group of dedicated listeners obsessively documenting such broadcasts.

Here are cataloged such classics as:
1920- 019 Gr. 19
1925- 001 Gr. 12
1930- 281 Gr. 14
1940- 154 Gr. 17
1945- 993 Gr. 14
1950- 231 Gr. 13
—"The Russian Woman" March 20, 1991 in AM mode on 4425 kHz

These books give detailed lists of frequencies, times, and language and phonetic alphabets used, with example transmissions. **BW**

†**$14.95** *(PB/84)*
††**$4.00** *(Pamp/12)*
†††**$12.95** *(PB/70)*

revenge

"My first selection of original bumper stickers to be honored came from the Mad Bomber of Steubenville and his magic imagination of how to decorate a mark's car, home, or whatever.
- LEGALIZE [NAME A DRUG] NOW!
- HONK IF YOU LIKE [NAME SOME BIZARRE SEX ACT]
- KILL ROCK'N'ROLL
- I'M NO VIRGIN. ASK YOUR MOTHER.
- SATAN IS MY GOD
- I [HEART] LITTLE BOYS
- I EAT [NAME A COLOR OR ETHNIC GROUP] CHICKS [OR BOYS]

"Other friends sent in photos or sketches of bumper stickers they had made for their marks' cars. Here are a few:
- EAT SHIT, WATERMELON LIPS
- WHITE TRASH & REDNECKS FUCKING = EARTHWORM SNAILS

"Here is one of Dick Smegma's original designs, which, by the way, he also had reproduced as a business card, distributing a thousand in local airports, bars, store bulletin boards, etc. Dick says if the mark has an unlisted telephone number, it's even more fun. Here is his design:

DIAL A SHITHEAD . . . IT'S FUN!!
CALL (303) 555-6969 ASK FOR [NAME OF MARK]
CALL 24 HRS."

— from *Advanced Backstabbing and Mudslinging Techniques*

Craft Cast expanding foam resin. "This wondrous material consists of two separate chemicals. When they are mixed together, the stuff begins to expand, overflowing its original container until it has displaced approximately 25 times its original volume! . . . Fill an offending neighbor's burglar alarm bell with Craft Cast . . ." — from **High-Tech Harassment**

Advanced Backstabbing and Mudslinging Techniques

George Hayduke

"As every good Hayduker knows, any repressive society offers vast opportunities for excitement, humor and payback for those willing to assume minor risks on behalf of freedom and the repressed. For too many people, resignation to all of that repression is the lock on their lives. The ideas and the fun in my books are the key that will open that repressive lock. The tumblers of that lock of repression also respond to the picks of humor, satire and irony. Indeed, the great power of irony is its subtle and lasting effect. My idea is to lightly etch a lasting scar on your mark's memory (rather than the direct force of blunt, troglodyte trauma)." Easy-to-follow plans for fun with bumper stickers, a can of snakes, farts, homophobia, smegma, televangelists and more.

$14.95 (PB/176)

Get Even: The Video of Dirty Tricks

George Hayduke

Beginning with the inspiring motto "where the law stops, the vigilante begins," *Get Even: The Video of Dirty Tricks* is a rousing call-to-arms to "turn the tables on your tormentors" presented in the form of a psychotic infommercial. In episodes such as "Fecal Attraction!" and "Fowl Play," vengeance techniques are couched in sleazily endearing SCTV-style parodies ranging from the elementary (junk mail sign-ups, Krazy Gluing the locks) to the finer points of harassment. Hide a chicken bomb (raw chicken parts + milk, placed in a glass jar) in your enemy's couch; thrill to the knowledge that the noxious gases will deliver a putrid explosion a week later—"use chicken against the turkeys who try to keep you down, baby!" Low-tech electronic sabotage of asshole co-workers, bumper-sticker warfare, character assassination via the posting of flyers, as well as some cautionary CYA suggestions to stay clear of The Man should set the most long-suffering viewers on the payback trail. **SS**

$14.95 (VIDEO)

The CO$_2$ paintball gun. Like most things in life, it works better when you take the original idea and twist it just a little bit . . . — from **High-Tech Harassment**

Getting Even: The Complete Book of Dirty Tricks
George Hayduke
Original monkey-wrencher George Hayduke suggests scenarios for getting even with the irritating and the ignorant, whether they be land-raping multinationals, Uncle Sam, or the benighted befouler of a favorite shirt.

NN
$12.95 *(PB/208)*

Getting Even 2: More Dirty Tricks From the Master of Revenge
George Hayduke
More low-down, sneaky, disreputable, maddening and mostly illegal scenarios for payback time from George Hayduke, the "hyena in swine's clothing." **NN**
$12.95 *(PB/138)*

High-Tech Harassment: How To Get Even With Anyone, Anytime
Scott French
A big, nasty revenge book. "Can you really grab life and make it sit up and listen? Damn right you can! Unruly neighbors, barking dogs, trespassers, the local bank, corporate America and all those people who seem to feel their day will be special only if yours is ruined can be twisted, taught and made to toe the line with the creative use of cutting-edge equipment and expert ideas on how to bypass even the securest security measures!" Tricks range from clever to criminal, innocent to illegal. Why listen to "Can't we all just get along?" wimps like Rodney King. "Harness the forces of science and technology and exercise your God-given

right to get even with anybody, anytime."

GR
$14.95 *(PB/152/Illus)*

Make 'Em Pay: Ultimate Revenge Techniques From the Master Trickster
George Hayduke
"Eat a colorful portion of your meal," then swallow one ounce or less of a vomit-inducer that contains the pharmaceutical ipecac. "In about ten minutes you will be wracked by projectile vomiting. Be creative and use all your acting ability here to get maximum splatter and audience effect . . . move erratically and quickly among the other diners as you appear to be headed toward the bathroom. Your real objective, of course, is to strafe as many people as possible with your vomitus." And hundreds of other get-even tricks "to strike yet another blow for the little guy."

GR
$8.95 *(PB/209)*

Righteous Revenge: Getting Down to Getting Even†
Make My Day!: Hayduke's Best Revenge Techniques for the Punks in Your Life††
Mayhem: More From the Master of Malice†††
George Hayduke
Random recipes for revenge from a known bully-buster and his prankish allies—Captain Video, The Razor, Dick Smegma, Belzebubba, Magic Z, Biggus Piraphicus, The Gooch, Prairie Dog, et al. Learn to make vengeful use of common things like glue, trash, pornography, chicken parts, roadkill and grafitti. (Also learn how not to get caught!)

From *Mayhem*, under "Toilets": "Your mark goes into the stall, slips down his or her pants, slacks, skirts, whatever . . . You stoop smartly down in front of the stall door and very quickly, briskly, and with great vigor, grab the skirt, pants or whatever and yank them toward you as fast and hard as you can. The immediate goal is to totally depants your mark. Hopefully, this will include the

. . . and here's how to twist the paintball concept. A large-bore hypodermic needle can load and unload the gelatin balls as easy as one, two, three. And the leopard changed his spots. — from **High-Tech Harassment**

mark's underwear as well. You then leave the bathroom area, keeping the garments, giving them to some needy soul outside, or tossing them in the nearest waste receptacle.

"Meanwhile, what of the mark, sitting there with no pants, skirt, underwear, etc.? Yes, what of the mark? I know I'm laughing already." **GR**
†**$8.95** *(PB/229)*
††**$7.95** *(PB/211)*
†††**$7.95** *(PB/185)*

BATAILLE

Civilization in its entirety, *the possibility of human life*, depends upon a reasoned estimation of the means to assure life. But this life—this civilized life—which we are responsible for assuring, cannot be reduced to these *means*, which make it possible. Beyond calculated means, we look for the *end—or the ends*—of these means. . . .

The response to erotic desire—and to the perhaps most human (least physical) desire of poetry, and of ecstasy (but is it so decisively easy to grasp the difference between eroticism and poetry, and between eroticism and ecstasy?)—the response to erotic desire is, on the contrary, an end.

In fact, the search for means is always, in the last instance, reasonable. Searching after an end arises out of desire, which often defies reason.

In myself the satisfaction of a desire is often opposed to my interests. But I give in to it, for in a brutal way it has become for me the ultimate end! . . .

The essence of man as given in sexuality—which is his origin and beginning—poses a problem for him that has no other outcome than wild turmoil.

This turmoil is given in the "little death." How can I fully *live* the "little death" if not as a foretaste of the final death?

The violence of spasmodic joy lies deep in my heart. This violence, at the same time, and I tremble as I say it, is the heart of death: it opens itself up in me! . . .

From sensuous pleasure, from madness, to a horror without limits. . . . Which brings us to the forgetting of the puerility of reason! Of a reason that was never able to measure its limits.

These limits are given in the fact that, inevitably the *end* of reason, which exceeds reason, is not opposed to the *overcoming* of reason!

In the violence of the overcoming, in the disorder of my laughter and my sobbing, in the excess of rapture that shatters me, I seize on the similarity between a horror and a voluptuousness that goes beyond me, between an ultimate pain and an unbearable joy!

— Georges Bataille, from *Tears of Eros*

**The Absence of Myth:
Writings on Surrealism**
Georges Bataille
Collection of newly translated writings from the period of 1945-1951 when Bataille rose to the defense of Surrealism's place in history at the point where it seemed the most trivial and passé, eclipsed by Existentialism and Communism in the chic circles of the French intelligentsia. Despite being previously denounced as an "excremental philosopher" by the impulsive and tyrannical Breton, Bataille prophetically writes of Surrealism as a potentiality yet to be realized. He discusses Surrealism in religious terms as a "spiritual authority" and a "moral imperative" and compares the advent of Surrealism to the Renaissance in its importance. "No one, then, can fail to know that the clearest certainty of surrealism is to manage to rediscover the attitudes of mind that allowed primitive man to combine in ritual and, more precisely, to find in ritual the most incisive and tangible forms of poetic life." Also contains the memorable quote, ". . . the absolute authority of the instant is the amok . . ." **SS**
$27.95 (HB/224)

The Accursed Share: Volume 1†
The Accursed Share: Volumes 2 and 3††
George Bataille

The Accursed Share is Bataille's warped three-volume study of political economy. As Bataille described his project, "I had to add that the book I was writing did not consider the facts the way qualified economists do, that I had a point of view from which a human sacrifice, the construction of a church or the gift of a jewel were no less interesting than the sale of wheat." The first volume, titled "Consumption," looks at these questions from an economic standpoint, concluding that utility can only end in uselessness. The second volume, "The History of Eroticism," in sections such as "The Problem of Incest" and "Unlimited Fusion, the Orgy," takes an in-depth look at the uselessness of erotic life: "Sexuality, at least, is good for something, but eroticism . . . We are clearly concerned with a sovereign form that cannot serve any purpose." The third volume, then, takes up the question of sovereignty, and after an examination of feudal society and the negative sovereignty of communism, Bataille concludes that sovereignty lies in a life beyond utility. **AP**

†**$12.95** *(PB/197)*
††**$16.95** *(PB/460)*

Against Architecture: The Writings of Georges Bataille
Denis Hollier

An academic interpretation of the "profoundly original and radical nature of Bataille's work": "Bataille's Acephalus does not merely represent a grotesque celebration of upsides down and bottoms up, but the more abysmal image of a topless bottom. The concept of heterology, a neologism invented by Bataille, does not simply indicate a warm, euphoric relationship to otherness. Otherness, in other words, is not simply a matter of pleasure and enjoyment. There is no carnival without loss. No Luna Park without a slaughterhouse."

$14.95 *(PB/201)*

Encyclopedia Acephalica
Edited by Georges Bataille, et al.

"Assembles three sets of texts written by a number of writers associated with Georges Bataille, some of whom were members of his Acéphale group, others being members,

ACÉPHALE
RELIGION SOCIOLOGIE PHILOSOPHIE REVUE PARAISSANT 4 FOIS PAR AN
NUMÉRO DOUBLE *NIETZSCHE et les FASCISTES* 21 JANVIER
6 frs *UNE RÉPARATION* 1937
PAR G. BATAILLE · P. KLOSSOWSKI · A. MASSON · J. ROLLIN · J. WAHL

The first issue of Acéphale, *June 1936, drawing by André Masson — from* Encyclopedia Acephalica

or ex-members, of the Surrealist groups in Paris and New York. Apart from the presence of Bataille and his concerns, what unites these texts is their form, which derives from that of dictionaries or encyclopedias. . . . *The Critical Dictionary* appeared in the magazine *Documents*, edited by Bataille. The second series of texts, the *Da Costa Encyclopedia* was published anonymously by members of the Acéphale group and writers associated with the Surrealists after the liberation of Paris in 1947. Both cover the essential concepts of Bataille and his associates: sacred sociology; scatology, death and the erotic; base materialism; the aesthetics of the formless; sacrifice, the festival and the politics of tumult, etc.: a new description of the limits of being human.

Humor, albeit sardonic, is not absent from these remarkable redefinitions of the most heterogeneous objects or ideas: 'Camel,' 'Church,' 'Dust,' 'Museum,' 'Spittle,' 'Skyscraper,' 'Threshold,' 'Work'—to name but a few."

$19.99 *(PB/173/Illus)*

Erotism:
Death and Sensuality
Georges Bataille

Eroticism, unlike sexual activity, Bataille argues, "is a psychological quest and not alien to death." In *Erotism* he pursues his historical inquiry into the erotic through subjects ranging from orgies and witches' Sabbaths, trance possession and mystical ecstasy, cruelty and organized war, the notions of sin and religious sacrifice to taboo and death.

$12.95 *(PB/276/Illus)*

The Impossible:
A Story of Rats Followed
by Dianus and by the
Oresteia
Georges Bataille

"Like the fictional narratives of novels, the texts that follow—the first two at any rate—are offered with the intention of depicting the truth. Not that I'm led to believe they have a convincing quality. I didn't wish to deceive. Moreover there is not in principle any novel that deceives. And I couldn't imagine doing that in my turn better than anyone else. Indeed I think that in a sense my narratives clearly attain the *impossible*. To be honest, these evocations have a painful heaviness about them. This heaviness may be tied to the fact that at times horror had a real presence in my life. It may be too that, even when reached in fiction, horror alone still enabled me to escape the empty feeling of untruth . . . "

$10.95 *(PB/164)*

Inner Experience
Georges Bataille

"By *inner experience* I understand that to mean what one usually calls *mystical experience*, the states of ecstasy of rapture, at least of meditated emotion. But I am thinking less of *confessional* experience, to which one has had to adhere up to now, than of an experience laid bare, free of ties, even of an origin, of any confession whatever. This is why I don't like the word *mystical* . . . We are totally laid bare by pro-

ceeding without trickery to the unknown. It is the measure of the unknown which lends to the experience of God—or of the poetic—their great authority. But the unknown demands in the end sovereignty without partition."

$18.95 *(PB/209)*

L'Abbé C
Georges Bataille

Charles and Robert are twin brothers. Charles is a modern libertine dedicated to vice and depravity; Robert is a priest so devout that he is nicknamed "L'Abbé." Charles tries to arrange for his mistress to sleep with the saintly brother. Despite

Charles' strong encouragement and the exhortations of his lover, Robert persistently refuses to succumb to the erotic obsessions shared by all three protagonists. As the story progresses, the suffocating atmosphere becomes increasingly permeated with illness, breakdown and eventual death.

$12.95 *(PB/158)*

Laure:
The Collected Writings
Laure

"Laure (1903-1938) was a revolutionary poet, masochist, Catholic rich girl, world traveler. Toward the end of her life she became the lover of French writer Georges

Georges Bataille circa 1933 — from Encyclopedia Acephalica

Bataille. Her writings and her life story were remarkable in their violence and intensity, and her relationships with Bataille and Michel Leiris clearly influenced their works. This complete collection of writings published for the first time in English includes 'Story of a Little Girl,' about the Catholic priest who sexually molested her sister; 'The Sacred,' a collection of poems and fragments on mysticism and eroticism; notes on her association with Contre-Attaque and Acéphale, and her involvement with the Spanish Civil War and the early years of the Soviet Union; a compendium of correspondence with her beloved sister-in-law, and tortured love letters to Bataille; and an essay by Bataille about Laure's death of tuberculosis at the age of 35."

$13.95 *(PB/314)*

Literature and Evil
Georges Bataille
Essays about the value of Evil in literature, not as a negation of conventional morality but as a means of attaining experience beyond morality. The writers considered include Baudelaire, Genet, Kafka, Blake, de Sade and Proust.

$13.95 *(PB/208)*

My Mother, Madame Edwarda and the Dead Man
Georges Bataille
The novella *My Mother*, which remained unfinished but is concluded with Bataille's posthumous notes, is about a young man's sexual initiation and corruption by his mother. In *Madame Edwarda*, a man becomes erotically obsessed with an old whore who turns out to be God. *The Dead Man* recounts a young woman's journey from the deathbed of a friend to orgiastic excesses in the taproom of a rural inn. Contains Bataille's own introduction to the texts as well as an introductory essay by Yukio Mishima, who rated Bataille one of the three Western authors he most admired.

$19.95 *(PB/224)*

On Nietzsche
Georges Bataille
Bataille's bleak personal journals written while he was waiting out the Nazi occupation of France in the countryside, constructed as a dialogue between himself and excerpts from Nietzsche's writings. Racked with self-doubt and far removed from the

icy ecstasy of his idol's words and his own later writings he noted: "Making my inner experience a project: doesn't that result in a remoteness, on my part, from the summit that might have been?" **SS**

$12.95 *(PB/256)*

Story of the Eye
Georges Bataille
"The entire *Story of the Eye* was woven in my mind out of two ancient and closely associated obsessions, eggs and eyes." First published in 1928 under the pseudonym "Lord Auch," this brilliantly lyrical pornographic novel from the young Bataille forecasts his later theories about ecstasy, death and transgression in the form of sharply obsessive fantasies of excess, ritualistic violence and sexual extremes. "Thus two globes of equal size and consistency had suddenly been propelled in opposite directions at once. One, the white ball of the bull, had been thrust into the 'pink and dark' cunt that Simone had bared in the crowd; the other, a human eye, had spurted from Granero's head with the same force as a bundle of innards from a belly. This coincidence, tied to death and to a sort of urinary liquefaction of the sky, first brought us back to Marcelle in a moment that was so brief and almost insubstantial, yet so uneasily vivid that I stepped forward like a sleep-walker as though about to touch her at eye level."

$7.95 *(PB/92)*

The Tears of Eros
Georges Bataille
The culmination of Bataille's inquiries into the relationship between violence and the sacred. Taking up such figures as Gilles de Rais, Erzébet Báthory, the Marquis de Sade, El Greco, Gustave Moreau, André Breton, voodoo practitioners and Chinese torture victims, Bataille reveals their common obsession: death. This essay, illustrated with artworks from every era, examines the "little death" that follows sexual climax, the proximate death in sadomasochistic practices, and death as part of religious ritual and sacrifice.

$14.95 *(PB/213/Illus)*

Theory of Religion
Georges Bataille
"*Theory of Religion*, along with its companion volumes of *The Accursed Share*, forms the cornerstone of Bataille's 'Copernican' project to overturn not only economic thought but its ethical foundations as well. . . . He proceeds to develop a 'general economy' of man's relation to this intimacy: from the seamless immanence of animality, to the shattered world of objects, and the partial, ritual recovery of

These are photographs of the voodoo ceremonial as it is practiced today in certain regions of America, where it developed among black slaves. — from **Tears of Eros**

the intimate order through the violence of the sacrifice. Bataille then reflects on the archaic festival in which he sees not only the glorious affirmation of life through destructive consumption but also the seeds of another, more ominous order—war. Bataille then traces the rise of the modern military order in which production ceases to be oriented toward the destruction of a surplus and violence is no longer deployed inwardly but is turned to the outside. In these twin developments may be seen the origins of modern capitalism."

$11.95 *(PB/127)*

The Thirst for Annihilation: Georges Bataille and Virulent Nihilism
Nick Land

"An accomplished sociologist, philosopher, literary theorist and fiction writer, who referred to himself as 'saint, perhaps a madman,' Georges Bataille made a habit of exploding the categories which we use to impose order upon the business of everyday life. This strange, yet lucidly written book is not so much an interpretation of Bataille's work but rather a no-holds-barred attempt to pursue Bataille's ideas to their conclusions. The result is an analysis of Bataille through the application of his style of thought and ideas rather than through conventional argument."

$29.95 *(PB/272)*

The Trial of Gilles de Rais
Georges Bataille

Bataille presents the case of the most infamous villain of the Middle Ages, Gilles de Rais. He examines with dispassionate clarity the legendary crimes, trials and confessions of this grotesque and still-horrifying 15th-century child-murderer, sadist, alchemist, necrophile and practitioner of the black arts. Gilles de Rais began his remarkable career as lieutenant to the devout martyr and saint Joan of Arc; after her execution he fled to his estates in the countryside of France, where he began to ritually slaughter hundreds of children. After his arrest and subsequent trials, he was hanged and burned at Nantes, France, on October 25, 1440. The latter section of *The Trial of Gilles de Rais* consists of actual ecclesiastical and secular trial transcripts annotated by Bataille and translated from the ecclesias-

Sacred site in Lithuania. The crosses planted by the peasants only perpetuate the meaning of a pagan tumulus where sacrifices were carried out. — from **Visions of Excess**

tical Latin by Pierre Klossowski.

$14.95 *(PB/281)*

Visions of Excess: Selected Writings, 1927-1939
Georges Bataille

"It is in this collection of prewar writings that Bataille's positions are most clearly, forcefully and obsessively put forward. Included are Bataille's polemics against André Breton; his conception of his own project as a kind of intellectual offal defying both idealism and traditional materialism; the rethinking of Marxism; the revalorization of de Sade and Nietzsche; the unrelenting critique of fascism and of a reductive Hegelian dialectic. . . . In the process, he comes to recognize the need for a 'science of the heterogeneous" that posits what is, strictly speaking, *impossible*: the individual and collective *experience* of the unassimilable waste products of the individual body, of society, of thought and of bourgeois industrial economies. Excrement, madness, poetry, automutilation, mystical trances, obscenity, unlimited proletarian revolution—all are taken up in these writings and considered in the context of an expenditure moving beyond all bounds."

$15.95 *(PB/271)*

The Whip Angels
Anonymous (Diane Bataille)

Hardcore filth by Georges' wife! And the crowd goes wild! This was originally published by the Paris Olympia Press in 1955 using one of the shortest (and finest) pseudonyms in the history of smut: "XXX." Why it was written is anybody's guess. It was published seven years before the death of Georges Bataille, at a point when he had conquered most of the controversy and arrived at the position of a grand old guy of letters, complete with the appropriate financial security, so it wasn't like they needed the money. . . . Neither Kearney, De St. Jorre nor Girodias have much more than this to say about the book in any of the tomes on Olympia. **JK**

$9.95 *(PB/192)*

NIETZSCHE

Why I Am a Destiny

I know my fate. One day there will be associated with my name the recollection of something frightful—of a crisis like no other before on Earth, of the profoundest collision of conscience, of a decision evoked *against* everything that until then had been believed in, demanded, sanctified. I am not a man I am dynamite. —And with all that there is nothing in me of a founder of a religion — religions are affairs of the rabble, I have need of washing my hands after contact with religious people . . . I do not *want* "believers," I think I am too malicious to believe in myself, I never speak to masses . . . I have a terrible fear I shall one day be pronounced *holy*: one will guess why I bring out this book *beforehand*; it is intended to prevent people from making mischief with me . . . I do not want to be a saint, rather even a buffoon . . . Perhaps I am a buffoon . . . And nonetheless, or rather *not* nonetheless—for there has hitherto been nothing more mendacious than saints—the truth speaks out of me. But my truth is *dreadful*: for hitherto the *lie* has been called truth. —*Revaluation of all values*: this is my formula for an act of supreme coming-to-oneself on the part of mankind which in me has become flesh and genius. It is my fate to have to be the first *decent* human being, to know myself in opposition to the mendaciousness of millennia . . . I was the first to *discover* the truth, in that I was the first to sense—*smell*—the lie as lie . . . My genius is in the nostrils . . . I contradict as has never been contradicted and am nonetheless the opposite of a negative spirit. I am a *bringer of good tidings* such as there has never been, I know tasks from such a height that any conception of them has hitherto been lacking; only after me is it possible to hope again. With all that I am necessarily a man of fatality. For when truth steps into battle with the lie of millennia we shall have convulsions, an earthquake spasm, a transposition of valley and mountain such as has never been dreamed of. The concept of politics has then become completely absorbed into a war of spirits, all the power-structures of the old society have been blown into the air—they one and all reposed on the lie: there will be wars such as there have yet been on Earth. Only after me will there be *grand politics* on Earth.

— Friedrich Nietzsche, from *Ecce Homo*

Beyond Good and Evil: Prelude to a Philosophy of the Future
Friedrich Nietzsche
A sampling of epigrams:

"There are no moral phenomena at all, only a moral interpretation of phenomena.

"The great epochs of our life are the occasions when we gain the courage to rebaptize our evil qualities as our best qualities.

"That which an age feels to be evil is usually an untimely after-echo of that which was formerly felt to be good—the atavism of an older ideal."
$5.95 *(PB/240)*

The Birth of Tragedy and The Genealogy of Morals
Friedrich Nietzsche
"*The Birth of Tragedy* (1872) was Nietzsche's first book, *The Genealogy of Morals* (1887) one of his last. Though they span the career of this controversial genius, both address problems such as the conflict between moral versus aesthetic approaches to life, the effect of Christianity on human values, the meaning of science, and the famous dichotomy between the Apollonian and

Dionysian spirits, among many themes with which Nietzsche struggled throughout his tortured life."

$8.95　　　　　　　　(PB/299)

Daybreak: Thoughts on the Prejudices of Morality
Friedrich Nietzsche

"Do not think for a moment that I intend to invite you to the same hazardous enterprise! Or even only to the same solitude! For he who proceeds on his own path in this fashion encounters no one: That is inherent in 'proceeding on one's own path.' No one comes along to help him: all the perils, accidents, malice and bad weather which assail him he has to tackle himself . . . I descended into the depths, I tunneled into the foundations, I commenced an investigation and digging out of an ancient *faith*, one upon which we philosophers have for a couple of millennia been accustomed to build as if upon the firmest of all foundations—and have continued to do so even though every building hitherto erected on them has fallen down: I commenced to undermine our faith in morality. But you do not understand me?"

$17.95　　　　　　　　(PB/233)

Ecce Homo
Friedrich Nietzsche

Late in 1888, only weeks before his mental collapse, Nietzsche set out "with a cynicism which will become world-historic" to narrate his own story.

$4.95　　　　　　　　(PB/144)

The Gay Science
Friedrich Nietzsche

Nietzsche called *The Gay Science* "the most personal of my books." It was here that he first proclaimed the death of God—to which a large part of the book is devoted—and his doctrine of eternal recurrence.

$9.00　　　　　　　　(PB/396)

Hammer of the Gods
Friedrich Nietzsche

"Presents Nietzsche's most prophetic, futuristic and apocalyptic philosophies and traces them against the upheavals of the last century and the current millennial panic. This radical reinterpretation sees Nietzsche as the true guide to the madness in our society which he himself diagnosed a century ago; Nietzsche as a philosopher

Above Airolo, on the southern side of the St. Gotthard Pass — from The Good European

against society, against both the state and the herd; Nietzsche as philosopher with a hammer."

$14.95　　　　　　　　(PB/256)

Human, All Too Human: A Book for Free Spirits
Friedrich Nietzsche

This work marked for Nietzsche a new "pos-

itivism" and skepticism with which he challenged his previous metaphysical and psychological assumptions.

$16.95　　　　　　　　(PB/312)

My Sister and I
Friedrich Nietzsche

The revised and updated edition of Nietzsche's disputed final work, including

textual research supporting its authenticity and translations of his final correspondence. Reportedly written in the mental institution at Jena following his celebrated mental collapse in Turin, and smuggled out by a fellow inmate to avoid the tyrannical eye of his sister (with whom he confesses to an incestuous relationship), *My Sister and I* is a reflective counterpoint to the megalomania and stridency of *Ecce Homo*.
$14.95 *(PB/255/Illus)*

On the Advantage and Disadvantage of History for Life
Friedrich Nietzsche

"The surfeit of history of an age seems to me hostile and dangerous to life," Nietzsche says midway through this, the second of his *Unzeitgemässe Betrachtungen* (*Untimely Meditations*), written only a year after his first book, *The Birth of Tragedy* was published in 1872. In this early work, Nietzsche warns his fellow 19th-century Europeans—newly drunk on the study of history—of the dangers of too much historical knowledge gained second-hand. These dangers, Nietzsche says, include the tendency to believe that we are late-comers, that everything has already been done; conversely that, with our knowledge we are the wisest of all ages; and the tendency to look backward for models on which to base our present conduct—in other words, imitation of dead heroes. Against this "decadent" reliance on dusty books, Nietzsche posits a "healthy-minded" psychological balance between digested historical knowledge and a kind of "willed forgetfulness"—that is, originality—in present-day conduct.

Despite the emphasis on history, one gets a glimmer here of Nietzsche's later, fully developed *Lebensphilosophie* (philosophy of life), in this case a sort of "history-for-life." Also contained in this rich essay are other "seeds" of Nietzschean themes that would be explored in later works: eternal recurrence, the critique of Christianity and German chauvinism (and this was written only two years after the Prussian victory over France!). In his questioning of "objectivity" Nietzsche seems to be taking an historical/relativist position. His warning against the feeling of modern man that his is an inevitable "evening" time finds echoes (however differently asserted) in his alleged "disciple" Spengler. A sheer delight! **TM**
$4.95 *(PB/64)*

Nietzsche in Basel, taken in late autumn 1873 — from The Good European

Thus Spoke Zarathustra
Friedrich Nietzsche

Nietzsche's only novel, a spiritual odyssey through the modern world:

"And Zarathustra thus spoke to the people: *I teach you the Superman.* Man is something that should be overcome. What have you done to overcome him?

All creatures hitherto have created something beyond themselves: And do you want to be the ebb of this great tide, and return to the animals rather than overcome man?

What is the ape to man? A laughing-stock or a painful embarrassment. And just so shall man be to the Superman: a laughing-stock or a painful embarrassment.

You have made your way from worm to man, and much in you is still worm. Once you were apes, and even now man is more of an ape than any ape.

But he who is the wisest among you, he also is only a discord and hybrid of plant and of ghost. But do I bid you become ghosts or plants?

Behold, I teach you the Superman."
$5.95 *(PB/352)*

The Twilight of the Idols and The Anti-Christ
Friedrich Nietzsche

The Twilight of the Idols summarizes

Nietzsche's views on nearly the whole range of his philosophical investigations: "There are more idols in the world than there are realities: that is *my* 'evil eye' for this world, that is also my 'evil ear' For once to pose questions here with a *hammer* and perhaps to receive for answer that famous hollow sound which speaks of inflated bowels—what a delight for one who has ears behind his ears—for an old psychologist and pied piper like me, in presence of whom precisely that which would like to stay silent *has to become audible* . . . "

The Anti-Christ, written immediately afterward, is his least restrained polemic against Christianity: "Wherever there are walls I shall inscribe this eternal accusation against Christianity upon them—I can write in letters which make even the blind see. . . . I call Christianity the *one* great curse, the *one* great intrinsic depravity, the one great instinct for revenge for which no expedient is sufficiently poisonous, secret, subterranean, *petty*—I call it the *one* immortal blemish of mankind . . . "
$5.95 *(PB/208)*

Will to Power
Friedrich Nietzsche

A selection from Nietzsche's notebooks assembled posthumously by his sister,

Elisabeth, in a topical arrangement: nihilism, art, morality, religion, the theory of knowledge, etc.
$15.00 *(PB/575)*

Forgotten Fatherland: The Search for Elisabeth Nietzsche
Ben Macintyre

"This book is the story of two journeys, one through a remote, largely forgotten part of central South America, the other through the thickets of the vast, sometimes impenetrable literature which surrounds Friedrich Nietzsche: both were in search of his sister, Elisabeth. . . . The story of Elisabeth Nietzsche is important partly because of the effect she had on her brother and his philosophy, both during his life and most emphatically after his death. She made him famous and she made him infamous; with her connivance, his name became associated with Nazism; but without her, he might never have been heard of at all outside a small circle of scholars. But her life is also illuminating in itself. Her ideas foreshadowed one of the darkest periods in human history, but for more than 40 years she enjoyed fame and wealth as one of Europe's foremost literary figures; no woman, except perhaps Cosima Wagner, was more celebrated in the cultural world of prewar Germany. . . .

Most fascinating of all to me was the unwritten story of New Germany, the racist colony Elisabeth helped to found in the

Lou von Salomé, Paul Rée and Friedrich Nietzsche, May 13, 1882 — from My Sister and I

Nietzsche's room in the house of Gian Durisch at Sils-Maria — from The Good European

middle of South America over a century ago. That community was a reflection and realization of those beliefs—anti-Semitism, vegetarianism, nationalism, Lutheranism—which Elisabeth shared with her husband, Bernhard Förster, one of the most notorious anti-Semitic agitators of his day. Elisabeth later tried to graft these ideas on to Nietzsche, the anti-anti-Semite, anti-nationalist and self-proclaimed 'Anti-Christ.' A measure of her success is the fact that Nietzsche's name has still not fully shaken off the taint of fascism."
$12.00 *(PB/256/Illus)*

The Good European: Nietzsche's Work Sites in Word and Image
David Farrell Krell Donald L. Bates

"Philosopher Krell and internationally recognized photographer/designer/architect Bates have teamed up to produce a stunning, visual biography of Nietzsche that focuses on the sites where he worked and on the significance of 'place' for his thought. In 217 black-and-white and color prints, including 44 from Nietzsche's own collection, Krell and Bates lead the reader along the trajectory of Nietzsche's life, presenting for the first time the visual aspect of his philosophy. Many of the included passages from Nietzsche appear here in translation for the first time, and all have been newly translated. The result is not merely an illustrated biography, but an aesthetic reve-

lation as to why Nietzsche thought of himself as a 'good European.'"
$65.00 *(HB/256/Illus)*

The Nietzsche Legacy in Germany, 1890-1990
Steven E. Aschheim

Pursues the issue of ideological appropriation of Nietzsche by the Nazis, the avant-garde, socialists of the Right and Left, and thinkers like Heidegger, Jung, Mann, Rosenberg, Derrida, and others. A good introduction to, and analysis of, some of Nietzsche's most meaningful thoughts: his critique of enlightenment, rationality, philosophical humanism, middle-class values, Christianity and its slave morality, and academia; and his emphasis on life, will to power, and cultural totality. Provides valuable insights into how these thoughts became national policy in the Third Reich, and the ideological foundation for some of the 20th century's greatest thinkers: "Man is Beast and Overbeast: the higher man is Nonman and Overman: these belong together. With every growth of man in greatness and height, there is also a growth in depth and terribleness: one should not will the one without the other—or rather: the more radically we will the one, the more radically we achieve precisely the other."—Heidegger. **BS**
$40.00 *(HB/368/Illus)*

Amok Books

Amok Journal: Sensurround Edition
Edited by Stuart Swezey

A compendium of psycho-physiological investigations compiled from the furthest reaches of forensic medicine, sexology, psychiatry, anthropology and hard science research. The focus of this compilation is the pursuit of a neurobiological basis for mystical and ecstatic experience. The *Amok Journal: Sensurround Edition* brings together accounts of the search for the erotic in the mechanical, the sublime in the visceral, and the spiritual in the electromagnetic, from explorations of the subtle effects of infrasound to death-defying grasps at the ultimate orgasm. The field of inquiry is the prodigious psychic démi-monde of hallucination, schizophrenia, religious fervor, ecstatic possession, sexual obsession, mass hysteria and private ritual, as documented by the rational methodology of science. Heavily and graphically illustrated.

Topics include:

- Autoerotic fatalities
- Self-mutilation/amputee fetish
- Infrasound
- Trepanation
- Mondo Film
- Cargo cults
- Neue Slowenische Kunst
- Psych-out

"It belongs alongside Krafft-Ebbing's *Psychopathia Sexualis* and Bataille's *Erotism: Death and Sensuality* in any well-appointed library of the unusual."
— *Bay Guardian*

"Swezey's anthology is in fact more than the sum of its parts, which are indeed profoundly esoteric. . . . When taken together, these detailed profiles form a commentary on the risks of individuality, conformity and desire. . . . It reminds us, participants in an artistic and political culture, that we need to constantly and expansively examine human experience afresh in order to reveal what is epic, and meaningful. How shocking, indeed." — *Buzz*

$19.95 *(PB/488/Illus)*

Severed: The True Story of the Black Dahlia Murder
By John Gilmore

The grisly 1947 murder of aspiring starlet and nightclub habitué Elizabeth Short, known even before her death as the "Black Dahlia," has over the decades transmogrified from L.A.'s crime of the century to an almost mythical symbol of Hollywood Babylon/film noir glamor-cum-sordidness. *Severed*, the first true-crime book published on the strangest of all "unsolved" murders in the annals of modern crime, offers the documented solution to the case as endorsed by law enforcement and forensic science experts. It is appropriate that hard-boiled, Hollywood-born author John Gilmore, whose father was an LAPD officer at the time of the murder, should be the one to unravel the multilayered mystery of this archetypal Los Angeles slaying, having begun his painstaking investigations into the case over 35 years ago.

With his hauntingly evocative prose, Gilmore tells several previously unrevealed stories at once, each filled with its own bizarre elements, which transcends the true crime genre. One is the tale of victim Elizabeth Short, small-town beauty queen with big hopes who seemed to float through her tragically futile life, already an alluring yet doom-laden enigma. Another is the tangled inside story of the police investigation and remorseless Hearst-stoked press hoopla which paralleled it.

Finally, Gilmore reveals the twisted psychology and down-and-out life story of the actual murderer—as well as the startling circumstances and gruesome details of the killer's indirect confessions to him. *Severed* contains a 32-page photo section with many never-before-published photos from the life of Elizabeth Short and from the case including graphic crime scene and post-mortem police photos.

"The most satifying and disturbing conclusion to the Black Dahlia case. After reading *Severed*, I feel like I truly know Elizabeth Short and her killer." — **David Lynch**

"My god this is a frightening tale . . . The most famous murder in L.A., and we suddenly see that we knew nothing before, only the glitter and red of blood. This is now a Pandora's Box." — **Kenneth Anger**

$16.95 *(PB/288/Illus)*

Laid Bare: A Memoir of Wrecked Lives and the Hollywood Death Trip
By John Gilmore

Acclaimed as a powerful chronicler of the American Nightmare through his gripping examinations of near-mythic Southern California murders (the Black Dahlia, Tate-LaBianca), author John Gilmore now draws upon his own reservoir of personal experiences to turn his sights on our morbid obsession with Celebrity and the ruinous price it exacts from those who would pursue it. Literally born and raised in Hollywood, offspring of an LAPD officer dad and a former starlet mom, John Gilmore has delved into the seamy underbelly of Fame in a plethora of guises: as child actor, stage and screen bit-player, screenwriter, journalist, pulp novelist, low-budget film director and true crime writer.

With caustic clarity and 20/20 hindsight, Gilmore unstintingly recounts his relationships with the likes of **Janis Joplin, Dennis Hopper, Jack Nicholson, Jane Fonda, Jean Seberg** and **Lenny Bruce** both on the way up and at the peaks of their notoriety. As a method-acting buddy of **James Dean**, Gilmore reveals his role in Dean's attempts to push the bounds of sexual experimentation and in his legendary fascination with speed, violence and death. In *Laid Bare*, Gilmore describes his illuminating and often haunting first-hand encounters with **Hank Williams, Ed Wood, Jr., Brigitte Bardot, Sal Mineo, Eartha Kitt, Charles Manson, Vampira, Mickey Cohen, Steve McQueen** and many other denizens of the twentieth century's dubious Pantheon. With hip, vivid prose Gilmore infuses new life into such legend-enshrouded Hollywood haunts as the lunch counter at Schwab's, the Garden of Allah nightclub and Googie's on the Sunset Strip. *Laid Bare* is strikingly illustrated with many heretofore-unseen photos from John Gilmore's personal collection.

"John Gilmore deals with mythically familiar subjects, but not to turn them inside out. Instead he boils off the myth and shows you how things really were, and what things felt like to the

people living what later became a myth. You will encounter no received ideas, no clichés, no deference to popular myths or opinions, and best of all, no lies. He's an amazing writer, and *Laid Bare* is his most astonishing book." — **Gary Indiana**

"Reads like a first-person *Hollywood Babylon*" — **V. Vale, V/Search Publications**

$16.95 *(PB/250/Illus)*

Howard Street
By Nathan Heard

Originally published in 1968, this is the searingly powerful first novel written inside Trenton State Penitentiary and based on the authentic first-hand Newark street experiences of one of the most accomplished living African-American writers. *Howard Street* is a uniquely powerful combination of the hard-earned insight into the ghetto world of pimps, 'hos, junkies, dope dealers, winos, corrupt cops, and young hoodlums of such "black experience" legends as Donald Goines and Iceberg Slim, with the disciplined and inspired pulp prose of Jim Thompson, Charles Willeford or Chester Himes.

"When I finished reading Nathan C. Heard's novel Howard Street for the first time, I felt that I'd been living under a cultural rock for too long. I'd read Richard Wright, Ralph Ellison, Malcolm X, and other great black male "individualist" writers. . . . Reading *Howard Street*, an American tragedy of Shakespearean quality and dimension, made me realize that I hadn't begun to dig shit." — *African American Review*

"A great American novel." — *i.d.*

"In *Howard Street* there were indications of a great author who could portray such profound pathos in his characters that a reader sensed the reincarnation of Richard Wright and a nightmarish William Faulkner of the American ghetto." — **Claude Brown**, author of *Manchild in the Promised Land*

"He is a writer, no question about that. An almost frightening one—his hatred and violence are so intense." — Henry Miller

$10.95 *(PB/248)*

A Cold Fire Burning
By Nathan Heard

A Cold Fire Burning brilliantly depicts an interracial love story amidst the political changes of the early Seventies. Shadow is a working-class black man in the ghetto of Newark, NJ. An affair with Terri, a liberal white woman who works at a storefront drug rehab center, begins to throw his sense of the world into turmoil. When the racial and psychosexual tensions inherent in their relationship finally reach the boiling point, Shadow rejects Terri and everything she represents to him and winds up the leader of a rag-tag band of would-be black nationalist urban guerillas. Tragedy ensues when Shadow tries to transform their revolutionary rhetoric into reality on the harsh streets of Newark.

"We have read James Baldwin's smoldering fire; we have witnessed Donald Goines' heat and smoke; now it is time to attend to the burning molotov cocktail Nathan Heard thrust into our hands so many years ago—we, too have a choice: let it explode in our faces or fling it away in fear. In either case, believe me, it's going to blow." — *Midwest Bookseller*

"A gripping, insightful, and wonderfully cynical novel that avoids the obvious clichés and soapboxes . . . Black experience novels don't get any better than this." — **John Marr, Bay Guardian**

"A sexually explicit satire of ignorance in all walks of life. More ambitious and realistic than Spike Lee's film *Jungle Fever* in that its black male and white female—the novel's problematic couple—come into their relationship with equal helpings of prejudice and minimal stereotypical qualities . . ." — *African American Review*

"Heard's erotically explosive novel is an ambitious and colorful work which looks to analyze as much as entertain on the race issue." — *Big Issue*

$10.95 *(PB/146)*

The Trial of Gilles de Rais
By Georges Bataille

Georges Bataille presents the case of the most infamous villain of the Middle Ages: Gilles de Rais. Fascinated with the depths of human experience—the meeting points of sexuality, violence, ritual, spirituality, and death—Bataille examines with dispassionate clarity the legendary crimes, trials and confessions of this grotesque and still-horrifying 15th-century child-murderer, sadist, alchemist, necrophile and practitioner of the Black Arts.

Gilles de Rais began his remarkable career as lieutenant to the devout martyr and saint Joan of Arc; after her execution, he fled to his estates in the countryside of France, where he began to ritually slaughter hundreds of children. After his arrest and subsequent trials, he was hanged and burned at Nantes, France on October 25, 1440. The latter section of *The Trial of Gilles de Rais* consists of the actual ecclesiastical and secular trial transcripts, annotated by Bataille, and translated from the ecclesiastical Latin by Pierre Klossowski.

"This book about the notorious 15th-century serial killer of young children, written by France's famous connoisseur of transgression—the man the surrealist André Breton labeled an 'excremental philosopher'—represents a marriage not made in heaven, perhaps, but surely nowhere on this earth . . . the fact is that *The Trial of Gilles de Rais* gives us Bataille at his most accessible—he had been trained as a medievalist librarian, after all—and is probably, taken in its entirety, the best thing now available in English on one of the most bizarre figures in European history." — *New York Times Book Review*

$14.95 *(PB/285)*

The Garbage People: The Trip to Helter Skelter and Beyond With Charlie Manson and the Family
By John Gilmore and Ron Kenner

Random murder and savage overkill, mind control and trips, satanism and witchcraft, cursed glamor, Haight Ashbury, rock'n'roll, biker gangs, sexual rebellion and dune buggies tearing across Death Valley in search of the "hole in the earth". . .

The persona of Charles Manson and his bizarre sway over the Family remain riveting to the public a quarter century down the line. *The Garbage People* is a gripping account of one of the most chilling and fascinating crime sagas of our time, now available in a revised and updated edition containing 32 pages of previously unpublished and very graphic crime scene and postmortem documentation photos showing the aftermath of the Family's frenzied brutality. New vectors into the kaleidoscopic tale which spins inexorably out of the slayings emerge in this updated edition with new material on killer Bobby Beausoleil and his occult alliance with experimental filmmaker Kenneth Anger. Also included are rarely seen images of life in the Family prior to the murders and through to the present, important locations and personalities, and the radiant beauty of slain actress Sharon Tate.

"Where does the garbage go, as we have tin cans and garbage alongside the road, and oil slicks in the water, so you have people, and I am one of your garbage people."
— Charles Manson, 1969

"Fascinating!" — *Library Journal*

"Vividly recounts in the Manson Family's own words the harrowing story of the Manson murders and Manson's bizarre life" — *Los Angeles Times Book Review*

$14.95 *(PB/190/Illus)*

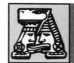
Behold!!! The Protong
By Stanislav Szukalski
Introduction by Robert Williams

Stanislav Szukalski (1896-1987) has been heralded as the greatest unrecognized artist of the twentieth century, acknowledged by cognoscenti as a sculptor on a par with da Vinci and Rodin. Szukalski was also a visionary who invented his own mystical anthropology, which he termed Zermatism, in which he proved to his satisfaction that all human culture, language, and pictography share a common origin. In *Behold!!! The Protong*, Szukalski illustrates his thesis of the Protong (or "first language") with his transcendently beautiful drawings and distinctive prose.

Born in Poland, Stanislav Szukalski was discovered as a sculptural prodigy soon after his family immigrated to Chicago where he was hailed by Ben Hecht in his *Child of the Century* as the world's greatest living artist. In 1936, Szukalski returned to Poland where he was honored with a Szukalski National Museum which was soon after obliterated by the Germans in the blitzkrieg. Szukalski then returned for the remainder of his life to Los Angeles where he further developed his philosophy of Zermatism. Yet Szukalski continued to believe in a messianic role for his native Poland in world history. In his later years of obscurity, Szukalski was championed by archivist Glenn Bray, painter Robert Williams and psychedelic cartoonist Rick Griffin, who spread his ashes on Easter Island in tribute to his genius.

"Szukalski is the silent player of that sacred yet godless chord upon the human soul . . . It is a voiceless song of utter compassion echoing like a disembodied lost spirit out of the dark and bottomless well of human concern and immortal, immutable dignity. I suppose it is the depth of Szukalski's work, the labor of his intensive digging down into his soul as well as the primordial ooze of prehistoric civilization which unleashed this effervescent sparkling pure fountain of youth in his art" — Carlo McCormick

"Plainly, he was one of the greatest artists of this or any age, a relentless creative force that produced an incredible number of astonishing works during the course of a career that spanned seventy-five years. . . . His works are things of self-evident genius and it speaks extremely ill of this society that for so long he has been hidden away as a threat to the complacency of our self-imposed limitations." — *Whole Earth Review*

$24.95 *(PB/96/Illus)*

NSK: Neue Slowenische Kunst/ New Slovenian Art
Edited by NSK

NSK is a full-color illustrated book documenting the controversial theories, statements, visual arts, music, film, video and theater work of the internationally acclaimed Slovenian arts collective from 1980 to 1989. *NSK* encompasses the innovative pop group Laibach, the IRWIN painter group and the Cosmokinetic Theater "Red Pilot," as well as philosophy, architecture, TV and motion picture departments. Strikingly compiled and designed by the New Collectivism graphic studio on behalf of NSK; includes 260 full-color reproductions.

"We understand politics as an integral part of culture and as the highest, all-embracing form of art." — NSK

"NSK is concerned with nothing less than the fate of the soul of Europe." — *Edinburgh Review*

"A hefty hardback in which design, illustrations and the text itself are welded into an experience which simple rock books can't dream of." — *Alternative Press*

$60.00 *(HB w/slipcase/288/Illus)*

My Sister and I
By Friedrich Nietzsche

The revised and updated edition of Nietzsche's disputed final work, including textual research supporting its authenticity and translations of his final correspondence. Reportedly written in the mental institution at Jena following his celebrated mental collapse in Turin, and smuggled out by a fellow inmate to avoid the tyrannical eye of his sister (with whom he confesses to an incestuous relationship), *My Sister and I* is a reflective counterpoint to the megalomania and stridency of *Ecce Homo*.

"To look at the text as if it were by Nietzsche is far more interesting and more in keeping with Nietzsche's spirit. . . . Nietzsche has accused philosophy of policing truth, of only allowing certain truths to be told. The damage done by not listening to other voices and not believing because of lack of preparation for a new truth is great. Why not believe this possible story?" — *Telos: A Quarterly Journal of Critical Thought*

"Is it Nietzsche's last work—a scabrous, incantatory memoir smuggled out of the mental hospital where he was confined in 1890—or an elaborate forgery, the Hitler diaries of its day? . . . Whether it's his own work or not, *My Sister and I* sounds like you always imagined Nietzsche would if you ever got him drunk enough." — *Lingua Franca*

"All that need be said is that surely no one interested in Nietzsche's thought, style or life can view dispassionately this apocryphal book's reappearance." — *International Studies in Philosophy*

"Nietzsche scholar Walter Stewart makes a convincing case for the work's authenticity" — *Publisher's Weekly*

"There is an adventure of both intellect and spirit to be had here." — *Contemporary Psychology*

$14.95 *(PB/330/Illus)*

The Wild Palms Reader
Edited by Roger Trilling and Stuart Swezey

Released as the ambitious companion book to the Oliver Stone-produced ABC mini-series, *The Wild Palms Reader* has now attained legendary status in its own right as a landmark work of subversive speculative fiction. The *Wild Palms* project is at once epistemological whodunit, comic book opera, and a hyperreal satire of contemporary culture, from cyberkitsch and Japanophilia/phobia to our most hallowed ideas of family and mortality. The *Wild Palms* mini-series detailed the rise of Synthiotics, a dynastic techno-cult which co-opts the public's dreams through 3-D TV and psychotropic drugs in an effort to induce mass psychosis. *The Wild Palms Reader* unfolds the saga of Tony Kreutzer, the brilliant and twisted guru of Synthiotics, and his sister Josie, grand dame of his mystical-fascist media empire.

Working from the dystopian script of acclaimed novelist Bruce Wagner, *The Wild Palms Reader* is an extravagantly illustrated dossier of pseudo-documents. Contributors to this powerful collaborative work of fiction include: novelists William Gibson, Thomas Disch, Bruce Sterling, Mary Gaitskill, Hillary Johnson, Bruce Wagner and ex-CIA operative E. Howard Hunt; essayists Ralph Rugoff and Peter Wollen; recording artists Lemmy (Motörhead), Genesis P. Orridge (Throbbing Gristle, Psychic TV) and Malcolm McLaren; scientists Hans Moravec (on neural implants) and Gary Henderson (on toxico-pharmacology); and many others. Stunningly designed by Tokyo's Yasushi Fujimoto, *The Wild Palms Reader* has been recognized as a template for cutting-edge work in graphic, new media and website design.

"This fanatically intricate subtextual pendant to Bruce Wagner's *Wild Palms* is a thing of beauty and genuine mystery: a vanished television mini-series gracefully everting itself to reveal literary formations of enigmatic depth and complexity. With its stunning production values and wonderfully eclectic posse of writers, *The Wild Palms Reader* is a secret masterpiece of esoterrorism." — William Gibson

"The excellent *Wild Palms Reader* is a symptom as much as a story, capturing the giddy sense of slipping into a future where an unholy alliance of technology, media, and pure power are tugging apart the dense social dream of the world—and letting some hungry ghosts loose in the process." — *Village Voice*

"WARNING: This is not a book about the world of *Wild Palms*, it is a book from that world. It doesn't know it's fiction, and continued attention is addictive." — *Los Angeles Times*

$14.95 *(PB/128/Illus)*

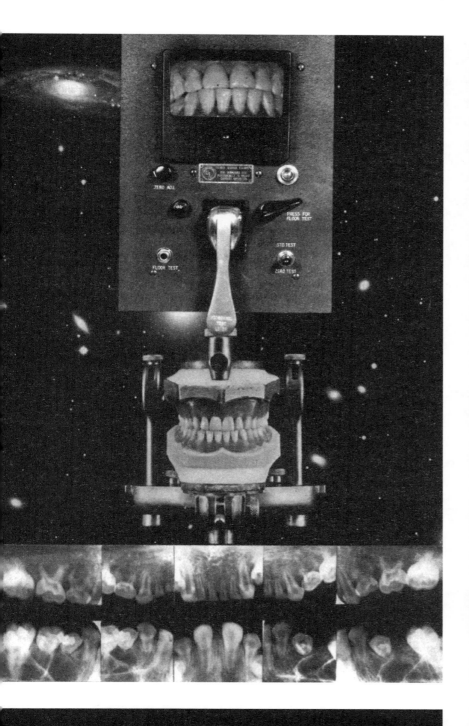

WEBSITES

This list was compiled by All–Electric Paperbacks (http://www.paper-backs.com), who assume no responsibility for its accuracy. The addresses in the list were current at the time of its compilation; some may have changed in the meantime. We apologize to anyone who was left off of the list; we were trying to keep it to a manageable length.
— SB

Updated by Maria V. Montgomery, January 1999

For more recently updated links information, please go to www.amokbooks.com.

CONTROL

A.R.S. Web Page Summary
http://www.best.com/~mchong/arsweb.shtml
A tremendous list of websites regarding Scientology. 50K of links!

Black Ops Encyclopedia
http://gate.cruzio.com/~blackops/
Brought to you by Robert Anton Wilson and conspiracy collaborator Miriam Joan Hill.

Black Planet Radical and Anarchist Books
http://www.blackplanet.com
Brings the world of radical and anti-author-itarian literature to you.

The Church of Scientology vs. the Net
http://www2.thecia.net/users/rnewman/
scientology/home.html
Documents their continuing efforts to keep church documents secret.

CIA/MKULTRA/Mind Control
http://www.parascope.com
http://www.wa.net/~ominverse/omnispy6.htm
Two sites with information on the CIA's MKULTRA Program.

CTHEORY
http://www.ctheory.com/
An international journal of theory, technology and culture. Features Baudrillard, Virilio, etc.

The Egoist Archive
http://pierce.ee.washington.edu/~davisd/egoist/
The Home of Egoism on the Net.

EMF Effects
http://www.yelmtel.com/~mrwizard/wizard
EMF.HTM
Information on biological and health effects of electric and magnetic fields.

Flashpoint: A Newsletter Ministry of Texe Marrs
http://www.texemarrs.com/
Loopy Xtian conspiracy nut selling his books.

Freedom of Thought
http://www.azstarnet.com/~freetht/
Info on trauma-based programming and EM tar-geting, propaganda, indoctrination, thought reform and covert psychological operations of "national security" states.

IllumiNet Press
http://www.illuminet.com/inet.html
Publishers of conspiracy books.

Intelligence Zone
http://www.ionet.net/~everett/index.shtml
Links to the CIA, FBI, etc.

The Konformist
http://www.konformist.com
Covers a broad range of subjects—conspira-cy theories and beyond.

Leading Edge International Research Group
http://www.cco.net/~trufax/welcome.shtml
Way, way too much weirdness to list here . . .

Martti Koski—Mindcontrol
http://www.netti.fi/~makako/mind/
Stories from people who have experienced electromagnetic mind control, more.

Matrix: Conspiracies, Assassinations, Cover-Ups, New World Order, Illuminati
http://site034145.primehost.com/matrix.htm
ParaScope's area for investigative reports on con-spiracies, crimes, cover-ups and disturbing social, political and economic goings-on.

The Max Stirner Web Site
http://pierce.ee.washington.edu/~davisd/eg
oist/stirner
Information on philosopher Max Stirner.

websites

Mind Control Forum
http://www.mk.net/~mcf/
Archives, news, resources, victims! Pictures of brain implants!

The Scandal of Scientology
http://www.entheta.net/entheta/books/sos
The complete text of the classic out-of-print 1970 exposé. Recommended.

Skeleton Closet
http://www.realchange.org/index.htm
Digs up the dirt on political candidates!

Some Aspects of Anti-Personnel Electromagnetic Weapons
http://www.parascope.com/articles/0797/em.htm
Synopsis prepared for the ICRC Symposium "The Medical Profession and the Effects of Weapons."

South End Press
http://www.lbbs.org/sep/sep.htm
Titles that nurture and inspire radical social change.

The Spoon Home Page
http://jefferson.village.Virginia.EDU/~spoons/
Devoted to free and open discussion of philosophical issues. Bataille, Baudrillard, Deleuze, Guattari, Foucault, Nietzsche, more!

T.A.Z.
http://www.geocities/CapitolHill/Lobby/7063/taz.html
Temporary Autonomous Zone text by Hakim Bey.

Anarchy

Anarchy
http://www.anarchy.org
Writings, links, resources.

The Seed Home Page
http://web.cs.city.ac.uk/homes/louise/seed2.html
Links to anarchist resources.

Baudrillard

Baudrillard on the Web
http://www.uta.edu/english/apt/collab/baudweb.html

Chomsky

The Noam Chomsky Archive
http://www.worldmedia.com/archive/
Exposing the global elite . . .

Foucault

Foucault Pages at CSUN
http://www.csun.edu/~hfspc002/foucault.home.html
Lots of links and information on Michel Foucault.

Situationism

Situationist International Archives
http://www.nothingness.org/SI/
Offers the most complete archive of texts by and relating to the Situationist International available on the Net.

Year Zero—RIP Guy Debord
http://myhouse.com/love/gate/sade.html
An internet translation of the 1952 French film "Howlings in Favor of Sade" by Guy Debord.

¡Zapatista!

Ejercito Zapatista de Liberacion Nacional
http://www.ezln.org/
Spanish language Zapatista site.

Radio Zapatista Chiapas Network
http://www.civila.com/mexico/archivos/radiozapatista/
Official page of Radio Zapatista.

The Zapatistas and the Electronic Fabric of Struggle
http://www.eco.utexas.edu/Homepages/faculty/Cleaver/zaps.html
A draft of a chapter of "The Chiapas Uprising and the Future of Revolution in the Twenty-First Century."

Zion

Jewish Defense League
http://www.jdl.org/
The Five Principles of the Jewish Defense League!

The Palestinian National Charter
http://www.jcrc.org/main/plocov.htm
The full text of the pre-1993 anti-Israeli covenant.

Anti-Defamation League
http://www.adl.org/
Your portal to hate sites on the Web.

EXOTICA

Easter Island Home Page
http://www.netaxs.com/~trance/rapanui.html
Information on Rapa Nui. Lots of links.

Jon Frum Home Page
http://www.altnews.com.au/cargocult/jonfrum/
Documents the cult's long wait for the arrival of a great white ship filled with cargo.

Lonely Planet Online
http://www.lonelyplanet.com
Good source for a variety of info on destinations.

Tahiti Web
http://www.tahitiweb.com/a/main.html
Surf Polynesia!

The Tiki News
http://www.indieweb.com/tiki/
Enter the world of exotica past and present.

Tiki Objects by Bosko
http://www.tikibosko.com
Create your own tiki bar with Bosko's original tiki poles, masks and ceramic mugs.

Burton

Sir Richard Burton
http://www.phuture.sk/drugs/nepenthes.lycaeum.org/Ludlow/People/burton.html
Searchable links and information on the famous explorer.

Sir Richard Burton Society
http://129.25.3.13/~libstaff/burton/burton.html
Dedicated to the study, bibliographical and otherwise, of the noted British Orientalist and explorer

Eberhardt

Isabelle Eberhardt
http://www.bmlisieux.com/litterature/eberhardt/eberhard.htm
French language site on Isabelle Eberhardt.

Maya

Four Ahau Press
http://phidias.colorado.edu/jenkins/fourahau.html
Publishes research relating to Mayan cosmology.

MAYHEM

Access Manson
http://www.atwa.com/
A Real Source for Manson Thought.

APB Online
http://www.apbonline.com/index.html
The source for police and crime news, information and entertainment.

Aum Shinrikyo
http://www.aum-shinrikyo.com/english/
Pro-Aum cult site with multiple-language links.

Black Dahlia Home Page
http://www.bethshort.com/dahhome.htm
Devoted to the unsolved crime of the century. It's noir, man!

TheElectricChair.com
http://www.theelectricchair.com/index.htm
Maybe I can talk my wife into doing a Guillotine.com . . .

Felicity Press
http://www.ozemail.com.au/~felpress/
A source of Unusual Publications. Carries used true-crime books, too.

Index of Home Pages Maintained by Ira Wilkser
http://www.ih2000.net/ira/
Includes his mind-boggling (600K!) collection of law enforcement links. You'll spend a month or two here . . .

Internet Crime Archives
http://www.mayhem.net/Crime/archives.html
Does not spare the gory details.

JusticeNet
http://www.prisonactivist.org/news/
Deals with various prison-related issues.

Murder Can Be Fun
http://www.dispatches.org/mrdrfun/
Online version of the legendary true-crime zine.

Rotten dot com
http://www.rotten.com/
Gallery of disturbing and disgusting images. Has some erotica, i.e., men fucking chickens, etc.

Secret Societies and Religious Cults (plus Crime)
http://www.totentanz.de/kmedeke/cults.htm
Excellent true crime links page.

The Truth Is Redacted
http://www.redacted.com
Dedicated to researching unsolved crimes. JFK, Zodiac, and more.

Forensic Pathology

Forensic Pathology Index
http://www-medlib.med.utah.edu/WebPath/FORHTML/FORIDX.html
Photos of death and disease.

Links to Forensic Science and Law Enforcement Sites
http://www.fsalab.com/index.htm
Brought to you by Forensic Science Associates, a consulting firm.

Victorian Institute of Forensic Pathology
http://www.vifp.monash.edu.au/
From Victoria Canada's Monash University.

Zeno's Forensic Page
http://zeno.simplenet.com/forensic.html
Links to hundreds of forensic sites around the world!

NATAS

Arachne's Web
http://www.cascade.net/arachne.html
One of the best Web directories of pagan sites.

Atheism
http://www.no-gog.org
http://atheism.miningco.com/MSUBag.HTM
A collection of modern and historical texts on Atheism.

Bob Larson Fan Club Home page
http://www.cris.com/~Ranger57/blm.shtml
Pictures of Bob's mansion, which you may have helped pay for. Did you know that "Bob Larson" is an anagram for "A Born Slob"?

The Center for Millennial Studies
http://www.mille.org/
Will the world end in the year 2000? Nah . . .

Chick Home Page
http://www.chick.com
Finally, an official Jack Chick site!

The Church of Euthanasia
http://www.paranoia.com/coe/
Promotes suicide, abortion, cannibalism,

sodomy, etc. Helpful article on butchering the human carcass.

Cults 'R' Us
http://mayhem.net/Crime/cults1.html
Don't practice unsafe sects!

Dark Side of the Web
http://www.darklinks.com
Over 6,000 working links to everything dark.

Dr. Laura
http://www.drlaura.com
Propheteer and Deryk's mom

Gonzo Links
http://www.capcon.net/users/lbenedet/
Your online guide to millennial America. Recommended!

The Hermetic Order of the Golden Dawn
http://www.golden-dawn.org/
http://www.golden-dawn.com/home.html
http://www.ccse.net/~mhenson/
Will the real Golden Dawn please stand up!

Satanic Ritual Abuse
http://web.canlink.com/ocrt/sra.htm
Exposes the "Satanic Panic"!

The Spirit of Truth
http://www.ucc.uconn.edu/~jpa94001/
Explains the Apocalypse and what you need to do before it happens.

Technology and Mashiach
http://www.chabad.org/techno.html
The late Lubavitcher Rebbe Rabbi Menachem M. Schneerson on the Messianic implications of modern techology, from talks given in the late 1960s.

Villa of The Mysteries
http://www.maroney.org/Esoteric_Links.html
Esoteric spirituality links.

Alchemy

The Paracelsus Site
http://pubweb.ucdavis.edu/documents/ASPANG/Modern/Paracelsus/Introduction.html
Small archive of writings, links.

Crowley

Aleister Crowley
http://members.aol.com/pachd/crowley.htm
Holy books of Thelema online, bio.

Ordo Templi Orientis—U.S. Grand Lodge
http://otohq.org/oto/
Online documents, membership require-
ments, links to other lodges, more.

Egyptiana

Ancient Egyptian Magic
http://www.geocities.com/Athens/Delphi/
2093/magic.html
Graphics-intensive gateway to the Egyptian
mysteries.

Gnosis

The Gnosis Archive
http://www.webcom.com/~gnosis/
Comprehensive.

Kabbalah

Colin's Hermetic Kabbalah Page
http://www.digital-brilliance.com/kab/
This site is dedicated to publishing mod-
ern material on Kabbalah and related
topics.

LaVey

Church of Satan
http://ariadne.blue-net.asca.de/~steuern/
chuofsat.html
Official Church of Satan site.

Spare

Austin Osman Spare
http://www.sonic.net/fenwick/spare.html
Many links to his writings.

Austin Osman Spare
http://www.southern.com/coil/magazin/
spare.html
Thumbnail biography with links and his
obituary.

Thule

The Troth Official Web Site
http://asatru.knotwork.com/troth/
For that old-time Norse religion

The Lance, the Swastika and the Merovingians
http://user.fastinet.net/kalogonis/index/lance.htm
The strange story of Hitler and the Spear of
Longinus.

Vampires

Vlad Tepes
http://www.nat.vu.nl/~radu/vlad.html
Article on Vlad the Impaler.

Dracula's Home Page
http://www.ucs.mun.ca/~emiller/
Home page of Dr. Elizabeth Miller, Dracula
scholar.

Vampires Only
http://www.vampyres-only.com//
One of the earliest and best vampire web-
sites.

Vatican

The Holy See
http://www.vatican.va/
Your connection to the Roman Curia.

The Monastery of Christ in the Desert
http://www.christdesert.org/pax.html
Monks with JavaScript!

Vatican Souvenir Store
http://www.visit.it/
Get parchment papers blessed by the Holy
Father!

Voodoo

Orishanet
http://www.seanet.com/~efunmoyiwa/
Great Santeria resource.

The Vodun (Voodoo) Religion
http://www.religioustolerance.org/voodoo.htm
Informative article.

Voodoo Information Pages
http://www.arcana/com/shannon/offbeat/
voodoo/index.html
Comprehensive articles and links.

NEUROPOLITICS

About Absinthe
http://www.webcom.com/~gumbo/food/
misc/beverages/absinthe.html
What is abinsthe? Find out here.

Brainville
http://home1.gte.net/mushaman/
Leary theory evolves on in cyberspace.
Hint: "entheogens" will get you high.

Deoxyribonucleic Autonomous Zone
http://www.deoxy.org/index.htm
Huge site, placed here because of Terence
McKenna and Timothy Leary sections.

Entheogen Dot
http://www.entheogen.com
Thorough resource on mind-altering sub-
stances.

General Semantics Home Page
http://www.kcmetro.cc.mo.us/pennvalley/
biology/lewis/gs.htm
Applying science-mathematical methods
and discoveries to daily living.

Le Fèe Verte Absinthe Gallery
http://www.sepulchritude.com/chapelper-
ilous/absinthe/
Recipes, artwork and discussion on
absinthe.

Levity
http://www.levity.com
Great links for Neuropolitics, alchemy and more!

Lyceum
http://www.lyceum.org
One of the most thorough drug information
pages on the Web.

Burroughs

The Unofficial William S. Burroughs Home page
http://www.peg.apc.org/%7Efirehorse/wsb/
wsb.html
Searchable memorial site with many links.

William S. Burroughs
http://porter.appstate.edu/~kh14586/links/
beats/burroughs/index.html
Collection of links and articles.

The William S. Burroughs Files
http://www.hyperreal.org/wsb/
InterWebZone.

Dreams

Dream Gate
http://www.dreamgate.com/
A public archive for the dissemination of
material related to dreaming.

Leary

Timothy Leary Home page
http://www.leary.com
Leary's page with a tour of his home.

Was Leary a CIA Agent?
http://home.dti.net/lawserv/leary.html
Was Timothy Leary a CIA agent? Was JFK the "Manchurian Candidate"? Was the Sixties revolution really a government plot?

Schizo

The Kooks Museum
http://www.teleport.com/~dkossy/
A virtual monument to kookdom.

The Kook of the Month Award
http://www.wetware.com/mlegare/kotm/KotM.html
Fifteen minutes of fame is a lifetime on the Net. Not recently updated.

Psychoceramics
http://dev.null.org/psychoceramics/
The study of crackpots and eccentrics and of bizarre, eccentric, outré or unaccepted beliefs and theses.

Schizophrenia Help Home Page
http://www.schizophrenia-help.com/dedication.html
Resource for those suffering from schizophrenia and their families.

True Rantings
http://www.ot.com/~white/rantings/rantings.html
A site of rants and raves by real people.

Sufism

Haqqani Foundation Home Page
http://www.naqshbandi.net/haqqani/
The Naqshbandi-Haqqani Sufi Order.

International Association of Sufism
http://www.ias.org/
A nonprofit group whose aim is to introduce Sufism in all its varied forms to the public

Wilson

Robert Anton Wilson
http://www.tcp.com/~prime8/raw/
The Robert Anton Wilson Page.

ORGONE

Ascot World
http://www.neosoft.com/~ascot/
For amputees and their friends.

Autoerotic Fatalities
http://members.aol.com/bj022038
An objective overview with an emphasis on the myths, criteria and issues faced by a medical examiner or coroner.

Bestiality
http://www.animalpassion.com
The best in bestiality.

The Body Space
http://www.surgery.com/body/topics/body.html
A before-and-after plasic surgery site.

The Burns Archive
http://www.burnsarchive.com/
You can buy photos from them. No online archive, however.

The Butt Page
http://www.well.com/user/cynsa/newbutt.html
Investigates reports of rectal foreign bodies.

Codpiece International Home Page
http://www.teleport.com/~codpiece/codpiece.shtml
No, it's not about fish . . .

Conde Mansion
http://www.geocities.com/Athens/Acropolis/7362/
Historical information on the Marquis de Sade.

The Contortion Home Page
http://www.escape.com/~silverbk/contortion/
Resources, training info, photo library. Videos and CD-ROMs for sale.

Different Loving Home Page
http://gloria-brame.com/diflove.htm
Erotic writing and art dealing with sexual dominance and submission.

In the Feet of the Night
http://www.inthefeetofthenight.com/
Foot fetish site.

Interactive Patient Home Page
http://medicus.marshall.edu/medicus.htm
Allows the user to simulate an actual patient encounter. I wonder if you can "kill" the "patient" . . .

The Electric Kool-Aid Urine Test (The Piss Page)
http://www.ior.com/~lylek/piss.html
Bathroom antics

The Marquis de Sade
http://www.illusions.com/sodoku/sade.htm
Sections on Sade's chronology, letters and works.

Sademania
http://www.jah.ne.jp/~piza/SADEE.html
"For everyone who loves the Marquis de Sade," many links.

Stanton Archives
http://www.stanton-fetish.com
The fetish art maestro is here to serve you!

The Tom of Finland Company
http://www.eroticarts.com/company/welcome.html
Make sure you're using at least a 17-inch monitor . . .

Death

City of the Silent
http://www.best.com/~gazissax/city.html
Cemetery Web page. Features virtual grave rubbings!

Sociology of Death and Dying
http://www.trinity.edu/~mkearl/death.html
More information of death and dying than you can possibly imagine.

Drag

Drag Queen City
http://internetdump.com/users/tvgirl/enterdqc.html
Drag Queen City is a cyber resource for crossdressers, transvestites, and transsexuals in the Carolinas, particularly Charlotte.

A Field Guide to the Drag Queens of the Commonwealth of Kentucky
http://qx.net/marc/kydrag/
Interesting items for Kentucky queens, fans and guests. Good links.

TV World's Maid in America!
http://www.lovenet.co.uk/halcyon/tvmaid.htm
Illustrated erotic stories. Has rubber and adult baby sections.

Foreskin

The Fate of the Foreskin
http://www.cirp.org/CIRP/library/general/gairdner/
Illustrated medical study guide to circumcision.

websites

Paul's Foreskin Restoration Progress
http://net.indra.com/~shredder/restore/
diary.html
Pictures and diary. This Web page documents his foreskin restoration progress.

The XS4SKIN Gallery
http://www.xs4skin.com/
Welcome to the foreskin page—a home for all fans of the uncircumcised penis.

NAMBLA

NAMBLA Home page
http://www.nambla.org/
The unhacked Home page.
http://www.flashback.se/hack/1998/03/05/1/
Hacked NAMBLA homepage.

Nambla Sickest Group on Planet Earth
http://www.otherside.net/nambla.htm
These people are not too fond of NAMBLA.

Nudism

CyberNude!
http://www.cybernude.com/
Nude resources! Nude shopping! Nude poetry! Nude everything!

Nude2000 Web Site
http://www.nude2000.com/
Surf naked . . .

Plague

Centers for Disease Control and Prevention Home Page
http://www.cdc.gov/
Features a downloadable edition of Morbidity and Mortality Weekly Report.

World Health Organization WWW Home Page
http://www.who.ch/
Latest disease news!

World Wide Web Server for Virology— University of Wisconsin, Madison
http://www.bocklabs.wisc.edu/Welcome.html
Articles, pictures and links of all your faves!

Reich

American College of Orgonomy
http://www.orgonomy.org/
A nonprofit educational and scientific organization.

Another Orgone Research Laboratory
http://www.geocities.com/CapeCanaveral/2
514/

Wilhelm Reich and Orgonomy
http://orgone.org/100eng/historie.htm
The Luminiferous Aether, Wilhelm Reich and the orgone

WR: The Mysteries of Western Orgasm
http://www.wr.opennet.org/
As opposed to, say . . . the mysteries of Eastern orgasm

PARALLAX

A-Albionic Books
http://www.a-albionic.com/
Conspiracy, new paradigms, more. Recommended search service. Archives and links too!

American Opinion Books Services
http://www.jbs.org/aobs/
An outlet for Americanist ideas, books and literature

American Renaissance
http://www.amren.com/
"A literate, undeceived journal of race, immigration and the decline of civility"

Aryan Nations
http://www.nidlink.com/~aryanvic/
The ongoing work of Jesus the Christ re-gathering His people . . .

Black Facts Online!
http://www.blackfacts.com/
"Our Internet Resource for Black History Information."

Blacks and Jews Newspage
http://www.tiac.net/users/lhl/
Dedicated to the dissemination of accurate information about the historical relationship between Blacks and Jews.

Camille Paglia
http://privat.ub.uib.no/BUBSY/nomore.htm
Feminist Fatale.

Conspire.com
http://www.conspire.com/
Scary links!

Dave Emory's Politics of Acrimony
http://www.io.com/~hambone/arch/aod.html
Alex Constantine lambasts Dave Emory.

Death of a Princess
http://www.internet-inquirer.com/
deathof.htm
Accident or assassination?

Doc Hambone
http://www.io.com/~hambone/
Great conspiracy site, with archives.

Extremism Links
http://www.stetson.edu/~mmcfarla/extreme.
html
Academic resource, many links.

The Green Book by Mu`ammar al-Qadhafi
http://www.geocities.com/Athens/8744/myl
inks1.htm
The complete text, online.

Knights of the Ku Klux Klan
http://www.kukluxklan.org/
Virtual cross burnings?

John Birch Society
http://www.jbs.org/
None dare call it conspiracy!

Kultcha: A Wallnewspaper by Kerry Thornley
http://www.impropaganda.com/kultcha.html
Rants and subversion from the master paranoiac.

Malcolm X
http://www.unix-ag.uni-kl.de/~moritz/malcolm.html
English-language German site with links and information.

Michael A. Hoffman II's Campaign for Radical Truth in History
http://www.hoffman-info.com/
White slaves in America, Holohoax, occult methodology in subliminal advertising, more!

Nation of Islam Online
http://www.noi.org/index.html
Articles and speeches by the Hon. Louis Farrakhan.

Princess Diana's Death and the Unanswered Questions
http://www.american-photo.com/paparazzi/
diana/DianaWEBwords/!dodi-1.html
If you were Dodi, would YOU have let a "drunk" person drive you and your girlfriend?

Princess Diana Conspiracy Theories
http://www.skeptics.com.au/features/weird/
media/mw-ditheory.htm
"Anyone who doesn't know that the order to murder Diana came from the Hanover/Windsor power structure is lacking an understanding of world affairs."

Sovereign's WWW Content Page
http://Syninfo.COM/Sov/index.htmlx
Links to news and events that the national and international media would never be allowed to print!

Steamshovel Press
http://jinx.umsl.edu/~skthoma/
Publishes excellent magazine on conspiracies.

Stormfront White Nationalist Resource Page
http://www.stormfront.org/
Can anyone tell me what "White Nationalist" means?

Student Revisionist Resource Site
http://www.wsu.edu/~lpauling/index1.html
Examines revisionist viewpoint on history.

Sumeria
http://www.livelinks.com/sumeria/
politics.html
A wide variety of articles on the dark side of politics and history.

White Aryan Resistance Hate Page
http://www.resist.com/
Not to be confused with Roger Metzger, former major-league shortstop.

Black Panther

The Black Panthers
http://www.afroam.org/history/Panthers/pa
nther-lead.html
History, biographies.

Black Power
http://www.umich.edu/~eng499/concepts/p
ower.html
Right-on links and resources!

Genocide

Factsheet: Armenian Genocide
http://www.umd.umich.edu/dept/
armenian/facts/genocide.html

Home Web page of Arthur R. Butz
http://pubweb.acns.nwu.edu/~abutz/
Introduction to the study of Holocaust revisionism.

Zundelsite
http://www.webcom.com/~ezundel/eng-
lish/welcome.html
"Ich bin kein bewaffneter Krieger, sondern ein militanter Pazifist!"

JFK

Col. L. Fletcher Prouty Reference Site
http://www.astridmm.com/prouty/main.html
Mr. X on the Net.

Fair Play
http://rmii.com/~jkelin/fp.html
Excellent e-zine on the JFK assassination. Archives, links.

JFK Assassination Home
http://www.weberman.com/
A growing database of documents . . .

Kennedy Assassination Home Page
http://mcadams.posc.mu.edu/home.htm
Presents evidence that Oswald acted alone.

Kennedy Assassination Records Collection
http://www.nara.gov/nara/jfk/jfk.html
An electronic index to records relevant to the assassination of President Kennedy.

The Nook of Eclectic Inquiry
http://www.jmasland.com/
You'll not find many answers . . . but per-haps more questions.

Real History Archives
http://www.webcom.com/%7Elpease/
Site designed to provide researchers with links and leads to finding real informa-tion about what our true history is, based on new but assuredly unpopular information.

Masonic

Acacia Press
http://www.crocker.com/~acacia/antim.html
Reprints of old anti-Masonic books with online excerpts.

R & D

Bureau of Atomic Tourism
http://www.oz.net/~chrisp/atomic.html
Promotes tourist destinations—in particular, the sites of atomic explosions.

Exploratorium Home Page
http://www.exploratorium.edu/
Features the Virtual Cow's Eye Dissection!

Forteana

Committee for the Scientific Investigation of Claims of the Paranormal
http://www.csicop.org/si/
Publishers of *The Skeptical Inquirer.*

Fortean Times Online
http://www.forteantimes.com
The journal of strange phenomena. Great links section.

Mu and Alternate Archeology
http://members.aol.com/theloego/index.html
Mu Revival Page.

Skeptics Society
http://www.skeptic.com/
The truth is out there . . .

The Sourcebook Project
http://www.knowledge.co.uk/xxx/cat/sourc
ebook/
Catalogs unusual natural phenomena. Recommended.

Strange Magazine
http://www.strangemag.com/
An objective, levelheaded approach to strange phenomena.

Museum of Jurassic Technology

The Museum of Jurassic Technology
http://www.mjt.org/
"A specialized repository of relics and artifacts from the Lower Jurassic, with an emphasis on those that demonstrate unusual or curious technological qualities." Huh?

Tesla

Muzej Nikole Tesle—Nikola Tesla Museum
http://www.yurope.com/org/tesla/
Home page for the Belgrade museum

Nikola Tesla Page
http://www.eskimo.com/~billb/tesla/tesla.html
Excellent Tesla link section!

UFO

websites

Aliens, Aliens, Aliens
http://www.xensei.com/users/john9904/
There are 59,980 Men-in-Black surrounding you . . .

The Art Bell Web Page
http://www.artbell.com/
Radio show site, with emphasis on UFO and cult activities.

Flying Saucer Review
http://www.bufora.org.uk/misc/store/clients/fsr.htm
The leading international journal on UFOs.

Internet UFO Group
http://www.iufog.org/
An excellent source of UFO-related material.

The J. Allen Hynek Center for UFO Studies
http://www.tje.net/para/organizations/c/cufosj.htm
Dedicated to the continuing examination and analysis of the UFO phenomenon.

Leading Edge International Research Group
http://www.cco.net/~trufax/
Publishers of the Matrix books on UFOs and mind control.

MUFON/Mutual UFO Network
http://www.rutgers.edu/~mcgrew/
Spotting 'em since 1969.

The National UFO Reporting Center
http://www.nwlink.com/~ufocntr/index.html
Dedicated to the collection and dissemination of objective UFO information.

Raelian Home Page
http://www.rael.com/
The message given to Rael by people from Space.

Saucer Smear
http://www.mcs.com/~kvg/smear.htm
Approaches the UFO mystery with a note of humor and common-sense skepticism.

UFO Coverup and Theories
http://www.v-j-enterprises.com/coverup.html
Document archive.

UFO Folklore
http://www.qtm.net/~geibdan/
UFOs 'R' Us!

UFOInfo
http://ufoinfo.com/
An excellent collection of Ufology resources.

Unarius

UNARIUS Academy of Science
http://www.serve.com/unarius/
Ten-time winners of the MUFON "Best Costume" award!

SCRATCH 'N' SNIFF

8-Track Heaven
http://pobox.com/~abbot/8track/
Your Guide to the World of 8-Track.

Analogue Modular Systems, Inc
http://www.analogsynths.com/mainpage.html
Museum of Synthesizer Technology.

Anime Shrine
http://www.animeshrine.com/movies.shtml
All things anime.

Anomalous Records
http://www.anomalousrecords.com/label.html
Specializing in experimental, abstract, electro-acoustic, ambient, textural, sculptural, surreal, modern classical and other strange musics.

Awful Music
http://redwood.northcoast.com/~shojo/Awful/awf.html
Really, really, really awful music. The kind we like . . .

Burt Bacharach: A House Is Not a Homepage
http://studentweb.tulane.edu/~mark/bacharach.html

A Brief History of Electronic Instruments
http://www.ief.u-psud.fr/~thierry/history/history.html
A look at the pre-digital era.

Karen Carpenter Home Page
http://www.geocities.com/SunsetStrip/Towers/9438/
Bio, discography, more!

Richard Carpenter Home Page
http://www.geocities.com/SunsetStrip/Palms/4331/
What's he doing now? Find out here . . .

Cluster Information Service
http://www.rcww.com/curious/clustinf.htm
Plenty of space here

Cool and Strange Music! Magazine
http://members.aol.com/coolstrge/mainpage.html
Resource for unusual tunes and vinyl

Klaus Dinger/Neu/La Dusseldorf
http://www.tp1.ruhr-uni-bochum.de/people/gawlista/mucke/dinger.html
Krautrock nexus.

Ebonics Online
http://www.auburn.edu/~ralphwc/ebonics.html
Ebonics translations of *Paradise Lost*, *Rime of the Ancient Mariner*, *Hamlet*, more!

Ebonics Links
http://members.tripod.com/~cdorsett/links.htm
Links to mo' Ebonics sites!

Experimental Musical Instruments
http://windworld.com/emi/
With an emphasis on the out-of-the-ordinary.

The Faust Page
http://andyw.zinc.co.uk/faust/
English-language repository for Faust fanatics.

Serge Gainsbourg
http://www.imaginet.fr/~relig/gainsbourg/
It's in French . . .

The Heino Links
http://www.geocities.com/Hollywood/5991/heinolinks.html
Ground zero for Heino.

Hyperreal
http://www.hyperreal.org
Extensive site devoted to rave culture and electronic music.

Internet Underground Music Archive
http://www.iuma.com
Lots of new and unusual bands here.

Kraftwerk Links
http://gyrogearloose.com/robot/kwlnx.html
Many, many links.

Laibach
http://www.laibach.nsk.si/
Totally!

websites

The Official Authorized Yma Sumac Home Page
http://www.accesscom.com/~pc/sumac
Wowowawowowow!

The Official Lego World Wide Web Site
http://www.lego.com/
A good place to meet kids . . .

Pink Frankenstein
http://www.frankenstein.com
Francoise Hardy, Scott Walker, Lee
Hazlewood, Universal horror, more!

Barbie Links on the Web
http://www.fau.edu/library/barblink.htm
HUGE Barbie site, with an emphasis on collecting.

Psychic TV Guide
http://www.halfass.com/ptv/
An extensive Psychic TV discography.

Public Access Television Web Sites
http://www.sfctc.org/centers.html
Links to over 113 access centers with sites
on the Net.

The Rat Pack
http://www.jcware.com/tributes/RatPack/
Default.htm
An homage to Dino, Frankie, Sammy and Las
Vegas culture

The Roadside America Home page
http://www.roadsideamerica.com/
Your travel guide to offbeat attractions,
tourist traps, weird vacations, hypertourism
marvels. Museums, mermaids, atomic
voodoo.

Gabor Szabo-Iconoclasm
http://www.siteworks.com/szabo/
All the facts on the King of Raga Jazz.

Sanrio Home Page
http://www.sanrio.com/
Where you can find out that Hello Kitty is a
Scorpio!

Shareware Music Machine
http://www.hitsquad.com/smm/
The world's biggest music software site.

Silver Apples Home Page
http://www.silverapples.com
Oscillate, oscillate!

Synth Zone
http://www.synthzone.com/
MIDI and synthesizer sites, sounds and
resources guide.

TelstarWeb
http://www.concentric.net/~meekweb/telstar.htm
The Joe Meek home page.

The Theremin Home Page
http://www.Nashville.Net/~theremin/
Historical information on this fascinating
electronic instrument.

Throbbing Gristle
http://www.mindstorm.com/~waxy/wserpent/TG.html
"Throbbing Gristle was the gigantic birth of
everything . . . "

Ultimate Band List
http://www/ubl.net
It's exactly what it says it is. Recently
updated and improved.

The Unofficial Sid and Marty Krofft Home Page
http://www.livingisland.com/
Interviews, tape exchange, chat room, puzzles, links, more!

The Urban Legends Archive
http://www.urbanlegends.com/
I still won't eat bubble gum . . .

Vik Trola's Lounge of Self-Indulgence
http://www.chaoskitty.com/sabpm/
Space-Age Bachelor Pad Music's new Web
home.

Scott Walker
http://www.novater.com/Talent20.html
Vox dei, vox Scott.

The Waltons Home Page
http://www.the-waltons.com
This site is dedicated to the global community that strives to maintain family values
as exemplified by the Waltons.

Web Page For Brian Wilson
http://www.cabinessence.com/brian/
Over and over the crow cries uncover the
corn field . . .

WFMU Radio 91.1 FM
http://wfmu.org/
The liver spot on your radio dial.

Carny

Coney Island Circus Sideshow
http://www.coneyislandusa.com/
The last remaining authentic Ten-in-One
Circus Sideshow in the United States.

Shocked and Amazed!
http://www.atomicbooks.com/shocked.html
Devoted to the lure of the midway and
sideshow.

The Tokyo Shock Boys!
http://www.shockboys.com/
Shooting fireworks out of their butts and
into your heart!

The Torture King
http://www.interacme.com/torture/
How does he do it?

Hot Rod

Ed "Big Daddy" Roth
http://www.wedge.org/bigdaddy.htm
Rat Fink News, a museum, lots of "hep" talk.

Manga

Welcome to Manga
http://www.manga.com/
Source for manga titles and links.

Pin-Up

A Bettie Page
http://home.att.net/~Mc-Kiernan/Bpage/
bettie_p.htm
The biggest Bettie Page link site on the Web.

Skinhead

Skinheads UK
http://www.skinnet.demon.co.uk/
Bands, links, Saxon Magazine.

Resistance Records
http://www.resistance.com/
Berserkr, Nordic Thunder, Rahowa, Ian
Stuart Tribute video, more!

Wagner

Richard Wagner Archive
http://users.utu.fi/hansalmi/wagner.spml
Comprehensive site from a Wagner scholar.

ʊʊɘɮɿɘɪ

SENSORY DEPRIVATION

Art Crimes
http://www.graffiti.org/
A gallery of graffiti art from cities around
the world.

Luis Buñuel
http://www.regent.edu/acad/schcom/rojc/p
apciak.html
His thought and films.

David Cronenberg
http://www.netlink.co.uk/users/zappa/cro-
nen.html
Excellent site. "I don't have a moral plan.
I'm a Canadian."

Film Noir Reader
http://members.aol.com/alainsil/noir/index.
htm
Some chapters from the book of seminal
essays on film noir.

Film Wizards' Cult Movie Arcade
http://www.filmwizards.com/
"Super Rare Cult Videos Uncut and
Uncensored for Adults Only!" Has Caligula
and cannibal sections . . .

Fluxus Online
http://www.panix.com/~fluxus/
Yes. No. What?

Futurism: Manifestoes and Resources
http://www.unknown.nu/futurism/
Manifestoes online!

Girls on Film
http://icarus.cc.uic.edu/~landes1/hkfilm/girl
film.html
Lots of photos of stars like Jackie Chan
without shirts or in bathing suits. Yeah! Also
features the "bad fashion page"!

Hong Kong Cinema
http://egret0.stanford.edu/hk/
The granddaddy of all Hong Kong sites.

The Internet Movie Database
http://us.imdb.com/
Excellent reference site.

interFACE - main PIRATE page
http://interface.pirate-radio.co.uk/
pirate.html
Home page for British pirate radio station.

Alejandro Jodorowsky
http://www.hotweird.com/jodorowsky/
"Audiences must be assassinated, killed,
destroyed, and they must leave the theater
as new people."

Neue Slowenische Kunst
http://www.nsk.org
Get your passport here for the virtual state!

PUG
http://www.pugzine.com
Quick-loading, high-grade underground
culture zine. Recommended.

Raw Visions Magazine
http://www.rawvisions.com/
Source for art brut and outsider art, great links.

Russ Meyer
http://www.picpal.com/rmhome.html
Bosomania!

Shocking Images
http://www.shockingimages.com
Everything from gore, [s]exploitation, hor-
ror, and Asian films as well as loads of video,
soundtrack, book and music reviews.

The Ray Dennis Steckler Homepage
http://www.astro.com/steckler/
King of the B movies offers monster, slash-
er and adult movies featuring nude Las
Vegas models.

Stelarc Official Web Site
http://www.stelarc.va.com.au/
The body and its relationship with technol-
ogy through human/machine interfaces
incorporating the Internet and Web, sound,
music, video and computers.

Survival Research Laboratories
http://www.srl.org/
Please stay behind the yellow line!

Cocteau

Jean Cocteau
http://www-scf.usc.edu/~pkon/
Cocteau.html
Survey of Cocteau's films.

Jean Cocteau: Poet of the Cinema.
http://www.elibrary.com/yahooligans/fetch/
beaut_09.htm
Essay on his life and art.

Dada

Dadaism
http://dept.english.upenn.edu/~jenglish/En
glish104/tzara.html
Tristan Tzara's essay on Dada.

Dada
http://www.lib.uiowa.edu/dada/index.html
The University of Iowa Libraries' International
Dada Archive.

John Waters

Welcome to Dreamland
http://www.blueperiod.com/Dreamland/
A site devoted to filmmaker John Waters.

Surrealism

Surrealism Server
http://pharmdec.wustl.edu/juju/surr/surre-
alism.html
"The Surrealism Server serves itself and no
other."

Warhol

The Andy Warhol Musem Page
http://www.warhol.org/

Wojnarowicz

David Wojnarowicz' Tongues of Flame
http://orathost.cfa.ilstu.edu/cfa/galleries/
wojn.html

SLEAZE

Cybersleaze
http://metaverse.com/vibe/sleaze/00latest.html
In Sleaze We Trust

The Drudge Report
http://www.drudgereport.com
Current king of sleaze.

Gossip Central
http://www.gossipcentral.com
Links to Liz Smith and E! Online.

Hollywood Gossip
http://www.jtj.net/jtj/gossip.shtml
Interactive gossip bulletin boards.

Sleaze
http://www.thesleaze.com
Check out the latest sleaze!

Lukeford.com
http://www.lukeford.com
Luke Ford, the Louella Parsons of porn.

TACTICS

Archive of Hacked Web sites
http://www.onething.com/archive/
An array of sites that have been hacked, for inspiration!

The Avenger
http://www.ekran.no/html/revenge/
Tips for revenge.

A Brief History of Hackerdom
http://www.tuxedo.org/~esr/faqs/hacker-hist.html
Hacker history in epic proportions, "The Rise of Unix" and "The End of Elder Days."

Get Primitive!
http://www.shelter-systems.com/get-primi-tive.html
Make your own Stone Age tools.

Gothic Martha Stewart
http://www.toreadors.com/martha/
Late-night how-to!

Gothic Gardening
http://www.gothic.net/~malice/
Theme gardens, includes a poisoner's garden.

Ground Zero
http://www.pipebomb.com
Backyard ballistics and homemade explosives.

The Kitchen Link
http://www.thekitchenlink.com
Make bombes!

Lenny's Blades and Things
http://usasn.com/~lbt/welcome.html
Knives, knots and herbs.

Linux NOW!
http://www.linuxnow.com
Linux now, Linux wow!

MkLinux: Linux for the Power Macintosh
http://www.mklinux.apple.com/
Linux source for PowerMac users.

Pure Rage
http://www.purerage.com/
Touts itself as "Ultimate Site of Sin," has revenge tactics.

Rocky Mountain Survival Group
http://www.artrans.com/rmsg/Default.htm
A treasure trove of information.

Slashdot: News for Nerds,. Stuff That Matters
http://www.slashdot.org/
Not just for nerds, essential tech info.

The Spy Store
http://www.thespystore.com
Lots of wonderful toys available.

Survival Webring
http://www.webring.org/
cgi-bin/webring?ring=SurvivalRing;list
List of all sites in the Survival Ring, over 250 sites.

The Underground List
http://www.fc.net/phrack/under.html
Plain-wrap archive of classic undergound websites.

World's Greatest Hacking Links
http://www.thecodex.com/hacking.html
"Hackers are America's Greatest Natural Resource."

Worldwide Piracy Initiative
http://www.piracy.com/
Indexes resources regarding freedom of information and expression, and forbidden knowledge.

Y2K Personal Preparedness Webring
http://www.webring.org/
cgi-bin/webring?ring=y2kppr;list
Lists over 200 sites to help you survive the new millenium!

BATAILLE

Georges Bataille
http://www.fringeware.com/subcult/
Georges_Bataille.html
Great introduction to Bataille's life and work.

Georges Bataille in America
http://www.phreebyrd.com/~sisyphus/
bataille/
Essays on Bataille.

NIETZSCHE

Nietzsche Aphorisms
http://infonectar.com/aphorisms.html
A new aphorism each new dawn!

Pirate Nietzsche Page
http://www.cwu.edu/~millerj/nietzsche/index.html
Comprehensive page of links with a discussion group.

Thus Spake Zarathustra
http://www.us.itd.umich.edu/~alexboko/
zar/
Hypertext version.

INTERNET

ADITOM AB
http://www.aditom.se/anonym.htm
Allows you to send anonymous e-mail to friend or foe.

Deja News
http://www.dejanews.com/
A great way to research newsgroups. Huge archive of articles.

terminal: home
http://www.paperbacks.com/links/
Awesome source for links.

ON-LINE BOOKSTORES

Blood on the Page
http://www.bloodpage.com
Specialists in rare and collectible books on true crime.

BookZone
http://ttx.com/bookzone/
In addition to their own catalog has "Literary Leaps," a used-bookstore link section.

Cloak and Dagger Books
http://www.cloakanddagger.com/dagger/
The world's largest dealer in new and out-of-print books on intelligence and related fields.

ON-LINE ZINES

Factsheet Five
http://www.well.com/conf/f5/f5index2.html
Your Net guide to parallel culture. Zines, zines, and more zines!

John Labovitz's E-Zine List
http://www.meer.net/~johnl/e-zine-list/
This is a directory of electronic zines around the world, accessible via the Web, Gopher, FTP, e-mail and other services.

Contributors

AK Press is an anarchist workers collective. They publish and distribute the finest literature in the world. (**AK**)

Skylaire Alfvegren, a descendant of the Black Elves of old Scandanavia, is an Aries and collector of gay comedy albums. She is intrigued by the idea of interdimensional travel due to the intolerable stupidity of this world. A dedicated Fortean, she lives in Los Angeles and dreams of purchasing an airplane. (**SK**)

Oscar Arce has an MFA in Directing and Choreography. He lives in Los Angeles where he works in dance, publishing and cinema. (**OAA**)

Skot Armstrong is the founder and director of Science Holiday, a creative think tank. He has been active in the mail art movement since the early 1970s. His paintings have been shown throughout the U.S. and abroad. The focus of his work is modern archeology. E-mail: scienceholiday@mindspring.com (**SA**)

Steve Baughman owns a used book store; collects bad poetry. Likes to work on his car; hates to drive it. All-Electric Paperbacks website and e-mail: http://www.paperbacks.com (**SB**)

Luis Bauz, a native of Mexico City, is a writer, performance artist, curator, translator and conceptual artist currently based in Los Angeles. His main influences are Surrealism, Situationism, the films of Buñuel, Jodorowsky and Polanski and the writings of Carlos Fuentes and Marguerite Duras. (**LB**)

Joe Bellinger, a resident of Los Angeles, is a freelance writer, musician and book dealer. (**JB**)

Tosh Berman is a writer, curator, and publisher of TamTam Books. His story "Honeycombing" will be released by HOB Press in 1998. (**TB**)

Jeff Berry is a Los Angeles-based writer and filmmaker. (**JAB**)

Don Bolles activates psychoacoustic environments as Kitten Sparkles (along with Joseph Hammer) using shortwave radio, tape loops and certain hermetic and forbidden light and sound pulsation techniques. He is a field agent for the American Song Poem Music Archive, an adept in the art of spreading the disease of radio surrealism, and is presently working on a book about his former teen rockestra The Germs. (**DB**)

CONTRIBUTORS

Rev. Al Cacophony is a licensed minister, writer and animator, and a connoisseur of cults, pyrotechnics and pickled oddities. He is also chief provocateur of the Los Angeles lodge of the Cacophony Society, a network of pranksters, artists, and thrill-seekers devoted to cultural spelunking and the acceleration of millenial giddiness. E-mail: cacophonyla@earthlink.net **(RA)**

Monte Cazzazza: "All I'm trying to do is survive and accomplish something of some value." **(MC)**

Tim Cridland is the publisher of *Off The Deep End*, a zine devoted to strange ideas, conspiracy theories, weird science, flying saucers and unorthodox notions. He is best known as a sideshow and stage performer under the name Zamora, the Torture King. He may be contacted at PO Box 2025, Napa, CA 94558 or zamoratk@hotmail.com. **(TC)**

Travis Dake is a writer and mortician currently working for the San Diego County Medical Examiner's Office in the field of crime-scene investigation. **(TD)**

Adam Dubov is a screenwriter and director living in Los Angeles. His debut feature *Dead Beat* was released by LIVE Entertainment in 1995. **(AD)**

Gene Evans' foray into the occult began when his spirit separated from his teenage body in a motorcycle accident. At age 18, an article in the *L.A. Times* named him America's most up-and-coming psychic, and revealed the names of several celebrity clients. Gene completed Samra University's Qi Gong and Feng Shui programs. **(GE)**

Michael Dylan Griffin is the author of *Nationwide Butterpump, Napoleon In Rags, Kicks In The Eye/Frozen Moments of a Life* and *The Undertow Rose*. He lives in Los Angeles. **(MDG)**

Carri Faber (just months away from 40 and at her fighting weight) has written the "La De Da" column for the L.A. Weekly, produced many of the infamous Goldenvoice rock shows and raised funds for the Jerry Brown 800 number. She is a casting assistant for a major casting agent, and became one very happily married woman six years ago on April Fool's Day. **(CF)**

Alejandro Flores has played with several Mexican rock bands: Exhibición Kitsch, Los Edipos, Mariquita y sus Tortibonos Eléctricos y Los Indígenas de la Tercera Dimensión. He is currently enrolled in the ethnomusicology program at UCLA, and has his own production company which records bands that play *rock en español*. **(AF)**

Mike Guerena is a psychedelic cyclone from the screaming unknown, and the Cramps' biggest fan. **(MI)**

Michael Glass is a writer living in Los Angeles. **(MG)**

Michelle D. Handelman is a filmmaker, writer and virtual artist. Inspired by her obsession with blood, guts, power and beauty, her titles, *BloodSisters, Sugar Baby, Bitch Goddess* and *A History of Pain* continue to irritate and fascinate audiences worldwide. **(MDH)**

Kevin Hanley—artist living in Los Angeles. DOB: 7/25/68. POB: Sumter, South Carolina. **(KH)**

Skip Heller is a record producer and freelance journalist, barely living in Los Angeles. **(SH)**

Melissa Hoffs' interest in the cruel and unusual began in childhood with furtive readings of her analyst father's copy of *Psychopathia Sexualis*. Her stalled efforts at self-integration have led her to a life of screenwriting. **(MH)**

Ken Hollings is a writer living in London. **(KXH)**

Patrick Hughes is a San Francisco-based book pimp who writes occasionally. **(PH)**

Hillary Johnson is the author of *Physical Culture* and *Super Vixens' Dymaxion Lounge*. **(HJ)**

Johan Kugelberg produces records and cooks dinner. He lives in Brooklyn and Ocean Grove. **(JK)**

I.S. Levine is co-author, with the late Dr. Robert J. Stoller, of *Coming Attractions: The Making of an X-Rated Video* (Yale University Press). His previous work has appeared in *Details*, *Rolling Stone* and *Esquire*. He has also written, produced and/or performed in a wide variety of adult film and video features. (**IL**)

Carlo McCormick lives in New York City. He is a senior editor at *Paper* magazine. (**CM**)

Jen McDonald is deeply resentful and living in the South Bay. (**JEN**)

Gabriella Malta is a retired criminal psychologist now residing in Los Angeles. (**GM**)

John Marr publishes the zine *Murder Can Be Fun*. In his free moments, he plays with his collection of 10,000 books, 40 of which are reviewed here. (**JM**)

Jim Martin is the editor of *Flatland* magazine and founded Flatland Books, a reliable source for unusual books, in 1984. (**FLA**)

Metrodoro is a Mexican writer, translator and historical critic. He is currently in law school and translating three works into English. (**MET**)

Maria Montgomery is a writer who lives in Los Angeles. She avidly collects books and enjoys cooking and gardening. (**MM**)

Tony Mostrom is a cartoonist and writer who is currently working on a true crime book. (**TM**)

Nick Noyes lives and writes in New York City and London. He recently collaborated on *The Travels of Father Gonzaga*, a pulp-picaresque novel about the adventures of a morally bereft 18th-century microbrewer. (**NN**)

Genesis P-Orridge was born with an eating disorder in Manchester, England 22nd May 1947. All his actions since have remained characterized by his penchant for gratuitously applying this puzzling malady to all forms of cultural indiscretion simply to observe what might occur. He now lives as a "cultural engineer" in anomalous seclusion in the United States. (**GPO**)

Robert Parigi is a Hollywood producer by day, esoteric ghoul by night. (**RP**)

Christine Palma's existence is analogous to plane trips between Los Angeles and Manila. Spending time at either destination, stopping over in other countries, and standing in customs lines at borders are incidental to the drug-like detachment from reality that is experienced flying at high-altitude over the Pacific Ocean. (**CP**)

Andrew Perchuk is currently working on his Ph.D. in the History of Art at Yale University. He was formerly the curator at the Alternative Museum in New York. (**AP**)

Lynn Peril is a San Francisco-based reader and writer. Her zine is called *Mystery Date: One Gal's Guide to Good Stuff*. (**LP**)

Born in North Wales, **Tracey Roberts** escaped to London in the early '80s and spent eight unglamorous years in the video industry. Disillusioned, she gave up on working for a living and shifted the financial burden to her mate when they moved to Los Angeles four years ago. "Nowadays, I fill my day with anything I damned well want!" E-mail: vestige@earthlink.net. (**TR**)

Gorilla Rose began writing and performing gay comedy in the '70s with the Whiz Kidz in Seattle, then went on to write porn in New York and review bands for *Slash* magazine in Los Angeles. He has written songs for Warhol Superstar Holly Woodlawn and for the legendary Los Angeles punk band, The Screamers. He is currently writing a full-length horror novel. Most treasured possession: photo of stripping policeman Jack the Stripper signed, "To Gorilla, One Hell of a Dynamite Guy." (**GR**)

Hiroshi M. Sasaki is a refugee from Academia. He currently devotes his time to serving the needs of homeless and runaway youth in Hollywood. (**HS**)

CONTRIBUTORS

Andy Schatzberg is currently writing, producing and directing television shows and believes that fish make wonderful pets as well as interesting jewelery. (**AN**)

Charles Schneider is a screenwriter-director whose hobbies include painting, acting and devising an unholy scheme hellbent on world domination. (**CS**)

Steve Schultz was an owner and founder of Extreme Books, one of the first bookstores on the net, and co-author of the *Internet Internatioal Directory for 1997*. Schultz, on his own admisson, is also a compulsive bookbuyer. He has been reseaching cults and and political fringe groups for over 10 years. (**SC**)

Michael Sheppard is the editor/publisher of the multimedia label Transparency. (**MS**)

Erron Silverstein is a multimedia producer in Los Angeles. He studied Classical and Medieval History at Cornell. His interest in authoritarian regimes was sparked by his childhood visit to Ecuador, when he slept in a urine soaked stairwell one night until curfew was over. (**ES**)

Brian Smith studied English literature at UCLA and now resides in Los Angeles working primarily in visual art which explores utopian and folk tale symbolism. His work can be seen at Zero One gallery. (**BS**)

Julia Solis, writer and German translator, currently lives in New York City where she collects pictures of shipwrecks and drowning victims and publishes the lit mag *The Spitting Image*. E-mail and website: http://www.bway.net/~seatopia (**JS**)

Andy Somma is an artist who was born in Italy, raised in Chicago and currently lives in the Bay Area. (**AS**)

Stuart Swezey is the publisher of Amok Books and editor of the *Amok Journal: Sensurround Edition*. (**SS**)

J.A. Tallon holds advanced degrees in mathematics and law. He collects fine art and talking toys. He is a co-director of Science Holiday and his name appears on patents for at least two carbon-related products. E-mail: scienceholiday@mindspring.com (**JAT**)

Jan Tumlir is a contributing editor at *Artweek* and *X-tra* magazines, and a regular contributor to *Frieze*, *Documents* and the *L.A. Weekly*. He is represented by Jan Kesner Fine Art Gallery in Los Angeles, where he lives and works. (**JT**)

Mike Webber is in recovery again. (**MW**)

Welsh-born **Brian Williams**, better known in some circles as "Lustmord," has released a series of recordings which some claim darken the hearts of men. He's the owner/manager of the record label Side Effects, and is considering bringing about world peace and finding a cure for cancer. Website and e-mail: www.soleilmoon.com/lustmord/ (**BW**)

Jonathan Williams is a painter living in Los Angeles. (**JTW**)

Dan Wininger is a self-taught artist, outsider and owner of KOMA Bookstore. "I was born in LA., I live in LA. and will most likely die in LA." (**DW**)

Jack Womack, who has a longstanding interest in all aspects of human misbehavior and folly, is the author of six novels, including the acclaimed *Random Acts of Senseless Violence* (Grove Press). (**JW**)

Lauren Zuckerman is a film editor living in Los Angeles. (**LZ**)

Ordering

The *Amok Fifth Dispatch* is a directory of titles which are currently available as of its publication date. We have endeavoured to make obtaining these titles as simple as possible. There are several methods of ordering titles which we recommend which vary according to the particular title and the preferences of the individual placing the order.

First, the mail order book company AK Distribution has agreed to carry as many of the titles reviewed in the *Amok Fifth Dispatch* as possible. AK Distribution is very well set up to deal with direct mail orders worldwide and will promptly ship those titles which are in stock. They accept personal checks, Visa and Mastercard. AK Distribution can be contacted directly by phone, fax, mail or e-mail and have agreed to go over with each individual customer which titles from the *Amok Fifth Dispatch* are currently in stock. Please contact them first, before placing an order. Be sure to mention the *Amok Fifth Dispatch* when contacting AK Distribution to receive their 150 page catalog for free. They can be contacted as follows:

AK Distribution
P.O. Box 40682
San Francisco, CA 94140
Phone: 415-864-0892
Fax: 415-864-0893
e-mail: akpress@akpress.org

Second, for those titles which are not carried by AK Distribution, we recommend contacting one of the mail-order suppliers listed below. Following the contact information for each mail order supplier, we have indicated which *Amok Fifth Dispatch* categories it specializes in. Particular subcategory specialties are indicated in parentheses following the category name. While a given supplier may specialize in only one of the *Amok Fifth Dispatch* categories, often they will carry a far wider selection of titles which are reviewed in the *Amok Fifth Dispatch*. Please mention the *Amok Fifth Dispatch* when contacting any of the following mail order suppliers:

Adventures Unlimited
P.O. Box 74
Kempton, IL 60946
Phone: 815-253-6390
Fax: 815-253-6300
e-mail/website:
www.azstarnet.com/~aup
Exotica, R&D

Africa World Press, Inc.
P.O. Box 1892
Trenton, NJ 08607
Phone: 609-844-9583
Fax: 609-844-0198
e-mail: awprsp@castle.net
Parallax

Amazon.com
www.amazon.com
Exotica, Mayhem, Natas, Sensory
Deprivation
Note: Their selection is very extensive,
especially for titles from larger pub-
lishing houses and university presses.

Atomic Books
1018 N. Charles St.
Baltimore, MD 21201
Phone: 800-778-6246
Fax: 410-625-7955
e-mail: atomicbk@atomicbooks.com
www.atomicbooks.com
Neuropolitics, Mayhem,
Scratch'N'Sniff (Carny), Sleaze

The Blowfish Catalog
2261 Market Street #284
San Francisco, CA 94114-1600
Phone: 415-252-4340
Fax: 415-252-4349
e-mail: blowfish@blowfish.com
www.blowfish.com
Orgone (extensive selection)

Flatland Books
P.O. Box 2420
Fort Bragg, CA 95437
Phone/Fax: 707-964-8326
e-mail: flatland@mcn.org
www.flatlandbooks.com
Control, Orgone (Wilhelm Reich),

R&D, Parallax
Note: All reviews attributed to **FLA** in
the *Amok Fifth Dispatch* are taken
directly from the Flatland Books cata-
log.

Homestead Book Company
P.O. Box 31608
Seattle, WA 98103
Phone: 800-426-6777
Fax: 206-784-9328
e-mail: davet@homesteadbk.com
www.angelfire.com/biz/
HomesteadBook
Neuropolitics

Last Gasp of San Francisco
777 Florida St.
San Francisco, CA 94110
Phone: 800-848-4277
Fax: 415-824-1836
Neuropolitics, Natas, Orgone,
Scratch'N'Sniff, Sleaze

Left Bank Distribution
1404 18th Ave.
Seattle, WA 98122
Phone/Fax: 206-322-2868
e-mail: jonkonnu@eskimo.com
www.eskimo.com/~jonkonnu
Control (Anarchy, Situationism)

Loompanics Unlimited
P.O. Box 1197
Port Townsend, WA 98368
e-mail: loompanx@olympus.net
www.loompanics.com
Mayhem, R&D, Tactics

The Noontide Press
P.O. Box 2739
Newport Beach, CA 92659
Fax: 714-631-0981
Parallax (Genocide)

Omni Publications
P.O. Box 900566
Palmdale, CA 93590-0566
Phone/Fax: 805-274-2240
Control, Natas (Vatican), Parallax

Paladin Press
P.O. Box 1307
Boulder, CO 80306
Phone: 800-392-2400
Fax: 303-442-8741
e-mail: pala@rmii.com
www.paladin-press.com
Tactics

Prevailing Winds
P.O. Box 23511
Santa Barbara, CA 93121
Phone: 805-899-3433
Fax: 805-899-4773
www.prevailingwinds.org
Control, Parallax (JFK)

Samuel Weiser Inc.
P.O. Box 612
York Beach, ME 03910-0612
Phone: 800-423-7087
Fax: 207-363-5799
Natas

Third, the reader can find the best **Source** for a given title in the Title Index which follows on the next page. All titles are arranged alphabetically and include information on the author, **Source**, ISBN (when available), and the page on which the title is reviewed in the *Amok Fifth Dispatch*. The bold-face word following the name of the author is the **Source** that we have determined to be the best for individual mail orders.

Following the Title Index is the **Sources** directory: a thorough alphabetical listing of all the suppliers (publishers, distributors, mail order houses, etc.) of the books, videos, CDs, CD-ROMs and audio cassettes featured in the *Amok Fifth Dispatch*. **Sources** are listed with the name, address and, where possible, phone number (toll-free if available) and (where available) e-mail or website address. We strongly recommend getting in touch with the particular **Source** first by phone, mail or e-mail to determine exact title availability, shipping and handling charges, price changes and method of payment (check or money order, credit card acceptance, etc.) before sending money. Prices and availability are only valid as of the exact moment when we were last in contact with the publisher and are often estimates based on foreign currency exchange rates. Therefore it is the responsibility of the customer to establish current prices, availability, and shipping and handling charges before attempting to order any title. Books which are listed as available only in hardback may become available in less expensive paperback editions subsequent to the publication of this sourcebook. **Sources** have been determined primarily with the North American customer in mind; readers in other parts of the world may be able to find more convenient suppliers closer to home.

Amok Books titles can be ordered directly from Amok Books by mail or email. Please send orders to:

Book Clearing House,
46 Purdy Street,
Harrison, New York 10528
Phone: (800) 431-1579
FAX: (914) 835-0398
Email: bookch@aol.com
Website: www.amokbooks.com

To view the complete Amok Books catalog, please go the Amok Books website at www.amokbooks.com. Payment can be made by check, money order, Visa, Mastercard or American Express. For shipping and handling, please include $3.00 for the first title and $1.00 per additional title and indicate whether you prefer U.S. Priority Mail or UPS ground shipping. Overseas orders please add $3.00 per additional title. To arrange international mail order shipments, please contact us in advance by e-mail or fax.

Title Index

Hey Skinny!, Miles Beller and Jerry Leibowitz, **Chronicle**, 0811808289, $10.95, 332

The Hidden Dangers of the Rainbow, Constance Cumbey, **Huntington House**, 0910311X, $8.99, 102

Hidden Faces, Salvador Dali, **Dufour**, 072060687X, $19.95, 421

The Hieroglyphic Monad, Doctor John Dee, **Holmes**, $7.95, 121

Hieroglyphs Without Mystery, Karl-Theodor Zauzich, **University of Texas**, 0292798040, $14.95, 128

High Performance, Robert C. Post, **Johns Hopkins University**, $35.95, 360

High Priest, Dr. Timothy Leary , **Ronin**, 0914171802, $19.95, 178

High-Tech Harassment, Scott French, **Barricade**, 0942637712, $14.95, 472

Hillbillyland, J. W. Williamson, **University of North Carolina**, 0807845035, $15.95, 332

Himpressions, Valerie B. Shaw, **Harper Collins**, 0060174358, $16.00, 436

Historical Evidence for Unicorns, Larry Brian Radka, **Einhorn**, 0930401816, $15.00, 249

The History of an American Concentration Camp, Francis Feeley, **Brandywine**, 188108955X, $10.00, 249

The History of the Devil and the Idea of Evil, Paul Carus, **Open Court**, 0875483070, $16.95, 102

The History of Farting, Dr. Benjamin Bart, **O'Mara**, 1854797549, $8.95, 200

The History of Magic, Eliphas Levi, **Weiser**, 0877280770, $14.95, 102

The History of Men's Underwear, Gary Griffin, **Added Dimensions**, 1897967065, $9.95, 200

A History of Pain, Michelle Handelman and Monte Cazzazza, **M+M**, , $25.00, 200

A History of Secret Societies, Arkon Daraul, **Lyle Stuart**, 0806508574, $10.95, 249

History of Sexuality, Vol. 1, Michel Foucault, **Random House**, 0679724699, $10.00, 31

History of Sexuality, Vol. 2, Michel Foucault, **Random House**, 0394751221, $12.00, 32

History of Sexuality, Vol. 3, Michel Foucault, **Random House**, 0394741552, $11.00, 32

A History of Underground Comics, Mark J. Estren, **Ronin**, 091417164X, $19.95, 332

History of the Universe, Vol. 1), Ruth E. Norman, **Unarius**, 0932642713, $17.95, 312

The History of Witchcraft, Montague Summers, **Lyle Stuart**, 0806514523, $12.95, 102

Hit Men, Rose G. Mandelsberg, **Pinnacle**, 0786000481, $4.99, 70

Hit Men: Power Brokers and Fast Money Inside the Music Business, Fredric Dannen, **Vintage**, 0679730613, $15.00, 436

Hitchcock and Homosexuality, Theodore Price, **Scarecrow**, 081082471X, $49.50, 389

Hitler: Black Magician, Gerald Suster, **Skoob**, 1871438829, $11.95, 140

Hitler: Speeches and Proclamations, Max Domarus, **Bolchazy–Carducci**, 0865162271, $135.00, 271

The Hitler Fact Book, Thomas Fuchs, **Fountain**, 0962320293, $14.95, 249

Hitler's Willing Executioners, Daniel Goldhagen, **Vintage**, 0679772685, $16.00, 271

Hitsville, Alan Betrock, **Shake**, 0962683329, $13.45, 333

The Hoax of the Twentieth Century, Arthur R. Butz, **Institute for Historical Review**, 0939484463, $9.00, 271

Hoaxes!, Gordon Stein and Marie J. MacNee, **Visible Ink**, 0787604801, $13.95, 333

The Hoffman Newsletters, Michael A. Hoffman II, **Independent History and Research**, $89.95, 249

Hole in Our Soul, Martha Bayles, **University of Chicago**, 0226039595, $16.95, 333

Hollerin', **Rounder**, $14.00, 333

Hollywood Hi-Fi, George Gimrac and Pat Reeder, **St. Martin's**, 0312143567, $14.95, 333

Hollywood Lesbians, Boze Hadleigh, **Barricade**, 1569800146, $21.95, 436

Hollywood Lolita, Marianne Sinclair, **Plexus**, 0869651304, $14.95, 436

Hollywood Madam, Lee Francis, **Holloway House**, 0870677276, $3.95, 436

Hollywood, Blaise Cendrars, **University of California**, 0520078071, $25.00, 389

The Holocaust Story and the Lies of Ulysses, Paul Rassinier, **Institute For Historical Review**, 0939484269, $12.00, 271

The Holotropic Mind, Stanislav Grof, **Harper Collins**, 0062506595, $14.00, 159

Holy Anorexia, Rudolph M. Bell, **University of Chicago**, 0226042057, $12.95, 200

The Holy Books of Thelema, Aleister Crowley, **Weiser**, 0877286868, $17.50, 125

Holy Killers, Brian McConnell, **Trafalgar Square**, 0747244405, $9.95, 71

The Holy Terrors, Jean Cocteau, **New Directions**, 0811200213, $8.95, 414

Home Workshop Explosives, Uncle Fester, **Loompanics**, 1559500220, $12.95, 451

Home Workshop Prototype Firearms, Bill Holmes, **Paladin**, 0873647920, $25.00, 451

Homemade Grenade Launchers, Ragnar Benson, **Paladin**, 0873646266, $16.00, 465

Homicidal Insanity, 18001985, Janet Colaizzi, **University of Alabama**, 0817304045, $23.95, 71

Homicide Investigation, Burt Rapp, **Loompanics**, 1559500204, $14.95, 90

The Homopolar Handbook, Thomas Valone, **Integrity Research Institute**, 0964107015, $20.00, 287

The Homosexual Person, Fr. John F. Harvey, **Ignatius**, 0898701694, $13.95, 145

Hong Kong Action Cinema, Bey Logan, **Overlook**, 1852865407, $29.95, 389

Hormonal Manipulation, William N. Taylor, **McFarland**, 0899501664, $23.95, 200

The Horseman, Mark Matthews, **Prometheus**, 087975902X, $27.95, 200

The Horsemen's Club, Gary Griffin, **Added Dimensions**, 1897967103, $9.95, 201

Hostage to the Devil, Malachi Martin, **Harper Collins**, 006065337X, $13.00, 102

Hot Blood, Ken Englade, **St. Martin's**, 0312143583, $23.95, 71

Hot Money and the Politics of Debt, R.T. Naylor, **Black Rose**, 1895431948, $19.99, 8

Hot Rods and Cool Customs, Pat Ganahl, **Abbeville**, 0789200260, $11.95, 360

Houdini on Magic, Walter Gilbert and Morris N. Young, **Dover**, 0486203840, $6.95, 334

How Big Brother Investigates You, Anonymous, **Eden**, 0873646630, $10.00, 451

How the Irish Became White, Noel Ignatiev, **Routledge**, 0415913845, $25.00, 250

How the Self Controls Its Brain, John Eccles, **Springer–Verlag**, 0387562907, $39.00, 159

How To Be Your Own Detective, Kevin Sherlock, **Flores**, 0918751330, $29.95, 452

How To Beat the IRS at Its Own Game:, Amir D. Aczel, **Four Walls Eight Windows**, 1568580487, $9.95, 452

How To Become a Schizophrenic, John Modrow, **Apollyon**, 0963262629, $14.95, 180

How To Build Your Own Flying Saucer or Mothership, Jorge Resines, **Borderland Sciences**, $19.95, 306

How To Buy Land Cheap, Edward Preston, **Loompanics**, 1559500646, $14.95, 452

How to Circumvent a Security Alarm in 10 Seconds or Less, B. Andy, **Paladin**, 0873647777, $12.00, 452

How To Disappear Completely and Never Be Found, Doug Richmond, **Citadel**, 0806515597, $7.95, 467

How To Embalm Your Mother-in-Law, Robert T. Hatch, **Citadel**, 0806514205, $8.95, 219

How To Get Anything on Anybody, Lee Lapin, **Paladin**, 0873645944, $30.00, 453

How To Investigate Your Friends, Enemies and Lovers, Trent Sands and John Q. Newman, **Index**, 1568661436, $34.95, 453

How To Live Safely in a Dangerous World, Loren W. Christensen, **Flores**, 0918751454, $17.95, 453

How To Solve a Murder, Michael Kurland, **Macmillan**, 0028604105, $15.00, 90

How To Start Your Own Country, Erwin S. Strauss, **Loompanics**, 0915179016, $9.95, 453

How To Survive Without a Salary, Charles Long, **Eden**, 1895629020, $14.95, 453

Molotov Remembers, V. M. Molotov, **Dee**, 1566630274, $29.95, 341

Mondo 3-D, Ray Zone, **3-D Zone**, $5.00, 374

Monitoring the Feds, John McColman, **Tiare**, 0936653701, $17.95, 469

The Monkey Wars, Deborah Blum, **Oxford University**, 0195094123, $25.00, 12

Monsieur d'Eon Is a Woman, Gary Kates, **Harper Collins**, 0465047629, $15.00, 225

Monster, Sanyika Shakur, **Penguin**, 0140232257, $9.95, 77

Monsters of Weimar, Theodor Lessing/Karl Berg, **Nemesis**, 1897743106, $15.95, 77

The Montauk Project, Preston B. Nichols with Peter Moon, **Sky**, 0963188909, $15.95, 290

Montauk Revisited, Preston B. Nichols with Peter Moon, **Sky**, 0963188917, $19.95, 290

Moon Equipped, David A. Fetherston, **Classic Motorbooks**, $19.95, 361

Moon Handbook, Carl Koppeschaar, **Moon**, $10.00, 291

Moonchild, Aleister Crowley, **Weiser**, 0877281475, $11.95, 126

Moonshiners, Bootleggers and Rumrunners, Derek Nelson, **Classic Motorbooks**, 0760300011, $24.95, 341

Mormon Polygamy, Richaed S. van Wagoner, **Signature**, 1560850574, $6.95, 206

The Morning of the Magicians, Louis Pauwels and Jacques Bergier, **Online/Pemberton**, 0812885325, $14.95, 162

A Morning's Work, Stanley Burns, **Twin Palms**, $60.00, 206

Mortgaging the Earth, Bruce Rich, **Beacon**, 0807047074, $16.00, 12

The Most Dangerous Game, Ragnar Benson, **Paladin**, 0873643569, $12.00, 465

Mother Love, Deadly Love, Anne McDonald Maier, **Birch Lane**, 1559721375, $18.95, 77

Mother's Maiden Name, Anonymous, **Index**, 1568660987, $29.50, 467

The Mothman Prophecies, John A. Keel, **IllumiNet**, 0962653438, $16.95, 296

Mouse Tales, David Koenig, **Bonaventure**, $13.95, 341

The Movement of the Free Spirit, Raoul Vaneigem, **Zone**, 0942299701, $24.95, 255

Mug Shots, George Seminara, **St. Martin's**, 0312143745, $8.95, 440

The Mummy, E.A. Wallis Budge, **Dover**, 0486226816, $10.95, 129

Murder by Injection, Eustace Mullins, **National Council for Medical Research**, $19.95, 12

Murder Can Be Fun #11, John Marr, **Murder Can Be Fun**, $1.50, 92

Murder Can Be Fun #12, John Marr, **Murder Can Be Fun**, $1.50, 92

Murder Can Be Fun #13, John Marr, **Murder Can Be Fun**, $1.50, 92

Murder Can Be Fun #15, John Marr, **Murder Can Be Fun**, $1.50, 92

Murder Can Be Fun #16, John Marr, **Murder Can Be Fun**, $2.00, 92

Murder Can Be Fun #17, John Marr, **Murder Can Be Fun**, $2.00, 92

The Murder Can Be Fun 1997 Datebook, John Marr, **Murder Can Be Fun**, $3.00, 92

Murder Guide to London, Martin Fido, **Academy Chicago**, 0897334000 , $8.95, 77

Murder in the Vatican, Avro Manhattan, **Ozark**, $8.95, 146

The Murder of Bob Crane, Robert Graysmith, **Berkley**, 042515808X, $5.99, 77

Murder of Innocence, Joel Kaplan, George Papajohn and Eric Zorn, **Warner**, 0446353124, $4.95, 78

Music and Trance, Gilbert Rouget, **University of Chicago**, 0226730069, $24.00, 162

Music Is My Mistress, Edward Kennedy (Duke) Ellington, **Da Capo**, 0306803300, $14.95, 342

Musique Fantastique, Randall D. Larson, **Scarecrow**, 0810817284, $45.00, 342

Mutual Aid, Peter Kropotkin, **Black Rose**, 0921689268, $19.99, 23

Muybridge's Complete Human and Animal Locomotion, Vol. 1, Eadweard Muybridge, **Dover**, 0486237923, $75.00, 206

Muybridge's Complete Human and Animal Locomotion, Vol. 2, Eadweard Muybridge, **Dover**, 0486237931, $75.00, 206

My Education, William S. Burroughs, **Viking**, 0670813508, $21.95, 174

My First 2, 000 Men, Liz Renay, **Barricade**, 0942637445, $21.95, 440

My Husband Wears My Clothes, Peggy J. Rudd, **PM**, $12.95, 225

My Last Sigh, Luis Buñuel, **Vintage**, 0394725018, $6.95, 423

My Life, Richard Wagner, **Da Capo**, 0306804816, $16.95, 372

My Mother, Madame Edwarda and the Dead Man, Georges Bataille, **Boyars**, 0714528862, $19.95, 476

My Sister and I, Friedrich Nietzsche, **Amok**, 1878923013, $14.95, 480

My Struggle, Vladimir Zhirinovsky, **Barricade**, 156980074X, $18.00, 12

My Troubles with Women, R. Crumb, **Last Gasp**, $16.95, 342

The Mysteries of Mithra, Franz Cumont, **Dover**, 0486203239, $8.95, 133

The Mystery of the Princes, Audrey Williamson, **Academy Chicago**, 0897332083, $12.00, 78

The Mystery of the Seven Vowels, Joscelyn Godwin, **Phanes**, 0933999860, $10.95, 108

The Mystery Religions, S. Angus, **Dover**, 0486231240, $8.95, 133

The Mystery Religions and Christianity, Samuel Angus, **Citadel**, 0806511427, $9.95, 133

The Mystical Qabalah, Dion Fortune, **Weiser**, 0877285969, $8.95, 135

The Mystique of Dreams, G. William Domhoff, **University of California**, 0520060210, $9.95, 177

The Myth of the Twentieth Century, Alfred Rosenberg, **Noontide**, 0939482444, $19.00, 273

The Myth of the Virgin of Guadalupe, Rius, **American Atheist**, 0910309523, $9.00, 146

Mythomania, Bernard Welt, **Art Issues**, 0963726439, $12.95, 342

Nadja, André Breton, **Grove**, 0802150268, $9.95, 423

Naked City, Weegee, **Da Capo**, 0306802414, $13.95, 395

Naked Lens, Jack Sargeant, **Creation**, 1871592194, $16.95, 395

Naked Scientology/Ali's Smile, William S. Burroughs, **Expanded Media**, 3880300119, $13.95, 175

The Name "Negro", Moore, Turner and Moore, **Black Classic**, 0933121350, $8.95, 255

NASA Mooned America!, René, **René**, $25.00, 291

NASA, Nazis and JFK, Kenn Thomas and David Hatcher Childress, **Adventures Unlimited**, 0932813399, $16.00, 276

The Nation of Islam, Martha F. Lee, **Syracuse University**, 0815603754, $14.95, 253

National Identity in Indian Popular Cinema, 19471987, Sumita S. Chakravarty, **University of Texas**, 0292711565, $19.95, 395

National Kid, Suehiro Maruo, **RAM**, 4792601916, $12.95, 363

Nationalism and Culture, Rudolf Rocker, **Black Rose**, 0679720340, $28.99, 23

Necessary Illusions, Noam Chomsky, **South End**, 0896083667, $18.00, 29

The Necromantic Ritual Book, Leilah Wendell, **Westgate**, 0944087035, $6.50, 108

Necronomicon, Andy Black, **Creation**, 1871592372, $16.95, 396

Neither God Nor Master, Book 1, Daniel Guerin, **AK**, 1873176693, $16.95, 23

Neither God Nor Master, Book 2, Daniel Guerin, **AK**, 1873176694, $16.95, 23

Neoism, Plagarism and Praxis, Stewart Home, **AK**, 1873176333, $18.95, 34

Net of Magic, Lee Siegal, **University of Chicago**, 0226756874, $19.95, 47

Neue Slowenishe Kunst, NSK, **Amok**, 1878923056, $60.00, 3986

Neuropolitique, Timothy Leary, **New Falcon**, 1561840122, $12.95, 179

The Pyramids of Montauk, Preston Nichols and Peter Moon, **Sky**, 0963188925, $19.95, 290

Q-Saku, Suehiro Maruo, **RAM**, 479260110X, $12.95, 363

Quantum Psychology, Robert Anton Wilson, **New Falcon**, 1561840718, $12.95, 185

Queen of Burlesque, Yvette Paris, **Prometheus**, 087975639X, $19.95, 442

The Queen's Throat, Wayne Koestenbaum, **Vintage**, 0679749853, $12.00, 345

Queer Blood, Alan Cantwell Jr., **Aries Rising**, 091721126X, $12.95, 233

The Queer Dutchman, Peter Agnos, **Green Eagle**, 0914018035, $7.95, 209

R. Crumb's America, R. Crumb, **Last Gasp**, $16.95, 345

R. Crumb's Carload O' Comics, Robert Crumb, **Kitchen Sink**, 0878164030, $16.95, 345

Ra-Mu of Lemuria Speaks, Ruth Norman and Charles Spaegel, **Unarius**, 0935097082, $17.95, 313

Race, Ivan Hannaford, **Johns Hopkins University**, 0801852234, $19.95, 258

Rack, Rope and Red-Hot Pincers, Geoffrey Abbott, **Trafalgar Square**, 0747239843, $9.95, 82

Radical Vegetarianism, Mark Mathew Braunstein, **Panacea**, 0963566318, $9.95, 209

Radically Gay, Harry Hay, **Beacon**, 0807070807, $27.00, 209

Radiotext(e), Neil Strauss, **Autonomedia**, $12.00, 469

Ragnar's Homemade Detonators, Ragnar Benson, **Paladin**, 0873647378, $10.00, 465

Rancho Mirage, Aram Saroyan, **Barricade**, 094263795X, $18.99, 82

Rapanui, Grant McCall, **University of Hawaii**, 0824816412, $14.95, 48

Rapid Eye 1, Simon Dwyer, **Creation**, 1871592232, $17.95, 399

Rapid Eye 2, Simon Dwyer, **Creation**, 1871592232, $17.95, 400

Rapid Eye 3, Simon Dwyer, **Creation**, 1871592240, $17.95, 400

Raw Creation, John Maizels, **Phaidon**, 0174831492, $69.95, 412

Raw Talent, Jerry Butler, **Prometheus**, 087975625X, $16.95, 442

Raymond Chandler in Hollywood, Al Clark, **Silman-James**, 1879505290, $19.95, 400

Raymond Pettibon, Hans Rudolf Reust and Dennis Cooper, **DAP**, 3857801069, $50.00, 400

Re/Search #4/5, V. Vale, **V/Search**, 0965046915, $15.99, 175

Reagangate, Larry Flynt, **Prevailing Winds**, $.50, 442

The Real Terror Network, Edward S. Herman, **South End**, 0896081346, $16.00, 15

The Real Unfriendly Skies, Rodney Stich, **Diablo Western**, 0932438024, $25.00, 15

The Realization and Suppression of the Situationist International, Simon Ford, **AK**, 1873176821, $11.95, 35

Rebels Against the Future, Kirkpatrick Sale, **Quartet**, 0704380072, $14.95, 259

Recovery from Cults, Michael D. Langone, **Norton**, 0393313212, $17.95, 110

Recreational Drugs, Professor Buzz, **Loompanics**, 1915179881, $21.95, 167

Red Light, Sylvia Plachy and James Ridgeway, **DAP**, 1576870006, $39.95, 442

Reinventing Anarchy, Again, Howard Erlich, **AK**, 1873176880, $19.95, 24

Relativity and Common Sense, Herman Bondi, **Dover**, 0486240215, $6.95, 293

Remembering Aleister Crowley, Kenneth Grant, **Skoob**, 1871438225, $49.95, 126

Renaissance Magic and the Return of the Golden Age, John S. Mebane, **University of Nebraska**, 080328179X, $12.95, 111

Resisting the Virtual Life, James Brook and Iain Boal, **City Lights**, 0872862992, $15.95, 15

Restoration of the Interplanetary Confederation, Ruth Norman, **Unarius**, 093264290X, $17.95, 313

Return from Madness, Kathleen Degen and Ellen Nasper, **Aronson**, 1568216254, $30.00, 181

Return of the Furies, Hollida Wakefield and Ralph Underwager, **Open Court**, 0812692721, $16.95, 112

Return to Atlantis, Uriel and Antares, **Unarius**, 0932642519, $24.95, 313

Return to Jerusalem, Ruth Norman (Uriel) and Unarius Students, **Unarius**, 0932642780, $12.95, 314

Revelations, Kathy Kemp and Keith Boyer, **Crane Hill**, 1881548074, $60.00, 412

The Revenge of God, Gilles Kepel, **Penn State**, 0271013141, $14.95, 112

A Review of the Book Entitled "Morals and Dogma", A. Ralph Epperson, **Publius**, Free, 282

The Revival of Israel, Moses Hess, **University of Nebraska**, 0803272758, $10.00, 39

The Revival Styles in American Memorial Art, Peggy McDowell and Richard Meyer, **Bowling Green**, 0879726342, $22.95, 220

Revolt Against the Modern World , Julius Evola, **Inner Traditions**, 089281506X, $29.95, 112

The Revolt of the Elites and the Betrayal of Democracy, Christopher Lasch, **Norton**, 03930313719, $12.95, 16

Revolution and Genocide, Robert Melson, **University of Chicago**, 0226519910, $16.95, 274

Revolution of Everyday Life, Raoul Vaneigem, **Left Bank**, $16.00, 35

Revolution of the Mind, Mark Polizzotti, **Farrar Straus Giroux**, 0374249822, $35.00, 423

Revolutionary Brotherhood, Steven C. Bullock, **University of North Carolina**, 0807845558, $19.95, 282

Rhythmajik, Z'ev, **Temple**, 1871744407, $17.95, 112

The Rhythms of Black, Jon Michael Spencer, **Africa World**, 0865434247, $16.95, 259

Right Where You Are Sitting Now, Robert Anton Wilson, **Ronin**, 0914171453, $9.95, 185

Righteous Revenge, George Hayduke , **Lyle Stuart**, 0818405694, $8.95, 472

Ring of Fire, Vol. 1, Lorne and Lawrence Blair, **Mystic Fire**, $24.95, 48

Ring of Fire, Vol. 2, Lorne and Lawrence Blair, **Mystic Fire**, $24.95, 49

Ring of Fire, Vol. 3, Lorne and Lawrence Blair, **Mystic Fire**, $24.95, 49

Ring of Fire, Vol. 4, Lorne and Lawrence Blair, **Mystic Fire**, $24.95, 49

Ringolevio, Emmett Grogan, **Citadel**, 0806511680, $12.95, 259

Riots and Pogroms, Paul R. Brass, **NYU**, 0814712746, $40.00, 82

The Rise and Fall of the Jewish Gangster in America, Albert Fried, **Columbia University**, 0231096836, $14.50, 82

Ritualized Homosexuality in Melanesia, Gilbert H. Herdt, **University of California**, 0520080963, $16.00, 49

Rituals and Spells of Santería, Migene Gonzalez-Wippler, **Magical Childe**, $5.95, 149

Rituals, Initiation and Secrets in Sufi Circles, Franz Heidelberg et al, **The Society for Sufi Studies**, $7.00, 183

The Riverman, Robert D. Keppel, **Pocket**, 0671867636, $5.99, 82

The Road to Hell, Michael Maren, **Free Press**, 0684828006, $25.00, 16

Road to Rembetika, Gail Holst, **Harvey**, 0907978274, $10.00, 345

Roadfood, Jane and Michael Stern, **Harper Perennial**, 0060965991, $15.00, 345

Robert Fludd and Freemasonry, A. E. Waite, **Holmes**, 1558182926, $5.95, 282

Rock and the Pop Narcotic, Joe Carducci, **2.13.61**, 1088098511X, $18.00, 369

Rock'n'Roll Babylon, Gary Herman, **Plexus**, 0859651991, $14.95, 442

Rockers, John Stuart, **Plexus**, 0859651258, $14.95, 346

The Rocket and the Reich, Michael J. Neufeld, **Harvard University**, 067477650X, $15.95, 259

Rodin on Art and Artists, Auguste Rodin, **Dover**, 0486244873, $8.95, 400

Rogue Asteroids and Doomsday Comets, D. Steel, **Wiley**, 0471308242, $24.95, 293

Rogue Primate, John A. Livingston, **Roberts Rinehart**, 1570980586, $22.95, 167

The Secrets of Doctor John Dee, Gordon James, **Holmes**, $19.95, 121

The Secrets of Houdini, J.C. Cannell, **Dover**, 0486229130, $7.95, 347

Secrets of Magical Seals, Anna Riva, **Indio**, 0943832047 , $4.50, 149

Secrets of Methamphetamine Manufacture, Uncle Fester, **Loompanics**, 1559501448, $24.95, 168

Secrets of Rennes-Le-Château, Lionel and Patricia Fanthorpe, **Weiser**, 0877287449, $12.95, 115

Secrets of a Super Hacker, The Knightmare, **Loompanics**, 1559501065, $19.95, 458

Secrets of Voodoo, Milo Rigaud, **City Lights**, 0872861716, $14.95, 149

Seize the Time, Bobby Seale, **Black Classic**, 093312130X, $14.95, 267

Selected Letters, D.S. Ashwander, **Tray Full of Lab Mice**, $2.00, 181

Sell Yourself to Science, Jim Hogshire, **Loompanics**, 1559500840, $16.95, 458

The Senator's Whore, Leo Guild, **Holloway House**, 0870673556, $3.95, 443

A Separate Cinema, John Kisch and Edward Mapp, **Noonday**, 0374523606, $20.00, 347

Serial Slaughter?, Michael Newton, **Loompanics**, 1559500786, $19.95, 83

The Serpent and the Rainbow, Wade Davis, **Warner**, 0446343870, $6.50, 149

Serpent-Handling Believers, Thomas Burton, **University of Tennessee**, 087049788X, $19.95, 115

Severed, John Gillmore, **Amok**, 1878923102, $16.95, 83

Sex and Drugs, Robert Anton Wilson, **New Falcon**, 1561840017, $12.95, 211

Sex Drugs and Aphrodisiacs, Adam Gottlieb, **Ronin**, 0914171569, $9.95, 211

Sex in Films, Parker Tyler, **Citadel**, 0806514655, $16.95, 403

Sex Murder and Sex Aggression, Eugene Revitch and Louis B. Schlesinger, **C. C. Thomas**, 039806346X, $24.95, 84

Sex Mythology, Sha Rocco, **American Atheist**, 0911826349, $4.00, 116

Sex, Sin and Mayhem, Edward W. Knappman, **Visible Ink**, 0787604763, $12.95, 443

Sex Work, Frédérique Delacoste and Priscilla Alexander, **Cleis**, 0939416115, $16.95, 443

Sexual Aberrations, Wilhelm Stekel, **Norton**, 08714099, $5.95, 211

Sexual Art, Michael A. Rosen, **Shaynew**, 0936705035, $30.00, 211

The Sexual Brain, Simon LeVay, **MIT**, 0262620936, $10.95, 212

Sexual Homicide, Robert K. Ressler, **Lexington**, 066916559X, $39.95, 84

Sexuality and Eroticism Among Males in Moslem Societies, Arno Schmitt and Jehoeda Sofer, **Haworth**, 0918393914, $12.95, 49

Sexually Transmitted Diseases, Barbara Romanowski, M.D. and J.R.W. Harris, M.B., **CIBA-GEIGY**, 0914168361, $3.50, 212

Sexwise, Susie Bright, **Cleis**, 15734400297, $10.95, 212

Shadows of Tender Fury, Subcomandante Marcos, **Monthly Review**, 0853459185, $15.00, 36

Shamans of the 20th Century, Ruth-Inge Heinze, **Irvington**, 082902459X, $14.95, 168

Shattered Innocence, Shattered Dreams, Susan Hightower and Mary Ryzuk, **Pinnacle**, 0786002190, $4.99, 84

Shock Value, John Waters, **Thunder's Mouth**, 1560250925, $12.95, 419

Shock XPress 2, Stefan Jaworzyn, **Titan**, 1852865199, $16.95, 403

Shocked and Amazed #1, James Taylor, **Atomic**, $9.95, 357

Shocked and Amazed #2, James Taylor, **Atomic**, $12.95, 357

Shocked and Amazed #3, James Taylor, **Atomic**, $12.95, 357

A Short Lexicon of Alchemy, A. E. Waite, **Holmes**, $6.95, 121

Shortwave Clandestine Confidential, Gerry L. Dexter, **Universal Electronics**, 0961661024, $8.95, 470

The Show Must Go On, Rick Sky, **Carol**, 0806515066, $10.95, 443

Siege, James Mason, **Storm**, $20.00, 260

The Sieve of Time, Leni Riefenstahl, **Quartet**, 0704370212, $40.00, 402

Silent Death, Uncle Fester, **Loompanics**, 0915179865, $14.95, 459

Simon Wiesenthal, Mark Weber, **Noontide**, $.20, 276

Simple Living, Frank Levering and Wanda Urbanska, **Penguin**, 0140123393, $10.00, 459

Simulations, Jean Baudrillard, **Autonomedia**, 0936756002, $7.00, 26

Sindh Revisted, Christopher Ondaatje, **Harper Collins**, 0002554364, $30.00, 53

The Sirius Mystery, Robert Temple, **Destiny**, 0892811633, $16.95, 294

The Sixties, Gerald Howard, **Marlowe**, 1569248249, $14.95, 347

Skin Problems of the Amputee, S. William Levy, **Green**, 0875271812 , $49.95, 212

Skinhead Nation, George Marshall, **S.T.**, 18898927456, $26.95, 371

Skinheads Shaved for Battle, Jack Moore, **Bowling Green**, 0879725834, $14.95, 371

Skins, Gavin Watson, **S.T.**, 1898927057, $19.95, 371

Skoob Esoterica Anthology, Christopher R. Johnson, **Skoob**, 1871438462, $11.95, 116

Slave Girls, Wensley Clarkson, **St. Martin's**, 0312958706, $5.99, 84

Slavery, Milton Meltzer, **Da Capo**, 0306805367, $19.95, 260

Slavery in the Arab World, Murray Gordon, **New Amsterdam**, 1561310239, $14.95, 261

Sleazy Business, Alan Betrock, **Shake**, 0962683388, $14.95, 347

Sleeping Beauty, Stanley Burns, **Twin Palms**, 0942642325, $50.00, 220

Slimetime, Steven Puchalski, **Critical Vision**, 0952328852, $19.95, 403

SM: The Last Taboo, Gerald Greene and Caroline Greene, **Blue Moon**, 1562010662, $8.95, 212

Snitch, Jack Luger, **Loompanics**, 155950076X, $16.95, 459

Snowdomes, Nancy McMichael, **Abbeville**, 1558590366, $24.95, 348

So You Bought a Shortwave Radio, Gerry L. Dexter, **Tiare**, 0936653043, $6.95, 470

Social Anarchism or Lifestyle Anarchism, Murray Bookchin, **AK**, 187317683X, $7.95, 24

A Social History of the Minor Tranquilizers, Mickey C. Smith, **Haworth**, 056024142X, $14.95, 168

Social Security Number Fraud, Anonymous, **Eden**, $12.95, 467

Socialists and the Fight Against Anti-Semitism, Peter Seidman, **Pathfinder**, 087348293X, $3.00, 40

The Society of the Spectacle, Guy Debord, **Zone**, 0942299795, $10.95, 35

Sodomy and the Pirate Tradition, B. R. Burg, **NYU**, 0814712363, $14.95, 261

Soiled Doves, Anne Seagraves, **Gem Guides**, 096190884X, $11.95, 443

Soledad Brother, George Jackson, **Hill**, 1556522304, $14.95, 267

Some Effects of Music, D. B. Fry, **Octagon**, 0950002976, $6.00, 169

Some Like It Dark, Kipp Washington, **Holloway House**, 0870673440, $3.50, 443

Some of My Best Friends Are Naked, Tim Keefe, **Barbary Coast**, 0963446606, $12.95, 443

Songs of Experience, William Blake, **Dover**, 0486246361, $3.95, 404

Songs of Innocence, William Blake, **Dover**, 0486227642, $3.95, 403

Soul in the Stone, John Gary Brown, **Univ. Press of Kansas**, 0700606343, $39.95, 221

Soul Music A-Z, Hugh Gregory, **Da Capo**, 0306806436, $17.95, 348

Soul on Ice, Eldridge Cleaver, **Dell**, 044021128X, $5.99, 267

Title Index

Sources

2.13.61
2.13.61
P.O. Box 1910
LA, CA 90078
213-969-8131

A & B
A & B Books
149 Lawrence Street
Brooklyn, NY 11201

A Cappella
a cappella Books
c/o Chicago Review Press
814 N. Franklin St.
Chicago, IL 60610

Abbeville
Abbeville Publishing Group
488 Madison Avenue
New York, NY 10022
800-ART-BOOK

Abrams
Harry N. Abrams, Inc.
100 Fifth Avenue
New York, NY 10011
212-206-7715
Fax: 212-645-8437

Abrasax
Abrasax/James M. Martin
PO Box 1219
Corpus Christi, TX 78403-1219

Academic
Academic Press
525 "B" Street
Suite 1900
San Diego, CA 92101-4495
800-321-5068/800-235-0256

Academy Chicago
Academy Chicago Publishers
213 W. Institute Place
Chicago, IL 60610
312-751-7300
Fax: 312-751-7306

Access Unlimited
Access Unlimited
PO Box 1900
Frazier Park, CA 93225

Added Dimensions
Added Dimensions Publishing
100 S. Sunrise Way #484
Palm Springs, CA 92262

Adventures Unlimited
Adventures Unlimited
303 Main Street-Post Box 74
Kempton, IL 60946
815-253-6390
Fax: 815-253-6300

Africa World
Africa World Press
11-D Princess Road,
Lawrenceville, NJ 08648
609-844-9583
Fax: 609-844-0198

African American Images
African American Images
1909 West 95th Street
Chicago, IL 60643

AK
AK Press
P.O. Box 40682
San Francisco, CA
94140-0682
415-864-0892
Fax:415-923-0607
akpress@org.org

Alamo Square
Alamo Square Press
P.O. Box 14543
San Francisco, CA 94114
415-863-7410
Fax: 415-863-7456

Aldine de Gruyter
Aldine de Gruyter
200 Saw Mill River Road
Hawthorne, NY 10532
914-747-0110
Fax: 914-747-1326

Alecto
Alecto Enterprises
PO Box 460473
San Francisco, CA
94146-0473

Allison & Busby
Allison & Busby
5 The Lodge
Richmond Way
London W12 8LW
U.K.

Alpha
Alpha Publications of Ohio
PO Box 308
Sharon Center, OH 44274-0308
216-239-2327

Alyson
Alyson Publications
40 Plympton Street
Boston, MA 02118
800-283-3572

Amarillo
Amarillo Records
P.O. Box 24433
San Francisco, CA 94124

American Atheist
American Atheist Press
P.O. Box 140195
Austin, TX 78714-0195
512-458-1244
Fax: 512-467-9525

American Psychiatric
American Psychiatric Press
1400 K Street, N.W.
Washington, DC 20005
800-368-5777
Fax: 202-789-2648

Amok
Amok Books
1764 N. Vermont Ave.
Los Angeles, CA 90027
323-663-8618
Fax: 323-550-8833
orders@amokbooks.com

Anchor
Anchor Books
P.O. Box 54
Two Harbors, MN 55616
800-323-9872
Fax: 715-824-5806

Andrews and McMeel
Andrews and McMeel
4900 Main Street
Kansas City, MO 64112

Anthroposophic
Anthroposophic Press
R.R. 4, Box 94A1
Hudson, NY 12534
518-851-2054
Fax: 518-851-2047

Aoroa
Aoroa
P.O. Box 420464
San Francisco, CA 94142-0464

Aorta
Aorta
c/o Petak
Postfach 778
Vienna 1011
Austria

Aperture
Aperture
20 East 23rd Street
New York, NY 10010
212-505-5555
Fax: 212-979-7759

Apollyon
Apollyon Press
PO Box 5114
Everett, WA 98206

Appleton & Lange
Appleton & Lange
P.O. Box 120041
Stamford, CT 06912-0041
800-423-1359
Fax: 203-406-4602

Applewood
Applewood Books
128 The Great Road, P.O. Box 365
Bedford, MA 01730
617-271-0055
Fax: 617-271-0056

Aquarian
The Aquarian Press
c/o Thorsons Publishing Group
Wellingborough
Northamptonshire NN8 2RQ
UK

Architectural Association
Architectural Association Publications
34-36 Bedford Square
London WC1B 3ES
UK
071/6360974
Fax: 071/4140782

Archives Szukalski
Archives Szukalski
PO Box 923308
Sylmar, CA 91392

Aries Rising
Aries Rising Press
PO Box 29532
Los Angeles, CA 90029
818-504-6569
213-462-6458

Arkana
Arkana Books
375 Hudson Street
New York, NY 10014
800-526-0275
Fax: 212-366-2933

Aronson
Jason Aronson Inc., Publishers
230 Livingston Street
Northvale, NJ 07647
800-782-0015
201-767-4093

Art Issues
Art Issues Press
c/o Foundation for Advanced
Critical Studies
8721 Santa Monica Blvd., Suite 6
Los Angeles, CA 90069
213-876-4508
Fax: 213-876-5061

Artspace
Artspace Books
123 S. Park
San Francisco, CA 94107

AskWhy!
AskWhy! Publications
Selwyn, 41 The Butts
SomersetBA11 4AB
U.K.

Atlan Formularies
Atlan Formularies
P.O. Box 95
Alpena, AR 72611
870-437-2999
Fax: 501-437-2973
www.kurtsaxon.com

Atlantic Monthly
Atlantic Monthly Press
19 Union Square West
New York, NY 10003
800-788-3123
Fax: 617-227-0730

Atlas
Atlas Press
c/o Serpent's Tail Books
180 Varick St.-10th Flr
New York, NY 10014
800-283-3572
Fax: 212-741-0424

Atomic
Atomic Books
1018 North Charles Street
Baltimore, MD 21201
410-625-7955
Fax: 410-625-7945
www.atomic.books.com/
atomicbk@atomicbooks.com

Autonomedia
Autonomedia
POB 568 Williamsburg Station
Brooklyn, NY 11211-0568
800-869-7553
Fax: 718-963-2603

Avon
Avon Books
Box 767
Dresden, TN 38225-0767
800 223 0690

Ayer
Ayer Company Publishers
Lower Mill Road
N. Stratford, NH 03590
603-922-5105
Fax: 603-922-3348

Ballantine
Ballantine Books
201 East 50th Street
New York, NY 10022
(800)733-3000

Bantam
Bantam Doubleday Dell
666 Fifth Avenue
New York, NY 10103
800-323-9872
Fax: 212-765-6500

Barbary Coast
Barbary Coast Press
PO Box 425367
San Francisco, CA 94142

Bare Facts
The Bare Facts
P.O. Box 3255
Santa Clara, CA 95055

Barricade
Barricade Books
61 Fourth Avenue
New York, NY 10003
212-627-7000
Fax: 212-673-1039

Basic
Basic Books, Inc.
10 East 53rd Street
New York,NY 10022-
800-242-7737
Fax: 212-207-7057

Beacon
Beacon Press
25 Beacon Street
Boston, MA 02108
617-742-2110
Fax: 617-742 2290

Berkley
The Berkley Publishing Group
P.O. Box 506
East Rutherford, NJ 07073
800-631-8571

Berkshire House
Berkshire House Publishers
P.O. Box 297
Stockbridge, MA 01262
413-243-0303
Fax: 413-243-4737

Berrett-Koehler
Berrett-Koehler Publishers Inc.
450 Sansome Street, Suite 200
San Francisco, CA 94111
415-288-0260
Fax: 415-362-2512

Beyond Words
Beyond Words Publishing, Inc.
4443 N.E. Airport Road
Hillsboro, OR 97124-6074

Birch Lane
Birch Lane
c/o Carol Publishing

Bison
Bison Books
c/o University of Nebraska Press
312 North 14th Street
Lincoln, NE 68588-0484
(800)755-1105
Fax: (402)472-6214
press@unlinfo.unl.edu

Black Book
Black Books
P.O. Box 3115
San Francisco, CA 94131
415-431-0171
Fax: 415-431-0172
http://www.queernet.org/
Black Books/

Black Classic
Black Classic Press
P.O. Box 13414
Baltimore, MD
21203-3414
(800)476-8870
Fax: 410-358-0987

Black Rose
Black Rose Books
c/o AK Press
800-565-9523
(716)683-4547
612-221-0124.
www.web.net/blackrosebooks/

Basil Blackwell
Blackwell Publishers
238 Main Street
Cambridge, MA 02142
800-445-6638
Fax: 617-547-0789

Blank Tapes
Blank Tapes
P.O. Box 8263
Emeryville, CA 94608
510-655-7399
Fax: 510-655-3351

Blue Moon
Blue Moon Books, Inc.
61 Fourth Avenue
New York, NY 10003
212-505-6880
Fax: 212-673-1039

Blue Water
Blue Water
P.O. Box 190
Mill Spring, NC 28756

Bolchazy-Carducci
Bolchazy-Carducci Publishers
1000 Brown Street, Unit 101
Wauconda, IL 60084
708-526-4344
Fax: 708-526-2867
www.bolchazy.com /latin@bolc-hazy.com

Bold Type
Bold Type, Inc.
P.O. Box 1984
Berkeley, CA 94701

Bonaventure
Bonaventure Press
P.O. Box 51961
Irvine, CA 92619-1961

Bonus
Bonus Books
160 East Illinois Street
Chicago, IL 60611

Book Tree
The Book Tree
c/o AK Press

Books in Focus
Books in Focus
P.O. Box 77005
San Francisco, CA 94107
800-463-6285

Borderland Science
Borderland Sciences Research
Foundations
P.O. Box 220
Bayside, CA 95524
707-825-7733
Fax: 707-825-7779

Borderline
Borderline Productions
P.O. Box 3819
Glasgow G43 1UT
Scotland

Bowling Green
Popular Press
Bowling Green State University
Bowling Green, OH 43403
419-372-7865

Boyars
Marion Boyars Publishers
237 East 39th Street
New York, NY
10016
800-243-0138
Fax: 212-808-0664

Brandywine
Brandywine
c/o AK Press

Braziller
George Braziller Inc.
60 Madison Avenue
New York, NY 10010-1682
212-889-0909
Fax: 212-689-5405

Bridge of Love
Bridge of Love
c/o M. Ed. Marketing
P.O. Box 28550
San Diego, CA 92198
800-551-5328

Bridger House
Bridger House Publishers, Inc.
PO Box 2208
Carson City, NV 89702
800-729-4131

British Film Institute
British Film Institute
c/o Indiana University Press
601 North Morton Street
Bloomington, IN 47404-3797
800-842-6796
Fax 812-855-7931

Broadwater House
Broadwater House
30 Park Parade
Harrogate, N. Yorks
HG1 5AG
UK

Brotherhood of Life
Brotherhood of Life
110 Dartmouth S.E.
Albuquerque, NM 87106
505-873-2179
Fax: 505-873-2423
brohood@thuntek.net

Bulfinch
Bulfinch Press
c/o Little, Brown

Bureau of Public Secrets
Bureau of Public Secrets
P.O. Box 1044
Berkeley, CA 94701

C.W. Daniel
C.W. Daniel Company, Ltd.
1Church Path
Saffron Walden, Essex CB10 1JP
UK
0799-521909
Fax: 0799-513462

Cambridge University
Cambridge University Press
40 West 20th Street
New York, NY 10011
800-872-7423
Fax: 212-691-3239

Cambrix
Cambrix Publishing, Inc.
9304 Deering Ave.
Chatsworth, CA 91311
818- 993 -4274
Fax: 818-992-8781

Carol
Carol Publishing Group
120 Enterprise Avenue
Secaucus, NJ 07094
800-866-1966
Fax: 201-866-8159

Carroll and Graf
Carroll and Graf
c/o Publishers Group West
4064 Holden Street
Emeryville, CA 94608
800-788-3123

Carson Street
Carson Street Publishing, Inc.
205 East John Street
Carson City, NV 89701

Center for Land Use Interpretation
The Center for Land Use
Interpretation
499 Embarcadero
Oakland, CA 94606
510-"COVER-IT"

Chapman and Hall
29 West 35th St.
New York, NY 10001-2291
212-244-3336 X323
Fax: 212-268-9964

C.C. Thomas
Charles C. Thomas Publishing
2600 South First Street
Springfield, IL 62794-9265
217-789-8980

Charles F. Miller
Charles F. Miller, Publisher
708 Westover Drive
Lancaster,PA 17601

Kerr
Charles H. Kerr
c/o **AK Press**

Chelsea Green
Chelsea Green Publishing Co.
205 Gates-Briggs Building
P.O. Box 428
White River Junction, VT 05001
802-295-6300
802-295-6300
blackmer@sover.net

Chicago Review
Chicago Review Press
814 N. Franklin St.
Chicago, IL 60610

Chick
Chick Publications
PO Box 662
Chino, CA 91710
800-932-3050
Fax: 909-941-8128

Chronicle
Chronicle Books
275 Fifth Street
San Francisco, CA 94103
800-722-6657
Fax: 415-777-7240

Chronos
Chronos
c/o **AK Press**

CIBA-GEIGY
CIBA-GEIGY Corporation
P.O. Box 18060
Newark, NJ 07191
800-631-1181

Circumcision
Circumcision Resource Center
P.O. Box 232
Boston, MA 02133
Phone/Fax: 617-523-0088
crc@circumcision.org

Citadel
Citadel Press
c/o **Carol Publishing**

Citadel Underground
Citadel Press
c/o **Carol Publishing**

City Lights
City Lights Books Mail Order
261 Columbus Avenue
San Francisco, CA 94133
Fax: 415-362-4921

Civilized
Civilized Publications, Inc.
2019 S. 7th St.
Philadelphia, PA 19148

Clarity Press
Clarity Press c/o **AK Press**

Classic Motorbooks
Classic Motorbooks
c/o **Motorbooks International**

Cleis
Cleis Press
P.O. Box 8933
Pittsburgh, PA 15221
800-334-3892
Fax: 412-937-1567

Cleopatra
Cleopatra Records
8726 S. Sepulveda Blvd.
Suite D-82
Los Angeles, CA 90045

Codex
CodeX Publications
c/o **AK Press**

Collective Action
Collective Action
c/o **AK Press**

Columbia University
Columbia University Press
136 South Broadway
Irvington, NY 10533
800-944-8648

Common Courage
Common Courage Press
P.O. Box 702
Monroe, ME 04951
800-243-0138

Consolidated
Consolidated Press International
3171-A South 129th East Avenue
Siute 338
Tulsa, OK 74134
918-664-6163

Constantine Report
Constantine Report
c/o **AK Press**

Consultant
Consultant Press
163 Amsterdam Ave. #201
New York, NY 10023
212-838-8640
Fax: 212-873-7065

Contemporary
Contemporary Books
2 Prudential Plaza
Chicago, IL 60601-6790
312-540-4500
Fax: 312-540-4687

Continuum
Continuum Publishing Group
370 Lexington Avenue
New York, NY 10017
212-953-5858
Fax: 212-953-5966

Cornell University
Cornell University Press
Sage House, 512 East State Street
Ithaca, NY 14851-0250
800-688-2877
Fax: 607-277-2374

Cosmic Field Guide
Cosmic Field Guide
c/o Head Heritage/KAK, Ltd.
P.O. Box 3823
London N8 8TQ
UK

Council on Foreign Relations
Council on Foreign Relations
58 East 68th St.
New York, NY 10021
212-734-0400
Fax: 212-861-2759

Country People
Country People Productions
2554 Lincoln Boulevard, Box
#456-L
Marina Del Rey, CA 90291
800-287-9477

CPA
CPA Book Publisher
33838 SE Kelso Road, Suite 2
P.O. Box 596
Boring, OR 97009

Crane Hill
Crane Hill Publications
2923 Crescent Avenue
Birmingham, AL 35209
800-841-2682
Fax: 205-871-7337

CRC
CRC Press, Inc.
2000 Corporate Blvd., N.W.
Boca Raton, FL 33431
800-272-7737

Creation
Creation Books
c/o AK Press

Creative Design
Creative Design Services
P.O. Box 61263
King of Prussia, PA 19406-1203

Creatopia
Creatopia Productions
730 Independence Drive
Orange City, FL 32763
floral@n-jcenter.com

Critical Vision
Critical Vision
c/o AK Press

Crossing
The Crossing Press
P.O. Box 1048
Freedom, CA 95019
800-777-1048
Fax: 408-722-2749

CrossRoads
CrossRoads Books
P. O. Box 506
Notre Dame, IN 46556
800-561-6526
Fax: 219-273-5973

Crown
Crown Publishing Group
201 East 50th Street
New York, NY 10022
800-726-0600
212-572-2600

Cures Not Wars
Cures Not Wars
9 Bleecker Street
New York, NY 10012
212-677-4899

Da Capo
Da Capo Press
233 Spring Street
New York, NY 10013-1578
800-321-0050
212-807-1047

Daedalus
Daedalus Publishing Co.
584 Castro Street, Suite 518
San Francisco, CA 94114
415-626-1867
415-487-1137
daedalus@bannon.com/
www.bannon.com/daedalus

DAP
Distributed Art Publishers
636 Broadway, 12th Floor
New York, NY 10012
800 338 BOOK
Fax: 212 673 2887

Data News
Data News Press
11736 3rd St.
Yucaipa, CA 92399

December
December Press
Box 302
Highland Park, IL 60035
847-940-4122

Dedalus
c/o Subterranean Company
P. O. Box 160
265 South 5th Street
Monroe, OR 97456
541-847-5274
Fax: 541-847-6018

Dee
Ivan R. Dee, Inc. Publisher
1332 North Halsted Street
Chicago, IL 60622-2637
800-634-0226
Fax: 312-787-6269

Dell
Dell Publishing Co., Inc.
666 Fifth Avenue
New York, NY 10103
800-223-5780
212-765-3535
Denise Harvey
Denise Harvey and Company
340-05 Limni
Evia, Greece

Destiny
Destiny Books
One Park Street
Rochester, VT 05767

Diablo Western
Diablo Western Press
PO Box 5
Alamo, CA 94507
800-247-7389
510-295-1203

Dickens
Dickens Press
Five Dickens Court
Irvine, CA

Dirk Nishen
Dirk Nishen Publishing
c/o AK Press

DK
DK Publishing
95 Madison Avenue
New York, NY 10016

Doubleday
Doubleday & Co., Inc.
666 Fifth Avenue
New York, NY 10103
800-457-7605

Dove
Dove Books and Audio Books
301 North Cañon Drive
Beverly Hills, CA 90210

Dover
Dover Publications, Inc.
31 East 2nd Street
Mineola, NY 11501
516-294-7000
Fax: 516-742-5049

Down There
Down There Press
938 Howard Street, #101
San Francisco, CA 94103-4114
800-289-8423
Fax: 415-974-8989

Duckworth
Duckworth Press
Old Piano Factory
48 Hoxton Square
London N1 6PB, UK
Dufour
Dufour Editions Inc.
P.O. Box 7
Chester Springs, PA 19425-0007
800-869-5677
Fax: 610-458-7103

Duke University
Duke University Press
Box 90715
Durham, NC 27708-0715
919-688-5134

E.P. Dutton
Dutton Books
375 Hudson Street
New York, NY 10014
800-526-0275

Earthpulse
Earthpulse Press
P.O. Box 201393
Anchorage, AK 99520
907-249-9900
www.earthpulse.com

Ecco
Ecco Press
100 West Broad Street
Hopewell, NJ 08525
609-466-4748

Eden
Eden Press
PO Box 8410
Fountain Valley, CA 92728
800-338-8484
Fax: 714-556-2023

Einhorn
Einhorn Press
c/o **Adventures Unlimited**

Element
Element Books
P.O.Box 830
Rockport, MA 01966
800-526-0275
Fax: 508-546-9882

Elephant
Elephant Editions
c/o **AK Press**

Elysium Growth
Elysium Growth Press
700 Robinson Rd.
Topanga, CA 90290
800-350-2020
310-455-2007

Emissary
Emissary Publications
9205 S.E. Clackamas Rd., #1776
Clackamas, OR 97015
503-824-2050

Enthea
Enthea Press
c/o Ariel Press
Box 1411
Des Moines, IA 50305-1411

Equilibrium
Equilibrium
c/o M. Ed. Marketing
P.O. Box 28550
San Diego, CA 92198
800-321-9054

Erlbaum
Lawrence Erlbaum Associates, Inc.
365 Broadway
Hillsdale, NJ 07642
800-926-6579
Fax: 201-666-2394

Exact Change
Exact Change
P.O. Box 1917
Boston, MA 02205
617-269-6227

Expanded Media Editions
Expanded Media Editions
Postfach 190136
53037 Bonn
0228-219507

Faber and Faber
Faber and Faber, Inc.
50 Cross Street
Winchester, MA
01890
617-721-1427

Factor
Factor Press
P.O. Box 8888, Dept FA
Mobile, AL 36689

Facts on File
Facts On File, Inc.
460 Park Avenue South
New York, NY 10016-7382
800-678-3633

Fag Rag
Fag Rag Books
P.O. Box 331, Kenmore Station
Boston, MA 02215

Fantagraphics
Fantagraphics Books Inc.
7563 Lake City Way N.E.
Seattle, WA 98115
206-524-1967
Fax: 206-524-2104
fgraphic@halcyon.com

Farrar, Straus and Giroux
Farrar, Straus and Giroux
19 Union Square West
New York, NY 10003
212-741-6900

Feral House
Feral House
2532 Lincoln Blvd. #359
Venice, CA 90291
cult@feralhouse.com

Fithian
Fithian Press
P.O. Box 1525
Santa Barbara, CA 93102-1525
800-662-8351
Fax: 805-962-8835

Five Leaves
Five Leaves
c/o **AK Press**

Flammarion
Flammarion
200 Park Avenue South
Suite 1406
New York, NY 10003
212-777-6888
Fax: 212-777-6938

Flatland
Flatland Distribution
PO Box 2420
Fort Bragg, CA, 95437
707-964-8326

Flores
J.Flores Publications
P.O.Box 830131
Miami, FL 33283-0131
800-472-2388

Floris/Anthroposophic
Floris Books
15 Harrison Gardens, Edinburgh
Scotland
UK

Flower
Flower Press
10332 Shaver Rd.
Kalamazoo, MI 49002
616-327-0108
Fax: 616-327-70092

Food First
Food First Institute for Food and
Development Policy
398 60th Street
Oakland, CA 94618
510-654-4400
Fax: 510-654-4551
foodfirst@igc.apc.org

Foot Fraternity
Foot Fraternity
P.O. Box 24102
Cleveland, OH 44124
216-449-4114

**Forest Lawn–Memorial Park
Association**
Forest Lawn–Memorial Park
Communications
1712 S. Glendale Ave.
Glendale, CA 91205
800-204-3131 X4782

Fortean Times
Fortean Times
20 Paul Street
Frome, Somerset BA11 1DX
UK
0373 451777

Fountain
Fountain Books
P. O. Box 931716
Los Angeles, CA 90093
213-656-7193

Four Walls Eight Windows
Four Walls Eight Windows
P.O.Box 548-Village Station
New York, NY 10014-0548
800-444-2524
Fax: 212-206-8799

Foxglove
Foxglove Press
P.O. Box 321
San Rafael, CA 94915-0321
415-499-0670

Free Press
The Free Press
125 Spring Street
Lexington, MA 02173
800-223-2348

Freedom
Freedom House
c/o AK Press

Frog
Frog, Ltd.
P.O. Box 12327
Berkeley, CA 94712
510-559-8277

Fromm
Fromm International Publishing
Corporation
560 Lexington Avenue
New York, NY 10022
212-308-4010
Fax: 212-371-5187

Galde
Galde Press
P.O. Box 65611
St. Paul, MN 55165-0611

Galen
Galen Press, Ltd.
P.O. Box 64400
Tucson, AZ, 85728-4400
602-577-8363
Fax: 602-529-6459

Garber
Garber Communications
5 Garber Hill Road
Blauvelt, NY 10913
914-359-9292

Garland
Garland Publishing, Inc.
717 Fifth Ave.
Suite 2500
New York, NY 10022-8102
800-627-6273
Fax: 212-751-7447

Gates of Heck
Gates of Heck, Inc.
PO Box 23073
Richmond, VA 23223
800-213-8170

Gem Guides
The Gem Guides Publishing Company
315 Cloverleaf Drive, Suite F
Baldwin Park, CA 91706
818-855-1611

General
General Publishing Group, Inc.
2701 Ocean Park Blvd.
Suite 140
Santa Monica, CA 90405
310-314-4000
Fax: 310-314-8080

Goad to Hell
Goad To Hell Enterprises
P.O. Box 31009
Portland, OR 97231

Moore College of Art
Moore College of Art
20th St. and The Parkway
Philadelphia, PA 19103

Godine
David R. Godine
P.O. Box 9103
9 Lewis St
Lincoln, MA 01773
800-344-4771
Fax: 617-259-9198

Grassfield
Grassfield Press, Inc.
P.O. Box 19-799
Miami Beach, FL 33119
305-672-0805

Green
Warren H. Green, Inc.
8356 Olive Blvd.
St. Louis, MO 63132
800-537-0655
Fax: 314-997-1788

Green Eagle
Green Eagle Press
P.O. Box 20329, Cathedral Stn.
New York, NY 10025
212-663-2167
Fax: 212-316-7650

Greenery
Greenery Press
3739 Balboa #195
San Francisco, CA 94121

Greensward
Greensward Press
1600 Larkin Street, #104
San Francisco, CA 94109
415-928-4142
Fax: 415-775-0634

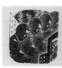

Greenwood
Greenwood Publishing Group
88 Post Road West
P.O. Box 5007
Westport, CT 06881-5007
800-474-4329
Fax: 203-222-1502

Grey Fox
Grey Fox Press
P.O. Box 31190
San Francisco, CA 94131

Grove
Grove Press
1224 Heil Quaker Blvd.
Lavergne, TN 37086-7001
800-937-5557

Guilford
Guilford Publications, Inc.
72 Spring Street
New York, NY 10012
800-365-7006
Fax: 212-966-6708

Hackett
Hackett Publishing Company
P.O. Box 44937
Indianapolis, IN 46204

Hanuman
Hanuman Books
P.O. Box 24
Woodstock, NY 12498
914-679-4701
Fax: 914-679-8803
bigpink@well.com/
www.levity.com/hanuman/

Harcourt Brace
Harcourt Brace and Company
525 B Street
San Diego, CA 92101
800-543-1918
Fax: 800-235-0256

Harcourt Brace Jovanovich
Harcourt Brace Jovanovich
1250 Sixth Avenue
San Diego, CA, 92101
800-543-1918
619-699-6335

Hardy Marks
Hardy Marks Publications
P.O. Box 90520
Honolulu, HI 96835

Hare
Glen Hare Publications
c/o Dyna Corporation
6300 Yarrow Drive
Carlsbad, CA 92009-1597

HarperCollins
HarperCollins
10 E.53rd St.
New York, NY 10022-5299
800-242-7000
Fax: 212-207-7222

Harper San Francisco
Harper San Francisco
1160 Battery Street
San Francisco, CA 94111
415-477-4400

Harvard University
Harvard University Press
79 Garden Street
Cambridge, MA 02138-9983
800-448-2242

Harvest
Harvest Books
c/o Harcourt Brace and Company
525 B Street
San Diego, CA 92101
800-543-1918

Harvester-Sussex
c/o **St. Martin's Press**

Hastings House
Hastings House
141 Halstead Avenue
Mamaroneck, NY 10543

Haworth
The Haworth Press, Inc.
10 Alice Street
Binghamton, NY 13904-1580
800-342-6784
Fax: 607-722-3487

Hayes
Hayes Publishing Company
6304 Hamilton Avenue
Cincinnati, OH 45224
513-681-7559
Fax: 513-681-9298

Headpress
c/o **AK Press**

Healing Arts
Healing Arts
c/o **Inner Traditions**

Hemp/Queen of Clubs
H.E.M.P./Queen of Clubs
5632 Van Nuys Blvd. #210
Van Nuys, CA 91401

Heyday
Heyday Books
P.O. Box 9145
Berkeley, CA 94709

Hightext
Hightext Publications
125 N. Acacia Ave.
Suite 110
Solana Beach, CA 92075

Hill and Wang
Hill and Wang
19 Union Sq. West
New York, NY 10003
800-631-8571
Fax: 212-741-6973

Hippocrene
Hippocrene Books
171 Madison Avenue
New York, NY 10016
718-454-2366
Fax: 718-454-1391

Holloway House
Holloway House Publishing
8060 Melrose Avenue
Los Angeles, CA 90046
213-653-8060
Fax: 213-655-9452

Holmes
Holmes Publishing Group
P. O. Box 623
Edmonds, WA 98020
206-771-2701

Holmes and Meier
Holmes and Meier
160 Broadway
New York, NY 10038
212-254-4100
Fax: 212-374-1313

Hood
Alan C. Hood and Co.
P.O. Box 775
Chambersburg, PA 17201
717-267-0867
Fax: 717-267-0572

Horus House
Horus House Press, Inc.
P.O. Box 55185
Madison, WI 53705

Houghton Mifflin
Houghton Mifflin Company
222 Berkeley Street
Boston, MA 02116-3764
800-225-3362
Fax: 212-420-5859

Hourglass
Hourglass Book Publishing
P.O. Box 171
Aptos, CA 95001
408-688-7535

Human Energy
Human Energy Press
1020 Foster City Blvd. #205
Foster City, CA 94404
415-349-0718
Fax: 415-349-1257

Humana
Humana Press, Inc.
999 Riverview Dr.-Suite 208
Totowa, NJ 07512
201-256-1699
Fax: 201-256-8341

Huntington House
Huntington House Publishers
P.O. Box 53788
Lafayette, LA 70505
318-237-7049
Fax: 318-237-7060

Hyperion
Hyperion Books
200 West Street
Waltham, MA 02154
800-759-0190
617-890-0875

Ignatius
Ignatius Press
15 Oakland Avenue
Harrison, NY 10528
800-537-0390
Fax: 970-221-3920

IllumiNet
IllumiNet Press
PO Box 2808
Lilburn, GA 30226
404-377-2590
Fax: 404-279-8007

Independent History and Research
Independent History and Research
P.O. Box 849
Coeur d'Alene, ID 83816

Index
Index Publishing Group
3368 Governor Drive
Suite 273F
San Diego, CA 92122
619-281-2957
Fax: 619-281-0547

Indio
Indio Products, Inc.
236 W. Manchester Ave.
Los Angeles, CA 90003
800-944-1414

Inner Light
Inner Light Publications
P.O. Box 753
New Brunswick, NJ 08903
800-700-4024
Fax: 212-685-4080

Inner Traditions
Inner Traditions International
One Oak Street
Rochester, VT 05767
800-246-8648
Fax: 802-767-3726

Institute for Historical Review
Institute for Historical Review
P.O. Box 2739
Newport Beach, CA 92659
714-631-1490
Fax: 714-631-0981

Institute for Palestine Studies
Institute for Palestine Studies
3501 "M" Street N.W.
Washington, D.C. 20007

Institute of General Semantics
Institute of General Semantics
163 Engle Street
Englewood, NJ 07631
201-568-0551
Fax: 201-569-1793

Integrity Research Institute
Integrity Research Institute
1413 K Street, Suite 204
Washington, D.C. 20005
800-295-7674

Intelligence
Intelligence, Inc.
2228 S. El Camino, #349
San Mateo, CA 94403
415-851-5403

InterVarsity
InterVarsity Press
430 East Plaza Drive
Westmont, IL 60559
630-887-2500
Fax: 630-887-2520
www.ivpress.com

Irvington
Irvington Publishers, Inc.
522 E. 82nd Street, Suite 1
New York, NY 10028
860-824-0680

Irwin
Irwin Professional Publishing
1333 Burr Ridge Parkway
Burr Ridge, IL 60521
800-634-3966

Ism
Ism press
P. O. Box 12447-M
San Francisco, CA 94112-0447
415-333-7641

Ivy
Ivy
c/o Ballantine Books

Jaico
Jaico Publishing House
121-125 Mahatma Gandhi Rd.
Bombay 400 001, India
022-270621

**Jews for the Preservation of
Firearms Ownership**
Jews for the Preservation of
Firearms Ownership, Inc.
2872 South Wentworth Ave.
Milwaukee, WI 53207
414-769-0760
Fax: 414-483-8435

Johns Hopkins University
Johns Hopkins University Press
2715 N. Charles St.
Baltimore, MD 21218
800-537-5487
Fax: 412-516-6998

Jolly Roger
Jolly Roger Press
PO Box 295
Berkeley, CA 94701
510-548-7123

Joseph
Joseph Publishing
2533 N. Carson St.
Carson City, NV 89706
800-942-0821

Judd
Ralph Judd Communications
1330 Bush Street #4H
San Francisco, CA 94109
800-637-2256

Juno
Juno Books
180 Varrick Street
New York, NY 10014
212-807-7300
Phone: 212-807-7355

Just Another Reality
Just Another Reality
P.O. Box 12419
Las Vegas, NV 89112

Kent State University
Kent State University Press
P.O. Box 5190
Kent, OH 44242-0001
330-672-7913
Fax: 330-672-3104

Kitchen Sink
Kitchen Sink Press
320 Riverside Drive
Northampton, MA 01060
800-365-7465
413-586-7040

Knopf
Alfred A. Knopf
201 E. 50th St.
New York, NY 10022
800-733-3000

Kodansha
Kodansha International
114 Fifth Avenue
New York, NY 10011
800-631-8571
Fax: 212-727-6460

Krause
Krause Publications
700 E.State St.
Iola, WI 54990-0001
715-445-2214
Fax: 715-445-4087

KRRIM
KRRIM
c/o AK Press

KTAV
KTAV Publishing House, Inc.
Box 6249 - 900 Jefferson St.
Hoboken, NJ 07030
201-963-9524
Fax: 201-963-0102
74631.2017@compuserve.com

Labor
Labor Publications
P.O. Box 48377
Oak Park, MI 48237

Labor Relations
Labor Relations, Inc.
P.O. Box 33023
Detroit, MI 48232

Labour
Labour Press Books
c/o Labor Publications
P.O. Box 367
Bankstown, NSW 2200
Australia

Lace
Lace Publications
c/o Alyson Publications

Last Gasp
Last Gasp of San Francisco
777 Florida
San Francisco, CA 94110
800-848-4277
Fax: 415-824-1836

Last Prom
The Last Prom
120 South San Fernando Blvd. #243
Burbank,CA 91502

Lawrence Hill
Lawrence Hill Books
611 Broadway
Suite 530
New York, NY 10012
212-260-0576
Fax: 212-260-0853

Left Bank
Left Bank Books
1404 18th Ave.
Seattle, WA 98122
206-322-2868

Lexington
Lexington Books
125 Spring Street
Lexington, MA 02173
800-223-2348

Leyland
Leyland Publications
P.O. Box 410690
San Francisco, CA 94141
415-824-3184

Liberty Library
Liberty Library
300 Independence Ave. SE
Washington, DC 20003
800-522-6292
Fax: 202-544-4101

Light Technology
Light Technology Publishing
PO Box 1526
Sedona, AZ 86336
602-282-6523
Fax: 602-282-4130

Limelight
Limelight Editions
118 East 30th Street
New York, NY 10016
212-532-5525

Lindisfarne
Lindisfarne Press
R.R. 4, Box 94 A1
Hudson, NY 12534
518-851-9155
Fax: 518-851-2047

Lindsay
Lindsay Publications
PO Box 538
Bradley, IL 60915
815-935-5353

Little, Brown
Little, Brown and Company
1271 Avenue of the Americas
New York, NY 10020
800-759-0190
Fax: 212-522-2062

Liveright
Liveright Publishing
c/o Norton

Living Truth
Living Truth Publishers
1708 Patterson Road
Austin, TX 78733-6507
512-263-9780

Llewellyn
Llewellyn Worldwide, Ltd.
P.O. Box 64383
St. Paul, MN 55164
612-291-1970

Long River
Long River Books
140 Commerce Street
East Haven, CT 06512
800-243-0138

Loompanics
Loompanics Unlimited
P.O. Box 1197
Port Townsend, WA 98368

Lumen
Lumen, Inc.
20 West 20 Street
New York, NY 10011
800-283-3572
Fax: 212-989-7944

Luna Info
Luna Info Services
6160 Packard Street
Los Angeles, CA 90035-2581
213-655-5440
Fax: 213-655-0691
lis1@cris.com

Lyle Stuart
Lyle Stuart
c/o **Carol Publishing**

M + M
M + M Productions
P.O. Box 170415
San Francisco, CA 94117
MMFilms@aol.com

Macmillan
Macmillan Books
866 3rd Ave.
New York, NY 10022

Macoy
Macoy Publishing and Masonic
Supply Co.
P.O. Box 9759
Richmond, VA 23228-0759
804-262-6551

Magickal Childe
Magickal Childe Publishing, Inc.
35 West 19th Street
New York, NY 10011
212-242-7182
Fax: 212-691-0361

Maisonneuve
Maisonneuve
c/o **AK Press**

Majority Press
Majority Press
P. O. Box 476
Canton, MA 02021
617-828-8450

Manic D
Manic D Press
Box 410804
San Francisco, CA 94141

Marlar
Marlar Books
Box 17038
4301 E. 54th St.
Minneapolis, MN 55417

Marlowe and Company
Marlowe and Company
632 Broadway 7th floor
New York, NY 10012
510-658-1834

Matilija
Matilija Press
323 E. Matilija St.
Suite 110-123
Ojai, CA 93023
805-646-3045

McFarland
McFarland and Company
Box 611, Highway 88
Jefferson, NC 28640
910-246-4460
Fax: 910-246-5018

Menil Collection
Menil Collection
1511 Branard
Houston, TX 77006
713-525-9442

Mercury House
Mercury House
785 Market Street
San Francisco, CA 94103-2003
Fax: 415-433-7042
415-392-3041

Message
The Message Company
R.R. 2-Box 307 MM
Santa Fe, NM 87505
505-474-0998
Fax: 505-471-2584

Michael Hunt Publishing
Michael Hunt Publishing
Box 226
Bensenville, IL 60106
773-927-5008
Fax: 773 927-5584

Midnight Marquee
Midnight Marquee Press, Inc.
9721 Britinay Lane
Baltimore, MD 21234

Millenia
Millenia Press
2761 N. Marengo Ave
Altadena, CA 91001
818-794-3119
Fax: 818-794-1301
skepticmag@aol.com

MIT
MIT Press
55 Hayward Street
Cambridge, MA, 02142
800-356-0343
617-625-0660

Miwok
Miwok Press
P.O. Box 1582
Novato, CA 94948
800-488-0550

Monkeywrench
Monkeywrench
c/o **AK Press**

Monthly Review
Monthly Review Press
122 West 27th Street
New York, NY 10001
212-691-2555

Moon
Moon Publications
330 Wall Street
Chico, CA 95928
916-345-5473
Fax: 916-345-6751

Morrow
William Morrow and Co.
105 Madison Ave.
New York, NY 10016
800-843-9389

Mosaic
Mosaic Media, Inc.
999 Main Street
Glen Ellyn, IL 60137
708-740-1117

SOURCES

Mosby-Wolfe
Mosby-Wolfe
c/o Mosby-Year Book, Inc.
11830 Westline Ind. DR.
St. Louis, MO 63146-3318

Motorbooks Intl
Motorbooks International
POB 1-Prospect Avenue
Osceola, WI 54020
800-458-0454
Fax: 715-294-4448

Mugwort Soup
Mugwort Soup Publications
2450 1/2 Barrington Ave.
Los Angeles, CA 90064

Mystic Fire
Mystic Fire Video
P.O. Box 422
New York, NY 10012-0008
800-292-9001

Mystic Rose
Mystic Rose Books
P.O. Box 1036/SMS
Fairfield, CT 06432

N
Naturist Society (TNS) "N"
P.O. Box 132
Oshkosh, WI 54902
800-558-8250
Fax: 414-231-9977

Na Kane O Ka Malo
Na Kane O Ka Malo Press
PO Box 970
Waipahu, HI 96797

Naiad
Naiad Press Inc.
P.O. Box 10543
Tallahassee, FL 32302
800-533-1973
Fax: 904-539-9731

NAMBLA
The North American Man/Boy Love
Association (NAMBLA)
P.O. Box 174
Midtown Station, NY 10018

National Council for Medical Research
The National Council for Medical
Research
P.O. Box 1105
Staunton, VA 24401

National Vanguard
National Vanguard Books
P.O. Box 330
Hillsboro, WV 24946

Natural
Natural Products Co.
P.O. Box 1251
Occidental, CA 95465
916-756-7177

Nemesis
c/o AK Press

New American Library
New American Library
1633 Broadway
New York, NY 10019
212-366-2000

New Amsterdam
New Amsterdam Books
P.O. Box C
Franklin, NY 13775-0303
Fax: 607-797-4823

New Beacon
New Beacon Books Ltd.
76 Stroud Green Road
London N4 3EN
UK

New Directions
New Directions Books
80 Eighth Avenue
New York, NY 10011
800-458-6515

New Falcon
New Falcon Publications
1739 East Broadway Road
Suite 1-277
Tempe, AZ 85822
602-708-1409
Fax: 602-246-3546

New Futurist
New Futurist Books
72 New Bond Street
London, W1Y 9DD
UK

New Press
New Press
450 West 41 Street
New York, NY 10036
800-233-6830
Fax: 212-268-6349

New Society
New Society Publishers
4527 Springfield Ave.
Philadelphia, PA 19143
800-333-9093
215-222-1993

New Star
New Star Books, Ltd.
2504 York Avenue
Vancouver, BC V6K 1E3
Canada
604-738-9429

Newcastle
Newcastle Publishing Co., Inc.
PO Box 7589
Van Nuys, CA 91409
800-932-4809
Fax: 818-780-2007

Nicolas-Hays
Nicolas-Hayes, Inc.
c/o Weiser
Box 612
York Beach, ME 03910-0612
207-363-4393
Fax: 207-363-5799

Noonday
Noonday Press
c/o Farrar, Straus and Giroux

Noontide
Noontide Press
P.O.Box 2719
Newport Beach, CA 92659
714-631-1490
Fax: 714-631-0981

North Ridge
North Ridge Books
P.O. Box 1463
Dept. L
El Toro, CA 92630
714-855-0640

Northwestern University
Northwestern University Press
625 Colfax Street
Evanston, IL 60208-4210
800-621-2736
Fax: 312-660-2235

Norton
W.W. Norton
500 Fifth Avenue
New York, NY
10110-0017
212-345-5500
Fax: 212-869-0856

553

SOURCES

NYU
New York University Press
70 Washington Square South
New York, NY 10012
212-998-2575
Fax: 212-995-3833

O'Mara
Michael O'Mara Books
9 Lion Yard, Tremadoc Road
London SW4 7NQ
UK
071-7208643
Fax: 071-6278953

Octagon
Octagon Press
c/o ISHK Book Service
Dept. B41, P.O. Box 176
Los Altos, CA 94023
800-222-4745

Odonian
Odonian Press
Box 32375
Tucson, AZ 85751
800-Real-Story
Fax: 520-296-0936

Ohio University
Ohio University Press
Scott Quandrangle
Athens, OH 45701-2927
614-593-1155

Olson
Olson Publishing
c/o AK Press

Omni Publications
Omni Publications
P.O. Box 900566
Palmdale, CA 93590-0566
805-274-2240

Online/Pemberton
Online Inc.
462 Danbury Road
Wilton, CT 06897

Onyx
Onyx Books
375 Hudson Street
New York, NY 10014

Open Archive
Open Archive Press
P.O. Box 23511
Santa Barbara, CA 93121
805-899-3433
Fax: 805-569-2411

Open Court
Open Court Publishing Company
PO Box 599, General Books
Division
Peru, IL 61354
800-435-6850
Fax: 815-223-2520

Optima
Optima Books
279 North Cañon Drive
Suite 170
Beverly Hills, CA 90210
818-981-3090
Fax: 818-981-3688

Orgone Biophysical Research
Orgone Biophysical Research
P.O. Box 1395
El Cerrito, CA 94530

OSJC
OSJC
P.O. Box 568
Quincy, IL 62306

Outbound
Outbound Press
89 Fifth Avenue
Suite 803
New York, NY 10003

Overlook
Overlook Press
149 Wooster St.
Fourth Floor
New York, NY 10012
212-477-7162
Fax: 212-477-7525

Owl
Owl Paperbacks
c/o Henry Holt and Company
115 West 18th Street
New York, NY 10011

Oxford University
Oxford University Press
198 Madison Ave.
New York, NY 10016-4314
800-732-3120
Fax: 919-677-8828

Ozark
Ozark Books
Box 3703
Springfield, MO 65808
417-883-0438

Paladin
Paladin Press
P.O. Box 1307
Boulder, CO 80306
800-392-2400
Fax: 303-442-8741

Panacea
Panacea Press
c/o AK Press

Pantheon
Pantheon Books
201 East 50th Street
New York, NY 10022
800-726-0600
Fax: 212-572-6045

Panther
Panther Press
1032 Irving, #514
San Francisco, CA 94122
415-665-1608
Fax: 415-665-3354

Paragon House
Paragon House
370 Lexington Avenue
New York, NY 10017
800-937-5557

Park Street
Park Street Press
One Park Street
Rochester, VT 05767
802-767-3174

Pathfinder
Pathfinder Press
410 West Street
New York, NY 10014
212-741-0690
212-727-0150

Peachtree
Peachtree Publishers
494 Armour Circle N.E.
Atlanta, GA 30324-4088
800-241-0113
Fax: 404-875-2578

Pelagian
Pelagian Press
c/o AK Press

Pelican
Pelican Publishing
P.O. Box 3110
Gretna, LA 70054
800-843-1724
Fax: 504-368-1195

Pen Power
Pen Power Publications
P.O. Box 25363
Anaheim, CA 92825

Penguin
Penguin USA
120 Woodbine St.
Bergenfield, NJ 07621
800-227-9604

Penn State
Penn State Press
USB I, Suite C
University Park, PA 16802
800-326-9180
Fax: 814-863-1408

Peter Owen
Peter Owen Publishers
c/o **Dufour Editions**

Phaidon
Phaidon Press
800-722-6657

Phanes
Phanes Press
PO Box 6114
Grand Rapids, MI 49516
800-678-0392
Fax: 707-995-1814

Pharos
Pharos Books
260 Park Avenue
New York, NY 10166

Phoenix
Phoenix Publishing, Inc.
P. O. Box 10
Custer, WA 98240
206-366-2204
Fax: 206-380-1859

Picador
Picador Books
175 5th Ave.
New York, NY 10010
212-674-5151

Pilgrims Book House
Pilgrims Book House
P.O. Box 3872
Kathmandu, Nepal
977-1-229983

Pinnacle
Pinnacle Books
475 Park Avenue South
New York, NY 10016
800-221-2647
Fax: 212-779-8073

Plenum
Plenum Books
233 Spring Street
New York, NY
10013
800-221-9369
Fax: 212-807-1047

Plexus
Plexus Publishing, Ltd.
26 Dafforne Rd.
London SW17 8TZ
UK
44 171 622 2440
Fax: 44 171 622-2441

Plume
Plume Books
375 Hudson Street
New York, NY 10014
800-526-0275
212-366-2000
Fax: 212-366-2933

Pluto
Pluto Press
345 Archway Road
London, N6 5AA
UK
0181-348-9133

PM
PM Publishers, Inc.
P.O. Box 5304
Katy, TX 77491-5304

Pocket
Pocket Books
1230 Avenue of the Americas
New York, NY 10020
800-223-2348

Police Bookshelf
Police Bookshelf
P.O. Box 122
Concord, NH 03302-0122
800-624-9049
Fax: 603-226-3554

Polinym
Polinym Press
P. O. Box 22140
St. Louis, MO 63116
314-968-0986

Polity
Polity Press
108 Cowley Road
Oxford, OX4 1JF, UK

Pomegranate
Pomegranate Press
P.O. Box 6099
Rohmert Park, CA 94927

Poorhouse
Poorhouse Press
8333 W. McNab Road
Tamarac, FL 33321

Popular Culture, Ink
Popular Culture, Ink
P.O. Box 1839
Ann Arbor, MI 48106
800-678-8828
Fax: 313-761-4301

Popular Reality
Popular Reality
135 West High Street
Jackson, MI 48203-3169
517-782-5605

Power
Power Publications
John Power Institute of Fine Arts
Univ. of Sydney
NSW 2006, Australia

Pressure Drop Press
Pressure Drop Press
P.O. Box 460754
San Francisco, CA 94146
415-648-3561
Fax: 415-665-3333

Prestel-Verlag
Prestel-Verlag
16 West 22nd Street
New York, NY 10010
212-627-8199
Fax: 212-627-9866

Prevailing Winds
Prevailing Winds
P.O. Box 23511
Santa Barbara, CA 93121
805-899-3433
Fax: 805-899-4773

Prima
Prima Publishing
PO Box 1260
Rocklin, CA 95677-1260
916-632-4400
Fax: 916-632-4405

Princeton University
Princeton University Press
41 William Street
Princeton, NJ 08540
800-777-4726

Prometheus
Prometheus Books
59 John Glenn Drive
Amherst, NY
14228-2197
800-421-0351
Fax: 716-691-0137

Psychiatric Genocide Research
Institute
Psychiatric Genocide Research
Institute
49 Trinity Terrace
Springfield, MA 01108
413-788-9523

Publius
Publius Press
3100 South Philamena Place
Suite B
Tucson, AZ 85730
602-886-4380

Putnam
Putnam Publishing Group
200 Madison Avenue
New York, NY 10016
212-951-8507

Pyewackett
Pyewackett Press
1312 N. Stanley
Los Angeles, CA 90046
Fax: 213-850-0206

Pyramid
Pyramid Books
P.O. Box 105
Burbank, CA 91503-0105
818-557-6707

QED
QED Press
155 Cypress Street
Fort Bragg, CA 95437
800-773-7782
707-964-9520
Fax: 707-964-7531

Quartet
Quartet Books Limited
27/29 Goodge Street
London W1P 1FD, UK
071-636-3992
Fax: 071-637-1866

Quest
Quest Books
PO Box 270
Wheaton, IL 60189-0270
708-665-0130
Fax: 708-665-8791

Quick Trading
Quick Trading
P.O. Box 4294477
San Francisco, CA 94142-9477
800-428-7825 X102
Fax: 510-533-4911

Quill
Quill Books
c/o **William Morrow**
105 Madison Ave.
New York, NY 10016
800-843-9389

Quintessence
Quintessence Publishing Co., Inc.
551 North Kimberly Drive
Carol Stream, IL 60188-1881
800-621-0387
Fax: 708-682-3288

Ralph Myles
Ralph Myles Press
c/o **AK Press**

RAM
RAM Publications
2525 Michigan Ave., #A2
Santa Monica, CA 90404
310-453-0043
Fax: 310-264-4888

Random House
Random House
201 E. 50th St.
New York, NY 10022
800-733-3000

Reality
Reality Marketing
5300 W. Sahara, Suite 101
Las Vegas, NV 89102
800-656-3597

Rebel
Rebel Press
c/o **AK Press**

Red Eye
Red Eye Press
845 West Avenue 37
Los Angeles, CA 90065-3201
213-225-3805
Fax: 213-225-3805

Regnery
Regnery Publishing, Inc.
422 First Street SE, Suite 300
Washington, DC 20003
202-546-500
Fax: 202-456-8759

René
René
31 Burgess Place
Passaic, NJ 07055
201-473-8825
Fax: 201-797-2028

Re/Search
c/o **V/Search**

Ritter Verlag
Ritter Verlag
Alter Platz 25
Klagenfurt, Austria

Roberts Rinehart
Roberts Rinehart Publishers
5455 Spine Road
Mezzanine W.
Boulder, CO 80301

Rogers
Helga M. Rogers
4975 59th Avenue South
St. Petersburg, FL 33715-1619
813-864-3292

Ronin
Ronin Publishing
P.O. Box 1035
Berkeley, CA 94701
800-788-3123
Fax: 510-548-7326

Rounder
Rounder Records
One Camp Street
Cambridge, MA 02140
617-354-0700
Fax: 617-491-1970

Route 66
Route 66 Publishing, Ltd.
4002 Silver S.E.
Albuquerque, NM 87108
800-687-0912

Routledge
Routledge
29 West 35th St.
New York, NY 10001-2291
800-634-7064
Fax: 212-268-9964

Rutgers University
Rutgers University Press
109 Church Street
New Brunswick, NJ 08901
800-446-9323
908-932-7039

S.T.
S.T. Publishing
c/o **AK Press**

Sabotage
Sabotage Editions
c/o **AK Press**

SAF
SAF Publishing Ltd.
12 Conway Gardens,
Wembley, Middx. HA9 8TR
UK
44 181 904 6263
Fax: 44 181 930 8565

Samisdat
Samisdat Publishers, Ltd.
P. O. Box 791
Niagara Falls, NY 14302
416-922-9850

Samuel French
Samuel French Publishing
7623 Sunset Blvd.
Hollywood, CA 90046
213-876-0570
Fax: 213-876-6822

Sarpedon
Sarpedon
166 Fifth Avenue
New York, NY 10010
212-741-9538
Fax: 212-633-1036

Scarecrow
Scarecrow Press, Inc.
4720 Boston Way, Suite A
Lanham, MD 20706-4310
908-548-8600
Fax: 908-548-5767

Schiffer
Schiffer
1469 Morstein Road
West Chester, PA 19380

Schocken
Schocken Books
c/o **Pantheon**

Scott-Townsend
Scott-Townsend Publishers
PO Box 34070, NW
Washington, DC 20043
202-371-2700
Fax: 202-371-1523

Scribner
Scribner Publishing
200 Old Tappan Road
Old Tappan, NJ 07675
800-223-2336

Seal
Seal Press
3131 Western Avenue, #410
Seattle, WA 98121
206-283-7844

Secrecy Oversight Council
Secrecy Oversight Council
HCR Box 38
Rachel, NV 89001

See Sharp
See Sharp Press
P.O. Box 1731
Tucson, AZ 85702
800-356-9315
Fax: 520-628-8720

Seeland
Seeland
1920 Monument Blvd. M-1
Concord, CA 94520
510-420-0469

Semiotext(e)
Semiotext(e)
522 Philosophy Hall
Columbia University
New York, NY 10027
718-387-6471

Serpent's Tail
Serpent's Tail Books
180 Varick St.
10th Floor
New York, NY 10014
800-283-3572
Fax: 212-741-0424

Servant
Servant Publications
P. O. Box 8617
Ann Arbor, MI 48107
313-761-8505

Shadow Lane
Shadow Lane
P.O. Box 1910
Studio City, CA 91614-0910
818-985-9151
Fax: 818-508-5187

Shake
Shake Books
449 12th St., #2-R
Brooklyn, NY 11215
718-499-6941

Shambhala
Shambhala Publications
Horticultural Hall
300 Massachusetts Avenue
Boston, MA 02115
800-733-3000

Shapolsky
S.P.I. Books/Shapolsky Publishers, Inc.
136 West 22nd St.
New York, NY 10021
212-633-2022
Fax: 212-622-2123

Shaynew
Shaynew Press
P.O. Box 11719
San Francisco, CA 94101

Sheep Meadow
Sheep Meadow Press
P. O. Box 1345
Riverdale-on-Hudson, NY 10471
212-549-3321

Sierra Club
Sierra Club Books
730 Polk Street
San Francisco, CA 94109

Signature
Signature Books, Inc.
564 W. 400 N.
Salt Lake City, UT 84116-3411
800-356-5687
Fax: 801-531-1488

Signet
Signet Books
375 Hudson Street
New York, NY 10014

Silman-James
Silman-James Press
3624 Shannon Road
Los Angeles, CA 90027
213-661-9922
Fax: 213-661-9933

Simon & Schuster
Simon & Schuster Publishing
200 Old Tappan Road
Old Tappan, NJ 07675
800-634-2863

Skoob
Skoob Books Publishing Ltd.
15 Sicilian Ave., Southampton Row
London, WCIA 2QH
UK
071-4043063
Fax: 071-4044398

Sky
Sky Books
P.O. Box 769
Westbury, NY 11590

SLG
Slave Labor Graphics Publishing
325 S. First St. #301
San Jose, CA 95113
800-866-8929

Sly Ink
Sly Ink
c/o Floradale Productions Inc.
c/o Gary Allen Pty Ltd.
9 Cooper St.
Smithfield, NSW
Australia
02-725-2933

Smart Art
Smart Art Press
2525 Michigan Ave., Bldg. C
Santa Monica, CA 90404
310-264-4678
Fax: 310-264-4682

Smith
Bradley R. Smith
P.O. Box 3267
Visalia, CA 93278
Fax: 209-733-2653

Smithsonian Institution
Smithsonian Institution Press
P.O.Box 960
Washington Institution Press
Herndon, VA 22070-0960
800-782-4612

Society for the Diffusion of
Useful Information
Society for the Diffusion of Useful
Information
9341 Venice Blvd.
Culver City, CA 90232-2621

Society for Sufi Studies
The Society for Sufi Studies
BM/Sufi Studies
London WCIV6XX
UK

Sourcebook Project
Sourcebook Project
PO Box 107
Glen Arm, MD 21057
410-668-6047

South End
South End Press
116 Saint Botolph Street
Boston, MA 02115
800-453-0075

Spring
Spring Publications
299 East Quasset Road
Woodstock, CT 06281-3308

Springer-Verlag
Springer-Verlag Publishers
175 Fifth Avenue
New York, NY 10010
800-SPRINGER
Fax: 212-553-3503

St. Martin's
St. Martin's Press
175 Fifth Avenue
New York, NY 10010
800-221-7945
Fax: 212-995-2584

Stabur
Stabur Press
11904 Farmington Road
Livonia, MI, 48150

Stackpole
Stackpole Books
5067 Ritter Road
Mechanicsburg, PA 17055
800-732-3669
Fax: 717-796-0412

Stanford University
Stanford University Press
Stanford, CA 94305-1593
415-723-1593
Fax: 415-725-3457

Stein and Day
Stein and Day Publishers
Scarborough House
Briarcliff Manor, NY 10510

Steiner
Steinerbooks
5 Garber Hill
Blauvelt, NY 10913

Sterling
Sterling Publishing Co., Inc.
387 Park Avenue South
New York, NY 10016-8810
800-542-7567

STH
STH-The Manhattan Review of
Unnatural Acts
P.O. Box 20424
New York, NY
10023

Stoeger
Stoeger Publishing Company
5 Mansard Court
Wayne, NJ 07470
201-872-9500
Fax: 201-872-2230

Storm
Storm
P.O. Box 3527
Portland, OR 97208
503-790-0677
Fax: 503-790-0677

Sub Rosa
Sub Rosa Records
P.O. Box 808
cm 1000 Brussels
Belgium

Subway and Elevated
Subway and Elevated Press
Company
P.O. Box 377653
Chicago, IL 60637
312-363-4516

Sun
Sun Publishing Company
P. O. Box 5588
Santa Fe, NM 87502-5588
505-471-6151
Fax: 505-988-2033

Sun and Moon
Sun and Moon Press
P. O. Box 481170
Los Angeles, CA 90048-9377
213-653-6711

SUNY
State University of New York Press
750 Cascadilla Street
Ithaca, NY 14850
800-666-2211

Survival Research Laboratories
Survival Research Laboratories
Video
1458C San Bruno Ave.
San Francisco, CA
94110
Fax: 415-641-8065

Synthesis
Synthesis
c/o AK Press

Syracuse University
Syracuse University Press
1600 Jamesville Ave.
Syracuse, NY 13244-5160
800-365-8929
Fax: 315-443-5545

Tal San
Tal San Publishing
7614 West Bluefield Ave.
Glendale, AZ 85308-8222
602-843-1119
Fax: 602-843-3080

Tan
Tan Books and Publishers
P.O. Box 424
Rockford, IL 61105

Tarcher
Jeremy P. Tarcher, Inc.
9110 Sunset Blvd.
Los Angeles, CA 90069
213-273-3274

Tartarus
Tartarus Press
5 Birch Terrace, Hangingsbirch
Lane
Horam, E. Sussex TN21 0PA
UK

Taschen
Benedikt Taschen Verlag
c/o Last Gasp

Telos
Telos Press, Ltd.
431 East 12th Street
New York, NY 10009
212-228-6479
Fax: 212-228-6379

Temple
Temple Press, Ltd.
P.O. Box 227
Brighton, Sussex BN2 3GL, UK
0273-679129
Fax: 0273-621284

Temple University
Temple University Press
1601 N. Broad St.
Philadelphia, PA 19122-6099
800-447-1656
Fax: 215-787-4719

Tetrahedron
Tetrahedron Industries, Inc.
P.O. Box 402
Rockport, MA 01966
800-336-9266
Fax: 508-546-9226

Thames and Hudson
Thames and Hudson, Inc.
500 Fifth Avenue
New York, NY 10110
800-233-4830
Fax: 212-398-1252

Third World
Third World Press
7524 S. Cottage Grove Avenue
Chicago, IL 60619-1999
312-651-0700
Fax: 312-651-0703

Thunder's Mouth
Thunder's Mouth Press
7th Floor
632 Broadway
New York, NY 10012
212-226-0277
Fax: 212-226-7682

Tiare
Tiare Publications
P. O. Box 493
Lake Geneva, WI 53147
414-248-4845

Timber
Timber Press, Inc.
Haseltine Bldg.
133 SW 2nd Ave.
Suite 450
Portland, OR 97204-3527
800-327-5680
Fax: 503-227-3070

Times
Times Books
400 Hahn Road
Westminister, MD 21157
800-733-3000

Times Change
Times Change Press
P.O. Box 1380
Ojai, CA 93024-1380

Titan
Titan Books
42-44 Dolben Street
London SEl OUP
UK
0171 620 0200
Fax: 0171 620 0045

Touchstone
Touchstone Books
c/o Simon and Schuster

Trafalgar Square
Trafalgar Square
PO Box 257, Howe Hill Road
North Pomfret, VT 05053
800-423-4525
Fax: 802-457-1913

Trans-High
Trans-High Press
c/o AK Press

Transaction
Transaction Publishers
Rutgers
The State University
New Brunswick, NJ 08903
201-932-2280

Transform
Transform Press
P.O. Box 13675
Berkeley, CA 94712

Tray Full of Lab Mice
Tray Full of Lab Mice Publications
c/o Melissa and Matt Jasper
P.O. Box 303
Durham, NH 03824

Tsurisaki Kiyotaka
Tokyo, Japan
Fax: 3339-4767
alvaro@wa2.s0-net.or.jp

SOURCES

Tuttle
Charles E. Tuttle Company, Inc.
28 South Main Street
Rutland, VT 05702-0410
800-526-2778

Twin Palms
Twin Palms Publishers
401 Paseo de Peralta
Santa Fe, NM 87501
505-988-5717

Tyndale
Tyndale House Publishers
351 Executive Drive
Carol Stream, IL 60188
800-323-9400

Unarius
Unarius Publications
145 S. Magnolia Avenue
El Cajon, CA 92020-4522
800-824-6741

Universal Electronics
Universal Electronics, Inc.
4555 Groves Road, Suite 12
Columbus, OH 43232
614-866-4605

Universal Force Dynamics
Universal Force Dynamics Publishing
P.O. Box 410
Leavenworth, KS 66048
913-651-8148

University Galleries
Illinois State University-University
Galleries
Campus Box 5620
110 Center for the Visual Arts
Normal, IL 61790-5620
309-438-5487

University of Alabama
University of Alabama Press
Box 870380
Tuscaloosa, AL 35487-0380
800-825-9980

University of California
University of California Press
2120 Berkeley Way
Berkeley, CA 94720
800-777-4726

University of Chicago
University of Chicago Press
5801 South Ellis Avenue
Chicago, IL 60657
312-702-7723

University of Hawaii
University of Hawaii Press
2840 Kolowalu Street
Honolulu, HI 96822
808-956-6214

University of Illinois
University of Illinois Press
1325 South Oak Street
Champaign, IL 61820
217-333-0950

University of Kentucky
663 South Limestone Street
Lexington, KY 40508-4008
800-839-6855
Fax: 800-870-4981

University of Massachusetts
University of Massachusetts Press
P.O. Box 429
Amherst, MA 01004
413-545-2217

University of Minnesota
University of Minnesota Press
2037 University Ave. S.E.
Minneapolis, MN 55414
800-621-2736

University of Nebraska
University of Nebraska Press
312 North 14th Street
Lincoln, NE 68588-0484
800-755-1105

University of North Carolina
University of North Carolina Press
P.O. Box 2288
Chapel Hill, NC 27515-2288
800-272-6817

University of Oklahoma
University of Oklahoma Press
P.O. Box 787
Norman, OK 73070-0787
800-627-7377

University of Tennessee
University of Tennessee Press
Chicago Distribution Center
11030 S. Langley
Chicago, IL 60628
800-621-2736

University of Texas
University of Texas Press
P.O. Box 7819
Austin, TX 78713-7819
800-252-3206

University of Toronto
University of Toronto Press
10 St. Mary Street
Suite 700
Toronto, ONT
Canada M4Y 2W8
800-565-9523
416-978-4738

University of Washington
University of Washington Press
P.O. Box 50096
Seattle, WA 98145-5096
800-441-4115
Fax: 206 543 3932

Univ. Press of Kansas
University Press of Kansas
2501 W. 15th St.
Lawrence, KS 66049-3904
913-864-4155
Fax: 913-864-4586

Univ. Press of Kentucky
University Press of Kentucky
663 South Limestone Street
Lexington, KY 40508-4008
800-839-6855

Univ. Press of New England
University Press of New England
23 S. Main St.
Hanover, NH 03755-2048
800-643-7110
Fax 603-643-1540

Univ. Press of Virginia
University Press of Virginia
Box 3608 University Station
Charlottesville, VA 22903-0608
804-924-3469
Fax: 804-982-2655

Upper Access
Upper Access Books
P. O. Box 457
Hinesburg, VT 05461
800-356-9315
V/Search
V/Search Publications
20 Romolo #B
San Francisco, CA 94133
415-362-1465

Veritas
Veritas Publishing Co. Pty. Ltd.
P.O. Box 42, Cranbrook
Western Australia 6321
Fax: 61-98-26-8051

Verso
Verso
180 Varick Street
New York, NY 10014
212-629-8549
Fax: 212-563-2269

Vestal
The Vestal Press, Inc.
P.O. Box 97
Vestal, NY 13851-0097

Victoria House
Victoria House Press
67 Wall St.
New York, NY 10005
212-809-9090
Fax: 212-809-9087

Viking
Viking Press
357 Hudson Street
New York, NY 10014

Vintage
Vintage Books
201 East 50th Street
New York, NY 10022
212-572-2428
Fax: 212-572-6045

Virgin
Virgin Books
338 Ladbroke Grove
London W10 5AH, UK
081-968-7554
Fax: 081-968 0929

Visible Ink
Visible Ink Press
P.O.Box 33477
Detroit, MI 48232-5477
800-776-6265

VIVO
Vivo
c/o AK Press

Viz
Viz Communciations, Inc.
P.O. Box 77010
San Francisco, CA 94107
415-546-7073
Fax: 415-546-7086

W.B. Saunders
W.B. Saunders Co.
Independence Square West
Philadelphia, PA 19106
215-238-7857

W.H. Allen/Virgin
W.H. Allen and Co.
PLC 44 Hill Street
London W1X 8LB, UK
01-493-6777

Warner
Warner Books
1271 Ave. of the Americas
New York, NY 10020-1393
212-522-7200
Fax: 212-522-7990

Washington Square
Washington Square Press
c/o Pocket Books

Waveland
Waveland Press, Inc.
P.O. Box 400
Prospect Heights, IL 60070

Weatherhill
Weatherhill, Inc.
568 Broadway
Suite 705
New York, NY 10012
800-437-7840

Weiser
Samuel Weiser, Inc.
Box 612
York Beach, ME 03910-0612
800-423-7087

Weisman
Weisman Publications
11751 W. Riverhills Dr. #107D
Burnsville, MN 55337

Wergo
Wergo Schallplatten Gmbh
Mainz, Germany

Wesleyan University
Wesleyan University Press
23 South Main Street
Hanover, NH 03755-2048
603-643-7100

Westgate
Westgate Press
5219 Magazine Street
New Orleans, LA 70115

Westview
Westview Press
5500 Central Avenue
Boulder, CO 80301-2877
800-456-1995

White Buffalo
White Buffalo
P.O. Box 9972
Memphis, TN 38190

White Lotus
White Lotus Co., Ltd.
16 Soi 47 Sukhumvit Road
GPO Box 1141
Bangkok 10501, Thailand
662-2587219
Fax: 662-258-7217

Wildfire Club
The Wildfire Club
9 Eagle Lane
Snarebrook, London E 11, UK

Wiley
John Wiley and Sons, Inc.
605 3rd Ave.
New York, NY 10158-0012
212-850-6000
Fax: 212-850-6088

Winston-Derek
Winston-Derek Publishing Group
PO Box 90883
Nashville, TN 37209
800-826-1888
Fax: 615-329-4824

Woodford House
Woodford House Publishing Ltd.
110 Chertsey Court, Clifford Ave.
London SW14 7BX, UK

Writers and Readers
Writers and Readers
Box 461-Village Station
New York, NY 10014

Yale University
Yale University Press
P.O. Box 209040
New Haven, CT 06520-9040
800-777-9253

Ziggurat
Ziggurat Books
P.O. Box 1767
Collingswood, Victoria
3066 Australia

Zone
Zone Books
611 Broadway
Suite 608
New York, NY 10012
800-356-0343